WORLD ARTISTS

1980–1990

Biographical Reference Books from
The H. W. Wilson Company

Greek and Latin Authors 800 B.C.–A.D. 1000
European Authors 1000–1900
British Authors Before 1800
British Authors of the Nineteenth Century
American Authors 1600–1900
Twentieth Century Authors
Twentieth Century Authors: First Supplement
World Authors 1950–1970
World Authors 1970–1975
World Authors 1975–1980
World Authors 1980–1985

The Junior Book of Authors
More Junior Authors
Third Book of Junior Authors
Fourth Book of Junior Authors and Illustrators
Fifth Book of Junior Authors and Illustrators
Sixth Book of Junior Authors and Illustrators

Great Composers: 1300–1900
Composers Since 1900
Composers Since 1900: First Supplement
Musicians Since 1900
American Songwriters

World Artists 1950–1980

American Reformers
Facts About the Presidents

Nobel Prize Winners

World Film Directors: Volumes I, II

WORLD ARTISTS
1980–1990

An H. W. Wilson Biographical Dictionary

Edited by
CLAUDE MARKS

THE H. W. WILSON COMPANY
NEW YORK
1991

Library of Congress Cataloging in Publication Data

Main entry under title:

World artists, 1980–1990 : a volume in the Wilson biographical series /
editor, Claude Marks.
 p. cm.
 ISBN 0-8242-0827-7
1. Artists—Biography. 2. Art, Modern—20th century.
 I. Marks, Claude.
 N6489.W67 1991
 709´.2´2—dc20
 [B]

91-13183
CIP

PRINTED IN THE UNITED STATES OF AMERICA

CONTENTS

List of Artists Included .. vii

Preface .. ix

Key to Pronunciation .. xii

Biographical Sketches .. 3

Photo Credits ... 414

Artists Included

Acconci, Vito ... 3
Alberts, Julien ... 7
Anderson, Laurie 11
Anselmo, Giovanni 15
Antes, Horst ... 18
Applebroog, Ida 21
Arman .. 23
Arneson, Robert 29
Arroyo, Eduardo 33
Artschwager, Richard 40
Auerbach, Frank 46
Aycock, Alice .. 49
Azaceta, Luis Cruz 53
Baldessari, John 56
Barceló, Miguel 60
Bartlett, Jennifer 63
Basquiat, Jean Michel 67
Bates, David .. 69
Beckmann, Max 71
Benglis, Lynda 77
Bleckner, Ross 80
Borofsky, Jonathan 83
Broodthaers, Marcel 87
Bury, Pol ... 92
Chase, Louisa 95
Chia, Sandro .. 97
Chicago, Judy 100
Clemente, Francesco 103
Coe, Sue .. 105
Colescott, Robert H. 108
Combas, Robert 111
Cragg, Tony .. 115
Curtis, Philip, C. 117
Dawson, John 120
De Forest, Roy 122
Di Rosa, Hervé 125
Dokoupil, Jiavri Georg 129
Fetting, Rainer 132
Fischl, Eric ... 135
Flanagan, Barry 138
Frank, Mary .. 140
Freilicher, Jane 143
Garouste, Gerard 148
Gilbert & George 151
Golub, Leon .. 157
Gonzalez, Patricia 161
Graves, Nancy 164
Haring, Keith 170
Heizer, Michael 173
Hesse, Eva ... 176
Hodgkin, Howard 179
Hoff, Margo .. 181
Holzer, Jenny 186
Honegger, Gottfried 190

Horn, Rebecca 193
Hunt, Bryan .. 197
Insley, Will ... 200
Jenney, Neil ... 204
Kiefer, Anselm 206
Koons, Jeff ... 210
Kossoff, Leon 213
Kosuth, Joseph 215
Kounellis, Jannis 219
Kruger, Barbara 223
Le Gac, Jean .. 225
Levine, Sherrie 229
Long, Richard 232
Longo, Robert 234
Longobardi, Nino 238
López-Garcia, Antonio 241
Lüpertz, Markus 243
Mahaffey, Merrill 248
Marden, Brice 252
Mendieta, Ana 255
Merz, Mario .. 257
Middendorf, Helmut 263
Miller, Richard 266
Moroles, Jesus Bautista 268
Moskowitz, Robert 272
Murray, Elizabeth 274
Paik, Nam June 277
Penck, A. R. ... 281
Pepper, Beverly 286
Pfaff, Judith .. 289
Poirier, Anne & Patrick 292
Polke, Sigmar 295
Rego, Paula .. 298
Richter, Gerhard 300
Ringgold, Faith 304
Rockburne, Dorothea 308
Rothenberg, Susan 312
Rousse, Georges 315
Ruscha, Edward 319
Ryman, Robert 323
Salle, David .. 326
Salomé .. 331
Samaras, Lucas 333
Schnabel, Julian 337
Schneemann, Carolee 339
Scholder, Fritz 342
Schönebeck, Eugen 346
Scott, Tim ... 347
Serra, Richard 349
Shapiro, Joel .. 354
Sherman, Cindy 357
Simonds, Charles 360
Slater, Gary .. 364
Soto, Jesús Rafael 366

Stämpfli, Peter369
Sugarman, George............................372
Sultan, Donald..................................375
Swartz, Beth Ames............................378
Taaffe, Philip....................................382
Twombly, Cy....................................385
Van Elk, Ger....................................388

Voulkos, Peter392
Waid, Jim...395
Walker, John398
Wegman, William...............................402
Westermann, H. C.405
Woodrow, Bill408
Yarber, Robert..................................411

PREFACE

IN THE 1950s, THE OPENING DECADE of the period covered in the previous volume of *World Artists*, the veterans of European modernism—Picasso, Braque, Matisse, Miro, Duchamp—were still alive. The leaders of the New York School—Pollock, de Kooning, Kline, Rothko, and in sculpture David Smith—had added a new dimension to the international art scene, with much of the energy emanating from the United States. There was already by the late 1950s a "second generation" of abstract expressionists, including such notable painters as Joan Mitchell and Helen Frankenthaler. Then came post-painterly abstraction, pop, minimalism, photo-realism, postminimalism, performance art, conceptualism, neoexpressionism, neo-geo, and other novel forms of expression, in which, to use Marshall McLuhan's terminology popular in the 1960s, the "cool," ironic detachment of Duchamp was a far more pervasive influence than the "hot" subjectivity and the "heroic" stance of the action painters, or the high drama of Picasso. (On hearing of the death of Duchamp in 1968, Picasso remarked simply, "Il avait tort"—he was wrong!)

The speed with which each new trend was embraced, not only by the cultural establishment but also by the worlds of commerce, industry, and fashion—very different from the hostility encountered by progressive artists on both sides of the Atlantic early in this century—has led to widespread doubts as to whether the concept of the "avant-garde" (a term originally associated with warfare) has any meaning today. It has been claimed that modernism, the movement in the arts that began roughly with Manet, and which offered a new and challenging reshaping of the world, has run its course—thus the ambiguous term "postmodernism," which has become a watchword for the decade covered in the present volume.

Since any artistic activity is inevitably a reflection of society, the grab-bag of styles and techniques that proliferate today surely tells us something about the state of flux in all things now. The pluralism that characterized the years from 1950 to 1980 was in most instances a sign of vitality, and so it should be today, provided that each art, or anti-art, form stems from genuine conviction, not from a "what shall we do now?" attitude. Nietzsche, writing at the beginning of the modern movement in art, spoke of the "Umwertung aller Werte," the revaluation of all values. However, what has been seen all too often in recent years is the *de*valuation, amounting to a trivialization, of all values, especially in many of Duchamp's artistic descendants (apart from the truly inventive Rauschenberg and Johns) who inherited his skepticism and seeming nihilism without his wit, intellect, and cultural background. Andy Warhol with his repetitive imagery cleverly pinpointed the desensitizing components of a consumer society lit by cool cathode rays from the TV screen, yet deliberately and perversely made himself part of the problem. But at least he was making a valid point, whereas some of his progeny, much publicized and working on an enormous scale, seem to be scornfully celebrating the "pointlessness of pointlessness," the assumption of an underlying chaos, deconstruction carried to its ultimate silliness and self-contradiction. Cultural fragmentation carries with it a lack of real commitment and an intentional hollowness.

Amid so much cynicism and exploitation, there are still grounds for hope, es-

pecially if those truly concerned with art cast their nets as widely as possible. It is admittedly a formidable challenge to attempt an overview of today's art scene—the necessary perspective is lacking—but it is to be hoped that from this volume of *World Artists* certain positive factors will emerge. Among internationally known figures the most significant are those who have internalized their experience, and who, nourished by a rich cultural heritage, have the inner resources, imagination, and energy to allow for growth and renewal. Artists of the stature of Sandro Chia and Anselm Kiefer enlarge and deepen our vision, and reaffirm our basic humanity. Even Julian Schnabel, whose work can be alternately shrill or bumptious, displays a powerful commitment to the medium and a conviction that painted imagery can speak to the human condition with the blow-to-the-solar-plexus immediacy of punk rock and the brutal honesty of literature like Hubert Selby's *Last Exit to Brooklyn*.

In the United States some of the boldest and most provocative statements have been made by women—Elizabeth Murray with her brilliantly diverse assemblages, Susan Rothenberg with her dense, careful brushwork and imagery that is most poetic when it seems most hard won, Jenny Holzer's startling and ironic use of electronic signs flashing ambiguous messages, Barbara Kruger and her incisively captioned "advertising" works, and Judy Chicago with her bold feminist approach. The rough world of graffiti, first explored by Jean Dubuffet in Paris in the aftermath of the Second World War, contributed to the potent imagery in the work of two artists whose careers were tragically brief, Keith Haring and Jean-Michel Basquiat. In artists of Afro-American and Hispanic origin there is often an urgency which makes such academic labels as "postmodern" seem irrelevant. Artists of the developing world will surely have much to contribute as we approach the 21st century, and who can predict what the rapidly evolving societies of Eastern Europe may have in store?

With regard to the United States, the selection of artists in this volume has not been confined to New York. Exciting work is being done in the Southwest and in other parts of the country—John Dawson in Arizona is an example—and some of New York's most prominent artists are from the West Coast or from the Midwestern heartland. Eric Fischl and David Salle, both graduates of Cal Arts outside of Los Angeles, come to mind in this regard, as does Jeff Koons from York, Pennsylvania. The New York scene would indeed be poorer without the work of several other artists untouched by the publicity mills of the prevailing commercialism but possessing the true creative spark, among them the late Julien Alberts, Richard Miller, and the late Ana Mendieta, a Cuban-born artist.

Two of the artists included in *World Artists 1980–1990* would at first glance appear to be anachronisms in this volume: Max Beckmann, who died in 1950, and Eva Hesse, who died in the middle of the 1970s. However, both of those artists exerted a strong influence on recent work, especially Beckmann, whose myth-laden painted narratives inspired many of the neoexpressionists of the 1980s. Moreover, inasmuch as Beckmann and Hesse were alive in the period covered by the foundation volume in this series (1950–80), it was felt that the anachronism of their inclusion in the 1980–1990 volume would be more than justified by the greater comprehensiveness of the *World Artists* series.

World Artists 1980–1990 would not have been possible without the participa-

tion of such enthusiastic and perceptive contributors as Eleanor F. Wedge, Eva S. Jungermann, Steven Anzovin, and Miriam Rosen.

Inevitably there have been omissions in such a wide-ranging undertaking. With regard to future developments, it may well be that the growing concern for the environment and the survival of planet Earth, as well as the exploration of outer space, will generate new approaches, involving syntheses of painting, sculpture, architecture, photography, and possibly desktop computer video that we can barely imagine. In art, as Picasso once said, "You can never write 'The End.'"

Claude Marks
New York, 1990

KEY TO PRONUNCIATION

ā	āle	ō	ōld		*menu* (mə-nü); German ü, as in *grün*
â	câre	ô	ôrb		
a	add	o	odd		
ä	ärm	oi	oil		
		o͞o	o͞oze	ə	the schwa, an unstressed vowel representing the sound that is spelled
ē	ēve	o͝o	fo͝ot		
e	end	ou	out		
					a as in sofa
g	go	*th*	*then*		e as in fitted
		th	thin		i as in edible
ī	īce				o as in melon
i	ill	ū	cūbe		u as in circus
		û	ûrn; French eu, as in *jeu* (zhû), German ö, *oe*, as in *schön (shûn), Goethe* (gû′te)		
κ	German *ch* as in *ich* (iκ)				
				zh	azure
N	Not pronounced, but indicates the nasal tone of the preceding vowel, as in the French *bon* (bôN)	u	tub		
		ü	Pronounced approximately as ē, with rounded lips: French u, as in	′	= main accent
				″	= secondary accent

KEY TO ABBREVIATIONS

Am.	American	inst.	institute
cntr.	center	instn.	institution
ca.	circa	MOMA	Museum of Modern Art
col.	college	NYC	New York City
gal.	gallery	univ.	university

WORLD ARTISTS

1980–1990

*ACCONCI, VITO (January 24, 1940–), American sculptor, installation and performance artist, has systematically examined the media intentions and distribution systems of contemporary art, adopting and rejecting them in an ongoing inquiry into what constitutes, and should constitute, the relationship between artist and viewer. In choosing to create performance and installation works, and in avoiding the conventional methods and media of fine art, Acconci sought to question the communicative powers of accepted formal elements—figuration, representation, and later even his own use of site and sound components, and to this end he has often been deliberately confrontational with his audience and the commercial art establishment. Though his works have been for the most part too controversial or unwieldy to find homes in major collections, he is widely known for the uninhibited and vigorous nature of his inquiry. Most recently, Acconci has put aside his overtly sexual or outrageous designs in favor of constructions that are much more like conventional sculpture, architecture, and even furniture, and that fit relatively smoothly into the aesthetic, if not the commercial, mainstream. His avowed purpose with those quieter works is to provoke thought, not through confrontation, but by causing subtle "double-takes" that make the viewer see the everyday world anew through juxtapositions of the commonplace and the unexpected.

Acconci's development as a visual artist, which began in 1969 when he turned from composing poetry on the page to creating performance and installation works in the "real" world, has been a series of carefully reasoned steps; he was called by one critic a "classic dialectician" for the cerebration behind each choice. Conflict and contradiction have engaged Acconci since he was a child growing up in the Bronx. He has recounted writing stories about such subjects as two brothers fighting on opposite sides during the Civil War; at that point in his career he resolved conflict "by killing everybody off at the end of the story." He applied a more considered approach to aesthetic dialectic after he returned to New York City in the late 1960s, having received his undergraduate degree in writing from Holy Cross College in Massachusetts and an M.F.A. degree from the writing program at the University of Iowa. In New York he attended poetry readings and happenings staged by the Fluxus group and others artists who drew a distinction between poetry, which confined one to the nonliteral expanse of the page, and actual events, which combined actions with the printed word. Acconci has said that his conversion from poet to visual artist came when he realized that he did not want to guide people from one side of the page to the other, but from one side of the room to the other. It seemed to him that the former act was a pale shadow of the latter.

It has been suggested that because he came from outside the visual arts, Acconci was able to identify, and chose to pursue, that which he has called "what all the arts have in common—the author mediating between object and viewer." The focus on the creative act, as opposed to the product, was an emphasis of visual art, a field Acconci saw to be "without parameters." He was "jolted" by the paintings of Jasper Johns which treated letters and numbers and flags as subject matter; out of context, those figures ceased to be meaningful symbols and became instead "flat objects," a conversion that seemed to Acconci to be "just perfect."

Greatly concerned with such procedural honesty, in which metaphor did not obscure the real presence or action of the artist, Acconci was also drawn to the works of minimalists such as Donald Judd and Richard Serra. Their site-specific installations eliminated internal details and conventions of sculptural representation so that the viewer remained constantly aware of the very fact of the piece's existence and the artist's activity instead of being referred to a specific formal concern or subject matter. The minimalists had cut through what Acconci saw as a major problem of the time: that art objects had become salable commodities, far removed from their creators and available only to those who could

afford to buy them or had the education to visit museums. Acconci immediately committed himself to artistic activity that would not result in salable works and that would keep him "present" for his audience, and he fulfilled that commitment in what some have considered an extreme fashion.

One of Acconci's first visual pieces was the *Following Piece* of 1969, part of the "Streetworks" series sponsored by the Architectural League of New York. Acconci followed strangers around the city for minutes or hours, documenting his surreptitious movements with photographs as he trailed his subjects until they entered a private place that Acconci could not, such as a home or an office. The intended aesthetic focus of the work was not the collection of photos that resulted, but rather Acconci's choice to follow. "My work is not about space," he wrote, "but about the act of making a space."

In 1970 Acconci created a piece that addressed the issue of how to connect museum space with what he called "everyday" space. At the Museum of Modern Art's "Information" show, he arranged to have all his mail forwarded to a spot in the museum. Acconci would come in each day to open his mail. He characterized such early pieces as enactions of a concise formula: "I—an agent—attend to IT—the world outside," a very literal attempt to tie himself to a universe outside the art world.

Acconci wrote of that approach that he would focus on himself as the instrument that acted on whatever ground was "from time to time available," setting himself up as "the receiver of an action/condition that's already occurring outside me." When he realized, shortly thereafter, that behind every art work there is necessarily *some* self, he decided to "push the self up to the foreground," recasting his formula as "I attend to ME." The "me" became the ground onto which Acconci would work, as though his particular personality were negligible and as though only carefully chosen actions represented the artist. Dick Higgins, a performance artist, has described the trend among artists of the late 1960s away from maintaining highly consistent and personal public image and toward focusing on the work, not the worker: "There is an unwillingness to impose oneself needlessly on the materials with which one is working," he wrote. Instead, "one is what one does." Acconci "did" himself, making himself the central subject and object of his work until the mid-1970s.

His works manipulated his naked body and those of his friends and lovers, using traditionally taboo verbal and visual content. In 1970, for example, he created a piece called *Conversion* in which, by depilating his chest and pulling on his own nipples, he symbolized conversion into a woman. Acconci cited the sheer concentration and futility of that pursuit (he disdained shaving his chest for the piece because that "would have been too quick and easy") as its basic point, and compared his work to that of Samuel Beckett, who also portrayed "the person alone with nothing but himself [who] works on himself." In other works, Acconci bit himself repeatedly and forced his hand down his own throat until he gagged.

Like other body artists of the time (Chris Burden, Dennis Oppenheim), Acconci employed his own body to counteract the influence of entrenched media and commercial methods, but body art was seen by many to consist primarily of attention-grabbing affectations. The critic Max Kosloff said: "The artistic search for indecency has often been justified by the need to lacerate the repressions that numb genteel order. But I believe that the urge to disassociate and depersonalize the body, to split it from awareness, flirts with a more profound indecency—since it leads to considering others as less than human." Though Acconci still maintains that the purpose of his works never was to shock his audience, and that the use of his own body was designed to cut out the material object that had always stood between artist and viewer in Western art, Acconci did feel by 1970 that he had turned his viewer into a voyeur, and that his work had become a closed circle of watcher and watched. To solve that inequity, he once again revised his working formula to bring in other persons: "I focus on HIM, HE focuses on ME."

At first, the other participants were actors, brought in by Acconci to enact such works as *Association* (1970), in which a blindfolded, deafened couple communicated by a sort of tactile ESP. But by 1971 Acconci had reached a point where he wished to involve the audience directly, and thus he created what were to be seen as some of his most aggressive and controversial works. In *Telling Secrets* Acconci stationed himself on a deserted pier every night between 1:00 A.M. and 2:00 A.M. and offered to anyone willing to join him there secrets "which could have been totally detrimental to me if revealed." In *Claim* he stood at the bottom of a stairwell in a SoHo gallery wielding a crowbar and broadcasting violent threats through a video monitor placed in the gallery upstairs. Speaking of that performance some years later, Acconci insisted that he was simply trying to make contact with his audience, and that such threats seemed the most direct way to do so. The difficulty with that was that it still kept the artist in a position of superiority over his audience, and what Acconci want-

ed instead was to reduce utterly his presence. To that end, and some say naively, Acconci created what may be his most notorious work: *Seedbed* (1972).

In an empty, white-walled SoHo gallery, Acconci built a false floor that sloped up slightly toward one end. He lay quietly under the floor until a visitor to the gallery walked above him, at which time he would begin to masturbate, loudly voicing his sexual fantasies about the unseen visitor. He did that for eight hours a day for the duration of the exhibition. According to Acconci, his purpose was to unite the private and public spaces of the gallery, in fact to activate, like "a worm under the floor," a space that would otherwise be ignored. It has been suggested that the work also associates the creative and sexual acts, and delivers the message that, as Ellen Schwartz has described it, a "partner is necessary for any sexual/creative act." In any case, *Seedbed* was greeted with skepticism by critics and viewers, and his message may have been overwhelmed by his medium. Many of Acconci's works have been received as "dirty" above all else, and over the years his acknowledgment of their reception has been nonchalant, as though he has only slowly realized that such controversy in itself manipulates the viewer as much as any commercial or social intent.

What did bother Acconci, however, was that many of his works treated the artist as a precious object, even when, as in *Reception Room* of 1973, where he lay naked on a table in a Naples gallery reciting his physical flaws, he degraded himself. He began to see his work as self-psychologizing and avoiding cultural and political issues. He thereafter left himself out of his works, except by implication, and began to create works that reflected their contexts rather than their creator.

Acconci solidified at that time his interest in the way in which spaces were defined by the viewers' use of them, and how, as the work of the architect Robert Venturi had suggested to Acconci, once a space is made it can carry a symbol or sign that bears a message or propaganda: "When the viewer leaves the piece, both the shelter and propaganda it bears collapse." Several pieces, such as *Where We Are Now (Who Are We Anyway?)* (1976), combined simple elements such as tables and chairs in galleries to move people into specific experiences with one another. He also began to creating "vehicle-transporting and self-erecting architecture": In Holland, he set up the *People Mobile*, which traveled from town to town with a set of movable walls that could be assembled into a variety of structures. A tape, played over a loudspeaker, warned of terrorist activities. In *Instant House* of 1980 walls painted with American flags would rise up around a viewer seated on a swing, revealing Russian flags to those standing outside the structure. Acconci wanted to make his audience consider images or actions as propaganda, and not use propaganda to further any particular political cause. He has said that art, unlike any political system, has the luxury of "thickening the plot, having both sides at once."

But although *People Mobile* and *Instant House* were intended to respond to viewers' inclinations and convey the artist's neutrality, the critic Carrie Rickey saw such pieces as carrying forth Acconci's tendency toward "embedded stoogedom," always placing the viewer in the position of dupe and generally furthering the causes of celebrity and sexism. *Gang-Bang* and *High-Rise* might be cited in that regard. In the former, Acconci created nine penises and one breast that he placed on top of ten small cars. As the nine penises chased the breast around a small European town, air rushing into the hollow appendages would inflate and erect them. In *High-Rise* the participant, through his own strength, hauled a cart across the length of the gallery, and as he did so a twenty-five-foot plastic "apartment house" with a large penis drawn on the side was erected by pulleys. As the tower grew, it took more strength to pull it up, mimicking society's attribution of a man's worth to his sexual prowess. In the most careful interpretation, those works may indeed act as cultural criticism, but the humor that Acconci hoped would incline people toward such generous introspection was lost on many viewers. Acconci ultimately realized that, and went on in the early 1980s to put aside the overt sexual references that had alienated the general public he sought to reach.

Acconci's emphasis became far more formal and less flamboyant at that point, but he continued to compose his installations from ordinary objects and materials, such as slingshots and bicycles, or cables and corrugated metal. Those elements were at first manipulated by gallery visitors, and with humor; in *Trailer Camp,* pink and blue bicycles pulled collapsed camouflage tents from opposite directions, revealing pink panties drying on a line at one end and blue long johns at the other. Several pieces involved walls that could be moved by viewers, perhaps the most ambitious being *Sub-Urb* (1983), an outdoor installation of a long, narrow house shape submerged upside down below sliding panels that formed an American flag when put together. The viewer could walk down stairs between these panels and move through small compartments encountering a series of stained animal silhouettes and word pairs such as "evolu-

tion/revolution," "sow/forage," or "father/patricide." With that piece, the house finally replaced Acconci's own body as his symbolization of society.

Among Acconci's house works were *House of Cars* (literally, a small set of apartments made from three cut up and reconnected cars), and *Bad Dream House,* two upside-down house shapes supporting a third right side up. Such mundane materials as false brick, vinyl, and Astroturf became his materials of choice as Acconci became thoroughly involved with twisting and playing upon the American dream of material wealth. By 1984 he had taken on the most familiar of American icons for his restatement: household furniture. *Sleeping Dog Couch* is a couch shaped like a sleeping dog; *Earth Face* is an oversize face onto which one can crawl and sit; and *People's Wall* and *Head Storage* are similarly direct renditions of common objects in the shape of seemingly arbitrary, nonfurniture objects. They are all manufactured with the materials and methods of real furniture, and they invite the viewer to sit and climb and, basically, live with them. But the twists and metaphors abound—the *Sleeping Dog Couch* has a red a leather belly that is a nasty reminder of where the leather came from. *Earth Face,* when covered with people, appeared to one writer as a skull crawling with insects, and many of the vertical pieces, while initially appearing accessible with their people-shaped niches, actually require strange contortions to penetrate.

Silvia Kolbowski, noting Acconci's use of quilted polyester, mirrors, and "hacienda-style facades," called those pieces "raunchy art, amorous of urban kitsch, evoking our collective slumming in Americana," hinting again at an elitist sarcasm on Acconci's part, but she saw the work as nonetheless successful in "its urge to employ [those materials] as a dialectic for public work." Acconci has said that it is still of utmost importance that his work engage the widest possible audience, and his recent works do draw in the viewer as though into the artist's own living room or, in the case of outdoor installations, his backyard.

Acconci recently said that his ideal piece would tie in very closely to things already extant in the world, but that through use they would bring us to a "shaky ground" where we would question their form and meaning. Where he once shunned the pursuit of beauty and decoration as being a way of hiding from more difficult issues, Acconci now uses a certain technical finesse to attract his audience. That shift to a subtle way of awakening his viewers' sensibilities has truly removed the artist from the pedestal he so strongly wishes to avoid, but, in achieving a kind of humility, it has also caused the artist to wonder if his work has lost some of its political punch; where his works may have formerly held "too much me," he has said, "now there is too little me." Throughout his career Acconci has wondered if he can moderate his presentation enough to attract an audience without losing his impact. Gruff-voiced, with thinning gray hair and disheveled clothing, Acconci has maintained a consistent if not stellar level of attention, seemingly preferring to pursue exposure through a considered and responsible relationship with the public rather than through the more lucrative channels of the commercial "art star." Though he has had two retrospectives at major museums and exhibits often, few enough of Acconci's works have been purchased so that he often leaves his New York home to speak and teach around the country, erecting temporary installations at universities and museums as he goes. Acconci came into the art world at a time when radical ideas, and inflammatory gestures of all kinds, were widespread. Now, through an evolving understanding of the public, Acconci ambitiously seeks a way to engage and move his audience in what seems, to him, to be a remarkably complacent and private period for Americans and American art.

EXHIBITIONS INCLUDE: Biennale, Mus. d'Art Moderne, Paris 1971; Documenta 5 Kassel, West Germany 1972; Sonnabend Gal, NYC since 1971; The Kitchen, NYC 1976, '78; Lerner-Heller Gal., NYC 1976; Ohio State Univ., Columbus 1977; School of Visual Arts, NYC 1977; Anthology of Film Archives, NYC 1977; Gal. Stample, Basel 1977; San Francisco Mus. of Art 1978; Kunstmus., Lucerne 1978; Retrospective, Stedelijk Mus., Amsterdam 1978; Young-Hoffman Gal., Chicago 1979; Gal. de Appel, Amsterdam 1979; "Acconci: A Retrospective 1969 to 1980," Mus. of Contemporary Art, Chicago; "Machineworks," Inst. of Contemporary Art, Philadelphia 1981; Mus. of Fine Arts, Montreal 1981; Univ. of Massachusetts, Amherst 1982; Virginia Mus. of Fine Arts, Richmond 1982; Whitney Mus. of American Art, NYC 1983; Nature Morte Gal., NYC 1984; Univ. of North Carolina, Chapel Hill 1985; Brooklyn Mus., NY 1985; Wadsworth Atheneum, Hartford, Conn. 1985; Palladium, NYC 1986; Kent State Univ., Ohio 1986; Zone Gal., NYC 1986; Internation Cntr. of Photography, NYC 1987; International with Monument, NYC 1987; "Concrete Crisis," Exit Art, NYC 1987; Barbara Gladstone Gal., NYC since 1989.

ABOUT: Diacono, M. Vito Acconci, 1976; Kirshner, J.R. and J.H. Neff "Vito Acconci: A Retrospective 1969 to 1980" (cat.), 1980; Lippard, L. Six Years: The Dematerialization of the Art Object From 1966 to 1972, 1973; Sayre, H. M. The Object of Performance, The American Avante-Garde Since 1970, 1989. *Periodicals*—Artforum November 1975, March 1979,

Summer 1980, Summer 1983, April 1990; Art in America January/February 1978, October 1980, December 1981, April 1984; ARTnews Summer 1981; Arts Magazine June/Summer 1985; Downtown Express August 20, 1990; East Village Eye October 1986; Flash Art Summer 1989; Interview v. 10, no. 5 1980, July 1990; New Art Examiner May 1, 1980; New York February 29, 1988; New York Times Magazine March 21, 1985.

ALBERTS, JULIEN (April 18, 1916–July 18, 1986), American graphic artist and painter, writes: "I entered this world in New York City, at home on Tremont Avenue and 181st Street in the Bronx, the fourth of five brothers. Nothing remains with me of these first years except that apparently my father owned a movie theater close by (the Orpheum?), which gave off a certain glamour in the shape of personal appearances by screen celebrities of the day—or so I was told.

"Subsequently my family moved to Yonkers, the first suburb in line up the Hudson River. These years, too, are shrouded in obscurity and ambiguity of outline. Perhaps this shifting sense of reality was to become a formative influence on my later work. In any case, our neighbors in the house next door were Richard Bennett, the famous actor, and his three to-be-famous daughters, Constance, Joan, and Barbara. It was reputed that I had an infantile tendresse for Constance, but that I caught whooping cough from Joan. There is also the recollection that my father came home one afternoon from New York at the wheel of a large black Pathfinder touring car, having been instructed in how to use it by the salesman (can this have been all the license one needed at that time to drive a car?) and we all forthwith set off to visit the Boston relatives. If this did in fact take place, apparently we survived the trip: the image of a chauffeur named Albert now materializes, complete with uniform, leather puttees, and a visored cloth cap. Did he double as the gardener? Or even the gamekeeper?

"Emerging (as they say) from an 'uneventful childhood' (I recall falling downstairs in my haste to get to the one 'boys' room' in the basement of P.S. 3, leaving a lifelong scar over my left eye; on the other hand, on the few occasions when, for whatever reason, I've been seduced into 'therapy' sessions, the operator always found it highly irregular that I couldn't give any clear definition of my parents!) I was sent to the Fieldston School, whose art department was run by Victor d'Amico, Peppino Mangravite, and the young Jack Tworkov. My interest in the visual arts was aroused to the point of composing arrangements of otherwise unrelated objects and

JULIEN ALBERTS

people, my premonition of surrealism. It would not be true, however, to say that I started my young life with an open commitment to becoming an artist. I was actually far more attracted to the written word, although on occasion combining the two interests into such essays as 'An Enquiry into the Nature of Modern Art' (published in the school literary magazine which I, inevitably, edited) which I blush to recall.

"This addiction to literature did, however, lead me to the visual arts, but by another route. At that time, to be a writer more often than not meant to write criticism. Wanting, therefore, to write criticism, and sufficiently involved with the visual arts to combine the two, and, further, having sense enough to want to write *from the inside*, on graduating from high school I started taking classes at the Art Students League in New York. By this time, the family fortune had disappeared in the first glorious dawn of the Depression, but my uncle Max had a sufficient amount of the green around and the commonsense to realize that it would do a sensitive youth no good to sit around the house waiting for nothing (it would be too much to assume that he recognized my talent)—and, after all, in 1933 not even Hoover still pretended that there were any jobs to be had. So he staked me to at least my first year at the League, after which I got work-scholarships.

"How shallow [were] my pretensions to expertise soon became obvious when it came to choosing from a roster of instructors whose names and qualities were unfamiliar to me, so on the strength of the basicness of anatomy I enrolled with George B. Bridgman, an error of judgment

from which a chance meeting in the halls with Winifred Milius, an erstwhile school friend from Fieldston, rescued me; through her [I] was introduced to the graphic studio, newly captained by Harry Sternberg. After a few tentative drypoints, my work focused on stone lithography, a beautiful medium indeed, and for some years to come I was primarily a graphic artist.

"At this point I should like to pay my respects to the 1930s in America, an exciting period, a creative period, and an excitingly creative period, the profits of contraceptualism to the contrary notwithstanding. It soon became apparent, as well, that a visual artist, and not a writer, was what I was going to be. For this I am duly grateful. To quote Edward Dahlberg, in his *Reasons of the Heart*: 'A painter can hang his pictures, but a writer can only hang himself.' I venture to say that this is not so flippant as it sounds. The visual image can stand for itself, if only well-intentioned individuals don't drag in symbols by the tail to mar its autonomy; preceding words, the visual image is subcognitive and personal, whereas words arose with the necessity of having symbols which defined *common* experience in undeviating terms which made communication possible. Still, the literary influences which were to lead me to being a visual artist saved me from the cul-de-sac of abstraction. The world, whether interior or exterior, was simply too much to settle within anything so restrictive.

"These influences, or parallel developments (after all, one is rarely influenced by anything toward which one is not instinctively drawn to begin with)—apart from an early addiction to the English drama, Tudor through the comedy of the Restoration—were a witch's brew of nineteenth-century French culture: Stendhal, Flaubert, Baudelaire, romantic eroticism (when will some academic type write an interdisciplinary dissertation on the role of the pantyhose in the decline of female visual eroticism?); and in the pictorial arts a leaning toward the Mexicans, Goya, Bosch, Greco, Modigliani, Nolde, Kirchner, Munch. Add to all this the politicalization, the radicalization of the 1930s. As the poet Barry Wallenstein once wrote: 'From the start [Alberts] has maintained two separate yet intimately connected positions: 1) that works of art emanate from personal and often private visions or impulses, and 2) that works of men reflect and are responsible to the world out of which art is made.' One probes deeper, perhaps, but basically I do not think [one] changes significantly. (Plenty of room here for dichotomy!)

"The Art Students League at that time, like the world it reflected, was an exciting place. Harry Sternberg had the faculty of turning the making of art into a surpassingly important process for young people at a time of shifting and ambiguous values and standards. There were George Grosz, John Sloan, Yasuo Kuniyoshi, Vaclav Vytlacil. While Hans Hofmann did not teach at the League, his seminal article did appear in the League magazine, and those of us not involved in furthering the stink of rotten eggs, which was the hallmark of true tempera, could be heard muttering the magic phrases: push-pull, positive and negative space, the space between the spokes is more important than the spokes. I myself briefly went the abstract route, but I was too firmly anchored in content for this to be more than a passing commitment.

"Among us, the younger generation, there were also memorable personalities: Claire Mahl, the expressiveness of whose lithographs I can still recall; Deyo Jacobs, a brilliant draughtsman and watercolorist, who was to die on a Spanish battlefield north of Madrid; Riva Helfond; Romare Bearden; Claude Marks, newly arrived from England and whom I somehow thought was the Parisian critic Claude Roger-Marx; Paul Vaupetich, an exceptional theoretical mind and a painter of great achievement and promise. Under the influence of William Gaunt's *Bandits in a Landscape* and contemporary racketeers, we—Paul and I—were given to inventing ways of breaking into the galleries, such as an example from the Beer Barons of the day: to descend on the Bignou Gallery or Valentine Dudensing with a truck full of our works, and if the gallery in question declined to jettison its painters in our favor, to toss a 'pineapple' through the window. We also made a pact dividing up the territory: he to take the painting sector, and I the graphic arts. Unfortunately for these plans, neither he nor I had the gangster quality of a Caravaggio to put them into effect.

"During those years I showed mainly my lithographs in group shows and not to any general, or as often as not, any acclaim. The John Reed Club; a large show at the Fine Arts Gallery next door to what was then the League—the National Academy had difficulty filling the space at their annual and came (hat in hand?) to us in the graphic studio to appeal for contributions, overcoming our disinclination with the presence in the show of Orozco and Boardman Robinson, and on this occasion Juliana Force of the Whitney bought several of my works. In 1936 Carl Zigrosser of the Weyhe Gallery placed my *Voices of Spring* in the Modern Museum Fantastic Art Dada Surrealism exhibition (although the catalog lists me, its youngest artist, as well as Hugo Gellert, its oldest, as 'Artists independent of the surrealist movement'—a categorization I would take issue with, at least so far as I was concerned).

"And so it went, and so it goes. Frank Crowninshield was set to run each month full-page caricatures like Covarrubias's—but *Vanity Fair* folded to be combined with *Vogue*. A picture shown here: a prize won there. The Federal Art Project was destroyed. The war not so much started as overtook us. The fall of Spain made Auschwitz and Hiroshima inevitable: the chickens coming home to roost. My years of war were passed in the Pacific, from Oahu west, ultimately to Okinawa, and thence home, to be discharged on 1 October of 1945. I was in the P.I.D., standing, according to inclination, for Photo Intelligence Detachment or Pelvic Infectious Diseases. Yet even the war had its profound insights: while stationed at Hickam Field I had a print show at the Honolulu Academy of Arts. While counting the house one day I overheard a young couple arguing, or at least the young man was complaining that his companion was taking too much time in looking at the exhibit. 'But surely, darling,' he said, all impatience, 'you wouldn't want to go to bed with someone who makes pictures like these!' Okay, Hilton Kramer, can you top that for grade A, top quality Art Criticism? I've heard worse from the professionals!

"After the war the Apes of God took over.

"Whole new generations of philistines have arisen.

"1949 I married Miriam Sussman, a ballet dancer I had known before the war started. We have three daughters and two grandsons. My wife died in 1976.

"Over the last number of years I have had regular one-man shows, a pattern broken by the cessation of function of my gallery, and not particularly helped by my spectacular lack of chic. However, one keeps on painting and making woodcuts, if only out of spite. Spite aside, I hold to the role model of Picasso, whose last show, representing his last ten years of life work, was prolific, fantastic and technically inventive beyond belief."

———

As an artist and a personality, Julien Alberts is a true original. His art, refreshingly free from "trendiness," has shown remarkable consistency over the years, without ever becoming repetitious.

The graphic media have always lent themselves to the expression of ideas, and Alberts was a firm believer in content; but his technical mastery of lithography and woodcuts, his strong sense of design, and his lively, bizarre, often surreal imagination prevent even his more complex imagery from becoming illustrational or anec-

dotal. Each print, whether conceived as an independent work or as part of a series, has its own forceful visual impact.

Although not a "literary" artist as that term is generally understood, Alberts always had close ties with the world of literature and poetry. He never went to Europe, but his familiarity with European culture far exceeded that of many people, whether artists or lay persons, who were born either in or have visited those countries. In his vast library in his Yonkers home one might come across anything from the works of obscure Restoration playwrights to German novels and art publications of the early 1920s, to the works of American writers of the Depression years. That rich intellectual and cultural background, rare among artists, gave an extra dimension to his aesthetic approach and to his perception of the world.

Alberts's originality was apparent from the very beginning. Theodore de la Torre Bueno, a fellow student in Harry Sternberg's graphic studio at the Art Students League in New York City in 1933, has recalled being struck by the curious contrast between "the charming, almost shy youth" and his "gritty art," consisting of "surreal etchings and lithographs of macabre wit and mordant black humor." Alberts remembered his first three prints as being "small, rather sardonic drypoints, perhaps retroactively influenced by Paul Klee's *Virgin in a Tree*."

Alberts then turned to lithographs, some of which reflected the social and political preoccupations of the 1930s. (His sympathies were always with the left.) But the textural richness, sense of the grotesque, and human involvement of those early works transcend their period. The ironically titled *Voices of Spring* (1936), both gruesome and wildly comical, suggests a latter-day Hieronymus Bosch; and, in fact, a lithograph of 1937 is titled *The Garden of Earthly Delights*. Stylistically there is an affinity with the graphic art of the German expressionists and with the satirical drawings of George Grosz, but the sardonic humor, the surrealistic imagery, and the weird, enigmatic poetry are Alberts's own. In addition to those imaginative compositions, his lithographs of the 1930s include expressive portraits of women such as the turbulent *Beatrice* (1937) and the haunting *Lydia* (1938), as well as forceful and sensuous nudes. All those works make dramatic use of the resources of the lithographic medium. At that time Alberts was starting to paint in oils, but he was still thinking so much in terms of the lithographic stone that, in retrospect, he regarded his first paintings as being more like "schematically produced drawings."

In a foreword written in 1947 to a projected volume (never published) of Alberts's lithography, the poet Robinson Jeffers described some of the artist's works before World War II as "storm warnings" that were also "true prophecy." Jeffers found in Alberts's use of symbols "a full-fledged mythology, violent and occasionally perverse." The poet admired in the most surrealistic of the lithographs, *Fragments* (1937), the "stretch of imagination between the massive human foot, bedded in brickwork, solidly planted, carefully carved, with all its tendons directed out—and the fantastic little figure beyond, rope-dancing on the wall-top against the sky." *Fragments* was reproduced on the cover of the catalog of Alberts's exhibit "Lithographs 1934–1951" at the Ashby Gallery in New York City in 1982.

After Alberts's first solo show in New York at Marc Perper's gallery in 1951, he produced no more lithographs but started to make woodcuts and has continued to do so ever since. He recalls: "I think I was disturbed by the *facility* with which I was able to work on the stone. It no longer was a challenge. There was no resistance." He felt the need for "a graphic medium which was more austere . . . but not ascetic or self-denying;" he found it in the woodcut. Concurrently he was seeking more truly "painterly" values in his canvases, sensuous qualities of texture and pictorial relationships for which he had previously found equivalents in black and white in his lithographs. Like many artists who are not primarily colorists, he used a limited palette, but the subdued, brownish tonalities served to reinforce the distortions of the drawing—less emphatic than in the prints—and the firmly knit composition. In contrast to the complexities of Alberts's graphic work, the motifs in his paintings are relatively simple and direct—portraits, nudes, or groups of two or three female figures. He never had the desire to use color in his prints, which do not need that extra element.

Despite interruptions due to family and health problems and the necessity of earning a living, Alberts continued to produce outstanding woodcuts. Steve Wheeler, a fellow-artist, wrote in the foreword to Alberts's exhibit of woodcuts at the Ashby Gallery in 1981, that "in contrast to the linear emphasis" that characterized most woodcuts before the twentieth century, Alberts's work "utilizes its bold graphic ability to manifest the peculiar contemporary nature of visual movement, mass, texture, and light." Among his major achievements was the series of ten large woodcuts "A Bouquet of Blooms," illustrating the "Nighttown" section of James Joyce's *Ulysses*. Those prints were first reproduced in the fall 1972 issue of *Mosaic*, a journal published by the University of Manitoba Press, on the fiftieth anniversary of the publication of *Ulysses*. As R. G. Collins remarked in the article introducing the woodcuts, "the illustrations of Julien Alberts complement Joyce perfectly. . . . They force us to take the images, and so the novel, seriously, in a way we are not apt to do otherwise." Collins added that the woodcuts also "stand on their own merit." Alberts's own titles and notes to each print are in keeping with the provocative imagery—in turn sinister, grotesque, eerie, melancholy, erotic, and wildly funny—very much in the Joycean vein. Fragmented images, "distorted clusters of heads and a highly stylized, unreal decor," to quote Alberts, set the tone for the series in the first of the woodcuts, titled *Nightown is the Righttime: metamorphic*. Throughout the series what Bloom experiences in the mind has been made visual, as in the comically outrageous voyeuristic humor of the two Dublin society ladies whipping Bloom ("euphoric"), which Alberts called *Just an old-fashioned Valentine*. Even more startling is *The Cuckolding of Mr. Bloom by Mr. Boylan: homiletic*, in which bowler-hatted "gentlemen of Dublin" stand in line in the background as Blazes Boylan copulates with Molly and as a stately society dowager surveys the scene from a theater loge through her lorgnette. In contrast to such highly explicit scenes, *The Mocking of Bloom* confronts us with a vast sea of derisive faces extending into the far distance and recalling the surging crowds in James Ensor's *Christ Entering Brussels*—a remarkable technical feat as well as a compelling image. The most nearly abstract of the prints is *The Dance in the Salon Cohen: frenetic*. Here the complex, interweaving linear forms are played against areas and accents of solid black, suggesting musical notes, the movement of the dancers, and possibly the percussive rhythms of the pianola in Bella Cohen's establishment. There is sadness as well as wry humor in the final woodcut *The End of Time: nostalgic*. Bloom, still bowler-hatted but in clown's attire and playing a violin à la Chagall, "perceives at last a vision of Rudy [his infant son], long gone, under a deathly sick moon."

"A Bouquet of Blooms" was displayed at the Bloomsday Bookstore in New York City in 1978, during a complete, all-day reading of *Ulysses*. In April 1981 Alberts was invited by the James Joyce Society to discuss his "Ulysses" prints at the Gotham Book Mart in New York City. Earlier that year they had been included in the show of his woodcuts at the Ashby Gallery.

A less familiar aspect of Alberts's talent was seen in public for the first time in an exhibition of his oils at the Ashby Gallery in 1982. Ted Bueno, in his foreword to the catalog, claimed

that the paintings revealed "the real personality of the private person" behind the "almost misogynistic and pornographic persona projected in his graphic art." Alberts remained, in the writer's opinion, "still a humanist after these years of war and nuclear doom," and these paintings of women revealed "the lyrical and tender essence of his psyche." A reviewer for *Artspeak* (May 12, 1983) commented that "these works have a consistency that is unusual for a space of far more than twenty years." The critic concluded: "His brush tries to fathom the soul of his subjects, which maintain a Germanic allure" and seem to be "undergoing great psychological strain."

Whatever his affinity with the German expressionists, Balthus, Masereel, and certain other moderns, Alberts is unique in the strong vein of humor permeating even his most macabre fantasies. In a lighter context that quality was displayed over the years in a succession of Christmas and greeting cards (usually linoleum cuts) which were so outlandishly droll that they are carefully preserved by his friends. His announcement of the birth of his youngest daughter, Becky, in 1962 showed a group of ghoulish-looking individuals with baleful or astonished expressions gathered in a circle around the new arrival. The caption reads: "Hilfe! Ein Kind ist vom Himmel gefallen" (Help! A child has fallen from heaven). In a large gathering Julien Alberts was usually rather quiet, but one was aware of his presence, and from time to time an amiably sardonic remark would issue forth, uttered with mock gravity. The receding hairline, the grizzled moustache—at one time joining up with Franz Josef-like side-whiskers—the knowing, hooded eyes, and the casual attire sometimes suggested a rumpled, philosophical character in a Russian novel. Beneath the wryly self-deprecating persona there was warmth, compassion, and great insight, and his work, for all its grotesque and satirical elements, reflects an abiding concern with the human predicament in a dangerously irrational world. As Alberts wrote to Robinson Jeffers as long ago as 1946: "Whatever the background, I think my work is of our time, however pale beside present-day reality."

EXHIBITIONS INCLUDE: Honolulu Academy of Arts 1943; 44th Street Gal. 1951; Canton Art Inst., Ohio 1953; Alicat Gal. 1970; Goddard Col. 1971; Dimitria Gal., Princeton, N.J. 1973; Grinton I. Will Library 1974; Hudson River Mus., Yonkers, N.Y. 1975; "A Bouquet of Blooms," Bloomsday Bookstore, NYC 1978; Ashby Gal., NYC 1981, '82, '83; Irish Arts Cntr. 1983.

ABOUT: Barr, A. H., Jr., (ed.) Fantastic Art Dada Surrealism, 1936; Jean, M. The History of Surrealist Painting, 1959; Mallett, D. T. Index of Artists/International/Biographical, 1948. *Periodicals*— Artspeak May 12, 1983; James Joyce Broadsheet October 1982; Mosaic Fall 1972; New York Times July 29, 1979, September 23, 1979.

ANDERSON, LAURIE (1947–), American performance artist, composer, musician, and storyteller, has become, in a relatively short period, one of the most popular performance artists. Her appealing persona—urban, self-wise, and deliberately gamine-like—matched with a verbal and musical cleverness rooted in a thorough understanding of pop culture, has enabled her to expand her reach beyond the performance-art audience and to tap the far larger audience for stage performers and progressive rock musicians. Her popularity is likely to become her biggest artistic problem as well. If dedicated artists who, like Carolee Schneemann, continue to work exclusively within the performance-art arena are unlikely ever to have the pleasure of seeing their faces on the cover of a major newsweekly, as Laurie Anderson has, they are also perhaps less likely to be corrupted by success. Anderson, whose first major work, a multimedia "opera" entitled *United States Parts I-IV*, was given a world premiere at the Brooklyn Academy of Music in 1983, is currently making the crossover to rock and movie stardom and might well exit the art world as it is presently defined.

Anderson's career in art was the result of a move away from music. Born in Glenn Ellyn, Illinois into a large, well-to-do family, she began studying violin at the age of five and later played with the Chicago Youth Symphony. However, she rebelled against the constant striving for technical mastery required of a violinist and stopped playing at the age of sixteen. "Practicing eight hours a day was very addictive," she told the *Chicago Tribune* in 1983. "I was becoming a technocrat, just wanting to play accurately and fast. So I stopped to learn other things." The other things were art and art history; she earned a B.A. degree in art history from Barnard College in New York City in 1969 and an M.F.A. degree in sculpture from Columbia University's art program in 1972. She studied privately with the sculptor Sol LeWitt and wrote reviews and interviews for the downtown art magazines. She early embraced a philosophy of determined eclecticism. "I tried to be as quirky as possible" she has said. *Mudra* (c. 1972), one of her earliest sculptures, was a small, hand-held object that forced the holder to shape his or her hand into a specific *mudra,* an Indian

LAURIE ANDERSON

gesture indicating speech mode. Her best-known sculpture is *Handphone Table (When You Were Here)* (c. 1975–78), a specially constructed table with a concealed tape recorder that conducts music through the bones of listeners who lean on it. Other works, such as *Story Show* (1972), mixed large photos with wall-sized text—the beginning of her experiments with narrative.

Already a seasoned performer from her years as a musician, Anderson fell naturally into performance art, then reaching its zenith of popularity in and around the burgeoning experimental art and music scene in the lower Manhattan district of SoHo. Everyone associated with the downtown art scene was doing performances of some kind. "I thought, it's silly to have all these giant words on the wall when they have very different kinds of meanings," Anderson recalled in a 1982 interview. "When you get a letter from somebody, you get a feeling of what's going on with them. But if you get a phone call and they say the same things, you get so much more information from the voice and the way they pause. So in looking at my pieces I thought, why flatten out the words like this. Just say them. So I started giving these performances which were really spoken stories; the music was an offshoot of this." Her first performance piece was *Automotive* (1972), a chorus of car horns on the Town Green of Rochester, New York. As music has for many other performance artists, the violin provided her with a familiar way into performance, but she used the instrument in unexpected ways. Looking as if she had just come off the farm, she played it on a SoHo street corner while standing on skates embedded in a melting block of ice and giving a "lecture" comparing ice-skating with violin playing (*Duets on Ice*, 1973). Or, á la John Cage and Nam June Paik, she replaced the violin's strings with a tape recorder (*Tape Bow Violin*, 1977) or mini-turntable (*Viophonograph*, 1975) and used the bow to distort the recording. (Some of Anderson's cleverest pieces have had an unusual instrument or electronic effect at their core; they include a necktie with a working keyboard; a system of pickups taped to her body that, when amplified, produce percussion when she dances; and, most striking of all, a harmonizer/vocoder that can turn her voice from an impressive basso to a thrilling contralto to a mousy squeak.) Other important performances of the 1970s included *From "For Instants"* (1976), *Songs for Self-Playing Violin* (1978), and *American on the Move—Preview* (1979).

Out of these performances evolved a musical style compounded of minimalist and pop rhythms and instrumentation, stories and lyrics straight from William Burroughs by way of an airport public address system, and a unique stage presence—waif-like, seductive, cool, and amused—to deliver it all. Her songs are the key to the success of her performances. "When I write a song," she said in 1982, "I make some sort of steady, almost rhythmic ground, not exactly a bass line or a drum line but some way for it all to sit while the language moves around on top of it. On its own speed, on its own steam, so that the talking rhythms are beneath the musical line and the instruments play off those words." Besides electronic effects, which she uses extensively, Anderson prefers a rock-based ensemble with pop drive and jazz fluidity. She hires well-known rockers like guitarist Adrian Belew to provide rhythmic and melodic backup while she plays synthesizer, altered violin, or sings center stage. The tunes themselves are mainly repetitive riffs with quirky twists, and with some of the feeling of Philip Glass's minimalism, though less rigorous. Anderson rarely sings in the usual sense of carrying a melody; she narrates, intones, confides, or simply observes, her alert voice, which has some of the unnatural resonance of a female Hal 9000, floating above the music or acting as a counterpoint to it. Jon Pareles called her singing an "all-American announcer's" variant of rap. "She has all the sultry, measured, utterly impersonal tone of a bureaucratic spokesperson," he wrote in *Rolling Stone* (February 14, 1985), "imparting neutral information or life-and-death bulletins as if purity of enunciation were all that mattered."

Equally important are her lyrics. Too frag-

mentary to be successful as sustained poetry, and sometimes too self-conscious to be convincing, at their best, as in the popular "O Superman" (1980), they are nonetheless affecting. "What lifts her texts beyond pop pastiche is her abrupt, glancing intimations of the erotic, the political, and the cosmic," wrote John Rockwell in *All-American Music* (1983). "Anderson's words are superior in wit and poetic resonance to most rock lyrics. But like them, they do not really find completeness apart from their musical accompaniment and performance." Anderson makes no bones about her borrowings from the likes of William Burroughs, whose cut-and-paste sci-fi surrealism she finds evocative (Burroughs recites the lyrics of "Sharkey's Night" on her album *Mr. Heartbreak* and appears, looking like a ghost from the 1940s in her concert film *Home of the Brave*), and the jazz-rock dadaist Captain Beefheart (Don van Vliet). To these sources she adds her own love of word games—it is obvious from her performances that she doesn't take herself too seriously, and her lyric messages about the dangers of depersonalizing technoculture are leavened with considerable wit—and with her belief in the magical significance of American idioms and clichés. As she recites in "Big Science": "Hey pal, how do we get to town from here? / And he said: 'Well, just take a right where they're gonna build that new shopping mall / go straight past where they're gonna put in the freeway / take a left where at what's gonna be the new sports center / and keep going until you hit the place where they're thinking of building the drive-in bank. / You can't miss it.' / And I said, 'This must be the place.'" Many of her lyrics first began as autobiographical stories or monologues—the artist still thinks of herself as primarily a storyteller—and were gradually developed and polished in performance before becoming the basis for songs. Her LPs *Big Science* (1982) and *Mr. Heartbreak* (1984) have been big sellers in Europe and among progressive rock fans in the United States.

The final element in her performances, and the one that owes the most to her art background, is the complex visuals she assembles to go with the music and stories. Typically they would include slides and short films or videotapes projected behind Anderson with precise orchestration. The still images and short cartoon animations pun on the musical proceedings and stories by presenting contrapuntal or contradictory words and pictures, or sometimes provide the punchline for a joke; at one point in *United States* Anderson points to all the expensive equipment onstage while behind her floats the corporate insignia of Warner Brothers, her record company, with dollar signs overlaid. She

also uses some of the standard repertoire of theatrical stagecraft—lighting tricks, costuming, exotic props. Anderson herself is the focus of the spectacle: white suited and petite, with spiky blonde hair and wide, amused eyes, she dominates the stage. She weaves gracefully around her performers, breaks out into awkward ragdoll choreography, or dons a stocking mask and cajoles the crowd like a stand-up comic.

By the late 1970s Anderson was in demand as a performer in the United States, Canada, and Europe. Her pieces during that period were diverse, some depending on altered violins, others on stories she conceived of or snippets of conversation she heard. One thread running through her work was the pressure she felt to explain "America" to her foreign audiences and to herself. Out of that urge she conceived the idea to "make a big portrait of the country"; that was the genesis for *United States Parts I-IV* (1983), a work that incorporated many of her earlier pieces and stretched to the limit her ability to organize and expand a talent oriented toward short-format epiphanies. With funding from Warner Brothers, the Brooklyn Academy of Music, and other sources, the complex, seven-hour "opera" was presented in early 1983, toured sixteen cities later that year, and was released as a five-disk live LP. It was conceived in four parts—"Transportation," "Politics," "Money," and "Love"—but the parts are loosely related at best, and the work as a whole lacks the structure needed to back up a major statement on the national psyche. Popular as that work was—it garnered enough media coverage to push Anderson over the top into music stardom—most critics couldn't get beyond its flaws and Anderson's own limitations as a performer. "In making this transition [to mass media performer] she has had to let go of the intimacy that was so captivating in her earlier work, the sense of confession and coy titillation," wrote Sarah Taylor States in *Flash Art* (May 1983). "She has also exposed the essentially shallow core of her message; a message that was camouflaged by the intimate presence she maintained with smaller audiences." But John Rockwell, one of Anderson's most dedicated critical supporters, sees her work, with that of Meredith Monk, Robert Wilson, and others, as contributing to the birth of a new kind of American opera.

Following the release of Anderson's *Mr. Heartbreak* LP in 1984, she toured with a band and elaborate visuals; the show was captured in the 1986 *Home of the Brave* concert film, which played in selected venues across the country during 1986–87. Such efforts cannot be said to fit any longer into the usual concept of performance art; they belong more accurately to show

business. Whether Anderson would be able to retain her freshness of perspective as her art expanded to fill the space made for it became a frequently posed question. The artist herself has few qualms. "In fact," she said, in a 1985 interview in *Mother Jones*, "I prefer the commercial record world to the art world. The art world's politics are, in general, incredibly Byzantine. It's about collectors and curators, critics and what's hot this week, and a lot of theoretical messing around, and a lot of parties. And that has *never* interested me. In the commercial record world the only rule is: If you sell records, you make more. If you don't sell records, you don't make any more records. It is *breathtakingly* simple. And I also appreciate the fact that I can make a work that can sell for the price of a dinner."

In October 1989 Anderson's first major solo performance in six years, entitled *Empty Places*, opened the Brooklyn Academy of Music's Next Wave Festival. The ninety-minute show features Anderson alone on stage with her violin, six electronically linked MIDI keyboards, and six screens onto which are projected films and stills of her own creation. In *Empty Places* Anderson sings without electronic filtering for the first time. Five of the songs in *Empty Places* were included on her album *Strange Angels*, which was also released in October 1989. In an interview with Catherine Texier for the *New York Times* (October 1, 1989), Anderson discussed the multiple meanings of *Empty Places*. The prevalence of imagery involving unpopulated ruins notwithstanding, Anderson said, "The word 'empty' to me doesn't necessarily mean desolate. A lot of the images have a lot of room in them. Maybe it's just the 'big western sky,' the cliché of Lebensraum. It may be the strongest American myth. That plus the need to change, sometimes interpreted as freedom. I think a lot of people mix up change and freedom." On the other hand, she said, "it might just be some delayed reaction to Ronald Reagan, this dreamworld legacy that Reagan seems to have left."

Anderson lives alone in a loft/studio in SoHo. Interviewer Adam Block described her as a "slightly built, strikingly beautiful woman with impossibly large sea-green eyes." She laughs easily and is highly articulate about her work and her crossover role as a performance mass-media artist. Her "post-punkette" style of hair and dress is a minor fashion force downtown; one of her favorite stories relates how she turned a corner one day and overheard one bystander say to another "Hey—there goes another Laurie Anderson clone."

EXHIBITIONS INCLUDE: Barnard Col., NYC 1970; Harold Rivkin Gal., Washington, D.C. 1973; Artists Space, NYC 1974; Holly Solomon Gal., NYC 1977, 80, 81; Hopkins Cntr. Dartmouth Col., N.H. 1977; And/Or Gal., Seattle 1978; MOMA, NYC 1978; Wadsworth Atheneum, Hartford, Conn. 1978; retrospective, Inst. of Contemporary Art, Philadelphia White Gal., Los Angeles, Contemporary Arts Mus., Houston, and Queens Mus., N.Y. 1983–84. GROUP EXHIBITIONS INCLUDE: "Story Show," Gibson Gal., NYC 1972; "Thought Structures," Pace Univ., NYC 1973; "Women Conceptual Artists," trav. exhib. 1974; "Narrative in Contemporary Art," Guelph Gal., Ontario 1975; "Not Photography" and "Self-Portraits," Artists Space, NYC 1975; "Autogeography," Whitney Mus., NYC 1976; "Performance/Object," Holly Solomon Gal., NYC 1976; "Choice," Yale School of Arts, New Haven, Conn. 1976; "Line Up," MOMA, NYC 1976; "Works on Paper" and "Surrogates/Self-Portraits," Holly Solomon Gal., NYC 1977; "Homecoming," P.S. 1, Long Island City 1977; "Words at Liberty," Mus. of Contemporary Art, Chicago 1977; "Words," Whitney Mus., NYC 1977; "American Narrative Story Art," Contemporary Art Mus., Houston 1978; "Narration," Inst. of Contemporary Art, Boston 1978; "Architexts," And/Or Gal., Seattle 1978; "Performance Art Festival," Brussels 1978; "Small Is Beautiful," Freedman Gal., Albright Col., Reading, Pa. 1979; "Words," Mus. Bochum, Cochum, W. Ger. 1979; Palazzo Ducale, Genoa, Italy 1979; "Stage Show," MOMA, NYC 1979; "Drawings: The Pluralist Decade," Venice Biennale, trav. exhib. Denmark, Norway, Spain, Portugal 1980; "Beyond Object," Aspen Cntr. for the Visual Arts, Col. 1980; "New York Studio Events," Independent Curators, Inc., NYC 1981; "Messages: Words and Images," Freedman Gal., Albright Col., Reading, Pa. 1981; "Soundings," SUNY Purchase, N.Y. 1981; "Language in the Visual Arts," William Paterson Col., N.J. 1981.

PERFORMANCES INCLUDE: "Automotive," Town Green, Rochester, Vt. 1972; "O-Range," Lewisohn Stadium, City Col., NYC 1973; Artists Space, NYC 1973; Clocktower NYC 1973; "Duets on Ice," NYC and Genoa, Italy 1973; "How to Yodel," Kitchen, NYC 1974; music, Whitney Mus., NYC 1975 (downtown); "Songs and Stories for the Insomniac," Artists Space, NYC 1975, 1976; "Out of the Blue," Univ. of Mass., Amherst 1975; "From 'For Instant,'" MOMA and Whitney Mus., NYC and trav. exhib. 1976;"Fast Food," Artists Space, NYC 1976; "English," Akad. der Kunst, Berlin and Louisiana Mus., Humlebaek, Denmark 1976; "Songs," New School for Social Research, NYC 1976; "That's Not the Way I Heard It," Documenta 6, Kassel, West Germany 1977; "On Dit," Paris Biennale 1977; "Like a Stream," Kitchen, NYC and Walker Art Cntr., Minneapolis 1978; "Down Here," Texas Opry House, Houston 1978; "Songs for Self-Playing Violin," Real Art Ways, Hartford, Conn. 1978; "One World Poetry," Het Tweed International Dichters Festival, Rotterdam 1978; "Americans on the Move—Preview," Carnegie Recital Hall, NYC 1979; Groningen Mus., Netherlands 1979; "Commerce," Customs House, NYC and trav. exhib. 1979; "Blue Horn Fole," Mudd Club, NYC 1979; "Per/for/mance Festival," Florence 1980; at "New Music America," Walker Art Cntr. 1980; Paul Klee Kunstmus., Bern, Switzerland 1980; Paramount

Theater, Oakland, Calif. 1980; Orpheum Theatre, NYC 1980; Art Inst., Kansas City, Mo. 1981; Pension Building, Washington, D.C. 1981; Inst. of Art, Detroit 1981; Palais des Beaux-Arts, Brussels 1981; Rimini Festival, Sant' Arcangelo, Italy 1981; Roxy Theatre, Los Angeles 1981, '82; "Privates," NYC 1981; Ritz, NYC 1981; "Bonds," NYC 1981; "It's Cold Outside," Alice Tully Hall, Lincoln Cntr., NYC 1981; Kabuki Theater, San Francisco 1981, '82; "Radio Broadcast," Westdeutscher Rundfunk Koln, Cologne, West Germany 1982; "United States," Moore Theater, Seattle 1982; Carnegie Music Hall, NYC 1982; Palladium, NYC 1982; Moderna Mus., Stockholm 1982; Adelphi Theatre, London 1982; Kool Jazz Festival, Los Angeles 1982; Dominion Theatre, London, 1983; Volkhaus, Zurich 1983; Olympic Theater, Rome 1983; Vienna Concert House 1983; Rainbow Theater, Denver 1983; "United States Parts I-IV," Brooklyn Academy of Music, NYC 1983. RECORDINGS: It's Not the Bullet That Kills You—Its the Hole, 1977; Airwaves, 1977; New Music for Electronic and Recorded Media, 1977; The Nova Convention, 1979; Big Ego, 1979; Word of Mouth, 1981; O Superman, 1981; You're the Guy I Want to Share My Money with, 1982; Let XX, 1982; Big Science, 1982; M. Heartbreak, 1984; Home of the Brave (soundtrack), 1986. Strange Angels, 1989. FILMS : Fourteen Americans, 1979; Film du Silence, 1981; Home of the Brave, 1986. BOOKS: The Package: A Mystery, 1971; October, 1972; Transportation/Transportation, 1973; The Rose and the Stone, 1974; Individuals, 1977; Notebook, 1977; United States, 1984.

ABOUT: Current Biography, 1983; Emanuel, M. et al. Contemporary Artists, 1983; Performance Text(e)s and Documents (Canada), 1981; Rockwell, J. All-American Music, 1983; White, R. American Artists on Art, 1940–1980, 1982; Who's Who in American Art, 1989–90. *Periodicals*—Artforum February 1980; ARTnews May 1984; Arts Magazine January 6, 1983; Flash Art May 1983; High Performance no. 10 1980; Mother Jones August–September 1985; Nation November 2, 1985; New York Times Magazine February 1983; Rolling Stone July 8, 1982, February 14, 1985.

ANSELMO, GIOVANNI (August 5, 1934–), Italian artist who works with the tangibles and intangibles of nature—stone, metal, wood, energy, gravity, infinity—to address universal questions of existence on a human scale. One of the original members of *arte povera* in the late 1960s, he has held closely to their shared vision of artistic expression beyond the received forms of painting and sculpture while constantly renewing and extending his personal idiom through an intense dialogue with the physical world.

Anselmo was born in Borgofranco d'Ivrea, near Turin. By the time he was in intermediate school, his artistic talent had been recognized by his teacher, who encouraged him to attend art school full time, but since there was none in the town, he went on to an academic high school. Nevertheless, it was his early exposure—a weekly two-hour class over a period of three years—that laid the groundwork for him to take up art on his own once he had completed his studies and moved to Turin. "It was the easiest way to do something," he has insisted; "it would have been hard to be a writer." After a period of experimentation with graphics and watercolors (and eighteen months' military service), he took up painting, but he was not satisfied with the results because, for him, the medium offered "something unrealizable." "The picture holds a fascination, it's true," he later remarked to Jean-Christophe Amman, "but it excludes you. You remain alone with your emotions."

In the course of the early 1960s it became clear to Anselmo that he wanted to "break out" of conventional painting and sculpture, but, by his own account, it was a very specific experience that set him on the path he has continued to follow for more than twenty years. On August 16, 1965, while watching a sunrise on the island of Stromboli, he realized that his shadow was not visible (because of the low angle of the sun), and he suddenly had a sensation: "My own person, via the invisible shadow, came into contact with the light, the infinite." In the wake of that revelation, he turned his attention to other natural forces with the hope of creating a similar interaction.

An untitled work from 1966, for example, consisted of a thin iron rod set in a wooden base; for Anselmo, the two issues involved were gravity and verticality: the 2.53-meter rod represented the maximum height that the block could support against the pull of gravity; if it were taller, if it approached the infinity that he would have liked to attain, the piece would have toppled over. In that piece, he later noted, "the traditional object is reduced to a minimum, or it only exists as a function of tension, of energy." Similarly, a work like *Torsione* (*Torsion,* 1968)—strips of leather tightly twisted around a wooden stick fixed in a cement block—gave concrete visual expression to the otherwise invisible force of torsion, while *Direzione* (*Direction,* 1967–68) —a compass embedded in a triangular block of granite which was then oriented with the needle to due North—reasserted global coordinates over the immediacy of place. (The initial version of *Direzione* was executed in wood covered with black formica, but Anselmo then turned to granite—obtained from a local tombstone carver—in order to incorporate weightiness, since, he explained, "the universe is not only bulk but weight.")

Still other works touched more directly on the cycle of life and death, both in the nonhuman and human spheres. One untitled work from 1968 maintained two granite blocks in a precarious balance by means of lettuce leaves; as the lettuce wilted and decayed over time, the balance was destroyed, and one of the blocks threatened to fall unless the lettuce was replenished. For *Neon nel cemento* (*Neon in Cement,* 1967–69), four fluorescent light tubes were completely embedded in cement, with only their ends protruding to give off a pale glow; attached to the same electrical circuit, the four tubes had a common, and finite, life span, at the end of which the work would effectively die. In the extreme, Anselmo actually hooked up a high tension wire, which he placed between two slabs of granite to separate the ends; "I wanted to create a work that contains the maximum of energy, which includes death," he told Amman. "If you decide to live, you only touch one of the ends. If you decide to die, you touch both of them."

Those early pieces, he has indicated, were things he made for himself—"things that were close to my identity, in which I could recognize myself." During most of the 1960s he knew none of the artists who were to become his partners in *arte povera*, but he began going to galleries and finally took photographs of his work to Gian Enzo Sperone, who invited him to participate in a May 1967 group show with a number of other young Turin artists (works by Dan Flavin, Andy Warhol, John Chamberlain, Robert Rosenquist, and Lucio Fontana were also exhibited). By that time a larger movement away from conventional painting and sculpture was apparent among Italian artists of Anselmo's generation, who were uninspired by the European art informel and resistant to American pop art and minimalism. On the occasion of a group exhibit in Genoa that September, which included Anselmo, Luciano Fabro, Jannis Kounellis, Giulio Paolini, Pino Pascali, Alighiero Boetti, and Emilio Prini, the critic Germano Celant dubbed the new trend *arte povera*, deliberately evoking Growtowski's "poor theater" in order to emphasize the simplicity of materials on the one hand and of ambitions on the other.

Within the overall movement, Celant characterized Anselmo's endeavor as "more subtly 'poor.'" In an article written just after the exhibit in Genoa, he explained, "His is a work that exalts precariousness. The objects are alive at the moment they are formed and assembled. They don't exist as immutable things but, rather, unceasingly recompose themselves; their existence depends on our action and behavior. These are unstable products, not autonomous ones; their existence is closely tied to our lives." And indeed, Anselmo himself was soon to declare in a catalog statement, "Life, the world, myself, we are energy situations. The point is not to resolve these situations by crystallizing them, but to keep them open so that they can respond and coincide with our living."

His initial experiments were quite diverse, in keeping, no doubt, with the newness of the venture, but also reflecting the common will of *arte povera* to defy the norms of establishment culture: "Coherence," wrote Celant, "is a dogma that must be destroyed." Buf if, in Anselmo's case, there was no unifying aesthetic to speak of, his intellectual preoccupations became more clearly defined in the period following his first solo exhibit in 1968, as he came to focus (so to speak) on problems of space, time, and infinity. *Per un'incisione di indefinite migliaia di anni* (*For an Incision of Indefinite Thousands of Years,* 1968), for example, was an inscription written on the gallery wall next to a steel post that had been smeared with grease; that work, Anselmo told Amman, "is like a drawing that others will continue when my life is over. It's a task that continues by itself, a struggle against death, against fixed time [that's] limited by others." Similarly, in *Verso l'infinito* (*Toward Infinity,* 1969), an iron block completely coated with grease was inscribed with an arrow directed at an infinity sign, to make the complementary point that if protected, the material could remain intact forever. Another long view of time yielded *Trecento milioni di anni* (*Thirty Million Years,* 1969), a block of anthracite bound with an electric lamp in order to begin restoring the light that had been absent during the thirty million years of the anthracites formation underground. And in one of his most lyrical pieces, *Trespolo* (*Bird Feeder,* 1969), Anselmo attached a granite bird feeder high on the gallery wall because, he later explained, "I imagined that on this spot there was once a forest where a lot of birds used to play about. I thought that one bird might remember it and find the way again."

In all of those works, as in his earlier exploration of natural forces, Anselmo's "art" consisted in effecting the delicate balance between a universal idea and a particular expression of it, so that the idea was never represented, but evoked. As Jean-Christophe Amman pointed out, "An invisible process can be detected only by its visible effect. In other words, the invisible is measured against the visible." That approach subsequently took a literal turn as Anselmo began to use language—or, more precisely, words—as the bridge between idea and image. Already in 1969 he had presented a penciled sheet of paper—*Particolare di infinito* (*Detail of Infinity*) as "a visible, measurable part of

infinity," and around the same time he began working on an idea for a book, *116 particolari visibili e misurabili di INFINITO* (*116 Visible and Measurable Parts of INFINITY*), consisting of fragments of an archetypal (and infinitely large) version of the word *infinity* as they might leave their traces on the standard page—all black sections of letters, all white blanks, portions of curves, corners, and angles in black and white. The book itself was not published until 1975, but in the interim, the word-object—*partícolo, infinito, tutto (whole), (in)visíbile*—served as a principal formal and thematic device in Anselmo's work.

Initially, the word remained basically illustrative: infinity, for example, became a word on a slide projected at the wall with the focus set on infinity, so that the word was dispersed into a white patch of light (*Infinito,* 1970). Similarly, in another transitional piece like *Dissolvenza* (*Dissolution,* 1970), the word *dissolvenza* projected onto an iron cube gave concrete visual expression to the ongoing process of oxidation taking place. But in short order, Anselmo's meditations on time and space became semantic deconstructions as well. In *Lato destro* (*Right Side,* 1970), a handsomely rendered self-portrait drawing is innocuously labeled "right side" at the lower right, which in fact corresponds to the viewer's right, but on reflection turns out to be the left side of Anselmo's neck; in a photographic version of the same work, the paradox of perception and self-perception is extended still further with the reversal of the negative, so that the label now corresponds to Anselmo's body orientation, but the image no longer corresponds to the model. Similarly, with *Invisíbile* (*Invisible,* 1971), a slide bearing the word *visible* was projected without a screen, effectively become invisible, but the moment anyone approached the projector to verify its invisibility, the light was blocked and the word reappeared. ("The invisible," notes Anselmo, "is what is visible but can't be seen.") Still other works played on the relationship of whole and part as both idea and image, as in *Tutto* (*Whole,* 1971), where two slide projectors broke the "whole" into two separate parts, "tut" and "to," or another work with the same title (*Tutto,* 1971) consisting of twenty slide projectors projecting as many "parts" ("particolari") all over the room.

Quite obviously, such exercises were inspired by contemporary debates in phenomenology, linguistics, and their respective repercussions on conceptual art, but even so, Anselmo's outlook remained fundamentally different: however conceptual his pieces were, they were never self-contained, much less hermetic; rather, the intervention of the viewer was essential for the completion of the meaning. As April Kingsley noted when *Invisíbile, Tutto,* and related works were shown at the John Weber Gallery New York City in 1972, "Anselmo's art exists in the tension between the idea and its realization by the viewer. You sense the work physically and intellectually, becoming aware of yourself in the process." In no small part, that orientation reflected the initial engagement of arte *povera,* and if, by the early 1970s, the movement had dispersed, the assumptions of the 1960s, remained operative— the opposition to art as object, as commodity, as novelty. Indeed, by the mid-1970s, Anselmo (and this was characteristic of the *arte povera* artists in general) had taken to reintegrating his early works with more recent themes and motifs, effectively defying a linear notion of "style" with an insistently cumulative development.

That tendency was already apparent in the various "Particolari" exhibits Anselmo presented in 1974 and 1975, where the use of six, ten, fifteen, or twenty slide projectors transformed the word-object into an environment, once again defined by the coordinates of time and space. By 1977 the compass (*Direzione*) was reintroduced and was soon combined with other early pieces—the glowing anthracite of *Trecento milioni di anni,* penciled fragments of INFINITO, projections of the "particolari"—into a coherent installation. "It's immense," wrote Stéphane Déliceorges in response to one version mounted in Paris in 1978. "From a limited number of concrete operations, Anselmo had produced a complex, inexhaustibly complex mental object. A network of relations that can be inventoried *ad infinitum.* A process of dialectical cascades that you traverse like a game, and all that's needed is the desire to play differently from the usual perceptions of art." And as Claude Gintz pointed out on the occasion of Anselmo's 1980 retrospective in Grenoble, France (titled *"Opere e particolare* to the North, South, East, and West/Northwest"), the "most remarkable" aspect of the exhibit was the unity of the component parts: "In attempting to seize the individual [work], it's impossible to ignore the existence of the totality."

Throughout the 1980s Anselmo continued to rework his repertoire of plastic images in site-specific installations. He added a note of lyricism with the blue-purple patches of paint identified as "oltremare" (ultramarine/overseas), but also reintroduced the precariousness and tension of the earliest works with huge chunks and slabs of granite hung from the walls with steel wire (*Grigi che si alleggeríscono verso oltremare/Greys That Become Lighter toward Ultramarine,* 1984). An occasional drawing served as a reminder of his exceptional draftsman's skills

(*Il panorama conmano che lo indicamentre . . .
/Panorama with Hand Indicating It . . . ,*
1984), and he appeared to be allowing himself
(and others) an even greater appreciation of the
sheer beauty of the materials, notably the differ-
ent textures and colors of the granite he brings
from Italy.

At the time of Anselmo's first solo exhibit in
1968, Maurizio Fagiolo acknowledged that the
thirty-four-year-old artist would certainly
change forms and materials in the course of his
career, "and strength[s] as well." But, he insisted,
the main features of his work were already
clear—the instability, the tension, the precari-
ousness, which, for Fagiolo, demonstrated that
"it is possible to fuse action and content . . . to
work in the gap between causality and chance.
To live on the razor's edge." Almost twenty years
later, Anselmo, a soft-spoken, reflective man lit-
tle given to talking about himself, confirmed
Fagiolo's prediction. The problem for the artist,
he said, is "to remain as lucid as possible, to re-
main oneself. You have to try to understand, to
resist the media, advertising. If everyone says
you have to make war because it's good, I can't
do that. I'm still like I was twenty years ago."

EXHIBITIONS INCLUDE: Gal. Sperone, Turin 1968–80; Gal.
Sonnabend, Paris 1969; Gal. Toselli, Milan 1970; Gal.
Multipli, Turin 1971; John Weber Gal., NYC 1972;
Gal. MTL, Brussels 1973; Kunstmus., Lucerne 1973;
Gal. Bonomo, Bari 1974; Gal. Sperone-Fischer, Rome
1974–77; Gal. Foksal, Warsaw 1974; Gal. Area, Flor-
ence 1975; Saman Gal., Genoa 1975–76; Gal. Ghirin-
gelli-Sperone, Milan 1976; Nuovi Strumenti, Brescia
1976; Kabinett für Aktuelle Kunst, Bremerhaven 1977;
Gal. G. de Crescendo, Rome 1977; Gal. Salvatore Ala,
Milan from 1978; Studio Tucci Russo, Turin 1978; Gal.
Paul Maenz, Cologne 1978; Gal. Durand-Dessert, Paris
from 1978; Superone-Westwater-Fischer Gal., NYC
1978; Kunsthalle, Basel 1979; Gal. Rudiger Schöttle,
Munich 1979; Gal. Emilio Mazzoli, Modena 1979; Ste-
delijk van Abbemus., Eindhoven 1980; Gal. Helen van
der Meij, Amsterdam from 1980; Forum Kunst, Rott-
weil 1980; Mus. de Peinture et Sculpture, Grenoble
1980; Salvatore Ala Gal., NYC 1981; Gal. Christian
Stein, Turin from 1982; Marion Goodman Gal., NYC
1984; Gal. M. Szwajcer, Antwerp 1984; ARC, Mus.
d'Art Moderne de la Ville de Paris 1985; Gal. Jean Ber-
nier, Athens 1986. GROUP EXHIBITIONS INCLUDE: "Arte
Povera e IM Spazio," Gal. La Bertesca, Genoa 1967;
Prospect 68, Düsseldorf 1968; "9 at Castelli," Leo Cas-
telli Warehouse, NYC 1968; "When Attitude Becomes
Form," Kunsthalle, Berne 1969; "Arte Povera
1967–1969," Gal. Bertesca, Genoa 1969; "Vitalita del
Negativo nell'Arte Italiano 1969–1970," Pal. delle Es-
posizioni, Rome 1970; "Conceptual Art, Arte Povera,
Land Art," Mus. dell'Arte Moderno, Turin 1970;
Documenta 5, Kassel 1972; "Idea and Image in Recent
Art," Art Inst. of Chicago 1974; Prospect 76,
Düsseldorf 1976; Sidney Biennale 1976; "Europe in the
70's," Art Inst. of Chicago 1977; "words," Kunstmus.,

Bochum 1978; Venice Biennale 1978; "Artistes
Italiens," Mus. d'Art et d'Industrie, Saint-Étienne
1979; "Pier and Ocean," Hayward Gal., London 1980;
Venice Biennale 1980; "Identité Italienne," Cntr.
Georges Pompidou, Paris 1981; "Linee della ricerca
artistica in Italia 1960–1980," Pal. delle Esposizioni,
Rome 1981; Westkunst, Cologne 1981; "Arte Povera,
Antiform," CAPC, Mus. d'Art Contemporain, Bor-
deaux 1982; Documenta 7, Kassel 1982; "Presence
disreète," Mus. des Beaux-Arts, Dijon 1983;
"Concetto-Imago," Kunstverein, Bonn 1983;
"Adamah—La Terre," ELAC, Lyon 1983; "Coerenze
in coerenza," Mole Antonelliana 1984; "An Interna-
tional Survey of Recent Painting and Sculpture,"
MOMA, NYC 1984; "Del Arte Povera a 1985," Pal. de
Velásquez, Pal. de Cristal, Madrid 1986; "The Europe-
an Iceberg," Art Gal. of Montreal, Toronto 1985; "Les
Immatériaux," Cntr. Georges Pompidou, Paris 1985;
"The Knot: Arte Povera," P.S. 1, Long Island City
1985; Skulptur Projekte, Munster 1987; "Italie hors
d'Italie," Carré d'Art, Mus. d'Art Contemporain,
Nimes 1987; "Turin 1965–1987," Mus. Savoisien,
Chambéry 1987.

COLLECTIONS INCLUDE: Stedelijk Mus., Amsterdam; Ste-
delijk van Abbemus., Eindhoven; Australian Nat. Gal.,
Canberra; Mus. de Peinture et Sculpture, Grenoble;
Groningen Mus., Groningen; Mus. Saint-Pierre Art
Contemporain, Lyon; Rijksmus., Kröller-Müller, Ot-
terlo; Mus. National d'Art Moderne, Paris; Mus. d'Art
Moderne de la Ville de Paris.

ABOUT: Anselmo, G. Leggere, 1974; Anselmo, G. 166
particolari visibili e misurabili di INFINITO 1975;
"Anselmo" (cat.), Gal. Sperone, Turin, 1968; Celant, G.
Arte Povera, 1969; Celant, G. The Knot: Arte Povera
(cat.), P.S. 1, Long Island City, 1985; Emanuel M., et
al. Contemporary Artists, 1983; "Giovanni Anselmo"
(cat.), Kunsthalle, Lucerne, 1973; "Giovanni Anselmo"
(cat.), Kunsthalle, Basel, 1979; "Giovanni Anselmo"
(cat.), Musée de Peinture et Sculpture, Grenoble, 1980;
"Giovanni Anselmo" (cat.), ARC, Musée d'Art Mod-
erne de la Ville de Paris, 1985; "Identité Italienne"
(cat.), Cntr. Pompidou, Paris, 1981. *Periodicals*—Art
and Artists June 1977; Artforum February 1973; Ar-
tistes October–November 1980, December 1983; Art
Press May 1980, October 1982; Flash Art December
1967, Summer 1986; Nouvelles Literaires November
16, 1978.

***ANTES, HORST** (October 28, 1936–),
German painter, printmaker, and sculptor, is
hailed as a modern master in Europe, where his
work has been exhibited extensively since 1960.
His enigmatic, metaphor-laden figurative art re-
mains unknown in the United States, however,
except for a relatively small group of admirers,
even though, somewhat paradoxically, one of his
major sources of inspiration is American Indian
mythology and tradition; and in general his
work transcends any specifically German or Eu-
ropean concerns or affinities. At the same time,

°äN´ tās

the artist has always described himself as "a link" to German masters of the past and to certain painters of the School of Paris.

Antes was born in the town of Heppenheim an der Bergstrasse, in Hesse, Germany, and received his education there before enrolling, at the age of twenty-one, in the Karlsruhe Academy of Fine Arts. He claims that he decided to become an artist instead of a farmer like his father when, as a little boy, his older brother showed him a reproduction of a painting of St. Francis. At Karlsruhe, from 1957 to 1959, he was the student of HAP Grieshaber, an abstract painter and woodcarver whose influence as a teacher in postwar Germany was considerable; it can clearly be traced in Antes's earliest paintings—erotic, brightly colored abstract expressionist works (somewhat de Kooningesque) that were a variant of the new figuration style then popular in avant-garde German art. In 1959 his career was launched with the receipt of an award from the city of Hanover; the following year he had his first solo show, at the Galerie der Spiegel in Cologne. In 1962 he worked in Florence, under the aegis of the Villa Romana prize, and in 1963 in Rome, on a Villa Massimo fellowship; in 1964 he held a Guggenheim Fellowship. Upon his return to Germany he began to teach at the Karlsruhe Academy, serving there from 1965 to 1971, and as guest professor at the Berlin Academy of Fine Arts in 1967–68.

With the encouragement of Grieshaber, Antes worked out his own idiom, independent of contemporary stylistic movements, and began to develop the highly stylized figural motif known as the *Kopfüssler* (cephalopod), which until about 1983 was central to his art. The genesis of that trunkless humanoid shape, most often suggestive of a male figure but occasionally female, monumental in scale and sculptural in effect, has been traced to the *Blue Maja* (1961–64), a still largely abstract expressionist painting. Thereafter, the *Kopffüsslers* have confronted viewers with their impassive gaze, demanding some communication but yielding only ambiguous clues as to what they might reveal. Certainly, the laconic titles of Antes's works provide no answer, typical labels being *Figure on Red* (1965–66), *Couple—Table* (1971), *and Green Portrait* Portait (1984). Like Easter Island figures, the Antes men/women are cut off and hermetic but are obviously weighted with personal meaning for the artist—symbolic, it is generally agreed, of the ability of twentieth-century human beings to withstand trauma and alienation. Some allusion to the primacy of head and eye, and the power of visual perception, is made by the *Kopffüssler*'s large head, usually attached directly to its arms and feet but often represented by

itself, almost always in profile (recalling certain of Picasso's figures) and dominated invariably by an eye, shown frontally. Sometimes there are two eyes, one above the other; there are even multiocular representations, as in the 1970 *Green Head with 17 Eyes*. Most frequently pupilless, the *Kopffüsslers'* eyes see both too much and nothing.

In addition to the influence of Picasso, Antes acknowledges references to certain truncated forms in Max Beckmann's paintings, and to the ponderous, tubular arms and legs in Fernand Léger's work. Over the years the artist has rung many formal changes on his "all-purpose manikin" (so the *New York Times* critic John Russell calls it), using the *Kopffüssler*, as he has affirmed, to mirror his own changing thoughts and moods. As a result, despite some general similarities, it is difficult to summarize the transmutations of the form. "No single work can stand for all the rest," declared Wolf Hermann, owner of the largest private collection of Antes's oeuvre in his home in Bremen. The *Kopffüssler* has appeared not only in paintings but in prints and as sculptures. It has been shown in mood-evoking acrylic colors that swing back and forth from a bright, mixed palette to somber monochromatic earth tones, always with a predilection for haunting greens. Most often Antes's figures are represented singly, but there are some compositions in which two or more are grouped. And while there are paintings and prints without backgrounds, in others the figure is silhouetted against a suggestion of landscape or a setting furnished with symbolic objects: spoons, balls, ladders, spermatozoon-like shapes, overturned chairs, and a whole repertoire of Hopi Indian motifs. For many years, since Antes first saw a group of kachina dolls in a Paris antique store, he has been keenly interested in Hopi culture and has traveled to the southwestern United States periodically to renew his visual inspiration. From 1980 to 1982 his collection of kachinas, the most extensive private one in Europe, toured Germany and Switzerland, and was documented in a scholarly catalog produced under Antes's editorial direction.

At times, the hairless *Kopffüssler* head assumes a helmeted shape, with an obvious affinity to Etruscan warrior figures, or the face has appeared to be marked, calling to mind pre-Columbian sculptures. Occasionally, the figure has been not only masked but almost obliterated with stripes of white, yellow, blue, and red, as in a 1968 painting; in *Figure in a Box*, another work of 1968, the year of violent student protests in Europe, the *Koppfüssler* crouches, knees drawn up, head in hands, one eye peering warily out, suggestive of unbearable sadness and isola-

tion. Two years later the artist announced his intention of sometime doing a painting of two hundred faces, and in 1982 his *232 Figures* fulfilled that prophecy. It is a claustrophobic crowding of heads in profile within a six-foot canvas expanse, the effect heightened by the haunting stare of the empty eyes. Only a few of the figures reach out to touch one another, tentatively. Some critics stress the surrealistic quality of Antes's work, and of that painting in particular. Riva Castleman, curator of prints at the Museum of Modern Art in New York City, contends that, on the contrary, no matter how obsessive or fantastic his approach, unlike the true surrealists, Antes is always concerned with the *reality* of the enigmas and difficulties of human experience. No matter how aesthetic theory changes, he himself firmly believes that "there always will be a Renaissance. There always will be that return to the human figure, to the value of man as prime measure."

About the time of his marriage, in 1961, to Dorothee Grossmann, Antes launched into what now amounts to a considerable body of etchings (some combining drypoint or aquatint) and lithographs. The first etchings show the influence of the Cobra group, a European facet of abstract expressionism, incorporating figurative decoration; but as he proceeded the *Kopffüssler* motif began to dominate, as it did in his paintings. Culled from the graphic work he had done in Italy is *Sicellino 1977* (printed in Munich and issued en suite in 1978), twenty-seven color and nineteen black-and-white etchings, pulled from copper, brass, and zinc plates on handmade rag paper.

Also in the early 1960s Antes began to represent his weighty, blocklike figures in truly three-dimensional form, seemingly a natural transition, since his palette has often suggested stone or metallic surfaces. Among such pieces is the grouping he was commissioned to execute for the 1967 Karlsruhe Bundesgartenschau (federal garden exhibition), which he titled *Garden of Delights,* alluding to the inspiration of Bosch. The familiar *Kopffüssler* heads, now in Cor-Ten steel, were placed in an outdoor setting where real light and shadow replaced the illusionistic depth and volume of his canvas and paper works. In 1976 he executed eight large steel heads of the grounds of Karlsruhe University, and in 1982 he did a group of five heads in Cor-Ten steel, each over twelve feet high, for the broadcasting center of Zweite Deutsche Fernsehen in Mainz. With that last project, discouraged by the outbreak of war in the Falkland Islands, and by the ever-present threat of nuclear catastrophe, Antes made the radical decision to give up figural representation.

A year later, though, he resumed his humanistic meditations, but with a change in the scale of representation that has persisted to the present. The transition seems to have begun earlier, actually, with the group of ten sculptures and ten paintings collectively titled "The Year of the Hopi," commemorating the tricentennial of Hopi freedom from Spanish rule. The assemblage was shown in 1981 at the Lefebre Gallery in New York (his American dealer for over twenty years, from the time he was given his first solo show in the United States in 1967). The sculptures, on a smaller scale than before, were fashioned of cast steel colored a weathered earth brown, and were displayed in tableaux that incorporated small replicas of ladders, the means of access of Hopi dwellings; tabletas, or ziggurat-shaped rain cloud symbols; and horned serpent figures.

Then in 1983, with the first of the series known as "Votives," Antes reduced the scale of his figures (by then mostly complete, whole bodies) and objects still more dramatically. Miniature in size, cut from gold foil to a thickness of .15 millimeters (.006 inches) by means of paper knife, fingernail scissors, and graver, the figures are arranged in "sculptural environments" in small Plexiglas vitrines, surrounded with the objects familiar from his earlier paintings— spoons (for feeding), ladders, chairs—a repertoire of the artist's symbols of human survival. As the observer moves about the vitrines, the sheet-thin figures appear to dissolve at certain angles; seen at other angles they deny that transparency by catching and reflecting the light. They are, according to the catalog of the exhibition of the first "Votives" in Frankfurt in 1983, a paradigm of the negative and positive aspects of human experience. An exhibition of thirty-eight "Votives" at the Guggenheim Museum in 1984 drew the first large American audiences to the artist's work, which was enthusiastically hailed for its innovative, dramatic effect. That same year he went back to his accustomed medium with *Large Painting. Untitled. Pink,* in which four incorporeal bodies float on a luminous pink field; and he, for the first time, began to represent the *Kopffüssler* face frontally, doing two heads side by side. That return to painting, yet in a manner markedly different from his previous work, seems another instance of the interplay of constancy and change characteristic of Antes's approach. Going his own way, he appears to be constantly working out his art, with no straight line of development yet with the figure always as keystone.

In physique and personality, the artist is quite the opposite of what one might expect from his art. He is, first of all, though solidly built, rather

short. As grave and as stoical his figures may be, their creator is warm and friendly, impishly playful, an affectionate father of two children whose births he celebrated (according to some interpretations) in representations of small, winged bird-angel forms. He is a man of passionate convictions, but on occasion, true to his art, he can be reserved and at times even irascible. While his figures seem closed off in their aura of pensive endurance, the artist's life is active, engaged, and divided between time in the Tuscan countryside, where he owns a farmhouse and maintains a productive vineyard, and teaching at the Karlsruhe Academy. In 1984, having become a member of the Berlin Academy of the Arts, he was reappointed as a professor at Karlsruhe.

EXHIBITIONS INCLUDE: Gal. der Spiegel, Cologne 1960, '63, '65, '82, '84; Mus. d'Art Moderne, Paris 1963; Atädtisches Gal., Munich 1964; Freie Gal., Berlin 1964; Kunstmus., Basel 1967; Lefebre Gal., NYC 1967, '69, '72, '74, '76, '78, '80, '82, '84, '86; Gimpel Fils, London 1968, '69, '73, '76; "Bilder und Skulpturen 1965–1971," Staatlich Kunsthalle, Baden-Baden 1971 (trav. retrospective); "Antes in der Sammlung Wolf und Ursula Hermann," Kabinett 2, Graphisches Kabinett, Bremen 1971; Arts Club of Chicago 1976; Nishimur Gal., Tokyo 1980, '84; Städelsches Kunstinst., Frankfurt 1983; Goethe-Inst. Athens 1983; Solomon R. Guggenheim Mus., NYC, 1984. GROUP EXHIBITIONS INCLUDE: Biennale des jeunes artistes, Mus. d'Art Moderne, Paris 1959, '61 (André Malraux prize); Carnegie International, Pittsburgh 1961, '64, '70, '77; Documenta, Kassel 1964, '68, '77; Venice Biennale 1966 (UNESCO prize); "Four European Artists and the Figure," Art Inst. of Chicago 1966; World's Fair, Montreal 1967; "European Painters of Today," Mus. des Arts Décoratifs, Paris 1968 (toured U.S.); "Sitzende Figur mit Scheibe und Ei," Gimpel and Hanover Gal., Zurich 1969; São Paulo Bienal 1969; "From Picasso to Lichtenstein," Tate Gal., London 1974.

COLLECTIONS INCLUDE: Neu Nationalgal., Berlin; Städtische Kunstsammlungen, Bonn; Kunsthalle, Bremen; Wallraf-Richartz-Mus., Cologne; Städtische Sammlungen, Düsseldorf; Städelsches Kunstin, Frankfurt; Niedersächsische Landesgal., Hanover; Staatliche Kunsthalle, Städtische Sammlungen, and Univ., Karlsruhe; Bayerische Staatsgemäldesammlungen, Munich; Staatsgal., Stuttgart; Mus. des 20. Jahrhunderts, Vienna; Kunstmus., Basel; Kunsthaus, Zurich; Musées Royaux des Beaux-Arts de Belgique, Brussels; Gemeente Mus., the Hague; Mus. Boymans-van Beuningen, Rotterdam; Mus. National d'Art Moderne, Paris; Mus. Ateneum, Helsinki; Mus. of Art, Univ. of Iowa, Iowa City; Guggenheim Mus. and MOMA, NYC; St. Louis Univ., St. Louis, Mo.; Nat. Mus. of Art, Osaka.

ABOUT: Castleman, R. Contemporary Prints, 1973; Current Biography, 1986; Emanuel,M., et al. Contemporary Artists, 1983. Grohmann, W. Kunst unserer Zeit, 1970. *Periodicals*—Apollo September 1976; Art: Das Kunstmag July 1982; Artforum January 1985; Art in America January 1967; ARTnews April 1986; Arts Magazine March 1969, February 1972, March 1972, February 1977; Quadrum no. 20, 1966.

APPLEBROOG, IDA (1929–), is an American sculptor turned illustrator and a performance artist turned painter who abruptly abandoned the minimalist formalism of the late 1960s for a multimedia art of unflinching social criticism. In an increasingly complex and monumental visual idiom, she has summoned up the uncomfortable evidence of society's ills— loneliness, violence, the corruption of youth, the abandonment of the elderly, and, above all, the manifold indignities of womanhood.

A consistent feature of Applebroog's art has been its deliberate and often impenetrable ambiguity, and the details of her life are no less incomplete. Her standard biography indicates that she was born in the Bronx and that she studied at the New York Institute of Applied Arts and at the Chicago Art Institute. Between 1962 and 1966 she taught painting at the Art Institute, then moved to the West Coast, where she began exhibiting modular sculpture in free-form materials like foam, gauze, and latex.

At the time, she was known as Ida Horowitz, which was her married name. In a 1987 catalog introduction, her current dealer, Ronald Feldman, recounted how he met "an Ida Horowitz" in 1971 and was struck by her sculpture but, like almost all the critics, was also struck by its resemblance to that of Eva Hesse. "She was good, she was very good—" Feldman has recalled, "still, the similarity was too obvious. We discussed how difficult her work could be to understand, exhibit and sell. She was doing it her way and that was it."

Seven years later, "an Ida Applebroog" was recommended to Feldman by a number of people, and eventually he was to discover that this was the same artist with a new name and new work. In the interim, she had taught painting and sculpture at the University of California at San Diego (1973–74) and, soon afterward, moved to New York City. The name change, according to Feldman, went back to a period of severe psychological problems sometime before 1971, when Horowitz was unable to say her own name and instead came out with "Ap . . . broog."

When Applebroog the artist reemerged in New York, it was with cartoon-like social commentaries that she published in book form and mailed out, unsolicited, to a select group of five hundred artists, critics, museum curators, and

gallery owners. In the first series of "Black Books" (*The Galileo Works*, 1977–78), Applebroog adopted a stage-set format—she called them "performances"—to present fairly enigmatic repeated images that suddenly took on an ironic, if not completely comprehensible, twist with the interjection of a caption/comment. In one booklet simply titled *A Performance*, for example, the image of a headless man standing with a suitcase in an exotic palm-tree setting is followed by the deadpan statement "Sometimes a person never comes back." In *Say Something*, another headless man is paired up with a naked woman crouching suggestively on the ground. One caption early on reads "Don't you want me?" and a few frames later comes the "Say something" of the title.

"Each book," Applebroog wrote in her working notes for the project, "is a series of images where nothing ever really happens, is composed more of silence (what isn't being said) than of words. It is the words that punctuate the silence. . . . But actually all the stories are the same story. It doesn't matter how I tell them; it all comes out the same. By the time you arrive on the scene, the story is over."

For all of the seeming contrast with the soft sculptures of Ida Horowitz, the *Galileo Works* were also an outgrowth of the earlier work, notably in the modular format and the conceptual approach it implied. In fact, some of the California sculptures were based on Galileo's theorems, and Applebroog subsequently investigated his life in a series of drawings that she called "chronological stagings." In addition, the images themselves were fabricated with materials similar to the earlier soft sculpture: each drawing was executed on vellum covered with a synthetic rubber called Rhoplex; the blank spaces were then cut away to leave outline figures and the theatrical frame. Placed in front of a light source (like Indonesian shadow puppets), cutouts cast rich shadows which became part of the photographic image reproduced in book form.

While the *Galileo Works* were circulating through the mails, the original vellum and Rhoplex "drawings" soon made their way back into the official art circuit with a solo exhibit at the Ellen Sragow Gallery in 1978. (The same year, a group of related video performance works, combining drawings with live actors, was also shown in an installation at the Whitney Museum.) Like the individual recipients who found themselves hooked on Applebroog's mail art, the critics were immediately won over to the force of her new idiom, resulting, in the words of Wade Saunders, from the "fusion of phrase and image and her astonishing empathy, gutsiness,

and ambiguity." In her next series of "White Books" (*The Dyspepsia Works*, 1979), Applebroog altered her metaphor and raised her psychological stakes. Using the same Rhoplex-vellum cutout technique, she placed the stage setting within a curtained window and a half-drawn shade, effectively transforming her audience from mere spectators to voyeurs. And indeed, the focus of the vignettes was more explicitly sexual ("Now then," says a fat man seated in a chair, "take off your panties.") Appropriately enough, that format was also translated into a group of large-scale window installations at the downtown Manhattan artists' book store Printed Matter where, as Carrie Rickey wrote in *Artforum*, the imposition of a private drama on a public space "entraps viewer in a voluntary naughtiness."

With the "Blue Books" (1981), Applebroog returned to the performances—in her titles at least—but abandoned the frame motif, quite literally projecting her characters into the world at large to address more explicitly social and political issues. Like another New York artist, Jenny Holzer, who was at that time plastering lower Manhattan with her anonymous "Truisms" and "Inflammatory Essays," Applebroog decided it was time to draw attention to the growing conservative tide through the "appropriation" of right-wing rhetoric, beginning with the title of the series, which alludes to the John Birch Society's "Blue Books." *So? A Performance*, for example, juxtaposes the repeated image of two women, one in bed and one standing at her side (captioned "He says abortion is murder . . . So?) with a final scene of three fat businessmen asking "Why else did God give us the bomb?"

Because of rising printing costs, Applebroog gave up her self-publishing venture after the "Blue Books." Instead, she continued to produce her vellum and Rhoplex modules in various formats, ranging from the small-scale series of the books to larger diptychs, and she also translated her vignettes into sculptural environments with tiny figures in solitary park settings. Common to all of those works, exhibited at Ronald Feldman Fine Arts in 1982 under the title "Current Events," was an increasingly grim view of daily existence, which gave the banal situations an unexpectedly devastating twist. The 1982 *Trinity Towers* diptych, for example, goes back to the curtain and window-shade format to pair up a view of two nude men sitting on the edge of a bed with that of their presumed neighbor, also nude but dangling from a noose. In his review of "Current Events," the painter-critic Paul Brach emphasized the "secret agenda" behind works like *Trinity Towers*, "the stories that only Applebroog knows." But at the same time, he in-

sisted, "there is a hint of a deeper common humanity here that allows us all to write our own scripts for these stills in Applebroog's ongoing movie."

There was considerably less ambiguity, and more controversy, surrounding the public installation called "Past Events" that originally formed a tandem with the Feldman show. The work was commissioned by a city art agency for the Great Hall of the New York Chamber of Commerce, which normally featured some two hundred portraits of the city's commercial patriarchs; Applebroog's contribution consisted of a centerpiece statue of a young girl with a comic-strip speech balloon announcing, "Gentlemen, America is in trouble," plus other speech balloons appended to the portraits with comments like "You can never be too white," "It's a Jewish plot," and "You are differently developed." A bureaucratic battle ensued, with the installation going up and down every time there was a meeting in the hall, until Applebroog finally withdrew it to her gallery.

In the works that followed, the confrontational stance of "Past Events" increasingly replaced the ironic understatement of her earlier works, and the change in tone was accompanied by a change in medium as well, with the minimalist line drawings giving way to large, brightly colored canvases. Her 1984 "Inmates and Others" show at Ronald Feldman featured five works pointedly titled with the names of hospitals, mental institutions, and retirement homes. Critics were generally uneasy with the jarring new paintings which, Grace Glueck wrote in the *New York Times*, "simply don't seem substantial enough to justify their scale." But as the new format evolved, Applebroog literally buttressed the monumentality of her canvases with multiple panels and composite images, whether in vertical triptychs like *Isham Street* (1985) and *Sunflower Drive* (1985) or two-part inverted altar pieces like *God's White Too* (1985) and *Peel Me Like a Grape* (1985). Through the mid-1980s the critics continued to stress the "enigmatic," "ambiguous," or "impenetrable" nature of her works, but by the time of her 1987 show at Ronald Feldman, where she exhibited tremendously complex but visually integrated paintings like *Crimson Gardens* (1986), *Noble Fields* (1987), and the haunting *K-Mart Village* diptych (1987), there seemed to be more direct appreciation of her approach. "There is no coherence to her world," wrote Kate Linker in *Artforum*, "because the work itself is incoherent and because the codes that would give it solidity are ruptured by the implosive turbulence of human cruelty."

EXHIBITIONS INCLUDE: Borhm Gal., Palomar Col., San Marcos, Calif. 1971; Newport Harbor Art Mus., Newport Beach, Calif. 1973; Max Hutchison Gal., NYC 1973; Women's Inter-Art Cntr., NYC 1976; Ellen Sragow Gal., NYC 1978; Whitney Mus. (Film and Video Dept.), NYC 1978; Franklin Furnace, NYC 1979; Williams Col. Mus. of Art, Williamstown, Mass. 1979; Ronald Feldman Fine Arts, NYC from 1980; Printed Matter Windows, NYC 1980; Rotterdam Arts Foundation, 1980; Apropos, Luzern 1980; Douglas Col., New Brunswick, N.J. 1981; Gal. del Cavallino, Venice from 1981; Gal. il Diagramma, Milan 1981; Bowdoin Col. Mus. of Art, Brunswick, Me. 1982; "Projects at the Chamber," NYC Chamber of Commerce 1982; Nigel Greenwood Gal., London 1982; Koplin Gal., Los Angeles 1983; Spectacolor Board, Times Square, NYC 1983; Chrysler Mus., Norfolk, Va. 1984; Anderson Gal., Va. Commonwealth Univ. 1984; Real Art Ways, Hartford, Conn. 1985; Inst. of Contemporary Art, Univ. of Pennsylvania, Philadelphia 1986; Wadsworth Atheneum, Hartford, Conn. 1987; Univ. of Kentucky Art Mus., Lexington 1987. GROUP EXHIBITION INCLUDE: "21 Artists: Invisible/Visible," Long Beach Art Mus., Calif. 1972; "From the Ceiling," Max Hutchison Gal., NYC 1973; "In Spaces," Sarah Lawrence Col., Bronxville, N.Y. 1973; "The Proscenium," P.S. 1, Long Island City, N.Y. 1977; "With a Certain Smile," Halle für Internationale Neue Kunst, Zurich 1979; "Erotik in der Kunst," Kunstverein, Bonn, West Germany 1982; "Directions '83," Hirshhorn Mus. and Sculpture Garden, Washington, D.C. 1983; "Time Line," P.S. 1, Long Island City, N.Y. 1984; "An International Survey of Recent Painting and Sculpture," MOMA, NYC 1984; "El Arte Narrativo," Tamayo Mus., Mexico City 1985; "The Guerilla Girls at the Palladium," NYC 1985; "Havana Biennale 1986; "MASS," New Mus. of Contemporary Art, NYC 1986; "Morality Tales: History Painting in the 1980s," Grey Art Gal., NYC 1987 (trav. exhib.); "Some Like It Hot," Washington 2 Project for the Arts, Washington, D.C. 1987; Documenta 8, Kassel 1987.

COLLECTIONS INCLUDE: Chrysler Mus., Norfolk, Va.; Williams Col., Williamstown, Mass.

ABOUT: "Ida Applebroog" (cat.), Ronald Feldman Fine Arts, NYC, 1987. Who's Who in American Art, 1989–90; *Periodicals*—Artforum March 1980, February 1983, January 1988; Art in America February 1983; Arts Magazine October 1984, April 1986; Artscribe June–July 1986; Print Collectors' Newsletter, January–February 1983; Village Voice November 10, 1987.

ARMAN (November 17, 1928–), born Armand Fernandez, now Armand Pierre Arman, Franco-American assemblagist and sculptor, was one of the founding members of the French *nouveaux réalistes* who turned away from the dominant abstract expressionist mode (and its European variant, tachism) in order to make an art of the "real." In contrast to his close friend Yves Klein, who was the metaphysician of the group, Arman was its materialist, the one, in

ARMAN

Pierre Restany's words, most committed to "the appropriation of reality through the object." *Nouveau réalisme* as a movement faltered not long after the death of Klein in 1962, but Arman has remained the master of the object, fashioning his various accumulations, constructions, and freestanding sculptures in ever more elegant and permanent materials, but with much the same ironic engagement in the dialogue between art and urban life.

Born Armand Fernandez in the Mediterranean town of Nice, Arman was the son of Marie Marguerite Jacquet and Antonio Fernandez. As his father's name suggests, the family was of Spanish origin, settlers in North Africa who had acquired French nationality and moved to France just after World War I. Arman began his education at the Cours Poisat, a local girls' school; as the story goes, his father enrolled him there so that he would not be separated from his best friend, who was a girl. In any case, he spent six years there before moving on to the Lycée de Nice and getting expelled three months later. A series of boarding schools followed until he finally reentered the lycée and completed his baccalauréat in philosophy and math in 1946.

Arman's father, a dealer in antiquities and secondhand furniture, was also a Sunday painter and amateur cellist, and he passed all of those interests—antiquarian, artistic, and musical—on to his son. Arman began painting at the age of ten and, after the lycée, he continued his studies at the National School of Decorative Arts in Nice. The following summer, while taking judo classes, he met the painter Yves Klein and the

poet Claude Pascal, and the three of them took off on a hitchhiking tour of Europe. Inspired by the example of Vincent van Gogh, they made a collective decision to abandon their family names. Over the next five years, they were to share an intensive involvement with spiritual trends that included Zen, Rosicrucianism, the teachings of Gurdijieff, and astrology.

In 1949 Arman (then Armand—he became Arman in 1958 when a printer's error dropped the *d* from the cover of an exhibition catalog) left the School of Decorative Arts after an argument with the administration and moved to Paris, where Klein was already living. At the time, his idea was to become an auctioneer, and to that end, he took courses at the Ecole du Louvre in archaeology and Far Eastern art. Two years later he gave up his studies—"I was in the nebulous pictorial pathos of young painters looking for themselves," he later told André Parinaud—and with Klein he traveled to Madrid and became an instructor at the Bushido Kai Judo School. Klein then went off on an extended trip to Japan, and Arman was drafted for the French war in Indochina, doing a brief tour of duty in the medical corps. On his release, he returned to Nice, where he married the composer Eliane Radigue in 1953. (They remained together until 1967 and had three children, Françoise, Anne, and Yves.) He supported himself by working in his father's furniture store and moonlighting as an underwater fisherman for the big tourist restaurants of the Côte d'Azur. In his free time he pursued his own interests with a passion: chess (which he had been playing since the age of eight), sharpshooting, archaeology, and art collecting. When Klein came back from Japan, they teamed up to do happenings that included a rollerskating race in a local museum and a picnic in a movie theater. He also continued to paint, moving from the surrealist mode of his days at the Ecole du Louvre to more contemporary abstraction along the lines of de Staël, Poliakoff, and Soulages—what he later described as "a sort of Mediterranean abstract landscape."

In effect, Arman had become a Sunday painter like his father, but as with his other interests and pastimes, painting was something he took very seriously, following current developments in art magazines and making regular trips to Paris to visit the galleries. Within a short time, exposure to various new influences set him on a path that led from Sunday painting to the vanguard of contemporary art. The first "catalyst," as he called it, was a Kurt Schwitters exhibition he saw in Paris in 1954 which "knocked [him] over." Even so, there was no immediate impact on his own work; it was only after he came across the graphic art of the Dutch typographer Hen-

drik Nicolas Werkman—entire pages filled with
repeated words and letters—that he began to ex-
periment, using rubber office stamps to create
abstract designs on paper. "I wanted to do rub-
ber stamps like Schwitters, like Werkman," he
recalled, "filling up the page. That was the first
thing I did that was a little personal."

In their initial form, the *cachets* (rubber
stamps) that Arman began making in 1955 had
an obvious sociological thrust in the transforma-
tion of a bureaucratic tool into an artistic one
(and with no small autobiographical overtones in
the use of stamps like "Fernandez and Son"). But
as Arman himself later acknowledged, it took a
third catalyst, the drip paintings of Jackson Pol-
lock, which he saw in a Paris gallery, to make
him aware of the structural possibilities of all-
over patterning.

In February 1956, following the lead and en-
couragement of Klein, he exhibited his paintings
at the Galerie Pavel in Paris, and he included
some of the *cachets* as well. As it turned out, the
paintings were of no particular interest—"I was
no more noteworthy than two thousand other
painters at that time," he told Parinaud—but the
cachets drew the attention of the critic Pierre
Restany, who urged Arman, both in print and in
person, to experiment with his rubber stamp
compositions on a large scale. Following Re-
stany's suggestion, he moved to bigger formats—
eventually several yards on a side, which obliged
him to work on the floor—and also began using
colored inks and traces of paint. In the process,
what had begun as a mechanical exercise in the
spirit of dada took on a much more existential di-
mension akin to Pollock's action paintings: "The
contact with the stamps," he told Restany at the
time, "creates a strange transformation in me. I
pick one of them, I take it, manipulate it, I put
it down, I take another one. I get excited. I'm
spellbound, little by little I go into a kind of
trance."

As Restany pointed out, Arman was strongly
influenced by Klein, but at the same time, he did
not share the "revolutionary messianism" that
impelled his friend's passionate avant-gardism;
indeed, Klein's formal education consisted of
two years at the merchant marine academy and
the School of Oriental Languages in Nice, while
Arman was a product of the art schools, with a
solid knowledge of conventional techniques and
traditions. Ultimately, and regardless of the ma-
terials and methods he was to use, Arman's work
was always informed with a certain classicism:
clarity of definition, of means, of structure.

The *cachets* continued until 1960 (the very
last is titled *La fin des cachets,* or *The End of the
Cachets*), but by then Arman was also working

in very different idioms and, more important,
had established the basic formats or "genres"
that his work was to follow to the present. He
had already abandoned painting—or, as he told
Sylvain Lecombe, "Let's say that painting aban-
doned me. . . . To have been able to abandon
it, I would have had to be a real painter, which
I never was. . . . At one point I thought I was
doing good painting, but I was fooling myself."
In 1957 he made an extensive tour of Turkey,
Iran, and Afghanistan with his wife and a friend
researching cuneiform languages, an experience
that reinforced his notions of geology and ar-
chaeology and brought him back to Nice eager
to experiment. On his return, he started using
other materials to imprint his paper—an old felt
hat, then rags, then random objects he found
around the house, ranging from eggshells to pis-
tons—and in that way, the *allures* (traces) were
created. As was the case with the *cachets,* the
allures led him in directions he had not antici-
pated: he began to work with the objects them-
selves, and, as he told André Parinaud two
decades later, "In 1959, everything exploded
and I really became the artist you know today."

It was a transitional group of *accidents,* for
which he filled vessels like bottles or teapots and
smashed them on the painting surface, that led
to his first "object-art": the remains of two cups,
a saucer, and a teapot that had been smashed
and mounted on a piece of wood (*Tea for Two,*
1958). He then turned back to Schwitters and
began making his own junk collages, an exercise
that led him to the *poubelles* (trash cans), which
were, as the name suggests, displays of the con-
tents of selected trash cans. With the collages, he
explained to Lecombre, "I was just arranging the
refuse; the fundamental gesture, in my opinion,
only came when I emptied an entire trash can
into a glass tank." Around the same time, a box
of radio tubes that he bought in a junk shop to
ink and smash for his *allures* gave him the idea
for another form of object-art, which he called
accumulations and which he inaugurated with
a one-meter cube full of toothbrushes. "The
accumulation," he told Parinaud, "makes me a
painter of my time. . . . The object, in a word,
belongs to my landscape, to our urban land-
scape. How can you ignore it?"

That repertoire, as many critics have noted,
corresponded at once to Arman's personal evolu-
tion and the collective experience of his genera-
tion. The *poubelles* and the *accumulations,* like
the *colères* (angers) that were to follow, offered
an ironic tribute to the consumer society that
was overtaking postwar Europe, and one that
was equally expressed in the supermarket objects
of Martial Raysse, the compressed cars of César,
and the torn billboard posters of Raymond

Hains, Rotella, and Villeglé. In fact, that group, along with Arman, Klein, Jean Tinguely and his wife, Niki de Saint-Phalle, Daniel Spoerri, and Christo, was to join the critic Pierre Restany under the banner of *nouveau réalisme*; they were, in Arman's words, "artists who perceived, before the others, the problems posed by relations with the object, the object that is produced, mechanical, rejected, with mass production, with posters. They tried to understand the civilization in its material aspect, the problem of the invasion of slogans, advertising, the machine, supermarkets, the urban world and the manufactured object."

The first time that Arman showed his *poubelles* and *accumulations*, in fact, was at a group exhibition organized by Pierre Restany in 1960 that also included works by Klein, Tinguely, Hains, Villeglé, and Dufrêne. That exhibit inspired Restany to issue a *nouveau réalisme* manifesto, in which he announced "the passionate adventure of the real perceived in itself" that was to supersede the outmoded "transcription" of reality through conventional painting and sculpture. One of the most notorious public demonstrations of that new spirit in French art was Klein's 1958 exhibit at the Galerie Iris Clert, "Le vide" (The Void), which consisted of the empty gallery, repainted white for the occasion, and several thousand guests invited for the opening. At the time, Arman had proposed a sequel that would have involved filling the gallery with the contents of the municipal garbage bins, but Clert backed off; two years later, after his successful one-man show in Düsseldorf, the dealer changed her mind, and on October 25, 1960 "Le plein" (Full Up) opened with several tons of trash filling the gallery from floor to ceiling (city officials had ruled out the use of garbage for health reasons).

In the period between the exhibition in Düsseldorf and "Le plein," Arman had spent much time reflecting on the implications of his work and composing a text on "The Realism of Accumulations." Echoing Klein's dictum that "one thousand square meters of blue are bluer than one square meter of blue," he explained that "quantity creates a change; the object is canceled out as an object. It becomes a kind of grain, surface, monochrome; its destination is different. A fork that you present by itself on a base on a certain angle evokes a certain analogy—animal, for example. But a hundred forks, that's something totally different."

In retrospect, the early *poubelles* and *accumulations* were quite similar—collections of discarded objects—and quite tied to dadaist and surrealist traditions of chance and incongruity. Arman himself later knowledged that there was

an anti-aesthetic thrust to his work during that period, "but very quickly," he told Alain Jouffroy in 1965, "I was overtaken by the object itself." Unlike Duchamp, he went on to explain, "I have absolutely no desire to reject aestheticism, because aestheticism is an absolutely variable quantity in the first place." And indeed, within a short time, that aestheticism became increasingly apparent in the attention paid to selection and presentation: instead of random collections of objects, the *accumulations* became displays of interesting forms—dolls' eyes in *Petit Argus* (*Little Argus*, 1961), electronic doorbells in *Ring the Bells* (1961), cogwheels in *Galaxie* (1962), machine-gun bullets in *The Spirit of Christmas* (1962), to name only a few. The *poubelles* meanwhile gave rise to individualized "portraits"—collections of personal effects belonging to the subject, as in the *Robot-portrait d'Yves Klein, le monochrome* (*Artist's Sketch of Yves Klein, the Monochrome*, 1960), an assortment of clothing and papers unmistakably personalized by the prominence of the so-called Yves Klein blue.

If the *accumulations* and *poubelles* were becoming, in Arman's words, more "cool," the elements of surprise, happenstance, and outright violence made their way back into his work in two new forms, the *colères* and the *coupes* (slices). Both in effect grew out of his first piece of object-art, *Tea for Two*, which was the result of an act of destruction. The first *colères* were created, happening-style, in 1961 with the smashing of a double bass before the cameras of NBC-TV in Paris, followed by a set of Henri II furniture at the first *nouveau réaliste* festival in Nice. The *coupes*, as the name suggests, consisted of objects that had been sliced and mounted, mainly musical instruments in wood or brass, but also metal pitchers, coffee pots, oil cans, and the like. Such destructions, Arman explained to Jouffroy, had a psychological value that lay "in the scandalous fact of having made an object undergo a transformation it wasn't destined to have: to slice a violin in fine slices is a scandalous act. The application of a technique or method you could use on a sausage but which isn't meant for a violin provokes a 'twisting' of thought, a change that naturally has a psychological effect."

The *colères* and *coupes* essentially completed Arman's repertoire of artistic functions corresponding to what he labeled the "pseudobiological cycle of production, consumption, and destruction." His sense of that phenomenon was soon to be reinforced by his exposure to the consumption capital of the world, New York City. He made his first trip there in October 1961 for a one-man show at the Cor-

dier-Warren Gallery, where, in fact, his *poubelles* and *accumulations* drew a mixed reaction (as had Klein's monochromes at Leo Castelli that April). Among the pop art contingent that turned out for the opening, Robert Rauschenberg was openly critical, declaring that "automatic repetition is not creation." Claes Oldenburg's and Andy Warhol's responses were more favorable; when Warhol introduced his Campbell's soup cans a year later, Tinguely accused him of imitating Arman.

In May 1962 Arman traveled to Los Angeles to inaugurate the Dwan Gallery with a "spontaneous accumulation"—visitors were invited to "cast your vote here for a cleaner Dawn Gallery" by depositing their trash in a receptable bearing that label. When he came back to New York the following year for an exhibit at the Sidney Janis Gallery, he spent several months at the Chelsea Hotel, and a pattern was established; for the next five years he returned to New York every winter and stayed at the Chelsea. In 1969 he bought the first of a series of part-time residences in lower Manhattan that enabled him to move back and forth between Europe and New York. "The fact of being from Nice, of never having had deep ties with Paris, helped me to take the leap," he told Sylvain Lecombre. "My first city is New York." In retrospect, he realized that the move produced "a very defined break in the way I saw my work and realized it, and in the final visual result." The pre–New York work, he indicated, had the "'antique' flavor of refused objects, sitting in boxes like memories," but after 1961, "aesthetic values became more essential, the visual quality became more important than the nostalgic and antique like quality of the earlier pieces."

In the midst of that transition, Yves Klein died of a sudden heart attack at the age of thirty-four, and by early 1963 the group activities of the *nouveaux réalistes* had come to an end. Arman himself continued to organize sporadic events in the spirit of their happenings throughout the decade. In 1963 he accepted a commission to dynamite the white Mercedes of photographer–film producer Charles Wilp; in 1965 he created an art lottery (the "Artist's Key Club Event") in New York, and the following year he held an art exchange at the Allan Stone Gallery; in 1969 he set up "Art by Telephone" at the Chicago Art Institute, inviting visitors to accumulate their own garbage, and in 1970, he organized one of his few overtly political actions, "America Cut in Two," where, for a fee, he cut and signed any object brought to him, in that way raising $5,000 for the Black Panther Party.

In fact, the main thrust of Arman's activity during that period lay elsewhere, in the exploration of new techniques and materials. In 1962, for example, he turned to welding to create freestanding *accumulations* such as the *Fétiche à clous* (*Nail Fetish,* apparently an allusion to a Congo nail fetish sculpture), an ominous pyramid of revolvers. He then began working with polyester and Plexiglas as a way of freeing his assemblages from wooden boards and boxes, alternately suspending small objects like cogwheels or ball bearings in transparent sheets or encasing the larger fragments of *colères* and *coupes* in three-dimensional blocks. Toward the mid-1960s he began using the Plexiglas to create what he called *couleurs* (colors), which were accumulations of paint tubes squeezed into streams and patches of brilliant color, most often in vertical patterns strongly recalling the stain paintings of Morris Louis.

In 1967 he embarked on an "art and industry" collaboration with Renault auto manufacturers that was to result in a total of sixty-five monumental *accumulations* over the next two years. The project grew out of an invitation to represent France at Expo '67 in Montreal; interested in working with car parts, Arman first approached Ford Motors with no success, but Renault offered him free access to one of their factories. "In showing me how these elements were manufactured and prepared before being assembled in the factory, they whetted my appetite," he explained to Claude-Louis Richard. "Imagine a starving painter who has the doors of a paint store opened for him and who's told 'Go ahead, do what you want.' That's exactly what happened to me with Renault." A number of pieces used small elements like pushbuttons, colored electrical wire, ventilator fans, or the metal lozenges bearing the Renault insignia for Plexiglas *accumulations* along the lines of his earlier work, although, as he noted, more "classical" in their compositions (in the spirit of the hard-edge paintings of the 1960s). But the freestanding works that he inaugurated with the swirling orange *Accumulation spirale Renault no. 101, 1967*, which he made for Expo '67, marked a clear departure in their scale, their volume, their dynamic interaction with the surrounding space, and their shiny newness. Not everyone was happy with that celebration of the industrial aesthetic—the students of Vincennes University denounced the Arman–Renault marriage as a publicity stunt for big business—but Arman was quite frank about his evolution: his roots, he indicated, were in *arte povera,* "but contrary to the art of my time, I evolved from poor art to rich art. And I don't suffer the slightest pangs of bad conscience. I was one of the first to create poor art, but I don't intend to keep on all my life."

In 1968 Arman, then separated from Eliane Radigue, met Corice Canton in southern France; three years later they were married in Nice, and in 1982 they had a daughter, Yasmine. With Corice he resumed the study of the martial arts (now Kung Fu Wu Su) that had been a consuming interest in his youth. He also became seriously involved with the Japanese game of *go,* to the extent of receiving two visits from the *go* master Isamu Haruyama in the mid-1970s and attaining the rank of *shodan* following a visit to Japan in 1980. In terms of his art, the 1970s were essentially a period of reworking motifs and formats with still other techniques and materials. In 1971, for example, he created a series of *nouvelles poubelles* (new trash cans), which, thanks to Plexiglas, were able to include real, perishable garbage. The same year, he started making *accumulations* in concrete, initially in order to work on a large scale (the first was an orchestra platform in Milan, which he embedded with chairs), but he soon brought the new medium back to the *colères* and *coupes* for various series of shattered and sliced objects. In contrast to the preceding works in polyester and Plexiglas, where rather humble objects were enhanced by their shiny casings, the concrete created a very different, downbeat effect: as Andrew Crispo wrote on the occasion of Arman's 1974 exhibit of sliced musical instruments, "These new works represent fossilized remnants of our culture."

At the time of the *nouvelles poubelles* Arman stressed that he was not just repeating himself; the new versions, he told Otto Hahn, were not remakes: "They're more total, more free. If I hadn't found a way of making them different, I wouldn't have done them over. The priest and the soldier, the artist and the prostitute, have to be moral." But in the mid-1970s he felt dissatisfied with the direction his work was taking and decided to take a break with a new series of *allures.* Once again, imprinting objects led him back to the objects themselves, in the form of the *nouvelles accumulations* of the late 1970s. Like the welded *accumulations* of the early 1960s, a number of those works were made out of household tools, such as hatchets, hammers, irons, and wrenches. But more than a decade later, with the switch from "poor" materials to "rich" ones, the found-object aesthetic yielded to an emphatic formalism, expressed in regular contours, shiny surfaces, uniform colors and textures. Those features are even more insistent in some of the accumulation-reliefs made in the early 1930s, where wrenches, saws, and other metal objects were fashioned into boldly decorative patterns. In those new sculptures, wrote Daniel Abadie, "it is a question for Arman . . . of using accumulation to counterbalance the intrinsic beauty of the object, thereby better displaying the 'facture' of the sculpture . . . and in the process affirming his classicism and his ability to integrate, beyond the first appearance, the elements of a modern world into the grand tradition of sculpture."

By the beginning of the 1980s Arman was making "classical" bronze sculpture himself. He had begun, in 1977, with a cast of a violin produced as a multiple; that was followed by an assortment of violins, cellos, and guitars—and one harp—sliced or smashed in the familiar way but then cast into bronze and welded into freestanding constructions collectively known as "Arman's Orchestra." In that form, the fragmented instruments are strongly reminiscent of the cubist imagery of Picasso and Braque, an association that Arman acknowledges with titles like *Cubist Composition* (1981), *Braque 1912* (1981) and *Picassien* (1982). A 1982 commission to create a monumental sculpture for the Picasso Museum in Antibes similarly resulted in an *accumulation* of thirty cast-bronze guitars which he called *À "Ma Jolie,"* alluding to Picasso's famous cubist painting of 1911–12. But in his catalog statement, he was careful to stress the differences in their approaches: "Picasso's investigations into forms and materials are not mine," he wrote; "the language of quantity, the interaction of repetitions among themselves better illustrate my preoccupations."

Arman continued to pursue those "preoccupations" in a number of monumental commissions during the 1980s, including an *accumulation* of ship anchors for the Dunkirk Museum (1982), a tower of supermarket carts for the Chicago Art Fair (1984), and a pair of *accumulations,* one of suitcases and the other of clocks, for the Saint-Lazare railroad station in Paris (1985). The largest and most controversial sculpture he undertook at that time was *Long-Term Parking* (1982), an *accumulation* of sixty cars embedded in concrete. Originally conceived for a monument in Philadelphia, it was finally executed in the parking lot of a country club outside Paris, but three years later it had to be rescued from a local "friends of the neighborhood" campaign (mounted, according to Arman, by a group of artists who were "a little frustrated and a little obscure") to have it moved or torn down on the technicality that it was really a building.

At the end of 1983 Arman began working on another new-old theme, a group of bronze sculptures cast from the remains of burned period furniture. He had begun burning furniture with a *combustion* called *Le fauteuil d'Ulysses*

(*Ulysses's Armchair*, 1965), but as with the smashing and slashing of musical instruments, the fragility of burned objects posed a problem that was only resolved with the transfer of bronze. Unlike "Arman's Orchestra," which subsumes the violence of the *coupes* and *colères* to the elegance of the material, the skeletal bronze furniture graphically records what Arman describes as "an arrested catastrophe," and he chose to carry the association to its most unsettling conclusion by calling the group of sculptures "The Day After" (in allusion to the recent television drama about the aftermath of nuclear war).

Arman, who became an American citizen in 1972 (and changed his name officially to Armand Pierre Arman the following year), to divide his time between New York, southern France, and Paris. Since the early 1980s he has curtailed some of his non-artistic pursuits, notably the game of *go* and his collection of African art, but he still travels extensively in Europe and Asia.

In 1969 Gregoire Müller characterized Arman as "the one who has opened the way for a direct, almost carnal action on the real; the one who has permitted the artist to abandon the role of exemplary witness and become not only a presenter but an 'actor,' a person who expresses himself in acting on the objects of his vital environment." As "Arman's Orchestra" and "The Day After" suggest, he has held to his course ever since. He would be the first person to acknowledge—and he does—that he is no longer pushing the limits of the avant-garde. his motivations are elsewhere. "I don't believe that an artist has more than one statement in his life," he told Sylvain Lecombre; "he can only draw different consequences out of it, which are called periods. . . . You have to have a certain humility. You have to know how to accept your limits. Myself, I feel humble enough to accept that I've only created that much and to try to draw out of it the greatest number of consequences and variations."

EXHIBITIONS INCLUDE: Marisa del Re Gal., NYC from 1983; Seibu Mus., Tokyo 1984; Walker Hill Art Cntr. Seoul 1985; Gal. Sonia Zannettacci, Geneva 1985; Wenger Gal., Los Angeles 1986; Goldman Craft Gal., Chicago 1985; Gal. Beaubourg, Paris 1987.

ABOUT: "Arman" (cat.), Galerie Ileana Sonnabend, Paris, 1967; "Arman: Accumulations Renault" (cat.), Union Centrale des Arts Decoratifs, Paris, 1969; "Arman Aujourd'hui" (cat.), Musée de Toulon, 1985; "Arman: La Parade des Objects" (cat.), Musée Picasso, Antibes, 1983; "Arman Objects Armés 1971–1974" (cat.), Musée d'Art Moderne de la Ville de Paris, 1975; "Arman's Orchestra" (cat.), Marisa del Re Gallery, NYC, 1983; "1960: Les Nouveaux Réalistes" (cat.), Musée d'Art Moderne de la Ville de Paris, 1986; Crispo, A. "Concrete Lyrics" and "Lyrical Surfaces 1955–1975" (cats.), Andrew Crispo Gallery, NYC, 1975, 1976; "The Day After" (cat.), Marisa del Re Gallery, NYC, 1984; Emanuel, M., et al. Contemporary Artists, 1983; Hahn, O. Arman, 1972; Lamarche-Vadel, B. Arman, 1987; Martin, H. Arman, 1973; Müller, G. "Arman, Oeuvres de 1960 à 1965" (cat.), Galerie Mathias Fels et Cie, Paris, 1969; Seitz, W. "The Art of Assemblage" (cat.), MOMA, NYC, 1961; Van der Marck, J. Arman, 1984: Who's Who in American Art, 1989–90. *Periodicals*—Art in America December 1983; Art Press November 1978; Cimaise September–December 1969, June–September 1978; Connaissance des Arts September 1982, June 1985; Galerie des Arts December 1978; L'Oeil June 1965.

ARNESON, ROBERT (September 4, 1930–), American ceramicist, sculptor, and draftsman, was born in the northern California coastal town of Benicia, where he attended high school and began his professional career as an artist by drawing weekly sports cartoons for the *Benicia Herald*. With the encouragement of his Norwegian father, Arneson emulated the style of his favorite comic strips, drawing his family and friends in the style of Al Capp. His adolescent newspaper cartoons, incorporating breezy caption summaries of the athletic triumphs of local high school heroes, display an eccentric boyish humor that has never left Arneson's work; it can be seen, for example, in the self-portrait busts for which Arneson became celebrated in the 1970s. Like comic strips, Arneson's work frequently includes a verbal component: his titles are often puns, and the pedestals of his portrait busts are often inscribed with jokes and quotations. His taste for juxtaposing image and word is particularly disturbing in *Portrait of George* (1981), a bust of George Moscone, the murdered mayor of San Francisco, commissioned and then angrily rejected by the city council. The genial, smiling bust of the mayor surmounts a pedestal on which allusions to the manner of his death and the character of his murderer are scrawled.

Portrait of George is characteristic of Arneson's ability to disorient his audience, and critical reaction to his work has often noted that his sculpture is powerfully original despite the materials and thematic concerns from which it is created. Some of his pieces, such as *Classical Exposure* (1972), in which a cigar-chewing self-portrait bust stands on a classical pedestal endowed with genitalia and feet, seem to be a self-denigrating joke about Arneson's place in art history. In *Pablo Ruiz with Itch* (1980), however, satiric implications seem to stretch more widely. In that bust, Picasso, in the act of scratching his back, strikes a pose that echoes his great cubist

ROBERT ARNESON

work *Les demoiselles d' Avignon.* The audience is left to wonder whether Arneson implies that Picasso, like his coyly named "demoiselles," sold himself.

The clash in Arneson's work between the comic and the serious, the dignified and the banal, is not only an outcome of his unique style and thematic concerns; it is also a product of his choice of medium. In deciding to work in clay he was flying in the face of sculptural tradition, while at the same time flouting assumptions about the proper uses of a functional material. By bringing ceramics into the mainstream of contemporary sculpture, Arneson advanced the movement begun in the San Francisco Bay Area by Peter Voulkos, once his teacher, and now continued by David Gilhooley and Richard Shaw, both students of Arneson. Voulkos was the initiator of the tendency to use clay to make large, nonfunctional objects, but Arneson also absorbed other influences from the experimental San Francisco climate of the 1960s, notably that of artists who assembled free of reference. The primary source of Arneson's inspiration has remained his personal perceptions, which give his work an extraordinary immediacy. The subjects of Arneson's works are frequently abstract, universal concerns, such as fear, embarrassment, or discomfiture, but these are always presented through an aspect of everyday reality—often the bald head of Robert Arneson. However serious its subject, Arneson's style always banishes solemnity, just as his medium is inextricably associated with pots rather than fine art: "the ultimate ceramic," he has pointed out, is a toilet.

Working in clay seems to have satisfied Arneson's need to remain marginal and unpretentious; it permits him to be serious without being taken seriously. As he told an interviewer in 1978: "Of course in ceramics you're not an artist so you're really innocent."

Arneson's progress toward his mature style has been long and tortuous, and it is only in hindsight that the cartoons he continued to draw while attending the College of Marin in Kentfield seem to contain the salient elements of his later manner: everyday people, often Arneson's friends, are elevated with ironic reverence into larger-than-life forms on which slangy, occasionally obscene remarks are inscribed. He was not a promising student of fine art, but showed enough talent as a commercial artist to win a scholarship to the California College of Arts and Crafts in Oakland in 1951. Discouraged by his failings as a draftsman, he dropped out after one semester, but returned in 1952 to study a craft curriculum that included bookbinding and watercolor painting. On graduating in 1955 at age twenty-three he took a job as an arts and crafts teacher at Menlo-Atherton High School near Palo Alto. Since the curriculum included pottery making, Arneson was obliged to study ceramics, a subject he had failed in college, but which he now found so intriguing that he devoted all his spare time to it. In 1956 he enrolled in the San Jose State College summer school to study with the well-known potter Herbert Sanders.

Arneson became a competent potter under Sanders' direction, and continued his studies during a second summer session at the California College of Arts and Crafts, where his instructor was Edith Heath, a specialist in the industrial uses of clay. Just as Arneson's experience in the artistic and commercial applications of clay was widening, he became aware of the work of Peter Voulkos, who taught at the Otis Art Institute in Los Angeles from 1954 to 1959. Taking Picasso's work in ceramics as a point of departure, Voulkos began creating works that, although thrown on a potter's wheel, questioned the traditional aesthetics of pottery with their size and expressive, gestural qualities. Voulkos, as Arneson recognized in a review for *Ceramics Monthly* in 1957, was in the process of creating an art form in which pottery assimilated the expressionist energies of action painting. "Many of these new clay forms," Arneson asserted, "belong in the classification of sculpture."

Arneson was attracted by Voulkos's example, but remained a traditional potter, enrolling in the M.F.A. program at Mills College to study with Antonio Prieto, a master ceramicist who emphasized fidelity to craft over self-expression,

although he had experimented with molded clay sculpture in the manner of his countryman Joan Miró. It was not until Arneson had graduated that he began to experience the tension between art and craft so acutely that it began to be reflected in his work. In 1959, having taken another high-school teaching job close to Berkeley, where Voulkos was teaching, he began to make eccentric stoneware vases that retained a vaguely functional air while taking on the rough textures and gestural forms that characterized Voulkos's work. One of those vases was chosen by Rose Slivka to illustrate her seminal article "The New Ceramic Presence," published in the summer 1961 issue of *Craft Horizons. Eviscerated Pot,* a work exhibited by Arneson in his first major show at the M. H. de Young Memorial Museum in San Francisco, in 1962, evidently marks his rejection of the standards of craftsmanship epitomized by Prieto and represents a watershed in his career. Dating from that time is another work, *No Deposit, No Return,* a meticulously executed ceramic beer bottle that reveals Arneson's growing interest in the possibility of surreal parody and his desertion of the use of clay to create functional objects.

Arneson's willingness to experiment in the unexplored territory between craft and fine art was stimulated by his association with the painters Wayne Thiebaud and Roy De Forest and the sculptor Manuel Neri, colleagues at the Davis campus of the University of California, where Arneson has taught since 1962. During the mid- and late 1960s produced a series of clay works based on everyday objects that are reminiscent of Claes Oldenburg and belong to the popular genre of California "funk art." Abandoning the rough monochrome textures of stoneware, he used brilliant glazes and began to paint his work after firing it, so taking another step in modifying the pottery techniques of his earlier training. Outstanding pieces of those years include *Toaster* (1965), a detailed replica that includes the surreal element of disembodied fingers protruding from the slots, and *Typewriter* (1966), in which red-painted fingernails are substituted for keys. Delicate surreal fantasy worthy of Magritte coexisted in those objects with a vein of scatological and sexual humor expressed by visual and verbal puns, an unstable balance that was noticed by Peter Scheldahl in an *ARTnews* review of a 1966 group show in New York that included Arneson. The objects, he wrote, "are uniform in innocence, obscenity, and something like grandeur." Whereas Oldenburg, and certain "funk" artists, seemed eager to denigrate and coarsen the objects they parodied, Arneson's sensuous glazes and brilliant colors granted his work a *trompe l'oeil* beauty that elevates it beyond

parody, and also dissociates him from the influence of Voulkos.

The humorous, self-deprecating note in Arneson's art that is most evident in his self-portraits of the 1970s began to emerge in the sculptures, drawings, and collages that he made of his own house in Davis. "Alice," a small, ordinary tract house at the intersection of L and Alice streets, assumes a personality in works that range from five feet high and ten feet wide to small, affectionate studies that can be held in the hand. That enterprise allowed Arneson to experiment with perspective and landscape, while the inherent banality of his subject systematically undercut any suggestion of pretension. On a visit to New York City in 1978 Arneson saw and admired Giacometti's *The Palace at 4 a.m.* (1932) in the MOMA exhibition "Dada, Surrealism, and Their Heritage" and was inspired to rework his own *Big Alice Street* (1966), retitling it *The Palace at 9 a.m.* That act, which he later repeated in comic deference to other masters, is a satiric homage that seems both to make a claim to a place in the history of art and yet to deny one. As Arneson said of his reference to Giacometti's classic: "It's a little later."

Apart from the ambitiously joking "Alice" works, Arneson's career seemed to reach an impasse in the late 1960s, becoming trapped in its own whimsy and brilliant command of technique. That was the time of his divorce from his first wife and return to his hometown of Benicia, where he bought an old saloon for use as a house and studio. There he embarked on a new project, a series of ceramic "meals" that was ultimately intended for inclusion in the show "Clayworks: Twenty Americans" in 1971 in New York City. As he finished the piece by combining his plates on a perspective table, Arneson realized that the work lacked a focal point, so he included a life-size self-portrait, clad in chef's smock and hat. *Smorgi-Bob, the Chef* (1971), both ludicrous and dignified, honored Arneson the pruveyor of baked goods and opened the way to a series of self-portraits that occupied the artist throughout the 1970s. In 1965 he had produced a self-portrait bust that cracked in the kiln, but which he had redeemed by gluing marbles into the crack and titling *Self-Portrait of the Artist Losing His Marbles.* Now he returned to a molding technique he had learned from Edith Heath and produced scores of generic Arneson heads on which myriad expressions and allusions were imposed. *Assassination of a Famous Nut Artist* (1972) borrows from Jacques-Louis David's portrayal of the dead Marat and shows the artist impaled in neck and head by daggers. In *Double Mask* (1978), he achieves his effects solely through personal reference, showing himself in

the act of replacing a grimly smiling face with a death mask. The power of that bust in particular seems to spring from tensions within Arneson's personal life. Having divorced, gained custody of his four children, won nationwide recognition, and remarried, he found that he had cancer and underwent a series of operations and a disfiguring course of therapy.

Those busts have the casual immediacy of a graffito and the fascination of a moment frozen in time, as if the artist, like a Pompeian victim, had been interred in lava. The potentially cloying self-awareness of his work is redeemed from narcissism by the variety of expressions and the skill with which the artist makes his own head a vehicle for a range of responses to the human condition. As a few titles of these works imply, self-portraiture is incidental to a generalized comment on the difficulties of living: *Facing Up to It, Balancing Act, Last Gasp, Clown*, and *Whistling in the Dark*. During the late 1970s, he began to extend the range of this style to include portrayals of friend, and of artists who have influenced him. Those likenesses are often distorted in allusion to idiosyncracies of the subjects. His student David Gilhooley, for example, is depicted in the green bust, *David* (1979), alluding to Gilhooley's sculptures of frogs; Marcel Duchamp appears in pink drag as his own persona, *Rose Selavy* (1978).

That period in Arneson's work, which Hilton Kramer described in 1977 as "unashamedly brilliant and amusing," culminated in his bust of George Moscone, the most complex of his portraits and the first to carry political overtones. Arneson's initial sketch for the project (1981) is a realistic likeness that is also a caricature of the public face of a politician. As he began work, however, Arneson decided to place the head on his customary pedestal, which he inscribed with sayings by Moscone and references to his career, so turning the likeness into a complex biographical summary. The public outcry that followed the unveiling forced Arneson to withdraw the work, but did not deter him from including it in the exhibition "Ceramic Sculpture: Six Artists," shown at both the San Francisco Museum of Modern Art and the Whitney Museum. In that context, too, it provoked a hostile reaction, and a dismissive re-evaluation by Hilton Kramer, who found Arneson's work "the mark of a mind too easily pleased with its own jokes. What this attitude amounts to is a kind of moral smugness that we see writ large in the artist's oversized self-portraits, too."

Kramer's remarks are illuminating despite their hostility because they suggest that humor is generally considered unacceptable in fine art,

especially when, as in Arneson's case, it reminds the audience of cartoons and therefore seems crude. Far from forsaking the style he had evolved during the 1970s, however, Arneson has continued to work in a manner that unites word and image, but his latest work is almost exclusively concentrated on a grim theme—the threat of nuclear war. *Holy War Head* (1982–83), the best known of his recent sculptures, is a battered child's head surmounting a column on which is inscribed a passage from John Hersey's *Hiroshima* describing the mutilation resulting from a nuclear explosion.

EXHIBITIONS INCLUDE: Oakland Art Mus., Calif. 1960; Richmond Art Cntr., Calif. 1963; Allan Stone Gal., NYC 1964; Hansen Fuller Gal. San Franciso 1968, '69, '70, '71, '72, '73, '74; Mus. of Contemp. Art, Chicago 1974; San Franciso Mus. of Contemporary Art 1974; Allan Frumkin Gal., NYC 1975, '76, '77, '78, '79; Moore Col. of Art, Philadelphia 1979; Fendrick Gal., Washington, D.C. 1980. GROUP EXHIBITIONS INCLUDE: Cellini Gal., San Franciso 1964; Everson Mus. of Art, Syracuse, N.Y. 1964; Mus. West, San Franciso 1966; Reed Col., Portland, Oreg. 1966; San. Franciso Mus. of Art 1967; Univ. of Calif., Berkeley 1967; MOMA, NYC 1968; Los Angeles County Mus. of Art 1968; Inst. of Contemporary Art, Univ. of Pennsyvlania, Philadelphia 1969; Whitney Mus., NYC 1970; Mus. of Contemporary Crafts, NYC 1971; National Mus. of Moderne Art, Kyoto, Japan 1971; Lowe Art Mus., Univ. of Miami, Coral Gables, Fla. 1972; San Franciso Mus. of Art, Calif. 1972, '76; Univ. of North Carolina, Chapel Hill 1977; Everson Mus. of Art, Syracuse, N.Y. 1979; America Craft Mus., NYC 1981; Rhode Island School of Design 1981.

COLLECTIONS INCLUDE: Whitney Mus., NYC; Mus. of Contemporary Crafts, NYC; Hirshhorn Mus. and Sculpture Garden, Washington, D.C.; Philadelphia Mus. of Art; Univ. of Calif., Berkeley; San Franciso Mus. of Moderne Art; Oakland Mus., Calif.; Crocker Art Gal., Sacramento, Calif.; Stedelijk Mus., Amsterdam; Australia National Gal., Canberra.

ABOUT: Anderson, W. American Sculpture in Process, 1975; Arneson, R. My Head in Ceramics, 1972; Benezra, N. Robert Arneson: A Retrospective, 1986; Coffelt, B. Robert Arneson: Self-Portraits 1965–1978, 1979; Emanuel, M., et al. Contemporary Artists 1983; Foley, S. A Decade of Ceramic Art 1962–1972; Foley, S., et al. Ceramic Sculpture: Six Artists, 1982; Foley, S. and Prokopoff. Robert Arneson, 1974; McTwigan, M. Heroes and Clowns, 1979; Selz, P. Funk, 1967; Smith, P. J. Clayworks: Twenty Americans, 1971. *Periodicals*—Artforum January 1964, September 1977; Art in America September–October 1974, July–August 1977, September 1980; Art International April 1975; ARTnews January 1976; Artweek May 23, 1970, October 26, 1974, January 23, 1982; Arts Magazine January 1965, April 1975, April 1984; Ceramics Monthly May 1982; Craft Horizons January–February 1970, February 1972, February 1974; New York

Times May 15, 1977, May 8, 1981, May 15, 1981; Newsweek July 5, 1971; Visual Dialog Fall 1976.

ARROYO, EDUARDO (February 26, 1937–), Spanish expatriate painter whose political and social commentaries continue the longstanding tradition of Spanish expressionist realism, employs a contemporary style which draws on advertising art, photography, and the cinema. In the 1960s, Arroyo was considered "subversive" for his dual assault on the art and politics of the day; by the mid-1970s and the end of the Franco dictatorship in Spain, his militancy gave way to a more contemplative view of society, while his visual idiom increasingly came to reflect his involvement with theater design.

Born into a comfortable middle-class family in Madrid, he was the first of two children of Consuelo Rodriguez and Juan Gonzalez Arroyo. His father, a pharmacist by profession, was active in the theater circles of Enrique Jardiel Ponciela, Jacinto Benevente, and Federico García Lorca; injured in a theater accident, he died early in 1942. Eduardo, who had been given his mother's family name at birth (following Spanish custom), took the name Arroyo when he reached adulthood and began to paint. After his father's death, he and his sister were raised by their mother, their grandfather, and an uncle. He began drawing at the age of six and often visited the Prado Museum, which was near his house. When he was seven, he was enrolled in the Lycée Français so that he would have a secular education, but in 1953 a disciplinary incident led to his expulsion, and he wound up finishing high school at a religious institution. In addition to his studies, he played sports, went to the cinema, and read a great deal of foreign literature, including the American writers John Dos Passos, Sinclair Lewis, and Erskine Caldwell, who were early favorites.

Arroyo was a child of the Spanish Civil War— he was born only weeks before the German bombing of Guernica that Picasso immortalized in his famous painting—and as he grew up, he witnessed the increasing repression of the Franco dictatorship. At the age of nineteen, he decided to leave the country; hoping to become a writer, he had started journalism school, but he now enlisted in the army in order to get his military obligation out of the way. After serving twenty-two months in the Spanish artillery— during which time he also completed his journalism studies—he left for France with a friend. Settling into the Spanish community in Paris at the end of 1955, he set about improving his French in order to become a journalist. In the meantime, he supported himself as a street artist and portraitist, and also as a lecturer at the Ecole Supérieure de Commerce.

On the advice of friends, he took some of his gouaches to the Galerie Claude Lévin in 1959 and made an immediate sale to the owner, Georges Détais, who encouraged him to come back with paintings on canvas. It was in that way that Arroyo turned to painting, aided by his landlord, who passed along odds and ends of painting supplies. While he still intended to become a journalist, he was struck by the immediacy of the visual medium, and used it as a means of social commentary. His first paintings were portraits of some of the iconic figures of Spanish society—bullfighters and cardinals—as well as shopkeepers and other local people from his new environment in Paris. That initial effort coincided with the opening of the Salon de la Jeune Peinture (Young Painting Salon), which was to become an annual event. Arroyo's entry in the first salon of 1960 again attracted the attention of Georges Détais, who arranged for him to have his first one-man show at the Galerie Claude Lévin the following year. That exhibit of some thirty satirical portraits was favorably received by the critics, and a year later, he had another one-man show in London.

During that period, Arroyo maintained close ties with the Spanish exiles in Paris, who gave him an extensive political education in the cafes of Montparnasse, but he was less a political activist than an avant-garde artist, equally concerned with the history of politics and the history of art. Nonetheless, in the midst of latter-day abstract expressionism, the beginnings of pop, and their French equivalents (tachism and *nouveau réalisme*), Arroyo and his friends were committed to using their art to speak out on political and social issues. At the time, he later recalled, he really didn't want to be a painter because of "the exclusive heritage of abstract painting, a School of Paris that was omnipresent, yet bloodless and agonized. You had to create a healthy reaction, paint something else, fight. And only the politico-cultural fight interested us."

For the 1963 Paris Biennale, he and five other artists—Mark Bruss, Mark Biass, Jorge Camache, Pierre Pinoncelli, and Gerard Zlotykamien—prepared a collective work of painting and sculpture which they called "L'abattoir" ("The Slaughterhouse"). Arroyo's contribution was *Les quatre dictateurs* (*The Four Dictators*), which presented surrealist X-ray portraits identifiable as Salazar, Franco, Mussolini, and Hitler from the flags painted behind them. In his catalog statement, he explained the logic of the X-ray images: "Painting these canvases gave me

very special pleasure. I imagined my characters—let's call them 'leaders' for the sake of clarity—spread out in the operating room. With my scalpel–paint brush I discover everything sinister that you can have in such bodies. What pleasure to reveal the scenes of their sordid lives hidden between heart and lungs, suspicious symbols concealed in the corner of a stomach, the secret of their devious attitudes in the swarming of their intestines." The message was not lost on the Spanish government, which lodged a protest, and Arroyo was forced to block out the identifying flags with sheets of poster-board. He was to have had his first one-man show in Spain that year, but the group of slightly less explicit portraits that he assembled was enough to get that exhibition shut down altogether.

Those confrontations only strengthened Arroyo's opposition to the Franco regime, and the battle of images went into another round. For the Spanish government, 1964 was meant to mark "Twenty-five Years of Peace"; Arroyo in turn adopted the slogan for a new series of paintings which he exhibited at the Galerie André Schoeller Jr. in Paris in 1965. The ironic appropriation of the title was indicative of his stance throughout: his biting denunciation of the dictatorship was expressed with images similarly appropriated from Spanish art of the past. In *La Maja de Torrejan,* for example, alluding to the American air base at Torrejan, Goya's *Naked Maja* is shown in front of the stars and stripes of an American flag, with her body turned shamelessly toward the viewer; the same aura of decadence and corruption is evoked in *Velázquez mon père* (*My Father Velázquez*), which places the Spanish painter in front of an explosion-scarred landscape with a dwarflike baby Arroyo on his arm. "It is not aesthetic pleasure that Arroyo seeks to obtain," wrote fellow Spanish exile Jorge Semprun in the exhibition catalog, "but moral joy—critical, ironic, unexpected—born of the destruction of Spanish myths, private or public."

In another series exhibited simultaneously, the same device of pastiche was used to satirize the pretensions of high art (with a sidelong glance at French chauvinism) through crudely painted variations on the Baronde Gros's *Le général Bonaparte au Pont d'Arcole* (*General Bonaparte on the Arcole Bridge*). Those works were shown at the exclusive Galerie Bernheim Jeune, which Arroyo rented for the occasion in order to make his point where it was most relevant.

Clearly, just as he had become more outspoken in his opposition to the Spanish dictatorship, his position on the Paris art world itself was also increasingly militant. In a 1963 "coup," the Sa-

lon de la Jeune Peinture came under the control of like-minded leftists, and Arroyo was one of those elected to the governing committee. "After fifteen years of nonparticipation in the spectacle of the world, of abstract experiments, of extreme narcissism," he declared to the critic Jean-Jacques Lévêque shortly afterward, "we're approaching a new phase—art that engages the spirit of art more than its vocabulary. We intend to participate totally in the real. That's to say, accuse, denounce, protest, and not back off from taboo subjects like politics or sexuality." The fifteen-member core of the new, radical Jeune Peinture met regularly to discuss politics, art, and the politics of art. For the 1965 salon, they created (at Arroyo's suggestion) "La salle verte" ("The Green Room") intended to negate the premises of artistic "sensibility" with twenty canvases that members of the committee executed in uniform size and color (i.e., green).

In addition to "Twenty-five Years of Peace" and the Napoleon series, which obviously fitted his prescription, Arroyo embarked on two more collective projects with his friends Gilles Aillaud and Antonio Recalcanti. The first of those, shown at the Galerie Saint-Germain in January 1965, was "Une passion dans le désert" ("A Passion in the Desert"), based on a short story by Balzac. In it the challenge to taboo was largely sexual, with thirteen paintings tracing, in storyboard form, a French soldier's erotic encounter with a panther. Their second collaboration, which proved far more controversial, was aimed directly at the art world and at one of its most venerated figures, Marcel Duchamp. "Vivre et laisser mourir, ou La fin tragique de Marcel Duchamp" ("Live and Let Die; or, The Tragic End of Marcel Duchamp," 1965), depicted, in James Bond–style, the interrogation, murder, and burial of Duchamp, interposed with images of his best-known works. The two interrogations are carried out by Aillaud, Recalcanti, and Arroyo, while the pallbearers at the grave site are Duchamp's disciples among the pop artists (Robert Rauschenberg, Claes Oldenburg, and Andy Warhol) and the *nouveaux réalistes* (Arman and Pierre Restany).

In the manifesto accompanying the exhibit, the "perpetrators" of the crime declared that they had (visually) assassinated Duchamp because of his lack of "the spirit of adventure, freedom of invention, sense of anticipation, and the power to go further." That text, coupled with the slick photo-realist style of the paintings, outraged most critics and artists. (At the gallery, the work was accompanied by a disclaimer in which the artists took all responsibility.) Duchamp himself dutifully visited the exhibit but declined to enter the fray: "These people want to make

a name for themselves, that's all," he told Pierre Chabanne; "If you want to be kind to these young people, go ahead; I'm starting to catch on to this sort of thing, and the only refutation is indifference." As for Arroyo, he continued to defend the paintings and the motivations behind them well into the 1970s: "For me, Duchamp represents everything that I don't share, that's to say, laxness, complacency, imprecise choices, everything that was in the air with the rarefied spontaneity of the 'abstractionist,' the impulsive avant-gardism of the 'nouveaux réalistes.'"

The eight Duchamp paintings had been part of a larger exhibit organized by the critic Gérald Gassiot-Talabot, "Narration figurative dans l'art contemporain." The figurative narration concerned was intended to present an alternative to the legacy of abstraction 1950s-style on the one hand and the budding nouveau réalisme on the other. In practice, it was more clearly figurative than narrative: as "The Tragic End" demonstrates, structure was more often based on key moments and emblematic representations intended to convey a message directly through the strength of the images. The other major thrust of figurative narration was its anti-elitism; the aversion to avant-garde notions of individual style was clear from the commitment to collective work, and in Arroyo's case, his frequent use of pastiche and variation. Yet, as Gassiot-Talabot pointed out in a 1967 article on "Arroyo or Pictorial Subversion," Arroyo "spent six years destroying all stylistic reflex, all formal wagering, and every time, even in his recent realist period, he paints canvases that could only be his."

In fact, following "The Tragic End of Marcel Duchamp," Arroyo pulled back somewhat from collective activities for a period of self-reflection with a group of self-portraits as Robinson Crusoe (1965), which "in a certain way let me catch my breath in the 'long march.' Sometimes sad, sometimes fatalistic, it was a way of recouping my health." But after another Napoleon series (1965-66), Arroyo was back in the public political arena with an even more controversial work: Miró refait, ou Les malheurs de la coexistence (Miró Remade; or, The Misfortunes of coexistence, 1967). In that work his attack on another patriarch of modern painting bridged art and politics around the issue that concerned him most directly: Spain. In Arroyo's view, Miró was guilty of lapsing into irrelevant fantasy instead of confronting the menace of Franco's Spain. "The work of Miró is the work of the archetypal artist, and in this way, [it] approaches that of Dali. It's for this reason that both are unacceptable. I would have liked that of Miró to be different. So I decided to take it out of the history of art to place it back in real history, in life itself."

In that way, Miró's famed La ferme (The Farm, 1921-22), for example, became Espagne je te vois (Spain, I See You), where the horses have disappeared from the stable, the roosters and rabbits from their coops; the leaves have shriveled on the trees, and the garden is strewn with skulls and bones. The newspaper that bears the name of L'intransigeant in Miró's painting is now the right-wing ABC; a swastika decorates the animal coop; an overturned pail spills blood; and the colors of the whole have been darkened from the lyrical pastels of the original to the red, yellow, green, and black of the Spanish flag. Other paintings allude to specific events, such as La femme du mineur Perez-Martinez, Constantina (dite Tine) rasée par la police (The Miner's Wife Perez-Martinez, Constantina [called Tine] Shaved by the Police, 1967), which "remakes" Miró's Portrait d'une danseuse espagnole (Portrait of a Spanish Dancer, 1921) by shaving her head to draw attention to the excesses of the Spanish police. Still others introduce Miró's familiar abstractions into macabre contexts, like Maison de la culture de Valdepeñas (Valdepeñas Cultural Center, 1968), where a group of children at the dinner table have nothing to eat but the decorative shapes.

While he was working on those paintings, Arroyo and other members of the Jeune Peinture traveled to Havana for the Salon de Mayo, organized to express solidarity with Cuban intellectuals in the face of the American embargo; in the course of their stay, about a hundred painters, critics, and others, including veteran fighters, combined their talents to paint a mural in homage to the Cuban Revolution. In the wake of that experience, the Jeune Peinture began organizing a "Salle Rouge pour le Viêtnam" (Red Room for Vietnam), but that effort was abruptly postponed with the outbreak of the student and labor strikes of May 1968. Arroyo and his friends plunged into the uprising by creating the Atelier Populaire at the Ecole des Beaux-Arts, where more than 300,000 posters were produced in support of the movement. For artists like Arroyo, who had long been seeking an activist role, the May events posed a supreme test of commitment, to which they gave everything they had. "I experienced '68 in a very concrete way," Arroyo recalled. "The People's Workshop was practically a factory where we were manufacturing all the iconography of the struggles."

But as he explained to Giovanni Jopolo ten years later, "I emerged exhausted from this great debate and all of this often useless rhetoric in 1968. I felt an overriding need to distance myself in order to reflect, to find a political identity." As a result, he decided to move to Milan, where he remained for the next five years. There he

met the photographer Grazia Eminente, who became his companion, and he began a longstanding collaboration with the theater director Klaus Grüber by designing sets and costumes for Grüber's 1969 production of "Off Limits" by Arthur Adamov. In his first major series completed in Italy, Arroyo paid ironic homage to Winston Churchill, not as an international statesman but as a Sunday painter setting up his easel in diplomatic outposts all over the world. In what was perhaps a logical consequence of his determinedly anti-aestheticizing stance, Arroyo came to draw more and more of his images from nonpainting sources, notably advertising, photography, and posters. And as can be seen from the Churchill paintings, it is with that shift that his painting style began to impose itself, not by default but by definition: the use of large, flat color areas for figures and background alike, strong surface patterns, and the juxtaposition of the stylization with just enough illusionism to call illusionism into question.

Arroyo soon brought that approach back to political subject matter with "30 ans après" ("Thirty Years After," 1970), another indictment of the Franco regime, carried out in twenty-six paintings. Although the series was obviously a sequel to "Twenty-five Years of Peace," Arroyo replaced the autobiographical element present in the earlier series with an insistently didactic approach, to the extent of accompanying the paintings with documentary texts and photographs (subsequently published as a book in Italy). As in the earlier series, his main weapons were satire and irony: the *Portrait du nain Franco Sebastien de Morra, bouffon de cour né à Cadaques dans la première moitié du XXe siècle* (*Portrait of the Dwarf Franco Sebastien de Morra, Court Jester Born at Cadaqnes in the First Half of the Twentieth Century*) is a caricature of Franco sympathizer Salvador Dali and is based on Velázquez's well-known portrait of Don Sebastien de Morra. *Types différents de moustaches* presents nine examples (including those of Franco and Dali) in chart form with an open razor looming above; *Iberia* groups together the visual clichés of Spanish castanets, a bullfighter, and the Iberian Airlines logo around a colorful flamenco dancer who happens to have a huge black book protruding from her ruffled skirt. Other paintings commemorate popular figures killed or exiled by the regime, one of the most striking of which is *Julio Alvarez del Vayo, Le dernier optimiste ou Les Souliers de l'exil* (*Julio Alvarez del Vayo, the Last Optimist; or, The Shoes of Exile*), showing an exiled Republican official with a suitcase and three extra legs for the long journey ahead. Still others draw attention to the complicity of the big powers in their political,

military, and cultural relations with the Spanish government.

"Thirty Years After" was exhibited in Milan, Paris, Frankfurt, Utrecht, and Berlin in 1970-71. During that time, Arroyo spent nine months in Rome, visited New York City (where he met and became friends with his fellow painter Saul Steinberg), and resumed his collaboration with Klaus Grüber to design the sets for Alban Berg's opera *Wozzek*. The following year (1972), opera made its way into his paintings with "Opere e operette," a series conceived as an homage to Milan, the home of Italian melodrama. Another operatic-sounding series from that year, "La forza del destino," was in fact devoted to boxing, and included portraits of various champions such as Panama Al Brown and Eugène Crique, who had lapsed into painful obscurity even before their deaths.

In 1973 Arroyo moved back to Paris with Grazia Eminente and settled in La Ruche, the Montparnasse "beehive" of artists' studios that had once been the home of Modigliani, Chagall, Soutine, and others. Continuing his collaboration with Klaus Grüber throughout the 1970s, he designed sets for Brecht's *In the Jungle of the Cities*, staged in Frankfurt (1973); Euripides's *Bacchantes* in Berlin (1974), Goethe's *Faust* in Paris (1975), Wagner's *Die Walkyrie* at the Paris Opera (1976), and Arrabal's *El Arquitectoy el Imperador de Asiria* in Barcelona (1977). One of the new activities he took up on his return to Paris was ceramics, to which his friends Aldo Mondino and Adriano Bocca had introduced him in Italy, and he also launched a radical art review, *Rebelote*, with Gilles Aillaud, Pierre Buraglio, John Berger, and Bernard Pautrat. Among his paintings during that period was a series of interpretive portraits of some of his artist friends, including *Aldo Mondino, peintre* (showing the Italian Mondino incongruously dressed in a Spanish bullfighter's costume made by Arroyo himself); *Gilles Aillaud regard la realité par un trou à côté d'un collègue indifférente* (*Gilles Aillaud Looks at Reality through a Hole next to an Indifferent Colleague*, based on a Cartier-Bresson photograph); *Saul Steinberg à l'ombre des pyramides* (*Saul Steinberg in the Shadow of the Pyramids*, executed in Steinberg's graphics style); and *Jean Hélion évadé, en route de Poméranie vers Paris* (*Jean Hélion Escaping, on the Way from Pomerania to Paris*, evoking Hélion's flight from the Nazis during World War II).

Commenting on those paintings in terms of his general evolution, Arroyo recalled an observation made by Hélion in the 1960s, namely that he [Hélion] painted what he loved, while Arroyo

painted what he didn't love. At that time, Arroyo recalled, "only action was important to us: our aim was the change and transformation of society. Of course I painted what I didn't like. I wanted to combat fascism in all its forms, to combat all police forces, oppressions, shameful compromises, treasons, and hypocrises, all the Civil Guards, the Bonapartes, the senile Churchills, the fake idols, the hollow and misleading slogans, the greased, moustachioed torturers, the conchitas with castanets, the Caudillos [i.e., the Francos]." But by the 1970s, he went on, "Suddenly I had the need to paint what I like, the people I love. . . . Looking back, how could I do all this? I'm surprised, intrigued. I don't always recognize myself, but I don't deny anything. I'll never be a painter with a carefully planned and permanent vocabulary. Violent satire and abrupt changes in style will probably remain the characteristics of my expression. I'll never be a triumphant painter, a painter-painter. I cannot breathe without irony. For me, painting is not a pretty gesture, an ensemble of sensitive little touches; no, it's a unified mass, a strong and irrevocable decision to make."

Over the next few years, Arroyo continued to give visual form to his reflections on art with a supremely ironic series targeting what he described as "gangster painters," and represented as such—in 1940s film noir style—except for the multicolored daubs of paint covering their faces and hands to identify them as artists. *Habillé descendant l'escalier (Clothed [Figure] Descending a Staircase*, 1976), for example, shows the title figure—another jibe at Duchamp—bouncing down the steps on his head, while in *Peintre contemplant sa propre marchandise (Painter Contemplating His Own Merchandise*, 1976), the object of contemplation is a dollar sign.

Appointed commissioner of the 1976 Venice Biennale, Arroyo had traveled to Spain in the autumn of 1974 to meet with artists, but he was arrested in Valencia and detained for three weeks before being expelled from the country. At that point, he received political asylum in France. Within a year, old age brought justice to Franco; while the world, and especially the Spaniards, were awaiting the dictator's death, Arroyo began a monumental painting, *La ronde de nuit*, based on Rembrandt's *The Night Watch*, to which he added side panels showing a sunset in Castille (a gesture that not only celebrated the end of the dictatorship but paid tribute to Rembrandt's original, which had been cut down to fit into the Amsterdam town hall). Franco died after one month; Arroyo worked on the painting for five, and it was exhibited in the Spanish pavilion at the Venice Biennale.

In 1975 Arroyo and Eminente were living in West Berlin as part of a German cultural exchange program for which he was expected to produce a group of paintings for an exhibition. One thing that drew his interest was the Turkish immigrant community in the rundown districts of Kreuzberg and Weding, but once his *Night Watch* was finished, he found it hard to paint in the divided city. Instead, he began to experiment with rubber cutouts, fashioning stylized models of Turkish prayer rugs and the Sunday-best shirts and ties of the immigrant workers, as well as art objects from the East that were on display in the local archaeological museum. His intention, he explained, was to "show this 'orientalization,' this 'turkicization,' if you can say that, of Germany, and this 'germanization' of Turkey."

Exhibited in Paris in 1978 along with Eminente's photographs of Kreuzberg, the cutouts provoked "confused" reactions because Arroyo was identified as a painter. But in fact, he had been experimenting in other media throughout the 1970s: leather, which he fashioned into cacti for a series of sculptures called "La fiancée de l'oquest" (The Fiancée of the West, 1972); the ceramics of 1972; terra cotta versions of *Saul Steinberg in the Shadow of the Pyramids* (1976, also cast in bronze); and sandpaper reliefs for portraits of friends and artist-gansters (1974–75). He was in the habit of "playing hooky from the painting," as he called it, so that "the painting doesn't get tired out and so that I don't tire out the painting. You have to know how to go away so that you can come back with maybe even more passion."

After his stay in Germany, Arroyo was able to return to Spain, obtain a new passport, and vote in the first free elections; in January 1977 he showed his work in Spain for the first time since his 1973 exhibition in Madrid had been shut down. The death of Franco, he told Ghyslaine Firard in 1982, "was like lifting a huge stone off my work; I started to consider other problems, I got interested in other things, and so Spain has remained in the background a little." Actually, for a time at least, the recent Spanish past, inseparable from his own, continued to manifest itself in his painting. The exposure to Kreuzberg had inspired a small group of paintings on Turkish exiles; those led to two larger series dealing with the Spanish experience, "Réflexions sur l'exil" (Reflections on Exile, 1977–78) and "José Maria Blanco White" (1978–79). Included in the first series were several paintings on Angel Ganivet, a late-nineteenth-century Spanish exile who committed suicide while serving as consul in the remote Lithuanian capital of Riga. In *28-11-1899 Angel Ganivet se jette dans la Dvina*

(11-28-1899 Angel Ganivet Throws Himself into the Dvina [River]) the suicide has become a spectacle taking place in an indoor swimming pool while a crowd of onlookers watches from the sidelines; all that is left of Ganivet are his two legs sinking into the pool.

That image, according to Pierre Astier, was an allusion to a letter the despairing Ganivet had written to Unamuno, declaring, "If you cut me off from the Arabs and the Gypsies, maybe there's nothing left but my legs," but Arroyo had already used it in a very similar context for *L'etudient Rafael Gujarro se jette par la fenêtre (The Student Rafael Gujarro Throws Himself Out of the Window)*, part of the series "30 Years After." Like the earlier work, *Angel Ganivet* is painted in the bright colors of tourist ads, but where Arroyo's paintings of the 1960s and early 1970s had basically been organized around two-dimensional design, the composition had now become emphatically three-dimensional: the "spectacle" takes place in a stage space carefully defined by architectural supports and the play of light and shade.

The same conception, doubtless influenced by Arroyo's theater activities, is even more apparent in the "José Maria Blanco White" series. Arroyo took as his starting point a historical figure, the Sevillian priest José Maria Blanco y Crespo, who fled to London in the early nineteenth century after a dispute with church authorities, took the name Blanco White, and lived out his days as an Anglican convert and man of letters. In the paintings, Blanco White is literally reduced to a shell—the upper half of a white tuxedo and tie, devoid of head and limbs—which is placed in a variety of public settings in London: "under surveillance" in the Tate Gallery, "watched for" in the British Museum, "observed" in Royal Albert Hall. As always, a wealth of iconographic detail provides an ironic commentary; in the Tate Gallery scene, for example, the paintings on the wall are quotations from Arroyo's earlier works, including the sinking feet from *Angel Ganivet*, while the other piece of art in the room is a large broken glass, conjuring up the ghost of Marcel Duchamp yet another time.

As prolific and provocative as Arroyo's work had been in the 1960s, it was only at the end of the following decade that he gained recognition for his artistic achievement, notably with the exhibition of the "Jóse Maria Blanco White" paintings in 1979. For Gérard Gassiot-Talabot, his friend and longtime supporter, it was "shocking that some of Arroyo's merits were [only] recognized after his last exhibit at Karl Flinker, when this show summed up ten years of work. It seems to me that anyone who had paid attention to his

earlier propositions would have been convinced several years ago."

At that point, Arroyo was about to take another of his breaks from painting. In 1978 he embarked on what was to become five years of research and writing for a biography of the boxer Panama Al Brown. "Boxing and painting, it's the same thing," he declares in the book's introduction; "I had to act because Al Brown haunted me, and I was incapable of painting him." During that period, when he did not always have time or space to paint, he worked on a series of drawings, sandpaper collages, and bronze sculptures based on the figure of the chimney sweep ("Le ramoneur," 1970-1982). The idea, he said, came out of a somewhat bizarre personal experience—he was on his way to the Zurich airport when his taxi accidentally hit a chimney sweep—but that solitary, unfamiliar figure obviously provoked resonances with Arroyo's exiles. Like José Maria Blanco White, the chimney sweep wears evening clothes (now complete with top hat and gloves), but the incongruous attire only serves to accentuate his marginality. In the collages, the use of sandpaper translates that ambiguity into visual terms; the texture, Pierre Astier pointed out, is at once that of velvet, of soot, of sweat. In the sculptures, likewise, as Arroyo said, he broke the "nobility" of the cast bronze by integrating other materials, including wood, copper, marble, and crystal; the visual incongruity captures the paradox of the chimney sweep's tragicomic existence.

A similar sensibility informs the painting series that he began in 1980, "Toute la ville en parle" (The Talk of the Town). The anecdotal canvases, devoid of the topical content—and militant stance—of many of his earlier works, nevertheless convey the energies and tensions found in the city as the locus of bright lights and dark alleys, social life and solitude, passion and violence.

In 1982 a major retrospective of Arroyo's work in Paris and Madrid brought to full term the process of recognition begun in the late 1970s. As various critics pointed out, with the passage of time and the cooling of political passions, the consistent formal achievements of Arroyo's work could be fully appreciated. "Among all the painters, I love Arroyo," wrote Claire Bretcher in the *Nouvel Observateur.* "His exhibit at the Beaubourg is sublime. He's very funny. Anti-Dali, anti-Miró. He detests Duchamp, makes idiocies, pastiches. But all of that wouldn't be very interesting if, in the end, his paintings weren't superb."

In the course of the 1980s, Arroyo worked with Klaus Grüber on three more productions,

including Calderón's *La vida es sueño* (1981), Franz Jung's *Nostalgia* (1984), and Rossim Guoacchino's opera *Le cenerentola* (1986), and in 1986 they collaborated on a play written by Arroyo himself, *Bantam* (the story of a reporter who recounts the life and death of an aged prize fighter). The changed political climate of Europe in the 1980s—which corresponded to Arroyo's approaching his fifties—undoubtedly imposed an adjustment in his expectations and the work that expressed them, but personal engagement remained central. In his 1982 conversation with Ghyslaine Girard he explained, "You know, my own training is in literature; I don't have any pictorial training, I never set foot in an art school in my life, I never attended a painting class. I think all that came naturally: I drew a lot, but as a hobby. What I wanted was to write, and so I studied literature. That's why, when I've been asked to explain about these issues, I say that I'm sort of a failed novelist and that my painting is like short stories or novels, in series, that retrace a little [of] this idea, let's call it autobiographical, of my life." Yet, in Arroyo's paintings there is always a larger dimension to his autobiographical concerns that allows them to transcend anecdote and self-indulgence. As Pierre Astier wrote of "The Talk of the Town," that "theater of shadows" corresponds to a particularly European sensibility, "a real dialogue with objects, with the human environment, with the era, the times, the world around in progress and in crisis: perhaps a moral dimension."

EXHIBITIONS INCLUDE: Gal. Claude Lévin, Paris 1961; Grane Kalman Gal., London 1962; Gal. Biosca, Madrid 1963 (censored); Gal. 20, Amsterdam and Arnheim 1964; Gal. André Schoeller, Jr., Paris 1965; Gal. Bernheim Jeune, Paris 1965; Gal. Il Fante di Spade, Rome 1967, '71; Gal. de Foscherari, Bologna 1967; Gal. Mendoza, Caracas 1967; Studio Bellini, Milan 1969; Studio Marconi, Milan, 1969; Gal. Il Canale, Venice 1969; Gal. La Chiocciola, Padua 1969; Gal. André Weill, Paris 1969; Gal. La Bussola, Turin 1969; Gal. La Robinia, Palermo 1969; Gal. Aldina, Rome 1970; Gal. Withofs, Brussels 1970; Gal. San Michele, Brescia 1971; Gal. de Governatore, Parma 1971; Gal. Arts Borgogna, Milan 1972; Gal. Gastaldelli Arte Contemporanea, Milan 1972; Gal. d'Eendt, Amsterdam 1972; Städtische Kunsthalle, Düsseldorf 1972; Gal. 9, Paris 1973; Gal. Flinker, Paris 1974–82; Studio P.L., Milan 1974; Gal. Fred Lansenberg, Brussels 1975; Gal. La Mela Verde, Turin 1975; Gal. L'Aprodo, Turin 1975; DAAD Kunstakad., Berlin 1976 (with Grazia Eminente); Gal. Leger, Malm 1976; Gal. Maeght, Barcelona 1977; Gal. Juana Mordo, Madrid 1977; Gal. Val y 30, Valenica 1977; Fondation National des Arts Graphiques, Paris, 1978 (with Grazia Eminente); Art Package Gal., Chicago 1979; Gal. Maeght, Zurich 1980; Städtische Gal. im Lenbachhaus, Munich 1980; Gal. Michael Hasenclever, Munich 1980; Eva Cohen

Gal., Chicago 1982; Mus. National d'Arte Moderno, Madrid 1982; Mus. National d'Art Moderne, Paris 1982; Leonard Hutton Gal., NYC 1983, '86; Gal. Alencon, Madrid 1983; Gal. Anton Meier, Geneva 1984; Guggenheim Mus., NYC 1984; Mairie de Villeurbanne 1985; Mus. Municipale, Santander 1985; Gal. Isybrachot, Paris 1985; Inter-Arte, Valencia 1986; Mus. für Kunst und Kulturgeschichte, Dortmund, 1987; Pal. des Papes, Avignon, 1987 (with Gilles Aillaud). GROUP EXHIBITIONS INCLUDE: Salon de la Jeune Peinture, Paris from 1960; Paris Biennale 1963; "La Nouvelle Figuration," Pal. Strozzi, Florence 1963; "Mythologies quotidiennes," Mus. d'Art Moderne de la Ville de Paris 1964; "Pop Art, *Nouveau Réalisme*, Nouvelle Figuration," Vienna, Brussels, Berlin 1964; "España libre," Rimini, Florence, Ferrara, Reggio Emilia, Venice 1964; "Une passion dans le désert," Gal. Saint-Germain, Paris 1965; "Vivre et laisser mourir, ou La fin tragique de Marcel Duchamp," Gal. Creuze, Paris 1965; Salon de Mayo, Havana 1967; "Le monde en question," Mus. d'Art Moderne de la Ville de Paris 1967; Paris Biennale 1967; Expo '67, Montreal 1967; "Salle rouge pour le Viêtnam," ARC, Mus. d'Art Moderne de la Ville de Paris 1968; "Police et culture," Mus. d'Art Moderne de la Ville de Paris 1969; "La Venus de Milo," Mus. des Arts Decoratifs, Paris 1972; "Monumente," Städtische Kunsthalle, Düsseldorf 1973; "Realismus und Realität," Kunsthalle, Darmstadt 1975; "European Painting in the 1970s," Los Angeles County Mus. 1975; Venice Biennale 1976; "Documenta 6," Kassel 1977; "Mythologies quotidiennes II," Mus. de l'Art Moderne de la Ville de Paris 1977; Sydney Biennale 1978; "The Museum of Drawers," Kunsthaus, Zurich; "Les uns par les autres," Mus. des Beaux-Arts, Lille 1979; "Nachbilder," Kunstverein, Hanover 1979; "Les quinze affiches officielles de la coupe du monde de football," Gal. Maeght, Paris and Zurich 1981; "Préscence contemporaine," Aix-en-Provice 1982; "Panorama de l'art Français 1960-1980," Mus. Moderner Kunst, Vienna 1982; "Arte frances contemporaneo," Buenos Aires, Montevideo, Lima, La Paz 1983; "Bonjour Monsieur Monet," Mus. National d'Art Moderne, Paris 1983; "L'art vivant de la ruche à Paris," Gal. Yoshii, Tokyo, 1983; "Art contre—Against Apartheid," Fondation National des Arts Graphiques et Plastiques, Paris 1983; "Contiguité de la Photographie à la Peinture," Cntr. National Photographie, Paris 1984; "Art et Sport," Mus. des Beaux-Arts, Mons 1984; "The Presence of Reality in Contemporary Spanish Art," Taudemus., Alvar Aalto Mus., Finland 1985; "Figurative Narration," Gal. des Arenes, Nimes 1985; "Très français," Yurakucho Asahi Gal., Tokyo 1986; "Les figurations des annes 60 à nos jours," Carcassonne 1986.

COLLECTIONS INCLUDE: Fondation National d'Art Contemporain, Paris; Mus. National d'Art Mod., Paris; Mus. d'Art Moderne de la Ville de Paris; Mus. Cantonal des Beaux-Arts, Lausanne; Coll. Crex, Zurich; Nationalgal., Berlin; Hirshhorn Mus. and Sculpture Garden, Washington, D.C.; Fondation Maeght, Venice; Mus. Progressivo, Livorno; Mus. di Caglieri; Utrecht Mus.; Städtische Gal. im Lenbachhaus, Munich.

ABOUT: Arroyo, E. Opere e operette, 1973; Astier, P.
Eduardo Arroyo, 1982; Bantam, pièce en 2 actes, 1986;
"Dreizig Jahre danach Trente ans après" (cat.), Frank-
furter Kunstverein, 1971; "Eduardo Arroyo" (cat.)
Musée National d'Art Moderne, Paris, 1982; Emanuel,
M., et al. Contemporary Artists, 1983; "En souvenir de
Kreuzberg" (cat.), DAAD, Berlin, 1977; "Gilles Ail-
laud, Eduardo Arroyo et le theater" (cat.), Festival
d'Avignon, 1987; Il poi viene prima, 1970; "Les
ramoneurs" (cat.), Galerie Maeght, 1980; "Miró refait
ou Les malheurs de la coexistence" (cat.), Galerie Il
Fante di Spade, Rome, 1967; Panama Al Brown, 1982;
Parent, F., and R, Perrot Le Salon de la Jeune Pein-
ture, 1983; "Reflexions sur l'exil" (cat.), Galerie Karl
Flinker, Paris, 1978; Trentecinq ans après, 1974; "Une
Passion dans le désert" (cat.), Gal. Saint-Germain, Par-
is, 1965; "Vingt-cinq ans de paix" (cat.), Galerie André
Schoeller Jr. and Bernheim Jeune, Paris, 1965.
Periodicals—Art in America November 1970; Art In-
ternational May 1979; Arts Magazine September 1983;
Cimaise November 1977–January 1978, October–
November 1982; Opus International October 1967,
March 1971, March 1974, Spring 1978, June 1983.
Films—Lancelot, M. Eduardo Arroyo, Antenne 2, Par-
is, 1979; Thorn-Petit, Eduardo Arroyo, TV Luxem-
bourg, 1980.

RICHARD ARTSCHWAGER

***ARTSCHWAGER, RICHARD** (December
26, 1923–), American painter and sculptor,
first came to the attention of the art world in the
mid-1960s at a time when pop art, minimalism,
and conceptualism were also coming to the fore.
Artschwager's art has often been identified with
one or another of those movements because of its
superficial formal resemblances and its contem-
poraneity. Today, twenty-five years after his
first solo exhibition, it is becoming increasingly
clear that he has always followed a unique vision
in his enigmatic paintings, sculptures, and draw-
ings, which have successfully resisted categoriza-
tion. A recent retrospective at the Whitney
Museum of American Art in New York City at-
tests to his renascent popularity and a feeling
among critics and younger artists that he is, in
Steven Henry Madoff's words, "one of the most
significant—and brilliant—artists in town."
Shortly after the Whitney retrospective, the
Daniel Weinberg Gallery in Los Angeles pre-
sented "Artschwager: His Peers and Persuasion,
1963–1988" in which artists as diverse as Mal-
colm Morley and Nancy Dwyer were included
in an attempt to demonstrate his roots and his re-
cent progeny among the younger generation.

Artschwager's work can generally be charac-
terized by his media, and since the beginning of
his career his signature materials have been For-
mica and Celotex. Formica, an inexpensive syn-
thetic veneer which can make any table look like
wood or any counter top look like marble, has
been the primary substance of his sculpture. Ce-

lotex, which is a cheap paper-based industrial
material used in ceiling panels, is the ground he
paints on.

The sculptures are mute-looking objects that
are carefully covered with a skin of Formica and
generally resemble furniture or furnishings.
Their referential titles, such as *Chair*, *Table*, or
Handle, invite the viewer's active participation
with the work, but the chair is a little too high
or narrow to sit on and the table has a solid space
between the legs. There are doors that do not
open and handles that are attached to nothing
but the wall.

The paintings are also somewhat inaccessible.
Most are copied from found photographs from
magazines or newspapers, enlarged and painted
in grisaille with acrylic paint on Celotex. They
are surrounded by large Formica or very shiny
aluminum frames. The prominent overall tex-
ture of the Celotex, which is their most obvious
physical feature, lends a fuzzy, out-of-focus
quality to the image while emphasizing its pho-
tographic origins. The imagery has been de-
scribed as "banal" and "dull and lifeless" and
there is hardly a style to speak of, but, as John
Yau has observed, "his hand and intelligence are
everywhere apparent."

Richard Artschwager came to art rather belat-
edly; he was forty-one years old at the time of
his first solo exhibition in 1965, which followed
a long career in furniture making. He was born
the day after Christmas, 1923, in Washington,
D.C., to European immigrant parents. His fa-
ther, Ernst, was a Prussian plant pathologist and
geneticist who had earned his doctorate in bota-

ny from Cornell University in 1918. His mother, Eugenia Brodsky, was a Ukranian-born immigrant of Russian-Jewish descent who was trained as a painter at the Corcoran School of Art in Washington, D.C., and at the National Academy of Design in New York. Three years after Richard was born, they had a daughter, Margarita. When he was ten, his father contracted tuberculosis and the family moved to the small town of Las Cruces, New Mexico, for the warm, dry climate. His father conducted research on sugar plants at the New Mexico College of Agriculture and his mother continued to pursue her interest in art. Richard spent time in his father's laboratory and went with his mother on sketching trips. In his 1979 *Autochronology*, Artschwager wrote of his early environment: "His parents, as well as the provocative natural milieu of the Southwest, provided stimuli toward art and science. [Artschwager] began with the latter and has for some years been busily engaged in the former."

In 1941, after two years in the New Mexico Military Institute, Artschwager enrolled at Cornell University, his father's alma mater. Like his father, he pursued plant biology, majoring in chemistry and minoring in mathematics. At the end of his sophomore year he was drafted into the army where he received artillery training, and in 1944 was shipped to England and then to France where he received a superficial wound at the Battle of the Bulge. He finished his tour of duty in 1946 as a first lieutenant in the counter-intelligence corps in Vienna. There he met Elfriede Wejmelka, a clothing designer. They were married in 1946 and in March of the next year they traveled back to New Mexico.

Following his European experience, Artschwager began to doubt his suitability for a career in science. His wife suggested one day that he should probably go into art rather than science. "The die was cast" he has recalled, "It was an impulsive, instant recognition." Nevertheless, he was determined to finish his degree and returned to Cornell for the fall semester of 1947. He took painting and life drawing as electives and graduated in 1948 with a B.A. degree in physical science.

Having decided to pursue art, the Artschwagers moved to New York City. His drawing instructor at Cornell had once studied with the French painter Amédée Ozenfant in New York and he suggested that Artschwager look him up. In the early 1920s Ozenfant and the architect Le Corbusier had formulated an aesthetic called purism, which was inspired by the purity of the machine, and sought to rectify the declining influence of cubism by employing simplified geometric and volumetric forms. Artschwager studied with Ozenfant from 1949–50 with the assistance of the GI Bill. Recalling the experience, he has said, "I was going through culture shock being with a bunch of artists. I wasn't an Ozenfant groupie, and I was probably the only student that he didn't invite to visit his studio." Ozenfant's geometrically controlled purism was almost the antithesis of the gestural painting style of the abstract expressionists that was so popular at the time. Artschwager's aversion to hanging out in the downtown art world, where those painters met, contributed to his feeling little affinity with contemporary trends.

Somewhat disillusioned, he left the field of art and from 1951–53 worked at a number of jobs including baby-photographer, bank clerk, and lathe operator. Meanwhile, he had bought an old building in the Chelsea section of Manhattan and, in order to do renovations on it, set up a woodworking shop in the basement with his brother-in-law. A commission from his brother-in-law's relatives to build some furniture inadvertently resulted in a new career. He started to build dressers, chests, and tables out of fine woods and in small numbers. But with the birth of his daughter Eva in 1954 he had to step up production, and by 1956 he was designing and mass-producing simple, modern, well-made furniture. In 1957, his desk, swivel chair, and shelves were included in a show at the Museum of Contemporary Crafts called "Furniture by Craftsmen." He was selling well to such places as the newly established Workbench and the Pottery Barn. The year 1958 brought a disaster in the form of a fire that extensively damaged his workshop and its contents. Depressed, he retreated to New Mexico to visit his sister; while there he spent some time doing landscape drawings. Returning to New York, he went heavily into debt opening a new shop. But it would never be the same again. "The furniture had lost its essential connection for me." he said recently; "Since I didn't know the people I was making the pieces for, all of those drawers and dressers became repeat work. They became versions of versions. I started seeing them more as designs, more as representations."

Artschwager had never lost his interest in art and started painting and taking life-drawing classes again. In 1959 he showed his paintings and drawings in a two-person exhibition at Art Directions in New York. They were landscape-derived abstractions, loosely based on his recollections of the Southwest. His work received a positive review by the sculptor Donald Judd, then a critic for *ARTnews*. New and significant events in the art world at that time eventually gave Artschwager the freedom to realize an art

that was very different from either the prevailing abstract expressionism or the purism of Ozenfant. In 1958 Jasper John's target and flag paintings and Robert Rauschenberg's important combines were shown at the Leo Castelli Gallery in New York. At the Green Gallery in 1960 he saw works by Mark di Suvero that were assembled from ordinary things and urban detritus. For Artschwager, the exhibit opened up the possibility that art could be made from anything.

That possibility was on its way to becoming a reality when, in 1961, he found a discarded snapshot in a pile of street trash. That picture of ordinary people playing on the beach facilitated a new type of painting for the artist. Artschwager recalled, "In the photograph were several people, not very glamorous looking. They would live their lives and they would be dead someday. I thought it would be good to paint them as they were, without satire . . . gridding off the photo and following it pretty closely. It was a romantic idea, rooted in lonely voyeurism." The labor of copying the photograph, grid by grid, would eliminate the free brushwork of his landscapes and the subject matter would be a neutral base from which to work, unlike the emotionally charged landscape of the Southwest.

A year later, while visiting Chicago, he realized that a Franz Kline painting he was looking at had been done on Celotex. The material enhanced Kline's strong brushstrokes, and Artschwager realized that the fuzzy texture would also amplify the grainy quality of the black-and-white newspaper photographs he was copying from. Celotex thus became his principal painting support.

Shortly thereafter, he happened on another medium that would serve him throughout his career. Formica in abundant supply had been around the furniture shop; he "discovered [it] underfoot." "It was Formica which touched it off," he has said. Formica, the great ugly material, the horror of the age, which I came to like suddenly because I was sick of looking at all this beautiful wood. . . . So I got hold of a scrap of Formica—something called bleached walnut. It worked differently because it looked as if wood had passed through it, as if the thing only half existed. . . . It was a picture of a piece of wood; If you take that and make something out of it, then you have an object. But it's a picture of something at the same time it's an object." Formica has found its way into a majority of Artschwager's sculptures and paintings since then.

As he became more and more committed to art in the early 1960s, furniture naturally became his subject and object. The level of craftsmanship was as high in his art as it was in his furniture, and for years both types of work were done in the same shop and with the same tools. But on approaching his sculpture, it is clear that it involves some very different furniture, or not furniture at all. In a well-known piece from 1964 called *Table with Pink Tablecloth* (Saatchi Collection, London), the viewer is confronted with a squat, near-cubic form about twenty-five inches high. Although it looks like a box, it is also recognizable as a table with a pink tablecloth set diagonally on top of it. The piece is completely veneered with Formica: pink for the tablecloth, beige for the table itself, and black for the empty space under the table. The two-dimensional image of a table composed of sheets of Formica carefully fitted together belies the three-dimensional qualities that the piece actually has: those of a tetrahedron, not that of a standing table with four legs, an overhanging cloth, and a space underneath. In speaking of that piece, Artschwager explained his essential approach to sculpture: "It's not sculptural. It's more like a painting pushed into three dimensions. It's a picture of wood. The tablecloth is a picture of a tablecloth. It's a Multipicture."

In 1966 Artschwager was included in the group show "Primary Structures" at the Jewish Museum in New York; it is considered the first major exhibition of work that became known as minimalism. Even today the blankness and simplicity of many of his structures are spoken of in relation to minimalism. But with that movement's strong bias against illusion and allusion, Artschwager just does not fit in. A comparison of *Table with Pink Tablecloth* with a Minimalist sculpture of the time reveals differences in attitude and form. For example, Tony Smith's *Die* (1962), is a perfect six-foot cube of black steel. It is pure in the minimalist sense: it makes reference to nothing outside of itself, it has a flat neutral color, it just *is*. The cube is its own reality. Artschwager's piece, by contrast, refers to wood, cloth, shadowy space, and something that one has dinner on, without actually being any of these. Steven Henry Madoff has summed up the problem with the following quip, referring to *Table with Pink Tablecloth* as "a minimalist box wrapped with pictures."

In a 1965 article Donald Judd, one of the foremost minimalist sculptors, criticized Artschwager's sculpture for not being pure enough because it refers to objects, such as furniture. Pier-Luigi Tazzi, in a more recent *Artforum* article, has called him "an improper minimalist, a warm minimalist, which by definition is a contradiction in terms." While making the same point as Judd, Tazzi offered his observation as a

compliment: " Artschwager's minimalism could not be taken as credo because the work's underlying nature is subversive—not only in terms of art conventions and the work of other leading artists (accepted codes, in other words), but also in terms of the work itself."

In the mid-1960's pop art was also exploding onto the scene, finding its subject and form in common objects, advertising, and popular culture. As Steven Henry Madoff stated, "While pop artists . . . reevaluated commercial culture and high art, Artschwager latched onto the use of mundane objects for entirely different purposes. It reflected his own situation: his relation to furniture making, which was becoming more and more abstract and which consequently began to focus on 'the business of looking.'"

His paintings at the time also bore a certain relation to pop art's use of banal and common subject matter. Jack Bankowsky recently observed that "Artschwager parades a stream of deadpan images under the sign of painting: sailors, found interiors, a half-demolished building frozen in mid-topple, are unceremoniously transferred onto his signature cylotex [sic] support." But seen in retrospect, neither his painting nor his sculpture have the ultimate purpose of pop art or the bright, dynamic formal qualities of the paintings of Roy Lichtenstein, Andy Warhol, or James Rosenquist.

Photorealism is another movement that Artschwager has had a brush with. In the early 1960s, before the movement really got under way, Artschwager and the painter Malcolm Morley used the grid technique to enlarge and transfer photographs to canvas. As Artschwager recalled, "I shared with Morley my idea of gridding off an 'anonymous' photograph and reproducing it square by square, giving oneself to the making of each square independently of the whole—indifferent to the whole, one might say." Morley went on to work in color in a superrealist style and Artschwager stayed with black and white.

In *Apartment House* (1964; Museum Ludwig, Cologne), copied from a newspaper photograph and transferred to Celotex, one can see that "indifference to the whole" in the slightly disjointed quality of the image itself: the lines of the building do not seem to meet exactly, as each grid had its own focal point during copying. The heavily textured Celotex also forces a certain imprecision of line. It is surrounded by a rather large, smooth, and perfectly fitted Formica frame, giving the whole a more three-dimensional or sculptural quality. By contrast, Artschwager's sculptures have a two-dimensional and pictorial quality. The smooth

Formica surfaces carrying a "picture of wood" contrast with the fuzzy textured surfaces of the paintings and their large frames which extend beyond the picture plane. As Artschwager explained, "Sculpture is for the touch. Painting is for the eye. I wanted to make a sculpture for the eye and a painting for the touch." Richard Armstrong, the curator of the 1988 Whitney retrospective, introduced Artschwager as a "maker of dimensional painting—surrogates and pictorial, furniturelike sculpture" and concluded that he has "consistently sought to use art to alter the context of viewing."

Artschwager had first contacted the Leo Castelli Gallery in New York in 1963. In January 1965 he had his first solo show there. In Richard Armstrong's words, the pieces he exhibited "embodied Artschwager's entire conceptual repertoire to date: furniture as sculpture, pictures as furniture, the material touchstones of Formica and Celotex, manifested constructions of perspectival space, and recontextualized, preexistent forms and imagery."

Artschwager continued to make his furniture-inspired sculptures and also made various relief constructions such as *Step'n'See II* (1966; Collection of Roy and Dorothy Lichtenstein). In that piece a rhomboid leans diagonally from the floor to the wall. It has a "step" in it which is too slanted, too high, and too shallow to use (as, prompted by the title, one imagines stepping up into it). Above it, on the wall, is a separate piece with a rectangular impression in its surface which is similar to the step and which one would "see" or peep through. Made completely of Formica, the bottom ledges of the step and peep holes are lighter in color, implying an overhead light source and creating the illusion of two-dimensionality.

For his second show at Leo Castelli in 1967, he exhibited somewhat more abstract works, using a heavily marbleized Formica which adds a rich baroque energy to their surfaces and further separates them from their furniture sources. Concurrently, he added to his painting repertoire by producing rather abstract pieces with only one or two painted lines on an even black-and-white field of Celotex. Some of them have illusionistically rendered concave-looking depressions in the field such as the suite called *Eight Rat Holes* (1967–1975; Saatchi Collection, London), in which the holes, or depressions, give the pictures a sculptural quality like relief.

In a series of landscape-figure drawings from 1967, Artschwager concentrated on reducing the actual number of marks he made on the paper, seeing how far he could go. "When there were few marks the work would represent the marks

themselves as well as the figures or landscapes. When they became very few they would only occasionally hint at [a] figure." A further reduction yielded an elongated oval-shaped mark: "Finally I got to the point where I honed in on one mark in an ideal scale." He called it the *blp*. The blp is sort of racetrack-shaped and has taken many physical forms. At first, the blps were inked onto randomly selected magazine photographs, but they were eventually stenciled, decaled, made of wood and other materials, and placed everywhere indoors and out. They are generally black when placed on a white surface and white when placed on black. In 1968, at the Galerie Konrad Fischer in Düsseldorf, Artschwager had his first solo show in Europe and the *blps* were stenciled on the walls, put on floors, or placed in corners. Some were made of rubberized hair, a material that, although used sporadically since 1968, became part of his repertoire of materials. It echoes the fuzziness of the Celotex paintings in a three-dimensional form.

The word blp has its origin in Artschwager's World War II experience as an intelligence officer. He recalls watching the tiny blips on the radar screen moving across a luminous compass, registering an approaching object. The *i* was omitted from the word blip so that it "would sound crisper . . . like the image itself on the radar screen." Of the blps, Madoff has said, "Placed in galleries, in museum installations, and on building sites, they're among the earliest examples of site-specific conceptual art—yet another hat that Artschwager could wear." According to Coosje van Bruggen, "The most original force in Artschwager's work is his *blp*."

By 1966, Artschwager was finding the pressures of his home life increasingly difficult: "It was too much being a husband and father and worker and artist. Elfriede felt left out." In 1968 he met Catherine Kord, a young graduate student at the University of Wisconsin, and eventually bought and restored a farmhouse with her in the upstate New York town of Charlotteville. They were married a few years later. Artschwager has recalled, "My work was beginning to sell a bit and the furniture shop either needed a big investment or it was gonna close down. I let it close. Responsibilities fell away. I could just be an artist. . . . For fifteen years up there I lived peacefully like a species of winter vegetable."

From 1970 to 1975 he did not have a workshop for his sculpture and so continued painting. Aside from some pastoral scenes and some paintings of buildings, the most common subjects were elaborate, well-to-do, domestic interiors, all depopulated and often with an emphasis on the furniture and furnishings. Of *Describing*

Polish Rider IV (1971; Kunstmuseum Basel), a typical example, Richard Armstrong wrote that "he paints what could be considered large group portraits of furniture. He now depicts what he had once constructed. The dialogue between his sculpture and his paintings suddenly becomes audible." The aluminum-framed painting is on two panels, and part of the image is repeated in each panel, effectively jolting the neat perspective of the interior scene. Also common to those paintings is the slight dissolution of the image in the random swirl and pattern of the Celotex.

Artschwager started a suite of fifty-three drawings in 1975 called "Basket Table Door Window Mirror Rug." They are ink-on-paper line drawings executed in a spare, descriptive, and straightforward style. In each drawing, each of the six objects in the title are pictured in various relationships to each other and the space they occupy. They are rolled, stretched, compressed, seen from above or below or obliquely, lined up together, or pulled apart. John Yau has observed, "Both spaces and objects—context and content—are constantly transformed while remaining an inseparable unity." Describing her reaction in *Artforum*, Roberta Smith wrote, "As you move along the row of them, everything shifts into an accelerating swirl, metamorphosing before your eyes. The progression is like watching someone's mental deterioration, and I begin to feel that Artschwager is behind one of the doors cackling madly—if I could only figure out which one."

Artschwager carried that idea further in his paintings and sculpture, including *Six Mirror Images* (1975–79; The Oliver-Hoffmann Family Collection), a large Formica polyptych with the six elements (door, window, table, basket, mirror, and rug) abstracted and molded in relief with vacuum-formed metallized Plexiglas.

In 1979 Artschwager had his first retrospective at the Albright-Knox Art Gallery in Buffalo, New York. The traveling exhibition was reviewed by Roberta Smith for *Art in America*: "The show . . . suggests that part of the Artschwager enigma is to seem almost disinterested in quality or development. Artschwager seems to have had most of his ideas, materials, and strategies in place by 1963 or 1964. Although the show's contents span seventeen years . . . they look as if they could almost all have been made at any one time." Whether in response to such criticism or not, his work did change during the early 1980s. In Richard Armstrong's words, "His previous restraints seem to give way to wittier, publicly scaled objects." An example is *Chair Table* (1980; Museum of Art, Rhode Island School of Design, Providence), a chunky oak-

grain Formica set, with a three-foot, three-dimensional exclamation point (not originally part of the piece) suspended over the table. Such three-dimensional typographical symbols, including quotation marks, question marks, and other signs, have been used in combination with the sculptures since then. In *Door* (1983–84; Collection of Martin Bernstein), the brace is six feet high and sits on the wall to the right of a ponderously wide and chunky door. With an oversize, blown-glass doorknob, its funtion as a door is instantly put to rest. The door is made of wood and completely painted over with a new, much enlarged, and exaggerated wood-grain pattern painted in a too-bright ochre. Twenty years earlier Artschwager had given a similar treatment to his *Table and Chair* (1962–63; Collection of Paula Cooper), an ordinary wooden table and chair painted over with an unnaturally-enlarged black-and-white wood grain. So while he was using Formica as a 'picture of wood,' he was also painting his own picture of wood onto the surfaces of his sculptures.

In 1980 and 1981 Artschwager produced three free-standing sculptures which are generally chunky in proportion and veneered in wood-grain Formica. *Tower III (Confessional)* (1980; Saatchi Collection, London) is a life-size open confessional with red Formica "cushions" for the kneeling penitent and a seat for the confessor. The screen through which the sins and penance would pass brings the piece very close to a real confessional. *Book II (Nike)* (1981; Saatchi Collection, London) is a standing lectern topped with a V-shaped book stand which recalls the general shape of the famous Hellenistic sculpture, the Nike of Samothrace in the Louvre. *Book III (Laocoön)* (1981; Musée National d'Art Moderne, Centre Georges Pompidou, Paris) is similar to a *pria-dieu*, or kneeler, but might also double as a chair. Again, its proportions and scale are such that one would like to try it out, but one soon realizes that it would be impossible without considerable contortions—not unlike those found in the Hellenistic sculptural after which the piece was subtitled.

Those works were shown at Leo Castelli Gallery in late 1981. In reviewing the exhibition, which included paintings, Barbara Cavaliere wrote in *Arts Magazine* that she felt a "sense of doom which begins to permeate throughout." William Zimmer of the *SoHo News* apparently agreed: "There was probably more cheer in the Reformation than there is in this latest arrangement in gray and brown by Richard Artschwager." Resurrecting the artist partially, he concluded, "But despite austere surfaces and themes, Artschwager still arrests you through dark and subliminal humor."

The religious references in those three pieces seem to echo Artschwager's experience of having made a number of portable altars for ships, around 1960, on commission from the Catholic church: "I was making something that, by definition, is more important than tables and chairs—that is, an object which celebrates something."

Artschwager's work during the rest of the 1980s has been characterized by an expansion of ideas and an exuberance in the painting and sculpture. For example, color has broken through his black-and-white palette. In the mid-1980s series of dinner table scenes, in which one is often given a bird's-eye view of the table, the predominant grisaille on Celotex has been invaded by warmly glowing egg- or biscuit-like substances standing for food on a plate. He has also recently employed an icy mint-green selectively in certain paintings. But those two colors had already been used in the 1973 painting *Bowl of Peaches on Glass Table* (Collection of Mr. and Mrs. Oscar Feldman), and the choice of colors now seems deliberately planned.

Since the mid-1980s, Artschwager's star has been increasingly on the rise. As Barry Schwabsky wrote of his 1986 mini-retrospective of furniture objects at the Mary Boone Gallery, "Artschwager looks rather less peripheral than he did before." In 1988 his largest and most important show, a twenty-five-year retrospective of his paintings, sculpture, and drawings was held at The Whitney Museum of American Art, and traveled to San Francisco and Los Angeles. His art continues to develop in new directions while incorporating and synthesizing motifs and conceptual ideas from even his earliest work.

Having divorced Catherine Kord in the late 1970s, Artschwager married Molly O'Gorman, a painter. They have a young daughter, Clara, and a newborn son, Gus, and live in the Fort Greene section of Brooklyn in a three-story white clapboard house which was once a funeral home. His painting studio is behind the house in a two-story former garage that three or more paintings along with studies for them, executed in charcoal on textured paper, interspersed with stacks of Celotex. The sculptures are built with the help of two assistants in a studio about a block and a half away from the house. Frames for the paintings are made there, and again, a few pieces are always in progress, with small-scale mock-ups lying about. He works regular daytime hours and averages about six hours a day.

Richard Artschwager is a refined-looking man, tall and thin with a somewhat gaunt look and thinning gray hair. He speaks slowly and deliberately with a wry sense of humor. He was

once described by a critic, in conversation, as one of the most intelligent artists she had ever met. He is also an avid pianist who once considered further training toward a career as a soloist. Today, he likes to play the works of the romantics and baroque music, especially Bach.

Richard Artschwager's path through an art world of constantly changing styles and attitudes has been slow and sure-footed and has kept him apart from the mainstream. His individuality and creativity still carry him through. His concerns lie more with his art's relationship to the viewer and to perception itself than with its relationship to art criticism, which, he has said, is its own truth. Perhaps the core of Artschwager's aesthetic is revealed in the following statement: "It has been known since the Renaissance that art is produced by artists, and the notion has been available for more than a century that art is internal to the recipient; in a sense, 'made' by the recipient. The first notion has tended to block off the availability of the second, and I think my contribution has been to make it not only available but necessary, i.e., to force the issue of the context or, to put it in more old-fashioned terms, to make an art that has no boundaries."

EXHIBITIONS INCLUDE: Leo Castelli Gal., NYC from 1965; Konrad Fischer Gal., Düsseldorf 1968; LoGuidice Gal., Chicago 1970; Mus. of Contemporary Art, Chicago 1973; Daniel Weinberg Gal., San Francisco 1974, '80, '86; Gal. Sonnabend, Geneva 1974, '75; Walter Kelly Gal., Chicago 1976; Inst. for Art & Urban Resources, Inc., Clocktower, NYC 1978; Kunstverein Hamburg 1978; Neue Galerie-Sammlung Ludwig, Aachen, West Germany 1978; Albright-Knox Art Gal., Buffalo 1979; Inst. of Contemporary Art, Philadelphia 1979; La Jolla Mus. of Contemporary Art, La Jolla, Calif. 1979, '80; Mus. of Art, Rhode Island School of Design, Providence 1980; Young Hoffman Gal., Chicago 1980, '81; Mary Boone Gal., NYC 1983, '86; Kunsthalle Basel 1984, '85; CAPC, Bordeaux 1986; Whitney Mus. of American Art, NYC 1986, '88; Galerie Thaddaeus Ropac, Salzburg, Austria 1987; Mus. of Modern Art, San Francisco 1988; Nicola Jacobs Gal., London 1988; Akira Ikeda Gal., Tokyo 1989; Mus. National d'Art Moderne, Centre Georges Pompidou, Paris 1989. GROUP EXHIBITIONS INCLUDE: "Dick Artschwager and Richard Rutkowski," Art Directions Gal., NYC 1959; "Beyond Realism," Pace Gal., NYC 1965; "Primary Structures," The Jewish Mus., NYC 1966; "Sculpture Annal," The Whitney Museum of American Art, NYC 1966, '67, '70; Documenta 4 and 7, West Germany 1968, '83; "Realism Now," Vassar Col., Poughkeepsie, NY 1968; "When Attitudes Become Form," Kunsthalle Bern, Switzerland 1969; "Hyperrealistes Americains," Galerie des 4 Mouvements, Paris 1972; "American Pop Art," Whitney Mus. of American Art, NYC 1974; "Artschwager, Gordon, Torreano, Zucker," Bykert Gal., NYC 1975; "Improbable Furniture," Inst. of Contemporary Art, Philadelphia 1977; "Art Begins with

A," Bodley Gal., NYC 1978; "American Painting of the 1970s," Oakland Mus., Calif. 1978; Venice Biennale 1980; "American Drawing in Black and White: 1970–1980," Brooklyn Mus., N.Y. 1980; "Rooms: Installations by Richard Artschwager, Cynthia Carlson, Richard Haas," Hayden Gal., MIT, Cambridge, Mass. 1981; "Postminimalism," Aldrich Mus., Ridgefield, Conn. 1982; Whitney Biennial, NYC 1983, '87; "Richard Artschwager, John Chamberlain, Donald Judd," Daniel Weinberg Gal., Los Angeles 1984; "The Box Transformed," Whitney Mus. of American Art, NYC 1985; "Artschwager, Judd, Nauman: 1965–1985," Donald Young Gal, Chicago 1985; "John Armleder, Richard Artschwager, Ti Shan Hsu," Pat Hearn Gal., NYC 1987; "Artschwager, Nauman, Stella," Leo Castelli Gal., NYC 1987; "Made in the USA: An Americanization in Modern Art, the 50s & 60s," Univ. Art Mus., Berkeley, Calif. 1987; "60s/80s: Sculpture Parallels," Sidney Janis Gal., NYC 1988; "Richard Artschwager: His Peers and Persuasion: 1963–1988," Daniel Weinberg Gal., Los Angeles 1988; "Altered States," Kent Fine Art, NYC 1988; "Richard Artschwager, John Baldessari, Jonathan Borofsky, Robert Gober, Peter Halley, Nancy Shaver," Paula Cooper Gal., NYC.

COLLECTIONS INCLUDE: Los Angeles Mus. of Contemporary Art; MOMA, NYC; Sony Corp.; Whitney Mus. of American Art, NYC; La Jolla Mus., Calif.; Milwaukee Art Mus.; Tate Gal., London; Detroit Inst. of Art; Metropolitan Mus. of Art, NYC; Kunstmus. Basel; Mus. Rotterdam; Rhode Island School of Design; Walker Art Cntr., Minneapolis.

ABOUT: Ammann, J. C. Art of Our Time: The Saatchi Collection, 1984; "Autochronology," (cat.) Albright-Knox Art Gal, 1979; Battcock, G. (ed.) Minimal Art: A Critical Anthology, 1968; Emanuel, M. et al. Contemporary Artists, 1983; "Frames," (cat.) Mus. of Contemporary Art, Chicago, 1973; Lippard, L. Pop Art, 1966, Six Years: The Dematerialization of the Art Object from 1966 to 1972, 1973; "Richard Artschwager" (cat.) Kunsthalle Basel, 1985; "Richard Artschwager" (cat.) Whitney Mus. of American Art, 1988. Sultan, D., and Davidson, N. (eds.) N.A.M.E. Gallery, Book I, 1977; *Periodicals*— Artforum March 1966, June 1970, February 1974, March 1979, September 1983, Summer 1985; Art in America May–June 1978, October 1979; ARTnews October 1959, January 1968, September 1977, January 1988; Arts Magazine November 1967, February 1968; Artweek July 23, 1988; Craft Horizons September 1965, June 1975, February 1982, June 1988; Drawing January–February 1985; Flash Art February–March 1987, March–April 1988; New York Times April 14, 1978; SoHo Weekly News January 26, 1978; Village Voice March 29, 1983.

AUERBACH, FRANK (April 29, 1931–), British painter and draftsman, was born in Berlin, Germany, the son of Max Auerbach, a patent attorney. His mother had attended art school. In early 1939 he was sent out of Nazi Germany by

his parents, whom he never saw again. Arriving in England, he was taken immediately to the Bunce Court School in Kent, where, he recalled in 1978, "we grew our own food and did our own housework. There was a considerable interest in things of the mind, considerable disdain for material things, a great emphasis on community spirit." During many school holidays he visited his cousin, Gerda Boehm, who was later to be an important subject for his paintings, and her husband.

In 1947, having gained his high school certificate at the unusually young age of sixteen, Auerbach went to London, vaguely intending to learn Latin for university entrance and wishing he could be an actor. Instead he enrolled in art classes, first at the Hampstead Garden Suburb Institute and then at the Borough Polytechnic, where his most influential teacher was David Bomberg, whom he has called "probably the most original, stubborn, radical intelligence that was to be found in art schools." He went on to attend the St. Martin's School of Art (1948–52) before winning admission to the Royal College of Art (1952–56), where in 1955 he was awarded the silver medal for distinction in painting. He began teaching soon after leaving the Royal College; he taught in several art schools, including the Slade, but never for more than one day a week. "I think," he told his friend and sometime model Catherine Lampert in 1978, "I was quite interested in what I had to say. . . . In my first two or three years as a teacher I found a way of talking about drawing and painting. . . . I did it for twelve years, and it became less interesting to me, and I think I had fewer hopes of it toward the end, and when I was able to stop, stopped." He is exceptionally articulate about his art; although he has not taught since the late 1960s, he grants interviews frequently.

Auerbach was fortunate early in his career to find a sympathetic dealer, and his five solo exhibitions (1956–63) at Helen Lessore's Beaux Arts Gallery in London, were instrumental in establishing his reputation in his adopted country. Although his technique has changed considerably over the years, his choice of subjects has never widened or varied beyond the readily accessible and familiar: the approach to his studio in Camden Town, north-central London (he has had the same studio since 1954); the urban-rural configurations of Primrose Hill, a park in nearby Chalk Farm; and the portraits of his wife, Julia, Gerda Boehm, Catherine Lampert, and a few others, including one E.O.W. whom he painted dozens of times over a period of twenty years in regular sittings three times a week. One of the E.O.W. paintings from the 1950s has been owned for several years by the poet Stephen Spender, who described it in 1983: "The picture was enclosed in a boxlike frame and was glued onto a board of coarse canvas. Most of the face was painted in yellow ochre, the only displeasing effect of the paint being that on part of the forehead it had clotted and was slightly wrinkled. In the brown shading of the temples and in the hair the paint had a quality as though it had been mixed with earth and rust. The density of the paint gave the eye sockets a scooped-out look, and the nose looked skeletal. The whole picture formed an unforgettable image. Its very weight gave it the look of a sacred object, like the image in a shrine encountered at crossroads."

That sense of "weight" in Auerbach's early works was due in no small part to his lavish use of paint. He would usually continue the impasto, in the case of an individual painting, for months or even years, and the surface might easily attain a thickness of three inches, causing several critics to term those paintings "bas-reliefs." They were not universally popular. "It is the paint one notices first," wrote one critic in the mid-1960s, "and it is only later, sometimes a good deal later, that one teases out what the paint is describing. This introduces a puzzle element into the works that does something to diminish their aesthetic value." Yet Auerbach's longtime friend, the painter Leon Kossoff, easily saw through the surface of his "work from the early days, where the painting, from continuous effort, has become thick and heavy and the ochre still seems wet enough to slide off. . . . The effect of these works on the mind is of images recovered and reconceived in the barest and most particular light, the same light that seems to glow through the late, great, thin Turners. This light, which gleams through the thickness and finally remains with us, is an unpremeditated manifestation arising from the constant application of true draughtsmanship. Whether with paint or charcoal, pencil or etching needle, it is drawing that has constantly engaged Frank Auerbach."

From about the early 1970s, Auerbach began to alter his technique radically. Instead of building up the surface week after week, he now scrapes it down after each sitting so as to be able to begin afresh with the next encounter. Each encounter—he may work from a model, a sketch, or a photograph—thus becomes a sort of rehearsal for the final performance, when the picture may be finished within a few hours. "I tend," he told Lampert, "to set up an image and destroy it many times a day. . . . I finish pictures again and again . . . until finally it seems to me that it's got a little something. . . . I think that on the whole I make the crucial and radical decisions—they're not decisions, they're things that occur to me—at the end of the paint-

ing. . . . I tend to scrape it off and do it again from top to bottom, after months or years of working, in a relatively short time." The comparative flatness of those more recent works led many critics to praise the rapidity and fluency of Auerbach's gestures and brushwork. In a work such as *Head of Julia* (1980), for example, the subject seems to lie close to the surface, and the paint to have little substance. The subject, according to Sarah Kent, "appears in a morass of fast-moving paint as though her head and the artist's hand have not yet come to rest. One's eye travels restlessly across the picture following the sweep and flow of the brush, while a high pitch of emotional intensity is sustained across the whole canvas and concentrated in the sitter to suggest vulnerability and nervous tension."

The sense of tension, or even anguish, in Auerbach's portraits has also been a constant from the beginning of his career. Spender has seen that best: "The images in his portraits belong often to the world of bombings and refugees; construction sites (which are of course also the destruction sites of buildings that preceded those being put up) are almost obsessive subjects in his paintings, which abound in craterlike excavations, scooped-out surfaces, tunnels, and mud." If his portrait subjects are in fact burdened with terrible experience, his technique at all stages of his career has served to accentuate that.

In all his statements about his art, Auerbach has insisted again and again on the importance of what he calls "fact." He has defined it as "the thing one's worked on"; Spender has likened it to "a kind of sheet anchor holding his interior imagination to external reality. . . . Fact provides a point of overlapping of internal with external likeness within a surrounding apparent unlikeness. It is a test of the artist's truth and it also is the new and outside element which prevents the painting being either a photographic likeness, on the one hand, or a mere repetition of other paintings, images made by his predecessors and his contemporaries." The understanding of "fact" also explains why the artist has such an apparently obsessional relationship with his few subjects—he wants always to see them anew: "I don't visualize a picture when I start," he told Lampert. "I visualize a piece of recalcitrant fact and I have a hope of an unvisualized picture which will surprise me arising out of my confrontation with this fact. . . . These facts that we knock against, . . . these facts, the solid floor beneath our feet and then, these things on the table—that's the stuff of painters. This recalcitrant, inescapable thereness of . . . everyday objects, which to people with an imagination seem about the most amazing thing."

Auerbach has a great respect for the painters of the past, constantly seeking out their work, reflecting on it, and being inspired by it. What impresses him most about great paintings is their uniqueness and integrity: "They are great images which don't leak into other images; they are real things. . . . One hopes somehow to make something that has a similar degree of individuality, independence, fullness, and perpetual motion to these pictures. But actually one hopes, although of course one won't achieve it, one actually hopes in one's heart of hearts to surpass them." In an essay in which he describes the experience of being drawn by Auerbach, Michael Podro recalled, "During the sittings [he] would frequently have books on the floor open at portrait heads of Dürer or Hals or Rembrandt— mostly paintings. They were not superficially like the drawing he was doing. He seemed to regard them as pacing him, as setting up a standard of articulateness which he had to try to match." The artist himself, in his conversation with Lampert, confirmed the truth of his sitter's observation: "My most complimentary and my most typical reaction to a good painting is to want to rush home and do some more work. . . . I find that toward the end of a painting I actually go and draw from pictures more to remind myself of what quality is and what's actually demanded of paintings. Without these touchstones we'd be floundering. Painting is a cultured activity—it's not like spitting, one can't kid oneself."

Auerbach's drawings—in pencil, colored pencil, charcoal, or drypoint— have occasionally been shown on their own, most notably in New York City in the spring of 1979. Although many of them are studies for paintings, they seem to manifest the artist's prodigious energy even better than do the more finished works. Michael Klein, in a review of the New York show, called the drawings "vivid, rich, teeming with urgency, and stunning in the breakneck speed that goes into their making. . . . The flat surface is filled with a kind of perpetual motion, nothing lyrical, sweet, or melodious; rather it is biting, stubborn, and staccato in temperament. Auerbach's line charges across the page like a lightning bolt, flashing back and forth, electrifying the scene. The surface reads as if it has been covered with tiny explosions which send shock waves across the paper colliding with other lines, causing still further explosions."

The artist's routine varies little from day to day, year to year. "Finding myself in a situation where I've been able to arrange for all the practical circumstances of painting, I'm extremely nervous about changing them because it seems to me that one's situation as a painter is highly

his parents, whom he never saw again. Arriving in England, he was taken immediately to the Bunce Court School in Kent, where, he recalled in 1978, "we grew our own food and did our own housework. There was a considerable interest in things of the mind, considerable disdain for material things, a great emphasis on community spirit." During many school holidays he visited his cousin, Gerda Boehm, who was later to be an important subject for his paintings, and her husband.

In 1947, having gained his high school certificate at the unusually young age of sixteen, Auerbach went to London, vaguely intending to learn Latin for university entrance and wishing he could be an actor. Instead he enrolled in art classes, first at the Hampstead Garden Suburb Institute and then at the Borough Polytechnic, where his most influential teacher was David Bomberg, whom he has called "probably the most original, stubborn, radical intelligence that was to be found in art schools." He went on to attend the St. Martin's School of Art (1948–52) before winning admission to the Royal College of Art (1952–56), where in 1955 he was awarded the silver medal for distinction in painting. He began teaching soon after leaving the Royal College; he taught in several art schools, including the Slade, but never for more than one day a week. "I think," he told his friend and sometime model Catherine Lampert in 1978, "I was quite interested in what I had to say. . . . In my first two or three years as a teacher I found a way of talking about drawing and painting. . . . I did it for twelve years, and it became less interesting to me, and I think I had fewer hopes of it toward the end, and when I was able to stop, stopped." He is exceptionally articulate about his art; although he has not taught since the late 1960s, he grants interviews frequently.

Auerbach was fortunate early in his career to find a sympathetic dealer, and his five solo exhibitions (1956–63) at Helen Lessore's Beaux Arts Gallery in London, were instrumental in establishing his reputation in his adopted country. Although his technique has changed considerably over the years, his choice of subjects has never widened or varied beyond the readily accessible and familiar: the approach to his studio in Camden Town, north-central London (he has had the same studio since 1954); the urban-rural configurations of Primrose Hill, a park in nearby Chalk Farm; and the portraits of his wife, Julia, Gerda Boehm, Catherine Lampert, and a few others, including one E.O.W. whom he painted dozens of times over a period of twenty years in regular sittings three times a week. One of the E.O.W. paintings from the 1950s has been owned for several years by the poet Stephen Spender, who described it in 1983: "The picture was enclosed in a boxlike frame and was glued onto a board of coarse canvas. Most of the face was painted in yellow ochre, the only displeasing effect of the paint being that on part of the forehead it had clotted and was slightly wrinkled. In the brown shading of the temples and in the hair the paint had a quality as though it had been mixed with earth and rust. The density of the paint gave the eye sockets a scooped-out look, and the nose looked skeletal. The whole picture formed an unforgettable image. Its very weight gave it the look of a sacred object, like the image in a shrine encountered at crossroads."

That sense of "weight" in Auerbach's early works was due in no small part to his lavish use of paint. He would usually continue the impasto, in the case of an individual painting, for months or even years, and the surface might easily attain a thickness of three inches, causing several critics to term those paintings "bas-reliefs." They were not universally popular. "It is the paint one notices first," wrote one critic in the mid-1960s, "and it is only later, sometimes a good deal later, that one teases out what the paint is describing. This introduces a puzzle element into the works that does something to diminish their aesthetic value." Yet Auerbach's longtime friend, the painter Leon Kossoff, easily saw through the surface of his "work from the early days, where the painting, from continuous effort, has become thick and heavy and the ochre still seems wet enough to slide off. . . . The effect of these works on the mind is of images recovered and reconceived in the barest and most particular light, the same light that seems to glow through the late, great, thin Turners. This light, which gleams through the thickness and finally remains with us, is an unpremeditated manifestation arising from the constant application of true draughtsmanship. Whether with paint or charcoal, pencil or etching needle, it is drawing that has constantly engaged Frank Auerbach."

From about the early 1970s, Auerbach began to alter his technique radically. Instead of building up the surface week after week, he now scrapes it down after each sitting so as to be able to begin afresh with the next encounter. Each encounter—he may work from a model, a sketch, or a photograph—thus becomes a sort of rehearsal for the final performance, when the picture may be finished within a few hours. "I tend," he told Lampert, "to set up an image and destroy it many times a day. . . . I finish pictures again and again . . . until finally it seems to me that it's got a little something. . . . I think that on the whole I make the crucial and radical decisions—they're not decisions, they're things that occur to me—at the end of the paint-

ing. . . . I tend to scrape it off and do it again from top to bottom, after months or years of working, in a relatively short time." The comparative flatness of those more recent works led many critics to praise the rapidity and fluency of Auerbach's gestures and brushwork. In a work such as *Head of Julia* (1980), for example, the subject seems to lie close to the surface, and the paint to have little substance. The subject, according to Sarah Kent, "appears in a morass of fast-moving paint as though her head and the artist's hand have not yet come to rest. One's eye travels restlessly across the picture following the sweep and flow of the brush, while a high pitch of emotional intensity is sustained across the whole canvas and concentrated in the sitter to suggest vulnerability and nervous tension."

The sense of tension, or even anguish, in Auerbach's portraits has also been a constant from the beginning of his career. Spender has seen that best: "The images in his portraits belong often to the world of bombings and refugees; construction sites (which are of course also the destruction sites of buildings that preceded those being put up) are almost obsessive subjects in his paintings, which abound in craterlike excavations, scooped-out surfaces, tunnels, and mud." If his portrait subjects are in fact burdened with terrible experience, his technique at all stages of his career has served to accentuate that.

In all his statements about his art, Auerbach has insisted again and again on the importance of what he calls "fact." He has defined it as "the thing one's worked on"; Spender has likened it to "a kind of sheet anchor holding his interior imagination to external reality. . . . Fact provides a point of overlapping of internal with external likeness within a surrounding apparent unlikeness. It is a test of the artist's truth and it also is the new and outside element which prevents the painting being either a photographic likeness, on the one hand, or a mere repetition of other paintings, images made by his predecessors and his contemporaries." The understanding of "fact" also explains why the artist has such an apparently obsessional relationship with his few subjects—he wants always to see them anew: "I don't visualize a picture when I start," he told Lampert. "I visualize a piece of recalcitrant fact and I have a hope of an unvisualized picture which will surprise me arising out of my confrontation with this fact. . . . These facts that we knock against, . . . these facts, the solid floor beneath our feet and then, these things on the table—that's the stuff of painters. This recalcitrant, inescapable thereness of . . . everyday objects, which to people with an imagination seem about the most amazing thing."

Auerbach has a great respect for the painters of the past, constantly seeking out their work, reflecting on it, and being inspired by it. What impresses him most about great paintings is their uniqueness and integrity: "They are great images which don't leak into other images; they are real things. . . . One hopes somehow to make something that has a similar degree of individuality, independence, fullness, and perpetual motion to these pictures. But actually one hopes, although of course one won't achieve it, one actually hopes in one's heart of hearts to surpass them." In an essay in which he describes the experience of being drawn by Auerbach, Michael Podro recalled, "During the sittings [he] would frequently have books on the floor open at portrait heads of Dürer or Hals or Rembrandt—mostly paintings. They were not superficially like the drawing he was doing. He seemed to regard them as pacing him, as setting up a standard of articulateness which he had to try to match." The artist himself, in his conversation with Lampert, confirmed the truth of his sitter's observation: "My most complimentary and my most typical reaction to a good painting is to want to rush home and do some more work. . . . I find that toward the end of a painting I actually go and draw from pictures more to remind myself of what quality is and what's actually demanded of paintings. Without these touchstones we'd be floundering. Painting is a cultured activity—it's not like spitting, one can't kid oneself."

Auerbach's drawings—in pencil, colored pencil, charcoal, or drypoint— have occasionally been shown on their own, most notably in New York City in the spring of 1979. Although many of them are studies for paintings, they seem to manifest the artist's prodigious energy even better than do the more finished works. Michael Klein, in a review of the New York show, called the drawings "vivid, rich, teeming with urgency, and stunning in the breakneck speed that goes into their making. . . . The flat surface is filled with a kind of perpetual motion, nothing lyrical, sweet, or melodious; rather it is biting, stubborn, and staccato in temperament. Auerbach's line charges across the page like a lightning bolt, flashing back and forth, electrifying the scene. The surface reads as if it has been covered with tiny explosions which send shock waves across the paper colliding with other lines, causing still further explosions."

The artist's routine varies little from day to day, year to year. "Finding myself in a situation where I've been able to arrange for all the practical circumstances of painting, I'm extremely nervous about changing them because it seems to me that one's situation as a painter is highly

precarious and to fiddle with it in any way at all is likely to endanger it. I do in fact like to work every day; it seems to me to be madness to wake up in the morning and do something other than paint, considering the fact that one may not wake up the following morning." His longtime studio, in William Feaver's words, "hasn't so much changed over the years as silted up. Reproductions of Poussin, Goya, Dürer, Rembrandt, pinned up like talismans, . . . sheaves of drawings, albums with photographs of all his work, seven volumes by now, paint petrified on tables, swollen on the shelves of an orange box, splattered up the wall beside his easel and trodden into the floor, the bed in a corner with the oil stove in front of it. . . . Everything is to hand, even the exteriors, Primrose Hill and Mornington Crescent, are nearby." So hermit-like an existence in the service of art is at once a popular, romantic notion of how painters live and a far from common situation. For Auerbach, it is simply natural, the only way to get at "fact," a subject's quintessence: "To put down an ideogram of a table so that people will recognize it as a table is not the work of a painter, but to sense it for a moment as a magic carpet with a leg handing down at each corner is the beginning of a painter's imagination, and there would be a million ways of sensing this table on the floor, this invisible box. This is where the painter's imagination begins and this is what a painter's imagination is. It's not a question of fancy dress, or symbolic objects. It's this reinvention of the physical world, and everything else comes from that."

EXHIBITIONS INCLUDE: Beaux Arts Gal., London 1956, '58, '59, '61, '62, '63; Marlborough Fine Arts, London 1965, '67, '71, '74, '76, '78, '83; Marlborough Gerson Gal., NYC 1969, '82; Villiers Gal., Sydney 1971; Municipal Gal, Dublin 1971, '74; Toorak Gal., Melbourne 1972; Univ. of Essex, Colchester 1973; Gal. Bergamini, Milan 1973; Marlborough Gal., Zurich 1976; Hayward Gal., London 1978; Fruit Market Gal., Edinburgh 1978; Bernard Jacobson Gal., NYC 1979. GROUP EXHIBITIONS INCLUDE: Arthur Tooth and Sons, London 1958; Carnegie Inst., Pittsburgh 1958, '61; Dunn International, London 1963; Gulbenkian International, London, 1964; Stuyvesant Foundation, London and Zurich 1967; Univ. of Stirling, Scotland 1970; Palazzo dell'Accademia and Palazzo Reale, Genoa 1972; Royal Academy, London 1977, 1981; Louver Gal., Venice, Calif. 1979; Marlborough Fine Art, London 1981; Plymouth City Mus. and Art Gal., England 1981; Burgh House, London 1981; Jacobson Hochman Gal., NYC 1981; Yale Cntr. of British Art, New Haven 1981.

COLLECTIONS INCLUDE: MOMA and Metropolitan Mus. of Art, NYC; British Mus. and Tate Gal., London; Scottish National Gal. of Modern Art, Edinburgh; National Gal. of Australia, Canberra; National Gal. of Victoria, Melbourne; Los Angeles County Mus. of Art; Tamayo Mus., Mexico City; Hull, Nottingham, Manchester Gals., England.

ABOUT: Emanuel, M., et al. Contemporary Artists, 1983; Feaver, W. "Frank Auerbach" (cat.), 1976; Kossoff, L., and Lampert, C. "Frank Auerbach" (cat.), 1978; Spender, S. "Frank Auerbach" (cat.), 1982. *Periodicals*—Apollo January 1974, April 1974, May 1978, January 1982; Art and Artists January 1971, November 1975, July 1978, January 1983; Art International November 1969, March 1971, May 1975, December 1975, January 1977, February 1978, Summer 1978, January–March 1983; Burlington Magazine February 1971, June 1974, June 1978; Connoisseur July 1978, January 1983; Flash Art Summer 1983; Listener October 10, 1973; New Statesman November 16, 1959, April 23, 1961.

AYCOCK, ALICE (November 20, 1946–), American sculptor, who has translated over nearly two decades of prodigious activity, the intangibles of the human psyche into an elaborate repertoire of architectural and machine forms. While rooted in the earth art, process art, and systems aesthetics trends of the late 1960s and early 1970s, Aycock's work, like that of her German contemporary Karen Horn, represents a marked departure from the impersonality of conceptualism in its insistence on personal, emotional content.

Born in Harrisburg, Pennsylvania, Aycock had what she calls "one of the most peaceful, normal childhoods possible." Two formative influences she often cites were her father's interest in architecture and her grandmother's storytelling. Her father, the owner of a construction company, built the family house himself and, while Aycock was still quite young, gave her a scale model of it. The experience, she recalled at the time of her 1983 retrospective in Stuttgart, was important "because I could mentally possess something, control it, see it as a whole. Literally hold it in my hand and then later I was inside of it, surrounded by a physical, large structure." This conceptual side was complemented in turn by the creative impulse that her grandmother's stories nurtured, with the result, she told Maurice Poirier in a 1986 interview, that she always wanted to be an artist. Initially, because of her grandmother, she leaned toward literature, but she had turned to the visual arts by the age of eighteen: "It was like falling in love. No matter what anyone tells you, you know you're going to do this thing. It became an obsession."

At Douglas College in New Jersey, where she studied from 1964 to 1968, Aycock began with painting but moved "very fast, very naturally"

ALICE AYCOCK

into three dimensions. Even then she was drawn to the first stirrings of conceptual art, with its interdisciplinary approach and its emphasis on investigation. That orientation was amply reinforced by three years of graduate work at Hunter College in New York City with Robert Morris, who, in her words, "used art as a kind of probing device." Under his direction, she prepared a thesis dealing with network structures which she called "An Incomplete Examination of the Highway Network/User/Perceiver System(s)." She also created a number of her own investigative works, mainly dealing with physical changes over time: *Clay* (1971), for example, consisted of troughs of clay left to dry out for several months; *Cloud Piece* (1971) documented the movement of cumulus clouds with black-and-white photographs taken at fixed intervals; and *Fanned/Sand* (1971) set four industrial fans blowing on a pile of sand.

Those and other works were included in various group exhibitions at the time—*Fanned/Sand* was singled out by one reviewer as being "of unusual interest" in a group show at 112 Greene Street Gallery—but once Aycock finished at Hunter, she turned her attention elsewhere. "I started off looking for more than a thing that took up space, something that was in the world, not just in a glass case," she later commented to Leo Van Damme, explaining that she was drawn to architecture because it was "directly related to both life itself and to more cosmological and fantasy things. A more appropriate area for me to work in." Even while she was at Hunter, she had been so intrigued by an-

cient shrines that she traveled to Greece in 1970 to visit the beehive tombs at Mycenae and the labyrinth in Crete, and it was that experience that prompted her thesis on network systems. Her first architectural work was a six-foot-high wooden structure of concentric circles, with three openings intended to draw visitors in and oblige them to find the center. *Maze* (1972) was directly inspired by the ancient monuments Aycock had seen in Crete, but it had a personal, psychological point of departure as well. "I hoped to create a monument of absolute panic—when the only thing that mattered was to get out," she told Janet Kardon in 1976. "I wished to externalize the terror I felt the time we got lost on a jeep trail in the desert."

At the outset, she doubted that the piece, erected on the Gibney Farm near New Kingston, Pennsylvania, would attract any visitors at all, but during the two years that it remained standing, it became a kind of modern-day cult site, attracting local teenagers "who would drink, smoke grass and engage in their 'ritualized' social activities" much as their forerunners had done in Greece. A similar adaptation of archetypal forms to contemporary situations soon resulted in a second piece at the Gibney Farm, *Low Building with Dirt Roof (For Mary)* (1973). Some seven tons of dirt were piled on a squat wooden shed: intended as a tomblike memorial for Aycock's twelve-year-old niece—a "house for a child who would never have one of her own," she remarked to Poirier—it was also a potential tomb for anyone who dared to crawl into the precariously overloaded shed.

Over the next few years Aycock pursued the creation of such anxiety-producing situations with what she described as "a determination verging on the obsessive." The *Project for a Simple Network of Underground Wells and Tunnels* (1975), for example, executed in Far Hills, New Jersey, was a claustrophobic labyrinth of concrete wells, half of which were blocked at the opening; visitors who chose to climb down a seven-foot ladder to enter one of the wells then had to crawl through a system of tunnels just over two feet high without knowing which wells would permit them to exit again. Similarly, the *Project for a Circular Building with Narrow Ledges for Walking* (1976), located on the Fry Farm in Silver Springs, Pennsylvania, confronted the visitor with a seventeen-foot-deep cavity to be entered by means of a steep stairway with no protective railing, while the unexecuted *Masonry Enclosure: Project for a Doorway* (1976) envisioned a stairway composed of steps that increased in height as they descended, effectively preventing anyone who arrived at the bottom from climbing back up again.

For Aycock, who freely admitted her own fear of heights and closed spaces, such works were a means of exorcising childhood phobias: "Something I learned from the stories my grandmother told me was that if you could make those awful things into a story, then you could control them." But in the course of the 1970s, those phobic underpinnings yielded to less menacing, visionary aspects. A key work in that evolution was *The True and False Project Entitled "The World Is So Full of a Number of Things"* (1977), created for the gallery space at 112 Greene Street. As Ronald Onerato pointed out in the *SoHo Weekly News*, the claustrophobic crawl spaces, labyrinthine tunnels, and perilous stairwells now opened outward—and upward—in the form of a fifteen-foot-high tower construction of wood, chalkboard, and plaster. According to Aycock, the new direction was inspired in part by a trip to Hollywood and Century City, which, she told Onerato, "opened up a new way of working indoors," and, in particular, made her realize that it was possible to "admit the artificiality of your premises." For 112 Greene Street, she chose to pair up a rectangular chamber inspired by the Roman catacombs she had recently visited with a curved unit taken from Bosch's *Temptation of St. Anthony,* and in an accompanying text she cited a number of other influences, including a Russian expressionist set designer. "I don't want to pretend the work came from nowhere," she insisted. "I get delight out of art appreciation, and it leads you to discover other things."

Aycock moved outdoors again with the *Project Entitled "The Beginnings of a Complex"* (1977) at Documenta 6 in Kassel, West Germany, which evoked the remains of a medieval castle with a five-part wall facade and adjacent towers. (An accompanying text related the story of "Gilles the medieval sadist who wallowed in the intestines of children.") The piece was a big hit with Documenta visitors—so much so that Aycock decided that her art should not be taken so easily for entertainment. Over the next two years, in what she called her "theatrical period," she consciously excluded the possibility of public participation, apart from reading the elaborate texts that she wrote to accompany her work. In those works, the middle ages gave way to the industrial revolution, but that seeming gesture toward scientific order was amply counterbalanced by the web of fantasies Aycock extrapolated from it. A complex of five wooden structures erected among the footpaths at Cranbrook Academy in Michigan, for example, was designated *Project Entitled "On the Eve of the Industrial Revolution—A City Engaged in the Production of False Miracles"* (1978), while another cluster of towers, domes, bridges, and ladders installed at the Stedelijk Museum in Amsterdam the same year was entitled *The Angels Continue Turning the Wheels of the Universe, Part II.*

At the end of the decade, Aycock shifted formal metaphors as well, moving into the domain of architecture and into the machinery of modern science and technology. "I was always feeling guilty that I wasn't taking on the iconography of my own period," she later explained to Aimée Brown Price. "Particle accelerators, reactors—they are very much there and have to be dealt with, just as you would go to a cathedral and experience it." The new direction was first signaled by *How to Catch and Manufacture Ghosts* (1979), consisting of a wooden stage platform, an assortment of cranks and wheels hanging from the ceiling, and a glass jar containing a live pigeon attached to a galvanic battery; seated on the stage was an attendant blowing bubbles—the "ghosts" of the title, intended as a metaphor for memory. As Edward Fry has suggested, in Aycock's contemporary cosmology, science (which includes pseudoscience as well) provided her with a "baroque metaphor for invisible forces and energies . . . beyond logical cause and effect."

One work that particularly caught her attention at that time was Geza Roheim's *Magic and Schizophrenia,* in which she encountered the hallucinations of a schizophrenic who, in her words, "seemed at home rambling through history, through walls, through matter, and was not ashamed of his needs and desires." Recalling that her early works had "recalled terror from a secure plane," she explained to Stuart Morgan that she later felt she "had to let the self go to see what would happen." In other works of that period, she introduced the themes of levitation (*Explanation, An, of Spring and the Weight of Air,* 1979; *Flights of Fancy,* 1979) and mesmerism (*The Rotary Lightning Express,* 1980), then came back to ghosts for *Collected Ghost Stories from the Workhouse* (1980), a permanent site installation at the University of Southern Florida with a ground plan based on electrical circuits, a suspended platform alluding to eighteenth-century balloon launchings, a constellation of rotating rings derived from early models of the universe, and, to contain the ghosts, a group of metal cannisters. In a last gesture toward the architectural sculpture of the 1970s, she installed a three-part environment on New York's Battery Park City Landfill under the name of *Large-Scale Disintegration of Micro-electric Memories (A Newly Revised Shantytown)* (1980), drawing on her earlier vocabulary of sheds, scaffolds, wheels, and underground chambers to create what Edward Fry described

as "a kind of mental city inhabited by imaginary characters."

During that key period in her evolution, Aycock was living with fellow-artist Dennis Oppenheim—they met in 1979, married in 1982, and separated later that year—and as she commented to Poirier, "Creatively and intellectually it was very dynamic. He would follow every idea to its limits." For her part, Aycock also seemed to be pushing her conflation of science and the supernatural to the limit. To create *The Savage Sparkler* (1981), for example, an agglomeration of revolving drums, hot coil racks, fluorescent lights, and hanging fans, Aycock told Poirier, "I tried to imagine myself just as an inanimate force that was tumbling and moving, just feeling these gusts of force or energy through my body." Inspired by the whirring flint sparkler known as the Catherine wheel, Aycock's monumental version in fact did not sparkle at all—just as her ghost machines did not produce ghosts—but, she explained to Kay Larson, her titles were "a tease. They raise expectation. I like art that makes you anticipate, makes you excited."

Over the next couple of years Aycock dipped into a vast range of sources for her magical machines, from the diagrams of the English Renaissance mystic Robert Fludd (*The Solar Wind,* 1983) and Leonardo's drawings (*The Leonardo Swirl,* 1984) to video games (*Donkey Kong,* 1983). The constructions themselves became more elaborate as well—a six-part *Thousand and One Nights in the Mansion of Bliss* shown at the Protetch-McNeil Gallery in 1983, for example, involved thirteen "production assistants"—and as titles like *Preliminary Study for a Theory of Universal Causality* (1982) suggest, the scope increasingly approached the global. As in the early site pieces, the inherent playfulness of a model was often tempered by a threatening undercurrent, especially in the so-called blade machines that Aycock fashioned throughout the 1980s, incorporating giant metal blades that she derived from Cuisinart prototypes. In some of the more recent versions, she told Stuart Morgan in 1985, the association was quite specific: "I became more and more convinced that killing and eating were irrevocably locked together, however much you want to whitewash it. . . . The blade that tills the soil can also kill."

In 1983–84, Aycock was recognized with a major retrospective of her work which traveled through Germany, Holland, and Switzerland, and which was followed by a number of commissions in the United States and elsewhere, including the monumental *Tower of Babel (for Sue Pittman's Farm)* erected in Houston, Texas

in 1986. But as she indicated to Maurice Poirier at that time, with cutbacks in public funding, notably the National Endowment for the Arts, it was becoming more difficult to create large-scale installations, and as a result, she devoted more attention to the elaborate hand-colored prints and drawings she had been executing on mylar and vellum (and which she had already sold to raise money for larger projects). Shortly afterward, she also began working with free-standing sculpture, including the painted steel *Threefold Manifestation II* (1987) commissioned by New York's Public Art Fund.

Notwithstanding the image of the mad scientist that her most fantastic works might conjure up, Aycock is a very delicate-looking woman with curly reddish brown hair, blue eyes, and soft features. She now has a young son who, she told Maurice Poirier, has given her new energy. "Art has been a very hard taskmaster for me. I probably would not have been able to continue my work unless I had something that was really sustaining. This child has renewed my enthusiasm. I feel rejuvenated."

EXHIBITIONS INCLUDE: Fry Farm, Silver Springs, Pa. 1971, '76; Gibney Farm, New Kingston, Pa. 1972, '73, '74; Williams Col. Mus. of Art, Williamstown, Mass. 1974; 112 Greene Street Gal., NYC 1974, '77; Hartford Art School, Conn. 1976; MOMA, NYC 1977; Philadelphia Col. of Art 1978; Muhlenberg Col. Cntr. for the Arts, Allentown, Pa. 1978; Gal. Salvatore Ala, Milan 1978; Cranbrook Academy, Bloomfield Hills, Mich. 1978; Univ. of Rhode Island, Kingston 1978; John Weber Gal., NYC from 1978; Portland Cntr. for Visual Arts 1979; Protetch-McNeil Gal., Washington, D.C. 1979; San Francisco Art Inst. 1979; Contemporary Art Cntr., Cincinnati 1979; P.S. 1, Long Island City 1980; Univ. Southern Florida, Tampa 1980; Battery Park City Landfill, NYC 1980; State Univ. of N.Y., Plattsburgh 1981; Locus Solus, Genoa, Italy 1981; Lawrence Oliver Gal., Philadelphia 1982; Douglas Col., New Brunswick, N.J. 1982; Mus. of Contemporary Art, Chicago 1983; Protetch-McNeil Gal., NYC 1983; Roanoke Col., Salem, Va. 1983; Wurttembergischer Kunstverein, Stuttgart (trav. exhib.) 1983–84; Salisbury State Col., Salisbury, Md. 1984; Serpentine Gal., London 1985; Sheldon Memorial Art Gal., Lincoln, Neb. 1985; Sculpture Park, St. Louis, Mo. 1986; Tel Aviv Mus. 1986; Kansas City Art Inst. 1987; Central Park, NYC 1987; Gal. Walter Storms, Munich 1987. GROUP EXHIBITIONS INCLUDE: "26 Women Artists," Aldrich Mus. of Contemporary Art, Ridgefield, Conn. 1971; 112 Greene Street Gal., NYC 1971, '75; MOMA, NYC, 1972; "Conceptual Art," Women's Interart Cntr., NYC 1973; "C. 7500," California Inst. of the Arts, Valencia (trav. exhib.) 1974; "Project '74," Wallraf-Riehartz Mus., Cologne 1974; "Projects in Nature," Merriwold, Far Hills, N.J. 1975; Paris Biennale 1975; Documenta 6, Kassel 1977; "Made by Sculptors," Stedelijk Mus., Amsterdam 1978; Venice Biennale 1978, '80, '82; "The Great Big Drawing Show, P.S. 1, Long Island City 1978; Whit-

ney Biennial 1979, '82; "Machineworks," Inst. of Contemporary Art, Philadelphia 1981; "My and Ritual," Kunsthaus, Zurich 1981; "Past-Present-Future," Wurttembergischer Kunstverein, Stuttgart 1982; "ARS 83," Atheneum Art Mus., Helsinki 1983; "Cosmic Images in 20th-Century Art," Staatliche Kunsthalle, Baden-Baden (trav. exhib.) 1983; "Time—4th Dimension in the Visual Arts," Palsais des Beaux-Arts, Brussels (trav. exhib.) 1984; "A Contemporary Focus, 1974–1984," Hirshhorn Mus. and Sculpture Garden, Washington, D.C. 1984; "On Drawing Aspects of Drawing," Frankfurter Kunstverein (trav. exhib.) 1985; São Paolo Bienal 1985; "A New Beginning," Hudson River Mus., Yonkers, N.Y. 1985; "Sitings," La Jolla Mus. of Contemporary Art, Calif. 1986; Documenta 8, Kassel 1987.

COLLECTIONS INCLUDE: Kunstmus., Basel; Mus. Ludwig, Cologne; Walker Art Cntr., Minneapolis; Guggenheim Mus., Metropolitan Mus. of Art, and MOMA, NYC; French Ministry of Culture, Paris; Williams Col. Mus. of Art, Williamstown, Mass.

ABOUT: "Alice Aycock: Installations and Retrospective of Projects and Ideas" (cat.), Wurttembergischer Kunstverein, Stuttgart, 1983; Emanuel, M., et al. Contemporary Artists, 1983; Lippard, L. "26 Contemporary Women Artists" (cat.), Aldrich Museum of Contemporary Art, Ridgefield, Connecticut, 1971; Who's Who in American Art, 1989–90. Periodicals—Arte Factum May–June 1984; Art International April 1976; ARTnews October 1986; Arts Magazine June 1982; Artscribe December 1978; Craft Horizons August 1971; New Jersey Monthly October 1980; New York May 25, 1981; Portfolio November–December 1981; SoHo Weekly News April 14, 1977; Tracks Spring 1977, Spring 1978.

*AZACETA, LUIS CRUZ (April 5, 1942–), who considers himself a New York artist of Cuban origins, was born in Havana, Cuba. As a painter, Azaceta is concerned with psychological and physical brutality, with man's fate, and with his search for his own identity in an indifferent society. He sees man as both aggressor and victim, Cain and Abel. Though of Cuban origin, Azaceta feels a definite kinship with the alienation experienced and depicted by the German expressionists and with the wordless despair of Edvard Munch's The Scream. Azaceta sees man embarked on a voyage, looking for a home and tilting at the windmills of fate.

One of two children, Azaceta was born into a working-class family. His father was an aircraft mechanic with the military, his mother a housewife. There were no artistic aspirations or interests in his early upbringing. His family on his mother's side were all carpenters who were considered good craftsmen. In Cuba, Azaceta attended a private commercial high school where he studied accounting and was expected to be-

LUIS CRUZ AZACETA

come a businessman. But his plans changed when the Batista dictatorship was overthrown, and then replaced, by Fidel Castro and his followers in 1959. "I was expected to work after graduation—and took several inconsequential jobs,"Azaceta has recalled. "However, I became alienated by the Castro revolution. They began to confiscate businesses and you were required to become a militia man. This meant that after working eight hours a day, you were supposed to work an additional four hours voluntarily for the revolution. I never joined the militia. Working for a builder, commercial activities came to a standstill and I was fired. This is why I left Cuba. My father, who was close to retirement, was put in prison for four days. We were really scared."

"It was difficult to come to the U.S. I stood in a line at the U.S. Embassy for three days just to get a number. We stayed in line for forty-four hours with family members alternating. I came legally to this country in 1960. I was eighteen when I came to the U.S. and spoke little English. Coming in from the airport and going over the 59th Street Bridge and seeing the skyline of New York City was like living in a postcard. I lived in Hoboken, New Jersey, with relatives, but I went to Manhattan every week to visit museums, to see buildings and to go dancing. I worked in a button factory for two and a half years. I felt great. My uncle was the foreman. I was working and away from all that pressure in Cuba. Most of the other workers were Jewish, black and few Hispanics. I worked sixty hours a week."

After several years in the United States during

°ä zä sē ´tä

which he saved his money, Azaceta began to draw. "I wanted to say something about my condition as an immigrant. In Cuba, art was for the rich, it was not considered macho; here I could paint." Azaceta attended the School of Visual Arts, which was both a fine art and a commercial school and worked part-time at the New York University library. After attending NYU for four years he graduated in 1969 with a certificate equivalent to a batchelor's degree. He was then painting geometric abstraction. In an interview with Friedhelm Mennekes in Germany, Azaceta explained the prevailing attitudes in art school: "No one was dealing with political issues. That's what's so funny. Here you had the Vietnam War, racial riots, and sexual revolution and art was primarily concerned with aesthetics. Everyone was doing geometric abstractions [that followed the lead of] Frank Stella. There were those who dealt with politics or who painted figuratively like Leon Golub. He was one of my instructors. But these artists were totally ignored." One of the teachers helping Azaceta was Frank Roth, who taught him how to manipulate paint: "For example, Roth would use a big brush applying strokes widely with liquified paint on my canvases; I would be more timid. We worked together. One has to learn technique in order to produce something."

When Azaceta graduated from art school, he had no idea how to make a living or what to do with his life. His parents, who had immigrated to the United States questioned his desire to become an artist, but did not interfere. He supported himself by continuing to work fulltime in the library, because, he said, "I knew I wanted to be an artist." In 1969, he married a young Puerto Rican women who had been raised in New York. They had one child, born in 1975, but got a divorce two years later.

Nineteen sixty-nine was an eventful year for Azaceta. After graduation, he and his wife went to Europe. They saw five different countries in a period of five weeks and visited all the museums. "In Madrid I went to the Prado every day. Goya made a big impact on me, the composition, the handling of the paint." Paris, Rome, Amsterdam, and London followed. "I was still working on geometric abstraction. In all Europe, I did not see one stripe! It made me think what kind of an artist I wanted to be. I was looking only for formalistic, aesthetic-type paintings. I realized I needed more than that. I needed a subject matter so that I could deal with the human condition."

On his return from Europe, Azaceta rented his first studio, a storefront. By 1970, he stopped working for the library and started painting full-

time. "I was just painting, painting, trying to find an iconography." For four years Azaceta explored his themes: man's inhumanity to himself and others, his own status as a Cuban immigrant, the menace of an urban environment, life in the New York subways. All the anxieties he felt were expressed in his paintings.

In 1974, Azaceta felt ready to exhibit. With a list of galleries in hand, his first stop was the Allan Frumkin gallery. "I went there without making an appointment carrying my original work with me—no slides! I was told that I needed an appointment. I played dumb. Frumkin was a curious man. I layed out my paintings on the floor and he started looking at the work. Four weeks later, he called to visit my studio and said that he would give me a show."

The Allan Frumkin gallery, at the time, represented Peter Saul, Robert Arneson, and Roy De Forest. In the spring of 1975, Azaceta had his first exhibition in a "new talent show" with Michael Isen, a sculptor who sold out his show. Only one Azaceta painting was sold. "It did not discourage me," added Azaceta. "By then, I was looking at the realities of life; the subway in New York City was one of the things that attracted and fascinated me. It was like a zoo on wheels; it was a stage. I substituted some people for animals, doing violence to each other, while the rest sat passively reading." In a poem, Azaceta expressed his feelings:

I am a potential murderer and also
a potential comedian,
and my paintings are the results
of these potentialities . . .

My works are a tragicomic outcry
of Man's Condition-Slaughterhouse
of a world of Violence, Cruelty,
Madness absurdity etc., etc.

Through my art I try to communicate
some kind of consciousness
about this condition "Abrigando Una Esperanza."

Azaceta had found his subject matter. Some of his early images were cartoonlike. In an article in *Arts Magazine* (June 1985), headed "Painting His Heart Out," the critic Linda McGreevy discussed Azaceta's work: "In the early 1970s, the newly liberated artist chose to focus on heads—huge pink crania with staring eyes and pointed teeth. . . . But increasingly these heads filled Azaceta's huge canvases, jostling with bird-beasts, snarling dogs, hybrid monsters that threatened the meaty humans. One of these, an inverted crucifixion, featured a confrontation between the blue-faced victim and a vicious black dog. Their mirrored snarls were viewed by a group of heads, whose masked faces recall the

disturbing crowds who press against Christ in Bosch's cruel Passion imagery."

Azaceta continued showing at the Allan Frumkin gallery. His work *The City Painter of Hearts* was considered particularly abrasive. Susan Torruella Leval, curator for the Museum of Contemporary Hispanic Art, wrote: "The flaming city is an agonizing body: A skyscraper grows a breast while another sprouts a shapely leg; a torn limb balances on a church sediment; a limp arm hangs from a skyscraper while a penis grows at its top. Two skyscrapers end in decapitated heads. Above, sparks turn to confetti, then to blobs of paint. In front of the impeccable neutral foreground, a dog chases a cat who chases a mouse who chases a bone. Meanwhile, the master of transformations paints at his easel, oblivious to the apocalyptic bloody debris around him; coyly hiding his sex, he paints a perfect red heart onto a miniature blue canvas. He understands his role; painting reveals a caring heart. He understands also the humor of his position, its theatricality. He places himself on stage with the rest of his illusion, ready to be scrutinized by the multicolored spots that sweep the stage."

While color is important in Azaceta's early work, he does not associate it with his Hispanic heritage. Philosophically, he feels closer to German painters like Max Beckmann and George Grosz and the German expressionists. He has asserted that "there is a perception that with Latin American artists everything has to be colorful. I question that. I think I follow the tradition of German expressionism."

Azaceta appears in many of his paintings as a symbol of "Everyman"—with all humankind's dilemmas and demonstrating both humor and hope. Commenting on his self-portraits, Azaceta added, "I am an actor playing different roles. Most of my work is serious. The subject matter may be tragic, but I do have a certain humor to balance out the seriousness. In that I am different from Red Grooms. His work is 90 percent humor—it is entertaining. I do not conceive art as entertainment." Azaceta has portrayed himself as Homo Cockroach, Homo Beef, as a Mechanized Dog, and as Man with a Split Head.

One of his recent paintings, *Exile IV* (1988), shows a man struggling with a sacklike carapace of his back. It is Azaceta as "Everyman" setting forth on a journey. The numbers in the painting symbolize time *versus* space. Closer inspection shows that the naked figure carries the island of Cuba on his back. He may be an exiled figure, yet he is a familiar one, for we all carry our own burdens. He is a stranger, yet Azaceta has made him universal.

Azaceta is influenced by literary sources like Céline's book *Journey to the End of the Night*, a book about human suffering and cruelty that is important to him. Its characters are not too dissimilar from some of Azaceta's, who stand homeless in utter desolation, alienated by contemporary society, unable to relate. Azaceta, too, sees humanity overwhelmed by chaos and destruction. His paintings are not easy to look at and the viewer can only wonder whether his mutilated figures and fractionated desires represent humanity.

Azaceta became a United States citizen in 1967; he is well aware of the need for refuge. In *Hideout* (1980), he has two naked figures cowering together in a dark tunnel, not unlike primitive man in his cave. Yet, Azaceta also sees man as an antihero, who sets forth undaunted on a journey. The artist sees both the delusion and humor in that voyage into the unknown. His antihero is a modern picaresque figure tilting with some effect against the injustice and coldness of society. Azaceta elaborated: "I do not see myself as a political artist. Of course, politics and social issues overlap. I deal with social issues; I do not deal with political issues."

From 1981 through 1984, Azaceta taught at institutions like the University of California at Berkeley, Louisiana State, the University of California at Davis and the Cooper Union. He has also lectured on topics like "The Visibility of Minority Artists." While he enjoys teaching, he would like to be free to use all his time for painting. A friendly man with a ready smile, Azaceta speaks softly with a slight accent sentences that are fluid and whose meanings are direct.

Azaceta's recent paintings rely heavily on symbolism. He sees both progress and menace in science. "I believe that by the next century most people will be thoroughly mechanized. Half will be human, half will be mechanical apparatus. People today are dependent on mechanical hearts, lungs and plastic organs. We live and see the mechanization of man." He is also emotionally involved in the multifaceted question of evil, and the coexistence of poverty and wealth. Well aware of the doppelganger within each of us, Azaceta shows man divided between good and evil, subjugated by fate, and victimized by global politics.

In 1985 Azaceta received grants from the National Endowment for the Arts, and the Guggenheim Memorial Foundation. In 1972 and 1975, he had received grants from the Cintas Foundation. In 1988 Azaceta had his first European solo exhibition, in Cologne, West Germany, Kunst Station Sankt Peter.

Azaceta occupies a studio in the SoHo district of Manhattan. It has one large window looking

out on the street. Azaceta works with artificial light. He works from memory, and relishes having his own studio. In 1982 he married Sharon Jacques, an American from New Orleans who is also a painter. They live on the outskirts of Queens. He and his wife share a second studio near their home where they work together in the evenings.

Though Azaceta thinks of himself as a New York artist, his roots are firmly in Cuba. "I spent my first 18 years in Cuba; you cannot erase that". He does not consider himself in the mainstream of art and does not mind being an outsider. He says "I am moving towards the center." He feels that success was slow in coming. "In the seventies, I was a pioneer. I was one of the few Hispanic artists who exhibited. I was 33 years old when I started looking for a gallery. I was not one of the wonder painters who have a retrospective at the Whitney at that age."

Some of Azaceta's work is touring the United States as part of "Hispanic Art in the United States: Thirty Contemporary Painters and Scuptors". It is a pioneering show bringing together many diverse artists. The show is creating a new consiciousness for Hispanic art. It shows the richness and diversity of these artist working in this country. It is Azacetas' belief that in the nineties, minority artists will step out of the shadows and be acknowledged.

One of Azaceta's paintings in this touring exhibition "Homeless" (1986), is typical of the mature Azaceta. It shows a dark anonymous figure standing on one leg, while the other leg, cut off at the knee has an electric cord hanging from it. Azaceta commented on this work: "It represents the image of homeless man, looking for a place to walk, a place to belong to, to be part of. The man is carrying a little house in his outstreched arms, a reminder of the American dream. The electrical plug is a symbol, or substitution for plugging into a given place, of belonging to a given community." It is not an easy painting to contemplate. The artist has moved into a new more symbolic form of meaning. He is still painting out his concerns. Azaceta put it succinctly: "I have ideas that I want to do all the time. As long as there are issues that I can address, I will not run dry."

Azaceta is a serious artist. His earlier more cruel and obvious characterization of the city with its cannibalism and brutality has given way to inner self-examination. His colors are somewhat darker, somber and more restrained. As an artist, he shows and experiences the fragmentation of society. He sees the mechanization of our time. Still, his subject matter, which is all important to his art is not without redemption, hope and some humor.

Azaceta, the artist and the man, has learned to confront the terror of exile, and terrors within him. He represents the victim in all of us. His vision is apocalyptic. His artistic statements are not without hope. He also represents man's dreams. Fuelled by what he sees around him, he creates a new awareness in his art, and a new consciousness in the spectator. The artist shows a willingness to blend his message with greater aesthetic concerns. In a cool and reserved world, Azaceta's paintings have conscience, passion and heart.

EXHIBITIONS INCLUDE: Allan Frumkin Gal., Chicago 1978; Cayman Gal., NYC 1978; South Campus Gal., Miami-Dade Community Col., Fla. 1978; New World Gal., Miami-Dade Community Col., Fla. 1978; Allan Frumkin Gal., NYC 1979, '82, '84, '85, '86, '88; Richard L. Nelson Gal., Univ. of California, Davis 1981; The Candy Store, Folsom, Cal. 1981, '84, '86; Louisiana State Univ. Gal., Baton Rouge 1982; Chicago International Art Exposition 1985; Mus. of Contemporary Hispanic Art, NYC 1986; Virginia Commonwealth Univ., Richmond 1986; Gal. Paule Anglim, San Francisco 1987; Fondo del Sol Visual Arts, Washington, D.C. 1987; Kunst Station, Sankt Peter, Cologne, West Germany 1988; Sette Gal., Scottsdale 1988, '89.

COLLECTIONS INCLUDE: Metropolitan Mus. of Art, NYC; Alternative Mus., NYC; Rhode Island School of Design Mus.; Delaware Art Mus. Del.; Virginia Mus. of Fine Arts; Fulton Montgomery Community Col., N. Y.; Mus. del Barrio, NYC; Harlem Art Collection, NYC; Miami Public Library Art Col., Fla.; MOMA, NYC; Huntington Gal. Mus., Univ. of Texas.

ABOUT: Beardsley, J., Livingston, J. Paz, O. Hispanic Art in the United States, 1987; McGreevy, L., and Torruela Leval, S. Azaceta's Tough Ride Around the City, 1986; Mennekes, F., and Goodrow, G.A., Luis Cruz Azaceta, 1988. *Periodicals*—Artforum November 1987; ARTnews April 1984, March 1985; Arts Magazine vol. 54 no. 6 1980, February 1982, January 1985, June 1985, March 1986; Artweek March 16, 1985; Baton Rouge Sunday Advocate January 31, 1982; Kunst & Kirche April 1987; Miami Herald February 7, 1988; New York Times April 28, 1978, November 14, 1982, December 30, 1983; Sacramento Bee October 7, 1984, May 26, 1986; Washington Post April 24, 1987; Washington Times April 30, 1987.

BALDESSARI, JOHN (June 17, 1931–), American conceptual artist, is known for the use of photography and language in his work. His creative output encompasses an extraordinary range of artistic styles, media, and concerns. Addressing a range of authentic issues, Baldessari ventures into areas little explored by other visual artists, especially painters. In conceptualism the idea or concept behind a work's inception is its subject and is at least equal in importance to the

JOHN BALDESSARI

finished object of art. As a movement, conceptual art has its foundations in painting and sculpture. It sprang on the international art scene in the late 1960s, and Baldessari, a member of the exploratory California School, became one of its first exponents following his burning, in the mid 1960s, of all his unsold paintings he had made in the preceeding thirteen years.

In 1971 Baldessari published the lithograph *I Will Not Make Any More Boring Art*. Done in his own handwriting over and over again, like a schoolboy writing on the blackboard, completely covering a piece of paper, the statement after which the work was titled proved to be attention-getting for both Baldessari and conceptualism. Although obviously not a picture in any conventional sense, it was in its way a striking image (though its impact was not "retinal" in the way a de Kooning or a Schnabel is.) There is ironic humor in Baldessari's wish to make his art interesting by presenting the viewer with a classically boring image: one sentence written over and over again on a piece of paper.

Baldessari was born and raised in National City, California, just south of San Diego. His Danish mother and Austrian father did not encourage his interest in art. Nevertheless, Baldessari persevered in his resolve to become a painter. After he graduated from San Diego State College in 1953 he moved to Los Angeles, married, worked as a technical illustrator, and taught art in the poorer neighborhood schools. In 1968 he was invited to teach in the art department at the University of California, San Diego, where his interest turned away from painting to

the more experimental conceptual art. He even titled his course at U.C.S.D. "Post-Studio Art," implying that young artists might get out of their canvas-filled studios and into the world to explore less traditional materials, methods, and subject matter. Indeed, iconoclasm, wit, and a healthy subversiveness characterize Baldessari's own work. Earlier in his career, when he was still doing conventional drawing and painting, a Los Angeles art critic wrote of Baldessari that "it was nice to know that someone in L.A. knows how to draw." Baldessari told an interviewer years later that this comment convinced him to stop drawing.

Photography seemed like the next logical step for Baldessari and, as he told Nancy Drew in an interview published in the New Museum's catalog, "I stopped trying to be an artist as I understood it and just attempted to talk to people in a language they understood, such as hyperrealism, etc. But rather than paint realistically and aspire to the conditions of a photograph, why not just use the photograph or a text?" While he was still using photographs as models for his paintings he asked himself, "Why do I have to translate this into painting? What's wrong with a photograph?"

But there is a big difference between Baldessari's photography and the more traditional photography of someone like Ansel Adams, whose art aspires to similar aesthetic goals as those of painting: composition, classical beauty, and symbolic expression of deep emotion. Baldessari uses the camera as a tool to express and carry out ideas that veer drastically away from the concerns visual artists have had throughout the history of painting and sculpture, although, ironically, classically visual art issues are often touched on and explored in his work. For example, in a 1972–73 piece titled *Throwing 4 Balls in the Air to Get a Straight Line (Best of 36 Tries)*, the artist took thirty-six pictures (which is the number of exposures in a roll of 35 millimeter film) of four balls tossed up into the air with the goal of trying to photograph them at the instant they form a straight line. Not only is the basic element of drawing the line being investigated in a rather novel way, but the whole concept of a picture's composition is paradoxically dealt with; the strategy behind the making of the piece virtually eliminates the opportunity for the artist to compose a handsome picture in any conventional sense.

The humor there, as in much conceptual art in general and Baldessari's work in particular, is intended and results from the artist's combination of the element of change and accident with unexpected methods and unusual materials.

Baldessari's concern with color and the acts of visual perception and selection were refreshingly highlighted in a 1976 work entitled *Car Color Series: All Cars Parked on the West Side of Main Street.* . . . In the work, Baldessari presented color photographs he had taken of a row of parked cars. Where no car was parked, a blank space appears between photographs. "It's a matter of focus," Baldessari told Marcia Tucker in the New Museum's 1981 catalog. "If you believe your world is formed by what you look at, and you just don't look at the usual things, then your world will change."

Through his teaching Baldessari has had opportunity to help people change their outlook. Since 1970 he has been teaching at the California Institute of the Arts in Valencia, California. The school is a small, relatively unstructured one that has had a significant impact on contemporary art, and several of Baldessari's students, including David Salle, have enjoyed considerable success in the art world. Teaching in itself is extremely meaningful to Baldessari and his work. Perhaps it is the element of language as a vehicle of communication that is the common denominator between his teaching and his art. He has said that "there's a fuzzy boundary between my work as a teacher and my work as an artist. I often think that the art I do is saying, 'look, this is what I've been talking about': and when I'm teaching, I'm really doing art . . . I can give people permission. I can be out there to say, 'your own ideas might be okay.'"

Baldessari's work is extremely literary; he has said that what he likes to do most is to sit and read books all day. He considered pursuing a career as a writer or an art critic but found that visual images were necessary to his work. Furthermore, his interest in language is as much philosophical or linguistically oriented as it is literary. The ideas about structure in language and society in the work of the French anthropologist Claude Levi-Strauss and the linguistic theories of the Austrian philosopher Ludwig Wittgenstein as well as the work of Ferdinand de Saussure have led Baldessari to reflect on the semiotic relation between a word and a visual image. For example, how do a photograph of a *tree* and the word "tree" act similarly and differently to convey the idea of a tree? Combining photographs and language and incorporating such literary devices as narrative gave Baldessari a format for working that was perfectly suited to his investigation of the relationship between art and language. In a series titled "If it is a.m.: If it is p.m." (1972–73), the artist placed the following two sentences under a photograph of a slightly opened window in an anonymous apartment: "If it is a.m., the man who lives in the house opposite this window will water his garden," and "If it is p.m., the couple living in the apartment next door will probably argue." Not only do the words interact with the photograph, but the effect is to suggest images and actions that take place completely outside of the picture frame. Thus the piece reiterates the central tenet of conceptual art: that the ideas or concepts in a piece are as important as the finished art work.

Baldessari usually works with a series of images or with one basic image repeated, though slightly altered. He is a master of creating many levels of associations in his work and has declared, "I am less interested in the form art takes than the meaning an image evokes." A 1974 piece from the "Embedded Series" called *Cigar Dreams (Seeing Is Believing)* shows three images of a cigar in an ashtray, its smoke partially hiding the statement Seeing Is Believing. The word dream in the title and the cigar imagery make reference to Sigmund Freud who believed that personal content is hidden or "embedded" in the unconscious. It is a humorous and crafty piece, but more important is the artist's manipulation of various levels of invisibility and revelation.

As a conceptual artist Baldessari gives himself complete license to explore any and all ways of making art, no matter how spurious or unconventional they may appear. He once said, "I'm less interested in what is art than what is not art." In a 1972 videotape piece he spoofed the then popular trend to call anything that an artist does, says, or makes, art. Standing in front of the camera in a piece titled *The Way We Make Art Now,* Baldessari wrapped tape around one end of a stick and then picked the stick up at the other end, suggesting that he was indeed "making" art. He targeted body artists who experimented during the late 1960s with the idea that their own bodies were both the instrument for making art and the art product. For example, body artists might jump into a pool of paint, roll around on a blank canvas, and say that the shapes their rolling produced are art. Chris Burden, a California performance artist, actually shot himself in the arm with a pistol and declared that the scars of his healed wounds were his art. In response to that type of work Baldessari in a 1971 piece stood in front of a video camera and while slightly moving his arm or shoulder or head said "I am making art" after each move, representing Baldessari's interest and involvement in performance art.

During the late 1960s earth art, or environmental art as it was also called, was another significant offshoot of conceptual art. Environmental artists, such as Christo and Robert Smith-

son, used landscape, natural settings, and the earth itself as their material and subject matter for making art. Not surprisingly, Baldessari, in an early work titled *California Map Project/Part I: California* (1969), ventured into environmental art as well. In collaboration with artist George Nicolaides, Baldessari integrated his interests in language and photography into a visual-linguistic system derived from the word, California. The state of California was used as if it were a map and each letter of the state's name was reproduced in sizes ranging from one inch to one hundred feet and were made from diverse materials like paint, rocks, logs, and cloth. Each letter created was photographed; the resulting documentation, when the pictures were arranged back into the shape of the state, is both the actual work of art and its permanent record.

A prolific artist whose concern with producing work borders on the obsessive, Baldessari juxtaposed a photograph of a sharpened pencil and a photograph of a pencil with a dull point in *The Pencil Story* (1972), a kind of parable about the creative process itself. The photographs are accompanied by the following text:

I had this old pencil on the dashboard of my car for a long time. Every time I saw it, I felt uncomfortable since its point was so dull and dirty. I always intended to sharpen it and finally couldn't bear it any longer and did sharpen it. I'm not sure, but I think that this has something to do with Art.

Baldessari has made use of images from the movies and television to further investigate his interests in narrative structures and in the ways a photographic image signifies or expresses ideas and feelings. His *Black and White Decision* (1984) was exhibited in the 1985 Whitney Biennial. The piece consists of four movie stills from undisclosed films (one of the images is used twice), possibly dating from the 1940s to 1950s. In the center position a man in a business suit is partially concealing a woman who is standing indirectly behind him. Flanking that picture are identical photos of cowboys on horseback hiding behind a boulder. Above those three frames, in the center of the piece, is a triangular-shaped photograph of two people who are almost completely cropped out by the awkward shape of the picture, revealing little more than a man's hand holding a cigarette. There is a strong feeling of suspense in all three images: the man and woman might be lovers deciding the future of their relationship; the cowboys might be awaiting an ambush; and the hand might belong to a gangster facing the consequences of his outlaw life. The characters in the movie stills are acting out some moment of decision making, resulting in a reflexive situation common to much of Baldessari's work.

In his recent photographic work Baldessari seems to have digressed from using language as a necessary component in his art. *Eagle and Rodent*, presented in a 1984 exhibition at the Sonnabend Gallery comprises two side-by-side photographs of a sleek confident eagle and a rather innocent-looking rodent. It is fitting that at a time in his career when people expected combinations of photography and language, Baldessari deleted words from his pieces completely. Or perhaps he had finally come to embrace the adage that "a picture is worth a thousand words," since the preditory predicament the two creatures find themselves in needs no verbal clarification. What is characteristic of Baldessari's work is the tension that arises from such a juxtaposition of opposites.

In 1988 a limited editon of Lawrence Sterne's *Tristram Shandy* was published for which Baldessari made thirty-nine two-page spread photocollages; the books sold for $900 each and in late 1990 the Museum of Contemporary Art in Los Angeles mounted a major retrospective of over twenty years of his art. A big man, John Baldessari stands over six feet tall, "his hair a shock of white, his voice low, his demeanor anxious, but gentle," as described by Gerritt Henry in *The Print Collector's Newsletter*. Baldessari keeps a warehouse studio in Santa Monica.

EXHIBITIONS INCLUDE: La Jolla Mus. of Arts, La Jolla Calif. 1960, '66; Southwestern Col., Chula Vista, Calif. 1962, '64; Art and Project, Amsterdam 1971, '74; Gal. Konrad Fischer, Düsseldorf, West Germany 1971, '73; Sonnabend Gal., NYC and Paris since 1973; Gal. MTL, Brussels 1974, '75; The Kitchen (video), NYC 1975; Auckland City Art Gal. Auckland, New Zealand 1976; Gal. Massimo Valsecchi, Milan 1977; Matrix Gal., Wadsworth Atheneum, Hartford, Conn. 1977; Whitney Mus. of American Art (films), NYC 1978; Stedelijk van Abbemus., Eindhoven, Netherlands 1980 "John Baldessari; Work 1966–1980," New Mus., NYC 1981 Contemporary Arts Cntr., Cincinnati 1982; "John Baldessari: Art N Riddle," Univ. Art. Gals., Dayton, Oh. 1982. GROUP EXHIBITIONS INCLUDE: "Artists of the San Gabriel Valley," Pasadena Mus. of Art, Pasadena 1958; "Artists of Los Angeles County and Vicinity," Los Angeles County Mus., 1960; "San Francisco Annual," San Francisco Mus. of Art 1961; "Houston Annual: Western States," 1963; "Phoenix Annual," Phoenix Mus. of Art 1963; "Four Artists," Richard Feign Gal., NYC 1968; "Annual," Whitney Mus. of American Art, NYC 1969; "California Artist," Long Beach Mus. of Art 1969; "Konzeption-Conception," Städtisches Mus., Leverkusen, West Germany 1969; "Pop Art Redefined," Hayward Gal., London 1969; "Information," MOMA, NYC 1970; "955,000: Conceptual Art," Vancouver Mus. of Art, Vancouver 1970; Documenta 5, Kassel, West Germany 1972; Whitney Biennial, NYC 1972, '77 '79; "Story" John Gibson Gal., NYC 1973; "Projekt '74" Cologne 1974; "Projects: Video," MOMA, NYC 1975; Paula Cooper Gal., NYC 1975; "Video," Gal. D,

Univ. of Calif., Berkeley 1976; Castelli Graphics (films), NYC 1977; "Wit and Wisdom," Inst. of Contemporary Art., Boston 1978; "Word/Object/Image," Rosa Esman Gal., NYC 1979; "Contemporary Art in Southern California," High Mus. of Art, Atlanta 1980; "Pier and Ocean," Arts Council of Great Britain, London 1980.

BY THE ARTIST: Photo-collages for Tristram Shandy, 1988; (with Anne Ayres) L.A. Pop in the Sixties, 1989.

ABOUT: Battcock, G. Why Art?, 1977; Bruggen, Coosje van. John Baldessari, 1990; Gablik, S. and Russell, J. Pop Art Redefined, 1969; Kahmen, V. Art History of Photography, 1973; Kostelanetz, R. Assembling III, 1972; Myers, U. Conceptual Art, 1971. *Periodicals*—Artforum May 1969, November 1969, May 1970, February 1973, December 1975, September 1976, October 1979, December 1989; Art in America July 1990; ARTnews January 1986; Arts Magazine April 1988; Flash Art Summer 1987; New Yorker October 10, 1970; New York Times May 6, 1972, March 18, 1977; The Print Collector's Newsletter November/December 1986, May/June 1989; Village Voice October 15, 1975, December 19, 1975, October 16, 1978.

BARCELÓ, MIGUEL (1957–), Catalan painter, is generally considered the most talented among the new generation of artists to emerge from post-Franco Spain. Like his neo-expressionist contemporaries elsewhere in Europe, he couples explosive forms with highly introspective themes of artistic and cultural indentity, but while the instant youth movements of the early 1980s have largely lapsed out of fashion, Barceló continues to hold critical attention with the steady evolution of his plastic concerns.

Barceló was born in Felanitx, on the Spanish island of Mallorca, which was also the home of the painter Joan Miró. Barceló's family had lived there for several generations; they were, he told Helena Vasconcelos in a 1984 interview, "divided into two parts: 'one good' and 'one bad,'" with the latter including "those who produced the wealth of the family—smugglers and builders of dreams, while the former only worried about the conservation of the wealth which the other side dissipates." Faced with those two alternatives, he explained, he soon sought access to "the vibrant culture which was stubbornly ignored by the good side." He read voraciously from his grandfather's library and "pillaged" the collections of his friends, traveled to Paris while still in his early teens—his big discovery there was art brut—and by the age of fifteen, when his friends were all dreaming of "playing guitar with the Rolling Stones: to be rich and famous, to get all the beautiful women in the world be-

MIGUEL BARCELÓ

fore turning thirty," he opted for the "suicidal idea" of becoming a painter.

After two years at a very traditional art school in the capital, Palma de Mallorca—during which he mainly worked at home—he went to Barcelona in 1974 to enroll in the Fine Arts Academy, but he found their insistence on abstraction and conceptual art "too academic" for his taste and quit the following year. Up to that point he had been painting monochrome still lifes as well as landscapes, which, he indicated, were "very fashionable on Mallorca." (His mother is an outdoor landscape painter.) But during another trip to Europe in 1975, he met Joseph Beuys and stopped painting altogether in order to work with raw meat and other organic materials in the manner of the iconoclastic German artist-teacher. When he was offered a solo exhibit at the Palma Museum the following year, Barceló presented this new work in the form of wooden boxes filled with decaying substances and marked with their "date of fabrication." As he later explained in interviews with Jean-Luc Froment and Sylvie Couderc, such modernist tableaux were intended "to seek artistic expression by means other than those of traditional painting," but while they evoked some interest among younger artists, "the organizers, who expected rather more conventional painting, hardly appreciated these strange 'still lifes.'" Nonetheless, he noted, "this episode gradually led me to imagine a more direct relationship in my paintings between the subjects treated and the materials represented."

For the next five years, Barceló remained a

fairly marginal figure in Barcelona (which was the most dynamic city in Spain during the euphoric period following the death of Franco). The artist often uses Catalan, not Castilian (the official language of Spain), titles for his paintings. He set up a studio in an old plaster factory, where, inspired by the drip paintings of Jackson Pollock that he had seen exhibited in Madrid, he took to working on canvases spread out flat on the ground (and, also following Pollock's model, using different kinds of paint and foreign materials like sand). He had a dealer who gave him encouragement, but his paintings, now highly emblematic animal images, did not sell. In fact, when Barceló finally achieved recognition, it was on the international rather than the local level: in 1981, three of his animal paintings included in a Madrid exhibition of new figurative trends caught the attention of the German curator-critic Rudi R. Fuchs, and an invitation to Documenta 7 in Kassel followed.

Barceló was the only Spanish artist in the massive 1982 exhibit, and he later complained of the "Third World treatment" he received in the hanging of his work, but in the end, he emerged as a leading figure in the international neo-expressionist movement. Indeed, the rough, often menacing images in the three paintings he presented seemed to have much in common with the work of his youthful contemporaries in Europe and the United States, whose reaction to the austere and cerebral currents of the 1970s was a visceral return to the image, fueled by personal reflection (and anguish) in the one hand, and an engagement with the masters of the past on the other. In a statement accompanying his works at Kassel—the ironically titled *Nu pujant escales (Nude Climbing a Staircase,*1981 and two visionary cityscapes, *Volador sobre la ciudad (Flier over the City,* 1982) and *Persecucion nocturna a la periferia de la ciudad (Nocturnal Persecution on the Outskirts of the City,* 1982)—Barceló wrote, "I worked on [one of the canvasses] intermittently over a period of three months, which made for a total metamorphosis of what was going to be a self-portrait—which it still is anyway. . . . In each new session I contradicted the technique, style, and materials of the previous ones." And in a comment that might easily have been made by one of the young fauves from Germany or the Italian trans-avanguardia, he remarked, "I can go from a state of calm serenity to the utmost irritation in a single painting and in a single day; therefore I work with many techniques and apparently several styles. This may also explain the thickness of the layers of paint and the superimposition of images."

As a result of the exposure at Documenta,

Barceló was invited to inaugurate a new contemporary art space in Toulouse, where his work was seen by the Paris dealer Yvon Lambert. In early 1983, he found himself in the French capital to prepare for a solo exhibit at Lambert's gallery. Stimulated by the change of circumstances, environments, and above all, studios, he evolved his style rapidly during that period. He had taken up his flat, frontal animal images in Barcelona, he recalled to Sylvie Couderc, "because they were the easiest sign to represent." But between Toulouse and Paris, he developed increasingly complex compositions, introducing human figures and objects in more structured spatial arrangements. "I think I was trying to re-utilize the academic training I got in Palma and Barcelona," he explained to Couderc, "not out of any respect for the rules but because I realized that a more traditional technique could make the images that much more forceful." At the same time, he began to experiment with light and shadow, moving away from bright color contrasts to subtle, somber variations of tone. Those new preoccupations most often came together in heavily collaged and painted representations of the painter in his studio such as *El pintor amb el suo reflexe (The Painter Looking at His Reflection), Le Peintre avec pinceau bleu (The Painter with Blue Brush), Atelier avec poissons (Studio with Fish),* and *Peintre peignant le tableau (Painter Painting the Canvas)* all 1983, where the faunlike figure of the painter dancing over a room-size canvas laid flat on the ground gave Barceló ample opportunity to explore the nuances of space, depth, tonality, and self-identity.

In the neo-expressionist climate of the times, critics tended to stress the "wild" aspect of those works, as in the "almost wild relationship that a painter maintains to the point of obsession with his own image" that Maiten Bousset noted in the paintings on display at Yvon Lambert. Yet even at that relatively early point, some observers recognized that Barceló deserved to be seen apart from the wave of young fauves and new figuration painters sweeping Europe; as Denise Renaud, for example, wrote: "With a sure and original technique, Barceló's painting mixes 'barbarism' with great culture, and bespeaks the artist's anxious interest in himself."

Following the Lambert show, Barceló decided to remain in Paris, partly, at least, because of the access it offered him to the rest of Europe. That summer he traveled in Italy—Caravaggio was the main eye-opener—then visited Greece and Tunisia before returning to Naples for a five-month stay at the invitation of the dealer-patron Lucio Amelio (who had seen his work in Madrid that year and bought everything on exhibit).

There, installed in a studio that was literally in the shadow of Mt. Vesuvius, he worked in "a particularly devilish state of urgency" to turn out another group of paintings showing the artist in his studio, insistently monochrome and ever more complicated in surface-depth relations. A four-month visit to Portugal the following spring with his old friend and fellow painter Mariscal opened yet another chapter in his work with a series of seascapes painted entirely out of doors with what he called "a direct look at the motif"—consisting of heavily impastoed sea and shore, to be sure (*Ponto Corvo, Les Rochers*, 1984), but also the presence of the painter in that new setting (*El pintor borratxo*, 1984).

By that time Barceló had found an abandoned nineteenth-century church in Paris's Latin quarter to serve as his studio. The unusual work site not only stimulated his interest in architecture and architectural space, but also seems to have reinforced his sense of artistic mission, if not without a certain ironic awareness of the contrast between the spirituality of the church and the crudeness and physicality of his paintings. He was inspired by the idea of such "shitlike work" in a holy place, he told Sylvie Couderc, and that polarity was intentionally reflected in his insistent palette of brown and gold: "I think that, in the brown, shitlike thickness of my painting, in the superimpositions of materials, and in these strange, formless mixtures, in the paste that I don't always manage very well, in the secret alchemy of the substance I devour, I hold onto all my acquired knowledge and my obsessions about the culture." Another metaphor Barceló introduced in that period to express his dual confrontation with matter and culture was the bowl of soup, a tactile swirl of paint that imposed itself in the midst of still lifes, or even seascapes (*Sopa marina*, 1984), as a primordial image of what he called "cultural chaos."

In the course of 1984–85, Barceló's new environment and ongoing cultural obsessions were reinforced by the example of the mannerist and baroque painters he had encountered in Italy, or a combination of the two, with the painter smoking a cigarette (*Bibliotheque avec cigarette [Library with Cigarette,]* 1984) and on occasion, in the wake of the Portuguese visit, with the painter in his studio library flooded by the sea (*Le Peintre dans son atelier avec bibliotheque [The Painter in His Studio with Bookcase,]* 1984). In contrast to the acrobatic painter of the Barcelona days or the lyrical seascapes from Portugal, those dark, moody paintings show the artist as thinker rather than painter, effectively hemmed in by the artifacts of Western literary culture (and reflecting Barceló's still voracious appetite for reading). The thread of cultural autobiography

takes a broader, and less claustrophobic, turn with a 1985 series set in the grand galleries of the Louvre and the equally vast halls of Paris movie theaters (*Le Louvre avec statues The Louvre with Statues, Le debut du film The Beginning of the Film*). But even those paintings, perhaps the most grounded in literal detail, were rather more intended to express the physical basis of the image, the materiality of the paint; as he told Jean-Louis Froment, the curator of his 1983–1985 retrospective at Bordeaux, "I want to show painting for its own sake, its richness and its misery."

That impulse soon led to a variety of new forms (as Dan Cameron wrote in a 1985 survey of the new Spanish painting, versatility was Barceló's strong point), including eerie impastos setting off the surfaces of elegant objects like candlesticks or necklaces (*Lumiére avec bijoux [Light with Jewels]*, 1986), visionary variations on the artist in his studio/library (*The White Rose*, 1986), and a zany series of Chinese restaurant interiors with Barceló as chef and the cubists as interior decorators (*Cuisinier chinois [Chinese Cook]*, 1986). Following a three-month visit to Mallorca in 1986, the nomadic artist wound up settling New York City, where he was invited late that year to prepare an exhibit for Leo Castelli. His reception there was as enthusiastic as it had been in Europe, with a consensus that, in Nancy Grimes's words, "Barceló's belief in the efficacy of making art, obvious in his regard for tradition and the aesthetic object, gives his work an earnestness lacking in that of many of his peers." The artist himself, just approaching thirty, insisted that that international reknown has not "turned" his spirit: "I had never picked up a brush before noon," he told *Beaux-Arts* magazine, "and that hasn't changed."

EXHIBITIONS INCLUDE: Casa de la Cultura de Manacor, Mallorca 1974; Mus. de Palma de Mallorca 1976; Gal. 4 Gats, Palma de Mallorca 1977; Gal. Sa Pieta Freda, Son Servera, Mallorca 1978; Metronom, Barcelona 1981; Col. de Arquitectos, Palma de Mallorca 1982; Gal. Trece, Barcelona 1982; Gal. Fucares, Almagro 1982; Axe Art Actuel, Toulouse 1982; Med-a-Mothe, Montpellier 1983; Gal. Bruno Bischofberger, Zurich from 1984; Gal. Juana de Aizpuru, Madrid 1984; Gal. Zwirner, Cologne 1985; Akira Ikeda Gal., Nagoya 1985; CAPC Mus. de Bordeaux 1985; Palacio de Velasquez, Madrid, 1985; Inst. of Contemporary Art, Boston 1986; Anders Tornberg Gal., Lund 1986; Gal. Michael Haas, Berlin 1987; Waddington Gals., London, 1987. GROUP EXHIBITIONS INCLUDE: Gal. Mec-Mec (Neon de Suro), Barcelona 1977; São Paulo Bienal 1981; "Otras Figuraciones," La Caixa, Madrid 1981; Documenta 7, Kassel 1982; "26 pintores, 13 criticos," La Caixa, Barcelona 1982; "Libros de artists," Salas Pablo Ruiz Picasso, Madrid 1982; "Trans-figurations," Gal. Arca, Marseille 1983; "La Imagen del Animal," Casa de las

Alhajas, Caja de Ahorros, Madrid 1983; "Identitats," Sala de la Caixa de Pensions, Barcelona 1983–84; Venice Biennale 1984; "International Survey of Recent Painting and Sculpture," MOMA, NYC 1984; "Art espagnol actuel" (trav. exhib.), Toulouse, Fontevraud, Strasbourg, Nice 1984; "7000 Eichen," Kunsthalle, Tübingen and Kunsthalle, Bielefeld 1985; Artists Space, NYC 1985; "5 artistes espagnols," Europalia, Gent-Namur 1985; Paris Biennale 1985; "Barcelone, art contemporain," ELAC, Centre d'Echanges de Parrache, Lyon 1986; "Pintores y escultorers espanioles 1981-1986," Fundacion Caja de Pensiones, Madrid 1986; "Zehn Maler aus Spanien," Kunstverein Hamburgs 1986; Sydney Biennale 1986; Prospect 86, Kunstverein Frankfurt 1986; "Paisatges, Sa Llonja, Palma de Mallorca 1986–1987.

COLLECTIONS INCLUDE: Lucio Amelio, Naples; Lia Rumma, Naples; Bruno Bischofberger, Zurich; Yvon Lambert, Paris, and private collections in Barcelona, London, Madrid, Paris, Vienna, and Zurich.

ABOUT: "Documenta 7" (cat.), Kassel, 1982; "Miguel Barcel (cat.), CAPC Mus. de Bordeaux, 1985; "Terrae Motus" (cat.), Villa Campolieto-Ercolano, 1984; Vial Sanjuan, S. Agenda Barceló. *Periodicals*—Actuel September 1983; Artforum May 1985; Art in America February 1985, September 1983; ARTnews October 1986; Art Press February 1983; Axe Sud (Toulouse) Spring–Summer 1982; Beaux-Arts March 1987; Domus July–August 1985; Flash Art March–April 1983, March 1985, Summer 1986; Goya March–April 1983, November–December 1985; Le Matin (Paris) October 14, 1983; Studio International December 1984.

BARTLETT, JENNIFER (March 14, 1941–), American painter, achieved international fame in the 1970s for works that recorded images of the same "banal yet poignant" objects, over and over again, almost obsessively, in a variety of media and styles. Each of the very large, complex series of repetitions of images analyzes visual experience and at the same time invests the mundane with meaning and variety. In the early 1980s the artist's reputation was affirmed by private and corporate commissions for large-scale multimedia projects; only recently has she decided to relinquish such work in order to concentrate on her own aesthetic concerns.

A favorite subject with the trendier popular magazines, Bartlett established a public persona as a "serious thinker, obsessive worker, yuppie paradigm, [[and] international art world diva," in the words of a critic for *Art in America*. Her dedication to art cannot, however, be discounted, and she is also to be reckoned with as one of the generation of gifted female artists—among them Nancy Graves, a fellow student at Yale University, and Elizabeth Murray, one of her closest friends—who in the early 1970s success-

JENNIFER BARTLETT

fully challenged the male-dominated art establishment.

The fact that Bartlett grew up with the Pacific Ocean literally at her door is significant; images of water are a dominant theme throughout her work. Born Jennifer Losch (a descendant of the famous Austrian dancer Tilly Losch), she was raised in Long Beach, California, the oldest of four children of a pipeline engineer and a former fashion illustrator. At the age of five she announced her ambition to be an artist and live in New York City. Doing imaginative narrative drawings (she had trouble with realistic renditions) was a favorite childhood activity. As a student at Mills College in Oakland, she began painting in an abstract style inspired largely by the work of Arshile Gorky. Paintings exhibited in her first solo show, during her senior year at college, won her acceptance to the prestigious Yale University School of Art and Architecture in 1963. The following year she married Edward Bartlett, a Yale medical student. Studying under Jack Tworkov, James Rosenquist, Jim Dine, and Al Held, she received her B.F.A. degree in 1964 and her M.F.A. degree in 1965, after which she started teaching art at the University of Connecticut in Storrs. Soon she achieved part of her early ambition by renting a loft in New York, from which she commuted to Storrs. Exposed to the ferment of ideas that characterized the New York art scene in the 1960s, she began to forge her own artistic identity, moving away from a splashy abstract expressionism toward conceptualism and minimalism—first with a series of drawings of colored dots arranged with pseudo-

mathematical precision on the squares of sheets of graph paper. "Mathematics' goofy side," Calvin Tomkins good-naturedly described her method in his *New Yorker* profile of the artist.

As Tomkins also noted, while at Yale Bartlett found herself subjected to the sexist attitudes of certain of her male colleagues and devised a coping ploy, distancing herself from them by building huge stretchers for her canvases. A few years later she decided that a less cumbersome method might help her develop her own style. If she could "restrict all the physical decisions about the work, maybe something would happen with the content." Building on an idea inspired by subway-station signs, she transposed her graph-paper drawings to painted form. On one-foot-square steel plates covered with baked enamel and superimposed with a silk-screen grid, she positioned clusters of vivid dots of Testor's enamel paints. Several hundred such individual plates made up her first solo show in New York, in 1970, at Alan Saret's studio-gallery in SoHo. At her next exhibition, at the Reese Palley Gallery in 1972, the modules were arranged in series; in one of them, the dots had given way to recognizable images of a house, painted in different colors that suggested times of day or seasons of the year. By 1974, in *Drawing and Painting,* while some sections of the work were still composed of dots on grids, in others loose brush strokes obliterated the grid on the metal plates.

By that time, too, there were other significant changes in the painter's life. In 1972, having been divorced, and having resigned from the University of Connecticut, she joined the faculty of the School of Visual Arts in New York and was now able to concentrate on her painting and on the book she had begun to write several years earlier. To that none-too-veiled autobiographical account of the life of a young artist she gave the facetious title *History of the Universe: A Novel.* Distilled from a two-thousand-page manuscript and illustrated with several of Bartlett's own photomontages (eerily unpeopled outdoor scenes), it was eventually published in 1985. Book and paintings are alike in their conceptual basis, their "attempt to categorize, catalog, and classify," to include absolutely everything—the "novel" stringing together prosaic factual statements that add up to candid descriptions of the author's family and art-world friends.

In the spring of 1974, Bartlett, who has, in turn, been candidly described by one of those friends, Elizabeth Murray, as "sort of a brat," managed to persuade the gallery owner Paula Cooper (now her dealer) to exhibit her steel-plate paintings; the show marked the beginning of their association. Two years later *Rhapsody,* still perhaps Bartlett's best-known work, was shown at the Paula Cooper Gallery.

In the summer of the previous year she had started work on another series of painted steel plates. By the time it was finished in the winter, it comprised 988 units; assembled and mounted on the gallery walls, it wound its seven-foot-high, 154-foot length around the entire exhibition space. The individual plates in which images are repeated in a diversity of pastel or more vibrant hues, are rendered in so many different styles that they constitute, many critics have declared, a veritable history of modern painting. Basic to the work are four figures, which she claims occurred to her spontaneously and which she defines as archetypal: house and ocean (both to be encountered again, both central to her later paintings and photographs), tree and mountain. *Rhapsody* also includes plaques painted simply with lines, or with squares, circles, or triangles, done freehand, ruled, or strippled. There also are plates completely covered in icily brilliant tones of enamel paint; the work's finale is a sequence of 126 plates, evoking ocean waters, painted in fifty-four shades of blue. In the artist's own words, "*Rhapsody* was conceived of as a painting that was like a conversation in the sense that you start explaining one thing and then drift off into another subject . . . and then come back again, and include as much as you can so that you are able to follow those elements through separately or look at them in total."

It was an architect friend who gave the work its title, which its creator declares "was so awful I liked it. The word implied something bombastic and overambitious, which seemed accurate enough." (Despite her reputation for forthrightness and contentiousness, the artist can be self-deprecatingly humorous, interviewers have found.) An instantaneous success, the painting was shown in several museums throughout the United States before being sold to a collector for an unprecedented $45,000; despite the windfall, Bartlett kept on teaching. One of the tangible rewards of her continuing success, however, was the enormous art-deco-appointed loft she subsequently bought in SoHo, which she still maintains as her New York home and studio.

John Russell's much-quoted *New York Times* review (May 16, 1976) of *Rhapsody* declares it to be "the most ambitious single work of new art that has come my way since I started to live in New York," a work that "enlarged our notions of time, and of memory, and of change, and of painting itself." His opinion has been confirmed by honors such as the Harris Prize of the Art In-

Alhajas, Caja de Ahorros, Madrid 1983; "Identitats," Sala de la Caixa de Pensions, Barcelona 1983–84; Venice Biennale 1984; "International Survey of Recent Painting and Sculpture," MOMA, NYC 1984; "Art espagnol actuel" (trav. exhib.), Toulouse, Fontevraud, Strasbourg, Nice 1984; "7000 Eichen," Kunsthalle, Tübingen and Kunsthalle, Bielefeld 1985; Artists Space, NYC 1985; "5 artistes espagnols," Europalia, Gent-Namur 1985; Paris Biennale 1985; "Barcelone, art contemporain," ELAC, Centre d'Echanges de Parrache, Lyon 1986; "Pintores y escultorers espanioles 1981-1986," Fundacion Caja de Pensiones, Madrid 1986; "Zehn Maler aus Spanien," Kunstverein Hamburgs 1986; Sydney Biennale 1986; Prospect 86, Kunstverein Frankfurt 1986; "Paisatges, Sa Llonja, Palma de Mallorca 1986–1987.

COLLECTIONS INCLUDE: Lucio Amelio, Naples; Lia Rumma, Naples; Bruno Bischofberger, Zurich; Yvon Lambert, Paris, and private collections in Barcelona, London, Madrid, Paris, Vienna, and Zurich.

ABOUT: "Documenta 7" (cat.), Kassel, 1982; "Miguel Barcel (cat.), CAPC Mus. de Bordeaux, 1985; "Terrae Motus" (cat.), Villa Campolieto-Ercolano, 1984; Vial Sanjuan, S. Agenda Barceló. *Periodicals*—Actuel September 1983; Artforum May 1985; Art in America February 1985, September 1983; ARTnews October 1986; Art Press February 1983; Axe Sud (Toulouse) Spring–Summer 1982; Beaux-Arts March 1987; Domus July–August 1985; Flash Art March–April 1983, March 1985, Summer 1986; Goya March–April 1983, November–December 1985; Le Matin (Paris) October 14, 1983; Studio International December 1984.

BARTLETT, JENNIFER (March 14, 1941–), American painter, achieved international fame in the 1970s for works that recorded images of the same "banal yet poignant" objects, over and over again, almost obsessively, in a variety of media and styles. Each of the very large, complex series of repetitions of images analyzes visual experience and at the same time invests the mundane with meaning and variety. In the early 1980s the artist's reputation was affirmed by private and corporate commissions for large-scale multimedia projects; only recently has she decided to relinquish such work in order to concentrate on her own aesthetic concerns.

A favorite subject with the trendier popular magazines, Bartlett established a public persona as a "serious thinker, obsessive worker, yuppie paradigm, [[and] international art world diva," in the words of a critic for *Art in America*. Her dedication to art cannot, however, be discounted, and she is also to be reckoned with as one of the generation of gifted female artists—among them Nancy Graves, a fellow student at Yale University, and Elizabeth Murray, one of her closest friends—who in the early 1970s success-

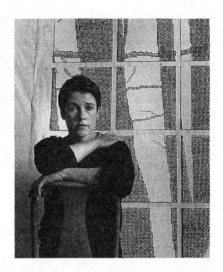

JENNIFER BARTLETT

fully challenged the male-dominated art establishment.

The fact that Bartlett grew up with the Pacific Ocean literally at her door is significant; images of water are a dominant theme throughout her work. Born Jennifer Losch (a descendant of the famous Austrian dancer Tilly Losch), she was raised in Long Beach, California, the oldest of four children of a pipeline engineer and a former fashion illustrator. At the age of five she announced her ambition to be an artist and live in New York City. Doing imaginative narrative drawings (she had trouble with realistic renditions) was a favorite childhood activity. As a student at Mills College in Oakland, she began painting in an abstract style inspired largely by the work of Arshile Gorky. Paintings exhibited in her first solo show, during her senior year at college, won her acceptance to the prestigious Yale University School of Art and Architecture in 1963. The following year she married Edward Bartlett, a Yale medical student. Studying under Jack Tworkov, James Rosenquist, Jim Dine, and Al Held, she received her B.F.A. degree in 1964 and her M.F.A. degree in 1965, after which she started teaching art at the University of Connecticut in Storrs. Soon she achieved part of her early ambition by renting a loft in New York, from which she commuted to Storrs. Exposed to the ferment of ideas that characterized the New York art scene in the 1960s, she began to forge her own artistic identity, moving away from a splashy abstract expressionism toward conceptualism and minimalism—first with a series of drawings of colored dots arranged with pseudo-

mathematical precision on the squares of sheets of graph paper. "Mathematics' goofy side," Calvin Tomkins good-naturedly described her method in his *New Yorker* profile of the artist.

As Tomkins also noted, while at Yale Bartlett found herself subjected to the sexist attitudes of certain of her male colleagues and devised a coping ploy, distancing herself from them by building huge stretchers for her canvases. A few years later she decided that a less cumbersome method might help her develop her own style. If she could "restrict all the physical decisions about the work, maybe something would happen with the content." Building on an idea inspired by subway-station signs, she transposed her graph-paper drawings to painted form. On one-foot-square steel plates covered with baked enamel and superimposed with a silk-screen grid, she positioned clusters of vivid dots of Testor's enamel paints. Several hundred such individual plates made up her first solo show in New York, in 1970, at Alan Saret's studio-gallery in SoHo. At her next exhibition, at the Reese Palley Gallery in 1972, the modules were arranged in series; in one of them, the dots had given way to recognizable images of a house, painted in different colors that suggested times of day or seasons of the year. By 1974, in *Drawing and Painting,* while some sections of the work were still composed of dots on grids, in others loose brush strokes obliterated the grid on the metal plates.

By that time, too, there were other significant changes in the painter's life. In 1972, having been divorced, and having resigned from the University of Connecticut, she joined the faculty of the School of Visual Arts in New York and was now able to concentrate on her painting and on the book she had begun to write several years earlier. To that none-too-veiled autobiographical account of the life of a young artist she gave the facetious title *History of the Universe: A Novel.* Distilled from a two-thousand-page manuscript and illustrated with several of Bartlett's own photomontages (eerily unpeopled outdoor scenes), it was eventually published in 1985. Book and paintings are alike in their conceptual basis, their "attempt to categorize, catalog, and classify," to include absolutely everything—the "novel" stringing together prosaic factual statements that add up to candid descriptions of the author's family and art-world friends.

In the spring of 1974, Bartlett, who has, in turn, been candidly described by one of those friends, Elizabeth Murray, as "sort of a brat," managed to persuade the gallery owner Paula Cooper (now her dealer) to exhibit her steel-plate paintings; the show marked the beginning of their association. Two years later *Rhapsody,* still perhaps Bartlett's best-known work, was shown at the Paula Cooper Gallery.

In the summer of the previous year she had started work on another series of painted steel plates. By the time it was finished in the winter, it comprised 988 units; assembled and mounted on the gallery walls, it wound its seven-foot-high, 154-foot length around the entire exhibition space. The individual plates in which images are repeated in a diversity of pastel or more vibrant hues, are rendered in so many different styles that they constitute, many critics have declared, a veritable history of modern painting. Basic to the work are four figures, which she claims occurred to her spontaneously and which she defines as archetypal: house and ocean (both to be encountered again, both central to her later paintings and photographs), tree and mountain. *Rhapsody* also includes plaques painted simply with lines, or with squares, circles, or triangles, done freehand, ruled, or strippled. There also are plates completely covered in icily brilliant tones of enamel paint; the work's finale is a sequence of 126 plates, evoking ocean waters, painted in fifty-four shades of blue. In the artist's own words, "*Rhapsody* was conceived of as a painting that was like a conversation in the sense that you start explaining one thing and then drift off into another subject . . . and then come back again, and include as much as you can so that you are able to follow those elements through separately or look at them in total."

It was an architect friend who gave the work its title, which its creator declares "was so awful I liked it. The word implied something bombastic and overambitious, which seemed accurate enough." (Despite her reputation for forthrightness and contentiousness, the artist can be self-deprecatingly humorous, interviewers have found.) An instantaneous success, the painting was shown in several museums throughout the United States before being sold to a collector for an unprecedented $45,000; despite the windfall, Bartlett kept on teaching. One of the tangible rewards of her continuing success, however, was the enormous art-deco-appointed loft she subsequently bought in SoHo, which she still maintains as her New York home and studio.

John Russell's much-quoted *New York Times* review (May 16, 1976) of *Rhapsody* declares it to be "the most ambitious single work of new art that has come my way since I started to live in New York," a work that "enlarged our notions of time, and of memory, and of change, and of painting itself." His opinion has been confirmed by honors such as the Harris Prize of the Art In-

stitute of Chicago, given to Bartlett in 1976, a creative arts prize from Brandeis University in 1983, and an award from the American Academy and Institute of Arts and Letters, also in 1983.

One of *Rhapsody*'s archetypal figures became the focus of a whole series, the "house paintings" (1976–77), which take their titles from addresses of people significant to the artist, and which, by color and style, become metaphorical portraits of them. *White Street* (Elizabeth Murray's New York address), for example, uses twenty-five colors to allude to the "contained chaos" associated with that friend. Another, *Graceland Mansion,* is Bartlett's tribute to her youthful idol Elvis Presley. It consists of five separate paintings, in five different styles, presenting the house in aspects that reflect subtle mood shifts. This work has also been translated (1978–79) into a sequence of eighty prints, in lithograph, silk-screen, woodcut, drypoint, and aquatint versions, each executed by a different printmaker. The collaborative venture was issued "en suite" in a limited edition of forty copies.

It was in 1979 that the artist accepted her first commission. *Swimmers Atlanta* was designed for the lobby of the Richard B. Russell Federal Building and United States Courthouse in the Georgia capital. Consistent with Bartlett's conceptualizing approach, the project was methodically worked out in a series of preliminary sketches. One-half of the finished "mural" consists of the by-then usual enamel-on-steel plates; the other half is composed of oil paintings on canvas, her first use of that medium in ten years; and the whole shows an even more painterly approach than was first evidenced in *Rhapsody*. The ensemble is divided into nine sequences, differing in imagery and style (representational and abstract), color and mood; thus, one-half of each sequence is sad/turbulent, the other half happy/calm. The unifying motif is a "swimmer," an abstract, flesh-colored ellipsoid shape, challenged by the ocean environment: icebergs, whirlpools, seaweed, boats—a metaphor, one critic has suggested, for the vagaries of judicial opinion and thus appropriate for a courthouse setting. The differences in scale of the individual components, which range from easel-painting size to enormous eighteen-foot-square surfaces, contribute to an illusion of depth in the narrow lobby.

Later in 1979 the artist found herself in a situation and environment that at first threatened complete stultification but in the end proved of the greatest importance to the development of her work. Having agreed to exchange houses with the English writer Piers Paul Read, she spent a drizzly winter in his villa near Nice. Unable to go on with her plans to visit European museums and write, she set herself, with typical pertinacity, to learn to draw, remedying a deficiency in her earlier training. Many critics, though, contend that drawing is still her weak point. Over a fifteen-month period she drew and redrew, in all kinds of light and weather, the same subject: the villa's "awful little garden," with its dried-up pool, statue of a urinating cherub and row of cypresses in the background. Using, variously, pencil, Conté crayon, or charcoal, pen or brush and ink, watercolors, pastels, or gouache, she interpreted the scene in styles ranging from completely abstract to wholly representational; and by sketching from multiple vantage points she achieves the almost cinematic effect of panning in on the garden.

As Tomkins has commented, that exercise was a remarkable work of self-discovery, ultimately about the process of drawing itself. The resulting suite of two hundred sketches was exhibited at Paula Cooper's in 1981 and published the following year as a monograph, *In the Garden,* with an introduction by John Russell. The image of "her little private Giverny," as an *Art in America* (May 1986) critic termed it, remained persistent, however. In 1980 it formed the dominant element of her second commissioned work, for the Philadelphia headquarters of the Institute for Scientific Information (ISI, a Robert Venturi building); in 1983 she worked it up into a series of eight large paintings.

Invited to devise a wall decoration on the theme of information for ISI, she produced an ensemble of 270 enameled steel plates that seem, superficially, to have little to do with the assigned subject. The images are of water, a swimmer, and a recapitulation of the garden motifs: pool, putto, and cypresses. A core group of the plates hangs in the lobby; the rest, scattered throughout the hallways of the building and repeating segments of the core design, make a visual pun alluding to ISI's function as an information-gathering service.

In 1981 Bartlett painted the dining room in the London home of the collectors Charles and Doris Saatchi, covering walls, a mirror, and a folding screen with a combination of images and colors evocative of parts of a garden seen at different times of the year. The decoration indeed is designed to link the small, low-ceilinged room with the actual garden onto which it opens. Once again the work is multimedia, incorporating oils on canvas and on the mirror; casein on plaster; paper collage; enamels on glass and on steel plates; pastels, charcoal, and colored pencils, and it runs the usual gamut of styles.

The artist, who had been doing photography for some time (part of *In the Garden* was actually drawn from her photographs, after she returned to New York), now developed two multimedia series from photos of vacation settings in upstate New York and in the Caribbean. Again there is a hint of cinematic technique. In the way long shots are alternated with closeups in a film, Bartlett alternates distance views and magnified representations of leaves in both *Up the Creek* and *To the Island* (1981–82). And in the latter the artist for the first time used a three-dimensional object to adumbrate the theme of the painting; a small sailboat was set out on the floor of the Paula Cooper Gallery, almost as if to place the viewer "at sea," in real space.

Since then Bartlett has frequently used photographs rather than drawings as a starting point for her paintings, with the result that narrative wins out over pure concept and process. *Dog and Cat* (1983), for example, an oil painting on paired canvases, gives the feeling of a nighttime encounter caught by chance in the glare of a camera flash.

Taking to the ocean again, in 1984, Bartlett painted two murals for the staff dining room of Philip Johnson's new AT&T headquarters building in New York, titling them *Atlantic Ocean*—appropriately hung on the east wall—and *Pacific Ocean,* across from it. The former of the moody, turbulent nine-by-thirty-foot paintings is painted on metal plates; the latter is oil on canvas. The artist's next corporate commission—and her last, she has announced—was a multimedia installation, also executed in 1984, for the Volvo Corporation's international headquarters in Göteborg, Sweden. As with the Saatchi project, the scheme was to unite outdoors with indoors, but on a much-expanded scale and through the developed use of three-dimensional equivalents (she refused to call them sculptures) of images in the paintings on the walls inside. Thus, a cabin and a rowboat made of Cor-Ten steel, and granite chairs and a table occupy the wooded hillside outdoors. The motifs go through yet a third incarnation, becoming small objects for actual use in the staff lounge area. There is a cigarette box in the shape of the cabin, and the boat becomes a silver ashtray. Such transmogrifications, with their discrepancies in scale and in the relationship between object and material, have led some art critics to abstruse speculation on how intriguingly—or disturbingly—Bartlett has blurred the distinction between the real and the simulated.

Since the Volvo commission her work has given much impetus to that line of criticism. *The Creek* (1984) includes a boat, an oar, and a railing, constructs that, as John Russell put it, "have walked out of [the] paintings" to highlight and echo passages in the wall-hung canvases behind or around them. In the 1985 "Luxembourg Garden" series, little boats built to scale and flying tartan sails (tartan is "deeply entertaining" the artist explains), are set out on the floor beneath their painted counterparts. For such mini-environmental projects Bartlett now relies on the help of a group of construction assistants.

Defending herself against charges that her work has become excessively pretty and decorative, she argues that all painting is to some extent decoration. In any case, her early popularity was renewed and enhanced by the 1985–86 traveling retrospective exhibition of fifteen years of her work, mounted first at the Walker Art Center in Minneapolis.

At a New York dinner party in 1980 Bartlett met her second husband, the German film actor Mathieu Carrière. They were married in 1983 and lived in the apartment in which *Last Tango in Paris* was filmed, not far from the Jardin du Luxembourg. She freely acknowledges that she has "a very happy relationship with luxury," despite which she still puts in twelve- to fourteen-hour working days. In August 1985 the artist had her first child, Alice. She has spent the last few years shuttling between her SoHo studio and Paris. Contrary to her first impressions, she finds Paris an increasingly stimulating place to live and work. Jennifer Bartlett is undeniably, elegant, stylish, and attractive, with mobile features, deep blue eyes, and a distinctive helmet of dark hair *à la gamine*. She is also, in John Russell's words (*New York Times*, May 19, 1985), indeniably a woman of "ferocious and gleeful intelligence."

EXHIBITIONS INCLUDE: Mills Col., Oakland, Calif. 1963; Alan Saret, NYC 1970; Reese Palley Gal., NYC 1972; Paula Cooper Gal., NYC 1974–85; Saman Gal., Genoa 1974, 1978; Grage, London, 1975; MOMA, NYC 1978; The Clocktower, NYC 1979; Albright-Knox Art Gal., Buffalo, N.Y. 1980; Gal. Mukai, Tokyo 1980; Tate Gal., London 1982; Walker Art Cntr., Minneapolis (trav. exhib) 1985–86. GROUP EXHIBITIONS INCLUDE: "Paintings: New Options," Walker Art Cntr., Minneapolis 1972; Whitney Mus. of American Art Annual, NYC 1972–83; Kunsthaus Hamburg 1972; MOMA, NYC 1973, '82, '83; Corcoran Gal. of Art Biennial, Washington, D.C. 1975; Art Inst. of Chicago 1976; Kunstmus., Düsseldorf 1976; Documenta 6, Kassel 1977; "New Image Painting," Whitney Mus. of American Art, NYC 1978; "Printed Art: A View of Two Decades," MOMA, NYC 1980; Venice Biennale 1980 (drawings).

COLLECTIONS INCLUDE: MOMA, Metropolitan Mus. of Art, and Whitney Mus. of American Art, NYC; Phila-

delphia Mus. of Art; Yale Univ. Art Collection, New Haven, Conn.; Walker Art Cntr., Minneapolis; Mus. of Fine Arts, Dallas; Art Gallery of South Australia, Adelaide.

ABOUT: Bartlett, J. History of the Universe: A Novel, 1985; Current Biography, 1985; Emanuel, M., et al. Contemporary Artists, 1983; Goldwater, M., et al. Jennifer Bartlett, 1985; Who's Who in American Art, 1980-90. *Periodicals*—Art in America, November 1979, May 1986; ARTnews November 1983; Arts Magazine November 1985; Newsweek January 10, 1985; New York Times Magazine May 16, 1976, May 19, 1985; New Yorker April 15, 1985; Vanity Fair April 1985.

***BASQUIAT, JEAN MICHEL** (1960–August 12, 1988), American painter, was born in Brooklyn to a middle-class family. His Haitian father, a successful accountant, and his Puerto Rican mother separated when he was seven. Early on, Basquiat dreamed of becoming a cartoonist or a writer. He drew on paper his father brought home from the office, and his mother took him to museums, where he was transfixed by Picasso's masterpiece, *Guernica*, which at that time hung in the Museum of Modern Art.

By the time he was in high school, his heroes were legendary—and troubled—musicians, notably Charlie Parker and Jimi Hendrix. Basquiat's ambition was to become a culture hero like his idols. "Since I was 17, I thought I might be a star," Basquiat told Cathleen McGuigan, who reported on the rise of the young artist at the height of his fame in a much-noticed article in *The New York Times Magazine* (February 10, 1985). "I had a romantic feeling of how people had become famous. Even when I didn't think my [work] was that good, I'd have faith."

Basquiat's rebelliousness surfaced when he was fifteen. He dropped out of high school for a while, leaving home to become a New York street urchin, sleeping on friend's couches and joining the brigades of hustlers and transients whose social center was Washington Square in the Village. "I just sat there dropping acid for eight months," he admitted in an interview with Suzi Gablik for her book *Has Modernism Failed?* "Now all that seems boring. It eats your mind up." In 1977 he dropped out of school again, this time for good, after an altercation with the principal.

At this time Basquiat and a friend, Al Diaz, began writing messages on walls of Manhattan buildings, primarily in SoHo. These magic-marker musings were "street" observations of contemporary urban life. The phrases ranged from the acidulous—"Riding around in daddy's

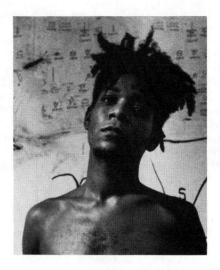

JEAN MICHEL BASQUIAT

convertible with trust fund money"—to the ominous—"Plush safe . . . he think." Diaz and Basquiat signed their work with the tag "SAMO" and a crudely drawn copyright symbol. Basquiat intended SAMO as a brand name or trade mark, and conceived the term from the expression, "Same Old. . . . "

In the late 1970s Basquiat had neither a permanent home nor a regular job. He prowled the streets, made painted T-shirts at art dance clubs like the Mudd, and crashed art-world parties. For spending money he sold junk jewelry on Sixth Avenue in the Village. He also played in an avant-rock band called Gray. "It was a noise band," he recalled, "I played a guitar with a file. . . . I was inspired by John Cage at that time—music that really isn't music. We were trying to be incomplete, abrasive, oddly beautiful." Basquiat also began showing drawings on paper at Club 57, an art and performance space in the East Village organized by the young art-school graduates Keith Haring and Kenny Scharf.

In the summer of 1980 Basquiat participated in the attention-getting "Times Square Show," put together by a group of young subway graffitists from the Bronx and by white art-school "punks" and "new wavers" from the Lower East Side. The work was raw, angry, and largely figurative. It confirmed the larger trend toward turbulent canvases and angst–ridden depictions of the human figure then being revived by Julian Schnabel and other so-called neo-expressionists. The "street funk" look of the show was appropriate for its site—a former massage parlor. In an

*bäs´ kyä

Art in America review of the "Times Square Show," Jeffrey Dietch singled out for praise the work of the "omnipresent graffiti sloganeer SAMO," whose painting of a patch of wall was a "knockout combination of de Kooning and subway spray paint."

About this time Diaz and Basquiat fell out, and Basquiat dropped the SAMO tag. In the 1960s practitioners of *arte povera* fashioned work out of debris and refuse gathered from city streets. Now Basquiat began to do the same. His new work was in part a clever, calculated gesture, a sly, knowing quotation from Robert Rauschenberg–influenced styles. It was also partly an expression of a naif's primitivist impulse. Mainly, however, it was the consequence of Basquiat's poverty and his complete lack of training in oil painting. "He had no real materials," wrote McGuigan. "He painted on salvaged sheet metal or broken pieces of window casement and made assemblages out of junk." The images were crude and childishly drawn, but painters like Francesco Clemente admired their power and radiant authenticity.

In January 1981 Basquiat was selected to show at the landmark "New York/New Wave" show at P.S. 1, an alternative studio-gallery in Long Island City. For the first time, Basquiat showed his still-tentative crayon-and-paint drawings on unprimed canvas. "The message," McGuigan noted, was clear. "Though Basquiat had cruised onto the underground art scene on the crest of the graffitists' new wave, his work was distinctly different."

About this time a handful of critics, collectors, and artists became Basquiat's patrons. An art advisor for Citibank visited the young artist in his tenement apartment on the Lower East Side and bought five drawings on typing paper. Henry Geldzahler, curator of 20th century art at the Metropolitan Museum of Art, also bought work from Basquiat. The Italian painter Sandro Chia commented that Basquiat's raw work captured the "emotional reality" of New York City.

In an atmosphere that Suzi Gablik likened to a "hothouse for forced growth," Basquiat began painting in the basement of the dealer Annina Nosei's SoHo gallery. Nosei provided him with materials and sold several of his canvases, most of them to influential European collectors, for about $1,000 to $1,500 a piece. However, Basquiat often felt that these paintings, with their grimacing African masklike faces and scrawled massages, were unfinished. In a *Flash Art* review of a Basquiat show at Nosei's gallery in March 1982, Jeffrey Deitch wrote: "Basquiat is likened to a wild boy raised by wolves, corralled into Annina's basement and given nice clean canvases to work on instead of anonymous walls. A child of the streets gawked at by the intelligentsia. But Basquiat is hardly a primitive. He's more like a rock star. . . . [He] reminds me of Lou Reed singing brilliantly about heroin to nice college boys."

Feeling that he was expected to perform on command and churn out paintings like a factory, Basquiat rebelled. He went to Nosei's basement and destroyed ten of his canvases. In the fall of 1982 he was living alone on Frosby Street, between SoHo and the Bowery, where he said he "made the best paintings ever." "I was completely reclusive," he said, "worked a lot, took a lot of drugs, I was awful to people." In November he showed his new paintings at the Fun Gallery, a ramshackle, unheated but ultratrendy graffiti-art emporium in the East Village. The opening of the show turned out to be one of the glitziest New York art world happenings of the decade, and was attended by collectors from uptown and Europe as well as by rappers and subway graffitists from the Bronx.

By now several influential gallery owners were ardently courting Basquiat. One of them was Tony Shafrazi, a SoHo dealer who had helped to promote graffiti art to international significance and who had gained notoriety by trying to spray-paint the phrase "Kill Lies All" on *Guernica* at the Museum of Modern Art. Because he wanted to sever ties to graffitism and because he was repelled by the attempted *Guernica* vandalism, Basquiat refused Shafrazi and instead joined Mary Boone's gallery, also in SoHo.

Boone once said that she considered all the fuss over Basquiat unseemly; nevertheless "I'd walk into some collector's home and there would be something by Jean, hanging next to Rauschenberg and Stella. It looked great. It surprised me." Basquiat now acquired another new and quite powerful patron-collaborator, Andy Warhol, who befriended Basquiat, painted and exhibited with him, and tried to caution the young man against living to excess.

Basquiat took up residence in a Lower East Side building that he rented from Warhol. His studio was on the street level, the upstairs his living quarters. He took to wearing expensive dark Italian suits and was often photographed standing in a paint-splattered Armani, brush in hand, next to a new canvas. He liked to go to clubs downtown, then return home in the wee hours and paint until he would collapse into sleep.

"Some days," He once said, "I can't get an idea, and I think, man, I'm just washed up, but it's just a mood. . . . If I'm away from painting for a week, I get bored. . . . There's really noth-

ing else to do in life, except flirt with girls." He continued to play the part of art-world *enfant terrible* well into the decade, until the role no longer suited one who had obviously outgrown it. Eventually, he fell out with Boone and left her gallery. He had developed an addiction to heroin, and began to show his work only sporadically. In the summer of 1988 he died of a heroininduced overdose not long after returning to New York from a trip to Europe. Basquiat's death came less than two years after Warhol's. It was reported that he had grown despondent after the death of his friend, who had tried to exercise a restraining influence on the young painter.

EXHIBITIONS INCLUDE: Mudd Club, NYC 1979; Club 57, NYC ca. 1980; "Times Square Show," NYC 1980; "New York/New Wave," NYC 1981; Mazzoli Gal., Modena, Italy 1981; Annina Nosei Gal., NYC 1982; Gagosian Gal., Los Angeles 1982; Gun Gal., NYC 1982; Mary Boone Gal., NYC 1984–87; "Basquiat/Warhol/Clemente," Tony Shafrazi Gal., NYC 1985.

ABOUT: Gablik, S. Has Modernism Failed?, 1984; Warhol, A., The Warhol Diaries, 1989. *Periodicals*— Art in America November 1984; New York Review of Books February 18, 1982; New York Times Magazine February 10, 1985; Time November 4, 1984.

BATES, DAVID (November 18, 1952–), American painter and sculptor, creates works that reflect his love of folk art and an intimate association with his subject matter. He is considered a narrative artist by many critics. His love of the outdoors, swampy mysterious lakes, and hunting and fishing is mirrored in his rendition of nature. His paintings contain bold and sometimes harsh outlines in which every detail is rendered. His nature is genuinely wild; his personages look straight at the viewer. Bates is an artist without pretensions, both universal and regional in his outlook, who feels that his paintings speak for him.

Bates was born in Dallas and has lived in Texas all his life, except for a year he spent in Arkansas when he was a boy and a year in New York City on a Whitney fellowship. His father was a salesman who became part-owner of a men's wear store, where young Bates worked during his summer vacations. His father took him on hunting and fishing trips that left Bates with a lifelong interest in nature, wildlife, hunting and fishing. His mother encouraged his artistic talents.

After graduating from Garland High School, Bates attended Southern Methodist University in Dallas, where he was a popular student. He re-

DAVID BATES

ceived a B.F.A. degree in 1975 and an M.F.A. degree in 1976. It was there that he met fellow art student Jan McComas, whom he married in 1980. A successful artist in her own right, McComas had participated in the 1975 Whitney Biennial. Bates also was invited to enter an independent study program of the Whitney Museum in 1977. He applied almost by chance: "I was in New York for two weeks with a group of ten art students from SMU. I met Julian Schnabel on that visit, who had been in the program a couple of years earlier. Schnabel asked me whether I wanted to get in. I said I would like to be in the program but would not grovel around the floor and get holes in the knees of my pants to achieve my end. It is usual to go to New York for an interview, but I declined because of a lack of funds. It was lucky in more ways that one—I would have given all the wrong answers to their questions. My work was figurative and something they would not have been interested in. So I did not come to New York and was invited anyhow."

In New York, Bates was the only Texan among a group of East Coast intellectuals that included Jenny Holzer and Michael Kessler. New York was a challenging but difficult place for Bates: "In New York, you live in a city that gives you trouble and you live with art that gives you trouble. Here I was, the only fellow who did figurative work among a group of abstractionists. I was told, don't paint figures, don't get sentimental with your subject matter." After one year of study at the Whitney, Bates returned to Texas, still a figurative painter.

At the outset of his career, Bates felt himself influenced by Red Grooms: "After all, there were not too many painters who painted people and familiar scenes and Grooms gave me some justification to do paintings of everyday Texas life. It made me feel what I did was okay." In his early works, Bates painted honky-tonk bars, grocery stores, and state fairs. His paintings were primarily colorful, bright, and easy to look at. Bates still paints what is around him, but the subject matter has become more serious. Now in his thirties, Bates feels that he has become his own man and that his style has become his own.

In order to support himself after his return from New York, Bates taught at Eastfield College in Dallas for seven years. "I taught a course in art history for those who were not interested," he has said. "Classes could be lively at times; I also tried to teach a sense of individuality to my art students."

Bates, a compulsive painter, likes to work every day starting early in the morning. Until around 1986, he had no real studio, working instead in his living room surrounded by various paintings which he moved from space to space. That year he built an addition to the house and now, for the first time, has his own studio in which he works until late at night. "Jan, my wife, was very active in my development as a painter; she has checked every painting that ever left the house. At one point in my life I did fifty paintings a year. It seems that at the beginning, when you are unsure of yourself, you are pursuing four painting careers at the same time and you keep turning out the work. Once you start figuring out what you are doing, you put more time and care into each painting and you become concerned with quality. I do about fifteen paintings a year now, as well as numerous drawings and sketches."

Bates's work has been likened to naive art, folk art, and narrative art by various critics. His work was included in the Metropolitan Museum's exhibition of "New Narrative Paintings," which was curated by William Lieberman. According to an introductory essay to the catalog for that exhibition, "David Bates assumes a naive style that is usually associated with self-taught painters such as John Kane and Horace Pippin, who also depicted ordinary people in everyday surroundings. Unlike such painters, Bates received extensive artist's training, and his evocation of folk idiom is deliberate. Compositional structures are studied. Indeed, they are extremely sophisticated and they cohesively combine color and shape. Spatial relationships that at first seem flat are, in fact, carefully considered in depth. As in the paintings of Kane and Pippin, each ele-

ment depicted receives similar attention to detail. Thus the figures join with the landscape or interiors that surround them to form one uniform pattern."

Will Torphy, in a review for *Artweek* in 1985, described Bates's work: "David Bates is at once a self-conscious sophisticate and a celebrant of the naive. His narrative paintings defy conventional criticism; a formalist approach emanating from the self-enclosed concerns of the art world won't work here. Bates may, in fact, effectively create the basis of his own criticism since it is undeniable that his is the mind of an accomplished artist who has taken on certain characteristics of the primitive in order to reveal his subjects more fully and, at the time, flail away at complex art-world issues. . . . The deceptively simple style of Bates's work contains these qualities of metaphor that make the self-awareness of contemporary painters and the entry of art history itself into the very images we create today."

Despite the fact that Bates has been called a figurative and narrative painter, he shies away from labels. "It could be close to the mark; those terms and titles are always tough. For instance, *Feeding Dogs* is a painting with an interesting history; I did different versions of this painting for three years and it changed quite a bit every year. I did one in 1982, 1983, and 1984. I usually started out by doing a drawing and then did a small version of what I intended to do and then went on to do the large painting. My newest is *Ed with Birdy*. While the earlier versions were more cheery and used bright colors, *Ed with Birdy* is more somber, serious, and sedate. It has more feeling to it and more mystery."

Much of Bates's recent work is concerned with nature and the wildlife of eastern Texas and Arkansas. It takes him over two hours to travel from Dallas to Grassy Lake, one of his favorite spots. Attracted by the dense swamps and tangled vegetation that birds, fish, and alligators claim as their natural habitat, Bates has spent much time absorbing and experiencing that landscape. "I go to the lake to make notes to remember particular colors or plants. I also take pictures. I make abstract sketches to show how a light hits or the shadows lengthen and then get back to the studio and put it all together. Though I take some snapshots, primarily, I work from memory."

It was on a fishing trip that Bates became friendly with Ed Walker, a ninety-year-old fishing guide. In the swamps and bayous, Bates found a subject that has fascinated and excited him ever since, resulting in images of great originality, surreal feeling, and eerie beauty. Bates speaks fondly of Ed, with whom he spends time

exploring the wilderness. He likes to listen to the mysterious, strange tales related by the old man, in whom he sees pioneer virtues.

Bates does not like to paint and repaint a surface. "If I don't like a painting, I just junk it. It used to happen a lot to me. Now that I have more of an idea of what I want, it happens less." Bates does not run out of ideas, but occasionally feels that he needs to do something different. He returns to nature for his inspiration.

Recently Bates has turned to sculpture. He renders heads of likable dogs, mutts for the most part, in bronze. The bronzes are heavily hand-painted, giving a feeling of folk art, realism, and humor.

Bates is grateful for the success that has come his way since 1983, for it allows him to paint full-time. "Success was not as quick as it seems. I suffered a lot of arduous torture in the years 1978 to 1980. These years were really more like twenty years trying to figure out what I was doing. Jan helped every day. I did paintings which were abstract like Brice Marden; I did cubist paintings; I did performances; it was like years of torture for me."

Bates is pleased that his work hangs in many institutions and that he was part of a cultural exchange of Texan artists showing their work in Berlin in 1986–87. Bates's work was also represented in the 1987 Whitney Biennial. "I think my greatest ambition is to be able to paint. To see my paintings in public collections and to see people enjoy them. To do what I love to do. Success has given me an option to try new things!"

Bates admires and praises many of his contemporaries—Red Grooms, Elizabeth Murray, Milton Avery, Mimmo Paladino, Julian Schnabel, and Gregory Amenoff—but he also refers to Giotto, whom he considers the greatest narrative painter. "You can see his panels and they tell the story."

He is familiar with the works of Rousseau, which he loves, but finds that Rousseau's landscapes are much more refined than his own. "The reason I do what I do, I want my paintings to be understood, I want them to be enjoyed and get a sense of place. In a number of years when style and fashions change, I would like to think that people from various classes and origins could look at these paintings and understand."

In defining his subject matter, Bates feels that he does not paint the stuff of life or death; yet when one looks closely, danger lurks in some of his landscape paintings. A snake can lie in a swamp ready to jump on unsuspecting prey. In *Summer Storm* (1987) an alligator crunches a fish between its jaws. It is life in the raw, life in nature, but in a setting removed from the angst and neurosis so often expressed by contemporary painters like Anselm Kiefer. Bates elaborates: "Artists like Picasso went from very controlled, very meticulous brushwork and style, as time went on, to a wilder and freer way of thinking and painting. In my lifetime, painters were taught to be wild and free, to have wild thoughts and working habits; I became much more conservative and controlled as time went on."

Bates continues to paint the subject matter that invigorates and intrigues him. His is a life-affirming art. Sophisticated, yet attuned the simple virtues, he observes the eerie, swampy, mossy landscape of to eastern Texas and Arkansas with a painter's eye and imagination. He luxuriates in the images that give him strength, endowing them with an exotic feeling. "Sentimentality is a deadly word in art, but in the end, you must do what is right and somebody will respect you for it!" Bates continues to do his own thing; as he puts it, "hopefully it's right."

EXHIBITIONS INCLUDE: Eastfield Col., Dallas 1977–78; DW Gal., Dallas 1981–83; Charles Cowles Gal., NYC 1983–87; Texas Gal., Houston 1984–86; Betsy Rosenfield Gal., Chicago 1985; John Berggruen Gal., San Francisco 1985, '87; Texas–Berlin Art Exchange, Amerika Haus, Berlin 1986–87; Gene Binder Gal., Dallas 1986.

COLLECTIONS INCLUDE: Contemporary Arts Cntr., Honolulu; Dallas Mus. of Art; Fort Worth Mus.; Hirshhorn Mus. and Sculpture Garden, Washington, D.C.; J. B. Speed Mus., Louisville, Ky; Memphis Brooks Mus. of Art, Tenn.; Metropolitan Mus. of Art, NYC; Mus. of Fine Arts, Houston; New Orleans Mus. of Art, La; Phoenix Art Mus. Ariz.; San Francisco Mus. of Modern Art.

ABOUT: Who's Who in American Art, 1989–90. *Periodicals*—Artforum November 1984, October 1985, January 1986; Art in America November 1983; Arts Magazine December 1985; Artspace Spring 1984, Winter 1985–1986, Spring 1987; Artweek January 26, 1985; Chicago Tribune February 1, 1985; Dallas Morning News April 21, 1983, December 1, 1983, June 23, 1985; Dallas Times Herald September 27, 1986; Haute: Conversation March 1983; Houston Chronicle May 16, 1986; Houston Post May 11, 1986; New York Times March 27, 1983, August 1, 1986; Village Voice October 18, 1983; Washington Post February 2, 1983.

BECKMANN, MAX (February 12, 1884–December 27, 1950), German painter and graphic artist, is regarded as one of the leading German expressionist painters, although his work defies easy classification. In general, expressionists, apart from those who died young, have been unable to sustain the emotional inten-

sity of their work throughout their careers—this is true even of such masters as Munch, Kokoschkar, and Kirchner. Yet Beckmann's art grew in strength and authority until the very end, despite inner conflicts, political harassment, and exile. That consistency was due in part to his firm grasp of pictorial structure, his constant exploration of the problem of space, and his creation of a powerful and enigmatic imagery. Beckmann's work can be viewed as a symbolic modern morality play, reflecting his anguished vision of a harsh, tormented world, relieved by occasional glimmers of hope and an underlying will to live. He was always searching, in his words, for "the idea which hides itself behind so-called reality."

Max Beckmann was born in Leipzig, the third child of Carl Heinrich Christian Beckmann, a Brunswick real-estate agent and flour merchant, and the former Antonie Henriette Berthe Duber. There were two older children, Grethe and Richard. From 1892 to 1894 Max attended school in Falkenberg in Pomerania, while living with his married sister, Grethe Lüdecke. After his father's death in 1894, Max moved with his mother and elder brother to Brunswick, where his parents had lived before settling in Leipzig in 1880. He attended various schools in Brunswick and Königslütter, but preferred to draw rather than study his lessons. At a strict boarding school in Gandersheim he arranged for his comrades to pose for him and rewarded them by giving them the food sent him by his mother as a relief from the terrible boarding-school fare. Finally he ran away and returned to his mother. He had left school without any academic qualifications, including the middle examination, the "Einjährige," for which he later prepared at the academy in Weimar, finally passing it in Brunswick. In 1896 he illustrated in watercolor a fairy tale in which a little shepherd tells a king how many seconds eternity has, and the following year he painted one of his earlist self-portraits—there were to be over eighty in the course of his fifty-one creative years. In that early canvas he appears in profile as a youth blowing soap bubbles, a traditional symbol of the transience of life. Around that time he read about the Amazon River and was so enthralled that he applied for the position of cabin steward, but was rejected because of his young age. He already had the desire to explore foreign cultures, and other major themes of his life's work were also manifest—concern with eternity, involvement in the human condition, and the constant questioning of self that was to find expression in his many self-portraits.

Having been rejected by the Dresden Academy in 1899, Beckmann was admitted in 1900 to the Weimar School of Art. In his first etched self-portrait, a drypoint of 1901, he depicted himself emotionally as a screamer, taking his cue from the 1895 lithograph *The Scream* by Edvard Munch, the Norwegian artist, who was already well-known in Germany. Also in 1901 he entered the "nature" class conducted at the Weimar Academy by the Norwegian Frithjof Smith, whose method of sketching directly on the canvas with charcoal Beckmann later retained.

Beckmann graduated from the Weimar Academy with commendations in drawing in 1902. It was at a school carnival party that he met his future wife, Minna Tube, who had studied painting in Munich before coming to Weimar and who soon afterward was to study in Berlin with Louis Corinth, one of the leading German impressionists. After leaving the academy in October 1903, Beckmann went to Paris, where he was deeply impressed by the work of Cézanne. In December he visited Minna Tube in Amsterdam, where she was copying works by the Dutch masters. He returned to Paris, where he remained until March 1904, traveling through France, Geneva, and Frankfurt; he arrived in late April in Berlin, where he again met Minna. During a summer spent at the seaside, he developed an abiding interest in painting coastal landscapes and sea scapes. In the fall he moved to Berlin, where in 1905 he completed the most ambitious work of his early period, *Young Men by the Sea*, now in the Schlossmuseum in Weimar. That painting, with its forcefully modeled figures of youths set against the depth of beach, sea, and sky, was influenced both by Signorelli's *School of Pan*, then in Berlin, and by the short, stiff brush strokes of Cézanne, and it won Beckmann the prize of honor in June 1906 from the German Künstlerbund, along with a scholarship at the Villa Romana in Florence. Also in 1906 he exhibited for the first time at the Berlin Secession and continued to do so until his withdrawal in 1913. In late September 1906, before taking up his scholarship at the Villa Romana, Beckmann married Minna Tube. A photograph taken on their wedding day shows a warm, loving relationship. Under a somewhat dour exterior, and along with an ambivalent approach to the problems of sexuality and human relationships, influenced to some extent by the philosophy of Schopenhauer, Beckmann was capable of deep and lasting affection. In *Young Men by the Sea* he used for the first time his signature HBSL ("Herr Beckmann seiner Liebsten—to his beloved), and also MBSL (Max Beckmann to his beloved). He used HBSL for the last time in his painting of 1913, *Nativity*. From 1912 Minna Tube pursued a career as an opera singer.

During his six-month sojourn at the Villa Ro-

mana in Florence, Beckmann painted a striking self-portrait (1907), in which he stands at his studio window with a portion of Florence and Fiesole in the background. Although the frontal pose would recur in many later self-portraits, the image does not yet have the characteristic expressionist intensity. The main influence is that of Manet, evident in the treatment of the black suit and high white shirt collar, and in the relatively urbane attitude of the young artist, a cigarette held casually in his right hand.

After his return to Berlin in 1907, Beckmann painted *The Battle*, which, in spite of its theme of conflict, is not radically different in its virtuoso brushwork from *Young Men by the Sea*. The Beckmanns built a house in Berlin-Hermsdorf, and in August 1908 their son Peter was born. Beckmann tackled an apocalyptic theme in *The Flood* (1908), but was encouraged by Max Liebermann, the most important impressionist painter in Germany, to continue in the vein of the *Large Death Scene*, painted by Beckmann in the summer of 1906 in reaction to the death of his mother, and recalling both in theme and composition the symbolic expressionism of Munch.

In 1909 Beckmann was inspired by a major catastrophe to paint *Scene from the Destruction of Messina*. Like *The Flood* and *Shipwreck*, it had some of the full-bodied drama and heroic pathos he admired in the work of Géricault and Delacroix. All three canvases, along with a large *Resurrection*, inspired by Rubens's *Great Last Judgment* in Munich, and in which Beckmann included himself, were shown in an exhibition at the Berlin Secession, where they received hostile criticism. In 1909 Beckmann declared artistic objectivity and space to be the fundamental laws of painting. "For my part, I follow with my whole soul the art of inner space and seek to achieve my own style. In contrast to the overly decorative art, I want to penetrate nature and the soul of everything as deeply as possible."

While searching for a personal style, Beckmann, for all the boldness of his attack, had not altogether freed himself from the academic tradition, and his youthful taste for the exotic and dramatic was part of the heritage of symbolism. Those elements are evident in such scenes of combat and calamity as *Battle of the Amazons* (1911) and *The Sinking of the Titanic* (1912). The latter painting, inspired, like the *Destruction of Messina*, by a contemporary catastrophe, was exhibited in the Berlin Secession in 1913. Whereas a comparable painting of the preceding century—Géricault's *Raft of the Medusa*—was based directly on survivors' accounts, Beckmann avoided a documentary approach and depicted a collective catastrophe, with the struggle for survival the dominant motif. Those monumental paintings added considerably to Beckmann's reputation. In 1911 he exhibited in major German cities, and his graphic works were published in Berlin by the dealer Israel Ber Neumann, who later, after moving his gallery to New York City in 1923, became a major promoter of Beckmann's art in the United States. Up until 1912, Beckmann's graphic work consisted mainly of lithographs, some dealing with city life, including cafés, brothels, and bars, but after 1912 he turned increasingly to etching and drypoint.

In January and February 1913 Beckmann had his first solo retrospective in the Berlin gallery of Paul Cassirer, who also published the first monograph about the artist, written by Hans Kaiser. Beckmann's career, then and later, was marked by controversy. In 1912 he had taken issue with Franz Marc and the Blauer Reiter group in the journal *Pan* on the subject of abstract and "overartistic" art, and in 1913 he was one of the many artists, including Max Liebermann, who withdrew from the Berlin Secession. That act of protest was followed in 1914 by the founding of the new "Free Secession" in Berlin, and Beckmann was nominated to the board. He was also a corresponding member of the Munich New Secession. In the first exhibition of the Berlin Secession in April, Beckmann exhibited *The Street*, a crowded urban scene, which he later considered to be one of his most successful early works. As a result of being trimmed down by two-thirds in 1928, the canvas, still painted with loose, heavy, semi-impressionist brush strokes, has a tall, narrow format; the passersby include Beckmann, his wife, Minna, and their six-year-old son Peter, who pulls a wagon and waves the black, red, and white flag of Imperial Germany.

That detail held special significance in that Beckmann, like many other German artists and intellectuals influenced by Nietzschean philosophy, was carried away by the general euphoria that greeted the outbreak of World War I in August 1914. He volunteered for service as a medical orderly, and early in 1915 was working in hospitals in Belgium. Faced with the actual horrors of war and the agonies of the wounded and dying, an experience very different from the dramatic, generalized catastrophes he had hitherto depicted, Beckmann was appalled by the "savage insanity" of that "murdering on a gigantic scale." He suffered a nervous breakdown in July 1915 and was sent to Strassburg, where he painted *Self-Portait as Medical Orderly*, still in a semi-impressionist style but revealing great inner tension. In his drypoint of 1915 *The Morgue*, bodies are laid out on tables. Two other dry-

points relentlessly depict the devasting effects of an exploding grenade. Even after Beckmann was given a leave of absence from the medical corps in October and went to live with his friends the Battenbergs in Frankfurt, his dry-points of evening parties have an anguished, claustrophobic feeling, anticipating his later style. Still on leave in Frankfurt in 1916 and working in isolation, he embarked on another *Resurrection* in a new expressive style—more jagged and fragmented than his earlier *Resurrection* of 1909; he worked on that composition until 1918, and while it remained unfinished, it marks a turning point in the development of his work, in which, to quote Doris Schmidt, "reality is fused with vision."

The traumatic rupture that the First World War caused in Beckmann's psyche also helped to bring about his fulfillment as an artist. The distinctive Beckmann graphic style—harsh, thrusting, angular, a late Gothic vision in a modern context—appears in full force in his series of ten lithographs of 1919 titled "Hell." In paintings such as *The Night* of 1918–19 (Kunstsammlung, Düsseldorf), Beckmann used what he described as "sharp, crystal-clear lines and planes" to depict a nightmarish scene; three cutthroats have forced their way into a garret in which a family is gathered for supper. The husband is being tortured and strangled, but the whole complex composition has an asphyxiating quality. In that truly expressionist canvas, Beckmann moved away from the impasto of his pre-war painting; the color, evenly applied in cold, gray-green tones, still served to model volume but did not yet have the heavy black contours of his later period. The disturbing effect of the interior is heightened by the extremely foreshortened perspective. Beckmann's work at that time reflected the grim, disillusioned atmosphere of the post-war years, but although one of the 1919 "Hell" lithographs, *Martyrdom*, referred to the assassination of the German revolutionary Rosa Luxemburg, and although Beckmann's sympathies were generally to the left, he was far less specific in his attacks on society than were Georg Grosz and Otto Dix. His themes, then and later, tended to be metaphysical statements of victimization in a demented world, and over the years his imagery was to become ever more enigmatic and esoteric.

Beckmann's spiritual link with late Gothic and early Renaissance German masters was evident in the forceful, if unorthodox, religious imagery of *Deposition* of 1917 and *Christ and the Woman Taken in Adultery*, also of 1917. In *Women's Bath* of 1919, Beckmann transformed the genre like motif of Dürer's pen-and-ink drawing *Women's Bath* of 1496 into a bizarre vision of women and children in grotesque attitudes in a cramped, oppressive, prison like space. A sharply distorted perspective is used in the Frankfurt townscape *The Synagogue* of 1919, with its strange, lonely mood, and in the sardonic *Self-Portrait with Champagne Glass*, which suggests the problems of adjusting to the pleasures of "normal" life after the trauma of the war years.

In 1919 Beckmann declined an invitation to teach the "nature class" on nudes at the Weimar School of Art (later the Bauhaus). He continued to live in Frankfurt, where in 1920 he painted *Family Portrait* and *Carnival*. While less tormented than *The Night*, and containing portraits of himself, Minna Tube, their son, and his wife's relatives, *Family Portrait*, with its figures assembled in the horizontal space of a cramped, box-like room, conveys a sense of unease. *Carnival*, a narrow, vertical composition, introduces the theme of Mardi Gras, or masked ball, a key motif in Beckmann's often despairing view of the "world theater" with its absurd and sinister role-playing. Masks, trumpets, and other carnival props are given a symbolic as well as formal significance in the tightly knit pictorial structure. *Self-Portrait as Clown* of 1921 is more detached in feeling despite the tension created by its diagonal thrusts and formal distortions. In his still lifes and cityscapes, and in his expressive painted and etched portraits of friends, Beckmann achieved a certain equilibrium, a respite, as it were, from the disquieting complexity of the larger compositions. A high point in his graphic work of the early 1920s the bold, striking, and much reproduced self-portrait woodcut of 1922, one of his very few works in that exacting medium. There is a sense of confidence in the determined expression and the bold execution. In the painting *Self-Portrait with Cigarette on a Yellow Background* (1923), the viewer is confronted with a proud, stubborn, defiant Beckmann, seen with a tough, relentless realism closely related to the neue Sachlichkeit (new objectivity) being practiced at that time in Germany by Otto Dix and others. Although Beckmann sometimes exhibited with the neue Sachlichkeit painters, he was not part of that short-lived movement or of any other organized group.

A calm, monumental, almost classical portrait of Minna was painted in 1924, only a few months before the couple separated. Soon afterward Beckmann met Mathilde von Kaulbach, youngest daughter of the painter August von Kaulbach. She was studying voice in Vienna, and was nicknamed "Quappi." In 1925, the year of several important solo exhibitions, Beckmann obtained an uncontested divorce from Minna, who was enjoying growing success as a singer.

However, he remained in contact with her for the rest of his life. In September he and Mathilde were married in Munich. Shortly before their wedding Beckmann had painted a strange and joyless *Double Portrait Carnival,* of himself and Quappi, but their marriage proved to be a long and happy one, and Beckmann declared, "It is an angel that has been given to me." Their honeymoon journey took them to Rome, Naples, and Viareggio. In October 1925 Beckmann was invited to teach a master class at the Städel School of Arts and Crafts in Frankfurt, and was appointed to a professorship in 1929. His *Self-Portrait in Tuxedo* of 1927 (Busch-Reisinger Museum, Harvard University), expresses the self-assurance of a successful artist who feels himself to be at the height of his powers. Purchased in 1928 by the Nationalgalerie in Berlin, it was sent as part of the Carnegie exhibition on a tour of the United States. It was judged by many to be Beckmann's greatest masterpiece since *The Night.* Others regarded it less favorably, describing it with some exaggeration as an expression of an arrogant Germanic superman metality.

Between 1929 and 1932 Beckmann spent from September to May of each year in Paris, but traveled for one week of each month to Frankfurt to correct the work of his students at the Städel. The new painterly freedom he acquired during his years in Paris can be seen in the rich color and vigorous use of intense black in *Parisian Carnival* of 1930. The theme of temptation and the "femme fatale" (another legacy of the symbolist movement) is emphasized, along with a hint of aggression, but the spirit is broodingly ironic rather than tragic. Beckmann's women, whether fully clothed, scantily dressed, or nude, as in *The Bath,* (1930), often have a heavy carnality, but there is hardly ever direct eye contact with the spectator. The erotic element is countered by Beckmann's "transcendental objectivity," a phrase coined by the artist.

In 1931 Beckmann had major solo exhibitions in Paris, Brussels, and Hanover, and six of his paintings were included in the group show "German Painting and Sculpture" at the Museum of Modern Art in New York City. But already his work was being attacked by the National Socialist press in Germany, where the Nazis would soon come to power. Some of Beckmann's canvases in the early 1930s, such as the ambiguous *Man and Woman* of 1932, were personal "mythologies" dealing with male-female relationships. At the same time, with a premonition of things to come, he began work on his first and possibly his greatest triptych, *Departure.* Events were moving fast. On January 30, 1933,

shortly after the Beckmanns moved to Berlin, Hitler seized power. On March 31, Beckmann, Willi Baumeister, and two other colleagues were dismissed from their posts at the Städel in Frankfurt, and the Beckmann room in the Nationalgalerie was closed. Not being Jewish, Beckmann was spared the worst indignities and horrors, but he suffered from the horrible climate of the times, and was forbidden to hold solo exhibits in Germany. He still appears composed in *Self-Portrait in Black Beret* of 1934, but he was experiencing a growing sense of isolation, and on the occasion of his fiftieth birthday only a single article appeared, published in a Leipzig newspaper. In 1935 he completed the *Departure* triptych, subsequently acquired by the Museum of Modern Art. In that pictorial drama, the left panel contains themes of torture and fettering, and in the right panel a man and a woman are bound together—the man hangs upside down while a bearded medieval-looking figure beats a drum in the foreground, as if announcing a circus or vaudeville act. In contrast to the scenes of brutality and violence in the side panels, with their constricted, prison like interior space, the central panel, with figures in a boat on the open sea against a limitless horizon, offers a vision of peace and freedom and contains some of Beckmann's most vivid and radiant color. The man, seen from the back, has a purple garment attached by a golden belt to his naked body and wears a royal crown; the woman, directly facing the viewer, holds a blond infant. The woman was described by Beckmann as "the Queen," who "carries the greatest treasure, freedom, as her child in her lap." Only the mysterious masked figure accompanying the fugitives strikes a somewhat ominous note, for that is also a voyage into the unknown. Beckmann wrote in a letter that he was working intensively "to get myself through the talentless insanity of the times," but though he deplored the "political gangsterism" of the Nazi regime, he insisted that *Departure* was not a tendentious picture and could be applied to any age: "Departure, yes, departure from the deceptive surface appearances of life, to those things which are essential in themselves." While this and later triptychs had a metaphysical significance and referred to an existential situation, there is no doubt that the deadly proximity of Nazism and the horrors it would soon unleash on the world gave those allegories a particular urgency.

In 1937 five hundred works by Beckmann, including watercolors, drawings, and prints, were confiscated in German museums, and a number of his paintings and prints were included in the notorious exhibition of so-called degenerate art which opened in Munich at the "Haus

der Deutschen Kunst" on July 18. The day after hearing Hitler's speech at the opening ceremony, Beckmann and Quappi left Germany and settled in Amsterdam. About a year after his arrival, Beckmann appeared gloomy and tense in his enigmatic *Self-Portrait with Horn* of 1939, although the brushwork shows a growing freedom, especially in the striped robe. The horn is like a signal sent out into a dark, empty world. A happier, more relaxed mood is expressed in a series of beach landscapes in fresh, clear colors, and in several portraits, including *Quappi with a Green Parasol.* In July 1938 the New Burlington Galleries in London opened its "Exhibition of Twentieth-Century German Art," with Herbert Read as its chairman. At the opening Beckmann delivered his now-famous speech "On My Painting" in German, with a simultaneous English translation. Among his statements was his declaration that he was "seeking for the bridge which leads from the visible to the invisible." He added that he was helped in that search by the "penetration of space" and that his task was the transference of the "three phenomena" of height, width, and depth "into one plane to form the abstract surface of the picture." Color, he said, was a "beautiful and important" thing to a painter, but should be "subordinated to life and above all to the treatment of form." A two-dimensional, decorative concept of space could be boring, "as it does not give me enough visual sensation."

Despite the growing threat of war, Beckmann decided in the summer of 1939 to remain in Amsterdam, where he completed the triptych *Acrobats,* using the circus once again as a symbol for the chaos of human life and the "little madness of the world." Beckmann's fame was spreading in the United States, and he was awarded first prize for the triptych *Temptation* at the Golden Gate International Exhibition of Contemporary Art in San Francisco, but after the German occupation of the Netherlands in 1940 the Beckmanns' life in Amsterdam became increasingly difficult. Yet he produced major works during the war, including the strong *Double-Portrait, Max Beckmann and Quappi* of 1941, in which Beckmann's introversion and sense of isolation is contrasted with the warmth and active encouragement of Quappi. At the same time the painting conveys the intimate companionship uniting those two very distinct individuals.

After the German occupation of the Netherlands ended in 1945, Beckmann, as a German citizen, was still isolated and kept under surveillance. Art materials were very hard to obtain. In 1946 he was offered teaching assignments in Munich, Darmstadt, and Berlin, all of which he declined, but in 1947 he accepted an invitation from the Art School of Washington University in St. Louis to take over Philip Guston's chair during the latter's leave of absence. On August 19 the Beckmanns sailed from Rotterdam on the *Westerdam,* on which Thomas Mann was also traveling. On their first visit to New York City the Beckmanns were shown the town by the architect Mies van der Rohe, who took them to the top of the Empire State Building. On September 19, shortly after arriving in St. Louis, Beckmann noted in his diary: "A park at last, trees at last, ground under my feet . . . possible, that here it will be possible to live again." He taught his first class on September 23; he had begun to study English before leaving Amsterdam, but his address to the students was read in English by Mrs. Beckmann, who acted as interpreter during instruction. Beckmann preferred to let the students work on their own, and come once a week to receive criticism. His comments, often monosyllabic, were made in a spirit of suggestion rather than explicit direction. The students, who were helped by his wife's able translations, were struck by the way her petite figure complemented Beckmann's monumental, awesome presence.

Unlike George Grosz, whose art underwent a complete transformation (not for the better) after he moved to the United States, Beckmann's style and iconography remained consistent. As he himself wrote in a letter, "My world view hasn't changed since Frankfurt." During a brief visit with his wife to Amsterdam in the summer of 1948, he began work on *Fisherwomen,* which was completed after his return to St. Louis in the fall. In that painting, to quote Peter Salz, "the phallic-looking fish are held by sensuous young women in seductive gestures." Yet the erotic element in the relief like composition is combined with symbolic implication of transience in the enclosure of the colored areas by heavy black lines, as in stained glass. That painting was awarded first prize at the Carnegie Institute in Pittsburgh in October 1949, and now hangs in the St. Louis Art Museum.

Stopping in New York on the way back to St. Louis in October 1948, Beckmann had applied for American citizenship. In September 1949 he began teaching at the Art School of the Brooklyn Museum in New York. Fascinated, as always, by city life, he explored Chinatown, the Bowery, and the seedier dance halls of the Times Square area. *Large Still Life with Black Sculpture,* painted in New York, recalls earlier still lifes by Matisse and Picasso, but the composition is denser, and neither of those artists would have introduced the romantic symbolism of the rising moon framed by part of a ladder.

Beckmann, though solitary by nature, thoroughly enjoyed his celebrity in New York. A recurring image in his work, the ladder, a segment of which appears in the above-mentioned still life, and which he often used as a symbol of anguish or longing, is present in the central panel of his last completed triptych, *The Argonauts* of, 1950, which is often regarded as his testament. In the central panel a wise old man, rising on a ladder from the sea—often a symbol of liberation in Beckmann's work—seems to beckon two young Argonauts to embark on their heroic adventure. The motif recalls Beckmann's *Young Men by the Sea* of 1905, a key painting of his early period, and is another indication of the remarkable continuity of his work. The space in *The Argonauts* is less jammed than in the earlier triptychs with their *horror vacui,* and the painting seems to hold out the promise of peace and redemption.

There is also a calmer, more reflective mood in Beckmann's last self-portrait, the *Self-Portrait in Blue Jacket* of 1950. Mellowed by success after so many difficult years, yet with no lessening of his powers, the artist stands, relaxed and smoking a cigarette, in a studio setting, apparently contemplating an unseen canvas. With its large, flat, yet painterly color areas, that self-portrait is an excellent example of Beckmann's later style. On the morning of December 27, 1950, he left his New York studio on West 69th Street to walk through Central Park to go to the Metropolitan Museum to see his *Self-Portrait in Blue Jacket* hanging in the exhibition "American Painting Today." At the corner of 61st Street and Central Park West he collapsed and fell dead. He was sixty-four and at the height of his career.

Although Beckmann had achieved international renown, and his work had had great impact on American artists in the late 1940s, the year of his death coincided with the upsurge of abstract expressionism and the action painting of the New York School, about which he would have had very strong feelings. He would have had even less use for pop art and minimalism. There was renewed critical interest in his work in the early 1980s with the emergence of so-called neo-expressionism and an apparent return to the figurative. But by 1985 influential critics were already proclaiming that neo-expressionism had had its day, and indeed it depended more on its large scale, slapdash brushwork, and striving for effect than on, by Beckmann's standards, any significant content. Beckmann's expressionism, even if its symbolism is sometimes heavy-handed and portentous, and its emotional range limited, has a tensile strength and conviction which should ensure its permanence. Above all, Beckmann never compromised nor lost his concern with human destiny.

Max Beckmann's letters reveal a tender, considerate, even humorous side to his nature, rarely visible beneath the somewhat forbidding exterior. His writings include two dramatic works, and he was an avid reader, not only of Nietzsche and Schopenhauer, especially in his earlier years, but of esoteric and mystical texts. His metaphysical preoccupations and his Faustian search for an underlying, universal truth—a Germanic tradition far removed from the aesthetics of the School of Paris—are implicit in his statement made in London in 1938, in which he declared: "One of my problems is to find the ego which has only one form and is immortal—to find it in animals and men, in the heaven and in the hell which together form the world in which we live."

ABOUT: Barker, Walter. Max Beckmann—Retrospective, 1984; Lackner, Stephan. Max Beckmann, 1983. *Periodicals*—Archives of American Art Journal 29 (no. 1, 2) 1989; Art & Artists June 1984; Art Bulletin September 1989; Artforum May 1984, December 1984; Art International Autumn 1989; Art Journal Winter 1984; ARTnews October 1983, March 1987; Arts Magazine September 1984; Artweek January 12 and 19, 1985, September 27, 1986; Connousseur January 1985; Flash Art Summer 1984; New York February 4, 1985; New York Times Magazine August 19, 1984; Print Collector's Newsletter January/February 1985; Time January 14, 1985; Visible Language Spring/Summer 1990; Vogue May 1984.

BENGLIS, LYNDA (October 25, 1941–), American sculptor, painter, and video artist, is a dedicated feminist whose work, even when it appears to be concerned primarily with form and process, is intended as a knowing commentary on the social and sexual values of the artworld and the world at large. Reversing the usual dictum that form follows function, Benglis claims that in her art, "content grows out of form. Having an iconographic content can give me a form—say, feminism; say, pop."

Benglis was born in Lake Charles, Louisiana, and attended Sophie Newcomb College in New Orleans, where she studied with Zoltan Buki, Harold Carney, Ida Kohlmeyer, and Patrick Travigno, and earned a B.F.A. degree in 1964. Early on she was oriented toward the abstract expressionists. "The first abstract paintings I ever thought about were some Klines shown at the Delgaio Museum [in New Orleans]," she recalled. After her graduation she moved to New York City, taking classes at the Brooklyn Museum Art School. Benglis especially admired the work of Jackson Pollock and the first generation of abstract expressionists (she points to Pollock's

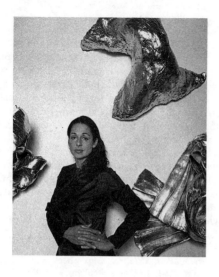

LYNDA BENGLIS

gesturalism as a particularly important inspiration), but she was determined to make a very different kind of art, "something very tactile, something related to the body." In contrast to the immense color-field paintings popular at the time, she began to make narrow, vertical paintings about three feet high and five to six inches wide (for example, *Tulip*, 1968). A masonite or wood ground was encrusted with layers of pigmented wax laid on with a wide brush; those paintings were not only very tactile but, to the artist, overtly, even obsessively, sexual. "The wax paintings were like masturbating in my studio," she told Robert Pincus-Witten; "nutshell paintings dealing with male/female symbols, the split and the coming together. They are both oral and genital. But I don't want to get Freudian; they're also Jungian. Ying-Yang." A later painting, *Gray* (1972), in the same narrow shape as the others, is more of an abstract bas-relief, with expressive squiggles and drips at either pole melding into a solid central mass, carefully split at the equator.

The breakthrough work, for Benglis, was her series of poured latex or polyurethane painting/sculptures dating from 1969. Those freeform pieces were created by spilling buckets of rubber or plastic over forms or directly on the floor of the exhibition space, creating what the artist called "frozen gestures." The colors she preferred, eye-popping Day-Glo and fluorescent pinks, purples, blues, and oranges, reflected Benglis's developing taste for the deliberately tawdry.

Difficult as it is to believe—the plastic pours

do not seem all that disturbing today, especially when seen in the context of Pollock's huge action paintings, with their saturated colors and enthusiastic drips—one of her early floor pieces was rejected by the Whitney Museum for inclusion in its "Anti-Illusion" show in 1969. Apparently the curators were uneasy with the fact that her works existed in a gray area between painting and sculpture (although she still was referring to them as paintings); Benglis was asked to hang her piece on the wall, but she refused. Another floor pour, *Bounce* (1969), was included in a show at the Bykert Gallery later that year; Emily Wasserman called it a "protoplasmic mat."

Soon enough, however, the pours became entirely sculptural, and Benglis began mounting them on the wall. A typical series, "Adhesive Products" (1971), appeared to reach into the exhibition space like giant questing psuedopodia; they were made by layering polyurethane over a chicken-wire and plastic-sheet armature. When the plastic cured, the armature was removed and the pieces mounted in a row on the gallery wall. Others, like "Untitled" (1970), were straight pours, looking like gushes of jazzy toxic waste. In every case, the act of making them was very clearly preserved. "I was interested in process," she said. "When I learned what the material could do, then I could control it, allowing it to do so much within the parameters that were set up. So the material could and would dictate its own form."

The poured latex/urethane pieces earned her good press, especially from "process"-oriented critics, like Pincus-Witten, who were searching for new aesthetic directions after minimalism's demise, but, as far as public attention is concerned, a series of four magazine ads and exhibition notices in 1974 were by far the most significant statements of her career. The first showed Benglis dressed as a child dressed as a chitoned Greek soldier; the second, as a mean-looking butch leaning against a car; the third, as a nude pinup, jeans around her ankles, with her back to the camera; the fourth, as a new-wave virago, completely naked except for sunglasses and body oil, defiantly flaunting a rubber dildo between her legs.

The last ad caused an uproar, appearing as it did in the same issue of *Artforum* (November 1974) as a serious article on her sculpture by Pincus-Witten. Five of the magazine's editors (Lawrence Alloway, Max Kozloff, Rosalind Krauss, Joseph Masheck, and Annette Michelson) wrote an angry letter condemning the Benglis ad—an "object of extreme vulgarity," in their words—and *Artforum's* "role as devoted to the self-promotion of artists in the most debased

sense of the term." The letter only helped focus further attention on the artist, who said that she had conceived the ads as media statements "to end all statements, the ultimate mockery of the pinup and the macho." Accused by some critics of simple exhibitionism, Benglis replied: "My work contains an ironic self-parody of sexuality, and the exteriorization of a root eroticism." Commenting on the controversy, Lucy Lippard noted that "certainly it was a successful display of the various ways in which woman is used and therefore can use herself as a political sex object in the art world, and it was thus that the series was generally understood by the audience to whom it was directed in the first place—younger woman artists." Benglis later had the dildo ad reprinted on a limited series of T-shirts.

While developing the poured sculptures and the wax paintings, Benglis turned to an entirely different medium—video, which she first encountered as an instructor at the University of Rochester in 1970. Nearly every New York and West Coast artist was playing with video in some form during the 1970s, when the cost of equipment fell to the consumer level. Typically, Benglis perceived the video movement as "a big macho game, a big, heroic, abstract expressionist, macho sexist game. It's all about territory. How big?" Benglis's videos were not sexist, but sexual parodies; for example, *Now* (1974) is a stutter-looped sequence of the artist teasingly saying the word "now," as her colorized lips are obscured by feedback, static, and synthesized effects. A later work, circa 1980, possessed an actual narrative—the sexual exploitation of a dog Candide (actually an actor in a dog suit). Other video works were experiments in accreting random and/or deliberately confusing events in an attempt to break the viewer's expectation of logical continuity. *Hometape Revised* (1973) shows a succession of people carrying on incomprehensible conversations obscured by a loud roaring noise; a voice-over by Benglis purports to tells the viewer what is being discussed, but in fact obscures the meaning even more. "What Benglis seems to be after, and gets, is some sort of grasp on or presentation of the contingency and sheer ungraspable nature of reality," wrote Bruce Boice about *Hometape Revisited* (*Artforum*, May 1973). The sculptor Robert Morris collaborated with Benglis on a series of sexually explicit (and sexually parodic) videotapes; he also issued a Benglis-inspired exhibition invitation depicting him as a seminude leatherboy, an act that raised none of the furor created by Benglis's earlier dildo ad.

By the mid-1970s Benglis's wax paintings and urethane amoebas had converged in a series of eclectic, wall-mounted forms that were primarily knot like in shape. Some of those mixed-media pieces were sprinkled with glitter and other cheap "luxe" materials over fabric, plaster, and paint. Many critics decided at the time that her work had crossed over into the realm of self-parodic kitsch: "Benglis's knots have that look-at-me, I'm-in-the-spotlight, don't-I-shine look of an abstract Liza Minelli strutting her stuff," wrote Donald B. Kuspit. In retrospect, however, that phase of her work can be seen as a clear precursor to the East Village style of the early 1980s.

As Benglis continues to explore the knot theme, the pace of stylistic change in her work, the source of much energy in her earlier career, has slowed, and has been replaced by a steady investigation of the effects of light, color, and subtle variations of form. She has also traded the chicken wire, plaster, and funky paint of her mid-1970s knots for bronze, nickel, aluminum, copper, chrome plate, and gold leaf. Her latest knots, constructed of bent bronze wire sprayed with one or more coats of metal, also have the appearance of flowers—recalling Judy Chicago's sexual blooms. Ellen Lubell found in them "comments on femininity, on the kind of elaborate, frilly dressing that makes women into decorations. Though almost abstract, they recall bows, bustles, ruffles—drama without function. But those works also evoke Bernini's *Ecstasy of St. Theresa*, in which the marble folds of the saint's garment convey the dramatic emotionalism of that piece."

Unlike many feminist artists, Benglis does not make explicit use of autobiographical material in her work; oblique references to her family and lovers in her videotapes are heavily obscured by layers of irony and deliberate obfuscation. In fact, she is very sparing in revealing details of her personal life. Benglis has taught at several universities, including the University of Rochester, California Institute of the Arts, Kent State, and Princeton University; she has also received a steady succession of grants, including a Guggenheim in 1975 and a National Endowment in 1979. She spends much of her time in California.

EXHIBITIONS INCLUDE: Univ. of Rhode Island, Kingston 1969; Paula Cooper Gal., NYC from 1970; Gal. Muller, Cologne 1970; Janie C. Lee Gal., Dallas 1970; Hayden Gal., Massachusetts Inst. of Technology, Cambridge 1971; Hansen-Fuller Gal., San Francisco from 1972; Portland Cntr. for the Visual Arts, Oreg. 1973, '80; Clocktower, NYC 1973; Texas Gal., Houston from 1974; State Univ. of New York, Oneonta 1975; Kitchen, NYC 1975; Margo Leaving Gal., Los Angeles from 1977; Douglas Drake Gal., Kansas City, Mo. 1977; Cedars-Sinai Medical Cntr., Los Angeles 1977; Dart Gal., Chicago 1979; Real Art Ways, New Haven, Conn. 1979; Georgia State Univ., Atlanta 1979; Gal. Albert

Baronia, Belgium 1979, '80; Suzanne Hilberry Gal., Birmingham Mich. 1979, '80; Univ. of South Florida, Tampa 1980; Lowe Art Mus., Miami 1980; Heath Gal., Atlanta 1980; Chatham Col., Pittsburg 1980. GROUP EXHIBITIONS INCLUDE: "Group Show," Bykert Gal. NYC 1969; "Nine Sculptors," Nassau County Mus. of Fine Arts, N.Y. 1976; "Recent Acquisitions," Guggenheim Mus., NYC 1977; "Ten Years: A View of a Decade," Mus. of Contemporary Art, Chicago 1977; "Art at Work," Whitney Mus., NYC 1978; "Made by Sculptor," Stedelijk Mus., Amsterdam 1978; "Contemporary Sculpture," MOMA, NYC 1979; "Extensions," Contemporary Arts Mus., Houston 1980; "Painting in Relief," Whitney Mus., NYC 1980; "Three-Dimensional Painting," Mus. of Contemporary Art, Chicago 1980; "Drawings: The Pluralist Decade," Venice Bennale 1980; "Decorative Sculpture," Whitney Mus., NYC 1981.

COLLECTIONS INCLUDE: Guggenheim Mus., MOMA, Whitney Mus., NYC; Donnell Film Collection, New York Public Library; Pratt Inst., Brooklyn; Detroit Inst. of Arts; Philadelphia Mus. of Art; Milwaukee Art Cntr.; Walker Art Cntr., Minneapolis; National Gal. of Australia, Canberra.

ABOUT: Antin, David, et al. Video Art, 1975; Davis, Douglas. Artculture, 1977; Emanuel, M., et al. Contemporary Artists, 1983; Lippard, Lucy. From the Center, 1976; Pincus-Witten, Robert. Postminimalism, 1977; Price, Jonathan. VideoVisions: A Medium Discovers Itself, 1977; Robbins, Corinne. The Pluralist Era: American Art 1968–81, 1984; Who's Who in American Art, 1989–90. *Periodicals*—Art and Artists May 1972; Art in America July 1977, Summer 1980, September 1984; Artform May 1973, November 1974, December 1974, Feburary 1976, October 1979, January 1982; ARTnews March 1979, October 1983, Summer 1985; Arts Magazine March 1975, November 1980, June 1984, April 1987; New York October 6, 1980.

BLECKNER, ROSS (1949–), American painter has said: "I have seen my paintings as a meditation on light," and this emphasis seems to inform the artist's remarkably varied body of work. In the earliest paintings Bleckner showed in New York, black and white predominate, the light and dark playing off each other. Elegantly handled geometric shapes and organic forms merge incongruously on these canvases, whose matte surfaces also feature small incised images. In a radical stylistic shift around 1981, Bleckner began producing his stripe paintings, in which vertical lines bar the viewer from the luminous field behind them. Using the mechanistic vocabulary of op art, Bleckner expressed ideas about place and perception in this series. In late 1983 he showed the near-monochromatic "Atmosphere" paintings, which feature ambiguous forms whose definition is suggested but fi-

ROSS BLECKNER

nally subverted by the glimmering surface, so that lack of image becomes the paintings' subject. Even more elegiac compositions followed, in which mysterious, melancholic objects—a gate, an urn—hover in dark backgrounds and sometimes radiate incandescent light. From geometric abstractions to nocturnal visions, "there is always light—between the bars or in the atmosphere," Bleckner has noted—light which in all his paintings feels to the artist "like, oh, the *stuff*, from history."

A preoccupation with the historical terms of painting is not surprising given the time when Bleckner became an artist. Born in New York City in 1949, he grew up in an upper-middle class home in the prosperous Five Towns area of Long Island, New York. Bleckner told Ingrid Sischy that his family was "extremely permissive in the sense that a lot of my life now is spent finding the mental discipline that wasn't given to me when I was younger" (*Interview*, Feb. 1990). Bleckner decided to become an artist while attending New York University, where he majored in art. The artist Chuck Close was one of his teachers, and he prompted the young painter to visit galleries around the city. "I was *shocked*," says Bleckner, who had grown up in a "no-art" environment. "I couldn't believe that people were alive and that this is what they *did*." His own work then was "very Ad Reinhardt or Mark Rothko—dark, hovering things."

After graduating from NYU, feeling he had "missed something," Bleckner attended the California Institute of Arts in Valencia, California, obtaining an MFA in 1973. The doctrine that de-

clared that painting had reached its culmination in minimalism held sway at the school, and conceptualism, which focuses on conveying the idea of the artist rather than the creation of a fetishized object (i.e., a "great" painting), was a popular movement. Like other young artists of his generation, Bleckner was faced with the quandry of being an artist at a time when traditional art was considered moribund by many of his peers. Bleckner, responding to the "overwhelming" California light, blacked out his studio with curtains and made dark landscapes. At Cal Arts "they gave you a studio and left you on your own," he recalls. "The school functioned as a temporary community [for those] halfway between being a student and being an artist."

In 1974 Bleckner moved to downtown Manhattan, where he bought a converted industrial building, which in addition to his own loft studio contained space rented by the artist Julian Schnabel. Between 1977 and 1983, the Mudd Club occupied the bottom floor; Bleckner would paint late into the night, then go downstairs and be at one of the centers of the downtown club scene frequented by many young artists, including Keith Haring and Jean-Michel Basquiat. Lisa Liebmann, writing in *Art News*, describes him as a "kind of symbolic 'godfather' to the musicians and artists, the graffitists and budding art entrepreneurs who helped set the tumultuous pace of the early '80s scene." Bleckner's work continued to be heavy, black, seemingly angst-ridden. Betty Cunningham of the Cunningham Ward Gallery, which gave him his first one-person show in 1975, says his work "appeared to be about effects and entrances—looming black areas in which he was trying to find an entrance. . . . so much darkness . . . it was almost scary" (*Art News*, May 1988). A painting selected for the 1975 Whitney Biennial, *After Count Thun's Dream*, was the first work Bleckner sold.

Along with Schnabel and his fellow Cal Arts graduate David Salle, Bleckner joined the Mary Boone Gallery in 1978. His paintings from this period feature both geometric elements—triangles, columns, grids of intersecting lines—and more representational images—trees, mantelpieces. Often on disjunctive planes, these interlocking forms create what the critic Robert Yoskowitz called "unattainable architectonic spaces" (*Arts*, Feb. 1982). The alternating use of black and white delineates negative and positive shapes, contributing to the overall effect of formal control and somber intensity. In these semi-abstract works, Bleckner seems to be working through a kind of debased modernist sensibility; in a dramatic stylistic reversal, his next group of paintings would refer directly to a discarded abstract art movement of the 1960s.

Op art, to which Bleckner's new stripe paintings directly refer, was an ephemeral movement that, in Bleckner's words, "attempted to construct a conceptual relationship to abstract painting," a specifically progressive modernity. In a 1982 article that brought much attention to Bleckner's work, the artist Peter Halley described the aesthetic strategy of op: "Ignoring history, ignoring traditional artistic craft, Op depicted the pulsating, almost electrical energy with which the markets of the industrial world were supposed to function. To create its effects, it used only the scientific rules of optical interaction and the most recently developed synthetic colors and paints" (*Arts*, May 1982). Bleckner's interest, however, was not in the optical or mechanical aspect per se. If traditional painting had culminated and was no longer viable in an age of devalued meanings, a discarded movement like op could be recycled—and in the process used to convey new ideas about cultural fragmentation and personal anomie. Bleckner told Jeanne Siegel, "I was interested in the metaphorical relationship of a place in a painting or to the perceptual inability of a spectator to choose a point of focus" (*Arts*, March 1986). While many of his contemporaries were creating media art and image-laden neoexpressionist works, Bleckner was finding imagery oppressive. In the stripe paintings he explored "collapsing the idea of an image," and the work reflects disorientation, not formalist order or scientific precision. The bold parallel vertical lines—originally black and white but in later paintings vibrantly hued—function in a narrative way as the bars of a cell. "There were these lights inside the painting and as a viewer I would be this person who was perpetually locked out of the painting," says Bleckner. "I think a lot of the theme of death was also implied in the sense that you have ideas, you put them in a painting, and they are locked in there forever. . . . My work is very much about a kind of degraded sublime, like Barnett Newmans gone wild" (*Arts*, March 1986).

The earliest stripe paintings were first shown at the Mary Boone Gallery in November 1981; they attracted practically no critical attention and only two were sold. But many young artists began to follow and be influenced by Bleckner's work. David Ross, director of the Institute of Contemporary Art in Boston, where Bleckner's work has been displayed, notes that the early stripe paintings "really opened the area of geometric abstraction to a thorough reinterpretation by a new generation" of artists, for whom Bleckner has been "an influence and a force" (*The New York Times*, Feb. 19, 1987). Critical recognition and commercial success followed, and the

highly distinctive stripe paintings now hang in museums and major private collections. Over the years they have evolved; the hand-painted stripes have been adorned with realistic-looking painted bows, wreaths, and decorative borders. The works generate myriad associations—a gift box, a cage, a papered wall, a screen—but never settle on a meaning, hovering as they do between abstraction and representation. For all their bright flair, they are essentially elegiac in tone. They reflect the spiritual fragmentation of the viewer and his age, and also refer to the "failed dream" of op, which idealistically celebrated the notion of social progress attained via scientific and technological advances.

Two years after the initial showing of the op-related works, Bleckner produced a group of paintings that signalled yet another stylistic shift. In a November 1983 show at Mary Boone, Bleckner showed six (of eight) "Atmosphere" paintings, in which the vague sense of loss that permeates earlier works is isolated and distilled. In these extremely dark quasi-landscapes, the natural world images—forest, mountains, water—are more inferred than discerned by the spectator. Their presence is hinted at but the shapes remain amorphous. Dan Cameron, in an article on the paintings, finds that this "complete ambiguity of form . . . reveals an artist who is provocatively testing the conceptual limits of both naturalism and high abstraction at the same time, without ever showing his hand" (*Arts*, February 1987). The murky scenes are eerily illumined by whitish streaks and pods of light, revealing Bleckner's continued interest in light as a source and a subject.

Bleckner's next paintings were also dark and moody, and again offered a plurality of meanings. Some, like two paintings entitled *X-Friends*, are primarily nightscapes, relieved by scattered dots or streaking arcs of light. More often a light-shot image is suspended in a darkly glistening background. Cinerary urns, empty rooms, disintegrating bouquets—the images are frequently necrotic. Even when not explicitly identified with death, they portend it—three chandeliers about to burn out in *Chamber*, for example, and crumbling iron grillwork in *Gate*. Memory too is a pervasive theme, and some of the works address the AIDS epidemic in this context. Certain paintings directly commemorate those who have died of the disease; *8,122+ As of January 1986*, one of a series of works numbering the victims, features a Gothic digit in each corner of the glowing blood-red canvas. More obliquely, the surface welts in the lyrically beautiful *Architecture of the Sky* are, according to the artist, visual metaphors for AIDS sarcomas. For all their obsession with death, however,

Bleckner's paintings are also about transcendence. Disembodied luminosity is present in the darkest nocturne; the artist's capacity to bestow light on his terrible subject makes for a kind of redemption.

Mason Klein locates Bleckner's work firmly in the post modern aesthetic: "By denying the situational context of narrative, the artist momentarily deflects the viewer away from specific meaning. . . . Absent of history or context, these paintings betray a cultural condition alluded to by the social artifacts depicted—an anonymity predicated upon a fractured sense of identity as well as a lost individualism" (*Arts*, Oct. 1986). As light flickers in the paintings, so does any reading remain equivocal, a glimpsed essence. The images Bleckner uses—urns and goblets, vases and gates—typically resonate with symbolic meaning, but here their contextual isolation, poised in the enveloping darkness of the canvas—preserves their mystery. A similarly paradoxical dynamic has to do with style. Klein points out that a latent classicism is suggested by the compositional symmetry of many images, yet the eerie luminosity of the paintings is more redolent of a Symbolist work than a classical one. And the sketchy geometries used (two grids in the background of *Memoriam*, for instance) are overpainted with the evocative, neoromantic chandeliers and chalices. In these paintings Formalist values of unity are subverted even as traditional forms are presented.

Bleckner continues to live and paint in his Manhattan loft. According to Douglas C. McGill, his studio is "meticulously clean, with cans and tubes of paint lined up in careful rows" (*The New York Times*, Feb. 19, 1987). He likes to buy new art for his home, explaining, "if I walk into a gallery and maybe I'm not crazy about something, but it's by a young artist and it's cheap, and I like it, so big deal, I buy it. It would have meant a lot to me if someone did that when I was a younger artist. Anyway, I like having other people's art around more than having only my own art around all the time" (*Art News*, May 1988). Known for his generosity toward other artists, Bleckner is described as sociable, with an explosive laugh and an unpretentious manner.

EXHIBITIONS INCLUDE: Cunningham Ward Gal., NYC 1975; John Doyle Gal., Chicago, Ill. 1976; Cunningham Ward Gal., NYC 1977; Mary Boone Gal., NYC 1979, '80, '81, '83, '86, '87, '88; Patrick Verelist Gal., Antwerp, Belgium 1982; Portico Row Gal., Philadelphia 1982; Nature Morte Gal., NYC 1984; Boston Mus. School 1985; Mario Diacono Gal., Boston 1986; Margo Leavin Gal., Los Angeles 1987; Waddington Gal., London 1988; San Francisco Mus. of Modern Art 1988; Gal. Max Hetzler, Cologne, West Germany 1989; Milwaukee Art Mus. 1989; Contemporary Arts Mus.,

Houston, Tex. 1989; Carnegie Mus. of Art, Pittsburgh 1989; Art Gal. of Ontario, Toronto, Canada 1990. GROUP EXHIBITIONS INCLUDE: Whitney Biennial, NYC 1975, '87; Paula Cooper Gal., NYC 1975; Cunningham Ward Gal. NYC 1976; "New Work/New York," Fine Arts Gal., Los Angeles 1976; "New Painting/New York," Hayward Gal., London 1979; Mary Boone Gal., NYC 1979, '80, '82, '87; "Four Artists," Hallwalls, Buffalo, NY 1979; "Nouva Immagine," Milan 1980; "Tenth Anniversary Exhibition," California Inst. of the Arts, Valencia 1981; "New York in Black and White," MOMA NYC 1981; John Weber Gal., NYC 1983; "Selected Drawings," Jersey City Mus., NJ 1983; "Mary Boone and Her Artists," Seibu Gal., Tokyo 1983; "Modern Expressionists," Sidney Janis Gal., NYC 1984; "The Innovative Landscape," Holly Solomon Gal., NYC 1984; "Abstract Painting Redefined," Louis K. Meisel Gal., NYC 1985; "Currents," Inst. of Contemporary Art, Boston 1986; "End Game: Reference and Simulation in Recent American Painting and Sculpture," Inst. of Contemporary Art, Boston 1986; "Emerging Artists 1986," Cleveland Cntr. for Contemporary Art, Ohio 1986; "Still Life, Beyond Tradition," Visual Arts Mus., NYC 1987; Gal. Albrecht, Munich 1987; "Armitage Ballet Benefit," Mary Boone Gal., N.Y. 1987; Ronald Greenberg Gal., St. Louis, Mo. 1987; "The Image of Abstraction," the Mus. of Contemporary Art, Los Angeles 1988; "The Binational/Die Binationale," Mus. of Fine Arts, Boston 1988; "The Binational/Die Binationale," Künsthalle Düsseldorf, West Germany 1988; "Carnegie International," Carnegie-Mellon, Pittsburgh 1988.

ABOUT: *Periodicals*—Art and Antiques May 1984; Artforum April 1984, November 1985, May 1986, May 1987; Art in America January 1982, May 1986, December 1986, July 1987; ARTnews November 1980, November 1983, Summer 1985, May 1986, May 1988; Arts Magazine December 1979, September 1980, January 1981, February 1982, May 1982, November 1982, Summer 1985, March 1986, April 1986, October 1986, February 1987, April 1987, June 1987, September 1988; Avenue October 1982; Flash Art March 1985, April 1986, Summer 1986, May 1987; Harper's July 1983; New York April 19, 1982, October 25, 1982, May 30, 1983, March 2, 1987, November 14, 1988; New Yorker September 1982, November 24, 1986; New York Times February 10, 1984, March 8, 1985, February 14, 1986, February 13, 1987, February 19, 1987, February 23, 1987, July 6, 1987, October 28, 1988; Village Voice February 18, 1986, March 10, 1987.

BOROFSKY, JONATHAN (December 24, 1942–), American installation artist, was a leader of the move away from minimalism and conceptualism to the more spontaneous figurative style sometimes termed "new image" art or neo-expressionism. His installations—assemblages of multimedia art both two-dimensional and three-dimensional—have a way of transforming an art gallery or museum

JONATHAN BOROFSKY

space into a total, highly charged environment. A typical Borofsky exhibition is animated by an array of self-referential objects separately and cumulatively expressive of the artist's anxieties and affirmations—a repertoire of motifs by now well-established as Borofsky's alter egos. He *is* the *Running Man,* or the *Molecule Man,* or the *Man with a Briefcase:* figures that have assumed archetypal significance for him and that appear drawn on paper or painted directly on gallery walls; or are translated into any one of a number of graphic art forms; or, as free standing sculptures, rest on gallery floors, hang from ceilings, or float over museum stairwells. The inspiration may come directly from his own dreams; photographs, advertisements, TV-screen images serve as bases for his scathing visual commentaries on political and social conditions. Many of the figures bear some resemblance to the artist's own features. As he contends, "everything is my portrait. Some look like me; some don't. But they're all at least parts of my mind."

The energy and ingenuity involved in creating the figures and putting them together in one of his installations contrast radically with Borofsky's work in the late 1960s, when he was immersed in a form of conceptual art: an obsessive numbering of sheets of graph paper, with the goal of going from one to infinity. Sometimes working for eight hours at a stretch, the only variety and letup he allowed himself was to switch pens and colors. Through the efforts of the influential art critic Lucy Lippard, a computer printout of this numerical sequence to date was included in "No. 7," an exhibition of conceptual

art at Paula Cooper's first art gallery in New York City in 1969; it marks the beginning of the artist's extensive list of exhibitions. *Counting Piece,* to which he is still adding intermittently, is now a Plexiglas-enclosed stack, over four feet high, of his sheets of numbers. First shown (at the insistence of another friend, the conceptual artist Sol LeWitt) at the Artists Space Gallery in New York in 1973, the piece remains a regular part of Borofsky's installation repertoire, a literal manifestation of his continuing interest in concept and process. Before conceptualism, however, there were many years of academic art training and experiments with abstract expressionism, especially under the influence of Jackson Pollock's drip-painting style.

Jonathan Borofsky was born and raised in the suburbs of Boston. His father taught music and his mother, a painter, had originally studied to be an architect. From the start their son was encouraged to become an artist, and he took weekly painting lessons throughout his childhood, at the same time maintaining teenage interests in singing and in sports. Both interests have surfaced in his art, the latter in recurrent flying, running, or skating figures, the former as an aural concomitant of the installations.

As an undergraduate at Carnegie-Mellon University in Pittsburgh—from which he received a B.F.A. degree in 1964—he started doing abstract welded-metal sculpture based on plant and animal forms; he continued that work, developing a technique of plastering the forms together instead of welding them, during a summer of graduate work in 1964—at the Ecole des Beaux-Arts in Fontainebleau, France. He then enrolled at the prestigious Yale University School of Art and Architecture, where fellow students included such now-famous artists as Jennifer Bartlett and Richard Serra, and received his M.F.A. degree in 1966. It was at Yale that he began to arrange his disparate welded and plastered forms in groupings; as he later recalled, "if it fell together real good, that was the kick." After graduating from Yale Borofsky settled in a lower Manhattan loft studio and started experimenting with different post–abstract expressionist approaches, including, at one point, keeping a 450-page notebook of cosmic thoughts. That conceptualizing activity in turn led to the numbering, which he described in retrospect, as having been a way "to reduce the noise in my head to one simple, clear, poetic, mathematical noise."

Borofsky started to doodle stick figures on his counting sheets, and one day in 1972 he went so far as to elaborate one of those drawings into a painting on canvas board. It turned out to be a representation of a tree with a head sprouting from it. As he once explained, by adding to that painting—his first in several years—the number he had reached at that point (843,956), "had both a recognizable image and a conceptual ordering in time." That has been his method almost invariably ever since; the corners of his latest works now bear numbers approaching the three-million mark. As well as a personal signature, it is a way of unifying the varied forms his creativity takes.

Borofsky's course of group therapy in the early 1970s led to his working out some of his problems in drawings and paintings of his dreams. Quite different in purpose from the surrealists' manipulation of dream imagery, Borofsky's representations are literal transcriptions. The self-consciously naive, cartoon-like illustrations deal with childhood anxieties and fears of persecution, very often with a figure that tries to escape by walking, running, flying about a room, or roller skating away from a Hitler-like pursuer. Typically, the illustrations are inscribed with handwritten notes, often deliberately misspelled to further the effect of a child's perception. Among this series, a group of which were reproduced in *Paris Review* (Winter 1981), are "I dreamed a dog was walking a tightrope," "I dreamed that Salvador Dali wrote me a letter ('Dear Jon, There is very little difference between the commonplace and the avantgarde . . . ')," and "I dreamed I found a red ruby." The last latter exists as a drawing, as a small painting, and as a two-color lithograph. The ruby, in fact, has become a persistent image in Borofsky's work, presumably functioning as a metaphor for his own heart. Thus a "ruby" fashioned of translucent resin was set on top of *Counting Piece* in a 1980 installation, denoting the union of the spiritual and the cerebral/conceptual. And there was *Fish with Ruby Eye,* an enormous construction (forty-two feet by eighteen feet) that, throughout most of 1987, undulated sixteen feet above the nave of the Cathedral of St. John the Divine in New York City. Though originally designed for an installation at the Los Angeles Museum of Contemporary Art, its temporary setting was a particularly apt one—*nave* coming from the Latin for *ship*—for a fish, the symbol of Christ. Borofsky's fish, made of thirty-six cylinders of bubble wrap, hung from a motorized truss; optical fibers within the cylinders picked up light from bulbs shining through revolving colored wheels, making an ever-changing ribbon of color underneath the vault. As a writer in the St. John the Divine publication, *Cathedral,* described it, Borofsky's "great color-chorded fish" gave a "visual focus to the meditative silence about it." And as the

artist himself commented, the piece "sees with the heart of humanity. . . . It sees that all things are connected and that we are all related to each other."

Sol LeWitt's influence was decisive again, about 1974, in giving Borofsky encouragement to follow his example by painting or drawing directly on walls. Developing that procedure, the younger artist began working larger and larger until the figures were covering his studio floors and ceilings as well. He then hit upon the space- and labor-saving method of using an opaque projector to beam small drawings, done on paper, onto the walls. By swiftly tracing the enlarged images he managed to preserve the spontaneity of line of the originals. The next step was a commission-fulfilling method: by carrying those small originals about with him in a briefcase, he could project them onto the walls of collectors' homes or of galleries or museums. In that way, too, his *Man with a Briefcase,* a figure dressed in hat and business suit, was born. But the method actually belies the businessman implication and makes a comment on the present-day commercialization of art—for drawings or paintings done on walls are site-specific, have no resale value, must be appreciated for themselves alone, and in any case can be effaced at will.

It was Lucy Lippard's article about Borofsky in a 1974 issue of *Artforum* magazine that first aroused interest in the artist. Then in 1975 Paula Cooper, who had opened a new gallery in Manhattan's SoHo district, visited his studio and was so impressed by the "strange and metaphysical" works pinned to its walls or strewn on the floors that she arranged to have them taken, just as they were, to her gallery for his first exhibition. She has been his dealer ever since. A major 1983 installation at the Paula Cooper Gallery greatly furthered Borofsky's reputation, which had been growing, amid much publicity, both in the United States and abroad since about 1976. Significant among the 1983 mélange were several works of overt political commentary. An enlargement of an El Salvador postage stamp was juxtaposed with a painted version of a Maidenform brassiere ad, in which a scantily clad model saunters past a lineup of faceless American army generals. The message: their lack of concern about global matters as well as obliviousness to more immediate stimuli. Throughout the gallery large figures of *Chattering Men* and *Hammering Men* (made of various materials, including motorized parts) kept up their incessant chattering sounds and pounding noises to underscore Borofsky's message about the inanity of modern media hype and how it deadens awareness. Somewhat more obvious messages came from the sports-loving artist's installation

of a real Ping-Pong table (on which spectators were invited to play, much as in the performance art of the 1970s), one side marked for the Soviet Union, the other for the United States, displaying their respective defense-budget figures. In 1983 also Borofsky made headlines by painting his *Running Man* on the stretch of the Berlin Wall just outside the Martin-Gropius-Bau where the international "Zeitgeist" exhibition was being shown. Another very obvious political comment is made by a 1981 drawing of the *Hammering Man* figure that incorporates the Polish word *strajk,* in reference to the Solidarity labor movement.

Meanwhile, however, the artist had never relinquished his self-awareness. The eleven-foot-high *Dancing Clown,* at 2,845,325 (1982–83), which has become one of his best-known pieces, is a dead-faced androgynous figure, fabricated of wood, urethane foam, fiberglass, and styrofoam. Dressed in a pink tutu, it whirls about on one ballet-slippered toe to a taped recording of Borofsky singing the Frank Sinatra tune "My Way." Critics agree that its autobiographical import is unmistakable and that it says something about Borofsky's view of himself as an artist. Sometimes self-concern and world-concern coexist, as in his 1980 self-portrait, a photograph scribbled over with numbers, that not only efface his image but allude to the concentration camp tattoos borne by victims of Nazi persecution. As befits an imagination capable of working on several levels simultaneously and utilizing many forms of communication, Borofsky's personal philosophy is summed up as "All is one." That mantra, in Persian calligraphy, has reappeared in many of his drawings and prints since 1976.

Throughout his career Borofsky has extended his ideas, repeating many of the archetypal themes in silk screens and lithographs, media that ensure both their longevity and their accessibility to a wider audience beyond the exhibition halls. To the usual graphic-arts forms he has added another technique, making cutouts of figures fashioned from sheets of aluminum. Recently sound has been given a greater role in the installations as, more and more, his objects are equipped with electronic devices—"noisemakers," he calls them. A frequently encountered image is a human head with exaggerated rabbit ears that call attention to their *hearing* function. *Sing* (1978–83) combines a self-portrait in acrylics on canvas with appended photographs of Borofsky's hands and feet, and with a sound track of his voice. In addition, one of his aluminum cutouts, here of the artist's profile, extends from the top of the ten-foot canvas to the floor—inviting the viewer, in effect, to en-

ter the artist's head. *Self-Portrait in Closet,* at 2,
490,197, is painted over and inside an actual
closet, the door of which is ajar; opening and
closing right through the painting, it dematerial-
izes the painter's body in much the same way as
do the 1980 portrait photograph and the
Molecule Man figures, cutouts of the artist's
body drilled with holes, which have been inter-
preted as a metaphor for the insubstantiality of
matter.

The 1984 exhibition of Borofsky's works
mounted by the Philadelphia Museum of Art—
the first solo showing of a living artist ever origi-
nated by that august institution—stirred up even
more enthusiasm about his work. A focus of the
attention lavished on the show was the huge neo-
prene *Flying Man* poised over one of the muse-
um staircases; and as a retrospective within a
retrospective there was *Age Piece* (1972–73), an
assemblage of Borofsky's works representative of
each stage of his life, beginning with a still life
in oils painted when he was eight years old (sal-
vaged by his mother) and including some of his
welded steel and plaster sculptures. As the exhi-
bition traveled from Philadelphia to New York's
Whitney Museum of American Art and on across
the country, ending at the Corcoran Gallery of
Art in Washington, D.C., it played to packed
houses.

Borofsky's putting together of one of his in-
stallations is very much part of the creative pro-
cess, usually involving several weeks of work at
the site, which he conceives of as one enormous
canvas to be filled with painted, drawn, sculpt-
ed, projected, and found-object images against
a background of cacophonous sound. "Part car-
nival, part seminar," the *New York Times* art
critic John Russell described a Borofsky installa-
tion; the artist himself calls what he does
"blasting the space with a lot of images." De-
pending on the combinations of objects he
chooses for different shows and their juxtaposi-
tions, and upon viewers' reactions to them, the
same objects will send out different messages at
different times and places. By the same token,
an object included as part of an installation will
take on different connotations when it is exhibit-
ed alone. Thus, where the freestanding
Hammering Men seen in the context of the 1983
Paula Cooper show make a political statement,
the gigantic Cor-Ten steel *Hammering Man,* at
2,947,538 (1984–85), on exhibition in a 1987
sculpture show at the National Gallery of Art in
Washington, D.C., appears to make a comment
on the drudgery and boredom of mechanical la-
bor, expressed in the contrast between its heroic
proportions and the meaningless repetitive
movement of its motor-driven arm.

Two years after his first Paula Cooper solo ex-
hibition, Jonathan Borofsky moved from New
York to California. Throughout most of his New
York years, from 1969 to 1977, he had taught at
the School of Visual Arts. On the West Coast, he
taught at the California Institute of the Arts in
the artists' and writers' colony of Valencia. With
sales to private collectors and several museums,
his financial success has been phenomenal. De-
spite the fact that the money he earns is almost
entirely ploughed back into purchasing the ex-
pensive equipment needed for his multimedia
work and paying the salaries of the construction
assistants his work now requires, Borofsky was
able to give up teaching in 1980. He still main-
tains a studio in Valencia, however. Bare of fur-
niture and dominated by elaborate recording
devices, it is a place in which to alight between
his constant travels to far-flung cities to arrange
his installations. The contrast between that
stripped-down space and his studio-home in the
mountains north of Los Angeles (well-suited to
his outdoors-loving side) parallels the distinction
between Borofsky's dynamic restlessness and his
amiable, easygoing personality. There is a simi-
lar paradox in the contrast between the artist's
ubiquitous self-portraiture and the humble per-
sona revealed in those portrayals. Like the
Dancing Clown, the little paintings *Mom, I Lost
the Election* (1972) or *I Dreamed I Was Taller
than Picasso* (1973) reveal an ability to laugh at
his own egotism. Decidedly in keeping with his
not taking himself too seriously is his success in
discouraging speculative revelations about his
private life. Tall, athletic in build, with deep-set
dark eyes and wiry black hair just beginning to
turn gray, Borofsky has a ready smile that ani-
mates his long, thin face. Despite several mean-
ingful relationships he has never married. "I
don't have that many distractions in my life," he
acknowledged, "to probably make it a little
more pleasant. I don't have a wife, I don't have
children." Nevertheless, he went on, "I don't
think I'm too excessive, just very directed toward
work. Ninety percent of my life revolves around
it." But, as he remarked in a 1983 interview, "I
am . . . really more involved with my own spir-
itual quest—not with where my art goes."

EXHIBITIONS INCLUDE: Paula Cooper Gal., NYC from
1975 (including 1983 retrospective); "Matrix 18,"
Wadsworth Atheneum, Hartford, Conn. 1976; Hay-
den Gal., MIT, Cambridge, Mass. 1980; Contemporary
Arts Mus., Houston 1981; Kunsthalle, Basel 1981, '83
(drawings); "Jonathan Borofsky: Dreams, 1973–81,"
Inst. of Contemporary Art, London 1981; Mus. Boy-
mans-van Beuningen, Rotterdam 1982; Israel Mus., Je-
rusalem 1984; Gal. Watari, Tokyo, 1984–85;
Philadelphia Mus. of Art (trav. retrospective) 1984–86.
GROUP EXHIBITIONS INCLUDE: "No. 7," Paula Cooper Gal.,

NYC 1969 (conceptual art); Whitney Biennial 1975, '79, '81–83; "Drawings: The Pluralist Decade," Venice Biennale 1980; "Twenty Artists: Yale School of Art 1950–1970," Yale Univ. Art Gal., New Haven, Conn. 1981; "New Directions: A Corporate Collection," Sidney Janis Gal., NYC 1981; "New Work on Paper," MOMA, NYC 1982; "Zeitgeist," Martin-Gropius-Bau, Berlin 1983.

COLLECTIONS INCLUDE: MOMA, Whitney Mus., NYC; Los Angeles County Mus. of Art.

ABOUT: Current Biography, 1985; Emanuel, M., et al. Contemporary Artists, 1983; Rosenthal, M., and R. Marshall, "Jonathan Borofsky" (cat.), Philadelphia Mus. of Art, 1984; Who's Who in American Art, 1989–90. Periodicals—Architectural Digest June 1983; Artforum November 1981, Art in America November 1974, September 1980, February 1985; ARTnews March 1981, March 1984; Philadelphia Inquirer October 7, 1984; Print Collectors Newsletter June 1983.

BROODTHAERS, MARCEL (January 28, 1924–January 28, 1976), Belgian assemblagist and conceptual artist, is perhaps best described as a poet of word and image. After an early engagement in the Belgian surrealist movement, more than a decade of poetry writing, and some initial attempts at filmmaking and photography, he took the decision, late in 1963, to enter the arena of the visual arts, and in the twelve years that remained before his death, Broodthaers made his way through the art of the object to what was essentially the art of the word as image and idea. Formidably erudite without being esoteric, committed but never polemical, and above all a master of demystification, he raised the hard questions of the 1970s for the whole of the art world—artists, dealers, critics, curators, and collectors alike.

Broodthaers was born and raised in Brussels. As his name indicates, he had roots in both of Belgium's cultural communities, the French and the Flemish, but his immediate environment was solidly francophone. In his youth, he was interested in art history but was persuaded to study chemistry instead; although he was intrigued by the workings of the lab, he would end up quitting school and going to work in a bank. By the age of sixteen he had met the surrealist painter René Magritte. By the age of twenty-one he had one of his poems published in the Belgian surrealist review Le ciel bleu. For a brief period around the same time, he contributed articles— mainly pseudonymous—on politics, literature, and cinema to a leftist weekly, Le salut public. He then became involved in the attempt to create a new surrealist group, "La centrale surréaliste," and was named to the editorial committee of their proposed review, La centrale. Like Magritte, Paul Nougé, and other Belgian surrealists, he was a member of the Communist Party (until the early 1950s), and, in the ongoing factional disputes that raged within the surrealist movement in the late 1940s, joined the short-lived revolutionary surrealist movement in opposition to André Breton's mainstream group. Lending his name to various tracts that denounced Breton and upheld Communist revolution, he also contributed two poems to the lone issue of their review, Le surréalisme révolutionnaire, published in March 1948.

Over the next fifteen years, Broodthaers settled into the marginal existence of an avant-garde intellectual. He continued to write poetry, which he published in reviews and three of his own collections (Mon livre d'ogre, 1957; Minuit, 1960; La bete noire, 1961). In 1957 he turned to film in order to make what he called a "cinematographic poem" in honor of Kurt Schwitters (La clef de l'horloge), and he also began doing photography. His income, of course, was unrelated to those activities: from 1950 to 1962, he supported himself as a bookseller and also gave tours in the Brussels art museums; in 1962–63 he worked with a press service in Paris. Not particularly accepted in literary circles, he tended to have friends among the visual artists; he followed the abstract expressionists; by the beginning of the 1960s he was familiar with the emerging nouveaux réalistes, and in 1962 he became friends with the iconoclastic Italian artist Piero Manzoni (who promptly inscribed him "an authentic and true work of art").

It was on a trip to Paris with a friend who was exhibiting there that he discovered his first pop artist, George Segal, in 1963: "I was shocked," he recalled. "Therefore I decided to write about the Segal exhibition. I took a flaming critical position against this art. One should not forget that our generation had an artistic background which was essentially surrealistic and somewhat mystical." In spite of this initial reaction, and his general aversion to "the literalness shown in the appropriation of the real" by both the nouveaux réalistes and the American pop artists, Segal's cast plaster figures (followed by the paintings of Dine and Lichtenstein, and Oldenburg's soft sculptures) started Broodthaers thinking about work of his own. In practical terms, it was his wife, the photographer Maria Gilissen (whom he had met in 1962), who not only encouraged him to turn his idle drawings and "casual critiques" into artworks but actually assembled his collages for him (and documented all of his subsequent exhibitions with her photographs). Assemblages of eggshells, mussel shells, moulds, and bricks followed, and early in 1964 Broodthaers found

himself officially welcomed into the ranks of the visual artists with a prize for "Young Belgian Sculpture," as well as an exhibit at the Galerie Saint-Laurent in Brussels. With characteristic irony, he put that turn of events in context on the invitation to the gallery opening:

> I too wonder whether I could not sell something and succeed in life. For some time, I had been no good at anything. I am forty years old. . . . Finally the idea of inventing something insincere crossed my mind and I quickly set to work. Three months later I showed what I had produced to Ph. Edouard Toussainte, the owner of the Galerie Saint-Louis. 'But this is art,' he said, 'and I'll gladly exhibit it all.' OK I replied. If I sell something, he'll take 30 percent, which seems to be the usual arrangement. Some galleries take 75 percent.

Among the "objects" that Broodthaers put on display in this exhibit was an assemblage made out of fifty unsold copies of his latest poetry collection, *Pense-bête* (*Think Stupid/Think Animal*), set in plaster *à la* Segal. "With the transition toward the visual arts," he told Ludo Bekkers in 1970, "I wanted to turn my back on poetry. Symbolically I wanted to free poetry from its ivory tower and therefore I threw it into the wet plaster to make a sculpture out of it." But at the same time, very much in the tradition of Magritte, he also wanted to play on the tension between what was written and what was seen, to confront viewers with what he called an "object of prohibition"—a book they were unable to read. (Much to his surprise, visitors to the gallery were oblivious to the prohibition: "Nobody was curious to read the text" he reported, "not knowing whether they were looking at buried poetry or prose, [whether it was] happy or sad.")

In fact, as was to be the case throughout his career, Broodthaers's determinedly anti-art (or anti–art establishment) stance was coupled with an equally determined pursuit of artistic expression. His assemblages, like the statement on his invitation, might have been provocative, but there was certainly nothing casual or haphazard about them. The ubiquitous mussel shell, for example, which Broodthaers heaped into pots and piled onto table tops was, in its literal emptiness, full of figurative associations. For one thing, it evoked mussels and chips, the Belgian equivalent of hamburgers and french fries. But there was also a play on words, between *la moule* (the mussel) and *le moule* (the mold), which Broodthaers the poet had already explored in *Pense-bête*: "The mussel [*la moule*]," he wrote in a poem of that name, "has avoided the molds [*les moules*] of society by casting itself into its own proper mold. Therefore it is perfect." For Broodthaers the poet, the autobiographical im-

plications are obvious; at the same time, and with no small dose of irony, in the hands of Broodthaers the artist, the mussel shells, like the eggshells, the glass jars, and the wine bottles that he also used for his objects, were the "perfect" raw materials for modern art, which was also devoid of content and cast into its own mold.

As Michael Compton pointed out on the occasion of the 1980 Broodthaers exhibition at the Tate Gallery, "Such an art, however lowly its materials, demands a sophisticated, or rather a cultured audience. It is made up not of Coca Cola bottles or urinals but of some of the traditional elements of a good life, European style: food, wine, literature, and wit." Broodthaers himself tended to blur such distinctions—notably between the legacies of dada and surrealism—and at the time, the issues were further confused by the dada-inspired climate of *nouveau réalisme*, but in retrospect, it is clear that his youthful experiences with the surrealists played a significant role in shaping his later activities. Marcel Mariën, a friend from revolutionary surrealism, recalled in his history of the Belgian surrealist movement how he told Broodthaers that one of his objects—*Fémur d'homme* (1967), a thigh bone painted in the colors of the Belgian flag—was obviously surrealist, to which Broodthaers replied, "Yes, of course . . . but don't tell anybody."

Broodthaers was the product of another intellectual milieu as well—that of Marxist literary theory, which he studied with Lucien Goldmann, a disciple of Georg Lukács. As a result, he had a markedly sociological bent to his thinking, to the extent, he told Irmeline Lebeer in the early 1970s, that Margritte reproached him for being more of a sociologist than an artist. In any event, after three or four years of expanding his repertoire of objects, Broodthaers began to address himself directly to the theoretical and ideological issues they implied: the role of art, the nature of the contemporary museum and gallery system, the relationship of artist and public. The major vehicle for that inquiry was the Museum of Modern Art, Department of Eagles, a fictitious institution that he created in September 1968. Since the mid-1960s he had participated in various conferences and discussions on contemporary art, and he also used his home in Brussels, on the rue de la Pépinière, for several happenings, but it was in the wake of May 1968 that he got the idea for the museum. By his own account, he had convened some sixty people to attend a seminar in his home on the subject of art and society, and some three days before the event, when he realized that nothing was prepared, he arranged with a local art mover to set up an "exhibit" of empty packing crates, repre-

senting, as Michael Compton pointed out, the shells of artworks that had been shown in museums all over the world. For the official opening on the day of the seminar, the mover's van was stationed outside the house, and a German museum director presented an inaugural address (in his native tongue, which was incomprehensible to most of those attending). That first manifestation of the museum was identified as the "Nineteenth-Century Section," and, accordingly, Broodthaers complemented the packing crates with postcards of nineteenth-century masterpieces by David, Ingres, Delacroix, and others.

The "Nineteenth-Century Section" remained open for an entire year—at the end of which the moving van returned to mark its official closing. Broodthaers then set up what he called the "Seventeenth-Century Section" (of the Museum of Modern Art) in Antwerp with another collection of postcards and another inaugural address delivered by a museum curator. Those activities continued apace in 1970, when Broodthaers was working in Düsseldorf: a "Nineteenth-Century Section (bis)" and the Düsseldorf Kunsthalle featured eight nineteenth-century paintings (and an inaugural address by the director of the Kunsthalle); "Folklore" and "Documentary" sections were also organized. A "Cinema Section" announced for November 1970 got off to a late start the following January in a rented hall in Düsseldorf, and in October 1971 a "Financial Section" was sold (because of bankruptcy) at the Cologne Art Market.

The museum's most ambitious undertaking was the "Figure Section," an apotheosis of the eagle that had been associated with the museum from the start. Exhibited at the Düsseldorf Kunsthalle in 1972, "The Eagle from the Oligocene Era to the Present" included more than two hundred objects ranging from pre-Columbian statues to Walt Disney comics, by way of Greek pottery, church pulpits, typewriters, and Sioux dance costumes. Like the mussel, the eagle offered Broodthaers a multilayered metaphor on art and society: "Everything is an eagle in art," he explained; "everything comes back to seeing things from far away, from above, separately. For simple people, the artist is a kind of intermediary between gods and mortals, like the eagle." By choosing to present the "Figure Section" in Germany, Broodthaers had added an unmistakable political dimension, through the highly charged association of the eagle with the Nazi flag (duly exhibited), and at the same time, the aggregate display of objects ranging from high-art masterpieces (borrowed from forty-two European museums) to butter wrappers (also German) offered an ironic comment on the

museum's pretense to meaningful organization of knowledge. Evoking his two forerunners in the domain of artistic parade, Broodthaers accompanied each object with the statement, neatly scripted in German, French, or English, "This is not an object of art"—a conflation of Marcel Duchamp's proposition that the urinal was an object of art and René Magritte's contrary pronouncement "This [the image of a pipe] is not a pipe." (He also decorated a Duchampian urinal with the image of an eagle smoking a pipe.)

Invited to participate in Documenta 5 at Kassel the same year, Broodthaers offered two manifestations of his museum: photographs of the recent Düsseldorf exhibition, which he showed in the "Publicity Section," and a "Modern Art Section" that consisted solely of a plaque with that name and a museum guard rope hung with a "Private Property" sign. (Before the end of that "exhibit" he changed the somewhat redundant title—for a museum of modern art—to "Museum of Ancient Art, Twentieth-Century Gallery.) With that unambiguous commentary on the institutionalization of art, Broodthaers chose to end the activities of his museum, which, he said, had "gone from a heroic and solitary form to one that is close to consecration." In a closing statement, he declared, "This museum is an imaginary one. It plays the role at one and the same time of a political parody of artistic events and an artistic parody of political events. Which the official museums and organizations like Documenta also do. But with the difference that a fiction permits [us] to seize both reality and what [that reality] hides."

During the five years that he "curated" the museum, Broodthaers had kept up his own production of images, objects, and texts in what was basically an artisanal fashion. Around the time that he launched the Museum of Modern Art, he discovered vacuum-formed plastic signs—the kind used by shopkeepers and luncheonette owners—and he adopted the technique for his own parody and punnery. For Broodthaers, these "industrial poems," as he called them, provided a welcome break with the past because of the new material and technique, but in fact, as Michael Compton remarked, in the age of neon and photo-offset, the vacuum-formed aesthetic had the same anachronistic look to it as the rest of his oeuvre—painted objects, paintings of objects, stenciled letters, photographs, and modest little films ranging in length from one second to seven minutes—all of which made use, in rather classic Magritte fashion, of the disjuncture of image and word.

In the middle period of his artistic career, Broodthaers became a master of mixed media,

not in the conventional sense of combining materials but as a kind of conceptual alchemist, transmuting artistic statements from one form to another. As Compton explained, citing the gamut of Broodthaers's endeavors, "he continued to superimpose one on another, to combine one with another, to use characteristics of one in another, and to use elements or parts of one in another." In 1967, for example, he had given a reading of one of La Fontaine's fables, "Le corbeau et le renard" (The Crow and the Fox), in a street event in Brussels; he then used the fable as the basis for an album of prints and a seven-minute film, and when the prints were exhibited in an Antwerp gallery in 1968, he marked the opening by projecting the film onto special photographic screens imprinted with the text. The following year he turned to another literary work, Mallarmé's *Un coup de dés jamais n'abolira le hasard* (*A Throw of the Dice Will Never Abolish Chance*), painting extracts onto a canvas, then reprinted the 1914 edition under his own name. When this appropriated version, which he subtitled "Image," was shown in a "Literary and Musical Exhibition Dealing with Mallarmé" in 1969, it remained open to two pages, so that, as with *Pense-bête* four years earlier, the viewer was unable to read the text. The "prohibition" was reinforced by an accompanying group of aluminum plates engraved with the configuration of the words on each page—likewise unreadable—but at the same time, a tape recording offered a sound version of the poem (in Broodthaers's voice). Three years later, on the occasion of the "Amsterdam Paris Düsseldorf" exhibition at the Guggenheim Museum, Broodthaers presented his version of *Un coup de dés* along with a two-part collage entitled *My Collection,* one wing of which was consecrated to Mallarmé, identified as "the founder of modern art." (The statement accompanying *My Collection* was dedicated to Broodthaers's friend Daniel Buren, ostensibly because of their shared interest in "structures of repetition," but not without an implicit reproach for the Guggenheim, which had refused to exhibit a large work by Buren the year before.)

As his contribution to the Guggenheim show suggests, the continuous recycling of his own work became a form of curatorial activity that paralleled the Museum of Modern Art, Department of Eagles; once the latter ceased to exist, Broodthaers effectively fused the two currents, presenting his own work in the form of self-contained museum installations, complete with catalogs of his own design. The first of those, "Catalogue-Catalogus," presented at the Palais des Beaux-Arts in Brussels in 1974, for example, included various objects from the 1960s and 1970s (accompanied by a catalog and color poster reproducing them); a collection of "portrait" paintings representing famous men by their names and dates, neatly printed on the canvas; a room full of alphabet letter paintings, and the "Winter Garden," an installation of potted palms, folding chairs, and exotic prints that Broodthaers had created for a group exhibit at the same museum earlier that year as a parody of nineteenth-century colonial chic and its seventies revivals.

A week after the opening of "Catalogue-Catalogus," Broodthaers inaugurated a second exhibition in Basel, "Eloge du sujet" (Eulogy of the Subject). The title installation consisted of various objects bearing unrelated names—a hat labeled "subject," a palette labeled "pipe," and so forth; a "Winter Garden II" took the form of "The Entry to the Exhibition," with seven giant palms literally overshadowing various prints and photos mounted on the walls (most of which offered even more acerbic commentaries on art as commerce); poems and objects from one of Broodthaers's earliest exhibitions were presented in the "Parakeet Room," while other objects, paintings, and drawings displayed in nearby rooms were also shown on slides in the "Pedagogic Room," and Broodthaers's films were projected in the "Lumière [Light] Room."

As Barbara M. Reise observed at the time of those first two installations, in Broodthaers's hands the time-honored retrospective had become a beginning rather than an end, a "turnabout" that he had achieved "by, in effect, using his 'old' works as material for new works, which were the exhibitions themselves. It was as if the old works became his alphabet or dictionary and he evolved a new grammar for them to make a fresh statement: a statement about the experience of exhibiting and of experiencing exhibitions." The term that Broodthaers himself used for that kind of (re) installation was "decor," by which he sought to counter the artistic framework automatically generated by the museum setting: the decor, he explained in one of the elaborate catalogs he created to accompany his self-retrospectives, "could be characterized by the idea of the object restored to a real function, which is to say that there, the object is not considered as a work of art."

In the course of the following year, such reconstituted decors were presented in four different museums—"Invitation for a Bourgeois Exhibition" at the Nationalgalerie in Berlin, "Decor (A Conquest by Marcel Broodthaers)" at the Institute of Contemporary Art in London, "No Photographs Permitte" at the Museum of

Modern Art in Oxford, and "L'Angélus de Daumier" (The Angelus of Daumier) at the Centre National d'Art Moderne in Paris. As the titles themselves suggest, his dual assault on art and society was in no way tempered by the recognition and material support now at his disposal. In his statement for the Oxford exhibit (with its title stamped on every page to ridicule the museum's proprietary attitude toward art), Broodthaers railed against the "transformation of Art into merchandise" and declared: "Art adorns our bourgeois walls as a sign of power, a prisoner of its fantasies and of the magical uses to which it is put." And then, confessing to his readers (much in the style of his first gallery invitation eleven years before) that he had no discoveries to offer, "not even America," he indicated that "I choose to consider Art as a useless labor, apolitical and of little moral significance."

With "Decor (A Conquest by Marcel Broodthaers)," he went one step further, equating artistic and military activity with an elaboration on the "Winter Garden" in the form of nineteenth- and twentieth-century period rooms filled with palm trees, lawn furniture, and weaponry. For "L'Angélus de Daumier," Broodthaers's motto, adopted from a French comic book, was "new tricks, new schemes"—fair warning for an exhibit that by its title attracted no small number of unwary art lovers in search of Millet's painting of that name (there was a Millet exhibition in Paris at the same time). What they found instead was another sequence of decors, including the "Winter Garden" ("Green Room"), a wooden reconstruction of the room where Broodthaers had mounted the original Museum of Modern Art, Department of Eagles, now labeled with words from the various lexicons of art—"light," "shadow," "composition," "price" ("White Room"), and a screening room for his films ("Black Room").

"L'Angélus de Daumier" was to be Broodthaers's last major exhibit during his lifetime. Suffering from leukemia, he died in a Cologne hospital on his fifty-second birthday; a last invitation, printed in his favorite, anachronistic typeface, summoned friends to his funeral on behalf of his wife and their daughter, Marie-Puck. At his death, he left vast numbers of objects and projects in various stages of completion, but with foresight and unrelenting irony, he delegated his wife to decide which would become works of art. The precedent he had established with the decors guaranteed his works a posthumous life of their own at the hands of museum curators and gallery owners, and in the decade after his death there were more major Marcel Broodthaers exhibitions than there had been

during his lifetime. Even if those institutionalized decors did not necessarily correspond to Broodthaers's own idiosyncrasies, ideologies, or creative genius, they have at least permitted a greater appreciation of his work. What stands out most in retrospect is his powerfully synthetic vision—his ability to play on paradox, contradiction, and ambiguity, as they occur in language, in life, and in museums—and this at a time when such a synthesis was as much out of fashion as the three-piece, pin-striped suits he wore. In that respect, as Jürgen Harten wrote a decade after his death, "Marcel Broodthaers was probably the first to cross the threshold between the cultural revolution that had failed and a new sense of tradition."

EXHIBITIONS INCLUDE: Gal. Saint-Laurent, Brussels 1964; Gal. Smith, Brussels 1964; Palais des Beaux-Arts, Brussels 1964, '67, '72, '74, '76; Gal. J., Paris 1966; Wide White Space Gal., Antwerp 1968, '74; Gal. Gerda Bassenge and Benjamin Katz, Berlin 1969; Gal. Michael Werner, Cologne from 1969; Gal. M.T.L., Brussels 1970, '72, '75; Städtische Mus., Mönchengladbach 1971; Art and Project, Amsterdam 1973; Gal. Francoise Lambert, Milan 1973; Gal. Rudolf Zwirner, Cologne 1973; Basel Kunstmus. 1974; Nationalgal., Berlin 1975; Städtische Kunsthalle, Düsseldorf 1975; Inst. of Contemporary Arts, London 1975; Cntr. National d'Art et de Culture, Paris 1975; Freiburg Kunstverein 1976; John Gibson Gal., NYC 1976; Tate Gal., London 1977, '80; Gal. Gillespie-Laage, Paris 1977; Gal. Helen van der Meij, Amsterdam 1978; Gal. Heiner Friedrich, Munich 1978; Gal. Isy Brachot, Paris 1978; Marion Goodman Gal., NYC 1978, '82; Hamburg Kunstverein 1979; Mus. Ludwig, Cologne 1980; Mus. Boymans-van Beuningen, Rotterdam 1981; Berne Kunsthalle 1982; Modern Mus., Stockholm 1982; Mary Boone/Michael Werner Gal., NYC 1984. GROUP EXHIBITIONS INCLUDE: "Distinction Jeune Sculpture Belge 1963," Palais des Beaux-Arts, Brussels 1964; "Pop Art, Nouveau Realisme, etc. . . . " Palais des Beaux-Arts, Brussels 1965; "La lecon des choses," Ranelagh, Paris 1965; "2e International de Galeries pilotes," Mus. Cantonal des Beaux-Arts, Lausanne 1966; "Three Blind Mice," Stedelijk van Abbemus., Eindhoven 1968; "Prospect 68," Städtische Kunsthalle, Düsseldorf 1968; Sixth Avant-Garde Festival, NYC 1968; "Konzeption-Conception," Stadtisches Mus., Schloss Morsbroisch, Leverkusen 1969; "Language III," Dwan Gal., NYC 1969; "Information," MOMA, NYC 1970; "La Metamorphose del'objet—Metamorfose van het objet" (trav. exhib., Brussels, Rotterdam, Berlin, Milan, Basel, Paris), 1971; "Prospect 71," Städtische Kunsthalle, Düsseldorf 1971; Documenta 5, Kassel 1972; "Amsterdam—Paris—Düsseldorf," Guggenheim Mus., NYC 1972; "Bilder-Objekte-Filme-Konzepte," Städtische Gal. im Lenbachhaus, Munich 1973; "Maler, Painters, Peintres," Städtische Kunsthalle, Düsseldorf 1973; "Carl Andre, Marcel Broodthaers, Daniel Burin . . . et al.," Palais des Beaux-Arts, Brussels 1974; "Von Pop zum Konzept," Neue Gal., Sammlung Ludwig, Aa-

chen 1975; Venice Biennale 1976; "Prospect retrospect, Europe 1946–1976, " Kunsthalle, Düsseldorf 1976; Documenta 6, Kassel 1977; "Europe in the Seventies" (trav. exhib., Chicago, Washington, D.C., San Francisco, Fort Worth, Cincinnati), 1977; Venice Biennale 1978; Sidney Biennale 1978; Wahrnehmungen–Aufzeichnungen–Mitteilungen," Mus. Haus Lang, Krefeld 1979; "Mus. des sacrifices/ Mus. de l'argent," Cntr. Georges Pompidou, Paris 1979; Venice Biennale 1980; "Printed Art: A View of Two Decades," MOMA, NYC 1980; "Westkunst," Mus. der Stadt, Cologne 1981; Documenta 7, Kassel 1982; "60, 80, attitudes/concepts/images," Stedelijk Mus., Amsterdam 1982; "Der Hang zum Gesamkunstwerk" (trav. exhib., Zurich, Düsseldorf, Vienna, Berlin), 1983; "Von hier aus," Meddehallen, Düsseldorf 1984.

COLLECTIONS INCLUDE: Art and Project, Amsterdam; Basel Kunstmus.; Mus. des Beaux-Arts, Brussels; Mus. van Hedendaagse Kunst; Vereniging voor het Mus. van Hedendaagse Kunst, Ghent; Stedelijk van Abbemus., Eindhoven; Arts Council, Great Britain; Stadtisches Mus., Monchengladbach.

ABOUT: "Amsterdam Paris Düsseldorf" (cat.), Guggenheim Museum, NYC, 1972; "L'Angélus de Daumier" (cat. in two parts), Centre National d'Art Moderne, Paris, 1975; "Catalogue-Calalogus" (cat.), Palais des Beaux-Arts, Brussels, 1974; "Decor (A Conquest by Marcel Broodthaers)" (cat.), Institute of Contemporary Art, London, 1975; "Defense de Photographier" (cat.), Museum of Modern Art, Oxford, 1975; "Eloge du sujet" (cat.) Kunstmuseum., Basel, 1974; Emanuel, M., et al. Contemporary Artists, 1983; Gilmour, P. "Marcel Broodthaers," New 57 Gal., Edinburgh, 1977; "Marcel Broodthaers" (cat.), Tate Gallery, London, 1980; "Marcel Broodthaers" (cat.), Museum Boymans-van Beuningen, Rotterdam, 1981; "Marcel Broodthaers (1924–1976)" (cat.), Kunsthalle, Berne, 1982; "Marcel Broodthaers: Catalogue of Books . . . 1957–1975" (cat.), Gallerie Michael Werner, Berlin et al., 1982; "Marcel Broodthaers: Seventeen Photographic Portraits: 1957–1974," 1983. Periodicals—Artforum May 1980, October 1982; Art in America May 1975, September 1982; Art Press November 1982; Arts Magazine June 1980, November 1982; Chronique de l'art vivant December 1972; Domus November 1978; Flash Art January 1985, March 1979, October 1987 (Broodthaers issue).

BOOKS BY BROODTHAERS: Mon livre d'ogre, 1957; Minuit, 1960; La bête noire, 1961; Pense-bête, 1963; Le Corbeau et le renard, 1968; Un coup de des n'abolira jamais le hasard, 1969; Plan vert, 1972; Tractatus logico-catalogicus, 1972; Magie (art et politique), 1973; Je jaie le mouvement qui deplace les lignes, 1973; Jeter du poisson sur le marche de Cologne, 1973; Un jardind'hiver, 1974; A Voyage on the North Sea, 1974; Racisme vegetal, 1974; Pauvre belgique 1974; En lisant la morelei oder wie ich die Lorelei gelesenhabe, 1975; Atlas a l'usage des artistes et des militaires, 1975.

FILMS: La clef de l'horloge (7'), 1957; Le corbeau et le renard (7') 1967; Section XIXe siecle (12'), 1968; La signature (1') 1970; La pluie (3'), 1970; La pipe (René Magritte) (5'), 1970; MTL DTH (5'), 1970; Un film de Charles Baudelaire (7'), 1971; Histoire d'amour (Dr. Huysmand) (5'), 1971; Le poisson (7'30"), 1971; Paris (2'), 1971; Au dela de cette limite (7'), 1972; Chere petite soeur (5') 1972; Ah que la chasse soit le plaisir des rois, 1972; Voyage en mer du Nord (4'), 1973; Un jardin d'hiver (7'), 1974; Eau de Cologne (2'), 1974; Berlin oder ein Traum mit Sahne (15'), 1974; Jeremy Bentham (15'), 1974; The Battle of Waterloo (10'), 1975–76.

BURY, POL (April 26, 1922–), Belgian sculptor, painter, printmaker, jeweler, and writer, was born in Haine-Saint-Pierre, a village east of Mons in Wallonia, southern Belgium. He amused himself as a child by copying drawings of Mickey Mouse, the Little King, and Bécassine, and from his midteens he played an active part in the cultural life of the small provincial city of the Louvière, very near his birthplace. He studied at the Ecole des Beaux-Arts in Mons in 1938–39, served during World War II in the resistance to the Nazi occupation, and all the while continued to paint in a surrealist manner that owed much to the established styles of Dali and Bury's fellow Belgian, Magritte. In one canvas from the period, *The Illuminated Sky* (1942), clouds filled with reflection like fragments of farms, roads, telephone poles, and skeletal trees float over a featureless landscape. Several of his paintings were included in the" International Exposition of Surrealism" in 1945 in Brussels. He abandoned surrealism the same year, soon associating himself with Jeune Peinture Belge, a mostly expressionist group consisting of, among others, his friends Pierre Alechinsky, René Guiette, and Jean Milo. Bury exhibited with the group from 1947, the year he finally abandoned figurative painting. He was, at the same time, along with Alechinsky, among others, an adherent of Cobra, the European international outgrowth of surrealism that advocated the unmediated expression of the unconscious. At that time he also illustrated some friends' books, notably Joseph Noiret's *L'aventure dévorante* (The Consuming Adventure, 1950) and Marcel Havrenne's *La main hereuse* (The Happy Hand, 1950).

After completing the quasi-cubist and very accomplished oil-and-gouache series "Compositions" (1952), he definitively abandoned painting. He turned almost immediately to sculpture, and in late 1953, at the Galerie Apollo, in Brussels, he showed the first of his *plans mobiles* (moving planes), black-and-white incised planes of masonite or colored metal that could be fitted together to produce various pat-

terns. He continued work on the *plans mobiles*; they formed the basis of his contribution to the 1955 exhibition "Le Mouvement", mounted at the Galerie Denise René in Paris and including sculptural works by Agam, Calder, Duchamp, Jacobson, Soto, Tinguely, and Vasarely. Yet he also included in the show a few pieces from *Girouettes*, a new series of moving sculptures, which were the progenitors of much of his later work. He recalls having been greatly stimulated around that time by seeing an exhibition of Calder's mobiles, in much the same way that Calder himself, after a visit to Mondrian's studio in Paris around 1930, decided "to put Mondrian into motion."

Bury soon began experimenting with electric motors as the moving force in his *plans mobiles*, coining the the word *multiplan* to describe that sort of sculpture. The first of them were rectangular constructions of long vertical slats painted with an abstract design and set into frames: the motor caused the slats to move and the design to alter slightly. In 1959 he exhibited his *ponctuations*: perforated black-and-white metal discs were spun and superimposed to produce a variety of patterns. Variations of those works, called *ponctuations molles* and *ponctuations érectiles* (soft and erect punctuations), consisted of stems, either supple or rigid, arising from a curved or flat surface. Underneath the surface a hidden motor caused an irregular movement in the stems. Here is Bury's own description, complete with his characteristic ellipses, of those creations: " . . . what is it all about? . . . from a white . . . or black surface . . . there emerges . . . a relatively large number . . . of rigid stems . . . or soft stems . . . black and white . . . animated electrically . . . they are agitated . . . or not . . . at unpredictable moments . . . by erectile movements and immobilities . . . they also tend to express a . . . fairly . . . extreme . . . impotence . . . only the structure itself . . . of these black against white . . . rigid . . . or soft stems . . . is perceptible . . . and even this varies according to the time of day . . . according to the light . . . on these rigid . . . or soft stems . . . black against black . . . a white dot . . . at their tips . . . crystallizes all the movements which are dictated to them . . . by the laws of chance . . . "

During the 1960s Bury refined and elaborated the mobility of his *entités érectiles*—the motors ever more sophisticated and adroitly hidden, the surfaces (what the spectator saw) ever smoother and more highly crafted. By the middle of the decade he had exhibited in London and New York City and was an internationally established modern sculptor. His first one-man American show, in October 1964 at the Lefebre Gallery in New York, consisted of twenty-odd pieces, each of which was sold at the opening or before, including two simultaneous purchases by the Museum of Modern Art. His works of that period are usually of stained, polished wood: spheres and other shapes attached by wires to variously inclined planes and caused to move slightly by the hidden electrical motors. By 1969 he was working almost entirely in highly polished, reflective metal—stainless steel, chromium-plated steel, or brass. In that medium he created what is by most accounts his greatest body of work.

Bury's elegant, immaculate constructions of the late 1960s and early 1970s found a wide and appreciative audience, as critics increasingly perceived his work proceeding far beyond the limitations of kinetic art. He used single or multiple spheres, hemispheres, or ovoids, usually poised precariously on rectangles, cubes, or cylinders. The movement of the shapes is very slow and irregular: "You stand and watch and nothing seems to be happening," wrote Michael Peppiatt, "then . . . a ball bearing nudges another, belying the apparent immobility and making you aware that such tiny changes have been taking place all along." Jean-François Revel agreed: "Instead of creating, according to the old trick, the illusion of movement, [Bury] actually creates the illusion of fixity. . . . You think that nothing is moving, but, finally, everything is." In *22 Balls Placed on a Platform* (1968), an early work in polished copper, twenty-two different-sized spheres inch their way with extreme slowness to the sheer edge of the polished platform, then stop. The sense of mysteriousness in that movement, suspenseful and even magical—as if the work of an invisible hand—is an effect that Bury was able to create over and over again. In another work, the stainless-steel *Horizontal Monument No. 3 Dedicated to 12,000 Ball Bearings* (1971), the movement is no less random and slow, but the sheer number of the tiny spheres on the polished five-foot-wide circular platform gives an impression of perpetual motion.

The aesthetic appeal of slowness has for a long time exercised Bury's imagination. "Between the immobile and mobility," he wrote in 1964, "a certain quality of slowness reveals to us a field of 'actions' in which the eye is no longer able to trace an object's journeys. Given a sphere traveling from A to B, the memory we retain of its point of departure is a function of the slowness with which it makes its journey. . . . Slowness not only multiplies duration but also gives to the eye that follows the sphere the possibility of escaping from its own imagination as spectator to allow itself to be led by the imagination of the traveling sphere itself. The imagined journey be-

comes an imagining one." If slowness in modern life has become devalued, associated with insufficient speed or with old age or menial work, Bury's work entirely challenges that association. One is virtually forced to go through his exhibitions slowly and attentively.

The sense of attentiveness and intimacy that Bury's smaller-scale work establishes with the spectator is sustained in his larger pieces as well. *50 Tons of Columns* (1972), for example, consists of a grouping of fifty columns of Cor-Ten steel, each three meters high and each obliquely articulated at midheight, allowing each to oscillate slightly, independently. Maitien Bouisset called them "gigantic and outlandish temple pillars from the modern world, . . . a forest . . . which escapes the coldness of the technology that permitted its realization." This work, and others like it, was the fruit of Bury's cooperation with the special projects division of the Renault corporation. He has also, from the mid-1970s, made several extraordinary fountains for public places. These are constructed of cylinders of stainless or other steel, assembled roughly into the shape of a tree or serpentine knot. The limbs slowly fill with water until their balance is upset, then droop to empty their contents and slowly rise again, nodding to each side, to refill with water. Among his largest commissions of the late 1970s was a ceiling piece for the Brussels metro consisting of seventy-five stainless-steel mobile elements.

The deformation of photographic reality is another theme that has fascinated Bury since 1961, when he suddenly realized the artistic potential of the soft (or fun-house) mirror. The two extensive series of works in which he explores that theme he calls *cinétisations* and *ramollissements* (softening). Of the former, his best-known works are three films made with Clovis Prévost: *8,500 Tons of Iron* (1971), in which the complex structure of the Eiffel Tower is dissolved and broken up in a bewildering number of ways; *135 Kilometers per Hour* (1972); and *A Lesson in Plane Geometry* (1972). His *ramollissements* (the word means both "softening" and "quasi-imbecility") usually involved the progressive deformations of famous human faces. The poet and playwright Eugène Ionesco, who with André Balthazar wrote and edited the luxurious volume *Pol Bury* (1976), discussed the two series of a dozen portraits each of Mao Zedong and Pope Paul VI: "These are not polemical portaits, not caricatures, but twelve deformations of the face, twelve increasingly great deformations of one or another of these two people. In the first image, Mao and Paul VI still resemble Mao and Paul VI, then the succeeding images resemble them less and less, the

last ones not only do not resemble these people at all, they are not even faces any longer, they are nothing, only a kind of pudding. The goal is achieved: expression is abolished and becomes inexpression." What is "new" in all of Bury's work, according to Ionesco, is that he is always coming upon "another way of showing us forms, a way of giving the impression of disequilibrating what is in equilibrium, . . . another way of leading us to the borders of silence."

From about the late 1970s, Bury's work seemed to move into a minor key. His jewelry designs, small constructs of precious metals featuring his typically slow, incessant movement, were offered for sale with increasing frequency, even appearing at Cartier's in New York. He even returned—"to fulfill kinetic needs," he said—to two-dimensional art in the form of printmaking. Employing a somewhat unusual technique for one graphics show in 1978, he cut from paper simple squares, circles, rectangles, and triangles, placed them on an inked piece of plywood, and ran the wood through the press. He would then carefully lift the print, rearrange the paper shapes, and repeat the printing, a repetition that might occur as many as ten times.

Bury has been publishing small books, consisting for the most part of subtle reflections of what he is trying to accomplish in his art, since the early 1960s. His writing is usually difficult in that he is always attempting to put into concrete terms abstract ideas and artistic principles. Among his dozen books, none of which has been translated into English, are *La boule et le trou* (*The Ball and the Hole*, 1961), *La boule et le cube* (*The Ball and the Cube*, 1967), L'art à bicyclette et la révolution à cheval (*Art on a Bicycle and Revolution on Horseback*, 1972), and *Les petits moutons blancs qui sortent en rang du lavoir* (*The Little White Sheep That File Out of the Washing-Place*, 1976).

Some critics, despite their admiration for the subtlety of Bury's sculptural work, have seen him as a kind of *farceur*, a person forever looking for the humorous in everything he does. To the extent that that is true, it is merely the continuation, from his earliest days as an artist, of surrealist mockery and raillery in his work. He agreed that "it is possible, especially in my sculpture, to rediscover the surrealist spirit." Ionesco does not entirely agree, maintaining that Bury "has distanced himself from surrealism" and is, quite simply, compellingly bizarre: "One could say that Bury's art is naturally strange or strangely natural. Anti-naturally natural. Pol Bury himself, as a personage, seems to me a real Martian: he has the head of one, moreover, if one looks closely. Since I've known him, I've known how

Martians are. Anyhow, that's his function: to create the strange with the natural. He denaturalizes everything. I believe that that's the exact definition of *l'insoline* [one who acts contrary to customs and rules]."

Bury left Belgium in 1961 and has since worked and resided in France, successively in the villages of Fontenay-aux-Roses, near Paris (1961–65), Sault-les-Chartres (1965–73), and Perdreauville, in the Yvelines (since 1973).

EXHIBITIONS INCLUDE: Gal. Lou Cosyn, Brussels 1946; Gal. Apollo, Brussels 1953; Gal. Les Contemporaines, Brussels 1955; Gal. du Verseau, Brussels 1957; Gal. St. Laurent, Brussels 1959, '60; APIAW, Liège, Belgium 1961; Gal. Iris Clert, Paris 1962, '63; Lefebre Gal., N.Y.C 1964, '66, '68, '71, '76; Landau Gal., Los Angeles 1965; Gal. La Hune, Paris 1966; Kasmin Gal., London 1967; Gal. Pierre, Stockholm 1969; Gal. Maeght, Paris 1969; Univ. of Calif., Berkeley 1970; Guggenheim Mus., NYC 1971, '80; Estudio Actual, Caracas, 1971; Gal. Moos, Toronto 1971; Kestner-Gesellschaft, Hanover 1971; Nationalgal., Berlin 1971; Kunsthalle, Düsseldorf 1971, '72; Weintraub Gal., N.Y.C 1971; Palais des Beaux-Arts, Charleroi, Belgium 1972; Cntr. National d'Art Contemporain, Paris 1972; Mus. Boymans-van Beuningen, Rotterdam 1973; Louisians Mus., Humlebaek, Denmark 1973; Foundation Maeght, St. Paul de Vence, France 1974; Mus. d'Art Moderne, Brussels 1976; Mus. de Arte Modern, Mexico City 1977; F. S. Wright Art Gals., Univ. of Calif., Los Angeles 1978; Univ. of Texas, Austin 1978; Portland Art Mus., Oreg. 1978; Univ. of Georgia, Athens 1978; Mus. St. Georges, Liège, Belgium 1979; Cloître St.-Trophime, Arles, France 1979; Mus. d'Art Moderne de la Ville de Paris 1982. GROUP EXHIBITIONS INCLUDE: "Surréalisme," Gal. des Editions La Boétie, Brussels 1945; "Le Mouvement," Gal. Denise René, Paris 1955; "Breer, Bury, Klein, Mack, Munari, etc." Hessenhuis, Antwerp 1959; Venice Biennale 1964; Documenta 3, Kassel, West Germany 1964; "Living Structures, Mobiles, Images," Redfern Gal., London 1964; "Dix années de l'art vivant," Gal. Maeght, Paris 1967; "Douze ans d'art contemporain," Grand Palais, Paris 1972; "Hommage à Picasso," Kestner-Gesellschaft, Hanover 1973.

ABOUT: Ashton, D. Pol Bury, 1970; Balthazar, A. Pol Bury, 1967; Balthazar, A. "Pol Bury" (cat.), 1971; Calas, N. and E. Calas. Icons and Images of the '60s, 1971; Emanuel, M., et al. Contemporary Artists, 1983; Ionesco, E. "Twice Pol Bury: Cinetizations, Moving Sculptures" (cat.), 1966.

CHASE, LOUISA (March 18, 1951–), American painter of the new image generation, attracted considerable attention in the early 1980s for the seeming economy of painterly means used to convey powerful psychological content, but in the course of the decade she gradually eliminated the image and arrived at a lan-

LOUISA CHASE

guage of pure, gestural form in the abstract expressionist tradition.

Born in Panama City, Chase was one of three children in a serviceman's family. When she was three years old the family moved to Oklahoma, then settled near Lancaster, Pennsylvania, where she spent most of her teens. It was the woods and lakes of that area, she indicates, that suggested the imagery in her early landscape paintings. Although she was involved with a small theater as a child in Oklahoma, she had no particular interest in art, and when she entered Syracuse University in 1969, she intended to major in classics, only later switching to painting. In college, she recalls, "there was very little emphasis on painting, formal painting. A lot more on the combination of painting and sculpture." Her own studies included multimedia and electronic music, and she says, she was "always involved with making things."

Just before her final year at Syracuse, Chase attended the Yale summer school in Norfolk, Connecticut and then went on to Yale's prestigious M.F.A. program in New Haven. There her work was still more involved with mixed media than with painting—"very animated" sculpture and floor pieces—but through the school's dominant formalist current, she also had her first real exposure to "the language involved in putting a painting together." Like her classmate Judy Pfaff, she was inspired by the teaching of hardedge painter Al Held, but also got to know the abstract expressionist Philip Guston when he was a visiting professor and was later significantly influenced by the psychological dimension of his paintings.

After graduating from Yale in 1975, she moved to New York City, where she soon had her first solo exhibit at the Artists Space, consisting of colorful geometric objects and cutouts assembled in toy like configurations. By the time of her next exhibit, at the Edward Thorpe Gallery in 1978, her work reflected a strong connection with the circus (a number of her friends were circus performers). But while there was obviously something of Calder's whimsy involved, as Tiffany Bell pointed out in *Arts*, Chase was clearly more concerned with form.

Throughout the late 1970s Chase taught painting at the Rhode Island School of Design, but it was only in 1979 that she began to paint on flat surfaces herself. From the outset, there was a certain symbolism involved: the early "Lives of the Saints" series, for example, represented the saints as headless figures floating cross-armed among geometric forms, with none of the identifying attributes found in traditional Christian iconography. For William Zimmer, writing in the *SoHo Weekly News*, those paintings were the "true find" of the "New Work/New York" show at the New Museum, but for Chase herself, they were a preliminary phase in her development, insofar as the symbolism remained abstract. It was only later, she explains, that her imagery became "more specifically symbolic."

The works that she considers her first "real" paintings featured three elements—a landscape image, a human figure imbedded as "the spirit of the place," and a flat, emblematic motif, often a flower—rendered in a naive, greeting-card style with pretty colors and fine finish. The jubilant *Falls* (1980), for example, situates a gesturing torso and a sprig of flowers in front of a lush cascade of water, while the ominous *Ravine* is populated by a limbless torso and a thorny rose. Those "klutzy but smart" paintings, as Kim Levin described them in the *Village Voice*, intrigued critics with their combination of sensuous form and decidedly elusive content—"something like sleepwalking," in Levin's words.

A key influence beyond that symbolic use of figuration, Chase indicates, was early Sienese painting, which she first encountered during a trip to Italy in 1980. But as her idiom evolved, it was the landscape, and the natural phenomena occurring in it, that became her main vehicle of symbolic expression, yielding works like *Storm, Squall,* and *Limb* (1981). Although they were compared to the work of nineteenth-century romantic landscape painters like Allston and Ryder, to primitives in the line of the Douanier Rousseau, and to modern symbolists like Georgia O'Keeffe and Albert C. Dove, those paintings functioned primarily on an abstract, formal level, where the image resonated with completely nonnaturalistic colors, stylized forms and surface patterns, and fast-and-furious brushwork in the best tradition of the abstract expressionists (and notably Chase's mentor Philip Guston). "The brooding conviction of Chase's paint pushing," wrote Kay Larson in *New York* magazine, "seems to come straight from some inner source of strength." According to Chase, those paintings "had a lot to do with memory and a psychological interior." At the time, she acknowledged, "I really did want to retreat—or I was caught in between—I knew about the retreat and yet I wanted to come out." Gradually, she says, the imagery began to break down, and what mattered to her more and more was the "mark making." The greeting-card colors of her earlier works gave way to muddied natural tones and black outlines incised into the paint surface. In a group of 1983–84 landscapes, she reintegrated body parts—hands, feet, and the burning torso that she identified as Joan of Arc—"in order to make those paintings feel real, like I was inside of them." As Pepe Karmel pointed out when the paintings were exhibited in 1984, in contrast to the "deliberately dumb images" of her earlier landscapes, Chase's new work "resonates with emotions grounded in real experience: anxiety and awe, humor and desire, the frustrations of painting and the sensual pleasures."

Ironically, Chase herself was perhaps most aware of the frustrations: "I didn't have a form for what I was thinking about or how I was seeing things." When she went back to Italy for the 1984 Venice Biennale, she recalled, she visited Siena again and realized that the paintings there did not mean the same thing to her as they did in 1980: "They were charming, but they didn't seem real to me anymore." But while she was in Venice, the combined impact of Tintoretto's giant canvases from the Italian baroque and the early Jackson Pollocks in the Peggy Guggenheim collection gave her new inspiration and dramatically changed her concept of space.

By the time of her 1986 exhibit at Robert Miller, she was immersed in gesture, creating large, murky abstractions heavily reworked with a palette knife to inscribe (or dissolve) human heads into the paint surface. While some reviewers were enthusiastic about her evolution—Holland Carter called the new paintings "the most charged-up work she has yet done"—most sensed a crisis of direction, and Chase was inclined to agree. Late in 1986 she left the gallery and spent the following year and a half working alone to recreate her visual language, or to find what she calls her "marks." At the end of that time, her studio was filled with large canvases

densely incised with gray and black calligraphic lines and punctuated with small geometric patches of primary colors. As Chase pointed out, the work is still about forces and still evokes some of the earlier images of forests, tree limbs, ruins, and gardens, but it is now conceived in strictly plastic terms. "I'm working with the most simple elements that I can—the drawing's just completely what it is: black, white, gray, and then the red, yellow, and blue. . . . It's a really different head; I don't think I could come up with an image now to save my life."

A short, brown-haired woman who still has a slight twang in her voice from Lancaster, Pennsylvania, Chase comes across as someone both energetic and reflective. She lives and works in a giant double loft in Tribeca downstairs from her longtime friend and fellow artist Elizabeth Murray; her other close artist friends include Judy Pfaff, Susan Rothenberg, and Brice Marden.

EXHIBITIONS INCLUDE: Bond Gal., NYC 1981, '84, '85; John Weber Gal., NYC 1985, '86, '87; Paula Cooper Gal., NYC 1986, '88, '89; Vox Populi, NYC 1985; Piezo Electric, NYC 1984, '85.

COLLECTIONS INCLUDE: Albright-Knox Art Gal., Buffalo; Morton Neumann Family Col., Chicago; American Can Co., Greenwich, Conn.; MOMA, Prudential Life Insurance, Lehman Brothers, Newsweeek, NYC; Library of Congress, Washington, D.C.

ABOUT: "Louisa Chase" (cat.), Robert Miller Gal., NYC, 1982, 1984; Who's Who in American Art, 1989–90. *Periodicals*—Art in America October 1984; ARTnews May 1981, December 1982; Arts Magazine January 1981, January 1984, May 1986; New York September 27, 1982; SoHo Weekly News January 3, 1980; Village Voice January 20, 1981.

***CHIA, SANDRO** (April 1946–), Italian painter, sculptor, and printmaker who was born in Florence. His father, an engineer who worked as a salesman for an American-owned machine-tool company, occasionally took his family on Sunday afternoon outings to the Uffizi Galleries. "Once," the son recalled in an interview in 1982, "I asked my father why a painter makes paintings. He said, 'When a painter is hungry, he paints an apple so he can eat that apple and be satisfied.' I thought it was such a marvelous thing. I had to be a painter."

In 1962, despite the misgivings of his parents, who wanted him "to be a professional, a lawyer, perhaps," Chia entered the Instituto d'Arte, the venerable school housed in the former stables of the Pitti Palace on the edge of the Boboli Gar-

SANDRO CHIA

dens. The school was not far from the Chia family's residence in the middle-class neighborhood of San Frediano, across the River Arno from central Florence. The materials and techniques of fine art were almost the entire curriculum, and Chia considers his five years at the Instituto "one of the most interesting periods of my life." His teachers were mostly artists, yet they never forgot that they were teaching a craft: "I remember how they would repeat to us that painting is a trade," he said to Gerald Marzorati in 1983. "I had an almost childlike curiosity about them. I never saw their paintings, and they never talked about them. They just taught you the basics: the chemistry, tempera, fresco, brushes. You would paint for eight-hour stretches. And they would never use the word 'art.' To be an artist was something more, something beyond the skills. It was something that happened *to* you—it could come to you or not. It was a secret."

The traditional craft of the artist seemed greatly undervalued in 1967–69, the years Chia spent at Florence's Accademia di Belle Arti. The radical political-cultural ferment of that time affected him deeply: "It was like being emptied," he told Marzorati. "There was only politics, slogans, demonstrations, student strikes. There was no material work. It was unthinkable to paint. Painting is a matter of something private. Everything was to be collective. This was the generation from which was to come the Red Brigades, the generation that believed art was possible only in the service of political ideas." Along with many of his contemporaries, Chia "came to believe" in these revolutionary ideas, but his turned out to be a false conversion.

°k ē´ ä, sän´ drō

Chia moved to Rome in 1970, a year after passing his final examination at the Accademia. A year later he mounted the first of several exhibitions at the Galleria La Salita. His early work reflected the arte povera movement, which was conceptualist in inspiration and one of the dominant forces in Italian art during the 1960s. *L'ombra e il suo doppio* (*The Shadow and Its Double*, 1971), from his first show, was an installation consisting of a stuffed bird and a plastic rose, lit from the side so that their shadows were projected against blank canvases on the gallery's walls. Such installations of found, natural materials constituted much of the artist's output during the first half of the 1970s. "I had given up," he said to Marzorati, "all those things I knew about painting. I had assumed as my own problem things which seemed to be the problem of the generation around me. I was even a bit late, perhaps, to be doing this sort of work. But I wasn't very well informed. In a way, I felt that perhaps I was experiencing something and working in ways that were not original, not me." Little by little, however, he began to paint again, while continuing to exhibit his conceptualist installations.

Chia's paintings—from the beginning they were almost entirely figurative in style—soon came to the attention of Gian Enzo Sperone, whose gallery, moved from Turin to Rome in 1975, became the focal point of the new Italian painting. Sperone also became the dealer of Enzo Cucchi, Francesco Clemente, and Mimmo Paladino, Italian artists a few years Chia's junior who were also abandoning conceptual art for figurative painting. That group of artists became known, in the catch phrase of the Roman critic Achille Bonito Oliva, as the "transavanguardia," by which he meant to describe their art's tendency to have "everything on the table in a revolving and synchronous simultaneity which succeeds in blending, inside the crucible of the work, both private and mythic images, personal signs tied to the individual's story and public signs tied to culture and art history." To other, more politically committed Italian critics, that new image painting, as it came increasingly to be called, was simply a regression, a conservative reaction to the hard-to-understand and uningratiating works of the conceptualist and minimalist movements. (Moreover, unlike new image painting, conceptual and Minimalist works lacked dramatic flair and generated comparatively little excitement among influential collectors.) "New image painting," wrote Ida Panicelli, "compensates the spectator for past 'difficult' art, offering 'easy' iconic interpretation. It returns art viewing to the galleries and museums, and consolidates, with increasing force, the power of the art market. The desire to be provocative at all costs, in pictorial terms, is merely a pretext to hide what lies behind—a restoration of the artist/artwork/market/collector relationship, which in previous years had been politicized and deeply questioned."

After a remarkable series of group exhibitions, including star turns at the 1980 Venice Biennale, Sperone brought his "three C's" (Cucchi, Clemente, and Chia) to New York City in 1980, just as the first of the so-called American neo-expressionists, led by Julian Schnabel, were beginning to show their work. "Professionally it was good for us," said Chia, referring to his having been grouped at first with his countrymen. "It was clear to us just watching each other that we were probably the best painters Italy could give at that moment. It probably couldn't have turned out as it has otherwise. We wanted to show paintings at the very core of the art world, not in some marginal gallery somewhere. But to paint in Italy then—it was so hard." All three painters have prospered greatly since.

Chia's paintings of the 1980s have a distinct and immediately recognizable style. They are almost always large in size, and are full of visual quotations from the work of earlier artists, especially Chagall, the German expressionists, and the Italian futurists and metaphysicals, notably de Chirico and Carrà. His figures are usually bulbous, sensuously modeled, and are painted with comparatively restrained brushwork. His backgrounds, on the other hand, are rendered boldly and quickly, in thickly applied pigment and with vigorous brush strokes. His colors are nonnaturalistic, with a general preference for sharp expressionist reds and greens. *Genova* (1980), a seven-by-thirteen-foot canvas, shows many of those characteristics. In the foreground, two huge male figures, arms outstretched, float Chagall-like across the landscape, which is dominated by a long, neoclassical facade, sharply painted, in perfect perspective, and straight out of de Chirico. The background to that spectacle is an angry, explosive expressionist sky. The painter's style has not changed radically since the early 1980s, and he has continued to use the most classical of materials: oil on canvas. "I use oil paint," he said in 1982, "because it has the richest possibilities. You can go over it as many times as you want, and it's still alive. The touch of the brush is always building and visible. If you use acrylics, it is always the last touch of the brush that is visible."

Many American critics have welcomed Chia and his compatriots, feeling that they are breathing new life into painting, an art form grown somewhat creaky from disuse. Others, however,

have been far from charmed. Robert Hughes, in particular, pictures the Italians as "floating to New York City like *putti* on roseate, gaseous clouds of hype." He sees Chia's talent as "light-operatic" in style, and his originality as "more national than real. It depends on the unfamiliarity of the sources he adroitly quotes. How many people in America have heard of, let alone seen, the work of Ottone Rosai (1895–1957), a Florentine painter whose roly-poly figures were part of a conservative reaction against Italian futurism in the 1920s? Chia has, and his rotund bodies—thighs like boiled hams, buttocks like blimps, coal-heaver arms—are straight out of Rosai, though bigger and endowed with a crustier decorative surface." More seriously, Hughes sees the giant figures in Chia's canvases as having Italian fascist forebears: they are descendants "of Mussolinian strength-through-joy nudes and post office murals from Turin to Ladispoli." The painter had discovered "how to take authoritarian images and render them cuddly, defusing their latent political content." Those paintings do not function as parodies, in that critic's opinion, but, in part because of their size, "look stodgy and overblown."

Chia remains resolutely unrepentant about his work: he has a flair for self-promotion, and even his greatest admirers would never accuse him of selling himself short. "It's very easy," he told Marzorati, "to criticize my art, and almost everything they are saying is in some way true. But when they say 'Italian,' this doesn't mean anything to me. It's lazy. Some of the imagery—it's part of my culture, it's what was around me, though the Italian art of this century is not too well known in Italy. But is it *Italian*? Italy is many Italies; Italy is an invention." He is most particular on the question of art and politics: here, he seems still to be reacting against the political indoctrination he received at the Accademia: "To say my work is not good politically, to say it has nothing to do with changing society—I completely agree. These critics, these people, want a conjunction between art and life. But art and life are not compatible phenomena. They want art taken into the streets. But the streets are everything but art! Art is too delicate. It cannot be in the service of political ideas."

Chia has exhibited a few monumental bronze castings, which have, in general, been less widely admired than his paintings. *Man and Vegetation* (1983), for example, presents a half-kneeling man, eight feet high, head thrust upward in defiance; vinelike tendrils climb over his huge, heroic limbs, which are changing into brick columns. To one critic, the work's combination of heavy realism and surrealist metamor-phosis seemed academic: the work "could have been made at any time over the past forty years by this or that peripheral antimodernist. That these sculptures look more reactionary than the paintings says something about Chia's relative skill as a painter, about the flexibility of figurative painting to absorb aspects of abstraction, and about the problems of using the figure straight, unadulterated even by geometry, in sculpture these days. It may be that sculpture's intermittent progress away from the figure is more irreversible than painting's."

Chia's etchings have not been widely exhibited, but as of 1982 he was regularly turning to them from painting as a form of relaxation. Etching, he told Danny Berger, "is a communicative channel with painting. Sometimes something from my painting transfers to prints, and sometimes it is the opposite. When I am in my studio, I have at my disposal the press, canvas, and pigments. I like to pass between the two disciplines. This makes the work grow, which can manifest itself in prints, painting, or drawing. As if one thing pulled along the other, or one thing grew on top of the other."

Chia maintains a studio in Ronciglione, a village about an hour's drive north of Rome, but spends increasing amounts of each year in and around New York, where he has a large loft and studio on West 23d Street as well as a house upstate. He is emphatic and voluble about the differences between the perception of art in Italy and America, and how happy he is to be in New York. "New York needs art," he has said. "Most people everywhere else don't know about it and are quite happy to live without it. Not here. So here I can work." He often speaks of the wandering artist, of how the American abstract expressionists learned so much from Europeans in the 1940s. "Now the Europeans are here again. Of course, we aren't trying to provoke anybody, we aren't against anything, like the abstractionists after Mondrian." Yet he will rarely let pass any opportunity to attack abstract painting. "Abstraction," he said in 1984, "is always against something. But for me, a painting is an adventure with its own aim. It has to go somewhere, and the viewer has to get something out of it. I think abstract painting lacks generosity: it doesn't give the viewer anything to hold on to. My figures do." One well-known painting of his, *The Painter and His Little Bears* (1985), makes that point with a good deal of irony. With a grand, invitational gesture, a heroically sized painter exhibits a freshly finished abstract canvas to an audience of five red teddy bears. The bears seem enthralled enough, but the spectator quickly realizes that they could simply have been posed to give that effect.

Also in 1985 Chia painted some spectacular murals for the Palio Bar in the Paine Webber building in Manhattan, between West 51st and 52nd streets. The bar is named for the famous twice-yearly medieval horse race in Siena. The murals, painted in hot colors in a flamboyant, neobaroque style, contain figures of men and horses. Chio rented a barn in Rhinebeck, New York to execute the paintings, which cover all four walls of the bar and have drawn favorable responses from the clientèle.

Chia was involved in an international art-world controversy in 1984–85. Charles and Doris Saatchi, the British couple who, thanks to an immense fortune made in the field of public relations, have amassed one of the world's largest collections of contemporary art in just a few years, decided to sell off all of their numerous acquisitions by Chia. The Saatchi Collection, for reasons that are not entirely clear, was determined to publicize these "dispersals," as they termed the sales, and did not permit the artist to buy back his own work. It was widely speculated that a clash of personalities was responsible for the affair, and that there was at least some attempt to denigrate the young artist's growing reputation. Yet nothing of the sort occurred; neither party appears to have suffered any lasting damage.

EXHIBITIONS INCLUDE: Gal. La Salita, Rome 1971, '72, '73, '75; Gal. L'Attico, Rome 1975; Gal. dell'Occa, Rome; Gal. Gian Enzo Sperone, Rome 1979; Art and Project, Amsterdam 1980; Gal. Paul Maenz, Cologne 1980; Sperone-Westwater, NYC 1980, '81, '82, '85, '87, '88; Gal. Bruno Bischofberger, Zurich 1981; Leo Castelli Gal., NYC 1983; Stedelijk Mus., Amsterdam 1983; Gal. Daniel Templon, Paris 1983, '88; "Six in Bronze," Williams Col., Williamstown, Mass. 1984; "700 Eichen," Kunsthalle, Tubingen, West Germany 1985; Akira Ikeda Gal., Tokyo 1986.

ABOUT: Bastian, H. "Sandro Chia" (cat.), 1985; Mazzoli, E. Sandro Chia/Enzo Cucchi: Scultura Andata/ Scultura Storma, 1982; Oliva, A. B. La Transavantgarde en Italienne, 1980; Geldzahler, H. "Sandro Chia: Bilder 1976–83" (cat.), 1983; Seymour, A. The Draught of Dr. Jekyll: An Essay on the Work of Sandro Chia, 1981.

CHICAGO, JUDY (July 20, 1939–), American painter, sculptor, designer, organizer, writer, and feminist, is an artist whose work is universal and global in concept. Passionate in her beliefs and an aggressive leader, Chicago successfully merges feminist and social concerns into art. An accomplished writer with four books to her credit, Chicago has created mammoth artworks that are historical in outlook, including

JUDY CHICAGO

The Dinner Party, The Birth Project, and her latest undertaking, *Holocaust,* which is yet to be completed. There is no doubt that Chicago's work reaches outside of museum walls.

Chicago has worked in many media. An artist of tremendous energy and intelligence, her subject matter often is concerned with female imagery; her work has been applauded by some art critics and derided by others. Highly motivated by her beliefs, Chicago tackles historical projects that take years to accomplish. In her scope, Chicago is unique among contemporary artists, who are often more self-absorbed than she.

Born Judy Cohen, Judy Chicago grew up in Chicago; her parents were secular Jews and did not require their children to go to religious school. "My father was an atheist, a radical and a labor organizer; his family gave me a strong sense of connection with being Jewish. My father himself was a natural teacher, and from him I got a kind of reverence for human life and struggle. He was very identified with the black struggle, the civil rights movements and equal rights for women."

"Being Jewish for me was always identified with high aspiration, which for me was expressed through artistic achievement. I was not oppressed as a child as a girl. In my family there was a lot of respect for being smart, and it did not matter what gender I was, and I was a smart kid. I know there have been a lot of stories about how patriarchal Judaism is and how many women have felt very oppressed by it. That was not my experience. I have always felt very connected as a Jew—connected to the cultural and intel-

lectual condition, to the fights for social justice in which so many Jews participate."

In her book *Through the Flower* Chicago states, "Because my mother worked and because I saw women participating fully in all the discussions that went on in the house, I grew up with the sense that I could do what I wanted and be what I wanted. . . . When I was three, I began drawing, and my mother, who had wanted to be a dancer, gave me a lot of encouragement. . . . Throughout my childhood, she told me colorful tales about the creative life, particularly when I was sick in bed, and these stories contributed to my developing interest in art, for from the time I was young I wanted to be an artist. My father, on the other hand, could never relate to my artistic impulse, so it was to my mother that I brought my artistic achievements and to my father that I brought my intellectual ones."

In 1947, at age eight, she started attending the Chicago Art Institute for art lessons. Later, following her father's wishes, she atteded Lakeview High School, rather than the all-white Senn High School in Chicago.

Her father died when Chicago was thirteen years old, and it was a traumatic experience for her. Her teens were a blur. Making a break with her hometown, Chicago attended the University of California at Los Angeles from 1960 to 1964, receiving a B.A. degree in 1962 and an M.F.A. degree in 1964. It was there that she married fellow student Jerry Gerowitz in 1961, who was later tragically killed in a car accident. Chicago continued to sign her paintings Judy Gerowitz.

In 1969 Chicago decided to identify herself as an independent woman. At her show at the California State College at Fullerton, she announced her change of name: "Judy Gerowitz divests herself of all names imposed upon her through male social dominance and freely chooses her own name, Judy Chicago."

In 1973 Chicago received the Woman of the Year Award from *Mademoiselle* magazine. With Mimi Schapiro, she founded the Feminist Studio Work Shop. As a teacher, she became actively involved in the Feminist Art Program at the California Institute of the Arts.

In 1974 *The Dinner Party* brought both fame and notoriety to Chicago. A five-year project, Chicago organized and supervised about four hundred women who donated their talents as ceramicists, needleworkers, stitchers, carvers, and china painters. Set on a large triangular structure, fifteen feet on each side, were thirty-nine individual place settings. Each setting included a china-painted ceramic plate set upon an elaborately embroidered runner. The runners incorporated techniques of lacemaking, needlework, and weaving, reflecting the period each woman lived in. Each individual place setting represented women of high achievement like Sappho, Mary Wollstonecraft, Isabella d'Este, or mythical female figures.

Chicago has commented on her concept of *The Dinner Party*. "A powerful work of art has the ability to shape the way we see reality which women have not participated in. We have participated in prevailing art values. And that's the other thing when you work alone, it's very difficult to buck a whole set of values by yourself, and that's one of the things women are learning. You don't take on sexism and change it yourself."

The work can be regarded as a landmark in women's art. In an article in *Newsweek*, the critic Mark Stevens commented, "The title is a reference, at once ironic and celebratory, to the place of women as preparers of the table. The principal techniques on display—china painting and needlework—were deliberately employed. Once passive feminine arts, they are now part of feminine values. . . . Her imagery owes much to O'Keeffe, whom she calls 'a mother of us all.' But many of her plates don't work. In the flowers of O'Keeffe the vaginal imagery is muted. In Chicago's plates, it often seems forced. . . . There is too much message and not quite enough art."

Despite repeated criticism of "vaginal art," the impact of *The Dinner Party* cannot be denied. Though the size of the exhibit made it difficult to circulate, it has been exhibited widely throughout the United States; it has been exhibited in museums, galleries and alternative spaces. *The Dinner Party* was also exhibited in England, Scotland, Canada, and, in 1987, in Germany. The following year *The Dinner Party* traveled to Melbourne, Australia.

In 1980 Chicago started *The Birth Project*, again a large undertaking, consisting of one hundred pieces and eighty-five exhibition units. The project took five years to complete. In it Chicago not only gives a new meaning to the concept of birth, but again transforms the traditional feminine craft of needlework and stitching into a new art form. *The Birth Project* has images ranging in size from six by nine inches to 140 by ninety-six inches. The needlework techniques used were quilting, needlepointing, smocking, weaving, macrame, applique, pulled-thread work, and crochet.

Describing the genesis of *The Birth Project*, Chicago has written: "I have approached the subject of birth with awe, terror, and fascination and I have tried to represent different aspects of this universal experience—the mythical, the

celebratory, and the painful." *The Birth Project* combines art, craft, and message; however, they are so closely interwoven that they are virtually inseparable.

Asked about her relationship to the one 150 needleworkers, Chicago stated: "Yes, I feel connected to the needleworkers and there is still this connection—but while the contact can be very close, it is in the context of the work, it is not a personal connection. Some of them were like my students that I taught; when the work was finished, I went on to other things."

Elaborating on the distinction between art and crafts, Chicago said: "In art the technique is in the service of the image, and in craft, the technique is something inherent and in itself; that does not mean that there are not a lot of situations where the line is unclear. In the case of the needleworkers I used the craft to make art. I have used a lot of fringe techniques in my work—needlework, plastics, china paint[ing], fireworks—and a lot of techniques that are not considered art."

Chicago kept meticulous records on *The Birth Project*, with which she put together a book. She considers women of all ages to be her natural constituency. Through the Flower, Chicago's nonprofit organization, is coordinating the touring of the project. The exhibition will be broken into smaller units to be shown in different parts of the country.

Chicago's values are not shared by the majority of contemporary artists, as she has freely acknowledged. "I would not want to be in the mainstream of contemporary art. The mainstream has taken a turn away from what I believe art is all about. It has become more concerned with commerce; commerce and fashion and decoration."

She has defined universal art and feminist art in these words: "I don't think there is any contradiction between those two. All feminist means to me is that it is a 'feminist experience,' that is, art from the point of view of a woman; if it had been from the point of view of a man, it would be universal! This is one of the problems when you are a member of a disenfranchised group: it is said it's *only* a woman's experience, it's *only* a black experience, it's *only* a Hispanic [experience; it] is not considered universal."

In 1986 Chicago had an exhibition at the ACA Galleries entitled "Powerplay." The exhibition dealt exclusively with men. The titles are self-descriptive: *Study for Driving the World to Destruction, Weeping Male Heads—If Only They Would, Power Headache: Disfigured by Power.*

In her introductory essay to the exhibition cat-alog, Paula Harper wrote: "In 'Powerplay' Chicago draws on her past pattern of aesthetic interests and her solid academic training to realize her new subject matter. Formally, the series extends Chicago's lifelong love of drawing, and her preoccupation with the interaction and fusion of color and surface, with two- and three-dimensional form, with a variety of media and materials combined, and with the highest level of craft. The series includes drawings, weavings, oil and acrylic paintings on Belgian linen, cast paper pieces and patinated bronze reliefs, all executed with an intense attention to technique. Each media modulates the expressive content in ways to illuminate the effect of different forms on similar imagery. . . . The large paintings are inhabited by symbolic figures in a surreal, transparent, prismatically colored space. They are not men but Man and they are, as Chicago says, 'on the planet.' The themes are power, violence and their consequences." *Driving the World to Destruction* deals with a class of men who "have the power that no human being should have, the power to destroy the planet. Who could handle the burden of that much responsibility? . . . It would drive one mad, literally power mad. Some men are victims of that—they can't help themselves, can't stop. Men need women to stop them. They can't do it themselves. But women can't, they are afraid." Those new images reflect an increasing maturity and Chicago's strong commitment to humanity.

Chicago lives with her husband, Donald Woodman, a photographer and designer, in Santa Fe. They live in a comfortable, old adobe house which has undergone a number of renovations. Her studio, which serves as both office and workspace, was recently enlarged to accommodate her current project on the Holocaust. In 1987 she and Donald and the weaver Audrey Cowan visited various concentration and internment camp sites in Germany, France, Austria, Czechoslovakia, Poland, and the Soviet Union.

Chicago and her husband are creating a large body of work that combines painting and photography on the Holocaust. In a newsletter on the Holocaust Project/1990, Chicago elaborated: "The images will represent the experiences of all those who were victims of the Holocaust and will transform those experiences into art that is understandable, accessible, and important to a wide audience of viewers, . . . Jewish and non-Jewish alike.

"The Holocaust occurred here on our planet and we hope to show—through our art—how confronting the reality of this tragic event can help us see and change the conditions under which we as a human species live so that another Holocaust can never occur."

In her newsletter, Chicago explained her purpose: "My mission as an artist has always been to express aspects of the human experience that have been forgotten in, omitted or distorted by history. Over the last fifteen years my work has been seen by hundreds of thousands of viewers around the world. My four books, chronicling the development of my art, and published in numerous countries, have been read by thousands of people. The continuing response to my work has shown that if art is made accessible and relevant to people's lives, it can have a profound effect."

Chicago's first artistic effort to deal with the Holocaust is a tapestry called *The Fall.* It is mammoth in concept, fifty-four inches high and eighteen feet long. It will be woven by Audrey Cowan and will take three to four years to complete.

A successful author, Chicago is nonetheless quite modest about her writing. Asked whether she enjoyed writing, she answered with a quotation from Dorothy Parker: "I hate writing, I love having written. . . . Writing is not my first love, it is mainly an outgrowth of my work."

Judy Chicago is a controversial figure in the art world because she challenges institutions and does not woo the art establishment. Her projects are large in concept and in execution. Her approach to art is without inhibitions, a direct reflection of her personality. She is a magician at synthesizing the raw material of daily experience and transmuting it into something universal. A creative artist with a quick intellect, she cares deeply for *la condition humaine,* and has stated, "I believe art must come out of its fortress and into our lives."

EXHIBITIONS INCLUDE: Pasadena Mus. of Art, Calif. 1969; California State Univ. at Fullerton 1970; Grandview Gal., Woman's Building, Los Angeles 1973; Artemisia Gal., Chicago 1974; JPL Fine Arts, London 1975; Quay Ceramics, San Francisco 1976; Ruth S. Schaffner Gal., Los Angeles 1976, '77, '79; Hadler-Rodrigues Gal., Houston 1980; Parco Gal., Tokyo and Osaka 1980; Robertson Gal., Ottawa, Ontario 1984; Marilyn Butler Fine Art, Scottsdale, Ariz. 1985; Contemporary Arts Cntr., Santa Fe 1985; Visual Arts Cntr. of Alaska, Anchorage 1985; Vancouver Mus., Canada 1985; Shidoni, Santa Fe, N.M. 1986; ACA Gal., 1984–86.

EXHIBITIONS OF THE DINNER PARTY INCLUDE: San Francisco Mus. of Modern Art 1979; Univ. of Houston at Clear Lake City 1980; Boston Cntr. for the Arts 1980; Brooklyn Mus. 1980–81; Mus. d'Art Contemporain, Montreal 1982; Art Gal. of Ontario, Toronto 1982; Glenbow Mus., Calgary, Alberta 1982–83; Edinburgh Festival Fringe, Scotland 1984; Warehouse, London 1985; Melbourne, Australia 1988.

EXHIBITIONS OF THE BIRTH PROJECT INCLUDE: Southeast Arkansas Art Cntr., Pine Bluff 1983; Moody Medical Library, Univ. of Texas, Galveston 1983; Indiana Univ., Bloomington 1984; Univ. of North Carolina, Chapel Hill 1984; Visual Arts Cntr. of Alaska, Anchorage 1985; Alberni Valley Mus., B.C. 1986; Grants Pass Mus., Oreg. 1986; Rosemont Art Gal., Regina, Saskatchewan 1986; Glass Growers Gal., Erie, Pa. 1986; Kodiak, Alaska 1986; Marin Civic Cntr. San Rafael, Calif. 1986; Philadelphia Art Alliance 1986; R. H. Love Gal., Chicago 1986; Bergen Community Col. Gal. 1986; Univ. of Rochester Student Union Gal. 1987; Fresno Art Cntr., Art Space Gal., Gal. 25, Phebe Conley Gal., Fresno State Univ. in Fresno, Calif.; Ella Sharp Mus., Jackson, Mich. 1987.

COLLECTIONS INCLUDE: Brooklyn Mus., NY; Los Angeles County Mus. of Art; Mills College, Oakland, Calif.; Mus. of Fine Arts, Santa Fe, N.M.; National Mus. of Women in the Arts, Washington, D.C.; Oakland Mus. of Art, Calif.; Penn. Acad. of Art, Philadelphia; De Cordova and Dana Museum, Lincoln, Mass.; First Women's Band, NYC.

ABOUT: Chicago, J. The Birth Project, 1985; The Dinner Party: A Symbol of Our Heritage, 1979; Embroidering Our Heritage: The Dinner Party Needlework, 1980; Through the Flower: My Struggle as a Woman Artist, 2d ed., 1982; Emanuel, M., et al. Contemporary Artists, 1983; Current Biography, 1981; Who's Who in American Art, 1989–90. *Periodicals*—Artforum October 1970, September 1974; Art in America April 1980; ARTnews January 1979; Ceramics Monthly May 1978; Chicago Tribune August 19, 1979; Chronicle of Higher Education April 16, 1979; Life May 1979, June 1979; Los Angeles Herald Examiner March 20, 1979; Los Angeles Times April 6 1978; Mother Jones January 1979; New York Times, April 1, 1979, April 8, 1985; New York Times Book Review September 15, 1985;. Newsweek April 2, 1979; St. Louis Jewish Light April 9, 1980; Seven Days April 1979; SoHo News October 22, 1980; Village Voice June 11, 1979, November 1, 1983; Washington Review October–November 1985; Womanspace Journal Summer 1973;

***CLEMENTE, FRANCESCO** (March 1952–), Italian painter, was born into a well-to-do family in Naples. His father was a judge and his mother a cultivated woman who loved to paint. She encouraged her only child to write poetry, which he began to do when he was about five. Solitary and somewhat melancholic, the boy recited his poems to his mother but turned to painting before reaching adolescence. "Painting," he explained, "became a way of realizing my sexual identity at an age when we are very conscious of sex, but I had always been exposed to art. Titian, Raphael, Goya, Caravaggio, Botticelli—they were all around me. And the frescoes of Luca Giordano." When he was 18, Clemente dropped out of school and moved to

°klem en´ tā

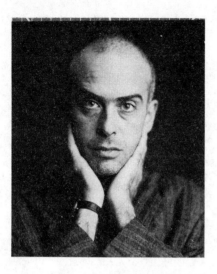

FRANCESCO CLEMENTE

Rome, where he took a studio and began to make drawings. "I wanted to do something on my own," he explained in an interview with Paul Gardner of *ARTnews* (March 1985). "I never went to art school. I like teachers. I don't like school."

In all, Clemente made about 800 drawings at this time. Although comparatively rudimentary, these drawings bore the stamp of his signature images, which Gardner described as "gargoylelike heads, nude goddesses, staring eyes, and ravenous mouths." These images, Clemente has explained, flow from his unconscious; they are informed by his reconstructions of lyrical fragments of half-remembered dreams and by the art of the past, with which he strongly identifies. According to Clemente, he is a "link in the long chain with the past. The Egyptians, Greeks, and Romans are still more alive for me than live people, other painters." Beyond those historical and personal sources, Clemente's imagery derives from the religious traditions of both the East and the West. In the early 1970s, for instance, he traveled to India, where he now spends almost half of each year studying Sanskrit and Buddhism. "The gods who left us thousands of years ago in Naples are still in India," he told Gardner. "So, it's like going home for me. In India, I can feel what it was like many years ago."

A gifted and elegant draftsman, Clemente had his first showings in Florence, Rome, Milan, and Turin well before he had turned 30. He achieved international recognition in 1980, when his work was shown at the Venice Biennale along with that of other promising young Italian

painters like Sandro Chia, Enzo Cucchi, and Mimmo Paladino. These painters, together with such Americans as Julian Schnabel and David Salle and such Germans as Jorg Immendorf and Georg Baselitz, were dubbed "neoexpressionists" by critics. Clemente has always shunned the label, especially since his work, however personal and poetic, has more to do with the frescoes of Giotto and Fra Angelico than the planar distortions and sociopolitical enthusiasms of Weimar Republic painters. In 1980 he and his wife, Alba, an actress in avant-garde theater in Italy, moved to New York City, where his work was very warmly received by gallery-goers as well as by critics and influential dealers like Leo Castelli and Mary Boone.

Clemente's hallucinatory canvases of this time stood out in their references to myth and allegory, especially in images that were disquietingly sensual. "Painting," Clemente has said, "is like making love." In his work there is an obsessive interest in the human face, with perhaps a narcissistic dimension, for the face depicted is almost invariably Clemente's own. He has explained that the "nakedness of the human face has a great attraction for me. It is the one part of the body that we do not cover. . . . The face, my face, is something I know. I'm interested in the body as a conductor between what we show on the outside and what we feel within. And this is reflected in our eyes, our mouths." His fascination with the human body also manifests an interest in the body's orifices. In *Circuito* (1981), for example, a baby issuing forth from its mother's womb is in a loving embrace with a man who stands in a suggestive position. *Interior Landscape* (1980), painted in bright red, depicts a lover's close-up view of a woman's sexual organs.

The figures in Clemente's paintings seem to be engaged in a quest for redemption, for the radiant innocence that is possessed only, and ephemerally, by the child. "Clemente," wrote Robert Storr in *Art in America* (November 1987), " . . . looks both East and back, drawing on a host of abandoned mystical systems to feed a contemporary appetite for semiotic complexity and a hunger for the marvelous. Yet (unlike the mystical German painter Josef Beuys), Clemente has no program of reform, no tangible social vision. . . . Clemente's stance represents a refusal to dichotomize the sensual and the intellectual. Above all, it is a quest for this unity that seems to guide his hand. 'I trust all those who have "thought" with their bodies. . . . ' he has said. And, one supposes, he mistrusts commensurately those who have not. Drawing after drawing reflects this preoccupation with the osmosis between mind and matter."

Clemente and his wife have two daughters and make their home in a Manhattan loft, on lower Broadway. The loft also doubles as the artist's studio. "The studio," observed Paul Gardner, " [has] a bookcase containing the works of Emily Dickinson ('She has perfect poems,' says Clemente), Ezra Pound, William Blake, and various philosophers. [It] is a vast space lined with windows, which shower the area with plenty of light, clearly an important factor in the artist's environment." Clemente has compared his adopted city to his native Naples, saying that "New York is also a pagan city, it is skeptical. I am fascinated with history, but New York is the present, it is the future. I have covered every inch of Manhattan. I do not go to art openings unless someone carries me, but with Alba and our friends I go to rock clubs in the East Village and jazz clubs in Harlem. Very few European artists have made it here since the '60s, so for me this is magic."

SUE COE

EXHIBITIONS INCLUDE: "Italy Two," Civic Cntr. Mus., Philadelphia 1973; São Paulo Bienal 1975; Gal. Gian Enzo Sperone, Rome since 1975; Europa '79, Stuttgart 1979; Venice Biennale 1980; "Westkunst," Cologne 1981; "Zeitgeist," Martin-GropiusBau, Berlin 1982; Documenta 7, Kassel, West Germany 1982; Mary Boone Gal., NYC 1982, '83, '84; Leo Castelli Gal., NYC 1984; Sperone-Westwater Gal., since 1981; "India and the Contemporary Artist," MOMA, NYC 1985; Ringling Mus., Sarasota, Fla. 1985; Walker Art Cntr., Minneapolis 1985–86; Dallas Mus. of Fine Arts 1986; Univ. Art Mus., Berkeley, Calif. 1986; Albright-Knox Art Gal., Buffalo 1986; "Avant-Garde in the Eighties," Los Angeles County Mus. of Art 1987.

ABOUT: Auping, M. Francesco Clemente, 1985; Bonito Oliva, A. The Different Avant-Garde: Europe/America, 1976; Francis, M. "Francesco Clemente: The Fourteen Stations" (cat.), 1983. Periodicals—Artforum February 1981, June 1982; Art in America November 1987; ARTnews March 1985; Flash Art November 1979; Kunstforum December 1982; Newsweek June 7, 1982; New York Times June 5, 1981; Village Voice September 17, 1980.

COE, SUE

COE, SUE (1952–), English-American illustrator and painter is noted for grimly incisive social commentaries which appear on the pages of major newspapers and magazines throughout Europe and the United States, as well as in mass-market illustrated books and gallery and museum exhibits. Backing off from the label of "political artist," Coe characterizes her work as "message art" aimed at bringing current issues to the attention of the broadest possible audience.

Coe was born into a working-class family in Tamworth (Staffordshire), England. She recalled her childhood in postwar London in an interview with Susan Gill in 1987: "I feel that my first political consciousness came with that early knowledge of bombed houses, bomb shelters, and family members talking about the buzz bombs." That experience translated into early childhood drawings of the war through which she herself had never lived; when she took up drawing again as a teenager, it was in a social realist vein.

Although her mother, a factory worker and amateur painter, encouraged her artistic pursuits, Coe (who worked in a mothball factory as a child) believed that a career as an artist was "out of the question because we didn't have money." But at sixteen she entered the Chelsea School of Art and three years later was able to continue at the Royal College of Art. "I got in for free, otherwise I couldn't have gone," she told Gill, explaining that the Labor party was then strongly committed to higher education for working-class students. Art schools in England have always been "hotbeds," she points out, and during her years at the Royal College, student rebelliousness took the form of punk: "We shaved our heads and wore brooches made of raw liver. We incorporated razor blades and blood in our paintings." As she noted in an earlier interview with Pat Hinrichs, the Royal College was completely unstructured: "You received no training whatsoever. What you did receive was a lot of equipment and [an] excellent library and a lot of support."

By the time Coe graduated from the Royal

College she was publishing drawings in English and European magazines, but the market was drying up, so, at the age of twenty-one, she decided to head for New York City. As she told the story to Valerie J. Brooks in a 1983 interview, she hopped on a plane with her portfolio and went directly from the airport to the *New York Times* and her first American commission: "I didn't have enough money even to get a hotel room so I asked to be paid straightaway, and I was, so I stayed." Between 1973 and 1978 she taught at the School of Visual Arts in New York while publishing her illustrations in an increasing number of newspapers and magazines, from the *Times* to *Ms.* and the *National Lampoon.* Throughout the 1970s she took on a variety of topical and controversial subjects—a series on the Ku Klux Klan that she began in 1973; another on Northern Ireland that grew out of a 1975 riot, "Terrorists and Mercenaries," begun in 1978; a parody of television game shows for the *National Lampoon*; a treatment of a mugging based on her own experience.

Like the long line of European social protest artists going back, in effect, to the pamphleteers and caricaturists of the sixteenth through the eighteenth centuries, Coe intended her works to speak to a mass audience if not to incite them and force them to take a stand one way or another. "Fine art and illustration, especially American," she explained to Lanny Sommese in a 1979 interview, "are too much involved in creating a mystique which the common person can't understand. I feel my typography, graffiti, calligraphy, or whatever you want to call it, is not only an important visual element, but provides the layman with a way of seeing and interpreting the artwork, thus demystifying it." To that end, working with a combination of drawing, tempera, watercolor, and collage, she used the imagery and formal conventions of the mass media—comic books, newspaper headlines, and the American television that had provided her own cultural fare as a child in London—to piece together visual vignettes that are gripping mainly in their rawness.

Grand Central Station (1976), for example, conveys the seediness of a big-city train station with the ironic representation of an injured man held by a policeman in the traditional pose of the *Pietà.* Even more emblematic is a *New York Times* illustration on the Ethiopian famine (1977): an emaciated mother and child form the centerpiece of a ghastly triptych with military men on one side and vultures on the other. And in *Strike* (1979), made for a union exhibition and book called *Images of Labor,* a teeming composition of black workers, white bosses, and factory machinery and clocks is held together by the

towering figure of a black leader and the title labeled across the bottom of the picture.

In 1979 Coe had her first solo exhibit, "All Over Town," at the Tom Thumb Gallery in London. Her reputation in Europe—and Japan—continued to grow, although she remained somewhat marginal in the United States, mainly getting one-time commissions for magazines and books: "I've done more spots than any other human being," she quipped to Brooks. While stressing that she was no commercial illustrator for hire—she did not accept "neutral" assignments, she told Brooks—she also kept a distance from mainstream notions of high art. Toward the end of the 1970s she did begin to pay more attention to fine-art models (at the same time that she introduced color into her previously black-and-white work), but, she explained, "I look much more at the moods of painters than their styles." Because her work was a response to ideas, not images, she insisted, style was unimportant.

In the early 1980s, Coe turned her attention to such topics as the Irish hunger striker Bobby Sand (who died in 1980), vivisection, and El Salvador. She toured Germany, Sweden, Switzerland, and Norway and then, in 1983, returned to England to visit the black community of Brixton and research the riots that had occurred there. The same year, she published her first book, *How to Commit Suicide in South Africa,* a kind of comic-book primer on apartheid, which she coauthored with the journalist Holly Metz. Aware of the situation in South Africa since the Soweto uprising of 1976 and the prison death of black power leader Steve Biko the following year, Coe was moved to undertake the book project in 1982, after the well-publicized "suicide" of labor organizer Dr. Neil Aggett (the first white South African to die in detention). *How to Commit Suicide in South Africa* combines Metz's carefully documented texts on South Africa, its politics, and its American corporate ties with Coe's nightmarish visualizations. The centerfold, for example, inspired by a newspaper photo of two men beating a black South African woman (the original image is collaged onto the drawing), shows Ronald Reagan holding the rope that binds the woman's hands.

For Coe, Metz's text, like the captions and quotations used in her earlier works, was essential to the overall presentation: "I don't like freeranged, loosely based paintings floating around," she indicated to Sylvia Falconer in a 1987 interview, explaining that without the text, *How to Commit Suicide* "would be a lot of indulgent S&M pictures, but the text gives it a viewpoint." In the opinion of *Artforum*'s Joe Lewis, Coe's "successful but chilling union of art and politics"

was "a very difficult book to (re)view" because, he acknowledged, "it makes you ashamed of being human." In fact, the book's main impact was outside the narrow world of art altogether; inexpensively printed and sold ($5 a copy) as a Raw Books and Graphics One-Shot, it found an avid readership on college campuses at the time of the divestiture movement, and according to Coe, "it became an organizing tool, which is our highest ideal of how the book can be used."

Following that successful venture—How to Commit Suicide went through two printings for a total of ten thousand copies—Coe turned to another means of mass-producing her art with a series of seven self-published photo-etchings based on earlier graphic works. These included two versions of her controversial drawing Woman Walks into Bar—Is Raped by Four Men on the Pool Table—While Twenty Men Watch (1983), based on a recent incident in New Bedford, Massachusetts where, as the title indicates, a woman was gang-raped before a crowd of onlookers. Uncompromising in its depiction of victim and predators, the drawing shows the woman spread-eagled on the pool table (seen from above) while the men grotesquely drop their trousers to the ground in anticipation. (The removal of a subsequent painted version from a museum exhibition on grounds of pornography provoked a demonstration by a group of irate women contending that "a woman has the right to depict rape.")

As an illustrator, Coe continued her visual assaults on a gamut of the world's ills, ranging from militarism and the threat of nuclear war to urban blight, but toward the mid-1980s she began to do individual paintings as well. As critics pointed out after her 1985 show of oils and graphics at New York's PPOW Gallery, Coe made no compromises to artistic sensibility in the new works, which she displayed unstretched and mounted from floor to ceiling. Rather, she used the new medium to intensify and eternalize the topical issues that were evoked much more ephemerally in her graphic works. That shift is perhaps most apparent in various reworkings of earlier graphic themes, such as Romance in the Age of Raygun (1984), a painted version of the New Bedford rape drawing now translated into a cubist-inspired composition (with particular echoes of Picasso's Guernica, not only in the emblematic lamp overhanging the pool table but in the three-part composition itself). The result was what Donald Kuspit approvingly characterized as "somewhere between political cartoon and history painting . . . an original, moral style of picture, in which social truth is hammered home without becoming artistically trivial." Borrowing a term he had earlier applied to the paintings of Leon Golub, Kuspit characterized Coe's new work as "psychotic realism"—essentially, a mad art created in response to a mad world.

The major undertaking of that period was a series of paintings on Malcolm X. After writing her book on South Africa, Coe explained to Susan Gill, "I wanted to do something about America, about racism here, and not just something exotic and far away." Once again she undertook extensive research, reading everything she could find on the life of the slain black leader, including FBI surveillance records. In the resulting paintings (which were exhibited at P.S. 1 in Long Island City in New York in 1986), Coe's customary roughness—in style and sensibility alike—is tempered somewhat by a visionary quality. The Assassins (1986), for example, is a Goyaesque night scene counterposing a ghoulish parade of killers and, in a mysteriously deep space, the wounded Malcolm and his attendants, with the audience in the theater where the murder took place.

The Malcolm X paintings were soon recycled into book form with another Raw Books and Graphics One-Shot succinctly titled X. As in How to Commit Suicide, the images were combined with elaborate commentaries—Coe's own text, written with Art Spiegelman (of Maus fame), and a chronology of "Concurrent Events" by the journalist Judith Moore. "My dream," she told John Yau in a 1986 interview, "is that people don't discuss the work but discuss the content. Of course the work has formal qualities. The form is given; content creates the form. But critics are concerned with form creating content." Indeed, certain critics were more prone to criticize "formal laxness" with the shift to oil. For New York Times critic Michael Brenson, for example, the paintings posed "considerable" artistic problems: while praising Coe as "one of the most inventive and gifted graphic artists around," he suggested that her desire to abstract events into good and evil ran a "constant danger of illustrations," further compounded by her apparent difficulties with the painting medium. Nonetheless, the artist had her defenders as well: "Her oils aren't badly done," commented Linda F. McGeevy in a review of Coe's four-year mini-retrospective, "Police State: 1982–1986." Dubbing her the "reigning Queen of Confrontation," McGeevy maintained that the violence and cruelty of her work was virtually unmatched among contemporary critical realists such as Leon Golub and Ida Applebroog, with the lone exception of the Austrian Josef Schüzenböfer.

As McGeevy and others have pointed out, Coe's art, for all of its polemical stance, is rooted less in political ideology than in ethics. Indeed,

"Police State" overwhelmed more than one observer with the unrelenting pessimism of the artist's vision. *Artforum*'s Ray Kass, for example, suggested that the work's "revolutionary spirit" was swallowed up by the artist's "own sense of visionary despair." For *Arts Magazine*'s John Longbery, meanwhile, the issue came back to the troubled union of art and politics, where, in the extreme (represented for him by the New Bedford rape paintings) the "obsession with the horror of the event" was "at odds with any imaginative account of it." But if Longbery was troubled by a seeming ambivalence "between those roles of impassioned radical and exuberant creator," Coe herself had no such doubts about her mission: as she explained to Sylvia Falconer in 1987, "When I go down to get a cup of coffee, there are six people sleeping out in my doorway who are dying of malnutrition. Am I supposed to step over them and pretend I'm in the art world? I'm not in the art world, I'm here."

A lanky woman with long blonde hair, Coe shares a walkup apartment on Manhattan's Upper East Side with her cat, Mauser. Following the publication of *X*, she began preparation of a new book on the 1973 overthrow of Chilean president Salvador Allende.

EXHIBITIONS INCLUDE: P.P.O.W. Gal., NYC since 1983; Gal. St. Etiene, NYC 1989; 57th Street Gal., NYC 1989.

COLLECTIONS INCLUDE: Arts Council of Great Britain; Edward F. Broida Trust, Los Angeles; Metropolitan Mus. of Art, NYC; Portland Art Mus.

ABOUT: Coe, M., et al. "Police State" (cat.), Anderson Gal., Virginia Commonwealth Univ. 1987. *Periodicals*— Artforum April 1984, September 1985, Summer 1987; Art in America January 1990; ARTnews October 1987, December 1989; Arts Magazine April 1985, February 1987, November 1987; Eye January 1987; Flash Art May–June 1986; Graphis no. 204, 1979–1980; New Art Examiner April 1987; New York Times April 19, 1985; Print September–October 1981. *Film*—Kladowsky, H. Painted Landscape of the Times, 1986.

COLESCOTT, ROBERT H. (August 26, 1925–), an African-American painter who has explored in his art the human condition and American social taboos. His paintings are narrative and figurative in style. The message can be savage, but it is also humorous and funky. He explores and reinterprets the Old Masters. Colescott appropriates ideas that are recognizable, but novel in their interpretation. His view of history can be vulgar, but it is also invigorating and forceful. He feels that blacks have been written out of Western history. His canvases are giddy and intense with color and visually exciting. Colescott provides the viewer with richly executed works which satirize racial and sexual mores. Though seldom subtle, his paintings can amuse, offend, and sensitize the viewer to familiar ideas made new by shifting the emphasis. His infectious spirit communicates his message forcefully. At the core of his art is the black experience and its role in history and society. It is Colescott's intelligent and ironic view of mankind, black and white, that makes his art universal.

Colescott was born in Oakland, California, where he spent his formative years. He attended grade school and high school in his home town. His parents were natives of New Orleans and moved to Oakland after World War I. His father worked on the Southern Pacific Railroad as a dining car waiter. Colescott said in an interview for *World Artists*, "I always painted and drew, but considered it something pleasurable and had no aspiration to become an artist. I was more interested in jazz and drumming. Education was of the highest priority to black families like mine. I took a class at the San Francisco State College with Edward Corbett, an ex-student of Clyfford Still, who was a very fine painter. His attitude proved to me that someone who knew about art appreciated what I could do and less than a year later, I started to study art seriously and became more involved. At first, when I got into college, I began to study things that were considered more practical. But I found out that I was not good at them. I liked history, but then I thought, is being a historian any more practical than being an artist? I decided at that point, I might as well do what I liked best. I chose to study art."

Having served in the U. S. Army in France, and armed with a degree from the University of California, Colescott returned to Paris. Funded by the G. I. Bill of Rights, he studied with Fernand Léger from 1949 to 1950. "Léger," said Colescott, "operated a small studio; his teaching was very simple—things were 'good' or 'not good.' The cumulative effects of these simple words added up to some powerful lessons in simplicty and monumentality. The fact that Léger would not look at my abstract work at all, convinced me to work figuratively, which I have done ever since."

Léger had told Colescott that he felt that abstraction didn't communicate ideas. "So I just figured, well I'm a student and I came all the way over here and this guy's not going to look at my work so I'm going to start working from

the figure to get his attention. And I did." Colescott also spent a lot of time visiting the museums of Europe.

In a conversation with Ann Shengold reported in the catalog "Robert Colescott: Another Judgement," the artist described his paintings and formal concerns: "I use a lot of colors; that's really important to me. I think the surface is important to me. Drawing is important to me. I think my sense of craft and my technique have developed in very personal ways. I can't give myself external assignments; I think the concreteness of drawing establishes a tactile rapport with the subject. I am really convinced of that. That's why, to me, the drawing is as important as color."

In 1952 Colescott received an M. A. in drawing and painting from the University of California, Berkeley. However, Colescott felt that the school was in the backwaters of contemporary art. While the dominant art form of the time was abstract expressionism, he learned about cubism and Cézanne. From 1952 to 1957, Colescott taught in the Seattle public schools system. From 1957 to 1966, he was associated with Portland State University in Oregon. He was the recipient of the National Endowment Arts Grant for Creative Painting in 1976, 1980 and 1983. Colescott presently resides with his wife in Tucson and teaches at the University of Arizona.

In 1964 Colescott spent a year in Cairo, Egypt, as the first artist in residence at the American Research Center. This represented a complete break in environment for him. He continued his stay in Egypt as a teacher on the faculty at the American University but in 1967 he was forced to evacuate from Cairo during the Six Day War.

In an interview at the University of Richmond in 1988, Colescott reminisced about his stay in Egypt:"The raw energy of Cairo is not like anywhere else. That brought a response and change. I had already been directing my work toward a change so I was ready for new influences. I responded to the art history there and the people; the 3,000 years of nonwhite culture affected what I did. In particular, I developed some thoughts about life and death and the futility of civilization, which came out in my work. I began to equate these ideas to things in America. It also changed some of my formal attitudes in terms of color and shapes."

Another journey abroad, to Paris in 1967–68, gave further stimulus to his work. Though Colescott, a Californian, is a product of a West Coast environment, he felt less influenced by the Bay Area school of painting. He had already left the San Francisco area when these artists abandoned abstraction and started painting figuratively.

Remembering and describing his earlier paintings, Colescott observed: "Abstract expressionism certainly did influence me, but I always had figures—I thing there is still some gesture in my work. I was already doing work that was a little on the de Kooning side."

Early in his career as a painter, Colescott was fond of doing preliminary sketches before tackling a painting. Having a definite idea, he would follow up with three or four watercolors or pencil drawings, exploring those ideas he wanted to emphasize in the final work. He is no longer doing these preliminary sketches, but works directly on canvas.

In an article in *Artforum* (March 1984) Lowery S. Sims of the Metropolitan Museum of Art characterized Colescott's work: "Although Colescott is impelled by one overriding purpose—to interpret black people into Western art—an important component of his art is consistent with the satirical approach. If we perceive a marked defensiveness in such a stance, a chip-on-the-shoulder attitude regarding official 'culture' then we can have a handle on Colescott's work. His esthetic affinities are with Dada, Surrealism and Pop art; . . . his politics are those of exclusion."

Significantly in the same article, Sims comments on one of Colescott's most successful paintings *George Washington Carver Crossing the Delaware* (1975). "On the most elementary level the humor is sourced by a familiarity with Emmanuel Leutze's original 1851 composition; Colescott replaces the whilte male revolutionaries (including one black man) with a boatload of black cooks, sporting lifes, mammies and banjo players, under the leadership of a scholarly, bespectacled "colored gentleman"—George Washington Carver standing in for the "Father" of the United States. Sims also offers an interesting commentary and description of Colescott's painting *Shirley Temple Black and Bill Robinson White* (1980). He commented: "Shirley Temple is depicted here as a little black girl, and Bill 'Bojangles' Robinson has become white. The switch forces us to wonder at the nature of this movie relationship; would it have been presented as quite so chaste and nurturing if the kindly, dependable butler and the curly-haired tyke had changed race? The Uncle Tom stereotype was so effectively [emasculating] that he represented no sexual threat to American white women and indeed could be entrusted with their welfare."

It is interesting to note what Colescott had to say about his two Shirley Temple paintings. In an interview with Ann Shengold he explained his ideas: "Well, they come from different

places. They come to me from my own experience. A lot of things in the paintings are autobiographical, although not in a precise, specific way; I get ideas from a lot of sources; I got my idea for 'Shirley Temple Black' from her name. She was Shirley Temple and then she married and became 'Black.' When she went to Ghana, as ambassador for the United States, I felt something in my insides, I should have known that when a 'Black' went to Africa as ambassador, it would be Shirley Temple. I have never met her, except in the movies. I have played with that a little bit, and I call it a "what if" painting. I think you can't be faced with Shirley Temple being 'Black' without asking why. What kind of a country would America have been if America's sweetheart was a black little girl? It isn't there, but it may be close enough to get you thinking about those things. That all started in my perverse mind, with just a play on words. There's another one, a sequel to this painting called 'Shirley Temple Black and Bill Robinson White' where I reversed the races of that dance team."

In an article titled "Colescott on Black and White" in *Art in America* (June 1989), Ken Johnson remarked: "Colescott paintings call attention to the exclusion of blacks from Western art history, while his exaggerated cartoon figures force us to wonder about the extent to which certain myths and fantasies about blacks remain with us today. . . . But racism, though it is his most salient theme, is not all that Colescott's art is about. Implicit in his work is a much broader cultural critique, an argument against the tendency of Western culture to discriminate not only racially but in all sorts of ways between what it designates as superior and what it designates as inferior."

In response to the many articles written about his work, Colescott, a lively and complex man, felt that "critical attention has been very good over the years, though there has been a tendency to overemphasize painting I did in the 1970s. Critics tend to write about my work because its literary precision gives them something to talk about." Asked about future plans, Colescott likes to take it one step at a time. He believes that irony plays an important part in his paintings. "I don't want them to be one-line jokes. I don't want them to be so abstract that they don't communicate."

He commented further on his status and role as an artist: "As to being a minority artist, I will try not to sound too pretentious, but as an example only, I am an artist in the sense that Picasso was. He was a Spaniard and did paint bulls derived from El Greco, and Goya as well as from Velazquez. *Guernica* was just one of his political

paintings. He painted from and about his background. My background is Afro-American, but I am an artist like other artists of any color or nationality painting from my background and about things that move me, or disturb me or people I love and identify with."

In a review in the *New York Times* (March 3, 1989) of a retrospective of Colescott's work from 1975 to 1986, John Russell stated: "Mr. Colescott today is now very much on his own where images are concerned, and many have diluvian quality, as if he had more ideas than he could cope with. There is no reason to think he will run out of them either."

Colescott's work has been described as avantgarde, daring, and humorous; his work has also been characterized as vulgar and obnoxious. He has been part of the figurative revival and of what was known as new image painting. His work actually predates that trend. Being a black artist, he has had to struggle, as an outsider, with the establishment, yet because of the shock value and literary roots of his work, art critics have come to terms with his vision.

Colescott communicates his ideas with humor that can be both biting and funny. He challenges the current attitudes of society and reserves for himself the freedom of a devil-may-care attitude. There is no doubt that some feelings of anger, bitterness, and alienation are expressed in Colescott's imagery. He tends to question established values and reserves complete freedom of expression for himself. Combative, but with his work rooted in the context of western civilization, Colescott engages the attention of the viewer and has ensured his place in art history.

EXHIBITIONS INCLUDE: Phyllis Kind Gal., NYC 1987, '89; "Robert Colescott: A Retrospective 1975–1986," San Jose Mus. of Art, Calif. and traveling exhibition; Contemporary Arts Cntr., Cincinnati, Ohio; Baltimore Mus. of Art., Md.; Portland Art Mus., Ore.; Akron Art Mus., Ohio; Mus. of Art, Univ. of Oklahoma, Norman; Contemporary Arts Mus., Houston; The New Mus., NYC; Seattle Art Mus., 1987–89; "The Eye of the Beholder: Recent Work By Robert Colescott," Marsh Gal., Modlin Fine Arts Cntr., Univ. of Richmond, Va.; Georgia State Univ. Art Gal., Atlanta, 1988; Koplin Gal., Los Angeles 1986, '88; Laura Russo Gal., Portland, Ore. 1988; Semaphore Gal., NYC 1981, '82, '85, '87; "Les Demoiselles D'Alabama," Semaphore East Gal., NYC 1986; "Robert Colescott: Another Judgement," Knight Gal., Charlotte, N. C.; "Robert Colescott, New Paintings," Dart Gal., Chicago, Ill.; "Here and Now," Greenville County Mus. of Art, Greenville, S.C.; "Robert Colescott, Paintings," Hadler/Rodriguez Gal., Houston; "Robert Colescott, The Artist and The Model," Inst. of Contemporary Art, Univ. of Pennsylvania, Philadelphia, 1985; Freedman Gal., Albright Col., Reading, Pa., 1983; Hamilton Gal., NYC 1979; John Berggruen Gal., San Francisco, 1978;

Razor Gal., NYC 1975, '77; Spectrum Gal., NYC 1973; Friedlander Gal., Seattle 1972; Portland Art Mus., Ore. 1958, '60; Fountain Gal., Portland, Ore. 1960, '66; Reed Col. Art Gal., Portland, Ore.; Salem Art Mus., Salem, Ore. 1961; Univ. of Oregon Mus. of Art, Eugene, Ore. 1960.

COLLECTIONS INCLUDE: Metropolitan Mus. of Art, NYC; Newark Mus. of Art, N. J.; Oakland Art Mus., Oakland, Calif.; Portland Art Mus., Portland, Ore.; Reed Col., Portland, Ore.; San Francisco Mus. of Modern Art; Seattle Art Mus.; American Research Cntr. in Egypt, Inc., Cambridge, Mass.; Bagley Wright Col., Seattle, Wash.; Brandeis Univ. Rose Art Mus., Waltham, Mass.; Columbia Col., Portland, Ore.; Delaware Mus. of Art, Wilmington; Greenville County Mus. of Art, S.C.; Univ. of Massachusetts, Amherst, Mass.; Univ. of Oregon, Mus. of Art, Eugene, Ore.; Victoria Art. Gal., Victoria, B. C.; Standard Insurance Company, Portland, Ore.; United States Steel, Pittsburgh; Hilton Hotel Col., Portland, Ore.

ABOUT: Artforum March 1984; Art in America November 1981, June 1989; ARTnews September 1984; Art Papers May/June 1985; Arts Magazine April 1979, December 1988; Artweek May 10, 1986; East Village Eye October 1983; Los Angeles Times April 24, 1986; Los Angeles Weekly May 9, 1986; New York Times April 6, 1984, November 15, 1985, March 3, 1989; Seven Days March 1, 1989; Village Voice January 14, 1981, April 26, 1983, March 21, 1989.

ROBERT COMBAS

COMBAS, ROBERT (May 25, 1957–), prime mover of the youthful *figuration libre* movement in France during the early 1980s, has developed into a seasoned painter on the French art scene. His comic-book imagery remains as irreverently crude, rude, satirical, and pornographic as it was at the beginning of his rapid rise to celebrity status, but in the intervening years he has arrived at an increasingly sophisticated visual idiom.

Combas was born in Lyon, but his parents moved back to their native Sète, in the southern region of France, when he was quite young. A town with a large immigrant population from southern Italy and Spain, Sète was, according to Combas, very alive politically but culturally dead. "People knew what was happening in Paris," he observed, "but it was still nowhere." He was one of six children in a family of modest means; his father, Mario, worked in a warehouse, and his mother, Raymonde, was a cleaning woman. Of his childhood, he has given few details apart from the fact it was "very unhappy" and that he was always drawing—from the age of one or two, he insists. "It might sound somewhat pretentious," he told Démosthènes Davvetas in 1987, "but I was born an artist, in the sense that right from the start my parents used to tell me I was an artist." In fact, it was his parents who took his work seriously enough to send him to weekly art classes at the local fine-arts school; "I wasn't all that happy to be there," he has recalled, " . . . but if my parents hadn't pushed me, I probably wouldn't have done anything by myself." His parents also exposed him to left-wing political culture, which not only gave him an ideological sense of his own social identity, but offered models of creative expression, notably the biting political cartoons of the satirical newspaper *Le Canard enchaîné*.

After high school Combas passed the entrance exam for the School of Fine Arts in nearby Montpellier (thirty-fourth out of the thirty-seven acceptances), and he started to recognize what it would mean for him, a working-class kid, to become an artist: "Maybe it was at that point that I realized I could use my childhood to get ahead." Nonetheless, he did not thrive in the structured atmosphere at Montpellier, a situation further complicated by his living at home and having no place to work by himself. But at the same time, he was closely involved with a group of friends in Sète—Hervé Di Rosa, who had been in his childhood art classes, Di Rosa's brother Richard (Buddy), and Catherine (Ketty) Brindel. What brought them together was a passion for comic books, graphic arts in general, and rock music. In 1979 they started a magazine, *BATO*, as a "work of assemblage art" consisting of their own collective drawings, reproduced by hand (in one hundred copies) since they had no money for printing. Combas, Ketty, and Buddy DiRosa also formed a rock band, Les Démodés

(The Obsoletes), which played in local clubs and got as far as Avignon and a write-up in the Paris daily *Libération*. Their music, Combas recalled, was "quite simple, quite harsh, with really elementary rhythms. It was really weird though, considering that there were three of us, that there was no bass, and that the one with the electric guitar [Combas] didn't know how to play."

In the fall of 1979, Hervé Di Rosa moved to Paris to study at the School of Decorative Arts; shortly afterward, Ketty went there as well to act in a film, and Combas decided to join her for a couple of months before completing his last year at Montpellier. At some point during his last two years of art school (his accounts vary), he had started doing paintings as well as drawings. In much the same way as his New York contemporaries, the graffiti artists and the young punks of the East Village, he exercised his art on every possible surface—doors, tables, cardboard cartons, and sheets—and for his imagery, he drew on the comics, TV and magazine ads, and his own postadolescent imagination. But his brief stay in Paris brought him in contact with another important subculture, the African and Arab immigrants in the neighborhood of Barbès, and that, he said, made him aware of his own Mediterranean origins. The street life that he saw in Barbès, and especially the ethnic stores with their colorful signs and products, inspired him to start a sketchbook, in which, he has explained, "there were all the ideas that I was later going to develop: the comic-book frames, images brought together in Zen-style, abstract calligraphy influenced by Mirò and the warm countries."

Combas was then twenty-two years old and preparing for his final diploma review at Montpellier; in the eighteen months that followed, through a combination of talent, timing, and several strokes of good luck, he became one of the hottest new painters in France. In the late spring of 1980, when he presented the first of his comic-book paintings and drawings for his diploma review, one of the jury members, Bernard Ceysson, promptly invited him to participate in "Après le Classicisme," an international exhibition of contemporary art at the Museum of Art and Industry in St. Etienne. Seen alongside the work of the Italian new image painters and the German neo-expressionists, Combas's two untitled paintings—one on unstretched canvas, the other on plywood—attracted immediate attention as a sign of new stirrings in the French school as well. According to Combas, he was not looking to sell his work—"It was meant to be provocative and nothing else," he told Davvetas—but he caught the attention of the dealers, and the collectors began to form a line.

After graduation from Montpellier, Combas went back to Paris, where Ketty was staying with Hervé Di Rosa and another friend from Sète, photographer Louis Jammes. Their idea was to continue making collective illustrations, and they succeeded in convincing *Libération* to do a special black-and-white supplement. But along the way, another fruitful coincidence contributed to Combas' career: in the course of looking for an apartment, the father of a friend, François Boisrond, met an art critic who was not only moving but looking to organize an exhibit to commemorate the event. Boisrond Sr. proceeded to introduce his son and his son's friends to Bernard Lamarche-Vadel, with the result that in June 1981, Combas, Di Rosa, Boisrond, and five others were featured in "Finir en Beauté" (To End in Beauty). Combas was already recognized—his first one-man show, held that month at the Galerie Swart in Amsterdam, was completely sold out—but Lamarche-Vadel had calculated that a group of young artists would be taken more seriously than isolated individuals, and he was right: they immediately became a movement. Within a couple of months, artist-critic Ben Vautier had given them another exhibit and a name—*figuration libre* (free figuration). In an interview with *Libération*, Vautier characterized the youthful group as "30 percent anticultural provocation, 30 percent *figuration libre*, 30 percent *art brut*, 10 percent madness," concluding that "the whole gives something new." Exactly a year after Combas's breakthrough in St.-Etienne, the group received official recognition by their inclusion in the "Ateliers 81/82" exhibit organized by the Museum of Modern Art of the City of Paris.

Combas had no hesitation about asserting his status, declaring in the "Ateliers 81/82" catalog that he was "as you may already know, the leader of *figuration libre* in France." He was also quite adamant about the originality of his work; often asked about his relationship to the new image painters and the neo-expressionists, he disavowed any influence: a teacher at Montpellier had told him about the others in his last year of school, he explained, but "it had no connection whatsoever with what I was doing. . . . I personally was trying to create a brand-new style of painting from the very start." The influences he did acknowledge ranged from African painters to textbook illustrations, Picasso and Mirò to comic books, art brut to pseudo-Arabic calligraphy. "Like Jules Verne," he wrote in the "Ateliers 81/82" catalog, "without leaving my house I went to Timbuktu."

And indeed, the distinctive element of his early work in 1980–81 was the seemingly unconscious way in which he combined images from

the comics, record jackets, magazine ads, and Barbès shop windows, crowding the surface of the paintings with decorative detail in an attempt to create what he called a "universal language." The untitled canvas shown at St.-Etienne, for example, juxtaposes a bathing beauty, three frogs, and a spray of outsized Italian peppers between two vertical borders of imitation Chinese and Arabic calligraphy. The implications of such a mix, totally devoid of the aestheticizing finish of the 1960s artists, are stated outright in the title/caption of a 1981 painting on cardboard (showing two comic-book characters, Flash and Tatou, playing Ping-Pong, accompanied by the appropriate sound effects— FLASH! TATOU!! ping-pong-ping-pong-ping-pong): "Flash and Tatou play Ping-Pong . . . It's unbelievable to see a thing like that being art."

While Combas cultivated the image of the youthful rebel, for whom rock 'n' roll and comic strips were more important than books and art museums, he was no naïve painter. According to Hervé Di Rosa, who apparently did fit that model as a teenager, Combas used to bring him art books and talk about art brut and pop art, along with African sign painters and other ethnic artists. And in fact, a work like *Gorilee* (1980) pairs up a green man, a dragon, and a winged monster with one of the nudes from Picasso's *Demoiselles d'Avignon* and a Christlike figure suspiciously close to Rouault.

In retrospect, it is clear that Combas and the rest of *figuration libre* were presented by art dealers as ferocious iconoclasts in order to appeal to collectors who were bored with the recondite theories and fussily intellectualized trends that artists of the 1970s had promulgated and subscribed to. As more than one critic pointed out at the time, the enthusiasm that greeted those youthful painters, and especially Combas, was not unrelated to the demands of an otherwise stagnant French art market. After twenty-five years of following the American lead, France, like Germany and Italy, suddenly had something of its own to offer, and to sell. In 1982 Combas, Di Rosa, Boisrond, and Rémy Blanchard had a show at the Holly Solomon Gallery in New York as part of "Statements One," a cultural exchange organized by the French government; later in that year, they and their friends designed subway posters for "L'Art en Sous-sol, ou Félix Potin vu par la Figuration Libre" (Art Underground, or Felix Potin seen by Figuration Libre), which was essentially a giant publicity campaign for a Paris grocery chain. Another group of posters that year were sponsored by the Paris newspaper *Actuel*, and the release of a record called "Taxi Girl" became an occasion for

Combas to execute a public painting on the Champs-Elysées.

His work during that period did not change— on the one hand, iconic juxtapositions of incongruous images like *Les Sabres, allure slave* (Sabers, Slavic Look, 1982), a two-tiered painting with the head of a Slav above and free-floating sabers and pseudocalligraphy below; on the other, elaborate narratives in comic-book style, full of sex, violence, and lengthy captions like *Punks, Rockers, Skinhead, Mods, Hell's Angels et Country Rock en Pleine Bataille d'Amour* (Punks, Rockers . . . Fighting It Out Over Love, 1982), also in two tiers, with a single combat above and a grotesque free-for-all below.

It was only the following year that Combas's style began to evolve significantly. Di Rosa and Boisrond went off to the United States on French government grants; Combas, who had also visited New York at the time of "Statements One," preferred to stay in France; "The Americans don't need me," he explained, "but France needs its artists." The choice of words would seem to be significant: if Di Rosa insisted that *figuration libre* was "not about painting; it's about comic strips," Combas was clearly introducing more pictorial concerns into his comics. The themes remained tenaciously and sometimes offensively the same, but the images took on a greater fluidity: the surface of the painting was no longer simply filled, but patterned, as juxtapositions of figure and ground gave way to allover designs. For example, in a kind of family potrait, *Ketty et le chat Voyou et moi caché sous le drap . . .* (Ketty and Voyou the Cat, and Me Hidden Under the Sheet for Fear the Cat's Going to Eat My Feet or Tickle Me. What a World of Contentment, 1983), the figure of Ketty floats in the air in a manner redolent of the lovers in Chagall's *The Birthday* (1915); all the empty space around her and the cat is filled in with tiny white figures of naked warriors, musicians, Combas's private collection of triangle-headed figures, and the caption, while the rest of the canvas is taken up with the bright purple and yellow patterning of the sheet. A prominent element in this and other compositions is Combas's signature, now in the form of a fixed logo that he copied from his first identification card; "the signature of the autodidact, of the illiterate," he contends, explaining that "it goes totally with that decorative side of my paintings, as a little picture that I like to have inside the canvas."

His preoccupation with design soon translated into a kind of monumental colored drawing incorporating his lengthy written captions. *La Pluie* (The Rain, 1984), for example, is a visual mélange of pornography, caricature, and self-

portraiture that has very little to do with rain except for a couple of "peering clouds" at the top and the lengthy written explanation that "Rain is a transparent liquid, carried by white clouds that become gray when they're full (of rain, to be sure). They got filled up in the sky by God's cisterns. Then the clouds go on to their destination, peeing down rain on our fields and our heads." The function of the caption here is obviously not to describe or encapsulate, but to elaborate, as a verbal equivalent of the intricate visual imagery. In contrast to the austere wit of a Klee or a Magritte, Combas pours out his Sètois slang with seemingly little reflection; like his signature, it is the mark of the autodidact turned artist. As he explained in a 1985 interview with Françoise Bruetsch and Didier Moiselet, he started incorporating words and phrases into his work when he was still in art school, not simply because of the comics, but because he was trying to overcome his own inhibitions about writing: "I wanted to turn my writing, which I thought was marginal, or rather mediocre, into something artistic, so that it would enter the culture," and, he added, "I did."

In 1984 the twenty-seven-year-old Combas had his first retrospective, in Marseille; by that time figuration libre was still providing an umbrella for contemporary art exhibitions here and there, but as the members of the group began to emerge as individual artists—with Combas in the forefront—the significance of the original movement, such as it was, began to be seen in a different light. As Delphine Renaud pointed out in a review of the Marseille exhibition, Combas's success with a nonspecialist public attested to the "resonances" his work found with an entire generation weaned on TV and pop culture. But these "resonances," she continued, went beyond the trappings of comic-strip characters and punk rock: "In an era when utopias and revolutions no longer summon up energies, withdrawing into oneself, into a universe reinvented by each person and all the more comforting for it, often appears as the only possibility."

Combas's work since 1984 accords well with such an emphasis on the "me generation." Indicating that the comic strip is "blocked," he has added new themes to his repertoire and tightened his visual idiom, although subject and form ultimately remain subordinate to his personal statement, which is identified by his logo, itself reminiscent of the "signatures" on designer jeans and T-shirts. When, for example, his dealer funded a series of variations on classical paintings, he used the opportunity to experiment with depth and perspective, but the results were more caricatural than formal. For example, in Le Narcisse (1985) a comic-strip Narcissus is perched on the banks of a shimmering, multicolored river with a drugged-out look on his face. Similarly, Le Bacchanale (1985) suggests an anarchic, 1960s vision of a drunken brawl on New York's grim Lower East Side, with Bacchus advertising a cheap brand of wine.

In an essay on "The Combas Paradox, " Didier Semin suggested that painting plays much the same role for Combas that literature did for Jean Genêt: "to compensate for an original defect—being born into a modest family, a culture made up of pop music, newspapers, and fairy tales—not by hiding it (or glorifying it naïvely, which amounts to the same thing), but by giving it a kind of pride of place in an exemplary and unquestionable visual schema." In Semin's view, "Everything happens as if painting [were] the stage where he accomplishes the contradict[ory] desire to be recognized (as the only, the best, the first) without at the same time being compromised (by the market, the milieu) or, as Cézanne put it, being 'taken over.'" At the time of his third major exhibit, held at the Museum of Contemporary Art in Bordeaux in 1987, Combas was living in Paris with his companion, Ketty Brindel, and their two cats, and painting in a borrowed studio just outside the city. He continues to avoid the art world, preferring to spend his free time with friends, watching old movies and game shows on television, and making his way through the immense stack of newspapers and magazines that he buys every month. For him, the recognition that he has achieved at such a young age and so quickly is "the proof that what I do—assuming it's not seen as idiocy or trash—is important and new. It's the proof that a person who's average from the standpoint of intellect and other capacities can create. It's the proof that anyone can do something creative if they want to go to the trouble and especially to do personal things."

EXHIBITIONS INCLUDE: Gal. Errata, Montpellier 1980; Gal. Eva Keppel, Düsseldorf 1981; Gal. Swart, Amsterdam 1981, '82; Gal. Yvon Lambert, Paris, from 1982; Gal. Baronian-Lambert, Ghent 1982; Gal. Bernier, Athens 1982; Gal. Il Capricorno, Venice, from 1982; Gal. Buchman, St. Gall 1983; Leo Castelli Gal., NYC 1983, '86; Gal. Le Chanjour, Nice, from 1983; ARCA, Marseille 1984; Mus. de l'Abbaye Ste.-Croix, Les Sables d'Olonne 1985; Gemeentemus., Helmond 1985; Halle Sud, Geneva 1985; Foundation du Château de Jau, Cases-de-Pene 1985; Mus. d'Art et d'Industrie, St.-Etienne 1986; Mus. d'Art Contemporain, Bordeaux 1987; Stedelijk Mus., Amsterdam 1987. GROUP EXHIBITIONS INCLUDE: "Apres le Classicisme," Mus. d'Art et d'Industrie, St.-Etienne 1980; "Finir en Beauté," Paris 1981; "2 Sètois à Nice," chez Ben Vautier, Nice 1981; "Quoi de neuf," Espace Cacherel, Paris 1981; "to End in a Belief of Glory," Paris 1981; "Ateliers 81/82,"

ARC Mus. d'Art Moderne de la Ville de Paris 1981; "L'Air du Temps," Gal. d'Art Contemporain des Mus. de Nice 1982; "Reseau Art," Art and Prospect, Paris 1982; "Figuration Libre," Gal. Fernando Pellegrino, Bologna, and Gal. Marilena Bonomo, Bari 1982; "L'Art en Sous-sol la ou Félix Potin vu par Figuration Libre," Paris Métro 1982; "Statements One," Holly Solomon Gal., NYC 1982; "Perspectives 82," Basel Fair 1982; "Peinture en Direct," Comédie de Caen 1982; "Figures Imposées," Espace Lyonnais d'Art Contemporain, Lyon 1983;"Blanchard Boisrond Combas Di Rosa," Groningen Museum (Netherlands) 1983; "New Art," Tate Gal., London 1983; "Bilder aus Frankreich," Gal. Krizinger, Innsbrück 1983; "Neue Malerei aus Frankriech," Gal. Hans Borlach, Hamburg 1983; "Fransen en Amerikanen," Groningen Mus. (Netherlands) 1983; "Trans figuration," ARCA, Marseille 1983; "New French Painting" (trav. exhib.), Riverside Studio and Gimpel Fils, London; Mus. of Modern Art, Oxford; Fruitmarket Gal., Edinburgh 1984-85; "France une nouvelle géneraton," Hotel de Ville, Paris 1984; "Légendes," CAPC, Bordeaux 1984; "French Spirit Today," Univ. of Southern California Art Gal., Los Angeles 1984; "Individualités," Gal. d'Arte Moderna, Rome 1984; "Rite, Rock, et Rêve," Mus. des Beaux Arts, Lausanne 1984; "Paris-New York," Robert Fraser Gal., London 1984; "5/5 Figuration Libre France USA," ARC Mus. d'Art Moderne de la Ville de Paris 1985; "Autour de la B.D.," Palais des Beaux Arts, Charleroi 1985; "Anni Ottanta," Gal. Comunale d'Arte Moderna, Bologna 1985; "La Methode ABD," Mus. de Beaux Arts, Angoulême 1985; "La Couleur depuis Matisse" (trav. exhib.), Louisiana Mus., Humlebaek (Denmark); Palais des Beaux Arts, Brussels; Mus. des Beaux Arts, Nantes; Royal Scottish Mus., Edinburgh 1985-86; "Luxe, Calme, Volupté," Vancouver Art Gal. 1986; "Zeitgenössische französische Malerei," Gal. Krings-Ernst, Cologne 1987.

COLLECTIONS INCLUDE: Gemeente Mus., Helmond; Mus. de l'Abbaye Ste.-Croix, Les Sables d'Olonne; Fonds National d'Art Contemporain, Paris; Stedelijk Mus., Amsterdam; CAPC Mus. d'Art Contemporain, Bordeaux; Groningen Mus. (Netherlands).

ABOUT: Perdriolle, H. Figuration Libre, 1983. Catalogs—"L'Air du Temps," Galerie d'Art Contemporain des Musées de Nice, 1982; "Anni Ottanta," Galleria Comunale d'Arte Moderna, Bologna, 1985; "Après le Classicisme," Musée d'Art et d'Industrie, St.-Etienne, 1981; "Ateliers 81/82," ARC, Musée d'Art Moderne de la Ville de Paris, 1981; "Autour de la B.D.," Palais des Beaux Arts, Charleroi, 1985; "Blanchard Boisrond Combas Di Rosa," Groningen Museum, 1983; "5/5 Figuration Libre France USA," ARC Musée d'Art Moderne de la Ville de Paris, 1984; "Ecritures dans la Peinture," Villa Arson, Nice, 1984; "Figures Imposées," Espace Lyonnais d'Art Contemporain, 1983; "France, Une Nouvelle Generaton," Hotel de Ville, Paris, 1984; "French Spirit Today," University of Southern California Art Gallery, Los Angeles, 1984; "Legendes," Musee d'Art Contemporain, Bordeaux, 1984; "Luxe, Calme, Volupté," Vancouver Art Gallery. 1986; "La Methode ABD," Musée de Beaux Arts, Angoulême, 1985; "New French Painting," Museum of Modern Art, Oxford, 1983; "Perspektive 82," Kunstmesse, Basel, 1982; "Richard Combas," ARCA, Marseille, 1984; "Richard Combas Peintures 1985-1987," capc Musée d'Art Contemporain, Bordeaux, 1987; "Robert Combas Retrospective," Musée de l'Abbaye Ste.-Croix, Les Sables d'Olonne, 1985. Periodicals—Art in America Summer 1982, September 1982; Artistes June-July 1982; Beaux-Arts March 1987; Connaissance des Arts April 1983; Kanal July 1987; Studio International no. 1004 1984.

CRAGG, TONY (1949-), British sculptor, was born in Liverpool. He studied at the Gloucestershire College of Art in Cheltenham, at the Wimbledon School of Art, and from 1970 to 1973 at the Royal College of Art in London. Since the mid-1970s he has lived and worked in Wuppertal, a small industrial West German city near Essen in the Ruhr.

Despite his relative youth, Cragg—whose career began to come into full focus in the 1980s—is seen as one of the foremost practitioners of bricolage sculpture, which reuses discarded pieces of manufactured material, in his case mostly plastic, transfiguring them into something memorable. It is the things he makes of the detritus of modern civilization, the robust irony that informs his work, as well as the deep resonance and tension in that work between material used and meaning intended, that have won him international acclaim.

The artist's work has, in retrospect, shown considerable consistency of purpose and even linear development since the early 1970s. In 1970 he was placing objects found on a beach within grids of squares drawn in chalk on concrete blocks. The objects he used then were primarily natural—shells, pebbles, sand, pieces of wood, string, paper, and even plastic bags. The grid pattern occasionally served to classify the objects, but any strong sense of the artist's personal involvement was missing. In 1971 he drew on a beach a random sequence of numbers: they were similar in shape to the machine-readable numerals found on bank checks, but their outlines were filled with seaweed, and he later added other found objects to the assemblage. Here again he emphasized the fusion of and tension between a mechanical language, in this case numbers, and the material reality of found objects; yet his ratiocination here was markedly less intense than it was to become. In 1973 he produced Drawing, today memorialized in a sequence of photographs. In each photo he is seen adding another rough chalk outline of himself against the wall of his studio; all the outlines cap-

ture the same static pose. In the same year he worked with bricks, stacking them until they fell, or sticking them to a wall and tracing their falling paths as the elastic holding them gradually gave way. Those works seemed to explore the relationship between an object and the action that produces or controls it. Most of the aforementioned pieces, indeed most of the work Cragg produced up to the mid-1970s, is documented today only in photographs; if there is one theme running through it all, it is an interest in the fragment. In a remarkable series produced in 1976 and still in existence, he smashed plates, spreading the fragments in ever-wider circles. In one of those works, only one shard can be seen from any given vantage point. As the fragments' dispersal increases, the idea of the plates' wholeness becomes increasingly abstract. In 1977 he was compressing various sorts of found objects—natural materials and manufactured goods—into solid geometric forms such as cubes and prisms.

New Stones—Newton's Tones (1978) represents a watershed in the progress of Cragg's art, as well as an early sign of a distinct change of direction in British sculpture. The eleven-by-eight foot piece consists of small plastic objects and fragments of objects equally spaced across a floor. The few objects that are still whole—a bottle cap, a water pistol, a comb—offer the viewer a sense of scale, but most of the material is unrecognizable—broken plastic fragments, useless rubbish. As Michael Newman wrote, however, the artist "reuses these objects by reclassifying them within the rectangle—arranging them not as to use, but according to the chromatic sequence of Newton's spectrum, from red to violet. This unexpected method of organization emphasizes the objects' loss of function and redirects our attention toward their material presence in the world. . . . The principle by which Cragg chose to arrange them is a given law of nature and not arbitrary or subjective; we are asked to consider their relation to the natural universe." It was snidely remarked that the work, the centerpiece of Cragg's first one-man show in 1979 at the Lisson Gallery, London, seemed to be a riposte to Richard Long's *Driftwood Line* and similar pieces shown at the Whitechapel Gallery in 1977. Yet where Long's work of the period used found objects or rural and natural origin and seemed essentially romantic and rural itself, Cragg's art is grounded in urban reality and the many ways of perceiving it: the city's landscape is full of the shards of modern civilization; his genius is to have made that landscape seem just as natural as "new stones," he created a new way of looking at the modern urban, social environment, and in addi-

tion he made something of striking, profound beauty from a material generally considered unartistic and even antiaesthetic.

Having found so satisfactory a means of expression, Cragg adumbrated his vision in many different ways. In *Black and White Pile* (1980) he massed objects, one on top of another, into two side-by-side rectangles, one side consisting entirely of white found objects, the other of black. Those objects are not entirely made of plastic, but include rubber, metal, and ceramic, even expanded polystyrene. The effect is one of great power: at once repellent, impressive, and beautiful. According to Newman, "Again a comment is being made on the absolutism of an earlier aesthetic: the too-easy unity of the monumental minimalist cube." *Pile: Red Skin* (1980) was Cragg's first work to use a recognizable "natural" form. Within the profile suggested by a child's toy—a plastic American Indian—red plastic shards were spread across a floor. Such "natural" forms were much in evidence in the spring of 1981 when, for an exhibition at the Whitechapel Gallery, he spread his found objects across walls for the first time. Here were shown his now-famous plastic-shard sculptures of the Union Jack, the royal crown, a submarine, and a soldier in riot gear. Another piece, *England Seen from the North* (1981), which is owned by the Tate Gallery, is a multicolored map of Britain on its side being regarded by a life-size figure—all in plastic fragments.

Sponsored by the Nouveau Musée of Lyon, France, Cragg spent some time during 1981–82 working in an abandoned factory in that city, using as his material the refuse he found lying about the building. The pieces he produced there are concerned with scale, and the found objects that constitute them are arranged in several ways: an axe head consisting of wooden objects and those that resemble wood; a horn consisting of blue objects of all sorts; and a canoe made of several kinds and colors of metal. The idea of the artist at work in the postindustrial world was aptly summarized by Newman: Cragg in a disused factory is a "telling image of the artist at the end of the mechanical age, searching, as more and more factories fall idle, for a new way of apprehending the objects that surround us in our daily lives."

One of the most striking of Cragg's works of the mid-1980s is *David* (1984), a wall arrangement of off-white plastic fragments outlining the very well known sculpture by Michelangelo. It is a piece redolent of the kind of irony Cragg has made his own: in transfiguring modern trash into a memento of high Renaissance sculpture, the artist makes a comment on art as commodi-

ty, for the original figure has become in our age an object almost endlessly reproducible in any number of materials, including the one that Cragg has used.

Cragg, Bill Woodrow, Richard Deacon, and Jean-Luc Vilmouth have come to be jocularly called the "Lisson Boys," for they are among the small number of new and influential British sculptors represented in London by the Lisson Gallery, an establishment founded in 1967 and still run by Nicholas Logsdail. The gallery is in Marylebone, and the feeling of the neighborhood and the building itself places it at a considerable remove from the Bond Street-Mayfair axis that has for more than a century signified power and establishment in British art. Those artists have participated in several momentous group exhibitions in the early 1980s: "Objects and Sculpture" at the Institute for Contemporary Arts, London, in 1981; "Lecons des Choses" at the Kunsthalle in Bern, Switzerland, in 1982; "British Sculpture Now" at the Kunstmuseum, Lucerne, also in 1982; and, perhaps the most celebrated case, the Arts Council of Great Britain's major exhibition of 1983, "The Sculpture Show." Some members of Britain's artistic establishment attempted to exclude Cragg and his contemporaries from the Arts Council show, but at the very last minute resignations from the selection committee and a good deal of unfavorable publicity forced the Arts Council to reinstate them. Extensive media coverage of the affair resulted in a huge attendance—three times greater than for any previous British contemporary art exhibition—as well as growing popular awareness and appreciation of the newness and excellence of British sculpture.

EXHIBITIONS INCLUDE: Lisson Gal., London 1979; Marion Goodman Gal., NYC 1984 ,' 86; Gal. Schellman und Kluser, Munich 1984. GROUP EXHIBITIONS INCLUDE: Whitechapel Gal., London 1981; "Objects and Sculpture," London and Arnolfini Gal., Bristol 1981; "Lecons des Choses," Kunsthalle, Bern, Switz. 1982; Documenta 7, Kassel, W. Ger. 1982; Venice Biennale 1982; "British Sculpture Now," Kunstmuseum, Lucerne, Switz. 1982; "The Sculpture Show," Arts Council of Great Britain, 1983.

COLLECTIONS INCLUDE: Tate Gal., London.

ABOUT: *Periodicals*— Art and Artists October 1982; Artforum October 1980, September 1981, November 1981; Art in America September 1982, September 1984, April-May 1984, November 1984; Art Journal Spring 1981; ARTnews Summer 1983, January 1984; Connoisseur April 1984. Domus November 1980: Flash Art November 1980,

CURTIS, PHILIP, C. (May 26, 1907–), American painter and genuine American surrealist, paints vast, dreamlike landscapes, peopled with gentlemen and ladies in turn-of-the-century costumes in somnambulent poses and situations. Starting on the staff of the Works Progress Administration, Curtis turned seriously to painting after World War II. He was not attracted by abstract expressionism, with its heavy brush strokes and occasional self-indulgence. Avoiding all trendiness, he turned to surrealism, with its timeless vision of a fused symbolic past and present. Curtis has found his own cast of characters that repeatedly appear in imaginary rooms, trains, landscapes, wedding parties, and staged settings. He paints ambiguous fantasies where the reality of the subject matter alternates with a deliberate vagueness. He suggests ideas without concern for logic. In so doing, Curtis engages the viewer to enter his particular world.

Curtis grew up in Jackson, Michigan. His father was a judge, his mother a musician who played the organ and the piano but spent most of her time bringing up four boys. Curtis remembers them "as middle-class people. They tried to be part of the community in a quiet way." Curtis remembers Jackson as a small town: "My beginnings in Jackson were pretty dull. I never thought school stuck to me at all. I sort of disliked school, an attitude that was shared by a lot of healthy males. I seemed to have some talent. So I went through high school; I did the least I could. When I got to college, all that changed. I found out a lot about life. I became interested in writing. I wrote fiction and nonfiction, but nothing great at all."

After graduating from Albion College in 1930, Curtis attended the University of Michigan Law School, thinking of following in his father's footsteps. His law studies lasted one year, for at the Ann Arbor campus, Curtis met people in the arts and his interest in writing started to wane. His father did not nag him to continue his law studies. "I put myself through college" said Curtis, "but my parents helped. They cared about education. There were four of us, all went to college."

Following the advice of a teacher, Curtis applied to Yale University though he had no portfolio to show. Curtis remembers it well: "So I went to Yale! It was not the best. There isn't any best, I think. I put in about three years and did very well. I learned some history, and began to admire the works of the fifteenth-century artist Piero della Francesca. I realized for the first time that there was art, music, and theater, I graduated in 1935 with a four-year certificate.

"From Yale, I went to New York, because that

PHILIP C. CURTIS

is where the action was. It was during the Depression. The federal art program was underway. I immediately started work as an assistant supervisor of mural painting, because Yale had emphasized mural painting. I did not do any painting myself; I was an administrator. I had some artists in my group who became well known, people like Philip Guston, Arshile Gorky, and Stuart Davis for whom I felt a great admiration. In 1936, I was sent to Phoenix to start an art center. Again, this was a government program. The idea was to start permanent art centers in cities across the country, and that appealed to me very much. Phoenix wanted that type of program. They had a fine arts society. When the federal government sent me I didn't know much about Phoenix. I came in July, it was hot; this was before air-conditioning. There were many unemployed artists applying for relief and the government's motto became 'Let's give them brushes, instead of shovels.' The art center I started eventually became the Phoenix Art Museum. So I stayed for three years. It was then located at Adams and 7th Street on donated land."

In 1938 Curtis married Mary Majorie Yaeger. (They were divorced in 1959.) In 1939, Curtis was sent to Des Moines, Iowa, but found the community of artists less friendly. "We did not get along," he explained. "I decided to go to Harvard to become a curator. I enrolled in the summer of 1941 and left in the fall to join the Office of Strategic Services during World War II. I was accepted despite my arthritis. I was stationed in Washington. We had a big pool of talent, movie makers, and artists of all sorts. Our job was to vi-

sualize information. We worked independently. When the war ended in 1945, I stayed on for two more years. I knew I wanted to paint. I was almost forty. It was now or never. I had to make a choice whether to go to New York where most of my painter friends were; abstract expressionism was in full bloom. I knew enough about it to know that it did not hold much for me. I did not want to be influenced by it. I felt attracted by the abstract cubism and modernism of Stuart Davis."

Curtis and his wife returned to live in Arizona in 1947. "My wife and I had saved enough money during the war years to carry me for a couple of years," he said. He felt that the spinal arthritis that had afflicted him would be helped by the dry southwestern climate and he also liked the Arizona light and the open spaces. The art community, though, was quite small. He recalls that "there was only one gallery in town, really more like an antique shop. We were isolated and that is what I liked about living here. I did not want to be influenced by other artists. You had to look elsewhere to exhibit your work. In 1948 I had my first show at the San Francisco Museum of Art. The work consisted primarily of cubist still-life gouaches and objects in juxtaposition. But I also had to give time to selling. I was painting every day. In 1957 I had developed my present style and subject matter." That same year, Curtis had an important solo show at the Arizona State College, exhibiting his first oils and earning the label of surrealist and magic realist from critics.

In a catalog, "Philip C. Curtis, Known and Unknown," the art critic Rudy Turk described the work: "Curtis paints in riddles which may never be perfectly understood or perfectly answered. Indeed, there may be many answers, different meanings for different people. Over and over and over again he asks, 'Where?' 'When?' 'How?' 'Why?' But this sage artist poses the disquieting eternal questions in forms that are not threatening, even charming or whimsical.

"For Curtis life is full of illusions, a wondrous theater or circus where bravado performances are interspersed between empty scenes. A master magician, he conjures, from the turn of the century, a vast repertory of players: bandsmen, in splendid uniforms, carrying or playing bright instruments; graceful singers trilling the scales; moustachioed pugilists in long tights; dapper gentlemen in dapper frock coats and top hats; wasp-waisted ladies in elegant finery and laces and silks. With absurd gravity his people march across a desert or through a forest, gaze out the windows of a lonely hotel or an opera box, enjoy tea on a porch overlooking vast vistas. They are

caught in a world of illusion, a world where there are many levels of perception."

In 1960 a group of Phoenix businessmen formed the Curtis Trust, which was to support Curtis for three years to enable him to assemble more of his paintings and be freed from the unrelenting economic pressure to sell. Success followed swiftly. By 1963 Curtis had enough paintings to have an exhibition at the prestigious Knoedler Gallery in New York. The gallery agreed to represent his work and that association continued for a number of years. In 1967 Curtis had his first European exhibition at the Galerie Krugier in Geneva, giving him a European outlet for his work. Curtis attended the Manhattan openings, enjoying the crowds, the attention, the feedback, but his arthritis kept him from attending the openings in Europe.

Curtis is a tall, spare, and slightly stooped man, with penetrating blue eyes and bushy eyebrows. He speaks softly and his manner is gregarious, though he is a very private man. In 1949 he bought his present house, which is surrounded by acres of desert. It was once a stable, but Curtis converted and remodeled it, adding rooms and a studio. Just in front of his entrance stands a weather-beaten, painted torso of a carousel horse. Though the house is close to the center of Scottsdale, it is on what used to be a cattle trail. His studio is a small room with a large north window facing Palo Verde trees and other indigenous shrubbery. In the distance are the McDowell Mountains; the vista is quiet and peaceful. Curtis paints sitting down, sliding a small, hard chair forward and backward. He paints three to four hours every day and never seems at a loss for subjects. At one point in his career, he made detailed sketches before starting a painting but found that he was making finished sketches "which later on I could not turn into paintings." For the most part, Curtis paints directly on Masonite board backed by plywood. He prepares the board with gesso, using "only the best materials and colors."

The artist has never done large-scale paintings because of his meticulous brushwork and arthritis. His larger paintings measure approximately thirty-six by twenty-four inches, but he also has done paintings as small as ten by eight inches. He executes about twelve paintings a year. Curtis does not like texture. His painting technique consists of creating invisible brush strokes by putting tiny dabs of paint on the board. His work is delicate and painstaking. The paintings are highly varnished. Curtis explains that it is a Renaissance technique. He mixes stand oil, linseed oil, and varnish thinned with turpentine. "I use it as a glaze; the purpose is not preservation. I use it to give quality, depth, and richness to my paintings." Noticeable to the viewer is the precision of the artist's technique and the clarity of the paint.

In *Artspace* (Spring 1984), Barbara Cortright wrote, "His method—calm, methodical, precise—removes the evidence; lacking the brush strokes the act of painting is not trapped. This is accomplished with clean colors meticulously brushed on a well-sanded, gessoed panel. In this nonpainterly classic presentation, the image, and only the image, which represents the thought, becomes that much clearer, more impeccably defined." Curtis considers himself a surrealist, but not in the Dali or Ernst tradition. Possibly he is closer to the Belgian painters Delvaux and Magritte. (Max Ernst lived in Sedona, Arizona during World War II, but the two artists's paths never crossed.)

When asked to discuss the meaning of one of his paintings, Curtis can become a bit testy. "I don't discuss my paintings as a matter of policy," he has remarked. "Once I was asked what I meant to express in a particular painting—and I elaborated. What the questioner saw and what I meant were not the same and so I limited his imagination. But his idea was just as good as mine. I am not a psychiatrist. Psychiatrists can look at one of my paintings and give me six explanations, all of them good. If you are a good viewer you can bring your own explanation to it; it may not necessarily be what the artist sees." As John Russell noted in the *Sunday London Times*, "The paintings of Philip Curtis do not fit into any of the accepted notions of American Art. . . . Curtis is something different: a special, authentic, discreetly stubborn poet-in-paint who has never let anyone tell him what to do." Dr. Karl Menninger, of the Menninger Clinic, once wrote to Curtis that he made "not pictures, but painted thoughts."

In 1988 Curtis had an exhibition at the Scottsdale Center of Fine Arts, prompting the critic James Todd to write, "The essence of superior surrealist art is not that the content is filled with irrational subject matter, but rather that it enables the viewer to pass from sensation to insight. . . . Curtis exposes the theatrics, superficiality, humor, and seriousness of life all in one breath. Such a perspective might suggest a cynical or sarcastic attitude, but Curtis consistently expresses great empathy and gentleness towards his subjects. This empathy is given equally to both male and female in the paintings, and when asked about this, he said he had always assumed the equality of the sexes."

Speaking of the dreamlike appearance of many of his paintings, Curtis explains that "it re-

flects my attitude towards life. I try to select things that have substance, and try to keep them simple and strong. I have a repertoire of certain figures and props that keep reappearing in my paintings. My landscapes are flat vistas; that is more peaceful. Empty chairs are very important to me; they have more meaning empty than with people." Curtis has never taught art, because, he says, "I don't like to teach, I don't know what I would teach! What you learn in art school is not important." In 1969 Curtis was elected Benjamin Franklin Fellow of the Royal Society of Art in England, and in America, among many other honors, the National Society for Arts and Letters awarded Curtis the Gold Medal for Distinguished Achievements in the Arts. He serves as a member of the Fine Arts Commission for the City of Scottsdale.

The works of Philip Curtis mirror the independent spirit of the artist. There is a desire to explore symbolism and appearances in a surreal world, an ambiguity that analyzes the exterior world in an inner way. His people are without passion. Those contradictions make the paintings fascinating. Ideas are explored, hinted at, but never explained. Curtis is a master storyteller, but the stories have no ending. He is content to remain detached in a world that is comfortable for him. He has isolated himself, so that he can create away from the pressures of big city life. Like Magritte, to whom he has been compared, his paintings have a universality that will intrigue future generations.

EXHIBITIONS INCLUDE: San Francisco Mus. of Art, 1949; Weyhe Gal., NYC 1950; Phoenix Art Mus. 1960, '63; M. Knoedler & Co., N.Y. 1964; California Palace of the Legion of Honor, San Francisco 1966; Feingarten Gal., L.A. 1966; Gal. Krugier et Cie, Geneva 1967; Northern Arizona Univ., 1967; Betty Thomen's Gal., Basel 1967; Coe Kerr Gal., NYC 1969, '70; Univ. of Arizona, Tucson 1970; Oklahoma Art Cntr., 1970; Palm Springs Desert Mus., Palm Springs 1971; Univ. of California at Los Angeles 1972; Utah Mus. of Fine Arts 1972; Ariadne, Vienna 1974; "Arizona Invitational," Phoenix Art Mus. 1975; Scottsdale Cntr. for the Arts, Scottsdale 1978, '88; Phillips Collection, Washington, D.C. 1978; Gal. 609, Denver 1980; Fine Arts Cntr. of Tempe, 1984; Northern Arizona Univ. Art Gal., Flagstaff 1986; The Plains Art Mus., Moorland, Minn. 1987.

COLLECTIONS INCLUDE: MOMA, NYC; National Mus. of American Art, Washington, D.C.; Brandeis Univ., Rose Mus., Waltham, Mass.; Univ. of Notre Dame, South Bend, Ind.; Phoenix Art Mus.; Matthews Art Cntr., Arizona State Univ., Tempe; Univ. of Arizona Art Mus., Tucson; Northern Arizona Univ., Flagstaff; Des Moines Art Cntr., Iowa; Valley National Bank; Arizona Bank; Pinnacle West Capital Corporation, Phoenix; Lamar Savings Association, Austin, TX.

ABOUT: Bermingham, P. et al. "Philip C. Curtis: Known and Unknown, A Retrospective Exhibition, 1947–1987" (cat.), 1987; "Philip C. Curtis—Paintings," (cat.) Phoenix Art Museum, 1963; Who's Who in American Art, 1989–90. *Periodicals*— Arizona Highways November 1963; Artspace Summer 1978; Christian Science Spring 1984; Christian Science Monitor March 22, 1963, December 7, 1979; Esquire December 1982; Metro Phoenix Magazine August 1986; Phoenix Gazette January 24, 1982; Ramparts Magazine August 1965; Rocky Mountain News (Denver) October 5, 1980; St. Gallen Tageblatt (Switzerland) November 7, 1967; Time May 29, 1964, October 5, 1970.

DAWSON, JOHN (September 12, 1946–), American painter and sculptor fits no pattern or label, although he considers himself in the humanist tradition of art. Concerned with psychological impact, he paints people constrained by their own limitations, scarified in their relationships, and with flesh that is temporal. His paintings shock and overwhelm. Emphasizing face, figure fragmentation, and distortion, Dawson predates the narrative and figurative painting of the 1980s.

Dawson was born in Joliet, Illinois, into a family active in the insurance business. He started drawing at age ten, and two years later received private art lessons. His family was tolerant, but not enthusiastic. At age twelve he started painting with oils. "I thought that painting was the greatest thing there ever was," he has recalled, "and I spent the rest of my childhood literally painting. Being an artist was the only thing I ever wanted to do. I never considered being anything else. When I was in grade school, I wanted to be a cartoonist, but it did not last. I did my first oil painting on an old piece of canvas when I was fourteen years old. It took me a whole year! The painting was three by four feet."

He attended Dundee Junior and Senior High School but shunned art classes because of a personality conflict with the art instructor. However, on Saturday mornings, he attended classes for children at the Chicago Art Institute. After high school, Dawson enrolled at Northern Illinois University in DeKalb, receiving a bachelor's degree in fine arts in 1969. He went on to the University of New Mexico (1970–72) but found Albuquerque a depressing town. He also found himself alienated by the drug culture. At that point he had decided to transfer to the University of Hawaii, but ended up accepting an assistantship instead to Arizona State University where he studied with Ron Wagner and Art Hahn. Working for the most part on his own, he received a master of fine arts degree in painting

JOHN DAWSON

in 1974. Dawson immediately followed that up with an appointment as artist in residence in the Mesa public school system.

Dawson admits readily that as a young painter he was influenced by Rembrandt, Francis Bacon, and Larry Rivers, but says that writers have influenced him more than artists, citing Faulkner, Balzac, Hemingway, Eugene O'Neill, Tennessee Williams and Arthur Miller.

One of his early seminal shows, at the Elaine Horwitch Gallery in Scottsdale, Arizona, was "Portraits and Old Master Paintings," which reflected his philosophy and feelings about Rembrandt, and his concept of time versus timelessness. Running concurrently, Dawson had a second exhibition at Arizona State University entitled "Slaughtered Animals," a series reflecting his feelings about the violence of the Vietnam War.

A prolific painter, Dawson who produces thirty to forty paintings a year. He has recently taken up sculpture. He does not enjoy lithographs, but produces many mixed-media works on paper. He keeps ideas for paintings in a notebook and adds little sketches, which he has been doing for nearly twenty years.

Dawson usually paints entire scenes on one theme. In 1976 he produced a series on "Scarified Ladies" consisting of women with scarred figures. Dawson commented: "Primitive people tattoo and scarify their bodies in order to make themselves more attractive—I felt these physical scars on skin had a relationship to mental scarring so I did a series of nudes based on this idea." Those "Scarified Ladies" were part of the Phoenix Art Museum invitational show.

Dawson followed that exhibition with series on "Dancers," "Horse and Riders" (he does not feel himself to be in the Marino Marini tradition), and "Ladies in Big Hats." In 1978 he met his wife-to-be, Linda, and three weeks later they were married.

In 1980 Dawson created his "Wedding Series," which received much critical comment and acclaim. "In my 'Wedding Series,' in the background I have a little house; in some cases it is a mansion or a cottage realistically painted. The background is splattered with expressionistic patterns. The house floats. In the foreground are the bride and groom. I wanted to contrast the ideal with the flesh that is temporal and deteriorates. I tried to set up a juxtaposition between what people think of marriage and reality. Ironically, I don't go through this in my own life. 'The Wedding Series' is more a divorce series. In the last painting I did, I added something like a jigsaw puzzle. These puzzle pieces have found their way into subsequent paintings."

In *Artweek* (February 4, 1978) Barbara Cortright described Dawson's portraits: "Revelation need not be appalling. . . . The thing is, Dawson has a knack for portraiture, for catching characteristics that is more rare. He tells the truth and looks for qualities that are common to us all. That's why with him people catch their breath at other people's portraits. . . . The Dawson subjects, in their exposed state, like the dissected frog with its peeled layers, reveal the works within. His brush is an exploratory scalpel."

Art and invention in Dawson's life do not take place only in the studio. He bought six acres of desert land in Mesa and in 1980 proceeded to build a house and studio. He was dealing with a lot of blueprints. "I thought it would be an interesting idea to take a blueprint and use it. I asked the architect and found out that blueprints are done in such a ways that they fade. So I took a blueprint, traced it on a piece of vellum, silkscreened it on a dry paper and did a series of mixed-media drawings which resulted in the 'Pine Box Series.' However, I never did build the boxes around them. In this series, time is a destroyer, never a creator, and all life is a kind of erosion or race." The "Pine Box Series" is a valid comment on birth, decay, and death. The paintings are stark and startling; masklike faces seem to stare vacantly, reminding one of one's own mortality.

Dawson is a literate man who has described his work in this way: "I paint paintings of private desperation. They are not tranquil. They are violent. They are often elegant but seldom pretty. They are nervous systems with a thin layer of

covering skin. They are scarred. They are paint-
ed. They are tattooed. They are paintings of in-
dividuals incarcerated beneath their own flesh
and bone, peering out from under their skin at
other beings trapped beneath their own flesh
and bone. They breathe, they cry, they sweat,
they bleed, and they die. They are humans
caught in a private empty environment, a closed
but empty space. They are lost. They are lonely.
They are desperate. They are paintings about
time, time that corrodes, time that changes, time
that wrinkles, time that destroys. A merciless de-
stroyer, a dispassionate, tireless, constant de-
stroyer. They are about time that runs out and
yet never runs out."

Honors and awards that have come to Dawson
range from purchase awards to first place
awards in painting and drawing. Having recent-
ly completed an "Old Masters Series," he subse-
quently began exploring the idea of "unfinished
paintings." He explains it in these terms: "What
I have been doing is to paint a painting and an-
other painting on top of it so that you have the
sensation that a painting is in progress; I call it
unfinished paintings; they are unfinished paint-
ings for unfinished people."

Dawson is a friendly man whose open face is
at odds with the tortured and lonely figures he
paints. "Painting to me is like a puzzle with a
tantalizing conclusion waiting to be discovered
at the end." Dawson works every morning for a
couple of hours but considers the afternoon his
best time. He also likes to read every day. He
considers himself an excellent draftsman and
criticizes the technical quality of some contem-
porary art. His studio, which stands one hundred
yards from his house, has ten-foot ceilings and
is a large paint-splattered room in which he
keeps a record player, storage racks, a desk and
an old sofa.

Dawson is somewhat outspoken in criticizing
conceptual art as a movement that is nourished
and sustained in academia. "Everything that was
done in conceptual art was done by Duchamp
fifty years ago," he has stated.

EXHIBITIONS INCLUDE: 73rd Chicago and Vicinity Exhibi-
tion, Chicago Art Inst., Chicago 1971; 15th Annual Art
Exhibition, El Paso Mus. of Fine Art, El Paso, Tex.
1970, '74; Annual Exhibitions Prints and Drawings,
Oklahoma Art Cntr., Oklahoma City 1972, '73, '77;
Elaine Horwitch Gal., Scottsdale, Ariz., Santa Fe, N.M.
Sedona, Ariz. 1975, '76, '78, '80, '81, '82, '84; Benjamin
Mangel Gal., Philadelphia 1975, '77, '82, '85; Arkansas
Art Cntr., Little Rock 1979; Oklahoma Art Cntr.,
Oklahoma City 1979; Springfield Art Mus., Mo. 1980;
Arizona State Univ., Tempe 1986; Segal Gal., NYC
1983, '86.

COLLECTIONS INCLUDE: Western New Mexico Univ., Sil-
ver City, N. M.; Del Mar Col., Corpus Christi, Tex.; El
Paso Mus. of Art; Phoneix Art Mus.; Scottsdale Cntr.
for the Arts; Oklahoma Art Cntr., Oklahoma City; Ar-
kansas Art Cntr., Little Rock; Ulrich Mus. of Art,
Wichita State Univ., Kan.; Tucson Mus. of Art; Orme
Lewis Collection, Rosenzweig Collection.

ABOUT: Who's Who in American Art 1989–90.
Periodicals— Arizona Arts and Lifestyle Winter 1982;
Arizona Republic June 20, 1986; ARTnews April 1975;
Arts Magazine December 1983; Artweek January 25,
1975, February 28, 1976, February 4, 1978, January
12, 1980, November 7, 1981; Philadelphia Sunday Bul-
letin October 2, 1977; Phoenix Gazette May 30, 1984;
Southwest Art February 1977.

DE FOREST, ROY (February 11, 1930–),
an American painter, sculptor, and teacher of
art, describes himself as an "obscure visual con-
structor of mechanical delights." The self-
deprecating tone may reflect the undeniable
fact that De Forest is much better known in
West Coast art circles than he is to the East Coast
art establishment. He is hardly "obscure,"
though, since his first solo shows were mounted
while he was still a student, and he has been ex-
hibiting regularly ever since. For "mechanical
delights" read a body of quirky, wholly original
paintings, drawings, and multimedia construc-
tions in which zany, cartoon-world images in
carnival colors act out the artist's own fantasy
scenarios. "For me," De Forest says, "one of the
most beautiful things about art is that it is one
of the last strongholds of magic."

Typically, in his paintings and drawings, ani-
mate and inanimate forms—strangely menacing
dogs, exotic flora, humanoid shapes—jostle and
overlap one another to form a dense allover pat-
terning with no focal point. The viewer can en-
ter the composition anywhere and wander at
will with the protagonists on the mysterious jour-
neyings that often seem to be the subject of these
works. These "crazy-quilt aggregates," as one
critic described his compositions, defy conven-
tional stylistic labels. Cocking a snook at so-
called high art, they nevertheless only play at be-
ing folk art; their innocence is somewhat
factitious. For, as Henry Hopkins, former direc-
tor of the San Francisco Museum of Modern Art,
has observed, you can read De Forest's painting
"on many different levels; you can look at it as
purely decorative . . . but you can also read it
environmentally and sociologically when you
watch what those dogs are doing." Also, despite
irreverent remarks like comparing paintings and
drawing to making mud pies, De Forest is actu-
ally widely read, especially in art history, and
acknowledges his response to the work of Mon-

drian, Léger, Matisse, Max Beckmann—and of artists like Paolo Uccello, to whom he feels akin because they made art that dealt "with a possible existence other than the one they found themselves . . . living in." Waggishly disrespectful of academic conventions, De Forest's rowdy, whimsical work is often considered as allied to that of the funk artists, a loosely defined Bay Area group active in the late 1960s and 1970s.

Roy Dean De Forest, born in North Platte, Nebraska, was raised and educated in Yakima, Washington. Growing up in a Depression-era farm family, he made his own toys—such as Viking ships shaped from cornstalks. His interest in drawing began as early as the first grade. Since the 1950s he has been a resident of northern California and identified with the Bay Area cultural milieu. After attending Yakima Junior College from 1948 to 1950, he transferred to the California School of Fine Arts in San Francisco, where he studied with Elmer Bischoff and Hassel Smith, among others. He then went on to San Francisco State College, from which he received a B.A. degree in 1953 and an M.A. degree in 1958. Two years of service in the U.S. Army (1953–55) intervened. His considerable, and varied, teaching career began with three years at the San Francisco Museum of Art (1955–58), serving as children's painting instructor and gallery assistant. He then went on to a dual post as instructor at Yakima Junior College and director of its Larson Gallery (1958–60). Following that he taught at San Francisco State College in 1961–62; the California College of Arts & Crafts, Oakland, in 1964–65; and, concurrently, in 1964, at San Quentin Prison. From 1965 to 1982 he was a professor of painting and drawing at the University of California at Davis, where, with a group of colleagues that included the pop-realist painter Wayne Thiebaud and the sculptor Robert Arneson, he helped raise that campus to national prominence as an art school. As to the teaching of art, while De Forest has always encouraged his students to take themselves less seriously and to do what interests them, he stresses the importance of academic discipline—but only up to the point where repetition and lifelessness may result.

Early paintings such as the 1953 Snake Bite Is Serious, Ladies and Gentlemen (done on the side of a packing crate) show De Forest working in the prevailing abstract expressionist mode, which was promoted with messianic fervor by teachers at the California School of Fine Arts such as guest instructor Clyfford Still. Very soon thereafter De Forest began disassociating himself from this style, with its heavily applied brush strokes of dark colors. With conscious heretic intent he satirized their efforts by painting thin,

using polymers instead of oils, and applying bright, frivolous colors in little dots. Fueling his rejection of abstract expressionism was his interest in Depression-era fiction, with its ironic treatment of American life. In fact, De Forest's interest in literature has always informed his art and may also explain the clever whimsy of the titles he gives it. Living in San Francisco on the fringe of the Beat poets' group, he began to absorb their influence also, and to write poetry of his own, which he now regards as "a great learning experience that brought together some ideas about verbal and visual symbolism." One of his first paintings in his mature style is My Life and Times in Yakima (1959). Described by the artist as "more or less what you'd think of when you see a landscape from an airplane," it is an abstract maze of dabs of color crisscrossed by calligraphic paths. In about 1960, images such as hands, arms, or small whole figures were superimposed on the quiltlike blocks of flat color that now made up those bird's-eye-view landscapes. By 1971, in paintings like Steamship to the Interior, his work had become more object-oriented and narrative. Dogs and partly human creatures seem to tell tales of their voyages through, as the artist puts it, "a phantasmagoric microworld." De Forest has even given an idea of what those travelers' tales might be like, in the essay (itself phantasmagoric) he wrote for the catalog accompanying his 1974–75 retrospective exhibition.

Asked why dogs are central and humans secondary in his figurative repertoire, De Forest has explained that the conventions of painting the human figure apply equally to animals, and that is "the sort of art-historical parody that amuses me very much." As the sculptor Clayton Bailey has described it, De Forest "translates the human world into dog poetry." Progressively, the animal figures and the human forms have gotten larger and more defined, as in Country Dog Gentlemen (1973), with its two dogs that confront the viewer with glowing eyes (demoniacal menace? comic caricature?); Keeper of the Bull (1976), the keeper a ridiculous figure in sunggogles, the bull with bright blue eyes; or Let Sleeping Dogs Lie (1979), where animal and humanoid shapes overlap and thus defy the orderly quilt pattern of square sections by which the composition is held together—one of many evidences (to which De Forest himself attests) of the influence of Mondrian's grids. The grid structure also appears in De Forest's ceramic-tile murals, his first being one for the exterior of the California Energy Commission Building in Sacramento (1982). A De Forestian menagerie of odd creatures in bold colors, organized in discrete sections, it tells the history of the state of

California. Who or what is represented may not be clear. The artist himself insists, anyway, that art is "simply a matter of appearances," which are "never deceiving unless given critical interpretation."

De Forest's first three-dimensional objects were the constructions he made in the 1950s, assembled from found materials (cardboard, wood slats), much of it rescued from trash cans. In the early 1960s, using the power tools he loves, he began to make small polychrome wall pieces: band-saw-cut shapes of dogs, birds, or horses, looking out over constructed "landscapes"; and all having themes inspired by naturalists' books such as W. H. Hudson's *Green Mansions*. The 1962 piece called *A Traveler Returns to the Shetland Islands* was fashioned of wood, wool (wittily alluded to in the title), polyvinyl acetate, and oil paint. Not essentially sculptural, such wall pieces reveal the artist's primary interest in colors and shapes. He took up this mixed-media work again in the mid-1970s; but not until 1983 did he start to do larger, freestanding sculptures. *Lair of the Giant Moa* (1985), for example, is a construction measuring 68 x 138 x 30 inches, made of tree branches and various found objects.

Works on paper form another important part of De Forest's prolific output, despite the fact that he has claimed to consider drawing nothing more than an act of modifying a paper surface. His are color drawings, largely untitled but united by a common theme: a sea voyage, presumably, with human and other beings sailing in fanciful boats. Favored media are oil pastels, gouache, ink, and wax color pencils, used by themselves or in various combinations. With only two exceptions the drawings follow from rather than precede his paintings—from which they differ in their light tonality and use of calligraphic marks. Their distinctness as an entity is further marked by the wooden frames De Forest makes for them, decorated with dots, triangles, or knobs of gay colors, like circus lights ringing the stage of action within. Noteworthy among his prints are two series of lithographs (1985–86) devoted to an exotic conglomeration of strange creatures—including the eponymous dog—and inanimate shapes. *Bigfoot* and a nighttime variant, *Bigfoot, State II* (printed on black paper), are handcolored in red, silver, and green, with the dog's eyes highlighted in yellow.

If De Forest's work is beyond interpretation, even trying to describe it is difficult, according to *New York Times* writer Vivien Raynor, in a review of a 1985 one-man show of new work at the artist's New York dealer, the Allan Frumkin (now Frumkin Adams) Gallery. But the critic was evidently delighted by the "violently col-

ored and richly patterned" landscapes, the "wild polymer colors . . . heavy on red and yellow," which are sprayed or brushed on the canvas in rows of circular dabs (and which another critic once compared to "candy kisses"). Raynor's pleasure is echoed by the comments of De Forest's San Francisco dealer, Diana Fuller of the Fuller Goldeen Gallery: "I . . . have never met anyone who doesn't respond to Roy's work. We can't keep it in the gallery; everything . . . is snapped up right away. . . . [His] enthusiasm seems to come through and get to people."

Honors from his peers have taken the form of a San Francisco Art Association Award in 1954; the Nealie Sullivan Award of the San Francisco Art Institute, 1962; a La Jolla Museum of Art purchase prize, 1965; and a National Endowment for the Arts Fellowship in 1972. In 1964 he served as chairman of the artists' council of the San Francisco Art Association.

A genial, humorous man, bearded and moustached, somewhat burly, Roy De Forest lives in a small town just north of Berkeley, with his wife, the former Gloria Scott, also an artist (whom he married in 1974), their teenage children, Oriana and Pascal—and, as might be expected, a number of dogs, including the domesticated dingoes that have figured in some of his paintings and wall pieces. Free now of teaching duties, De Forest is able to do art full-time in the studio and woodworking shop that adjoin the well-stocked library in his Port Costa home, and to accomplish what he really wants to do: "pass on to someone else some of the pleasure" art has given him.

EXHIBITIONS INCLUDE: East and West Gal., San Francisco 1955, '58; Stone Court Gal., Yakima 1959, '60; Dilexi Gal., San Francisco 1960, '62, '63, '66, '67; San Francisco Art Association 1962; Allan Frumkin Gal., NYC, from 1966; California Palace of the Legion of Honor, San Francisco 1971; Manolides Gal., Seattle 1971, '72; Hansen Fuller Gal., San Francisco, from 1971; San Francisco Mus. of Modern Art and Whitney Mus. of American Art, NYC, traveling retrospective, 1974–75; Gal. Darthea Speyer, Paris 1974, '77; Inst. of Contemporary Arts, Boston 1977; Crocker Art Mus., Sacramento 1980. GROUP EXHIBITIONS INCLUDE: "West Coast Now," Portland [Oregon] Art Mus. 1968; "California Works on Paper 1950–1971," Univ. of California Art Mus., Berkeley 1971; "Extraordinary Realities," Whitney Mus., NYC 1973; "Painting and Sculpture in California: The Modern Era," San Francisco Mus. of Modern Art 1975; "West Coast Artists," New Gal. of Contemporary Art, Cleveland 1978; "Works on Paper," Allan Frumkin Gal. 1978; "Dog Images through the Century," Downtown Cntr., San Francisco Mus. of Art 1978.

COLLECTIONS INCLUDE: California Col. of Arts & Crafts, Oakland; Univ. of California Art Mus., Berkeley; San

Francisco Mus. of Modern Art; Crocker Art Mus.; Stanford Univ. Mus. of Art; Art Inst. of Chicago; Philadelphis Mus. of Art; Whitney Mus.

ABOUT: Crocker Art Mus. (cat.), 1980; Emanuel, M., et al. Contemporary Artists 1983; Humphrey, John, Roy De Forest: Retrospective, 1975; Who's Who in American Art, 1989–90. *Periodicals*—ARTnews April 1984; New York Times September 27, 1985; Print Collectors Newsletter September/October 1986; San Francisco Chronicle March 8, 1973; Studio April 1966.

DI ROSA, HERVÉ (December 17, 1959–), French painter, cartoonist, and designer, arrived on the Paris art scene at the age of twenty-one with the emergence of *figuration libre* (free figuration). His "bad art" cartoons and paintings, like those of the New York graffiti artists, were immediately welcomed as an alternative to the austere and cerebral trends of the art of the 1970s. With age, time, and practice, some of the visual rawness has disappeared from Di Rosa's work, but like the artist himself, it has maintained an antielitist, antiaesthetic stance.

Hervé Di Rosa was born into a working-class family in the southern fishing town of Sète, which boasts a large community of immigrants from Spain and southern Italy, as well as a strong tradition of political activism. His father, Marius Di Rosa, was a carpenter turned mechanic who moonlighted as a docker to earn extra money. His mother, Yvonne Villespasa Di Rosa, worked as a cleaning woman. Di Rosa grew up in a large extended family of Italian immigrants on his father's side. He was a good student but not very outgoing, and from an early age he amused himself with the private activity of drawing cartoons. His parents sent him to twice-weekly drawing classes at the local fine arts school, where he developed into a prize-winning student. This exemplary childhood veered somewhat off course when punk came to Sète in the 1970s: Di Rosa, now sporting blue hair, was absorbed by the "hard core" music scene, and his schoolwork suffered. Although he managed to pass his high school exams, it was evident that he would not become a doctor as his parents wanted. Instead, he enrolled full-time in the School of Fine Arts.

During his last year of high school, he had become good friends with Robert Combas, a slightly older art student whom he knew from Sète record stores. Music was their main bond, but Combas also tried to arouse Di Rosa's interest in the fine arts, and in painting particularly. At the time, though, Di Rosa preferred to find his inspiration in comic strips, and he, Combas, and another friend from Sète, Catherine (Ketty)

Brindel, launched *BATO,* a magazine of their own collective drawings which they reproduced by hand for four issues. Combas, Brindel, and Di Rosa's younger brother, Richard (Buddy), also formed a rock group, Les Démodés (The Obsoletes), which played in local clubs.

After a year at the School of Fine Arts, Di Rosa gained admission to the School of Decorative Arts in Paris, and scraping together the money from a scholarship and a large portion of his parents' earnings, he started taking classes there in 1979. By chance, he ran into another friend from the record stores in Sète, Louis Jammes, who was studying photography, and eventually they shared an apartment. By the summer of 1980, Combas and Brindel had joined them in Paris. Their intention was to continue doing graphics together, but their interests started to diverge and in the end they worked separately. Already invited to participate in an international exhibit of contemporary art at St.-Etienne, Combas was involved with painting, and Di Rosa continued with drawing, making his comic book illustrations in color and trying without luck to attract the interest of publishers. But when he finally managed to sell two episodes to the magazine *Charlie Mensuel,* he received advice that proved to be crucial: pointing out that Di Rosa's drawings were devoid of narrative, the editor of *Charlie Mensuel* suggested that he turn to painting and work on a larger scale.

In fact, Di Rosa made the switch by putting several small illustrations together on one large page (which was still divided down the center like a comic book). The images came from his growing repertory of fantastic creatures—figures that were very schematic visually but had already taken on pronounced identities in Di Rosa's private microcosm. In *Mais C'est Monsieur V.* (But It's Mr. V., 1980), for example, the title character is an angular muscleman with a V-shaped head, eyes, nose, and mouth who, according to the captions, "defends all the poor against the rich . . . watches out for workers . . . loves animals, especially zebras. He protects the weak. He's the strongest of all." Among Di Rosa's other early creations were Professor X, another figure of "extraordinary physical force," this time with a red body and a star-shaped head; the Green Monster, later renamed Raphael and consigned to a life of drugs and crime with Raoul, the four-armed transexual dragon; M. Plat (Mr. Flat), appropriately constructed out of flat rectangular forms and married to the Woman with a Flat Head (herself endowed with enormous breasts); Dr. Tube, who resembled a barrel with a long, protruding nose and was equipped with a Body-Reactor; Rot, a "fetish creature" consisting of a round head/

body on two legs; the "little hoodlum" Taymond, a kind of mushroom with four paws; Mique the stick-man; Kodo the Asiatic gorilla; and the triangle-headed Mimi whose adventures appeared in *Charlie Mensuel.* These characters were at once projections of Di Rosa and his friends and personifications of general psychological types, expressed in the language of the comics and animated cartoons. According to Di Rosa, he was telling his life story but "in a kind of code. . . . To understand me, you really have to get into my personal life."

Those very private paintings, along with those of Combas and six of their friends, entered the public arena quite precipitously in June 1981 with a group exhibition, "Finir en Beauté" (To End in Beauty). The circumstances were themselves the material of a comic book adventure: in the course of looking for a new apartment, the father of one of Di Rosa's art-school friends, François Boisrond, met the art critic Bernard LaMarche-Vadel, who not only was moving out of his loft but wanted to organize an exhibit to celebrate the move. Boisrond Sr. proceeded to introduce the critic to his son, Di Rosa, Combas, and other art students in their circle; Combas had already made a name for himself at St.-Etienne and was scheduled for a one-man show in Amsterdam, but LaMarche-Vadel felt that a group show would help the others to be taken seriously, and "Finir en Beauté" was the result. A few months after that event (which featured Les Démodés at the opening), the artist-critic Ben Vautier organized another show for Di Rosa and Combas at his gallery in Nice, and more important, he gave them a name: *figuration libre.* By November, Di Rosa, Combas, Boisrond, Rémy Blanchard, and others in what was now perceived as a full-fledged movement had made their way into the art establishment with "Ateliers 81/82," an exhibition held at the Musée d'Art Moderne de la Ville de Paris.

The enthusiasm with which dealers and museum curators welcomed *figuration libre* was not unrelated to the dismal state of the French art market, which had long been stagnating in the shadow of American art. The Italians and the Germans had begun to reassert their own cultural identities with the transavangardia and neo-expressionism, and *figuration libre*, spearheaded by Combas and Di Rosa, clearly offered a French variant on the theme. With the backing of dealers, the immediate encouragement of collectors, and also a tremendous publicity effort on the part of the newly elected socialist government, they were quickly to become, in the words of Otto Hahn and Franck Maubert, "the only French artists these last ten years to be as well recognized in New York as in Germany."

Di Rosa seems to have had a mixed reaction to his sudden success. The statement that he submitted for the "Ateliers 81/82" catalog was a graphically erotic fantasy that the organizers refused to print; what appeared in its place was a short text declaring, "Painting, for me, has almost no importance—it's the pleasure of doing something, and my motivations; it's something like FUN ROCK, complete refusal of all intellectual or critical discourse. . . . Painting for me is only a sensation, with no rationalization to it." In terms of other painters, he explained, "I'd put myself alongside the comic strip, more impressed by Tintin than by Schnabel." But, he concluded, "basically I'm influenced above all by Matisse for the simplification and the use of color . . . and by all the people like Utrillo, Rouault, Soutine for the mythic dimension tied to death."

The paintings that Di Rosa showed at "Ateliers 81/82" grouped together his comic strip creatures in larger numbers and smaller frames, and with fewer captions. Of all the young painters who found themselves identified as *figuration libre*, he remained closest to comic book design with his simple forms, pale colors, and separation of image and text, but at the same time, the nonlinear, nonnarrative format, clearly aimed at expression much more than exposition, put his work in a category that was at once iconic and iconoclastic. As Paulet Guy wrote in the Paris daily *Libération,* Di Rosa was "a comic strip designer who doesn't make comic strips and a painter who doesn't make paintings."

In any event, success allowed him ample opportunity to experiment, although, like Combas, he held onto his working-class, Sètois origins in what he had to say and how he said it—even after he had the money to buy canvas, he continued to paint on cardboard cartoons and cloth sacks.

Early in 1982 the French government sponsored a cultural exchange, "Statements One," that sent a number of "leading contemporary French artists" to the United States for exhibitions in New York galleries. Di Rosa was not part of the official selection, but his paintings, along with those of Boisrond, wound up in a separate room at the Holly Solomon Gallery, where Combas and Rémy Blanchard were the featured artists. At the opening, Di Rosa seized the opportunity to tell the French minister of culture Jack Lang, "My father is a docker in Sète. He carried these sacks for pratically nothing. So to get even, I paint on them and sell them for a lot of money."

For the most part, the four representatives of

figuration libre did not create the same sensation in the United States that they had in France— they were seen as a derivative offshoot of the graffiti artists. One New York critic particularly taken with Di Rosa was Nicolas Moufarreg, who wrote, quite accurately, that "his works are bothersome, aggressive, and vulgar, but they are also very funny. He admits to being anarchic and twisted (he hates the Louvre, abstract painting, society's elite) and dreams of changing the world with his art." Within such a frame of mind, "Statements One" turned out to be a decisive experience for Di Rosa. He established ongoing connections with his American counterparts Keith Haring and Kenny Scharf (Scharf was to pay a return visit to Sète the following summer), and beyond the immediate effect on his paintings—he moved out of the comic strip format and started working on a larger scale—he decided to go back to the United States for nine months in 1983. He and Boisrond both received French government grants to work at P.S. 1, the well-known artists' space in Long Island, New York, and they then traveled to the West Coast, where they executed a joint mural in Los Angeles.

During the period just before he left for the United States, Di Rosa found himself "disgusted with color" and temporarily restricted himself to black-and-white paintings. On his arrival in New York, he went to the other extreme; immersed in the counterculture of rock music and comic books, he began using pure colors, right out of the tube. He discovered the works of cartoonists Jack Kirby and Steve Dikto, which inspired him to create jarring images of violent combat on the one hand, and ever-increasing numbers of fantastic creatures on the other. The influence of his friend Keith Haring, meanwhile, gave rise to new pictorial techniques (while Haring in turn followed Di Rosa's example and started to create his own characters rather than borrow existing ones); his compositions were consolidated, and essentially he began producing real paintings.

In the autobiographical book that he produced with the critic Jean Seisser in 1983, Di Rosa indicated that for him, *figuration libre* was finished: "It helped all of us. A group makes you stronger, more effective. But now the name has fallen into the public domain and anybody can claim it. In a word, it bothers me to be associated with it now." In fact, the association lingered, in museum exhibitions at least, for several more years, but Di Rosa started moving in directions of his own, inspired in part by the mass productions of Haring's Art Factory in the United States. He collaborated with his photographer friend Louis Jammes on black-and-white photo-

montages that situated images of himself, and sometimes of his girlfriend, in fantastic, hand-drawn settings. "What interests me," he told Seisser, "is that I can reach another public with this new work. I think that people who don't like my paintings can more easily get into another phase of my work." He also considered making three-dimensional versions of his painted creatures, but realized that his brother, Buddy, was more skillful at modeling. He began collaborating with his brother, as well, producing brightly painted plaster sculptures that were initially assembled in dioramas like *Chef d'oeuvre* (Masterpiece, 1983), a battle scene in which Professor X and Mique were pitted against the Big Bad Block. But by the time of their two-man show at the Tony Shafrazi Gallery in New York, in January 1984, Buddy was making large floor pieces as well. In the gallery, their physical presences lent greater immediacy to the painted world of Di Rosa's monsters and extraterrestrials, but they soon came to exert a marked influence on the paintings themselves: not only did Hervé's figures assume the sculptural form of Buddy's replicas, but the overall flatness of the comic strip gave way to compositions conceived, like the dioramas, in deep space. In contrast to Di Rosa's first one-man show in New York the year before, which was "a total failure," the Shafrazi exhibit generated enthusiastic responses. For the critic Delphine Renard, among others, it was a sign that Di Rosa and his *figuration libre* friends were making a successful transition from "new products" to real artists; the comic strip influence, she noted, had "metamorphosed into visually convincing images that unleash an intense emotional power."

In the summer of 1984, Di Rosa returned to the south of France to work; in 1986 he was to settle permanently in Sète with his wife and child. "I feel good in Sète," he told Agnes Cazenare. "I see ordinary people, my parents, my friends. They don't know anything about painting, but we talk colors, and I prefer that." But, he quickly added, "I'm far from being a health nut or an Occitan [farmer]. I really like factories and concrete. I love Montlaur [supermarket], it's my favorite museum." In any case, the break with Paris coincided with a certain artistic break, as he immersed himself in apocalyptic visions somewhat reminiscent of the psychedelic art of the 1970s with its intricate webs of fantastic images in ambiguously infinite space.

What was actually happening in works like the *Dirosapocalypse* (1985) and *La Fin du monde* (The End of the World, 1985) was that Di Rosa was changing his cast of characters by eliminating all of the old ones in a global disaster: "I had to kill these characters to get myself

out of the egocentric, almost schizophrenic world they kept me in," he later explained. The new characters were intended to be less schematic, in both conception and form, than the early comic strip types, and as a result, Di Rosa's painting became more fluid. At the end of 1985 he switched from acrylics to oil paint, which, he felt, would allow him to "return to simpler forms." Returning also to smaller formats, he began enclosing his images in illusionistic frames of wood, seashells, or strips of metal (bolted with screws) and his signature, which had formerly been such a prominent part of the composition, now often appeared on an equally illusionistic bronze plaque set into the frame.

As the representations themselves made clear, Di Rosa was not turning into an academic painter, but rather into an ever more tongue-in-cheek critic of the art world. *Au bord de la mer* (At the Seashore, 1985), for example, appropriately bordered with seashells, fills up a fish-tank-like space with a green monster and a nude bather whose breast is being bitten by a crab; *Diropolis: La Cité sans pitié* (Diropolis: The City without Pity, 1985) uses strips of metal like a window frame looking in (or out) on the sorry metropolis peopled with Di Rosa's second generation of fantastic creatures.

At the same time that Di Rosa was making those emphatically pictorial paintings, he realized his long-term dream of publishing a comic book, the *Di Rosa magazine*. Like his first cartoons, the large format *Di Rosa magazine* did not really fit into the going trends in comics, and Di Rosa, who had hoped to put it on the newsstands, was forced to admit, somewhat bitterly, that that low-cost edition of his work didn't sell, "while my paintings at forty thousand francs go like hotcakes." In other attempts to break out of high-art circles, he started manufacturing stickers and a line of toys featuring Hank, Raymond, Raphael, Mique, and other members of his original entourage; he also entered negotiations with a television chain for a series of animated cartoons. At the end of 1986, he painted an automobile for the Paris–Dakar race (and named it the Diromobile).

For some, those ventures, like the T-shirts and jewelry that other *figuration libre* and graffiti artists were marketing, represented crass commercialism; for others, they offered further signs of his ingenuity. For Di Rosa himself, they were a fitting expression of his attitude toward art, which remains thoroughly personal and indifferent, if not antagonistic, to time-honored conventions. As Delphine Renaud has pointed out, Di Rosa's stance, like his art, belongs to an entire generation: "Rich in timeless fantasies trans-

posed to the era of Star Wars, the little world of Hervé Di Rosa also bears witness to a vision of the future shared by his generation: after the faith in a better world, [which was] common in the years of 'crisis,' the future looks neither better nor worse than the past or the present."

When he was twenty-three and invited to participate in a major exhibition of contemporary art in Nice ("L'Air du Temps), Di Rosa couched his views in the form of yet another fantasy: "Upon my descent from the train that had left Paris a few hours before, I raised my head and saw DI ROSA written in letters of fire across the skies of Nice. With my suitcase full of albums by Gil Jourdain, Tif and Tondu, Blake and Mortimer, Marc d'Acier and the Four Fantastics, I walked toward the Grand Hotel, my spirit elsewhere, wondering: 'And if one day they caught on to the hoax, what would become of me? I shake with horror at that idea. Yes, what to do if one day they figure out that it's not painting but comic strips?'" Three years and more than thirty exhibitions later, he characterized what was essentially the same effort with much more confidence: "I'm trying to bring art down to the level of the comic strip," he told a Montpellier newspaper, "going in that direction against the tendency that wants to pull the comic strip up to the level of art."

EXHIBITIONS INCLUDE: Gal. Ricky Swart, Amsterdam 1981, '82, '83; Gal. Eva Keppel, Düsseldorf 1981, '82; Gal. Gillespie-Laage-Salomon, Paris, from 1983; Barbara Gladstone Gal., NYC 1983; Cntr. d'Art Contemporain de Flaines, Haute Savoie 1983; Tony Shafrazi Gal., NYC 1984; "Les Aventures de Richard et Hervé Di Rosa," Groningen Mus. (Netherlands) 1986; Gal. 121, Antwerp 1986; Gal. Le Chanjour, Nice 1986; Mus. Paul Val., Sète 1986. GROUP EXHIBITIONS INCLUDE: "Finir en Beauté," Paris 1981; "To believe in an end of glory," Paris 1981; "Deux sètois à Nice," chez Ben Vautier, Nice 1981; "Ateliers 81/82," ARC, Mus. d'Art Moderne de la Ville de Paris 1981; "L'Air du Temps: Figuration Libre en France," Gal. d'Art Contemporain des Mus. de Nice 1982; "Four Contemporary French Artists," Holly Solomon Gal., NYC 1982; Gal. Catherine Issert, St. Paul de Vence 1982; Salon de Montrouge 1982; "Ecole Normale and Friends," Gal. Hartmut Beck, Frauen Mus., Bonn 1982; "Reseau Art," organized on billboards by Art and Prospect, Paris 1982; "L'Art en Sous-sol," or "Félix Potin Seen by the Figuration Libre Group," Invalides Bus Station, Paris 1982; Gal. 121, Antwerp 1982; "Figuration Libre," Gal. Fernando Pellegrino, Bologna, and Gal. Marilena Bonomo, Bari 1982; "Figures Imposées," Cntr. d'Echanges de Perraches, Lyon 1983; "Blanchard Boisrond Combas Di Rosa," Groningen Mus. (Netherlands) 1983; "France-Tours Art Actuel," Tours 1983; "25 Artistes et David Bowie," Association Beau Lezard and Gal. Creatis, Paris 1983; "Artes Frances Contemporaneo," Buenos Aires, Montevideo, La Paz, Lima 1983; "La Nouvelle Peinture en France et Ailleurs," Church of

St.-Nazaire, Mus. de Bourbon Lancy 1983; "Intoxication Show," Monique Knowlton Gal., NYC 1983; Tony Shafrazi Gal., NYC 1983; "Transfigurations," ARGA, Marseille 1983; "Loupian '83," Loupian Chapel, Herault 1983; "Peintres du Sud à la Gare du Sud," chez Ben Vautier, Nice 1983; "Images de la France," Gal. Ursula Krinzinger, Innsbrück 1983; "French Spirit Today I," Univ. of Southern California Art Gal., Los Angeles Mus. of Contemporary Art, La Jolla, Calif. 1984; "Aspects de la Peinture Contemporaine," Principality of Andorra and Mus. d'Art Moderne, Troyes 1984; "Rite, Rock et Rêve" (trav. exhib.), Mus. Cantonal des Beaux Arts, Lausanne Kunstverein, Heidelberg; Kunsthaus, Aarau; Sonja Henies og Niels Onstads stiftelser, Oslo; Nordjyllands Kunstmus., Aalborg 1984–85; Mus. d'Art Contemporain, Montreal 1984; "5/5, Figuration Libre France/USA," Mus. d'Art Moderne de la Ville de Paris 1984; "Autour de la B.D.," Palais des Beaux Arts, Charleroi (Belgium) 1984; "De Fil en Images, d'Images en Récits," Château de la Roche-Jagu, Côtes du Nord (France) 1985; "Figures Libres et Bandes Dessinées," Mus. Goya, Castres 1985; "Figuration Libre," Cntr. Culturel du Parvis, Tarbes (France) 1985; "Expressionnisme, Esprit Sauvage, et Neoprimitivisme," Bologna 1985; "BD Boum," Lisbon 1986; "Zeitgenössische französische Malerei," Gal. Krings-Ernst, Cologne 1987.

COLLECTIONS INCLUDE: CAPC Mus. d'Art Contemporain, Bordeaux; Cntr. National d'Art Contemporain, Paris; Fonds National d'Art Contemporain (France); Fonds Regional d'Art Contemporain, Midi-Pyrenées; Groningen Mus. (Netherlands); Mus. d'Art Moderne de la Ville de Paris.

ABOUT: "L'Air du Temps" (cat.), Galerie d'Art Contemporain des Musées de Nice, 1982; "Ateliers 81/82" (cat.), ARC, Mus. d'Art Moderne de la Ville de Paris, 1981; "Blanchard Boisrond Combas Di Rosa" (cat.), Groningen Mus., 1983; "De Fil en images, d'Images en Récits" (cat.), Château de la Roche-Jagu, 1985; "5/5: Figuration Libre France/USA" (cat.), ARC, Mus. d'Art Moderne de la Ville de Paris, 1984; "French Spirit Today" (cat.), Univ. of Southern California Art Gal., Los Angeles, 1984; "Hervé Di Rosa" (cat.), Cntr. d'Art de Flaine, 1983; "Hervé Di Rosa" (cat.), Gal. Gillespie-Laage-Salomon, Paris 1982, 1983, 1985; Perdriolle, H., Figuration Libre, 1984; Seisser, J., "Jean Seisser presente Hervé Di Rosa," 1983; Seisser, J., "Jean Seisser presente les aventures de Hervé et Richard" (cat.), Groningen Mus., 1986. *Periodicals*—Art in America Summer 1982, September 1982, May 1984; ARTnews March 1983; Art Press September 1982; Arts Magazine October 1983, November 1983, February 1984; Beaux-Arts February 1984; Connaissance des Arts April 1983; Eighty Magazine May–June 1987; Flash Art International Spring–Summer 1985; Libération (Paris) September 29, 1981, January 21, 1985; Studio International no. 1004, 1984.

***DOKOUPIL, JIRI GEORG** (March 6, 1954–), Czech painter and sculptor, is one of the expatriate artists of Eastern Europe's postwar generation who have contributed to the renewal of painting in West Germany. A member of Cologne's Mülheimer Freiheit group in the early 1980s, Dokoupil remains a leading practitioner of the willful eclecticism that is characteristic of much of the new German painting.

Born in Krnov (near the Polish border with Czechoslovakia), Dokoupil was one of three children in a comfortable family of professionals. He had a grandmother who was one of the first women to become a doctor in Czechoslovakia and a grandfather who was a mathematician; his own father, a mechanical engineer, was a successful inventor with over seventy patents in his name. An exemplary student as a child, Dokoupil demonstrated an early interest in art and attended a fine arts day school, but he was also involved with sports (including youth championship Ping-Pong), and enjoyed working on scientific projects with his father.

In 1968, when the Soviet Union invaded Czechoslovakia, Dokoupil and his family left the country, going first to Vienna and then to West Germany. Fourteen at the time, he was deeply affected by the move—he knew no German, for one thing—but after a few months he was able to resume painting. When he completed his secondary education in 1975, he applied to the Munich Academy but was rejected, so he entered art school in Cologne. Thoroughly dissatisfied with the school's program, he and a friend, Gerard Kever, began looking for ways to escape, and the solution they finally found was a one-year scholarship to study in New York City.

The experience was overwhelming for both of them: New York, Dokoupil has recalled "was like a whole other world, and a nice little shock." Suddenly exposed to countless new movements and ideas, he plunged himself into the library to read up on the history of what he was seeing, and he became an avid consumer of all the city had to offer in the way of film, video, and the media. For his formal education, he enrolled in the Cooper Union, where he studied with the conceptual artists Joseph Kosuth and Hans Haacke. On his return to Cologne, he undertook a Haacke-like investigation of the art school, and he and Kever made a film, *Poisoned Holiday,* which they modeled on the work of the filmmaker Robert van Ackeren.

In 1979 Dokoupil became part of a group of young artists who took to meeting in bars to discuss their work and also to collaborating on drawings and cartoons. Among the others were Walter Dahn, who had come to Cologne from

°dō koo´ pil, zhē rē´

Düsseldorf (where he was a student of Joseph Beuys); Hans-Peter Adamski, whom Dokoupil had met in New York; and Adamski's friend Peter Bömmels. The following year they organized an exhibition of wall paintings, silhouettes, and small sculptures that they called "Even If the Guinea Fowl Softly Weeps"; held at the gallery of the local artists' association, it succeeded in attracting the attention of the Cologne gallery owner Paul Maenz, who offered them their show. It was at that point that they decided to rent a studio together—located at 110 Mülheimer Freiheit—and with the addition of Gerard Kever and Gerhard Naschberger, the Mülheimer Freiheit group was born. Their exhibit at the Paul Maenz Gallery in late 1980 brought them national recognition, and four months later they found themselves featured at the Groningen Museum in Holland, with invitations to participate in major exhibitions of German art in Cologne, Munich, and Berlin.

Paralleling similar groups of young, expressionist painters elsewhere in Germany (notably the "young fauves" of Berlin), Italy, and France, the members of Mülheimer Freiheit were quickly dubbed "the punks of the palette" for their irreverent and unaesthetic paintings, which they often executed collaboratively. "We do not want a new style, a new direction, least of all a Mülheimer Freiheit school," they declared at the time of the Groningen exhibit. "We want to be ourselves and put ourselves to the test over and over again." In Dokoupil's case, his rejection of consistent style and statement translated into voracious eclecticism. Initially, at least, much of his inspiration came from artistic models, ranging from classical antiquity to the modern masters: "In many cases," he explained, "I quote from art history in response to a momentary need. I use it as if it were conventional found language. In this respect, my interests are very volatile. I slip into another hole and then that's what I am." This mutability took on yet another dimension through his continous collaboration with Walter Dahn, to the extent of becoming what they referred to as a "third person." According to Dokoupil, "Walter was the chaos principle, I was the ordering one. He splashed out all over the place, I channeled the energy." In their joint works, that encounter of chaos and ordering frequently translates into paintings that are visually quite free and seemingly haphazard, but brought under control by an overriding concept. "Drei Gitarren" (1980), for example, consists of three guitars done in collage, one covered with abstract expressionist drips and brush strokes, one painted white and marked with the conceptual artist's mathematical calculations, and one decorated with brightly colored but regular daubs of paint, all of which, taken together, offer an ironic commentary on the notion of style in modern art. The same dynamic informs Dokoupil's individual works of that period, but the visual component is generally more reserved. In "Frülhingsturm I-III" (Spring Storm I-III, 1981), for example, an El Greco nude in a stormy landscape, two swordbearers borrowed from a Nazi war memorial, and three statuesque wrestlers from classical antiquity invite similar contemplation of the meaning of style, as well as of the heroic values those particular styles are intended to transmit.

The Mülheimer Freiheit group dissolved in 1982, and while Dokoupil and Dahn continued to work together, Dokoupil himself attracted increasing attention for what came to be perceived as much more of a conceptual enterprise than an expressionistic one. Following his 1983 exhibit at the Mary Boone Gallery in New York, Donald Kuspit wrote, "In fact I think these are really nineteenth-century paintings masquerading as twentieth-century novelties," because they seemed much more "tame" than the so-called neo-expressionist works and, at the same time, "more eloquent in their sociopolitical commentary."

By that time, Dokoupil had evolved from pastiche-as-style to style as a one-shot affair consecrated to an individual series of paintings. His output in the course of 1982, for example, included a four-part "Geschichte des Universums" (History of the Universe) in a biomorphic style; the "Studie zu einem neuen Menschenbild" (Studies for a New Image of Man), which was somewhat more three-dimensional and illusionistic; the "msterdam Bilder: Befehle des Barock" (Amsterdam Paintings: The Commands of the Baroque), a group of dream-image heads somewhere between Paul Klee and psychedelic art; the "Maske" (masks), which were completely abstract paintings in a tall, slender Barnett Newman format; and the "Blaue Bilder über die Liebe" (Blue Paintings on Love), combining banal imagery with overbearing blue paint to arrive at a jarring level of bad taste (that series was accompanied by eleven "Blue Sculptures on Love"). "The continuity in my works doesn't interest me," Dokoupil insisted at the time. "What interests me in my [paintings] are the ruptures and contradictions." For the critic Ingrid Rein, among others, that unpredictability was stimulating insofar as it "clears the viewer's head of remembered images. One has to look with a fresh eye, turning one's attention to the picture at hand and not to developments within a personal style."

Also inherent in his nonlinear approach is a

challenge to art criticism, which assumes a certain pattern of incremental change, and it is that deconstructionist path that Dokoupil has pursued through the second half of the 1980s. Insisting that he wants to make "international icons" and "religious images" like the Hollywood films of the 1940s and 1950s or Michael Jackson's *Thriller* album, he has increasingly drawn on mass culture for the subjects, the forms, and sometimes even the materials of his art. With the "Frotee Bilder" (Terry Cloth Paintings, 1984), fashioned out of zippers and buttons on brightly colored terry cloth; the "Schnuller Bilder" (Pacifier Paintings, 1984), a series of tumescent pacifiers paired up with various objects and animals in greeting-card settings; or the "Baby Pictures" (1985), creating similarly vapid vignettes with wide-eyed cherubs, large blue globes, and pink sunrises (often executed in pastels), Dokoupil confronted the contemporary art establishment with works that were not lacking in artistic or social commentary but which drew their visual idioms straight from the world of kitsch. "Ideally every Baby Picture should be capable of being hung as a poster in every fourteen-year-old boy's bedroom," Dokoupil claimed in a 1986 conversation with his dealer, Paul Maenz, explaining that what he saw as important now—as opposed to his early, expressionist phase—was "to create a picture which may be capable of speaking on a level representative of the aspirations of many."

Along with those and other mass-culture icons, Dokoupil also undertook such varied projects as the self-descriptive "Nasenblutendes Selbstporträts" (Nose-Bleeding Self-Portraits, 1984); the "Therapeutische Bilder" (Therapeutic Paintings, 1984), huge canvases teeming with detail and no recognizable images; the monochromatic "Grünspan Bilder" (Verdigris Paintings, 1984); and a series of screenprints (The D Portfolio, 1986) converting the motifs of the "Baby Pictures" into stylized designs. Early in 1985 he embarked on "Corporations and Products," a double series of forty-three painted clay sculptures and thirteen paintings composed of a gamut of brand names (from Adidas to ZDF) rendered in an artisanal style ironically at odds with their habitual advertising logos. That was followed in 1986 by a group of bronze sculptures similarly presenting the names of contemporary art institutions and their increasingly corporate patrons.

When the Mülheimer Freiheit and the rest of the explosive German painting scene first attracted international attention in 1982, the critic Donald Kuspit astutely identified a major aspect of the new movements: unlike their American counterparts among the "bad painters," he ar-

gued, they were not making antiart but rather were "testing the limits of what is culturally acceptable. . . . In effect, they are saying 'This is a bourgeois society claiming to exist in the name of freedom. Does a free, unrestricted, seemingly dissolute art that takes all kinds of liberties, that ruthlessly tampers with our expectations, have a place in a free society?'" That gesture, as he noted at the time, is particularly significant for artists like Dokoupil who come from the Eastern bloc. Dokoupil himself explained early on, as "My rejection of any form of programming in my art probably has something to do with the fact that I grew up in Czechoslovakia. This made me mistrustful of any dogma or predetermination." To which it may be added that his present situation, as a Czech emigré dividing his time between Cologne and Santa Cruz de Tenerife (Spain), with a major part of his audience in New York (where he has also lived from time to time) clearly reinforces his "peripatetic aesthetic" (in the words of Stephan Ellis). For some observers, including Ellis, the danger of that "constant travel" is that "variety itself becomes habitual, and a stop at any single point along the way inconsequential." But others, such as Dokoupil's longtime supporter Jean-Christophe Amman, continue to be fascinated by the mentality underlying the paintings; "One thing is sure," wrote Amman on the occasion of Dokoupil's 1984 retrospective: "at the base of this polyglot intuition is a mental capacity for linking an element of play to curiosity and experience to experimentation. Dokoupil is an artist hungry to know. . . . His painting is not painting pure and simple but an instrument, a method of creative appropriation on different levels, which he uses for his representations."

EXHIBITIONS INCLUDE: Gal. Paul Maenz, Cologne, from 1982; Gal. Chantal Crousel, Paris 1982; Helen van der Meij, Amsterdam 1982; Gal. t'Venster, Rotterdam 1982 (with Walter Dahn); Produzentengal, Hamburg 1983 (with Walter Dahn); Gal. Six Friedrich, Munich 1983 (with Walter Dahn); Mary Boone Gal., NYC 1983; Gal. Ursula Schurr, Stuttgart 1984; Mus. Folkwang, Essenn 1984; Gronigen Mus., Gronigen 1984 (with Walter Dahn); Kunstmus., Luzerne 1985; Gal. Leyendecker, Santa Cruz de Tenerife 1985; Gronigen Mus., Gronigen 1985; Espace Lyonnais d'Art Contemporain., Lyon 1985; Paule Anglim Gal., San Francisco 1985; Asher-Faure Gal., Los Angeles 1985; Gal. Heinrich Ehrhardt, Frankfurt-am-Main 1985; Leo Castelli Gal., NYC 1985; Gal. Vera Munro, Hamburg 1985 (with Walter Dahn); 121 Art Gal., Antwerp 1986; Gal. Marilena Bonomo, Bari 1986; Gal. Ileana Sonnabend, NYC 1986. GROUP EXHIBITIONS INCLUDE: "Auch wenn das Perlhuhnmeise weint," BBK, Hahnentorburg, Cologne 1980; "Mülheimer Freiheit und interessante Bilder aus Deutschland," Gal. Paul Maenz, Cologne 1980; "Neue Duitse Kunst I—M'ulheimer Freiheit," Groningen

Mus., Groningen 1981; "Rundschau Deutschland I," Lothringer Strasse 13, Munich 1981; "Bildwechsel—Neue Malerei aus Deutschland," Akademie der Künste, Berlin 1981; "Die heimliche Wahrheit—Mülheimer Freiheit," Kunstverein, Freiburg 1981; "10 Künstler aus Deutschland," Mus. Folkwang, Essen 1982; "12 Künstler aus Deutschland," Kunsthalle, Basel and Mus. Boymans- van Beuningen, Rotterdam 1982; Documenta 7, Kassel 1982; "Zeitgeist," Martin-Gropius-Bau, Berlin 1982; Venice Biennale 1982; "Expressionisten—Neue Wilde," Mus. am Ostwall, Dortmund 1983; "Mülheimer Freiheit Proudly Presents the Second Bombing," Scottish Arts Council, Edingurgh and Inst. of Contemporary Arts, London 1983; "Ursprung und Vision—Neue Deutsche Malerei," Barcelona and Madrid 1984; "An International Survey of Recent Painting and Sculpture," MOMA, NYC 1984; "Painting Now," Mus. of Art, Kitakyushu (Japan) 1984; "7.000 Eichen" Kunsthalle, Tübingen 1984; "Von hier aus," Messegelände, Düsseldorf 1984; "Rheingold," Pal. della Società Promotrice delle Belle Arti, Turin, 1985; "Tiefe Blicke; Kunst der achtziger Jahre aus der Bundesrepublik Deutschland, der DDR, Österreich und der Schweiz," Hessisschaen Landesmus., Darmstadt 1985; Paris Biennale 1985; São Paolo Biennale 1985; Carnegie International, Pittsburgh Mus. of Art, 1985; "1945-1985—Kunst in der Bundesrepublik Deutschland," Nationalgal., Berlin 1985; Sydney Biennale, 1986; "Den globale Dialog," Louisiana Mus., Humlebaek (Denmark) 1986; "Sonsbeek 86," Arnheim 1986; "Beuys zu Ehren," Städtische Gal. fa Lenbachhaus, Munich 1986; "Prospect 86," Kunstverein, Frankfort 1986.

COLLECTIONS INCLUDE: Tobb Collection, Antwerp; Van Abbemus., Eindhoven; Mus. Folkwang, Essen; FER Collection, Laupheim; Schürmann Collection, Herzogenrath.

ABOUT: "Dokoupil Arbeiten/Travaux/Works 1981-1984" (cat.), Mus. Folkwang, Essen, 1984; Faust, W., and G. de Vries. Hunger nach Bildern, 1982; "Mulheimer Freiheit" (cat.), Groningen Mus., Groningen, 1981; "Mulheimer Freiheit Proudly Presents the Second Bombing" (suppl. to exhib.), Inst. of Contemporary Arts, London, 1983; "1945-1985—Kunst in der Bundesrepublik Deutschland" (cat.), Nationalgal., Berlin 1985; "Tiefe Blicke, Kunst der achtziger Jahre . . . " (cat.), Cologne 1985. Periodicals—Art (Hamburg) August 1984; Artforum March 1983, November 1983, November 1984; Art in America February 1982, September 1982, January 1986; Artscribe December 1983; Flash Art March 1984, April 1984, January 1985, April 1987; Print Collectors' Newsletter September–October 1986.

FETTING, RAINER (December 31, 1949–), German painter is a member of the second postwar generation of artists, which has been variously identified as the neo-expressionists "violent painters," and the "young

fauves." Along with his friends Helmut Middendorf, Salomé, and Bernd Zimmer, he first attracted attention as a youth-culture phenomenon, a brash young artist whose student paintings gave visual form to life on the margins of Berlin society. Ever since his first exhibition in 1977, he has continued to explore the urban scene, but the rawness has given way to the studied compositions and deliberate brushwork of a gifted colorist.

Fetting was born in the port city of Wilhelmshaven in Lower Saxony. The son of an art and music teacher, he grew up in a home filled with art books. At the age of eleven, he was enrolled in a children's workshop, and he kept at it from then on. After high school, and a failed baccalaureate exam, he wanted to become an artist or an actor, but he was discouraged by the psychotherapist he was seeing and became a carpenter's apprentice instead. Nonetheless, he continued as a volunteer set painter at the National Theater of Northern Lower Saxony, and three years later, he passed the entrance exam for the Hochschule der Künste and moved to Berlin to study painting with the colorist Hans Jaenisch.

During his six years at the Hochschule, he shared a loft with one of the livelier students there, Wolfgang Cielarz, a painter, dancer, musician, waiter, homosexual activist, and sometime transvestite who had already taken to calling himself Salomé. In 1977, Fetting and Salomé, together with Helmut Middendorf and Bernd Zimmer, set up their own art gallery, the Galerie am Moritzplatz, in the rundown immigrant quarter of Kreuzberg. At that point, their activities as painters were part of the larger punk scene. "Deep down, we're all would-be rock stars," he explained. "Once I studied—or *had to* study—the piano, though I did not want to. If I had studied guitar, today I would be a rock star." In fact, he did play the drums in a rock group, Geile Tiere, with Salomé and Luciano Castelli, while Middendorf and Zimmer painted collective murals at SO-36,a Kreuzberg supermarket converted into a popular discotheque. From 1976 on, Fetting also began making films in super-8, including a ninety-minute collaboration with Salomé, *R und S in B* (1977).

Fetting had his first exhibit at the Galerie am Moritzplatz in October–November 1977; in comparison with the animated painting styles of Middendorf and Zimmer, not to mention the provocative images of Salomé, Fetting's early city scenes and figure groups were fairly conventional. One of his earliest adult paintings, *Klaus, Jorge, and Barbara* (1977), for example, is more interesting for its innuendo than its handling of paint: a young man is ambiguously posi-

tioned between a woman and another man, one arm draped over the woman's shoulder, the other interlocked with that of the man, and each figure stares into a separate space. By the next year, though, Fetting's style had come into its own, with loose and agitated brushwork, and a vibrant palette of reds, yellows, greens, and blues. One recurring theme was that of the late nineteenth-century artist Van Gogh, transposed into the twentieth-century milieu, just as Van Gogh's postimpressionist brushwork and use of color was given a postexpressionist equivalent, based above all on the juxtaposition of color areas to create mass, depth, and movement all at once. For Fetting, Van Gogh did not evoke the "suffering artist," but rather, "tremendous power, action in his life, tremendous joy. . . . He recognized that color is what's exuberant, and a brush is what's exuberant. . . . He painted abstractly, he applied his colors and started out from things that mattered to him emotionally." This spirit is apparent in Fetting's paintings of the emblematic artist figure. In *Van Gogh in New York,* a 1978 watercolor, the artist, garbed in green with a purple backpack and broad-brimmed yellow hat, strides into the deep space of a city sidewalk defined by the exaggerated perspective of a gleaming red-orange wall; in *Van Gogh—Landschaft* (Van Gogh—Landscape, 1978), the most fluid of figures, now in flaming red pants and white shirt, makes his way toward the viewer against a purple "landscape" demarcated by a receding row of tree trunks; and in *Van Gogh und Mauer* (Van Gogh and Wall, 1979), another green-garbed figure proceeds along a bright yellow wall.

The same play of color and space is brought to more topical subjects in paintings like *Drummer und Guitarist* (1980)—where two contradictory perspectives are joined in a surface pattern of dazzling yellow, red, and orange—or *Another Murder at the Anvil* (1979), a visionary rendering of an incident at a gay bar in New York (where Fetting spent part of 1978–1979 on a grant from the German Office of Academic Exchange). In still other works—male nudes, portraits, gay couples, the whole series of "Shower" paintings inspired by E. M. Kirchner's *Artilleristenbad* (Artillerymen's Bath, 1915)—the energy becomes sensual. An example is *Large Shower (Panorama)* of 1981. The male body, Fetting told Helena Kontova, is "more sexual" for him than the female body, and on the canvas, that sexuality is transmitted not by any particular action, but by the rendering of the figures.

In the early 1980s, Fetting and his friends, along with a group of young artists working together in Cologne (the Mülheimer Freiheit), and

other Berlin painters from the generation of the 1960s (Georg Baselitz, Markus Lüpertz, Karl Horst Hödicke) gained international attention as the exponents of a new style, collectively identified as neo-expressionism. Within the general trend, the Galerie am Moritzplatz group found themselves labeled with the name they had chosen for their first group show in 1978: heftige malerei, or violent painting. Under that title they were given an exhibit at the Haus am Waldsee in Berlin in 1980, and, the same year, they were invited to participate in the Goethe Institute's exhibit of "Young Art from Berlin," which traveled to Essen, Basel, Rotterdam, London, and Bologna. In 1981 Fetting was included in five group exhibits signaling the "new wave" in German painting, along with the seminal international exhibition "Après le Classicisme," which marked the broader revival of national painting schools throughout Western Europe. He also had his first solo show in New York and a two-man show with Middendorf in London. As with the transavangardia in Italy and *figuration libre* in France, the sudden fame of the German neo-expressionists (also called the young fauves) had a great deal to do with external circumstances: the stagnation of the European art markets in the face of American domination since World War II, the related desire for a reassertion of national identities, and disaffection with the overly intellectual trends of the 1970s. Fetting and his friends, like their peers in Italy and France, offered critics, dealers, and collectors a group phenomenon that permitted identification with Germany's prewar modernist tradition in its style, and at the same time, in the words of the critic Wolfgang Max Faust, the most enthusiastic promoter of the new art, represented "a rediscovery of simple, spontaneous drawing and painting."

The danger posed by that sudden success was signaled by Edward Lucie–Smith as early as 1981: after seeing Fetting's work in London, he acknowledged that the thirty-two year old artist was "clearly a fluent painter who works very rapidly," but expressed concern that the demand for his work was pushing him into overproduction. "One wonders," he asked, "if his talent will stand up to the pressures which are clearly going to be put on him." In fact, Fetting managed to hold his own and establish an identity apart from the market phenomenon of the neo-expressionists. As Marco Meneguzzo wrote following his one-man show in Milan in 1983, Fetting stood out from the other young fauves because of "a greater cultural heritage, a wider repertoire of images, and a more highly developed capacity for visual translation."

For a time, he expanded his dialogue with the

art of the past: Picasso gave rise to his "Bügler" series (*Man Ironing*, 1983); Manet's *Man with a Palette* inspired his *Selbst-Portrait mit Palette* (1983), and earlier masters like Velázquez and Delacroix emerged as points of reference in Velázquez-Claus (1983) and *Delacroix-Hercules* (1983). Nor was the exchange simply thematic: it was by working through the earlier styles that he was able to find his own visual idiom. Describing the evolution of his portraits, for example, he explained to Sibylle Kretschmer in 1984, "You see something, a particular expression, and then somehow you start out yourself, and perhaps you don't put heads on your portraits at all at first because you simply can't do it, so you experiment with lots of things. . . . That was a very long process for me, a very roundabout route. I tried impressionism, I tried expressionism, before arriving at a painting style which uses strong, broad strokes."

In 1983 Fetting settled in New York. "I was starting to get bored, so I decided to go somewhere else," he told Kontova very matter-of-factly. The city itself obviously generated its own repertoire of subjects—new friends and lovers, new settings, new fantasies—but there were changes in his technique as well. Following the move to New York, Fetting switched from the emulsions he had been using since his student days to oil paint, which allowed him even more rapid, fluid brushwork, as well as a richer texture. The result was a more spontaneous, subjective, and sometimes even bizarre form of expression, as in *West-Nacht* (West-Night, 1984), an eerie night scene populated by the city's homeless and a Michelangelesque figure who soars in to join them around the trash can fire they've made to keep warm. In many of the New York works, urban blight assumes a physical presence with scraps of wood attached to the canvas and painted into the composition (in *West-Nacht,* a man is sawing one of those accretions). The mix of nocturne and nightmare is accentuated in a series of subway scenes from 1985 (*Halloween Mask in Subway, Frankenstein in Subway, Candleman in Subway*) and the "Wolf" paintings that he began in 1983. ("I can just imagine here in New York that suddenly there's this wolf around the corner," Fetting told Richard Sarnoff. "In winter especially, people have something of wolves about them.")

The outsider's eye was evident in Fetting's paintings from the very beginning; as Heinz-Peter Schwerfel has pointed out, he treated the same subjects as his friends Salomé, Middendorf, and Zimmer—Berlin night life, the gay subculture, the countryside—but with less engagement than they did: "His personal experiences always come through in his paintings, but not without a certain filtering to begin with. Essentially pictorial, his approach often parts company with the thematic in the strict sense of the word." That sense of distance becomes all the more apparent in the New York paintings—isolated nudes, portrait heads, distant views of New Jersey from deserted piers, and the ultimate image of the loner, the wolf.

According to Fetting, he has no set way of painting: "It's always different," he told Helena Kontova. "I never thought about having rules. I paint with everything, even my fingers. . . . I work on whole areas to get a kind of harmony. Sometimes I start with a head, sometimes with the interior. I need to take a distance from the painting and then I go back. But it's kind of instinctive painting, and I don't realize how I do it." For the critics, it is the strength of his instinct for color and composition that makes his work stand out. Assessing Fetting's work on the occasion of his 1986 retrospective in Essen and Basel, Jean-Christophe Amman wrote that "his particular achievement is to have brought forth the subject as a patently sensual thing from the painting itself." His paintings do not interpret, Amman noted; "they make interpretation possible."

EXHIBITIONS INCLUDE: Gal. am Moritzplatz, Berlin 1977, '78; Gal. Interni, Berlin 1979; Musikhalle SO-36, Berlin 1979 (with Bernd Zimmer); Anthony d'Offay Gal., London 1981 (with Helmut Middendorf), '82; Mary Boone Gal., NYC, from 1981; Gal. Bischofberger, Zurich 1981; Gal. Paul Maenz, Cologne 1982; Gal. Sylvia Menzel, Berlin, from 1982; Gal. Yvon Lambert, Paris 1983; Gal. Helen van der Meij., Amsterdam 1983; Studio d'Arte Cannaviello, Milan 1983; Gal. 5, Stockholm 1983; Gal. Raab, Berlin, from 1983; Gal. Maier-Hahn, Düsseldorf 1983; Marlborough Gal., NYC, from 1984; Mineta Move Art Gal., Brussels 1984; Gal. Pierre Hubert, Geneva 1985; Gal. Thomas, Munich 1985; Mus. Folkwang, Essen, and Kunsthalle, Basel 1986; Gal. Würthle, Vienna 1987. GROUP EXHIBITIONS INCLUDE: "Neue Gruppe," Grosse Münchner Kunstausstellung, Munich 1976; "Die Zwanzigen jahre Heute," Hochschule der Künste, Berlin 1977; "Photographien," Gal. am Moritzplatz, Berlin 1978; "Alkohol, Nikotin, fff," Gal. am Moritzplatz, Berlin 1979; Deutscher Kunstlerbund, Stuttgart 1979; "Heftige Malerei," haus am Waldsee, Berlin 1980; "Junge Kunst aus Berlin," Goethe Inst. (trav. exhib.) 1980; "New Spirit in Painting," Royal Academy, London 1981; "Rundschau Deutschland," Fabrik, Munich 1981; "Bildwechsel: Neue Malerei aus Deutschland," Akademie der Kunst, Berlin 1981; "Après le Classicisme," Mus. d'Art et d'Industrie, Saint-Etienne 1981; "Situation Berlin," Gal. d'Art Contemporain, Nice 1981; "Berlin, Die Letzen 20 Jahre," Kunsthalle, Wilhelmshaven 1981; "Return to Euros," Gal. Paul Maenz, Cologne 1981; "Im Westen Nichts Neues," Cntr. d'Art Contemporain, Geneva 1982; "10x10 Malerei," Kunstverein, Munster 1982; "The Pressure to Paint," Marlborough

Gal., NYC 1982; "Zeitgeist," Martin-Gropius-Bau, Berlin 1982; Venice Biennale, 1982; "Spiegelbilder," Kunstverein, Hanover 1982; "Castelli, Salomé, Fetting," CAPC, Bordeaux 1984; "New German Painting," Tel Aviv Mus. 1984; "Expressionistische Malerei nach Picasso," Gal. Beyeler, Basel 1983; "25 Junge Deutsche Künstler," Moderna Gal., Lubljana and Sociedad Nacional de Bellas Artes, Lisbon 1983; "Terminal New York," Brooklyn 1983; "Marathon 83," Brooklyn 1983; "New Art," Tate Gal., London 1983; "New Figuration: Contemporary Art from Germany," Frederick S. Wight Art Gal., UCLA 1983; "The European Attack," Gal. Barbara Farber, Montreal 1984; "New Expressionism," Art Gal. of Ontario 1984; "The Human Condition," San Francisco Mus. of Modern Art, 1984; "An International Survey of Recent Painting and Sculpture," MOMA, NYC 1984; "Zwischenbilanz: Neue Deutsche Malerei," Neue Gal. am Johanneum, Graz, Mus. Villa Stuck, Munich, and Rheinisches Landesmus., Bonn 1984; "Origen y Vision, Nueva Pintura Alemana," Cntr. Cultural de la Caixa de Pensions, Barcelona, Palacio Velasquez, Madrid, Mus. de Arte Moderno, Mexico City 1984–85; "Neue Malerei—Berlin," Kestner Gesellschaft, Hanover 1984; "Nine Berlin Artists," 44 White Street, NYC 1984; "Neue Expressive Malerei," Nassauischer Kunstverein, Wiesbaden 1984; "La Metropole Retrouvée: Nouvelle Peinture à Berlin." Palais des Beaux-Arts, Brussels 1984; "Von Hier aus." Messehallen, Düsseldorf 1984; "Nackt in der Kunst des 20. Jahrhunderts," Sprengel Mus., Hanover 1984; "Selbst-Portrait in Zeitalter der Photographie," Mus. Cantonal des Beaux-Arts, Lausanne, Württembergischer Kunstverein, Stuttgart, Akademie der Künste, Berlin 1984; "States of War: New European and American Paintings," Seattle Art Mus. 1985; "Intorno al Flauto Magico," Palazzo della Permanente, Milan 1985; "Moritzplatz," Kunstverein, Bonn 1985; "Modus Vivendi," Mus. Wiesbaden 1985; "Apokalypse—Ein Prinzip Hoffung," Wilhelm-Haak-Mus., Ludwigshafen 1985; "Anni Ottanta," Bologna 1985; "1945–1985: Kunst in der Bundesrepublik Deutschland," Nationalgal., Berlin 1985; "La Nouvelle Peinture allemande dans la collection Ludwig," Goethe Institute (trav. exhib.) 1987.

COLLECTIONS INCLUDE: Ludwig Collection, Aachen; Metzger Collection; Morton G. Neumann Collection.

ABOUT: "Berlin, Die Letzen 20 Jahre" (cat.), Kunsthalle, Wilhelmshaven, 1981; "Bildwechsel: Neue Malerei aus Deutschland" (cat.), Akademie der Künste, Berlin, 1981; Emanuel, M., et al. Contemporary Artists, 1983; Faust, W. M. and G. de Vries, Hunger nach Bildern, 1982; Klotz, H. Die Neuen Wilden in Berlin, 1984; "1945–1985, Kunst in der Bundesrepublik Deutschland" (cat.), Nationalgal., Berlin, 1985; "New Spirit in Painting" (cat.), Royal Academy, London, 1981; "Rainer Fetting" (cat.), Gal. Raab, Berlin, 1983; "Rainer Fetting" (cat.), Mus. Folkwang, Essen, 1986; "Rainer Fetting: Bilder 1973–1984" (cat.), Gal. Raab, Berlin, 1985; "Rainer Fetting: Holzbilder" (cat.), Marlborough Gal., 1984; "Rundschau Deutschland" (cat.), Fabrik, Munich, 1981; "Salomé Castelli Fetting: Peintures 1979–1982" (cat.), CAPC, Bordeaux, 1983; "Situation Berlin" (cat.), Gal. d'Art Contemporain,

Nice, 1981; Who's Who in American Art, 1989–90. *Periodicals*—Art in America February 1982, September 1982; Art International August-September 1981; ARTnews November 1986; Connaissance des Arts January 1985; Flash Art May 1983, January 1984, March 1985; Kunstwerk September 1985, June 1985; Libération (Paris) December 12, 1984; L'Oeil October 1985.

FISCHL, ERIC (1948–), an American painter who defies stereotypes, is noted for his large, figurative paintings, which are decidely aggressive in subject matter and psychologically intrusive. His depictions of the suburban, leisured existence of the American middle class has been analyzed in terms of sexuality, hidden violence, and the observed intimate moment. Fischl's work has been admired by critics, but has also been described as voyeuristic. His work can be disturbing, but it is also illuminating, for he places the viewer in the middle of a drama. More than any neo-expressionist, realist or representational painter, Fischl depicts the human being in a hidden drama. He is in many ways comparable to the novelist John Updike as a chronicler of the manners and morals of the contemporary American middle class.

One of four children, Eric Fischl was born in New York. He lived in a middle-class environment near Port Washington, Long Island. He considered himself a shy child. His father was in sales and his mother a housewife who was an alcoholic. In an interview with Nancy Grimes in *ARTnews,* he expressed the trauma and conflict of his youth: "My mother was a very frustrated creative person. I also think she was chicken. I used to think she was a victim of circumstance and I really resented the male authority that would keep such a creative person down —not just my father, but the social situation. A lot of my energy focused on that anger. But the reality is, it's a disease as well. She wasn't particularly courageous."

Fischl was not a great student, getting into trouble in school by being something of a cutup and an irritant to teachers. In 1966, he enrolled in a small school in Pennsylvania and on advice from his father took business courses. Leaving school after a short time, he became a flower child and gravitated to the Haight-Ashbury district of San Francisco during an era of social protest, psychedelic drugs and communes. Despite his attempts to fit in, Fischl could not accept the communal life-style. Frustrated and confused, considering himself a loner, Fischl left San Francisco and went to Arizona, where his family had moved. Groping for a new beginning, he enrolled at the Phoenix Junior College and took art

ERIC FISCHL

classes with Merrill Mahaffey, a well-known and respected landscape painter. It seemed to Fischl as if he had found himself. On a scholarship, he continued his studies at Arizona State University with Bill Swaim; as his iterest in art became more serious, he discovered the works of Kandinsky, Gorky, and de Kooning. Fischl finished his studies at the California Institute of Arts, Valencia, where he received a B.F.A. degree in 1972. Dring his studies there his mother died in an automobile accident.

Fischl has spoken of the influence of Arizona on his art; "When I lived in Arizona, I was moved by the light and the architecture that is so prevalent in most of the work. It's a sort of flat light that delineates all the shapes—everything has clear sharp edges to it. It's a Western light."

After graduation, Fischl felt that his abstractions were too limiting: "The forms only had large meaning for me. They didn't have specific moment meaning. They represented absolutes and I couldn't break my absolutes down into subtler things. I loved the way all these people (abstract painters) produce this variety of language. From little bitty things here to large things there. I could only do that when I got representational art."

In the early 1970s Fischl was still groping for a style of painting that would give him satisfaction. He supported himself by working as a guard at the Museum of Contemporary Art in Chicago. In 1974, seemingly out of the blue, he was asked to teach at the Nova Scotia College of Art and Design in Halifax. Fischl accepted quickly and taught there for four years during

which time his representational style evolved. Nancy Grimes has described Fischl's first figures as generic family, modeled on Halifax fishermen. Fischl himself said that he drew fishermen because they were there; however, he became dissatisfied with the simplicity of the subject matter and sought to give additional meaning to his paintings by adding descriptive and explanatory sentences.

Considering himself part of the mainstream of art, he left his teaching position to move to New York City: "I moved to New York," he has explained " because it is a power center, to take responsibility for my ambitions, for my work." The art critic Donald Kuspit has said that a mood of "contained despondency" is pervasive in Fischl's work. The artist himself has said: "I have a unique position, because I don't have many people imitating what I do. . . . I am not a movement. I think I am in a central position based on the argument that surrounds content, meaningful versus meaningless. My work is not autobiographical, but you always know best what is closest to you. But I am an artist interested in fictionalizing, making it more interesting, incorporating ideas."

Fischl has identified with the adolescent, but considers himself in transition. "At some point, you grow up; I just happen to be doing it at thirty-eight. Unsure of where the transition was leading, he has indicated, "We will see whether there is as much gold in the new vein." Asked where art was headed in the 1980s, Fischl had no ready answer. He felt it was hard enough for his generation of painters to go from abstraction to the narrative-figurative.

Fischl's rise to artistic prominence was swift. In 1976 he exhibited with Canadian artists at the Vancouver Art Gallery in a show entitled "A Portean View." In 1978 he became an internationally known artist by exhibiting in the Kunsthalle, Basel, Switzerland in a show entitled "Nine Canadian Artists." Exhibitions in New York at the Edward Thorp Gallery followed. In 1984 Fischl exhibited at the Mary Boone Gallery, and in 1986 the Whitney Museum of American Art gave Fischl a retrospective. The exhibition included twenty-eight paintings, among them *Bad Boy* (1981), *Sleepwalker* (1979) and *A Funeral* (1980). All of those can be considered seminal works. The show was an immediate success. Fischl expressed his delight openly: "I think the biggest thing in my life was the show at the Whitney. The show originated in Saskatoon, Saskatchewan, if you can believe that! Why was I included? I had lived in Canada for four years and I had shown there before I moved to New York. Anyway, the show circulat-

ed and was booked into Holland, London, Switzerland. It just kept growing. It ended up in Toronto, Chicago, and New York."

In *Bad Boy*, an adolescent boy has entered a bedroom and contemplates a naked woman while putting his hands into her purse, which is on a dresser. That ambiguous situation is typical of Fischl: Is the boy bad because he watches a naked woman? Is he bad because he has his hand in her purse? Is the woman bad because she allows the boy to witness her voluptuous nakedness? It is up to the viewer to resolve the plurality of the situation. In another important painting, *Digging Children* (1982) the subject matter seems simple and obvious. Children are on a beach playing, holding down and tackling a small child. Everyone is naked. A black boy is either jogging or running away. Adults are also present, relaxing quietly on the beach. The sea is distant and placid. As the viewer focuses on the dynamics of the situation, the question arises—what are these children doing? Is the situation playful or dangerous? Are we witnessing an innocent game? Are there racial overtones? Is violence about to erupt? Fischl felt that because the subject dealt with children, the viewer is exposed to a kind of unconscious violence that is more elemental, more dangerous.

Asked whether Freud, Jung, Adler, or Rank influenced him, Fischl shrugged and stated: "Of course, I am familiar with Freudian doctrine. . . . It is not really necessary to study these subjects to be aware of them. I have never read Freud, but Freud is pervasive. You don't have to read the Bible to know what Christianity is about. There is a political way of analyzing society, and Marxism became popular in analyzing capitalist society because it could stand outside of it. Psychology is away of analyzing behavior, giving it a kind of order. I am not really political!" Fischl's favorite author is the Czech writer Milan Kundera: "He is a writer who writes fiction as a way of conveying wisdom. His stories teach you about situations, at the time you can see behavior that is both personal and cultural."

In analyzing Fischl's subject matter, Donald Kuspit wrote in his essay "Voyeurism, American Style: Eric Fischl's Vision of the Perverse": "Eric Fischl is a master of such perverse realism, of implying the perverse as a response to the real, but not actually representing perverse activity. The conspiratorial air of his pictures, with their often photo-sleazy Hollywoodesque air—which I see as directly antidotal to the medicinal niceties and finesses of prim American realism, from photorealism to Pearlstein, where a pseudovacuousness masks the voyeuristic obsession—helps the implication."

In 1986 Eric Fischl's book, *Sketchbook with Voices*, was published. It is a creative workbook for artists that includes suggestions by artists—Jasper Johns, David Salle, and Elizabeth Murray for example—who pose assignments. Discussing his work patterns, he has said that he likes to paint every day: "I paint one canvass at a time, watch one TV program at a time, read one book at a time! I can't go from one to another. I always try to find a specific relationship to what I am making. I have many more ideas than I can do. It seems pretty easy for me to set up what at first seems like an interesting situation. As I get into it I find out that I am not emotionally connected to it at all and it is therefore not an interesting situation."

Asked whether he discarded paintings that did not please him, Fischl had an interesting answer: "Any paintings that you see in public are paintings that at the time pleased me. Underneath are paintings that did not please me."

Fischl usually produces about seven paintings a year. He makes no preliminary sketches, but may add some while doing the painting or when the painting is finished. He enjoys doing large-scale works. His brush strokes are heavy and emphatic. Asked what was most important to him as a painter—content, color composition, or light—Fischl responded, "All these elements are important, not necessarily in that order. They are elements of making a picture. Content stays primary. In order to sustain interest, it has to be articulated well. This is where light, color, and composition come in. In personal terms, I am more interested in content than composition. I want to explore subject matter to make life more interesting!" Asked about his place in art history, he replied: "The judgment is still out."

More than any of the neo-expressionists, realist or narrative painters, Fischl's work defies easy labels; he depicts the human being. His fascination with adolescent sexuality, cultural taboos, and the intimate gesture create a new articulate language in painting. He realizes that his vision can be unsettling to others. As Fischl moves toward a new transition, which he feels necessary for his development as a painter, he continues to paint his personal vision with honesty and integrity. Perhaps, like the writer Milan Kundera, whom he admires, he paints not only to show us hidden aspects of ourselves and our society, but in order to convey wisdom.

EXHIBITIONS INCLUDE: Dalhousie Art Gal., Halifax, Nova Scotia 1975; Gal. B, Montreal, Quebec Studio, Halifax, Nova Scotia 1976; Gal. B, Montreal, Quebec 1978; Edward Thorp Gal., NYC 1980, '81, '82; Emily H. Davies Art Gal., Univ. of Akron, Ohio 1980; Sable-Castelli Gal., Toronto, Ontario 1982; Univ. of Colorado Art

Gal., Boulder 1982; Larry Gagosian Gal., Los Angeles 1983; Mario Diacono, Rome 1983; Multiples/Marian Goodman Inc., NYC 1983; Niegel Greenwood Gal., London 1983; Saidye Bronfman Cntr., Montreal, Quebec 1983; Sir George Williams Art Gal., Concordia Univ., Montreal, Quebec 1983; Mary Boone Gal., NYC 1984, '87; Whitney Mus. of American Art, NYC 1986.

COLLECTIONS INCLUDE: Downe Collection; Rivendell Collection; Sable-Castelli Gal., Ltd.; Collection of the RSM Company; Saatchi Collection; Collection of Lonti Ebers Fine Arts, Inc.; Menil Foundation; Mus. of Contemporary Art, Los Angeles; Whitney Mus. of American Art, NYC.

ABOUT: Amman, Jean-Christophe. "Zur Ausstellung, " Kanadische Kuenstler, Kunsthalle Basel, 1978; Amman, Jean-Christophe, et al. "Eric Fischl Paintings," Mendel Art Gallery, 1985; Balkind, Alvin. "17 Artists—A Protean View." Vancouver Art Gallery, 1976; Current Biography, 1986; Diacono, Mario, Eric Fischel: "Birthday Boy," (cat.) Mario Diacono Gallery, Rome, 1983; Haskell, Barbara. "Focus on the Figure: Twenty Years," (cat.) Whitney Museum of American Art, 1982; Who's Who in American Art, 1989–90. *Periodicals*—Art in America November 1980, November 1984; Dialogue, The Ohio Arts Journal September–October 1980; Toronto Globe and Mail February 14, 1981; Vanguard April 1982; Artforum Summer 1982; Kunstforum May 1983; Art in America 72, November 1984; Art Talk December 1986; Contemporary Forum Newsletter Winter 1986; ARTnews September 1986.

PERFORMANCES: "Prayers of Our Sisters" by Eric Fischl, Carol Wainio, Paul Theberge, Annaleonowens Gal., Halifax, N.S., Canada (1977); and Music Gal., Toronto (1978); Mus. des Beaux Arts, Montreal (1978).

FLANAGAN, BARRY (January 11, 1941–), British sculptor and draftsman, was born in Prestatyn, on the north coast of Wales. He attended school in Sussex before entering the Birmingham College of Art (1957–58). For the next several years he studied at several British art schools, traveled in Canada, and worked at various jobs around Britain, including a stint at Pinewood Studios making bas-reliefs for the Taylor-Burton film *Cleopatra*. Then from 1964 to 1966 he followed the advanced sculpture curriculum at the St. Martin's School of Art, London, studying under Anthony Caro, Phillip King, and William Tucker.

Flanagan rejected the avant-garde orthodoxy that informed the study and practice of sculpture at St. Martin's during his time there. In a letter to Caro, published in 1964 in *Silâns*, a student magazine that Flanagan coedited, he wrote, "Rejection has been a motivation for me. . . . Am I deluded . . . or is it that in these times positive human assertion, directed in the chan-

nels that be, leads up to the clouds, perhaps a mushroom cloud. Is it that the only useful thing a sculptor can do, being a three-dimensional thinker and therefore, one hopes, a responsible thinker, is to assert himself twice as hard in a negative way? Effort in this direction at this time is progress as it will encourage general redirection." His subsequent career may be seen as a witty acting-out of the principle of rejection of generally perceived orthodoxy and artistic authority. He particularly hated the idea that art was expected to comment on or reflect social reality. The visual arts, he wrote in 1969, "maintained by the vested interests of the industrial machine in New York, education in London, and politics on the Continent, solely maintained to these purposes, cannot make any genuine contribution of their own to the culture." A revolution in artistic perception was necessary, for the visual arts "must no longer be called to order by their literary affiliates because they are not known to solve, entertain, articulate, or demonstrate the perversities and difficulties (social and semantic) the culture has invented for itself, so that it knows its ugly face a little better, with a self-respect established and made available for the visual arts in this culture, the life we know now may then be illuminated, colored, shaped, and ordered with more beautiful consequence on the human life-style, semantic stalemate cut through."

Flanagan's determination not to succumb to the mystique of the art object was apparent even in his earliest publicly shown works. *Aaing j gni aa* (1966), for example, consisted of brightly colored curtain material sewn to form organic, animallike shapes, which were then filled with plaster. The playful forms, shown clustered together within a circle, reminded one viewer of "shapes you guess at when moving round an unfamiliar room in total darkness." Those pieces were quickly succeeded by a series of works in dyed hessian, sewn into bags and filled with various materials—sand, foam, or paper. Entitled *Pile, Stack, Heap, Line, Bundle, Rack,* etc. (all 1967–68), the works examined the nature of the title concepts, reinventing them, in a way, as part of abstract sculpture's vocabulary. Three other works, similar in feeling, were shown at the Paris Biennale des Jeunes in 1967. The artist commented on them two years later: "One of the three pieces consisted of four vertical objects made as a single work. Another was a linoleum ring or perimeter; and the third was a sixty-foot rope, placed linearly on the floor. The three pieces together challenged my assumption that they were autonomous. As a result of having made them and of having shown them together, I became interested in their interrelationships."

Finally, in 1968–70, he made several works of hessian, linen, or canvas, in which the material was simply draped over suspended string or loosely attached to frames leaning against a wall. All such pieces, imbued with humor and ephemeral in the extreme, reacted against the accepted idea that art, in order to make a strong statement, had to have an air of solidity and permanence.

Several of Flanagan's early works were the targets of serious abuse by various Western European philistines: vulnerability seemed almost to be a factor of their existence as sculpture. One sand-filled hessian bag, part of an exhibition in the supposedly enlightened London borough of Hampstead, was stabbed to pieces in 1967. Another similar piece, set up on a beach in Cornwall, was destroyed by a group of soldiers. His 1967 exhibit in Paris received a lot of rough handling by the French public. The most astonishing case of vandalism against Flanagan's work occurred in the university town of Cambridge in 1972, after he was commissioned by the artistic foundation of the Peter Styvesant Tobacco Company to create a large public sculpture for temporary summer exhibition. The piece, consisting of four irregularly shaped blue fiberglass poles around conventionally shaped black steel goalposts with crossbars, was set up in Laundress Green, a small public park surrounded by university buildings and private housing. Soon after its installation, a local Anglican clergyman declared, "If this is supposed to be young art then I think it is revolting. Perhaps somebody should come along and blow it up." Sure enough, the sculpture was attacked five times over the next two weeks: lines of dirty washing were strung across the plastic uprights; there were attempts to set it on fire; toilet seats were thrown over several of the uprights; three of the posts were uprooted and the fourth was chopped in half. Finally, after three weeks, the sponsors ordered the work's removal. "It is the only statue," said a spokesman, "among all those [sixteen in all] we are exhibiting throughout the country which has received this sort of treatment." He might have added that many of the other artists' works, all of them undamaged, were placed in working-class, inner-city neighborhoods, areas supposedly far more inhospitable to modern art than the brainy, bucolic environs of Cambridge. Flanagan hardly knew what to make of the mess: as a temporary installation, his work had not been designed to withstand attempts at what he called "general and systematic destruction." "Any artist," he said ruefully, "can expect a few tomatoes in his time, but this is ridiculous."

During the 1970s, Flanagan seemed to do an about-face, turning to two materials—first stone and then, later in the decade, bronze—associated with all that is most classical, hallowed, and permanent, even rigid, about sculpture. The stone works, in particular, confirmed the artist's essential aversion to the grandiose gesture. *Secret Field* (1974), for example, is a rough piece of Italian sandstone, found by the artist in an Italian quarry, which he split and lightly incised with a point. *Via dei Tempii di Fiore* (1975) is a single slab of marble also scratched on with a point. The scratchings on those two works have no representational form, although on others (*Hello Cello,* 1976, for example) such forms are clearly suggested. What seemed remarkable about those stone sculptures was their context: they were placed atop large, white, wooden pedestals, as if inviting minute examination; furthermore, transposed into an art gallery, their reality was modified. As Catherine Lampert noted, "they adopted a cheeky look, like lucky orphans carried from the Italian hillsides to cushy Bond Street to amuse the sophisticates." That series was yet another example of Flanagan's witty iconoclasm, showing a respect for and interest in the organic nature of the material, yet steadfastly refusing to do with it what might be expected of a sculptor.

Flanagan's cast bronze hares, dating from the late 1970s and early 1980s, are certainly his best-known and least enigmatic sculptural series. The thin, lithe creatures, all looking pretty much as hares are supposed to look, are made to adopt a variety of poses, only a few of which are hare-like. They all seem uncannily debonair, cavorting and strutting on their hind legs atop such anomalous bases as an anvil, a helmet, a ball-and-claw foot made of Portland stone, even a set of cricket stumps. Although cast in bronze—a technique of ancient lineage, almost entirely shunned by most contemporary sculptors—the animals have a loose, disjointed look, as if they were glued together out of originally separate parts. Critics vied with one another in attempting evocations of that surprising series of works—among English critics, in particular, one could detect a good deal of sentimental anthropomorphization of our winsome furry friends. "They have all the traditional attributes of the March Hare," wrote William Fever, "nervous energy, randiness, gangling panache, endearing eccentricity." "Flanagan's hare," in Richard Flood's opinion, "is an inspired updating of a charming nineteenth-century sculptural subgenre, animal modeling, merged with a story-telling tradition that reached its apogee with Beatrix Potter." Lynne Cooke seemed closer to grasping the artist's intention; to her, the bronze hares "mock precepts dictating what is considered proper to cast in sculpture. Since the use of

bronze has often been believed to confer eternity on a work of art, . . . nonserious qualities, whether a playful mood or an insignificant subject, have generally been avoided."

Drawing has been Flanagan's strong second suit throughout his career. He is an exact and accomplished draftsman, always aiming at—and usually achieving—representational fidelity rather than abstract suggestiveness. In the mid-1970s he showed line drawings of Etruscan statues and bas-reliefs. Executed in felt-tip pen, the subjects seemed to one critic "totally isolated, deprived of perspective lines or shading. Hence they are seen, very flatly, as though pressed into the smooth page." Around the same time he also exhibited several fine-line drawings of well-known English personalities, renderings full of expression and bluntness, "an honest description of the subject's flesh and blood." Those last works were often favorably compared with the life drawings of friends completed in the early 1970s by David Hockney.

Flanagan underwent at least two other abrupt changes of material and style. In a series of lumpish, nonrepresentational works from the early 1980s he devised out of malleable clay and plasticene a series of maquettes, which he then gave to skilled Italian craftsmen who in turn translated them into marble and sandstone. The fat shapes, enlarged by the Italian sculptors, retained the look of the original, pliable maquettes yet had a smoothness and solidity absent from the originals. The essential lesson of the exercise seemed to be the overturning of two more sculptural shibboleths—the notions of "direct carving" (i.e., an artist must do his own work) and "truth to materials" (i.e., stone must not be used to represent clay) are shown to be no more inviolate than any others in the artistic code. His second transformation, *Bronze Horse* (1983), a life-size heroic casting of a great horse, took up by itself nearly a year of Flanagan's time. Quite reminiscent of the four bronze horses overlooking the Piazza San Marco in Venice, it is one of the few examples in contemporary art of bronze casting in the grand manner and shows the artist at his iconoclastic best. Along with its massive musculature and Roman impassivity, the animal shows a few of Flanagan's special touches—a tiny unicorn just beginning to grow out of its forehead, and a pair of small, pointed devil's ears.

In his witty and compulsive way, Flanagan has questioned many of the conventional, preconceived notions of contemporary sculpture in terms of material, technique, and content. Yet he does not simply overturn one idea after another, putting each reversed concept into physi-

cal form: "The business is in the making of a sculpture. . . . The sculptor cannot divorce himself from the physical world; sculpture isn't an idea to me, it's a practice. . . . In sculpture, facts must speak physically." A work, he believes, "is something to look at rather than something to read; my tongue dropped out of my head long ago."

EXHIBITIONS INCLUDE: Rowan Gal., London 1966, '68, '70, '71, '72, '73, '74; Gal. Ricke, Kassel, West Germany 1968; Gal. Dell'Ariete, Milan 1968; Mus. Haus Lange, Krefeld, West Germany 1969; Fischbach Gal., NYC 1969; Gal. del Leone, Venice 1971; MOMA, NYC 1974; Mus. of Modern Art, Oxford 1974; Hogarth Gals., Sydney 1975; Art and Project, Amsterdam 1975, '77; Apeldoorn Mus., Holland 1977; Arnolfini Gal., Bristol 1977; Serpentine Gal., London 1978; Waddington Gals., London 1980, '81, '83; New 57 Gal., Edinburgh 1980; British Pavilion, Venice Biennale, 1982; Gal. Durand-Dessert, Paris 1982; Whitechapel Gal., London 1983; Cntr. Georges Pompidou, Paris 1983; Pace Gal., NYC 1983, '84. GROUP EXHIBITIONS INCLUDE: "British Drawings," MOMA, NYC 1967; Biennale des Jeunes, Paris 1967; "When Attitudes Become Form," Kunsthalle, Berne 1969; Tokyo Biennale 1970; "The British Avant Garde," New York Cultural Cntr. 1971; "The New Art," Hayward Gal., London 1972; Biennale, Mus. National d'Art Moderne, Paris 1975; "Made by Sculptors," Stedelijk Mus., Amsterdam 1978; "Pier and Ocean," Hayward Gal., London, traveled to Rijksmus. Kröller-Müller, Otterlo, Holland 1980; "Aspects of British Art Today," Metropolitan Mus., Tokyo 1982; Documenta 7, Kassel, West Germany 1983.

ABOUT: *Periodicals*—Art and Artists June 1980; Artforum September 1969, April 1974, October 1982, March 1984; Art in America September 1969, September 1970, March 1983; Art International November 1969, January 1970, Summer 1971, November 1972, February 1973, September 1973, January 1975, February 1975, May–June 1982; ARTnews October 1966, November 1969, March 1974, April 1982, April 1983; Arts Magazine December 1965, December 1969, January 1984; Burlington Magazine July 1983; Connoisseur February 1970, July 1970, January 1973; Flash Art Summer 1980, February 1982, January 1983, May 1983, Summer 1983, April–May 1984; Studio International September 1966, October 1966, September 1967, May 1968, January 1969, July 1969, October 1969, December 1969, July 1970, July 1972, December 1974, June 1982.

FRANK, MARY (February 4, 1933–), American sculptor and printmaker, works in clay to create multifaceted, multipart figures that are sensuous, mysterious, jarring, and seductive. For sheer beauty of line, unfettered form, and richness of metaphor, her work has no equal on the contemporary scene; it is not, however, pretty, but rather harks back to the older tradi-

MARY FRANK

tion of making art that happens to be beautiful as the natural by-product of skill and passion. Her monoprints, drawings, and cutouts are equally accomplished, containing some of the best American draftsmanship of the last decade.

Born in London in 1933, Frank is the daughter of the painter Eleanor Lockspeiser and the musicologist Edward Lockspeiser. During the Blitz she and her family left England for New York. Her mother stimulated her to draw and introduced her to art. "When I was a little," Frank recalled in 1973, "she would give me books on Picasso and old copies of *Verve* magazine to read when I went to bed. The *Verves* were full of Indian and Persian miniatures, Chinese and Japanese art. I didn't read them; I only looked at the pictures. I loved those books." She recalls being an "intensely romantic" adolescent; "I remember often drawing a woman standing on the edge of something. . . . In a sense the subject matter was not very different than it is today." At thirteen she began four years of study with the dancer Martha Graham. Frank's acute sensitivity to the expressiveness of the human body in motion may have stemmed from her observation of dancers, but Frank claims for Graham an even greater influence: "It wasn't so much what I learned about dance—it was something to be in the presence of a passionate person."

Married at the age of seventeen to the Swiss photographer Robert Frank (they separated in 1969), she had two children by the time she was twenty. In New York she briefly studied drawing with Max Beckmann, and then with Hans Hofmann (in 1951 and again in 1954), but she never trained formally in sculpture or ceramics. In the mid-1950s she began making small, polished wooden figures, heavily indebted to Henry Moore's reclining women; they grew in size through the decade as she began using large logs, and, later, cast cement. Moore's and Picasso's sculpture and Rodin's studies and partial figures were important stylistic influences, but Frank had already begun to identify her own subject matter: the female figure as a concrete structure of forms in (and of) the landscape and as the focus of dreamlike or mythic metamorphoses (as in *Rainbow Figure*, 1965–66, and *Leda*, 1965). Perhaps more than modern sculpture, to which she claims not to be especially sensitive or sympathetic ("Much modern sculpture," she says, "looks to me as if it's to be seen from a moving car"), Frank has found inspiration in ancient and non-Western art, from the prehistoric fertility figures of Europe to the complex fecundity of Indian and Chinese sculpture.

By the mid-1960s Frank had abandoned carved wood, inherently weighty and unresponsive, for molded wax and cast plaster, producing Giacometti-like works—tiny figures growing out of rolling landscapes. Inspired by the ceramic work of the sculptors Margaret Israel and Reuben Nakian, she then tried clay, which she had been using to create the molds for her plaster pieces. Ceramic, which can be a difficult sculptural medium—pieces must be of uniform thickness (and thus often hollow), restricted in size, and free of enclosed air pockets—posed some initial problems for her. "Orthodox ceramists are shocked by the way I work," she said in a 1973 interview. "I have lost a lot of pieces, and there have been accidents in the firing. Sometimes the accidents turn out to be the most beautiful things." Clay—terra-cotta or stoneware—proved to be the ideal medium for Frank: it is spontaneous, ductile, not entirely predictable, and literally earthy.

Frank's mature ceramic sculptures (from the mid-1970s) are distinguished by a number of formal innovations that grow in part out of the limitations of the medium itself. Her figures, which range in size from tiny to over life-size, are constructed of multiple parts so that the finished piece can be larger than the interior of the kiln in which it is fired. A clay armature is built, then elegantly cut, incised, and molded slabs are draped and fitted over it to create three-dimensional forms. This support structure is clearly visible through gaps behind and in between the slabs; in fact, Frank often fills those mysterious inner spaces with smaller figures or allows the armature to extrude and become part of the figure's exterior. The clay surface is left plain, or may be drawn on, stamped with a vari-

ety of small images, or decorated with plant patterns shadowed in iron oxide. The larger figures are generally horizontal to provide the greatest support for the structure and the many loosely connected slabs. Standing figures are thickly reinforced at their base.

What is immediately striking about Frank's sculptures is their fluid draftsmanship, which recalls the later drawings of Picasso in its simplicity and apparent effortlessness. With great sensitivity and economy, she uses a knife or scribe to define a face from a simple convex slab, or cut out an expressive hand or firmly implanted foot. Roughly torn planes are freely juxtaposed with sharp-edged ones; she is as skillful in drawing with the negative spaces created between planes as with the knife. Frank also incises small drawings or stamps images of racing animals, riders, and lovers onto larger planes. Those small images suggest, according to Martica Sawin (*Arts Magazine,* March 1977), "the sway of passions much as they might be symbolized in dreams and act as externalized projections from within, not as something imposed by an outside hand."

Dreamlike transformations of scale and shape are common in Frank's work. In works like *Lovers* (1973–74), *Lying Winged Figure* (1975), and *Lover* (1977), the reclining figures appear to be living, fertile extensions of the landscape—expressing, wrote the critic Hayden Herrera (*ARTnews,* March 1975), "the old longing for physical and spiritual absorption into the elements—all time captured and encompassed within the animate body." (In the grimmer works, exhausted clay bodies appear to be decomposing back into the earth.) Naked lovers are melded into each other so that it is impossible to tell where one body ends and the other begins—the ideal of physical love—or what appears to be a woman's head on one side is a ram's head on the other. Figures offer different scales and aspects, even different bodies, as the viewer walks around them.

Sawin sees a sexual basis for those metamorphoses. "Eros as the connective principle is at the core of Mary Frank's art," she wrote; "it impels her to bring together antithetical elements like the impress of actual leaves and ferns, the imprinting of cryptic signs and symbols from seals, to split a head revealing a figure within, to terminate limbs in unfurling slabs that seem to return the figure to earth, to constantly suggest that flow of energy from earth into bodily form, from one body to another, a current seeking to complete its circuit, through sex, through procreation, through metamorphosis." The artist draws deeply on her own sexuality, but also from other, harsher emotions. The transformations can be monstrous. Two seated figures, male and female, made in 1975 shortly after her daughter's death in a plane crash, are screaming, stiffening into death.

Some of Frank's most engaging works are monoprints and "shadow drawings." She is drawn to both for their unpredictability. With monoprints, color paintings on glass then run through a press and printed on paper, no two works are exactly alike. Hers tend to be of plant forms, and, like the sculptures, may be in several parts. The shadow drawings (first shown in 1978), dark paper cutouts mounted on light boxes, move gently with passing air currents that change the amount and area of light bleeding through the cuts. Even more than the sculpture, those paper works demonstrate the artist's mastery of line. Ellen Schwartz (*ARTnews,* September 1978), called them "worthy successors to Matisse's brilliant cutouts." Leo Rubinstein (*Artforum,* September 1978) saw in the shadow drawings many of the same concerns that can be found in Frank's sculptures. "All her shadow figures are physically idiosyncratic, imperfect characters, however delicately they are seen, and their contorted poses seem both the cause and the symptom of their vulnerability. As they bend and writhe they both conceal and proclaim themselves. It is this familiar conundrum that Frank's pictures ultimately describe, the struggle of these people to live with their bodies, themselves."

Frank had her first one-person show at the Stephen Radich Gallery in New York in 1961. Since 1968 she has shown regularly with the Zabriskie Gallery; in 1970 she began teaching at the New School for Social Research in Manhattan and at Queens College. In 1973 she was awarded a Guggenheim Fellowship. Her studio in lower Manhattan is crammed with sculpture parts, fired and unfired; like Rodin, she often employs several models to move around in the space while she quickly sketches them. The collections of ancient and oriental art at the Metropolitan Museum and Asia House are her chief inspiration, after her own emotions, fantasies, and daily rhythm. "I have to work where I live, to be in contact with the pieces daily. Sometimes I sense that it would be some kind of salvation if I could work much more. Often I'm on the outside, distracted, distracting myself. I know I could go much farther. Some of my friends fear that if I did, I would close myself off to everything else."

EXHIBITIONS INCLUDE: Stephen Radich Gal., NYC 1961, '63, '66; Boris Mirski Gal., Boston 1964, '66; The Drawing Shop, NYC; Bennett Col., Greensboro, N.C. 1966;

Zabriskie Gal., NYC 1968, '70, '71, '73, '75, '77, '70, '80–81, '83; Donald Morris Gal., Birmingham, Mich. 1968; Richard Gray Gal., Chicago 1969; Univ. of Connecticut, Storrs 1975; Benson Gal., Bridgehampton, N.Y. 1975; H.K.R. Sonnabend, Boston 1976; Alex Rosenberg Gal., NYC 1979; Quay Gal., San Francisco 1984. GROUP EXHIBITIONS INCLUDE: MIT; Art Gal., Yale Univ.; Art Gal., Brandeis Univ.; "Hans Hofmann and His Students," MOMA, NYC 1963–64; "American Women Artists Show," GEDOK, Hamburg, West Germany 1972; "Annual," Whitney Mus. of American Art, NYC 1972, '73; "Focus," Mus. of Philadelphia Civic Cntr./Philadelphia Mus. of Art 1974; "Ten Sculptors Working with the Figure," Univ. Art Mus., California State Univ., Long Beach 1984.

COLLECTIONS INCLUDE: Art Inst., Akron, Ohio; Brandeis Univ., Mass.; Brown Univ., R.I.; Art Inst., Chicago; Bank of Chicago; Connecticut Collection, New London; Hirshhorn Mus. and Sculpture Garden, Washington, D.C.; MOMA, NYC; Univ. of Massachusetts; Univ. of New Mexico; Univ. of North Carolina; Southern Illinois Univ.; Whitney Mus. of American Art, NYC; Art Mus., Wichita, Kans.; Art Mus., Worcester, Mass; Art Gal., Yale Univ., New Haven, Conn.

ABOUT: Dictionary of American Artists, 1981; Munro, E. The Originals, 1979. Periodicals—Artforum May 1977, September 1978; ARTnews Summer 1973, March 1975, Summer 1976, September 1978; Artscanada April–May 1978; Arts Magazine March 1977; Quest July–August 1977.

JANE FREILICHER

FREILICHER, JANE (November 29, 1924–), American painter, is one of the most respected among the first generation of painterly realists. Her current critical reputation and commercial success have much to do with the ascendancy of naturalism and realism in art during the past fifteen years. But her unusual celebrity derives in part from her earliest years as an artist, when, after studying with Hans Hofmann, she became an articulate member of the New York School of art (second generation) in the early 1950s, when that city replaced Paris as the capital of the art world. Also during those years began her close friendship with John Bernard Myers, cofounder of the Tibor de Nagy Gallery, and with the poets whom Myers first published and whose portraits she painted: James Schuyler, John Ashbery, and Frank O'Hara. Admired for her warm sociability, intelligence, and wit, she persistently defended the value of representational painting in an artistic era famous for abstraction.

Her most important friendship with another artist was that with Fairfield Porter (1907–1975), whom John Arthur has characterized as "to realism what Jackson Pollock is to abstract expressionism." Porter is now considered by

many to be the purest exponent of the style of painting that a number of critics call painterly realism, which eschews rhetorical, mystical, symbolic (and usually ironic) content in painting for a lyricism that originates both in the artist's frankly appreciative, often mediative, outlook upon the beauty of the external world and in the love of handling paint. Porter had reviewed for *ARTnews* Freilicher's earliest exhibitions, at the Tibor de Nagy Gallery where Porter also was shown, but their relationship became especially close when she and her husband became Porter's neighbors in Southampton. There, or more precisely, at Water Mill, Long Island, Freilicher established the way of life and the inspiration for most of her paintings that would continue from the 1960s to the present day: winters in her Greenwich Village penthouse; summers in her studio at Water Mill. The views from each of those homes provided her with the subject matter of her cityscapes and landscapes. Although she also painted still lifes and interior scenes in those homes, it is the frequent combination of a still life or an interior with a landscape or cityscape seen through a large window that she has developed and refined into a distinctive genre that juxtaposes indoors and outdoors, man-made objects and nature. More generally, as she remarked to Gerrit Henry, she seeks to portray "opulent beauty in a homespun environment."

Her paintings have not infrequently been criticized for their narrow range of subject; and some viewers dislike what has been termed their "sweetness of tone." In the 1980s, however, admirers seem to predominate. Her quietly accom-

plished synthesis of many influences and elements—including those from post-impressionism, from abstract expressionism, and even, in her preoccupation with the rendering of the soft light often characteristic of places near the sea, from Venetian old masters—can now seem a well-balanced alternative to the restless search for novelty that has often defined modernist painting. Although, at least on first viewing, her paintings almost invariably depict quite pleasant subject matter, they may also contain subtle wit or humor, and their formal and color compositions are designed to offer intellectual almost as much as sensory stimulation.

Born and reared in Brooklyn, New York, Freilicher was the second of Martin and Bertha Niederhoffer's two children. Her father was a linguist and her mother a pianist. It was her brother who introduced the thirteen-year old Jane to modern art by taking her to the Museum of Modern Art. Picasso displeased her then, and, indeed, she never did develop a love for that master's art as she did for that of Bonnard and Matisse. Fairfield Porter quoted her as saying: "I used to draw faces in my notebook and my father thought they looked tragic and carried them around in his wallet."

At age seventeen, upon graduating from high school, Jane eloped with Jack Freilicher, a jazz musician who also played trombone in the West Point Army Band during the war years. The Freilichers lived at West Point for over a year. She soon developed a friendship with Larry Rivers, who played in an orchestra with her husband. Her interest in jazz and contemporary music also led to a friendship with Nell Blaine, whose husband played the French horn. Blaine, a few years older than Freilicher, was, as the latter called her, "the first real artist" whom she knew. Then a committed abstractionist, Blaine had already studied with Hans Hofmann and had her own loft.

Freilicher decided to major in art at Brooklyn College, but in those years its art department, under the apparent influence of Bauhaus, emphasized the study of design, with relatively little concern for painting. By the time she received her B.A. degree in 1947, her marriage had been annulled, and she, as did Larry Rivers, readily followed the advice of Nell Blaine to study painting with Hans Hofmann. That instruction took place largely during the summer of 1947 at Hofmann's school in Provincetown, Massachusetts. The regimen included sketching and painting from live models, but the students would portray them in an abstract and cubist manner, with the instructor directing his students to sustain an awareness of picture planes and surface.

Freilicher, unlike Nell Blaine, did not continue to paint abstractly after her experience with Hofmann. Even though her first independent work was straightforwardly figurative, Hofmann did have a lasting impact on the young artist, as in his insistence upon "working over the whole surface." Decades later Freilicher told Gerritt Henry: "I never think of Hofmann's famous 'push-pull' consciously, but I always have a sense of the surface of the painting as something alive and vibrant." The often aggressive "push-pull" device in abstract painting of producing vitality and creating depth by juxtaposing advancing and receding colors and tones has its counterpart in the mature Freilicher's deft distortions and blurring of forms by means of color and tone and in her use of subtle ambiguities when indicating pictorial space.

The practical minded Freilicher soon returned to school to obtain an M.A. degree in art education from Teachers College, Columbia University, where she studied art history with Meyer Schapiro. As much as she has always disliked teaching, Freilicher taught frequently—and worked occasionally as a waitress, receptionist, or stenographer in the first decade of her career. She continued to study closely the work of such masters as Matisse, Vuillard, and Bonnard. Following the latter's death in 1947, MOMA organized a large exhibition of his work that profoundly influenced Freilicher and other artists of her generation. She shared in the sense of community and the often passionate discussions of aesthetics that were so much a part of the lives of many of the painters belonging to the New York School during the 1950s.

The young artist often experimented as she reacted to the diverse influences and impulses of that surcharged world, but she always returned to recognizable subject matter. She recently recalled that period for Gerrit Henry: "I relied increasingly on a motif. Still, the paintings composed themselves very much by what happened moment to moment on the canvas." Her emphasis was somewhat different in 1956, when she told Fairfield Porter: "Realism is the only way I can do it. Every so often I get an anxious feeling and would like to produce that bombed-out effect of modern painting. Maybe my form is too closed. . . . Can you explode a painting realistically? I don't know."

In reviewing her first exhibition at the Tibor de Nagy Gallery in May 1952, Porter asserted, "Nature is what she is, perhaps more than what she sees." This perception held by the older artist may testify to her early concern, which she would retain, with reconciling the realist's interest in objective nature with the abstract expressionist's interest in an inner, unique vision. At

any rate, she never did "explode" her paintings. Although she usually adopted the large, assertive scale, expressive brush stroke, shallow space, and bold colors typically favored by the New York School, her paintings, whether landscapes, interiors, still lifes or portraits, tended more and more to align with the French tradition of harmony and restraint. Thus, such an experimental painting from her first exhibition as *Figure on a Bed*—in which psychological tension exudes from an interior scene painted to resemble a turbulent landscape—would not be seen in her subsequent exhibitions. Her third exhibition, in 1954, included some of the interiors with window views of Manhattan that she would elaborate and refine in the years ahead. In his review of that show Frank O'Hara identified several qualities that have remained characteristic of Freilicher: "The landscapes are individualized through detailed attention to the specific nature of the mass. . . . She seems not to struggle with the picture but to identify with them in a quiet unassuming way—the way Matisse does."

O'Hara had bought the first painting Freilicher ever sold, at a time when she shared a kitchen in a rooming house on Third Avenue in Manhattan's East Village with him, Kenneth Koch, and John Ashbery. They, along with James Schuyler—originators of the New York School of poetry—participated with Freilicher, Elaine de Kooning, Grace Hartigan, Larry Rivers, and other artists and writers (including Tennessee Williams) in the Artist's Theater, an experimental forum cofounded by John Bernard Myers.

Of Freilicher and her poet friends, Ted Berrigan, himself a poet and a reviewer for *ARTnews*, has observed that in their work they all value spontaneity and spirit while disliking obvious symbolism and dramatic intensity. Freilicher's best-known portraits are those of the poets Arnold Weinstein, O'Hara, Ashbery, and Schuyler, all of which, except the last-mentioned, were done in the 1950s. She painted portraits of some of those poets more than once, and several of the portraits show the subject seated, life-size.

Freilicher's first substantial success as an artist occurred when Al Lerner, Joseph Hirshhorn's curator, cast an admiring eye upon her and Fairfield Porter's paintings at the Tibor de Nagy Gallery. Decades would pass before those two painters' work, esteemed as painterly realism, would be sought out by visitors to the Hirshhorn Museum in Washington, D.C. But that early recognition must have encouraged the struggling young artist, who was then teaching in a primary school.

In February 1957 Freilicher married Joseph Hazan, a wealthy Seventh Avenue clothing manufacturer, and she henceforth was able to devote as much of her time as she wanted to art. She and her husband, himself an amateur artist, built their summer home in Water Mill, Long Island, where she spent each summer painting. Often her subject consisted of the surrounding farms and wetlands as seen in their hourly or monthly variations. The nearness of the ocean, the flat, open but not desolate landscape, and the clear light have inspired her for twenty-five years. In the early 1980s she told Mark Strand: "I'm sort of depressed by mountains and lonely vast vistas. I enjoy the intimation of a human touch in the landscape."

The summer home enabled the artist and her husband to live near Fairfield Porter, his wife, Anne, and their family. Porter and Freilicher influenced each other's work. John Bernard Myers reported that Porter credited her use of intense colors with having inspired him to lighten and brighten his own palette during the 1960s. Porter's influence upon Freilicher may perhaps be seen in her landscapes of the 1960s, which appear more realistic and less impressionistic than those of earlier years. Her brush stroke, though relaxed, served to define or delineate natural objects more precisely than had usually been the case earlier, when her draughtsmanship was purposely casual. Nevertheless, she retained a tendency to render locally some details of a painting, such as clumps of flowers, that resembles abstract expressionism in technique even as it defies, along with her formal compositions, the "allover" ideal of so much American painting since Jackson Pollock.

Although Freilicher's consistent painterly realist style in landscape, cityscape, and still life, with its emphasis on both the physicality of paint and the stimuli conferred to the artist by the external world, became evident in her work of the 1960s, she continued to paint an occasional portrait. Her 1965 portrait of James Schuyler, who is depicted in brilliant sunlight, is her last major portrait. A series of female nudes, perhaps self-portraits, from that decade were described by Gerrit Henry as "creamy, sensuous—sentimentally appealing perhaps, but still displaying a no-nonsense terseness of brush stroke." Since then Freilicher painted the human face or figure, including self-portraits, only as elements in landscapes or interiors. But her remark to Mark Strand is telling: "Landscape and still life are probably metaphors for the human figure, and your own sense of your body is probably lurking on a subliminal level."

Freilicher exhibited at the Tibor de Nagy Gallery from 1952 to 1972. With the realist revival

in the 1970s, her work, handled now by A. Aladar Marberger of the Fischbach Gallery, began to sell briskly. In 1975 she was one of forty-five American artists chosen by the Department of the Interior to provide a painting for "America 1976," a touring exhibition which opened at the Corcoran Gallery in Washington, D.C. Each artist was given $2,000, the use of a car, and traveling expenses. But Freilicher chose to go no farther than the Montauk Wildlife Refuge, near her home in Water Mill, where she painted *Wetlands and Dunes,* a panoramic view of salt marshes that incorporates virtuoso technique in its depiction of sky, water, vegetation, and foliage, and in its rendering of texture and light.

That painting shares with a number of other landscapes painted in the mid-1970s a boldness in the division of the canvas into sky and earth planes without the usual mediating trees. Instead Freilicher unifies the composition by means of subtle tonal variation along the horizon. Comparing the landscapes of the 1970s with those done previously, one finds that, in place of the former casualness and breadth of execution, there is now, for each element in a painting, "the language appropriate to its peculiar vitality," according to Robert Berlind. The big landscapes in her 1975 Fischbach exhibition were similarly praised by Hilton Kramer as having "a new clarity and precision." But he found that Freilicher's "handling of still-life space has not yet, for the most part, caught up with her mastery of landscape space. . . . *One Cat, Two Fish* remains a collection of still life fragments rather than a fully realized unity." The latter painting features a window view of Manhattan in the upper right corner. The artist had done urban landscapes from an interior perspective, inspired perhaps by Bonnard, as early as the 1950s. But the cityscapes, often on a large scale, whether pure or in combination with interior or still life, which date from the late 1970s into the 1980s, have become her own distinctive and accomplished genre. By 1980 John Russell could write of her summer work at Water Mill (but this could also be said of her winter paintings in Manhattan): "She can combine indoors and outdoors on one and the same canvas and keep them in equilibrium."

Freilicher's work in the 1980s can easily be seen as a continuation and further mastery of the artistic objectives that preceded that decade. Nevertheless, the mastery enables her to achieve a complexity and ambiguity that can also be seen as a departure from much of the previous work. The passage of time recurs as a haunting theme. Tragic overtones appear even as she continues her celebration of the act of painting color, form, and light. Happiness and humor remain charac-

teristic, but now a dark underside can often be perceived. In the paintings done in the winter, such as *February* (1984), she succeeds in rendering a specifically winter light and the cold grayness of the city. Yet the latter painting is not grim. Potted plants in the foreground, though vividly painted, have drooping flowers, while the distant chimneys spouting smoke seem, perversely, to be vital and growing.

Quiet wit and humor not infrequently have appeared as an element in her work, but in the 1980s she used those qualities for more ambitious purposes. In *Flowers and Mirror before a Landscape* (1983) a vase of flowers in a window seems almost situated in the distant landscape. But also, a still life, the artist's working table, and corners of a porch or studio are all seen reflected in a standing mirror. In that painting the viewer must consider not only what is real, but what is most significant for the painting's composition and for the life depicted. As the artist indicated to Mark Strand in 1981: "Painting the outside from the inside through a window adds another dimension and raises questions of the relation of the painter to the landscape." Throughout the 1980s Freilicher sought to increase the number of dimensions in her paintings and the questions they raise.

Although Grace Glueck in 1983 found that in the artist's recent paintings "a happy feeling for life and its quieter pleasures permeates, . . . an effect hard to bring off without sentimentality," other critics, such as John Yau and John Ashbery, have found darker implications as well as joy. A series of paintings featuring sunsets shows the brilliant, circular sun as a kind of clock hauntingly suspended above the ocean's horizon and framed by fir trees, "whose passive role," to quote John Ashbery, "is like a Greek chorus." In general, Freilicher's handling of color in recent years has continued her trend toward greater brilliance and intensity. Indeed, Mark Stevens wrote that "her color is not ingratiating. She keys it so high that a kind of tonal shiver comes into the painting."

In *The Changing Scene* (1981), the artist combines a self-portrait with a disturbing landscape, as, in this painting, she stands by the wide window through which one can see the effect of a bulldozer that is transforming some of the land surrounding her studio in Water Mill. Although the freshly turned earth, the workers, and the machine are almost livingly depicted along with the rest of the landscape, the expression on the averted face of the standing figure portraying the artist leaves little doubt as to her feelings.

Freilicher's exhibition at the Fischbach Gallery in 1988 included a large painting, *Parts of*

a *World,* that consists of an upper and a lower zone, and in which, for the first time, the artist depicts still life, interior and cityscape with no window frame to separate inside and outside space. The juxtaposing of disparate elements, such as a small reproduction of Venus de Milo on a table before distant skyscrapers, is thus all the more immediate. Hilton Kramer found it to be "an audacious painting, one which suggests that the artist has found a promising new vein in the dusky light and elusive space that transforms Manhattan just before nightfall."

Although Freilicher's work has been included in many group exhibitions, especially since the revival of realism in the 1970s and the organization of shows featuring female artists, her first touring retrospective was organized in 1986 by the Currier Gallery of Art in New Hampshire. Michael Brenson, in an overview of the artist's paintings on the basis of that exhibition, wrote that "there are big feelings throughout the work—of joy, emptiness, exuberance, and dread. There is an awareness of change, growth, illusion, and time." But he asserted that the artist "wants to control the metaphorical dimension of her work, and she is successful. . . . If Freilicher's celebration of painting and light is not quite a festival, it is because her work consistently touches something big but prefers to remain small." Hilton Kramer, on the other hand, deplored that the retrospective was not shown in New York City and speculated that it was because Freilicher's paintings tend to provide "unalloyed aesthetic pleasure" rather than to elicit painful existential or political awareness.

Jane Freilicher continues the way of life— summers in Water Mill, winters in New York City—that has fulfilled her artistic objectives since the early years of her marriage to Joseph Hazan. The couple's only child, Elizabeth, recently graduated from Bryn Mawr College. Unpretentious in dress and manner, Freilicher favors sandals and simple wraparound skirts paired with white blouses. Those who know her are impressed by her wide-ranging knowledge and her keen sense of humor. Although the artist does not travel extensively and dislikes teaching, she has occasionally consented to serve as a visiting critic and lecturer at a number of colleges and universities, mostly in the northeast.

Her honors include a 1960 Hallmark International Art Award; a 1974 fellowship from the American Association of University Women; a 1976 grant from the National Endowment for the Humanities; a 1987 gold medal from the National Academy of Design; and election in 1989 to the American Academy and Institute of Arts and Letters.

When in 1986 she was asked what her intentions are when she starts a painting, Freilicher expressed attitudes that one could attribute to her roots in the New York School, yet which seem apt for her present characterization as a painterly realist: "I start with an apprehension or feeling about something; an inner impulse that wants to be expressed or a sensation of color or atmosphere or arrangement of shapes that will suggest to me that I can make a painting." She added that for her "a painting is an exploration of how one sees, a representation of the process of seeing."

EXHIBITIONS INCLUDE: Tibor de Nagy Gal., NYC 1952–72 (12 exhibitions); Cord Gal., Southampton, N.Y. 1968; John Bernard Myers Gal., NYC 1971; Benson Gal., Bridgehampton, N.Y. 1972, '74; Fischbach Gal., NYC 1975, '77, '79, '80, '83, '85, '87, '88; Wadsworth Atheneum, Hartford, Conn. 1976; Utah Mus. of Fine Arts, Salt Lake City 1979; Louise Himelfarb Gal., Water Mill, N.Y. 1980; Lafayette Col., Easton, Pa. 1981; Kornbluth Gal., Fair Lawn, N.J. 1981; Col. of the Mainland Art Gal., Texas City 1982; Kansas City Art Inst., Mo. 1983; Currier Gal. of Art, Manchester, N.H. and tour, 1986–87. GROUP EXHIBITIONS INCLUDE: Annual Exhibition of Contemporary American Painting, Whitney Mus. of American Art, NYC 1955, '72; "Recent Drawings," MOMA, NYC 1959; "The 158th Annual Exhibition: American Painting and Sculpture," Pennsylvania Academy of the Fine Arts, Philadelphia 1961; "Students of Hans Hofmann," MOMA, NYC 1963; "Eight Landscape Painters," MOMA, NYC 1964; "Recent Landscapes by Nine Americans," Festival of Two Worlds, Spoleto 1965; "Current Trends in American Art, Pop, Op, Top," Westmoreland Mus. of Art, Greenburg, Pa. 1967; "Eight Americans," Kunstakademie, Amsterdam 1968; "Painterly Realism," American Federation of Arts, NYC 1970; "Focus: Woman's Work, American Art," Philadelphia Civic Cntr. 1974; "Invitational Award Exhibition," American Academy and Inst. of Arts and Letters, NYC 1975; "America 1976," Dept. of Interior at the Corcoran Gal. of Art, Washington, D.C. and tour 1976; "American Painterly Realists," Univ. of Missouri, Kansas City 1977; "American Realism," Col. of William and Mary, Williamsburg, Va. 1978; "Painterly Realism in America," A. J. Wood Gal., Philadelphia 1979; "Realism/Photorealism," Philbrook Art Cntr., Tulsa 1980; "Contemporary American Realism Since 1960," Pennsylvania Academy of the Fine Arts, Philadelphia and tour 1981; "Painterly Realism," Rahr-West Mus., Manitowac, Wisc. 1982; "156th," "160th," and "162nd" Annual Exhibition, National Academy of Design, NYC 1981, '85, '87; "American Still Life 1945–1983," Contemporary Arts Mus., Houston 1983 and tour; "Major Contemporary Women Artists," Suzanne Gross Gal., Philadelphia 1984; "The Painterly Landscape," C. Grimaldis Gal., Baltimore 1986; "In the Country," Bronx Mus. of the Arts, NYC 1987.

COLLECTIONS INCLUDE: American Federation of Arts, Brooklyn Mus., Metropolitan Mus. of Art, MOMA, Na-

tional Academy of Design, New York Univ., Whitney Mus. of American Art, NYC; Board of Governors of the Federal Reserve System, Corcoran Gal. of Art, Hirshhorn Mus. and Sculpture Garden, Washington, D.C.; Currier Gal. of Art, Manchester, N.H.; Marion Koogler McKay Art Mus., San Antonio; Parrish Art Mus., Southampton, N.Y.; Mus. of Art, Rhode Island School of Design, Providence; Rose Art Mus., Brandeis Univ., Waltham, Mass.; Utah Mus. of Fine Arts, Univ. of Utah, Salt Lake City.

ABOUT: Arthur, J. Realist Drawings and Watercolors, 1980; Cathcart, L. L. American Still Life 1945–1983, 1983; Crane, D. The Transformation of the Avant-Garde, 1987; Current Biography, 1989; Doty, R., ed. Jane Freilicher: Paintings, 1986; Downes, R. Fairfield Porter, 1979; Goodyear, F. H., Jr. Contemporary Realism Since 1960, 1981; Keller, A. M. Jane Freilicher Matrix 27, 1976; Moffett, K., and J. Ashbery. Fairfield Porter, 1982; Munro, E. Originals—American Women Artists, 1979; Myers, J. B. Poets of the New York School, 1969; Rubinstein, C. S. American Women Artists, 1982; Russo, A. Profiles on Women Artists, 1985; Strand, M., ed. Art of the Real, 1983; Van Wagner, J. C., and H. A. Harrison. Artist in the Theater, 1984; *Periodicals*—Art in America May–June 1975, May–June 1979, September 1981, Summer 1983; ARTnews May 1952, February 1953, April 1954, April 1955, September 1956, October 1956, May 1957, March 1958, November 1958, February 1960, November 1961, November 1963, November 1965, April 1967, December 1968, February 1971, April 1975, January 1976, May 1976, May 1977, March 1979, September 1979, March 1981, May 1983, November 1984, January 1985; Newsweek May 13, 1974, June 7, 1982, April 1, 1985; New York Observer April 25, 1988; New York Times February 8, 1975, April 8, 1977, January 19, 1979, September 21, 1980, November 28, 1980, March 11, 1983, August 3, 1984, December 21, 1984, March 8, 1985, September 7 and 21, 1986, April 8, 1988.

***GAROUSTE, GERARD** (March 10, 1946–), French painter and designer, has earned a respected place among the postmodernists by adopting a resolutely antimodernist if not antimodern stance. Arguing that "originality is no longer original," he has developed an archaizing painting style rooted in the tradition of El Greco and the Italian mannerists.

Born in Paris, Garouste was soon sent off to an eccentric Italian uncle in Burgundy for reasons of health, but by the time he was ten his parents had second thoughts about village schooling and brought him back to *la capitale* so that he could attend the exclusive Collège de Monel. "I was in another world," he recalled, "among the children of rich and famous people who seemed awesomely sophisticated compared to me." After completing his baccalauréat in math, he attended the Académie de la Grande Chaumière

and the Académie Charpentier for several years, then entered the Ecole des Beaux-Arts. The year was 1968, and in the aftermath of the May uprising Garouste found himself in an emphatically egalitarian milieu where the demarcation between teacher and student was supposed to exist no longer. "That's how I learned to paint from books," he explained. But Garouste soon came to feel that the Beaux-Arts was a dead end: "Frightening reality: I told myself that knowing how to draw was of no importance, that painting didn't mean anything."

In 1969 he made a brief appearance on the Paris art scene with an exhibition of monumental Michelangelesque drawings that was generally well received. But it was ten years before he exhibited again. In the interim, he married, had two children, and earned his living as a decorator. He continued to draw and paint, but his major artistic interest was the theater. Since 1966 he had been working with the director Jean-Michel Ribès, first at the Théâtre de Plaisance, then the Théâtre des Champs-Elysees and the Théâtre de la Ville; he designed sets for a number of productions, ranging from Ben Jonson to Pirandello, and in 1977 he staged and performed a work of his own, "Le classique et l'indien," which he described as "a combination of Italian theater spectacles and happenings."

Garouste had turned to the theater as a way of analyzing the world around him; for him, "the idea of directing corresponded to putting all the cards on the table, trying to take things up at the essence." But ultimately he realized that the theater represented as much of an impasse as the visual arts and decided to reorient his creative activity altogether, turning his back on the notion of originality for a hyperconscious reworking of traditon. His first exhibit of paintings, which he called "Comédie policière" (Detective Comedy, 1979), strongly suggested the theater, not only in the stage-set compositions and decor of the individual works, but also, as the title implies, in the overall conception of the show as a kind of performance or spectacle, in this case, an apparent mystery to be unraveled ("Who does the dog belong to?"). The ten paintings offered various combinations of "evidence": a disembodied gathering of men, women, and children, dogs with muzzles, and three objects—a lipstick, a champagne bottle cork, and a chess pawn. Garouste freely acknowledged that he was "flirting" with conceptual art at the time, but the lesson he learned from the conceptualists, he explained, was that "all the artists of every era were conceptual, and that what is hidden could be the essential." His real point of departure was Duchamp, or rather, the failure of the avant-garde to go beyond Duchamp's

"deconsecration" of the work of art. What he was trying to do, he told the Paris daily *Libération* in 1980, was to "consecrate things within the avant-garde. . . . It's necessary to play their cards, to worm your way in, set up your pieces to find the weak point, something abrasive. I've played the painting card to make a beautiful canvas, consecrated in the system of the avant-garde."

After the "Comédie policière," Garouste turned to classical mythology as a source of traditional imagery to be brought into the avant-garde fold. "Cerbère et le masque" (Cerberus and the Mask, 1980), again presented as a gallery installation, used four mythological figures and their attributes for an elaborate game of permutations and combinations played out with symbolic objects and diagrams, photographs of sculpture, and small paintings. Meanwhile the painting that represented the key to the puzzle, *La neuvième combinaison* (*The Ninth Combination*), was pointedly absent from the gallery, exhibited instead at the Paris Biennale. With the works that followed, Garouste moved into a full-blown archaizing mode, composing paintings out of a repertoire of motifs vaguely borrowed from post-Renaissance art and rendered with sepia and varnish to give them the look of age. As in the "Comédie policière," enigma prevailed, with dramatic figures and settings evoked just enough to raise the question of what they were supposed to mean.

For the critics and the curators, those paintings seemed to belong to the "new figuration" that had taken the French art scene by storm just at the time Garouste started exhibiting again. Garouste himself, a good ten years older than the youthful protagonists of the figuration libre (free figuration) group, and not particularly fond of the comic books and hard-core rock music that provided much of their inspiration, declined the label and refused to be included in their exhibitions. "I don't see a return to figuration," he later told Catherine Strasser, "but a deeper appreciation of it. . . . In the wish to renounce all styles, and not getting there because of weakness, this weakness becomes my style. Style is what remains after years of trying to erase my personality. It's what I wasn't able to efface."

That operation of painterly deconstruction left Garouste with the pictorial vocabulary of post-Renaissance art—the figure style, dramatic perspectives and lighting, the palette, the brushwork—without the narrative content. In *Les incendiaires* (*The Firebrands*, 1982), for example, three figures emerge from their nocturnal surroundings with vigorous gestures but no specific action or purpose. Other paintings offer more specific references—Orion, Adhara, Orthros—as well as Garouste's competing alter egos, the Classic and the Indian, but the costumes, the settings, and ultimately the situations are timeless. As Jesa Denegri wrote in the introduction to the catalog for the 1982 exhibit "In Situ," that approach was, paradoxically, quite modern: "From the standpoint of form, the work, the process of realizing his painting, and above all his iconography represent a conscious distancing from the experience of modern art. [But] from the standpoint of substance, it is clear that this work is fully penetrated by the experiments of modern art, which hold that the subject of the art is reflection on its nature, manifested not through theory, but through artistic practice itself." And indeed, Garouste himself defined his project in the current terms of postmodernism: "This painting that refers to painting," he told Gérard-Georges Lemaire, "brings us back to the structure of language, where each word is defined by other words. . . . So my intention is not to plagiarize ancient painting, or to make an apology for it; I use it as a syntax to play with writing that is itself extremely contemporary."

In a Paris art scene that had been dominated by the Americans for more than two decades, Garouste's initiative—like that of the young figuration libre painters—was enthusiastically welcomed by critics, curators, and collectors alike; in the words of Otto Hahn, Garouste was the "great success of the 1982 season." Early that year his work was shown at the Holly Solomon Gallery in New York City as part of the French government's showcase of contemporary artists, "Statements One" (organized by Hahn), and he was quickly picked up by the courtly and immensely influential New York dealer Leo Castelli. But the response to Garouste in Manhattan was somewhat cooler, as was also the case for figuration libre. Neither his archaizing nor his modernism seems to have been fully appreciated; Vivian Raynor, for example, was willing to acknowledge that "to the degree that it excites dramatic associations, the show [at the Castelli and Sperone-Westwater galleries in SoHo] can be counted a success," but added, "the more so if you are not yet bored with art that poses but never answers questions." Susan Harris likewise wrote that the painings were beautiful to look at but asked, "What is he doing or saying that has not been done or said by others?"

In France, Garouste's success continued unabated and even included official sanction from President François Mitterrand's socialist government, in the form of a 1983 commission for ceiling paintings in the first lady's bedroom of the presidential palace. Three years earlier he had collaborated with his wife, Elizabeth Garouste,

on the decor and ceiling paintings of Le Palais, an exclusive Paris discotheçue. Both commissions raised eyebrows in high-art circles, but Garouste again held to his own definition of what was avant-garde. As he later explained to the fashionable women's magazine *Femme*, "Marcel Duchamp brought back an object from the supermarket and put it in a gallery. Myself, I don't hesitate to take down a painting from a gallery to put it in a nightclub." But he was also keenly aware of the dangers that attended his recognition: "What is happening to me now is almost like a poisoned present," he told an Irish newspaper in 1984. "Fifteen years ago I was already painting the same subjects as today and I was considered a total outsider. . . . The only people who appeared to like my work were the very worst painters and dealers. I was very worried that I might be completely off the track. And now I am aware of another danger . . . a surfeit of paintings. Personally I cannot paint to order. I enjoy the risks too much. I cannot paint the same things over and over."

In fact, his paintings underwent a noticeable evolution around that time, with a shift to still-life subjects. That seeming banalization, with simplified and often repetitive images—*Still Life with a Mirror, Still Life with a Rabbit, Still Life with a Woman in Blue, Still Life with a Blue Vase,* and so on—actually became a vehicle for greater personal expression, much in the spirit of the traditional still lifes of the seventeenth century. Through distortions of shape and scale, and the juxtaposition of human figures with inanimate objects, his pictorial language became more accessible.

Once typically bohemian in appearance, Garouste now cuts a very dapper figure and seems to welcome the celebrity treatment he gets from the media. In a 1987 feature on "Seven Who Make the Style of the Eighties," *Connaisance des arts* characterized him as someone who "loves anguishing subjects treated in a light manner," and explained that "he escapes toward a second-degree classicism, where the varnish is perceived as a sign, where the sketch tells the whole history of painting. If Garouste has attained a dazzling success in 1980, it's because, at the dawn of a new millenium, in the midst of uncertainties, he is one of those who helps to keep believing." His wife, Elizabeth, is an interior decorator who helped to design the fanciful House of LaCroix.

EXHIBITIONS INCLUDE: Gal. Zunini, Paris 1969; "Comédie policière," Gal. Travers, Paris 1979; "La reğle du 'je,'" Gal. Enzo Cannaviello, Milan 1979; Gal. Liliane & Michel Durand-Dessert, Paris from 1980, incl. "Cerbère et le masque," 1980, and "Canis major. L'indien heroïque ou idiot," 1982; "La règle du 'je,'" Vereniging voor het Mus. van Hedendaagese Kunst, Ghent, Belgium 1980; "Dall'enigma del canis major," Mus. Civico d'Arte Contemporanea, Gibellina, Italy 1982; Leo Castelli and Sperone-Westwater Gals., NYC 1983; Gal. Hans Strelow, Düsseldorf 1984; Gal. Cleto Polcina, Rome 1984; "La Cinquième Saison," Mus. de Bourbon-Lancy 1984; Leo Castelli Gal., NYC 1985; Mus. d'Art Contemporain, Montreal 1986. GROUP EXHIBITIONS INCLUDE: "Nueva imagine," Pal. della Trienale, Milan, 1980; "Apreś le classicisme," Mus. d'Art et d'Industrie, Saint-Etienne 1980; Paris Biennale 1980; "Encyclopedia II magico primario in Europa," Gal. Civica, Modena, Italy 1981; "Aljofre Barroco," Mus. dell'Arte, Noto, Italy 1981; "Generazioni a confronto," Univ. of Rome 1982; "Statements One," Holly Solomon Gal., NYC 1982; "In Situ," Mus. National d'Art Moderne, Paris 1982; "Mythe, drame, tragedie," Mus. d'Art et d'Industrie, Saint-Etienne 1982; Venice Biennale 1982; "Zeitgeist," Martin-Gropius-Bau, Berlin 1982; Tours Biennale 1983; "Saint Thérèse d'Avila dans l'art contemporain," Mus. du Luxembourg, Paris 1983; "Transfiguration," ARCA, Marseilles 1983; "New French Painting" (trav. exhib.), London, Oxford, Southampton, Edinburgh 1983–84; "References," Palais des Beaux-Arts, Charleroi, France 1984; "Il riso dell'universo," Gal. Carini, Pisa 1984; Venice Biennale 1984; "Alibis," Mus. National d'Art Moderne, Paris 1984; POSC, Dublin 1984; Biennale of Small Sculpture, Budapest 1984; "Metaphor and/or Symbol," National Mus. of Modern Art, Tokyo 1984; Paris Biennale 1985; "Le Dessin dans la ville," ARCA, Marseilles 1985; "New European and American Drawings," Piran, Yugoslavia 1986; "Pictura Loquens," Villa Arson, Nice 1986; "Terrae Motus 2," Foundation Lucio Amelio, Naples 1986; "Un Choix," Kunstrai, Amsterdam 1986; "Qu'est-ce que c'est l'art français," Cntr. Regional d'Art Contemporain de Midi Pyrennée, Toulouse 1986; Sydney Biennale 1986; Venice Biennale 1986; "Luxe, calme, et volupté," Vancouver Art Gal., British Columbia 1986; "Paisatges," Palma de Majorca Spain 1986; "Le Regard du Dormeur," Mus. de Rochechouard, France 1987; São Paulo Biennale 1987; "L'enoque, la mode, la morale, la passion," Pompidou Cntr., Paris 1987.

COLLECTIONS INCLUDE: Fonds Regional d'Art Moderne, Aquitaine, Pays de Loire, Rhone-Alpes; Mus. National d'Art Moderne, Paris; Mus. de Nîimes; Mus. Departemental de Rochechousart 9 Limousin; Fondation Cartier; National Gal., Canberra; Ludwig Mus., Cologne; Mus. d'Art Contemporain, Montreal; Mus. of Modern Art, Tokyo.

ABOUT: "Alibis" (cat.), Centre Pompidou, 1984; "Cerbère et le masque ou la neuvieme combinaison" (cat.), Galerie Liliane & Michel Durand-Dessert, 1980; Dennison, L. "Angles of Vision: French Art Today" (cat.), Guggenheim Museum, NYC, 1986; Georges Garouste: L'indien et le classique, 1984; "In Situ" (cat.), Centre Pompidou, 1982; Lemaire, G.-G. "Pictura Loquens" (cat.), Cntr. National d'Art Contemporain, 1986; "Luxe, calme, et Volupté" (cat.). *Periodicals*— Art in America September 1982; Art Press November 1984; Arts Magazine April 1983, November 1985; Cahiers de l'energumine Summer 1983; Cimaise March–

April 1979; Connaissance des arts February 1983, November 1984, June 1987; Demme June 1985; Elle January 23, 1984; Flash Art International November 1980, January 1983; Galerie des arts November 14, 1969; Ireland Sunday Tribune August 12, 1984; Le matin June 15, 1983; Libération October 27, 1980; New York Times February 18, 1983; Nouvelles littéraires February 23, 1979; Opus International Winter 1983.

GILBERT & GEORGE (1943– and 1942–), British artists who began their joint career as "living sculptures" in the conceptual climate of the late 1960s. Since then, their public persona, largely established through photographic tableaux, has become a vehicle of social commentary, fairly iconoclastic in its overt (homo) sexuality while otherwise upholding the conservative values of Margaret Thatcher's England.

Until they met at St. Martin's School of Art in 1967, Gilbert & George were Gilbert Proesch and George Passmore, the former born in the Dolomites of northern Italy and the latter a native of Devon, England. What they already had in common were their modest origins in "poor country families": Gilbert, one of five children, was the son of a shoemaker; George, the son of a carpenter (whom he saw for the first, and only, time in 1966). Gilbert, who indicates that he always wanted to become an artist and began doing figure sculpture at the age of eight or nine, made his way to St. Martin's School in London via art schools in Italy, Austria, and West Germany. George, who claims that his original aspiration was "to be Terry-Thomas" (an English actor-comedian), nonetheless studied at Dartington Hall College of Art and Oxford School of Art.

They both arrived to study sculpture at St. Martin's in the heyday of the Anthony Caro aesthetic, with its austere vocabulary of form and materials, but remained resolutely on the margins of the "little élite" that spent its time theorizing the latest developments. Their own friends included Hamish Fulton, Barry Flanagan, and Bruce McLean. "We never had discussions about art," they recalled to Jean-Hubert Martin. "That only took place among other people we never spoke to. . . . Our own group was very anti-academic. Indeed, their teachers also remembered them as "given to long stretches of silence." Their first collaborative effort was "Three Works/Three Works," the exhibition which they "presented" in May 1968. Renting a sandwich bar near the school for two hours one afternoon, they set out six of their rough-cast sculptures and objects on the tables and formally invited their fellow students to come for cheese

GILBERT

and drink. Their intention to transcend the spatial and conceptual limits of traditional sculpture was also apparent in the "Snow Show," an installation they created for their end-of-college exhibit the following month: it consisted of sculptures and objects placed in an empty room with artificial snow on the floor; a sheet of Plexiglas at the entrance prevented viewers from entering, but at the other end of the room a window (specially washed for the occasion) opened onto the whole city of London.

Once they were out of school, their attempt to bridge the worlds of art and life led them to present themselves directly, without any art objects at all. Through letters and phone calls, for example, they began soliciting meetings with prominent London art personalities to discuss art. "When we said that," they told Barbara Reise in 1970, "90 percent just laughed. It was amazing, really, and quite a revelation to us, the whole experience." As with the sandwich-bar event, the meetings were pursued with a level of decorum that bore little relation to the status of Gilbert & George. They had taken to wearing slightly undersized Edwardian suits—with garish neckties and pocket handkerchiefs—quite distinct from the hippie look then current among young artists. Before each meeting they sent their invitee a photographic calling card signed by the two of them, and eventually they hired a business manager to develop their contacts.

Among the other activities they pursued during that period was the "Bacon Show," a November 1968 exhibition held at the Bethnal Green

GEORGE

Bacon Factory, where George had worked as a student. The display of forty paintings of bacon done by local youths was intended for the factory workers, whom Gilbert & George leafleted at the entrance; the organizers themselves never went back to see it. "We just wanted to make an exhibition in a factory. We were doing this kind of experiment to try to get away from student life." In January 1969 they presented "Reading from a Stick" at the Geffreye Museum, where they showed 160 slides of Gilbert's resin-covered walking stick projected against a background of dead silence; those who sat through the hour-long event were rewarded with a homemade candy in the form of the stick as a souvenir. For "The Meal," held in May 1969, one thousand art "personalities" were invited to join David Hockney for a formal meal served by Lord Snowden's butler. "I wouldn't have gone to watch, but I did enjoy the meal," Hockney has acknowledged, but he praised his hosts as "marvelous surrealists, terribly good," and said, "I think what they're trying to do is an extension of the idea that anyone can be an artist, that what they say or do can be art."

The work that really crystallized their orientation—and ultimately assured their career—was the "Singing Sculpture." Originally scheduled as a "lecture" at St. Martin's in January 1969, it was heralded by a veritable publicity campaign, including tape-recorded announcements ("Come see our new sculpture") and handmade badges, signed by the artists, which their former instructors agreed to wear to class. The event itself lasted for all of five minutes: after a short in-troductory speech in which Gilbert & George presented their feelings about sculpture and sculptors, they turned on a record player and pantomimed two repetitions of "Underneath the Arches," an English music-hall ballad romanticizing the life of hobos who "dream our dreams away" underneath the arches of the railroad tracks.

For Gilbert & George, the song itself had personal associations: it was, they said, "a portrait of us. To be bums with nothing at all . . . that was our situation as artists at the time." But the performance was also an artistic statement: "We were completely submerged by minimal art," they recalled to Jean-Luc Chalumeau. "During this period, the only work considered valuable was that which took account of materials and formal aspects. We felt that all of that was decadent because we believed in the artist as a being and not in minimalist intentions." Nonetheless, the packed audience that they managed to drum up at St. Martin's was apparently quite outraged by what was perceived as a display of camp presented in the name of art, and in subsequent performances at other art schools, Gilbert & George stuck with the nondescript title "Our New Sculpture." By the summer, they had begun to perform with bronze paint on their faces and hands—a guise they had adopted a few months earlier for a party at Studio International—and by early 1970, they had abandoned their introductory remarks and, more important, started singing with the record as "Gilbert & George the Living Sculptures." Although they didn't make the association with the initial form of "Underneath the Arches," they explained at the time, the concept had come to them while they were still in art school, in connection with John Dewey's "art as experience" and John Latham's event-sculpture. And as they later indicated to Jean-Hubert Martin, they had no resources at all when they finished school: "All we had was ourselves, and as a result, we were objects. So you could say that we became living sculptures quite naturally by the force of circumstances."

In addition to the performances of "Underneath the Arches," they also presented themselves at rock concerts and other youth-culture events, always dressed in their suits and ties and often made up with metallic paint. The reactions were mixed, they recalled: young people in the audiences sometimes approached them with questions, and rock stars were impressed with their multicolored faces, but on at least one occasion they had to be saved from bands of skinheads by the police. In fact, and contrary to their avowed intentions, the "living sculptures" soon found their most responsive audience in the art galleries and museums. In the

fall of 1969, at the same time they were celebrating the anniversary of "Underneath the Arches" under the real arches of a London railway line, they were invited to perform at the opening of a vanguard exhibit of conceptual art at the Institute of Contemporary Art in London, and later the same year, at the Stedelijk Museum in Amsterdam. In that new art context, the "living sculptures" assumed another dimension: extended time. In February 1970, for an appearance at the Düsseldorf Kunsthalle, they presented themselves as immobile objects for two eight-hour days; in Krefeld that October they performed "Underneath the Arches" for a total of ten eight-hour days; the following month, at the Nigel Greenwood Gallery in London, they did five seven-hour days in a row, and the following year, to celebrate the opening of Ileana Sonnabend's downtown New York gallery, they were on hand five hours a day for ten consecutive days.

During that period, Gilbert & George the sculptures were also Gilbert & George the sculptors, and as such, they pursued an ever-increasing variety of activities, all of which they called sculpture and placed under the institutional banner of "Art for All" (located in the Fournier Street flat that they began renting in London's East End in 1969). Their "postal sculpture," for example, was inaugurated with a mailing of about a hundred Easter greetings penned by two young boys they recruited in the neighborhood. A "magazine sculpture," created for *Studio International*, consisted of color photographs of the two young sculptors with paper letters pinned to their jackets and ties to spell out "George the Cunt" and "Gilbert the Shit." Printed along with the photographs (but without the captions, which were duly blocked out by the magazine) were the first of many texts that Gilbert & George were to issue, written in English as idiosyncratic as their outfits and affirming their commitment to "a world of reeling and meaning, a newer better world, a world complete, all the world an art gallery." Various texts—"Walking, Viewing, Relaxing," "The Pencil-on-Paper Descriptive Works of Gilbert & George" (a one-sentence essay of about twelve hundred words), "To Be with Art Is All We Ask"—were combined with "charcoal-on-paper sculptures," which were, in fact, large and not particularly skillful drawings based on photos of outdoor settings, generally including the artists themselves. The same photographs also generated a group of painting-sculptures, "The Paintings (with Us in Nature)," which were exhibited in 1971, while a second set of photos, taken in the parks of London, yielded an eight-part postal sculpture combining images with limericks

("The Limericks," 1971) and another group of wall-sized charcoal sculptures ("There Were Two Young Men," 1971).

Each of those sculptures actually enjoyed a multiple existence: mailings might serve as announcements; booklets might wind up in exhibitions; exhibitions would assuredly be combined with a performance by the "living sculptures." That seeming disregard for art-world conventions—actually the cutting edge of conceptual art—was marked by the same display of etiquette that had accompanied their art-school ventures, a seemingly incongruous combination of outmoded manners and avant-garde art aimed, as Barbara Reise pointed out in 1971, at "very precisely cultivating the cultural anachronism of themselves and their confusion of life with art and their world with the art world."

In 1972 the London *Daily Mirror* hailed Gilbert & George as "the great new phenomenon of the art world." One critic who was not impressed was Barbara Rose, who dismissed them early on as "impersonally singing automata," but as El wyn Lynn perceptively noted in a 1974 assessment of their otherwise unblemished fame and fortune, "there is such a confluence of prevailing aesthetic-social notions embodied in their work (which is primitive vaudeville) that one is inclined to treat them not as art but as symptomatic; not as something for aesthetic appraisal but as documentation."

From the outset, Gilbert & George themselves had been quite preoccupied with the documentary aspect of their work, through all of their printed communications—calling cards, announcements, invitations, mailings, booklets—as well as photographs of their public events. By 1969 they had amassed sufficient memorabilia to create three boxes of "Our Art/Life until the Summer of '69," which they took around with them on their art visits. The use of photographs as documents led in turn to the "Photo-Pieces," which were wall displays of fifteen, twenty, even fifty black-and-white photographs of the kind used for the charcoal sculptures—Gilbert, George, Gilbert and George (taken with an automatic shutter release) in close-up, middle-view, and long-range shots, juxtaposed with chunks of the natural settings in which they initially chose to present themselves (although, they insist, "we never put a foot in the countryside"). Establishing the practice they have continued ever since, they always shot the photographs themselves, and they never used the same photo twice.

Like their prose, those early photographic images offered what Barbara Reise characterized as "a coherent mix of naïveté, sentimentality, and refinement." But within a short time, other,

less sanguine aspects of their joint persona became apparent. Two monumental, floor-to-ceiling charcoal-on-paper sculptures installed at the Hayward Gallery in 1972 ("The Shrubberies"), for example, once again showed Gilbert & George in a woodsy setting, but this time the two sculptors/sculptures appeared only once on each wall, and the string of phrases running along the bottom of the already ominous scenes offered comments like "Strange Circumstances," "Out of Bounds," "Gin & Tonic," "The Firm Stick," "Bad Blood," "Terribly Naughty," and "Smashed." In the works that followed, Gilbert & George quit the idyllic outdoors for the somewhat antithetical ambiance of the bar. One critic at the time tried to suggest that the blurry, distorted, overexposed images of the resulting photo-pieces were meant to indicate that Gilbert & George were "drunk on art," but titles like "Balls, or the Evening Before the Morning After" (1972), "Staggering" (1972), "Slippery Glasses" ((1972), or "Modern Rubbish" (1973) cast their predicament in a more realistic light, which, they later acknowledged, basically had to do with drinking too much.

During that period of intoxication, whether physical or psychic, Gilbert & George also transformed the visual presentation of their work: in marked contrast to the disarray of the images within each photograph, the aggregate photo-pieces came to assume bold and expressive patterns—a cascade of slivers in "Raining Gin" (1973), crosses in "True Man" (1973) or "Gin & Tonic" (1973), a row of X's in "The Secret Drinker" (1973), or even totemic human forms in the "Inca Pisco" series (1974, named after a Peruvian brandy). That formalistic tendency and its emotive impact became even more apparent in "Human Bondage" (1974), where variously under- and overexposed images of Gilbert & George and the evidence of their debauchery are assembled into a seven-part series of reversed swastikas. In the nine-part "Dark Shadow" series (1974), they evolved an even stricter geometry of forms, tones, and patterns that now included their own images photographed from odd angles, under harsh lighting, and disposed or superimposed like inanimate objects. "There seems to be little difference between the flatness of the panels and the expressions of the two human beings," observed Mario Codognato, noting that such images go beyond autobiography in the strict sense: "Their fears are symbols, metaphors, representations, visions of our fears; their reasons for happiness or sorrow, love or hate, participation or isolation stand for ours."

With "Cherry Blossom" (1974), "Bloody Life" (1975), and "Bad Thoughts" (1975) the stylization of form and mood was further intensified by the use of red, Gilbert & George's "color of desperation." During that period, they created a "Red Sculpture" as well—a ninety-minute pantomime in redface performed to a tape recording of key phrases from "Human Bondage," "Dark Shadow," "Cherry Blossom," and the like. In retrospect, such works are perhaps most significant for their thematic preoccupation with violence and sexuality. Speaking of "Cherry Blossom," for example, Gilbert & George explained that the image, as they had learned during a visit to Japan, was associated with the young soldiers killed in the Second World War and suggested manhood, purity, and death. "Oriental violence, such as one finds in the extreme discipline of the martial arts," they said, "fascinated us, and the title 'Cherry Blossom' was born out of that fascination." In the actual photo-pieces, clenched fists, splotches of blood, and repeated images of Gilbert & George contorting with sticks of bamboo like latter-day St. Sebastians (though still in their suits and ties, to be sure) create an ominous, disquieting mood quite removed from the "naïveté, sentimentality, and refinement" with which they had once been associated.

"Bad Thoughts" (1975), "Dusty Corners" (1975) and "Dead Boards" (1976) were far more austere—the latter two reverting to black and white—with pensive staring figures of Gilbert & George in the solitude of their home and mind. For "Mental" (1976) they went outdoors again, photographing flowers and trees and city streets by day and night, but their own sense of isolation is more strikingly depicted (beyond the title, which is British slang for "crazy") by the fact that Gilbert & George are never directly present in the social settings but rather, occupy their own, otherwise empty spaces (one figure to a photo, as had been the case since "Cherry Blossom"). The pattern most often formed by that juxtaposition of tones, textures, and colors (red once again) is the cross, intended to signal the crusading mission that the artists had in fact assumed from the outset of their career.

The personal torment portrayed in such photo-pieces, according to Gilbert & George, is as much a fact of their lives as the matching suits they wear: "We are quite unhappy people," Gilbert declared to Robert Becker in a 1983 interview; "I think we are very desperate, very desperate. We don't believe in an art world. We are not encircled by artists—by nobody in fact. We are completely alone." But in their art, at least, they apparently sought to end their isolation by introducing the images of other people, and in so doing they expanded their "mission" to broader social and political concerns. The break

came with the seventeen-part "Red Morning" (1977), where, for the first time, the individual photo-pieces bore their own, provocative subtitles—Dirt, Blood, Scandal, Hell, Hate, Violence, among others—and in several of them, photos of East Asians from their neighborhood (obviously taken with a telephoto lens) are included. (Another notable feature of that series, which is otherwise fairly similar to "Mental" in its format, is the fact that Gilbert & George make their sole appearance in shirtsleeves.)

By the time of "Red Morning," Gilbert & George had reached the status of "cult figures"—they were, according to Edward Lucie-Smith, "the leaders of the new amateurism in the visual arts: their claim is not so much to create as to *be*. They are their own found objects, art because they claim to be art." Yet, Lucie-Smith has suggested, there was a price to be paid—the obligation to maintain the proper persona they had created—and in his view, they had become "victims of 1960s jokiness, as well as being products of it." It was perhaps in reaction to that situation, or at least their public image, that Gilbert & George ceased to present the "living sculptures" in 1977—they did not want to be lumped in with performance artists, they said—and proceeded to dispel the last pretenses of their naïveté with a twenty-six part series of photo-pieces called "Dirty Words" (1977). Here, in a marked visual and conceptual departure from all that had gone before, Gilbert & George fashioned emblematic tableaux of lumpen life—the symbols of power (London bobbies, toy soldiers, government buildings, banks) and powerlessness (immigrants, unemployed, winos). These were labeled with the found poetry of street graffiti, mainly the four-letter variety, placed at the top of four-photo grids, but also venturing into longer phrases like "Prostitute Poof," or "Smash the Reds." In none of these pieces, nor in any later ones, were women included: "A woman in our work would seem as odd, as artificial, as our bank manager in drag," they later declared to the *Washington Post.* (They have also argued that women's bodies are not shown because they are always exploited by pornography.)

For Brenda Richardson, the "Dirty Words" series represented the "full maturity of the photo-pieces": "The content of the series is extraordinary for its culminating authority and intensity of vision," she wrote in a 1984 retrospective essay. At the time, while those works were widely exhibited—in Amsterdam, Düsseldorf, New York City, Tokyo, and even George's alma mater, Dartington Hall—it was precisely the content that tended to be judiciously overlooked. As Rosetta Brooks pointed out,

English critics in particular lapsed into silence at the first signs of impropriety, and Gilbert & George were effectively marginalized, but even in the United States, where they were always enthusiastically received, an *Artforum* review illustrated with "Piss," for example, chose to compare "Dirty Words" and other photo-pieces to Renaissance altarpieces and contended that their "rigorous pictorial syntax serves less to aestheticize the composite talbeaux of slangy imagery than to anesthetize us to the often 'raw' visual material."

As for Gilbert & George, following a related group of individual photo-pieces (after "Dirty Words" they dropped the series titles), they took a break. For about a year they devoted themselves to renovating the weaver's house on Fournier Street where they had been living since 1969, now filled with nineteenth-century Gothic revival furniture and an enormous collection of Victorian pottery. (Once the furniture and the pottery took over the house, they bought an adjacent textile factory to serve as their studio, which they call their "workshop.") They also began preparing for the mammoth exhibition of their work that made its way through Europe and England in 1980–81, and in that retrospective mode they undertook a seventy-minute film, "The World of Gilbert & George" (1980). As Patrick Frey pointed out, that last project was "'Gilbert & George the sculpture' reanimated," a cinematic summary of their work to date, with lots of short, discontinuous shots of urban blight and attractive working-class youths juxtaposed with the ever-correct (and increasingly Christian) title characters.

This mixed message of populist politics, homoeroticism, and missionary zeal was to characterize the rest of their work throughout the 1980s. The "three driving work forces" of their art, they took to explaining, were the brain, the soul, and the sexual organ, and if their imagery was increasingly complex, it was because they were "more complicated than not." In formal terms, that complexity followed the cultivated anachronism of the artists' lives—after a decade of decorous black and white, punctuated by the red of despair, Gilbert & George began experimenting with color in 1980. They had already been using photograms and templates to produce silhouettes, and the combination of bright color with flat areas—the ever-present grid on an increasingly monumental scale—achieved an effect not unlike stained-glass windows. In the early 1980s that allusion seemed largely ironic, applied as it was to images of naked youths and other erotica ("Fruit, God, Fear," 1982; "World," 1983), but by the middle of the decade, the crusader element came increasingly to

the fore and found appropriate expression in the pseudoreligious format ("Life without End," 1984; "Death after Life," 1984; "Class War," 1986).

With the second wave of Gilbert & George retrospectives that began in 1984, critics tried to come to terms with the polyvalent statements of the polychromatic period. Some were decidedly disappointed with the seeming banality of the new decorative icons: for Holland Cotter, Gilbert & George were "settling into nothing more inventive or critical than the art world's postmodernist Monty Python." Yet, as Rosette Brooks noted in an article pointedly entitled "Gilbert & George; Shake Hands with the Devil," the underlying social implications of that work had never really been confronted. Like the erotic imagery—pools of sperm, sexual organs, and the ever-present adolescents as objects of desire—which routinely passed without comment, their populist political stance and its evangelical trappings, extolling what Brooks characterized as a "lost social norm" corresponding to the white, British, middle-class majority, hardly drew the same kinds of reactions that a political candidate affecting them would have. Still other critics have read straight through the apparent social commentary to arrive at the opposite interpretation: Bernard Marcadé, for example, acknowledged that the costumes Gilbert & George wear (and which they describe as "South African vacation suits") endorse "a moral and political reality of England that doesn't dare to state its name," but, he contends, "in endorsing it, they also oblige us to relativize our viewpoint and admit that in spite of our grand principles, we also participate in this mediocrity and stupidity." And for Jean-Luc Chalumeau, "Gilbert & George cast a truly tender regard on humanity as it is, and their life as it goes along. It's not their fault if both are drifting away."

Gilbert & George live in a seventeenth-century house in the East End of London, which they have described as "more rushing, more animal" than the relatively "soothing" milieu of New York City. Although they proudly declare that they are "very right wing," the impulse behind their work, they insist, remains artistic and personal: "And the suffering. Amazing feelings of unhappiness inside. Then you search for the pictures to visualize that." The form, they say, "is cool (technological); the content is warm (human)."

EXHIBITIONS INCLUDE: Frank's Sandwich Bar, London 1968, '69; St. Martin's School of Art, London 1968; Allied Services Bacon Factory, London 1968; Robert Fraser Gal., London 1968, '69; Geffreye Mus., London 1969; Royal Col. of Art, London 1969; Camberwell School of Art, London 1969; Slade School of Fine Art, London 1969; with Bruce McLean: Royal Col. of Art, St. Martin's School of Art, Hannover Grand Preview Theatre, London 1969; with David Hockney: Ripley, Bromley, Kent 1969; Marquee Club, London 1969; The Lyceum, London, 1969; National Jazz and Blues Festival, Plumpton, Sussex 1969; Inst. of Contemporary Art, London 1969; Cable Street, London, 1969; Stedelijk Mus., Amsterdam 1969, '71, '77; Art and Project, Amsterdam from 1970; Konrad Fischer Gal., Düsseldorf from 1970; Gal. Françoise Lambert, Milan 1970; Folker Skulima Gal., Berlin 1970; Heiner Friedrich Gal., Cologne and Munich 1970; Nigel Greenwood Gal., London 1970–74; Mus. of Modern Art, Oxford 1970; Leeds Polytechnic 1970; Kunsthalle, Düsseldorf 1970; Kunstverein, Hanover 1970; Block Gal. Forum Theater, Berlin 1970; Kunstverein, Recklinghausen 1970; Württembergischer Kunstverein, Stuttgart 1970; Mus. d'Arte Moderna, Turin 1970; Sonja Henie/Niels Onstad Foundation, Oslo 1970; Stadsbiblioteket Lyngby, Copenhagen 1970; Gegenverkehr, Aachen 1970; Kunstverein, Krefeld 1970; Gal. Sperone 1974; "Arte inglese oggi," Palazzo Reale, Milan 1976; "Europe in the '70s," Art Inst. of Chicago, 1977 (trav. exhib.); "Made by Sculptors," Stedelijk Mus., Amsterdam 1978; Documenta 6, Kassel 1977; Venice Biennale 1978; "Un certain art anglais," Mus. d'Art Modern de la Ville de Paris 1979; "Gerry Schum," Stedelijk Mus., Amsterdam 1980 (trav. exhib.); "Westkunst," Cologne 1981; São Paulo Bienal 1981; "British Sculpture in the Twentieth Century," Whitechapel Gal., London 1981; "Aspects of British Art Today," Mus. of Modern Art, Tokyo 1982; Documenta 7, Kassel 1982; "Zeitgeist," Martin-Gropius-Bau, Berlin 1982; "Photography in Contemporary Art," Mus. of Modern Art, Tokyo 1983; "Acquisition Priorities," Guggenheim Mus., NYC 1983; "Trends in Postwar American and European Art," Guggenheim Mus., NYC 1983; "New Art," Tate Mus., London 1983; Sydney Biennale 1984; "The Critical Eye," Yale Cntr. for British Art, New Haven, Conn. 1984; "Artistic Collaboration in the Twentieth Century," Hirshhorn Mus. and Sculpture Garden, Washington, D.C. 1984; POSC, Dublin 1984; "Content," Hirshhorn Mus. and Sculpture Garden, Washington, D.C. 1984; "Via New York," Mus. d'Art Contemporain Montreal 1984; "The British Show," Art Gals. of Western Australia and New South Wales, Queensland Art Gal, 1984; "Dialog," Moderna Mus. Stockholm 1984; "Overture," Castello di Rivoli, Turin 1985; Paris Biennale 1985; Carnegie International, Pittsburgh 1985; "A Journey through Contemporary Art," Hayward Gal. 1985; "Forty Years of Modern Art," Tate Gal., London 1985: "Falls the Shadow," Hayward Gal., London 1985; "La mode: l'époque, la morale, la passion," Cntr. Georges Pompidou, Paris 1987; Robert Miller Gal. and Sonnabend Gal., NYC 1990.

COLLECTIONS INCLUDE: Art Gal. of South Australia, Adelaide; Art and Project, Amsterdam; Stedelijk Mus., Amsterdam; Baltimore Mus. of Art; Chicago Art Inst.; Scottish National Gal. of Modern Art, Edinburgh; Stedelijk van Abbemus., Eindhoven; Arts Council of Great Britain, London; Kunstmus., Lucerne; Rijksmus. Kröller-Müller, Otterlo; Mus. National d'Art Moderne,

Paris; Mus. Boymans-van Beuningen, Rotterdam; Southampton Art Gal.; Norton Gal. of Art, West Palm Beach.

ABOUT: Emanuel, M., et al. Contemporary Artists, 1983; "Gilbert & George 1968 to 1980" (cat.), Stedelijk van Abbemuseum, Eindhoven, 1980; "Gilbert & George" (cat. suppl.), Mus. National d'Art Moderne, Paris, 1981; "Gilbert & George 1971–1985" (cat.), Guggenheim Mus., NYC, 1985; "Gilbert & George: The Charcoal-on-Paper Sculptures" (cat.), CAPC, Bordeaux, 1986; "The New Art" (cat.), Hayward Gal., London, 1972; Richardson, Brenda. "Gilbert & George" (cat.), Baltimore Mus. of Art, 1984. Periodicals—A.E.I.O.U. July 1984; Afterimage November 1983; Aperture Winter 1984; Art and Artists March 1977; Artforum February 1974, June 1984; Art in America September 1970, May 1982, October 1984; Art International March 1974, March–April 1981; ARTnews November 1971; Art Press April 1981, May 1986; Artscribe February 1981; Avalanche Summer–Fall 1973; Daily Mirror (London) September 5, 1972; Domus March 1972; Flash Art October–November 1985; Interview August 1983; L'artvivant April 1972, December 1981; Monthly Film Bulletin December 1981; Opus International Autumn 1987; Parkett no. 1 (1984), no. 14 (1987); Studio International May 1970, July–August 1974.

BY THE ARTISTS: Side by Side, 1971; The Paintings (with Us in Nature) of Gilbert & George the Human Sculptures, 1971; Dark Shadow, 1974. Videotapes—The Nature of Our Looking, 1970; A Portrait of the Artist as a Young Man, 1972; Gordons Makes Us Drunk, 1972; In the Bush, 1972. Film—The World of Gilbert & George, 1980.

GOLUB, LEON (ALBERT) (January 23, 1922–), American painter, has steadfastly retained his belief in the primacy of the human figure in painting, and the importance of representational art in general, even as movements of formalism and abstraction have, over the last thirty years, pervaded contemporary art and dominated critical attention. He helped to found the image-oriented School of Chicago art after World War II, which has remained a strong regional influence, and went on to investigate issues of classicism and content that have been generally outside the mainstream of modern and postmodern art. It has only been in the last five or ten years, with the resurgence of interest in figure painting and narrative content, that Golub has received widespread critical acclaim. His work has become increasingly tied to political issues of the day, and recent works are direct, expressive restatements of the news photos from which he works. His interests in power and language—once rendered in generalized, primitive figuration—are now presented in startling tableaux of white colonialism, American interventionism, and other moments of modern warfare.

LEON GOLUB

Golub was born in Chicago to Sam and Sara (Sussman) Golub. In his teens, he attended WPA art classes and later entered the University of Chicago with a scholarship after two years at Wright Junior College. He received his B.A. degree in art history in 1942, and spent the next four years serving with the U.S. Army Corps of Engineers in Europe. Golub returned to study at the Art Institute of Chicago in 1946, and there painted under Paul Wieghardt, Kathleen Blackshear and Robert Lifuendahl. Those instructors presented the works of African and Oceanic tribal cultures as inspiration for their students, thus planting the seeds of what was later to be called the "Monster Roster" of Chicago art, a group of highly expressive imagist artists lead by Golub, George Cohen, and Cosmo Campoli.

While artists in New York were working in the nonobjective, abstract styles of certain refugee European painters, the atmosphere in the Chicago art scene following World War II was one of highly psychological "surrealist expressionism" which portrayed fresh memories of the war and the harsh, inelegant industrialism of Chicago itself. Although there were painters in Chicago interested in geometric abstraction, particularly the students of the Bauhaus-influenced Institute of Design, many students and alumni of the Art Institute (where Golub received his M.F.A degree in 1950) maintained the local tradition of distorting the figure that had begun in the 1920s with the nightmarish portraiture of Ivan Albright. In 1948 Golub helped to organize the "Exhibition Momentum," a forum for the debate between the two groups that was

to be held regularly for the next ten years. Earning the facetious label of "prerationalist," after the nineteenth-century British "pre-Raphaelites," Golub and his colleagues incorporated the postwar anxiety and existential inquiry around them into iconic figure paintings and sculptures. They worked from photographs of Auschwitz victims while at the same time drawing heavily on the primitive art that they saw as providing a myth or symbol system sorely needed by modern society. In 1957 Jean Dubuffet, whose early work Golub greatly admired, delivered his notorious "anticultural" lectures in Chicago, praising the value of the survival instincts of jungle-dwelling primitives to twentieth-century man living in hostile, noncohesive societies. Golub, Cohen, and Campoli borrowed the simplified, broken-down manner of rendering the human body from the primitive artists to create paintings and assemblages that used hands, arms, legs, and faces as fragmentary symbols of contemporary urban disaffection.

Golub's subjects of the early 1950s were simple, flattened bodies roughly worked in grisaille or earth-tone lacquers. The characters were limbless and contorted, many drawn from pre-Columbian or Assyrian images of frozen, front-facing warriors. The paintings share a tone of frustration, as though each figure's power is defeated by his lack of limbs or joints. *Thwarted* (1953) is a particularly pathetic piece, having as its source the ruined classical sculpture known as the Belvedere Torso. Golub's rendition of the behemoth nearly pushes off the edges of the canvas, its face pursed in agony. The critic Donald Kuspit has located in *Thwarted,* and in Golub's other works of the period, the artist's ongoing internal debate about primitive impulses and developed rationalism. Golub chose the broken classical torso because its decay suggested that the discipline of classicism cannot really control the primitive, or organic, in man, and that any attempt to gain that control through heroic action is bound to fail. Golub saw a basic impossibility in the search for rational control of self or world, but his hope that man could learn to accept that impossibility and arrive at an existential awareness of his condition led the artist to seek the appropriate visual counterpart for his tragic/hopeful philosophy.

Birth (1953) is a strong, explicit interpretation of Golub's wife's (the painter Nancy Spero, whom he married in 1951) giving birth to their first son. That piece, intended by Golub to "combine the terrible ecstasy of giving birth with the tired relaxation thereafter" is an example of his using ritualized, nonspecific shapes to universalize a personal experience. Working without preparatory drawings, Golub employed right angles and activated strokes to describe his wife's face and limbs as she gave birth. The painting is compositionally sound and beautifully colored, but the surface is quite turbulent and disturbing. For Golub, the most natural act can also be the most frightening, part of the ambiguity of the human condition that he sought to bring to his viewers' attention. The immediacy of Golub's paintings of the 1950s—*Damaged Man* and the "In-Self" series, among others—can be seen also in the work of his abstractionist contemporaries, but Golub found their work to be impoverished because it neglected the material world and dwelt exclusively on the isolated act of painting itself.

In 1955 Golub published his "Critique of Abstract Expressionism" in the *College Art Journal,* in which he denigrated the abstract expressionists' pursuit, with their "unfettered brushes," of primitive thought unmediated in any way by developed common language. Golub did not see man as being capable or needful of languageless expression, and his own respect for primitive expression was for the simplicity of its symbols, not the absence of a formulated vocabulary. Golub suggested that the process-oriented and automatic techniques of abstract expressionism "wallowed in the orgiastic harassment of self," and that if action is to be accepted as the meaning of a work, then all action paintings have the same meaning, and by extension, all painters may as well be the same. He saw the loss of naturalistic, discrete descriptions in painting as "equivalent to the cultural dehumanization of man."

Golub's vocal rejection of the "over-intellectualized . . . empty aesthetic" of abstract expressionism came at a time when some of its key practitioners—Pollock, de Kooning, Kline—were rapidly gaining popular and critical esteem. But as Max Kozloff wrote of the "inwardness" of Chicago art since 1945, Chicago artists have never felt particularly obliged to advance the history of art. Kozloff has pointed out that Golub and others of his generation laid the groundwork for a type of art in which we are "obliged to revert to our own backlog of alarms . . . sensations, antagonism, conceits, nostalgia . . . all those inarticulate or uncommunicable moments in our lives of which we doubt others have an inkling." The sheer intensity of Golub's vision and his willingness to mix elegant composition and coloration with the harshest of subjects led Kozloff to write that Golub has "exerted his important influence on the Chicago School by anticipating both the repressed and hyperactivated subjects of younger artists."

The year 1954 brought Golub his first museum exposure in "Younger American Painters" at the Guggenheim in New York City, his first solo exhibition there at the Artists Gallery, and the Florsheim Memorial Prize at the Chicago Art Institute's sixty-first American Exhibition. He continued to exhibit in both cities as he worked on his "Burnt Man" and "Sphinx" series, each featuring anxious figures, not clearly human but with human faces, awkwardly staring from rough surfaces. Golub spent 1956 and 1957 in Italy, on the Island of Ischia and in Florence, and there he encountered Etruscan and Roman art that he felt expressed the stresses of urban cultures throughout the ages. The stiff and broken forms of antiquity, unable to resist aging and ruin, were rendered by Golub in gouged, wrecked layers of lacquer. The "Athlete" and "Philosopher" series followed shortly thereafter while Golub was living in London, and the simple, fleshy "Colossal Heads" were painted in 1957 when Golub had returned to the United States to teach at Indiana University in Bloomington. In 1959 the Museum of Modern Art in New York held the "New Images of Man" show in which Golub was represented, and that year, too, marked the end of his primitive-inspired work. Golub and his wife moved to Paris in 1959, and there he immersed himself in the art of Hellenistic Greece.

In the huge fighting figures depicted on the Altar of Zeus at Pergamon (180 B.C.) Golub found a crumbled majesty that perfectly embodied the "extraordinary levels of conflict and personification" that he sought for his own portrayals of society. He saw that "late classical proportion is a canon of gesture under stress," and after working on his second "Burnt Man" series and a group of "Combat" paintings, he began his "Gigantomachies" series, a subject he was to work on until the late 1960s. Working now in acrylic paint instead of lacquer, Golub turned to multifigure compositions which were rendered on virtually empty backgrounds. Carter Ratcliff has described Golub's preoccupation with the "battered, dubious grandeur" of the Greeks as his "Ozymandias phase." While the paintings of the 1950s had been thickly rendered, the Gigantomachies began to show deeply scraped surfaces, as though the canvas itself were as defenseless from the ravages of fate as the figures depicted on them. They are huge, dramatic pieces, like stage sets without scenery, which for Golub recall the great history paintings of David, Gérôme and Delaroche, but with the added component of irony, and without the harmony of the older paintings' smooth execution. Golub has described his own backgrounds as being "modernized to a very large degree . . . for au-

tonomous, existential action." The unpainted or solid-color grounds recall the cubists' original rejection of perspectival illusion and associate Golub with the color-field painters of his own day, but they function most immediately to keep his viewers' attention on the battles depicted in the foreground; there is no illusionary distance or extra scenery into which one might retreat.

As he pieced together aspects of classical figuration into his own restatement, Golub traded the harmonious idealization of the Olympian scene for what he called a "rough-hewn Mediterranean purgatory." The forms become successively less interrelated in each Gigantomachy painting until each figure appears to be fighting alone, striking out at warriors who look much like him but are clearly his enemies. The original Pergamon figures were presented with all the trappings of Greek cosmology: appropriate attendants, names, lists of their victories. By contrast, Golub's figures fight in a void, like mythic beings stripped of myth, and therefore of purpose. In describing those paintings, Golub has concluded that the "postmythic is the existential," and his figures from that point on express the devaluation of faith in man's purpose and societal connections that, for Golub, characterizes our "war-technology civilization."

Golub has said of his work that it is not political as much as it is existential, but in the late 1960s he began to paint identifiable political sentiments. The "Gigantomachies IV" of 1967 was a response to American involvement in Vietnam, and the figures are huge and unnatural-looking machines or cyborgs, "portents of automatized destruction," according to the artist, with the "paradoxical violence of manufactured (robotlike) objects." Technology, from that viewpoint, begins to seem just another means for satisfying primitive desires for power. Though he had his own retrospectives at the Tyler School of Art in Philadelphia in 1964 and at the University of Chicago in 1966, many of Golub's activities and exhibitions were parts of activist artists' projects, including the "Artists and Writers Protest" and the "Art Workers Coalition." When he returned to New York in 1967, Golub participated in "Angry Arts Week" with six-hundred other artists. The protest against the war in Vietnam included a 10-by-120-foot *Collage of Indignation* to which Golub contributed photostats of his 1961 "Burnt Man" paintings; the final mixed-media composition was displayed with a tape of Pope John XXIII's arrival in New York playing in the background. Describing the installation, Golub related his belief in putting emotion before aesthetic: "Today's art is largely autonomous and concerned with perfectability. Anger cannot easily burst through such chan-

nels. . . . The collage is gross, vulgar, clumsy, ugly . . . artists striving to split, let go. . . . This is not political art, but rather popular expression of popular revulsion."

With his "Vietnam" paintings of the early 1970s (originally called "Assassins," a title Golub found to be too general), one begins to see who is the victim and who the oppressor in each composition. These paintings were cut and torn, as though wounded, showing Golub's interest in connecting his technique to experience in as graphic and immediate a way as possible. "Napalm Gates" of 1970–71 remain some of Golub's few nonfigurative works, but they have been compared to vast renderings of napalmed skin.

In 1972 Golub first used distinct uniforms and weapons, thus rooting his warriors in contemporary situations. The figures in the "Vietnam" series are also much more like photographic or comic-book images than earlier subjects, being quite flat despite their evident care of execution. Critics asked why such an accomplished draughtsman would work from such unsophisticated sources, but Golub's increasing use of detail and narrative made it clear that the sources themselves were the real subjects of his paintings. The way in which news photos, as well as sports and pornographic photos, reduced those holding power to identifiable, iconic images suggested to Golub that that is in fact how power is disseminated. In the late 1970s he painted a series of about one hundred small portraits of modern leaders—Franco, Chou En-lai, and Nelson Rockefeller, for example—devoid of any emotional or personal inflection, but identifiable by each leader's "public persona": hairstyle, epaulets, horn-rimmed glasses. In 1977 Golub said of his art that "this is not make-believe, this is not fantasy, this is not symbolism. It is but it isn't." The crossover between language and reality, especially the language of technology and mass communication, was his main concern, and he found the thin line between knowledge and belief to be rather frightening. The manipulation of that line by the powerful he found to be particularly dangerous.

Ultimately, the styles and aims of both primitive and classical art seemed inadequate to Golub for his contemporary concerns and proved to be no more concrete or lasting than those of abstract expressionism. Golub sought to "break down the barriers between depicted and real space" and thus achieve "a barbaric realism" that used the human body (as always) as an "abbreviated symbol . . . conveyed in stringent simplicity." To that end, Golub's most recent series, "Mercenaries" and "Interrogations," begun in 1976, are abrasive, violent paintings of figures committing acts of torture and fighting depicted in graphic detail. Largely based on reportorial photos of Central American conflicts, they thoroughly describe the personalities and power plays of political criminals with unrelenting exactitude. Faces now take on highly individualized appearances, and Khaki uniforms mix with colorful civilian clothes against bright red backgrounds. The faces of Golub's oppressors belong to coarse, soulless men who have hired themselves out as thugs. And while Golub does not sentimentalize either the victims or their plight, their very defeat has purchased them a kind of grace that will never visit their brutishly simple tormentors. Loutish grins and dangling cigarettes add "tatters of individuality" to that astonishingly cruel world of the "irregulars," and Golub makes sure, once again, that viewers are drawn into the paintings by having faces look directly at us and by using the spare backgrounds he had developed earlier. Those works have been described as not so much entering one's senses as taking over, and in surface and image they do just that. Golub pulls together episodes of torture and murder on large canvases, transferring them to the floor to build up, then dissolve and scrape off, his figures in acrylic paint. At times he uses a meat cleaver to scrape the paint; as in "Combats" and "Gigantomachies," the porous surfaces are crucial to their impact. Carter Ratcliff has written of those surfaces that they are "rubbed raw. Forced into a state of extreme receptivity, as though our own privileges of inwardness, of subjectivity, can no longer be maintained."

The "frozen tension" and "abrupt immediacy" that Golub sees in the media photos of foreign events parallel, for him, the way in which those events occur. In an interview for a show of "Mercenaries" and "Interrogations" at the Institute of Contemporary Art in London in 1982, Golub said that he does not find television and newspapers to have devalued the realities of war by placing them amid situation comedies and advertisements, but rather that that "atomized chaos of media information bombards us from all sides" in the same way that the chaos of war bombards those trapped within it. Further, Golub said that those manipulating the images know nothing more than the viewers, that the conflict we see on the nightly news "jitters in the skulls of onlookers even as it jitters in the skulls of media manipulators." Carter Ratcliff has pointed out that such a view suggests a world without a center of power, one in which each viewer and each manipulator tries to create his or her own universe of power as both offense and defense. That is the feeling conveyed by

"Interrogations II," for example, in which posturing mercenaries seem to pose for the "camera," torturing their victims with obvious bravado, and in "Horsing Around," in which the soldiers, in their time off, cruelly tease prostitutes and one another.

Although Golub has said that the mercenaries are representative of irregulars everywhere, he does acknowledge something particularly American about the intensity of the paintings themselves. Golub has expressed his appreciation for the political candor allowed American artists even as his work has derided American governmental policies. He seems fully aware of his own conflicting impulses about excessive nationalism and the reasonable need to feel at home in some part of an increasingly complex world, but he maintains that the existential truths he sought early in his career are still to be found only by facing such conflicts head-on. The disturbing nature of his work has very recently engendered very positive responses from critics as the neo-expressionist movement has brought fame to European and New York painters of similar intent, though most are much newer to figure-painting than Golub and generally less topical in their subjects. In 1982, when Golub had his first solo show in New York since 1963, critic Peter Schjeldahl wrote of the artist that he was like "an alarm clock set to go off in the early 1980s and wake everybody up." The importance of Golub's faith that "no work is so ugly that it can't be assimilated" is confirmed by Ratcliff's placement of that agenda in political terms: "To know, to confront directly, our moment's images of vicious manipulation is to get some of one's own legitimate strength back."

In marked contrast to the grim, brutal, disturbing character of his imagery, Leon Golub in person is pleasant, friendly, and communicative. He is tall and dark-haired, and those meeting him for the first time find him "handsomely attractive." Recalling his visit to the Corcoran Gallery, Washington, D.C., in July 1985, in connection with his solo exhibition, the woman who organized the show described him as "the easiest person I've ever worked with—kind, articulate, bright." She added that he was a "fascinating guide" to his paintings, welcoming questions and answering them fully.

Leon Golub and his wife have exhibited together frequently over the years and currently live in New York City. They have three sons. Golub has been a professor of art at Rutgers University since 1970, and in 1983 he became the John C. Van Dyke Professor of Visual Arts. He is represented by major galleries in New York and Chicago, and has written numerous articles and art reviews over the course of his career.

EXHIBITIONS INCLUDE: Contemporary Gal., Chicago 1950; George Wittenborn Gal., NYC 1952; Allan Frumkin Gal., Chicago 1955–64 and NYC 1959–63; Inst. of Contemporary Arts, London 1957, '82; Cntr. Culturel Americain, Paris 1960; Tyler School of Art, Temple Univ., Philadelphia 1964; Univ. of Chicago 1966; National Gal. of Victoria, Melbourne 1970–71; Mus. of Contemporary Art, Chicago 1974; New York Cultural Cntr., NYC 1975; Visual Art Mus., School of Visual Arts, NYC 1979; Susan Caldwell Gal., NYC 1982; Sarah Campbell Blaffer Gal., Univ. of Houston 1983; New Mus. of Contemporary Art, NYC 1984–85. GROUP EXHIBITIONS INCLUDE: "Exhibition Momentum," Roosevelt Col. and other locations, Chicago 1948–58; 61st American Exhibition, Art Inst. of Chicago 1954; "Younger American Painters," Guggenheim Mus., NYC; Whitney Mus. of American Art, NYC Annual 1955 and Biennial 1983; "New Images of Man," MOMA, NYC 1959; 2nd International Biennial, Academy of Fine Arts, Mexico City 1961; "New Directions," San Francisco Mus. of Fine Arts, 1963; American Academy of Arts and Letters, National Inst. of Arts and Letters, NYC 1964, '70; "Le monde en question," Mus. d'Art Moderne, Paris 1967; "Chicago Imagist Art," Mus. of Contemporary Art, Chicago 1972; "Paris–New York," Cntr. d'Art et de Culture Georges Pompidou, Paris 1977; "The Figure in America Art," Art Mus. of Southwest Texas 1981; "Artists Call Against U.S. Intervention in Central America," Judson Church, NYC 1984; "The Human Condition," San Francisco Mus. of Fine Art Biennial III 1984.

COLLECTIONS INCLUDE: MOMA, NYC; Art Inst. of Chicago; Smithsonian Inst. Washington, D.C.; La Jolla Art Inst., Calif.; Univ. of Berkeley, Calif.; Indiana Univ., Bloomington; Los Angeles County Mus.; National Gal. of Victoria, Melbourne; Tennessee State Mus., Nashville.

ABOUT: Alloway, L. "Leon Golub, Paintings from 1956–57" (cat.), Allan Frumkin Gallery, NYC, 1957; Alloway, L. "Leon Golub, the Development of His Art" (cat.), Museum of Contemporary Art, Chicago, 1974; Bird, J. "Leon Golub: 'Fragments of Public Vision" (cat.), Institute of Contemporary Art, London, 1982; Emanuel, M., et al. Contemporary Artists, 1983; Fuller, P. "Leon Golub," Beyond the Crisis in Art, London, 1979; Gumpert, L., and N. Rifkin, "Golub" (cat.), New Museum of Contemporary Art, NYC, 1984; Kuspit, D. Leon Golub, Existential/Activist Painter, 1985; Schulze, F. Fantastic Images: Chicago Art Since 1945, 1972. Periodicals—Art in America July–August 1975, July–August 1979, January 1984; Artforum April 1972, May 1981; ARTnews November 1970; Arts Magazine May 1981; College Art Journal Summer 1956; Dialogue May–June 1984; New Yorker May 12, 1975.

GONZALEZ, PATRICIA (April 3, 1958–), Latin American painter who was born in Cartagena, Colombia. In a wild rush toward multiplicity of art movements in the 1980s, Hispanic art has sometimes been neglected. It has been con-

PATRICIA GONZALEZ

sidered a minority art, somewhat regional and out of the mainstream of current art. Gonzalez is an international artist by training and upbringing whose limits are her own imagination. A romantic painter, concerned primarily with landscape and scenery, Gonzalez remembers, fantasizes, abstracts, and communicates her mysterious inner visions to the viewer.

One of three children, Gonzalez grew up in Cartagena, a small town located on the Caribbean coast. Both parents were architects, though her mother never finished her architectural studies. Gonzalez attended the American school in Cartagena, appropriately called George Washington School, where all classes were conducted in English. Her mother wanted her to be bilingual, feeling that English was the language of the future. Neither of her parents spoke English at the time. Although Gonzalez was brought up in a Catholic environment, she did not attend religious school. "I was not an active child," Gonzalez has recalled. "I read a lot of fairy tales and was interested in imaginary things." Though she attended an American school, she did not expect to come to the United States and did not contemplate a career as an artist. A sensitive child, she was mainly preoccupied with her parent's divorce and what it would do to her life. In 1970 she went to England. She spent the first year and a half in a Catholic boarding school that was quite strict, providing a kind of stability in her life. Her mother and brother joined her in England. Gonzalez experienced no culture shock and assimilated into the English school system without difficulties. In 1976 Gonzalez attended

the Central School of Art and Design in London and continued her studies at the Wimbledon School of Art in London where she received a B.F.A. degree in painting and printmaking in 1980. Reflecting upon her schooling, Gonzalez has said: "I entered art school almost by chance. When I was in high school, I used to play truant and go to the Victoria and Albert Museum which fascinated me. I also visited the National Gallery and its collection of Blakes. I thought, I should do something practical in art school, and earn a living doing fabric design. I spent some time in the fabric design department and did not like it at all. I found instead that painting attracted me."

One of her teachers in art school was Derek Boshier, an English painter who encouraged her work. When Boshier accepted a teaching position at the University of Houston, true to her romantic nature, Gonzalez followed him to Texas in 1981. They were married in 1986. Speaking of Boshier's work, Gonzalez has explained their difference in style: "Boshier's paintings are much more externally oriented and have to do with landscape and symbols around him. I am more introspective, more internally oriented."

After her graduation from art school, Gonzalez returned to Colombia in 1980 and taught English and art for the next nine months at the American school. (Her mother was still living in England, her father in the United States.) However, she found the Colombian environment confining. "Cartagena is a tight-knit community and I felt constricted by its smallness. It was not that I was unhappy, and I was glad to see my grandmother again to whom I am close. I was glad to be in Colombia again and I like the people very much. I just did not feel positive anymore about having my future in Colombia." Having made that decision, Gonzalez joined Boshier in Texas.

In discussing her work Gonzalez stated: "It really has to do with undercurrent, with the thing we keep inside ourself. It is what we don't show on the outside, it becomes subjective on how I perceive the world; it is really how I feel and gives a definition of place and of my own identity.

"I don't consider myself part of the protest movement in Hispanic art. I think that art is not about propaganda; you need to make your own art. In the end, you will effect change by being successful rather than by making political art. I am interested in what is internal and that can be just as effective in changing things, but it takes a lot longer. Leon Golub is a very good political artist; I don't see myself in that role."

In discussing her paintings, Gonzalez dis-

played a certain reluctance to analyze her work: "My paintings are romantic. I usually do not try to assess myself with other artists. Painting is very much like poetry, in a sense that you allude to things not tied to literalness."

The art critic Susan Freudenheim, in assessing Gonzalez's work, put it this way: "Many of the paintings evoke a sense of nostalgia. Figures, when they appear, are often hidden in the bushes protected by oversized plants. There is a kind of puckishness to the pictures of tiny people peeking out from trees and bushes, bringing forth memories of mythic stories such as *A Midsummer Night's Dream* or, perhaps, children's fairy tales. Other pictures provide a sense of reminiscence, as if the artist were digging deep into recollections of the distant past. . . . Because the paintings are so much a part of her inner self, the artist confesses some difficulties in talking about them: 'I paint them really so that I don't have to talk about them.'"

Asked how she gets inspiration for a painting, Gonzalez said: "I start with things that are around me, like sunflowers, and then work with that theme. I make some very rough sketches and usually make the drawing directly on the canvas. Most of the time, I like to tackle the canvas immediately. If I do not like a painting I take it off the stretcher and start over again. You must start over again. You have to accept some failure and not fear that it is the end; rather you have to assume that it is the beginning of something else."

Gonzalez's work has been exhibited in England as well as in the United States. Recently, she was one of the featured artists of "Hispanic Art in the United States: Thirty Contemporary Painters and Sculptors," an exhibit that originated in Houston and toured galleries and museums in Washington, D.C., Miami, Los Angeles, and Mexico City.

In his essay "Hispanic Art, American Culture," John Beardsley stated: "A similar penchant for the fantastic is manifest in much of this work (hispanic) especially in the treatment of landscape. Seldom is landscape depicted literally; more often, it is drawn from commingled recollections and images. . . . Alternating nocturnal and diurnal landscapes signify the passage of time in Paul Sierra's *Three Days and Three Nights* while Patricia Gonzalez suggests the ways in which fecundity can assume bizarre and even malevolent characteristics: winged and feathered creatures are secreted among colossal plants in *Eccentricities in Nature*, and the landscape is virtually engulfed by a glorious flowering vine in *Affection*.

Gonzalez is ardent in her conviction that

paintings have to come from the inner self. She is aware of the English landscape tradition and while she admires the work, she does not feel influenced by it. Gonzalez calls her own landscapes "landscapes of the mind"; her landscapes are never real. She feels more drawn to the visionary paintings of Blake. "I love Blake, he is one of my favorite painters. He is such a visionary and belongs to no time, no place, no category. I admire him immensely."

Gonzalez has a shy and introverted manner and speaks with a soft English accent. She loves living in Houston. "It's different from any other place I have lived in; it's sort of free, it's not terribly citylike. I live in a wooden house with a porch. I have a garden and I love gardening. I like a lush garden that takes care of itself and grows, rather than clipping it all the time to control it. I love a natural garden, one that takes over."

It is easy to correlate those sentences to some of Gonzalez's work. In a painting entitled *Night Bloomer* she depicts a verdant cactus with a white blossom next to a succulent. Both plants sit in a verdant desert, one that does not exist in reality. Gonzalez has explained the source of her inspiration: "I have never been to a desert, so I invented it. It's my idea what a desert might be like. I painted *Night Bloomer* in anticipation of coming to the desert. When I was in Arizona, I visited the Superstition Mountains. It takes time for me to digest information and to transform it; what you use is sometimes a coincidence."

Gonzalez has looked at western art and calls it "genre" painting—uninteresting, too literal, leaving little to the imagination. She calls her own work intuitive and not very naturalistic and likes to use brilliant colors and heavy brush strokes. In an article in the *Houston Home and Garden Magazine*, Gretchen Fallon described Gonzalez's elusive appeal as Brontëesque in its scenes of cozy domesticity mingled with mysterious hints of the graveyard.

Gonzalez adjusted easily to living in Texas, where she and her husband became part of an active artistic community. Gonzalez rents a warehouse for her studio which has high ceilings and four large windows. The building contains other artists' studios as well. Her husband maintains a separate studio several blocks away.

Gonzalez goes to her studio every day to paint: "If I'm painting, I need all my concentration. Sometimes I turn on the radio for background music. I'm tired after painting, and I'm sure I walk miles walking back and forth looking at what I'm doing. There is something exciting and exhilarating in doing this work. I paint in daytime. I don't paint at night; I have an organized

routine. If I go out to lunch, I keep it brief. I need the concentration and the time to think. I need to look. I think ideas for paintings come from everywhere. They come from books, music, or a conversation you may have. At the most, I do thirty paintings a year. Yes, I believe there is a fantastic aspect to my art, especially when dealing with the landscape; there is a kind of unknown element, because that is what we all have inside of us, an inner tension." A shy person, Gonzalez does not interpret her own work for others. "I feel it limits other people's visions as to what the work is like. It limits it to what I might intend. It limits the feedback. It's probably the only area in your life where you do exactly what you want without suffering horrible consequences."

Among her favorite artists are Frieda Khalo, Gauguin, Van Gogh, Manet, and Nolde. Since she moved to the United States, Gonzalez has received professional recognition and has a heavy exhibition schedule. She found that England was more stratified. In the United States, she feels that gallery directors and curators are more willing to look at people's work. While there can be a genuine rejection of work, she has not felt a lack of interest in her work because she is female. In 1984 she won the Grumbach Award and in 1985 the Anne Giles Kimbrough Fund was awarded to her by the Dallas Art Museum.

Gonzalez considers teaching an important part of her life. "I like this very much because I think it's important that I teach in a program that deals with teachers and children. I teach creativity; I teach them how to find out what they can do; to learn how to have confidence. It's done in a roundabout way; you have children ask questions, rather than telling them what to do. This program is not part of the Houston school system, but it works within it. The Houston district likes it so much that they try to build it into their regular curriculum. I think it is very important to impart the visual world to children at an early age."

Gonzalez's paintings are conceptually related to the southern landscape and distinguished by brilliant colors and heavy brush strokes. They are created from memory and abstracted in her imagination. Though aware of the English landscape tradition, Gonzalez does not paint "genre" paintings that can be related in form or content to an existing place. Her paintings are subjective, have an internal life, and project a personal intensity. Sometimes menacing and mysterious themes assert themselves. Her paintings depict the world of dreams, fears, and imagination in which the landscape dwarfs the human figure. Though her flowers are always decorative, they

can also look like carnivores taking over the canvas. Like her fellow artist Therese Oulton, Gonzalez feels that "recognition stops the imagination."

EXHIBITIONS INCLUDE: "Young Contemporaries," Inst. of Contemporary Art, London 1979; "Colombian Artists," Canning House, London 1983; "Texas Only," Laguna Gloria Art Mus., Austin, Tex. 1984; "Houston Contemporary Art in Public spaces," Houston, Tex. 1984; "Texas Artists in Houston Corporate Collections," Houston, Tex. 1984; Graham Gal., Houston, Tex. 1983, '87; "East End Show," Lawndale Alternative, Houston, Tex., 1984; "Texas Paintings: Twelve Artists," Univ. of Texas at El Paso 1985; "Self Images," Midtown Art Cntr., Houston, Tex. 1983, '85; "Masque," Galveston Art Cntr., Tex. 1985; "The New Nude," Midtown Art Cntr., Houston, Tex. 1985; "Synergy," Glassnell School of Art, Houston, Tex. 1986; "Juried Latina Women Exhibition," Guadalupe Art Cntr., San Antonio, Tex. 1986; "Chulas Fronteras," Midtown Art Cntr., Houston, Tex. 1986; "Hispanic Art in the United States: Thirty Contemporary Painters and Sculptors," The Mus. of Fine Arts, Houston, Tex. 1987; "Flowers and Gardens," D. W. Gal., Dallas 1987; "Susan Wynne/Patricia Gonzalez," Univ. of Texas at El Paso 1987; Sette Gal., Scottsdale, Ariz. 1988; Corcoran Gal. of Art, Washington, D.C. 1988; Lowe Art Mus., Miami, Fl. 1988; Mus. of Fine Arts, Santa Fe, N. Mex. 1988; Cntr. Cultural de Arte Contemporaneo, Mexico City 1988; Contemporary Art Mus., Houston 1989.

COLLECTIONS INCLUDE: Newsweek Magazine; AT&T; Enron Corporation, Helen Elizabeth Hill Trust; Rockefeller Foundation; Shell Oil Company; Texas Commerce Bank; Derek Boshier Collection, Tex.; Candice Hughes, N.Y.; James T. Chambers, Jr. Collection; R.L. Kotrozo Collection, Ariz.

ABOUT: Beardsley, J., J. Livingston, O. Paz. "Hispanic Art in the United States: Thirty Contemporary Painters and Sculptors," 1987 (cat.). *Periodicals*—Art in America April 1987; Houston Chronicle May 20, 1986; Houston Home and Gardens August 1984; Houston Post March 30, 1984; Texas Homes November 1986.

GRAVES, NANCY (December 23, 1940–), American sculptor and painter who appeared on the minimalist art scene of the late 1960s with an iconoclastic trio of life-size camel sculptures and quickly established herself as one of the most innovative and productive talents of her generation. Looking equally to ancient cultures, modern science, the natural world, and state-of-the-art technology, she bridges the concerns of the conceptualists and the formalists with an art that is rigorously intellectual in concept yet sensuous in its expression.

A New Englander by birth and disposition, Nancy Stevenson Graves was born in Pittsfield,

NANCY GRAVES

Massachusetts. She is a direct descendant of the Puritan minister Cotton Mather and identifies herself with his tradition: "There's a strong ministerial line in the Graves family," she told the *Archives of American Art*, "which I am very much a part of by my own personality." Graves's father was assistant to the director of the Berkshire Museum in Pittsfield, and she spent her childhood exploring the museum collection, which included both fine arts and natural history artifacts. She also took after-school art classes and by the age of twelve had decided to become an artist.

An ambitious, straight-A student, she attended Vassar College with the intention of majoring in applied arts, but found the program oriented too much to art history and wound up completing her B.A. degree in English literature in 1961. Her teachers nonetheless encouraged her to continue studying art, and after winning a scholarship to the Yale Summer School of Music and Art, she gained admission to Yale's School of Art and Architecture for a combined B.F.A./M.F.A. degree. Among the other students there at that time were Chuck Close, Richard Mangold, Janet Fish, Richard Serra, Brice Marden, and Rackstraw Jones. As part of a distinct minority of women students—the ratio, she recalled, was one to eight, and the one-eighth were not eligible for assistantships—she was given her own studio and pursued her painting studies with Jack Tworkov, Alex Katz, William Bailey, and Neil Welliver.

After graduating from Yale in 1964, Graves went to Paris on a Fulbright-Hays fellowship.

Her paintings then consisted largely of still lifes and fauvist abstractions, and in Paris she applied herself to the study of Matisse and Derain, as well as Brancusi's sculptures and Indian miniatures. In the summer of 1965 she married Richard Serra, and the two of them became part of a circle of American expatriates that included the composer Philip Glass and the painters Joan Mitchell and Joanne Akalaitis. Graves herself was becoming increasingly dissatisfied with the derivativeness of her paintings, and at the same time she was drawn to more recent developments in American art, notably David Smith's organic constructions, Claes Oldenburg's soft sculptures, and Bruce Nauman's assemblages in unusual materials. As a result, when she and Serra moved to Florence in 1966, she decided to take a break from the study of art and look to natural history for inspiration.

It was in the Museum of Natural History in Florence that Graves came upon a collection of meticulously executed casts of animal and human forms made by the eighteenth-century anatomist Clemente Susini. For her, the interest of the casts lay not in their realism but in their surrealism: "bodies of women splayed at the breast, lying on pink satin, with pink bows in their natural hair." Her initial response was to begin making small animals of her own, stuffed or assembled with found objects (all of which apparently wound up in the Arno River), but she then decided to study one particular animal form: the camel. Her seemingly idiosyncratic choice was actually based on a number of logical concerns: the focus on a specific image, she explained, left her "free to investigate the boundaries of art making. By limiting my choice of content, it frees me to explore and invent." As for the camel, its shape, she felt, lent itself to sculpture, while its associations with ancient cultures provided a welcome departure from the usual domains of modern art: "I was trying to open doors to areas not considered for art."

Graves spent three months studying carpentry so that she could build armatures for her camels—table legs and market baskets, which she covered with animal skins. The dozen or so camels that resulted had to be abandoned when she and Serra returned to the United States later in 1966—they were too cumbersome to ship back—but Graves continued her work in New York City with increasing sophistication. A 1968 exhibit of the New York camels at the Graham Gallery attracted the attention of Whitney Museum curators Marcia Tucker and James Monte, and the following year Graves had her own one-woman, three-camel show at the museum's small, first-floor gallery.

At the time, the eight-foot-high creatures (Mongolian, Bactrian, and Kenyan, all of the two-hump variety), thoroughly appealing in their animated poses and facial expressions, were something of a curiosity. Critics generally placed them in the context of pop art, with strong conceptual overtones: "Because they seem to share an identity with objects found outside the museum, . . . " wrote Anita Feldman in *Arts*, "they seem related to the realism of Oldenburg and the naturalism of Segal; or perhaps Graves sculptures camels as Gallo sculptures girls. Their immediacy, however, seems to ally them with the work of artists like Morris or Irwin, in the sense that Graves is using the gallery or museum environment to mark out a border between hallucination and fiction." Graves herself stressed that the camels were not intended to reproduce their living prototypes: "The degree of surface incident articulated in my camels," she explained in the catalog for the Whitney exhibit, "has a different dimension from the camels in the 'real world.' The work refers to itself, making the idea of similar objects being equal or replicas irrelevant to my concern. . . . I cannot imagine or perceive a camel until it is completed."

The thrust of Graves's formal and thematic intentions became clearer in the works that followed, where she literally stripped the camels down to their skeletons (*Miocene Skeleton from Agate Springs, Nebraska*, 1969) or skeletal parts (*Vertebral Column with Skull and Eyes*, 1970) to create assemblages of freestanding and hanging sculptures. In a series of floor pieces, she worked with more fragmented forms, which she called "fossils." One of the earliest of those, *Fossils Incorrectly Located* (January 1970), covered some five hundred square feet with skeletal parts: "It was a departure I made from the camel skeletons," she explained to Emily Wasserman at the time. "After its completion, I realized that it was more complex than any other floor piece. . . . The forms are never reducible to a *singular* whole but can only be perceived in terms of partite groupings. You can absorb the whole but you can't define it in terms of something rational." In *Variability of Similar Forms*, completed two months later, a cluster of thirty-six leg bones (made out of sculpted wax and modeling paste on steel armatures) rises up from the floor, each bone uniquely positioned in its own pose of movement. The piece is simultaneously perceived as artifact/skeleton, ritual object, static configuration, and forms in motion.

According to Graves, one of the influences on her thinking at that time was the work of the nineteenth-century photographer Eadweard Muybridge, whose motion studies bear an obvi-

ous resemblance to the thirty-six moving units of *Variability of Similar Forms*. From Muybridge and the multiple image, film became a logical next step, and Graves soon embarked on a "study project" that yielded an eight-minute silent montage of two hundred black-and-white camel images projected for two and a half seconds each (*200 Stills at 60 Frames*, 1970). She then went to Morocco in the summer of 1970 to shoot two films on location in the Sahara. *Goulimine* (1970), filmed by Robert Fiore and edited by Linda Leeds, focuses on camels in the marketplace—their parts, wholes, images, and sounds, juxtaposed in a tightly edited eight-minute film—while the twenty-minute *Izy Boukir*, shot by David Anderson and edited by Leeds, studies a herd of camels in their individual and collective activities of grazing, drinking, nursing their young, and relieving themselves. Both films found an eager following in independent film circles for what Jonas Mekas was later to characterize as their "classic simplicity, no unnecessary effects, total dependence on subject and respect for the subject."

Following her return from Morocco and a teaching stint in San Francisco, Graves began preparing for an exhibit of paintings, drawings, and films at the Neue Galerie in Aachen, West Germany. In a six-week burst of activity, she created seven new sculptures that invested the formal idiom of the earlier bone and fossil pieces with a more explicit ritual connotation, opening up the art-science continuum to include magic as well. The inspiration once again came from a natural history museum, this time in New York, where she discovered the artifacts of the Pacific Northwest Indians. In the resulting works, such as *Totem* (1970), a hanging sculpture in thirty-eight parts, the anatomical armature of the camels became a ceremonial support for simulated fetishes of twigs, vines, berries, shells, and insects (made out of the same materials as the camel bones—steel, wax, latex, and modeling paste, along with strips of gauze).

In her introduction to the Aachen catalog, Phyllis Tuchman recalled the somewhat misdirected response to Graves's earlier works and suggested that that third cycle of sculptures—which also included pieces such as *Bones, Skin, and Feathers* (1970), *Cast Shadows Reflecting from Four Sides* (1971), *Fifty Hair Bones and Sun Disc* (1971)—"more fully communicates her intentions, and her work now more clearly resides in the domain of art." But Graves herself was shortly to render the debate moot: in the fall of 1971, she abandoned her problematic sculptures to resume painting. With that switch, her aesthetic preoccupations, while by no means separated from her scientific or spiritual con-

cerns, assumed a more conventional form: the two-dimensional easel paintings left no ambiguity about whether she was replicating camels or meditating on them.

Her first paintings, the "Camouflage" series, begun in October 1971, were studies of sea animals rendered in a pointillist idiom that translated the natural phenomenon of camouflage into the painterly one of figure-ground and surface-depth relations. Like her sculptures, those paintings were clearly intended to convey what Lizzie Borden described as "the multiplicity and abundance of possibilities from basic structures," but as Borden noted in *Artforum,* while the sculptures functioned as an environment that could envelop the viewer, the paintings were far more restricted in their impact, and as a result, "their lack of organization and discrimination leads to utter confusion."

The problem of structure and ordering was more successfully resolved in Graves's next series of paintings (1972–73), for which she turned to the science of cartography and various topographical and bathymetric maps of the moon, Mars, and the earth's ocean floor. Here the scale was much larger—at least six by seven feet—and while she continued to work with allover dot patterns, the map, as a two-dimensional rendering of three-dimensional surfaces, offered more coherent elements to be reassembled on the canvas. The result, as seen, for example, in an early "moon painting," *Part of Sabine D Region of the Moon, SW Mare Tranquilitatis* (1972), was a sensuous overlay of line grids, color grids, and dot grids accented with topographical shapes and features. In a later, untitled series based on satellite weather photos (1973–74), Graves began to shape the canvases as well, grouping together slanted panels corresponding to the satellite scanning sequences—fifteen of them in *Untitled no. 1* (1973)—to suggest yet another instance of what she had called *Variability of Similar Forms* in the bone sculptures.

In a much-quoted remark about mapmaking that appeared in the catalog of her 1973 exhibition in La Jolla, Graves cited the wooden maps carved by Eskimo fishermen to represent the Atlantic coast. "These wooden maps have nothing written on them," she explained; "it is simply their shapes that makes them maps. They are practical charts which show the fisherman how many bays he is from home." From that example, she concluded, "A good map has mastered the complexities of nature and idea and resolved them so as to form a necessary—utilitarian—design." Alluding to that definition in order to characterize the artist's own map paintings, Robert Arn observed, "Graves's maps are

good maps, but their utility is not so simple as to merely locate or describe. The use of these maps is to reunify the scattered aspects of vision, to draw together conception and perception, figurative and nonfigurative, word and experience, mind and body in the moving eye."

Once again, such preoccupations with the "moving eye" turned Graves toward film as well. In 1973 she began work on what was to be a three-part, three-color study of birds in flight. In fact, it took her and her cameraman, Herman Kitchen, two years to track down and record their soaring black frigate birds and flapping pink flamingos (the white egret had to be abandoned), but in the end, the stark footage, shot almost entirely against the open sky, was edited into a twenty-three minute study of what Graves called "the disparate motion of overlapping forms in flight." In 1974 she did another montage, collaborating with her editor, Linda Leeds, to assemble some two hundred black-and-white photographs of the moon, generated by NASA's Lunar Orbiter, into the thirty-three minute *Reflections on the Moon.*

Writing about those and Graves's earlier films in 1975, Lucy Lippard stressed their links to her other work, not the least of which was her commitment to preparatory research: unlike most artists, Lippard wrote, Graves "does not skim the surface of another field to skim the visual cream, but demands of herself a fundamental understanding before she begins to interpret aesthetically." Characterizing Graves's cinematic style as "one of deceptive simplicity underlaid by acute attention to detail and variety," Lippard explained that the films are "neither narrative nor documentary, neither openly didactic nor overtly ingratiating. Like her paintings, they are fundamentally abstract even though the images are 'representational.' Their real impact comes not from the initial image—camel, bird, or moonscape—but from the unfolding in time of explorations of color, light, form, surface."

By the mid-1970s, Graves's paintings had in fact become increasingly abstract, and as if to signal the futility of seeking external referents, her titles were reduced to single words, some of them erudite Greek or Latin prefixes, others seemingly culled from another language, if not another world. The canvases of the 1976 "Lo" series, for example—with titles like *Duir, Lemoin,* and *Strateo*—offered an accumulation of multicolored smudges and scribbles in a consistently delicate and/or tentative style that was not particularly compelling. In subsequent works—oils and watercolors from 1977–78—the paint became denser, the colors more intense, the echo of abstract expressionism more insistent. While

some critics welcomed the new "personal and whimsical" quality of those works, others were again bothered by the lack of structure—in the words of the *SoHo Weekly News,* "an orchestra badly in need of a conductor."

Graves herself had apparently sensed the need for new directions; in 1976, after a five-year hiatus, she started doing sculpture again. The initial impetus came from a commission from the Ludwig Collection in Aachen to create a permanent version of one of her early fossil pieces, which became *Ceridwen, Out of Fossils* (1969–77), a sixteen-foot-square floor piece cast in bronze. The new project, as usual, spurred Graves to undertake intensive research; working with the Tallix Foundry in Peekskill, New York, she began to explore the possibilities of lost-wax casting, and by 1978 she was starting to make new sculptures in bronze. Unlike the Ludwig commission, those works were not intended to replicate impermanent originals, but instead drew on the earlier vocabulary of form and theme for new and more imposing ends. In that way, *Graph* (1970), for example, a hanging wall piece, yielded *Evolutionary Graph II* (1978), a polychrome floor piece, while *Variability and Repetition* (1971) gave rise to at least two bronze variations of its own, the fairly abstract *Seven Legs* (1978) and *Column* (1979), a single, six-foot leg bone rising from a small base.

Significantly, Graves's move into bronze casting—unlike most of her other initiatives to date—was not an isolated phenomenon but part of a growing trend among the sculptors of her generation. One of the first to start casting (albeit in lead rather than bronze) was Richard Serra, whose first thrown lead casts date from 1968. Serra, like Bill Bollinger and Joel Shapiro, turned to what was then considered a classical technique in the context of process art; Graves's concerns, at the outset, at least, were quite different—Wade Saunders, who described her early bronze pieces as "reissues," noted that they were essentially conservative in nature and "brittle" in appearance. But she, along with Bryan Hunt, Isaac Witkin, Michael Steiner, Lynda Benglis, Marjorie Strider, and others, were soon to exploit the properties of the material and the technique in ways not unrelated to process art, and, at the same time, in ways that reflected their new status as artists aspiring to permanence and—as Saunders points out, alluding to the cost involved—able to afford it.

In Graves's case, the interplay between two and three dimensions was to provide a major formal orientation, one that was all the more challenging in view of the physical properties of bronze, a medium traditionally associated with great mass and volume. In 1979 she undertook a series of cast and welded sculptures based on drawings she had made from archaeological reports—site maps, charts, renderings of artifacts. The problem she was trying to address, she told Richard Polich, was "the question of the third dimension and how to realize it without having seen it." In fact, the individual elements of each piece corresponded to specific drawings, but in the transformation to sculptural form, they were abstracted and reassembled in new relations of space and scale. *Archaeoloci,* for example, is based on drawings from a Mediterranean site, but the resulting construction presents itself solely in terms of its dynamic visual forms: swirling blue ribbons (the sea) and an ochre chain (a breakwater) rising up from a black and red-orange base (inscribed with the site map).

By 1979 she had stopped using preparatory drawings altogether and was working with the crew at the foundry to develop new patinas to color the sculpture more brightly. But the crucial turning point in her evolution came when she began experimenting with direct casting. In that technique, the form to be cast is directly encased in a ceramic mold and burns away during the firing. For Graves, the elimination of the wax model opened the way to a whole new repertory of found-object forms—from exotic plants and sea animals to household objects and industrial debris—for her welded constructions.

While obviously influenced by Picasso's found-object sculptures, along with the open-form constructions of Julio Gonzalez and David Smith, Graves has nonetheless broken new ground in her use of techniques and materials as well as the resulting formal and aesthetic sensibility. "There are two things going on as [I continue] to work on the new pieces," Graves explained to Polich. "The choice of materials and surfaces and processes of forms expand, and at the same time, the end image is less clear at the outset. As I increase the complexity of sculptural parts, the solution becomes more open." Implicit in the direct casting process is the uniqueness of each cast object, since the original is destroyed in the firing. That artistic risk-taking—reinforced by Graves's intuitive approach to the assembling of the pieces—translates, via contrasting forms and fine surface detail, into a forceful immediacy that completely transcends the physical medium. In a fairly simple piece like *Kylix* (1982), for example, three vegetal forms—a frond, a stem, and a leafy stalk—undulate horizontally to create a vibrant design in two and three dimensions. In a more complex work like *Cantilever* (1983), a base of soundproofing and raffia fans supports a gyrating assemblage of ferns, palm leaves, and lotuses

topped with a free-form bronze "drawing" made with a high-speed drill in a sand mold. Elizabeth Frank commented, "Here is a world where the laws of gravity no longer hold, where gorgeous chromatic forms branch out, float, and spiral into the seemingly weightless posture of dance-like motion."

Graves herself has described those sculptures as "3-D Pollocks," an analogy that holds both formally—in terms of the dynamic images she produces—and in the way that she polychromes the bronze by dripping and spattering paint and patinas. Throughout the 1980s Graves also translated her sculptural forms back into two-dimensional abstractions, and in her 1984 "shadow series" she attempted to fuse the two forms by working aluminum sculptures into painted canvases. "I want it all," she told Frank in 1986. "My work is about permutation on all levels, in terms of process, structure, content, and technique." That freewheeling approach has gained Graves an enthusiastic following among collectors: her large sculptures were selling for upward of $75,000 in 1986. Critics have usually been favorable—less so for her paintings—although some see her slipping into decorative repetitiveness. But according to E. A. Carmean, who organized a major retrospective of her sculpture at the Fort Worth Museum in 1987, "She is one of the most creative people working today."

According to her friends, she is also one of the most energetic: "Nancy Graves is a verb!" quipped choreographer Trisha Brown. "She's as fast as a whip and she's got ten balls in the air at any given time." A tall, elegant woman who never looks like a welder in photographs taken at the foundry, she lives in a SoHo loft with a cat and a hoard of cactus plants (she and Serra were divorced in 1970). Two or three times a week she goes to Peekskill to work at the foundry; she makes frequent trips to Europe and in recent years has also visited China and Australia. While clearly one of the most admired artists of her generation, she has a reputation for being extremely conscientious and considerate of others. "She had to be ambitious to accomplish as much as she has," explained another friend, choreographer-filmmaker Yvonne Rainer, "but she is one of the most genuinely altruistic people I've ever known in the art world."

EXHIBITIONS INCLUDE: Berkshire Mus., Pittsfield 1964, '73, '86; Graham Gal., NYC 1968; Whitney Mus. of American Art, NYC 1969; National Gal., Ottawa 1970, '71, '73; Neue Gal. Alten Kurhaus, Aachen, West Germany 1971; Gal. Reese Palley, NYC and San Francisco 1971; Vassar Col., Poughkeepsie 1971, '86; Wallraf-Richartz Mus., Cologne 1971 (films); Univ. Art Mus.,

Berkeley 1971 (films); Walker Art Cntr., Minneapolis 1971 (films); Yale Univ., New Haven 1971 (films); Pratt Inst., Brooklyn 1971 (films); MOMA, NYC 1971–72; New Gal., Cleveland 1972; Janie C. Lee Gal., Dallas from 1972; Inst. of Contemporary Art, Philadelphia 1971 (films); Contemporary Arts Cntr., Cincinnati 1972 (films); Whitney Mus. of American Art, NYC 1972 (films); La Jolla Mus. of Art 1973; Art Mus. of South Texas, Corpus Christi 1973; André Emmerich Gal., NYC 1974, '77; Albright-Knox Art Gal., Buffalo 1974 (drawings); Getler-Paul Gal., NYC 1977 (prints); Gal. Im Schloss, Munich 1977–78; Hammarskjold Plaza Sculpture Garden, NYC 1978; Gal. Diane Gilson, Seattle 1978; M. Knoedler & Co., NYC from 1978; Barbara Toll Fine Arts, NYC 1983; Richard Gray Gal., Chicago 1986; Vassar Col., Poughkeepsie 1986; Fort Worth Art Mus. 1987. GROUP EXHIBITIONS INCLUDE: "Program 3," Gal., Ricke, Cologne 1970; "Information," MOMA, NYC 1970 (films); Whitney Annual for Sculpture 1970–71; National Film Theatre Festival of Independent Avant-Garde Films, London 1970–71; "Depth and Presence," Corcoran Gal. of Art, Washington, D.C. 1971; "Prospect 71 Projection," Stadischen Kunsthaus, Düsseldorf, West Germany 1971; "Six Sculptors," Mus. of Contemporary Art, Chicago 1971; Whitney Annual for Painting, 1972; "American Women Artists," Kunsthaus, Hamburg, West Germany 1972; "Eight New York Painters," Univ. Art Mus., Berkeley 1972; Documenta 5, Kassel, West Germany 1972; Women's Film Festival, NYC 1972; Whitney Sculpture Biennial 1973; "3-D into 2-D: Drawing for Sculpture," New York Cultural Cntr. 1973; "Photo-Realism," Serpentine Gal., London 1973; Festival du Court-Metrage, Grenoble 1973 (films); Smithsonian Inst., Washington, D.C. 1973 (films); Festival of Women's Films, Boston 1973; British Film Inst. Festival of Independent Avant-Garde Films 1973; International Film Festival, Cologne, West Germany 1973; Women's Film Festival, Washington, D.C. 1973; "Art Now '74," John F. Kennedy Cntr., Washington, D.C. 1974; "Kunst der Sechziger Jahre," "Project 74," Wallraf-Richartz Mus., Cologne, West Germany 1974; "A Response to the Environment," Univ. Art Gal., Rutgers, New Brunswick 1975; "Primitive Presence in the '70s," Vassar Col. Art Gal., Poughkeepsie 1975; "200 Years of American Sculpture," Whitney Mus., NYC 1976; "America 1976," Corcoran Gal. of Art, Washington, D.C. 1976; "Amerikanische Kunst von 1945 bis heute," Nationalgal., Berlin 1976; "The Liberation: 14 American Artists," U.S. Information Agency, Washington, D.C. 1976; "Artists' Maps," Philadelphia Col. of Art 1977; "Art around 1970," Kunstlerhaus, Vienna 1977; Documenta 6, Kassel 1977; "The Ludwig Collection," Tehran Mus. of Contemporary Art, Tehran 1978; "American Painting: The 80s," Grey Art Gal. and Study Cntr., NYC 1979; "Weich und Plastich," Kunsthaus, Zurich 1979–80; "Masks, Tent, Vessels, and Talismans," Inst. of Contemporary Art, Philadelphia 1979–80; "Perceiving Modern Sculpture: Selections for the Sighted and Nonsighted," Grey Art Gal. and Study Cntr., NYC 1980; "Six in Bronze," Brooklyn Mus., NYC 1984; "Primitivism in Twentieth-Century Art," MOMA, NYC 1984–85.

COLLECTIONS INCLUDE: Ludwig Collection, Aachen; Neue

Gal., Aachen; Whitney Mus. of American Art, MOMA, Metropolitan Mus. of Art, NYC; Wallraf-Richartz Mus., Cologne; Chicago Art Inst.; Mus. of Fine Arts, Houston; Univ. Art Mus., Berkeley; Albright-Knox Art Gal., Buffalo; Art Mus. of Southern Texas, Corpus Christi; Des Moines Art Cntr.; La Jolla Mus. of Contemporary Art; Brooks Memorial Art Gal., Memphis; Yale Univ. Art Gal.; Vassar Col. Art Gal.; Mus. des 20. Jahrhunderts, Vienna.

ABOUT: Cathcart, L. "Nancy Graves: A Retrospective 1969–1980" (cat.), Albright-Knox Art Gal., Buffalo, 1980; Collins, J. L. Women Artists in America, 1975; Emanuel, M., et al. Contemporary Artists, 1983; Lippard, L. From the Center: Feminist Essays on Women's Art, 1976; Lucie-Smith, E. New in the '70s, 1980. "Nancy Graves: Sculpture, Drawings, Films 1969–1971" (cat.), Neue Galerie im Alten Kurhaus, Aachen, 1971; Who's Who in American Art, 1989–90; *Periodicals*—Artforum October 1970, Summer 1978, March 1983, March 1985; Art in America November 1975, May 1980, Summer 1980, March 1983; Art International November 1974; ARTnews September 1980, January 1983, March 1985, February 1986; Artscanada Spring 1974; Arts Magazine April 1972, October 1975, March 1977, April 1977, May 1978, September 1983, November 1984; Connoisseur February 1986; New Art Examiner December 1986.

HARING, KEITH (May 4, 1958–February 16, 1990), American painter and sculptor. Beginning in the late 1970s, denizens of the Upper East Side and other swank Manhattan addresses found themselves drawn to an area that had previously existed only as a nebulous stretch of old warehouses that separated them from their jobs on Wall Street. Downtown—the area of Manhattan from 14th Street to the island's southern tip—suddenly became the place to go. The aging warehouses, still musty with the smell of the accumulated sweat of the generations of immigrants who had lived and worked there since the turn of the century, were being converted into lofts. Rents were low, at least by Manhattan's surreal standards, and a few successful police operations that drove the pushers from some of the neighborhoods' public spaces contributed to reassurance that the streets could be navigated with minimal risk.

At the heart of the real-estate renaissance was the downtown art scene, which formed the core of the area's still-burgeoning night life. Galleries, performance-art spaces, and nightclubs sprang up first in SoHo, in the late 1960s and early 1970s, and about a decade later in the East Village (the heart of which, Avenues A through D, had been the home of the heroin "shooting galleries") in rapid-fire profusion. The artists whose work filled those galleries— young iconoclasts whose loud, colorful work adorned outside

KEITH HARING

walls and playgrounds as well as gallery and club interiors—included such figures as Julian Schnabel, Francesco Clemente, Kenny Scharf, and Keith Haring, who was perhaps the most daring of the group. Haring and his cohorts became stars on a monumental scale in New York, and though critics may debate the merit of their work, none can deny its impact on the art world.

Keith Haring was born in Kutztown, Pennsylvania on May 4, 1958. His father, an electric plant foreman, encouraged him from an early age to create his own cartoon characters and drawings, and as he grew into adolescence he became more and more obsessed with the art world, voraciously reading biographies and critiques of the artists whom he most admired. His other preoccupation as a youth was with television, especially the animated shows of the 1960s such as *The Flintstones* and *The Jetsons* and situation comedies of the same period like *My Favorite Martian* and *I Dream of Jeannie* ("what television should be," he said of the latter in a New York *Talk* interview). Indeed, as Haring named his influences, he just as readily included those television shows as he did the artists who provided him with a basis for his own work.

After his graduation from high school in Kutztown, Haring moved to Pittsburgh, where he worked and studied art. Though formal training did not appeal to him, it was in Pittsburgh that he first came into contact with some of the artists he had respected, such as Christo, who gave a lecture Haring attended in connection with the showing of his film *Running Fence*. Indeed, that film deeply influenced Haring, because, he re-

called, it represented a kind of art that was "open to everybody, not something that was exclusive." Despite such encounters, he did not find Pittsburgh especially stimulating, and he left after only six months and moved to New York City in 1978. He enrolled in classes at the School of Visual Arts, which through the school (and as often on his own) he came into contact with the work of artists who would have a profound influence on his own work—Jean Dubuffet, Pierre Alechinsky, Joseph Beuys, Vito Acconci, and Andy Warhol. While there, he began to refine his strong interest in the so-called primitive African and Aztec art that some critics have suggested his own art most closely resembles.

Still ambivalent about formal training, Haring considered much of his course work anathema, and he began to work on his own. His first works to be "displayed" in New York lacked the sanction not only of his instructors, but of the law as well—he became a graffiti artist, drawing chalk figures against the black background of unused advertisement spaces at subway stations. His faceless, sexless figures, surrounded by kinetic lines that suggested a frantic, enervated movement, seemed somehow appropiate for the subway. Moreover, Haring's hit-and-run subway art foreshadowed what he would bring to his later canvases and projects, creating an art form of spontaneity (he never worked from sketches or preformulated ideas, and he worked quickly, owing in part to the fact that he had to avoid transit police) that was truly second-generation pop, art that was open to everyone. Indeed, Haring was the New York art world's most successful populist, even more authentically so than his friend, Andy Warhol.

Those two themes—art as immediate response and art as populism—are as central to his work as anything. In an article for the March 1984 issue of *Flash Art*, Haring wrote, "One of the things I have been most interested in is the role of chance in situations. . . . Whatever marks I make are immediately recorded and immediately on view." Tied into that is his notion that his art's primary function is to reach as many people as possible, not just those who attend gallery openings and can afford to adorn their living-room walls with canvases priced in the five-figure range. Haring's work appears not only in public spaces, but on T-shirts, refrigerator magnets, watches, and radios—his acumen for marketing himself outstripped any other contemporary artist, save for Warhol, thereby reaching an audience that extends far beyond the traditionally insular art audience. It was, Haring explained, a natural extension of "what he had been doing in the subway, doing things

in public, doing things to break down this supposed barrier between low art and high art."

If it was his subway art that first gained him an audience, then that audience was certainly enlarged by his participation in the club scene. Starting in such East Village clubs and performance spaces as the Mudd Club, Club 57, the Limbo Lounge, and the Pyramid Club, Haring and other downtown artists created decors by painting the interiors of those venues. A lively amalgam of art, music, and live performance, the clubs attracted (and still attract) throngs of brightly attired glitterati and hangers-on for whom the art was the raison d'être of clubs. The club scene expanded through the early 1980s and culminated with the opening of such spots as the Palladium and Area. The Palladium, especially, trumpeted the arrival of artists as popular celebrities on the level of rock stars; for the club's May 1985 opening, owners Steve Rubell and Ian Schrager signed on Henry Geldzahler, a former curator of twentieth-century art for the Metropolitan Museum of Art in New York City, who commissioned Haring, Jean-Michel Basquiat, and others to adorn the walls with their huge Day-Glo and raw, street-art canvases. The habitues were not the only ones impressed by the work. Calvin Tomkins wrote in the *New Yorker* that "the truth is that in this environment the art looks sensationally good," and he noted that Haring "seem[ed] to have risen to a new level."

Haring's "level" was counterpoised on several tightropes—between high and low art, between the transitory and the enduring, between a specific and disciplined aesthetic viewpoint and an all-encompassing (verging on commercial) expression. His best-known and most imitated works, such as the *Radiant Child* and the *Barking Dog*, are Dubuffet-like abstractions done in a rather spare, dimensionless style, surrounding his thick black-outlined figures with bright blues, yellows, and reds. The colors create a cheerful, cartoonlike mood, while the subject matter (is the Radiant Child a victim of some nuclear meltdown, or of some chemical sickness he/she inherited from the mother?) presents a disturbing anomaly.

In other works, every inch of the canvas is utilized, as if, as Nena Dimitrijevic pointed out in a review of his show at the Robert Fraser Gallery in London for the January 1984 issue of *Flash Art*, Haring harbors a "fear of leaving space empty, because if you do so an evil spirit can hide in it." In those works, human identity is suffocated by an overbearing crush of technology, as legs, arms and heads seem to be trying to crawl their way out from under a pile of spare machine parts and other, less identifiable rubble.

That fear of technology is more overt in some pieces, such as in an untitled work from 1984, in which an R2-D2-type robot holds yet another faceless figure upside down, shaking it like one shakes a bottle of orange juice. Haring's preoccupation with the consequences of technology, with the subsumation of personality and identity in an ever more highly mechanized, computerized, and homogenized society, manifests itself regularly in his work, and he made his feelings on the point clear in his *Flash Art* article: "I think the contemporary artist has a responsibility to humanity to continue celebrating humanity and opposing the dehumanization of our culture. This doesn't mean that technology shouldn't be utilized by the artist, only that it should be at the service of humanity and not vice-versa."

The result of Haring's artistic worldview—his disdain for the distinction between high and low art, his belief that his function as an artist is to reach as wide an audience was possible—was in many ways an extension of the mass culture he grew up embracing and, to which he eventually aspired. As a teenager, he grew his hair long, experimented with LSD, and attended Grateful Dead concerts. His admiration for Warhol was a natural outgrowth of his affection for Warhol's work and for the whole 1960s movement that tied in art, music, and fashion in a way that Haring and others had hoped to recreate in the 1980s. One effect of that attachment is that some aspects of Haring's work take on the tenor of a sort of generational in-joke: it is as if to understand Haring's work, one must also understand not only Warhol, but rock 'n' roll, pop fashions, and rap music. From that perspective, Dubuffet seems less compelling a point of reference than the musical group Talking Heads.

Yet Haring himself refrained from making judgments about his work or insisting that something—anything—is in there. He summed up his attitude pithily in his *Flash Art* article. He wrote that often, when he was doing a subway drawing, an observer would watch until he had finished, "and then, quickly, as I attempt to walk away, [he] will shout out, 'But what does it mean?' I usually answer: 'That's your part, I only do the drawings.'" Haring seemed to avoid at all costs having any strict definitions placed upon his work, and he did not believe that any interpretation was necessarily more valid than any other. The obvious connections to pop art did not, to Haring, limit the breadth of levels in which the work can be seen. As he said in the New York *Talk* interview, "I met a professor from Yale who had this whole interpretation of my work from the viewpoint of African art, how dance is so much a part of it on a whole anthropological level. So people can still intellectualize my work however much they want."

Haring compared his style of gestural line drawing to Japanese calligraphy. His drawings, he said, had a "logical beginning and end. . . . I never go back and change things. It's a record of that moment, which becomes what my work is about. . . . " Although critics were generous in their praise of Haring, some of his fellow graffitists were regarded as overblown products of the "great art hype" of the 1980s. Robert Hughes, the art critic for *Time* magazine and a former artist, was scathing in his evaluation of the downtown art scene. "What finds favor here," he wrote of the East Village, "is young, loud, and, except in terms of careerism, invincibly dumb." Downtown's simultaneous embrace of art, pop, hip-hop and, to Hughes, just plain slop has created a milieu in which the artist's palette is inexorably linked to the gold cards of his customers, and it is the nature of Manhattan these days that where artists choose to live and work, realtors are never far behind. SoHo, where the downtown scene started in the late 1960s, has become largely an enclave of the monied classes, and the same thing later happened in the East Village. The "hype and careerism," of which Hughes accuses the downtown artists, put the art, to some critics, in the same category as the $200 jeans and the $1.50 bottles of soda one now finds downtown: so many disposable artifacts of a puffed-up junk culture.

But in Haring's defense, he could hardly have been accused of class elitism, and it is almost fair to say that his financial success (his large canvases sold for $50,000 or more) came in spite of his attitude. He continued to paint the subways for a couple of years after he could have shown the same work in a gallery and collected quite a tariff for it, and he painted teenagers' skateboards for free. "It's great," he said, "when a kid gets something from me for free and sells it in the Village to some tourist from Europe, and the kid ends up with some pocket money." He was very involved with children and teenagers, often lending his talents to work for causes on behalf of the city's school-children, such as campaigns to raise money for hospitals and drug-abuse education.

One of his latest public wall-painting sprees promoted the idea that "Crack is Wack." The downside of accessibility with which Haring was concerned was not that wealth would affect him, but his fear that his work would not last—that Hughes was right. "The danger of making art that is so accessible is that it could get watered down or something," he admitted. "I don't just want to be a piece of pop nostalgia. That's my one fear, operating in both worlds. It's something you have to guard against all the time." The critic Donald Kuspit touched on that dilem-

ma in his review of Haring's show at the Tony Shafrazi Gallery (Shafrazi was Haring's sponsor from the beginning) in the February 1986 *Artforum*, in which he wrote that "in order to reach the broadest audience, one's style must tend toward lowest-common-denominator configurations, at once instantly recognizable and comprehensible." The starkness and ready comprehensibility of such works as *Portrait of Macho Camacho,* in which the prizefighter fends off a two-headed snake that protrudes from one of his own legs, and his South African anti-apartheid pieces, in which a large black figure stomps on the head of a small, pitiful white one, veers toward such pop sentimentality. In the final analysis, though, Haring (and Kuspit) comes down on the side of populism.

Perhaps the ultimate expression of that attitude was Haring's "street" boutique, the Pop Shop, which sold such Haring accoutrements as shirts, decals, magnets, and Radiant Child inflatable dolls. Haring was delighted that street kids—teenagers who were into skateboards and breakdancing—made the shop a kind of headquarters for themselves. Seeming to revel in the fact that the very notion of selling art like one sells New York Mets memorabilia was offensive to some aesthetes, Haring insisted on making his art accessible to a mass audience without pandering to anyone. He was in the vanguard of a movement that took art out of its cloistered habitat and into a real, contemporary world that has as much to do with the pulse of the street as it does the niceties of uptown gallery openings.

Keith Haring died of AIDS-related complications. He spoke openly of his illness in interviews, and he seemed to work even harder as the end grew near even though he had always maintained a factory-like standard of productivity. Haring's death brought forth an outpouring of bereavement across New York City. In his one decade of fame, he had become one of Gotham's most celebrated and beloved public figures.

EXHIBITIONS INCLUDE: Club 57, NYC 1979, '80; Tony Shafrazi Gal., NYC since 1983; Leo Castelli Gal., NYC since 1984; Larry Gagosian Gal., Los Angeles since 1984; Salvatore Ala, Milan 1984; Alexander Roussos Gal., London 1987; Daniel Templon, Paris 1987; Queens Mus., NYC 1990.

ABOUT: Current Biography, 1986. *Periodicals*— Artforum February 1986, May 1990; ARTnews February 1985; Arts Magazine September 1985, September 1990; Cimaise January/March 1990; Drawing May/June 1989; Flash Art January 1984, March 1984, May/June 1986, Summer 1990; New York Talk June 1986; Rolling Stone August 10, 1989; Time June 17, 1985.

HEIZER, MICHAEL (1944–), American site artist, sculptor, and painter, is now the leading figure of that group of American artists attempting to resurrect the age-old tradition of earth art. His major works, and the related efforts of Walter de Maria, Nancy Holt, and the late Robert Smithson, among others, are not merely huge, they are intrinsically of and about the land (and thus, so the artists claimed, not of and about the "art world," although that has not proved to be true). Heizer takes his inspiration from the oldest human structures—Egyptian necropoli, the ruined cities of pre-Columbian America, and the neolithic stone works of Europe—and more anciently still, from the vast silence of the desert. The earthworks movement, which he was instrumental in launching, can be viewed as the ultimate extension of the trend toward gigantism of 1950s and 1960s American art, but Heizer portrays himself as an art outsider, with no connections to any recent aesthetic. Rather, the lean, reticent Westerner is contemptuous of perishable "city" art and now engineers his gigantic concrete and earth structures, displaced, buried boulders, and mammoth drawings on the land to survive the apocalypse.

Born in Berkeley, California, Heizer as a teenager explored Egypt and the Yucatán with his father, the anthropologist Robert Heizer, an expert in ancient architecture and technology. The elder Heizer explained to him how the builders of Stonehenge moved huge blocks without the wheel and how the Maya dressed stone without steel. Judging from the artist's work, which abounds in quotes from pre-Columbian, Mesopotamian, and Egyptian sources, Heizer listened carefully. Around that time he must have conceived the ambition to recreate, with modern technology and in a modern idiom, geometric structures and excavations like those he had seen: massive, desolate, and empty, integrated through eons into the landscape and into human history as well.

Heizer's formal education, by contrast, left him disaffected. He began drawing early on, and when he was fourteen he spent a year on his own in Paris looking at art. Later, Heizer dismissed the entire European tradition, claiming that it was "finished" as an important source of ideas. His two years at the San Francisco Art Institute were unhappy ones. "I didn't go for it," he recalled in a 1977 interview with John Gruen for *ARTnews*. "I didn't like the school idea—the programs, the courses, the studies. . . . Finally, I got fed up with San Francisco. There just wasn't any art to look at. No one worked . . . and there was no art. So, I came to New York." At that time Heizer was painting, but not selling anything and living in poverty; he did construction work and painted tenements to survive.

MICHAEL HEIZER

The artist has destroyed many of his early paintings, which were large, geometric, and subdued in color, and the elements have filled or worn away his early site pieces, which were executed during several trips to Nevada in 1967–68. The first, unfinished, was *N/NESW* (1967, 122 x 122 x 122 cm), one of four proposed plywood boxes sunk into the soil of the Sierra Nevadas outside Reno. Two of Heizer's basic ideas appear in that initial work: his concern with volume, mass, and space as pure physical properties—*N/NESW* is not about the box but about the mass of land it displaces and about the shape of the space the land's removal creates—and his use of the land itself as an art medium that is universal and of the natural order. By contrast, according to Heizer, traditional art objects are unnatural, ego-infected, and perhaps unfit to survive. In his words, "The intrusive, opaque object refers to itself. It has little exterior reference. It is rigid and blocks space. It is a target. An incorporative work is aerated, part of the material of its place, and refers beyond itself."

Max's Kansas City, a trendy, quasi-underground Manhattan nightclub, was the meeting place for the nascent earthworks movement. There Heizer met Smithson, Holt, and Carl Andre in 1968. Earlier that year Heizer, well versed in the acquisition of government land leases in the western states, had helped Walter de Maria find land in the Mojave Desert for the first earthwork. That summer Smithson and Holt helped Heizer dig *Isolated Mass/Circumflex* (1968, Vya, Nevada, 36 x 3 x 3 m), the last of his "Nine Nevada Depressions,"

which included *Windows* and *Dissipate* (both 1968). Robert C. Scull, who commissioned the "Depressions," was fascinated by the early earthworks activities and was the first collector to give Heizer substantial monetary support. *Displaced/Replaced Mass* (1969, Silver Springs, Nevada), another of Scull's commissions, involved the depositing of multiton granite blocks into specially lined depressions. The three granite boulders, weighing fifty-two, sixty-eight, and eighty tons, were cut high in the Sierra Nevadas and carried by double-goose Lo-Boy transport to a valley more than fifty miles away. Heizer tersely described the climactic moment in the installation of the first of the pieces: "The transports were unloaded on the dry lake at night. We worked by headlight. The fifty-two ton mass was laid on the edge of the hole with one-half of the rock overhanging the space. The crane then jerked it and it toppled into the excavation. There was no way to see the piece until morning."

Double Negative (1969–70, Virgin River Mesa, Nevada, 457 x 15 x 9 m) was the piece that brought Heizer to the attention of the art world. Using massive earth-moving equipment, Heizer and a crew of hired workers cut two unequal channels—two negative signs, two slashes of negative space—on a north-south axis along the edge of the rhyolite and sandstone mesa. Two hundred forty thousand tons of rubble and rock were displaced. Lawrence Alloway visited the site in 1976: "From the valley where the Virgin River creates a skinny belt of green in the desert, Heizer's *Double Negative* is hard to see; from this angle the main feature is the fanning out of the rock spill where the excavated earth from the two cuts was pushed down the cliff. On the mesa, however, the scale is impressive, big but not enormous, pitched with a sense that is very different from the portentous look photographers often give it. . . . The mesa, though high, is flat. The edge is not visible from far away as a rule: just sudden plunges. *Double Negative,* cut into the edge of the mesa, is one of the few mediating forms between the top and the drop. Each cut is fifty feet deep and thirty feet wide, sloping down at the inner end, originally for the earth-moving equipment and now providing slippery access. Right up to its abrupt edge the mesa is a desolate place. Wind continually hisses through the low scrub, sometimes rising to a moan. Otherwise it is silent." Not all critics were affected positively; Joseph Masheck, for one, after seeing documentation of the piece at the Dawn Gallery in 1970, wrote in *Artforum* that "it proceeds by marring the very land, which is what we have just learned to stop doing."

The scale of that work was sufficiently auda-

cious to ensure Heizer's prominent place in the small pantheon of earth artists. But it is mute abstract, not emotionally engaging. By comparison, Heizer's next major work, *Complex One/City* (1972–76, 7 x 33.5 x 43 m) is unmistakably a human artifact. A huge bunker of concrete, compressed earth, and steel, *Complex One/City* stands alone on a high plateau north of Alamo in central eastern Nevada. The work vividly calls to mind Egyptian mastabas, Mayan playing fields, the pyramidal temples of Teotihuacán, and North American Indian burial mounds, but it is also modern. A minimalist arrangement of steel beams running along the top and out in front of the mound give the illusion of framing it when viewed from a distance directly in front—the direction one would take in approaching a ceremonial site. In fact, Zdenek Felix has likened *Complex One/City* to "a deserted, secretive site for cult worship." That impression is likely to be reinforced if and when he finishes the work, which is to include other structures arranged around a sunken plaza. Several writers have speculated on what manner of "worship" Heizer intends in his ceremonial city, whose construction was not animated by any conventional religious feeling. Clearly, it is an act of homage to huge physical effort in defiance of emptiness. "When the final blast comes," Herzer says, "a worklike *Complex One* will be your artifact. It's going to be yourself, because it's designed to last."

Complex One absorbed the bulk of Heizer's efforts through the mid 1970s. His recent works, most still in the planning stage, have been on an even larger scale—perhaps meant to be seen from space—or have been designed to fit comfortably into an urban setting. As the artist's site works get ever-larger, corporations have been replacing private individuals as his patrons. *Effigy Tumuli* (Ottawa, Ill.; proposed) is intended to be part of a coal mine reclamation project: coal slag and rubble are to be compacted into abstract animal shapes up to 1,000 feet long and twenty-five feet high. Another proposed reclamation is a mile-long postindustrial necropolis, complete with pyramids, of mining debris donated by Anaconda Minerals. A much smaller piece, but probably on the most expensive real estate Heizer had used, is *Levitated Mass* (1983), a fountain for the IBM building in midtown Manhattan and one of the few Heizer site works that the casual observer can see in its actuality, and not only in photographs.

In contrast to the earthworks, Heizer's paintings, prints, and gallery-sized sculptures are concerned with conventional art problems—the handsome or intriguing arrangement of colors, shapes, and masses—and give the impression of having been created to finance the artist's more important efforts. Not that they are blatantly commercial, or even that they lack interest in their own right. His "Circle" series (1977–78) of sculptures is obviously a further working out of the idea behind *Circular Surface Planar Displacement* (1971), a pattern of circles Heizer etched into the surface of a dry lake by riding a motorcycle. Many of his paintings are diptychs or triptychs, usually of latex paint of powdered pigment rolled on canvas; they incorporate simple geometrics and ovals (as in *Cycladic Ovals 1 and 2*, 1979, 244 x 366 cm). By any other artist, those works would constitute a respectable oeuvre. But from Heizer, they are secondary efforts and lack impact. As Grace Glueck noted in the *New York Times* in 1985, "scale is his métier."

Heizer's show at the Whitney in 1985 marked a further effort by the artist to bring at least some elements of his earthworks within physical reach of a larger audience. *Dragged Mass Geometric* (1985), the single work on view, occupied almost the entire top-floor gallery. It was a recasting in temporary materials of the "process" of an earlier work, *Dragged Mass* (1971, destroyed). The huge granite block and high dirt moraines of *Dragged Mass* were transformed at the Whitney into levitated angular shapes of silkscreened cardboard skinned over a complex framework of aluminum studs held together by tens of thousands of screw fasteners. Viewers could climb up onto the work to get an overview of the "block," "mound of dirt," and the "hole" in which the block was toppled. Around the corner from the museum, Heizer's dealer, Xavier Fourcade, showed the artist's recent paintings and small sculptures.

Heizer is an intensely private man. Almost no details of his personal life are known to the public. Tall and slim, with the weathered skin of the desert dweller (he spend much of his time in a cabin in Nevada), the artist is slow and quiet in speech. He is quick, however, to defend himself against misconceptions about his work. "What people don't seem to realize," he told Gruen in 1977, "is that I'm interested in the *issues* of art. Frankly, I'm tired to having my scene slowed down by people who don't get what I'm doing. . . . I don't think of myself as an artist who's running around expressing himself. I feel I'm performing a function for society." Despite the sheer size of his earthworks, Heizer understands that his efforts are miniscule, merely human. "Man will never create anything really large in relation to the world—only in relation to himself and his size. The most formidable objects that man has touched are the earth and the moon. The greatest scale he understands is the distance between them, and this is nothing com-

pared to what he suspects to exist." He comments, however, that, the artist must not ignore the possibilities of scale, of art that makes use of rangeless, deserted spaces. "I'm not interested in the kind of work that's being done in the delicate world of the studio or seen in the quiet atmosphere of museums. That's not where my head is. What I'm after is investigation and exploration. . . . The work I'm doing in the desert *has* to be done, and *somebody* has to do it."

EXHIBITIONS INCLUDE: Gal. Heiner Friedrich, Munich 1969, '77; Dawn Gal., NYC 1970; Detroit Inst. of Arts, 1971; Ace Gal., Los Angeles 1974, '77; Fourcade Droll, Inc., NYC 1974; Xavier Fourcade Inc., NYC 1976, '77, '79, '84, '85; Gal. im Taxispalais, Innsbruck, Austria 1977; Ace Gal., Venice, Cal. 1977; Gal. am Promenadeplatz, Munich and Frankfurt 1977–78; Gal. der Speigel, Cologne, 1978; Mus. Folkwang, Essen 1979; Rijksmus. Kröller Müller, Otterlo, Netherlands 1979; Richard Hines Gal., Seattle 1979; Oil and Steel Gal., NYC 1983; Janie C. Lee Gal., Houston, 1983; Whitney Mus. of American Art, 1985. GROUP EXHIBITIONS INCLUDE: Park Place Gal., NYC 1967; "Earthworks," Dawn Gal. 1968; "Sculpture Annual," Whitney Mus. of American Art 1968; Richard Feigen Gal., Chicago 1968; "Prospect '69," Kunsthalle, Düsseldorf, West Germany 1969; "Bienal, Venice 1979; "Prospect '70," Düsseldorf, West Germany 1970; "Other Ideas," Detroit Inst. of Arts 1970; "International," Guggenheim Mus., NYC 1971; "Biennale," Nuremberg, West Germany 1971; "Diagrams and Drawings," Rijksmus. Kröller-Müller 1972 and Kunstmus., Basel 1973; "Art Now '74," JFK Cntr. for Performing Arts, Washington, D.C. 1974; "Drawing Now," MOMA, NYC 1975, Tel Aviv 1977; "200 Years of American Sculpture," Whitney Mus. of American Art 1976; "Probing the Earth: Contemporary Land Projects," Hirshhorn Mus. and Sculpture Garden, Washington, D.C., La Jolla Mus., and Seattle Art Mus., 1977; Documenta 6, Kassel, West Germany 1977; "Painting and Sculpture Today," Indianapolis Mus. of Art, 1978; Mus. of Contemporary Art, Los Angeles 1984.

COLLECTIONS INCLUDE: Robert Scull, private collection; Virginia Dawn, private collection; Xavier Fourcade, Inc., NYC; IBM Corp., NYC; Whitney Mus. of American Art, NYC.

ABOUT: Beardsley, John, Earthworks and Beyond, 1985; Detroit Inst. of Arts, Michael Heizer/Actual Size (exhibition catalog), 1971; Mus. Folkwang and Rijksmus. Kröller-Müller, Michael Heizer (exhibition catalog), 1979; Tomkins, Calvin. The Scene, 1976. *Periodicals*— Artforum May 1971, October 1976, December 1979, September 1980; Art in America November 1974, January 1976; ARTnews May 1971, December 1977, Summer 1979; Arts Magazine December 1969, February 1981, March 1983; Newsweek November 18, 1974; New York Times June 28, 1985; Vogue August 1981.

HESSE, EVA (January 11, 1936–May 29, 1970), German-born American sculptor and draftswoman, lived to complete a considerable body of drawings, and some seventy pieces of sculpture. Despite the brevity of her career, she is ranked as one of the major American postmodern artists, whose mixed-media innovations broadened the rigors of minimalist sculpture. Initially, Hesse's style was influenced by artists such as Carl Andre, Robert Smithson, and Sol LeWitt. But she went beyond their approach to a form of process art, introducing into her work a personal, associative quality, a degree of chance and randomness, and a wry humor that soften the minimalist characteristics—serial order and modular repetition—that remained basic to her style.

According to the critic Lucy Lippard, in the five years before the artist's death her work achieved a unique fusion of formal and emotional intensity; in the words of Hesse herself: "Everything for me is glossed with anxiety." Certainly, from 1965 to 1968, as her stature began to increase, the background of personal trauma steadily darkened: the death of her father after years of illness; her separation from her husband in 1966 (they were never divorced); and the first symptoms, in 1968, of the brain tumor that ended her life. Despite this, her artistic courage never failed. As she recorded in one of the notebooks she had kept since adolescence (which form an invaluable record of her methods and goals): "I don't want to keep any rules. That's why my art might be so good, because I have no fear. I could take risks."

Hesse's childhood set the pattern for lifelong dislocation, an existence "alternating between external fears and interior visions," as the art historian Cindy Nemser has summed it up. The artist was born of a Jewish family, Wilhelm and Ruth (Marcus) Hesse, in Hamburg, but was almost immediately separated from them—taken in and sheltered by a Catholic family—until the Hesses could escape the Nazi menace. In 1939 she and her older sister and their parents resettled in New York, but the nightmarish terror of her first three years never left her; fears of abandonment persisted throughout her life. In 1945 (the year she became an American citizen) her parents were divorced, and the following year Eva Hesse's seriously disturbed mother committed suicide. Growing up in Manhattan's Fort Washington area (where many refugee families had located), Hesse was educated in city schools and in 1952 graduated from the High School of Industrial Arts. She then enrolled at the Pratt Institute for a course in advertising design. The following year she got a part-time job on *Seventeen* magazine, taking a few classes at the Art Stu-

EVA HESSE

dents League. Some of her illustrations won a *Seventeen* competition award and were featured in the September 1954 issue. From 1954 to 1957 Hesse studied at Cooper Union, under such artists as Neil Welliver, Will Barnet, and Robert Gwathmey. Considered extraordinarily gifted, she was then accepted at Yale University's School of Art and Architecture—where her teachers included the color theorist Josef Albers, and from which she received a B.F.A. in 1959.

As a student, and for several years following, Hesse thought of herself as a painter. Her early canvases were abstract expressionist and reveal the influence of Willem de Kooning's gestural approach and Arshile Gorky's biomorphic imagery. But after leaving Yale she became increasingly occupied with ink drawings, employing free, vigorous brush strokes and broad washes. An untitled 1961 drawing of repeated circles with lines descending from them established a configuration that would reappear throughout her graphic work and sculpture. By 1960, settled in a downtown Manhattan studio, Hesse began to sell her work. Her first showings, of watercolors and of drawings, were in group exhibitions in 1961, the year of her marriage to the sculptor Tom Doyle. Not until the summer of 1962, spent in Woodstock, New York, did she do her first sculpture (a piece mentioned but not described in the published literature about Hesse) for the Ergo Suits Traveling Carnival. The following year she had her first solo show, of drawings, at New York's Allan Stone Gallery.

In 1964 Hesse and her husband went to Kettwig-am-Ruhr, Germany, the guests of a wealthy art collector. The fifteen-month stay abroad was of the utmost significance to her career, providing her with an opportunity to build up her own self-confidence, away from a circle of New York peers who (at that point) were much better known. According to a notebook entry of the time: "It just seems to me that the 'personal' in art if really trusted is the most valued quality and what I want so much to find in and for myself." Making space for herself in the midst of the enormous studio in Kettwig that had been turned over to Doyle, Hesse concentrated on drawing rather than painting—which she finally abandoned in 1965. Unlike her previous work, those drawings were of single shapes, with flowing contours, images derived from the industrial parts Doyle used for his work. To those large, elegant "machine drawings" Hesse first applied the adjective she thereafter used frequently to describe her art—"absurd." As those first images became larger and bolder she started to cut them away from their surrounding paper, and to use them in collages, a form she had been employing since 1962. It was at that point, according to Doyle, that she began to perceive as a sculptor. At first, however, in dissolving the boundaries between drawing and sculpture (in the same way that her last drawings were really more like paintings), Hesse transformed the drawn images into a form of relief, to be hung from walls, using rope and cord for the linear elements. It has been pointed out that in fact a very early (1954) lithograph of bare trees, built up of multiple drooping, stringlike lines, clearly anticipates one of her later three-dimensional constructions, *Laocoön* (1966): a ladder form, its uprights and rungs strangled (hence the title) by a tangle of ropes. *Ringaround Arosie* (1965) is a concretion of two circles, made of cloth-covered electrical wire, mounted on masonite. Both circles are built out to pink-tinted, nipplelike points. *Ishtar* (1965) is composed of rows of halves of paper cups, mounted on a narrow vertical backing, with stringy rubber tubes that pass through and dangle from the centers of the hemispherical shapes. The work, according to the art critic Kim Levin, is prototypical of Hesse's obsession with the circle and the linear grid arrangement. And although later in her career Hesse stated that she regarded the circle merely as an abstract geometrical form, not an allusion to the human breast or symbolic of eternity, the choice of *Ishtar* as the title would seem to have significance. As is borne out by many of her journal entries, the artist chose the titles of her works with great care and deliberation.

Back in the United States, Hesse began to enlarge her reliefs, incorporating into them pieces of wood or steel, built out and layered (or

"bandaged") with various soft materials: latex rubber tubing, papier-mâché, cheesecloth, rope. Her feeling for those eccentric, utilitarian materials bears out her disdain for the merely pretty or decorative, which she pronounced "the only art sin." As a notebook entry records: "I do . . . have a very strong feeling about honesty—and in the process I like to be . . . true to whatever I use and use it in the least pretentious and most direct way. I can control it, but I don't really want to change it. I don't want to add color or make it thicker or thinner." Thus, organic forms were allowed to emerge, as by accident, from the way combinations of materials, leaning against walls or suspended from above, responded to gravitational pull and sagged toward the floor. Characteristically, the strings or the lengths of rubber tube that hang from her pieces subside into chaotic tangles and knots, which (according to the critics) bespeak the quality of anxiety and absurdity central to her work. One of the key works of that period is the wall piece *Hang-Up* (1965–66), described by the artist in great detail in her journals and characterized by her as "the most ridiculous structure I ever made, and that is why it is really good. It has a kind of depth of soul of absurdity." *Hang-Up* is a six-foot by seven-foot wooden frame—which frames nothing—wrapped in cord and rope (like a surgical dressing) and painted with Liquitex; a thin steel rod loops from top to bottom. Similar opposition between form and content is apparent in *Accession III* (1969), a thirty-inch cube of clear fiberglass within which lies a tangle of rubber tubing; inner chaos contrasts absurdly with outer geometrical order. It was translucent fiberglass, incidentally (which she began to use in 1968), that allowed Hesse, while eschewing color, to realize "the beautiful things light does" to her work.

Another of Hesse's central ideas, part of her minimalist heritage, was that "if something is meaningful, maybe it's more meaningful said ten times. . . . If something is absurd, it's . . . more absurd if it's repeated." Thus, *Repetition 19, III* (1968) is composed of nineteen fiberglass units shaped somewhat like wastepaper baskets, each unique but similar in media and method. *Contingent* (1969) consists of eight rectangular bannerlike units of latex rubber over ripplecloth, encased in fiberglass; hanging in a row from the ceiling, each unit catches the light in a different way. The ordering is serial, but the eight modular elements actually differ from one another in length and in the height from which they are suspended. Like all her sculptures neither carved nor modeled, it is additive, built up of layers of fiberglass and rubber as a painter would use layers of pigment. Reflecting on that

piece the artist indeed concluded: "It is really hung painting in another material than painting." One critic, writing in 1968, commented on the ceaseless play of the systemic and the organic in such works, while another described the effect of the modular units, systematically organized but subject to knotting and collapse, as "surreal serialism." For *Contingent* Hesse uncharacteristically did a preliminary working drawing; "just a quickie," she called it, "to develop it in the process," but which was subsequently modified in the working out of the sculpture.

Just as her reliefs and sculptures are, in general, not single, isolated objects but composed of modules alike in materials and form, her later drawings were conceived as series of images. In her best-known series, done between 1966 and 1968, the circle motif is repeated in rows on paper marked off in parallel lines or squares. Each circle is formed of concentric bands of light or dark gray ink washes. In another series, the window drawings of 1968–69, the central image is predominantly done in light gray washes framed in darker grays or browns. In a third series, the delicately colored abstract drawings begun in Woodstock in the summer of 1969, Hesse worked in painterly fashion, building up layers of fine washes using gouache, Chinese ink sticks, colored inks, lead pencil, casein, crayon, and gold and silver paint.

As Hesse's three-dimensional work became larger and more complex she took on two assistants to carry out her concepts and speed up the construction time. With their help (increasingly essential as illness incapacitated her) she continued working at a furious pace and completed a substantial number of pieces in her last year— works such as the 1969 *Vinculum II*, one of her favorites. (The title is the name of a mathematical bracketing symbol, as well as having, perhaps, linguistic connotations of "invincibility.") Into its making went latex on wire mesh, staples, string, reinforced fiberglass, and lines of rubber hose of different lengths that dangle to the floor from a pole that slopes from wall to floor. Tension and flexibility are opposing principles here. An untitled 1970 work consists of a knotted tangle of rope, string, and wire, wrapped in latex rubber, looped in arcs that dangle like a translucent cobweb from ceiling and walls—an epitome of limp chaos that suggests ordered structure of a new kind. *Expanded Expansion* (1969), a ten-foot-high flexible construction, consists of three units of rubberized cheesecloth and reinforced fiberglass that hang (like shower curtains) from poles. According to Hesse its connotations are merely potential; it is not anything per se, and that increases its final absurdity. Her concern here, as in all her art, had been with the

making of it and with the materials so employed, despite the fact that (as she realized) the materials she chose would last for only a relatively short time.

In 1968–69 Hesse taught at the School of Visual Arts in New York, and in 1968 gave classes at Oberlin College as a visiting teacher. It was to that Ohio College that Helen Hesse Charash later bequeathed a collection of her sister's drawings and notebooks. Asked by Cindy Nemser, in the course of one of her interviews with women artists, to comment on their position in the contemporary art world, Hesse responded: "Excellence has no sex. . . . The way to beat discrimination in art is by art." For her own achievements she was awarded a grant, posthumously, by the National Endowment for the Arts.

In a photograph taken in 1964, which captures an impish grin, Eva Hesse appears as a small, lively figure, dark haired, with an attractive oval face in which her wide, mobile mouth and emphatic dark eyebrows are prominent features. Two years after her death her sculptures and drawings from 1965 to 1970 were shown at the Solomon R. Guggenheim Museum in New York, a memorial exhibition arranged by her friend Sol LeWitt. Twenty years after her death, some of those "elegant" and "triumphant" works (on exhibition at the Whitney Museum of American Art) had not, according to a New Yorker notice, "lost their potency; on the contrary, they now appear seminal."

EXHIBITIONS INCLUDE: Allan Stone Gal., NYC 1963; Kunstverein für die Rhein und Westfalen, Düsseldorf, West Germany 1965; Fischbach Gal., NYC 1968, '70; Solomon R. Guggenheim Mus., NYC 1972–73 (trav. retrospective); Mayor Gal., London 1974; Droll/ Kolbert Gal., NYC 1977; Whitechapel Art Gal., London 1979 (trav. exhib.); Allen Memorial Art Mus., Oberlin Col., Ohio 1982 (trav. retrospective of drawings); "Eva Hesse: The 1965 Reliefs," Robert Miller Gal., NYC 1989. GROUP EXHIBITIONS INCLUDE: International Watercolor Biennial, Brooklyn Mus. 1961; John Heller Gal., NYC 1961 (drawings); "Winterausstellung," Kunstverein, Düsseldorf, West Germany 1964; "Abstract Inflationists and Stuffed Expressionists," Graham Gal., NYC 1966; "Eccentric Abstraction," Fischbach Gal. 1966; "Art in Series," Finch Col. Mus., NYC 1967 (trav. exhib.); "Nine at Leo Castelli," Leo Castelli Gal., NYC 1968; Whitney Annual, Whitney Mus. of American Art, NYC 1968–69; "Anti-Illusion: Procedures/Materials," Whitney Mus. of American Art 1969; "A Plastic Presence," Milwaukee Art Cntr. and Jewish Mus., NYC 1969; "When Attitude Becomes Form," Kunsthalle, Bern 1969 (trav. exhib.); "New Media: New Methods," MOMA, NYC 1970; Documenta 5, Kassel, West Germany 1972; "Sculpture of the '60s," Whitney Mus. of American Art 1975; "Two Hundred Years of American Sculpture," Whitney Mus. of American Art 1976; Documenta 6, Kassel, West Germany 1977; "New Sculpture 1965–75: Between Geometry and Gesture," Whitney Mus. of American Art 1990.

COLLECTIONS INCLUDE: Solomon R. Guggenheim Mus., MOMA, and Whitney Mus. of American Art, NYC; Allen Memorial Art Mus.; Art Inst., Milwaukee; Tate Gal., London; Australian National Gal., Canberra.

ABOUT: Johnson, E. Eva Hesse: A Retrospective of the Drawings, 1982; Lippard, L. Eva Hesse, 1976; Nemser, C. Art Talk: Conversations with Twelve Women Artists, 1975; Pincus-Witten, R. and L. Shearer. Eva Hesse, (cat.) 1972; Serota, N. Eva Hesse, (cat.) 1979. Periodicals—Artforum May 1970, November 1971, November 1972, March 1973; Art in America May 1971, March 1973, Summer 1983; Art International January 1969; ARTnews February 1973, November 1986; Arts Magazine December 1979; Time January 1, 1973; Village Voice December 21, 1972.

HODGKIN, HOWARD (August 6, 1932–), British figurative painter, is the product of two eminent British dynasties: the scientific Hodgkin family and the reforming and artistic Fry family. He was born in London; where his father was the foreign manager of Imperial Chemical Industries and a noted amateur horticulturist who helped design the plantings on British motorways; his mother, though a cousin of Roger and Margery Fry, insisted that her son complete a traditional education and go into the diplomatic service. Young Howard, however, was determined to be an artist: he ran away from Eton College, then from Bryanston School and several other public schools before his parents relented and allowed him, at the age of seventeen, to enter the Camberwell School of Art. He later attended the Bath Academy of Art. His teachers included Victor Pasmore, William Scott, and Kenneth Armitage.

Hodgkin spent many years teaching art before becoming sufficiently established as an artist to be able to paint full-time. He was a lecturer at Charterhouse School (1954–56), the Bath Academy (1956–66), the Slade School of Art and the Chelsea School of Art (1966–72). He has also been a visiting fellow in creative art at Brasenose College, Oxford (1976–77), and a trustee of the Tate Gallery (1970–76) and the National Gallery (from 1978).

"I paint representational pictures of emotional situations," Hodgkin has said. The situations may be, he told Edward Lucie-Smith in 1981, "extremely respectable—people having dinner, when conversation suddenly becomes a little heated or a little intense and perhaps one person makes a gesture toward another which sets off

something in my head. But then they may also be erotic situations—people in bed, or oneself in bed with somebody—which would probably end up more abstracted than some of my other pictures."

Once a situation or subject has suggested itself to him, he proceeds to translate that feeling into a picture. First he chooses a wood panel of appropriate size. His works are mostly small, and he has been painting exclusively on wood since 1969, finding the hardness of the surface congenial to his layering method of painting. With his subject's realistic image clearly in mind, or even drawn onto the panel, he assigns it forms and colors. These may stand for items of clothing or furnishing, or, less straightforwardly, for the light or space his subject seems to occupy. Hodgkin's struggles with form and scale, subject and object, his attempt to wedge the shapes together, give his pictures their remarkable tension. He calls that process "anxious improvisation," and considers it "agony, because I have to invent so much." Although his pictures average perhaps a foot square, they routinely take years to complete, and he may work on dozens at a time. He often overpaints, sometimes obliterating years of work in a few minutes, but he has "tried increasingly," he has said, "to sit for hours in front of the picture and make the mistakes in my head rather than on the picture surface." He knows a picture is done "when the subject comes back" in all its emotional intensity and he can clearly see its spontaneous origin "with the same surprise and interest" as someone who regards the work for the first time.

About the same time that he changed his preferred surface from canvas to wood, Hodgkin began painting frames around most of his pictures. He has steadily refined that technique, using more elaborate real frames and increasing the size of both the real and the trompe l'oeil frames in relation to the picture itself. "The stronger the identity of the frame," he has explained, "the greater the illusion of depth one automatically gets—provided one can join the frame to the picture, because there's no real contrast unless there's also a relationship." He feels that in recent years his pictures, as he told his friend Patrick Caulfield in 1984, have become "much more illusionistic, the sort of depth of space in them is much greater than it used to be." That echoes a remark he made to David Sylvester in a 1981 interview: "For me nothing in painting matters more than that an artist should create the illusion of depth without disturbing the flatness of the picture surface."

While he has been refining and accentuating the tension between surface and depth, Hodgkin

has also been bolder in his use of opulent colors. He sees color as "language. [It] contains a great deal of feeling. It's also part of the pictorial architecture. It expresses form and light and space." He added that "traveling has made me feel more ready to use colors in unlikely combinations." That observation seems confirmed by his many trips to India, where he first went in 1965 and has returned every winter since. The country immediately seemed to him "that other world, somewhere else," and he had a deep response to the life of the country. "It's more the moods, the way people live in India, that has probably influenced my paintings. . . . There's a sort of naked sensitivity about the people which probably affects me very much." Many critics also point to the influence of Rajput and Mogul miniatures, a passion of his from childhood, on his sense of color and composition. "What excites me," Hodgkin says, "is the tension between the extremely tight visual language of Indian painting and the reality it depicts. I have absolutely no interest at all in the iconography of Indian art. If I look at a picture of a Hindu legend, I don't want to know what the legend is about."

The "new" Hodgkin, with all his recent refinements of depth and color, is epitomized in the series of Neapolitan paintings he has been producing since the early 1980s. *In the Bay of Naples* (1980–82) expresses, within a strikingly painted frame, the intimacy of two friends, whose heads appear at the bottom of the picture, as they look out a window at the color and feeling of Naples. There is no attempt to reproduce realistically the place referred to in the title, but the interplay of colors—watery blues and greens, vibrant reds and oranges—and the effective illusion of depth create associations in the spectator, transporting his mind to the feeling and memory of the site.

For Hodgkin, 1984–85 were banner years. A retrospective exhibition of forty-two of his oil-on-panel paintings produced in 1973–84 was a considerable international success. It traveled from the Venice Biennale to the Philips Collection in Washington, the Yale Center for British Art, the Kestner-Gesellschaft, Hanover, and finally was the principal exhibition at the opening of the remodeled Whitechapel Art Gallery in London. On November 12, 1985, the jury at the Tate Gallery awarded Hodgkin the second annual Turner prize (the first was given to Malcolm Morley in 1984) "for a substantial body of work that shows continuing vitality and unswerving personal vision."

For many years, Hodgkin has been a compulsive collector of objects in a few categories. He

once sold his entire collection of books to buy—for its botanical illustrations—the first Persian translation of the Greek Materia Medica. His art master at Eton, Wilfred Blunt, introduced him to Mogul painting and he began buying first-rate examples when they could be had in London for well under a hundred pounds. His very fine collection, now worth thousands of times what he paid for it, is on loan to the Victoria and Albert Museum. His converted mill house, near Chippenham, Wiltshire, is reportedly filled to overflowing with chairs of every decorative style. "I love chairs of all periods," he has said. "They have a curious identity of their own. If you walk into a room full of them, it isn't like walking into a room empty of people: there's something faintly anthropomorphic about them."

The artist is also a renowned aesthete, famously demanding during the hanging of his exhibitions. He has switched dealers several times because of dissatisfaction with the rooms they chose to hang his work in. He has left opera performances soon after arriving, unable to bear the color of the lighting. Laurence Marks has called him "our most famous aesthete since Sir Philip Sassoon ordered the Union Jack over his house in Park Lane to be hauled down because it clashed with the sunset."

Hodgkin divides his time in Britain between Wiltshire and a house in Bloomsbury, London. He married a fellow student, Julia Lane, in 1955; they have two sons. Although he has been widely acknowledged as a painter of exceptional originality—Lawrence Gowing has called him "a painter more naturally and effortlessly original, more entirely himself than anyone else alive"—Hodgkin is, by his own estimation, still far from his goal. In 1985 he called his successful retrospective exhibition "only a beginning. I must paint much better pictures. I want to include more, because the more feeling and emotion you include in the painting, the more it will come out the other side to communicate with the viewer. . . . I want to keep trying."

EXHIBITIONS INCLUDE: Arthur Tooth and Sons, London 1962, '64, 67; Kasmin Gal., London, 1969, '71; Arnolfini Gal., Bristol 1970, '72; Dartington Hall, Devon 1970; Gal. Muller, Cologne 1971; Gal. Staedler, Paris 1972; Kornblee Gal., NYC 1973; Tate Gal., London 1976, '82, '85; Serpentine Gal., London 1976; Mus. of Modern Art, Oxford 1976; Waddington Gals. II, London 1976, '80; André Emmerich Gals., Zurich and NYC 1977; Bernard Jacobson Gal., NYC 1980, '81; M. Knoedler Gal., NYC 1981; Bernard Jacobson Gal., Los Angeles 1981; Philips Col., Washington 1984; Yale Cntr. for British Art 1985; Kestner-Gesellschaft, Hanover 1985; Whitechapel Art Gal., London 1985. GROUP EXHIBITIONS INCLUDE: Mus. of Modern Art, Tokyo 1970; Mus. d'Art Moderne de la Ville de Paris, 1973; Hay-ward Gal., London 1974; Royal Academy of Art, London 1977; Venice Biennale 1984.

COLLECTIONS INCLUDE: Art Council of Great Britain, London; Tate Gal., London; British Mus., London; Victoria and Albert Mus., London; São Paulo Mus., Brazil; Walker Art Gal., Minneapolis; MOMA, NYC; Fogg Art Mus., Cambridge, Massachusetts.

ABOUT: Emanue, M., et al. Contemporary Artists, 1983; Morphet, R. Howard Hodgkin, 1976; Lucie-Smith, E. Art in Britain 1969-70, 1970. Periodicals—ARTnews Summer 1985; Arts Magazine March 1985; London Magazine March 1965; Observer September 15, 1985; Spectator March 1967; Studio International Summer 1975; Times (London) February 20, 1962, April 17, 1980; Village Voice November 26, 1985.

HOFF, MARGO (June 14, 1912–), American painter and collage artist, writes: "I am a painter living in New York City. I am an autobiographical artist in that I have always used the events, places, images, remembrances of my life as central themes of my work. I am looking for an essence, or inner life of an idea.

"When asked what my influences have been my answer is 'Almost anything except the work of other artists.' I've been influenced by rocks, weeds, views from airplanes, rivers, subways, forests, machines, kinds of lights, red things and imagination.

"One of my constant companions is my sketchbook. Since it is a small black book, people have thought me a poet, a scholar, a religious person carrying a prayer book. Once at Customs in Moscow, my sketchbook was taken from me (later returned) because my notes were a "code." The sketches are actually a kind of shorthand writing. The world moves so quickly that images are blurred or lost. I try to record responses and moments. Later, I work with the note-sketches, developing them to the final form.

"I was born into a large family of six brothers and two sisters which lived in a small house. This made it natural to spend much time out of doors. In Oklahoma the summers were long and hot and filled with small adventures. In my childhood explorations of nature (plants, rocks, caves, landscapes) I made discoveries that I use even now in my painting.

"At six years, I modeled small animals and people from clay that the well-drillers dug. I learned about color from rocks, leaves, and berries. A game we had was 'coloring rocks.' We pounded small rocks to dust, mashed berries or leaves, made colors, painted surfaces of large rocks and let them dry in the sun.

"At eleven I had typhoid fever. For a summer

MARGO HOFF

I was bedridden. I did many drawings and cut-outs, and my imagination came alive.

"Thirteen was an important year. I began high school. I saw an oil painting for the first time. It was called *Moonrise on Blue River.* I began drawing from a live model, from casts, from imagination. I did a mural on four sides of the art room.

"The following year I won a silver medal in 'Free-Hand Drawing' at the Scholastic Meet at the University of Oklahoma. Many years later I won another silver medal, at the Art Institute of Chicago.

"After two years at the University of Tulsa, I left Oklahoma to study at the Art Institute of Chicago. I did not know how much of early life would be relived in later works: themes of suns, moons, flat landscape, games, patterns, moods.

"Chicago brought other elements and discoveries: cold and wind, ice on the river. I learned about being alone in a large city, of wandering, drawing, and getting lost. I found people with whom to speak in a vocabulary I never knew, Art. I met students who became friends, teachers who believed in me. I went to galleries and museums.

"I kept drawing, observing, studying. I worked in factories, lived in one room. I studied dancing so I could earn more money to study art. I traveled to Mexico and to the Southeast. I was adding to my store of 'images': structures of a city, bridges, colors, theater, lights. The small gouaches that I did were 'documentaries' for what I was living.

"Living became filled with people: artists, ac-tors, dancers, musicians. There was good spirit, talk, hope, work. I met a fine gallery and its two directors. We became close friends and the gallery has represented my work for thirty years.

"I met a man who was important in my life. He was a painter, and from a family of painters. I had never seen Art as such a living force, as a way of life. We were married, and the following years were rich and eventful. They were of working, having a house, having a child, traveling, coming home, juggling all the things that are important to living.

"New themes were added to painting: children and their world, holidays, animals, seashores. I visited New York at intervals. From the first time I felt that eventually it would be my home. I was at home in it. One day, many years later, the child had gone to college. The man had left on a two-year assignment (cultural affairs officer in the Mideast and Far East). I knew that it was time to move to New York City. So my life changed again, as did my work.

"There are many experiences that are unforgettable because they changed our point of view or sense of the visual world.

"For me: seeing Sputnik flying over the Earth. Until that night, the human figure had always been the center of thinking of Art. Suddenly, people became small huddled shapes on tops of buildings watching a moving light across space that they could never reach. Then the space itself became the theme.

"A view through the electron microscope—a view of pure abstraction—reinforced this notion. The view on a riverboat in China, moving into the immense verticality of the stone gorges, is visually opposed to the patterned land and sea spied from an airplane window. I have used both points of view.

"Describing 'canvas collage,' the medium in which I am thought to have found my metier, the color is acrylic, the canvas is unsized cotton. The adhesive is gel, acrylic medium, or a combination of glues.

"The colors are brushed on large pieces of raw canvas. Sometimes there is a small sketch for the work. Sometimes it is done directly from the idea. The layers of painted canvas are built, one at a time. They are laminated under weights. The painting becomes color against color, shape against shape. Action of color next to stillness of color.

"The collage is done on the floor. I work from four sides of the canvas. My perspective while working is unique. Sometimes I don't see it vertically until it is stretched and hanging. I often paint over parts of the work with transparent color, or draw with crayons.

"The simplification (or abstraction) of forms in my work is intended to hold the theme at its basic form. I like to think that it relates to a poetry that reduces words to the essence.

"Art has nothing to do with 'inspiration.' It is more like an enduring warmth. It is a path one travels, not being able to see far ahead.

"What is abstraction? To me it is a state just before or just after—reality. One observation on being a painter is that painting can contain so many elements of other arts: the drama and light of theater, choreography or design of dance, the image making of graphics, the poetics of written words.

"I find that many of my friends are in other professions: an economist, a mathematician, a weaver, a playwright, a medical researcher, a composer, a dancer, a lawyer, and so forth. I learn from their discoveries. We are searching for the same thing in different ways.

"Not long ago I had an exhibition at a university gallery. On opening day, a student ran down the hall to tell me, 'I have just seen your show. It is a room full of light and color.' Later, the university president called me to ask, 'Will you go through your exhibition with me so that I will know what I am seeing?' With two such different responses, the artist stands somewhere in between.

"He stands in front of his works, to consider them, to question them. He stands in front of nature, his teacher, his source. He stands in front of memory and the observed world. He stands in front of change, and moves with it. He searches for greater awareness.

"Some themes that I find recurring in my work are: kinds of light, aspects of time, celebrations, sounds and rhythms, life of a city, elements of nature.

"The two elements, the unknown and the familiar, play equally important parts in an artist's life. It may be more difficult to see depth in everyday life than to look for the new, but to do so may be a way of looking for another layer of reality."

Although her work has received international recognition, Margo Hoff has never sought the glare of the public spotlight. A versatile and prolific artist, she has maintained over the years her complete integrity, and her eagerness to explore new means of expression, especially in her preferred medium, canvas collage.

Margo Hoff's life was described by Nancy Carroll in an interview for a Mayo Clinic publication in 1972 as "a collage of experiences, over-lapping and blending to cause the point of view that we see in her art." Born in Tulsa, Oklahoma, the second child of C. W. Hoff, a carpenter, and Ada (Hayes) Hoff, she had six brothers and a sister. She received her early education in Oklahoma, but spent her summers with her grandparents in the Ozarks. Three years after graduating from Tulsa University in 1931, she enrolled at the National Academy of Art in Chicago, which later became affiliated with the Chicago Art Institute. Several months of self-directed study in Europe in 1939 were crucial to her development; she traveled in Holland, France, Italy, Greece, and Yugoslavia, where she studied medieval Serbian frescoes under George Buehr. Always seeking wider horizons, Hoff, in the course of her extremely active and varied working career, has traveled and painted in, she estimates, "about twenty-five countries." While the works inspired by her travels are never literal transcriptions of what she has seen, her vision, in terms of color, space, and overall design, has undoubtedly been enlivened and enriched by her contacts with many lands and cultures.

Hoff's early works were figurative paintings, but with a difference. *Dream of Flying*, painted in Chicago in 1950, shows the horizontal figure of a young girl; her body, formalized and somewhat flattened, and covered by a white gauze-like fabric, levitates against a dark background and above a blurry-edged horizontal band of incandescent red. The artist's six-year-old daughter, Mia, had recently undergone an operation. When asked what she had experienced under the anaesthetic, she replied that she had had the sensation of flying or floating in space, and that is what Hoff sought to convey. Her imagery, whether figurative or abstract, has always been, in her words, "related to a human experience." A richly decorative sense of pattern and a subtle geometry were already apparent in *Woman in the White Room*, also of 1950. In *Night Storm* (1952), drastically simplified but evocative, near-silhouetted forms of a woman, a little girl, and a tree are set against a muted yellow background crossed diagonally on the left from top to bottom by a sharp, bright yellow bar like a stylized bolt of lightning.

Hoff had been exhibiting in Chicago since 1944, and the following year she won the Armstrong Prize of the Art Institute's "Chicago and Vicinity" show, the first of many awards. Her work was exhibited in 1953 at the American University in Beirut, Lebanon, where she held the post of visiting artist in 1955–56. That proved a most stimulating experience. She had students from twenty-one countries; from Beirut, at that time the most beautiful city she had ever seen, there was easy access to Damascus,

and, by plane, to Cairo and the Valley of the Kings.

The year 1955 had been an eventful one for Margo Hoff. She was presented as an *Art in America* "New Talent Artist," and she held her first solo show at Chicago's Fairweather-Hardin Gallery, which has represented her ever since. Also in 1955 she had solo exhibitions at the Saidenberg Gallery, New York City, and, to her great delight, at the prestigious Wildenstein Gallery in Paris. A photograph taken in 1955 shows her sketching at 5:00 A.M. in a deserted Paris Métro station.

Hoff was deeply moved by the circling of the Earth by Sputnik I in 1957. She feels that from then on the human figures in her work were receding, and that "other forms" were taking over. The measurements of human beings seemed so miniscule suspended in the vastness of outer space; many years later she stated, "I often look at the world from a kaleidoscopic viewpoint, turing from one aspect to another." Moving permanently in 1960 from Chicago to New York City, she felt that a new phase in her life and career was beginning. In that year she made her first collages, using painted paper, finding the directness of that medium more satisfying than oil on canvas, to convey her new feeling for space. There were still human figures in *Ball Game* of 1962, but the curvilinear rhythms were far more abstract than in her previous work. Another, very different, painted-paper collage of 1962—her work is never repetitious—was *Color Saints.* Three luminous vertical figures—one red, one golden yellow, one blue, as hieratic and glowing as Byzantine mosaics or medieval stained glass—rise majestically side by side against a dark background. Exhibited in Hoff's solo show at the Banfer Gallery, New York City, in 1962, *Color Saints* was chosen by UNICEF for its Christmas card. It was later purchased by the writer James Michener, who was startled and amused to receive about a dozen Christmas cards of "his" painting.

"Wherever she travels," Dr. Lee Hall wrote in 1981 in a monograph on the artist, "Margo is at home among the religious of the world. She takes comfort and meaning from ritual and sign." The ritualistic feeling is present in *Room of Madonnas* (1970), a large painted-paper collage (seventy-two by forty-eight inches), in which eight Romanesque Madonna and Child statues, painted, appropriately, in grisaille, are stuck separately on eight red, roughly rectangular shapes of varying size against a background of vertical stripes of nocturnal blues and dull red.

In 1970 Hoff turned from collages in painted paper to cut-canvas collage, which has remained her favorite medium. However, she has worked in many other techniques, including oil, casein, acrylic, ink, the graphic media and litho–silk screen. Her commissions have included an opera stage set, a design for the Murray Louis Dance Company of New York, tapestries, murals, and illustrations for poems. She approaches each assignment as a challenge and an adventure, and brings the same sense of excitement to her teaching.

Among Hoff's many mural commissions, two in particular should be mentioned. One was a design made in 1964 for a wall measuring nine by fifty feet in the lobby of the Home Federal Bank on State Street, Chicago. The mural included seventy-five separate oil collage paintings of Chicago houses built from 1833 to 1964, framed in free-form aluminum bands symbolizing major streets and highways. Hoff began the series with the oldest house in Illinois, a French-style log cabin built by an early settler, Jean-Baptiste Saucier, in 1737 in Cahokia, Illinois, east of present-day St. Louis, but the remaining seventy-four were all built in or near Chicago. Houses still standing, including the house built in 1891 by Frank Lloyd Wright in Oak Park for his family, Wright's Robie House, and the Potter Palmer mansion, were sketched from life; the "portraits" of those demolished were based on research in the prints and photographic departments of the Chicago Historical Society. By choosing as her theme "the homes Chicagoans live in past and present" Hoff "wanted to escape the limited image of the city that so many outsiders have. "They think of 'windy city,' gangsters, meat packing, and writers, generally." The mural was to provide an insight into the cultural heritage of the city in which she had resided in earlier years and for which she has always retained a certain affection.

Another ambitious project was the ten-by-thirty-three-foot mural on the eighteenth floor of the Mayo Clinic in Rochester, Minnesota, completed in 1969. The theme of the mural, *Land and Sea,* was related to the overall iconographic scheme planned for several floors of the clinic under the title "Mirror to Man." Unlike some of Hoff's other murals, it was painted directly in oil on canvas. Since it was meant for the room where patients waited, the aim was to create a calm atmosphere, free from agitation. Large, simplified areas of green and blue rendered in an almost pointillist technique were contrasted with smaller areas representing farms, factories, and other indications of human activity. Since the painting was to be one large canvas it was necessary to rent a loft on Greene Street in downtown Manhattan's SoHo district, build a wall, stretch the canvas on it, size the

canvas, make the color sketch and cartoon, fly to Rochester, try it on the wall, then fly back to New York to do the actual painting—all of which took four months. The completed canvas was shipped by air freight to Rochester, unrolled, and laminated to the wall in June 1969.

Hoff has described commissioned work as "a different process of thinking and performing than painting for one's own reasons." As highly original as her murals are, her most personal creations are her canvas collages, free-hanging works that can be installed as paintings against a wall, hung as tapestries, or hung away from a wall. A characteristic work is the five-foot-square canvas collage *Disco* (1981), exhibited in 1981 at Hoff's first show at the Betty Parsons Gallery, New York City, and acquired by the Metropolitan Museum of Art for its twentieth-century collection. Another Metropolitan Museum acquisition was *Vermilion Banners* (1983). The vibrant colors and lively curling shapes in *Disco* not only express action on the dance floor but create an equivalent of sound. In *Street Music* (1975) and in several other works Hoff seeks an approximation of how various sounds would *look*; for instance, "a jazz piece, percussion, and night sirens." In *Rose and Flame* (1972), poetry provided the stimulus—the closing lines of "Little Gidding" in T. S. Eliot's "Four Quartets"—"when the tongues of flame are infolded/Into the crowned knot of fire/And the fire and the rose are one." In keeping with Hoff's "kaleidoscopic" view of life, urban scenes, even such features as manholes and traffic snarls, have provided themes for her work, as have the varied forms of nature and "all kinds of light and almost anything red." Her glowing reds, lustrous blues and velvety dark colors often impart a near-oriental softness and richness to her orchestration of color, which is always dynamic but never harsh or aggressive. Her works range in size from large pieces to a small, delicate series called "Weeds," inspired by a stay in Martha's Vineyard in 1984.

Hoff's adaptability to difficult conditions in far-off places was well demonstrated when she was teaching in Fort Portal in western Uganda in the summer of 1971. Since "materials were scarce and expensive," she cut papyrus stalks to be used as rulers by her students. She recalls: "We used . . . seeds, stones, beads for mosaics, burnt wood for charcoal, a white muslin cloth to draw and paint on, mud and grass for making masks, dry colors and dyes from the market." She tried to plan projects meaningful to the young Africans "so that they could see art as communication." At the school near São Paulo, Brazil, where she taught in the summer of 1974, materials were almost as limited, so she had her class, comprising teachers from Amazonia and other inland regions of Brazil, work on a group mosaic, obtaining the stones from the local market. In 1985 she went to the People's Republic of China at the invitation of the Ministry of Education as a visiting lecturer at North East University, Chang Chun, Jilin. Those attending her lectures were teachers from the three northern provinces. Hoff was impressed by their eagerness to learn something about modern American art, which was quite unknown to them. Their knowledge of modern European art was limited to occasional glimpses of reproductions in magazines.

Margo Hoff's residence is an apartment on the East Side of Manhattan, but her studio is a spacious loft on West 14th Street. She has remarked, "I am a painter though I do not own an easel. I am a printmaker though I do not have a press. I make collages and have eight pairs of scissors. I have a library of my sketchbooks." Small, with dark, expressive eyes and delicate features, she has a quality slightly reminiscent of Lillian Gish, but the bone structure is more pronounced, accentuated by the heavy, black-rimmed spectacles she often wears. In her personality she combines sensitivity and determination, containment and a warm openness to people, places, and ideas. Sally Fairweather, codirector with Shirley Hardin of the Chicago gallery that has represented Hoff since 1955, described her work as "the most powerful and most knowledgable statement. In spite of its abstraction, it's always intellectual. That is why I think the titles are important to her work—as a clue—although it's beautiful without knowing what inspired her." The artist herself has said: "Art is not oil on canvas of the view from the window. It is a view from a thousand personalities, concepts, material, light, hunger, history, frustration, and some small hopes."

Betty Parsons, who died in 1982, and in whose New York gallery Margo Hoff exhibited in September 1981, wrote the following poem to accompany the show: "It's a dance with the night and day/The Earth and the sky want to join in the fray/While the joy in the energy makes the forms/Embrace with delight."

EXHIBITIONS INCLUDE: Wildenstein Gal., Paris 1955; Saidenberg Gal., NYC 1955; Banfer Gal., NYC 1960, '62, '66, '68; American Univ., Beirut 1953; Fairweather Hardin Gal., Chicago from 1955; Drew Univ., Madison, N. J. 1983, '84; Univ. of Minnesota, Minneapolis 1948; Bednarz Gal., Los Angeles 1967; Betty Parsons Gal., NYC 1981, '82; Hadler Gal., NYC 1979.

COLLECTIONS INCLUDE: National Gal. of Art and Smithsonian Inst., Washington, D. C.; Victoria and Albert

Mus., London; Carnegie Mellon Univ., Pittsburgh; Brooklyn Mus., Metropolitan Mus. of Art, NYC; Univ. of Minnesota, Minneapolis; Univ. of Notre Dame, South Bend, Ind.; and many corporate art collections.

ABOUT: Who's Who in American Art, 1989–90. *Periodicals*—Art in America June 1957, April 1959, November 1960, March 1964; ARTnews September 1959, March 1961, May 1963, January 1965.

HOLZER, JENNY (July 29, 1950–), American artist whose mastery of texts and contexts allows her to exhibit her work in a diverse array of settings without sacrificing effectiveness. Her signs—often short, aphoristic messages—have appeared everywhere from the huge Spectacolor electronic signboard above Times Square in Manhattan to the rims of baseball caps; they have shown up anonymously on parking meters, wall plaques in banks, billboard-size signs that can be seen from freeways, and on the lids of granite sarcophagi in more traditional museum spaces. Influenced by dadaism, conceptualism, feminism, and strongly engaged with issues of survival in the face of environmental deterioration, the threat of nuclear holocaust, and the AIDS epidemic, Holzer's art is at once political and relevant to individuals on a very direct, personal level. The effectiveness of her texts derives not only from their tone and content, but also from their context. Presented with an apothegm where one expects to see an advertisement or official announcement, one is left to consider only the message itself; the artist's insistence on anonymity (in her public works) helps to ensure that outcome by removing even the distraction of consideration-as-artwork.

Born in the rural town of Gallipolis, Ohio, Holzer was one of three children in what has the air of a quintessentially midwestern family: her father sold cars (like his father before him) and her mother, formerly a college horseback riding instructor, was active in community affairs. In an interview with Bruce Ferguson in 1986, Holzer indicated that she grew up thinking of herself as an artist, and she spent her early childhood making large drawings of "big moments in history." But around the age of eight, she became self-conscious and gave up that activity. It was only toward the end of college that she took up art again. After two years in a liberal arts program at Duke University and a third year at the University of Chicago, she eventually enrolled in art classes in her final undergraduate stint at the University of Ohio. "I thought that artists could make things—miraculous things—things that were really special and absolutely sublime," she recalled, explaining that that idealistic notion

JENNY HOLZER

led her to abstract painting and graduate study at the Rhode Island School of Design.

Increasingly frustrated with the "secondhand sublime" that she found in painting (and especially in RISD's conservative painting department), she started looking for other artistic outlets. Through a friend from school she learned about the conceptual art of Joseph Kosuth and started reading the *Fox*, a short-lived but lively magazine devoted to art and social change. A collection of diagrams she was making to study visual representation turned her attention to the use of captions, and she began experimenting with writing. She also tried to do some public works—leaving painted strips of fabric on the beach, and putting out bread in geometric patterns "so people could watch pigeons eat in squares and triangles"—but these works, she acknowledged, "weren't beautiful enough or compelling enough or understandable enough to make people watch."

After a year at RISD, from which she received her M.F.A. degree, Holzer decided it would be better to spend some time in New York, and in 1976 she enrolled in the independent study program at the Whitney Museum, where she embarked on a year-long "crash contemporary art history course" in the form of weekly seminars with visiting artists. Through contact with conceptual artists like Dan Graham and Vito Acconci, she realized that she wanted to keep doing public pieces. A rather impenetrable reading list that she received from the Whitney provided the final catalyst: "I figured I was reasonably bright and reasonably well educated, and if I

couldn't plow through it, certainly a lot of other people couldn't either. I realized the stuff was important and profound, so I thought maybe I could translate these things into a language that was accessible." Still intrigued by the power of the word and inspired by the profusion of posters and leaflets that she saw in the streets of New York, she started writing her own texts, which she then typed, offset, and pasted all over her SoHo neighborhood in 1977.

Those "Truisms," as she called them, offered reflections on power, love, money, violence, and other aspects of the human condition in the form of one-line statements like "ABUSE OF POWER COMES AS NO SURPRISE"; "ENJOY YOURSELF BECAUSE YOU CAN'T CHANGE ANYTHING ANYWAY"; "EXPIRING FOR LOVE IS BEAUTIFUL BUT STUPID"; "MONEY CREATES TASTE"; or "MURDER HAS ITS SEXUAL SIDE." The tone, like the typeface, was uniform and declarative, and the order strictly alphabetical, but the content was quite opinionated and often contradictory (as in "CHILDREN ARE THE CRUELLEST OF ALL" followed by "CHILDREN ARE THE HOPE OF THE FUTURE"). For Holzer, that mélange of seemingly received wisdom was not simply intended to make the fashionable point that reality itself is contradictory, but also "to show that truths as experienced by individuals are valid." As she explained to Jeanne Siegel in 1985, "I wanted to give each assertion equal weight in hopes that the whole series would instill some sense of tolerance in the onlookers or the reader." But at the same time, she added, "The other thing I was going for was the absurd effect of one Truism juxtaposed against the next one. I hoped it would be adequately ridiculous."

Holzer continued to create new "Truisms" over the next two years. At first they were strictly a street affair: emulating an equally anonymous leafleteer who had covered the Times Square area with dire warnings about leprosy and local vice, she tried to keep her neighborhood saturated with posters. In addition to monitoring the graffiti they inevitably attracted, she took to eavesdropping in order to get feedback from onlookers. ("To write a quality cliche," she announced to Siegel, "you have to come up with something new.") In 1978 she ventured indoors as well, hanging large photostat versions of her "Truisms" in the window of Franklin Furnace, a SoHo artists' space, and the window of Fashion Moda, another alternative gallery, in the South Bronx in 1979. Her intent, she has insisted, was not to enter the gallery scene, but to work on a larger scale and to use shop windows, which were more accessible at Franklin Furnace than they would have been at a clothing store.

Around the same time, she also began working with a new group of texts, "Inflammatory Essays" (1979–82). These were longer and more discursive than the single-sentence "Truisms," but mainly, as the title suggests, they were intended to be more provocative: "With the 'Truisms' I was aware that sometimes because each sentence was equally true it might have a kind of leveling or a deadening effect. So, for the next series, I made flaming statements in hopes that it would instill some sense of urgency in the reader, the passerby." The study of Lenin, Trotsky, Emma Goldman, Hitler—"anyone with an axe to grind so I could learn how"—led her to such confrontational prose as "PEOPLE MUST PAY FOR WHAT THEY HOLD, FOR WHAT THEY STEAL. YOU HAVE LIVED OFF THE FAT OF THE LAND. NOW YOU ARE THE PIG WHO IS READY FOR SLAUGHTER."

In 1980 Holzer initiated yet a third group of texts, the "Living" series (1980–82), in order to deal with issues of daily life. Here she resumed a dispassionate discourse, but one that was more personal and anecdotal—in focus and tone—than the "Truisms": "ONCE YOU KNOW HOW TO DO SOMETHING, YOU'RE PRONE TO TRY IT AGAIN. AN UNHAPPY EXAMPLE IS COMPULSIVE MURDER. THIS IS NOT TO BE CONFUSED WITH USEFUL SKILLS ACQUIRED THROUGH YEARS OF HARD WORK." "MORE THAN ONCE I'VE WAKENED WITH TEARS RUNNING DOWN MY CHEEKS. I HAVE HAD TO THINK WHETHER I WAS CRYING OR WHETHER IT WAS INVOLUNTARY, LIKE DROOLING." "AFTER DARK, IT'S A RELIEF TO SEE A GIRL WALKING TOWARD OR BEHIND YOU. THEN YOU'RE MUCH LESS LIKELY TO BE ASSAULTED."

As Carter Ratcliff rightly suggested, in contrast to the "rapid-fire assault" of the "Truisms," which were geared to street reading, the "Living" texts, with their meandering logic, "unfocus the mind, then leave it on edge." In fact, by the time she undertook the "Living" series, Holzer was no longer an unknown street artist, or even a window artist: she had organized a "Manifesto Show" (of manifestos written by 150 artists) with a group called Collaborative Projects and then participated in their "Times Square Show"; she had published several artist's books, including *A Little Knowledge* (1979), *The Black Book* (1980), and *Hotel* and *Living* (both with Peter Nadin, 1980), and most significantly, she had been included in more than a dozen group shows in New York, Los Angeles, London, Zurich, Munich, and elsewhere. For the "Inflammatory Essays," she had consciously retained the poster style of the "Truisms": as she indicated to Ferguson, "They're really hot, flaming, nasty things and they need to have an underground format for immediacy." But with the "Living" series, she began to explore new ways of getting her message across. "I became ostensibly 'upper-anonymous' instead of 'lower-anonymous,'" she told Ferguson, alluding to the

painted metal signs and cast bronze plaques that started to make their way not only into galleries and museums but also into other institutional settings, like office buildings and universities.

The "Truisms," too, received more upscale treatment: translated into German, they were painted on the wall of Kranefuss Haus in Kassel for Documenta 7; they were printed on styrofoam coffee cups (for corporate cafeteria fare), and they were stamped on T-shirts (and later baseball caps). In February 1982 they wound up on display at the Marine Midland Bank on lower Broadway as part of the "Art Lobby" project. But as Holzer quickly discovered, that kind of institutional recognition—her first public-art commission—carried its own risks: after one week, bank officials noticed that her collection of home-grown wisdom included "IT'S NOT GOOD TO LIVE ON CREDIT," and promptly removed the piece. "It was a real education to find out that with commissioned art, you can still get slammed," she remarked to Ferguson, adding that afterward, she "tried to figure out how to make the same thing happen, but not in a situation where you have to ask permission to do it."

A month after that setback (which was not without its positive side, according to Holzer, in that "somebody actually read the thing"), she was back in public with another group of "Truisms," a different sponsor, and an altogether different format: Invited by the Public Art Fund to display her work on the giant Spectacolor signboard over Times Square (where the ball drops on New Year's Eve), she saw a series of her "Truisms" flashing in forty-second sequences for two weeks. And in the wake of that project, Holzer adapted both the "Truisms" and the "Living" series to other electronic formats as well, ranging from the relatively modest LED (light-emitting diode) signs that usually beam their continuous horizontal messages in shop windows and waiting rooms to state-of-the-art TransLux News Jet signboards that are telex programmed to emit words and images in complex multicolored patterns. With much the same logic that had prompted her to cover SoHo with street leaflets five years earlier, Holzer turned to the electronic sign because of its attention-getting capacity and the "shock value" her messages introduced in a medium normally reserved for the time, the weather, and the authority of advertising. Stressing that her inspiration came from a sign she saw in Kennedy Airport ("I just get nervous when people say it looks like art," she told Siegel), Holzer explained that, for her, the advantage of the moving word is that it represents an approximation of the spoken word: "You can emphasize things; you can roll and pause, which is the equivalent of inflection in

the voice." The other side of that immediacy, of course, was that the duration of the printed word was lost, and as Holzer realized early on, it was no longer possible to bring together forty or fifty conflicting statements and expect a viewer to analyze them as they flashed by. But in the process of sorting through the "Truisms" for the Times Square signboard, she realized that her own attitude had changed as well: "I suddenly didn't want to put up any that I disagreed with," she said, "so I chose half a dozen that I felt comfortable with. That was a funny development for yours truly."

The closing of the gap between the author and her chosen voice of authority was reinforced with a new group of texts that Holzer introduced—on ten-foot Unex signs—in 1983. The "Survival" series (1983–85) was intended to address much the same issues as the "Living" series, but with a greater sense of urgency. For the "Living" series, she explained to Ferguson, "I took things from everyday life and tried to put a twist on them. But I don't think I twisted enough. . . . So I decided to up the ante from living to survival." Here her messages are conveyed in a talky, often playful language that lends itself to the visual gymnastics of the electronic signs (and vice versa): "HONEY, TELL ME EXACTLY WHAT WILL HAPPEN ON EARTH AND IF YOU WANT IT" (accompanied by the image of a globe turned to North America). "DANCE ON DOWN TO THE GOVERNMENT AND TELL THEM YOU'RE EAGER TO RULE BECAUSE YOU KNOW WHAT'S GOOD FOR YOU." "WHEN YOU EXPECT FAIR PLAY YOU CREATE AN INFECTIOUS BUBBLE OF MADNESS AROUND YOU."

When the electronic version of the "Survival" series was shown at the Barbara Gladstone Gallery in 1983 (along with a number of cast bronze plaques and two paintings done in collaboration with the graffiti artist Lady Pink), Richard Armstrong wrote, "From their humble origins on photocopied colored paper to their latest incarnations in state-of-the-art electronic message machines, Jenny Holzer's homemade Truisms—part homily, part syllogism, all confounding—have been the most intriguing variation on and the final apotheosis of word art." But neither the critics nor Holzer herself failed to recognize that what had begun as an iconoclastic act of guerrilla art had evolved into expensive gallery icons; she later told Ferguson, "Selling my work to wealthy people can be like giving little thrills to the people I'm sometimes criticizing."

At the time, Holzer's response was to find ways of taking her message back to the streets. Before long, stickers bearing selections from the "Survival" series were making their way onto trash cans, parking meters, and public tele-

phones all over New York. In November 1984 she organized an ambitious public event called "Sign on a Truck," which involved twenty-one other artists and various passersby in a kind of video forum on the upcoming presidential election: an eighteen-foot-long Diamond Vision Mobile 2000 screen was set up in two locations in downtown Manhattan and Brooklyn to project artists' videos, prerecorded street interviews, and spontaneous responses from onlookers, large numbers of whom, in contrast to Holzer's own position, supported Ronald Reagan. Over the next two years, Holzer found other public outlets for her work in Washington, D.C., Philadelphia, Toronto, and Vienna; in 1986, she brought the "Truisms" and the "Survival" series to Las Vegas to mark the opening of the Nevada Institute of Contemporary Art with electronic signs at Caesar's Palace, the university sports center, two shopping centers, and the airport.

In her conversation with Ferguson just afterward, Holzer stressed the need to keep up her "practice" outside museums and galleries: "This is where my work went originally and where I still feel it operates best." But she also acknowledged the benefits of "coming indoors," in terms of the opportunity for sustained discussion and critical insights; when she returned to the gallery in 1986 (for her first real solo exhibition in three years), it was very obviously with the intent of maximizing the intellectual advantages while making the fewest possible concessions to the system as a whole. The new work, "Under a Rock," consisted of two LED signs and ten black granite benches disposed chapel-style under individual spotlights in a darkened room; the same apocalyptic messages that flashed out from the signs (incantory visions of rape, murder, war) were carved into the benches for a more reflective/sedentary reading. With texts like "YOU SPIT ON THEM BECAUSE THE TASTE LEFT ON YOUR TEETH EXCITES. YOU SHOWED HOPE ALL OVER YOUR FACE FOR YEARS AND THEN KILLED THEM IN THE INTERESTS OF TIME," the pieces were, as Holzer explained, "literally harder to read and to comprehend, and this slowness leads to a complexity that I'm trying for."

The juxtaposition of high-tech electronics and the ancient medium of stone was one of the hallmarks of her next series, entitled "Laments," which Holzer began in 1987 while traveling the summer exhibition circuit in Europe and which was displayed in its completed form in 1989–90 at the Dia Art Foundation's Chelsea warehouse space. Comprising thirteen sarcophagi and an equal number of columnar LED signs, the "Laments" read as though spoken by individuals who are "measuring their lives against what might have been," in Holzer's description. As in

"Under a Rock," the same messages can be read on the electronic signs and the corresponding sarcophagi: "I BECAME TOO HOT. THE BLACK DIRT'S HEAT MADE THE AIR WRIGGLE." "THE NEW DISEASE CAME. I LEARN THAT TIME DOES NOT HEAL." "I DO NOT WANT TO STOP KNOWING ALL MY FACTS." The critic Roberta Smith praised Holzer's skillful combination of electronics and engraved stone, writing that Holzer "succeeds for the first time in orchestrating these two opposed forms of communication into an elaborately perceptual environment whose nonverbal effects are as powerful as its linguistic ones."

For most critics, "Laments" was clearly Holzer's most accomplished series to date, demonstrating a powerful mastery of words, technologies, and galleries alike. The question of "radical chic" that some have been raising since she first switched from leaflets to lights still remains, but the rather striking consistency of her aims and commitments over thirteen years of activity suggests that she is unlikely to get stuck "indoors." Indeed, as the United States representative to the 1990 Venice Biennale—the first woman so honored—Holzer utilized not only the American pavilion for her exhibition, but also the surrounding outdoor areas. Just prior to the May Biennale, there was an exhibition of her works at the Guggenheim Museum in New York City in 1989–90, for which she programmed hundreds of texts into a 535-foot-long electronic message board, prompting one critic to call the exhibit "the best spectacle in town"; there were also a number of granite benches, arranged in a circle and in rows.

The tall, long-haired Jenny Holzer is married to the artist Mike Glier. Along with their young daughter, Lili, they divide their time between an apartment on the Lower East Side and a former dairy farm in Hoosick, New York. Living in the country, Holzer has said, has helped her "in writing more concrete descriptions of things." But rural living has its depressing aspects as well, as she told Ferguson: "Little birdies and things rejuvenate your sense of tragedy."

EXHIBITIONS INCLUDE: Gal. Rudiger Schottle, Munich 1980; Onze Rue Clavel, Paris 1980; Le Nouveau Mus. Lyon 1981, '84; Mus. fur (Sub) Kultur, Berlin 1981; One Times Square, NYC 1982; Barbara Gladstone Gal., NYC from 1982; Artists Space, NYC 1982; American Graffiti Gal., Amsterdam 1982; Gal. Chantal Crousel, Paris from 1982; A Space, Toronto 1982; Inst. of Contemporary Art, Philadelphia 1983; Inst. of Contemporary Art, London 1983; Lisson Gal., London 1983; Seattle Art Mus., Wash. 1984; Amelie Wallace Gal., SUNY, Old Westbury, L.I., N.Y. 1984; Cranbrook Mus., Bloomfield Hills, Mich. 1984; Gal. Venster, Rotterdam Kunststichting 1984; Kunsthalle Basel 1984 (with Barbara Kruger); Univ. Gal., Univ. of

Mass., Amherst 1984; Mus. of Art, Dallas 1984; Palladium, NYC 1986; Israel Mus., Jerusalem 1986 (with Barbara Kruger); Am Hof, Vienna 1986 (with Keith Haring); Contemporary Arts Cntr., Cincinnati 1986 (with Cindy Sherman); Gal. Monika Sprüth, Cologne 1986; Des Moines Art Cntr., 1986 (trav. exhib. also shown at Aspen Art Mus., Colo.; Artspace, San Francisco; Fruit Market, Edinburgh; Mus. Contemporary Art, Chicago; List Visual Art Cntr., MIT, Cambridge, Mass.); Rhona Hoffman Gal., Chicago 1987; Dia Art Foundation and Guggenheim Mus., NYC 1989–90.
GROUP EXHIBITIONS INCLUDE: P.S. 1, Inst. for Art and Urban Resources, Long Island City 1978; "Artwords and Bookwords," Los Angeles Inst. of Contemporary Art, 1978; "Show/515 Broadway," NYC 1979; "Doctor and Dentist Show," 591 Broadway, NYC 1979; "Income and Wealth Show," "Manifesto Show," 5 Bleecker Street, NYC 1979; "New York Video," Kunsthaus, Zurich and Städtische Gal. im Lenbachhaus, Munich 1980; "Times Square Show," NYC 1980; "Collaborative Projects," Brooke Alexander Gal., NYC 1980; "Issue," Inst. of Contemporary Art, London 1980; "Vigilance," Franklin Furnace, NYC 1980; "Represent, Representation, Representative," Brooke Alexander Gal., NYC 1981; "Pictures and Promises and Pictures Lie," The Kitchen, NYC 1981; "Westkunst Heute," Cologne 1981; "Art Lobby," Marine Midland Bank, NYC 1982; Documenta 7, Kassel 1982; "Presence Discrete," Mus. des Beaux-Arts, Dijon 1983; "The Revolutionary Power of Women's Laughter," Max Protech Gal., NYC 1983; "Currents," Inst. of Contemporary Art, Boston 1983; "Ansatzpunkte Kritischer Kunst Heute," Kunstverein, Bonn 1983; "Dahn, Daniels, Holzer, Longo, Genzken, & Visch," Stedelijk van Abbemus., Eindhoven 1983; Whitney Biennial, NYC 1983; "Disarming Images: Art for Nuclear Disarmament," Contemporary Arts Cntr., Cincinnati 1984 (trav. exhib.); "Time Line," P.S. 1, Long Island City 1984; "Art as Social Conscience," Bard College, Annandale-on-Hudson, N.Y. 1984; "12 Women from New York," Gal. Engstrom, Stockholm 1984; "Szene New York," Cologne Art Fair 1984; "Women of Influence," Amerika Haus, Berlin 1984; "A Different Climate," Kunsthalle, Düsseldorf 1984; "New York—Ailleurs et Autrement," ARC Mus. d'Art Moderne de la Ville de Paris 1984; Sydney Biennale 1984; "Kunst mit Eigen-Sinn," Mus. Moderner Kunst/ Mus. des 20. Jahrhunderts, Vienna 1985; "Signs," New Mus. of Contemporary Art, NYC 1985; "Currents 7: Words in Action," Milwaukee Art Cntr. 1985; "Ecrans Politiques," Mus. d'Art Contemporain Montreal 1985; "Eau de Cologne," Gal. Monike Sprüth, Cologne 1985; Paris Biennale 1985; "Secular Attitudes," Los Angeles Inst. of Contemporary Art 1985; Whitney Biennial 1985; Carnegie International, Carnegie Inst., Pittsburgh 1985; "Europa/Amerika," Mus. Ludwig, Cologne 1986; "Artware," Hanover Messe, Hanover 1986; "Dissent: The Issue of Modern Art in Boston," Inst. of Contemporary Art, Boston 1986; "A Different Climate," Städtische Kunsthalle, Düsseldorf 1986; "In Other Words," Corcoran Gal., Washington, D.C. 1986; "Prospect," Kunstverein, Frankfurt 1986; "Products and Promotion: Art, Advertising and the American Dream," San Francisco Camerawork; Ohio State Univ., Columbus Franklin Furnace, NYC 1986;

"Resistance," White Columns, NYC 1987; "Contemporary American Artists in Print," Yale Univ. Art Gal., New Haven 1987; "20 Artists 20 Stations," Cntr. of International Contemporary Art, Montreal 1987; "L'epoque, la morale, la mode, la passion," Mus. National d'Art Modern Paris 1987; Documenta 8, Kassel 1987; Venice Biennale 1990.

COLLECTIONS INCLUDE: Mus. of Contemporary Art, Chicago; van Abbemus., Eindhoven; Tate Gal., London; MOMA, NYC.

ABOUT: Current Biography, 1990; "A Different Climate: Women Artists Use New Media" (cat.), Städtische Kunsthalle, Düsseldorf, 1986; "Jenny Holzer: Signs" (cat.), Des Moines Art Cntr., 1986; "New York—Ailleurs et Autrement" (cat.), ARC Mus. d'Art Moderne de la Ville de Paris, 1984; "Private Property Created Crime" (cat.), Kunsthalle, Basel and Le Norveau Mus., Lyon, 1984; Who's Who in American Art, 1989–90. *Periodicals*— Artforum April 1981, February 1984, May 1987; Art in America November 1982, January 1985, December 1986; Art Journal Fall 1985; Arts Magazine December 1985, January 1987; ARTnews January 1984, Summer 1988; Artscribe January–February 1987; Print Collectors' Newsletter November–December 1982; Tema Celeste January–March 1987.

BY THE ARTIST: A Little Knowledge, 1979; The Black Book, 1980; Hotel, 1980 (with Peter Nadin); Living, 1980 (with Peter Nadin); Eating Friends, 1981 (with Peter Nadin); Eating through Living, 1981 (with Peter Nadin); Truisms and Essays, 1983.

HONEGGER, GOTTFRIED (June 17, 1917–), Swiss painter and sculptor whose thirty-year career reflects an ongoing dialogue with the European constructivist tradition in the light of subsequent developments in art and technology alike. Lapsing in and out of the public eye since his breakthrough in New York in 1960, Honegger has never been particularly fashionable as part of a larger trend or movement, but his artistic preoccupations have remained consistently relevant to a wide audience in Europe and abroad.

Honegger began his career in the fine arts only at the age of forty-one, when he shut down his graphic arts studio in Zurich and moved to Paris to devote himself to painting. His initial involvement with applied art, he later explained, was very much a result of his immediate surroundings. Born in Zurich, he was the son of a worker who was active in the religious socialist movement, and he grew up with the idea that art should serve as a vehicle for social change. Even in the larger Swiss society, according to Honegger, a "useful" art like design was more valued than a "luxury" art like painting or sculp-

ture. "This moral idea, [which was] essential for me," he told Serge Lemoine in 1973, "made me consider art immoral if it wasn't in the service of *design*." In fact, what he described as the "Zwinglerian, Puritan, rather Germanic" atmosphere of Zurich was not his only heritage: his mother came from the Grisons canton, and a week after his birth he was brought back to her native Engadine, where he grew up. As he takes pains to point out, his first language was Grison (a Latinate tongue) rather than German, and he considers himself to be "Latin."

Nonetheless, by the age of fifteen he was enrolled in the Zurich School of Applied Art (Kunstgewerbeschule). After two semesters he went to work as an apprentice window designer; three years later, he began studying graphic design with Warja Lavater, a young designer four years older than himself. In 1939 he went to Paris to work as a free-lance artist but returned to Zurich with the outbreak of the Second World War and spent the following six years in the Swiss army. He and Lavater were married in 1940, and after the war they ran a successful graphics atelier together. By the 1950s Honegger was a well-known advertising artist and designer with commissions ranging from glassware and tapestries to wall reliefs and poster design; he taught at the Kunstgewerbeschule, and he was involved in political and union activities as a member of the Swiss socialist party, the Werkbund, and the International Association of Graphic Artists. Painting, meanwhile, was something that he did on the side, initally in a straightforward figurative style but with increasing abstraction after his visit to Paris and his encounter with cubism there. By the 1950s he had arrived at a geometric idiom playing on the juxtaposition of forms, colors, and textures, a sensibility that was very much in keeping with the prevailing, Bauhaus-influenced movement in Zurich, art concret.

Honegger was in fact a close friend of two of the leading concretists, Max Bill and Richard P. Lohse, but he tends to minimize any direct aesthetic influence: "Since my stay in Paris, I was working in the cubist tradition," he explained to Lemoine, "but little by little I was caught up in the Zurich ambiance: not by the aesthetic of art concret, but by their moral ideas. I tried to find a simple language that could be used in industry, and I standardized my forms; I used numbers more and more. Later than they did, under their direct influence, especially that of Bill, I made use of a fixed mathematical system."

In any event, the turning point in his career (or careers) came in 1958 when the Swiss pharmaceutical company he had been working for sent him to New York for two years. There,

through his friend Arnold Rüdlinger, the director of the Basel Kunsthalle, who was a frequent guest, he got to know some of the leading figures in the New York School—Al Held, Sam Francis, Al Jensen, Barnett Newman, George Sugarman, Franz Kline, Ludwig Sander, Mark Rothko. He was already aware of their work through an exhibition of American painting held at the Basel Kunsthalle in 1957, but as with art concret, what was important for him was not so much the aesthetics of the New York school artists as their "moral" attitude. In the late 1950s, it should be remembered, practically no one in New York—except for Sander and Ellsworth Kelly—was even involved with geometric abstraction; what affected Honegger was their radically different attitude toward art. For the action painters, unlike his compatriots back in Zurich, design was not a noble enterprise but a commercial one, and they disdained it. At first, he recalled, "I still had Swiss reflexes, and it was hard for me to communicate with them. One night Sam Francis told me, 'Go to hell with your message.'" And, he added, "They convinced me I was right to leave Zurich."

In 1960, before his return to Europe, Honegger had a highly successful one-man show at the Martha Jackson Gallery in New York; there he exhibited the distinctive "tableaux-reliefs" that he had begun making three years before. They were canvases built up with mosaiclike patterns of geometric shapes, mostly squares and triangles, cut out of cardboard, pasted in place, and then painted in all-over colors. As he had acknowledged, he followed the example of the concretists in deriving his compositions from predetermined mathematical formulas, but he rejected the "smooth outer skins" of their canvases, and because of the welter of surface detail—variations of shape, placement, texture, and above all, light—the final effect of the tableaux-reliefs was anything but formulaic. In *Navaho* (1959), for example, what on first glance resembles an Albers painting with a green square bordered in cobalt blue, actually has a surface pattern of raised squares and triangles that forms a diamond within the square; that internal shape is further modulated with irregular identations along its outer edge and projections within, constantly playing on the tensions between shape and surface, form and contour.

In the catalog essay accompanying the Martha Jackson exhibit, Aleksis Rannit stressed the iconic nature of the tableaux-reliefs, pointing out that Honegger himself referred to them not as paintings but as "things" or "objects" in the sense of an object of meditation. That contemplative dimension was stressed as well by Herbert Read in an often-quoted "Letter to a Young Artist"

written the same year: in his view, the tableaux-reliefs constituted "an art constructed in time, and for time." For Honegger himself, the elements of time and duration were bound up in the aesthetics of silence that the composer John Cage had begun to explore in the 1950s (and in that respect, he has indicated, Cage was a more direct influence on his work than were the abstract expressionists). But from the outset, the tableaux-reliefs involved other considerations as well: insofar as art concret was intended to parallel industrial production, he later explained to Lemoine, it was standardized and ultimately anti-individualist, while he, on the other hand, "wanted to make an art that, while utilizing a determined geometry, would be individualist. The introduction of relief catches light on the canvas. The changing light modifies the composition: it introduces chance. In this way I've been able to combine determinism and chance."

It was after the Martha Jackson exhibit that Honegger took the decision to become "an unengaged, free artist, because I no longer believed in the value of artistic engagement." He gave up his design work, along with his union and political activities (he had already left the Werkbund in 1957), and while maintaining a base in Zurich, where he continued to spend several months a year, he moved to Paris with his wife and two daughters. In the course of the 1960s the tableaux-reliefs evolved from cardboard collages to cast polyester reliefs; they increased in size and regularity, they came to include curves as well as angular forms, and toward the end of the decade, the monochrome that had most often been red gave way to the insistent gray of graphite rubbed into gesso. "Basically I'm not a painter," he told Lemoine a few years later. "It's not the color that attracts me but rather the material."

His interest in materials led him in several other directions as well. In 1962 he began working with another kind of relief which his friend Michel Seuphor dubbed "biseautages," or bevelings: made out of matte board cut away with a knife, the biseautages offered another approach to the play on form and contour through the distinctive shapes and light patterns created in negative relief. During that period he also started experimenting with small sculptures that paired up natural materials—uncut rocks—with precise geometric forms cast in bronze. From the titles that he gave them—Pénétrer (Penetrate), Revéler (Reveal), Découvrir (Discover), Métamorphose (Metamorphosis)—it is clear that they were more than an exercise in visual contrasts; rather, they were again intended to explore the dynamic between determinism and chance. That initial venture was limited to eleven works executed in 1961–62, and it was only

six years later that Honegger turned again to sculpture. From that time on, he was to work simultaneously in relief and freestanding sculpture.

The first of his new sculptures, which he called Volumes (1968–70), consisted of various combinations of spherical sections which were made out of polished steel or polyester and assembled according to mathematical formulas. As with his two-dimensional works, the constructions derived their visual appeal from the complexity of their component forms and the surface properties of the materials used. But for Honegger, the limitations of mathematical programming were beginning to outweigh the advantages. "This system," he observed in 1973, "allowed me to develop a great number of ideas, with the exception of one: freedom. Knowing the result in advance, I was afraid of boredom." As a result, he adopted another method for designing both sculptures and reliefs with a wider range of possibilities: computer programming. He had already used a computer for his earliest tableaux-reliefs, but rather quickly switched to the dice that he was to rely on throughout the 1960s; but more than a decade later, following the example of the composer Pierre Barbaud, he began working with computer-generated designs based on horizontal probabilities.

For Honegger, the advantage of the computer was that a single program could generate as many as ten thousand designs, creating more visual possibilities than any individual could imagine. "This free choice open to anyone doesn't mean that there's chaos," he explained; it's the proof of a greater freedom. The idea of style goes against the exercise of freedom. A style is always the reflection of an ideology." In addition to expanding on the geometric, mosaiclike tableaux-reliefs that he had been doing, Honegger used the computer to generate emphatically nongeometric, free-form designs—somewhat like the early biseautages—which became the basis for a new series of cast polyester reliefs (1969–70), as well as relief aquatints (1970) and lithographs (1971). In his sculptures, meanwhile, the spherical Volumes gave way to the angular Structures (1970–78), which, quite apart from the computer, reflect a certain debt to developments in the United States, notably Tony Smith's modular constructions like Gracehoper (1961) or Willy (1962). The Hommage à Jacques Monod (Homage to Jacques Monod, 1975–76), for example, was based on a design selected (by computer) from 6,720 permutations of eight structures arranged in groups of five. That particular work provoked strong negative reactions from faculty and students at the University of Dijon, where it had been commissioned, rather

appropriately, in honor of the Nobel Prize–winning author of *Le hasard et la nécessité (Chance and Necessity*, 1970), with the result that it was moved to a less conspicuous site on the campus.

By that time, Honegger had been working as an artist for over fifteen years, with more than thirty one-man shows in Europe and the United States behind him. But he himself had little desire to remain in the spotlight. "I think that art should beware of publicity," he told Lemoine, "because it wears out creativity. I'm against all the movements that want to bring art into the streets; art should be made difficult so that it can only be discovered through profound necessity." Describing how he gave his tableaux-reliefs a base coat of paint that he then covered over, he explained that "I love hidden things, things that can't be read at first glance. I want people to make an effort to see my paintings." In the course of the late 1970s, he increasingly refined and reduced his visual means as if to minimalize the technical intervention and give pride of place to the underlying idea. Among his sculptures, for example, the *Steles* that he introduced in 1978 were thin columnar presences evoking primitive totems in all but their polished metal surfaces, while the *Monoforms* that he began in 1979 were based on the repetition of a single geometrically derived form. In the tableaux-reliefs, likewise, he turned increasingly to problems of unitary form, working with brightly colored diptychs and triptychs that boldly played off borders and fields rather than small internal units.

In 1980 Honegger decided to give up the use of chance altogether. As he explained to Gérard Gassiot-Talabot, it had served to free him from the mathematical determinism of his "ancestors" in Zurich, but he felt that it had come to dominate his paintings so much that critics were unable to see "the work on the canvas." Toward the middle of the decade, he abandoned symmetry as well, because, as he told Gassiot-Talabot, "for thirty years my work has been given a mystical, spiritual orientation. The one word I can't bear anymore is 'silence.'" At seventy, Honegger indicates that he is "drawing up the inventory, the balance sheet. I keep what seems to be to be a contribution to modern art and I eliminate everything that could have been an 'amusement' for me. Through this separation, I can destroy the icon and indicate that I'm involved with what's happening in the world." Why paint, he asks? Because "art is a means of changing the world. Art in general is a means for human beings to better confront life and to change it."

EXHIBITIONS INCLUDE: Gal. Chichio Haller, Zurich 1950;

George Wittenborn Gal., NYC 1951; Gal. 16, Zurich 1952; Gal. Laubli, Zurich 1958; Martha Jackson Gal., NYC 1960, '64; Gal. Fillon, Paris 1961; Gal. Lawrence, Paris 1962; Gal. Gimpel und Hanover, Zurich from 1963; Gimpel Fils, London 1964, '68; Gal. M. E. Thelen, Essen 1965; Württembergischer Kunstverein, Stuttgart 1966; Kunsthaus, Zurich 1967; Mus. am Ostwall, Dortmund 1968; Gal. Heseler, Munich 1968; Valley House Gal., Dallas 1969, '72; Gal. M. E. Thelen, Cologne 1970; Gal. Swart, Amsterdam 1972; Badischer Kunstverein, Karlsruhe 1972; Gal. Teufel, Cologne 1972; Gal. d'Art Moderne, Basel 1974; Gal. Denise Rene, Paris 1974, '75; Gal. Muller, Stuttgart 1975; São Paolo Bienal 1975; Mus. d'Art Moderne de la Ville de Paris 1978; Abbaye de Senaque, Gordes, France 1979; Gal. Nouvelles Images, the Hague 1979; Annely Juda Fine Art, London 1979; Kunstmus., Ulm 1980; Gals, de la Vieille Charité, Marseilles 1985; Mus. Saint-Pierre, Lyon 1986; Helmhaus, Zurich 1986. GROUP EXHIBITIONS INCLUDE: "Kunst und Naturform," Kunsthalle, Basel 1958; "Avant-Gard '61," Städtisches Mus., Trier 1961; Carnegie International, Pittsburgh 1962; Salon des Réalités Nouvelles, Mus. d'Art Moderne, Paris 1965, '66, '68; "The Swiss Avant-Garde," New York Cultural Center, NYC 1971; "12 Ans d'Art Contemporain en France," Grand Palais, Paris 1972; "Mouvement Peint, Mouvement Agi," Abbaye de Beaulieu-en-Rouerge, France 1976; "Von der Ungleichheit des Ahnlichen in der Kunst," Städtisches Mus., Gelsenkirchen 1983.

COLLECTIONS INCLUDE: Dana Col., Boston; Albright-Knox Art Gal., Buffalo; Mus. of Fine Arts, Dallas; Didrichson Art Foundation, Helsinki; Israel Mus., Jerusalem; Mus. Cantini, Marseilles; IBM Corp., N.Y.; CBS, NYC; Chase Manhattan Bank, NYC and Zurich; MOMA, NYC; Philadelphia Art Mus.; Pittsburg Art Mus.; Carnegie Inst., Pittsburgh; Princeton Univ. Art Mus., N.J.; Cntr. National d'Art Moderne, Paris; Hirshhorn Mus. and Sculpture Garden, Washington, D.C.; Kunstgewerbe Mus., Zurich; Kunsthaus, Zurich.

ABOUT: Emanuel, M., et al. Contemporary Artists, 1983; Forster, K. Gottfried Honegger: Works from 1939 to 1971, 1972; "Gottfried Honegger: Tableaux-Reliefs, Biseautages, Sculptures 1980–1985" (cat.), Gals. de la Vieille-Charité, Marseilles, 1985; "Honegger" (cat.), Mus. d'Art Moderne de la Ville de Paris, 1978; Honegger, G. Form in Art and Nature, 1958; Honegger, G. Hommage à Cercle et Carrée, 1964 (with Michel Seuphor); Honegger, G. Le jardin privé du géometre, 1975; Lemoine, S. Gottfried Honegger, 1983; Lemoine, S., M. Besset, and H. Heissenbüttel, Gottfried Honegger Tableaux-Reliefs/Skulpturen 1970–1983, 1983; Rannit, Aleksis. "Gottfried Honegger" (cat.), Martha Jackson Gal., NYC 1960. *Periodicals*—Art International January 1967; Art Press September 1987; Chronique de l'art vivant May 1973; Opus International Winter 1987.

HORN, REBECCA (March 24, 1944–), itinerant German artist who has used performance and body art, video, film, and installations to

elaborate a personal mythology that encompasses the primal world of nature and the technological possibilities of the machine age. Like other female artists of her generation, she has challenged basic assumptions of traditional art by taking personal, intimate experience as her point of departure and by placing women in the role of subjects rather than objects.

The daughter of a businessman–textile designer, she was born in Michelstadt (Odenwald) and grew up in postwar Berlin. After graduating from high school she studied in Hamburg, "as far away from the family as possible," she has explained; following her father's wishes, she took courses in business economics but pursued her own interest in painting secretly until Kai Sudeck, a professor at the Hochschule für Bildende Kunst in Hamburg, intervened on her behalf with her father and she began preparing for entrance exams for the art school. Before she actually transferred, her father died, followed a year later by her mother; "I was standing on my own feet very early," she has said. "From then on, everything was fine."

In fact, there ensued a very troubled period, during which she suffered various phobias—fear of airplanes, open spaces, and so forth—and toward the end of her studies she had an accident with polyester resin and was nearly asphyxiated by toxic fumes. During the yearlong convalescence that followed, Horn, who had been training as a sculptor, rethought all of her artistic activity; when she resumed work in 1968, her primary vehicle had become the human body, fitted with uncanny sculptural extensions intended to provoke both sensory and sensual awareness. *Arm Extensions* (1968), for example, consisted of padded black tubes that "extended" the arms down to the floor; laced around the body from breasts to ankles, they had the effect of completely immobilizing the wearer, and in that way also drew attention to the body's potential movement and gracefulness. Another work was *Cornucopia: Séance für zwei Brüste* (*Cornucopia: Séance for Two Breasts,* 1970), a kind of halter-mask connecting the breasts to the wearer's mouth and intended, according to Horn, to "create a sensation of communication with oneself; by isolating the breasts and separating them from each other," she explained, "one's perception expands triangularly, allowing them their individuality as any two separate beings."

Those and other pieces were presented in small private performances aimed, in Horn's words, at "creating new models of interaction rituals." Each situation, she said "should result in dissolving barriers between passive spectators and active performers. There should only be

participants." The sculptures were custom-made for the wearers—Horn herself, her friends, or an occasional stranger who caught her attention, as was the case with *Einhorn* (*Unicorn,* 1970), where a woman she had seen walking down the street was persuaded by Horn to don a black horn and prance naked in an open space.

As Nena Dimitrijevic has remarked, there was nothing casual about those pieces: in the tradition of ritual, every movement was carefully chosen and ordered, and the performers subject to a strict discipline. In fact, because of the effort that the performances demanded, they tended to be one-time events, and for that reason, beginning with *Unicorn,* Horn turned to film as a means of documentation. In the process, her focus shifted somewhat, from the immediate awareness of the body—"interpersonal perception," as she calls it—to the broader interaction of the body with the environment. That evolution is reflected in *Performance* (1972–73), the two-part film she and the Berlin filmmaker Helmuth Wietz edited from her early footage: while the first part presents various transformations of the body itself, including body painting (*Red Limbs*) and an oneiric vision of pubic hair (*Hair Grows*), the second highlights the extension of the body into the environment, as with *Finger Gloves,* in which Horn is fitted with long sticks protruding from her fingers like a blind person's cane, or *Pencil Mask,* which shows her wearing a face mask of radiating pencils with which she "draws" on the wall.

Horn herself was well aware of the added dimensions film brought to her work: "While filming the actions," she explained to Bice Curiger, "I noticed how it is possible to create a personal statement through the use of the camera with different angles, shots, and movements and then through the editing of the material. . . . I can capture all of the details that seem important to me, details that would be lost on the stage during a performance, where everything is seen from the same distance." As the complexity of the performances increased, notably with the introduction of multiple participants, the narrative element became more prominent as well; an invitation to Documenta 5 in 1972, for example, gave Horn the opportunity to stage her first major public work, *Kopf-Extension* (*Head Extension*), where one performer outfitted with a tall post harnessed to his head and shoulders was guided by four others holding ropes attached to the top of the post. As Michael Bonesteel commented, there was a certain "majesty and mystery" in that unlikely cortège, with all of its implications for the broader social theme of dependency. In another work of that period, *Feather Instrument* (1972), the same is-

sue is examined, somewhat humorously, in terms of man-woman relations through a situation where two women alternately raise and lower a pair of blinds to reveal a nude man covered with feathers.

In the course of the 1970s—when Horn was dividing her time between Hamburg and New York—her work became at once poetic and more discomforting. Feathers, for example, became a prominent motif, used in masks and body fans to reinforce the sensuous, often erotic element of the body extensions, but conveying great vulnerability at the same time. "The bird dies, the feathers live on," Horn has commented, explaining that "the feather covering is a layer for protection and warmth and also becomes in my objects a second body space that surrounds the person and hides parts of the body. With these wings that are fastened to the body, the performer can wrap himself up, open them out, only to enclose himself again in the protective interior." For the feminist critic Lucy Lippard, who situated such works within the larger phenomenon of women's "transformational" art, there was even something of "a medieval aura of torture" about the masks and body sculpture that "are as often prisons or cages as they are a means of communication."

With the "Berlin Exercises in Nine Parts," a series of individual segments filmed over a ten-week period in 1974–75, Horn created a virtual summary of her performances to date. A number of the pieces consisted of ever more elaborate body extensions—feather fans mounted on her shoulders like a giant bird, mirror panels that dissolved her body into an infinite regression of reflections—while others offered more vignette-like commentaries, as in Keep Those Legs from Cheating Each Other, where Horn and a male friend had their legs bound together by strips of cloth sewn with magnetic buttons, or Cutting Hair with Two Pairs of Scissors, where Horn actually chopped off her hair with scissors in both hands. In a concluding section, The Immaculate Conception, a surrealist text on lovemaking positions, was adapted with male and female roles reversed.

The "Berlin Exercises" brought Horn the 1975 German Critics Prize as the outstanding artist of the year, and it was highly acclaimed in experimental film circles—Ann-Sargent Wooster wrote in Afterimage, for example, of "a series of magical transformations wrought by superlative costumes (more like sculpture) and props, highly nuanced performances, and an astute use of the camera to redefine the space of a room." In terms of her own development, as Zdanek Felix pointed out, it marked a definite turning point,

with the interpersonal focus of the earlier pieces giving way to a more individualized, subjective expression (explicitly conveyed in the film's subtitle, "Dreaming Under Water").

In the works that followed, that subjectivity became more pronounced, even, somewhat paradoxically, as Horn withdrew her own physical presence. Her next major work, for example, was a video piece for two monitors, The Dialogue of the Paradise Widow, created for the 1975 Paris Biennale and featuring a tall column of black feathers with a nude woman inside (The Paradise Widow), which was accompanied by a woman's voice (Horn's) reading a mélange of diary entries, fantasies, and personal recollections. The same dynamics of space (female) and power (male) were then strikingly inverted with The Chinese Fiancée (1976), a hexagonal black booth with doors that snapped shut as soon as someone entered; before being released at the end of a very long sixty seconds, the unwitting detainee was entertained with the sounds of young girls giggling and whispering in Chinese. Here Horn has been inspired by a Chinese custom of blindfolding a prospective bride and shutting her in a closet until her fiancé freed her, but as in The Feather Instrument or the Immaculate Conception section of the "Berlin Exercises," the element of role reversal in the implied male visitor cast the sexual undertones in a very different light.

Notwithstanding that thematic continuity, The Chinese Fiancée marked another major turning point in Horn's evolution, insofar as it was not a body extension but an autonomous mechanical device. Indeed, that seemingly unlikely (but thoroughly Duchampian) use of machine forms to express human content is the most characteristic feature of her work from that point on. Beginning with The Chinese Fiancée, the (kinetic) object superseded the performance and with it, Horn's direct participation. She continued with film, but now turned to dramatic fiction—which included the mechanical devices among the characters—and at the same time began to work with installations, which ultimately reinforced the sculptural aspect of her expression. Her next film, for example, Der Eintänzer (The Dancing Cavalier, 1978), included actors, dialogue, narration (Horn's voice)—and a mechanical table in the title role. Structured around characters, who are as idiosyncratic as the earlier body extensions—an absent dancing teacher, twin sisters who come to stay in her loft (one of whom winds up flying off a swing and out of the window to her death), a contentious piano player, a blind man who wants to learn the tango, and the tango-dancing table—the film basically presents a series of encounters (in seventeen tab-

leaux) rather than a linear narrative. To be sure, all of the familiar motifs are woven in—feather fans, bound bodies, mirrors—with much the same cumulative effect as the performances; in Nena Dimitrijevic's words, "the abstract notion of sensitivity [is] counterbalanced by the tension of lurking danger."

The Dancing Cavalier was shot in Horn's New York studio, with her friends in all but one of the roles (the blind man, Frazer, was played by a professional actor, David Warrilow, a leading interpreter of Samuel Beckett). In that way, she insisted, it was just as autobiographical as her earlier work: everything was "so much from and about me that I just couldn't accept the idea of appearing in it myself." For some critics, such as Michael Bonesteel, the result was too disjoined, and in particular, the dancing table too contrived, but most saw it as an innovative personal expression: "The effect is striking," wrote Helena Kontva. "It is as if everything she had done before constituted single pages in a book and now she has bound all the pages together." Yet, as Horn herself pointed out, the film itself was not a definitive statement, or even a definitive format; once completed, she told Bice Curiger, the objects "develop a new life of their own. The story of the film belongs to them, they fill it out and carry it on to further stages."

In that way, Horn assembled the table and other objects from the film into an installation that paralleled the screenings at the Hanover Kestner-Gesellschaft; the following year, she transformed the swing that had served to catapult the twin out of the window in the film into "The Dialogue of the Twin Swings," a gallery installation featuring two silver-plated metal swings mechanically propelled toward each other in what she described as "an endless dialogue of motion." That translation of themes and motifs continued throughout the 1980s: the shoulder fans of the mid-1970s, for example, were transformed into the imposing *Pfauenmaschine* (*Peacock Machine,* 1980), a mechanized metal armature that orchestrated the delicate plumage into a symmetrical dance of attraction and repulsion. That kinetic sculpture was then incorporated into Horn's next film, *La Ferdinanda: Sonata for a Medici Villa* (1981), along with other objects (including the motorized swing that originated in *The Dancing Cavalier*), all of which were presented in an installation accompanying the première of the film. The film itself is another collage of eccentric characters whose lives intersect without interconnecting; in this instance, the setting is the Medici hunting lodge of the title, where a spurious "doctor" and his failed artist friends play out their pretensions in what Annie Pohlen described as "a timeless picture of erotic creativity and cultic masquerade."

After *La Ferdinanda,* Horn began work on another film, *Buster's Bedroom,* inspired by the life of comedian Buster Keaton, whose frustrations with Hollywood (and fascination with mechanical devices) lent itself to another drama of the absurd, this time set in the sanatorium where Keaton and other victims of Hollywood ended their days. As the project dragged on, Horn continued to expand her repertoire of kinetic sculpture and to attract increasing recognition for the originality of her vision. In the early 1980s there were a number of cyclical pieces that, like *Peacock Machine,* offered pointed commentaries on the difficulty of human, and especially male-female, interaction. For Documenta 7 in 1982, for example, Horn created a featherless version of *Peacock Machine*—variously interpreted as the female of the species or the male stripped of his plumage; a similar movement was abstracted into the *Kleine Federrad* (*Small Feather Wheel,* 1982) and given perhaps its most poignant expression in the highly acclaimed *Ohnmacht der Gefühle* (*Unconsciousness of Feelings,* 1982), where two small hammers (another motif from *La Ferdinanda*) swung up toward each other without meeting and then fell back to their separate, supine positions. Along with those ultramodern metaphors of the human condition, Horn worked with a series of timeless motifs—ostrich eggs, pools of liquid, boxes of alchemical elements, piles of richly colored pigment—which in their immobility created both a visual and a conceptual counterpoint to the automated rhythm of the machines.

Increasingly, Horn has brought those two worlds together in what Mona Thomas aptly described as "the dialogue between the mechanical and the organic." Following a series of installations in New York, London, Vienna, and Paris in 1986, where the major pieces of the 1980s were combined and recombined like variations on a theme, she created her most ambitious and successful public work to date, *Das Gegenläufige Konzert* (*The Countermoving Concert*), for the 1987 Projekt Skulpturen in Münster. Working in the ruins of a sixteenth-century fortification tower that had been used as a torture chamber by the Nazis, she filled the cells with the sound of steel hammers knocking on the walls and ceilings, and in the courtyard, now overgrown with trees and plants, set up a giant Plexiglas funnel to drip water at twenty-second intervals into a steel basin below (thus creating the "countermoving concert" of ripples) and installed a pair of snakes that were fed with a local mouse every day. Through those "subtle, simple means," observed Bice Curiger, "the passage through the staccato concert of thin hammer

blows became a passage through the collective memory, seizing the viewers with extremely physical, though undefined, inner sensations."

In artistic terms, what is perhaps most striking about the Münster project is that such a topical statement was achieved with the same basic vocabulary of motifs that Horn has explored in all of her work for the last decade (even the snakes were nothing new—the title of her Paris installation was "Night and Day on the Back of the Two-Headed Serpent"). In fact, as Jan Debbaut observed at the time of the Paris exhibit, "For fifteen years Rebecca Horn has been continuously seeking the optimal form of expression, from the most traditional to the most experimental, with just as much audacity and variation." Despite that diversity, he continued, her work does not seem fragmented, but rather, each piece is a part of the larger oeuvre, "a story that develops slowly but surely."

Writing in the wake of the Münster project, Dan Cameron acknowledged that if Horn has only recently been recognized as a "world-class sculptor," the fault lies more with the critics than the artist, insofar as "her art is composed of those elements that criticism seems least equipped to address: touch, confluence, the body as machine, accumulation, integration." Otherwise stated, her distinctly female sensibility (what Lucy Lippard calls "transformational") falls outside the traditional canons: in the words of Nena Dimitrijevic, "The authentic quality of Rebecca Horn's work comes from the successful merging of two opposite principles which correspond to two diverging traditions of modern art: the 'male,' i.e., technical, cool, and mechanical side of the work, with its roots in constructivism, Bauhaus and kinetic art, is united with the 'female,' that is, the organic, vulnerable and fantastic aspect which springs from the surrealist tradition."

EXHIBITIONS INCLUDE: Gal. René Block, Berlin 1973; MOMA, NYC and Inst. Contemporary Art, Philadelphia 1974 (video); Palais des Beaux-Arts, Brussels 1975 (video); Gal. Nächst St. Stephan, Vienna 1975; Saman Gal., Genoa from 1975; Anthology Film Archives, NYC 1975 (film); Gal. René Block, NYC 1976; Gal. H. Graz 1976; Kunstverein, Cologne and Haus am Waldsee, Berlin 1977; Gal. Ala, Milan 1977; Kunsthalle, Baden-Baden 1977; Kestner-Gesellschaft, Hanover 1978; Van Abbemus., Eindhoven 1979; Kunstverein, Munster 1979; Ala. Gal., NYC 1979; Staatliche Kunsthalle, Baden-Baden 1981; Stedelijk Mus., Amsterdam 1981; Gal. Eric Franck, Geneva from 1983; Cntr. d'Art Contemporin, Geneva 1983; Kunsthaus, Zurich 1983; Serpentine Gal., London 1983, '84; John Hansard Gal., Southampton 1983; Mus. Contemporary Art, Chicago 1984; Marion Goodman Gal., NYC 1986; Hayward Gal., London 1986; Theater am Steinhof, Vienna 1986. GROUP EXHIBITIONS INCLUDE: Documenta 5, Kassel 1972;

Projekt 74, Cologne 1974 (film); Paris Biennale 1975; "Hambourger Künstler," Kunstverein, Hamburg 1975; Edinburg Film Festival 1975; Berlin Festival, Haus am Waldsee, Berlin 1975 (film); Documenta 6, Kassel 1977; "Artist's Books," MOMA, NYC 1977; Spoleto Festival 1980; Sydney Biennale 1982; Documenta 7, Kassel 1982; "Von Hier Aus," Düsseldorf 1984; Japan Biennale, Toyama 1984; "The European Iceberg," Art Gal. of Ontario, Toronto 1985; Sonsbeck 1986, Arnheim 1986; Venice Biennale 1986; Projeckt Skulpturen, Münster 1987; Documenta 8, Kassel 1987.

COLLECTIONS INCLUDE: Stedelijk Mus., Amsterdam; Staatliche Kunsthalle, Baden-Baden; Kunstverein, Cologne; van Abbemus., Eindhoven; Kunsthalle, Hamburg; Kestner-Gesellschaft, Hanover; Anthology Film Archives, NYC; MOMA, NYC.

ABOUT: Brann, T. Rebecca Book I, 1975; Dimitrijevic, N. "Rebecca Horn" (cat.), Serpentine Gal., London, 1984; Emanuel, M., et al. Contemporary Artists, 1983; Horn, R. Dialogo della Vedova Paradisiaca, 1976; "Rebecca Horn" (cat.), Gal. H. Graz, 1976; "Rebecca Horn" (cat.), Kunstverein, Cologne, 1977; "Rebecca Horn" (cat), Kestner-Gesellschaft, Hanover, 1978; "Rebecca Horn—La Ferdinanda" (cat.), Staatlich Kunsthalle, Baden-Baden, 1981; "Rebecca Horn" (cat.), Kunsthaus, Zurich, 1983; "Rebecca Horn" (cat.), ARC, Mus. d'Art Moderne de la Ville de Paris, 1986; Vergine, L. Il Corpo come Linguaggio, 1974. Periodicals—Afterimage May 1983; Art (Hamburg) April 1983; Artforum December 1981, October 1984; Art in America May 1984; Art Press June 1986; Arts Magazine January 1980, November 1987; Beaux-Arts September 1986; Parkett 13, 1987.

HUNT, BRYAN (June 7, 1947–), American sculptor, draftsman, and photographer, was born in Terre Haute, Indiana, to parents he has described as "very aesthetic." The family moved to Tampa, Florida, when he was ten, and he spent his teens in that area, eventually enrolling as an architecture student at the University of South Florida in Tampa. He excelled in drawing and design, but soon tired of architecture because of what he has called its "limitations of scale and application," and left the university after two years.

He knew by then that he wanted to be an artist but had no clear idea how to realize his goal. He took a job in the mailroom at the Kennedy Space Center at Cape Canaveral, which was then gearing up for the Apollo moon landing. "They were hiring everyone," he told Phyllis Tuchman in 1985. "It was a boom town at the time. I was hired as a mail boy, which was nice because the mail boy gets to meet all the top engineers. The next summer I was hired as an engineer's aide." The exploration of space, Hunt believes, has radically altered the way sculptors

BRYAN HUNT

approach the concept of space: "In Brancusi's day the concept of space was vertically aligned. Today we know that most things that go up eventually orbit on a track, and so the concept of flight is three-dimensional."

On his return from a summer in Europe in 1968, during which he sketched a great many of the sites he visited, Hunt decided he must apply to art school. He was accepted by the Chouinard Art Institute in Los Angeles on a scholarship, a promise that was withdrawn upon the school's purchase by Walt Disney Enterprises. By then, however, he had already traveled to the West Coast, where he found a job as a draftsman with a structural engineer in Beverly Hills and began taking night classes at the Otis Art Institute. There he studied with the painter Miles Forst, who remembers Otis as a "tepid" place, specializing in "monuments for banks and in classical drawings," but recalls Hunt as "one of the most talented people around school, and he was serious about what he was doing. He knew architectural drawing, and he could make it specific in terms of materials and dimensions. He had ideas, ambitions, and goals, and he was able to set them forth in a concrete way. It seemed he should go someplace where people would care." Forst encouraged Hunt to apply for the independent study program run by the Whitney Museum of American Art in New York City. He was accepted and, after taking his bachelor's degree in fine arts from Otis, arrived in New York in 1972. "I realized New York was where I wanted to be," he said to Tuchman, "the energy, the firmness of purpose were so clear. But economically, I

knew I could never survive [t]here." He went back to California, returning to live permanently in New York in 1976.

Hunt first came to public attention with an extensive series of airships, of which the prototype was *Empire State* (1974), an eight-foot model of the building in balsa wood and silk paper, to the mooring pole of which was tethered a model of the *Hindenburg,* constructed of the same materials and overlaid with metal leaf. He has continued to make his airships—which he likes to do in the privacy of his studio, without assistance—and they have steadily become more stylized. The ones he made in the 1980s have no tail fins and very streamlined forms, are usually cantilevered from the wall and extend about six feet into the room, several feet above the viewer's head. Their thin metal skins change color and seem to glow; their essential quality is lightness. "The less physical weight the airship seems to support," Hunt said in 1980, "the more it looks like it's floating, so it has a psychological presence based on this characteristic of weightlessness." He finds the shapes continually fascinating, quintessentially sculptural: "They're so provocative," he told Tuchman, "in the way that I can keep permutating their abstraction. . . . They deal with gravity. They instill life within a contained form. And they create a place of experience."

Since about the mid-1970s, in common with several other sculptors of his generation, Hunt has been refining his mastery of the process of casting. His earliest casting, *Wall of China (Nankow Pass)* (1973), was originally intended as a work in clay. "When I saw it in clay," he explained in a 1983 interview, "I wanted to preserve it, so I thought bronze was the way that you translate it. . . . I had to cast it myself, everything myself, because I couldn't afford to have it done. I worked for this guy who had a little backyard foundry in Venice, California, and that's how I learned the process, working for him. All I had to do was buy the bronze and work for him. It was a good experience." Turning to bronze, supposedly an outmoded material, posed definite problems for Hunt: "In one sense it was reactionary to turn to such a classical material when everything so modern was happening. For example, I'd go see a Donald Judd show, which seemed so modern, but after a while I'd think, 'Where am I? How am I going to do it?' Bronze had an intense tradition and was natural at the same time. It wasn't the act of an antiillusionist or a process artist. There are so many phenomena about certain materials, but bronze could suspend the content in a quiet way." His works in cast bronze—he uses both the ancient, time-consuming lost-wax method and also the

faster but rougher sand-casting method—have expanded in number and type. One series of lakes are in modest scale, with ripples, patinated flat surfaces, and craggy bottoms; another series of water-filled quarries—a reflection, perhaps, of his Indiana childhood—are somewhat squarer in outline. Both series are intended to be shown on the floor, and the artist sees both as naturalistic in conception. "Nature in landscape *becomes* the figure," he stated in 1982. "The lake and quarry . . . are the 'reclining' idea—the passive reclining figure in a very abstract sense."

The "active figure" of Hunt's cast works is probably his series of waterfalls, studies, some eight feet high, of the form of falling water, with all earthly support and framing removed. "It's absolutely flat between Indiana and Florida," he said, with some exaggeration, in 1983. "I never saw a waterfall until I was twenty. I didn't exactly know what a mountain was, either, except from pictures, which is pretty amazing." Like the airships, Hunt's waterfalls represent arrested motion, suspensed in midair, defiant of gravity. The waterfalls are first created in plaster or plasticene: the material is spread over an armature, then worked at with gouging tools, and finally cast in bronze. They do not, in general, represent specific places, but try to capture falling water's many aspects.

Among Hunt's new departures in the 1980s were a series of skeletal-appearing welded steel and iron sculptures, many of them mounted on limestone pedestals, and another series of armaturelike works, mostly in cast bronze, more schematic and abstract than any of his earlier sculptures. He affirms that his newer work is more purely abstract in conception: "The armatures and the linearity of the subject matter," he said to Tuchman, "become the most refined kind of drawing in space. A painter can make the illusion of a line in space, but sculptors truly have the ability to make a line in space."

Like most sculptors, Hunt draws a great deal. Unlike some, he believes his drawings have a life of their own, and are not merely sketches for later sculptural works. "My drawings are all about line," he said in 1980. "I love to draw a line. I love the idea that you can make a variation on a line that has an emotion itself, or that you can put lines together and this juxtaposition creates another tone." Many of his drawings, largely executed in the unusual medium of turpentine, linseed oil, and graphite on high-quality, handmade paper, depict falling water: "If I just want to make a line, I'll make that gesture. If I see what I want to achieve is that inner relationship between the figure and the landscape, or the falls as the figure, or the negative shape of

the falls as the figure . . . the lines are the signals on the paper that you can read as the form. Somehow, all of a sudden, you perceive that the line is both a figurative line and exists in the landscape at the same time." He sees the very activity of drawing as "fulfilling," and another kind of work that he can do in private, away from the semipublic world of the sculptor in bronze. By the mid-1980s he had switched from graphite to oilsticks because of their greater permanence.

Hunt's photography dates from his teenage years, when he worked during a summer as staff photographer for a local Florida newspaper. He covered several sporting events, including the Sebring Grand Prix auto race, and learned in the process about photography's technical side: different cameras and the shots they produce, darkroom procedures, and the minutiae of exposure time and f-stops. Much of his current work in photography tends to be in the service of his sculpture, documenting his work at various stages of completion and in installation views of his exhibitions. His own shots usually appear on the exhibition's announcements and catalogs. He is the author of *Conversations with Nature* (1982), a book of his photographs and drawings, published by New York's Museum of Modern Art.

From about the mid-1980s, Hunt was engaged in making and showing a series of studies for the "Barcelona Project," a commission by that city as part of its plans for the celebration, in 1992, of the five hundredth anniversary of Columbus's first voyage. The project will ultimately consist of a single large sculpture, which will be sited beneath a skylight in the middle of a restored Catalonian ruin, for which Hunt intends to design benches, paths, and even the floor.

EXHIBITIONS INCLUDE: Inst. for Art and Urban Resources, Clocktower, NYC 1974; Jack Glenn Gal., Corona del Mar, Calif. 1974; Palais des Beaux-Arts, Brussels 1975; Daniel Weinberg Gal., San Francisco 1976, '78, '82; Blum Helman Gal., NYC 1977, '78, '79, '81, '83, '85; Greenberg Gal., St. Louis 1978; Bernard Jacobson Gal., London 1979; Gal. Bischofberger, Zurich 1979; Margo Leavin Gal., Los Angeles 1980, '83; Akron Art Inst., Ohio 1981; Gal., Hans Strelow, Düsseldorf, West Germany 1981; Bernier Gal., Athens 1982; Los Angeles County Mus. of Art 1983; Amerika Haus, Berlin 1983; John C. Stoller Gal., Minneapolis 1984; Knoedler Gal., Zurich 1985; Gillespie, Laage, Solomon, Paris 1986. GROUP EXHIBITIONS INCLUDE: Portland Cntr. for the Visual Arts, Ore. 1976; Daniel Weinberg Gal., San Francisco 1978, '79, '80, '83; Solomon R. Guggenheim Mus., NYC 1978, '82; Stedelijk Mus., Amsterdam 1978; Whitney Mus. of American Art, NYC 1979, '81, '82, '83, '85; MOMA, NYC 1979, '80, '82; Venice Biennale

1980; Blum Helman Gal., NYC 1981, '82, '84, '86; Brooklyn Mus., N.Y. 1985.

COLLECTIONS INCLUDE: San Francisco Mus. of Modern Art; High Mus., Atlanta; Mus. of Fine Arts, Houston; Metropolitan Mus. of Art, MOMA, Solomon R. Guggenheim Mus., and Whitney Mus. of American Art, NYC; Albright-Knox Art Gal., Buffalo; Yale Univ. Art Gal., New Haven, Conn.; Lehmbruck Mus., Duisberg, West Germany; Louisiana Mus. of Modern Art, Humlebaek, Denmark; Stedelijk Mus., Amsterdam; Art Inst. of Chicago; Fogg Art Mus., Cambridge, Mass; Mus. Moderner Kunst, Vienna.

ABOUT: Emanuel, M., et al. Contemporary Artists, 1983; Hunt, B. Conversations with Nature, 1982. *Periodicals*—Architectural Digest March 1983; Artforum Summer 1977, May 1979, September 1981; Art in America Summer 1980, April 1981; ARTnews October 1978, Summer 1979, May 1980, September 1981, January 1983, April 1984, October 1985; Arts Magazine May 1977, September 1984; Artweek January 31, 1976, August 26, 1978, August 25, 1979, April 25, 1981, February 27, 1982, June 4, 1983; Flash Art October–November 1981, Summer 1983; New Yorker December 22, 1980; New York Times February 8, 1981, May 24, 1981, April 8, 1983, July 20, 1984, November 4, 1984, December 23, 1984, May 10, 1985.

INSLEY, WILL(IAM) (October 15, 1929–), American draftsman, painter, sculptor, and "abstract architect," was born in Indianapolis, Indiana. "I was always interested . . . in architecture," he told Linda Shearer in 1984. "My father subscribed to architectural magazines and, with my grandfather, built houses for a brief time. I was aware of architecture as a subject to read about and discuss. I constantly fiddled with my room at home, changing its design—and did the same at college. Give me a space and I would try to dominate it." He went to art classes at the John Herron Art Museum in Indianapolis while attending public schools in that city. He has recalled two childhood pastimes that seem directly connected to his later work as an artist. One was designing puppet theaters: "I built the stage, the puppets, the scenery," he remarked in 1984; "I took all the parts and put on the entire performance. The idea of doing the whole thing, of having control over this whole world, fascinated me." The second pastime, which continued into adulthood, was his seeking out of empty spaces: "I was particularly fascinated with secret places," he said to Shearer, "and had a history of breaking into empty buildings, starting with the abandoned house next door when I was just a kid. My final 'break in' was an accidental job on Grand Central Station at two o'clock in the morning when

WILL INSLEY

it is supposed to be locked up. I took advantage of the opportunity to investigate the immense deserted space all alone. I got caught."

Insley earned a bachelor's degree in 1951 from Amherst College, where he studied art with Jud Judkins and wrote a senior thesis on Mies van der Rohe. He immediately began graduate study under Paul Rudolph and others at the Harvard Graduate School of Design, where his thesis was a proposed design for the Guggenheim Museum, which had not yet been built. He took a master's degree in architecture in 1955. The following two years (1955–57) he spent in the army, during which he decided, after much soul-searching, that he would not practice architecture for his life's work. He determined on being an artist instead, and in the fall of 1957 arrived in New York City.

Until about 1961, his painting, he has said, "was both figurative and abstract in a variety of expressive styles." It was never exhibited. During the next two years he completed his first series of what he called "shaped paintings, using cloverleaf forms around a central hole." In 1963, "at a time of crisis in my work," he experienced an artistic revelation, which two decades later he explained to Shearer: "I saw a green and yellow diagonally striped square painting by Frank Stella in a group show at Green Gallery. Its diagrammatic and technical clarity was the trigger that exploded the bomb. I suddenly realized that all my problems came from *thinking too much as a painter* and that if I reached back into my past and *thought as an architect* I would get further." The Stella, he declared at the time, was

"the most amazing painting I've ever seen." It became the catalyst for a complete reorientation of his artistic direction.

From his days as a student of architecture, Insley had worked with the system of grids and ratios well known to the technicians within the profession. "Living in New York," he wrote in 1983, " . . . I was preoccupied with walking the street grid and exploring empty parking lots and playing fields at night. When it rained, their dark asphalt surfaces gridded with gray and yellow lines provided liquid mirrors for visual descent to 'Wall Fragments' and not as paintings per se, and to use the grid as a basic system for the investigation of two-dimensional space." This he has continued to do since the mid-1960s in an extensive series of colored grids painted on variously sized gray-black masonite grounds.

With the choice of the term "wall fragments," with its architectural and archaeological overtones, Insley was on the brink of discovering his life's obsession. "If there is a wall fragment," he considered, "there must be a wall, and if a wall, a building; and if a building, a city; if a city, a civilization; if a civilization, a religion; and ultimately an unknown seed of cryptic signals. In 1967, I uncovered the first buildings of abstract architectural space. Upon digestion of their vocabulary, I was able to move in 1977 to the investigation of their focus, ONECITY, a mythological labyrinth in unlocated time and buried in the central North American plains between the Mississippi River and the Rocky Mountains. ONECITY houses four hundred million people. In its center is hidden the Opaque Library, the source of the 'Fragments.' ONECITY is concerned not with the mechanics of cities but with their essence and mystery. ONECITY is both dream and nightmare, a dialogue of the order relating good and evil conducted by unidentified ghosts." The artist was on his way to becoming a futuristic architectural archaeologist, the kind of urban planner and visionary no one had ever seen before. He was intent on designing a 675-mile-square spiral, home for the entire population of North America. He worked from 1959 to 1966 as a file clerk in the archives of the Metropolitan Museum of Art, handling photographs and records of the museum's extensive collection. "One assignment," he recalled in 1983, "was to sort the record cards, and I thus became aware that every separate thing had its own record. Suits of armor were in hundreds of pieces. Greek vases were often in fragments and each fragment could stand for an unavailable whole. Each piece and fragment had its separate card and was thus singularly recognized. Their odd shapes evoked reference to some greater 'elsewhere.'" Even the most mundane of jobs, therefore, was capable of feeding Insley's hunger for the enigmatic, the totemic, and the ritualistic.

The "uncovering" of the first abstract /buildings/, as Insley has come invariably to style them, dates from 1967. Their function, or lack of it, was described by the artist in an introduction to the catalog of the exhibition "The Opaque Civilization" at the Guggenheim Museum in 1984: "Abstract /buildings/ are buried in the wilderness outside ONECITY. Their only reason for existence is to contain spatial situations sympathetic to the religious beliefs of the civilization. These focus on a worship of the horizon line and on a passing through a space within that line between the earth and sky and on then embarking on travel into and return from the future with future information. Human participation in the three-dimensional architectural space serves as a parallel to the mind wandering as a character in a drama of numerical (real) and philosophical (unreal) theories. The civilization signals formal ratio theories; the /buildings/ play upon the themes. Some /buildings/ are solid, all spaces open to the sky, and one must climb up and down their slanted sides to experience a series of 'hills' and 'valleys' as removed horizons. Others offer narrow passages cut through the corrugated mass and rise above and sink below the horizon line in dialogue. Some do not rise above the earth at all, but are pits and tunnels boring down into the ground and are virtually invisible from any distant view. These interior 'mental' structures are the most frightening and it is easy to get lost in the tangle of their dark mazes." By the time of the Guggenheim exhibition, Insley had designed some forty of the outer /buildings/. Their general layout always respects the horizon line; all have a low profile, blending into the landscape, and many reach their fullest development below ground. Those that do rise above ground are never more than twelve feet (one story) high: these are the Stage Spaces, Channel Spaces, and Passage Spaces. In one of the most elaborate of the last type, /Building/ No. 42, Passage Space Hill Slip (1975), "many of the passages and walls," wrote Insley, "lead to dead ends, and there is constant frustration and denial of further progress. It is merely by chance that one reaches the center and still more by chance that one returns to the outside. There are many entrances and numerous routes of travel within, and the visitor may spend several days investigating the complex without exhausting the possibilities of experience." The Volume Spaces, the most mysterious and even forbidding of the /buildings/, never rise above the ground and seem inconspicuous from the surface. They may extend more than a hundred feet below ground, however, and

are explorations of the sinister and frightening aspects of space. "Volume Space," the artist wrote in 1972, "refers to /buildings/ with no projections above the ground. Most secret of all mythological structures, they are negative impressions of space. Simplest of the /buildings/ in form, these wells, pits, hollows, are nothing more than mere shadows on the land. Aloof. Harsh. Mysterious. Very few have been found. Their experience is of a single open, variant-to-ratio sequence, of removed horizons, dropped to a single point. Tombs of space, dangerous by implication, they are usually avoided."

Only after several years of work on the outer /buildings/ did Insley arrive at planning the enormous inhabited city itself, the residing places of the four hundred million. By the mid-1980s, he was still elaborating these plans. He described some of the city's physical and civic qualities in 1984: "A hive of cellular spaces climbs up and down 'hills' and 'valleys' and is separated into an Over- and an Under-Building, the former containing living units and the latter, areas for work. Public Theater Space between the Over- and Under-Building is the meeting place of those descending from their private sky chambers and those emerging from the earth chambers below. The city is a chain of buildings, each two-and-a-half miles square. In the center of each building are the Nine Arenas. Major ceremonies take place on the exposed surface of the Eight Outer Arenas and within the Upper-Building below are museums, performance halls, and the various establishments of leisure entertainment. The Ninth Arena is different. Its top surface is normal compared to that of the others, but the inside spaces twist away from expected configuration. Buried in this dark contortion are the Theaters of Death, administering city justice. ONECITY eliminates the innocent victims of evil and criminals are separated from the rest of the population to dwell in the indulgent luxury of the Ninth Arena basement and prey upon each other. Commitment is usually voluntary. Most citizens have only voyeuristic interest in crime and come to spy on whatever small amount of basement activities they may glimpse through slits in the Arena surface. The Theaters of Death are contained within a labyrinthian system of hide-and-seek leading ultimately to the Courts in which the decisive Games are played."

It is clear from such descriptions that Insley is not inventing a utopia; nor is he a visionary architect in the accepted sense of the term, as he made clear in his 1984 interview: "What is usually called visionary architecture is concerned with good. The city must be good; if we plan well, we'll solve the problem, i.e., create utopia.

I'm not interested in utopia and its morality as a problem. As we all know, utopias never work. ONECITY is a nonutopia and therefore lies outside the agreeable projects of the practical architectural world when this world deals in 'visionary' projects, dedicated as they are to *good*. . . . It makes no moral judgment whatsoever."

At the very center of the inhabited spiral square is the Inner Field, a wasteland 135 miles square. Visitors must hike across this vast emptiness to arrive at the essential center, the "seed and soul" of Insley's civilization, the Opaque Library. This is "an empty building," Insley wrote in 1984, "analogous to the abstract /buildings/ outside ONECITY." It exemplifies the idea of denied space, central to Insley's explorations: "Access is denied to this cache, twisted away from expected nomologies of reason, and thus its essence is elaborated only through the devious rumors of mythological origin. Brief slits in its shell allow only sparse beams of light to penetrate the interior. The visitor is left to spy on mystery, but only the upper chambers are visible and they reveal nothing. A maze of slanted tunnels descends. Dust swirls in their erratic drafts and spills into the lower chambers." The gridded paintings of Wall fragments which the artist continues to produce show the walls of the Opaque Library in facsimile.

Insley's plans for ONECITY, ever more refined, are usually presented to the public in gallery and museum exhibitions. The means involve careful architectural drawings, cross-sectional and isometric, architectural models, and photomontages of these in a flat landscape. Everything is executed with a subtle eye for detail and a minute attention to scale. One of his most memorable exhibitions occurred in May 1974 at both New York branches of the Fischbach Gallery: the drawings and models occupied the entire downtown gallery, while the uptown space showed on its walls 468 pages of Insley's *Fragments from the Interior Building*, all in the artist's dense, often lyrical and playful prose. The book, in spite of its author's acknowledged "difficulty in translation of many obscure passages from future into present," offered the first extensive evocation of the Opaque Library and the Opaque Civilization. It confirmed the extent to which writing is a major tool for the investigation of his ideas.

Among the many influences on Insley's work, are Etienne-Louis Boullée, the eighteenth-century architect of vast, imaginary public buildings and monuments, to Le Corbusier, who in 1923 designed a city for three million inhabitants. Critics have suggested parallels in the work of the French utopian Nicolas Ledoux, the

Italian futurist Antonio Sant' Elia, and the more recent visionary schemes of Paolo Soleri or the Archigram group. Insley is also an admirer of the writer H. P. Lovecraft and seems to share his macabre imagination. Despite a few early attempts, none of ONECITY's structures has been built, and Insley acknowledges that, considering the cost involved, none are likely to be any time soon. Yet this does not concern him: he sees it, in fact, as one of the project's chief virtues. He wrote in 1978 of his admiration for the earthworks of Robert Smithson (*The Great Salt Lake Spiral Jetty*, 1970), humorously describing the vital importance to Smithson that his massively scaled projects be built: "They achieved true 'reality' to him only in physical manifestation. His drawings were no more than shopping lists. The meal was not a meal until it was on the table. Luckily, he saved the shopping lists, for the meals were infrequent." This is not at all Insley's way. "I felt," he told Shearer, "it was more important to go *in*, into my own mental space, and deal totally in potential and thus bypass the hindrance of realization. The only limitation became that of my imagination and thus I have been able to pursue information the earthworks artists were never able to get to. My working definition of art is the investigation of the structure of abstract space in all possible extensions of dimension. I had to move beyond the thought processes normal to the production of sculpture and painting and think instead as a theoretical architect pondering the issues of full-scale space and then shrink them to a piece of paper by drawing *in* scale."

Insley's vast plan has often elicited consternation from critics. One wrote of his work as "frightening" and "dictatorial." Jean-Louis Bourgeois thought him "an example of the Bauhaus bent run amok. . . . That Mies's current friends would sooner or later light upon such an enormous field in which to practice their favorite visual virtues, strictness and sterility, was perhaps inevitable." In general, his severest critics have perceived him as an earthworks artist about to realize his projects in a grotesque and grandiose rape of nature. Insley professes not to be concerned by such attacks. "My work is complex," he said in 1976, "and few people understand it." What his detractors seem to fail to see is that his /buildings/ exist at a distant remove from practical architecture. "Art," he said to Shearer, "should exist beyond moral responsibility. Architects, of course, are very concerned that things work and people don't fall down the stairs. I've been called 'immoral' by architects. I suppose there are many things in ONECITY that are immoral or at least physically dangerous. I don't necessarily consider ONECITY a good city to live in; it could be a nightmare. I don't think that's important. What is important is that it offers the investigation of abstract architectural space on an enormous and thus challenging scale."

Since 1965 Insley has worked in a loft on the Bowery in Manhattan. He has taught briefly in the art departments of a few American colleges: Oberlin (1966), the University of North Carolina at Greensboro (1967–68), and Cornell University (1969). He received a grant from the National Foundation for the Arts and Humanities in 1966, then a Guggenheim Fellowship in 1969, which triggered fifteen years of extensive work and exhibiting. It was not until 1983 that he began teaching intensively again, in the newly established masters program at New York's School of Visual Arts, where he had lectured occasionally from 1969.

EXHIBITIONS INCLUDE: Stable Gal., NYC 1965, '66, '67, '68; Allen Memorial Art Mus., Oberlin Col., Ohio 1967; Weatherspoon Art Gal., Univ. of North Carolina at Greensboro 1967; Walker Art Cntr., Minneapolis (traveled to Albright-Knox Art Gal., Buffalo), 1968; Inst. of Contemporary Art, Univ. of Pennsylvania, Philadelphia 1969; John Gibson Commissions, NYC 1969; MOMA, NYC 1971; Gal. Paul Mainz, Cologne 1972; Visual Arts Gal., NYC 1972; Fischbach Gal., NYC 1973, '74, '76; Mus. Haus Lange, Krefeld, West Germany 1973; Gal. Annemarie Verna, Zurich 1974, '76; Allen Priebe Art Gal., Univ. of Wisconsin at Oshkosh 1975; Col. of Arts Gal., Ohio State Univ., Columbus 1975; Mus. of Contemporary Art, Chicago 1976; Max Protetch Gal., NYC 1977, '80, '82; Protetch-McIntosh, Washington, D.C. 1977; Gal. Orny, Munich 1978; Solomon R. Guggenheim Mus., NYC 1984. GROUP EXHIBITIONS INCLUDE: "Systemic Painting," Solomon R. Guggenheim Mus., NYC 1966; "Painting Annual," Whitney Mus. of American Art, NYC 1966, '68; "Art Objectif," Gal. Stadler, Paris 1967; "Painting: Out from the Wall," Des Moines Art Cntr., Iowa 1968; "Will Insley, Fred Mitchell, Steve Poleskie," Andrew Dickson White Mus. of Art, Cornell Univ., Ithaca, N.Y. 1969; "L'art vivant aux Etats-Unis," Foundation Maeght, Saint-Paul-de-Vence, France 1970; "International Frühjahrmesse," Berliner Gal., Berlin 1971; Documenta 5, Kassel, West Germany 1972; "Making Megalopolis Matter," New York Cultural Cntr. 1972; "Labyrinth: Symbol and Meaning in Contemporary Art," Watson Gal., Wheaton Col., Norton, Mass. 1975; "Dwellings," Inst. of Contemporary Art, Univ. of Penn., Philadelphia 1978; "Pier and Ocean: Construction in the Art of the Seventies," Hayward Gal., London (traveled to Rijksmus, Kröller-Müller, Otterlo, Holland), 1980; "Architectural Sculpture," Los Angeles Inst. of Contemporary Art 1980; "Drawing Distinctions: American Drawing of the Seventies," Louisiana Mus. of Modern Art, Humlebaek, Denmark (traveled to Kunsthalle, Basel, Switzerland, Städtische Gal. im Lenbachhaus, Munich, and Wilhelm-Hack-Mus., Ludwigshafen, West Germany), 1981–82; "Dreams and Nightmares: Utopian Visions in

Modern Art," Hirshhorn Mus. and Sculpture Garden, Smithsonian Inst., Washington, D.C. 1984; "Indian Influence," Fort Wayne Mus. of Art, Indiana 1984.

ABOUT: Ashton, D. A Reading of Modern Art, rev. ed., 1971; Johnson, E. H. Modern Art and the Object, 1976; Belford, M., and J. Herman, eds. Time and Space Concepts in Art, 1980; Sky, A., and M. Stone, Unbuilt America, 1976. Periodicals—Artforum February 1970, June 1973, September 1974, February 1976, April 1976; Art in America May 1976, October 1983; Art International February 1969, April–May 1976; ARTnews Summer 1968, January 1970, January 1973, May 1973, January 1974, October 1974, November 1984; Arts Magazine December 1969, February 1973, September 1973, September 1974, November 1974, November 1975, May 1978; Design Quarterly no. 122; Studio International June 1974.

JENNEY, NEIL (1945–), sculptor and painter, is recognized as a founder of postmodern realism and distinguished by his prevailing interest in the humanitarian, political, and environmental problems of the late twentieth century. In the course of his career, Jenney has been labeled process sculptor, earth artist, "bad" painter, new image painter and, finally, postmodern realist. While his work incorporates important concepts and styles of contemporary art, it transcends those approaches by the time they become trends.

Jenney was born in Torrington, Connecticut into a family that had made its living from the New England assembly lines for generations. Growing up in the Berkshire hills of western Massachusetts, Jenney worked part-time on local farms rather than in factories and became attuned to the landscape that surrounded him. "Being a little biological organism on the third stone from the sun," he has said, "you can't help but be in awe of what's around you."

He began painting abstract expressionist pieces in high school, but had no ambition to pursue a career in art.

> When I graduated from high school in 1964, I had a choice of going to war or going to the only college that accepted me—the Massachusetts College of Art. That's why I became an artist: the war. At that stage, I did not want to become an artist, because in those days becoming one was like taking a vow of poverty.

Jenney attented the Boston art school from 1964 to 1966, doing some color-field painting and minimalist sculpture. After two years of studying, he moved to New York to begin a career as a sculptor. His friends included the artists John Duff, Robert Lobe, Ed Shostak, and Gary Stephan, all of whom valued idiosyncrasy in art over adhering to current trends; Jenney credits

Stephan with coining the term "maximalism" in rebellion against minimalism.

Although Jenney's sculptures bear the influence of contemporary trends, their crude realism is peculiar to Jenney. In works such as *David Whitney Piece* (1968), a three-legged table supporting a bundle of wood splints, above which hangs a high shelf holding pennies and plates, and *Earth Art Piece* (1968), piles of earth and disused objects on a rickety wooden scaffolding, Jenney rejects conceptualism and minimalism by placing real objects in real space. He has explained that these works represent "event as evidence," a phrase he has used repeatedly to define his brand of realism. In other words, the objects or installations record what they are, where they were made, or the process by which they were made. For example, *Linear Piece* (1967), parallel wiggly wires protruding from a pair of horizontal wires, and *Untitled Volumetric Piece* (1968), four volcanic-looking lumps, record line and mass.

Although Jenney became a recognized sculptor during his first few years in New York, he was not commercially successful. He earned extra money by restoring nineteenth-century paintings, which later significantly influenced his own painting. His last sculpture, *Press Piece* (1969), documents Jenney's transition from sculpture to painting. An homage to the New York Mets' 1969 World Series victory, the piece consists of two deep shelves holding framed *Daily Post* articles about the Mets' success. Below, a red, white, and blue neon sign reads "Americana." The sculpture recalls the nationalistic pop art of Andy Warhol's *Dollar Bill* and Jasper Johns's *Flags* but at the same time introduces several trademarks of Jenney's future paintings: thick black frames, large titles, outstanding images, and American subject matter.

In 1969 Jenney abandoned sculpture completely. "I couldn't sell sculpture and I was starving," he later explained, "so I decided to do paintings." His dramatic transformation did not result entirely from his need to make a living, of course, but also from his desire to express more important, universal ideas through his art. Moreover, he was motivated by a historical sensibility which continues to guide his artistic progress: "I decided that realism was going to come back. Simply because we had abstraction for fifty years, we were not going to have abstraction in the next fifty."

Jenney did not immediately produce "realistic" paintings in the accepted sense of the term. His first pieces, done between 1969 and 1970, inspired art critics to call him America's première figure painter. *Girl and Doll* (a young,

crying girl in the forefront of a broken doll),
Them and Us (Soviet and American fighter
planes flying side by side), and *Forest and
Lumber* (a stand of trees juxtaposed against a
section of razed forest), among other works from
1969, were executed in a primitive, apparently
careless style that prompted comparisons with
Robert Ryman's early work.

To offset the deceptive simplicity of his first
paintings, Jenney framed them in heavy black
wood. He gave the pictures bold, ironic titles,
stenciled in Helvetica, to reinforce the content
and underlying seriousness of each piece. In the
three works mentioned above, for example, Jen-
ney comments respectively on human emotion,
political conflict, and the destruction of the envi-
ronment. "Art," he maintains, "is a social
science."

No one knows exactly how many paintings
Jenney made from 1969 to 1970. He once
claimed he did one a day but later said he paint-
ed "a hundred or so" in all. However many he
produced, Jenney's painting improved marked-
ly as he gained experience. *Here and There* (two
fields of green separated by a white fence) and
Threat and Sanctuary (a raft floating in danger-
ous waters), both from 1970, are more carefully
conceived and less formulaic than works from
the previous year.

As his concern with showing complex subject
matter grew, Jenney decided to develop system-
atically his technique and style. "I didn't know
how to draw or paint," he has remarked. "I never
learned that in art school. I'm entirely
self-taught." His self-education included study-
ing realist painters, particularly nineteenth-
century American artists and most importantly
the Hudson River School painters. He also spent
two years reading widely about technique. As
his new style developed, Jenney began to paint
with oils, which allowed him to work in greater
chromatic detail and with more accuracy than
the acrylics he had used previously.

The first painting in his new style was *The
Modern Era* (1971–72), which was initially titled
More Surrealism, then *Modern Art*. The painting
consists of two chairs, painted very precisely in
black and white, suspended in the upper left-
hand corner of the small canvas. Like earlier
works, it has a thick black frame; here, however,
the frame is deep enough to hold a plaque which
bears the painting's title. Instead of the stark
Helvetica he had used before, Jenney lettered
the title in a style reminiscent of nineteenth-
century newspaper headlines of the old West.

While *The Modern Era* is well executed, it
seems like an exercise in the possibilities of mod-
ern art and of Jenney's idiosyncratic approach to

it. In his subsequent works, however, Jenney
combined proficiency with timely, universally
meaningful content. His paintings express, with
increasing urgency, a personal and political con-
cern for the endangered American landscape as
well as for the global environment. The
"Window" series (1971–76) is a collection of tele-
scopic views of meticulously rendered trees and
grass. The paintings, with their trapezoidal
shapes and thick, architectural frames, give one
the sensation of looking at the landscapes
through attic windows. In the "Biosphere" series
(1971–76), Jenney further manipulated his win-
dow-framing technique to endow his work with
a more serious, political message. The canvases
in that series have extremely elongated shapes,
so that the viewer seems to look up at the frag-
mented skyscapes through a narrow aperture,
such as the door of a fall-out shelter.

Although Jenney continued to paint and to de-
velop both his subject matter and its presentation
throughout the 1970s, he exhibited his work in-
frequently. Since the early 1970s, he has not
been affiliated with a gallery and excludes even
close friends from his studio. While he maintains
that his disassociation with a gallery was not mo-
tivated by art-world politics, he obviously values
his independence. In response to the question
"When is a painting finished?" he commented,

> When I hear artists talk too much about finishing a paint-
> ing, it often suggests to me that they're working "for" a
> show—on deadline. That really makes me nervous be-
> cause I can't be ruled by deadlines. They are foreign to
> me. And I don't make paintings "for" a show.

The often long delay between the completion of
a work and its exhibition has made it difficult to
categorize Jenney's works. In 1979 he displayed
several paintings from 1969 and 1970 at the
"Bad Painting" show at the New Museum in
1979. Also in that year, five of his paintings from
the same period were included in the "New Im-
age Painting" exhibit at the Whitney Museum;
one reviewer called Jenney's contribution to the
show "one of the best performances in contem-
porary art."

In 1981, a retrospective of Jenney's works
from 1967–80 provided a novel opportunity to
discern the artist's development. Organized by
Mark Rosenthal for the University Art Museum
in Berkeley, California, the show contained thir-
ty-four sculptures and paintings, some shown
publicly for the first time. The range of works,
Rosenthal noted, delineated Jenney's "gradual
transition from self-styled naive to self-styled
master." Eleven of the paintings date from
1971–76, when Jenney produced what he calls
"good" or "honest" art. The only post-1976
painting shown was *North America Abstract*

(1980), a composite of pieces of sky and land-
scape and the first completely abstract painting
exhibited by the artist. The retrospective trav-
eled to Houston, Washington, D.C., Amsterdam,
Humlebaek, Denmark, and Basel.

In the 1980s Jenney continued to experiment
with new subjects and styles. *Portrait of Willie
Eisenhart*, a delicate, faintly drawn profile por-
trait in the neolassical style, definitively demon-
strates Jenney's artistry. At times, he created
new content by combining universal imagery
and overtly personal subjects. A landscape called
Bruce Hardie Memorial (1978–82) shows a fall-
en tree in which the initials BH have been
carved. The painting is at once a memorial to a
childhood friend and to the vanishing country-
side in which Jenney and Hardie grew up. *New
Mets Uniform* (1984), a cap labeled with the let-
ters NY in a salute to the Mets' second world
championship, reflects both Jenney's love of
baseball and that sport's honored place in Ameri-
can society.

Jenney's most recent works represent nature
in a postapocalypse world. The paintings memo-
rialize lost landscapes and criticize the technolo-
gies and policies that threaten what remains of
them. In *Acid Story* (1983–84), acid rain falls be-
side a defoliated tree. *Outside* (1984) presents a
landscape whose endangerment is signified by
the almost illegible title painted below it. *Venus
from North America* (1987) shows barren yet
still beautiful terrain beneath a threatening sky.
At his solo exhibit at Oil and Steel in 1985, Jen-
ney reemphasized the modern threat to the nat-
ural world by sharply lighting each piece while
leaving the gallery in darkness, as if his paintings
were valuable relics of a lost world.

Even though his paintings prophesy uncon-
trolled destruction, however, Jenney has suggest-
ed that his own future will be creative and self-
determined.

> I am where I am today because of my clear sense of his-
> torical imperative. I think invention is what separates the
> good artist from the not-so-good artist. In everything I've
> done I've had to have a new challenge or a new horizon.
> But I feel there is enough here to occupy me for a long
> time.

EXHIBITIONS INCLUDE: Goldowsky Gal., NYC 1967; Gal.
Rudolf Zwirner, Cologne 1968; Richard Bellamy/
Noah Goldowsky Gal., NYC 1970; David Whitney
Gal., NYC 1970; "Seven Paintings from 1969," 98
Greene Street Gal., NYC 1973; Blum Helman Gal.,
NYC 1974; "Matrix" show, Wadsworth Atheneum,
Hartford 1975; "Neil Jenney: Painting and Sculpture,
1967–1980," (Univ. Art Mus. Berkeley, Contemporary
Arts Mus., Houston, Corcoran Gal., Washington, D.C.,
Stedelijk Mus., Amsterdam, Louisiana Mus., Humle-
baek, Denmark, and Kunsthalle, Basel, Switzerland),
1981–82; "60-80 Attitudes-Concepts-Images," Stedeli-

jk Mus., Amsterdam 1982; Annina Nosei Gal. 1983; Oil
and Steel Gal. 1985; Carpenter and Hochman Gal.
1985; Vivian Horan Fine Art Gal. 1988. GROUP EXHIBI-
TIONS INCLUDE: "Anti-Illusion: Procedures/ Materials,"
Whitney Mus. of American Art, NYC 1969; "Three
Young Americans," Oberlin Col. 1970; Edward Thor-
pe Gal. 1976; "Bad Painting," New Mus. 1979; "New
Image Painting," Whitney Mus. of American Art,
NYC 1978–79; Vassar Col. Mus., Poughkeepsie, N.Y.
1979; Marion Goodman Gal. 1980; "Die Neue
Wilden," Neue Galerie-Sammlung Ludwig, Aachen,
West Germany 1980; "American Art from the 70s,"
Nordjyllands Kunstmus., Aalborg, Denmark 1980;
Whitney Biennial 1981; "The Seventy-fifth American
Exhibition: Tradition Confronts the Future," Art Mus.
of Chicago 1985; "Von Twombly bis Clemente: Select-
ed Works from a Private Collection," Kunsthalle, Basel
1985; Barbara Mathes Gal. 1987.

COLLECTIONS INCLUDE: Mus. of Fine Arts, Boston; Whit-
ney Mus. of American Art, NYC.

ABOUT: Emanuel, M., et al. Contemporary Artists, 1983;
Rosenthal, M. Neil Jenney: Painting and Sculpture
1969–1980 (cat.), Univ. Art Mus., Berkeley 1981.
Periodicals—Architectural Digest November 1987;
Artforum April 1981, March, 1985; Art in America
Summer 1976, Summer 1982, April 1985; ARTnews
March 1975, March 1985, November 1985, November
1987; Arts Magazine October 1978, June 1982, Febru-
ary 1985.

***KIEFER, ANSELM** (March 8, 1945–),
German painter, photographer, and book
crafter, was born in Bavaria two months before
the end of World War II. His work is a direct re-
sponse to the German war experience, both the
aspects of the Teutonic past that are cited as
causes and the effects as they are evidenced in
ideas and attitudes within modern-day Germa-
ny. Kiefer raises the highly sensitive issue of
what it means to be German in the postwar
world. As Donald B. Kuspit wrote in *Arts
Magazine* (October 1984) " . . . Kiefer shows us
that in today's world there is really very little
depth of meaning to being German. He demon-
strates that the 'eternal German' is absurd, a pa-
thetic joke that makes itself manifest in isolated
historical moments in which the Germanic was
not as unequivocally triumphant as was later
supposed. He shows us that German power—be
it military or intellectual power—was not so ab-
solute as was later thought. By articulating Ger-
man megalomania in profoundly abstract
fantasies, he reduces it to the symbolic fiction it
always was."

Reclusive and media-shy, the artist makes his
home in Buchen, a small town in the south of
Germany. His reluctance to discuss the details of
his existence stems from his belief that such

°kē´ fer

ANSELM KIEFER

knowledge would be detrimental to the full appreciation of the spiritual and philosophical content of his art. He is equally reluctant to be photographed, and will request that photographs of him not appear in publication. He explained in a 1988 interview with Paul Taylor for the *New York Times*, "You know, I don't allow myself to be photographed because that kind of genius behavior really is 19th century. It was then that the bourgeoisie needed heroes. The Industrial Revolution meant that ordinary people could do everything, that they could be omnipotent, so they invented geniuses. I don't think I'm so important."

Kiefer began his studies at the University of Freiburg in 1965. In 1966, after spending a year studying French and law, he turned his attention to painting. An early and pivotal experience for him in terms of his decision to become an artist was a visit to the monastery of La Tourette in France, designed by Le Courbusier.

In 1970, after graduating, Kiefer began to study informally with Joseph Beuys in Düsseldorf. During this period, when conceptual art had come to the fore and painting as traditionally practiced had fallen to the wayside, Beuys encouraged him to paint. Mark Rosenthal has written, "at a time when painting was said in avant-garde circles to be dead, and spatial concerns and subject matter an anathema, Kiefer offered canvases that possessed emotionally charged themes in more or less naturalistic spaces."

The following year Kiefer married and moved to Hornbach in the Odenwald, located in the south of Germany. He converted his house attic into a studio whose wooden rafters feature in a number of his early works (*Holzraum*, 1972, *Notung*, 1973).

His current studio is located in an old factory where, with four assistants, he produces between 3 or 4 paintings a year. Of the paintings stacked in his studio the artist explained to an interviewer in 1973, "I work on them off and on, sometimes for years." Notably, his involvement with his work extends beyond the confines of his studio to the eventual placement of his paintings, which he rigorously controls.

Kiefer's themes are diverse, complex and deeply traditional. His subjects include both the Old and New Testaments, mythology, psychology, philosophy, history and technology. Yet, if his themes recall the masters of Western art, his painterly style is highly inventive and completely modern. While achieving an "old master" effect through his deep brown, almost lugubrious, tonalities his employment of media remains unique. His supports, which often consist of enlarged photographs, are commonly subjected to a variety of disfiguring elements, including staining, tarring, singeing and scorching. These processes, all of which involve a change of state, reflect the artist's interest in alchemy, the pseudo-science of turning base metals to gold. Kiefer was encouraged in this by his mentor, Beuys, who believed in the mystical transforming powers of art.

Kiefer's work emphasizes the alteration and metamorphosis of the media used and by association the objects represented. He stresses the evolution or becoming of an image, as much as the final state, and makes his viewer acutely aware of this developmental process. In many of his paintings, for instance, *The Meistersinger* (1982), the sere black landscape is evocative both of the lush pasture it once was and its present aridness, while the straw strewn over its surface carries connotations of the world outside the studio, transplanted and isolated from its natural setting. In addition to straw, sand, oil, tin, burlap, iron, emulsions, latex, bitumen, and shellac number among his most frequently used materials.

Among the different elements, fire and its aftermath are particularly meaningful to the artist. A desolate stretch of scorched earth is a recurring motif in Kiefer's art, as in *Nero Paints* (1975), which returns to the annals of ancient Rome and the mad emperor who "fiddled" during the fiery destruction of his city. The painting shows a singed and furrowed meadow that drips blood with a painter's palette hovering across its surface. More recent pieces, *Painting-Burning*

and *Painting of the Scorched Earth* (1983), deal with the potentially destructive and creative powers of nuclear energy. "Scorched earth is a technical term used by the army," Kiefer explained to Taylor. "Retreating troops set fire to the area they are leaving so that the enemy won't be able to grow crops there anymore. . . . I don't want to illustrate an ordinary military operation, but to depict the problem of the contemporary art of painting. If you like, you might view it as a new start that every painting has to make. Each work of art destroys the one before it."

Kiefer's interest in the land, and especially his attempt to capture and reveal the underlying cyclical processes of nature, recall such German Romantic landscape painters as Caspar David Friedrich and his close contemporary Carl Gustav Carus. Kiefer is particularly close to Carus who developed and expounded the concept of "Erdlebenbildkunst," or the "pictorial history of the life of the earth," which also attempted to embrace and illustrate the growth and decay, birth and death of a landscape. Like the German Romantics, Kiefer's motifs are explicitly German. The Mark Brandenburg outside Berlin, the meadows of southern Germany, feature among his most favored locations.

Kiefer's links to this school are also apparent in his choice of certain moments in the Teutonic past. Like Friedrich, Kiefer has painted the mythical story of Valerius, a Roman general defeated by Hermann, a legendary German "barbarian." For the 19th century this tale pretold the unification of a then politically fragmented country. For Kiefer, the legend assumes other implications. His painting *Wege der Weiseheit* ("Way of Worldly Wisdom," 1976–77) depicts the clearly labeled heads of famous Germans (for instance, Schleiermacher, Fichte, Rainer Maria Rilke, Kleist) intertwined by, and connected with, thick vines before a forest which the artist has clearly labeled as Hermann's. Art historian Gunther Gerkin explains the connection the artist intended as a juxtaposition of extremes. "The great heritage of all the poets and thinkers," he wrote, "could not prevent this nation from plunging into the depths of barbarism."

Much of Kiefer's early work took the form of books which he has continued to produce. They offer the artist expressive potential that is absent in painting. "My books are films in a way," he explained to Taylor. "In the books time is important. There is a type of cinematography, as in films. But in looking at paintings there is no time. They are a kind of apparition."

One of the artist's earliest book-format projects is the 1969 photographic series entitled *Occupations*. The images in this book consist of Kiefer, dressed in riding-boots and breeches, giving the Nazi salute before such major monuments of past civilization as the Colosseum in Rome and the ruins of Pompeii.

Kiefer's lack of inhibitions in treating sensitive subject matter has incited virulent criticism. Accusations of Nazi sympathies have been common. Kiefer, however, would describe his work as a call to memory and an attempt to understand the past. "You have to understand," he explained, "I was born the year the war ended and we were taught very little about what happened. I had to live through it myself to understand."

The artist has carried the stigma of neonaziism with him for a number of years. In an interview conducted in 1987 he rhetorically addressed the question to himself: "Are you fascist or anti-fascist?" He responded, "I need to know where I came out of. There was a tension between the immense things that happened and the immense forgetfulness. I think it was my duty to show what is and what isn't. Now I don't say we have a fascist state. But it's still there. Circumstances are quite good now. But they can change, and then we'll see what happens. In '69, when I began, no one dared talk of these things."

In 1980 Kiefer and George Baselitz were invited to represent West Germany in the Venice Biennale. Kiefer's paintings received considerable attention, bringing the artist instant notoriety. His work was unanimously condemned by critics who sensed disquieting undertones that recalled too strongly less than admirable elements in the Germanic past. Gunther Gerken has written that the critics "thought they perceived an 'overdose of Teutonic zeal' when it was in fact they who were introducing the Teutonic spirit." Kiefer was accused of "flouting his Germanness" and "flirting with the ghosts of the fatherland."

In response to the protest following the exhibition of paintings such as *Germany's Spiritual Heroes* (1976) Kiefer stated in an interview that he was "not primarily concerned with the persons who are portrayed." He continued, "it is the history of the reactions to their work . . . When I cite Richard Wagner, I do not mean the composer of this or that opera. For me, it is more important that Wagner 'changed,' if you will, from a revolutionary into a reactionary . . . the way in which he was used in the Third Reich and the problems associated with this."

Kiefer is often described as a religious artist, though his themes are not exclusively religious. In a 1986 interview he made reference to his preoccupation with this subject matter. "I think

a good deal about religion," Kiefer said, "because science has no answers." In the mid-70s the artist produced paintings concerned with the central mystery of Christianity, the Holy Trinity. These works often employed obvious and traditional Christian imagery, such as a snake to represent the devil (*Resurrexit*, 1973; *Quaternity*, 1973) or flames to embody the three-person God (*Father, Son, Holy Ghost*, 1973). The artist has gradually moved away from these almost banal Baroque images developing more subtle and evocative ways to convey a religious sentiment.

In 1984 Kiefer made a trip to Israel, one which prompted him to return to the Bible for inspiration, in this instance turning not to the New Testament but to the Old. The painting *Departure from Egypt* (1985), a direct response to the trip, refers to the story of Exodus. Here the artist has expunged all stereotypical allusion to the theme, presenting instead a vast landscape across whose foreground is placed a shepherd's staff. Another painting, named simply *Aaron* (1984–85), is similarly characterized by a prominently placed staff. As Mark Rosenthal has noted, Kiefer concentrates not on Moses, but on Aaron in his paintings of the Exodus theme. Rosenthal, who has given extensive study to Kiefer's use of symbolism, explains Kiefer's use of this motif in both works, and hypothesizes an empathetic relationship between Kiefer and Aaron. "Aaron and his staff are not without taint . . . ," he wrote. "In contrast to Moses who is unwaveringly loyal and spiritual, Aaron is a troubled and troublesome figure. The differing positions of the two in the hierarchy of biblical personages are symbolized by the nature of their staffs. That of Moses is identified as a 'rod of God'; with it, Moses makes serpents appear, parts the Red Sea, and strikes the rock to obtain water. . . . the rod of Moses is considered more sacred than Aaron's, which is defiled by contact with those of the Egyptian magicians. Aaron's questionable character is revealed when he rebels against Moses, creating the Golden Calf and encouraging the Jews to worship it. Thus, not withstanding his role as founder of the Jewish priesthood, Aaron is clearly an ambiguous figure."

In recent years Kiefer has turned increasingly to myth and history for his themes, in both instances choosing subject matter with layers of meaning beyond the obvious or superficial reading. In describing the process behind his work, he likens himself rather remarkably to a story teller. "I tell stories in my pictures to show what's *behind* the story. I make a hole and go through. I use perspective to draw the viewer in like a bee to the flower. But then I want the viewer to get

by that, to go down through the sediment, so to speak, and get to the essence."

To clarify his meaning he often uses words and phrases in his paintings. They serve to identify a myth, a geographical region, a particular song or poem, at times the person represented in the image. The inscriptions are not, however, intended as titles.

The myths that Kiefer most often chooses are either indigenous Teutonic legends (*Siegfried vergisst Brunhilde*, 1976) or deal with primal truths that relate to quests for identity and self recognition. Of the latter, among his most powerful are the paintings based on the Egyptian myth of Osiris and Isis. The 1985–86 paintings of this myth combine two unlike elements, an ancient tale of love and devotion and the modern reality of nuclear power. Both are linked in Kiefer's work through the underlying principles of destruction and generation.

Osiris, the son of the earth and sky, was betrayed by his jealous brother who murdered and dismembered him, scattering his remains throughout the world. Isis, his wife and sister, devastated at her loss, endeavored to collect the pieces of her lover. In one version of the myth, Isis finds and buries the individual pieces separately, in another she reassembles Osiris who became the ruler of Eternity, and the embodiment of everlasting life.

Kiefer's painting *Osiris and Isis* presents a vast step pyramid upon whose apex stands Isis, who is composed of a TV circuit board. From Isis extends a series of wires, each connected to a broken pottery shard, representative of Osiris's scattered remains. In another painting of this legend, *Fuel Rods*, Kiefer is more obvious in his imagery. Osiris is a miniature nuclear reactor.

Kiefer is probably best known for his series of paintings based on Paul Celan's poem "Death Fugue." Written in 1945 when the poet was in a concentration camp, the poem contrasts the Aryan blond Margarete with her dark Jewish counterpart, Sulamith. In Kiefer's series of paintings (*Margarete; Sulamith; Dein goldenes Haar, Margarete*, 1981) Margarete is embodied in straw, while Sulamith is represented by a gray paste formed of ash and paint. The paintings, shown in 1984 at the Israel Museum in Jerusalem, inspired a critic for the *Jerusalem Post* to comment: "Mourning might be the key to the psyche of Kiefer. It is not a mourning comparable to the mourning of the Jews in our times. Kiefer seems to be mourning the indigestibility of his heritage by battling with it in a series of waking dreams."

These are not the only works in which the artist has sought to confront events most in his

homeland would prefer to forget. *Operation Sea Lion* (1975) and *Johannisnacht II* (1981) both return to the Hitlerian past, while paintings such as *Dem unbekannte Maler* ("The Unknown Painter," 1983) and *Sulamith* (1983) are set in architectural spaces as conceived by Albert Speer, Hitler's architect.

Kiefer's work has changed very little over the course of his career. His paintings evidence a movement toward less strictly representational imagery and as a result his later works require more from his viewer than his earlier ones. He has also turned increasingly to the depiction of architecture, or more precisely architectural space, in his paintings.

While more accepted and better understood than when he first began, the artist still grapples with a lack of understanding and a complex distrust of his work. He currently lives in Hornbach with his wife Julia and two children.

EXHIBITIONS INCLUDE: Gal. am Kaiserplatz, Karlsruhe 1969; Goethe-Inst./Provisorium, Amsterdam 1973; Gal. Felix Handschin, Basel 1974; Gal. t'Venster/ Rotterdam Arts Foundation, Rotterdam 1974; Gal. Michael Werner, Cologne 1974, '75, '76, '77, '78; Bonner Kunstverein, Bonn 1977; Gal. Helen van der Meij, Amsterdam 1977, '79, '80; Gal. Maier-Hahn, Düsseldorf 1978; Kunsthalle, Bern 1978; Stedelijk Van Abbemus., Eindhoven 1979 '80; Mannheimer Kunstverein, Mannheim 1980; Wurttembergischer Kunstverein, Stuttgart 1980; Groninger Mus., Groningen 1980; Gal. Paul Maenz, Cologne 1981, '82, '84; Kunstverein Freiburg, Freiburg 1981; Mus. Folkwang, Essen and Whitechapel Art Gal., London, 1981; Marian Goodman Gal., NYC 1981, '85; Gal. Salvatore Ala, Milan 1981; Gal. Friedrich und Kunst, Munich 1981; Mary Boone Gal., NYC 1982; Sonja Henie-Niels Onstad Foundations, Oslo 1983; Anthony d'Offay Gal., London 1982; Hans-Thoma-Mus., Bernau 1983; Stadtische Kunsthalle, Düsseldorf 1984; Mus. d'Art Contemporain, Bordeaux 1984; Israel Mus., Jerusalem 1984; Art Inst. of Chicago, 1987–88. GROUP EXHIBITIONS INCLUDE: Gal. Zelle, Reutlingen 1969; Gal. Altes Theater, Ravensburg 1970; Deutscher Kunstlerbund, Bonn 1970; Staatliche Kunsthalle, Baden-Baden 1973; Frankfurter Kunstverein, Frankfurt 1976; Gal. Seriaal, Amsterdam, 1976; Mus. d'art moderne de la ville de Paris, 1977; Tehran Mus. of Contemporary Art, Tehran 1978; Badischer Kunstverein: Karlsruhe 1979; Neue Gal.-Sammlung Ludwig, Aachen 1980; Royal Academy of Arts, London 1981; ARC/Mus. d'art moderne de la ville de Paris 1981; Suermondt-Ludwig-Mus. und Museumsverein, Aachen 1981; Mus. d'art et d'Industrie et Maison de la Culture, Saint-Etienne 1981; Martin-Gropius-Bau, Berlin 1982; Mura Aureliane da Porta Metronia a Porta Latina, Rome 1982; Cntr. d'art Contemporain, Geneva 1982; Milwaukee Art Mus., Milwaukee 1982; Rosa Esman Gal., NYC 1982; Frederick S. Wight Art Gal., Univ. of Calif., Los Angeles 1983; The Saint Louis Art Mus., Saint Louis 1983; Kunstmus., Winterthur 1984; Williams Col. Mus. of Art, Williamstown 1984; MOMA, NYC 1984;

Scottish National Gal. of Modern Art, Edinburgh 1984; Hirshhorn Mus. and Sculpture Garden, Washington, D.C. 1984; Rijksmus. Kroller-Muller, Otterlo 1984; Villa Vauban, Luxembourg 1984; Solomon R. Guggenheim Mus., NYC 1988.

COLLECTIONS INCLUDE: MOMA, NYC; Art Inst. of Chicago, Chicago; Mus. of Contemporary Art, Los Angeles; San Francisco Mus. of Modern Art; Philadelphia Mus. of Art; The Carnegie Mus. of Art, Pittsburgh; Stedelijk Mus., Amsterdam; Stadtische Gal. im Lenbachhaus, Munich.

ABOUT: Beeren, W., Anselm Kiefer: Bilder 1986–1980, 1986; Denisot, R., Anselm Kiefer: Peintures 1983–84, 1984; Felix, Z. and N. Serota, Anselm Kiefer, 1981; Osterwald, T., Anselm Kiefer, 1980; Rosenthal, M., Anselm Kiefer, 1987; Schmidt, K., Anselm Kiefer: Bucher und Gouchen, 1983; *Periodicals*—Artforum Summer 1981, Summer 1982, September 1982, January 1983, September 1985, May 1986; Art in America Summer 1981, January 1983; Art International April–June 1983; ARTnews March 1984, September 1985; Artscribe October 1983; Arts Magazine October 1984; Burlington Magazine September 1984; Flash Art February–March 1982, March 1984, May–June 1986; Portfolio May–June 1983; Print Collector's Newsletter May–June 1984.

BY THE ARTIST: *Die Donauquelle* 1978; *Hoffman von Fallersleben auf Helgoland* 1980; *Nothung* 1983.

KOONS, JEFF (1955–), leading neo-geo sculptor, is best known for using commercial and commonplace objects to comment on consumerism in both contemporary society and the art world. Koons was born in York, Pennsylvania. He attended the Maryland Institute College of Art, receiving a bachelor of fine arts degree in 1976. As a student he was especially influenced by Byzantine paintings and folk art. In his senior year of college, he participated in a student mobility program which took him to the Chicago Art Institute. While in Chicago, he became friends with the artist Ed Paschke, who introduced him to the street and club scene where Paschke found "information for his art." "Seeing him pick up his source material from the street," Koons has said, "was very helpful for my own personal development because that's where I get my information. I look for it in different corners."

After completing his studies in 1976, Koons moved to New York City, mostly for the club scene, where he perceived "a certain energy taking place that seemed exciting." His initial years in New York were a period of experimentation and self-editing. He defines his earliest work as having been in a "pop vein." One visitor to his

JEFF KOONS

small East 4th Street apartment cum studio described it as "a bombardment of total art," filled with gaudy, commercial objects like plastic inflatable toys from carnivals and parades. Hundreds of brightly colored inflatable flowers, each mounted on and backed by a square of mirror, covered the floor and shelves (*Inflatable Flowers*, 1978).

Koons eventually grew bored with his inflatable sculptures and began refining his art, making it more ascetic and less colorful. While employed at the Museum of Modern Art, he decided to redirect his approach toward creating "modernist backgrounds from pedestrian materials." As a result, he produced a series of wall sculptures made from household appliances, such as electric kettles and toasters, which he glued to plastic tubing and lit from the back with fluorescent tubes. Koons felt those works fell short of "real art," however, because he "wasn't maintaining the integrity of the object." By late 1979, his desire to preserve objects' integrity had led him to mount them on a clear or white base and enclose them in "pure" Plexiglas display boxes. "Once I encased it," he has explained, "that's when it really happened for me, I was starting to make art."

Koons's art has been categorized as "neo-geo," a movement that began in New York's East Village in the early 1980s but did not become widely recognized until the middle of the decade. The label "neo-geo" was originally used to describe abstract geometric painting, such as Peter Halley's and Phillip Taaffe's: hard-edged, flatly colored compositions diametrically opposed to the frenzied, emotional neo-expressionist painting of previous years. Since the mid-1980s, neo-geo has signified a diverse group of artists whose work simulates and comments on postindustrial American consumer culture. Alternately referred to as neopop, neoconceptualism, new abstraction, neominimalism, neofuturism, and postappropriationism, among other things, neo-geo art borrows heavily from earlier trends. Marcel Duchamp's readymades and his notion of "art as a mental act" have been especially influential. For all its diversity, however, neo-geo art is unified conceptually by the influence of poststructuralist theory (principally the French philosopher Jean Baudrillard's concept of simulationism) and aesthetically by its tendency toward cool, distant presentation rather than passionate expression.

Koons's mature work has earned him a reputation as a leading neo-geo artist. Although Koons himself has not read Baudrillard, Peter Halley, the neo-geos' "house intellectual," considers his work simulationist. Critics refer to Koons's sculptures as "simulacra" and discuss the irony with which they articulate his social critique. Koons produces his simulacra in discrete series devoted to exploring specific themes, such as the desire for "the new" or "luxury and degradation."

[I do] a conceptual body of work and then—Boom!—I'm divorced from it. . . . It's information that's important to me, to present it from a different view is the creative process I'm involved with. I like to push myself to the point where my work is done purely mentally without having any interaction with materials in process.

"The New," Koons's first major series, consists primarily of appliances (vacuum cleaners are particularly well represented), all in brand-new condition, displayed in sealed Plexiglas cases and lit by fluorescent tubes. Pieces include *Hoover Convertible* (1980), a gray and silver upright vacuum cleaner; *New Hoover Deluxe Shampoo Polishers* (1980), two shampoo polishers side by side; and *New Shelton Wet/Dry Triple Decker* (1982), a stack of three wet/dry vacuum cleaners. According to one reviewer's interpretation, the pristine appliances, packaged forever in Plexiglas, satisfy the consumer's desire for brand-new objects but thwart the desire for security, sexual gratification, and insurance against death that is implicit in acquisition.

The sculptures are accompanied by advertising posters mounted on Duratran light boxes. The ads picture luxury items like big cars and cigarettes and often have "new" in their slogans. Koons preserved the advertisements' integrity by using full-size negatives obtained from advertising agencies. He then had the ads printed by

machine in oil-based ink on primed canvases. The resulting "paintings," Koons asserts, are more real than illusionary glossy prints and therefore more likely to be taken seriously by people. "The New" also includes "The New Jeff Koons," a back-lit photograph of Koons as a five-year-old, grinning over a box of new crayons. By portraying himself as a "new" human being, he suggests that people, unlike machines, cannot preserve their integrity through non-participation. To "have your own integrity you have to live and you're not immortal."

In 1982 Koons displayed works from "The New" in the "Moonlighting" show at the Josef Gallery. The exhibit showcased young New York artists who had "real" jobs to support their art and whose employment influenced as well as financed their artistic work. At the time, Koons was employed as a very successful Wall Street commodities broker. Works from the series were also exhibited at LACE in Los Angeles (1982), and the John Weber Gallery (1983). One reviewer commented that "The New" serves to "expose the appearance of things already present in our lives to see in the imagination the appearance of what is missing."

Koons's second body of work, "Equilibrium" (1985), focuses on what the artist calls "unachievable states of being." Several pieces in the series consist of basketballs floating in aquariums. *One Ball Total Equilibrium Tank* and *Number Two Ball Total Equilibrium Tank* for example, are composed of one and three basketballs, respectively, bobbing in tanks of distilled water. Koons partially filled the Spalding basketballs with either water or mercury so they would remain wholly or partly submerged in their tanks.

Oil paintings made from Nike basketball-shoe advertisements accompany the tanks. The ads feature famous black basketball players portraying *Dr. Dunkenstein*, *Sit Sid*, and *Moses*. To Koons, the ads suggest the commercialism of the game and the "unachievable sociological states of being" of its stars, who are lifted out of the ghetto by basketball only to be exploited by it.

The series also includes bronze casts of water-related items, such as *Snorkel*, *Aqualung*, *Lifevest*, and *Boat*. To Koons, those luxury objects represent a false sense of equilibrium. He had each object cast so that all the moving pieces actually work (the aqualung alone required thirty different molds). While this preserves their integrity, however, it renders them dysfunctional as breathing or flotation devices. As Koons has pointed out, they would drag people to the bottom rather than buoy them up on the surface.

"Equilibrium" was shown at the New York City gallery International with Monument in 1985. The critic Gary Indiana explicated the show, Koons's first solo exhibit, as a commentary on "current conditions in the biosphere—in art, culture, and the social world." Other critics found the installation "usually poetic" and full of "indelible images." Koons also exhibited works from the series in the "New Ground" show (1985) at the Luhring Augustine & Hodes Gallery and in a group show at the 303 Gallery (1985).

The third Koons series, "Luxury and Degradation," opened at International with Monument in 1986. The collection consists of a variety of drinking paraphernalia, from a "proletarian" water bucket to an "upper-middle-class" Baccarat crystal ice bucket, all cast in stainless steel. The most striking piece in the series is a Jim Beam train decanter, complete with engine, five cars, caboose, and track. Koons arranged for the Beam distillery to refill the decanter with whiskey and seal it with a tax stamp. If the collector breaks the seal to get the liquor, he contends, the integrity of the piece will also be broken. Koons intends those pieces to show how luxury and abstraction are used to control social class structure. By recontextualizing the drinking-related pieces, he illustrates how degrading it is for liquor to be a symbol of social status. That sentiment is echoed by accompanying oil paintings of whiskey and liquor advertisements.

The critic Roberta Smith praised "Luxury and Degradation" as "an elegant, insightful installation piece." The *New York Times* reviewer commended it as a "tough and clever show":

> By changing the material, and by placing the familiar objects in a gallery, Koons creates a mirror that can be held up to the Medusa-like power of the images. . . . [He] has taken a mythology of manipulation and manipulated it in turn. Instead of criticizing it from the outside, he tries to beat it as its own game. The objects that he appropriated are intended to produce desire, but Koons's work is chilling. The appropriated objects are sentiment, but this is a show without any sentiment at all.

Koons exhibited some of his "Luxury and Degradation" pieces at a group show at the prestigious Sonnabend Gallery in 1986. The show, which also included Haim Steinbach, Peter Halley, and Ashley Bickerton, drew large, international crowds and sold out quickly. Although high-profile collectors like Barbara and Eugene Schwartz and the British advertising giant Charles Saatchi had begun buying neo-geo works about a year earlier, the movement did not achieve worldwide prominence until the Sonnabend show. Exhibition pieces sold for $10,000 to $50,000; Koons's work brought espe-

cially high prices. Despite its commercial success, however, the show got a mixed critical reception. While some reviewers praised the neo-geos for producing some of the most interesting, energetic work around, the critic Donald Kuspit pronounced their work "dead on arrival" and Kay Larson advised *New York* magazine readers to "make way for the art of the next fifteen minutes."

"Statuary," Koons's fourth series, included pedestrian statues such as a marble-dust, life size bust of Louis XIV (1986), a copy of a popular nineteenth-century reproduction; *French Coach Couple,* a Rococo courting scene (1986); and *Rabbit* (1986), a child's inflatable mylar rabbit. Cast in stainless steel, the pieces are highly reflective and distort their surroundings so that the viewer must reinterpret their meaning. *Rabbit,* considered one of Koons's best pieces, is especially effective at making a very familiar object mysterious.

According to Koons, the kitschy quality of the statues contest the conventional ideas that art must be made from materials that have intrinsic value and that art has the power to transform society. In actuality, art is not "resplendent with transcendent significance and referents," but only a simulacrum of itself. This once prompted a curator from the Whitney Museum to remark that Koons's high-priced simulacra in effect "indict" their collectors. Some critics of Koons's work perceive his commercially successful sculptures as complicitous with the art market, which has experienced a financial boom since the 1970s. Many perceive Koons as a marketing genius who, far from criticizing consumerism in the art world, actively exploits it.

In 1987 Koons participated in the "Skulptur Projekte in Munster," a site-specific, citywide exhibit of projects by sixty-four European and American artists. He contributed a stainless steel cast of "Der Kiepenkerl," a bronze sculpture of a tenant farmer who carried wares to town in a large basket strapped to his back. The sculpture has almost mythical significance because it represents pre–World War II values and traditions; reproductions are displayed in city squares throughout Germany. Koons's reflective rendition of the figure, the reviewer David Joselit wrote, "opened new wounds in which the present met the past."

In 1988 Koons exhibited a new series at the Sonnabend Gallery. These sculptures consist of huge wooden and porcelain figures such as those found at carnivals and novelty shops. In her review of the show, Eleanor Heartney interpreted Koons's "kitsch carnival" as an expression of his disdain for lower-class aesthetics. As such,

Heartney wrote, his work is the "by-product of a decade that has made elitism and self-interest its guiding principles."

Other critics and observers also have seen Koons's art in that light and accordingly predicted its early demise. The artist, at least in one sense, has greater faith in the staying power of his work:

These objects show their strength, that they are stronger than the individual. My objects, maybe not in a traditional art sense, last longer than you or myself. Maybe they'll die off as art, but they're equipped to out-survive us physically.

EXHIBITIONS INCLUDE: Anna Nosei Gal. 1981; "Lighting," Sperone Westwater Fischer Gal. 1981; LACE, Los Angeles 1982; Artist's Space NYC 1982; "Moonlighting," Josef Gal. 1982; "Science Fiction," John Weber Gal. 1984; "New Ground," Luhring Augustine & Hodes 1985; "Equilibrium," International with Monument 1985; "Luxury and Degradation," International with Monument 1986; Group Show, Sonnabend Gal. 1986; "Post-Abstract Abstraction," The Aldrich Mus. of Contemporary Art, Ridgefield, Conn.; "NY Art Now," Saatchi Collection, London 1987; "Skulptur Projekte in Munster" 1987; Whitney Biennial 1987; "60s/80s Sculpture Parallels," Sidney Janis Gal. 1988; Sonnabend Gal. 1988.

ABOUT: Current Biography, 1990. *Periodicals*—Art in America May 1988, February 1989; ARTnews, January 1988; Arts Magazine November 1983, October 1986, May 1988; New Yorker November 24, 1986.

KOSSOFF, LEON (December 7, 1926–), British figurative painter and draftsman, wrote in 1973, in a remarkable autobiographical statement that has since been widely quoted: "I was born in a now-demolished building in City Road not far from St. Paul's. Ever since the age of twelve I have drawn and painted London. I have worked from Bethnal Green, the City, Willesden Junction, York Way, and Dalston. I have painted its bomb sites, building sites, excavations, railways, and recently a children's swimming pool in Willesden.

"The strange, ever-changing light, the endless streets, and the shuddering feel of the sprawling city linger in my mind like a faintly glimmering memory of a long forgotten, perhaps never experienced childhood which, if rediscovered and illuminated, would ameliorate the pain of the present.

"I have also, ever since I can remember, drawn and painted my father and I have worked from others close to me who were able to persevere with the sittings.

"Although I have drawn and painted from

landscapes and people constantly, I have never finished a picture without first experiencing a huge emptying of all factual and topographical knowledge. And always, the moment before finishing, the painting disappears, sometimes into grayness forever, or sometimes into a huge heap on the floor to be reclaimed, redrawn, and committed to an image which makes itself."

Kossoff's parents were Jewish immigrants from Russia. In 1945 he briefly joined the Jewish Brigade before entering the British Army's Royal Fusiliers, and he served in France, Belgium, Holland, and Germany. On returning to London he began formal studies at the St. Martin's School of Art (1949–53) and attended evening classes at the Borough Polytechnic under David Bomberg, the leader of the so-called Kitchen Sink school. He gained admission to the Royal College of Art (1953–56) and has served as lecturer at the Regent Street Polytechnic (1959–64), the Chelsea School of Art (1959–64), and at St. Martin's (1966–69). Since the late 1960s he has been able to paint full-time. From 1957 to 1964 he had six one-man exhibitions at London's Beaux Arts Gallery, and since the early 1970s he has been represented by Fischer Fine Art, London.

Kossoff and Frank Auerbach, his longtime friend and contemporary in Bomberg's classes, are frequently mentioned together as the chief protagonists of modern British expressionism, an artistic tendency that came into international fashion and prominence only in the 1980s. The two artists are, indeed, in many ways remarkably similar. Both demonstrate an intense familiarity with a limited range of subjects, all of which are close to home; both have established drawing as the prime foundation of their art; and the painting techniques of both are so similar that on occasion the work of one could almost be mistaken for that of the other.

The parts of northeast London that Kossoff invariably paints are among Britain's drabbest: working-class areas of no architectural distinction in which most postwar building has seemed only to reinforce the unimaginative tedium in which the inhabitants are forced to live. Yet it is the very banality of his sites, when conjoined with the great strength and energy of his realization of them, that gives his cityscapes their power. Furthermore, his most successful works of that kind focus on people, and their theme is human activity in an urban social context. In that regard his highly respected series from the early 1970s of the Willesden swimming pool is typical. *Children's Swimming Pool, Autumn* (1972), for example, is seven by six feet in size and fairly teeming with life; the rendering of each ele-

ment—the architecture of the building, the quality of the water, and the swimming, diving, splashing, lounging, and laughing of the dozens of bodies—serves to reinforce the vibrant energy of the whole. That sense of careful organization is always evident in his large-scale works. *Outside Kilburn Underground, for Rosalind, Indian Summer* (1978), which was considered by at least one critic to be the best British painting of the decade, is a grandly composed six-by-eight-foot board consisting of six principal figures, all slightly aslant, all radiating outward from some central, invisible force: it is, on its primary level, a crowd coming up from the London tube, but it is at the same time, and unmistakably, an arresting image of the multifaceted social city in action.

Such major works by Kossoff are, unfortunately, far fewer in number than his single-figure studies. He has, as he has noted always considered his father as a principal model, and his many renderings of the older man have increased in assurance and emotional content over the years. His paintings of nudes have become more frequent since about 1980, although one of his earliest essays in that genre, *Nude on a Red Bed* (1972), shows the artist at his best. The reclining figure, head cradled on both arms, stares out at the viewer with an expression deeply moving in its quiet tenderness and vulnerability. In virtually all his single-figure works, the subjects display a stoic passivity, which at one level, perhaps, is the result of the long hours of posing Kossoff is known to require of his sitters, but which operates in the paintings or drawings themselves to provide a calm counterpoint to the almost furiously energetic, seemingly spontaneous realization of the finished works.

Drawing is at the root of Kossoff's approach to his art. It involves an extremely laborious, almost endlessly repeated attempt, in his words, to "get things right." He has drawn his father literally thousands of times, and has been observed sitting with his sketch pad outside Kilburn station every day for months on end. His drawings record his errors as well as his successfully rendered subject, and when one attempt can be taken no further, he begins another. "Drawing," he wrote in 1977, "is not a mysterious activity. Drawing is making an image which expresses commitment and involvement. This only comes about after seemingly endless activity before the model or subject, rejecting time and again ideas which are possible to preconceive. And, whether by scraping off or by rubbing down, it is always beginning again, making new images, destroying images that lie, discarding images that are dead. The only true guide in this search is the special relationship the artist has with the person

or landscape from which he is working. Finally, in spite of all this activity of absorption and internalization, the images emerge in an atmosphere of freedom. This is the nature of true draughtsmanship." Kossoff's images are almost always very simple, and his determination to repeat them until they seem right to him is the best example of his obsession with perfection. It also suggests that he is ultimately concerned with more than mere line and form—he wants to create emotions in the viewer by means of those lines and forms. In this he is the lineal descendant of such proto-expressionists as Edvard Munch and Emil Nolde.

Kossoff's painting technique has changed little over the years. Although his lavish use of paint suggests an impasto built up over a long period of time, that suggestion is entirely deceptive. Each painting is, finally, entirely painted in a day, although each may have been worked on for months or even years before the final, satisfactory effort. The artist paints a work in its entirety each time he works on it. Then, as a rule dissatisfied with his work, he scrapes it all off the board (his oils are invariably done on board) and begins afresh the next time. One day he will actually finish the work, having created an image as close as possible to his perfectionist requirements. Then the entire process of painting, scraping off, and restarting will begin again with a new painting—although, because he frequently repeats his subjects, that next painting may bear a nearly identical image to the one just completed.

The writer Marina Vaizey is one of the closest and most perceptive critics of Kossoff's works. She has called his technique "sublime extravagance, such a bountiful and tenacious use of resources, both physical and psychical, as must rarely be practised." Once satisfied by the quality of the image, the artist adopts a finishing technique that is entirely his own. "Finally," wrote Vaizey, "very light, vibrant, sinuous and narrow dribbles of paint act as a kind of loose web over the entire picture surface. Here the color may be arbitrary; the web of paint so subtle as to appear almost a faint shimmer. But this device—instinctive, brilliantly controlled—acts as one of the ways of drawing the entire picture surface together." Kossoff rarely varies the structure of technique of that finishing coat, which in color may be soft or vibrant; it has become a subtle signature, distinguishing his paintings from all others.

The surface of Kossoff's paintings—glowing and fresh, like molten plastic—is doubly effective. The rendering of the figure has a carved, totemic quality, reinforced by the stolidity and passiveness of the subjects. Yet it also seems to shimmer and almost to flow—to have captured "the strange, ever-changing light" that must explain at least a part of the obsession which grips the artist. And all that fruitful tension between solidity and fluidity (itself reinforced by the Rouault-like use of thick black outlining) is put at the service of conveying both emotion and the artist's sense of compassion for human endurance. The consistently successful rendering of so much primal material has caused one critic to consider Kossoff "perhaps *the finest* of post–Second World War British painters."

EXHIBITIONS INCLUDE: Beaux Arts Gal., London 1957, '59, '61, '63, '64; Bruton Place Gal., London 1957; Marlborough Fine Art, London 1968; Whitechapel Art Gal., London 1972; Fischer Fine Art, London 1973, '74, '75, '79; Riverside Studios, London 1980; Mus. of Modern Art, Oxford and Graves Art Gal., Sheffield 1981; Louver Gal., Los Angeles 1982; Hirschl & Adler Modern Gal., NYC 1983. GROUP EXHIBITIONS INCLUDE: "British Painting in the '60s," Tate Gal., London 1963; "Painting and Sculpture of a Decade, 1954–1964," Tate Gal., London 1964; "Recent British Painting," Tate Gal., London 1967; "British Painting, 1952–1977," Royal Academy of Arts, London 1977; "13 Britische Kunstler," Neue Gal., Aachen, West Germany 1981; "8 Figurative Painters," Yale Cntr. for British Art, New Haven, Conn. and the Santa Barbara Mus. of Art, Calif. 1981.

COLLECTIONS INCLUDE: Tate Gal., London; British Mus., London; Fitzwilliam Mus., Cambridge; Whitworth Art Gal., Manchester; Thyssen-Bornemisza Collection, Lugano, Switzerland; Chrysler Mus., Provincetown, Mass., National Gal. of Victoria, Melbourne.

ABOUT: Elliott, D. Leon Kossoff: Paintings from a Decade, 1970–1980, 1981; Emanuel, M., et al. Contemporary Artists, 1983; Leon Kossoff: Recent Drawings and Paintings, 1974; Mercer, D. Leon Kossoff: Recent Paintings, 1972. *Periodicals*—Apollo May 1964, April 1968, January 1974, July 1975, May 1979; Art and Artists April 1974, April 1979; Artforum October 1979; Art International March 1972, April 1972, March 1974, September 1979, January–February 1981, March–April 1982; ARTnews December 1974, January 1980, April 1983; Arts Magazine May 1974, February 1982, May 1983; Burlington Magazine June 1979, August 1981, November 1984.

KOSUTH, JOSEPH (January 31, 1945–), American conceptual artist, has demonstrated a wide knowledge of and affinity for the methods of philosophical investigation pioneered by the linguistic philosophers Ludwig Wittgenstein and A. J. Ayer. From the beginning, his works have consisted, in whole or in part, of written displays that attempt to reexamine and reclassify the

JOSEPH KOSUTH

very nature of art. These displays have been mounted, most notably, under the title of "Investigations" (a conscious borrowing from Wittgenstein), a series of propositions about art.

Born in Toledo, Ohio, he had a varied artistic training, starting at the Toledo Museum School of Design (1955–62) and simultaneously with the Belgian-born painter Line Bloom Draper in Toledo. He studied painting at the Cleveland Art Institute (1963–64), then spent a year in Paris (1964–65) under the direction of Roger Barr. He returned from Europe to New York City, where he enrolled at the School of Visual Arts (1965–67). He also studied philosophy and anthropology during 1971–72 under Stanley Diamond and Bob Scholte at the New School for Social Research in Manhattan.

Kosuth's manifesto, written in 1969 and widely discussed, was *Art after Philosophy,* a lengthy text filled with quotations from philosophers, literary critics, and artists. Everything in modern art, he believes, dates from Marcel Duchamp's first unassisted readymades, among the best known of which was a bicycle, taken straight from the cycle manufacturer and exhibited by Duchamp as a work of art. With that daring innovation, wrote Kosuth, "art changed its focus from the form of the language to what was being said. Which means that it changed the nature of art from a question of morphology to a question of function. This change—one from 'appearance' to 'conception'—was the beginning of 'modern' art and the beginning of 'conceptual' art. All art (after Duchamp) is conceptual (in nature) because art only exists conceptually.

"The 'value' of particular artists after Duchamp can be weighed according to how much they questioned the nature of art; which is another way of saying 'what they *added* to the conception of art' or what wasn't there before they started. Artists question the nature of art by presenting new propositions as to art's nature."

Once these revolutionary premises are accepted, much must change in the values generally accepted in the art world: "The value of cubism—for instance—is its idea in the realm of art, not the physical or visual qualities seen in a specific painting, or the particularization of certain colors or shapes. For these colors and shapes are the art's language, not its meaning conceptually as art. To look upon a cubist 'masterwork' *now* as art is nonsensical, conceptually speaking, as far as art is concerned. . . . The 'value' now of an original cubist painting is not unlike, in most respects, an original manuscript by Lord Byron or 'The Spirit of St. Louis' as it is seen in the Smithsonian Institution. (Indeed, museums fill the very same function as the Smithsonian Institution—why else would the Jeu de Paume wing of the Louvre exhibit . . . Van Gogh's palettes as proudly as they do their paintings?) Actual works of art are little more than historical curiosities. As far as *art* is concerned, Van Gogh's paintings aren't worth any more than his palette is. They are both 'collector's items.'"

Kosuth concludes by returning to the venerable, late-nineteenth-century notion of "art for art's sake": "In an age when traditional philosophy is unreal because of its assumptions, art's ability to exist will depend not only on its *not* performing a service—as entertainment, visual (or other) experience, or decoraton—which is something easily replaced by kitsch culture and technology, but rather, it will remain viable by *not* assuming a philosophical stance; for in art's unique character is the capacity to remain aloof from philosophical judgments. It is in this context that art shares similarities with logic, mathematics, and, as well, science. But whereas the other endeavors are useful, art is not. Art indeed exists for its own sake. . . . Art's only claim is for art. Art is the definition of art."

Kosuth's overall aim in his manifesto was nothing less than to dematerialize the art object. He was far from alone in that aim at the time. Modern abstract art, it was widely agreed, had become wretchedly materialistic, concerned not with ideas outside itself but only with the picture as an object in itself. That attitude had led to the most sordid spectacles of rampant careerism, unmodulated hype, and the vulgarization of art's meaning into a series of fluctuating monetary values.

Art after Philosophy was used as an introduction to the exhibition "Conceptual Art and Conceptual Aspects," a show of twenty-nine artists from seven Western countries seen in 1970 at the New York Cultural Center. Kosuth's other contribution to the exhibition was a piece called *Information Room,* consisting of utility-type chairs in front of two long tables, on which were displayed paperback books (mostly on linguistic philosophy), art magazines, and newspapers. The spectator was evidently expected to sit at the tables and read the books, although no particular order of reading was suggested and no excerpts were provided. Critics delighted in pointing out that they had observed no visitors doing any such thing.

From the beginning, the critical response to Kosuth's work has been characterized by mild enthusiasm and bewilderment, with a strong admixture of unrelieved, scornful antagonism and outright dismissal. "Cultural nihilism," Peter Schjeldahl called conceptual art, "a moral crusade" whose "Savonarola" was Joseph Kosuth. "The implied (conceptual?) arrogance of [*Information Room*] is fairly breathtaking, since what we are invited to sit down and study seems no more or less than a 'documentation' of the artist's mind, in which we are evidently presumed (or enjoined) to be very interested." Schjeldahl concluded by firing the most destructive weapon in the critic's arsenal, the accusation of inconsequence and boredom: "It's hard to know what to do with a movement which demands so much from its audience in return for so little. What makes it harder is one's suspicion that painting and sculpture, being a few thousand years old, will survive even this current fit of iconoclasm. At the same time, one cannot but admit the force of the conceptual critique in an art scene poisoned by the market mentality. Boring as it is to watch, it keeps scoring points. The answer may be that conceptual art is an event less in art history than in social history, being part of the present radical ferment in every field, heightened and modified by the new wide availability of informational media. Its effect remains to be seen. Meanwhile art, the product of impure men, can be expected to go on its impure way." The critic Carter Ratcliff, a persistent Kosuth antagonist, called the artist's forays into linguistic philosophy "a pure contrivance which allows him to substitute for genuine advances in the field the aura of having completely mastered it." For Ratcliff, Kosuth's work is simply vulgar ambition of a particularly virulent American sort: "When an ambitious person commits himself to an outward look—of efficiency, of historical importance, of personal or stylistic attractiveness—he can only be convinced of his value by his audience, some

segment, large or small, of our generally unaccomplished population, the American 'folk.' If it is a small segment, the ambitious person is likely to be an art specialist, not . . . a genuine folk artist, but a folk linguist, logician, mathematician. If his audience is large, he becomes that American specialty, the folk aristocrat, the star. Kosuth's pretensions make him a specialist, but his ambitions will only be satisfied by stardom. Everything considered, his vulgarity is quite marvelous. I hope I'll be understood when I say that if Kosuth would only strike it rich, he'd be the Jackie Onassis of the American art world."

Quite undaunted by such critical diatribes, Kosuth persisted during the first half of the 1970s with his "Investigations," constantly intending to get away from the unique art object, to present verbal information as the equivalent of an image, and, most important, to show that content in art does not depend on a sensuously appealing form. The "Investigations"—there were ten in all—took various forms, all of which were hard to understand, provocative, or even irritating, and extremely resistant to evaluation. There were wall panels bearing dictionary definitions of words from a basic art vocabulary ("abstract," "visualization," "meaning," etc.); there were pieces consisting of words in neon tubing, each word describing some aspect of the piece of which it was a part (one read, NEON ELECTRICAL LIGHT ENGLISH GLASS LETTERS YELLOW EIGHT); there were variations on *Information Room,* in which segments of the texts fastened to the tables were blown up on panels attached to the surrounding walls. That last gambit baffled even so friendly a critic as Elizabeth Baker: "By annexing large chunks of theoretical material and presenting them 'raw,' Kosuth seems to incorporate a strategy of mixed aggressiveness and untouchability, warning off all comment from the nonspecialist—when, of course, his normal audience is composed entirely of nonspecialists or, at best, specialists only in art."

The Tenth Investigation (1975), Kosuth wrote in "A Notice to the Public," is "my last. The point of my saying this is not that I intend to stop working, but that it has become extremely difficult for me to support the epistemological implications and cultural ramifications of the uncritical analytic scientific paradigm which the structure of this work (regardless of my own attempts to subvert it) inescapably implies. My study of anthropology in the past few years was initiated out of a desire to acquire tools which might make possible the overview of art and culture that my earlier work finally necessitated." Further study, particularly the cultural relativism he learned about in his forays into anthropology, led him to regard much of his work up

to then as ethnocentric. "The ideological package has become inappropriate. That the work was viable eight or nine years ago within that structure is no justification for cultural self-perpetuation *ad infinitum*. Our war at that time against formalism's mindless aestheticism was 'won' at the expense of our being responsible (after proliferation has begot proliferation) for a replacement which is functionally decorative and potentially even more 'mindless' because of its inability to be self-reflexive in spite of its claims. The revolution didn't even simply end, it continues as a style. I don't like the work I see being done around me, and to the extent that I am a co-participant (even if as an antithesis) I must somewhat alter my course."

In 1975–76 Kosuth became, along with Sarah Charlesworth, founding editor of an important art-political magazine, the *Fox*. (In 1970 he had been American editor of *Art-Language*, a journal founded by the British conceptualists Terry Atkinson, David Bainbridge, and Harold Hurrell.) The origins of the *Fox* may be traced, in the opinion of several critics, to the sense of emptiness and disillusion that followed conceptual art's considerable commercial success. The magazine aimed, according to the advertisements for it, at "a revaluation of art practice"; the editors wanted to create a dialogue within the art community. The first issue, appearing in the spring of 1975, offered jaded art-magazine readers, according to Nancy Marmer, "a unique blend of fragmentary Marxian analysis, ponderous sociological jargon and bitchy ad hominem attacks. Opaque theoretical analyses of art and culture often had a disturbing tendency to dwindle off into breezy, petulant jabs at individual instances of careerism, consumerism, formalism, culturism, adventurism or imperialism." In the end, dissension within the Art and Language Foundation, whose members controlled the *Fox*'s editorial board, caused the magazine to founder in early 1976 after three issues. "A majority of the foundation's members," wrote Marmer, "decided to adopt more orthodox Marxist-Leninist positions and to collectivize their group, a step which would make it unacceptable for any member to continue to exhibit under his or her own name and mandatory that all submit work to the group for majority approval. Since most of the Art and Language people already worked and tended to exhibit together, it was Kosuth, whose 'art star' status had already provoked some ill feeling within the group, who was conspicuously singled out by the decision. Refusing to submit to the new orthodoxy, he and Charlesworth withdrew, effectively dissolving the foundation and ending the life of the *Fox*."

Kosuth returned to his one-man shows in the late 1970s; in New York, his exhibitions were invariably mounted at the prestigious Leo Castelli Gallery. Although the "Investigations" series had ended, his new shows bore close similarities to the earlier ones: oblique, difficult texts printed in large letters on transparent acetate screens or on walls. The shows' subject, as always, was the nature of art, and only their titles differed from what had gone before: *Text/Context* (1978); *Cathexis* (1981); *Fort! Da! 1–6* (1985). In an introductory note to *Cathexis*, the artist wrote of his aim: "This work attempts to understand the 'conditions' of content, with, finally, the process of understanding those conditions becoming the 'content' of the work. By 'content,' of course, I refer not to meaning as a kind of instrumentality, but rather, 'what are those conditions which permit the construction of meaning?' The material of this work is *relations*, and to establish those relations 'things' are used. The desire is to construct the work (the meaning it makes as art) below the surface of the fragments of other discourses (systems of meaning). The *remaking* of meaning with given parts (a combination of 'found,' made, and misused) is meant to cancel parts of some meanings with parts of other meanings, permitting the viewers to trap themselves on one of various surfaces (not unlike a kind of labyrinth) and assume the meaning of the whole within an eclipse by a part (the vulgar example will be those that see the work in relation to dada or Baselitz). In short, for those able to see beyond the 'form' of the work (how it's made) there is to be seen that combination of relations which is the work (what is made). Such 'seeing,' however, is only a momentary event, a point of understanding that structure of relations which construct all works of art, and in this sense such works can be experienced as models of art itself."

EXHIBITIONS INCLUDE: Mus. of Normal Art, NYC 1967; Gal. 669, Los Angeles 1968; Douglass Gal., Vancouver 1969; Inst. Torquato di Tella, Buenos Aires 1969; St. Martin's School of Art, London 1969; Mus. of Contemporary Art, Chicago 1969; Art and Project, Amsterdam 1969; Gal. Sperone, Turin 1969, '70; Kunsthalle, Berne 1969; Leo Castelli Gal., NYC 1969, '71, '75, '79, '82, '85; Art Gal. of Ontario, Toronto 1969; Pasadena Art Mus., Calif. 1970; Aarhus Kunstmus., Denmark 1970; Gal. Daniel Templon, Paris 1970; Gal. Paul Maetz, Cologne 1971, '79; Protetch-Rivkin Gal., Washington, D.C. 1971; Gal. Bruno Bischofberger, Zurich 1971; Cntr. de Arte y Comunicación, Buenos Aires 1971; Lia Rumma Studio d'Arte, Naples 1971, '75; Carmen Lamanna Gal., Toronto 1971, '74, '78; Gal. Toselli, Milan 1971; New Gal., Cleveland 1972; Sperone-Fischer Gal., Rome 1972, '74; Gal. Gunter Sachs, Hamburg 1973; Gal. Paul Maetz, Brussels 1973; Copley Gal., Los Angeles 1974; Gal. La Bertesca, Düsseldorf 1974; Gal. Peccolo, Livorno, Italy 1975; Gal. MTL, Brussels 1975;

Gal. Liliane et Michel Durand-Desert, Paris 1975; Renaissance Society, Univ. of Chicago 1976; Kunstmus. van Hedendaagse, Ghent 1977; Van Abbemus., Eindhoven, Holland 1978; Mus. of Modern Art, Oxford 1978; New 57 Gal., Edinburgh 1979; Gal. Eric Fabre, Paris 1979; Gal. Rüdiger Schottle, Munich 1979; Saman Gal., Genoa 1979; Mus. de Chartres, France 1979. GROUP EXHIBITIONS INCLUDE: Camden Art Cntr., London 1970; Australian National Gal., Canberra 1977; Solomon R. Guggenheim Mus., NYC 1977; Mus. of Contemporary Art, Chicago 1977, '79; Seibu Mus. of Art, Tokyo 1978; Stedelijk Mus., Amsterdam 1979; MOMA, NYC 1980; Inst. of Contemporary Arts, London 1980.

COLLECTIONS INCLUDE: MOMA, Solomon R. Guggenheim Mus., and Whitney Mus. of American Art, NYC; National Gal., Ottawa; Tate Gal., London; Van Abbemus., Eindhoven and Stedelijk Mus., Amsterdam; Kunstmus. van Hedendaagse, Ghent; Cntr. Georges Pompidou, Paris; National Gal., Canberra.

ABOUT: Emanuel, M., et al. Contemporary Artists, 1983; Kosuth, J. January 5–31, 1969, 1969, and Notebook on Water, 1965–66, 1970. Who's Who in American Art, 1989–90. Periodicals—Artforum March 1973, April 1975, Summer 1985; Art in America July–August 1977, March 1979, December 1980; Art International November 1968, May 1971, January 1983; ARTnews February 1973; Art Press March–April 1974, December 1981; Arts Magazine September–October 1968, February 1969, October 1975, May 1976; Flash Art February–March 1971, June 1979; Newsweek December 18, 1972; Studio International October 1969, December 1973; Vanguard February 1979.

KOUNELLIS, JANNIS (1936–), painter, sculptor, performance artist, and writer associated with the Italian arte povera group in the late 1960s. Kounellis was born in Greece but has spent all of his adult life in Rome, and those dual roots have never ceased to infuse his work with a profound historical consciousness that manifests itself in a continuous engagement with history and, at the same time, in a challenge to historical tradition. "I am a partisan of all theories, however radical," he has declared, "that permit the survival of contradictions, nuances, and stratifications."

Born in Piraeus, the port of Athens, Kounellis had what he has described as a typical childhood, albeit within the context of the Second World War and, immediately afterward, the ten-year Greek civil war. His father, who served in the Greek army, joined the resistance against the Italians and the Germans and was active in helping the Jews of Greece to escape. After the liberation, the elder Kounellis went to the United States to work as a mechanic. His son, meanwhile, attended art school to prepare for the Fine Arts Academy. The experience, he re-

called, was "very restrictive, very academic," but he persisted in doing his own work: "Let's say I had a will to change," he told Willoughby Sharp in a 1972 interview, indicating that even as a teenager he saw himself as an artist, not an art student. During the early 1950s he did "a lot of work, but not to exhibit," and he started planning to leave Greece for Italy, where he felt that modern art (which he had not actually seen) was waiting for him. With money from his father, he and his wife of three years were able to move to Rome in 1956, where both enrolled in the Accademia di Belle Arti.

Among the friends he made in Rome were other young artists such as Francesco Lo Savio, Pino Pascali, Giulio Paolini, Piero Manzoni, Luciano Fabro, and Enrico Castellani; in his words, they shared a "critical vision" that attempted to situate the artist in the larger context of history, a consciousness that "an artist must not make an apology for [the system]. But at the same time, one knows also that artists are nourished by ancient dreams." During his first year in Rome, he recalled to Sharp, "I did a lot of thinking, I discovered there was a contemporary sensibility, which obviously did not exist in Greece." In the tangle of artistic currents that made up the postwar Italian scene, the influence of Lucio Fontana and Alberto Burri was dominant, while abstract expressionism and its French variant, art informel, were regarded as foreign intrusions. Kounellis was actually more impressed by abstract expressionism than the "little canvases" of Fontana, mainly because of the use of space, and in that respect, he noted to Bruno Corá in 1980, he saw Jackson Pollock as "the father and mother of American art."

The paintings that Kounellis undertook in 1958 and 1959 drew on certain premises of abstract expressionism—the primacy of process, the integrity of the picture plane—but, inspired by the tentatives of Yves Klein and Manzoni, as well as the example of Fontana, he turned away from painterly abstraction and attempted to put material life on the canvas, as it were. He began with letters crudely stenciled on raw canvas, sometimes including entire words, and at one point, a real street sign; he then added numbers and various other marks—dots, dashes, arrows. "I wanted to form a discourse," he later explained to Carla Longi, "even with very few letters, a hermetic discourse like someone who has to write things and then perceives that the letters don't correspond to that pronouncement; they become something else when you reread them systematically."

Like the musical notations that he had been painting in Greece, these "phonetic poems," as

he called them, were meant to be sung aloud, and eventually, in 1960, he turned the paintings into performances, initially in his studio and then at his first solo exhibit at the Galleria La Tartaruga, where he donned a painted canvas robe (modeled on that worn by the dadaist Hugo Ball at a famous soiree at the Cafe Voltaire in Zurich in 1916), executed his paintings, and then sang them. For a time, he painted on newspaper in order to forge a more explicit link with "real" life; next he spent a year and a half doing daily paintings in large stripes of different colors that varied according to the day of the week, and then he turned to very studied renderings of individual words: "yellow," for example, painted in red (*Giallo,* 1965), or "petit," alluding to Sidney Bechet's "La petite fleur," represented with three bars of music from the score (*Petit,* 1965).

As he indicated to Sharp, all of those works were aimed at establishing "a new kind of painting, something after *art informel.*" But ultimately he decided that the problem was not a particular style of painting, like *art informel,* but painting itself, which, he came to believe, created a false sense of synthesis at the very moment when society at large was in the throes of fragmentation and disintegration. With that recognition—in 1965—he stopped painting and embarked on a period of rethinking his mission as an artist. The context of that effort was a political one—by way of explanation, he cited the fact that he came from "a family of leftists"—and at the time, in Italy, as elsewhere in Europe and the United States, there was growing concern for the issue of how art might serve as a vehicle of change. In any event, when he resumed working, he had put aside the traditional materials of painting for what Henry Martin aptly described as "tableaux-vivants." In March 1967 he exhibited his first "cloth roses" at the Galleria L'Attico—large, flower-shaped cutouts thumbtacked onto stretched canvases that were framed at either side with vertical rows of bird cages, complete with live birds. This very literal injection of life into art was taken a step further in another show, in November 1967, where he dispensed with the canvas (as well as the cages) and simply put a live parrot on a gray wall board (*Papagallo*). Other works from that new phase included a metal container overflowing with cotton (*La coltoniera*), long metal planters filled with cacti (*Campi*), a low bin full of coal (*Carboniera*), a dolly piled with gunny sacks (*Carrello con sacchi*), hanks of raw wool (*Lana*), and hissing, flaming acetylene torch set into a daisy-shaped metal frame (*Marherita con fuoco*).

The echoes of Kounellis's forerunners were not hard to find—Fontana's canvas sacks, Manzon's *achromes,* Burri's sacks, Klein's fires—yet where these works broke new ground was precisely in their eclectic assortment and visceral intensity (like the earlier letters and numbers that obviously grew out of the cubist/constructivist tradition but resolutely abandoned artistic logic and symbolism for semantic statement).

Nor was the evolution an individual one: alongside Kounellis, a whole group of Italian artists had chosen to put aside gestural abstraction and to explore the possibilities of reestablishing an elemental language of artistic communication. It was on the occasion of a 1967 group exhibition in Genoa, featuring the works of Kounellis, Fabro, Paolini, Alighiero Boetti, Emilio Prini, and Pino Pascali, that the critic Germano Celant dubbed the new trend *arte povera,* alluding to Grotowski's "poor theater" to single out the modesty of the materials on the one hand and the artistic concept on the other. Within less than a year, the events of May 1968 were to give further impetus to the collective movement (with no small element of reaction against the prevailing pop and minimalism emanating from the United States), and in that climate, Kounellis quickly emerged as one of its leading practitioners.

His ultimate goal, wrote Maurizio Calvesi in 1969, "seems to be the elaboration of a space where, upon entering, the visitor wouldn't feel superior to an animal, or even to a piece of coal, but rather an integral part of a world that's free and without hierarchies." As Calvesi pointed out, the "poor" materials he used—fire, coal, raw wool, live birds and plants—were pointedly rich, not only in terms of their appeal to the senses, including sight, sound, and touch, but also in cultural associations—Prometheus and the myth of fire, coal as a symbol of industrialization, the Golden Fleece, the brightly colored parrot as a metaphor for painting. And indeed, Kounellis himself indicated, "I think my greatest aspiration—to be paradoxical—is to become a need to sew everything up, but first to push my way there and sew all this history up again. I don't want to delve into the past for archeological pleasure—though it could have been that—but because the past has a reality which conditions us deep down. Then if you bring it slowly to the surface, it's full of possibilities."

By the end of the decade, Kounellis was giving full rein to the spectacle that was inherent in such an approach: the lone oxyacetylene torch, for example, gave way to rooms full of acetylene torches or small flares similarly distributed across the floor or positioned on steel bed frames or hung on metal balances; the parrot pieces, likewise, had as their "logical consequence"

(Kounellis's words) a 1969 "installation" at the Galleria L'Attico featuring a dozen live horses tethered to the walls of the converted garage space. Music reentered his work as well: for a 1970 retrospective of the Italian avant-garde, he offered his own piano rendering of Verdi's *Nabucco* (i.e., a spirited anthem commemorating the Jews' rebellion against Nebuchadnezzar, often compared to the French *Marsellaise*); the following year (to celebrate the birth of his son), he assembled a violinist and a ballerina to "accompany" a pink painting of a fragment of Stravinsky's *Tarantella*, and on two other occasions (New York and Naples), he brought a cellist to perform before a green painting of Bach's *St. John Passion*; for an homage to Morris Louis (*Omaggio a Morris Louis,* 1971), he positioned himself, hand painted blue, green, yellow, purple, and red, next to a violin and the music for Dvořák's *New World Symphony.*

Notwithstanding those seemingly bravado gestures, Kounellis's work of the late 1960s and early 1970s is also marked by a strain of melancholy quite different from the élan of May 1968. As Henry Martin wrote of the horses Kounellis "installed" in the Galleria L'Attico, "the environment as a whole was something of the quality of an anxiety dream." Much the same could be said of other pieces from that period, such as the blocked portal (*Porta murata*)—a doorway filled with stone rubble—first introduced in 1969, or two of his human tableaux, the often-cited *Woman with Blanket and Flame* (1970), for which Kounellis positioned a nude woman wrapped in a blanket on the floor of a gallery and taped a burning oxyacetylene torch to her foot, and the *Motivo Africano* (1970), featuring a pregnant nude woman seated on a tall stool, her honey-smeared stomach spotted with the cockroaches Kounellis set loose in the gallery.

In the course of the 1970s, the optimism of the previous decade all but disappeared from Kounellis's work: even the fires were quite literally extinguished to create traces of soot on the gallery walls (*La ciminiera,* 1976). Replacing his belief in the future was a new appreciation of the past, incorporating Kounellis's own Greco-Roman heritage as well as the broader legacy of European art and culture. In particular, fragmented casts of classical sculpture (often Roman copies of Greek originals) made their way into his installations and performances, and Kounellis himself frequently donned the mask of Apollo to assert his identity as the artist-seer. Byzantine Christian motifs appeared as well, notably the gold leaf backgrounds of medieval manuscript illustrations and a blocklike wooden form representing a truncated crucifix. There were also citations of modern artists, such as the 1977 installation at the Lucerne Kunsthalle, which incorporated a portrait of Soutine into a wall full of fires, or the 1980 wall panels painted with anguished faces obviously taken from Edvard Munch.

As Germano Celant pointed out, Kounellis's works from the mid-1970s on effectively constituted a "re-presentation" of earlier motifs in new, site-specific contexts, but in the process, a new sense of order was also imposed—the random piling up of stones in the blocked doorways, for example, gave way to systematic arrangements of stones, plaster casts, and wooden boards more reminiscent of museum cases than rural masonry. Toward the mid-1980s, Kounellis imposed an even more encompassing order by mounting the individual elements of his "accumulations," as he called them, on large sheets of metal which were then hung on the walls like monumental paintings. One of the most majestic of these installations was created for the Musée d'Art Contemporain in Bordeaux, where Kounellis filled the arcades of the vast space—a converted nineteenth-century warehouse—with a rhythmic alternation of hissing fires mounted on iron sheets, stacks of gunny sacks, a panel of shelves and smoke traces, barriers of wood, and two huge monochrome panels, one red and one black. The iron sheets from Bordeaux were exhibited in turn at the major retrospective of Kounellis's work in Chicago the following year, and Kounellis's dialogue with personal and collective history assumed still another dimension as he attempted to adapt the European idiom to the American context, even going outside the museum to create installations in old commercial buildings elsewhere in the city. The striking success of his effort is reflected in the nature of the critical response to the exhibit. Even though Kounellis was no stranger to New York galleries—he had begun exhibiting at the Ileana Sonnabend Gallery in 1972—he had remained largely overlooked and underrated in the United States; the Chicago exhibit not only drew long overdue attention to his artistic achievement, but stirred up larger questions about the relationship between European and American art, beginning with the recognition of vast differences in outlook between the two communities. Dan Cameron went so far as to argue that Kounellis's work could not even have the same message for Americans that it has for Europeans: "His great theme is history, yet what America proffers as history is in fact the unmediated whirlwind of perpetual change. . . . Far from underscoring the problem of cultural fragmentation, Kounellis's work seems to present the hypermodernized world with a sense of comfort that is a continuity with the past."

Kounellis himself continues to live "in the midst of his own past," as Mary Jane Jacob noted in the Chicago catalog, referring to the fact that he and his longtime companion and collaborator, Michéle Coudray, reside in what was once the Galleria La Tartaruga, where he had his first solo exhibit in 1960. For many years after his arrival in Rome, he did not return to Greece and refused to speak his native language; it was only in 1977, after the fall of the junta, that he made his first, one-day visit for a performance in an Athens gallery, and he returned only three more times in the next eight years. "I am a Greek person but an Italian artist," he insists.

EXHIBITIONS INCLUDE: Gal. La Tartaruga, Rome 1960, '64, '78; Gal. Arco d'Alibert, Rome 1966; Gal. L'Attico, Rome 1967–76; Gal. Iolas, Milan 1968; Gal. Carella, Naples 1968; Gal. Sperone, Turin 1968, '71; Gal. Incontri Internazionali d'Arte, Rome 1971, '72; Gal. Volker Skulima, Berlin 1971, '74; Modern Art Agency, Naples 1971; Gal. Ileana Sonnabend, NYC from 1972; Gal. La Salita, Rome 1973; Gal. Ileana Sonnabend, Paris 1973; Gal. Forma, Genoa 1974; Gal. Cortile, Rome 1974; Gal. Christian Stein, Turin from 1974; Studio d'Arte Contemporanea, Rome 1975; Gal. Lucio Amelio, Naples from 1975; Gal. Mario Pieroni, Pescara 1975; Gal. Rudolf Zwirner, Cologne 1975; Gal. Salvadore Ala, Milan from 1976; Mus. Boymans-van Beuningen, Rotterdam 1977; Gal. Jean Bernier, Athens from 1977; Kunstmus., Lucerne 1977; Gal. PioMonte, Rome 1977; Studio Tucci Russo, Turin 1977; Gal. Mario Diacono, Bologna 1978; Städtische Mus., Mönchengladbach 1978; Gal. Konrad Fischer, Düsseldorf from 1979; Gal. Salvadore Ala, NYC 1979; Mus. Folkwang, Essen 1979; ARC, Mus. d'Art Moderne de la Ville de Paris 1980; Gal. Marilena Bonomo, Spoleto 1980; Gal. Mario Diacono, Rome 1980; Gal. Annemarie Verna, Zurich 1980; Gal. Durand-Desert from 1981; Gal. Karsten Greve, Cologne 1981; Gal. Schellman & Klüser, Munich from 1981; van Abbemus., Eindhoven 1981; Obra Social, Caixa de Ascanio, Rome 1982; Staatliche Kunsthalle, Baden-Baden 1982; Mus. Comunali, Rimini 1983; Mus. Haus Esters, Krefeld 1984; Gal. Franca Mancini, Pesaro 1984; Gal. Ugo Ferranti, Rome 1984; Städtische Gal. im Lenbachhaus, Munich 1985; Mus. d'Art Contemporain, Bordeaux 1985; Gal. Christian Stein, Milan from 1985; Anthony d'Offay Gal., London 1986; Mus. of Contemporary Art, Chicago 1986. GROUP EXHIBITIONS INCLUDE: "Schrift en Beeld," Stedelijk Mus., Amsterdam 1963; San Marino Biennale 1963; "L'art actuel en Italie," Casino Municipale, Cannes (trav. exhib.) 1965; "Stuazione 67," Gal. Civica d'Arte Moderna 1967; "Arte povera e Im-spazio," Gal. La Bertesca, Genoa 1967; "Young Italians," Inst. of Contemporary Art, Boston 1968; "Cento opere d'arte dal futurismo alle tendenze attauli," Pal. Zacheta, Warsaw 1968; "Op Losse Schroeven," Stedelijk Mus., Amsterdam 1969; "Live in Your Head: When Attitude Becomes Form," Kunsthalle, Bern 1969 (also Mus. Haus Lange, Krefeld, and Inst. of Contemporary Art, London); "Quatre Italiens plus que nature," Mus. des Arts Decoratifs, Paris 1969; Prospect 69, Düsseldorf 1969; "Between Man

and Matter," Metropolitan Art Gal., Tokyo 1970; "Processi di pensiero visualizzati," Kunstmus., Lucerne 1970; "Conceptual art arte povera land art," Gal. Civica d'Arte Moderna, Turin 1970; "Vitalitá del negativo nell'arte italiana 1960/70"; Pal. delle Esposizioni, Rome 1970; "Arte povera—13 italienische Künstler," Kunstverein, Munich 1971; Documenta 5, Kassel 1972; "Ada II: Aktionen der Avantgarde," Neuer Berliner Kunstverein, Berlin 1974; Venice Biennale from 1974; Arte in Italia 1960–77," Gal. Civica d'Arte Moderna, Turin 1977; Documenta 6, Kassel 1977; "Omaggio a Brunelleschi," Chiesa di Sta Maria Novella, Florence 1977; "Per una politica della forma," Gal. Mario Diacono, Bologna 1978; "Potische Aufklärung in der europäischen Kunst der Gegenwart," Zurich 1978; "Der Erweiterung des Wirklichkeitsbegriffs in der Kunst der 60er und 70er Jahre," Mus. Haus Lange, Krefeld 1979; "A New Spirit in Painting," Royal Academy of Art, London 1981; "Che fare?" Mus. Haus Lange, Krefeld 1981; "Identité italienne," Cntr. Georges Pompidou, Paris 1981; "Arte povera antiform," Mus. d'Art Contemporain, Bordeaux 1982; Documenta 7, Kassel 1982; "Zeitgeist," Martin-Gropius Bau, Berlin 1982; "Der Traum des Orpheus," Städtische Gal. im Lenbachhaus, Munich 1984; "Legendes," Mus. d'Art Contemporain, Bordeaux 1984; "Coperenza in coperenza," Molle, Turin 1984; ROSC 84, Dublin 1984; "Il Modo Italiano," Fredrick S. Wight Art Gal., UCLA 1984; "Het voorbeeld van de klassieken," Mus. Boymans-van Beuningen, Rotterdam 1984; "L'Oeil: Musicien," Pal. des Beaux-Arts, Charleroi 1985; "Raum zeit Stille," Kunstverein, Cologne 1985; "Don Giovanni," Stedelijk van Abbemus., Eindhoven 1985; "Del Arte Povera a 1985, Pal. de Velasquez and Pal. de Cristal, Madrid 1985; "Iterno al Flauto Magico," Pal. della Permanente, Milan 1985; "The Knot: Arte Povera," P.S. 1, Long Island City, N.Y. 1985; Carnegie International, Pittsburgh 1985; "The European Iceberg," Art Gal. of Ontario, Toronto 1985; "Terrae Motus 2," Villa Campolieto, Herculaneum 1986; "Falls the Shadow: Recent British and European Art," Hayward Gal., London 1986; "Wien Fluss," Wiener Secession and Am Steinhof, Vienna 1986.

COLLECTIONS INCLUDE: Fundacio Caixa de Pensions, Barcelona; Stedelijk van Abbemus., Eindhoven; Kaiser Wilhelm Mus., Krefeld; Städtisches Mus. Abterberg, Mönchengladbach; MOMA, NYC; Mus. National d'Art Moderne, Paris; Gal. Naz. d'Arte Moderna, Rome; Crex Collection, Schaffhausen; Art Gal. of Ontario, Toronto.

ABOUT: Celant, G. Identité italienne, 1981; Celant, G. "The European Iceberg" (cat.), Art Gal. of Ontario, Toronto, 1985; Celant, G. The Knot: Arte Povera, 1985; "Ceroli, Kounellis, Marotta, Pascali: 4 artistes italiens plus que nature" (cat.), Mus. des Arts Decoratifs, Paris, 1969; Emanuel, M., et al. Contemporary Artists, 1983; "Jannis Kounellis" (cat.), Stedelijk van Abbemuseum, Eindhoven, 1982; "Jannis Kounellis" (cat.), Mus. of Contemporary Art, Chicago, 1986; "Kounellis" (cat.), ARC Mus. d'Art Moderne de la Ville de Paris, 1980. *Periodicals*—Art and Artists June 1972; Arte Factum September–October 1985; Artforum January 1973, September 1982, October 1983, February 1987;

Arts Magazine December 1986; Arts Review June 4, 1982; Avalanche (New York) Summer 1972; Flash Art May 1982; Galeries Magazine December 1986–January 1987; New Art Examiner January 1987; Parkett no. 6, 1985; Studio International January–February 1976; View (Oakland) March 1979.

KRUGER, BARBARA (January 26, 1945–), American artist and conceptual critic who is known for her stark, politicized photomontages. The images, primarily black-and-white and borrowed from various media sources, are enlarged, cropped, combined, and superimposed with one-line slogans that suggest a social order of oppressors and oppressed: "You are a captive audience"; "We are your circumstantial evidence"; "If its sees, blind it." Almost universally, the works present women as the subjects of stereotyping that subjugates them to men, and Kruger ensures—through her direct, almost accusative address of the viewer—that the stereotyping be reconsidered. Kruger has said that "there is a politic—a hierarchic arrangement of power in every conversation we have—in every deal we close, in every face we kiss." She uses photographs recognizably not her own (most are from ads and films produced between 1920 and 1960) to convey the notion that representations are created to serve the ends of certain individuals and that no representation can be neutral.

Born in Newark, New Jersey, Kruger studied at Syracuse University, Parsons School of Design, and the School of Visual Arts in New York City. She was a designer and photo editor for Condé Nast magazines for eleven years, but her own artworks during that time were not commercially derived. Instead she created large abstract paintings and assemblages on canvas, often incorporating quilted fabric, feathers, and other materials or traditional women's handwork. Kruger left New York in 1974 to teach at the University of California, Berkeley; she spent the next three years writing poetry and film criticism but producing little visual art. In 1977 she began using text and photographs in compositions that came out of current tenets of feminist and film criticism that called for a reconsideration of the great numbers of commercially produced images and messages with which we are surrounded.

Among her first works of that kind were a series that alternated panels of photos and text and a book entitled *Picture/Readings* (1978) that presented photographs of California homes along with fictional descriptions of their inhabitants. Shortly thereafter Kruger brought the images and words into the same composition, using

BARBARA KRUGER

many of the familiar visual conventions of commercial ad design—glossy, high-contrast images, often black-and-white, placed in bright red frames, and featuring big, bold, easily readable typeface. They are in some ways reminiscent of the constructivist collages of Lissitzky, Rodchenko and Heartfield. Recently Kruger has also used four-color images and lenticular screens, a medium associated more often with sentimental postcards than fine art, but she continues to emphasize clarity and graphic sophistication as she adds design elements.

The sensational photographs that Kruger borrows from tabloids and ads are made oversized or cut up into sharp fragments, and the phrases she appends are usually terse and confrontational, creating shocking or grotesque, if aesthetically strong, pieces. Among the artist's manipulations of images are a boxer's nose being smashed by the glove of an unseen opponent in a 1985 piece bearing the legend "We get exploded because they've got money and God is in their pockets"; a shattered mirror reflecting a grimacing female face behind the words "You are not yourself" (1983); a dental tool probing a huge mouth as we read "You are a captive audience" (1983). Kruger steps out of the traditions of purely formal art photography, but neither is her work considered to be documentary photography. Abigail Solomon-Godeau described Kruger as participating in the postmodern critique of photography that understands it to be selective and subjective, rather than objective or "true." Kruger's purposely disruptive effect is interpreted by Linda Nochlin as "new dada . . . a very

antisensual art. It doesn't permit easy sensual gratification, it puts the teeth slightly on edge—and that's part of it being political."

Though she is concerned with all power structures and their promotion through stereotyping, Kruger's most consistent concern is with deconstructing the functioning myths of male dominance. The silhouette of a woman secured with giant pins to the background is overlaid with the words "We have orders not to move" (1982). A prim young woman in a cardigan sweater—head cropped off the photo—is labeled "Perfect" (1983). A golf ball rolling toward a hole is captioned "We are your elaborate holes" (1985). Each piece posits a complete division of genders into I/you, though the female and male viewers may associate themselves with I/we or You; this ambiguity challenges the role of the male as controlling perceiver and that of the female as what the artist calls the "silent stereotypical figure that settles the male gaze." The viewer cannot rest comfortably with a single understanding of his or her own position, or of the artwork, and in this Kruger separates her work from true propaganda or advertising, the purpose of which is to collapse meaning, or to direct thinking and action toward a single end.

Because it rejects so many of the common expectations of art—beauty, familiarity, resolution—Kruger's work can be considered as having radical roots and purposes. The deconstruction of visual information in which Kruger participates has a history that perhaps began with Duchamp, who, in appropriating everyday objects (readymades) for aesthetic consideration, prompted a broad questioning of how images and values (beauty, among them) gain currency in contemporary society. In the late 1950s, Roland Barthes outlined an agenda for identifying the mythologies behind received texts and meanings. At the same time, artists such as Johns, Rauschenberg, and Warhol began depicting mass-produced, everyday objects and images—placing them and the conventions of their representation on pedestals for scrutiny and, often enough, derision. Pop art ran counter to theories that treated the art object as an autonomous item isolated from worldly sources or uses. The rise of conceptual art in the late 1960s reflected solidified interests in issues of linguistics and semiotics, and the contemporary art object lost whatever preciousness it still had in works by Hans Haacke, Michael Asher, and Daniel Buren that critique art institutions, often with appropriated or invented text in addition to visual documentation. Kruger is one of a group of artists—including Dara Birnbaum, Jenny Holzer, Louise Lawler, and Cindy Sherman, Sherrie Levine, among others—that has broadened the investi-gation of representation and its uses even further, beyond the boundaries of the art world, to critiques of the languages of television, advertising, photography, and all systems of communication.

Summarizing the consumer's relationship to her source photos, Kruger wrote: "Through your worshipful response, these objects d'art become much like the insistent sun and safe breezes that caress them: they seem to be nature." Kruger would have us "denature" these images, and she has us see the ads anew in what might be called her own propaganda about propaganda. But, as Craig Owens has pointed out, where propaganda guides the viewer to a single, instant absorption of a symbol or message, Kruger juxtaposes images and text deliberately to "impede circulation, postpone subjection, invite us to decode the message." The critic Kate Linker has lauded Kruger's work for its "refusal of stature, . . . which opens points of intrusion within dominant ideology; which works to unmoor the unity of the masculine perspective leading to the proliferation of meanings, none of them subjectively centered." Indeed, Kruger has rejected the idea of a "feminist art" in favor of "feminisms. . . . There is not one singular way of being a critically active feminist today." She has also rejected the idea of making art for posterity or of becoming a "great artist. I don't want to be one. I decline the title." For Kruger, any message presented as an unquestionable judgment, even the message of an individual's greatness, would be just another myth created in the service of power.

But the line between effectively dismantling social power structures and being a wielder of partisan power oneself is a thin one, and the plurality with which radical or political art protects itself from that crossover can be problematic. With no single message, and yet without the traditional narrative or expressive content of visual art, political art can leave viewers confused or alienated, rather than thoughtful and engaged, a difficulty Kruger has acknowledged. Also dangerous, according to Kruger, is the possibility that the artist's critique can backfire. She cited "traps of appropriation": "The implicit critique within the work might easily be subsumed by the power granted its 'original,' and the 'negativity' of this work, located in its humor, can merely serve to congratulate its viewers on their own contemptuous acuity." Indeed, the critic Donald Kuspit saw in Kruger's work—and that of other artists who use contemporary language in their work—a reliance on "criticality's inflated status as a tickler of our fancies." He saw in those manipulated photos no information that is not available elsewhere. But Kruger's work has been

regularly praised for its commitment and effectiveness. Describing one of her solo exhibitions, Gary Indiana wrote: "Kruger's exposition doesn't proceed from an us-against-them binary model of human interaction. She is, rather, a phenomenologist of attitudes created by sexually determined power structures—structures in which everyone participates consciously or not. . . . Kruger's stance refuses to nurture misery, instead prescribing intelligent ridicule."

Kruger lives and works in Manhattan. She teaches regularly and writes on film and television for *Artforum* and other publications. She has published several books, including *No Progress in Pleasure* (1982), a compilation of her own images, and *T.V. Guides* (1984), an anthology of writings on broadcast media edited by Kruger.

EXHIBITIONS INCLUDE: Artists Space, NYC 1974; Fischbach Gal., NYC 1975; John Doyle Gal., Chicago 1976; Franklin Furnace, NYC 1979; P.S.1, Long Island City, N.Y. 1980; Larry Gagosian Gal., Los Angeles 1982, '83; Inst. of Contemporary Art, London 1983; Annina Nosei Gal., NYC 1983, '84, '86; Croussel/Hussenot Gal., Paris 1984; Rhona Hoffman Gal., Chicago 1984; Watershed Gal., Bristol, England 1984; Nouveau Mus., Lyon, France 1984; Sydney Biennial, Australia 1984; Contemporary Arts Mus., Houston 1985; Wadsworth Atheneum, Hartford, Conn. 1985; Los Angeles County Mus. of Art 1985; Mary Boone Gal., NYC 1987. GROUP EXHIBITIONS INCLUDE: Whitney Biennial, Whitney Mus. of American Art, NYC 1973, '85; "False Face," N.A.M.E. Gal., Chicago 1978; "Gender," Group Material, NYC 1981; "The American Exhibition," Art Inst. of Chicago 1982; Venice Biennale 1982; Documenta 7, Kassel 1982; "Art and Social Change, U.S.A.," Allen Memorial Art Mus., Oberlin, Ohio 1983; "Contra-Media," Alternative Mus., NYC 1983; "Artist-Critic," White Columns Gal., NYC 1983; "Difference: On Representation and Sexuality," New Museum/Inst. of Contemporary Art, NYC/London 1984; "Holzer/Kruger Prints," Spirit Square Art Gal., Charlotte, N.C.; "Photography Used in Contemporary Art," National Mus. of Modern Art, Kyoto 1984; Cntr. for Contemporary Art, Seattle, Wash. 1985; "Secular Attitudes," Los Angeles Inst. of Contemporary Art, 1985; "New York, New Art," ARCA, Marseilles 1985; Metro Pictures, NYC 1986; Kunsthalle Düsseldorf, 1986; "The Real Big Picture," Queens Mus., N.Y. 1986.

COLLECTIONS INCLUDE: Montreal Mus.; Milwaukee Mus.; National Gal. of New Zealand; Baltimore Mus. of Art; Whitney Mus. of American Art, NYC.

ABOUT: Documenta 7 (cat.), Kassel, Germany 1982; Owens, C. and J. Weinstock, "We Won't Play Nature to Your Culture, (cat.), Inst. of Contemporary Arts, London, 1983; Wallis, B., ed. Art after Modernism: Rethinking Representation, 1984; Who's Who in American Art, 1989–90. *Periodicals*—Afterimage Summer 1984; Artforum September 1982, September 1983; Art in America November 1982, January 1984; ARTnews May 1983, November 1985; Creative Camera May 1984; New York Times March 31, 1984; Village Voice October 15, 1985, February 26, 1986, October 6, 1987.

BY THE ARTIST: Picture/Readings, 1978; No Progress in Pleasure, 1982; Beauty and Critique, 1983; T.V. Guides, 1984.

LE GAC, JEAN (May 6, 1936–), French artist and drawing teacher whose allegorical/ autobiographical figure "Painter," presented through photographs, texts, drawings, pastels, and paintings, offers ongoing reflections on the image of the artist in contemporary French society. Strongly influenced by the new criticism of the 1960s but equally drawn to popular literature and book illustration, Le Gac developed a personal idiom of narative art within the larger context of 1970s conceptualism, and his Painter who never seemed to paint provided a fitting commentary on much of the artistic activity of the decade. With the general reassertion of visual concerns in the 1980s, Le Gac's commentary on the state of the arts has become increasingly painterly.

Le Gac was born Jean Kyriakos, the natural son of a seventeen-year-old miner's daughter from Tamaris, a small town in the coal region of southern France. With the death of his grandfather in 1942, the family moved to Carmaux, another mining town, and the following year, when his mother married a local miner, Georg Le Gac, Jean Kyriakos became Jean Le Gac. Those events profoundly affected him; as he told Anne Dagbert, reflecting on the string of pseudonymous characters he has created in the course of his career, "Maybe once you've changed your name the first time, it's easier to keep doing it later."

In various autobiographical narratives, Le Gac traces his fascination with art to his earliest years: he writes of his excited discovery of paint jars alongside the river, of an unsuccessful request for a set of water colors (his grandmother misunderstood and bought him a cutout instead), of a chance encounter with Francis Picabia, whose car broke down outside the family home. By the time he entered school in Carmaux, he realized that he had "the gift," and, inspired by the sight of a local landscape painter, he decided that he, too, would paint. In contrast to the miners all around him, he later explained to Effie Stephano, painters "seemed to have a profession, they had tools, they seemed to do what they were doing well, it didn't seem tiring . . . and most important, they didn't get dirty. They gave me the impression of being free." He continued to take art classes right

through high school—with the best grades and a certain renown among the other students—and also delved into the lives of famous artists (through Vasari's *Lives* and *The Secret Life of Dali*, among other things) and followed the contemporary art scene through magazines and newspapers. But however much he had expected to become a great painter as a child, when it came time to embark on a career, he opted for a more conservative path: that of a drawing teacher.

To that end, he went to Paris in 1955 with a scholarship for teacher training courses. In one of his drawing classes, he met his future wife, Jacqueline Denoyal, and they completed their studies together. "Armed with our diplomas," he wrote, "we were a very successful couple of young drawing teachers, Jacqueline and I," recalling the "special ties" that they developed with their first students in the northern French town of Bethune. In 1959, their son, Renaud, was born, and the following year, they had twin daughters, Agnès and Martine. Le Gac then completed eighteen months of military service at the end of the Algerian War and returned to his post in Bethune. He was, in effect, a Sunday painter: "The idea of becoming a great painter stayed with me," he told Stephano, "but I did nothing to further it substantially."

Making his way through the successive stages of modern painting, from landscapes to abstraction to pop, he actually had an exhibition in 1965, but he found it disappointing—"it didn't correspond to my concept as an artist"—and two years later he decided to quit painting altogether, "leaving the stage of art without having played the smallest role." In the interim he had discovered the new novel (nouveau roman) and the new criticism that accompanied it, and through his readings of Butor, Barthes, Genette, and others, he became convinced that the notion of discourse, narrative commentary, was essential to art as well as literature.

Following his decision to give up painting, an "autistic" period set in, but in 1968 an appointment to teach at the Lycée Carnot brought him and his family back to Paris, and he was soon inspired to pursue a new direction altogether. As Le Gac tells the story, it was during a vacation that Easter, while playing with his children on the beach with bits of wood and pebbles, that he got the idea for the casual arrangements of stones, sticks, and the like that he called "manipulations": "It had to do with disrupting the placement of things that I encountered in my travels. . . . From the beginning I systematically photographed these manipulations, in response perhaps to the need to know, at any given moment, the distribution of my sites, which were scattered all over the terrain." Within a few months the photographs evolved into plastic sheets (*bâches*) bearing images from vaporized negatives, which were intended to "preserve the memory of this whole series of vague operations." Fastened to rectangular metal frames, the *bâches* could be set up anywhere outdoors as a kind of "mobile encampment," but unlike the vast projects of the contemporary land artists like Michael Heizer, Walter di Maria, or Richard Long—whom Le Gac did not know at the time—they were confined to a very limited space.

Since his return to Paris, Le Gac had been collaborating with Christian Boltanski, a kindred spirit whom he had met in 1966. In the fall of 1969 they did several joint projects including a photo-documentation for the Paris Biennale, based on a day spent on a kilometer of land in Normandy, and, with Gina Pane, an outdoor exhibit at the American Center in Paris. By that time, land art had attracted critical attention, and Le Gac, who considered himself completely outside the new movement, quickly realized that "even this withdrawal into myself, this retreat . . . would be stolen from me by the art gallery crowd." As a result, he staged what he thought was a further retreat: he turned to mailings—"anonymous letters" as he called them—as a means of communicating his thoughts and documenting his work at a time when he believed that "all the doors of the art world were closed to me." Between May 1969 and May 1971, he did twenty-two of these mailings based on a core mailing list that he and Boltanski obtained from the Galerie Gevaudan—photographs of his outdoor works or places he visited on his vacations, photographs taken by others, especially early twentieth-century views, original writings, and literary texts he had read.

Once again, as Le Gac tells the story, he found himself caught up in a new movement, mail art. But this time, even if, as he insists, he was seen as "a French painter influenced by the fashions coming from New York and reacting to them with an art deriding and gently denouncing these same fashions," he, too, benefited from the fashion, culminating in an invitation to participate in the 1972 Venice Biennale. In fact, he had already begun to exhibit at the Galerie Daniel Templon, and he had participated in a special mail art section of the 1971 Paris Biennale, but as he later recycled the sequence of events in his writing, the Biennale was the catalyst: "At the age of thirty-six," he declares (with slight exaggeration), "I was going to exhibit for the first time, and at a great international event, and I didn't have a body of work."

It was under those circumstances, Le Gac contends, that he gathered together the notes, letters, and photographs he had been accumulating since his days in Bethune and exhibited them as the *Cahiers (Notebooks)* in Venice. The organizing principle he invoked for those three years of memorabilia was that of his vacations, which was in fact the only time he was able to function as an artist. In that way, he came up with more than twenty notebooks, each of which began with a phrase borrowed from Samuel Beckett: "When I received the order to take care of him . . . "; through that device, used to introduce a series of alter egos, Le Gac assumed the dual posture of actor-observer that has characterized his work ever since.

In fact, that relationship was implicit in the mailings as well, where, for example, Le Gac sent out postcards he had already mailed to himself with observations like, "There wasn't any wind today," or he passed along the views recorded by early twentieth-century photographers in order to create "a greater distance in which to watch myself operate." In every case, the end result was purposefully undefined if not, in the view of the critics, mysterious. As Bernard Borgeaud observed in a very early article about the mailings, "What matters is the way [the texts] obscure any possible or potential reality. In this way, Le Gac's work appears as a kind of exploration of the subjective relations that each person maintains with the real world."

At the time, the pseudonymous element in his activities was not apparent even to Le Gac, although he was later to acknowledge that all the characters in the *Cahiers* were really prefigurations of what was to become "the Painter." But in another project from 1971, he did in fact present an artist figure in his own place: in the booklet *Florent Max/Jean Le Gac*, based on Maurice Renaud's popular novel *La rumeur dans la montagne* (*Murmur in the Mountain*, 1958), a failed painter, Florent Max, has a momentous encounter with an echo. For the booklet, Le Gac excerpted portions of the text and accompanied it with three photographic illustrations showing himself in the role of Florent Max. By his own account, he subsequently took a vacation in the mountains and discovered an echo of his own, which he listened to while reading Renaud's novel. "From here onward," he told Stephano, "I entered into the story, Florent Max becoming more part of my reality than many people who surround me daily." The doubling was carried still further in *Le récit* (*The Account*, 1971), a kind of scrapbook, issued in an edition of two hundred, in which Le Gac combined press clippings about his work with samples of mailings, gallery invitations, and other memorabilia, but

in each case his own name and wrote in that of Florent Max in order to show that "the press creates myths; the painter is magazines and the art press."

For the remainder of the decade Le Gac continued to offer "echoes" of his own life through pointedly unartistic texts and photographs that he took himself, often in connection with his vacations, "the period when one can take oneself for a hero." For *Le roman d'aventures (Adventure Novel*, 1971), he turned to an illustrated children's novel, *Hermit's Island* (1913) and created photographs to correspond to the hundreds of phrases chosen by the original illustrator. In each photograph, a camera was positioned in the foreground because, he explains, "I wanted to accentuate the false aspect. In contrast to certain photographs which say 'I acted and here are the visual proofs of my action,' these photos clearly say that I acted but it wasn't anything serious."

In no small part, Le Gac's nostalgic return to the milieu of popular literature, his refusal to present, much less assert, himself as a creative artist, came in reaction to the avant-gardism of the 1960s, notably the support/surface movement then current in France. It was in opposition to the bohemian image of support/surface, he explained to Hervé Gauville, that he attempted to de-dramatize the notion of the artist by adopting the persona of Florent Max, basically an Ivy League type, "a little snobbish, more or less a dilettante (even though I didn't see myself that way)." His answer to the emphasis on theory, meanwhile, was to work with popular literature, and likewise, in the face of a veritable invasion of American art and culture, he cultivated a French identity.

Somewhat ironically, Le Gac's retreat from the contemporary scene by means of what he called his "little stories" landed him in the thick of a new movement: narrative art. He had met the New York gallery owner John Gibson through the "Amsterdam Düsseldorf Paris" exhibit at the Guggenheim Museum in 1972 and was invited to participate in Gibson's "Story II" show the following year, along with such artists as David Askevold, John Baldessari, Peter Hutchison, Ger Van Elk, and William Wegman. As his own renown grew, Le Gac, who had never traveled outside of France before 1972, was invited to participate in exhibitions throughout Europe and the United States.

His work, meanwhile, continued to reflect the world of a high school drawing teacher (which he continued to be for twenty hours a week at the Lycée Carnot), although, in keeping with his own experience, the contemporary art world also made its way into the local geography, with

a corresponding acceleration of the pace of the written narrative. New characters appeared, such as the landscape painter Ramon Nozaro in *Le professeur de dessin* (*The Drawing Teacher*, 1975) or Angel Glacé, the title character in a 1978 series (and an anagram for Jean Le Gac), but from 1973 on, the central figure was most often identified simply as "the Painter."

What is perhaps most intriguing about his long evolution, as Kate Linker has pointed out, is that throughout all the variations on the theme of the painter—more than sixty titles ranging from *Le peintre en excursion fait des photos* (*The Painter on Holiday Takes Photographs*, 1974) to *Le monstre de Loch Ness et le peintre* (*The Loch Ness Monster and the Painter*, 1977) —the one activity singularly absent from the repertoire of "the Painter" and Le Gac alike was painting. Le Gac himself has declared, "I am a painter of photographs and texts that one hangs on the wall." But as he was later to acknowledge, that was a very 1970s attitude: "We had put the visual aspect of things aside a little," he told Gauville, "because we all thought it was the most superficial side of art." But "at the end of ten or twelve years of this kind of cleaning up the act, without holding a pencil or brush, this medium which I thought was too old for me, completely used up, voilà, I rediscovered it in all its innocence."

In fact, it was neither the pencil nor the brush that he took in hand, but a set of pastels, which he claimed to have inherited fortuitously from his daughter. Whatever the case (he also acknowledged that he felt the pressure of the new generation of figurative painters—the trans-avanguardia in Italy, the neo-expressionists in Germany, and figuration libre in France. "With all my life engaged in painting, I couldn't just disappear like that," he soon applied his new medium to a new activity: copying and reworking illustrations from children's books and magazines. In the multiple series of works that followed, beginning with "Les délaissements du peintre" ("The Painter's Relaxations," 1981), Le Gac coupled the "relaxing" painter, who was now identified as "the painter L . . . ," with a vast range of subjects from the world of imaginative literature. Indeed, by repeating the motif of the painter (subsequently identified as "the French painter" and then "the Parisian painter"), he translated the ironic self-reflection of the photo-texts into a strictly visual idiom. In *Le délaissement du peintre (avec dompteur)* (*The Painter's Relaxation [with Lion Tamer]*, 1981), for example, the two-tiered composition combines the vivid pastel rendering of lions and tamer, whip in hand, a second, enlarged version of the tamer's face, and a representation of the

magazine from which the image is copied, with an equally vivid color photograph from the painter's studio, showing his paint tubes spread out on a table.

The texts in those works were greatly reduced and then abandoned altogether in favor of the unstated discourse created through the juxtaposition of printed, drawn, and photographed realities. As Philippe Arbaizar has pointed out, the compositions, with their shifting perspectives and closeup enlargements, began to resemble film techniques, and eventually he not only expanded his repertoire of copied images to include movie stills, but, paralleling the camera that he had insistently included in his early photo-texts, began to include the representation of a movie camera as well. (Since 1970 he had, in fact, been making short films of his own, most recently in collaboration with his son.) Then, with the "Story Art" series (1987), his painter-photographer and painter-illustrator actually became a painter-filmmaker of the silent film era. Working on large unstretched canvases, he represented his painter on the monumental scale of the movie screen; unlike the elaborate montage effects of "The Painter's Relaxations," the cinematic vignettes remained much sketchier, with large sections of raw canvas showing through and brief handwritten captions recalling the intertitles of silent films. An old movie projector positioned in front of each canvas effectively defined the image not as a painting (for Le Gac was finally working in a combination of paint and charcoal) but as a film projection.

In 1982 Le Gac told Anne Dagbert: "Myself, I'd really like to be a Sunday painter, but a famous one, and that's not possible." And indeed, with "Story Art," once Le Gac the artist actually assumed the role of painter, his alter ego the Painter was effectively transformed into a movie actor. In that way he continued the provacative interrogation that began with the *Cahiers* nearly twenty years earlier: as Günther Metken observed, "He pretends to be a painter but produces images only in the second degree, reflections on images and their fabrication that can be simple photos as reproductions of images, photos of fantasy, photos of fictive artist ('the painter')."

EXHIBITIONS INCLUDE: Gal. Daniel Templon, Paris from 1970; Gal. Rive Droite, Paris 1971; Societe Infra-Watt, Paris 1971; Kunstmus., Lucerne 1972; Gal. Daniel Templon, Milan from 1972; Mus. of Art, Oxford 1973; Gal. 't Venster, Rotterdam 1973; John Gibson Gal., NYC 1974–79; Israel Mus., Jerusalem 1974; Gal. Loeb, Bern 1974; Gal. Ricke, Cologne 1974–79; Gal. Cannaviello, Rome 1975; Gal. St. Petri, Lund (Sweden) 1975; Gal. Daner, Copenhagen 1975; Art in Progress, Mu-

nich 1975; Kunstverein, Hamburg 1977; Städtische Gal. im Lenbachhaus, Munich 1977; Neue Gal., Aachen 1977; Gal. d'Arte Spagnoli, Milan 1977; Cntr. Georges Pompidou, Paris 1978; Kunstverein, Krefeld 1979; Le Coin du Miroir, Dijon 1980; Gal. Declinaisons, Rouen 1980; Gal. Hal Bromm, NYC 1982; Gal. Catherine Issert, St.-Paul-de-Vence from 1982; Gal. France Morin, Montreal 1982; Mus. de Toulon 1982; Gal. Chanjour, Nice 1983; Mus. Municipal, La Roche-sur-Yon 1983; Studio Marconi, Milans 1984; Gal. Athanor, Marseilles 1984; ARC, Mus. d'Art Moderne de la Ville de Paris 1984; Andata/Ritorno, Geneva 1985; Chapelle des Carmelites, Toulouse 1985; Elisabeth Franck Gal., Knokke-le-Zoute (Belgium) 1987. GROUP EXHIBITIONS INCLUDE: "Occupation des lieux," American Cntr. Paris 1968; Paris Biennale 1969; "La Journée du 5 octobre," American Cntr., Paris 1969; Paris Biennale 1971; "1960–1972: Douze ans d'art contemporain en France," Grand Palais, Paris 1972; Venice Biennale 1972; Documenta 5, Kassel 1972; "Amsterdam, Düsseldorf, Paris," Guggenheim Mus., NYC 1972; "Story I," John Gibson Gal., NYC 1973; "Pour memoires," Entrepôts Laine, Bordeaux 1974 (trav. exhib.); "Ars 74," Helsinki 1974; "Project 74," Kunsthalle, Cologne 1974; "Story II," John Gibson Gal., NYC 1974; "Narrative Art," Palais des Beaux-Arts, Brussels 1974; "New Media I," Kunsthalle, Malmoe (Sweden) 1975; "Je/Nous," Ixelles Mus. (Belgium) 1975; "Europalia 75," Palais des Beaux-Arts, Brussels 1975; "Memoire d'un pays noir," Palais des Beaux-Arts, Charleroi (Belgium) 1975; Venice Biennale 1976; "The Artist and the Photograph," Israel Mus., Jerusalem 1976; "Panorama of French Art 1960–1975," Pinacotheca, Athens 1976; "Trois villes, trois collections," Mus. Cantini, Marseilles 1977 (trav. exhib.); Documenta 6, Kassel 1977; "Europe in the Seventies," Art Inst. of Chicago 1977 (trav. exhib.); "Aspects de l'art en France," Art 9' 78, Basel 1978; Sydney Biennale 1979; "Words," Mus. Bochum and Palazzo Ducale, Genoa 1979; "Cine qua non," Journee Internale de Cinema d'Artistes, Florence 1979; "Concept-Narrative-Document," Mus. of Contemporary Art, Chicago 1979; "L'artiste," Mus. d'Angoulême 1979; "Text-Foto-Geschichten," Kunstvere in Heidelberg, Bonn, and Krefeld 1979; "Eremit? Forscher? Sozialarbeiter?" Kunstverein and Kunsthaus, Hamburg 1979; "Narrative," Groniger Mus., Groningen (Holland) 1979; "Artist's Books, cento libri d'artista cento," International Biennale of Graphic Art, Florence 1979; "Tendances de l'art en France 1958–1978," ARC, Mus. d'Art Moderne de la Ville de Paris 1980; Venice Biennale 1980; "Artist and Camera," Arts Councils of Sheffield, Durham, Bradford 1980; "37 aktuella Konstaarer fran Frankrike," Liljevalchs Konsthall, Stockholm 1981; Salon de Montrouge 1981; "Autoportraits photographiques," Cntr. Georges Pompidou, Paris 1981; "Westkunst," Cologne 1981; São Paulo Bienal 1981; "Twelve Contemporary French Artists," Albright-Knox Art Gal., Buffalo 1982; "Faire semblant," Mus. Grenoble 1982; "Peindre et photographier," Espace niçois d'art et de culture, Nice 1983; "ARS 83," Art Mus. of the Ateneum, Helsinki 1983; "Individuallités," Mole Antonelliana, Turin 1984; "International Survey of Recent Painting and Sculpture," MOMA, NYC 1984; "L'autoportrait à l'epoque de la photographie," Mus. Cantonal des Beaux-Arts, Lausanne 1984.

COLLECTIONS INCLUDE: Neue Gal., Aachen; MOMA, NYC; Cntr. Georges Pompidou, Paris; Fonds National d'Art Contemporain, Paris; Mus. d'Art Moderne de la Ville de Paris; Mus. Boymans-van Beuningen, Rotterdam; Mus. d'Art et Industrie, St.-Etienne.

ABOUT: "De fil en images, d'images en recits" (cat.), Château de la Rouche-Jagu, 1985; "Le Coin du miroir" (cat.), Mus. des Beaux-Arts, Dijon, 1980; "Le Delaissement du peintre Jean Le Gac" (cat.), Mus. de Toulon, 1982; Emanuel, M., et al. Contemporary Artists, 1983; Franklin, C. Jean Le Gac, 1984; "Jean Le Gac" (cat.), Cntr. Georges Pompidou, Paris, 1978; "Jean Le Gac" (cat.), ARC Mus. d'Art Moderne de la Ville de Paris, 1984;"Jean Le Gac" (cats.), Gal. Daniel Templon, 1985, 1987; "Jean Le Gac: Dix apparitions du peintre" (cat.), Mus. Municipal, La Roche-sur-Yon, 1983. Periodicals—Art and Artists May 1973; Artforum February 1987; Artistses 1984; Art Press May 1974, March 1978, May 1982; Arts Magazine March 1977; Artstudio Summer 1987; Chronique de l'art vivant June 1971; Eighty Magazine no. 13 1986; Libération (Paris) August 25–26, 1984; Opus International December 1969; January 1971; January–February 1988; Studio International March 1973, July 1975.

BY THE ARTIST: Les cahiers 1968–1972, 1972; Jean Le Gac/Florent Max, 1972; Le recit, 1972; Le decor, 1972; The Painter, 1973; The Initiation of Jean Le Gac, 1973; Les anecdotes, 1974; Le fantôme des beaux-arts, 1975; Le professeur de dessin, 1975; Der Maler, 1977; Le peintre—exposition romancée, 1978; Le peintre de Tamaris près d'Ales, 1980; Image et texte dans le peintre de Tamaris près d'Ales de Jean Le Gac, 1981; Introductions aux oeuvre d'un artiste dans mon genre, 1987. Films—Signal, 1970; Jean Le Gac, artiste peintre, 1973 (with Michel Pamart and J & J [Jacques Caument and Jennifer Cooper]; La fausse ruine et le peintre, 1979 (with Michel Pamart); L'hydravion et le peintre, 1980 (with Renaud Le Gac); Le tour du monde, 1982 (with Renaud Le Gac).

LEVINE, SHERRIE (1947–), American painter, who gained public recognition in the early 1980s as an appropriator of other artists' images. She copied and exhibited the works of photographers and painters—all of them male, mostly modernist—as a way of challenging what she saw as the patriarchal, consumerist nature of contemporary Western society in general and the art world in particular. Her faithful copies of modern masterworks were not executed in the spirit of imitation-as-flattery. The originality of Levine's attention-grabbing appropriations lay in their statement that artistic originality is no longer possible, in their argument that the myth of modernist originality (such as the Russian constructivists' belief in the creation of new

SHERRIE LEVINE

forms as emblems of a new, more perfect world) had become as oppressively outworn as the traditions that modern art had broken with and then helped to inter. That rather obvious—and fashionably fin-de-siècle bleak—irony made Levine's work seem quintessentially postmodern in the early 1980s. Also, according to the novelist Donald Barthelme, who wrote about Levine in a brochure prepared by the Mary Boone Gallery for her show there in 1987, her work unmasks the relations between power and creativity by flatly stating, "*Of course* art is a commodity at this stage in the period known as late capitalism. What isn't? The air is a commodity, one's feelings are commodities. Isn't it about time to stop worrying about art-as-commodity?"

Levine has since moved on to painting original, if rather derivative, abstract compositions, seeking to avoid purely conceptual interpretations of her work. Nonetheless she retains her association with postmodern art practice and its intellectually rigorous critique of traditional art forms.

Levine was born in Hazelton, Pennsylvania and moved with her family to Beaumont, Texas and then to St. Louis. When she entered the University of Wisconsin at Madison in 1965, she attended classes in studio art, literature, film, and social theory. She found the latter classes to be more interesting and enjoyed the prevailing atmosphere of social protest and inquiry. She focused on the ideological implications of mechanical reproduction of art. Levine has attributed that focus in part to having been raised and educated "outside the mainstream" of origi-

nal art production and thus having been exposed to art primarily in reproduction. She completed her undergraduate work in 1967 and stayed on at Madison to receive her M.F.A. degree in photo printmaking in 1974.

Levine lived briefly in Berkeley, California, teaching part-time and doing commercial art, before moving to New York City in 1975. In New York, she encountered a group of young artists (among them David Salle, James Welling, and Matt Mullican) interested in the nature of representation. As Levine has described it, those artists built on the questions about traditional art that had been raised in the 1960s by conceptual art and minimalism but were concerned with the position of imagery and figuration in art rather than with formal issues. In 1976 Levine painted a series of large silhouette heads in tempera on graph paper, some recognizable as the profiles of presidents seen on coins, an exhibition entitled "Pictures" curated by the critic Douglas Crimp. The show featured works by Troy Brauntuch, Robert Longo, and Jack Goldstein that took images out of context—from popular culture, for example—and pointedly spoke about their political alignments.

The purpose of much of that work was to reveal how images affected their viewers, how they evolved from and shaped notions of sexuality, class, and desire. The strong presence of the artist's hand in a painting was considered to be a distraction, and Levine felt that her own work, with its boldly drawn contours, failed to reveal adequately its sources and meanings. After a year of doing little art work and a great deal of reading works by structuralists such as Derrida, Barthes, and Foucault, Levine again started making silhouetted heads, but this time by cutting them out of magazine pictures, sometimes photographing them and projecting them as slides on gallery walls. In one, the image of a mother and child appears inside Kennedy's profile. Because Levine had "put a picture on top of a picture so that there are times when both pictures disappear, and other times when they're both manifest," neither picture can be passively taken in without some thought as to where it came from. That "borrowing" was partially inspired by Levine's work in commercial art, a field in which originality was dealt with very differently than in the fine arts: "It was never an issue of morality," she later explained, "it was always an issue of utility . . . as an artist I found this very liberating." As Duchamp had presented manufactured and found objects as art (readymades), so Levine would use existing images to call attention to the social uses and sources of art.

The denial of a purely emotional or aesthetic way of making or looking at art was to remain part of Levine's agenda and to be expressed in many different forms that responded to changing trends in the art world. By 1979 neo-expressionism was quickly becoming the most popular and marketable type of art in New York and Europe. Levine responded with anger to the rise of that individualistic movement, and particularly to the predominance of men among its practitioners. Feminist criticism held that women had thus far been defined and dominated by male expression, and Levine saw the sudden popularity of male neo-expressionist painters as furthering that oppression:

> I felt angry at being excluded. As a woman, I felt there was not room for me. There was all this representation, in all this new painting, of male desire. The whole art system was geared to celebrating these objects of male desire. Where, as a woman artist, could I situate myself?

In answer to her own question, Levine began in 1981 to rephotograph the work of the photographer Edward Weston. That seemingly simple gesture was seen by Levine and others as being a harsh challenge to reigning notions of art's material and social value, to the importance of individual expression or authorship, and to the whole idea of ownership. Levine described her intentions:

> What I was doing was making this explicit: How this Oedipal relationship artists have with artists of the past gets repressed; and how I, as a woman, was only allowed to represent male desire.

For the average viewer, Levine's "After Edward Weston" pieces were indistinguishable from, and thus denied the preciousness of, the original photographs. The idea that one image can have multiple authors undermines the whole art-sales market, and many critics thought this a radical and valuable stance. Benjamin Buchloh wrote in 1982 that her work functioned "as the strongest negation within the gallery framework of the reemergent dominance of the art commodity. . . . At a historical moment when a reactionary middle class struggles to ensure and expand its privileges, including hegemony and legitimization, and when hundreds of talents in painting obediently provide gestures of free expression with the cynical alibi of irony, Levine's work places itself consistently against the construction of the spectacle of individuality."

When lawyers for the Weston estate questioned the legality of Levine's appropriations, she began to rephotograph the work of Works Progress Administration artists such as Walker Evans on which there were no copyrights. She had a show of her work at Metro Pictures Gallery in New York in 1981, but came to feel that, though radical, her work was ultimately self-defeating because it had ceased to be treated like art; it was perceived, instead, as though it were merely an amalgam of cold, unemotional political gestures. In 1983 Levine turned from rephotographing photographs to manually copying art reproductions in watercolor and graphite, working from art books and prints of modernists such as Mondrian, Miró, Egon Schiele, El Lissitzky and de Kooning, always entitling her works "After Joan Miró" or "After Egon Schiele." These were shown without their original titles and were all offered for sale at the same price. But despite their uniformity, they were much warmer and more idiosyncratic than Levine's photographic appropriations. Using watercolors, Levine faithfully copied any deviations in color that had occurred when the original was first reproduced as book or print, and she allowed hand-drawn edges and textures to reveal her involvement and even affection for the original works. Her actual subject in each piece was not the depicted landscape, figure, or abstraction, but rather her relationship, and ours, to the modernist artworks.

Levine's recreations are intentionally controversial and difficult to interpret, or even accept, for many viewers. She has said that she is trying to suspend meaning while pushing viewers to make their own interpretations. To that end, she mounted "1917/1984," an exhibition of cool, suprematist works "After Kasimir Malevich" in casein on mahogany and intense, erotic drawings "After Egon Schiele." For Levine, the combination of two disparate kinds of work and the reenactment of a long-lost moment in art history created a flow "between an imaginary future, between my history and yours," and allowed these famous icons to suggest new ideas about radicality and obsession.

Levine and other postmodernist artists and critics turn our attention to the broad and pervasive "social constructs"—gender, history, individuality, and ownership—that we live within but, which, they say, we tend to take for granted. In her book *Has Modernism Failed*, Suzi Gablik pointed out that appropriations such as Levine's function as critiques of the commodity system only until they are themselves bought and sold, at which point they are "more parasitic than critical, feeding on the very system they are meant to criticize." Levine, in rebuttal, noted that her works were never meant *not* to be commodities because she wanted to make people think about what it means to own pictures. But Levine has steadily increased the "individuality" of her works, seeking to avoid their being seen

as conceptual "position papers" without expressive content. In 1985 Levine ceased her practice of "direct" appropriation and began to paint abstract works reminiscent of, but not identical to, Brice Marden's and Blinky Palermo's stripe paintings of the 1960s. Levine's "Broad Stripe" series are all twenty-by-twenty-four-inch compositions of vertical stripes in bright casein and wax on mahogany, one end of a stripe often narrower than all the others. They have been called Levine's "abstract formal" paintings as opposed to her "abstract surreal" paintings: the "Gold Knot" series of plywood panels with their knothole plugs painted gold. The latter place the preciousness of the gold and the expressiveness of the brush strokes in juxtaposition to the random, machine-made knots, and in so doing reconfirm Levine's connection with Duchamp's readymades.

Those works are seen by some as Levine's sharpest critique to date because of their increased authorial presence; we see in them originality that cannot escape the social activity (from art movements like abstraction to great historical events like industrialization) that went before it. Gerald Marzorati praised the "Broad Stripe" paintings for their control and intensity of effect: "The Broad Stripes hold your gaze, but only long enough to get you to focus on that gaze itself: what memories and desires, which books and shows, whose tastes and attitudes have shaped it?"

Levine lives in New York, exhibiting often, receiving extensive art press coverage, and reading widely in art theory and philosophy. Levine's art asks whether originality is possible or desirable, and the critic Dan Cameron finds her practice to have an almost existentialist edge to it: "It is in the minute conceptual gap between what she makes and *not doing anything at all* that her work lies." While some postmodernist work announces the death of art, Levine's inclusion of original design and expression suggests a more constructive outlook, one of activism and energy. As Levine has put it, she tries to make work that "celebrates doubt and uncertainty."

EXHIBITIONS INCLUDE: De Saisset Art Mus., Santa Clara, Calif. 1974; 3 Mercer St., NYC 1977, '78; Metro Pictures, NYC 1981; A & M Artworks, NYC 1982, '84; Richard Kuhlenschmidt Gal., Los Angeles 1983, '85; Baskerville Watson Gal., NYC 1983, '85; Nature Morte Gal., NYC 1984; Block Gal., Northwestern Univ., Evanston 1985; Mary Boone Gal., NYC 1987. GROUP EXHIBITIONS INCLUDE: "Pictures," Artists Space, NYC 1977; "Pictures and Promises," The Kitchen, NYC 1980; "Couches, Diamonds and Pie," P.S. 1, NYC 1981; Documenta 7, Kassel 1982; "Art and Politics," Allen Memorial Art Mus., Oberlin, Ohio 1984; Artists Gal., Judson Mem. Church, NYC 1984; "New Images in

Photography," Visual Arts Mus., NYC 1984; "Ailleurs et Autrement," ARC Mus. d'Art Contemporain, Paris 1984; "Difference: On Sexuality and Representation," The New Museum, NYC 1984; "Repetition," Hunter Col. Gal., NYC 1984; "Correspondence," La Foret Mus., Tokyo 1985.

ABOUT: Buchloh, B. "Dissent: The Issue of Modern Art in Boston," 1986; Crimp, D. "Pictures" (cat.) 1977; Deitcher, D. "The Best of Both Worlds" (cat.), 1985; Foster, H. Recordings, 1986; Gablik, S. Has Modernism Failed? 1984; Krauss, R. The Originality of the Avant-Garde and Other Modernist Myths, 1984; Wallis, B., ed. Art after Modernism: Rethinking Representation, 1984. *Periodicals*—Artforum October 1982, September 1982, September 1983, April 1984, January 1985, February 1985; Art in America January 1983, April 1985, March 1986; Arts Magazine December 1977, December 1983, December 1984, February 1985, March 1985; October no. 13 1980, no. 15 1980, no. 18 1981; Village Voice December 13, 1983, October 30, 1984, October 15, 1985, December 3, 1985, October 6, 1987.

LONG, RICHARD (J.) (June 2, 1945–), British earth artist, was born in Bristol, the West Country city where he still lives. He attended the West of England College of Art in Bristol (1962–65) before enrolling in the St. Martin's School of Art in London (1966–68). He has always been reluctant to talk about his work and has never taught in art colleges. A rare statement by him of the aims of his art dates from the early 1970s: "My art is about working in the wide world, wherever. It has the themes of materials, ideas, movement (walking), and time. The beauty of objects, thoughts, places, and actions. I hope to make images and ideas which resonate in the imagination, that mark the earth and the mind. My work is about my senses, my scale, my instinct. I use the world as I find it, by design and by chance."

From the very beginning of his career, Long has worked in and with nature, and the few methods by which he has chosen to display his work have increased only slightly in number while remaining essentially unaltered in their structure and impact.

His first method is to go to a place, which may be near home or on the other side of the world, decide upon the project he wants to do there, and carry it out. The project will take one of several forms: a walk, short or long; a shallow digging in the earth; the displacement of stones or pieces of wood from their natural disposition into another form, such as a circle, line, or cross. If the project takes the form of a construction, the artist is careful not to alter radically the physical integrity of the material he touches.

Whatever scars he makes on the face of the eath are quickly healed, and he makes no effort to preserve physically what he has done.

Long's second method contrasts with the first, but often proceeds from it: it is to record his activities as an earth artist in order to indicate their essential facts. This recording may take the form of a photograph, an annotated map, a spare prose description of his accomplishment, or any combination of these. This method produces works that may be preserved, exhibited, bought and sold. Yet they are not, obviously, the same as the works produced by the first method.

The third method involves transferring the patterns he has found or formed out-of-doors and the materials he has worked with into a museum or gallery. This work ordinarily is specifically made for public exhibition, frequently for a particular time and place, and it usually derives its content and materials from a site near the place of exhibition. A good example of this method is Long's contribution to the Venice Biennale of 1976. The entire British pavilion, an austere Georgian building, was given over exclusively to Long. He installed a single sculpture, a continuous line of pink-colored stone, found near Venice, running in spirals through all the rooms, with its beginning and ending opposite the entrance.

The comprehension and representation of nature is basic to all Long's work, whatever the method he employs. His work has seemed subtle and fully formed, complex and personal, from the beginning. At his first one-man show in September 1986 in Düsseldorf, Germany, he chose a small, narrow, rectangular room and laid willow twigs, each about as long and thick as a pencil, end to end in nearly parallel lines that narrowed almost imperceptibly toward the room's far end. The result was magical, a sustained illusion: the real length of the room became impossible to measure; the physical was undermined and the metaphysical emphasized. The same exhibition contained a photograph of another sculpture (*England 1967*) that has remained in the minds of all who have been interested in Long's art. The artist, faced with a field of blooming daisies, removed the heads from some of them to produce a cross-shaped form, which he then photographed. So light a touch with natural forms seemed extraordinary: few conceptual-earth artists had approached their subject with such deft sureness and deep respect.

The concepts of duration and distance have informed much of Long's work. The modest physicality and scale of even his largest pieces also contribute to his art's personal quality. *A Sculpture by Richard Long Wiltshire 12–15 Oct., 1969* consisted of a British Ordnance Survey map and the legend, "Each square drawn on the map was walked separately and as accurately as possible, without rehearsal. The total walking time for each square is given." Accompanying this record of the walks is a series of small photographs illustrating it. While walking some of the squares he took a picture each 400 paces; on others, each five minutes. Long's black-and-white photos make no claim to artistry: always matted and framed in the same simple way, they intend only to record the work's accomplishment, and they rarely contain people. One exception is *A Sculpture at 19,340 ft. Mt. Kilimanjaro Africa 10-8-69*, a photo of Long and his fellow climbers standing in front of a simple hut with a corrugated iron roof, behind which is a somewhat indistinct, dark, fabriclike object hanging from a rock and another, rounded object to its left. Sometimes the records of his walks are accompanied by a handwritten list instead of photos. *Pico de Orizaba A 5 1/2 Day Walk from Tlachichuca to the summit at 18,855 feet and back Richard Long Mexico 1979* is illustrated with a two-page list of words or brief phrases describing places, climatic conditions, and feelings experienced on the route. By means of such elements, containing so little affection as to be almost neutral in their initial impact, Long engages the spectator's attention and directs it back to a contemplation of nature, leaving all he can to the imagination. Some critics, however, have maintained that by choosing the angles from which to photograph his landscapes, the artist effectively negates the principle of nonintervention in nature. "Even the most 'artless' situation," wrote Frances Carey, "a plain vista across the undisturbed Canadian prairie, predicates some degree of intervention. . . . The deference to nature is more imagined than real, for it is the artist first and foremost whom we are required to contemplate."

Long's installation pieces are always neatly related in size and form to the museum or gallery space they occupy. An exhibition at the Whitechapel in London in 1977 had that institution's main gallery looking extremely austere. Two pieces congenially shared the floor of the large room: *Stone Line* (1977), seven long, separate, parallel lines or rough gray slate; and *Driftwood Line* (1977), broader and shorter and made from gray wood. Around the corner on the floor of an adjoining room, yet seemingly integrated with the other two pieces, was a collection of dead twigs and branches from a forest floor arranged into a large, open-work circle. Long's photos on the gallery's walls connected the feeling evoked by these installation pieces to his works in nature: a line of stones in the Himalayas; a circle

of stones in Iceland; a ten-pointed star of stones on the Canadian prairie; a circle cut into an Irish peat bog. The installation pieces are also related to the artist's walks, even though he may not have found the materials he uses during any of those walks. Michael Craig-Martin describes viewing one such floor installation, *Somerset Willow Line* (1980), a six-by-fifty-foot rectangular arrangement of willow twigs: "One tends to look at it by walking round it, in a minutely scaled reflection of the artist's walks. Though virtually the same everywhere across its surface, the work's appearance changes as one's point of view changes. Viewed up its length, it is dramatically perspectival, with the sticks seeming to get denser in the distance. Viewed along its length, it fills one's peripheral vision in both directions and appears flat and endless. This . . . is the same as the visual experience of moving through a landscape."

During the early 1980s, a new method or element was included in Long's exhibitions: paintings of mud or clay applied by the artist, using only his hands, to the very wall of the gallery. *River Avon Mud New York* (1982), a recreation of a work done earlier the same year in London, consisted of four concentric foot-thick bands of brownish dried mud applied in an eleven-foot circle to the white wall of the Sperone Westwater Fischer Gallery. In a review, John T. Paoletti related that new manifestation of Long's art to the more familiar ones: "Despite the reality of the mud, the wall drawings are graphic signs, like the work pieces [the walks], and are an advancement of the spatial experiences of the floor pieces to another and equally powerful level of abstraction. The viewer is visually (and mentally) pushed toward the invisible center which is as empty as the end of Long's paths and as full as our imagination allows."

Dealing as he does in ordinary materials like sticks and stones, following ordinary pursuits like walking, Long runs the continual risk of being misinterpreted. In effect, according to John Coleman, he is dealing in "the mystified familiar. . . . Anyone could walk anywhere and by implication anyone could do Richard Long's art." Yet it is his art's entire reliance on subjective interpretation that makes it unique. "Seen in a white-walled gallery," wrote Coleman, Richard Long's work looks like various fragments of ancient history; seen in a tumbling church it assumes a cool and detached modernity. Seen in a color photograph it evokes remoteness and ritual, yet seen as black words on white paper it appears as a project, never to be actually undertaken. It is all the same work."

EXHIBITIONS INCLUDE: Gal. Konrad Fischer, Düsseldorf

1968, '69, '70, '73, '75, '76, '78, '80, '81; John Gibson Gal., NYC 1969; Gal. Yvon Lambert, Paris 1969, '72, '75, '78; Mus. of Modern Art, Oxford 1971, '79; Whitechapel Art Gal., London 1972, '77; MOMA, NYC 1972; Lisson Gal., London 1973, '74, '76, '77, '78,; Gal. Sperone Westwater Fischer, NYC 1976, '78, '80, '81, '84; Tate Gal., London 1979; Anthony d'Offay, London 1979, '80, '81, '82. GROUP EXHIBITIONS INCLUDE: "Information," MOMA, NYC 1970; "Guggenheim International," Solomon R. Guggenheim Mus., NYC 1971; "The New Art," Hayward Gal., London 1972; "British Sculpture in the 20th Century, Part 2: Symbol and Imagination, 1951–1980," Whitechapel Art Gal., London 1981.

ABOUT: Compton, M., Some Notes on the Work of Richard Long, 1976; Emanuel, M., et al. Contemporary Artists, 1983. *Periodicals*—Architectural Review December 1975, April 1977; Art and Artists April 1973, May 1976, October 1982; Artforum December 1970, March 1971, June 1972, September 1974, February 1980, Summer 1980, September 1983, October 1984; Art in America July 1974, January 1978, March 1979, March 1981; Arts Magazine April 1969, November 1970, December 1982, Spring 1983, September 1984, January 1985; Burlington Magazine October 1976, November 1980; Flash Art May 1982, January 1985; Interior Design March 1967; Studio International January 1969, March 1970, April 1974, September 1974, November 1975, January 1977, July 1983.

LONGO, ROBERT (1953–), American multimedia and performance artist who, like his friends and contemporaries Barbara Kruger, Sherrie Levine, Cindy Sherman, and Gretchen Bender, uses media forms as a critique of media society. Drawing on the vocabulary of advertising, television, and film—and adopting the same studio system of production as the ad agencies, the networks, or the Hollywood majors—he brings out the dark underside of power as it manifests itself in such diverse areas as women's roles, the nuclear threat, over reliance on technology, and the corporate mentality.

Born in Brooklyn, Longo was the youngest of three children in an Italian immigrant family. His father, who came from northern Italy, was a CPA; his mother, a native of Naples, worked as an administrative assistant. Following the familiar pattern of upward mobility, the family moved to Plainview, Long Island where, Longo recalls, they were the only Catholics in a Jewish neighborhood, and he spent his youth wanting to be Jewish. His school years, he told Paul Gardner in a 1985 interview, were "*awful*"—he could not seem to learn, panicked at exams, got terrible grades, and often turned to violence. "Aggression was a way out of any tight spot," he acknowledged, adding, "I majored in girls and sports."

ROBERT LONGO

After his last year of high school—when he finally found out that he was dyslexic—he ran off to Texas to become a "cool hippie" and started playing in a rock band there. Enrolling in North Texas State University, he tried to study music but could not read the scores and switched to art. After three years he flunked out but managed to get a scholarship to study art restoration in Europe; bored with the program, he quit in the middle, realizing that his interests lay elsewhere. "I don't want to save art; I want to make it." At that point he moved in with his sister on New York's Lower East Side, and, as he commented to Cookie Mueller, "I got my act together and went to night school." After an initial period at Nassau Community College, where he studied art history—"I guess because I was afraid of being an artist, of actually doing it," he told Mueller—he completed a B.F.A degree at the State University of New York at Buffalo in 1975. "The art school was lousy," he declared to Paul Gardner, "but I met Cindy Sherman. We began reading the art magazines and hanging out at the Albright-Knox Art Gallery. That was our education."

In Buffalo, Longo shared an abandoned ice factory with fellow student Charlie Clough, and eventually the two of them, along with Sherman, Michael Zwack, and Nancy Dwyer, began exhibiting their work there. That venture in turn gave rise to Hallwalls, an alternative space where they not only organized exhibitions but were able to invite artists to visit, including Longo's "spiritual forerunners," Vito Acconci, Sol LeWitt, Robert Irwin, Judy Pfaff, and Jonathan

Borofsky. Longo's own work during that time evolved from structures and environments to performances within such spaces, which he characterized as projects and activities introduced to create an atmosphere.

In 1977 Longo moved to New York with Sherman, only to discover that, as he told Gardner, "the art would in the late 1970s was dying. How many more Richard Serras can you see?" Installing himself in a loft not far from Wall Street, he got involved with a performance center, worked as Vito Acconci's assistant, drove a cab, and spent most of his spare time going to music clubs and film revival houses in Greenwich Village with Sherman. In his search for what Longo termed "*my* form," he went through a brief phase of working with magazine images, but decided that he "didn't need to be an appropriation artist." He then turned to drawing (a favorite pastime since childhood), which yielded large black-and-white images derived from movie stills and newspaper clippings. Those were followed by sculptural reliefs that also alluded to a movie aesthetic through the use of frozen images; *The American Soldier and the Quiet Schoolboy* (1977), for example, was based on a single figure from Fassbinder's 1970 film, *An American Soldier*, when the work was exhibited in a group show at Artists Space in 1977, the *Art in America* reviewer Thomas Lawson wrote that it was the "most stimulating piece" in "an immensely refreshing show."

In subsequent reliefs, Longo began to "customize" his figures—a repertoire of wrestlers and businessmen were also found in his performance pieces at that time—with glossy surface colors that gave them a decidedly high-tech look. A contemporary series of large-scale figure drawings had much the same impersonal sensibility—yuppie types in ambiguously spasmodic postures that were, as several critics remarked, somewhere between dancing and sudden death. In fact, his models for "Men in the Cities" (1979–1982) were friends (both men and women, notwithstanding the title), as well as random post "punk" types from the neighborhood, all of whom he photographed on his roof; to orchestrate the unusual poses, he pelted them with tennis balls or rocks and snapped their pictures as they recoiled. The resulting photos were then enlarged with a projector—eventually to as much as nine feet high—traced with charcoal or graphite, "dressed up" in corporate attire, and given dramatic touches with an exaggerated gesture or a shock of wind-blown hair.

"I was making a picture, not a fashion drawing," he explained to Richard Price in the 1986 interview accompanying the published

version of the series. As in the earlier sculptures and performances, the frozen image of the movie still provided a norm—the very first drawing of the series was again based on the man from *An American Soldier*—but the real breakthrough came when he started using his girlfriend, the multimedia artist Gretchen Bender, as a model: her image, he told Price, was "capable of being so many various kinds of females . . . and besides, I was in love."

According to Longo, "Men in the Cities" came out of a period of intense depression that began when he was still in Buffalo, as well as "incredible hostility for the viewer." For a number of critics, the violence in the images suggested a fascination with power which they equated with the aesthetic of fascism during the 1930s—monumental figures photographed from below, or, in the words of Paul Gardner, "the Leni Riefenstahl angle." Longo himself freely acknowledged that "the idea of visual seduction is very fascinating to me," but, he insistsed "fascist art? No." Hitler's art, he argued, "was slop, junk, sentimental crap. I make art for brave eyes."

It was in the three-year period of "Men in the Cities" that Longo's career really took off. When he began the series in 1979, his drawings were selling for $500 each; by the time of his first solo exhibit at Metro Pictures in 1981, they were going for ten times as much. Likewise, in 1979 his performances were making the rounds of New York's alternative spaces, and one of these, *Surrender*, first seen at the Kitchen in SoHo in 1979, subsequently toured museums and cultural centers in Stockholm, Berlin, Paris, and Eindhoven. Three years later, he was invited to present his multimedia performance *Empire* as a gala benefit at the Corcoran Gallery in Washington, D.C.

With that recognition came increasingly blunt attacks on the establishment that was granting it. As Robert Hobbs pointed out, the three-part *Empire*, for example, with its final section ending in a raucous battle, offered a rather dim pronouncement on "the elegant and frozen character of the American empire," and one that was all the more pointed for the fact that it was taking place across the street from the White House. Similar themes emerged from the sculptural works. In the mixed-media *National Trust* (1981), for example, Longo framed a fiberglass and aluminum sculpture of the notorious Manhattan courthouse-prison known as "The Tombs" with two of his figure drawings, now quite unambiguously dead. Similarly, *Love Will Tear Us Up (The Sleep)* (1982), a cast aluminum relief designed for the Federal Post Office in Iowa City, transformed a *New York Times*

Magazine ad for family leisure wear into an eerie tableau of corpses clustered on a bed. "A great deal of my art, particularly the relief *The Sleep*, is about blowing the whistle on society," he later remarked to Maurice Berger. At the same time, he acknowledged that the success this "whistle-blowing" brought him also created problems for him, and one of his most personal works, *Pressure* (1982), gives visual form to "the confusion and pressure I felt about being an artist and suddenly coping with acceptance and recognition" with the crestfallen figure of another artist type, the harlequin, towered over by a skyscraper cast in relief.

Notwithstanding his private anxieties, Longo continued his public assault with a double show of mixed-media works held at Metro Pictures and the Leo Castelli Gallery and collectively entitled "Now Everybody" (from the last line of Thomas Pynchon's *Gravity's Rainbow*: "Is now everybody?") in 1983. By general agreement, the most interesting piece in the array of drawings, reliefs, cast sculptures, and combinations thereof was *Corporate Wars*, which Longo had made for Documenta 7 at Kassel the year before. As the title suggests, the aluminum and plastic triptych shows some eighteen businessmen and women doing battle in the style of ancient warriors—or the damned on Rodin's *Gates of Hell*—while another set of skyscrapers looms up ominously on the side panels. For a number of critics, the double gallery spread wore a bit thin, and the *New York Times's* Grace Glueck went so far as to say that *Corporate Wars* was the only item of interest. But for Longo himself, the show seems to have provided a welcome opportunity for reflection, resulting in turn in a greater degree of complexity in his work, and at the same time, a tighter synthesis of formal elements.

The Sword of the Pig (1983), for example, which Longo calls "the first product of everything I learned from Castelli's and the Metro Pictures show," is composed of three manifestations of authority: the cross (church), a bodybuilder (macho), and an ABM missile site (militarism). Each element is elaborately fashioned—the bodybuilder alone is a composit of a magazine illustration, a publicity shot, and a photo taken by Longo, redrawn in black-and-white and overlaid with colored Plexiglas—yet the triptych holds together both formally and conceptually. Indeed, after his next show at Metro Pictures (sans Castelli), reviewers took note of the new richness: "Make no mistake," wrote Holland Carter in *Arts*. "Longo's work still casts a cold eye indeed, but one has the sense of its range of vision thawing and a tight grasp beginning to relax a bit."

For a solo exhibit at the Brooklyn Museum in 1985, Longo created an environment from six pieces that he had made over the previous five years. That miniretrospective was titled "*Temple of Hope*," and as the artist explained to the New York Times critic Grace Glueck, "If there's a message here, it's hope. I compete with things basically oppressive, like advertising. I'm like the revenge of the media. My art has accessibility, so that the average person can like it." In a *Saturday Review* interview around the same time, he alluded to a religious dimension to his work: "Instead of trying to paint pictures of God or something empirical," he explained to Cookie Mueller, "I try to create art where God has to appear."

As the work got more complex—"I'm interested in the monumental," he told Mueller "we all want to be giants"—Longo amassed a crew of artists and technicians headed up by his assistant, James Sheppard, who describes himself as the "producer" to Longo's "director." In fact, since 1978 Longo had been relying on the commercial artist Diane Shea to execute his drawings; "When she draws and paints," he later told Alan Jones, "I work through her." But by the time of his "Steel Angels: Part I" show at Metro Pictures in May 1986, a list of "credits" on the gallery wall ran to twenty-five names. For Longo, the logic of collective production was somewhat different from that of Andy Warhol's factory, to which it is often, sometimes invidiously, compared: "I'm trying to make a work that goes beyond simple private moments," he explained to Paul Gardner, but at the same time he acknowledged that "part of the myth is that I have people make my art. That disturbs people, and I like that."

While some observers have indeed become increasingly disturbed by what they consider a "production line," others see Longo's gutsy mixture of high art and mass media as an increasingly masterful way of facing the end of the twentieth century. Writing in *Artforum* after "Steel Angels II," Donald Kuspit, for example, argued that the monumental *All You Zombies (Truth Before God)*—an installation featuring a nine-foot monster cast in bronze plus a roster of New York City's homeless—was Longo's "best yet." "In its macabre universality," Kuspit suggested, "this figure summarizes our horrific, vulgar century. It epitomizes the theatrical/performance/waxworks ambition of Longo's art."

In the words of Paul Gardner, Longo is a "short, teddy-bearish man" whose unruly hair is worn long on the pate, short on the sides, and is styled so that it looks like a "mohawk gone

beserk." Well known for being manically energetic, he has four televisions in his loft, and keeps all of them going at once while he makes drawings and studies for future large-scale works. "My biggest fear in life," he told Gardner, "is getting bored." In a 1986 interview with *People* magazine, he acknowledged that for a number of years he kept going on cocaine, but after the death of his father in 1984, he indicated, he gave up drugs and cut back on his activities in order to lead what *People* called a "saner" life with his companion, Gretchen Bender. Nonetheless, in addition to his gallery and museum pieces, he has since collaborated with Bender on an experimental video (*Bizarre Love Triangle*, 1986), staged a multimedia theater piece ("Killing Angels," 1987), and continued to work on an even-more-colossal movie project (*Empire*), described by the scenarist, Richard Price, as "*Gone With the Wind* for below Houston Street." His dream, he told *People*, "is to somehow watch a film that I made while listening to music that I wrote as I'm making my own sculpture."

EXHIBITIONS INCLUDE: Hallwalls, Buffalo, N.Y. 1976; The Kitchen, NYC 1979; Studio Cannaviello, Milan 1980; Metro Pictures from 1981; Fine Arts Cntr., Univ. of Rhode Island, Kingston 1981; Larry Gagosian Gal., Los Angeles from 1981; Texas Gal., Houston 1982; Brooke Alexander Gal., NYC 1983; Leo Castelli Gal., NYC 1983; Gal. Schellmann & Kluser, Munich 1983; Art Mus., Akron, Ohio 1984; Brooklyn Mus., N.Y. 1985; Univ. of Iowa Mus. Art, Iowa City 1985; Stedelijk Mus., Amsterdam 1985; Lia Rumma Gal., Naples 1985; Donald Young Gal., Chicago 1986; Wacoal Arts Cntr., Tokyo 1986; Mackenzie Art Gal., Univ. Regina, Canada 1986; Univ. Art Mus., California State Univ., Long Beach (trav. exhib.) 1986; Gal. Daniel Templon, Paris 1987. PERFORMANCES AND INSTALLATIONS INCLUDE: "Artful Dodger/L'Espace comme fiction," Hallwalls, Buffalo, N.Y. 1976; "The Water in the Bucket/The Cloud in the Sky," Visual Studies Workshop, Rochester, N.Y. 1976; "Temptation to Exist/Things I Will Regret," Artists Space, NYC 1976; "Sound Distance of a Good Man," Franklin Furnace, NYC 1978; "Pictures for Music," Mudd Club, NYC 1979; "An Evening of Performance and Film," Fiourucci, NYC 1979; "Surrender," Moderna Mus. Stockholm, Amerika Haus, Berlin, American Cntr, Paris, van Abbemus. Eindhoven 1979; "Empire: A Performance Trilogy," Corcoran Gal., Washington, D.C. 1981; "Sound Distance," The Kitchen, NYC 1982; "Sound Distance of a Good Man" and "Surrender," James Corcoran Gal. Annex, Venice, Calif.; "Performance Works, 1977–1981," Brooklyn Mus., N.Y. 1985; "Killing Angels," Burchfield Art Cntr., Buffalo State Coll., Buffalo, N.Y. 1987. GROUP EXHIBITION INCLUDE: "Working on Paper," Hallwalls (inaugural exhibit), Buffalo, N.Y. 1975; "In Western New York," Albright-Knox Art Gal., Buffalo, N.Y. 1977; "Pictures," Artists Space, NYC 1977 (trav. exhib.); "Extensions," Contemporary Arts Mus., Houston 1980; "Westkunst," Mus. der Stadt Koln, Cologne 1981; "Body Language: Figurative As-

pects of Recent Art," Hayden Gal., MIT, Cambridge 1981 (trav. exhib.); "Dynamic," Contemporary Arts Cntr. Cincinatti 1982 (trav. exhib.); "Eight Artist: The Anxious Edge," Walker Art Cntr., Minneapolis 1982; Documenta 7, Kassel 1982; "The Image Scavengers," Inst. of Contemporary Art, Philadelphia 1982; "Urban Kisses," Inst. of Contemporary Art, London 1982; "Directions 1983," Hirshhorn Mus. and Sculpture Garden, Washington, D.C. 1983; Whitney Biennial, NYC 1983; "The New Art," Tate Gal., London 1983; "Back to the U.S.A.," Kunstmus., Lucerne 1983 (trav. exhib.); "The Heroic Figure: Thirteen Artists from the United States," Mus. de Arte Moderna, Rio de Janeiro 1983 (trav. exhib.); Sydney Biennale 1983; "An International Survey of Recent Painting and Sculpture," MOMA, NYC 1983; "Endgame," Hunter Col. Art Gal., NYC 1984; "Alibis," Cntr. Pompidou, Paris 1984; "Content: A Contemporary Focus 1974–1984," Hirshhorn Mus. and Sculpture Garden, Washington, D.C. 1984; "Disarming Images," Contemporary Arts Cntr., Cincinnati 1984 (trav. exhib.); "New York 85," ARCA Cntr. d'Art Contemporain, Marseilles 1985; "Body and Soul," Contemporary Arts Cntr., Cincinnati 1985; Carnegie International 1985; "New York Art Now," Laforet Mus., Tokyo 1985 (trav. exhib.); "Hommage a Beuys," Stadtische Gal. im Lenbachhaus, Munich 1986; Documenta 8, Kassel, West Germany 1987; "L'epoque, la Mode, la Morale, la Passion," Cntr. Pompidou, Paris 1987; "Avant-Garde in the Eighties," Los Angeles County Mus. of Art, Los Angeles 1987; "Implosion: A Postmodern Perspective," Moderna Museet, Stockholm 1987.

COLLECTIONS INCLUDE: High Mus., Atlanta; Albright-Knox Art Gal., Buffalo; Art Inst. of Chicago; Weatherspoon Art Gal., Univ. of North Carolina, Greensboro; Menil Mus., Houston; Tate Gal., London; Walker Art Cntr., Minneapolis; Mus. d'Art Contemporain, Montreal; MOMA and Solomon R. Guggenheim Mus., NYC; Lannan Foundation, Palm Beach; Power Gal. Contemporary Art, Univ. of Sydney, Australia.

ABOUT: Berger, M. "Endgame: Strategies of Postmodern Performance" (cat.), Hunter Col. Art Gal., NYC, 1984; Cathcart, L. Extensions (cat.), Contemporary Art Mus., Houston, 1980; Crimp, D. Pictures (cat.), Artists Space, NYC, 1977; Current Biography 1990; Francis, R. Robert Longo: Talking about The Sword of the Pig, 1983; Hobbs, R. Dis-Illusions (cat.), Univ. of Iowa Art Mus., 1985; Longo, R. Men in the Cities, 1986; Who's Who in American Art, 1989–90. Periodicals—Artforum February 1987; Art in America January–February 1978; ARTnews May 1985, January 1988; Artscribe Summer 1985; Arts Magazine September 1984, January 1985; Interview April 1983; New York Times February 11, 1983, March 10, 1986, May 30, 1986; People November 10, 1986; Saturday Review November–December 1985; Wolken-Kratzer Art Journal January–February 1988.

LONGOBARDI, NINO (November 30, 1953–), Italian painter and printmaker whose evolution from gallery installations to figure painting bridges Italy's two main postwar movements, *arte povera* and the *transavanguardia*. In the spirit of both, Longobardi has consistently maintained an oppositional stance that rejects conventional notions of culture and style for an art that is equally diverse in its sources and its manifestations.

Born in the southern Italian city of Naples, Longobardi grew up in a modest family; his father died when he was young, and he soon set out on his own. "I took care of myself," he explained to Danny Berger in 1982. "There is a tradition of children leaving home in Naples and making their own way on the streets." From the time he was a teenager, he told Berger, he wanted to be a painter, but there were no art schools in Naples apart from the moribund Academy of Fine Arts, so he decided "not to go to school, not to apply to the academy, but to attend a natural academy, which was an art gallery." Here, too, the options were limited: the only gallery that stood out was that of Lucio Amelio, who went beyond the local scene to exhibit the work of international figures such as Joseph Beuys, Andy Warhol, and Gilbert & George. While those artists did not influence him directly, Longobardi indicated, "they gave me . . . references on the politics of art; the idea of making art . . . the idea of art and what art stands for." As for technique, he recalled, "I was rather like an apprentice learning a trade. [The painter Carlo] Alfano taught me some technique. The tricks of the trade."

His early works, nonetheless, were not paintings, but installations that bore the mark of *te povera* That movement, which emerged in the northern city of Turin in the late 1960s, had mounted a dual assault on contemporary trends (paralleling conceptual art, process art, and land art elsewhere) by reasserting the social context of art—especially in the wake of May 1968—and rejecting the high-tech aesthetic of pop and minimalism for common, often natural materials. Longobardi was particularly inspired by the example of Jannis Kounellis, who was part of the original group. Setting out to do installations that utilized the gallery space itself in the "composition" of art in December 1977, Longobardi made his first move, quite literally, by opening the unused door of a friend's studio in a gesture of rebellion against the closed environment in which art was being made. Subsequent works (almost always untitled) explored the "symbolic space of art" through different kinds of intrusions into the gallery space: a broken wine glass precariously affixed to a wall in-

scribed with a charcoal line (1979); raw canvas tacked to the wall and extended into the room by means of draping over a table or winding around an upright wooden post (both 1979); other lengths of canvas hung like curtains in front of windows and joined, again, inside the gallery space (1980). In addition to those fairly understated commentaries on the juncture of art and life, he ventured into more ironic, and humorous, domains by, for example, attaching a tiger skin to a strip of canvas on the wall and then extending the tiger's stripes onto the canvas in charcoal (1979) or making a "painting" by firing a small wooden cannon loaded with mussel shells through a hole in the gallery wall so that the shells hit a canvas set up in the next room (1980).

In his irreverent transformations of the venerable artist's canvas, Longobardi was working very much in the line of arte povera, but as Giovanni Joppolo has pointed out, he had already begun to impose his own sensibility—a "problematic of danger" expressed, for example, in the broken wine glass hanging from the wall or the tiger threatening to come to life with the extension of his stripes, not to mention the cannon breaking through the wall of the gallery. For Joppolo, that undercurrent of instability has its origins in the day-to-day realities of Neopolitan life: "peril tied to the society's ideological sommersaults and peril incarnated in earthquakes, volcanic eruptions, natural disasters." And indeed, such an interpretation is more than confirmed by Longobardi's subsequent development, which, as the artist himself acknowledges, had its major turning point with the earthquake that struck Naples in December 1980. In the wake of the disaster, Longobardi, who lost both his home and his studio, immediately embarked on a series of ten large paintings called Terremoto (Earthquake, 1980), which he exhibited the following month at the Galleria Lucio Amelio.

The switch to painting had been underway throughout the year, and gradually, he explained to Berger, since "painting was already developed in my style, I started to make pictures in the traditional manner, on canvas and portable." In the beginning that "traditional manner" consisted basically of substituting a stretched canvas for the gallery wall and imbedding objects in its densely painted surface—one 1980 painting, for example, presents another tiger skin, this time draped over a broomstick; in several others, a small toy boat drifts on a sea of paint, alternately rendered in sunny yellow-greens and a much more ominous blue-black. Another series of five paintings, also exhibited at Lucio Amelio in 1980, was dedicated to Goya, Turner, Van Gogh, Cézanne, and Bacon. Neither direct pastiches nor variations on specific models, these works made rather general allusions to the artists cited—a side of beef, for example, evokes Bacon, but in Longobardi's painting, it is juxtaposed with a tiny devotional image of St. Francis and the wolf.

When Longobardi plunged into the "Terremoto" series he used similar principles of allusion and juxtaposition to fill wall-to-ceiling canvases with giant emblems of destruction and renewal, ranging from classical ruins and Pompeii-like corpses to a modern version of Fragonard's Girl on a Swing and the crowing rooster of resurrection. As he later explained to Francisco Rivas, it was the idea of the earthquake that was important to him: "It's not just an idea of destruction; it communicated to me a kind of optimism, a will to continue, to demonstrate that it's not the end." Indeed, with the burst of expression the earthquake set off—the paintings were done right in the gallery because he had no studio—Longobardi's personal idiom was formed: an art of motifs rendered (in marked contrast to his first object paintings) with a draftsman's concern for line, shape, and tone.

In the works that followed, Longobardi established a virtual dialogue between painting and drawing, using brush and oils—as well as charcoal and translucent glazes—with the speed and spontaneity of a sketch. "I love the idea of working quickly and when I feel the urge. I need the freedom from time," he explained to Berger, noting that his favorite artist was Caravaggio because of the rapidity with which the seventeenth-century master worked. In his attempt to "capture the moment," Longobardi took to completing each work in a single sitting, in order to move on to the next. "Actually," he told Berger, "the moment a work is completed, I hate it. After it is realized, I don't think of it." And he added, "for this reason I don't really believe in styles. For me, work is a thing I do day by day; every day is a new experience."

It was precisely because of this attitude that Longobardi quickly became associated with the transavanguardia, a group of young Italian painters—including Sandro Chia, Enzo Cucchi, Nicola De Maria, Francesco Clemente, and Mimmo Paladino—who achieved movement status at the end of the 1970s under the tutelage of the critic Achille Bonito Oliva. Their hallmark, according to Bonito, was "a nomad position which respects no definitive engagement, which has no privileged ethic beyond that of obeying the dictates of a mental and material temperament corresponding to the instantaneity of the work." Longobardi himself, freely acknowledging that his work was very different from that of the others, and even less mature in

comparison with that of Chia or Cucchi, identified with their "way of thinking" all the same, and benefited considerably from the international visibility of the group.

In the early 1980s his work evolved from the various emblematic representations of swimmers, lovers, athletes, animals, objects—notably skulls—that followed the "Terremoto" series, to a more sophisticated layering of the same kinds of images playing on juxtapositions of both form and theme. As Longobardi took pains to explain, the skull in Neapolitan culture was not associated uniquely with death, but with the celebration of life as well, and in his insistent repetition of the motif—coupled with espresso pots, nestled in dark shadows, or emerging from a web of white brush strokes superimposed on other images—he played doubly on its ambiguities before an audience unaccustomed to what Martin Kunz described as "Longobardi's life-and-death game." Maintaining a prolific output of paintings and drawings, as well as lithographs and etchings, he experimented with newspaper images, with bold sepia figures paired up with fluid charcoal drawings, and with complicated line drawings disposed over a compartmentalized, gridlike ground. With his 1984 exhibition at the Villa Campolieto, he reintegrated his images into real space by drawing nude figures directly onto the walls; in Paris the same year, he combined charcoal drawings of nudes with a real skull posed on a shelf, and subsequently he began using real skulls and skeletons in his paintings as well.

In 1982, when the twenty-nine-year old Longobardi was invited to participate in the Guggenheim Museum's exhibition of "Italian Art Now: An American Perspective," he presented himself as an artist indifferent to his early success: as he indicated to Danny Berger, "Frankly I tell you—without diminishing the value of the Guggenheim exhibition—that for me one wall or another wall, they are all the same. A work of art lives whether it is on the wall of a famous museum or not." In the intervening years, the *transavanguardia* has come to represent more of a historical moment than a movement—part of the larger reassertion of European identity that also included nouvelle figuration in France and the young fauves in Germany. Longobardi, who has not attained the same degree of individual recognition as some of the other artists with whom he was associated, continues to live and work in Naples, pursuing a personal idiom that gives contemporary expression to longstanding local tradition. As Philippe Piguet wrote on the occasion of his 1984 exhibition in Paris, "Nino Longobardi's figures couldn't be more animated; on the threshold of death, they're drunk with life. . . . In the taut silence of whiteness and elegance, Longobardi traces out paths. He inaugurates a new dandyism that makes a game of the anguishes of his time and gives painting the means of renewing itself again."

EXHIBITIONS INCLUDE: Studio Pisani, Naples 1978; Gal. Paul Maenz, Cologne 1978; Gal. Lucio Amelio, Naples from 1979; Gal. Marilena Bonomo, Bari 1979; Cntr. d'Art Contemporain, Geneva 1980; Gal. 't venster, Rotterdam 1980; Gal. Schellman & Kluser and Stadtische Gal. im Lenbachhaus, Munich 1980 (with Ernesto Tatafiore); Gal. Giuliana De Crescenzo, Rome 1981; Kunstmarkt, Cologne 1981; Centro d'Arte Contemporanea, Syracuse 1982; Gal. Leyendecker, Santa Cruz de Tenerife 1982; Art in Progress, Munich 1982; Gal. Fernando Vijande, Madrid 1982; Gal. Il Ponte, Rome from 1982; Inst. Italiano di Cultura, Madrid 1982; Kunstmus., Lucerne 1983; Charles Cowles Gal., NYC 1983; Galleriet, Lund 1983, '84; Gal. Paul Cava, Philadelphia 1984; Metropolitan Mus. of Art, NYC 1984; Gal. Montenay-Delsol, Paris 1984; Kunstnernos Hus, Oslo, 1986; Staatliche Mus. Nationalgal., Berlin 1986; Mus. d'Art et d'Histoire, Chambéry 1986; Bugdahn and Szeimies, Düsseldorf 1987. GROUP EXHIBITIONS INCLUDE: "Perspective '79," Art 10 '79, Basel 1979; "Europa '79," Stuttgart 1979; "Nuova Immagine," Pal. della Triennale, Milan 1980; "Arte Critica," Gal. Naz. d'Arte Moderna, Rome 1980; "Incontri 1980," Spoleto 1980; "Lineé della Ricerca Artistica in Italia 1960/1980," Pal. delle Esposizioni, Rome 1981; Saõ Paulo Biennale 1981; "Baroques '81," Mus. d'Art Moderne de la Ville de Paris 1981; "Registrazione di Frequenze," Gal. d'Arte Moderna, Bologna 1982; "Italian Art Now: An American Perspective," Guggenheim Mus., NYC 1982; "Avanguardia e Transavanguardia," Mura Aureliana, Rome 1982; Venice Biennale 1982; "Recent European Prints," Hayden Gal., MIT, Cambridge 1982; "Black & White: A Print Survey," Castelli Graphics, NYC 1983; "Terrae Motus—Andy Warhol, Nino Longobardi, Robert Mapplethorpe," Inst. of Contemporary Art, Boston 1983; "An International Survey of Recent Paintings and Sculpture," MOMA, NYC 1984; Paris Biennale 1985; "Representation Abroad: Diversity," Hirshhorn Mus. and Sculpture Garden, Washington, D.C. 1985; "Hommage aux Femmes," Kunstmus., Düsseldorf 1985; "11 Peintres Europeens," Europalia, Athens 1985; "Matière Première," Mus. des Beaux-Arts, Calais 1985.

COLLECTIONS INCLUDE: Fernando Vijande, Madrid; Haus-Jakob Oeri, Basel; Perry Rubenstein, NYC.

ABOUT: Bonito Oliva, A. Nino Longobardi, 1981; Dennison, L., and D. Waldman, "Italian Art Now: An American Perspective" (cat.), Guggenheim Mus., NYC, 1982; "Nino Longobardi" (cat.), Kunstmus., Lucerne, 1983; "Nino Longobardi" (cat.), Mus. d'Art et d'Histoire de Chambéry, 1986. *Periodicals*—Artforum Febuary 1986; Art in America September 1982; Comercial de la Pintura (Madrid) February 1983; Flash Art Summer 1983, March 1984, Summer 1987; Print Collector's Newsletter May–June 1982.

LÓPEZ-GARCÍA, ANTONIO (1936–), painter, sculptor, and draughtsman who has been hailed as "the undisputed master of contemporary Spanish figurative art." By the early 1960s he was identified within Spain as a pioneer among a whole generation of artists who turned to realism in reaction to the abstract styles that dominated the postwar European scene, and he soon attracted international recognition with a kind of "magic realism" in the surrealist tradition. Shunning that attention, along with the various movements with which critics attempted to associate him, he has immersed himself in an impassioned pursuit of his own surroundings and arrived at an idiom that extends the centuries-old Spanish realist tradition into the age of the camera.

Born into a family of small landholders in the town of Tomelloso (Ciudad Real), López-García was the nephew of the well-known realist painter Antonio López-Torres, who became his teacher. At the age of thirteen he was sent to Madrid to prepare for entry into the prestigious Escuelas de Bellas Artes de San Fernando, where he studied from 1950 to 1955. Although his talent was quickly recognized by the other students, and although he accumulated many prizes, he was already given to the self-doubt that has plagued him throughout his career, and along with his artistic training, he took it upon himself to learn typing and accounting so that he could work in an office.

Following graduation, he received a government scholarship for travel to Italy, but his month-long visit proved to be a tremendous disappointment. "I'd dreamed so much about this country," he recalled to José Migue Ullán, "that maybe it was impossible for the reality to correspond to what I'd imagined." Nonetheless, he acknowledged, it was his disappointment with Italian Renaissance painting that permitted him to appreciate the Spanish tradition, and especially the achievement of Velázquez. His own socialist realism (the natural channel of anti-Franco sentiment) evidenced what the writer-critic Francísco Nieves justly calls a "prudent mannerism." In several marriage portraits, for example (*Sinforosa y Josefa*, 1955; *Antonio y Carmen*, 1956), he ennobled humble peasants (actually his own relatives, recorded in photographs) with stylized poses and heavily textured painted surfaces.

His eclectic approach was sometimes tinged with the nostalgic classicism of the Italian metaphysical painters as well, and as Nieves pointed out at the time of López-García's retrospective at Europalia '86, "If he had continued to paint that way, he would not have been a great painter." But around the time of a second period

of travel, which took him to Italy and Greece in 1958, he began to introduce irrational elements into the rational framework of his paintings, notably with juxtapositions of scale and space and representation's of floating torsos and other objects. In *La Lámpara* (*The Lamp*, 1959), for example, the floating torso of a woman, a street scene, and an elaborate chandelier are juxtaposed in their respective spaces, yet bound together by the golden tones of memory. In the relief sculptures he began making around the same time—*Still Life by the Window*, (1958–59), *Aparición del hermanillo* (The Apparition of the Little Brother, 1959), *Mujer durmiendo* (Sleeping Woman, 1960–63)—a similar realism of detail and manipulation of spatial relations, coupled with the use of polychromy, created a particularly interesting effect reminiscent of the *bodegeones* (still lifes) of the Spanish baroque.

It was that style, variously labeled surrealist or magic realist, that brought López-García to international prominence. After several solo exhibits in Madrid, he was invited to participate in the 1964 Carnegie International, as well as the New York World's Fair, and the following year he had his first one-man show in New York at the Staempfli Gallery, where he was presented as "both realist and magician." For López-García, the public attention, and the influence he had come to assert on other Spanish artists, were extremely disquieting: "Since 1961," he told Ullán, "I've undergone a period full of difficulties and enormous doubts." In the course of the early 1960s he completely renounced the surrealist element in his work. "Perhaps I didn't reckon or I didn't understand reality itself very well," he explained to Ullán, "so I needed a seasoning, a sauce. I felt that if in a canvas with a street, I suddenly added a floating head somewhere, it created a suggestive effect," but in retrospect, he concluded, "it was a lack of penetration of reality. Without these floating heads, the canvas would have certainly been better."

As Elbia Alvarez has noted, López-García's evolution was never strictly linear: he continued painting in what she calls the "classical" manner of the 1950s through most of the so-called Surrealist period, as in the 1960 painting of Francisco Carratero and Antonio López-Torres, which represents a daily occurrence—the meeting of two friends in the streets of Tomelloso—with the same "prudent mannerism" of the marriage portraits. Similarly, the surrealist or magic realist phase continued well after the crisis period of 1961, as can be seen from *Atocha* (1964), an enigmatic painting that shows a nude couple making love in the middle of the Plaza Atocha in Madrid, which is incongruously devoid of passersby. Nonetheless, as he abandoned the surre-

alist "seasoning," López-García plunged himself more intently than ever into his immediate surroundings—Madrid on the one hand and Tomelloso on the other. "If I don't see New York," he declared in a 1972 interview, "I can't paint New York, and I prefer to paint this armoire rather than an armoire belonging to someone I don't know. I paint what's important to me." Indeed, the reality he now chose to represent was the most immediate imaginable: *Vaso con flores y pared* (Glass with Flowers and Wall, 1965), *Cuarto de baño con ventana* (Bathroom and Window, 1967–71), *La ropa entemoja* (Wash Soaking, 1968), along with various views of Madrid that he worked and reworked over periods of years. In his three-dimensional sculpture he likewise turned to portraits of his wife (the painter María Moreno, whom he had met in art school) and their two children: *Marí* (1961–62), *Marí Sleeping* (1963–64), *Head of Carmencita* (1965–68).

In fact, the effect of López-García's meticulous renderings (most detailed of all in his drawings, which he had been making since his teens) was no less unreal than the earlier floating heads and transpierced walls. The well-known *Vaso con flores y pared,* for example, presents the ostensibly straightforward images of white flowers on a white tablecloth and a section of dirty gray wall with light switches and a door hinge. Every glimmer of light and shadow, every texture, every contour is rendered, and yet there is no way to resolve those details into a coherent conceptual whole because the tablecloth and the wall, painted onto the panel like two elements in a collage, belong to two different spaces. In the various interiors, an even more subtle and disquieting sense of incongruity is generated by the manipulation of perspective; once again, individual objects—all the clutter of bathrooms, kitchens, workshops—are rendered with photographic precision, but a viewpoint that constantly readjusts from ceiling to floor provides a subliminal reminder that the scene was after all recorded by a moving eye and not a fixed camera lens.

This perceptual displacement, like the stylistic displacement of the earlier mannered realism and the conceptual displacement of the "surrealist" works, communicated a strong personal, psychological statement—in the words of Mary Rose Beaumont, those paintings were "realist to the point of discomfort"—but certain observers detected a broader political dimension as well, and López-García did not deny their interpretations. The foreboding atmosphere of works like *El teléfono en el vestíbulo* (The Telephone in the Hallway, 1963) or *Figuras en una casa* (Figures in a House, 1967), he indicated to

Ullán, was not necessarily voluntary, "but that doesn't make [the impression] any less real, because if you make paintings under a regime as repressive as that of Franco, it's hard for this climate not to manifest itself somewhere in the work."

In the early 1970s López-García, then in his mid-thirties, was once again discovered by the international critics, this time in the context of photo-realism and its European variants: at the 1971 Paris Biennale his paintings were shown in the "hyperrealism" section, and he was subsequently included in a wave of hyperrealism/realism exhibits throughout Europe. As a number of critics came to realize, his work had little to do with the dominant hi-tech sensibility, but once again, with the renewed exposure, he was hailed as the "unqualified master" of the so-called new Spanish realists. López-García's response to that second wave of notoriety was an even more pronounced retreat from the public arena: the two solo exhibits he had in 1972 (Paris and Turin) were to be his last for thirteen years. During the late 1960s he had taught at the Bellas Artes in Madrid, but he gave that up in 1969 because it was "too draining"; with his growing reputation, he explained to Ullán, he was able to live from his art, but at the same time, he was often unable to work because he was "paralyzed" by self-doubt.

In the years that followed, his subjects became more limited and his technique more elaborate, and it was not unusual for him to work on a painting or sculpture over a period of years, either because he felt compelled to change it, or because he was so intent on capturing the atmosphere of a particular moment that he put a particular canvas aside until the same time the following year. In such a way, the large pencil drawing of *The House of Antonio López-Torres,* begun in 1972, was completed eight years later; a panorama of Madrid begun in 1974 also took eight years, and *Window at Night,* begun in 1971, nine years. López-García himself continues to talk of the "periods of doubt" that bring on his "despairing slowness." He insists, "When I get out of this kind of tunnel, I think I'll be able to resume my rhythm. . . . I have an enormous facility for creating, imagining, or conceiving the painting. I could do many more paintings a year if my hand would obey me faithfully, if I knew how to resolve them."

For his many admirers, López-García's painful struggle against time is not without positive consequences, insofar as time itself has become the subject of his paintings. In the words of his friend Francisco Nieva, one such consequence is "a very Spanish, very baroque meditation on the

fugitive nature of time, the presence of death, the cruelty of the objective." And as Michael Brenson has pointed out, carrying that interpretation one step further, if it is "the experience of both the fullness and the corrosiveness that recalls the Old Masters, it is the speed with which the fullness and corrosiveness collide that anchors López-García's work in the late twentieth century."

EXHIBITIONS INCLUDE: Sala de Exposiciones del Ateneo, Madrid 1956; Gal. Biosca, Madrid 1961; Staempfli Gal., NYC 1965, '68; Gal. Claude Bernard, Paris 1972; Gal. Galatea, Turin 1972; Mus. de Albacete (Spain) 1985; Europalia '85, Mus. d'Art Moderne, Brussels 1985; Marlborough Fine Art, London and NYC 1986. GROUP EXHIBITIONS INCLUDE: Dirección General de Bellas Artes, Madrid 1955; "Exposición de Artistas Manchegos de Hoy," Mus. National de Arte Moderno, Madrid 1957; Carnegie International, Pittsburgh 1964, '67; "Spanish Contemporary Painters," The World's Fair, NYC 1964; "Profile VII: Spanische Kunst heute," Städtische Kunstgal., Bochum 1967; "Spanische Kunst der Gegenwart," Kunsthalle, Nuremberg 1967; "Hedendaagse Spaanse Kunst," Mus. Boymans-van Beuningen, Rotterdam 1968; "Magischer Realismus in Spanien heute," Kunstkabinett, Frankfurt 1970; "Contemporary Spanish Realists, Marlborough Fine Arts, London 1973; "Mitt Kamera, Pinsel, und Spritzpistole: Reallistische Kunstin unserer Zeit," Städtische Kunsthalle, Recklinhausen 1973; "Kunst nach Wirklichkeit: Einneur Realismus in Amerika und in Europa," Kunstverein, Hanover 1973–74; "Kijken naar de Werkelijkheid: Amerikaanse hyperrealisten, Europese realisten," Mus. Boymans-van Beuningen, Rotterdam 1974; "Hyperréalistes americains—Réalistes européens," Cntr. National d'Arte Contemporain, Paris 1974; "Contemporary Spanish Art," New York Cultural Cntr. 1975; "Realismus Realität," Kunsthalle, Darmstadt 1975; "Spanische Realisten," Gal. Brockstedt, Hamburg 1977; "Un tesoro del dibujo moderno," Mus. de Arte Moderno, Mexico 1978; "Spanische Realisten," Kunstverein, Braunschweig 1980; "I pittori spagnoli della dealitá," Centro d'Arte Montebello, Milan 1982; Venice Biennale 1982; "Representation Abroad," Hirshhorn Mus. and Sculpture Garden, Washington, D.C. 1985; "Le Siecle de Picasso," Mus. d'Art Moderne le la Ville de Paris 1987.

COLLECTIONS INCLUDE: Mus. Provincial de Jaéan; Mus. Provincial de Ciudad Real; Mus. de la Diputacion de Valdepeñas; Mus. Provincial de Toledo; Fundacion Juan March; Mus. de Arte Contemporáneo, Madrid; MOMA, NYC; Chase Manhattan Bank, NYC; Kunsthalle, Hamburg; Städtische Kunstsammlungen, Darmstadt; Cincinatti Art Mus; Cleveland Mus. of Art; Baltimore Mus. of Art; Detroit Inst. of Arts; Mus. National d'Art Moderne, Paris.

ABOUT: "Antonio López-García" (cat.), Staempfli Gal., NYC, 1965; "Antonio López-García" (cat.), Europalia '86, Mus. d'Art Moderne, Brussels, 1985; "Antonio López-García" (cat.), Marlborough Fine Arts, NYC, 1986; "Contemporary Spanish Realists" (cat.), Marl-borough Fine Arts, London, 1973; Fernández-Braso, M. "Magischer Realismus in Spanien Heute" (cat.), Frankfurter Kunstkabinett, 1970; Puento, J. Antonio López-García y su tiempo, 1978. Periodicals—Art International April 1972, September 1973; ARTnews Summer 1965, December 1968, January 1978, Summer 1986; Arts Review May 23, 1986; Chronique de l'art vivant February 1971; Cuadernas Guadalimir 2 1977; Goya May–June 1985; New York Times July 7, 1985; Nueva Forma July–August 1969.

LÜPERTZ, MARKUS (April 25, 1941–), painter, sculptor, and printmaker belonging to the first generation of postwar German artists, who were faced with the task of redefining and reestablishing a tradition of contemporary art in the wake of the rupture imposed by the Nazis. Linked with his contemporaries Georg Baselitz, Anselm Kiefer, Jorg Immendorf, and A. R. Penck (born Ralf Winkler) through the combination of figurative subjects, expressive if not expressionist rendering, and an intensely personal language of form and gesture, Lüpertz nonetheless seems to be a more elusive and idiosyncratic figure on the German art scene, and one whose work has been open to somewhat contradictory interpretations.

Lüpertz was born in Liberec, Bohemia, which became part of Czechoslovakia after the Second World War. When he was seven, his family crossed over to West Germany and settled in the Rhineland. "I was a very gifted boy," he told Dorothea Dietrich, noting, with the immodesty that has become his trademark, "I had no problems. I always knew that I was a genius." On completing elementary school at the age of thirteen, he was first apprenticed to a painter of wine-bottle labels but quit after one month and went to work for friend who was a commercial artist. Through that friend, he was able to enter the Krefeld Werkkunstschule (College of Commercial Art) in 1956, and he became a student of the master painter Laurens Goossens. His term at the Werkkunstschule was punctuated by a one-year stint as a coal miner in Hibernia to earn money and another year spent doing crucifixion paintings. "For me, these were simply extreme forms of self-discovery," he indicated to Dietrich, noting that his home environment had been devoid of intellectual stimulation. "There were perhaps five books, totally unimportant ones at that. But I had an enormous urge to learn and experience. My stay in the cloister was like an accelerated course of study in which I could make up for everything."

After additional studies in Krefeld and Düsseldorf, Lüpertz turned to road construction, again for financial reasons, paid a visit to Paris,

and then went to West Berlin. The impetus for the move, he insists, was a draft exemption for anyone who settled in the divided capital. Indeed, in the early 1960s West Berlin was hardly a cultural center, and as elsewhere in Europe, American art, and money, reigned supreme. Nonetheless, the Hochschule für Bildende Kunst was starting to emerge as a base of activity for a small group of aspiring avant-gardists largely motivated by the desire to shake off American influence. In 1961 Georg Baselitz and Eugen Schönebeck had created an exhibition-cum-manifesto, Pandämonium I, which they followed with Pandämonium II the next year. In 1963 Lüpertz, who had been painting repeated images like railroad tracks, fences, and telegraph poles, joined the pursuit of the new by inventing the "Dithyramb of the Twentieth Century." Inspired by the ecstatic hymns to the Greek wine god, Dionysus, Lüpertz's Dithyrambs, as he declared in his 1966 Dithyramb Manifesto, were intended to give visual form to the "fascination of the twentieth century."

In practice, his early Dithyramb paintings had little of the Dionysian about them; rather, they featured large, ponderous geometric shapes rendered in bright colors with careful attention to light and shade. They were followed by somewhat more representational forms, like the Baustamm Dithyramb (Tree Trunk Dithyramb, 1966), which alludes, at least, to a tree trunk that has been cut in four quarters, or the Rote Kreuze Dithyrambisch (Red Crosses Dithyramb, 1967) which presents a de Chirico-like mise-en-scéne of inanimate objects—two towering cross-shaped forms, each one bearing a torn Red Cross emblem, which stand opposite each other on a deserted field divided by a picket fence. By the end of the decade, the artistic climate in Germany, as elsewhere in Europe, was growing more politicized, not simply in terms of themes, like that of the Berlin Wall alluded to in Lüpertz's Red Crosses, but also in terms of the artists' consciousness of their social roles and the militant kinds of activity that generated. That was especially true in Düsseldorf, where Joseph Beuys was a mobilizing figure from 1964 on. For his part, Lüpertz, who had been one of the founders of the cooperative Gallery Grossgörschen 35 in 1964, remained outside of the political turmoil of the late 1960s, but nonetheless, the paintings he began to do at that time had tremendous political repercussions.

According to Lüpertz himself, the focal point of his "Motif Paintings" (1968–74) was repetition of gesture: "To repeat something so that you can't tell it apart from the original, that is an adventure. That is an attack on painting," he told Dietrich, explaining that at the time, he was try-

ing to challenge contemporary trends, notably multiple art. To that end, he painted serial canvases with giant emblematic images—tree trunks and leaves, grape clusters, snails and violins—in compositions that were virtually identical except for seemingly spontaneous variations in the brushwork. "They are dead clichés," wrote Richard Calvocoressi in 1983, "their literary connotations painted out by the artist's brush." But when his repertoire also included a group of highly charged images like steel helmets, German officers' caps, cannons, and guns, it was hard to argue that the motifs were mere pretexts for abstraction, least of all in works like the Schwartz-Rot-Gold Dithyrambisch I-III (Black-Red-Yellow Dithyramb I-III, 1974), where a collection of artillery pieces and army uniforms on a deserted field is painted in the colors of the German flag. By Lüpertz's detractors, they were seen rather absurdly, as a revival of Nazi iconography, while his defenders insisted that they were a repudiation of same; in any event, as Wieland Schmied observed a full decade later, they raised a question "which many Germans are all too eager to push aside, that of how they came to terms with their recent past."

Lüpertz himself refuses to acknowledge a political thrust behind these works: "I am the most unpolitical artist," he told Dietrich, "even during the 1960s in Berlin when people came running to my door and tried to prevent me from painting." His interest at the time, he contends, was in capturing a certain violence on the canvas: "I see painting in general as violent. For me there were certain very specific insignia which project violence, [which are] all expressive of violence if they are imbued with monstrosity." And even on that general level, he insists, the motifs were "only very superficial stimulations," because he considered himself an abstract painter: "That, to me, means a painter without responsibilities. I have no responsibility for the speed, beauty, or aggressiveness of the painting."

As Schmied and others have pointed out, Lüpertz tends to downplay the considerable bias against abstraction that prevailed in Berlin throughout the 1960s, and as the "Motif Paintings" attest, Lüpertz's own formal concerns were consistently expressed in terms of representational subject matter. It was only in the mid-1970s that the balance was reversed and, in Schmied's words, "motif as form" yielded to "form as motif." In a group of transitional paintings, Lüpertz turned to some of the touchstones of modern art, especially from the cubist period, and "abstracted" (or extracted) the style as his subject. Three "Mann im Anzug Dithyrambus" paintings (Man in Suit Dithyramb I-III, 1976), for example, reconstruct the title character with

the brushwork and palette of analytical cubism, while the ironic and self-reflexive thrust of the venture becomes quite explicit in a work like *Markus Maillol* (1976), where the image of a nude sculpture on a pedestal is actually a cross between Maillol and one of Picasso's *Demoiselles d'Avignon*.

In 1977 Lüpertz began a series of "Style Paintings" in which he worked through synthetic cubism and the decorative abstraction that it engendered—*Fassade-Stil* (Facade-Style), *Haus-Stil* (House-Style), *Stil-eins-zehn* (Style-One-Ten), all in 1977—to biomorphic surrealism (*Laocoön*, 1980). "I can only paint in relationship to all the painting that already exists," he has declared; "painting is always about birth and heirs." Like the "Motif Paintings" before them, the "Style Paintings" had a certain provocative impact among the critics, some of whom saw his use of pastiche as evidence of utter creative bankruptcy, others, as a timely critique of modernist art in general—"pompous art to undermine pomposity," according to Jack Cowart—and a response to the truncated history of German art in particular. In either case, by the end of the decade (marked by a retrospective at the Cologne Kunsthalle), Lüpertz was considerably more visible than he had been, in Germany and elsewhere.

Like Georg Baselitz, he had always enjoyed a certain reputation, to be sure—in 1974 he received the Villa Romana prize, which enabled him to spend a year in Florence; the following year he was awarded the German Critics' prize; in 1974 he began teaching at the state art academy in Karlsruhe, and he regularly exhibited his work in galleries in Cologne, Amsterdam, and Hamburg. But throughout that period, the cutting edge of German art was considered to be elsewhere—with Joseph Beuys and his circle in Düsseldorf, with Gerhard Richter and Sigmar Polke, Hanne Darboven, and the Pechters, among others—while the work of Lüpertz and Baselitz was, according to Craig Owen, held to be "naive, utopian, conservative." As Owen pointed out, the dramatic reversal of that situation in the 1980s stems from a number of factors: a more conservative political climate, the reassertion of nationalism, with its artistic parallel in the search for a national style; and the pendulum swing from conceptualism and minimalism toward renewed pictorial values. And in fact, the first artists to benefit from the new constellation were not Lüpertz, Baselitz, and their generation, but a younger group that was just emerging from the art schools of Berlin and Düsseldorf. Once the enthusiasm of the critics was sparked, the older generation came to the fore as well, under the all-encompassing rubric of "neo-

expressionism," which evoked the venerable precedent of Germany's pre-Nazi expressionist tradition. In a 1980 report from West Germany for *Artforum*, Mickey Piller wrote that Lüpertz was really the only member of the "new German expressionists" who was really an expressionist. And indeed, he was one of those invited to participate in "Aprés le Classicisme" (After Classicism), the seminal exhibit of new trends in contemporary art held in 1980 at Saint-Etienne, followed by a number of surveys of contemporary German art, notably "A New Spirit in Painting" at the Royal Academy in London, "German Art Today" at the Museum of Modern Art in Paris, and "Painting in Germany" at the Fine Arts Palace in Brussels, all in 1981, and then "Berlin—The Rage to Paint" in Lausanne and "Zeitgeist" in Berlin in 1982.

Lüpertz himself was quite responsive to the international attention he received but declined the Neo-expressionist label: "People make it too easy for themselves when they equate violent gestures and a harsh application of paint with expressionism," he told Dorothea Dietrich, explaining that the issue was rather one of outlook. "Expressionist themes had to do with *weltschmerz*, presentiments of war, fears of existence. I do not fear nuclear war. I do not fear death. All this is alien to me, because I subscribe to an ideal of art which claims the eternal, the ingenious, the elitist, the deliberately self-conscious, everything which is above the common."

In fact, that insular notion of art and artist dominates Lüpertz's work of the 1980s. In a series of forty-eight "Alice im Wunderland" paintings executed over a period of six months in 1980–81, he continued the basic enterprise of the style paintings—reworking the vocabularies of modern art—in two formats: surrealist portraits alluding to the White Rabbit, the Mock Turtle, the March Hare, and so on, and improvisations in a distinctly abstract expressionist mode, based on actual fragments of Lewis Carroll's prose, which served as the titles of the respective paintings. But in adopting a literary text as his point of departure, he opened up new areas of inquiry in terms of the relationship between the image and the word. Lüpertz had been writing poetry since the beginning of his artistic career—writing, he told Dietrich, aided him in his search for identity, "as a sort of self-control, if you will"—and his poems were regularly included in his exhibition catalogs. In another series from 1981, "Sechs Bilder aus dem Leben eines Dichters" (Six Paintings from the Life of a Poet), the poet himself provided the the thematic inspiration, which took visual form through the adaptation of Picasso's early cubist

still lifes and harlequins. The apotheosis of the creative artist continued with works like *Der Thron des Dichters* (The Throne of the Poet, 1981) and a series of self-portraits including *Selbst-Portrait: Ich als Dichter* (Self-Portrait: Myself as Poet, 1983); the "Jedermann" (Everyman) series of 1983, with its unmistakable allusion to the Salzburg Festival, similarly featured the dramatic arts, signaled by the theater masks that figure in the various still-life compositions.

In all domains the 1980s were a period of feverish activity for Lüpertz. He had more than twenty one-man shows, from Oslo to New York; published three separate collections of poems; and designed sets for two operas. Five years earlier, wrote Paul Groot on the occasion of his 1982 retrospective at Eindhoven, Lüpertz's art had been dimissed as "a regressive idea." Now, it was a public success, and in Groot's view, Lüpertz had established himself as a solid painter who "above all has something to say. Conversant with innumerable styles and idioms, he always makes them distinctly his own." It was also during that time that Lüpertz ventured into sculpture, in the form of plaster carvings (not unrelated to Georg Baselitz's wood carvings) that he cast into bronze and painted, or, in the case of some renderings from *Alice in Wonderland,* painted plaster with various accretions of wood, paper, cloth, and iron. He had actually begun working in plaster at the time of the first "Dithyrambs," creating three-dimensional models for the painted shapes in order to study the effects of light and shadow. The works of the 1980s retain the interest in volumetric form that characterized the "Dithyrambs," here often reinterpreted through Picasso's cubist and surrealist sculptures. With their boldly faceted or decorated surfaces, the sculptures remained with Lüpertz's pictorial idiom—in Wolfgang Max Faust's words, "painting jumps into the third dimension"—but a reciprocal influence was evident: within a short time, problems of space and volume, the tension between two-and three-dimensional form, dominated his canvases as well. The 1983 self-portraits, for example, are the painted representations of sculptured heads, again borrowed from Picasso; with the "Pierrot Lunaire" series (*Lunar Pierrot,* 1984), painted on cardboard, a chair and a head in various Picassoesque styles play out the permutations and combinations of three-dimensional images in relation to flat ground.

Lüpertz's sculpture, meanwhile, evolved into a group of modeled plaster heads (*Die Bürger von Florenz*/The Burghers of Florence, 1983) and monumental freestanding figures (*Titan, Ganymed,* both 1985). In those works, Lüpertz carried his dialogue with past art to another le-

vel, working through Picasso's variations on the art of the past to the ancient masterpieces themselves. The *Titan,* for example, is obviously modeled on the fifth-century B.C. *Poseidon* of Artemision, but its outsized proportions, iconic pose, and unfinished surfaces so totally negate the classical norms of beauty and harmony that the entire history of Western art from the prehistoric stone carvers to the contemporary bronze casters comes into play. A similar doubling occurs in his paintings from that period; in *Der Frühling* (Spring), for example, one of the ten "Bilder über das mydenische Lächeln" (Paintings about the Mycenaean Smile, 1985), an archaic Greek statue, the so-called Smiling Kouros from Tenea, is silhouetted against a dark scene that recalls Picasso's *Night Fishing at Antibes* (1939).

Since 1984 Lüpertz has been teaching at the Düsseldorf Art Academy, and he divides his time between Düsseldorf and Berlin. A prolific artist who works every day, regardless of his mood, he may have ten or twelve paintings underway at any one time. In recent years, doubtless spurred on by public acclaim, and perhaps also influenced by the example of some of the younger German painters like Salomé and Luciano Castelli, Lüpertz has adopted an increasingly flamboyant public persona—"a kind of Muhammad Ali of German painting" according to Wolfgang Max Faust. The preoccupation with the role of the artist that is so evident in his paintings and sculptures takes on a megalomaniacal dimension in his verbal pronouncements: "My paintings are coded secrets for a future that I do not understand and that the viewer does not understand," he declared in 1983: "I don't think that one has to make art understandable. I believe that one has to make art in spite of misunderstanding and incomprehension. If one tried to explain oneself, to show one's feelings, it would be disastrous." In his view, "the artist should make visible the divine, the uncommon, the exception. . . . The universe is defined through the artist's attempt at self-realization." On the occasion of four simultaneous exhibits organized in Berlin in 1986, Lüpertz took to holding court at the Springer Gallery, dressed alternately in evening clothes and metal-studded leather, and as Ursula Frohne reported in *Flash Art,* "the swaggering temperament of the socialite Prince of the Arts gives many critics an understandable shudder."

As has been the case throughout his career, a number of critics who may or may not be offended by Lüpertz's comportment take issue with the premises of his art. In 1982 Donald Kuspit, an early American advocate of the new German painters wrote, "To me, the restlessness

in Lüpertz's art—its constantly shifting stylistic base—is an ironic embodiment of an already ironically conceived decadence and degeneracy. . . . Not steadiness in a single style, but perverse quotation and reconstitution of what seems stylistically obsolete seems [to be] Lüpertz's conceptual method for advancing his art." And in 1986, Wolfgang Max Faust—the most ardent promoter of the current German movement—dismissed Lüpertz's reinvention of the past as "a parasitic anachronism that flatters an equally parasitic stratum of society." While acknowledging a few glimmers of insight into some of the more recent work, including the sculptures, Faust concluded that "there is no forward-looking vision here, and finally, no insight into the present." Others interpret the work differently and hold it to be a valid expression of the times. Richard Calvocoressi, for example, considers Lüpertz a supreme master of irony, "an artist who delights in contradiction. More of a stylist, more urbane perhaps, than either Baselitz or Penck, his coolness and detachment ('Picture-making is disgusting,' he has said) remind one of Warhol: the hiding behind banal, endlessly repeated motifs which cumulatively attain the status of icons."

EXHIBITIONS INCLUDE: Gal. Grossgörschen 35, Berlin 1964, '66; Gal. Potsdamer, Berlin 1966; Gal. Rudolf Springer, Berlin 1968 and from 1980; Gal. Michael Werner, Berlin 1968; Gal. David Friedrich, Gal. Hake, Cologne 1968; Gal. Gerda Bassenge, Berlin 1969; Gal. Benjamin Katz, Berlin 1969; Westwall, Gal. Hake, Cologne 1969; Gal. der Spiegel, Cologne 1972; Staatliche Kunsthalle, Baden-Baden 1973; Goethe Inst., Amsterdam 1973; Gal. Michael Werner, Cologne from 1974; Gal. Rudolf Zwirner, Cologne 1975, '76; Gal. Hans Neuendorf, Hamburg 1975, '77; Gal. Seriaal, Amsterdam 1976; Hamburger Kunsthalle, Hamburg 1977; Kunsthalle, Bern 1977; Stedelijk van Abbemus., Eindhoven 1977, '82; Gal. Heiner Friedrich, Munich 1978; Gal. Helen van der Meij, Amsterdam 1978, '80; Gal. Gillespie Laage Paris, 1978; Whitechapel Art Gal., London 1979, '81; Josef-Haubrich Kunsthalle, Cologne 1979–80; Sammlung, D. Slober, Berlin 1980; Gal. Rijs, Oslo 1981; Marion Gooham Gal., NYC 1981; Washington Gal., London 1981, '83, '84,; Gal. Fred Jahn, Munich 1981, '84; Kunstverein, Freiberg 1981; Gal. Onnasch, Berlin 1982, '86; Gal. Gillespie-laage-saloman, Paris; 1982, '84; Mus. d'Art Moderne, Paris 1983; Gal. Hubert Winter, Vienna 1983, '84; Gal. Thaddäus Ropac, Salzburg 1983, '84, '86; Gal. Maeght, Zurich 1983, '84; DAAD-Gal., Berlin 1983; Gal. im Körnerpark, Kunstamt Neuköln, Berlin 1983; Kestner Gesellschaft, Hanover 1983; Wiener Secession, Vienna 1984; Mary Boone/Michael Werner Gal., NYC 1984; Gal. Ascan Crone, Hamburg 1984; Gal. Ulysses, Vienna 1985; Gal. Herbert Meyer-Ellinger, Frankfort 1985; Gal. Beaumont, Luxembourg 1985; Castello di Rivoli, Turin 1986; Gal. Folker Skulima, Berlin 1986; Neuer Berliner Kunstverein, Berlin 1986; Städtische Gal. im

Lenbachhaus, Monaco 1986; Gal. Maeght-Lelong, Paris 1986. GROUP EXHIBITIONS INCLUDE: "Jeunes Peintres de Berlin," Gal. Motte, Paris 1967; "Berlin-Berlin," Athens 1967; "Sammlung Ströher" (trav. exhib.), Kunsthalle, Berlin, Nationalgal., Berlin, Kunsthalle Düsseldorf 1969; "14 x 14" Staatliche Kunsthalle, Baden-Baden 1969; "Akitiva '71," Haus der Kunst, Munich, and Westfälissches Landesmus., Münster 1971; "Zeichnungen 2," Städtisches Mus. Leverkusen/ Schloss Morsbroich 1972; "The Berlin Scene," Gal. House, London and Kunstverein, Hamburg 1972; "Prospect '73," Städtische Kunsthalle, Düsseldorf 1973; Paris Biennale, 1973; "Bilanz einer Aktivität," Goethe Inst., Amsterdam 1973; Berlin Biennale, 1974; "Zeitgenössische Kunst aus der Sammlung des Stedlijk van Abbemus." Kunsthälle, Bern 1977; Documenta 6, Kassel, West Germany 1977; "11 Artists Working in Berlin," Whitechapel Art Gal., London 1978; "Werke aus dem Sammlung Crex" (trav. exhib.), INK, Zurich; Louisiana Mus., Humlebaek; Stedelijk van Abbemus., Eindhoven; Städtische Gal. im Lenbachhaus, Munich 1979; "12 Künstler zu Gast im Völkerkundemus.," Munich 1979; "Figurationen," Gal. Schurr, Stuttgart 1979; "Malerei auf Papier," Badischer Kunstverein, Karlsruhe 1979; "Der gekrümmte Horizont," Akademie der Kunste, Berlin 1980; "Après le Classicisme," Mus. d'Art et d' Industrie, Saint-Etienne 1980; "A New Spirit in Painting," Royal Academy of Arts, London 1981; "Art Allemand d'Aujourd'hui," Mus. d'Art Moderne, Paris 1981; "Der Hund stösst im Lauf der Woche zu mir," Moderna Mus., Stockholm 1981; "Peinture en Allemagne," Palais des Beaux-Arts, Brussels 1981; Sidney Biennale, 1982; "Berlin—La Rage de Peindre," Mus. Cantonal des Beaux-Arts, Lausanne 1982; "Mythe, Drame, Tragedie," Mus. d'Art et d'Industrie, Saint-Etienne 1982; "Zeitgeist," Berlin 1982; "New Painting from Germany," Tel Aviv Mus. 1983; "Expressions: New Art from Germany," St. Louis Art Mus. 1983; São Paulo Biennale, 1983; "Mensch und Landschaft in der Zeitgenössischen Malerei und Graphik," Kunstverein für die Rheinlande und Westfalen, Düsseldorf 1983; "Ursprung und Vision/Neue Deutsche Malerei," Palacio Velázquez, Madrid and Centro Cultural de la Caixa de Pensions, Barcelona 1984; "Aufbrüche, Manifeste, Manaifestationen," Kunsthalle, Düsseldorf 1984; "Von hier aus: Zwei Monate neue deutsche Kunst in Düsseldorf," Messegelände, Düsseldorf 1984; "Content: A Contemporary Focus," Hirshhorn Mus. and Sculpture Garden, Washington, D.C. 1984; "100 Jahre Kunst in Deutschland," Staatliche Akademie der bildenden Künste, Karlsruhe 1985; "Das Selbstportrait im Zeitalter de Photographie," Mus. cantonal des Beaux-Arts, Lausanne 1985; "The European Iceberg," Ontario Art Gal. 1985; "Deutsche Kunst seit 1960—Sammlung Prinz Fraz von Bayern," Staatsgal. moderner Kunst Munich 1985; "Don Giovanni een opera vor het oog met D. Buren/J. Kounellis/M. Lüpertz/M. Merz/Marisa Merz/G.Paolini," Stedelijk van Abbemus., Eindhoven 1985; "Horses in Twentieth-Century Art," Nicola Jacobs Gal., London 1985; "1945–1985: Kunst aus der Bundesrepublik Deutschland," Nationalgal., Berlin 1985; Royal Academy, London 1985; Carnegie International, Pittsburgh 1985–1986; "New German Painting from the Ludwig Collection," Provincial Mus., Hasselt 1985–1986.

ABOUT: Cowart, J. Expressions: New Art from Germany, 1983; "German Art in the Twentieth Century: Painting and Sculpture 1905–1985" (cat.), Royal Academy of Art, London, 1985; Klotz, H. Die Neuen Wilden in Berlin, 1984; Lüpertz, M. Westwall, 1969; 9x9: Gedichte und Zeichnungen, 1975; Sieben über ML, 1979; Gedichte 1961–1983, 1983; Tagebuch New York 1984, 1984; Bleiben Sie sitzen Heinrich Heine, 1984; Zeichnungen 1963–1985, 1986; "Markus Lüpertz" (cat.), Musée d'Art Moderne, Strasbourg, 1973; "Markus Lüpertz: Bilder 1970–1983" (cat.), Kestner-Gesellschaft, Hanover, 1983; "Markus Lüpertz, Dithyrambische und Stil-Malerei" (cat.) Kunsthalle, Bern, 1977; "Markus Lüpertz Sculptures" (cat.), Galerie Maeght-Lelong, 1986; "Markus Lüpertz: 'Stil' Paintings 1977–1979" (cat), Whitechapel Art Gal., London, 1979; Naylor, C. and G. Porridge, Contemporary Artists, 1977; "1945–1985: Kunst aus der Bundesrepublik Deutschland" (cat.), Nationalgalerie, Berlin, 1985. *Periodicals*— Artforum April 1980, April 1982, January 1984, October 1986; Art in America February 1982, September 1982, January 1983; ARTnews March 1982, March 1984, December 1984; Art Press November 1980, July–August 1984; Flash Art January–February 1981, October–November 1986; Kunstwerk November 1983, February 1985; Print Collector's Newsletter March–April 1983.

MAHAFFEY, MERRILL (August 12, 1937–) is a leading landscape painter who was born in Albuquerque, New Mexico and has lived in the western United States all his life. His renditions of the Grand Canyon, the rugged rock formations, and the silvery streams allow the viewer to enter into the landscape. Like the nineteenth-century landscape painter Thomas Moran, Mahaffey sees the grandeur, but at the same time he is a painter of accurate and geological stratas. It is the wilderness that inspires his work. Mahaffey sees himself as conservator of our heritage, an ecologist and an explorer who believes that he is the chronicler of the past and present, a present that may slip away faster than anticipated.

Mahaffey is intensely interested in the play of light, the ever changing colors of nature, and the reflection of water. Much like Thomas Moran and Albert Bierstadt, who communicated the poetic power of nature, Mahaffey renders a powerful image with its telling particulars. Mahaffey painted the Grand Canyon for more than a decade with all its detail and panoramic views. His style has evolved from abstraction to photo-realism to the gestural, painterly brush strokes of the present. Mahaffey paintings are

MERRILL MAHAFFEY

both monumental and intimate; nature and art is fused. He typifies the artist-explorer who at his best creates vistas of beauty. His work is part of the great landscape tradition of the West.

Although Mahaffey was born in Albuquerque, his family moved to western Colorado when he was two years old. He grew up in Grand Junction, a small town of around 10,000 people. Mahaffey's father majored in landscape architecture, but because of the Depression had to fall back on his background in ranching. Mahaffey grew up on a sheep ranch. His mother had left the family and his father remarried. "I was raised by a father and three of his brothers who were all professional conservationists. I found a letter that my father had written to my maternal grandmother. They had made a cradle for me by hanging a saddle upside down by the stirrups from a peg in the ceiling. They put blankets in there and this is where I slept."

Mahaffey grew up with two half sisters and remembers his childhood as a "normal small-town upbringing. . . . In school, I remember the teacher put some of my Halloween drawings on the bulletin board. It was the first time anyone ever acknowledged that what I drew was better. I was always drawing and entertained everybody around me. I was usually in trouble for talking. I didn't think I was going to be an artist. My first inclination was to be a forest ranger. I also thought of becoming a geologist or a mining engineer. My father was also an amateur photographer and map maker. In those days, they made aerial photomaps. My father would tint these aerial photographs according to types of

vegetation. I made my first oil painting *Autumn Mountainside*, and used all his cadmium yellows, oranges, and golds. My father was horrified. I had used up his whole color set!"

A few weeks later, his father enrolled Mahaffey in a hobby painting class. "After about two paintings, I painted as well as most of the adults in my class. I thought maybe I should be an artist! I think that was when I decided to give up my career in geology."

In 1955, after graduating from high school, Mahaffey entered Mesa College in Colorado, majoring in art. Feeling that he needed greater exposure in art, he transferred to Sacramento State University where Wayne Thiebaud was teaching. Mahaffey also met Fritz Scholder, a fellow student; they attended class together for two years. Whereas most students were aiming to become art teachers, Mahaffey had other ideas: "Most students were just looking for a meal ticket. I wanted to be an artist. I didn't know that it was so hard to be an artist! I think it is persistence! A gifted child gets reinforcement. In college, it was good grades. I thought, if I worked harder than anyone else, at least, I would have a chance. An athlete practices all the time; I painted landscapes!"

In 1957 Mahaffey married Justine J. Helm and continued his art education at the California College of Arts and Crafts. In 1959 he returned to Sacramento, and upon the death of his father, returned to Colorado, becoming an art teacher in the Glenwood Springs Public Schools. After the birth of two children, his marriage ended in divorce in 1970.

The early 1960s were a difficult financial period for the artist. Having resigned his teaching position, Mahaffey worked in a variety of jobs. In 1963, determined to succeed as an artist, Mahaffey entered the fine arts program at Arizona State University as a graduate assistant. He studied with John Waddell, a well-known local sculptor who encouraged Mahaffey to believe in himself. "The art department tried to discourage me from painting landscapes. It was not considered a legitimate concern for a serious artist. I thought there was magic out there, and I would have a better chance of being successful." Mahaffey decided that realism in art was passé. Abstract expressionism reigned and Mahaffey wanted to be a modernist.

In 1965, more determined than ever to be a painter, Mahaffey completed his M.F.A. degree at Arizona State University. In his school notebook, he entered these remarks: "How many times have I opened a book as if the answers would be found inside its pages and always I am disappointed. . . . All my life, I have read books

in hope that answers could be found by reading . . . as if some quantum leap could be attained if only I could read the right source. Unfortunately, books only create more longing and raise more questions."

Again, Mahaffey returned to teaching, at the Western State College in Gunnison, Colorado. (Short of Alaska, Gunnison was the coldest place in winter in the United States. Temperatures fell to 40 degrees below, night after night.)

In 1967 an offer to teach at Phoenix College brought Mahaffey back to Arizona. He taught design, studio, arts and life drawing. Success followed. In 1968 Mahaffey had a one-man exhibition at the Phoenix Art Museum. In Mahaffey's book *Monumental Landscapes* published by the Northland Press, the art historian Rudy Turk described Mahaffey's work: "Between 1971 and 1975 [Mahaffey] produced a seemingly endless supply of paintings containing landscape-like formations with beautiful monochromatic stripes painted over them. These were lovely works that were avidly collected by their owners. They were easily recognizable 'Mahaffeys.'"

Paintings of that period were highly abstract, romantic in vision, and poetic in feeling. Though his work has become successful, Mahaffey began to feel that the monochromatic and polychromatic stripes were interfering with the landscape. He elaborated: "The subject matter had not changed, but my means of interpreting it had."

In 1972 Mahaffey made a trip to New York City. "I went to museums and galleries and I saw other artists who painted with stripes. They did not do landscapes, but they used the pattern of stripes—and I thought my work is not distinctive, it looked like the work of others. I went home and struggled trying to introduce subject matter into these shapes thinking that was the way to use the striped format—much like the linear pattern in a video. If you blew that up and froze the image you would see the stripes. But the stripes kept getting in the way of the information I wanted to describe. I was getting more literal with my subject matter. I started to study photography and darkroom techniques, began photographing landscapes. I decided that the important thing was subject matter for me, that stripes had become a manner and style rather than content."

It was during that period that his work changed; the distinctive abstract stripes and optical patterns dropped away as Mahaffey turned toward photo-realism. "Usually I would pour stains and colors out on the canvas, put it on the wall and project the image and draw it in. I would thus create a basic composition. Then, I

would use an airbrush and would render all the lines and shadows and linear patterns. I tended to pick subjects with a lot of linear patterns. I was using the airbrush trying to get linear details with the airbrush. Then I thought, let's strip that away and just take the brush. If you want to draw something just draw it. That happened around 1982-83. By 1984 I was not using the airbrush at all."

In an article in the *Scottsdale Progress* headed, "Moran vs. Mahaffey" (1986), Joseph Young stated, "Merrill Mahaffey often does succeed in creating what the nineteenth century would refer to as 'sublime paintings.' . . . Once the breathtaking novelty of the realistic scene is exhausted the viewer can begin to peruse the formal qualities of the painting where at close range the nearly palpable realism disintegrates into deftly applied patches, stains, and splatters of colors." Mahaffey put his ideas more succinctly: "Painting is a problem of using the medium to create the illusion of the intended subject."

As Mahaffey has explained, his work habits are erratic but fruitful: "I try to work every day. Usually, after a series of canvases, I will be exhausted and I will go dormant for two or three weeks. Then I will look at something and say, I like to paint these ideas." Mahaffey produces over forty paintings a year, as well as many sketches and watercolors.

In 1983 Mahaffey stopped teaching and moved to Boulder, Colorado. He enjoys painting full-time, but does participate in some teaching seminars. Mahaffey's house sits in the foothills, a few miles outside of Boulder, and has a special view. "You walk out of the door anytime and you can see deer. There are pine trees and prairie grassland. I have a large studio, about 3,600 square feet, with a picture frame shop in the basement." Mahaffey uses flood lights and fluorescent lights, but opens up the studio to let the outdoor light come in. He married for the second time in 1975. His wife, Jeanne Shirk, is also a painter. They both would like to spend part of each year in the Phoenix area and be part of its vital artistic community.

Unlike many painters, Mahaffey considers himself political. He believes that the most important problem the country has to face is deterioration of the environment. He participates in forums on ecology and conservation.

In 1988 Mahaffey began to feel the need to be working directly on location. As he has explained: "I will be painting with more arbitrary colors. Unlike the romantic school, I am not dealing with the sublime. I could paint any place! I am finding more and more that working in the studio with a slide projector makes me nervous. My next landscape project is in Utah. I am leaving with two big canvases, buckets of paint, and an easel. I am going to set up an outdoor studio."

In the catalog entitled "Canyons of the Colorado and Green Rivers," issued by the Museum of Art of the American West, Harry Rand, curator of painting and sculpture of the National Museum of American Art, stated: "A modernist painter who happens to live in the West, Merrill Mahaffey set goals for his art that do not resemble those of 'western' painters. . . . Rather than the hokum of sharply raking dawns and sunsets, Mahaffey takes his cue from Manet. . . . Mahaffey eschews dramatic lighting as a contrivance that adds excessive drama to scenes whose mystery and grandeur are amply supplied by the facts of the situation."

Rudy Turk commented: "A Mahaffey painting will most likely be a monumental landscape; the imagery will be refined, dignified, classic. It will be 'realistic' according to Mahaffey's interpretation of the concept that realism is not only what one sees, but also a state of mind and character." Mahaffey expressed it himself in these words: "Painting is an illusion, the illusion of form creating an experience you can get no other way."

A self-described adventurer and expedition artist, Mahaffey participated in an archaeological expedition into the interior of Peru in 1988. Like a modern day George Catlin, he saw and rendered a countryside unseen by any other artist. In 1988 Mahaffey spent some time travelling in Europe, and "tried to paint a little" in his sketchbook. But in Europe, he felt "there was no vitality. The land had been harnessed. I did not feel any inspiration. In Italy, I could paint, but it seemed so domestic! I like wild things, a new world of wilderness like South America!"

Mahaffey's work began to change again. He commented recently: "I like colors. In the future you will see my colors become less natural. I think, I am tired of painting natural colors. I am very conscious of light. I think my work will always be figurative. I may do human figures as well as landscapes in the future. The human figures would be the landscape. After all, I taught life drawing for many years." His focus in 1989 was on water. "I am looking at water and rocks together. I am starting to look at streams and I have painted Lake Powell, which is still water; then I painted the Colorado River, which is moving water. I just finished a series of rapids, which is the first time I have tried to paint real violent water. I am trying to paint the transparency and light refraction qualities of water. I think water has very provocative qualities."

In comparing Thomas Moran's work with his own, Mahaffey made this statement in the February 1989 issue of *Southwest Magazine*: "He set the standard. I have come to feel that I am doing as good a job. I see, he wasn't quite as great as I once thought. But more than anything else I feel part of the tradition of great landscape painting of the West."

Samuel Grove, the director of the Museum of Art of the American West, commented on this topic: "Art historians do not know when landscape painting as an art form was created, but they do know that there has always been an overwhelming need to cause nature to pause briefly on a canvas and allow the viewer to enjoy a moment a grandeur. Merrill Mahaffey is an American landscape painter who lives in the West. His renditions of the beautiful rugged land in which he lives not only enriches our lives but ensures the artist a place in history."

In assessing the next decade, Mahaffey believes representational painting styles will replace conceptualism and abstraction. "I believe that narrative painting is the future now. To me, narrative art has been the strength of American art. I like representational art because it does not imply a style. It just means that you can read the subject matter of a painting. In the final analysis, it is how you paint that makes art."

Mahaffey sees art heading in two directions: "I think painting is becoming less important in terms of communicating ideas. I thing cable TV is the medium that has the most impact on society in terms of thought and information because on cable you can have increasingly specialized topics." Yet, in his quiet, positive, and confident way, Mahaffey feels that his art will become more relevant to our lives: "I think there is going to be a vitality in landscape painting and collecting of landscape art and photography that has only been hinted at so far."

The concerns of all artists are not the same. The 1980s have seen a pluralism of ideas in which only the rapid succession of artistic movements has been constant. In this flux, the work and concerns of Merrill Mahaffey have not wavered—he explores the western landscape. His style has undergone major changes. The early semiabstract landscapes with their distinctive stripes gave way to the exact, site-specific stained color field, photo-realist landscapes of his middle-period paintings, which at times were described as regional. Do these labels matter? In his constant exploration and devotion to the landscape, Mahaffey is unique. As a painter, he explores every detail of a rock formation, the shifting effect of light, the fluidity and flow of water. As a mature artist, Mahaffey's work has become freer since he discarded photo-realism. His technique is more painterly. His renditions of nature are more interpretive. He has removed the cliché from the western landscape. Mahaffey's vision may be less sublime than the work of the nineteenth-century landscape painters, but the timelessness of his realizations transmit the beauty of nature, and convey myriad moods and colors.

EXHIBITIONS INCLUDE: Long and Company, Houston 1988; Elaine Horwitch Gal., Scottsdale, Ariz. 1981, '84, '86, '88; Univ. of Utah Mus. of Fine Art, Salt Lake City 1987; Elaine Horwitch Gal., Palm Springs, Calif. 1987; Mus. of Art of the American West, Houston 1986; MacClaren/Markowitz Gal., Boulder, Colo. 1986; Art Inst. for the Permain Basin, Odessa, Tex. 1985; Fischbach Gal., NYC 1985; Meredith Long Gal., Houston 1984; Mill Street Gal., Aspen 1984; Harris Gal., Houston 1983; Colorado Springs Fine Arts Cntr., Colo. 1983; Tucson Mus. of Art, Ariz. 1982; Portland State Univ., Oreg. 1981; Fresno Cntr. for the Arts, Calif. 1981; Northern Arizona Univ., Flagstaff 1981; Arizona Bank Gal., Heard Mus. Benefit, Phoenix 1980; Scottsdale Cntr. for the Arts, Ariz. 1979; First Western States Biennial Exhibition, Denver Art Mus., Colo., San Francisco Art Mus., National Collection, Washington, D.C., Newport Harbor Mus. of Art, Calif. 1979-80; Oklahoma Art Cntr., Oklahoma City 1978; Southwest Mus.'s Loan Collection, Mondale Residence, Washington, D.C. 1978. GROUP EXHIBITIONS INCLUDE: Artists of the Western States Exhibitions, Elaine Horwitch Gal., Palm Springs 1987; Boundless Realism, Contemporary Landscape Painting of the West, Rockwell Mus., Corning, NY 1987; "Capturing the Canyon," Mesa Southwest Mus., Ariz. 1987; "American Realism," William Sawyer Gal., San Francisco 1986; "Contemporary Art of the Southwest," Tampa Mus. of Art, Fla., 1986; "The Painterly Landscape," C. Grimaldis Gal., Baltimore 1986.

COLLECTIONS INCLUDE: Metropolitan Mus. of Art, NYC; Colorado Springs Fine Arts Cntr.; Phoenix Art Mus., Ariz.; Tucson Mus. of Art, Ariz.; Mus. of American Art, Smithsonian Instn., Washington, D.C.; Univ. of Utah Mus.; IBM Corporation; Phillip Morris Corporation, NY; Phoenix International Airport, Terminal 3; Atlantic Richfield Corporation; Hughes Aircraft, Los Angeles; United Energy Resources, NY.

ABOUT: Mahaffey, M. "Monumental Landscapes," 1979; Rand, H. "Merrill Mahaffey: Canyons of the Colorado and Green Rivers," 1986; Who's Who in American Art, 1989-90. *Periodicals*—Arizona Republic March 7, 1986; Artweek November 30, 1974; Art Voices September–October 1981; Phoenix Magazine November 1977; Scottsdale Progress February 5, 1986, March 7, 1986; Southwest Profile February 1989.

MARDEN, BRICE (October 15, 1938–),
American painter and draftsman, was born in
Bronxville and grew up in Briarcliff Manor,
New York. He received his bachelor's degree in
fine arts in 1961 from Boston University where,
he said in 1967, "constant painting and drawing
from nature developed a sense of the real, that
which was correct and had form." At Yale Uni-
versity's School of Art and Architecture, where
he received a master's degree in 1963, he prog-
ressed from an interest in fairly conventional ab-
stract expressionism through experiments with
drawing on collages to a large series of works in
tonal color painted on rectangles that were sub-
divided into sections horizontally and vertically.
He later described his divided-rectangle paint-
ings: "The color tended toward gray, with color
strips sometimes separating the large shapes.
Most were done in predominantly cool colors.
The surface was often cruddy and labored. It of-
ten shone as a result of an oily medium. The sur-
face was, to me, correct."

After leaving Yale, Marden went to live on
Avenue C on New York's Lower East Side. He
had, at first, relatively few contacts with fellow
artists, and held various part-time jobs that al-
lowed him to paint at night, a peculiarity he still
follows. One such job was as a guard at the Jew-
ish Museum at the time of Jasper Johns's retro-
spective there. Johns's work—largely mono-
chromatic at the time—seemed to confirm Mar-
den in a direction he had already taken. "There
was," he said later, "the whole idea of what's
real—like the flags were real but they were
paintings. And the grays, of course." By that
time he had begun producing one-color paint-
ings, many of them variations of gray. He dis-
cussed that while recalling his paintings of the
mid-1960s on the occasion of their exhibition in
a group show, "Abstract Painting: 1960–69," at
P.S. 1 in New York in 1983: "Gray was the way
I could deal with color at the time. What I liked
about it was how you could twist it, how you
could make it be gray, and also be a red—how
you could get two readings out of one thing. I
liked to read Zurbarán's paintings as very coldly
executed yet very passionate. I think of him as
a mystic. It interested me that he could make
something so realistic yet so absolutely full of
passion." An austere way with color and a rever-
ence for the old masters have characterized Mar-
den's art. He has always admired the painters of
the Spanish baroque, especially Zurbarán: "He
looked at things so hard he went off into a mysti-
cal state. When he paints silk it's like iron but it's
still like silk."

That last comment evokes Marden's own sur-
faces, which he has described as "not reflecting
light but looking like they are absorbing light

BRICE MARDEN

and giving off light at the same time." For sever-
al years after the mid-1960s, when he learned
the process, and even today, intermittently, he
has used hot beeswax mixed with turpentine and
pigment to make his colors less reflective and
more deep and resonant, a technique he de-
scribed in 1975: "When applying color to the
canvas, I mix standard artist's oil color (paint)
with a medium of wax and turpentine. (To one
part melted white refined beeswax, I add four
parts pure gum spirits of turpentine.) This medi-
um is kept warm (liquid) on a hot plate by my
palette and small amounts are mixed in with the
paint by brush just prior to applying color to the
canvas. The mixture is then applied to the can-
vas with a brush and worked over so the medium
and paint are thoroughly mixed and evenly cov-
er the shape. The paint is then worked with a
large painting spatula and a small painting knife
until it arrives at a satisfactory state."

Such a "satisfactory state" might come only
after many layers of slightly different colors
were applied to the surface, and the final results
often occasioned wonder and bewilderment in
critics of Marden's early works: the colors were
"indescribable" and "palpable": they created
"physical and emotional spaces surrounding
them." The complex hold of color on his imagi-
nation and work is apparent in a statement of
1971 entitled *A Mediterranean Painting*:

"It must hold as a color.

Color as character

Color as weight

Color as color

Color as value

Color as light reflector

Color as subcolor

"I paint paintings in panels. They are not color panels. Color and surfaces must work together. They are painted panels. A color against a color makes a color situation.

"How different situations work with each other.

"How the color relates to the outside edges of the painting.

"What kind of tension exists across the shape of each plane. How these tensions relate across the whole plane of the painting.

"Color working as color and value simultaneously.

"A color should turn back into itself. It should reveal itself to you while, at the same time, it evades you.

"I work with no specific theories or ideas.

"I try to avoid interior decorating color combinations."

By 1971 Marden had generally abandoned his single-panel paintings with their intricately crafted monochromes and characteristically unpainted bottom margins for multipanel, multicolor works. A significant painting in his newer mode is *Seasons* (1974–75), four panels, each five by eight feet, mounted side by side yet separated by about three inches. "The left-hand panel," in Carter Ratcliff's words, "is an earthy mustard color; the other three are various blues whose tonal range is great, from a washed-out, slatey sky blue to a blue so dark it looks almost black in reproduction. The mustard panel makes an imaginary leap from the left into the tonal sequence with an engaging ambiguity: is it keyed just higher or just lower than the middle blue, which is a sky (or stone) color a bit less washed-out than the slatey one?" In addition to such complex interplay among the work's colors, *Seasons* also manifests the artist's willingness, according to Roberta Smith, "to use a theme familiar in other art (and music) and to let it introduce an almost entirely new notion, the passage of time—change, transformation—into his work."

The five-panel "Annunciation" series (1977) carried Marden further along that road. Like Barnett Newman in his fourteen-panel "Stations of the Cross" series, Marden (who is not religious) took a religious theme with narrative variations, then attempted to formalize and universalize its message of transformation. Like the Stations of the Cross, the Virgin's Annunciation was believed in the Middle Ages and early Renaissance to have clearly defined stages. In the case of the Annunciation, those were sometimes called "the laudable conditions of the Virgin": *conturbatio* (disquiet), *cogitatio* (thought), *interrogatio* (inquiry), *humiliatio* (submission), and *meritatio* (merit). Each panel in Marden's series takes one of the Latin words as its title; by progressions of color and form from panel to panel, he reveals the drama of Mary's transformation. Smith called Marden's use of the religious theme "more integral and precise than Newman's." The sequence of vivid formal variation, the side-to-side sweeps of color, light, and form make "Annunciation" "one of the most important works of religious art in the twentieth century and also one of the most deeply satisfying groups of paintings to look at for the pure nondenominational joy of looking."

Marden's next major work was the eighteen-panel triptych, *Thira* (1980), named for the Cycladean island of Santorini, often taken for the location of the legendary Atlantis. Mediterranean themes and their abundant intensity of color have gradually infused Marden's art ever since he began spending summers on the island of Hydra in the early 1970s. The vigorous polychromy of *Thira* (which also means "door" in Greek) makes it yet another ground-breaking work in Marden's career: by placing horizontal panels on top of his familiar narrow vertical ones, he is able to add the suggestion of doors, primitive post-and-lintel structures, and the tau cross to the range of the work's figurative suggestiveness. His art becomes emblematic for the first time; he "locates the subject of his art," as Smith has written "squarely within the surface of his paintings." Marden himself commented on *Thira* three years after making it: "If you just look at these rectangles, you start making them into doors, into windows. There are all these options: this is a closed door, this is an open door; this is a door with light around it, this is a door with dark around it."

The artist sees a difference between the work he produces in Greece and in New York. "There is a tightness," he said in 1983, "a tension in the paintings made in the city that there isn't in the ones made in the country, which are more relaxed." In Greece, "you forget about a lot of things you're conscious of in New York. You're painting your pictures and living your life, and nobody's coming by."

Marden's drawings are in many ways quite unlike his paintings; typically, they are webs of inky black parallel and intersecting lines on white paper. The "Hydra" drawings, done in Greece in 1983 and exhibited the following year, were executed, like others of his drawings, with the straight, leafless branches of ailanthus trees, which he had gathered in New York the previous winter. The sticks, dipped in ink, allowed him to work up to six feet from the surface of the

paper. "There is an unpredictability as to what's going to happen," he said, referring to his unorthodox technique; "how you can't control what you normally would: with the stick, sometimes it might just hit a bump in the paper and splatter." Robert Storr has drawn a connection between Marden's drawings and paintings—not in their style, but in the artist's "attentiveness to the relation between density and luminosity. The relative contraction of the webs or grids in the drawings, and the relative opacity, tactility, or yielding shimmer of the colored rectangles in the paintings all respond to this central concern. . . . It is when Marden reduces the tonal value of his color or squeezes the white of the page out of his drawings that his work in both mediums is at its strongest and most evocative."

For several years in the late 1970s and early 1980s, Marden was engaged on a large commission to design and construct a series of stained-glass windows for the Basel Münster, a medieval cathedral in Switzerland overlooking the Rhine. He worked for years on a series of preparatory drawings showing the placement of the windows, how the light shines through them with infinitely varying intensity over the course of several days of changing weather. At first he thought of eliminating color altogether in favor of grisaille, but he eventually settled on the medieval primary glass colors: scarlet for fire, clear blue for water, pale yellow for air, and green for earth. "They are symbolic colors of the elements," he has said. He found the project "very different from a painting situation. When you're a painter, you deal with things in the most direct possible fashion; its in your hand, the paint, and you're really manipulating it. With the stained-glass project, the work was all at one or several removes from his direct control—yet he liked the discipline offered by the experience.

Marden has not succumbed to the prevailing rage for figurative, neo-expressionist painting. Certainly no trace of the figurative has crept into his work, which continues its careful preoccupations with questions of color, surface, planar conjunctions and projections. He thinks, he said in 1983, that the neo-expressionists "challenge a certain situation," but questions whether anything being introduced is truly new, or just unusual because we haven't been dealing with it for a while. He takes a fairly grim view of the art world: "The majority of people at any given time are just doing what's in vogue. I don't know if anything really changes, or opens things up. . . . What a few people do affects a lot of other people." Art has largely become "a quick commodity for consumption, sale, and increased value, . . . an incredibly speculative situation where people profit from short, skyrocketing ca-

reers. . . . Most careers that are worth anything are long careers usually."

EXHIBITIONS INCLUDE: Wilcox Gal., Swarthmore, Pa. 1964; Bykert Gal., NYC 1966, '68, '69, '70, '72, '73, '74; Gal. Yvon Lambert, Paris 1969, '73; Gal. Françoise Lambert, Milan 1970, '73; Konrad Fischer Gal., Düsseldorf 1971, '73, '75, '80; Gian Enzo Sperone Gal., Turin 1971; Locksley-Shea Gal., Minneapolis 1972, '74; Jack Glenn Gal., Corona del Mar, Calif. 1973; Cirrus Gal., Los Angeles 1974; Contemporary Art Mus., Houston 1974; Fort Worth Art Mus., Texas 1974; Minneapolis Inst. of Arts, Minn. 1975; D'Alessandro-Ferranti Gal., Rome 1975; Solomon R. Guggenheim Mus., NYC 1975; Sperone Westwater Fischer Gal., NYC 1976; Max Protech Gal., Washington, D.C. 1977; Gian Enzo Sperone Gal., Rome 1977; Pace Gal., NYC 1978, '80, '82, '84; Kunstraum, Munich 1979; Inst. für Moderne Kunst, Nuremberg 1979; InK Gal., Zurich 1980; Stedelijk Mus., Amsterdam 1981; Whitechapel Art Gal., London 1981; Mizuno Gal., Los Angeles 1982; Weinberg Gal., Los Angeles 1984; Mary Boone Gal., NYC 1986. GROUP EXHIBITIONS INCLUDE: Inst. of Contemporary Art, Philadelphia 1967; Kunsthalle, Düsseldorf 1969, '73; Whitney Mus. of American Art, NYC 1969, '71, '73, '77, '83; Fondation Maeght, Saint-Paul-de-Vence, France 1970; Minnesota Mus. of Art, St. Paul 1971; Mus. of Contemporary Art, Chicago 1972; Walker Art Cntr., Minneapolis 1972; Art Inst. of Chicago 1972; Documenta 5, Kassel, West Germany 1972; Yale Univ. Art Gal., New Haven 1973; Städtisches Mus., M'onchengladbach, West Germany 1973; ICC, Antwerp, Belgium 1973; Royal Col. of Art, London 1973; Scottish Arts Council, Edinburgh 1974; Fort Worth Mus. of Art, Texas 1974; MOMA, NYC 1974, '76; Stedelijk Mus., Amsterdam 1975; Rijksmus. Kröller-Müller, Otterlö, Holland 1975; Kunsthalle, Zurich 1976; Brooklyn Mus., N.Y. 1980; Royal Academy of Art, London 1981.

COLLECTIONS INCLUDE: MOMA and Whitney Mus. of American Art, NYC; Walker Art Cntr., Minneapolis; Fort Worth Mus. of Art, Tex.; San Francisco Mus. of Modern Art; Stedelijk Mus., Amsterdam.

ABOUT: Battcock, G. Minimal Art, 1968; Marden, B. Suicide Notes, 1974; Current Biography, 1990; Emanuel, M. et al. Contemporary Artists, 1983; Who's Who in American Art, 1989–90. Periodicals—Architectural Digest May 1983; Artforum April 1970, February 1972, October 1972, May 1973, June 1974, October 1974, December 1974, January 1975, June 1976, December 1980, September 1983; Art in America January–February 1967, November 1970, May 1973, May 1974, July 1975, September 1975, January 1981, April 1981, January 1983, October 1983, March 1985; Art International October 1966, November 1969, May 1970, February 1971, April 1972, Summer 1973, April 1975, June 1975, November–December 1978, January–February 1981, August–September 1981; ARTnews November 1966, December 1966, February 1968, January 1969, May 1969, March 1970, December 1970, March 1972, Summer 1972, April 1973, April 1974, Summer 1974, Summer 1976, September

1977, November 1978, January 1983, January 1985; Arts May 1967, February 1968, February 1970, March 1970, December 1970, January 1971, April 1972, Summer 1972, March 1973, May 1973, June 1974, September 1974, January 1975, March 1975, September 1975, December 1978, February 1979, December 1980; Connoisseur May 1981; Flash Art Summer 1982, May 1983; Fox April 1975; Studio International February 1969, July 1969, September 1973, February 1974; Time June 17, 1985.

*MENDIETA, ANA (November 18, 1948–September 8, 1985), Cuban–American artist whose works combined elements of earth art, performance art, conceptual art, and photo-documentation in forms that were intensely personal, often ephemeral, but also hauntingly universal and timeless in their expression of basic life experiences and forces.

Mendieta was born into a well-to-do family in Havana, but following the Cuban Revolution her father was imprisoned, and in 1961 she and her sister, Raquel, were sent to the United States. As a result, she spent her teenage years first in an orphanage and then in a series of foster homes in Iowa City. That experience, she insisted, lay at the root of her art: as she was to write some twenty years after she left Cuba, "I have been carrying on a dialogue between the landscape and the female body (based on my own silhouette). I believe this has been a direct result of my having been torn from my homeland (Cuba) during my adolescence. I am overwhelmed by the feeling of having been cast from the womb (nature). My art is the way I reestablish the bonds that unite me to the universe. It is a return to the maternal source."

Mendieta studied painting at the University of Iowa, completing a B.A. degree in 1969 and an M.A. degree in 1972. But in 1970—the year she became an American citizen—she began experimenting with body performances which she documented through photographs, film, and video. "My paintings," she later indicated, "were not real enough for what I wanted the images to convey, and by real, I mean I wanted my images to have power, to be magic." A key factor in her evolution was the opening of a new video art program at the university, which soon became a major center of avant-garde activity, in the words of program director Hans Breder, her work "exploded the canvas."

Parallel to her intensive exposure to the latest ideas and technologies, Mendieta also began immersing herself in the cultural heritage of the Caribbean and Latin America. Reading widely in anthropology, sociology, history, and literature, she was particularly drawn to the rituals and customs of the Santería, the syncretistic Afro-Caribbean religion that was strongly reflected in her work from 1972 to the early 1980s. In 1971 she went to Mexico for an archaeological dig at San Juan Teotihuacan and subsequently served as coordinator of the university's multimedia summer school program in Oaxaca. "Plugging into Mexico," she later remarked, "was like going back to the source, being able to get some magic just by being there."

The two poles of her interests soon came together in a series of ritualistic performances which she documented on film. In indoor works such as Blood Writing (1973) and Blood Sign #2 (1974), for example, she inscribed white walls with the gestures of her blood-covered arms and hands, while in an outdoor performance at Old Man's Creek in 1973, she rolled her blood-covered body in a pile of white feathers, alluding to the white cock used in a preparatory rite of the Santería. Following the 1973 murder of a female student at the university, she also did the first of her "rape" pieces, where a group of the artist's friends were invited to her apartment to find her half-naked and covered with blood.

By 1975 Mendieta's work was sufficiently well known to be included in a group show at the 112 Greene Street Gallery in New York City, and early the next year she had a solo exhibit there which included the documentation from her performances plus an installation called Nañiga Burial, again influenced by the Santería. During that period, her "dialogue between the landscape and the female body" gave rise to an ongoing series of earth-body works which she called siluetas (silhouettes). For these works, executed in the spring and summer months both in the Iowa countryside and in Oaxaca, Mendieta variously carved, sculpted, assembled, immersed, and burned her elfin five-foot silhouette into natural settings.

A silueta executed at Sharon Center, Iowa in 1979, for example, retained the imprint of her body—as one form among others—in a patch of muddy water. Another silueta, executed at Amana, Iowa, consisted of clumps of hair attached to a bodylike tree stump in the manner of an ex-voto, and yet another, executed at Old Man's Creek in 1977, was made by tracing the silhouette in a mound of earth with gunpowder and setting it on fire. (A similar gunpowder silueta was commissioned as an outdoor installation at the Everson Museum in Syracuse the same year, with the gunpowder set off for the opening of the exhibition.) As diverse as those works were in the choice of sites, materials, and moods, they were nonetheless consistent in expressing multiform contrasts and contradictions:

°men dē āt´a

the ephemerality of each silhouette captured in the permanence of a photograph; the mix of lyricism and danger, if not violence, in each form; the simultaneous evocation of life and death. But perhaps most striking was the extent to which Mendieta actually succeeded in bridging the gap between art and nature, so that, as Janet Heit pointed out in a review of her 1979 show of color photos and films documenting works done in Iowa, Colorado, and New York, her *siluetas* were imposed "upon the landscape so skillfully, and with such subtlety, that the shape suggests a phenomenon of nature rather than an artifact."

Mendieta moved to New York in 1978 and quickly made her way into the East Coast art world. Refusing to do simulated gallery installations, she mainly exhibited her photographs and films, or, on occasion, prepared a temporary outdoor installation, as with the gunpowder *silueta* at the Everson Museum. In 1979 she visited Cuba for the first time in eighteen years. On her return, she cocurated an exhibition of third world female artists in the United States called "The Dialectics of Isolation" (1980) and then arranged to return to Cuba, as she put it, "to bring the *silhueta* series to its source." With the support of the Ministry of Culture—she was the first expatriate Cuban artist to be officially welcomed in this way—she spent a month working in the limestone caves of Las Escaleras de Jaruco, a mountain town with a pre-Columbian culture some three or four thousand years old. Here, Mendieta left her traces in the form of archetypal female images carved into the natural rock formations. In form, iconography, and technique alike, she was strongly influenced by the now-extinct Indian cultures of the region—she first began using paint, for example, on the model of ancient cave paintings—and she made the connection explicit by giving the works titles in the Taino language. The result, wrote Lucy Lippard in *Overlay* (1983), was "stronger, cruder, more sexual, and more abstract than the delicate earlier work, as though the artist had gained strength from direct contact with her native earth and the myths of its ancient peoples."

Back in New York, Mendieta exhibited life-size black-and-white photographs of her "rupestrine sculptures," as they came to be called, but from that point on, she moved into other materials and other formats for her work. A 1982 commission in conjunction with an exhibition of the Cuba photos in Hartford, Connecticut, for example, resulted in one of her first permanent public works, a monumental female form carved from a seven-foot log and burned with gunpowder (*Arbitra*). Around the same time, she also experimented with "portable" works, mainly small drawings of labyrinths and female forms executed on bark paper and dry leaves. But the big change came in 1983, when she received a fellowship from the American Academy in Rome and for the first time began working in her own studio. Carrying over much the same totemic imagery as the bark drawings, the work from Rome alternately took the form of large mosaiclike plaques made from marble chips ("Stonewoman" series, 1983) and floor reliefs modeled out of sand and binder. These "giant biscuits," as one critic called them, were not among her most successful works, but Mendieta clearly felt the need for a new direction: "I don't feel that I can emulate nature," she wrote in an unpublished statement. "Installation is a fake art. So I've given this problem to myself—to work indoors."

In 1984 she tried another approach which incorporated earlier materials and motifs into freestanding sculptures in the form of tree trunks carved and/or burned with human forms. At the time of her death she was preparing an outdoor installation of seven of those sculptures for a public art project in Los Angeles.

Since her fellowship year at the American Academy, Mendieta had been dividing her time between the United States and Italy, where, once again, she felt closer to her Latin roots but where—unlike in Mexico or Cuba—she could also remain in the thick of the international art scene. In January 1985 she married fellow artist Carl Andre. The following September, in the course of an argument between them, she plunged to her death from the window of their thirty-fourth-floor Manhattan apartment. Although Andre was indicted for murder, he was acquitted in a 1988 trial.

In the words of her friend and mentor Al Nodal, director of exhibitions at Otis/Parsons Art Institute, whose personal tribute appeared in *High Performance* soon after her death, Ana Mendieta "was mysteriously beautiful, she was tiny, dark-skinned, with long flowing black hair, and she was lovable. She was ambitious. She was sharp. She was wild. She was totally *alive!*" Her artistic contribution, meanwhile, was aptly summarized by Donald Kuspit in a review of the memorial retrospective organized at the New Museum in 1987: "Out of the clichés of woman's earthiness, Mendieta has made an art that is simultaneously terrestrial and cosmic, abstract and primitive, personal and universal. It is perhaps narcissistic and reductive, hitting the one note of the bodily self over and over again, and abruptly simple. It is in just such unrelenting directness, though, that its power finally lies, a power that articulates the issue of woman's relationship to her mother and that connects with forces greater than either man or woman."

EXHIBITIONS INCLUDE: Iowa Memorial Union, Univ. of Iowa 1971; 112 Greene Street Gal., NYC 1976; A.I.R. Gal., NYC 1979, '81; Mus.de Arte Contemporaneo, São Paulo 1980; Kean Col., Union, N.J. 1980; Colburn Gal., Univ. of Vermont, Burlington 1980; Douglass Col., Rutgers Univ., New Brunswick, N.J; Lowe Art Mus., Univ. of Miami 1982; Univ. Art Mus., Univ. of New Mexico, Albuquerque 1982; Yvonne Seguy Gal., NYC 1982; Mus. Nacional de Bellas Artes, Havana 1983; Primo Piano, Rome 1984; Gal. AAM, Rome 1985 (with Carl Andre); "Ana Mendieta: A Retrospective," New Mus. of Contemporary Art, NYC 1987; Terne Gal., NYC 1988. GROUP EXHIBITIONS INCLUDE: 112 Greene Street Gal., NYC 1975; "Feminist Statements," Women's Building, Los Angeles 1977; "A.I.R. Invitational," A.I.R. Gal., NYC 1977; "Work in Progress," C-Space, NYC 1978; "Variations on Latin Themes in New York," Cntr. for Inter-American Relations, NYC 1978; "Window to the South," Henry Street Settlement, NYC 1979; "Raices Antiguas/Visiones Nuevas, Ancient Roots/New Visions," Everson Mus. of Art, Syracuse, N.Y. and New Mus. of Contemporary Art, NYC 1979; "Private Icon," Bronx Mus. of the Arts, Bronx, N.Y. 1979; "Expression of Self: Women and Autobiography," Douglass Col., Rutgers Univ., New Brunswick, N.J. 1979; "Dialectics of Isolation," A.I.R. Gal., NYC 1980; "Dialects," Franklin Furnace, NYC 1980; "Art across the Park," Central Park, NYC 1980; "Latin American Artists—80," Cayman Gal., NYC 1980; "Voices Expressing What Is," Westbeth Gal., NYC 1981; Medellin Art Biennial, Medellin, Colombia 1981; Primer Salon de Pequeñno Formate, Gal. Habana Libre, Havana 1981; "Four Manifestos," Lerner-Heller., Gal., NYC 1982; Primer Salon de Fotografia, Gal. Habana Libre, Havana 1982; "¡Luchar! An Exhibition for the People of Central America," Taller Latino Americano, NYC 1982; "Women of the Americas: Emerging Perspectives," Cntr. for Inter-American Relations and Konkos Gal., NYC 1982; "Projects in Nature," Wave Hill, NYC., 1982; "Seven Women: Image/Impact," P.S. 1, Inst. for Art and Urban Resources, Inc., Long Island City, N.Y. 1983; "Contemporary Latin American Art," Chrysler Mus., Norfolk, Va. 1983; "Phases I–IV" MacArthur Park Public Art Program, Los Angeles 1984; "Land Marks," Bard Col. Cntr., Annandale-on-Hudson, N.Y. 1984; "Aqui: Latin American Artists Living and Working in the United States," Fisher Gal., Univ. of Southern California Los Angeles and Mary Porter Sesnon Gal., Univ. of California, Santa Cruz 1984–85; "In Homage to Ana Mendieta," Zeus-Trabia Gal., NYC 1986; "Caribbean Art/African Currents," Mus. of Contemporary Hispanic Art, NYC 1986; "On the Other Side," Terne Gal., NYC 1987.

PERFORMANCES INCLUDE: Cntr. for the New Performing Arts, Univ. of Iowa, Iowa City 1972–75; Mus. of Art, Univ. of Iowa City 1974; "Escultura Corporal," Unidad Profesional Zacatenco, Mexico City 1974; Univ. of Wisconsin, Madison 1974; "Body Tracks," International Culture Cntr., Antwerp, Belgium 1976; "Body Tracks," Studentski Kulturni Cntr., Belgrade, Yugoslavia 1976; "La Noche, Yemaya," Franklin Furnace, NYC 1978; "Body Tracks," Franklin Furnace, NYC 1982.

FILM AND VIDEO SCREENINGS INCLUDE: 112 Greene Street Gal., NYC 1976; Li Yan-Chia Mus. Cambria, England 1976; Studenski Kulturni Cntr., Belgrade, Yugoslavia 1976; Hochschule fur Bildende Kunst, Hamburg, West Germany 1976; Kunstverein Kreis, Gutersloh, West Germany 1976; Franklin Furnace, NYC 1978, 1982; Fondo del Sol, International Sculptors Conference, Washington, D.C. 1980; A.I.R. Gal., NYC 1981.

ABOUT: Barreras del Rio, P., and J. Perreault. "Ana Mendieta: A Retrospective" (cat.), New Museum for Contemporary Art, 1987; Katz, Robert. Naked by the Window: The Fatal Marriage of Carl Andre and Ana Mendieta, 1990; Lippard, L. Overlay, 1983. Periodicals— Artforum February 1988; Art in America April 1980, April 1986; Arts January 1980, March 1988, April 1988; Flash Art March–April 1988; Heresies 5/2 1985; High Performance 31 1985; New York Times September 10, 1985, November 27, 1987, January 31, 1988, February 12, 1988; Village Voice September 16, 1986.

MERZ, MARIO (January 1, 1925–), Italian artist and writer whose profoundly philosophical vision has generated a repertoire of primal paintings, multi-media igloos, neon numbers, and other evocative forms belonging at once to a timeless world of archetypes and a particular moment of European cultural consciousness. Like his contemporaries Joseph Beuys and Marcel Broodthaers, he stands largely outside of contemporary movements and trends with a forcefully personal idiom combining analysis and intuition, political consciousness and spirituality, solemnity and wit. While he has been no stranger to the United States—his first New York exhibition was held in 1970, and he was featured at the Walker Art Center two years later—he is far less well recognized and understood on that side of the Atlantic than in Europe, where he is hailed as one of the major living artists of the late twentieth century.

Merz was born in Milan but moved with his family to Turin soon afterward. His childhood was apparently quite comfortable—Merz's father was an engineer and his mother a highly cultivated woman who introduced him to modern literature at an early age—but with the outbreak of World War II, life became very difficult, and the family wound up hiding in the bunkers like everyone else. In 1945 Merz was arrested by the fascists for political activity on behalf of the partisans (he was caught giving out leaflets in his high school) and spent a year in prison. It was then that he began to make art: He drew a portrait of a fellow prisoner who had caught his attention with a flowing red beard that reached down to his stomach. It was, he told Harold Szeeman in 1974, "an enormous red

beard, all curly. For me the whole person was in this curly beard, so I drew the motif of a curl, a motif that turns back on itself, and I made the portrait using the motif as the starting point of my drawing motif." According to Merz, after his release from prison he continued drawing in the same way but sought his subjects out-of-doors, "roaming the countryside and drawing fields, trees, grass—all with the curl motif."

Because of his father's insistence that he enter a university (he studied medicine), he was not able to pursue his interest in art, but during the late 1940s he read widely—from Leonardo to Marx, Kafka to Steinbeck—and through his brother, who taught art history, he familiarized himself with modern masters, including Picasso, Braque, and Morandi. By the end of the decade he had entered Turin's intellectual milieu, both literary and artistic, and in 1954 he had his first solo exhibition. By that time he was working with oil and mixed media to render natural subjects like trees (*Albero,* 1952) and leaves (*Foglia,* 1952), which he considered symbols of "contained organisms." While he was working in a very gestural style, he was not, as he indicated to the critic Germano Celant, particularly impressed by the art informel that dominated postwar European painting, preferring instead the paintings of Jackson Pollock, which he found "stronger and more important, less mechanical." As Celant has pointed out, his style still fell within the general idiom of art informel, but already his practice set him apart by the fact that he never finished his paintings—even after they were sold, as Celant has indicated, he kept reworking, "so much that the configuration of lumps and tangles actually changed over time."

His objective was to convey elemental experiences in the physical act of painting. The sight of workers soldering streetcar rails at night, for example, inspired a series of figure paintings because he found the light of their blow torches extraordinary. "My concern has always been with phenomena that related to reality itself," he later explained to Caroline Tisdall, "so that the representation of someone repairing a tram at night with an oxyacetylene flame seemed more relevant to me than sitting in my studio thinking of one color or another." As was his habit at that point, he threw himself into that series for a period of intense activity and after a period of "stagnation" took another approach. For a time he tried introducing wallpaper and other collage elements into the paintings in order to convey a kind of "fantasy"; then he experimented with different painting media, ranging from tar and asphalt to industrial varnishes, but again he was not satisfied with the effect and gave it up. A trip through Italy to study fresco painting turned his

attention to walls and, by extension, to the paper and canvas supports he was using, which he then began to build up in order to embed the painting in them. "My idea," he told Szeeman, "was that the painting should be made *in* the mansonry itself, instead of being built *like* a painted wall," adding that in the process of covering with ten or twelve inches of paint, he bought out more than one local paint store.

In the late 1950s Merz met the woman who was to become his wife, Marisa, and the two of them went to the Swiss Alps in search of solitude and renewed contact with nature. Various paintings in tempera and mixed media followed, and in 1962 he showed those recent works along with temperas and oil paintings from the 1950s at the Galleria Notizie in Turin. As Carla Lonzi pointed out in the catalog, the paintings of those eight years manifested one overriding characteristic (which has remained central to his work ever since): "They aren't connected to anything, they don't belong to any culture providing them with known terms of orientation. . . . His motifs have an objective justification; they articulate among themselves with the same precise articulation of his life, without a particular rule that predicts the path." For Merz, the gallery show was something of a turning point: "With this exhibit," he told Celant, "I accepted isolation as something positive." And indeed, in its aftermath, he abandoned painting altogether to experiment with other forms of visual expression. In fact, painting was to make its way back into his oeuvre by the mid-1970s, but in the intervening period—the six years before and after the pivotal events of May 1968—Merz engaged in an artistic production that had little equivalent within the parameters of contemporary art.

As he explained in a 1980 interview with Jean Christoph Amman and Suzanne Pagé, he and his friends in Turin were "embarrassed" by the painting of the time yet couldn't break out of the received categories. "You still didn't have the freedom to do what you wanted, but myself, I did what I wanted," he told them, describing how he started putting pebbles in his paintings, for example. "People were doing stupid things like that, which weren't really stupid but attempts to 'break out.'" Early on, with *Nella Strada (In the Street,* 1962–63), he turned to the use of neon tubing, which he bent into a drawinglike squiggle and looped through a stretched canvas, creating a soft play of light and shadows around the two rather violent holes in the canvas. From that point on, he told Szeeman, "I wanted to create something more complete, something self-sufficient, an object," and from that inclination came the "Structure attraversate dal neon" ("Structures Crossed Through with

Neon," from 1962), which consisted of everyday objects like a bottle, a raincoat, or an umbrella improbably combined with the glowing neon rods. As Merz himself was quick to point out, those totemic presences had little to do with the found objects of dada, most obviously because they had not been found but also because their intention was the very opposite of the dadaist negation of art: "For me, everything has been broken, and I want to put things in order, in place. . . . To put [everything] back together is to make a very, very traditional landscape, and at the same time, a transgression of the traditional painted landscape."

Those concerns for order and wholeness, in nature and in art, soon led Merz to even more elemental works—materials, shapes, and textures just barely fashioned into objects, such as *Cestone* (*Basket,* 1964), a wicker trapezoid topped with a curved rod; *Cono* (*Cone,* 1965), also in wicker; and *Cestone di vimini* (*Wicker Basket,* 1966), another cone with water bubbling inside; or *Il teatro* (*The Theater,* 1966), a trapezoid-shaped metal frame combined with a curved neon rod. In fact, the use of such simple materials and the return to basic values—artistic and social—that they implied (in marked contrast to the hi-tech orientation of pop and minimal art at that time) was common to the whole group of Turin artists that Merz was in touch with, including his wife, Giovanni Anselmo, Alighiero Boetti, Luciano Fabro, Giulio Paolini, Michelangelo Pistoletto, and Gilberto Zorio, among others. In the fall of 1967, Germano Celant dubbed their work "arte povera," in allusion to the "poor theater" of Grotowski, and a new movement was born. Merz himself has stressed the fact that the work predated the label—"First there are artists, then there are critics," he told Ammann and Page—but as Maria Volpi Orlandino pointed out in 1970, the collective arte povera identity was an important catalyst for him. Paradoxically, she noted, Merz, the "maladjusted" artist who had enjoyed such a long period of psychic freedom, "has discovered the means of fantastic expression within the new creative freedom that has emerged these last two years. Thus his work, which had been unknown and shapeless, even in his own eyes, emerged aesthetically with an exceptional weight. . . . The poverty of means attests justly to the quality of his imagination."

The work in question, which remains the emblem of Merz's creative output, was the *Igloo di Giap* (*Giap's Igloo,* 1968), a hovering, igloo-shaped structure made out of mud brick applied to a metal frame; on its surface was inscribed, in glowing neon letters, the dictum of North Vietnam's military leader, Gen. Vo Nguyen Giap: "If

the enemy concentrates itself, it loses territory; if it disperses, it loses strength." According to Merz, he arrived at the idea of the "igloo" through conversations with his wife, Pistoletto, Boetti, and other artists. It was, he told Amman and Pagé, "the organic form par excellence; at one and the same time, it's the world and the little house." In formal terms, he pointed out, it represented "a space absolute in itself: it is a hemisphere leaning on the earth"; as such, it allowed him to break away from the horizontals and verticals of conventional painting and sculpture, and through the use of "casual" materials like mud or clay, to avoid insistent geometry as well. The statement from Gen. Giap, he explained at the time, exercised some of the same fascination on him: "The idea is round," he told Michel Sonnabend. "If you follow the sentence, you'll return to its beginning, and you'll see how it winds around and calms down. There's no clarification, no logic, no progress. It's a continuous dynamic force." Notwithstanding this philosophical approach, the citation of a North Vietnamese military leader had obvious political implications as well—the Tet offensive had begun that January—but here, too, Merz sought to avoid the clichés of the time by practicing what he described as "a more subtle and hidden art, the art of observation." Accordingly, he explained to Celant, "I thought [Giap's statement] was more of reality than saying 'Long live the people of Vietnam, out with the French and American invaders!'"

In retrospect, the multifaceted consciousness that found expression in the iconoclastic postures of Merz and the other practitioners of arte povera uncannily anticipated the political and social eruption that was to occur in May 1968, and those events in turn reinforced the new artistic beginnings. Merz's second igloo, for example, bore a slogan from the streets of Paris—*Objet cache-toi* (*Objects, Hide Yourself,* 1968)—which stimulated his imaginaton. "I thought about hiding the object inside of an idea," he later explained. "The idea can be contrary to the object. We can say, 'We're all against the objects we create.' So I covered this half-spherical structure with earth and I made something halfway between a hut and the idea of a hemisphere, and on top I put the phrase 'Object cache-toi.'"

Working with other political phrases, like *Solidario/Solidare* (the Italian version of a French wall graffiti meaning "Solidarity/Solitary"), *Che fare?* (Lenin's *What is To Be Done?*), and *Sit-in,* Merz also fashioned a group of object-presences consisting of wax-filled containers topped with the neon slogans. But the politically evocative aspect of Merz's work was very much part of a larger synthetic vision, an

attempt to seize the moment in all of its dimensions. Indeed, at the same time that he was embedding topical slogans in wax, he was embedding wax between pairs of trees in the forests outside of Turin in order to obtain impressions of arrested growth in nature (*Calco in cera dello spazio fra due rami di albero,* 1969), and he was also piercing thin rods through bales of hay (*Trucioli,* 1967–69) and beginning to pile up dried branches into faggots. The igloos, meanwhile, proliferated in a variety of materials, from bundles of folded cloth (used by his wife in her work) to sheets of broken glass held in place with putty to fine mesh (literally illuminated with a neon quotation from Ezra Pound, who had profoundly influenced him with the notion of the "direct presentation of the object").

In the midst of that tremendously innovative activity ("I think that my biggest problem is a broad vision," he later remarked to Patrice Bloch and Laurent Pesenti), Merz came upon a conceptual framework that reinforced his artistic intuition with mathematical logic and gave his work a coherence that it has retained ever since. Interestingly enough, when conceptual artists were immersing themselves in the latest mathematical and linguistic theories, Merz turned to the early thirteenth-century writings of the distinguished mathematician Fibonacci, also known as Leonardo of Pisa (who, among other things, was responsible for bringing the so-called Arabic numerals to the West). Like Merz, Fibonacci based his work on direct observation—the proliferation of rabbits—from which he identified an infinite mathematical progression in which each number is the sum of the two numbers preceding it (i.e., 1, 1, 2, 3, 5, 8, 13 ,21, 34 . . .). The Fibonacci series, as it came to be called, manifests itself throughout nature—in the structures of pine cones, the scales of a crocodile. For Merz, the underlying logic that the series represented "was a path that contemporary art had left open. It was like finding a path in the forest that had not yet been built."

In short order, the Fibonacci numbers made their way into his work, not only as a symbolic affirmation but as a basic organizing principle. The igloos, for example, were festooned with neon numbers from the series (*Igloo fibonacci,* 1970); the numbers themselves, linked by digital counters and electrical wires as well as logic, were mounted on the wall to indicate *Relationships of Growth within the Development of a Tree Outlined in an Unbroken Line* (1970), or lined up behind a stuffed animal that similarly recalled their occurrence in nature (*Iguana,* 1971; *Crocodilus Fibonacci,* 1972). Implicit in the presence of part of the series, of course, was the idea that it could go on forever:

"I did not understand why a work of art has to be a certain length when it could be infinite," Merz told Richard Koshalek in 1972, commenting on his installation at the Walker Art Center, which included works with titles like *1, 1, 2, 3, 5—The Key of the Fibonacci Series, Function of the Fibonacci Numbers from 8 to 28657,* and *Proliferation of the Position of Newspapers on the Floor from 8 to 144.* But the numbers were more than signs or symbols, he insisted: "The Fibonacci series is natural; if you put a series of trees in the exhibition, you have dead entities. But if you put Fibonacci numbers in an exhibition, they are alive because men are like numbers in a series. . . . Numbers are the vitality of the world."

The spiral soon made its way into Merz's oeuvre as another visual manifestation of proliferation, "a symbol of time, expansion from the center toward the periphery," which was the antithesis of Renaissance perspective, with its fixed point of view and constant movement toward the center. In works like *6765* (1976), low spiral tables were covered with abundant but neatly ordered arrangements of fruits and vegetables, representing the productive power of nature. Meanwhile, the negative side of proliferation—waste—was evoked with piles of old newspapers (as at the Walker Art Center) lined up in chronological order and often strung together with a wired series of Fibonacci numbers. In 1972 he applied the numbers to a series of photographs taken in a London pub to show numbers in tangible, human terms ("A Real Sum Is a Sum of People"), and the following year he actually built wooden tables to accommodate the numbers of people in the Fibonacci series, from one to thirty-four, and exhibited them at the John Weber Gallery in New York under the title "It Is Possible to Have a Space with Tables for 88 People as It Is Possible to Have a Space with Tables for No One." This project, he noted, was a significant departure from "a description of what already exists to the actual realization of an environment," and the experience proved to be such a "tremendous jolt with reality" that he had to give it up. Recognizing that "art is really a phenomenon that absorbs the jolt, softens the blow," he decided to stick with representation, and made a series of "Table Paintings" (1974), which, like the spiral, ignored perspective, reverting instead to pre-Renaissance conventions of coloring to depict depth and volume.

At this point, painting again became a regular part of his artistic activity, with a repertoire of primal plant and animal forms unmistakably linked to the gestural images of the early 1950s and yet, like the igloos, the spirals, the numbers, and all the other projects of the intervening

years, creating physical and psychic presences that transcended the limits of art objects. Those giant apparitions—trees, leaves, lizards, crocodiles, tigers, vortices—executed in a mixture of oils, acrylics, spray and metallic paints, and charcoal, along with a Fibonacci number or two, seem to have more in common with cave or rock paintings than any modern art tradition; as Merz himself insists, "Those figures are mythic. They don't come from me." Many of them have been done *in situ*, with brush strokes continuing off the edges of the unstretched canvas and paint dripping down onto the floor, so that, like the Fibonacci numbers, they are individual units within a larger series.

By the 1980s, if not before, this contingency of place and space had become the dominant aspect of Merz's work as a whole: individual pieces are not simply presented but conceived in relation to each other and to their environment. When he went to Brisbane, Australia in 1979, for example, Merz created an igloo with eucalyptus branches from the outback; for an exhibition in Jerusalem in 1983, he used clay from nearby Jericho. As Denys Zacharoupoulos remarked when nearly two decades of igloos were reassembled for Merz's 1985 retrospective in Zurich, "the succession or the juxtaposition of igloos in the main exhibition hall does not constitute the formal evolution of his work, or the total of his artistic products, or even the sum of a successful artistic investigation, but reveals itself straightaway as the work's conquest of a new space, from which a new historical perspective unfolds." Even more dramatic in that respect was Merz's 1987 installation of eight works in the chapel of the Hôpital de la Salpêtrière in Paris, where the primal iconography of his igloos, dried branches, broken glass, newspapers bundles, and neon resonated with the domes and vaults of the sixteenth-century building and entered into a spiritual dialogue with the images of virgins and saints on the walls and the crosses on the altars.

In attempting to characterize Merz's artistic activity, more than one critic has compared him (like Joseph Beuys) to the traditional shaman, the seer-artificer who mediates between the worlds of the known and the unknown, and that image is amply reinforced by the artist's own description of his creative process. As he told Germano Celant, "I work with the emotions I get from the archetypal structure that cancels the material. Then, once I have procured the object, I try to take possession of its structure with my hands, arranging it in various positions until I feel it is in unison with me physically. I now intersect this form with an image with a different kind of energy, such as a calibrated weighing scale, for instance, or a neon strip. this way I

achieve a very physical and individual feeling of how I relate to the object's primary life."

Like the shaman, Merz acts (in his own words) "individually yet in community"; since the late 1970s, he has been much feted throughout Europe and the United States, with more than fifteen museum exhibitions and nearly three times that number of gallery shows. Yet he remains an elusive personality—he talks about his work and his world view a great deal, but reveals little about himself apart from a few anecdotes. A tall, imposing figure with statuesque features, he still sports the sideburns and long hair of the 1960s (now turned white). He identifies with the art world as a whole, he says, but not with specific artists: "I've taken too many risks to have a tie with some artists in particular." And indeed, as Denys Zacharoupoulos remarked in a 1986 appreciation of his work, "without the least postmodern ambiguity, Mario Merz will not have been either avant-garde or arrière-garde, because he will always have been *modern* . . . someone who belongs to neither ancient times nor classical times but who exists in the historical present."

EXHIBITIONS INCLUDE: Gal. La Bussola, Turin 1954; Gal. Notizie, Turin 1962; Gal. Gian Enzo Sperone, Turin from 1968; Gal. L'Attico, Rome 1969; Gal. Ileana Sonnabend, Paris 1969; Gal. Konrad Fischer, Düsseldorf and Cologne from 1970; Ileana Sonnabend Gal. NYC 1970–71; Gal. Françoise Lambert, Milan 1970; Kunstverein, Hanover 1970; Walker Art Cntr., Minneapolis 1972; Jack Wendler Gal., London 1972, '74; John Weber Gal., NYC 1973; Haus am Lützowplatz, Berlin 1974; Cascina Ova, Tortona 1974; Gal. Franco Toselli, Milan 1974, '79; Gal. Area, Florence 1974; Kunsthalle, Basel, 1975; Inst. of Contemporary Art, London 1975; Gal. Forma, Genoa 1976; Gal. Gian Enzo Sperone, Rome 1976; Gal. Mario Pieroni, Pescara 1976; Mus. Diego Aragona Pignatelli, Naples 1976; Gal. Tucci Russo, Turin from 1976; Gal. Salvotre Ala, Milan 1977, '80; Gal. Annemarie Verna, Zurich 1977; Gal. Jean & Karen Bernier, Athens from 1978; Mus. Folkwang, Essen 1979; Sperone Westwater Gal., NYC from 1979; Gal. Durand-Dessert, Paris from 1979; Gal. Giuliana De Crescenzo, Rome 1979; Whitechapel Art Gal., London 1980; Gal. Albert Baronian, Brussels 1980; Gal. Christian Stein, Turin from 1980; Stedelijk van Abbemus., Eindhoven 1980; Studio W Kwietniu, Warsaw 1981; ARC, Mus. d'Art Moderne de la Ville de Paris 1981; Kunsthalle, Basel 1981; Gal. Lucio Amelio, Naples 1982; Gal. Mario Diacono, Rome 1982; Flow Ace Gal., Venice, Calif. 1982, '83; Kestner-Gesellschaft, Hanover 1982; Gal. Marilena Bonomo, Bari 1982; Gal. Comunale d'Arte Moderne, Bologna 1982; Moderna Museet, Stockholm 1983; Anthony d'Offay Gal., London 1983; Gal. Mario Pieroni, Rome 1983; Israel Mus., Jerusalem 1983; Gal. Nachst St. Stephan, Vienna 1983, '85; Gal. Buchamann, Basel 1983; Gal. Naz. d'Arte Moderna, San Marino 1983; Inst. Contemporary Art, Boston 1984; Albright-Knox Art

Gal. and Hallwalls, Buffalo 1984; Kunstverein St. Gallen in Katharinen 1984; Gal. Pietro Sparta, Chagny from 1984; Mus. Toulouse Lautrec, Albi 1984; L'Atelier sur l'Herbe, Ecole des Beaux-Arts, Nantes 1984; Kunsthaus, Zurich 1985; Gal. Munro, Hamburg 1985; Leo Castelli Gal., NYC 1985; Mus. d'Art et d'Histoire, Geneva 1985; Westfalischer Kunstverein, Munster 1985; CAPC, Mus. d'Art Contemporain, Bordeaux 1987; Mus. di Capodimonte, Naples 1987; Chapelle St. Louis, Hopital de la Salpêtrière, Paris 1987; GROUP EXHIBITIONS INCLUDE: "Pittori astratto-concreti," Gal. Gissi, Milan 1952; "Niente di nuovo sotto il sole," Gal. La Bussola, Turin 1955; "Quattro giovani pittori torinese," Gal. Il Milione, Milan 1957; "Tre nuovi pittori afformali," Gal., Notizie, Milan 1957; "Mus. sperimentale d'arte contemporanea," Gal. Civica d'Arte Moderna, Turin 1967; "Arte Povere," Gal. De Foscherari, Bologna 1968; "Arte Povera," Centro Arte Viva Feltrinelli, Trieste 1968; "Percorso," Gal. Arco d'Alibert, Rome 1968; "Prospect 68," Stadtische Kunsthalle, Düsseldorf 1968; "Arte Povera + Azioni povere," Arsenali dell'Antica Republica, Amalfi 1969; "Op Losse Schroeven, situaties en cryptostructuren," Stedelijk Mus. Amsterdam 1969; "Live in Your Head: When Attitude Becomes Form," Kunsthalle Bern; Mus. Haus Lange, Krefeld; Inst. of Contemporary Art, London 1969; "Verbogene Structuren," Mus. Folkwang, Essen 1969; "Between Man and Matter," Metropolitan Art Gal., Tokyo 1970; "Processi di pensiero visualizzati,m" Kunstmus., Luzerne 1970; "Conceptual Art, Arte Povera, Land Art," Gal. Civica d'Arte Moderna, Turin 1970; "Vitalità del negative nell'arte italiana 1960–70," Pal. delle Esposizioni, Rome 1970; "Guggenheim International Exhibition," Solomon R. Guggenheim Mus., NYC 1971; "Arte Povera," Kunstverein, Munich 1971; "Sonsbeek 71," Park Sonsbeek, Arnheim 1971; "Kunst Theorie Werke," Kunsthalle Nürnberg 1971; "Arte de sistemas," Mus. de Arte Moderna, Buenos Aires 1971; "Persona," International Theater Festival, Belgrade 1971; Prospect 71, Kunsthalle, Düsseldorf 1971; "Pier 18," MOMA, NYC 1971; Venice Biennale 1971; Documenta 5, Kassel 1972; "Aktionen der Avantgarde 1973," Akademie, der Künste, Berlin 1973; "Kunst bleibt Kunst," Kunsthalle, Cologne 1984; "Spiralen & Progressionen," Kunstmus., Luzerne 1975; Venice Biennale 1976; Prospect-Retrospect-Europa 1946–1976," Kunsthalle, Düsseldorf 1977; "Arte in Italia 1960–1977," Gal. Civica d'Arte Moderna, Turin 1977; "Omaggio a Brunelleschi," Santa Maria Novella, Florence 1977; "Europe in the Seventies," Art Inst., Chicago 1977 (trav. exhib.); Venice Biennale 1978; "Poetische Aufklärung in der europaïschen Kunst der Gegenwart," InK, Zurich 1978; "European Dialogue," Art Gal., of New South Wales, Sydney 1979; "The Wind my Home," Inst. of Modern Art, Brisbane 1979; "Le Stanze," Castello Colonna, Genazzano 1979; "Kunst seit 1960—Sammlung Crex," Kunstverein, Karlsruhe 1980; "Fabro, Kounellis, Merz, Paolini," Kunsthalle, Bern 1980; "Ut Pictura Poesis," Pinacoteca Comunale, Ravenna 1980; "Pier + Ocean," Hayward Gal., London 1980; "Europe 80," ELAC, Lyon 1980; Venice Biennale, 1980; "A New Spirit in Painting," Royal Academy of Arts, London 1981; "Che Fare?" Mus. Haus Lange, Krefeld 1981; "Westkunst," Rhein-

hallen Messegalände, Cologne 1981; "Identité italienne," Cntr. Pompidou, Paris 1981; "Arte Povera, Anti Form," CAPC, Mus. d'Art Moderne, Bordeaux 1981; "'60–'80—Attidues/Concepts/Images," Stedelijk Mus., Amsterdam 1982; "Avanguardia- transavanguardia '68–'77," Mura Aureliana, Rome 1982; "New York on Paper," MOMA, NYC 1982; Documenta 7, Kassel 1982; "Zeitgeist," Martin-Gropius-Bau, Berlin 1982; "Arte Italiana 1960–1982," Hayward Gal., London 1982; "Vergangenheit, Gegenwart, Zukunft," Wurttembergischer Kunstverein, Stuttgart 1982; "Concetto-Imago: Generationswechsel in Italien," Kunstverein, Bonn 1983; "Adamah la terre," ELAC, Lyon 1983; "New Art," Tate Gal., London 1983; "Eine Kunst-Geschichte in Turin 1965–1983," Kunstverein, Cologne 1983; "Ars 83," Athenaeum, Helsinki 1983; "Coerenza in coerenza, dall'arte povera al 1984," Mole Antonelliana, Turin and Palacios de Cristal & de Velazquez, Madrid 1984–85; "Contemporary Italian Masters," Univ. of Chicago 1984; "Content: A Contemporary Focus 1974–1984," Hirschhorn Mus. and Sculpture Garden, Washington, D.C. 1984; "The European Iceberg," Art Gal. of Ontario, Toronto 1985; "Promenades," Cntr. d'Art Contemporain, Geneva 1985; "Don Giovanni: An Opera for the Eye," Stedelijk van Abbemus., Eindhoven 1985; "Arte Povera, the Knot," P.S. 1, N.Y. 1985; "La Grande Parade," Stedelijk Mus., Amsterdam 1985; "Transformation in Sculpture," Solomon R. Guggenheim Mus., NYC 1985; "Spuren, Skulpturen und Monumente ihrer prazissen Reise," Kunsthaus, Zurich 1986; "Hommage à Beuys," Stadtische Gal. im Lenbachhaus, Munich 1986; "Sonsbeek 86," Arnheim 1986; "Falls the adow," Hayward Gal., London 1986; "Qu'estce que la sculpture moderne?" Cntr. Pompidou, Paris 1986; "The Spiritual in Art," Los Angeles County Mus., Los Angeles 1986 (trav. exhib.); "1965–1987, de l'Arte Povera dans les collections publiques françaises," Mus. d'Art et d'Histoire, Chambéry 1987 (trav. exhib.); "Terrae Motus, Naples, Tremblement de Terre," Grand Palais, Paris 1987; "L'Epoque, la mode, la morale, la passion, Aspects de l'art d'aujourd'hui, 1977–1987," Cntr. Pompidou, Paris 1987; "October des Arts," Mus. Saint Pierre Art Contemporain Lyon 1987; Skultor Projekte, Munster 1987; "italie hors d'italie," Carré d'Art-Mus. d'Art Contemporain, Nîmes 1987.

COLLECTIONS INCLUDE: Stedelijk Mus., Amsterdam; Kaiser Wilhelm Mus., Krefeld; Mus. Saint Pierre Art Moderne, Lyon; Mus. Nat. d'Art Moderne, Paris; Mus. d'Art Moderne, Saint-Etienne; Art Gal. of Ontario, Toronto; Gal. d'Arte Moderna, Turin.

ABOUT: Celant, G. Arte Povera, 1969; Celant, G. "The European Iceberg (cat.)," Art Gal. of Ontario, Toronto, 1985; Celant, G. The Knot—Arte Povera, 1985; Celant, G. (ed.) Mario Merz, 1983; Emanuel, M., et al. Contemporary Artists, 1983; "Identité italienne" (cat.), Centre Pompidou, Paris, 1981; Merz, M. Fibonacci 1201-Mario Merz 1970, 1970; Merz, M. Fibonacci 1202-Mario Merz 1972, 1972; Merz, M. 987, 1976; Merz, M. Les Fruits, 1983; Merz, M. Voglio fare subito u libro/Sofort will ich ein Buch machen, 1985; "Mario Merz" (cat.), ARC Mus. d'Art Moderne de la Ville de Paris, 1981; "Mario Merz" (cat.), Kestner-Gesellschaft,

Hanover, 1982; "Mario Merz" (cat.), Israel Mus., Jerusalem, 1983; "Mario Merz" Albright-Knox Art Gal., Buffalo, N.Y., 1984; "Mario Merz" (cat.), Kunsthaus, Zurich, 1985; Müller, G. The New Avant-Garde, 1972. *Periodicals*—Art and Artists June 1972; Artforum December 1979; Art in America July–August 1979; Art Press May 1981; Artstudio Winter 1986–1987; Beaux-Arts May 1985; Du no. 3 1983; L'Artvivant November 1974; Plus (Dijon) April 1985; Studio International January–February 1976, July 1983.

MIDDENDORF, HELMUT (1953–), German painter identified with the "young fauves" of the early 1980s, who brought new energy to the Berlin art scene with their iconoclastic imagery and freewheeling styles. Drawing on a wide range of expressionist traditions, from the Italian baroque to the New York School, Middendorf has developed a highly charged personal idiom that nonetheless conveys the experience of Germany's postwar generation.

He was born in the provincial town of Dinklage but moved to Berlin at the age of eighteen to study at the Fine Arts Academy (Hochschule). That move to the capital had a major impact on him, but his initial experience at the Hochschule was far from positive—"totally lost time," he told Heinrich Klotz—because he was at odds with his instructor. After completing the foundation courses, he was able to seek out his own teacher and had the good fortune to join the class of Karl Horst Hödicke, who had just been hired. "Hödicke was my liberation: suddenly, three or four weeks after I started his class at the Hochschule, I finally had the feeling that now I was doing something meaningful, and something that also gave me pleasure."

Although Hödicke's own neo-expressionist painting style was to have a certain influence on Middendorf, it was his openness and encouragement to explore new possibilities that ultimately meant the most to the young student. It was in that spirit, for example, that Middendorf began experimenting with super-8 in 1976; he made more than fifteen films while he was at the Hochschule, and he also lectured there on super-8 filmmaking. In 1977 he started a cooperative art gallery with one of Hödicke's more colorful students, Wolfgang Cielarz, a sometime dancer, musician, gay activist, and transvestite who went under the name of Salomé. They were joined by Salomé's roommate, Rainer Fetting, and another friend from the Free University, Bernd Zimmer, and over the four years of its existence, the Galerie am Mortizplatz became an important part of Berlin's avant-garde art scene.

Middendorf participated in his first group show, the Free Berlin Art Exhibition, in 1976 with *Im U-V Licht (Die Männer mit dem weissen Hemd)* (In U-V Light [The Men with the White Shirts], 1976), a strange mixture of anecdote and advertising art showing two men in black faces and hands. Over the next few years, his work, like that of his friends from am Moritzplatz, was to erupt with the dramatic color and brushwork that earned them the young fauves label. A major influence for all of them was the punk music scene; according to Middendorf, he went every day to SO-36, a huge discothèque (formerly a supermarket) in the rundown immigrant quarter of Kruezberg where he lived and where Galerie am Moritzplatz was located. Not only did he and his friends listen to music, but they played it, at SO-36 and elsewhere, and that subculture became the subject of their paintings (some of which they executed, collectively, on the walls of SO-36). "The first concerts at SO-36 and in New York at that time had such an intensity, an enormous intensity, that I had to react in the paintings," he has recalled. "This intensity isn't found anywhere in art. You have to put it in."

Middendorf's first visit to New York in 1978 also gave him the opportunity to see abstract expressionist painting firsthand in the museums, and an experience that influenced him much more, he insists, than the legacy of Kirchner and the other German expressionists with whom his work is often compared. While his use of primary colors and abstract forms obviously links him with Kirchner, he explains, the speed of his painting and the spontaneous expression of themes is to be found not in the German expressionists of the 1920s but rather in the abstract expressionists. But the real catalyst that helped him to find his own visual language was Markus Lüpertz, another Berlin painter of Hödicke's generation, whose "Motif Paintings" had captured Middendorf's imagination since the early 1970s. Like Hödicke, Lüpertz played on the tension between representation and abstraction, but his was a more volumetric style: his "motifs"—emblematic images like snails or guitars, but also more highly charged symbols of the German past, such as army helmets and cannons—were rendered with mass and volume, light and shade. Some of Middendorf's canvases from the late 1970s reflect Lüpertz's particular preoccupation with the artist's craft (notably various *Pinsel* [Paintbrush] paintings from 1978–79) as well as his emphasis on geometric form and muted colors (*Häuse* [Houses, 1979], *Welt* [World, 1979]). But from the outset, Middendorf adopted that formal model to paint the icons of his personal subculture—guitars, conga drums, beer mugs, Berlin's stark apartment buildings and looming bridges, the rhinoceros in the city

zoo (which was for him the "embodiment of the irrational"). The departure from Lüpertz's imagery, Middendorf has pointed out, was significant because at the time, "it was considered inane to reflect one's own reality in painting." The older generation—Lüpertz, Hödicke, Baselitz, Koberling—had all resorted to metaphor.

Ultimately, Middendorf was to abandon objects, geometry, and earthy palettes alike, but the Lüpertz interlude left him with a sense of structure and composition that was crucial for his subsequent work. According to Middendorf, the "turning point" came in 1979, when he began a series of discothèque scenes called "Grosstadteingeborene" (Big-City Natives). What was significant about those paintings was the return to the human figure, albeit in a very crude and often inept way. "It shouldn't be forgotten that we all had big problems with the human figure, even Hödicke," he told Klotz. "In the beginning, Fetting painted trees in the wind, the beach, and so forth. I painted guitars and drums, then came the rhinoceros and the apartment buildings, and [only] with difficulty the singers and the big-city natives." That difficulty is apparent in one of the early paintings in the series, *Grosstadteingeborene—SO-36* (1979), where the four male figures looming out of the deep space that represents SO-36 are very awkwardly rendered (and the silhouettes of the musicians at the back even more so). But what overshadows the limitations of the figure style in such paintings is the vitality of the brushwork—as color, texture, line, and surface—and in that sense, it is clear that figural subjects gave Middendorf an expressive focus lacking in the earlier works. "What interests me," he has pointed out, "is the energy I put into the figure. It has something to do with making art energy, also with overloading the colors. . . . I try to create a synthesis of energy and color and energy and figure."

Within a year, his figure paintings had come into their own, largely through an explosion of primary colors, as seen, for example, in *Schwebender—rot* (Sireeping red, 1980) where a red male nude arching over a row of apartment buildings is set off from the same red of the background by intermittent streaks of an electric-blue outline. In subsequent works, such as *Electric Night* (1981) or *City of the Red Nights* (1982), a repertoire of singers, musicians, dancers—and painters—contort on their respective light-filled stages. Often the figures are nude, and their bold poses, streaming hair, and glowing bodies (beginning to assume muscular form) create a strikingly visionary effect in the implied discothèque settings.

By that time, Middendorf and his friends from the Galerie am Moritzplatz had achieved the status of a movement. As Lennart Gottlieb observed, "The canvases of Middendorf, Fetting, or Salomé embodied the painting that the public between the ages of twenty and thirty-five—or at least the most involved ones among them—had been waiting for—what they had been missing, perhaps unconsciously, throughout the decade of 'nonpainting' (late conceptual art) and antipainting (feminist, political, social realist) in the 1970s." But their sudden rise to prominence as representatives of the "new German art" was clearly a function of economics as well: for dealers and critics, regardless of age, they brought new life to a stagnant market, and as such, they enjoyed a good deal of promotion, not only within Germany but also on the international scene, beginning with "Après le Classicisme" (After Classicism), the survey of contemporary trends organized at Saint-Etienne in the fall of 1980. Earlier that year, they had been featured in a group exhibit at Haus am Waldsee in Berlin called "Heftige Malerie," or "Violent Painting"; that was the name they had used for one of their own group shows at Galerie am Moritzplatz, it soon became their label.

In 1980 Middendorf went to New York on a grant from the German office for academic exchanges (DAAD); between 1981 and 1983, he was included in more than a dozen group shows organized around the new German and/or European art. In 1981 he and Fetting had a two-man show at the Mary Boone Gallery in New York, followed by his first one-man shows in London in 1982 and in New York, at the Bonlow Gallery, in 1983. As had been the case with the French painters of figuration libre who made their way to New York in 1982, American critics were not overly impressed with the new German artists. On the occasion of the Bonlow Gallery show, Thomas Lawson wrote in *Artforum* that Middendorf and the other violent painters "were, and continue to be, sincere in the dopiest, least self-reflexive way possible," and contended that they were "simply lucky enough to stumble onto something so dumb that it had to be taken as smart." In Middendorf's work in particular, he found that the mood suffered from repetition, and the implied social criticism, from lack of wit, concluding that "his repertory of images and effect is too limited to sustain itself."

Whether consciously or unconsciously, Middendorf responded to such criticism with a certain evolution of style and subject matter. The discothèque went by the wayside, and the big-city natives were frequently reduced to isolated individuals—*Maniac* (1983), *Die Strasse* (The Street, 1984)—or just large heads that fused with

the cityscape—*Häuserkopf* (House-Head, 1983), *Kopfläufer* (Head-Runner, 1984). This considerably more sober vision was expressed in forms no less animated than before, but was more controlled, with colors juxtaposed rather than blended, with space and surface pattern more clearly defined. "The unifying element is the self," he told Wolfgang Max Faust in 1984. "The artist paints this series of paintings because he is attempting again and again to find his own nervous system."

In a number of works from that period, there are unmistakable allusions to the art of the past—from the exaggerated perspective of Tintoretto in *Die Strasse* to the signature brushwork of Clifford Still in *Hinter der Tür* (Behind the Door, 1984)—but unlike Fetting, who had consistently made art the subject of his art, Middendorf has insisted that"I don't paint paintings about paintings. . . . Refurbishing art history has never interested me." Rather, he seems to have absorbed various expressionistic modes (also including African sculpture and German Renaissance painting) into his stylistic repertoire, not in order to quote, but to derive a similar effect. The subjects themselves remain rooted in the city (alternately Berlin and New York), but the treatment has become increasingly visionary—a *Man with Fire* (1985) who wields a torch/penis against the backdrop of a city in flames; apocalyptic "Heaven" ("Himmel," 1986) studies; a crucifixion (*Doppelhamlet*, 1985–86). "My best paintings," he told Faust, "have an aspect of the not quite formulated, a moment of irrationality. I don't even know myself when they are painted just that way. They reach a point which surprises me, and often I realize only years later why I painted them."

For some critics, notably those in New York, Middendorf's brand of self-expression remains what Nancy Grimes has called "little more than a bravado display of ineptitude." But for others, his use of color, texture, and form constitutes an innovative language for expressing the mood of the late twentieth century; as Monique Fuchs wrote on the occasion of his 1987 retrospective, shown in Germany, France, and Sweden, what he presents is not the age-old confrontation with nature, but the individual confronting "the solitude of the cities and their dangers. . . . Beyond iconography, the motif yields its importance to the painting alone: the pleasure of the color, violent balance, the sensuality of the harmonies. . . . The brush doesn't describe, it models a character, constructs an object."

EXHIBITIONS INCLUDE: Gal. am Moritzplatz, Berlin 1977; Gal. Nothelfer, Berlin 1978; Gal. Gmyrek, Düsseldorf from 1981; Mary Boone Gal., NYC 1981 (with Ranier

Fetting); Gal. Albert Baronian, Brussels 1982; Studio d'Arte Cannaviello, Milan 1982, '84; Gal. Yvon Lambert, Paris 1982–84; Gal. Buchmann, St. Gall 1982; Bonlow Gal., NYC 1983; Gal. Munro, Hamburg 1983; Groningen Mus. 1983; Düsseldorf Kunstverein 1983; Staatliche Kunsthalle, Baden-Baden 1983; Oerlinghausen Kunstverein 1983; Gal. Silvia Menzel, Berlin 1983; Gal. Folker Skulima, Berlin 1983, '85; Gal. Buchmann, Basel 1984, '86; Braunschweig Kunstverein 1984; Annina Nosei Gal., NYC from 1984; Gal. 16, Stockholm 1984, '86; Winterthur Kunsthalle 1984; Gal. Limmer, Freiburg 1985; Gal. Albert Baronian, Knokke 1984; Gal. Thomas Cohn, Rio de Janeiro 1985; Gal. Thomas, Munich 1985; Gal. Capricorno, Venice 1986; Gal. Leger, Malmö 1986; Aarhus Kunstmus. 1987; Mus. des Beaux-Arts, Mulhouse 1987; Neue Gal., Ludwig Col., Aachen 1987. GROUP EXHIBITIONS INCLUDE: Freie Berliner Kunstausstellung, Berlin 1973, '79; "1 Jahr Galerie am Moritzplatz," Berlin 1978; "Alkohol, Nikotin fff.," Gal. am Moritzplatz, Berlin 1979; "12 Räume—12 Künstler," DAAD Gal., Berlin 1979; "Heftige Malerei," Haus am Waldsee, Berlin 1980; "Après le Classicisme," Mus. d'Art et d'Industrie, Saint-Etienne 1980; "Situation Berlin," Gal. d'art contemporanea des mus. de Nice 1981; "Berlin—eine Stadt für Künstler," Wilhelmshaven Kunsthalle 1981; "Ten Young Painters from Berlin," Goethe Inst., London 1981 (trav. exhib.); 'Szebeb der Volkskunst," Württembergischer Kunstverein, Stuttgart 1981; "Bildwechsel," Akademie der Künste, Berlin 1981; "Im Westen nichts Neues," Luzerne Kunstmus., Cntr. d'art contemponain, Geneva, Neue Gal., Aachen, 1981–82; "Gefühl und Härte," Stockholm Kulturhuset and Munich Kunstverein 1982; "Spiegelbilder," Hanover Kunstverein, Wilhelm-Lehmbruck Mus., Duisberg, Haus am Waldsee, Berlin 1982; "Berlin, la rage de peindre," Mus. Cantonal des Beaux-Arts, Lausanne 1982; "Currents II, New Figuration from Europe," Milwaukee Art Mus. 1982; "Thinking of Europe," Living Art Mus., Reykjavik 1982; "Zeitgeist," Martin-Gropius-Bau, Berlin 1982; "New Figuration—Contemporary Art from Germany," Frederick S. Wight Art Gal., UCLA, 1983; "New Painting from Germany," Tel Aviv Art Mus., 1983; "Mensch und Landschaft in der zeitgenössischen Malerei und Grafik," Moscow and Leningrad 1983; "Köpfe und Gesichter," Darmstadt Kunsthalle, 1983; "Junge expressive Kunst in Italien und Deutschland," Suermondt-Ludwig-Mus. and Aachen Museumsverein, Saarland Mus., Saarbrücken 1983; "Neue Malerei—Berlin," Kestner-Gesellschaft, Hanover 1984; "Ursprung und Vision," Madrid, Barcelona, Mexico City 1984; "An International Survey of Recent Painting and Sculpture," MOMA, NYC 1984; Venice Biennale 1984; "La Metropole retrouvee," Palais des Beaux-Arts, Brussels 1984; Neue Expressive Malerei," Nassauischer Kunstverein, Wiesbaden 1984; "Metaphor and/or Symbol," Tokyo, Kyoto, Osaka 1984; "Bilder für Frankfurt," Mus. für Moderne Kunst, Frankfurt 1985; "Moritzplatz," Bonn Kunstverein, Hamburg Kunstraum, Pforzheim Kunstverein 1985; "Modus Vivendi," Wiesbaden Mus., Oldenburg Landesmus. 1985; "Tiefe Blicke," Hessisches Landesmus. Darmstadt 1985; "Museum? Museum! Museum." Mus. für 40 Tage, Hamburg 1985; Sao Paolo Biennale

1985; "1945–1985 Kunst in der Bundesrepublik Deutschland," Nationalgal., Berlin 1985; "Chambres d'amis," Mus. van Hedendaagse Kunst, Ghent 1986; "Berlin aujourd'jui," Mus. de Toulon 1986; Momente—zum Thema Urbanität," Braunschweig Kunstverein 1986; "Berlinart 1961–1987," MOMA, NYC 1987.

COLLECTIONS INCLUDE: Ludwig Collection, Neue Gal., Aachen; Landesmus., Darmstadt; Mus. Folkwang, Essen; Mus für Moderne Kunst, Frankfurt; Mus. National d'Art Moderne, Paris; Heydt Mus., Wuppertal.

ABOUT: Faust, W. M. and G. de Vries. Hunger nach Bildern, 1984; "Helmut Middendorf" (cat.), Groningen Mus. and Kunstverein für die Rheinlande und Westfalen, Düsseldorf, 1982; "Helmut Middendorf: Die Umarmung der Nacht" (cat.), Staatliche Kunsthalle, Baden-Baden, 1983; "Helmut Middendorf" (cat.), Braunschweig Kunstverein and Gal. Gmyrek, Düsseldorf, 1984; Klotz, H. Die neuen Wilden in Berin, 1984; "Middendorf Malereir Peintures Bilder" (cat.), Gal. Gmyrek, Düsseldorf, 1987. *Periodicals*—Artforum September 1981, Summer 1983; ARTnews April 1986; Arts March 1986; Flash Art February 1981, November 1982, March 1984, Summer 1984.

MILLER, RICHARD (KIDWELL) (March 13, 1930–), American painter, writes: "I was born in 1930 in Fairmont, West Virginia, a town of about 18,000 people in the middle of the Appalachian coal-mining region. My family had given my brother a small set of oils. He had never used them, so they were handed down to me. We had no canvas, so my mother cut up an old window blind which served well enough. My first oil was painted at age five. It was of two deer standing in a snowy field. I still have that painting.

"When I was ten, a Works Progress Administration art center opened in Fairmont. I attended every class possible for the next three years, and when I was eleven, one of my paintings was included in an exhibition of children's art at the Metropolitan Museum in New York.

"In 1943 my father accepted a job with the Government Printing Office, and we moved to Washington, D.C. A whole world opened for me. I had never been in an art museum, or even seen a painting other than work by students at the art center. Washington, with all its magnificent art, was incredible.

"The following spring I received permission to copy the old masters in the National Gallery, and so, at thirteen, became the youngest artist ever to work there. I spent every day for the next three summers, from 9:30 to 5:00, at my easel in the museum. I copied Rembrandt, Frans Hals,

RICHARD MILLER

Corot, Tiepolo, Romney, and Aelbert Cuyp. My interest in these masters led to a real investigation of their techniques, which proved to be invaluable to me in later years.

"By 1947 I was showing my paintings in most of the juried exhibitions in the Washington area, and in 1948 was included in a group show of Washington artists at the Franz Bader Gallery. My work there was seen by Duncan Phillips, and I was invited to exhibit at the Phillips Collection. Thus began a long association with the lovely old mansion near Dupont Circle, and with the inspiring staff of people who worked there. I eventually shared the top floor of the Phillips Gallery, which had been turned into a magnificent artists' studio, with several other Washington painters. During this period Duncan Phillips purchased three of my paintings.

"In 1948 I was awarded the Gertrude Vanderbilt Whitney Scholarship given by the Washington chapter of the National Society of Arts and Letters. I spent one year at the Pennsylvania Academy of Fine Arts in Philadelphia, and the next three years at the American University in Washington, D.C. Upon completion of my degree, I received a Fulbright Fellowship to study in Paris.

"I spent a marvelous year painting in Paris, and traveled extensively in France, England, Italy, and Spain. During that winter, I exhibited a painting in the Salon de National in Paris.

"Upon my return, during the summer of 1954, I was given a one-man exhibition at the Franz Bader Gallery, Washington, and in 1955 a solo exhibition at the Baltimore Museum of Art. In

the fall of 1955, I moved to New York City and began work on a master's degree at Columbia University. This was made possible by a continuation of the Whitney Scholarship.

"During my high school and college years in Washington, I had appeared in a number of amateur theatrical productions as an actor, and had also studied singing. It was a great hobby. In addition, I had discovered that I could supplement my income by singing in churches. I had, during those years, worked as baritone soloist at St. John's church across from the White House. Harry Truman was in the front row every Sunday.

"In 1956 I decided to try and supplement my income from painting with work in the professional theater. During my first professional acting job, in the summer of 1956, in the Finger Lakes area of New York state, I met Teresa Robinson, a beautiful singer with the theater company. We were married in 1957, and for a number of years worked together in many summer theater productions, and in the Broadway production of *Oliver* in 1963. Teresa has been singing with the Metropolitan Opera Chorus since 1973.

"Between 1957 and 1968 I appeared in eight productions on Broadway and in many more summer theater productions. This in no way conflicted with my painting. On the contrary, it seemed to support and nourish it. Both art forms, to have validity, must be truthfully structured. In 1959 I became associated with the Graham Gallery Ltd., in New York City, and exhibited there until 1968.

"I have continued to live and paint in New York; my work has been included in major exhibitions in this country and abroad, and has been purchased by museums and collectors. Other gallery affiliations in New York City have included the Martha Jackson Gallery, the Peter Rose Gallery, and the Aron Berman Gallery. My most recent one-man exhibition was in 1983 at the last-mentioned gallery.

"Painting, for me, is like breathing. I have done it as long as I can remember. I draw constantly, and although my paintings are composites of many drawings, the sense of risk, of spontaneous discovery, is essential. When the conclusions become predictable, I know I must change. Because of this, throughout my life as a painter, my art has undergone many changes. In this way, the act of painting is continually exciting and unpredictable. Each change a rebirth. Yet, curiously, continuity prevails. In the profound sense, one never really changes. One's commitment of self and sensibility remains constant.

"Early in 1984 I began a new series of large monumental still-life paintings, and so, another change is under way. Incredibly exciting!"

———

Some artists who achieve early success subsequently lose their momentum and seem uncertain of their direction. That has never been a problem with Richard Miller, whose work, as Leslie Judd Ahlander pointed out in the *Washington Post* (May 14, 1961), "has always been highly original and independent." Underlying his various changes of styles over the years are an abiding structural integrity and a forceful, thrusting energy. Miller began with a group of monumental still lifes combining sculptural form with a near-monochromatic brown palette. One of those canvases, painted in 1952 when he was twenty-two, was acquired by the Phillips Collection, Washington, D.C.

The months of Miller's Fulbright Fellowship and travels in Europe (1953–54) represented a period of maturation. He was gradually moving toward abstraction, but went through a transitional phase in which his work was strongly influenced by Graham Sutherland, who, Miller feels, is still underestimated. Miller was fascinated by Sutherland's use of subject matter, the way he would "take a grasshopper and blow it up eight feet," making it monumental. Miller painted a ten-foot lobster in a similar vein. Before long, however, the subject was barely hinted at in his paintings, and often disappeared altogether.

By the early 1960s structure was suggested by strong horizontal and diagonal bands, and canvas collage was used to create textural variety. In such paintings as *Triple Bar Form* (1963), the bands were overlaid with flowing forms in intense color. John Gruen, reviewing Miller's exhibit at the Graham Gallery, New York City, in the *New York Herald Tribune* (October 12, 1963) was impressed by the "strong, almost brutal abstractions" which "swerve and slash in all directions to form supercharged paintings of uncommon beauty."

In the mid-1960s, as Miller recalled in an interview in the *Greenwich Village News Magazine* (March–April 1977), "my work became more precise and an illusion of three-dimensions began to interest me. [I set out to] create an almost conventional space with abstract form. It gradually developed into actual construction in canvas combined with three-dimensional illusion. Consequently, a crisp hard-edge treatment replaced the earlier expressionistic brushwork. Even though the work appeard to be more cerebral—the end product, the artist said, was "a much more controlled-looking

thing"—Miller insists that those compositions were anything but planned. The process was exactly the same as with the expressionist paintings—"hit or miss, trial and error, building up, tearing down, eliminating, erasing."

Experimentation with collage and three-dimensional forms continued through the late 1970s and into the early 1980s, but Miller was moving away from the precision of hard-edge toward a more dynamic and painterly expression. The change was evident in his solo show at the Aron Berman Gallery, New York City, in 1983. Miller had participated in 1981 in an unusual group exhibition, "Ambience/Stimuli" at the Alternative Gallery in downtown Manhattan, curated by the painter Benny Andrews. The purpose of the exhibit, as Andrews explained in the catalog, was "to explore the creative urge." Rather than exhibiting their finished works, the artists used "a juxtaposition of symbols, images and found objects to create the essential ambience from which their ideas emerge." Miller's installation, displayed in front of his finished painting on the wall, consisted of rocks, stones, pebbles and sand, as well as a photomontage of rocks and clouds. Even though Miller admitted that "the paintings don't look at all like rocks, . . . collecting rocks leads to drawings, then paintings." Martin Ries, in a review reprinted in *Re-dact: An Anthology of Art Criticism* (1984), wrote: "The message one gets from Miller's 'Ambience/Stimuli' structure as well as from the painting is one of solidity, unity, strength, and integrity."

Miller has noted with amusement that in a sense "the wheel has come full circle." In 1984 he returned to the theme of monumental still lifes that had preoccupied him early in his career. But his recent canvases reflect the struggles and achievements of the intervening decades, and he considers them "without question my strongest work."

Richard Miller, with his handsome features and graying hair, has a warm, forthright, and outgoing personality. With firm convictions about his own work, he is never dogmatic and has a good sense of humor. Moreover, his sympathetic understanding makes him an excellent teacher. Martin Ries, in the *Greenwich Village News Magazine* interview, sees Miller's work as "truly American in its social immediacy and its elevation of the sensation of the structure over decorativeness." He describes Richard Miller himself as "beautifully and wholly an artist."

EXHIBITIONS INCLUDE: Trans-Lux Gal., Washington, D. C. 1950; Franz Bader Gal., Washington, D. C. 1954; Baltimore Mus. of Art 1955; Graham Gal. Ltd., NYC 1960, '62, '65; Ardas Gal., Madison, N. J. 1966; Jeffer-

son Place Gal., Washington, D. C. 1967; Albrecht Gal., St. Joseph, Mo. 1969; Cntr. Gal., Kansas City, Mo. 1969; Long Island Univ., Brooklyn 1976; Westbeth Gal., NYC 1982; Aaron Berman Gal., NYC 1983. GROUP EXHIBITIONS INCLUDE: Smithsonian Inst., Washington, D. C. 1950; Corcoran Gal. of Art, Washington, D. C. 1953; Phillips Collection, Washington, D. C. 1953; Whitney Mus. Annual, NYC 1956; Carnegie International, Pittsburgh 1961; Chicago Art Inst. 1964; Pennsylvania Academy of Fine Arts Annual, Philadelphia 1964; Tokyo International 1967; "Ambience/Stimuli", Alternative Mus., NYC 1981; "Beyond the Wall", Aaron Berman Gal., NYC 1983.

COLLECTIONS INCLUDE: Hirshhorn Museum and Sculpture Garden, Washington, D. C.; Phillips Collection, Washington, D. C.; Rochester Mus. of Art., NY; Albrecht Gal. of Art, St. Joseph, Mo; Plessey Corp. Collection and Skidmore, Owings & Merrill Collection, NYC.

ABOUT: Who's Who in American Art, 1989–90. *Periodicals*—Christian Science Monitor, August 19, 1990; Greenwich Village News Magazine March–April 1977; New York Herald Tribune October 12, 1963; Washington Post May 14, 1961.

MOROLES, JESUS BAUTISTA (September 22, 1950–), an American sculptor, was born in Corpus Christi, Texas. Moroles is a mature artist who in the last nine years has created over three hundred sculptures, many of them monumental in scope. Moroles works exclusively in granite and is challenged by its hardness and its unyielding nature to push it to its outer limits. His works are abstract and combine form, texture, sensuality, and strength with purity of line, reflecting the value he places on having the freedom to experiment. His technical skills are formidable. He uses industrial equipment and techniques to make clean, razorlike incisions into the stone, revealing new shapes within the granite. There is a definite architectural and cultural relationship to the stone edifices of the Mayan culture and the stele of past cultures; Moroles's work is contemporary in concept and universal in appeal. It is also free of trendiness.

The oldest of six children, Jesus Bautista Moroles moved with his family to Dallas when he was young. His father had emigrated from Monterrey, Mexico and married the Texas-born Maria Bautista who shared his Hispanic heritage. In Dallas the family lived in a low- income housing project in a rough neighborhood. Moroles attended a minority elementary school at which, he has recalled, "the kids were running around wild, while the parents were working. We moved out of the neighborhood: in third grade, I attended the Sidney Lanier School, which was a better school. I was encouraged by

JESUS BAUTISTA MOROLES

my teachers. They told me I was very good. A gym coach took me in hand and the 'tough' kid became a normal kid. I liked school. Once I realized that school was a good thing, my grades became very good."

Moroles enjoyed being the oldest child in his family: "I was the first to try everything and I did not get any hand-me-downs." When his family left the housing project, they bought a house for $35 down and $35 a month. Moroles recalls: "It was a very old house and had a toilet outside, but it was only three minutes from downtown Dallas. I was nine years old. We had to dig ditches to put sewers in, and had to build a bathroom and add rooms. Being the oldest, I helped my father: I was always handing him tools. I learned to be mechanical and learned to work with my hands early."

Moroles attended Crozier Technical High School in downtown Dallas, whose student body comprised mainly minorities. The well-equipped school, which had the largest plastic shop in the United States, offered courses in printing, drafting, cosmetology and a host of other skills. "They offered a course called advertising and commercial art which was as close as you could come to art. I was fortunate. Some of the teachers who taught at Crozier also taught college. So the students were taught to have a portfolio in the hope of becoming illustrators. To some degree, my teachers were my parents; they took me under their wings. The school was so successful in training their students that years later another school was modeled after Crozier which was called Skyline High School.

"Already at that age I had my own business. I was doing silk screening. I started making banners for the school; I was also the yearbook editor and sports editor. I belonged to a national honor society. I enjoyed school! The teachers voted me 'most likely to succeed and most athletic.' All of my instructors were old. They believed in a work ethic: 'Just work hard, and you will get paid in the end.'"

Despite all his activities Moroles worked after school and during the summer. He was already five foot eleven in fifth grade and looked much older than his classmates. He worked in construction and factories and took other odd jobs. All along he liked school best. He was encouraged by his parents who sent him to art lessons at the YMCA, where he learned painting, photography, enlarging, and illustrating. The teacher offered him private art lessons, though he could not pay the extra tuition. She also found him a commission doing large murals.

Upon graduating from Crozier High in 1969, Moroles immediately found a job as an illustrator and received his draft notice in the mail the same day. Rather than be drafted, he volunteered for the air force, remembering only too well that his high-school yearbook had been dedicated to all the students who had died in Vietnam the previous year: "We were a minority school. When our students graduated, they were sent to the front lines. Many of them came back in a box the same year. This had been happening for a few years already. I tried to get out of it. I could not get a draft deferment. In 1969 I joined the air force and completed my tour of duty in 1973. They trained me to repair computers; I did not like the work too much. I did not fly any missions. The air force sent me to Thailand for one year. In 1973, I came home to Dallas and entered college."

Moroles enrolled at El Centro Junior College, from which he earned a B.F.A. degree in 1978. "I had registered at the school while I was in the air force in Thailand. I did not have a counselor. Nobody told me what to take. I took nothing but art courses; I took painting, drawing, and sculpture. The welding and woodworking courses which I had in grade school gave me good technical skills. I was the only one in my family who wanted a career in art. I loved my first two years at El Centro. After graduating, I continued on to North Texas State University in Denton. It was a four-year school and they had a better art department. North Texas State was the only school in the country that offered industrial arts as a minor for sculptors. In industrial arts we learned welding, foundry, sheet metal, woodwork, electronics—all the things a sculptor

should know, even if later on he has other shops doing it for him." Moroles added: "To be a sculptor you have to be very physical, strong, and smart."

In 1978, Moroles graduated with a B.F.A. He had enjoyed tremendously all the art courses he had taken. However, before graduation, he needed to catch up on required courses. He added: "I made it hard for myself in college. I took all these art courses at the beginning, but in order to graduate I had to take another 18 or 20 credits in English and history in one semester. I did it. It was not easy."

Comparing painting to sculpture, Moroles has said: "I was using my hands, it was more physical, I knew I was going to be a sculptor!" After graduation, Moroles apprenticed himself to an American-Hispanic artist, Luis Jimenez, whom he had met at a workshop. Jimenez lived in El Paso and Moroles became his apprentice for one year. Jimenez was well known as a painter and sculptor and connected with the Hispanic art movement. His subject matter was modern Hispanic pop culture, the Hispanic cowboy, and the Texas honky-tonk scene. Recalling his apprenticeship with Jimenez, Morales has said, "Jimenez worked in fiberglass. I did not like the medium. It was very hazardous. Yet, working and living with Jimenez was the best experience. I helped him with everything. His work was figurative, with a nontraditional subject matter. I would make his armatures. What was really helpful to me was living there. I worked on long projects for him and learned what it meant to be dedicated. I learned what you have to put out to be a committed artist. I lived in his house and his backyard. I was there to absorb, to be his right hand and his left hand. I would help him install the finished pieces at shows and museums. It was a hands-on experience. We did not discuss my aims or his aims. He was a figurative artist, and I was abstract and committed to stone. Though our art is different, he was one of the most influential people in my career."

After completing his apprenticeship, Moroles, like many young sculptors, felt the need to go to Carrara, Italy and see the famous stone quarries. Carrara had beginning studio schools and advanced studios where masters like Noguchi would take a few students at a time. Moroles could not get in with Noguchi, whom he admired. The next step down was a laboratory setup. Moroles comments: "Everybody would sit there carving and you could see what everybody was doing. It was just too much! I felt restricted. I got myself a private studio and worked by myself. While in Italy, I climbed Alissimo, the mountain quarry where Michelanglo got the

marble for much of his work. There were steps in the quarry worn in not by design, but usage. It looked as if you could see into the marble for almost two inches. It was like a hand-polished stone, but it was natural. Man had touched it, and left it beautiful." Moroles continued: "I was never tempted to work in marble. I liked granite because it was so hard, because it never wanted to yield, and because it was difficult. No one wanted to work with it. There is only a small number of sculptors who work with granite; I wanted to excel."

While in Italy, Moroles was in a serious car accident. When he recovered, he felt that he had been given a second chance to do his work. In 1980 he returned to Texas to work out his ideas. For the first three years he worked without assistants doing everything himself. As his work progressed, he hired his brother Hilario and several other people.

In 1982, Moroles settled in Rockport, Texas, a small town on the Gulf of Mexico. He chose that location deliberately, because he wanted to prove that "you don't have to live in New York to make it." It also enabled him to buy more land at a more reasonable price. He has five buildings, about two city blocks long, which are part of the complex. His workshops include warehouses, buildings with windows, open-ended factorylike structures, studios, and quarries. Moroles is involved with and enthusiastic about his equipment: "We have overhead cranes, cranes that pick up stones outside to bring to the shop, large and small diamond saws, some costing as much as $5,000, wire saws and polishers, as well as a number of pickup trucks." He works on many projects concurrently. His staff has grown to twenty-one assistants, including a secretary and a bookkeeper. "We have added people every year. The people I hire to assist me are not craftsmen. I don't let artists work in my studio. I get people who want to work hard; I show them how to do different aspects of the work, like welding, polishing, and crating. The work is arduous. My workers come in different shifts. They may be required to work through the night."

One of Moroles's largest projects was a commission he received from the Botanical Gardens in Birmingham, Alabama. "The work consisted of forty-eight sculptures and fountains, we lose a lot of time."

Though Moroles is married, the marriage has been inactive for many years. He sleeps in his studio and "does not have the luxury of a closet." His mother brings him meals because he is usually too busy to join the family at the table. "I know it's annoying to my mother," he has admit-

ted. "I love my work and it comes first, and that is all I have time for." Moroles sleeps only about five or six hours and finds that airplane trips allow him to catch up on his sleep.

An unpretentious, large man who is clearly in command, Moroles is competitive and ambitious. He carries within him a ten-year plan that he intends to follow and achieve. Asked about his goals, he answered without hesitation: "I want to be recognized and have a good reputation." In 1982 he was awarded a Visual Arts Fellowship. Despite Rockport's isolation, Moroles is part of the contemporary art scene. He feels his work is universal: "When I worked with Jimenez, I knew I did not want to do what he was doing, but I did not want to apprentice with a granite or marble sculptor. I did not want to be influenced and wonder where my ideas came from. I always tried to keep my ideas for myself and to make sure that my ideas came from me. If my work is reminiscent of others, I picked it up by osmosis. Actually, there are only certain things you can do to stone. Stone was used by the Egyptians, Romans, and Greeks. All the ancient civilizations used stone."

Some of Moroles's work has been compared to ancient edifices. Edward Lucie-Smith, in an essay introducing a 1988 catalog of Moroles's work, made the following statement: "Moroles looks to the ancient pre-Columbian cultures in much the same way Noguchi looks to Japan—his steles and other architectural pieces, for instance, immediately suggest the influence of the Maya. And even the sculptures based on landscape forms take their inspiration from the mesa of the high Mexican plateau and the similar terrain which stretches up the southwest of the United States. The influence of the pre-Columbian may be more profound than the artist realizes. . . . The ability to create powerful and convincing metaphors is really what Moroles's mature sculpture is about. It is also a clue to his ability to create monumental sculpture on any scale, small as well as large."

Although Moroles has never traveled to the Yucátan, Machu Picchu, or Stonehenge, he is keenly aware of those ancient monuments. "I do more than look at photographs, I read them. I see how everything is put together. I analyze every detail of the construction. I look for information. I love stone, water, and mountains."

Moroles travels to many different parts of the country with his installations. He admires the work of Isamu Noguchi: "I admire him because he has brought stone carving into the contemporary art form. Before that, the modern sculptor had to use steel or other modern materials. There is now a resurgence of stone carvers in the world.

Noguchi does everything! He is a universal person. He is not afraid. Art is about being free. I think we want to be free, . . . and one day would like to do a large cooperative project with him combining stone and glass."

In a review in *ARTnews* (January 1987), Mel McCombine discussed the technical and aesthetic aspects of Moroles's work: "Although Moroles does seemingly impossible things with unyielding granite, such as attenuating to razor-fine thinness and making pristine cuts, his intention seems to be to emphasize the medium's inherent solidity and weight. One receives an almost visceral satisfaction from his irresistibly tactile stones. At their best, they are both timeless and modern."

A friendly man, Moroles clearly enjoys his success and attends his openings. Some of his work is touring the United States as part of a show entitled "Hispanic Art in the United States." He feels that the show has created a new awareness of Hispanic art and that its influence will be around a long time to come. Moroles's work stands apart in its severity and monumentality.

Moroles works on both large and small pieces and feels that many of his ideas originate from smaller pieces. "In 1980 my first sculpture was a fountain twelve feet high. I realized I couldn't get anyone to see my work because it was too large to get into museums and as a young artist I needed to be noticed. Now my work stands in museums. I think it is also important for me to show in galleries and to accept large commissions, because it enables people to see more of my work."

In the summer of 1989 Moroles was planning to spend forty-five days in the city of Bath, England, to work and exhibit there. "They invite a sculptor every year. It will be more time than I have ever stayed in any place. When I am in Bath, a show of my work will be touring Europe. It will originate in Barcelona, tour Europe, and end in Madrid." Moroles will help with the various installations. He feels particularly comfortable in Spain, since he speaks the language. He would like to establish a studio there. Japan has also shown some interest in his work.

Moroles enjoys giving workshops: "I love getting people excited and interested in the arts." However, he feels that artists should primarily produce and not teach. "I had so many ideas when I got started and never the time to get to these ideas. Often the choice of a stone will help me conceptually. I like to pick my own stones. I don't think I can ever run out of ideas due to the slowness of the work. There are some things that I will not get to, because I cannot find the

right stone to do it. I may start a piece, finish it, and come back to the same style several years later. The names of my sculptures almost describe the pieces. For instance, a Geoprigia Stele will be made of Georgia granite and look like a stele. I love texture and putting smooth and rough edges together. One of the reasons I do all my own work is that factories do not want to make any changes. Thus, I have built my own 'factory' and I have full control."

Like other artists before him, Moroles considers the light in New Mexico special. He recently bought a school building that was built in 1880 in a little town south of Santa Fe, where he is establishing a studio for himself. The compound comprises five acres and is surrounded by adobe walls. The various buildings include a former gymnasium and a cafeteria and provide about 20,000 square feet of work and living space. Eventually, Moroles wants to invite foreign artists, working in different disciplines, to spend some time there and experience New Mexico. He sees it as an interdisciplinary and cooperative venture promoting good will and ideas.

In 1987 Moroles completed a commission for E. F. Hutton in New York City named *Lapstrake* which is made of Sardinian rose granite from Italy where the work was begun. Eventually, he finished the work on the East Coast. He had problems locating a large enough place to work in. *Lapstrake* is twenty-two feet high and weighs 180,000 pounds.

"Lapstrake" means layered and interlocked. It can be defined as forming a lap joint or placing the edge of a material above that of another to strengthen it. To Moroles, strake means the layering of the strata of the earth that humanity touched but not taken over. In *Lapstrake*, the polished flat surfaces, representing humanity, and the textured pieces hewed from the same enormous rock, representing nature, work together, one on top of another, like a balancing act.

A modest but intensely focused man, Moroles is immersed in his work. New ideas come to him constantly. He wants to be regarded as an American sculptor whose work has universal meaning. A specific stone can create the tension within him to create new work. He searches out shapes, curves, and textures to reveal the true nature of granite. In so doing, he creates works of contrast and power. Each sculpture has a presence. Some are architectural, some are sensual, all are timeless. Moroles's work knows no boundaries. His vision is large and growing larger.

EXHIBITIONS INCLUDE: Centro Col., Dallas 1981; Hill's Gal., Santa Fe, N.M. 1981; Amarillo Art Cntr., Tex. 1982; Nave Mus., Victoria, Tex. 1982; Mattingly Baker Gal., Dallas, Tex. 1982, '83; "Moroles: 1981–83, San Antonio Col., Tex. 1983; Bonner White Gal., Corpus Christi, Tex. 1984; Janus Gal., Santa Fe, N.M. 1984, '85, '86, '88; Davis/McClain Gal., Houston 1982, '84, '86; Five-Year Retrospective, Rockport Art Cntr., Tex. 1985; Ann Norton Sculpture Garden, West Palm Beach 1986; Virginia Miller Gal., Coral Gables 1987; Marillyn Butler Fine Art, Scottsdale, Ariz. 1986, '89; Simmons Fine Art, New Orleans 1988.

COLLECTIONS INCLUDE: Mint Mus., Charlotte, N.C.; Mus. of Fine Arts, Santa Fe, N.M.; North Texas State Univ., Denton; Jail Art Cntr., Albany, Tex.; Albuquerque Mus., N.M.; Botanical Gardens, Birmingham, Ala.; Columbia Companies, Houston, Tex.; E. F. Hutton, NYC; Hoefer Scientific Instruments, San Francisco; IBM, Raleigh, N.C.; Wyndham Hotel, Austin, Tex.; American Airlines, Fort Worth; American Republic Insurance Company, Des Moines, Iowa; Sienna Company, Boulder, Colo.; Equitable Life Assurance, Fresno, Calif.; Univ. of Houston.

ABOUT: Beardsley, J., J. Livingston, and O. Paz. Hispanic Art in the United States: Thirty Contemporary Painters and Sculptors, 1987; Lucie-Smith, E. American Art Now, 1985; Who's Who in American Art 1989–90. *Periodicals*—ARTnews January 1987; City Life February 19–25, 1986; Club Ties Summer 1985; Dallas Morning News April 17, 1986; Houston City Magazine February 1985; Houston Home and Garden April 1985; Houston Post June 29, 1985, July 27, 1985, August 24, 1985, May 3, 1987; International Sculpture June–July 1985; Rockport Pilot September 28, 1985; Sunday Camera February 17, 1985; Texas Business June 1985; Ultra May 1985.

MOSKOWITZ, ROBERT (1935–), American painter and draftsman, was born in Brooklyn, New York. In 1953 he began studying drafting at New York City's Mechanics Institute, then studied art at the Pratt Institute. From 1957 to 1959 he worked as a technical illustrator for the Sperry Gyroscope Company in Manhattan, then spent 1959–60 traveling in Europe and painting in London.

His first one-man show, in 1962 at the Leo Castelli Gallery in New York, consisted of window shades unrolled and glued flat to rectangular, monochrome canvases. Those odd works, in Katy Kline's words, "point to an interest in that which is concealed versus that which is revealed, in the relationship between something and the absence of something." Those forces have continued to motivate his work. Robert Rosenblum has described the window shades as seeming "to push both the basic language of painting and the fundamentals of imagemaking to a rock-bottom economy, where suddenly the two worlds were forever fused—a flat painting equalling a flat window shade." Such surprising conjunctions

and shifts between object and essence have remained hallmarks of Moskowitz's work.

From the early 1960s until about 1976, Moskowitz produced a series of paintings based on the schematic diagram of a corner of a room found in a do-it-yourself decorating book. Those works were largely monochromatic, and abstract in the extreme; they were records of a rigorous exploration of determinedly restricted means. Those and other early canvases often featured painted-on silver or gold borders or "frames." He gradually grew dissatisfied with that body of work, and began to turn slowly and deliberately—the unvarying pace of his career—toward the introduction into his painting of color and imagery. Images were at first merely superimposed onto the earlier format, as in *Sword* (1976), in which the outline of the weapon is overlaid on the implied room, thereby denying his corner its essential lineaments and hence its reality.

Color made a strong emergence in *Swimmer* (1978), one of Moskowitz's most striking paintings and the first to use elements of human figuration. At the upper center of a large midnight-blue ground are the head and arm of the swimmer, painted in a somewhat cursory manner that renders the figure distant and amorphous. The direction of the figure, even the question of whether or not it is struggling (drowning?), become first primary, then secondary to the luxurious, deep blue saturated pigment, which Moscowitz rubbed into the canvas by hand, producing a surface with a richly sensuous, complex texture. The artist himself described *Swimmer* as "like being in New York City—trying to survive. There is an ambiguity in the image—a balance between swimming and drowning, and a balance between a realistic thing and an abstract thing. It has double elements which I think is interesting."

Figurative elements began to appear regularly in Moskowitz's paintings in the mid-1970s. The images are simple, almost childlike, yet they have an undeniable psychological intensity. In the predominantly beige painting, *Cadillac/Chopsticks* (1976), geographical and cultural differences are the focus of the artist's comment: the materialistic, progress-oriented West is represented by the black silhouette of a Cadillac's tail fin seemingly about to drive out of the picture, while the calm respect for tradition characteristic of the East is seen in the immobile pair of crossed red chopsticks. That painting, the artist has said, "is about power, two different kinds of power—the passive power in chopsticks and the Cadillac being a kind of moving power. They are both extreme forms of power. The im-

ages are just recognizable enough; if you looked at it long enough you would be able to see it. This relates to the kind of abstraction I am involved with—I think if you did not see the Cadillac as a car, you would still see the point of the painting—the Cadillac is an aggressive image, whereas the X of the chopsticks is very stable. The ambiguity is always there, but I do not want it to be mystical. I will usually title the painting in such a way that it is clear. In all good work there is a kind of ambiguity, and I am trying to get the image just over that line." In his images of other man-made structures, particularly American skyscrapers, figures have been given increasing importance in his paintings since the mid-1970s. One of the most notable is *Flatiron (For Lilly)* (1979), a black-on-black rendering in which the well-known New York landmark becomes a metaphor for death—its facade bears a strong resemblance to a crumbling tombstone. "Accounting for the chameleonlike nature of the image," wrote R. Louis Bofferding, "is the change in the artist's perception of his intentions, for in the process of painting, Moskowitz realized that the work had become for him a commemoration of the recent death of his mother." The theme of death recurs often in the artist's work.

Moskowitz's figures are often rendered in silhouette, which, in conjunction with the exaggerated verticality of his canvases, results in solitary, looming hieratic forms with immediately strong yet abstract presence. In *Thinker* (1982), a nine-by-five-foot jagged schematization of Rodin's famous monumental bronze, the blue-black of the statue's outline is surrounded by a somewhat lighter blue, which has been sanded to reveal deeper layers of rust, black, and, in places, white canvas. The highly wrought surfaces of his paintings also seem to draw the spectator's attention away from the emotional impact of the subjects. His surfaces, in Rosenblum's words, "constantly call attention to their physical presence as gorgeously painted skins, sometimes burnished to the sleekness of dense slate, sometimes flickering and luminous, but always apparent as a major abstract component in a decorative jigsaw puzzle." His images, however, have an obvious primary hold on the artist's imagination; perhaps, as he suggested in 1979, they are the most important element of his work: "The paintings have a pretense about being grand and elegant, but on the other hand I think they are very threatening. I am involved in quality in the work and the kind of finish on it, even though I do not think that is important. I want to do the paintings in a convincing way, try to get as much as I can into them, and make them as dense as possible. There are many images that I have been

attracted to for a long time, and I am very obsessed with them. I am involved with a certain kind of image, even though it may not be totally apparent. Most of the images I use have been so stamped on my brain that they are almost abstract."

The central importance of those images is surely the motivating force behind his drawings, most of which are done in charcoal and pastels; they seem looser, more spontaneous than the same images rendered in paint on canvas. The oddest thing by far about Moskowitz's drawings, however, is that they are executed *after* the paintings they resemble—in some cases, several years after. "I had the idea," he said in 1985, "of making a drawing, full scale, of every painting I've done within the last ten years. I don't know what that means, but I just like it."

EXHIBITIONS INCLUDE: Leo Castelli Gal., NYC 1962; French & Co., NYC 1970; Hayden Gal., Massachusetts Inst. of Technology, Cambridge 1971; Nancy Hoffman Gal., NYC 1973, '74; Inst. for Art and Urban Resources, NYC 1977; Daniel Weinberg Gal., San Francisco 1979, '80; Margo Leavin Gal., Los Angeles 1979, '80; La Jolla Mus. of Contemporary Art, Calif. 1979; Walker Art Cntr., Minneapolis 1981; Hudson River Mus., Yonkers, N.Y. 1981; Kunsthalle, Basel 1981; Kunstverein, Frankfurt-am-Main 1981; Blum Helman Gal., NYC 1983, '86; Portland Cntr. for the Visual Arts, Oregon 1983. GROUP EXHIBITIONS INCLUDE: School of Visual Arts, NYC 1967, '69; Whitney Mus. of American Art, NYC 1968, '69, '73, '78, '79, '81, '83; Art Inst., Chicago 1975, '82; Paula Cooper Gal., NYC 1976, '77; Albright-Knox Art Gal., Buffalo, N. Y. 1978; Willard Gal., NYC 1978, '82; Biennale, Venice 1980; Blum Helman Gal., NYC 1981, '84; MOMA, NYC 1983, '84; Joslyn Art Mus., Omaha 1983; Max Protech Gal., N. Y. 1983; Palacio de Velazquez, Madrid 1983; Hirshhorn Mus. and Sculpture Garden, Washington, D.C. 1984; Monk Gal., NYC 1985.

COLLECTIONS INCLUDE: Albright-Knox Art Gal., Buffalo; La Jolla Mus. of Contemporary Art, Calif.; MOMA and Whitney Mus. of American Art, NYC; Univ. Art Mus., Berkeley, Calif.; Philadelphia Mus. of Art; Joslyn Art Mus., Omaha; Seattle Art Mus.

ABOUT: Seitz, W. C. "The Art of Assemblage" (cat.) MOMA, NYC, 1961; Hunter, S. "New Directions in American Painting" (cat.), Brandeis Univ., 1963; Marshall, R. "New Image Painting" (cat.), Whitney Mus. of American Art, NYC, 1978; Ratcliff, C. "Visionary Images" (cat.), Renaissance Society at the Univ. of Chicago, 1979; Cathcart, L. "American Painting of the 1970s" (cat.), Albright-Knox Art Gal., Buffalo, 1980; Lyons, L. "Robert Moskowitz: Recent Paintings" (cat.), Walker Art Cntr., Minneapolis, 1982; Blum, P. "Robert Moskowitz" (cat.), Kunsthalle, Basel, 1982; Freeman, P., ed. New Art, 1984; Fox, H. N., et al. "Content: A Contemporary Focus" (cat.), Hirshhorn Mus. and Sculpture Garden, Washington, D.C., 1985; Who's Who in American Art, 1989–90.

Periodicals—Artforum June 1970, February 1974, April 1981, November 1981; Art in America May–June 1978, March–April 1979, November 1981, May 1983; Art International Summer 1970; ARTnews May 1970, Summer 1983, April 1984; Arts May 1970, January 1974, November 1981; Artweek April 2, 1983; Flash Art October–November 1979, March–April 1979, Summer 1980, February–March 1982; New York Times February 18, 1983, February 14, 1986; Real Life March 1979.

MURRAY, ELIZABETH (1940–), American painter and printmaker, was born in Chicago and grew up in small towns in Michigan and Illinois. "We moved around a lot," she said to Paul Gardner in a 1984 interview, "and finally settled in Bloomington, Illinois. My family started out with the usual upper-class expectations, but my father became ill. Financial setbacks made it very difficult for my parents, who had to deal with the death of their dreams. My brother and sister and I learned at an early age that life wasn't like the movies. It was hard on us, but getting reality drummed into me at an early age made me strong. The important thing is that my parents always encouraged me. My mother had wanted to be an artist, but when she was growing up women didn't have careers. I loved to draw and started when I was very small, scribbling with a pencil. My father said, 'Oh, you'll be an artist.' Can you imagine what that meant to me, hearing him say that?"

She hated her high school years in the rigidly stratified town of Bloomington but continued to work hard at her drawing. Her school's art teacher, Elizabeth Stein, sometimes took her students into Chicago to see the superb collection of modern art at the Art Institute, and Murray developed a strong desire to study there after high school. Her family, however, had no money for such schooling. Stein encouraged her to apply for a scholarship, and, to Murray's surprise, she got one. She was stunned shortly afterward to discover that part of the money for the scholarship came from her teacher's own savings. "That act of generosity," she said, "changed my life."

Murray's recollections of her years at the Art Institute are remarkably candid and complete. "For the first time in my life," she told Gardner, "I was around people my age and older who liked art and poetry, who talked openly about their sexual relationships, who did not dress according to any code but their own. I was completely stunned. I never went back to Bloomington again!" She took academic courses in the evenings at the University of Chicago and art courses during the day. She was a keen stu-

ELIZABETH MURRAY

dent. "I learned how to paint figures and land-scapes, how to draw and use watercolors. The training was very traditional, but in retrospect I'm glad I had it. I was determined to learn everything. I wouldn't miss a class." At that time she intended to be a cartoonist or commercial artist.

Her decision to make a career of painting was the result of regular exposure to the Art Institute's collection. "To get to the art school in those days," she continued, "you had to walk through the museum. I intended to go into commerical art, but day after day, as I walked through the museum, I gradually began to absorb the art—the masterpieces—around me. One day I stopped to look at a Cézanne still life. I was thrilled by his use of color, his application of paint, his emotion. By the end of my second year, I realized that I wanted to go in pursuit of the Holy Grail—I wanted to be a painter. It was kind of [a] magical decision." She expanded on her encounter with the Cézanne to Kay Larson in 1985: "The little breads were piled up on the table with spaces between them. It was like doors opening, to realize that paintings were the equivalent of books. Just as Kafka could tell you about the mysteries of existence in words, Cézanne could tell you the same thing only in physical terms, using space."

After earning her bachelor's degree in fine arts in 1962, Murray spent two years in Oakland, California, at Mills College, working on her master's. One of her fellow students there, the painter Jennifer Bartlett, became a lifelong friend. Bartlett has recalled Murray's early influence on

her: "She worked *constantly*. . . . She had a very clear idea in her mind of what being an artist was. It was just putting in your time in the studio, clocking in. That cleared up a lot of problems I had about waiting for inspiration." The chief stylistic influences on Murray's art in those days were Willem de Kooning and Jasper Johns. Of the former, she remarked to Gardner, "There's something about his work of the early 1960s—the way he got paint to move across canvas, the way he used his brush—it's almost as if he was expressing words with paint. De Kooning could make his paintbrush say or do anything." Johns's work, which she discovered while at Mills, "knocked me out. Johns packs emotional and intellectual excitement into a painting and then forces you to see the physicality of the work by bringing it directly up to your face, saying, 'You see, *this* is how I do it.'"

Murray moved to New York City in 1967, and recently confessed to feeling at the time "quite out of it. Pop was so campy, and minimalism—just beginning—was equally off-putting. The word being spread was, 'Haven't you heard? Painting is dead!' I thought, 'Oh, really? Well, to hell with *that*. I'm painting.'" The sense of time passing impelled her to work even harder with even greater concentration: "I have to get on with it. I had to get a body of work done. I didn't have forever to become an artist."

Murray began to exhibit her typically large canvases in the early 1970s: *Dakota Red* (1971), a six-by-four-foot abstract picture, was admired at the 1972 Whitney annual in New York. By the mid-1980s her work had appeared in about twenty individual and nearly 150 group exhibitions. In 1975 she began to be represented by the highly regarded New York dealer Paula Cooper, who admires "the logic of continuity in Murray's work as well as her use of color and her creation of moods that make each painting seem very special."

The most significant stylistic departure in Murray's painting—the transition from the traditional square or rectangular canvas to an overlapping structure of irregular, individual forms—dates from the early 1980s. Although she continued to make a few pictures with regular, conventional outlines (such as the powerful *Sleep* of 1983–84), most of her work of the 1980s has adopted the style of the shaped canvas. "The work," she remarked to Gardner, "appears to be getting more sculptural, but I'm interested in the illusion of making something look three-dimensional in two-dimensional space. Anyway, I want the panels to look as if they had been thrown against the wall and that's how they stuck together." Her usual method is to draw a

painting's constituent shapes on paper, cut them out, and make plywood models of each shape. Once she is satisfied that a shape will work with the others to be used in a painting, the model is recreated in canvas. Each part is then painted, and finally overlapped with the other shapes to form the finished work. A given work may consist of anywhere from a couple to a couple of dozen different, interlocking shapes. And the shapes need not always interlock: in several notable pictures, including *Painter's Progress* and *Art Part* (both 1981), the forms, instead of overlapping, are disposed across a wall and only occasionally touch. Both works show the tools of the artist: palettes, brushes, and hands. Her aim in all her newer work, she has said, is for "paint to have a different relationship to the wall." When she began to construct paintings from irregular shapes, she told Larson, "I didn't have any idea what I was doing. I wasn't aware of what it meant to put a shape on the wall. Then I discovered it made the wall very different. In 1980 I put two shapes together and called it *Breaking*. I realized what I was after—a space where the wall could be seen through the picture. All my work is involved with conflict—trying to make something disparate whole. When I put these shapes together, the wall itself became part of the conflict."

Her paintings may take a year or more to complete, and she makes crucial decisions all along the way. "As I work on a piece over a period of time," she explained in 1985, "my vision becomes clearer. I know more about myself in relation to a painting and how I might trick myself into prematurely thinking that it's done. I suppose it sounds dramatic, but there's an agony about beginning and an agony about ending, although I don't have a feeling of panic anymore."

Although Murray's paintings have begun to sell for upward of six figures each, she is very conscious of the "trendy and fickle" nature of the art world. Because of the loneliness and relative isolation she experienced in the early years of her career, she has continued to teach—at Wayne State, Yale, and Princeton universities and at Bard College, among other schools—and is a frequent visitor to young artists' studios. "I really feel for younger artists," she told Gardner. "So many good ones get lost. They can't push their own work, not according to the art world's rules. It's a very tricky situation. I want to encourage young talent. I know what it means if I make a positive comment; I know because I remember how it affected me. And besides, studio discussions keep me on *my* toes."

Murray is also acutely conscious of the problems facing female artists. She is a feminist, yet is aware of the absurdity inherent in some of what is called "feminist art." "Looking at work by women," she said to Gardner, "is difficult for many people—including other women. It's too bad. You see, I don't believe there's such a thing as 'women's art.' It's a distasteful phrase, like any other categorization of art. If some women choose to push feminist images or make quilt art, that's fine, but I'm not interested in doing that. If the feminist emphasis seems too calculated, I find the art hard to take. I see my own work as androgynous. Art is about the male and female components in all of us. Art is sexy, but it doesn't have sex. When you think of great paintings, you don't think this image is masculine, that one feminine. . . . The United States is exceptional in that there *are* women artists here who are known and accepted. It's very difficult for women artists in Europe. Men jealously guard their territory; they're not interested in sharing their power. I heard one young European artist say that he didn't believe there were any good women artists. What a stupid remark! Paula Cooper heard a German dealer say about a painting of mine, 'But it's so large. I thought it was painted by a woman.' Another stupid remark." By the mid-1980s the artist had still not attracted a major European dealer.

Murray has become one of the small number of important contemporary American artists by entirely following her own instinct. She has remained leery of success and its often baleful effects on the artist. "I fight against it all the time," she told Larson. "Duchamp once said that when an artist becomes a success, you never see the *artist* again. When you meet the artist, you meet a faker." She has also resolutely steered clear of the highly social, careerist, power-oriented aspects of the current art scene, which, she has said, "doesn't always represent the best qualities of people. I want to stay removed. Art is not like film or theater—both group activities. Artists work individually, in isolation to some extent. I never heard of an artist getting a bright idea at some cocktail party." The key to ultimate success, for her, consists only in being true to her vision. "When you say to yourself, 'Nobody is going to like this, but it's under my skin,' that's when it works. If people imagine that I think about my career when I'm in front of a painting, they have no idea what being an artist is about."

EXHIBITIONS INCLUDE: Jacobs Ladder Gal., Washington, D.C. 1974; Paula Cooper Gal., NYC 1975, '76, '78, '81, '83, '84; Jared Sable Gal., Toronto 1975; Ohio State Univ., Columbus 1978; Phyllis Kind Gal., Chicago 1978; Mukai, Tokyo 1980; Susanne Hilberry Gal., Birmingham, Mich. 1980; Smith Col. Gal., Northampton, Mass. 1982; Daniel Weinberg Gal., Los Angeles 1982;

Portland Cntr. for the Visual Arts, Oreg. 1983; Knight Gal., Charlotte, N.C. 1984; Brooke Alexander, Inc., NYC 1984; Beaver Col., Glenside, Pa. 1984; Univ. Art Mus., Univ. of New Mexico, Albuquerque 1985. GROUP EXHIBITIONS INCLUDE: Whitney Mus. of American Art, NYC 1972, '73, '77, '79, '81, '82, '83, '84, '85; Gal. Doyle, Paris 1974; Michael Walls Gal., NYC 1975; Baltimore Mus. of Art, 1976; Solomon R. Guggenheim Mus., NYC 1977; Rhode Island School of Design, Providence 1977; New Mus., NYC 1977; Mus. of Contemporary Art, Chicago 1977; Inst. of Contemporary Art, Univ. of Pennsylvania, Philadelphia 1978; Tampa Bay Art Cntr., Fla. 1978; Hayward Gal., London 1979; Grey Art Gal., New York Univ., NYC 1979; Weatherspoon Art Gal., Univ. of North Carolina, Greensboro 1979; Gal. Lambert, Paris 1980; Brooklyn Mus., N.Y. 1980, '83; Contemporary Arts Cntr., Cincinnati, Ohio 1981, '82; High Mus. of Art, Atlanta 1981, '82; Otis Art Inst., Los Angeles 1981; Univ. Gal., Univ. of Massachusetts, Amherst 1981; Haus der Kunst, Munich 1981; Jacksonville Art Mus., Fla. 1981, '82; Mus. of Fine Arts, Boston 1982, '84; Milwaukee Art Mus., Wisconsin 1982; American Graffiti, Amsterdam 1982; Hayden Gal., Mass. Inst. of Technology, Cambridge 1982; Art Inst., Chicago 1982; Hirshhorn Mus. and Sculpture Garden, Washington, D.C. 1983; MOMA, NYC 1983, '84, '85; Lincoln Cntr. Gal., 1983; Inst. of Contemporary Art, Boston 1984; Indianapolis Mus. of Art, Ind. 1984; San Francisco Art Inst., Calif. 1985; Hudson River Mus., Yonkers, N.Y. 1985; Circulo de Bellas Artes, Madrid 1986; Fort Lauderdale Mus. of Art, Fla. 1986.

COLLECTIONS INCLUDE: MOMA, Solomon R. Guggenheim Mus., and Whitney Mus. of American Art, NYC; Art Inst., Chicago; High Mus. of Art, Atlanta; Philadelphia Mus. of Art, Pa.; Hirshhorn Mus. and Sculpture Garden, Washington, D.C.; St. Louis Art Mus., Mo.; Walker Art Cntr., Minneapolis; Cincinnati Art Mus., Ohio; Brooks Memorial Art Gal., Memphis; Mus. of Fine Arts, Boston; Yale Univ. Art Gal., New Haven, Conn.; European Fine Art Foundation, Paris.

ABOUT: *Periodicals*—Artforum January 1974, April 1975, May 1975, September 1975, June 1976, February 1978, January 1979, December 1982; Art in America March–April 1977, March–April 1979, April 1981, April 1984, December 1984; ARTnews April 1982, September 1982, Summer 1983, September 1983, January 1985, November 1985, January 1986; Arts March 1975, January 1979, May 1981, September 1982, June 1983, February 1985, Summer 1985; Harper's March 1985; New York March 19, 1979, May 14, 1984, February 10, 1986.

*PAIK, NAM JUNE (July 20, 1932–), Korean-American video and performance artist and composer. Once called "the George Washington of video," he inaugurated the field of video art in 1963 and is still its most adept, original, and entertaining practitioner, as well as a consultant to public television and a dedicated promoter of video art festivals and broadcasts. His colorful

NAM JUNE PAIK

public persona is a combination of media manipulator, visionary wizard, and Zen trickster. His art consists, in the main, of unfettered, sometimes violent musical performances, seemingly dislocated video collages, and one-shot video sculptures that assault our customary ideas of high art (or even high entertainment) and which often blast the very institutions—avant-garde music, broadcast television, American capitalism, Western values and perceptions—that have nourished him. Paik's program is aesthetic subversion; the exposure of social absurdity is at the heart of most of his art. But he is also fascinated by the technology that owes so much of its artistic development to his own efforts, and he has created some of the genre's most beautiful electronic abstractions. His best work is either deceptively dreamy and contemplative or faster and funnier than any sitcom or commercial. Either way, Paik extends to extremes the distortions—temporal, visual, moral—that are taken for granted on ordinary television.

Paik claims that what sets his work apart from that of other video artists is his early training in music. "As painters understand abstract *space*," he said in a 1974 interview, "I understand abstract *time*." Paik was born in Seoul, the youngest son of a sporadically well-to-do family that owned a textile mill, as well as two factories in northern Korea which were nationalized by the Communist regime in 1945. After the Korean War broke out in 1950, he and his family fled first to Hong Kong (where Paik saw his first television) and then to Tokyo. He had already become interested in twentieth-century Western

music, and in 1956 he graduated from Tokyo University with a degree in aesthetics (his thesis was on the composer Arnold Schönberg). Later that year he convinced his father to pay his way to Germany to continue his philosophy studies.

Instead, against his family's wishes, Paik took lessons in piano, composition, theory, and music history at the Freiburg Conservatory, the University of Munich, and Radio Cologne's Studio for Electronic Music. Germany was at that time the center of the electronic music scene, whose adherents included Karlheinz Stockhausen and Gyorgi Ligeti, both staff members at Radio Cologne. Paik was fascinated by their work and began, cautiously at first, to incorporate electronic elements—snippets of taped music, or his own chants and screams—into his compositions. He was already an expert pianist, but lacked the confidence to perform in public; his broken German, French, and English reinforced his timidity.

The crucial event in shaping his future career was his meeting in Darmstadt in 1958 with the avant-garde American composer John Cage. Cage had at that time abandoned electronic music for compositions that depended on theatrical elements—forerunners of the "happenings" of a few years later. It was Cage's hope that action on stage would keep audiences from falling asleep, as they often did at concerts of purely electronic music. In conversations with Cage, Paik realized that the composer was not afraid to appear ridiculous or funny during a performance, even if those effects were not intended. That revelation helped Paik exchange his own public shyness for an unpredictable aggressiveness that can still be found in his work. Characteristic of his early performances, which he called "action concerts," (they were still, to his mind, primarily musical), was the notorious *Étude for Pianoforte* (1960), in which Paik leaped off the stage, after playing Chopin, confronted Cage in the front row, snipped off part of the stunned composer's shirt and necktie with scissors, lathered Cage's head and that of pianist David Tudor with shampoo, and then ran from the theater to announce, via telephone, that the piece was over. This and other such works earned Paik the title in Germany of "the world's most famous bad pianist."

By the early 1960s Paik had crossed the invisible line that divided avant-garde music from the newly developing happenings/performance art. He allied himself with the loosely confederated Fluxus group, which included such like-minded artists and musicians as George Maciunas, Dick Higgins, Alison Knowles, Emmett Williams, La Monte Young, and George Brecht. Like most of the neo-dada groups then active in Europe, Fluxus was dedicated to combating "the exclusiveness and elitism of art" (according to Maciunas) and encouraged chance-based, open-ended experimental performances. Paik found that way of working very congenial; his continuing association with Fluxus (the group still clings to a tenuous existence) reinforced his inclinations toward irony, mysticism, and satire.

The pivotal event for Paik in terms of his impact on art, however, was his decision to become involved with television as an art medium. "I was working with electronic music at Radio Station Cologne everyday, which also transmits TV," he said in 1974. "It was natural for me to think that something similar to electronic music could also be done on the TV screen. I wrote to John Cage in 1959 that I would use a TV set in a multimedia concert. At that time John Whitney was experimenting with computer film and the German painter K. O. Goetz was talking about computer-programmed painting. From all those, the idea of TV crept in, though for a long time I thought it was a task for painters. I waited and waited but nobody did it. One late morning, the idea suddenly flashed, 'Why not me?' I learned from Arnold Schönberg to dig up the root and shake up the tree from the root on. Therefore I bought physics and electronics textbooks and started from the root."

Much of Paik's subsequent success was due to his willingness to confront the technical foundations of the medium. As he told fellow video artist Jud Yalkut in 1968, "Although the piano has only eighty-eight keys, now we have, in color TV, twelve million dots per second, which I have somehow to control for my work. It is like composing a piano concerto using a piano equipped with twelve million keys. How can you deal with that vast quantity of possibility without the painstaking study of your materials and instruments?" In 1962 he "sold everything" to buy thirteen used TV sets. Paik spent much of the next year tinkering with them in his studio in Cologne, trying various ways to alter the broadcast image. This was completely virgin territory; few artists had even seen the insides of a TV set, much less conceived of it as the medium for a new art. The following spring Paik exhibited the results of his experiments at the world's first show of video art, at the Galerie Bruce Kurtz, an event equal in significance to Robert Rauschenberg's display of his "combines." One of Paik's altered sets was sensitive to sound: speaking into a microphone made the TV image pulse and jump. Paik reversed the polarity on another, so that the screen showed black instead of white and vice versa. On several sets the artist had inserted degaussing coils or magnets into the

chassis to distort or stretch the picture. Nothing was sold from the show, but Paik was undismayed. "My experimental TV is not always interesting but not always uninteresting," he said at the time. "It is like nature, which is beautiful not because it changes beautifully but simply because it changes."

A year after his Wuppertal show, Paik moved to New York City, which has been his base of operations ever since. Cage showed him around the city and the American Fluxus artists Dick Higgins and Alison Knowles helped him find a studio in Chelsea. Paik immediately set about collecting junked television sets and perfecting two odd-looking robots. He even slept on a bed made of three television cabinets. His first show in the United States was in 1965 at the Galerie Bonino; over the next decade he exhibited steadily there and at the Galerie René Block.

Soon after his arrival Paik met the cellist Charlotte Moorman at a performance of Stockhausen's *Originale* (which featured such typical Paik additions as a performing chimp, Paik's robots, and Paik screaming and covering his head with shaving cream). The imperturbable Moorman was the perfect vehicle for one of Paik's longstanding ambitions—to put sex into music. She has starred in many Paik pieces, including *Cello Sonata No. 1 for Adults Only* (1965), in which she disrobed while playing a Bach prelude; the well-known *TV Bra for Living Sculpture* (1969), in which she wore two miniature TV sets over her breasts: and *TV Cello,* in which she played a "cello" made of TV sets displaying feedback of her own image. Both Paik and Moorman were arrested for public obscenity during the New York premiere of *Opéra Sextronique* (1967), which featured Moorman in a series of revealing costumes; but they were immediately contacted by a West Coast nightclub offering a large sum to recreate the piece. In a typically tongue-in-cheek pronouncement made in 1974, Paik credited Moorman with being "the embodiment of live video art. . . . If any other lady cellist did it [strip while performing], it would have [been] just a gimmick. Charlotte's renowned breast symbolizes the agony and achievement of the avant-garde for the past ten years." Those performances—one of which was shown on the *Tonight* show with Johnny Carson—were Paik's springboard to notoriety and a larger audience.

Concurrently with his work with Moorman, Paik was following the latest developments in video technology. He bought the first nonbroadcast portable video tape recorder and camera available in New York in 1965, using money from a John D. Rockefeller Foundation grant,

and on the ride home from the store he shot the first "video" from the window of his cab. What differentiates videotapes of that kind from commercial TV, Paik discovered, is their immediacy, individuality, freedom of conception, and essentially democratic nature. "Video art," he has said, "is to liberate people from tyranny of TV."

Paik was saved from chronic insolvency in 1967 when he was awarded a residency at the State University of New York at Stony Brook. Since the late 1960s he has also been extensively supported by the Rockefeller Foundation and by the public television stations WGBH in Boston and WNET in New York. His first videotape broadcast was the five-minute *Electronic Opera No. 1,* included in *The Medium Is the Medium,* a video art anthology produced by Fred Barzyk of WGBH. Paik intercut shots of the Boston Symphony Orchestra playing Beethoven's Fourth Piano Concerto with chroma bursts, feedback, and other images of his own devising, among them shots of Richard Nixon and John Mitchell undergoing droll video distortions. The piece concluded with a man's fist punching a bust of Beethoven and a toy piano being set aflame.

By that time Paik was practiced in deflating the high seriousness society bestows on great art and on the pronouncements of public figures, but he was also willing and eager to skewer commercial TV and his own adopted home town, as for example in *The Selling of New York* (1972). Using the quick takes and choppy cuts typical of commercials and action series, Paik shows a woman taking a bath and a couple making love in front of a TV. In a droning voice, the TV commentator praises the recent drop in New York City crime; but the TV itself, at the end of the tape, is stolen by a burglar.

In 1970 Paik took another step away from traditional forms when he and the Japanese engineer Shuya Abe invented a $30,000 analog video synthesizer that could mix, distort, polarize, and colorize existing images from several video and audio sources and create, deliberately or at random, totally new video patterns and colors. *Global Groove* (1973), probably Paik's best-known tape, makes extensive use of synthesized imagery—including colorization, feedback, chroma-keying, and other effects now tiresomely familiar to any TV viewer but then rarely if ever seen on commercial TV. The score is a playful mixture of "golden oldies" rock, traditional Korean ceremonial music, tap dance tunes, and electronic compositions by Cage and Stockhausen. By including shots of a topless dancer, the rubber-faced Nixon, and an interview with

John Cage (all taken from earlier works), Paik was plainly trying to discomfit the bourgeois TV establishment—*Global Groove* was produced at WNET's TV Lab—but it is the work's technical achievement, and not its satiric vision, that has been influential. As David A. Ross noted in his book *Nam June Paik* (1982), "This fast-paced, densely edited work was Paik's first use of state-of-the art editing techniques and represents a real milestone in the tempering of technology by precise aesthetic purpose. 'I make technology look ridiculous,' Paik has said, but in this work the artist revels in the spirit of the new technologies in a way that belies his oft-stated belief."

Guadalcanal Requeim (1977) was taped at the World War II battlefield, where Moorman plays her cello; it draws on old war film footage and includes an interview with a veteran of the battle and Solomon Islanders seeking the islands' independence from the United States. Failure of communication and understanding between nations leads to war, Paik demonstrated in this, his most overtly political work. Other videotape works of the 1970s include pieces on Cage and the choreographer Merce Cunningham, who is also a seminal influence on Paik, and *You Can't Lick Stamps in China* (1979), a Paik travelogue that counterposes a banal discussion by American tourists of the differences between cultures with scenes of political unrest in the Third World, lyrical Chinese exotica, and recurrent shots of delicious-looking food. The tourists, conditioned by their lives in what Paik shows us to be a ridiculously overstimulated and overstuffed New York City, can come to no real understanding of the rest of the world. *Stamps* stands as one of Paik's least abstract and most popular efforts on tape; one critic for *Artforum* called the fast-moving and image-packed work "the perfect combination of style and subject, experimental enough to satisfy hard-core art crowds, fascinating enough to capture the average television mentality."

The artist's retrospective at the Whitney Museum of American Art in 1982 allowed him to display in one place the full diversity of his work. Included were many of the major installation pieces that, when seen together, revealed Paik's contemplative side, though no work of his is without a punch line. *TV Buddha* (1974) is a small statue of Buddha meditating on its own closed-circuit video image. *Moon Is the Oldest TV* (1956–76) presents a bank of televisions arrayed and altered to suggest the phases of the moon. *Video Fish* (1978) filters video images of fish and other aquatic subjects on fifteen color monitors through a row of real aquaria. (Water has been a motif in Paik's work since his early performances, which often called for his immersion on stage.) *Fish Flies on Sky* (1975) involves ceiling-mounted TVs that show changing visions of fish, jet planes, and the like; Paik provided floor mats for visitors to lie on. *Global Groove* was displayed on twenty monitors simultaneously. In all, some sixty works were on display, by far the largest exhibition of video art held up to that time.

The Whitney retrospective was widely covered in the press and, for the most part, lavishly praised. It not only established Paik's own status but also firmly established the genre as a legitimate art category with its own bona fide master. TV viewers jaded by the ubiquitous video trickery on TV seemed to like the way Paik reversed all the usual expectations about television. Critics outside the small coterie of video followers were for the most part reassured by the familiarity of Paik's absurdism and sly political satire; he fit, they found, not too uncomfortably within the anti-art family of modernists whose paterfamilias is Duchamp.

For all the raucousness of his work, Paik himself is amiable and self-effacing. A small man, bohemian in his habits, he always wears a scarf around his middle because, he has explained, he is always cold. His loft in New York's SoHo, where he lives with his wife, the Japanese video artist Shigeko Kubota, is a vast tangle of television carcasses, mounds of wire, and piles of technical journals. Despite his considerable artistic success, he makes little money from his work; he lives mainly on income from a professorship at the Kunstakademie in Düsseldorf (where the late Joseph Beuys (d. 1986) was also a faculty member) and from public and private grants and the workshops he gives at colleges and universities.

Critics who view video art as an aberrant offshoot of traditional forms dismiss Paik's art as lightweight; its delights are "flickering, small-scale and fragmentary, and quickly dissipated," to quote Hilton Kramer. But within the field Paik is venerated as a minor deity (or perhaps an illustrious ancestor); in his work can be found practically every idea or process that other video artists have since made use of. "The issues Paik has addressed over the past twenty-five years have acquired particularly acute relevance today," wrote Bruce Kurtz in 1982. "The canny strategies he has developed demonstrate singular agility in moving among questions of 'seriousness' and frivolity, entertainment and art, at a time when the boundary area between such supposed opposites has attracted the attention of many younger artists. Combining aspects of popular culture, entertainment, electronic media, and formal manipulation in his work, . . .

Paik has annexed elements of 'low' culture to the 'high' culture of avant-gardism."

EXHIBITIONS INCLUDE: Gal. Parnass, Wuppertal, West Germany 1963; New School for Social Research, NYC 1965; Gal. Bonino, NYC 1965, '66, '68, '71, '72, '74, '76; Stony Brook Art Gal., State Univ. of New York; Millenium Film Workshop, NYC 1971; MOMA, NYC 1971, '77; The Kitchen, NYC 1973, '76; Everson Mus. of Art, Syracuse, N.Y. 1974; Anthology Film Archives, NYC 1974; Gal. René Block, NYC 1975, '76, '77; Martha Jackson Gal., NYC 1975; Kölnischer Kunstverein, Cologne 1976; Stedelijk Mus., Amsterdam 1976; Gal. Marika Malacorda, Geneva 1977; Gal. Watari, Tokyo 1978, '80, '81; Mus. d'Art Moderne de la Ville de Paris 1978; Global Village Gal., NYC 1979; Whitney Mus. of American Art, NYC 1980, '82; Stadtische Kunsthalle, Düsseldorf 1980; Sony Hall, Tokyo 1981; Neuer Berliner Kunstverein, Berlin 1981; Mus. d'Art Moderne, Paris 1983. GROUP EXHIBITIONS INCLUDE: "Music Notation," Minami Gal., Tokyo 1962; "Notations," Gal. La Salita, Rome 1962; "Fluxus Concerts," Canal Street, NYC 1964; "New Cinema Festival I," Filmmakers Cinematheque, NYC 1965; "Programmed Art," Mus. of Art, Rhode Island School of Design, Providence 1966; "Art Turns On," Inst. of Contemporary Art, Boston 1966; "Festival of Light," Howard Wise Gal., NYC 1967; "Light, Motion, Space," Walker Art Cntr., Minn. 1967; "The Artist as Filmmaker," Jewish Mus., NYC 1967; "Cybernetic Serendipity: The Computer and the Arts," Inst. of Contemporary Arts, London, Corcoran Gal. of Art, Washington, D.C.; Palace of Science and Art, San Francisco, 1968; "The Machine: As Seen from the End of the Mechanical Age," MOMA, NYC 1968; "Electronic Art," Art Gals., Univ. of California, Los Angeles, 1969; "New Ideas, New Materials," Detroit Inst. of Arts, 1969; "Happening and Fluxus," Kölnischer Kunstverein, Cologne 1970; "Sonsbeek 71," Arnheim, Holland 1971; "Videoshow," Whitney Mus. of American Art, NYC 1971; "Circuit: A Video Invitational," Everson Mus. of Art, Syracuse, N.Y. 1973; "New York Collection for Stockholm," Moderna Mus., Stockholm 1973; "Projekt 74," Kunsthalle Köln and Kölnischer Kunstverein, Cologne 1974; "Eleventh Annual New York Avant-Garde Festival," Shea Stadium, Flushing, N.Y. 1974; "Video Art," Inst. of Contemporary Art, Univ. of Pennsylvania, Philadelphia 1975; "Arte de Video," Mus. de Arte Contemporaneo, Caracas 1975; "Video Art USA," Saõ Paulo Bienal 1975; "Monumente durch Medien ersetzen," Kunst und Mus., Wuppertal 1976; "Documenta 6," Kassel 1977; "ARC Exposition," Paris 1979; "Mein Kölner Dom," Kölnischer Kunstverein, Cologne 1980; Whitney Biennial 1981; "National Video Festival, Washington, D.C. 1981; "Eine Kleine Düssel Video," Städische Kunsthalle and Staatlich Kunstakademie, Düsseldorf 1981; "International Video Festival," San Francisco 1982.

COLLECTIONS INCLUDE: MOMA and Whitney Mus. of American Art, NYC; Everson Mus., Syracuse; Electronic Arts Intermix, NYC; Donnell Film Library, New York Public Library, NYC; René Block; The Kitchen, Mercer Art Cntr., NYC; WNET-TV, NYC; WGBH-TV, Boston.

ABOUT: Battcock, G., ed. New Artists Video: A Critical Anthology, 1978; Cage, J. A Year from Monday, 1963; Current Biography, 1983; Emanuel, M., et al. Contemporary Artists, 1983; Gruen, J. The New Bohemia: The Combine Generation, 1966; Hanhardt, J. G., et al. Nam June Paik, 1982; Price, J., et al. Video Visions—A Medium Discovers Itself, 1977; Robins, C. The Pluralistic Decade, 1984. Who's Who in American Art, 1989–90; Youngblood, G. Expanded Cinema, 1970; *Periodicals*—Artforum April 1972, March 1979, October 1982; ARTnews January 1977, May 1982; Arts Magazine December 1972; Domus September 1977; Newsday August 24, 1970, August 8, 1977; New Yorker May 5, 1975; New York Times August 26, 1965, December 4, 1965, May 14, 1967, October 3, 1974; New York Times Magazine April 25, 1982; Time May 30, 1964; Village Voice March 3, 1980.

PENCK, A. R. (October 5, 1939–), German painter and sculptor, was born Ralph Winkler Penck in a working-class district of Dresden. In 1945 that majestic city was destroyed by Allied bombers, therein changing forever the five-year-old Penck's outlook on the world. Looking back, he recalled, "I saw the city in flames. . . . I experienced the distraught and the catastrophe constituted by the decomposition of a hierarchy through military annihilation . . . These were for me the most important and the most upsetting events of my childhood. They signify for me the negative, the horror of war and of destruction." Although he would soon experience the postwar division of Germany and be consigned to life in the Sovietized Eastern bloc, Penck never succumbed to despair or the temptation of nihilism. Later he felt urgently the need to express in his art the social reality of a postwar world divided into two armed camps, East and West—Germany's "ice age," as he termed it. His paintings were infused with an energy and optimism that expressed the spirit of the German people, who had been tainted by the shame of Nazism and traumatized by the superpowers' nuclear stalemate, yet were beginning slowly to regain their cultural identity.

Penck began painting at an early age; at ten he was painting oil scenes of Dresden, family life, and nature (paths through fields and forests, which he called "views into the open"). At age twelve, Penck was going to the Zwinger and making drawings of its florid sculptural interiors. Soon he was studying Rembrandt and Picasso, and by age sixteen he had decided to become a professional painter. Too poor to afford basic art materials, he would paint on found scraps from around the house. Meanwhile, he applied to schools in East Berlin and Dresden, but the academies considered him nothing more than a civil servant and would not admit him, fearing

A. R. PENCK

that his presence might be disruptive of their academic approach to art training. Penck then bounced from job to job, working as a boilerman and a postman, trying to save money to produce an occasional oil painting. At that time he was concentrating on portraits, but in 1961 he began to paint nudes. Also, he had begun sharing ideas with George Baselitz, who became an influential neo-expressionist with his crude, forceful "upside-down" paintings. Soon, however, the two were physically separated—Penck in the East, Baselitz in the West—by the construction of the Berlin Wall in August of 1961 at the height of Cold War tensions. Indeed, 1961 proved to be a pivotal year for Penck: he had work exhibited at the Academy of Arts and he took as his pseudonym the name of the geologist Albrecht R. Penck, who wrote *The Alps in the Ice Age* (1909), an early sign that Penck was preoccupied with the concept of identity and origin.

An early drawing of Penck's, *Kneeling Woman* (1959–1960), showing a woman kneeling, supported by her hands and arms, crouched like an animal, is a good example of his studies of Rembrandt and Picasso. Penck says that he was interested in reconstructing Rembrandt's manner of capturing an attitude in the process of using uncertain, quick, and wild brush strokes. Dieter Keopplin discussed that drawing in *Studio International* in 1974: "The woman in Penck's drawing . . . defines a mode of existence and secures for herself an enduring experience . . . although the attitude of the woman also portrays a search for support, dictated by uncertainty, just as the technique of the drawing

taken from older art plainly shows a non-individual and unstable quality."

During that period in his life, Penck was living an underground existence for safety. He was also developing his visual hieroglyphic language which was put into his series of *Standart* paintings—a phrase founded in the fusion of two German words. Sidra Stich defined the etymology of the term in *Arts Magazine*: "[It is the] conflation of the words *standard*—which denotes a model, common type, norm, pattern, rule, or basis of comparison—and *standarte*—which denotes a flag or banner used as a symbol for a people or military unit, especially Nazi regiments of the S.A. and S.S. Penck's term *Standart* thus embodies the idea of a basic construct or image, and the sense of a paradigm for imitation. Yet it also bears nationalistic and martial connotations calling forth memories of a situation where regulation led to tyranny." *Standart* is represented by a black stick figure, the Everyman, which has become a signature to most of Penck's paintings and drawings. The figure appears like a unifying and familiar constant. It acts as the stabilizing factor (as the kneeling woman's hands) in otherwise uncertain situations. Yet it can also be the instigator of the uncertainty, as when the figure is depicted holding a weapon in a threatening way. The paintings seem to tell a story or symbolize a belief and are usually executed in black and white, with quick, thin strokes—depicting arrows, male and female figures, signs, and suns, and are set in situations tense with contradiction, doubt, and division, but grounded in solidarity and friendship.

In Penck's text (addressed to children), *What Is Standart?* (1970), he provided some insight into his works: "Try out everything you can draw with a pencil or a piece of chalk: lines, dots, crosses, arrows, and whorls; . . . and practice imagining them . . . you will find that a feeling or sensation appears for each sign when you paint it; and also when you imagine it . . . You will even find that the feeling you had when you imagined the sign also appears suddenly and so creates for you an experience in reality." Many viewers feel that Penck is in fact attempting to come to terms with the division around him. For example, a 1971 acrylic painting depicts a male *Standart* figure centered on the border of two opposing forces of lines and dots. Sidra Stich has interpreted the figure to be "a mediator though it, itself, is mediated by its surroundings; the figure still appears as an indomitable force but it is riven by countercurrents, affected by both and centered in neither." The figure may also be semi-autobiographical, as Penck himself could be described as a person bordering two forces—East Berlin, the place of his origin, though social-

ly repressive, and West Berlin, a place of freedom, though unattainable.

Beginning in the late 1960s, Penck began sending his art to West Germany. He began showing mostly with Michael Werner in 1969 in Koln. His first major international appearance was in the group show Documenta 5 in Kassel, West Germany. He did not exhibit in East Germany, probably due to the "antisocial" subject matter in his art. In the early 1970s he was making sculptures—assemblages of cardboard boxes, cloth, tape, string, and wire. According to Peter Winter, writing in *Art International*, "They look like utensils made for a play by Beckett. . . . They would have looked out of place in an East German art parade." He was also making sculptures of hacked wood, in which Winter felt that Penck was expressing his anger (through choppings at the tree trunks) with the political authorities who apparently did not take his art seriously. "I began to chop around pieces of wood," Penck has recalled. "The result was a return to a kind of elementary experience . . . cutting wood was a symbolic liberation from theory. Life became the foundation. I called the sculpture 'resistance.' The works . . . bring to mind the bizarre images that an obsessive Sunday sculptor might make out of tree trunks and branches with his chain saw and axe."

In 1973 Penck was drafted into the People's Army for six months as a reservist. Following that, he moved to Prussia and painted his colorful Ninotschka series and made some art films. He then spent time in Budapest, where he was able to exhibit some work, and he returned to Dresden in 1977. In 1980 Penck was granted permission to leave East Berlin and settle in the West. The authorities realized that Penck was a major "thorn" and were glad to see him leave, though he did have to pay a large ransom for his freedom. Penck's decision to move was not seen as a resolution with or submission to the status of the Eastern sector's policies. For even in the West, he would still be living in a society that had been ripped from its whole. In the West, Penck realized that the two sectors were no longer complementary; each had been healing for years independently of the other. Two paintings exhibited in Gand in 1981 are diagrammatic of that: *Western* and *Osten*, each painting "the negation of the other. The West: black on white; the East: white on black. And yet these two halves are neither interlocking nor reducible. The two 'systems' [social and historical conditions] face each other, implacably," Bernard Marcade wrote in *Cimaise*. Penck does not paint a Utopian future for the two halves, nor does he paint the fatality of the system, but he addresses the state of the two sectors as oppositional dynamics. Michael Brenson discussed Pencks's technique of depicting the 'system' under attack in the *New York Times*: "Penck's work refuses to be anywhere. The artist changes style constantly, suggesting many artists, including Jackson Pollock, Clifford Still, Cy Twombly, and Adolph Gottlieb. He rejects both composition and space, either of which would create an anchor and a sense of place."

Many critics see Penck's *Übergang* series also as autobiographical in that it deals with his own passage from East to West. For example, Donald B. Kuspit described in *Art in America* one such painting that depicts a soldier (stick figure) holding a rifle and a larger figure who appears to be running with flapping arms and coming apart. Kuspit focused on Penck's rapidly painted strokes which create the figures and the "blotches" surrounding them: "The contradiction—the tension—between the two figures, their true commensurateness, is masked by the fact that they are both stick figures . . . They are lost in a field of more idiosynchratic strokes . . . which tend to pull their bodies apart, and are restrained from doing so only because of color differentiations. *Übergang*, as defined by Sidra Stich, means a "crossing-over, passage, change of tactics, conversion." Hence the link between Penck's own passage and the series' subject matter, which was early depicted in a 1963 *Übergang* painting that shows a *Standart* figure balancing in the center of a burning bridge, while maintaining a look of confidence on his face.

Jean Fisher reviewed a group of 1985 paintings that were shown at the Mary Boone Gallery and which center around a male hunter or soldier figure in various scenarios. *Der Jager* (*The Hunter*) depicts the figure standing among several deer, holding a spear, wearing an ornamental headdress, that Fisher calls an emblem of man's survival but which is also the bridger of death and destruction in nature. In another painting *Zwei im Westen* (*Two in the West*), the figure, now comical, stands precariously on one foot between an apparent communal ritual and a hunt. *The Brain* is a scene of the male figure holding a brain in one hand and a bunch of missiles (as if they were a bouquet of flowers) in the other; intellect on one side and Strength on the other. Fisher writes, "Penck's lexicon of signs has separated out into discretely spaced entities, isolated and yet trapped in a common force field. His genitally defined stick figures and emblematic fauna and symbols occupy a terrain, but they do not possess it." Fisher commends Penck's style which she sees as a challenge to recent representational pictorialism even though she noted the possibility that "the constitutive signs risk becoming sequestered in the realm of aesthetics."

Another painting of that period, *Der Pabst* (*The Pope*, 1985) illustrates the Pope blessing (with disproportionately long, noodlelike arms) a large dog while the man in the moon grins cunningly overhead. Maurice Poirier wrote of the piece in *ARTnews* and felt that "The superstitions and dark passions one associates with primitive man are here distilled and rerouted through the Catholic Church. . . . The disquieting mood of Goya's black paintings is here vividly evoked." Poirier designated *Der Pabst* the most compelling of the pieces in the 1985 show at Mary Boone's, his only negative criticism being that sometimes he found the relationship between images in the paintings unclear.

Of the same show and work, Jamey Gambrell in *Art in America* criticized Penck for trying to "legitimize his appeal to a mythic subconscious by claiming a geneology of modernist masters. A number of paintings deliberately invoke Miro and Kandinsky. . . . But heavy-handed and hemmed in by doodles, Penck's images have none of Matisse's energy and lightness, nor Klein's classical, weighted grace. They remain tiresomely, if unwittingly, in the realm of stereotype and caricature."

Meanwhile, Penck had been making sculpture of which an overview was shown in 1988 by the Kestner Gesellschaft in Hanover, Germany. Included were his three-dimensional assemblages of cardboard boxes and utensil objects, and chopped tree trunks from 1973–74. Also exhibited were his 1982 bronze works, which are carved roots, branches, and found stones cast in bronze; "[a] process [that] both unites and transforms" the organic and the alloys, wrote Peter Winter in *Art International*. Winter quoted Penck as saying, "The bronze makes things look strange, and objectifies the sculptural qualities of the wood." Roberta Smith reviewed a show of Penck's thin bronze sculptures (again the forms were originally carved in wood and then dipped) exhibited in 1989 at the Mary Boone Gallery for the *New York Times* and she felt that the pieces suggested "an artist working backwards from Brancusi toward African totems." From bronze, Penck moved into working with Carrara marble. Pinter described those pieces as "lumplike towers" and the cutting of his "well-known figures." "His involvement with chance forms and with tangible material is no pure artistic game for him, but rather part of a conversation with the present, with memory and with a traumatic collective consciousness," writes Pinter, noting also that Penck's titles, such as *Idol for Germany* and *Memorial for the Separated Germany*, reinforce and underline the artist's objectives.

The year 1988 seemed to be the time to honor Penck through retrospective. Along with the sculpture overview in Hanover, there was a retrospective of 137 of his paintings and drawings at the Neue Nationalgalerie in Berlin that documented his development into one of the leading German artists in contemporary art. Wolfgang Max Faust reviewed the exhibition: "Works that fail and succeed are hung side by side. This experience is a strange occurrence for a viewer . . . but it emphasizes that Penck's oeuvre is a field of questions and answers. This makes for both the intensity of this exhibition and the artist's promise for the future."

In 1989 Penck was still exhibiting internationally, his work progressing within the same vein he has been developing for twenty years. An example of his latest work is *How It Works*, which was shown at the Fred Hoffman Gallery in Santa Monica, California in the spring. The scene in the painting is of a large red lion towering over its kill—a black antelope whose neck the lion has in its jaws. In the zone above the scene are hieroglyphics including *Standart*, a target, sculls, a cube, and an eagle. Susan Kandel deciphers this in *Arts Magazine*: "For *How It Works* is just as much about a specific act of savagery as it is about a more general struggle for power, as timely a statement about prehistory as it is about the quickly approaching postapocolyptic age." Kandel distinguished Penck from the artist Keith Haring, to whom he has often been compared. She feels that Penck's work falters when he incorporates contemporary symbols and imagery into his art "—punk-rock stick figures with spiky hair, flying dollar signs, etc. It is here that it becomes obvious how easily Penck could degenerate into Haring; but since Haring no longer wants to be Haring, one hopes that Penck will assiduously avoid this trap."

Penck is living mostly in London now. He was once described by Robert Pincus-Witten as a "troll-like man (bearded, in a crumpled leather flying hat, with scarred thumb, like Frank Stella)." His interests, aside from art and film, lie in music and poetry.

EXHIBITIONS INCLUDE: Gal. Michael Werner, Koln, West Germany 1969; '71, '74, '75, '79, '80, '82, '83, '85, '86, '87; Gal. Heiner Friedrich, Munich, West Germany 1971; Mus. Haus Lange, Krefeld, West Germany 1971; W. White Space Gal., Antwerp, Belgium 1972, '74; Kunstmus., Basel, Switzerland 1972, '78, '81; Gal. Loehr, Frankfurt, West Germany 1973; L'Uomo e L'Arte, Milan, Italy 1973; Anna Leonowens Gal., Nova Scotia Col. of Art and Design, Halifax, Canada 1973; Daner Gal., Copenhagen, Denmark 1973; Gal. Nachst St. Stephan, Vienna, Austria 1974; Gal. Neuendorf, Hamburg, West Germany 1975; Kunsthalle, Bern, Switzerland 1975, '81; Stedelijk Van Abbemus., Eindhoven, Holland 1975; Gal. Seriaal, Amsterdam, Hol-

land 1977; Mannheimer Kunstverein, Mannheim, West Germany 1978; Mus. Ludwig, Koln, West Germany 1978; Gal. Helen van der Meij, Amsterdam, Holland 1978, '81; Gal. Rudolf Springer, Berlin, West Germany 1978, '83, '86, '87, '88; Mus. Boymans-van Beuningen, Rotterdam, Holland 1979; Gal. Fred Jahn, Munich 1980; Stadtisches Mus. Leverkusen, Schloss Morsbroich, West Germany 1980; G E W A D, Gent, Belgium 1981; Gal. Neuendorf, Hamburg, West Germany 1981; Josef-Haubrich-Kunsthalle, Koln, West Germany 1981; Ileana Sonnabend Gal., NYC 1982; Gal. Lucio Amelio, Naples 1982, '983; Gal. Toselli, Milan 1982; Studio d'Arte Cannaviello, Milan 1982; Gal. Gillespie-Laage-Salomon, Paris 1982, '83, '84; Waddington Gal., London 1982, '84, '86; Gal. Yarlow/ Salzman, Toronto, Canada 1983; Mary Boone Gal., NYC, 1984, '85, '89; Akira Ikeda Gal., Tokyo 1984; Gal. Maeght Lelong, Zurich, Switzerland 1984, '86; Tate Gal., London 1984; Alpha Gal., Boston 1984; Mus. d'Art et d'Industrie, Saint Etienne, France 1985; Stadtisches Mus. Abteiberg, Monchengladbach, West Germany 1985, '86; Gal. Meyer-Ellinger, Frankfurt am Main, West Germany 1985; Neue Gal.-Sammlung Ludwig, Aachen, West Germany 1985; Kunstverein, Braunschweig, West Germany 1985; Gal. Suspect, Amsterdam, Holland 1985; Gal. De Ganzerik, Eindhoven, Holland 1986; Gal. Tegenbosch, Amsterdam, Holland 1986; Gal. Christian Stein, Milan 1986; Deweer Art Gal., Zwevegem-Otegem, Holland 1986; Gal. und Edition Stahli, Zurich, Switzerland 1986, 1987; Kunstverein Freiburg, Freiburg, West Germany 1986; Barbara Toll Fine Arts, NYC 1986; Daad-Gal., Berlin 1986; Gal. Chobot, Vienna, Austria 1987; Orchard Gal. Londonderry, England 1987; Douglas Hyde Gal., Dublin, Ireland 1987; Fruitmarket Gal., Edinburgh, Scotland 1987; Gal. Steinmetz, Bonn, West Germany 1987; Gal. Thaddaeus Ropac, Salzburg, Austria 1987; Gal. Schnurr, Stuttgart, West Germany 1987; Gal. Lelong, Paris 1988; Neue Nationalgal., Berlin, West Germany 1988; Kestner-Gesellschaft, Hannover, West Germany 1988; Kunsthaus, Zurich 1988; Fred Hoffman Gal., Santa Monica, Calif. 1989; Gal. Harald Behm, Hamburg, West Germany 1989; Gal. Beyeler, Basel, Switzerland 1989; Gal. Juana Mordo, Madrid 1989. GROUP EXHIBITIONS INCLUDE: "Prospect 71-Projection," Kunsthalle, Dusseldorf, West Germany 1971; "Documenta 5," Kassel, West Germany 1972; "Zeichnungen der deutschen Avantgarde," Gal. im Tacispalais, Innsbruck, Austria 1972; "Zeichnungen 2," Schloss Morsbroich, Stadt Mus. Leverkusen, West Germany 1972; "Bilder-Objekte-Film-Konzepte," Stadtische Gal. im Lenbachhaus, Munich, West Germany 1973; Neue Staatsgal./Pinakothek, Munich, West Germany 1973; "Prospect 73-Maler/Painters/Peintures," Kunsthalle, Düsseldorf, West Germany 1973; "Bilanz einer Aktivitat," Gal. im Goethe Inst., Amsterdam, Holland 1973; "Prokect 74-Aspekte internationaler Kunst am Anfang der 70er Jahre," Kunsthalle Koln, West Germany 1974; "Kunst na 1960 int het Kunstmus. Basel," Nijmeegs Mus., Holland 1974; "Je-nous/ik-wij," Mus. d'Ixelles, Brussels, Belgium 1975; "Zeichnungen," Wide White Space Gal., Antwerp, Belgium 1975; "Functions of Drawings," Rijksmus. Kroller-Muller, Otterlo, Holland 1975; Karl A. Burckhardt-Koechlin-Fonds, Kunsthalle Basel, Swit-

zerland 1976; "Zeichnungen-Bezeichnen," Kunstmus. Basel, Switzerland 1976; "Xeichnungen," Gal. Seriaal, Amsterdam, Holland 1976; Biennale Venezia, Italy 1976; Sammlung Van Abbemus., Eindhoven, West Germany, Kunsthalle Bern, Switzerland 1977; "Penck mal Immendorff–Immendorff mal Penck," Gal. Michael Werner, Koln, West Germany 1977; "Photos der Maler," Gal. Maier-Hahn, Dusseldorf, West Germany 1977; "Zeichen setzen durch Zeichen," Kunstverein in Hamburg, West Germany 1979; "Malerei auf Papier," Badischer Kunstverein, Mannheim, West Germany 1979; Sydney Biennale, Australia 1979; Groninger Mus., Groninger 1979; "Werke aus der Sammlung CRE," Stadtische Gal. in Lenbachhaus, Munich, West Germany 1979; "Y. 35 Objekte aus Holz," Ink, Zurich, Switzerland 1979; '80; "Zeichnungen," Mus. Haus Lange, Krefeld, West Germany 1980; "Der gekrummte Horizont," Akademie der Kunste, Kunsttage Berlin, West Germany 1980; "Apres le classicisme," Mus. d'Arte Saint-Etienne, France 1980; CAPC, Bordeaux, France 1980; "The New Spirit in Painting," Royal Acad., London 1981; Gal. Gillespie-Laage-Salomon, Paris 1981; "Art allemand aujour'hui," Mus. de la Ville de Paris 1981; "Der Hund stosst im laufe der woche zu mir," Moderna Mus., Stockholm, Sweden 1981; "Malerei in Deutschland," Palais des Beaux-Arts, Brussels, Belgium, Gal. Christian Stein, Turin 1981; Studio Marconi, Milan 1982; Avantguardia-Transavantguardia, Rome 1982; Sydney Biennale, Australia 1982; Documenta 7, Kassel, West Germany 1982; "La Transavantguardia Tedesca," Gal. Nazionale d'Arte Moderna, Republica di San Marino, Italy 1982; "German Drawings of the 60's," Yale Univ., New Haven, Conn., Art Gal. of Ontario, Canada 1982; "Mythe, Drame, Tragedie," Mus. d'Art et d'Industrie, Sainte Etienne, France 1982; "New Work on Paper 2," MOMA, NYC 1982; "Zeitgeist," Martin Gropius Bau, Berlin 1982; Univ. of Calif. at Los Angeles 1983; "Content," Hirshhorn Mus. and Sculpture Garden, Washington, D.C. 1983; Tel Aviv Mus., Israel 1983; "L'Italie et l'Allemagne," Cabinet des estampes, Mus. d'Art et d'histoire, Geneva, Switzerland 1983; Biennale de São Paolo, Brazil 1983; "De Statua," Van Abbemus., Eindhoven 1983; "Expressions, New Art from Germany," Saint Louis Art Mus., Missouri, P.S. 1, NYC 1983; "New Art," Tate Gal., London 1983; "83," Fine Arts Acad. of Finland, Helsinki 1983; "Modern Expressionists," Sydney Janis Gal., NYC 1984; "New Art," Mus. d'Art Contemporain, Montreal, Canada 1984; "Legendes," Mus. d'Art Contemporain, Bordeaux, France 1984; "An International Survey of Contemporary Painting and Sculpture," MOMA, NYC 1984; "The Human Condition: SFMMA Biennale III," San Francisco, Calif. 1984; "Drawings," Mary Boone Gal., NYC 1984; "Kapelle am Wegesrand," La Paloma, Hamburg, West Germany 1984; "German Prints 1900–1984," Grace Borgenicht Gal., NYC 1984; "Sydney Biennale," Australia 1984; "VoHier Aus," Messegelande Halle 13, Düsseldorf, West Germany 1984; "Content," Hirshorn Mus. and Sculpture Garden, Washington, D.C. 1984; "Ouverture," Castello Di Rivoli, Turino, Italy 1984; "Creativity in Germany and Italy Today," Art Gal. of Ontario, Toronto, Canada 1985; Sable Castelli Gal., Toronto, Canada 1985;

"Drawings," Brooke Alexander Gal., NYC 1985; Texas Gal., Houston, Texas 1985; "German Art in the Twentieth Century," Royal Academy of Arts, London 1985; "ooghoogte, 50 yaar later," Stedelijk Van Abbemus., Eindhoven 1986; "Raumbilder in Bronze: per Kirkeby, Markus Lupertz, A.R. Penck," Kunsthalle Bielefeld, West Germany 1986; "Wild Visionary Spectral, New German Art," Gal. of South Australia, Adelaide, Australia 1986; "Wild Visionary Spectral, New German Art," National Art Gal., Wellington, New Zealand 1986; "Neue deutsche Malerei aus der Sammlung Ludwig, Aachen," Haus Metternich, Koblenz, West Germany 1986; "Zeitgeist II, 1945–1986," Gal. Pels-Leusden, Berlin, West Germany 1986; "Skulptur," Gal. Michael Werner, Koln, West Germany 1986; "Der unverbrauchte Blick. Kunst unserer Zeit in Berliner Sicht," Martin-Gropius-Bau, Berlin, West Germany 1987; "Exotische Welten. Europaische Phantasien," Inst. fur Auslandsbeziehungen und Wurttembergischer Kunstverein, Stuttgart, West Germany 1987; "Skulpturen von Malern," Kunstverein Mannheim, West Germany 1987; "Projekte fur Munster," Westfalisches Landesmus. fur Kunst und Kulturgeschichte, Munster, West Germany 1987; "Die Saul im Spiegel der Bildenden Kunst des XX Jahrhunderts," Gal. Silvia Menzel, Berlin, West Germany 1987; "Standing Sculpture," Castello di Rivoli, Turin 1988; "Refigured Painting: The German Image: 1960–88," Solomon R. Guggenheim Mus., NYC 1989; "Bilderstreit," Rheinhalle, Koln, West Germany 1989;

ABOUT: Emanuel, M., et al. Contemporary Artists, 1983. *Periodicals*—Artforum June 1981, April 1984, September 1984, December 1984, March 1986, November 1986, October 1988; Art in America September 1982, October 1984, January 1986, December 1987; Art International Winter 1988; ARTnews March 1984, January 1986, April 1986, May 1989; Arts Canada April-May 1978; Arts Magazine June 1984, January 1986, May 1986; Brutus February 1984; Canadian Art Spring 1985; Cimaise January–February 1989; Das Kunstwerk February 1988; Du 8 1988; Flash Art April–May 1984, December 1985, June 1987, Summer 1987, July 1989; Newsweek June 7, 1982; New York Times August 4, 1985, January 4, 1986, February 10, 1989, February 24, 1989; Portfolio September/October 1982; Studio International 197(1007) 1984; Tema Celeste March 1985, January 1989; Time December 23, 1985; Village Voice January 24, 1984; Vogue August 1984.

PEPPER, BEVERLY (STOLL) (December 20, 1924–), American sculptor and environmental artist who worked through a succession of popular styles—early 1960s formalism in steel, late 1960s geometric minimalism, and early 1970s environmental art—before making a major stylistic leap backward to highly successful evocations of ancient totems. She explains that eclecticism as growing out of her incessant search for "sculptural illusions" that "mirror an emotional reality." She has written: "I wish to make an object that has a powerful physical presence, but is at the same time inwardly turned, seemingly capable of intense self-absorption."

Pepper was born Beverly Stoll in Brooklyn in 1924. At the age of sixteen she entered Pratt Institute, where, as the only woman in the class, she was barred from taking courses in engineering; instead, she studied advertising design, photography, and industrial design and upon graduation took a job as a commercial art director. In 1949, after divorcing her first husband, she moved to Paris, studying painting at the Académie de la Grande Chaumière and attending classes with André Lhote, Ossip Zadkine, and Fernand Léger. In that period, before the advent of a strong "American" art, Pepper "suffered from an incredible sense of artistic inferiority. I had not been brought up in a museum-oriented world. I didn't even see art. At that time I was doing abstract, very Gorky-like watercolors, but I had never even seen a Gorky. I didn't know about any of those things." In Paris, she told Barbara Rose, "I used to hang around outside Brancusi's studio and peek in the windows. I was terrified—totally in awe of him."

Despite her fascination with Brancusi (his influence is very apparent in Pepper's later works), Pepper remained a painter for the time being. In 1949 she married Curtis Bell Pepper, a writer, and spent the early part of the 1950s traveling extensively in Europe and the Middle East, finally settling with her husband and daughter Jorie in Rome, where she had her first exhibition of paintings at the Galleria dello Zodiaco in 1952. Explaining her move to Italy just when New York art was in its ascendancy, Pepper said: "In Europe I could afford the domestic help that freed me to work as an artist. . . . The primary problem with living abroad was that I suffered from American chauvinism for a long time. Because I was an American, I kept feeling that I should go 'home.'" Pepper and her husband were well–connected with the Italian artistic scene, however, and counted among their friends the film directors Michaelangelo Antonioni and Federico Fellini.

Through the 1950s Pepper painted social realist works that were, in her own estimation, "terrible paintings" that nonetheless "touched some root base" of feeling. Her decision in 1960 to take up sculpture in a serious way (she had been experimenting with small clay and wood pieces through the 1950s), grew out of two weeks spent studying the overgrown Khmer carvings at Angkor Wat. "I walked into Angkor Wat a painter," she said, "and left a sculptor." The chance to create some large sculptures came lat-

er that year, when she found thirty-nine felled trees near her home in Rome. Lacking any knowledge of carving technique, she attacked the trees with drills and saws, crafting works that recalled carvings by Jean Arp. Several 1961 sculptures incorporated rough cast webs enclosed by smooth, organic wooden shapes (for example, *Laocoon*, 1961).

Pepper participated in the 1962 Spoleto exhibition *Sculture nella città* organized by the critic Giovanni Carandente. Among the other American artists participating were Alexander Calder and David Smith. Each sculptor was given access to industrial facilities; Pepper had agreed to create a number of welded pieces, although she didn't know how to weld. "No woman had ever made art in a factory," she recalled. "Finally, I had what I had always wanted: a factory, all the steel I could use, and the necessary tools and equipment. . . . When I got to Spoleto I had the time of my life. They had decided to send me to the Communist town of Piombino because they figured I was the ideal of what the Communists would want in a woman." By the time of the exhibition she was creating airy pieces like *Gift of Icarus* (1962) and *Spring Landscape* (1962), and works made of rolled, pointed strips of stainless steel welded in open arrangements of arcs and French curves. Those sculptures seemed weightless and ready to fly; in fact, she mounted one (*Leda*, 1962) from a wire over the rooftops of the city.

Pepper began working regularly with cut and ripped Cor-Ten and stainless-steel forms which evolved, by 1966, into stacks of open mirrored boxes, painted cobalt blue inside. The mirrored sculptures (including *Fallen Sky*, 1967, and *Excathedra*, 1968), mounted in the open air, appeared to vanish into their surroundings, reflecting sky and earth. As Rosalind Kraus noted, the mirrors destroyed "one's sense of the inner surfaces, causing them to appear at times as exteriors, not of the same, but of different sculptures." Originally favoring vertical stacks, Pepper began to flatten and open her forms and extend them in unexpected angles along the ground. The perfect polish began to give way to a soft polished sheen, then to red rust, flat orange, red, or white paint, and the forms began to change from boxes and truncated prisms to progressions of flat triangles (typically, *Alpha*, 1973–75). By the early 1970s Pepper's work existed in a locus somewhere between Calder's late stabiles and Tony Smith's big primary shapes.

At the same time Pepper began to think in terms of environmentally scaled works. One of the first of these was *Dallas Land Canal and Hillside* (1971–75), a 300-foot-long work of black pyramids along a highway divider that was meant to be seen primarily from passing cars. Depending on the viewer's trajectory and speed, *Dallas Land Canal* seems to push out of the ground or plow back into it. *Thel* (1976–77), on the campus of Dartmouth College, was thematically similar to *Dallas Land Canal*; a series of white triangular steel shapes emerge along 135 feet of lawn; the last and tallest shape turns unexpectedly to reveal a ribbed interior. Another, even larger work was *Amphisculpture* (1974–76), a concrete and grass amphitheater covering an acre in Bedminster, New Jersey. The huge circle is split by two huge wedges that create enormous tension at their meeting points. *Amphisculpture* is the best realization of Pepper's desire to make the environment part of her work. "I want people to walk through the works, to experience them. . . . What you try to do is to set up a situation in which people will want to participate." She has continued to develop ideas for massive public works, recently creating *Cromech Glen* for Laumeier International Sculpture Park in St. Louis in 1985 and beginning preliminary planning for a huge park, *Sol i Ombra*, to be constructed north of Barcelona. *Sol i Ombra*, a spiral of trees opposed by snaking curves of blue mosaic-covered walls, is an homage to the architect Gaudi.

Partly in reaction to the immense demands of creating huge public sculptures, in the late 1970s Pepper began to develop a second, very different style of working. Drawing on a variety of formal sources, including ancient Roman columns, the totems of Brancusi and Henry Moore, and, most important, the forms of chisels, punches, augers, and other handmade tools she had been collecting, Pepper began to create massive columns of cast metal. In 1979 she installed four of these huge (up to thirty-six feet high) rust-colored works in the piazza of Todi, Italy. The columns, though plainly derived from modern industrial shapes, had a primordial weight and presence: they reflected, according to Krauss, Pepper's "drive toward monumentality." Soon she began combining the columns into groups (*Moline Markers*, 1981), and drawing on the shapes of altarpieces and votive statuary to create what she called "urban altars" (*Ternana Wedge*, 1980, was the first of these). The urban altar series, based on the human torso and decidedly two- rather than three-dimensional, continued into the 1980s with such works as *Earthbound Altar* (1986) and a number of *Janus Altarpieces*, some painted in deep shapes of blue and red.

In 1982–83 Pepper began showing a related series of narrowly vertical sculptures of turned wood, bronze and iron castings, and forged steel.

Ranging in height from six to twelve feet, these scepterlike pieces were composed of stacked forms derived from handtools, Egyptian, classical, and art deco column decorations, and machine parts. Like Brancusi, Pepper incorporated base elements into the entire work (for example, in *Constantine Ritual*, 1982–83, which appears to balance on a floor-mounted parabola of steel). Several of the works are painted with expressive brushwork in shades of violet, cerulean, orange, and black, sometimes offset by chromed sections (as in *Livy Column*, 1985). Noting that the artist prefers to show these works in groups, the critic Kenneth Baker praised their "familial aspect . . . a sculptural analogy to the common humanity, rather than to the physical individuality, of the work's viewers [that] makes the abstractness of her work inspiriting rather than alienating."

Pepper has lived in a rebuilt castle just outside Todi, Italy, since 1972. Her studio-factory is equipped with a large forge and every kind of metal-forming and metal-bending machinery. The artist, who favors denims and knee-high leather boots, is known for her force of will and grand ambitions. "She makes no bones about her allegiance to an aesthetic of formal beauty, to an art intended to be universal, transcending the personal life of the individual artist," wrote Barbara Rose. "What really interests me," Pepper claims, "is turning my fantasies into reality."

EXHIBITIONS INCLUDE: Gal. dello Zodiaco, Rome 1952; Barone Gal., NYC 1954, '56, '58; Obelisk Gal., Washington, D.C. 1955, and Rome 1959; Gal. Schneider, Rome 1956; Gal. Pogliani, Rome 1959; Thibault Gal., NYC 1962; Marlborough Gal. d'Arte, Rome 1965, '68, '72; McCormick Place, Chicago 1966; Jewish Mus., NYC 1968; d'Arte La Bussoka, Turin 1968; Gal. Paolo Barozzi, Venice 1968; Marlborough-Gerson Gal., NYC 1969; Mus. of Contemporary Art, Chicago 1969; Hayden Court/Plaza, Massachusetts Inst. of Technology, Cambridge 1969; Albright-Knox Gal., Buffalo 1969, '87; Everson Mus. of Art, Syracuse, N.Y. 1970; Studio Marconi, Milan 1970; Rotonda della Besane, Milan 1970; Parker St. 470 Gal., Boston 1971; Gal. Hella Nebelung, Dusseldorf 1971; Piazza Margana, Rome 1971; Gal. Editalia qui Arte Contemporanea, Rome 1972; Tyler School, Temple Univ., Rome 1973; Andre Emmerich Downtown, NYC 1975; Hammarskjold Plaza, NYC 1975; Indianapolis Mus. of Art 1977; Andre Emmerich Gal., NYC 1977, '79, '80, '82, '83, '84; Art Mus., Princeton Univ., N.J. 1978; Hofstra Univ., Hempstead, N.Y. 1979; Piazza Mostra and Sala delle Pietre, Todi, Italy 1979; Thomas Segal Gal., Boston 1980; Nina Freudenham Gal., Buffalo 1980; Gimpel and Hanover and Andre Emmerich, Zurich 1980, '83; Greenberg Gal., St. Louis 1980; Makler Gal., Philadelphia 1981; Linda Farris Gal., Seattle 1981; Davenport Art Gal., Iowa 1981; Hanson, Fuller and Goldeen Gal., San Francisco 1981; Laumeier Intl. Sculpture Park, St. Louis 1982; Gal. il Ponte, Rome 1982; Yares Gal.,

Scottsdale, Ariz. 1982; Huntington Gals., W.Va. 1983; John Bergruen Gal., San Francisco 1985; Brooklyn Mus., N.Y. 1987. GROUP EXHIBITIONS INCLUDE: Palazzo dello Esposizioni, Rome 1954; "Contemporary Italian Art," Wakefield City Art Gal., U.K. 1954; "The Guest and the Quarry," Rome-NY Foundation, Rome 1961; "Sculture nella citta," Spoleto 1962; "Sculture in metallo," Gal. Civica d'Arte Moderna, Turin 1964; Jewish Mus, NYC 1967; "Jewelry by Contemporary Painters and Sculptors," MOMA, NYC 1967; "Plus by Minus: Today's Half Century," Albright-Knox Gal., Buffalo 1968; "Painting and Sculpture Today," Indianapolis Mus. of Art 1970; "Ommaggio a Roma," Gal. Nazionale d'Arte Moderna, Rome 1970; "Arts Festival XII," Jacksonville Art Mus., Fla. 1970; "XXXVI Biennale," Venice 1972; "Jewelry as Sculpture as Jewelry," Inst. of Contemporary Art, Boston 1973; "Twentieth-Century Monumental Sculpture," Marlborough Gal., NYC 1974; "Monumental Sculpture in the 1970s," Janie C. Lee Gal., Houston 1975; "Renaissance in Parkersburg," Parkersburg Art Cntr., W.Va. 1975; "IX Intl. Sculptor's Conference," New Orleans Mus. of Modern Art 1976, Documenta 6, Kassel 1977; "Drawings for Outdoor Sculpture," John Weber Gal., NYC 1977; "Private Images: Photographs by Sculptors," Los Angeles County Mus. of Art 1977–78; "Perspective 78—Works by Women," Freedman Gal., Albright Col., Reading, Pa. 1978; "Earthworks: Land Reclamation as Sculpture," King County Administration Bldg., Seattle 1979; "Drawings," Nina Freudenberg Gal., Buffalo 1980; "Art in Embassies," State Mus. of Art, Copenhagen 1980; "Sculpture at Sands Point," Nassau County Mus., N.Y. 1980; "Across the Nation," National Collection of Fine Arts, Smithsonian Instn., Washington, D.C., and Hunter Mus. of Art, Chattanooga, Tenn. 1980–81; "Area Sculpture—Ward's Island," Manhattan Psychiatirc Cntr., NYC 1980–81; "All in Line," Lowe Art Gal., Syracuse Univ., N.Y. and Terry Dintenfass Gal., NYC 1980–81; "Three Dimensional," Women in Focus, Vancouver, Canada 1981; "Outdoor Sculpture Exhibition," Palo Alto, Calif. 1981; "Casting: A Survey of Cast Metal Sculpture in the 1980s," Fuller Goldeen Gal., San Francisco 1982; "Born in Brooklyn," Rotunda Gal., Brooklyn, N.Y. 1983; "Sculpture," Janie C. Lee Gal., Houston 1983; "Sculpture as Architecture," Thomas Segal Gal., Boston 1983; "Iron Cast," Pratt Manhattan Cntr., NYC and Pratt Inst. Gal., Brooklyn, N.Y. 1983; "Bronze at Washington Square," Public Art Trust, Washington, D.C. 1983–84; "Sculpture: The Tradition in Steel," Nassau County Mus. of Fine Art, N.Y. 1983–84; "Vitalita deli'astrattismo," Comune di Foligno, Perugia, Italy 1983–84; "20th Century Sculpture: Selections from the Metropolitan Museum of Art," Storm King Art Cntr., Mountainville, N.Y. 1984; "Seven Sculptors," Andre Emmerich Gal., NYC 1984; "Works in Bronze: A Modern Survey," Univ. Art Gal., Sonoma State Univ. Calif. 1984; "American Sculptors: Three Decades," Seattle Art Mus. 1984–85; "Contemporary Classics," Andre Emmerich Gal., NYC 1984–85; "Public and Private: American Prints Today," Brooklyn Mus., N.Y. 1986.

COLLECTIONS INCLUDE : AT&T Corp., Bedminster, N.J.; Albertina Mus., Vienna; Albright-Knox Gal., Buffalo;

Atlantic Richfield Co., Los Angeles; Brooklyn Mus., N.Y.; Dartmouth Col., N.H.; Davenport Art Gal., Iowa; John Deere Foundry, East Moline, Ill.; Everson Art Mus., Syracuse, N.Y.; Federal Reserve Bank, Philadelphia; Fogg Mus., Cambridge, Mass.; Gal. Civica d'Arte Moderna, Florence; Hirshhorn Mus. and Sculpture Garden, Washington, D.C.; Richard J. Hughes Justice Complex, Trenton, N.J.; Huntington Art Gal., W.Va.; Indianapolis Mus. of Art; Inst. Italiano di Cultura, Stockholm; Jacksonville Mus. of Art, Fla.; Massachusetts Inst. of Technology, Cambridge; Metropolitan Mus. of Art, NYC; Milwaukee Arts Cntr., Wis.; Mount Holyoke Col., South Hadley, Mass; Mus. of Fine Arts, Boston; Parkersburg Art Mus., W.Va.; Charles Rand Penney Foundation, Olcott, N.Y.; Power Inst. of Fine Arts, Sydney, Australia; Rochester Art Mus., N.Y.; Rutgers Univ., New Brunswick, N.J.; Smithsonian Instn., Washington, D.C.; Vassar Col., Poughkeepsie, N.Y.; Walker Art Cntr., Minneapolis; Western Washington Univ.'s Outdoor Mus., Bellingham, Wash.; Worcester Art Mus., Mass.

ABOUT: Emanuel, M., et al. Contemporary Artists, 1983; Fry, E. F. Beverly Pepper, Sculpture 1971–75 (cat.), 1976; Krauss, R. Beverly Pepper: Sculpture in Place, 1987; Munro, E. Originals: American Women Artists, 1982; Rubeinstein, C. American Women Artists, 1982; Smagula, H. Currents: Contemporary Directions in the Visual Arts, 1983; Who's Who in American Art, 1989–90. Periodicals—Architectural Digest October 1979; Artforum December 1977, May 1979, October 1979; Art in America January 1980, April 1984; Art Journal Winter 75–76; ARTnews February 1985; Arts Magazine September 1975, December 1977, October 1983; New York Times December 30, 1983; Vogue May 1987.

PFAFF, JUDITH (September 22, 1946–), Anglo-American multimedia artist whose free-spirited, free-form installations and wall reliefs stand at the forefront of the mid-1970s sortie from minimalism. Breaking every imaginable canon of object sculpture—mass, gravity, and spatial coordinates, premeditation, permanence, and seriousness, among others—she has pioneered a personal yet publically accessible idiom of investing spaces with artistic form.

London-born Judy Baldwin was the younger child of an English mother and an Irish father who separated shortly after her birth. Her mother then went to Detroit, leaving the infant with friends in London; she never met her father and was seven years old before she learned of her older brother, Michael. "I have no fond memories of London," she declared in a 1983 interview with Paul Gardner, recalling that her early years were "difficult; I was a rebel—kicked out of every school in London for tardiness."

At the age of thirteen she rejoined her mother in the United States, crossing the Atlantic with her brother and grandmother on the Queen Elizabeth II. Although life in a Detroit ghetto was not much easier than London had been, she drew the attention of one of her junior-high-school teachers with her graphics and managed to get into a special high school for art. Nonetheless, by the time she was sixteen, she opted to break out of her environment altogether by marrying David Pfaff, an air force recruit twelve years her senior. For the three years they remained together, she followed him from one air force base to another. After their separation, she studied at Washington State University for one year, enrolled in art classes at Southern Illinois University two years later, and finally completed a B.F.A. degree at Washington University in St. Louis in 1971.

Pfaff's work at Washington University had consisted mainly of fanciful landscape paintings inspired by Kandinsky, but a stint at the Yale summer school just before her senior year set her in a new direction, largely owing to her encounter with the abstract painter Al Held. Through his sponsorship she got a scholarship for the M.F.A. program at Yale, where, she told Gardner, "I think we had an affinity for complex spatial arrangements." Under Held's tutelage, she began to transform the surface of her landscapes by adding found objects, ranging from fragments of wood and glass to seashells and rubber bands, and then abandoned the frame, moving onto a ladder "as if I were floating with the art." For her master's thesis, she created an installation of "random events" on a twenty-foot wall; it was, she indicated, "about illusion, the play of shadows on such elements as sticks and glass." During that time, as she later indicated to Wade Saunders, she was closely following the work of the new generation of conceptual artists, such as Barry Le Va, Richard Tuttle, Alan Saret, Richard Serra, Bruce Nauman, and Robert Morris. "My work really does come out of that period," she told Saunders, but noted that she "increasingly . . . had a hard time with the idea that things were so right, so secure—that there were so many seemingly neat circles."

After graduation from Yale in 1973 Pfaff made her way to New York City, where she taught at Queens College and moonlighted as a print framer, floor tiler, and brownstone restorer. Among her New York art world discoveries were the sculptor Lynda Benglis and the painter Elizabeth Murray, but she was also inspired by the experimental theater productions of Robert Wilson and Richard Foreman, particularly because of the impermanent nature of their work. Abandoning painting altogether, she embarked on the problem-solving ventures typical of conceptual art—tracking the sun around her studio,

for example, or designing sculpture from unusual perspectives. "Basically my process then was to start at one end of the room and fill out the floor and just," she recalled to Susan Krane in 1980. "Then I'd sweep that up and start back again."

Her first two New York shows (at the Razor Gallery and Artists Space) consisted of very understated environments—reviewing the show at Artists Space in 1975, Alan Moore wrote that "the forms on Pfaff's walls are tentative to the point of pathos." But over the next few years, the geometric abstractions she had initially applied to monochrome walls and floors evolved into installations of stylized freestanding figures which had decidedly human characteristics and were, according to Pfaff, based on "very real personal dilemmas and actual people I knew."

As Roberta Smith has pointed out, most of Pfaff's early installations were done outside of the New York scene (and the artist herself was teaching as far afield as Ohio State University and the California Institute of the Arts). "There was a hit-and-run aspect to the way she would come to town, install a piece, and be gone," wrote Smith in a 1986 essay, suggesting that "in all, the installation format may have been perfectly suited to the combination of ambition, insecurity, and nervous energy that comes across when Pfaff talks about her early years. She couldn't sit still, and she didn't want her art to either." Thus, in *Prototypes*, for example, a 1978 installation at the Los Angeles Contemporary Exhibits Gallery (LACE), Pfaff peopled the exhibition space with what she called a "crowd" of contact-paper-covered figures to create, in the words of the *Art in America* reviewer Barbara Noah, "a crazed gymnasium of activity, a population of wildly varying humanoids that seemed loaded with internal energy."

An early turning point in Pfaff's work came with her first museum piece, *Reinventing the Wheel* (1979), done for a group show at the Neuberger Museum in Purchase, New York, where she was able to dispose her brightly colored constructivistlike figures across a large (100´ x 50´ x 30´) space. Professionally, she also benefited from the museum's proximity to the New York dealer Holly Solomon, who was so impressed with the installation that she drove her clients out to Purchase to see it. Pfaff soon found herself involved in the contemporary museum-lecture-conference circuit.

At the beginning of the 1980s Pfaff made a major formal breakthrough with three installations—*Quintana Roo* (1980), *Deepwater* (1980), and *Formula Atlantic* (1981)—that broke with the remaining conventions of spatial orientation. The first two were directly inspired by underwater landscapes Pfaff saw while snorkeling off the coast of Mexico. *Quintana Roo*, she explained to Michael Auping shortly afterward, was "about the surface, that interface where one world slipped suddenly into another. . . . *Deepwater* went further. In the ocean, the deeper you go, the less light there is and the stranger the life forms become." The formal vocabulary for that work became more abstract and visually more dense. There were fewer fixed reference points. With its swatches of aquatic colors on the walls and completely unoriented confections of Day-Glo-painted wire, plastic net, and wicker suggesting the flora and fauna of the ocean floor, *Deepwater* was, in the words of John Perrault, "like an explosion in a Canal Street plastic shop." That spirit was exuberantly maintained in the installations that followed in 1981: *Rorschach*, a "fantasy mindscape" that "combined the best of Walt Disney and Clyfford Still" (Michael Auping). *Kabuki (Formula Atlantic)*, a hybrid mix of race-car culture and Japanese theater that Pfaff herself called "an erotic and fragrant exhibition"; the fiery *Dragon*, and the oneiric *Ziggurat*, a compact configuration of colored tree limbs and mirrored Plexiglas.

To create such installations, Pfaff amassed her tools and materials on the given site and then installed herself, so to speak, to work nonstop until, she told Paul Gardner, "the various shapes evolve concurrent with my feelings and emotions. . . . What interests me is energy and life and romance and passion. . . . We live in an unsettled, unstable world. . . . The nerve centers are constantly changing. An installation with its total openness allows me to plunge into that spacy void and edit the chaos into a dramatic and sensual environment." As more than one critic noted, the resulting effusions of color and form were like abstract expressionist paintings in 3-D, and Pfaff soon found herself numbered among neo-dexpressionists like Julian Schnabel and Jon Borofsky. While professing an interest in their work, the artist herself stressed her ties to Elizabeth Murray: Schnabel and Borofsky, she indicated to Michael Auping, "don't seem to have what Elizabeth has and what I think I have—worry and doubt, which I think is important for our kind of work." In fact, that mood soon became more evident in *Either War*, a "very impassioned piece" that Pfaff created for the 1982 Venice Biennale in response to the Falklands dispute and the Israeli invasion of Lebanon. A raucous assortment of cone/missile shapes cantilevered to the walls and rising ominously from the floor, *Either War* was, according to Pfaff, "about sound cracking over your head . . . fast and very abstract, with blinking

lights. The language of the piece was tougher, very heavy, solid—very different from what I've shown in New York."

With *3-D* (1983), one of her most frenetic pieces to date, Pfaff reached a plateau of sorts: she felt that the piece contained "everything I knew," and, in fact, it was two and a half years before she undertook her next installation, *Gu Choki Pa,* for the Wacoal Art Center in Tokyo. In the interim, she began working with more substantial and permanent forms—wall reliefs. The four-part "Badlands" series, which came out of a teaching stint in Maine the summer after *3-D,* combined real tree branches and treelike metal tubes into heavy, imposing relief structures measuring ten or eleven feet across. A trip to Japan the following summer introduced her to latticework, which became a new and more open support, once again disorienting the viewer by masking structural relations.

Her emphasis on disorientation was to carry over to the Tokyo installation and the three-part wall relief called *Superette* that she created on her return from Japan for a group show at the John Weber Gallery. In a catalog statement for that exhibit, she explained, "Initially I worked with a more cubist space, altering time and structure through the layering and fracturing of elements. The point of reference in my work is now more about vortices. I try to achieve a sense of spinning, being thrown visually as well as physically into the work." Other reliefs followed in a show at the Holly Solomon Gallery called "Apples and Oranges," where, as in *Superette,* mass-culture artifacts like supermarket signs, plastic fruits, and metal flowers now replaced the raw materials that she had used previously. In the title piece, *Apples and Oranges,* for example, brightly painted metal woks, aluminum spheres and discs of Plexiglas and carved wood balloon out from the wall with apparent (but deceptive) weightlessness. In contrast to the spontaneity of the installations, the reliefs were the result of prior planning and design: "Each sculpture," noted Lorraine Karafet in *ARTnews,* "is a carefully plotted composition with as much attention to formal arrangement as one of Cézanne's paintings of apples and oranges." At the same time, the effect was every bit as electric as that of the installations, and the mood considerably more upbeat, if not festive—in Pfaff's words, "hot rather than cold, fat rather than lean, accessible rather than hard to get at."

Pfaff herself, an attractive woman with an engaging smile, also gives the impression of warmth and accessibility. She lives with her cat, Eva, in a loft in Manhattan's Tribeca and works out of a studio in the industrial Greenpoint section of Brooklyn. As *Time* reviewer Robert Hughes suggested, "A few more artists like her and the '80s might be an interesting decade."

EXHIBITIONS INCLUDE: Webb and Parsons Gal., Bedford, N.Y. 1974; Artists Space, NYC 1975; Univ. South Florida, Tampa 1977; LACE, Los Angeles 1978; Neuberger Mus., Purchase, N.Y. 1979; Holly Solomon Gal., 1980, '83, '86; Rorschach, John and Mabel Ringling Mus. of Art, Sarasota 1981; Univ. of Massachusetts, Amherst 1982; Bennington Col. Art Gal., Bennington, Vt. 1982; Hallwalls, Buffalo, 1982; Albright-Knox Art Gal., Buffalo 1982; Venice Biennale 1982; Daniel Weinberg Gal. Los Angeles 1984; Knight Gal., Charlotte 1986; Susanne Hillberry Gal., Birmingham, Mich. 1987. GROUP EXHIBITIONS INCLUDE: Razor Gal., NYC 1973; 112 Greene Street, NYC 1975; Whitney Biennial, 1975; "Approaching Painting," Hallwalls Gal., Buffalo, N.Y. 1976; "New Work/New York," Univ. of Calif., Los Angeles 1976; California Inst. of the Arts, Valencia 1977; Artists Space, NYC 1978; "10 Artists/Artists Space," Artists Space, NYC 1979; "Canal Street," Barbara Gladstone Gal. 1979; "Extensions: Jennifer Bartlett, Lynda Benglis, Robert Longo, Judy Pfaff," Contemporary Arts Mus., Houston 1980; "Walls!" Contemporary Arts Cntr., Cincinnati 1980; Venice Biennale 1980, '82, '84; "Drawings: The Pluralist Decade," Inst. for Contemporary Art, Univ. of Pennsylvania, Philadelphia 1980; Whitney Biennial, 1981, '87; "Directions 1981" Hirshhorn Mus. and Sculpture Garden, Washington, D.C. 1981 "New Directions: Contemporary Art from the Commodities Corporation" (trav. exhib.) 1981–83; "Zeitgenossische Kunst seit 1939," Stadt Koln, Cologne 1981; "Post-modernist Metaphors," Alternative Mus., NYC 1981; "Body Language: Figurative Aspects of Recent Art," Hayden Gal., Massachusetts Inst. of Technology, Cambridge, Mass. 1981; "Energie New York," ELAC Centre d'Echanges, Lyon 1982; "New York Now," Kestner Gesellschaft, Hanover; Kunstverein, Munich; Mus. Cantonal des Beaux-Arts, Lausanne; Kunstverein, Düsseldorf (trav. exhib.) 1982–83; "Back to the USA," Kunstmus., Lucerne; Rheinische Landesmus., Bonn; Kunstverein, Stuttgart (trav. exhib.) 1983–84; "New Art," Tate Gal., London 1983; "Contemporary Drawing as Idea," Sarah Lawrence Gal., Bronxville, N.Y. 1984; "An International Survey Recent Painting and Sculpture," MOMA, NYC 1984; "A Decade of New Art," Artists Space, NYC 1984; "A New Beginning," Hudson River Mus., Yonkers, N.Y. 1985; "Eddies," Visual Arts Mus., NYC 1985; "Illuminating Color," Pratt Inst., Brooklyn, N.Y. 1985; "Working in Brooklyn/Sculpture," Brooklyn Mus., N.Y. 1985; "Vernacular Abstractions," Wacoal Art Cntr., Tokyo 1985; "Wall Works," John Weber Gal., NYC 1986. "Indoor/Outdoor Sculpture Exhibition," El Bohio, N.Y. 1986.

COLLECTIONS INCLUDE: Albright-Knox Art Gal., Buffalo, N.Y.; Contemporary Arts Cntr., Cincinnati; Saatchi Collection, London; Whitney Mus. of American Art, NYC; Hirshhorn Mus. and Sculpture Garden, Washington, D.C.

ABOUT: Cathcart, L. "Extensions: Judy Bartlett, Lynda Benglis, Robert Longo, Judy Pfaff" (cat.), Contemporary Arts Mus., Houston, 1983; "Judy Pfaff: Installations, Collages and Drawings" (cat.), John and Mabel Ringling Mus. of Art, Sarasota, Fla., 1981; "Judy Pfaff: Collages and Constructions" (cat.), Hallwalls Gal., Buffalo, 1982; McClintic, M. "Directions 1981" (cat.), Hirshhorn Mus. and Sculpture Garden, 1981; Smith, R. "Judy Pfaff: Autonomous Objects" (cat.), Knight Gallery, Charlotte, N.C., 1986; Watson-Jones, V. Contemporary American Women Sculptors, 1986; Who's Who in American Art, 1989–90. Periodicals—Art in America September–October 1982, December 1982, November 1985; ARTnews Summer 1983, November 1986; Arts Magazine December 1973, September 1982, October 1986; SoHo Weekly News (NYC) September 24, 1980; Village Voice February 1, 1983.

POIRIER, ANNE AND PATRICK

(1942– ; 1942–), French sculptors, mixed-media artists. The Poiriers are best known for their sculptural (re) constructions of ancient palaces, burial grounds and cities, and of sites and incidents mentioned in mythology and classical literature. In doing the research for their art work, they have traveled extensively in Europe, the Near East, and Asia, visiting ruins and archaeological digs. Though they often include documentation as part of their pieces and though some of their works are done to scale, their aim is not merely (or at all, in certain works) to recreate a ruin, but rather to explore the effects on the contemporary mind of ancient forms and geometries, concepts of order, and designs for living—in short, to explore the resonances of the ancient mind. As the Poiriers wrote in the Bulletin of the 1983 Festival d'Automne, "Archeology, architecture, mythology are the privileged metaphors for calling into being the phenomena of the unconscious. That's because the most widely separated mythologies, the most ancient and remotest places still interest man today; intuitively he knows that in some way there is a connection between these lost worlds and an unknown part of himself."

Anne and Patrick Poirier were born in Marseille and Nantes, respectively, in 1942. They met and married while students at the Ecole des Arts Decoratifs in Paris. Anne was enrolled as a painter, Patrick as a sculptor. From 1970 to 1973 they lived in Italy, supported by a Prix de Rome. Since 1967, they have done sculptures of the Domus Aurea (Nero's palace), the gardens of the Villa Medici, and the Villa Pamphili. The Poirier's early works tended to be essentially faithful recreations of the sites they selected.

The couple's first individual show in New York City was at the Sonnabend Gallery, where in early 1974 they exhibited Isola Sacra, a rendering of an ancient burial ground at the mouth of the Tiber. After visiting the site, the Poiriers returned to Paris (where they live and work) to make their piece. They have executed works in marble and have molded paper and made death masks and collages from archaeological documents and color photographs of the site. Gerrit Henry, reviewing the show in ARTnews (March 1974), described Isola Sacra as "a larger-than-life travel folder extolling the myriad beauties and mysteries of a cemetery." He found it "witless, leaden, and highly questionable art."

Ida Panicelli, an Italian critic who has followed the Poiriers' work since the late 1960s, described their art differently: "[Their] method [is] between history and myth and that of fantasy and dream, the two paths meeting in the end product, the work. . . . The most interesting aspect of the Poiriers' work: their rambling among ruins does not carry the stench of death; the stopovers along their physical and mental journeys have the sense of something lived. Their work goes beyond a conceptual evocation that draws on memory to become a present realization of a desire, an investigation of the roots of an ancient utopia—that of the imagination."

In 1978–79, the Poiriers exhibited an imaginary ancient town on the floor of the Galerie Sonnabend in Paris. Not yet ready to make a total leap of the imagination, the artists used the Pantheon as a sort of "bridge." They used the negative space of the dome's interior coffers as "molds" from which they created pyramidal structures (seven groups of 100 pyramids). These they assembled, with other structures, into a "town." A particularly interesting feature of this work—and a recurrent theme throughout the Poiriers' oeuvre—are the numerous miniature flights of stairs. Steps often survive longer than other parts of a building and therefore tend to be well represented at archaeological sites; it is the reason for their survival that intrigues the Poiriers. Stairs tend to be more geometrically perfect than other parts of buildings, as their fight against gravity is a harder one.

Unstable Stability (The Falling Tower), which the Poiriers erected especially for the space at the Philadelphia College of Art in 1980, explores the flip side of their fascination with survival against time. That installation consisted of a leaning white wooden tower constructed on the diagonal from the room's entrance. The tower, which reached almost to the ceiling, was bisected by forty-four steps built on one-half scale. Ann Jarmusch, reviewing the exhibit in ARTnews (March 1980), found that the installation recalled Pisa and the Jai Singh observatories in India. "Disorientation, vertigo, ambiguity—

these were the Poiriers' goals." But the artists accomplished this with a certain amount of playfulness. On one side of the tower was a miniature doorway and miniature steps. An adult could stand inside the doorway, but canted; the floor literally slanted away from his feet. The air shaft overhead admitted "a square beam of golden light," reminiscent for Jarmusch of that in medieval Italian towers. Six schematic drawings documented the evolution of the project. Included are all the mathematical calculations the couple had to make in order to erect the piece. The tower was first built years before in miniature as part of *Domus Aurea*, an indication of the evolution of the artists' point of view with regard to their work. In a commentary written to accompany *Unstable Stability*, the Poiriers pinpointed their concern: "There is a *time* of collapsing, during which the movement of the fall is suspended in empty space. . . . We tried to stop the collapse at [its] precise moment."

In 1979–80, the Poiriers were guest teachers at Harvard. While there, they completed (among other works) "Lost Archetypes," in which the ancient architecture is wholly imagined, the ruins wholly fictive. *The Temple of 100 Columns*, one of three archetypes, is a small-scale plaster model of imaginary ruins—some of the columns were broken, and some lintels were missing or partly smashed. Placed in the center of a white-walled, white-lit room in which viewers walked around it in very narrow walkways, *The Temple* was mounted on a square platform at about hip-height (on an average adult). Kenneth Baker, reviewing the exhibit for *Artforum* (September 1980), found that "at first, this fictive ruin seems to be about miniaturization, but when you see people passing around it, you realize it may be about magnifying the human form of the spectator. Peering into the center of the work, people loom over it like gods or giants, their movements, their very lives made to seem ponderously slow, relative to the hypothetical ages condensed in the process of simulating ruin by time." But this is a highly mysterious work. As Baker observed, "The process of looking at these structures under intense white light is a peculiar experience of seeing. All appearances seem to be raised to an unnatural pitch without really gaining in definition."

Douglas Blay, reviewing the "Lost Archetypes" for *Arts Décoratifs*, brought a different perspective to bear. "Archetypes were once classical conceptions of order, of perfection itself; before they were thrown into time, their whiteness must have been blindingly pure; their geometries, intact, surely sang in harmony with the spheres. . . . The spirit of geometry haunts them all, but it is everywhere implied and no-

where to be seen. The Doric column—the purist's order, the geometrician's dream; celebrated for its rationality, its tenure as a symbol of architectural perfection; its ideal 'Greekness' (not the Atomists Greece but the realm that claims Plato and Pythagoras as its only citizens) is in tatters; not one is as it might have been, a reference to an implied state of grace." Endless Colonnade, also part of "Lost Archetypes," is a structure of remarkable simplicity. Rising twenty-five and a half feet in the air, seventeen inches wide and eight inches deep, the colonnade is made of plaster and wood and has fluorescent light running along its entire vertical length. This piece makes a clean break with the Poiriers' earlier work, much of which invites storytelling. Why is the temple in ruins? Why was the city destroyed? Because of the Plague? War? Drought? Flood? While the wonderment inspired by *The Temple* derives from its explicitness, the strength of *Endless Colonnade* is in its suggestiveness, a suggestiveness with no relation to conventional narrative. "Instead," wrote Blau, "we are asked to focus our attention solely upon the presence of invented (but familiar) forms and to ponder the idea of their potential purity." Blau contrasted the Poiriers with Sol LeWitt, who, he wrote, "tries to render abstractions, to give invisible things shape. . . . The Poiriers, seemingly aware that LeWitt's approximations are merely *illusions*, have wisely chosen to *allude* to perfection; their archetypes (lost and ruined by time) hint at it, point to it, and tempt us to make responsibility for imagining form in full. Here things of the mind are things of the mind."

Oriental Dream (1981) is an installation made in a spirit kindred to that of the "Lost Archetypes"—particularly *Endless Colonnade*. Four panels—of wood, brilliant blue tempera, and gold leaf—are arranged in twos against two walls with a common corner. The bodies of the panels are blue, the tops—each somewhat different, each suggesting either a type of minaret, a mosque, or a pyramid. These simple pieces are terribly evocative. The blue calls up the water in Arab gardens—one can almost hear its trickle—the blues of mosques, the desert sky. The opulence of the gold leaf opens the imagination in a different direction—its suggestion is of people—of tea sets and jewelry and the marketplace—and of the slightly metallic quality to certain Arabian melodies. The power here is of the dream not wholly remembered—in delicious languor, we try to recapture the details of the vision, all the while relishing its gorgeous contours.

In 1983 the Poiriers did the enormous "Paysage Foudroyé" (Thunderstruck Landscape), consisting of The *Landscape* (39 X 19 1/2 X 2 feet), *The Death of Enceladus* (14 1/2 X 19

1/2 X 13 feet) and *The Death of Mimas* (9 3/4
X 22 3/4 X 16 feet). In Greek mythology, En-
celadus and Mimas, sons of Gaïda the Earth,
conspired against Jupiter, who smote them: En-
celadus was buried under rocks Jupiter threw
down at him from Mount Olympus; Mimas
drowned in a flow of hot lava activated by Bul-
can. Both Giants are represented solely by their
eyes. Enceladus's eyes are molded in one piece
of shattered Carrara marble; Mimas's bronze eye
is flanked by the thunderbolts hurled at him by
Jupiter. From Mimas' enormous eye trickles a
slender stream of water (tears? blood?). The Gi-
ants are located on either side of the thunder-
struck landscape—black, burned, a battlefield
with no trace of another human body. Claude
Gintz, writing in *Art in America* (April 1984),
drew a connection between the classical myth
and Freud's theory that "damaging or losing
one's eyes is a terrible fear of childhood. . . .
Morbid anxiety about the eyes is often enough
a substitute for the fear of castration." According
to Gintz, "The Poiriers' conjunction of Oedipal
imagery with a myth of violent rebellion and its
repression resulted in a powerful image of (per-
haps even an apologia for) the mechanisms of
domination." Like all of the Poiriers' art works,
this one seems to keep its share of secrets. Gintz's
interpretation has substance, especially as the
Poiriers represented only the Giants' defeat and
not their revolt ("what was ultimately affirmed
was the triumph of rationality over chaos, of law
and order over anarchy, of the superego over
subterranean impulses," wrote Gintz). Still the
scale of this work is grand and it is hard to recon-
cile such enormity and weight with *utter* loss. It
is the tension—*implied*—that helps make this
piece so strong; for there to have been an earth-
scorching reprisal, the threat must have been
powerful indeed.

In the winter of 1984 at the Sonnabend Gal-
lery in New York City, the Poiriers exhibited an-
other work inspired by myghology. Made of
charcoal, plaster, wood, and blue pigment, Pega-
sus measured 42 X 92 X 61 1/2 inches. The deli-
catly gorgeous animal, seemingly unaware of its
own ethereal blue glow, lifts two legs in a stage-
ly, but unaffected, canter. In mythology, it was
with a stamp of his foot that Pegasus caused Hip-
pocrene, the fountain of the Muses, to issue from
Mount Helicon. How simple is this explanation
for the beginning of the flow of the creative
juices—and how infinitely mysterious. That the
Poiriers do not seek to capture or explain the
enigma but rather to recreate Pegasus in all his
pristine (another enigma when considered in the
context of the creative process) glory, goes to the
heart of the Poiriers' very powerful art.

EXHIBITIONS INCLUDE: Arco d'Alibert, Rome 1970, '81;
Gal. Paul Maenz, Cologne 1972, '75, '77, '79; Gal. Son-
nabend, Paris 1973, '74, '77, '78, '79; Sonnabend Gal.,
NYC 1974, '78, '80, '84; Cntr. d'Arts Plastiques Con-
temporains, Bordeaux 1977; Neue Berliner Kunst-
verein, Berlin 1977; Cntr. Georges Pompidou, Paris
1978; MOMA, NYC 1978; Bonner Kunstverein, Bonn
1978; Palais des Beaux Arts, Brussels 1978; Philadel-
phia Col. of Art, 1979; Carpenter Cntr. for the Visual
Arts, Harvard Univ., 1979, '80; Palazzo dei Diamanti,
Ferrare 1979; Studio G7, Bologna 1980; P.S. 1, NYC
1980; Daniel Templon, Paris 1981; Villa Romana,
Florence 1981; Festival d'Automne, Paris 1983; Chiesa
di San Carpofore, Milan 1983; GROUP EXHIBITIONS IN-
CLUDE: Universal Exposition, Osaka-French Pavillion,
1970; "Biennale des Jeunes," Mus. d'Art Moderne, Par-
is 1971; "Projekt 74," Kunsthalle, Cologne 1974;
"Tempo e Ricognizione," Gal. La Bertesca, Milan
1974; "34th Exhibition," Society for Contemporary
Art, Art Inst. of Chicago 1975; Venice Biennale 1976;
"Art et Photographie," Maison de la Culture, Rennes,
1976; "Illusions of Reality," Australian National Gal.,
Canberra 1976; "Identite, Identification," Cntr. d'Arts
Plastiques Contemporains," Bordeaux 1976; Docu-
menta 6, Kassel, West Germany 1977; "Europe in the
70's: Aspects of Recent Art," Art Inst. of Chicago 1977;
"Imaginary Worlds," Rosa Esman Gal., NYC 1979;
"Architectural References in the Seventies," Los Ange-
les Inst. of Contemporary Art 1980; "Tendances de
l'art en France 1969–1979, parti pris autres," ARC,
Mus. d'art Moderne de la Ville de Paris 1980; Venice
Biennale 1980; "New Concepts for a New Art, Mus. of
Modern Art, Toyama 1981; "Twelve Contemporary
French Artists," Albright-Knox Art Gal., Buffalo 1982;
"Connections," Inst. of Contemporary Art, Univ. of
Pennsylvania, Philadelphia 1983; "Individualites,"
Gal. National d'Art Modern, Rome 1984; Venice Bien-
nale 1984; "Collaboration," Hirshhorn Mus. and Sculp-
ture Garden, Smithsonian Instn., Washington, D.C.
1984.

COLLECTIONS INCLUDE: Cntr. National d'Art Contem-
porain, Paris; National Mus., Jerusalem; Neue Gal.,
Aachen, Germany; Mus. of Modern Art, Krefeld, Ger-
many; Mus. of Modern Art, Sydney, Australia; Smith-
sonian Collection of Fine Arts, Washington, D.C.;
Montreal Mus. of Fine Arts; Australian National Gal.;
Tate Gal., London; Mus. d'Art Contemporain, Montre-
al.

ABOUT: A la Memoire de Romulus, 1974; Les Paysages
Revolus, 1975; Les Realites Incompatibles, 1975.
Periodicals— Architectural Review April 1979; Art
and Artists September 1974; Artforum February 1977,
February 1980, September 1980, February 1982; Art
in America April, September, December 1984; ART-
news March 1974, March 1980; Arts Magazine April
1980, December 1980, January 1982; Craft Horizon
December 1978; Flash Art April/May, December
1984; Siecle December 1978.

POLKE, SIGMAR (February 13, 1941–), German painter and photographer, began working and exhibiting internationally in the early 1960s, though his art did not begin to receive attention in the United States until 1982, when he had his first New York-based solo show. Perhaps the "ultimate 'post-Modern' artist," as characterized by Russell Bowman in his introduction to the "Warhol, Beuys, Polke" 1987 catalogue, Polke, using a mélange of techniques and materials, "is freely reshuffling the imagery of popular culture and art history into enigmatic questionings of the nature of meaning."

Polke had his earliest education in Silesia, East Germany, where he was born, but it was in 1953 at the age of twelve, when he moved to Düsseldorf, that he was awakened to the rampant modernism of West Germany, Paris, and New York. Polke began studying at the Düsseldorf Academy of Fine Arts in the late 1950s, and from 1961 to 1967, he was enrolled at the Staatliche Kunstakademie in Düsseldorf, where he was a student of Joseph Beuys. As a young, postwar, German artist, Polke was making sense of contemporary society and consumerism, while still trying to absorb his history, especially the legacy of German expressionism. His summarization of modern living in his art began to reflect an assimilation of these forces.

In the early 1960s, he began a collaboration with two other German artists, Gerhard Richter and Konrad Fischer-Lueg, on a project that became known as *Kapitalistischer Realismus* ("capitalist realism"), a German variant of American and British pop art. In contrast to the vibrant, glossy, and impersonal paintings of American pop artists such as Roy Lichtenstein, Polke's pieces were intentionally colorless and crude and it was always evident that the artist's hand was involved in the process of making the art, which strove to emphasize the interference that the human hand generates in the attempt to create a perfect image. The capitalist realists' aesthetic stance vis-a-vis popular culture was not an embrace of it, but instead they chose to question it through satire and thereby explore its impact on society. Their work can also be understood as playful taunts at earlier political movements in Europe, for example the artistically repressive reign of Socialist Realism, a propagandistic crusade endorsed by Stalin that commanded artists and writers to work in conventional realistic techniques while optimistically portraying socialist doctrines.

Polke's work during this period (1963–1969) basically fell into three practices: ballpoint pen or colored pencil sketches; gouache and watercolor drawings, often collaged with preprinted patterns like wallpaper or fabric; and benday dot paintings. The ballpoint pen sketches are mostly of German advertising images and common objects. "The witty production of a boring reproduction: that's the issue," wrote Donald Kuspit in *Art in America* (January 1988). The sketches do have a flippant, satiric air about them, in the casual way they were drawn and in the near-anonymous subject matter— phonographic records, peas, and sausages.

The gouache and watercolor drawings are executed in quick, gestural marks. These marks often coalesce into a figurative scene of flat space, as in *Reine Duo* (1966), in which a cartoonish-like couple is windowshopping for hats (they themselves wear none). From its title, *Pralinen* (1963), we assume we are looking at a drawing of three chocolates and in the child-like drawing *Winter Vacation for Everyone* (1963), Polke depicts a snowman in the center of a few purplish strokes of watercolor and ballpoint pen dots that signify snow. Seasonal messages like "good holidays" and "snow and sun" are scattered on the paper. Polke's use of irony in these paintings acts to demystify pop and abstract art, while at the same time leaving them open for new interpretation. For example, in *Höhere Wesen befehlen: rechte obere Ecke schwartz malen!*, 1969 (Higher Beings Command: Paint the Upper Right Corner Black!), Polke targets early abstract artists who believed that their work brought them in touch with higher beings and he pokes fun at the traditionally somber character of the Germans and at the authoritarian personality.

Polke's benday dot paintings look like magnified images taken from newspapers or advertisements. Often he magnifies (or breaks down) these images to the point where they are no longer recognizable; the canvas is merely a mass of dots. His earliest works in this style are cruder and less formal than his later pieces, which recall the more refined benday dot works of Lichtenstein or the silkscreens of the American pop artist Andy Warhol.

In 1987, the David Nolan Gallery in New York City exhibited a large collection of Sigmar Polke's drawings and watercolors from the 1960s and the response from critics was enthusiastic. Roberta Smith, in the *New York Times* (Nov. 6, 1987) called the show intriguing, and wrote, "It shows Mr. Polke exploring the different parts of his enigmatic, stylistically polymorphous sensibility. . . . One senses the artist's determination to make things that didn't look like art, that had about them an everyday anonymity. . . . " Meyer Raphael Rubinstein wrote in *Arts Magazine* (Feb. 1988), that Polke was "teaching himself the ABCs of capitalist consumer society,

but with a restraint, a kind of poverty induced by a consciousness of what it meant to be German."

In 1971 Polke took a series of photographs in Paris. His work in photography was mainly an investigation of the manipulations that can be made to the images in the print. He double-exposed and printed multiple negatives on one sheet of photographic paper and experimented, almost expressionistically, with the application of photographic chemicals that created hand-wrought, painterly effects. The photos, like his drawings and paintings, are of images of popular culture. One print in the Paris series depicts a tangle of film negatives; as a result one cannot see the original image. This dense overlapping of images or information breaks down the ability to transfer that information. Stephen Frailey, in the *Print Collector's Newsletter* (July–August 1985), compared looking at Polke's Paris photographs, which were on view in 1985 at the Alfred Kren Gallery in New York City, to the disorienting experience of flipping stations on a TV in a foreign country: "The familiarity of the medium is overwhelmed by the initially incomprehensible message."

Polke's recycled images often appear incomplete, undecipherable, and yet visually captivating. His strategy of manipulating and breaking down images to the point where they are no longer recognizable, tends to make the viewer question their understanding of their world. And while his art raises many questions, it rarely gives any answers. When he does make a piece that gives answers, for example one in which he writes "solutions" to equations (6+27, 4+45), he playfully makes suspect that which we take for granted to be true. Michael Brenson in the *New York Times* (Jan. 11, 1985) wrote that a major issue in Polke's art is memory. "The works are filled with phantoms and traces; what is present is never really fully present." He added, "How we respond to this work is likely to depend on whether we believe, in the end, that Polke's perversity is a device for making us care more deeply about what shadows him and all of us or whether it is ultimately a way of justifying self-involvement and distance."

Before his first one-man show in New York, Polke had been exhibiting in galleries in West Germany, Switzerland, and France, and had been in a few group shows in the United States. A major retrospective in 1976 in Tübingen and Düsseldorf, West Germany, firmly established Polke's standing as an artist in Europe, but it was his 1982 show at the Holly Solomon Gallery in New York City that launched his career in America. Thomas Lawson in *Artforum* (October 1982) shared the view of most critics and artists when he congratulated the gallery on "finally introducing Polke to New York. It is a scandal that he has never shown here before."

In 1984, Polke had his second solo show in New York at the Marian Goodman Gallery. Kay Larson in *New York* (June 4, 1984) called Polke's works "flinty and conceptually dense . . ." The works exhibited were again borrowed images, this time from grade-school and science textbooks and instruction manuals. One such painting was an image of a diagram taken from a physics textbook, of an eye looking at a candle, reflected in a mirror. Larson described it as a concoction "that is an illustration of transparency."

The Boymans van Beuningen Museum in Rotterdam, Holland, had a major show in 1983 of nearly eighty of Polke's paintings, most of which were made from 1979 to 1983. By then, he was applying layer upon layer of dripping oils and lacquers and working with glazes, "like an old master, while at the same time making use of chance spillages and freely allowing images to appear," as recounted by Saskia Bos in *Artforum* (June 1984). Paintings entitled *Halucinogen, Opium Raucher* ("Opium Smoker") and *Alice in Wonderland*, both from 1983, address the language of psychedelics. In *Alice in Wonderland*, a blue hookah-smoking caterpillar tells Alice that the mushroom will determine her metamorphosis.

Nightmarish images of the past also fill Polke's paintings—ovens, barbed-wire, and cages. *Lager* ("Camp"), a six-foot-tall painting exhibited in early 1985 at the Mary Boone Gallery, includes images of barbed wire, black clouds, and applied cut fabric suggests mattresses found in concentration camps. Polke also made little burn marks on the canvas and fabric. Most of these works still incorporate the humor that is characteristic of Polke. A 1984 acrylic and lacquer painting *Hochstand* ("Watchtower") depicts a menacing-looking watchtower floating on a backdrop design of seventies-style flower decals. Therese Lichtenstein, in a review for *Arts Magazine* (March 1985), wrote that in such works, Polke "appears to be parodying the recent monumental work of German neo-expressionist painters, in particular the apocalyptic imagery in Polke's contemporary, Anselm Kiefer."

The Mary Boone Gallery in New York City began representing Polke in 1985 with a solo exhibition of his new, abstract paintings. These consisted mainly of oil and lacquers that appeared to have been thrown at the canvas, creating dripping compositions. Flowing loops that

look as if they were mindlessly doodled on the works add a touch of frivolity to the paintings. Maurice Poirer described the works in *Art News* (February 1987) as showing "what appears to be a primeval world of unfathomable depth being shifted around by invisible cosmic forces." With these works, Polke was laying for himself a larger ground to experiment with paint as a material to create visually exciting objects. In a review for the *New York Times* (November 12, 1986) Joseph Masheck wrote, "A mess all this is, in a way, yet also gorgeous for anyone who can't get enough of the thrills of paint."

At the Venice Biennale in 1986, Polke represented West Germany with a project entitled "Athanor," or the alchemist's furnace. It included a 1,000 pound meteorite and a massive rock crystal that, as Max Weschler wrote in a review for *Artforum* (October 1986), "evoked evolutionary movements of the earth and the cosmos through epochs spanning millions of years." In his semi-circular mural in the center room of the pavilion Polke painted with a cobalt chloride pigment—a material that changes colors as the humidity and light in the room change. Polke's aim was to allow the painting to have its own individual existence. Paul Groot in *Flash Art* (May–June 1988) described this as Polke's interpretation of alchemy. He wrote that Polke "does not see paint as the carrier of color but as the color itself. . . . For him, what at first appears to be a restful color can actually be explosive as a material—as described by the theory of humors of medieval alchemy." Polke himself, in a conversation with Stephan Schmidt-Wuffen and reprinted in *Flash Art* (May-June 1988), said "When you set up your conditions, you also define your limits. But something can still happen inside of these limits, something you couldn't have foreseen! And only that, please, is what you want! I throw all the rest away. The unforeseeable is what turns out to be interesting."

With fourteen new paintings exhibited at the Mary Boone Gallery in 1989, Polke demonstrated his ability to pull together the many facets of his art. These paintings were made of extra-fine canvas stretched tightly over easels or stands and placed in the middle of the floor so that both sides of the work were displayed. The canvas, when painted with resins, became translucent thereby allowing the images printed on either side to mesh together. "By being freed from the wall," wrote Roberta Smith in the *New York Times* (April 7, 1989), the pieces "make us hypersensitive to the role the wall plays in the experience of painting—the sense of distance, and therefore of value, that it enforces." Smith also commented on the X-ray-like power the viewer has in being able to see, fully revealed, the processes that went into making in the work: "The translucent two-sidedness holds no secrets, hides no underpainting and abides no hierarchy." In his review of the show in *Arts Magazine* (October 1989), Barry Schwabsky wrote, "One hears it said that today's artists can be divided into believers and cynics, romantics and ironists, but Polke reminds us that one must be all these things, that a strong romanticism requires the most extreme skepticism."

While no longer needing to work to support himself (his paintings sell in the six figure range), Polke was in 1977 a professor at the Hochschule für Bildende Künste in Hamburg. He lives and works now in Cologne, West Germany, and continues to be represented by the Mary Boone Gallery in New York. Polke shuns personal publicity, believing that the focus of attention belongs solely to an artist's work rather than his personality. He does not like to be photographed, and even goes so far as to give misleading information about his family and date of birth.

EXHIBITIONS INCLUDE: Gal. Rene Block, Berlin 1966, '68, '69; Gal. Konrad Fischer, Düsseldorf 1970, '71, '73; Gal. Toni Gerber, Bern 1970, '71, '72, '76; Gal. Michael Werner, Cologne 1970, '72, '74, '75, '83; Gal. Klein, Bonn 1974, '75, '77, '79, '80, '84, '86; Kunsthalle Tübingen, West Germany 1976; Gal. Bama, Paris 1979, '82, '85; Holly Solomon Gal., NYC 1982; Mus. Boymans-van Beuningen, Rotterdam 1983; Kunsthaus, Zürich 1984; Marian Goodman Gal., NYC 1984; Mary Boone Gal., NYC 1985, '86, '88, '89, '90; Alfred Kren Gal., NYC 1985; David Nolan Gal., NYC 1987; Kunstmus., Bonn, West Germany 1988; Mus. d'Art Moderne de la Ville de Paris, ARC, Paris 1988. GROUP EXHIBITIONS INCLUDE: "Demonstrative Austellung," Metzgerladen an der Kaiserstrasse, Düsseldorf, West Germany 1963; "Objects," Philadelphia Mus. of Art 1970; "Polke, Palermo, Richter," Annemarie Verna, Zürich, Switzerland 1971; "Amsterdam–Paris–Düsseldorf," Solomon R. Guggenheim Mus., NYC 1972; "Fotografien," Kunstmus., Bern, Switzerland 1978; "Art Allemagne Aujourd'hui," ARC, Paris 1981; Documenta 7, Kassel, West Germany 1982; "New Art at the Tate," Tate Gal., London 1983; "Carnegie International," Mus. of Art, Carnegie Inst., Pittsburgh 1985; "La Grande Parade," Stadelijk Mus., Amsterdam 1985; "German Art in the 20th Century, Painting and Sculpture 1905–1985," Royal Academy of Arts, London 1985; Venice Biennale 1986; "Warhol, Beuys, Polke," Milwaukee Art Mus. 1987; "Refigured Painting: The German Image 1960–88," Solomon R. Guggenheim Mus., NYC 1989; "Yves Klein/Brice Marden/Sigmar Polke," Hirschl & Adler Modern, NYC 1989.

ABOUT: Drawings from the 1960s, 1987; Warhol, Beuys, Polke, 1987. *Peroidicals*— Artforum October 1982, June 1984, October 1984, May 1985, October 1986, December 1988, Summer 1989; Art in America January 1983, April 1985, December 1985, May 1986, Jan-

uary 1988; Art International Spring 1989; ARTnews
April 1985, April 1986, February 1987; Arts Magazine
March 1985, February 1988, October 1989; Burlington
Magazine April 1985, January 1989; Flash Art Sum-
mer 1984, May 1988, October 1988, March 1989, Oc-
tober 1989; New Art Examiner November 1987; New
York June 4, 1984; New York Times January 11, 1985,
November 12, 1986, November 6, 1987, February 10,
1989, April 7, 1989; Print Collector's Newsletter July–
August 1985; Studio International July–August 1976,
September–October 1976.

REGO, PAULA (1935–), Portuguese paint-
er, has gone through various techniques of col-
lage, drawing, and painting proper in the
pursuit of an expressive idiom that is at once
deeply personal and rooted in the collective ar-
chetypes of twentieth-century culture. In Portu-
gal she has been a leader of the new Portuguese
figuration since the late 1960s; with the subse-
quent renewal of interest in figure painting else-
where in Europe and the United States (as well
as the increased appreciation of women's art),
she has gained international recognition as well.

Paula Figueroa Rego was an only child of a
Lisbon engineer and his wife. When she was not
yet three, she came down with a lung infection,
and the family moved to Estoril for her health.
There, she grew up with nannies, tutors, ("whom
I loathed with every pore in my body"), and the
habit of spending long hours alone. "That kind
of childhood, when you're stuck in a room all
day," she told John McEwen in a 1988 interview,
"is the best training for a painter." Although her
mother had briefly studied art, it was her father,
an engineer, who actually encouraged her inter-
est, buying her art books when she was a child
and, much later, giving her money so that she
could continue to paint.

At the age of ten, she was sent to an English
school, St. Julian's, because her parents "wanted
me brought up in an English way." There, she
had the opportunity to study with good art
teachers, and with their support she decided to
become an artist. But in her view, the real form-
ative influence on her painting was not what she
studied but what she had lived as a child—fears,
fantasies, the endless stream of stories told by
one of her aunts, the annual visits to her grand-
mother's house on the Atlantic coast, movies like
Snow White ("which seemed to me like discov-
ering the world"), *Pinocchio,* and *The Wizard of
Oz.* "The influence of paintings, all that stuff,
that's fifth on the list," she explained to
McEwen. "The most important thing of all is the
early period, which I'm still living now."

In 1952 Rego went to London to study at the
Slade School of Art, which struck her as "weird,

dark, and bohemian. . . . After Portugal, it was
quite alarming again." Her first paintings there,
she told McEwen, were "these disgusting pic-
tures of cities in flames, with everybody scream-
ing, running away." At the time, she indicated,
she thought they were good, but now she consid-
ers them "terrible, really awful."

Soon after her arrival at the Slade, the seven-
teen-year-old Rego met the painter Victor Will-
ing, who was seven years her senior and quite a
"star" at the school. "He was my god," Rego re-
called, "smart, intelligent, handsome, talented,
the whole caboozle," and he soon became her
husband—and lifelong mentor—as well. In
1956, the year Rego completed her studies at the
Slade, their first child, Caroline, was born, and
the next year they went to live at her grand-
mother's house in Ericeira in order to paint.

Two dark years followed when, she acknowl-
edged, "I was stuck. It was a very difficult time."
Unable to paint, she finally took her husband's
advice and started drawing instead, "things from
my head mostly." The end of that impasse came
in 1959 (the year her second daughter, Victoria,
was born) with the double discovery of Henry
Miller and Jean Dubuffet. Through Miller's con-
troversial novels, she realized that sex and sexu-
ality did not have to remain taboo subjects, while
Dubuffet's art brut similarly legitimized an im-
provisational language of form that was other-
wise excluded from the canon of painting.
Leaving behind the imperatives of "serious
grown-up art," Rego began pouring out new
paintings at the rate of one a day. In those works,
which bore titles ranging from *Portrait of a Lady*
and *Schmit's Restaurant* to *The Eating* and
Persephone (all 1959), oneiric images of sex and
violence were rendered in crude, childlike
forms, first entirely painted and then incorporat-
ing collage from magazines. In addition to the
personal psychodrama cut and splattered on the
canvas, there were also explicit political refer-
ences, as in *Salazar Vomiting the Fatherland.* In
a 1967 catalog statement, Rego indicated that
such paintings were not, as some had suggested,
neo-dada, but "the result of a tradition of poetic
visual images. I don't like to paint the living. I
like to channel images that are naturalistic, ora-
mental, festishistic, infantile." For Germaine
Greer, writing at the time of the artist's 1988 ret-
rospective, the early paintings were "diffident,
derivative, academic, and self-conscious" but
clearly reflected "an effort to present a violent
and subversive personal vision in acceptable dec-
orative terms." The culmination of the first
phase of Rego's work came with *The Stray Dogs
of Barcelona* (1965), a monstrous frieze of writh-
ing animals and raw flesh inspired by a London
Times news item about the authorities' attempts

to solve the city's stray-dog problem by feeding them poisoned meat, with the result that that the animals were dying their torturous deaths in front of passersby. "I thought this reflected the political situation of the time in Spain and Portugal, which was also brutally dictatorial," she explained to McEwen, commenting that she also thought it was the "best painting" of her career to that point. Both *The Stray Dogs of Barcelona* and *Salazar Vomiting the Fatherland* were in fact included without incident in her 1965 show at the Lisbon School of Fine Arts because, she suggested, "they thought nobody could possibly understand abstract paintings so they must be harmless."

Difficulties of a different order overtook Rego's life in the late 1960s, notably when her husband was diagnosed as having multiple sclerosis (he was to die of the disease in 1988). She felt that the stress was manifesting itself in her work, which became "more forced, more willful," and she began suffering from severe depression, to the extent that she entered full-time psychotherapy. Her paintings, she indicated, "never stopped, but they were repellent" —deformed and defaced human figures acting out the scenarios of the artist's unconscious. In the mid-1970s—just before she and her husband resettled definitively in England—she undertook a series of gouaches based on popular Portuguese folktales, where her oneiric style was tempered by the impulse toward illustration in the linear manner of English illustrators like Arthur Rackham.

By the late 1970s, her children were grown up (the youngest, Vinvent, was born in 1961), and, as Germaine Greer observed, she resumed her "old defiant scale" with bold collage compositions of human and animal forms. *The Annunciation* (1981), for example, was a dense collage-and-acrylic variation on the famous Botticelli painting in the Uffizi Gallery, where the archangel Gabriel is virtually transformed into a rabbit. With her first solo exhibit in London the same year, described as "one of the highlights of the artistic season," Rego, long recognized in Portugal, established her reputation in England as well. And just afterward, another chance encounter, recalling the Miller–Dubuffet catalyst of the late 1950s, drastically altered her style: a Portuguese student whom she met through her husband came to see her work and remarked that there was really no need for her to cut the images up and paste them back on the canvas. "He said this to me on a Friday afternoon," she recalled to McEwen, "and I was so excited I couldn't wait for the weekend to be over so I could get back to the studio and start. I just drew and drew." Among the first products

of that new phase was a series of animal drawings, inspired in part by her husband's recollections of a toy theater he had as a child, as well as by a Spanish cartoon series about an embattled husband and wife, transformed into what Ruth Rosengarten has described as "scenarios of guilt, jealousy, power, and passion, the competitive and coercive aspects of triangular relationships."

In 1983 Rego returned to the Slade School of Art as a professor. The same year, she undertook a series of acrylics on paper illustrating four Italian operas (all of which she had seen with her father); in multiregister compositions equally evocative of Egyptian papyri, medieval manuscripts, or contemporary comic strips, she presented what Germaine Greer called "compendia of her personal imagery," mainly sexual and mainly mixed couples of humans and animals. One particular image introduced in that series—the "naughty" girl shown provocatively lifting her skirts—was to assume increasing importance in subsequent work. Her next series, for example, was inspired by the Chicago writer Henry Darger's prepubescent heroines in *Realms of the Unreal,* the Vivian girls. In individual works that followed, other female characters were depicted in similarly suggestive situations without explicit narrative themes—*Girl Playing with Gremlins* (1985), *At the Beach* (1985), *The Playroom* (1986), *In the Garden* (1986). For Frederick Ted Castle, reviewing her 1985 show at New York's Art Palace, her acrylic drawings were "a kind of 'bad painting' that has gotten good through practice." In each picture, he insisted, "she creates the world."

In the course of the next year, Rego narrowed her visual and thematic approach with a series of double-figure paintings—a girl and a dog in various defined situations. By 1987 most of the animals were gone, and the girls had grown into monumental figures reminiscent of Picasso's bathers of the 1930s. The title figures in paintings like *The Little Murderesses, The Policeman's Daughter,* and *The Soldier's Daughter* now dominate real (or surreal) perspectival space with deliberate but mysterious activities that once again deny the presumed innocence of youth. Her typically bright palette had gone somber, and, as Mary Rose Beaumont wrote in *Arts Review,* "the naughtiness has become something downright sinister." Yet as Ruth Rosengarten argued, in contrast to "the male fantasy of burgeoning female sexuality" that finds its quintessential expression in the paintings of Balthus, Rego's girls are "seen with the eye and memory of a woman. There is no idealization, no playing to a hidden male spectator."

Rego herself rejects the "woman artist" label because she does not want to be placed in a separate category, but beyond even themes and forms, her basic approach is completely consistent with the main thrust of the new women's art of the 1970s and 1980s. Citing Rego's own quip that "life is full of men making grand gestures and falling on their arse," Rosengarten pointed out how she has always found her sources in the "little gestures" of popular art forms—illustrations, cartoons, ads, storytelling—and at the same time, her technical experiments and changing vocabulary of form have bypassed the prevailing notion of an identifiable signature style. And as Germaine Greer wrote in her appreciation of Rego's 1988 retrospective organized at the Centro de Arte Moderna in Lisbon, "Paula Rego is a painter of astonishing power and that power is obviously, triumphantly female. . . . Her paintings quiver with an anger and compassion of which we have sore need."

EXHIBITIONS INCLUDE: Sociedate Nacional de Belas-Artes, Lisbon 1965; Gal. S. Mamede, Lisbon 1971; Gal. Alvarez, Oporto 1972; Gal. da Emenda, Lisbon 1974; Modulo, Cntr. Difusor da Arte, Lisbon 1975; Modulo, Cntr. Difusor da Arte, Oporto 1977; Gal. 111, Lisbon 1978, '82; AIR Gal., London 1981; Edward Totah Gal., London 1982, '85, '87; Arnolfini, Briston 1983; Gal. Espace, Amsterdam 1983; Midland Group, Nottingham 1984; Zurich Art Fair 1984; Art Place, NYC 1985; Aberystwyth Arts Cntr. 1987; Centro de Arte Moderno, Lisbon 1988; Casa de Serralves, Oporto 1988; Serpentine Gal., London 1988. GROUP EXHIBITIONS INCLUDE: "Young Contemporaries," London 1955; Calouste Gulbenkian Foundation, Lisbon 1961; London Group, London 1961–1965; "Six Artists," ICA, London 1965; Tokyo Biennale 1967; "Art Portugais," Palais de Beaux-Arts, Brussels 1967; São Paulo Biennale 1969, '75, '85; "Peintura portuguesa de hoje," Lisbon, Salamanca, Barcelona 1973; Expo AICA, SNBA, Lisbon 1974; "Arte Portugues Contemporanea," Gal. Nazionale d'Arte Moderna, Rome 1976; "Art Portugais Contemporain," Mus. d'Art Moderne de la Ville de Paris 1976; "Portuguese Art since 1910," Royal Academy, London 1978; "Femina," UNESCO, Paris 1978; "Inner Worlds," Arts Council Touring Exhibition, Great Britain 1982; Hayward Annual, London 1982; John Moores Exhibition, Liverpool 1982, '85; "Eight in the Eighties," NYC 1983; "The British Art Show," Birmingham, Edinburgh, Sheffield, Southhampton 1985; Paris Biennale 1985; "Passion and Power," La Mama and Gracie Mansion Gal., NYC 1985; ARCO 86 (Modulo), Madrid 1986; Pontevedra Biennale 1986; "Current Affairs: British Painting and Sculpture in the 1980s," MOMA, Oxford, and traveling to Hungary, Poland, Czechoslovakia 1987; "Introducing with Pleasure," Arts Council, London and traveling, 1987; "Cries and Whispers," British Council Exhibition, traveling in Australia 1988.

COLLECTIONS INCLUDE: British Council, London; Univ. Collection, London.

ABOUT: "Art portugais" (cat.), Palais des Beaux-Arts, Brussels, 1967; "Art portugais contemporain" (cat.), Mus. d'Art Moderne de la Ville de Paris 1978; Mannock, M. Portuguese Twentieth-Century Artists, 1978; "Paula Rego: Paintings 1982–83" (cat.), Arnolfini, Briston, 1983; "Paula Rego: Paintings 1984–85" (cat.), Edwin Totah Gal., London, 1985; "Paula Rego" (cat.), Cntr. de Arte Moderna, Lisbon, 1988; "Paula Rego" (cat.), Serpentine Gal., London, 1988; "Portuguese Art since 1910" (cat.), Royal Academy, London, 1978. *Periodicals*—Art in America February 1983, December 1985, July 1987; Arts Review March 27, 1987; Coloquio—Artes (Lisbon), April 1971, September 1981; Eighty Magazine (Paris) December 1987; Guardian (Manchester) May 20, 1988; Modern Painters (London) 1988; Studio International no. 1007, 1984.

***RICHTER, GERHARD** (February 9, 1932–), German painter whose signature style is marked by a rejection of a unitary style. Like his contemporaries Georg Baselitz and Sigmar Polke, among others, Richter is a "crossover" artist—a native of what became East Germany who crossed over to the West in the 1950s. More than any particular artistic movement or trend, it seems to be that history, as an individual and collective experience, that has shaped his work.

Richter spent his childhood in the village of Waltersdorf, where his father was posted as a school teacher. Growing up during the Nazi era, he was routinely enrolled in the Hitler Youth at the age of ten, but by the time he approached draft age the war was over. Gerd, as he was then called, was a bright child but a poor student—probably in reaction to his father; after leaving grammar school at fourteen, he went on to a commercial high school for two years. It was during a two-month vacation at a youth camp the following summer (1948) that he became seriously interested in art. "It had to do with being an introvert," he later told Coosje van Bruggen. "I was alone a great deal and drew a lot."

Since it was clear that he was unsuited for a profession like medicine or law, he decided to study commercial art. His mother, who was the daughter of a pianist and herself a music devotee, supported his choice and encouraged him to stand up to his more conservative father, with the result that in 1949 he left home and moved into an apprentices' residence in Zittau. There he supported himself by making souvenirs and wooden panel paintings (after dropping out of the lithography workshop his mother had enrolled him in); he took music courses at the adult school, delved into Marxist economics, and spent the rest of his free time reading, writing, and painting. Through friends, he began working as a volunteer set painter at the local theater, but

after two years he was dismissed for insubordination. He had applied to the Dresden Art Academy but was rejected; at that point he went to work for a company that made political banners, and they arranged to send him to the Dresden Art Academy to study large-scale painting.

Richter remained at the Academy for the following eight years (1952–1960). As a student of wall painting, he had more freedom than others, but the basic framework was still socialist realism, and the classes were structured around traditional genres like landscape and still-life painting. Modern artists were largely ignored—reproductions of their work were simply not to be found in the libraries, with the notable exceptions of Picasso and the Italian painter Renato Guttuso, who had been members of the Communist party. Under the circumstances, Richter opted for Picasso and Guttuso—"I was a modern painter," he told van Bruggen, "but with a horrible mixture of things"—and when he completed his master class at the academy he left for West Germany.

His original destination was Munich, the main art center in the western zone, but he wound up in Düsseldorf with a friend who had family there. The move stimulated another spurt of activity—reading, visiting museums, traveling, seeking out other artists—and he soon made his way into contemporary German art circles, which then revolved around French-inspired abstraction. Awarded a two-year scholarship to the Düsseldorf Academy, he took classes with Karl Otto Götz, an informel painter, and his own work evolved through figurative abstraction to a tachist idiom in the style of Fontana or Fautrier. (He later destroyed most of his early paintings, but a few of the tachist canvases, bearing names like Wunde [Wound] and Verletzung [Hurt], are known from photographs.)

His fascination with the latter-day School of Paris soon began to wane, and in the course of 1962, Richter turned to a radically different form of expression. Working from photographs cut out of popular newspapers and magazines, he produced black-and-white "photo-paintings," which he mechanically transferred from the originals but systematically blurred by going over the contours of the images with a dry brush. "I wanted to do something that had nothing to do with what I knew of art, nothing to do with painting, composition, color, discovery, formal elaborating and so forth," he told Irmeline Lebeer a decade later. The photographic image, he explained, "had no style, no composition, it didn't make judgments, it freed me from my personal life. For the first time, it had nothing, it was a pure image. That's why I wanted to have

it, to show it, not to use it as a pictorial medium but to use painting as a photographic one."

Richter had in fact worked as a photographer's assistant during his last three years in Dresden, but that experience, he indicated in an interview with Rolf Gunther Dienst, had far less influence on his new work than "friends, books, circumstances, etc." Of particular importance was the dual exposure to the American pop artists and the European Fluxus movement. "I thought that one was not allowed to paint from photographs until I saw the first reproductions of Roy Lichtenstein's paintings in Art International," he told van Bruggen, adding that he promptly threw away his existing canvases and began working from media images.

The early photo-paintings were often somewhat sensational—a portrait of Hitler, a firing squad bordered with an inverted row of women's heads, a giant mouth (Brigitte Bardot's), a group of pallbearers, and one canvas called Party which he slashed and sewed up again, adding paint from behind to create more "wounds." "It was perhaps a protest because people here in Germany were always looking at the formal side," he explained to van Bruggen. "I resist this because my art always has something to do with my life and how I deal with it." But at the time, he and his friends from art school—Sigmar Polke, Manfred Kuttner, Konrad Lueg (soon to become Konrad Fischer, the art dealer)—felt a certain pressure to conform to prevailing trends, and it was there that they found reinforcement in the freewheeling activities of Fluxus, spearheaded by Joseph Beuys from 1962 on, as well as in Jean-Pierre Wilhelm's adventuresome Galerie 22. In February 1963, George Maciunas brought the Festum Fluxorum Fluxus orchestra to the Düsseldorf Academy; three months later, Richter and others organized what they called the "first exhibition of German pop art" in a rundown shop across the street from Galerie 22. That October, Richter and Lueg, who had also gone to Paris and attempted (unsuccessfully) to present themselves to the gallery owners Iris Clert and Ileana Sonnabend as representatives of the German pop art movement, staged a "Demonstration for Capitalist Realism" in a Düsseldorf store. Declaring the various bedroom, living-room, kitchen, and playroom installations part of their exhibition, they placed themselves on display in a special living-room showcase they created by raising all the furniture on low pedestals (to indicate that they were works of art); eight of their own paintings were hung in nearby displays. While that event subsequently entered various accounts of the period as the serious beginning of a "capitalist realist" movement, Richter himself indicated that the

intentions were more satirical: "The term some-how attacked both sides," he told van Bruggen; "it made socialist realism appear ridiculous and did the same to the possibility of capitalist realism as well."

After finishing art school, Richter signed a two-year contract with the dealer Heiner Friedrich, and his photo-paintings were successfully exhibited in a number of West German galleries. While continuing to use some media images (including a particularly ominous series of war planes), he turned increasingly to the use of snapshots and postcards for family portraits, landscapes, and views of monuments that had far less in common with the ironic sensationalism of the American pop artists. Indeed, in contrast to some of the first provocative subjects—*Hitler, Pallbearers, Firing Squad*—even a potentially charged image like the grieving Jackie Kennedy became the anonymous *Frau mit Schirm* (*Woman with Umbrella,* 1964).

With the banalization of the subject, the distinctive conceptual underpinnings of Richter's enterprise became more evident. As he explained to Irmeline Lebeer in 1972, the photo-paintings had more to do with the relationship between photography and painting than with the creation of media icons in the pop art mode: "On the one hand, the photo is already a little painting, but not entirely. This quality is irritating and makes you want to transform it completely into a painting. On the other hand, a photo possesses specific characteristics that are lost when you paint directly from nature. It keeps you from stylizing, from seeing 'wrong,' from giving too much of a personal interpretation to the subject. Even technically the results are different. [And] it also allows you to be as universal, as little personal as possible." For such a venture, he contended, art photographs were far more cliché-ridden, "with their plays of light and shadow, their harmonies and compositional effects," than the snapshot which was "literally overflowing with life." "I don't want to imitate a photograph," he declared in an often-quoted statement; "I want to make one."

By the mid-1960s Richter began to tire of the snapshot motifs (he terminated the series in 1966 with *Act Lehrnschwestern,* portraits of the eight student nurses murdered by Richard Speck in their Chicago dormitory), and over the next few years he experimented with other subjects—nonphotographic images of doors, tubes, columns, corrugated iron, and so forth, which he rendered in the same deadpan illusionistic way, and another series that approached the same issues of impersonal observation and personal expression from the opposite angle, through

photographic images of women in various degrees of erotic display. The first of these, *Ema, Akt* (*Ema, Nude on a Staircase,* 1966), which was a portrait of his wife at that time, was also his first color painting from a photograph, rendered in nostalgically faded tones of peach and gold.

The romantic return to color, which was to remain one current in his rapidly diversifying oeuvre, was soon paralleled by a far more clinical approach in the *Farbtafeln* ("Color Charts") that he created intermittently between 1966 and 1974. Like the photo-paintings, those mosaic-like canvases of paint-store color samples, which eventually included as many as 4,096 units, represented an attempt to circumvent subjectivity—along with the color theories of Josef Albers and others—by what were initially random combinations of colors (later generated on a more systematic, mathematical basis). A third variation on the theme followed with the *Stadtbilder* ("Townscapes," 1968–73) which were based on aerial views of European cities. Notwithstanding the neutral, catalog-type titles those paintings bore (*Stadtbild M1-M9, Stadtbild Mü, Stadtbild Paris,* etc.), a number of canvases demonstrated what was for Richter at that time a surprisingly agitated and expressive (if not expressionistic) rendering, with very visible brush-work and thick impasto transforming topographical detail into abstract design.

In retrospect, the sudden burgeoning of Richter's subjects and styles had part of its logic, at least, in larger developments in contemporary art and Richter's response to them. By the end of the 1960s, his photo-paintings had been somewhat marginalized by the vogue for conceptual art; as Jürgen Harten pointed out, in 1967 his friend Konrad Fischer chose to inaugurate his Düsseldorf gallery with an exhibition of Carl Andre's work, and when the same taste made itself felt with Heiner Friedrich, Richter left the gallery and went to work as a high school art teacher. Although he was basically in favor of the new movement and soon adopted some of its trappings, his immediate response was an evocation of traditional painting values—color, romantic subjects, animated brushwork—which soon led to the first of the many landscapes, seascapes, and mountain views he was to paint during the next decade. "I wanted to see to what extent we can still utilize beauty," he explained to Lebeer; "if it's still conceivable today." As with the townscapes, the great expanses of land, sea, and sky easily lent themselves to abstraction, and, in the extreme, he arrived at the *Graubilder* ("Gray Paintings," 1967–74) and *Farbschlieren* ("Color Streaks," 1968) which were entirely nonfigurative. As he later acknowledged, the "Gray Paintings" reflected a rather desperate period in

his life—"the ultimate possible statement of powerlessness and desperation. Nothing, absolutely nothing left, no figures, no color, nothing."

On the occasion of a one-man show at Aix-la-Chapelle in 1969, Richter created a catalog of 122 works, which he grouped thematically. In fact, he had been cataloging his paintings since 1963, as a kind of "quality control" that permitted him to reassess the canvases and destroy those he felt did not conform to the principles of his oeuvre. Earlier in 1969 he had revised the numbered inventory to create a "List of Paintings"—very much in the style of conceptual art, as Harten noted—but with the thematic classification, Richter placed his artistic activity in a new context, where, in Harten's words, "the encyclopaedic order, seen as a concept, seemed the decisive alternative to a total lack of style." Over the next decade it was that principle of diversity, of willful eclecticism, that defined Richter's work. In addition to the townscapes, landscapes, seascapes, mountains, color charts, gray paintings, and color abstractions variously called *Fingerspuren* ("Finger Marks," 1970), *Ausschnitt* ("Details," 1970–71), *Varmalung* ("In-painting," 1972), and *Abstrakte Bilder* ("Abstract Paintings," 1976), there were cloud paintings, park pieces, and periodic photo-portraits. He further pursued the negation of individual style by collaborating with another East German artist, Blinky Palermo (born Peter Heisterkamp), on joint paintings and gallery installations until Palermo's death in 1977. In 1972 he attracted considerable attention at the Venice Biennale with forty-eight encyclopaedia-style portraits of nineteenth- and twentieth-century men of letters and science (there were no women, he said, because he wanted homogeneity, and no artists because he did not want to risk personal judgments); distributed around the exhibition space in a single horizontal row, the profusion of images had the effect of negating any single image in favor of the canvas as an object of the artist's making. The following year he broached the same issue with a four-painting series, *Der Verkündigung nach Tizian* ("The Annunciation after Titian"), in which he progressively dissolved a rendering of Titian's painting into abstract color and light.

The literal deconstruction of the image, which pointedly called into question the nature of representation, provided a kind of prologue to the abstract paintings that were to dominate his work in the late 1970s and into the 1980s. The early *Abstrakte Bilder* were essentially executed like the photo-paintings—Richter worked from small-scale abstractions ("roughly looking like small editions of not-too-successful Hans Hofmann paintings," in the view of Rudi H. Fuchs),

which he enlarged by projection and painted over again. In the process, the physical characteristics of the originals—the layering of the paint, its texture, its cast shadows—became the subject and the image of the meticulously rendered enlargements. By the 1980s he abandoned the small-scale models to work directly on the canvas; his colors, which had begun rather somberly, moved into the range of electric reds and greens, and above all, a vibrant yellow that set the compositions in motion. In spite of the obvious repetitiousness of the format, the "slickness" detected by more than one critic, the forms themselves often remained visually engaging.

Throughout the 1980s, Richter continued to make landscape paintings from his photographs, but he also introduced a group of still lifes—exactingly illusionistic representations of glowing candles and skulls—that offered a sharp, classicizing counterpoint to the abstract paintings. According to Richter, that change of "mood" was necessary in order to avoid facile personal expression. "I like to compare my process of making art to the composing of music," he explained to Dorothea Dietrich in 1985. "There, all personal expression has been subjugated to the structure and is not simply shouted." But that depersonalization of style had strong personal connotations, and it is probably there, as much as in analytical constructs, that the ongoing appeal of his work is to be explained. As Thomas Lawson observed in 1980, Richter's paintings "represent the vision of someone dislocated from daily reality; they are recollections of the uncertain fog of inebriation, a distracted vision, withdrawn from the world, looking for something else."

EXHIBITIONS INCLUDE: Mobelhaus Berges, Düsseldorf 1963 (with Konrad Lueg); Gal. Heiner Friedrich, Munich 1965, '67, '70, '72; Gal. Alfred Schmela, Düsseldorf 1964, '66; Gal. Rene Block, Berlin 1965, '66, '69, '74; Gal. Friedrich und Dahlem, Munich 1966; Gal. La Tartaruga, Rome 1966; Gal. Bischofberger, Zurich 1966; Gal. del Leone, Venice 1966; Wide White Space, Antwerp 1967; Gal. Ricke, Kassel 1968; Gal. Gegenverkeht, Aachen 1969; Gal. de Naviglio, Milan 1969; Palais des Beaux-Arts, Brussels 1970; Gal. Konrad Fischer, Düsseldorf, from 1970; Mus. Folkwang, Essen 1970; Gal. Jorg Schellmann, Munich 1970; Kunstverein, Düsseldorf 1971; Kabinett für Aktuelle Kunst, Bremerhaven 1971; Gal. Thomas Borgmann, Cologne 1971, '84; Gal. Rudolf Zwirner, Cologne 1972; Mus. van Hedendaagse Kunst, Utrecht 1972; Venice Biennale 1972; Gal. Seriaal, Amsterdam 1973; Onasch Gal., NYC 1973; Kunstverein, Bremerhaven 1973; Gal. La Bertesca, Milan 1973; Städtisches Mus., Mönchengladbach 1975; Kunstverein, Braunschweig 1975; Gal. Rolf Preisig, Basel 1975; Kunsthalle, Bremen 1975; Kaiser-Wilhelm-Mus., Krefeld 1976; Mus. Haus Lange, Krefeld 1976; Gal. Renzo Spagnoli,

Florence 1976; Gal. Durand-Dessert, Paris 1976, '84; Gal. Lucio Amelio, Naples 1976, '83; Cntr. Georges Pompidou, Paris 1977; Stedelijk van Abbemus., Eindhoven 1978; Mus. Folkwang, Essen 1980; Sperone-Westwater-Fischer Gal., NYC 1980, '83, '85; Kunstverein, Munich 1981; Padiglione d'Arte Contemporanea, Milan 1982; Kunsthalle, Bielefeld 1982; Kunstverein, Mannheim 1982; Gal. Fred Jahn, Munich 1982, '85; Gal. Konrad Fischer, Zurich 1982; Gal. Max Hetzler, Stuttgart 1982; Mus. d'Art et d'Industrie, Saint-Etienne 1984; Gal. Wilkens-Jacobs, Cologne 1984; Staatsgal., Stuttgart 1985; Marion Goodman Gal., NYC 1985; Gal. Jean Berner, Athens 1985; Städtische Kunsthalle, Düsseldorf 1986; Nationalgal., Berlin 1986; Kunsthalle, Bern 1986; Mus. Moderner Kunst, Vienna 1986. GROUP EXHIBITIONS INCLUDE: "14 Aspekte Moderner Malerie," Haus der Künste, Berlin 1965; "Junge Generation," Haus der Künste, Berlin 1965; "Junge Deutsche Kunstlerbund," Kunsthalle, Nuremberg 1968; "9 Young Artists," Guggenheim Mus., NYC 1969; "New Multiple Art," Whitechapel Art Gal., London 1971; Documenta 5, Kassel 1972; "Kijken naar de Werkelijkheid," Mus. Boymans-van Beuningen, Rotterdam 1973; Projekt '74, Kunsthalle, Cologne 1974; "Fundamental Painting," Stedelijk Mus., Amsterdam 1975; "Projekt Retrospekt," Kunsthalle, Düsseldorf 1976; ROSC 77, Gal. Modern Art, Dublin 1977; "21 Deutsche Künstler," Louisiana Mus., Humlebaek 1977; "Europe in the Seventies," Chicago Art Inst. 1977 (trav. exhib.); Documenta 6, Kassel, 1977; "Aspekte der 60er Jahre," Nationalgal., Berlin 1978; Sydney Biennale 1979; Venice Biennale 1980; "Pier and Ocean," Hayward Gal., London and Rijksmus. Krökeller Müller, Otterloo 1980; "Forms of Realism Today," Mus. d'Art Contemporain, Montreal 1980; "Der gekrümmte Horizont, Kunst in Berlin 1945–1967," Akad. der Künste, Berlin 1980; "Art Allemand Aujourd'hui," ARC, Mus. Art Moderne de la Ville de Paris 1981; "A New Spirit in Painting," Royal Academy, London 1981; "Westkunst," Messehallen, Cologne 1981; Documenta 7, Kassel 1982; "'60'80 attitudes/ concepts/ images," Stedelijk Mus., Amsterdam 1982; "Acquisition Priorities: Aspects of Postwar Painting in Europe," Solomon R. Guggenheim Mus., NYC 1983; "Vier Perioden deutschen Malerei," Städtische Kunstmus., Bonn 1984; "Toyama Now '84," Mus of Modern Art, Toyama 1984; "An International Survey of Recent Paintings and Sculpture," MOMA, NYC 1984; "Ein anderes Klima," Stadtische Kunsthalle, Düsseldorf 1984; "1945–1985 Kunst in der Bundesrepublik Deutschland," Nationalgal., Berlin 1985; "German Art in the Twentieth Century," Royal Academy, London 1985; "Rheingold: 40 Künstler aus Köln und Düsseldorf," Palazzo della Società Promotrice delle Belle Arti, 1985.

COLLECTIONS INCLUDE: Neue Gal., Sammlung Ludwig, Aachen; Kunsthalle, Bielefeld; Städtishces Kunstmus., Bonn; Hessisches Landesmus., Sammlung Ströher, Darmstadt; Kunstmus., Düsseldorf; Stedelijk van Abbemus., Eindhoven; Mus. Folkwang, Essen; Kunsthalle, Kiel; Mus. für Moderne Kunst, Frankfurt; Stadtisches Mus., Leverkusen; Tate Gal., London; Städtisch Gal. im Lenbachhaus, Munich; National Gal.

of Canada, Ontario; Mus. d'Art et d'Industrie, Saint-Etienne; Castello di Rivoli, Turin.

ABOUT: Emanuel, M., et al. Contemporary Artists, 1983; "Gerhard Richter" (cat.), Venice Biennale, 1972; "Gerhard Richter" (cat.), Mus. d'Art et d'Industrie, Saint-Etienne, 1974; "Gerhard Richter" (cat.), Cntr. Georges Pompidou, 1977; "Gerhard Richter Abstract Paintings" (cat.), Stedelijk van Abbemus., Eindhoven, 1978; "Gerhard Richter" (cat.) Whitechapel Art Gal., London, 1979; "German Art in the Twentieth Century" (cat.), Royal Academy, London, 1985; Harten, J. (ed.) Gerhard Richter Bilder Paintings 1962–1985, 1986; Joachimides, C. (ed.) Ursprung und Vision: Neue Deutsche Malerei, 1984; Loock, U. and D. Zachropoulos. Gerhard Richter, 1985; "1945–1985: Kunst in der Bundesrepublik Deutschland" (cat.), Nationalgal., Berlin, 1985; Richter, G. Atlas der Fotos, Collagen und Skizzen, 1976. Periodicals—Art and Artists, September 1973; Artforum May 1985; Art in America November–December 1969, September 1985, November 1986; Art International March 1968; Arts Magazine June 1978, May 1985; Chronique de l'art vivant February 1973; Flash Art May–April 1980, May 1983, May–June 1986; Print Collectors' Newsletter September–October 1985; Studio International September 1972.

RINGGOLD, FAITH (October 8, 1930–), painter, soft sculptor, performance artist, and activist who has been a provocative presence on the American art scene since the early 1960s. As a Black female artist, she has essentially mounted a double assault on the canons of white male modernism. Over the years, she has increasingly drawn on the dual legacy of African tradition and Afro-American experience for her subject matter while deriving her forms from women's crafts, notably wall hangings, dolls, and quilts.

Ringgold was born Faith Willi Jones, the youngest of three children in a modest but secure family in Harlem. Her father, Andrew Louis Jones was a truckdriver for the sanitation department; her mother, Willi Posey Jones, was a housewife turned seamstress and designer. Suffering from asthma as a child, Ringgold found a welcome pasttime in art and soon became "the kid who did Santa Claus on the blackboard every Christmas." By the time she was in high school she had decided to become an artist, but when she went on to attend the City College of New York in the late 1940s, she discovered that her only option was the school of education because women were not admitted to the liberal arts programs. Nor was her family entirely happy about her ambitions because, as she told Lucy Lippard, "I was supposed to go to college to be somebody; being an artist wasn't being anybody, wasn't a serious vocation."

FAITH RINGGOLD

In 1950 Ringgold married jazz pianist Robert Earl Wallace, a childhood friend, and within the space of twelve months gave birth to two daughters, Michele Faith and Barbara Faith. The couple separated in 1954 and Ringgold moved in with her mother, who was by then a successful fashion designer. The following year she completed her B.S. degree and began teaching art in the public school system while raising her daughters, modeling in her mother's fashion shows, and also working toward a master's degree at City College. In 1962 she married Burdette Ringgold, with whom she has lived ever since.

While at City College Ringgold studied with Yasuo Kuniyoshi and Robert Gwathmey, and until the early 1960s she remained a conventional oil painter. It was only in 1963—the year of Martin Luther King Jr.'s march on Washington—that she embarked on her first mature venture, the "American People Series" (1963–67). Strongly influenced by the writings of James Baldwin and LeRoi Jones (later known as Amiri Baraka), she turned from landscapes and seascapes to cubist figure compositions like *Between Friends* (1963) and *The Cocktail Party* (1964), which had as their subject the uneasy relationships between blacks and whites. By 1967 the tone of her work, like the black movement itself, had grown more militant. *U.S. Postage Stamp Commemorating the Advent of Black Power* (1967), for example, was composed of a grid of one hundred abstract (but individualized) faces, ten black and ninety white in proportion to the population, while *Die* (1967)

depicted a bloody riot of blacks and whites in what Barbara Rose called "the mock-epic style of pop art." Under the inspiration of Ad Reinhardt (who died in 1967), she then undertook a series of "Black Light" paintings, for which she limited her palette to dark tones as an affirmation of a black aesthetic. That series, as Lucy Lippard later pointed out, marked the beginning of a direct identification between the artist and her art. By 1969 she was also making political posters, and in response to the first moon landing she created one of her most famous political paintings, *Flag for the Moon—Die Nigger*, which was almost purchased by the Chase Manhattan Bank until the words of the subtitle were detected among the stars and stripes of the image.

Since the mid-1960s Ringgold had been in contact with other black artists and writers, including LeRoi Jones, Romare Bearden, Ernie Crichlow, Hale Woodruff, Betty Blayton, and, later, Jacob Lawrence, Henri Ghent, and Ed Taylor. In 1968, she initiated the first demonstration of black artists at the Whitney Museum and also mounted a campaign for the creation of a Martin Luther King, Jr. wing at the Museum of Modern Art. Over the next few years she was active in the Artworkers Coalition, a broadbased group of New York artists attempting, in effect, to politicize their art and aestheticize the political struggle. In connection with a 1970 anticensorship exhibit organized at the Judson Memorial Church, she was arrested with two fellow Artworkers, Jean Toche and Jon Hendriks. They were subsequently known as the "Judson Three."

In the course of that period of intense political activity, Ringgold, like many other artists, called into question the nature of conventional painting, and, in her particular case, the need for isolation it entailed. "No one in my family understood why I had to be alone undisturbed for such long periods of time," she explained to Avis Berman in 1980, noting that once she switched to other media, "I didn't have to close the world out." A major turning point came in 1971 with a mural she executed for the Women's House of Detention on Riker's Island just outside of Manhattan. Interested in doing a public project on a women's theme, she turned first to the universitities but found no takers; she then decided a prison would be her "best bet," because, her daughter Michele Wallace quoted her as saying, "nobody wants to go there, therefore they'll let me go." The mural depicts women in a variety of social roles, from a mother reading her daughter feminist literature to a priest conducting a wedding; the images were suggested by the inmates themselves, while the abstract composition of eight triangular sections was

based on a Central African motif known as Bakuba. For Ringgold, the mural marked "the beginning of my feminist painting. And the end of painting large paintings on inflexible canvases."

During a trip to Europe the following year, Ringgold turned to watercolor on paper with a series of fifty-seven abstract paintings which she combined with short texts written by herself and Michele. She called them "Political Landscapes," she explained with the bitter irony of the times, because "all the political people are buried in the ground which makes the landscape." On her return, inspired by an exhibit of Tibetan wall hangings she had seen at the Rijksmuseum in Amsterdam, she did a second series, the "Feminist Landscapes," painted in acrylic on cloth (with texts drawn from an anthology of black women's writings). Those "tankas," according to Ringgold, created a certain confusion in art circles: "People called them weavings, banners, textiles, etc.," she recalled in her unpublished autobiography "Being My Own Woman." "They didn't seem to realize that they were looking at paintings [on] canvas, just because there were no wooden frames and no stretchers." By the end of the year, she also collaborated with her mother to make the first of her soft sculptures out of raffia, beads, and scraps of fabric, and soon afterward, alongside another group of tankas (the "Slave Rape" series), she produced a series of ritualized "Witch Masks" and the portrait sculptures she called "The Family of Woman."

As Lucy Lippard pointed out, all of those works reflect a synthesis of the black and feminist concerns that Ringgold had entertained in the late 1960s—above all, perhaps, the blurring of the distinction between art and craft, but also the retrieval of traditional themes and forms, and the pursuit of collective rather than individual creation. At the time, her preoccupations had little to do with the art-world mainstream, and in fact, after two solo exhibits at the co-op Spectrum Gallery in 1967 and 1970, Ringgold disappeared from the New York gallery scene altogether, opting quite literally to take her show on the road with what she called "traveling art"—trunks full of tankas, masks, and dolls that could be shipped inexpensively and assembled from written instructions. For Moira Roth, those works from the early 1970s are "among the richest and most wide-ranging of the early feminist experiments in new imagery and materials, collaboration and distribution systems," paralleling the efforts of other female artists such as Judy Chicago, Betye Saar, Mary Beth Edelson, Miriam Shapiro, and Howardina Pindell.

In the course of the mid-1970s, Ringgold's dolls evolved into "soft people"—hanging and later freestanding sculpture (still costumed by her mother) which was often in a satirical vein. The basketball player Wilt Chamberlain, for example, who let it be known that he preferred the company of white women, was soon represented in a *Wilt Chamberlain Family* (1974) that included a black Wilt, a white wife, Willa, and their métis daughter, Wiltina. The masks and soft sculptures were also combined with painted panels to create environments and performances, notably *The Wake and Resurrection of the Bicentennial Negro* (1976), a modern-day passion play about the reform of a junkie, enacted with five masked characters and five soft sculptures. In the year of America's bicentennial, Ringgold made her first trip to West Africa and returned the following year for the Second World Black and African Festival of Arts and Cultures in Lagos, Nigeria. (In typical Ringgold style, when the other Americans opposed the inclusion of her masks in the festival, she wore them to the opening.)

At the end of the 1970s, Ringgold added a new medium to her repertoire: the quilt. In response to an invitation to participate with seventeen other women in an exhibit called "The Artist and the Quilt," she undertook *Echoes of Harlem,* a quilt that juxtaposed portraits of thirty men and women with scraps of fabric acquired at local street fairs. The figures were drawn and painted by Ringgold and then embroidered by her mother in what was to be their last collaboration, because Willi Posey died in 1981. In the period that followed, Ringgold briefly went back to painting as a kind of therapy for her grief. Eight large abstractions painted on unstretched canvas in 1982 ultimately became the "Emanon" series (i.e., "No Name," from the title of a well-known Dizzy Gillespie piece), while five smaller, more somber works made up the "Baby Faith and Willi" series, marking both the death of her mother and the birth of her first grandchild. Those were followed in turn by the six "Dah" paintings (a 1983 tribute to her granddaughter's first word) and then the "California Dah" (1984), executed while she was a visiting professor at the University of California at San Diego.

Acknowledging that abstraction reflected a more "inward" turn of mind, Ringgold insisted, "I'm retrenching now, but I still want to change the world in my own way." Indeed, her activist strain continued to manifest itself as she continued to make dolls—including the 1981 *Atlanta* piece commemorating the child murders that terrorized Atlanta's black community—to do performances, to curate exhibits, and, from 1983

on, to resume quilt making in the distinctive form of story quilts. As various critics have noted, Ringgold's message art has always had a narrative element, from the militant posters of the 1960s to the anecdotal soft sculptures and dolls of the 1970s, by way of the "Political Landscapes," "Feminist Landscapes," and the performance pieces, all of which paired up images and texts. With *Who's Afraid of Aunt Jemimah* (1983), made for her twenty-year retrospective at the Studio Museum in Harlem, she brought the story-telling impulse to the two-dimensional quilt medium and created what Moira Roth called "a strikingly revisionist, flamboyant tale" that turns everybody's favorite pancake maker into a shrewd businesswoman. In a burst of energy following the retrospective, Ringgold turned out a total of five story quilts in a single year, all of which conjure up the violence of the black experience in America (*Flag Story Quilt, Slave Rape Story Quilt, Street Story Quilt, No More War*) and South Africa (*Now You Have Touched the Woman*). Although each of those quilts is based on a narrative written by Ringgold, the visual images are emblematic rather than narrative, strongly recalling her "American People" paintings from the 1960s. In the two *Mask Face Quilts* of 1986, there is no text at all, just frontal figures patterned into an abstract design, while *The Purple Quilt* (1986), which incorporates two blocks of text from Alice Walker's novel *The Color Purple*, basically illustrates the cast of characters in three vertical rows of men, women, and children, respectively. With the three-part *Lover's Quilt* (1986), that formalism is carried to its extreme in *The Wedding* and *The Funeral*, where a literal patchwork of faces illustrates the opening and closing episodes of Ringgold's drama of adultery, while the central panel, *Sleeping*, breaks out of that mode entirely, depicting the lovers' nude bodies floating in sleep under a cloudlike blue sheet.

Meanwhile, Ringgold had put together her autobiographical *Change: Faith Ringgold's Over 100 Pounds Weight Loss Story Quilt* (1986). As the title suggests, the artist's diet-in-progress provided a narrative thread for the exploration of women's identity. Unlike all the previous quilts, painted and patched together in bright colors, *Change* was based on black-and-white photographs grouped together in scrapbook fashion to illustrate the decade-by-decade account of Ringgold's life; in an accompanying performance piece, the artist recited her incantory text about change while dragging a hundred pounds of water bottles across the stage.

When *Change* and other recent story quilts were exhibited at the Bernice Steinbaum Gallery in 1987, a number of critics were struck by the tenacity of Ringgold's formal and conceptual concerns: Her work, wrote Susan Gill in *Arts*, "is a good example of an art form that is impervious to the vagaries of the market and to the debates of the critics." The artist herself would hardly seem to disagree: "The fact that I'm considered a minority on every count," she declared at the time of her retrospective, "frees me to do what I want to do. I believe in being an artist as a way of life."

Since 1984 Ringgold has been teaching part time at the University of California at San Diego and leads what she calls a "bicoastal" life, but her base is still the Sugar Hill section of Harlem, where she grew up and raised her own children. Her older daughter, Michele, has become a successful writer and critic best known for the controversial *Black Macho and the Myth of the Superwoman* (1979); she has collaborated with her mother on exhibits and performance pieces and edited the catalog of the Studio Museum retrospective.

EXHIBITIONS INCLUDE: Spectrum Gal., NYC 1967, '70; Louisiana State Univ., Baton Rouge 1972; Wellesley Col. 1973; Rutgers Univ., New Brunswick 1973, '84; Univ. of Tennessee, Chattanooga 1973; Univ. of Wisconsin, Stevens Point, Superior, and Whitewater 1974–75; Southeastern Missouri State Col., Springfield 1975; Bowdoin Col., Brunswick, Me. 1976; Wilson Col., Chambersburg, Pa. 1976; Hamilton-Kirk-land Col., Clinton, N.Y. 1977; William Smith Col., Geneva, N.Y. 1977; Hampton Inst., Hampton, Va. 1978; St. Edward's Univ., Austin, Tex. 1978; Douglass Col., Rutgers Univ., New Brunswick, N.J. 1979; Summit Gal., NYC 1979; Mus. of African and African-American Art, Buffalo, N.Y. 1980; Univ. of Massachusetts, Amherst 1980; Middlesex County Col., Edison, N.J. 1980; Trinity Col., Hartford, Conn. 1981; Earlham Col. 1981; Youngstown State Univ., Ohio 1982; San Antonio Col., Tex. 1983; Lehigh Univ., Bethlehem, Pa. 1983; Studio Mus. in Harlem, NYC 1984; Appalachian State Univ., Boone, N.C. 1984; Wooster Art Mus., Ohio 1985; DeLand Mus. of Art, Fla. 1987; Baltimore Mus. of Art, Md. 1987; Bernice Steinbaum Gal., NYC from 1987; Thomas Center Gal., Gainesville, Fla. 1988; Educational Testing Service, Princeton, N.J. 1988; Simms Fine Art Gal., New Orleans 1989. GROUP EXHIBITIONS INCLUDE: "The Art of the American Negro," Harlem Cultural Council, NYC 1966; "Memorial Exhibit for Martin Luther King, Jr.," MOMA, NYC 1968; "Counterpoints 23," Lever House, NYC 1969; "New York Liberated Venice Biennial," Mus. [STET], NYC 1970; "Mod Donna Art," Shakespeare Festival Theater, NYC 1970; "Black Artist USA," Lobby Gal., Chicago (trav. exhib.) 1973; "Taking Care of Business," Mus. of the National Cntr. of Afro-American Artists, Boston (trav. exhib.) 1971; "Where We At: Black Women Artists," Acts of Art Gal., NYC 1971; Documenta 4, Kassel, 1972; "Women in the Arts," Finch Col. Mus., NYC 1972; "Women Choose Women," NY Cultural Cntr., NYC 1973; Afro-American Pavilion, World's Fair, Spokane, Wash. 1974; "The Year of the

Woman," Bronx Mus., NYC 1975; "Jubilee," Boston Mus. Fine Arts 1975; Second World Black and African Festival of Arts and Culture, Lagos, Nigeria 1977; "Afro-American Art 1950 to Present," Schenectady Mus. 1978; "Emergent African Art, Tribal Roots," Alternative Cntr. for International Arts, NYC 1978; "Africa in the America's Museum of African Art," Smithsonian Instn., Washington, D.C. 1980; "Fragments," Douglass Col, Rutgers Univ., New Brunswick, N.J. 1980; "Forever Free, Art by African American Women," Illinois State Univ., Normal, Ill. (trav. exhib.) 1981; "Sculpture Show," P.S. 1, Long Island City, NYC 1981; "The Prison Show," Whitney Mus. of American Art, NYC 1981; "Discover Dolls: Reflections of Ourselves," Brooklyn Children's Mus. 1982; "The Artist and the Quilt" McNay Art Mus., San Antonio, Tex. (trav. exhib.) 1983; "Artist as Shaman," The Women's Building, Los Angeles, Calif. 1985; Whitney Biennial 1985; "American Women in Art," United Nations International Conference on Women, Nairobi, Kenya 1985; "Black Artists: 1930–Present," Bucknell Univ., Lewisburg, Pa. (trav. exhib.) 1985; "Tradition and Conflict: Images of a Turbulent Decade 1963–1973," Studio Mus. of Harlem, NYC (trav. exhib.) 1985; "Liberty and Justice," Alternative Mus., NYC 1986; "Poetry of the Physical," American Craft Mus., NYC (trav. exhib.) 1986; "Progressions: A Cultural Legacy," The Clock Tower, NYC 1986; "The Artist's Mother: Portraits and Homages," Hecksher Mus., Huntington, N.Y. and National Portrait Gal., Washington, D.C. 1987; "The Art of Black America in Japan: Afro-American Modernism 1937–1987," Terada Warehouse, Tokyo 1987; "Narrative Images," Crescent Gal., Dallas, Tex. (trav. exhib.) 1987; "Art against Apartheid," Fashion Moda, NYC 1987; "Connections Project/Conexus," Mus. of Contemporary Hispanic Art, NYC 1987; "Contemporary Quilts," Boston Univ. Art Mus. 1987; "Made in the U.S.A.: Art from the '50s & '60s," Univ. Art Mus., Univ. of California, Berkeley (trav. exhib.) 1987; "We the Women," Metropolitan Mus. and Art Cntr., Coral Gables, Fla. 1988; "Just Like a Woman," Greenville County Mus. of Art, S.C. 1988; "Committed to Print," MOMA, NYC 1988.

COLLECTIONS INCLUDE: High Mus., Atlanta; Brooklyn Children's Mus., Brooklyn; MOMA, NYC; Studio Mus. of Harlem, NYC; Chase Manhattan Bank, NYC; Women's House of Detention, Riker's Island, NYC; Philip Morris, Inc., NYC; Bill Cosby, NYC; Newark Mus., Newark.

ABOUT: Baraka, Amiri and Amina Baraka. Confirmation: An Anthology of African–American Women, 1983; "Faith Ringgold: Black Women Artists 1963–1973" (cat.), Rutgers Univ., New Brunswick, N.J., 1973; "Faith Ringgold: Soft Sculpture" (cat.), Museum of African American Art, Buffalo, N.Y., 1980; "Faith Ringgold: Painting, Sculpture, Performance" (cat.), College of Wooster Art Mus., Wooster, Ohio, 1985; "Faith Ringgold: Change" (cat.), Bernice Steinbaum Gal., NYC, 1987; Lippard, Lucy. From the Center, 1976; Miller, Lynn and Sally S. Swenson. Lives and Works: Talks with Women Artists, 1981; Wallace, Michele. "Faith Ringgold: Twenty Years of Painting, Sculpture, and Performance 1963–1983" (cat.), Studio

Museum of Harlem, 1984; Who's Who in American Art, 1989–90. *Periodicals*—Art in America May 1972, May 1987; Arts March 1987; Feminist Art Journal April 1972; New York Times July 29, 1984; Women's Studies Quarterly, Spring–Summer 1984.

ROCKBURNE, DOROTHEA (1934–), Canadian-American painter, is one of the pioneers of the post-minimalist trend that succeeded pop and the bold abstract painting of the 1960s, but came before the 1980s and the return to the figure. Her paper constructions of the early 1970s, her folded drawings and paintings that followed in the mid-1970s, and her brilliantly colored works of the 1980s have consistently pushed the limits of intellectual premises about the media and methods of contemporary art.

Born in Verdun, Quebec, a suburb of Montreal, Rockburne grew up in a modest family where, she told critic the John Gruen, "there wasn't much money, but there was fun." In fact, she suffered from respiratory ailments throughout her early childhood and spent much time bed. As a result, her main activities were reading and listening to the radio, although she also enjoyed swimming and skiing when she was well. The sicknesses disappeared as she got older—because of the physical activity, she contends—and she began to channel her energy into art. At the age of twelve she enrolled in art school and "found a part of myself that wasn't fulfilled in any other way." The attraction, she told Gruen, "had to do with making things. All along I've been interested in the making of objects and how those objects function and enter the world. I feel that an object is really an emotional experience."

After three years at the School of Fine Arts in Montreal, she applied to art schools as far away from Quebec as possible (including the Slade School in London) and finally settled on Black Mountain College, the experimental school in the hills of North Carolina that was a meeting ground for some of the most creative visual and performing artists of the time. Rockburne's teachers there included the painters Philip Guston, Esteban Vicente, and Jack Tworkov, as well as the choreographer Merce Cunningham, and among her friends were Robert Rauschenberg, Cy Twombly, and Franz Kline. For Rockburne, as for many others, the learning experience was seminal, but in her case, there was an added personal dimension: while at Black Mountain, she married, had a child, and then got divorced. "Clearly I had learned to take risks at Black Mountain," she noted, pointing out that the responsibilities of being a single mother (in the 1950s) often isolated her, but "still, Black Mountain was the beginning."

In 1956 she moved to New York City with her daughter, Christine, and set about trying to earn a living for the two of them while continuing to paint. "Of course, at the time," she recalled to Gruen, "it was easier, as a woman, *not* to make art. . . . It seemed you got applause for doing nothing and criticized for doing something. . . . But I was making art—always." In addition to painting, she took photographs—black-and-white images of abstract forms—in order to work out pictorial problems. But she was not satisfied with her work, and in the mid-1960s, after a period of indulging herself in paintings that were "purposefully bad," she stopped altogether. "I had a lot of energy, and I started to take some dance classes," she explained. "I fooled around at the Judson Theater in the Village, dancing with Carolee Schneeman, Bob Morris, Steve Paxton, Bob Rauschenberg, and appearing in some [Claes] Oldenburg happenings. I did this for three years, and from that I found out what to do in my work."

When she resumed painting, it was in the austere mode of the minimalists, with a series of large metal panels in muted colors, such as *Tropical Tan* (1967–68), a sheet of pig iron divided into four vertical sections with an allover tan field and blue borders across the top and bottom. From such monumental works, which were nothing if not permanent, she moved to a more incidental phase, experimenting with rolls of paper variously hung from ceiling to floor (*Untitled*, 1969), and later combined with oil-stained chipboard in assemblages that were meant to function like mathematical sets (*Sign* and *Three*, both 1970).

Those elegantly simple works, fashioned out of modest materials and endowed with no more permanence than the duration of an exhibition, yet rooted in sophisticated (and fashionable) aesthetic theories, were eagerly welcomed among the emerging trends of the early 1970s. When several pieces were exhibited in downtown Manhattan group shows at the Bykert and Paula Cooper galleries, the critic Robert Pincus-Witten placed her in the postminimalist camp of Carl Andre and Richard Serra for her interest in "the meaning of matter and surface"—that is, the absorbency of the paper rubbed with oil or the way the rolls fell from wall to floor—and concluded that "Rockburne is surely inventing in an area of sculpture (drawing? painting?) in which the postulates have scarcely even been set." After her first individual show at Bykert in 1970, Pincus-Witten placed her work "among the most rare and beautiful experiments being conducted at the moment." Noting the influence of set theory (reflected in the titles of pieces like *A.C.+D.*), he nevertheless set her apart from her

precursors in the late 1960s, Sol LeWitt and Mel Bochner, because of Rockburne's intuitive approach.

In "A Note on Dorothy Rockburne," which introduced a selection of her paper assemblages in *Artforum* early in 1972, Bochner himself characterized her interest in terms of "interrelations and transformations" within a limited set of materials (cardboard, paper, nails, oil) and operations (soaking, rolling, unrolling, pressing, hanging, layering). Acknowledging that "Rockburne has developed a means of using materials which I personally would have thought impossible three or four years ago," Bochner placed her work among the most "penetrating being done today because it has broken with the use of language as representation," and concluded: "What is at stake here is determining a boundary of the most advanced thinking in art being done today."

When some of the same pieces were exhibited more than fifteen years later at the Xavier Fourcade Gallery, New York, the underpinnings of set theory were generally taken less seriously, and the importance of process—"How it got this way," in Brian O'Doherty's words—more so. At the time she was involved with those experiments—a moment when "emotional impetus" did not often enter critical discourse—Rockburne herself was nonetheless quite explicit about the expressive meaning they held for her. "Giotto ground the colors of the earth. I felt my sensibility [lay] there," she wrote in a note on one of her 1969 pieces, and as she told Jennifer Licht early in 1972, "I'm interested in the way I can experience myself, and my work is really about making myself."

Notwithstanding that personal, and private, content, Rockburne's next project seemed to pursue even more hermetic concerns in the form of sets, systems, and signs. The objective of the "Drawings Which Make Themselves" (1972), she explained, was to eliminate the usual external referents of drawings and to generate images solely from "one surface affecting another surface through interaction." In practice, that effort took the form of folded sheets of paper bearing carbon-paper markings, which were first exhibited in 1973 at the Bykert Gallery; the overall effect, according to one critic, was somewhat disorienting, since the entire gallery, including the floor, had been painted white for the occasion. But the real effect of those drawings, he explained, was that the viewer was forced to "think and learn" about the underlying vision that had determined the forms now looming in the gallery space, forms that, ironically, inverted the usual dynamic of drawing, in that the paper had effectively "activated" the line.

Rockburne continued to experiment with folded drawings in the "Object Identity Series" and "Conservation Drawings" (1973), as well as a series extrapolated from photographs of Florentine architecture, "In Consideration of the Curve" (1974). With the "Golden Section Paintings" (1974), she brought the logic of the set to bear on a new problem—that of shape—through the mathematical formula for harmonic proportions known as the golden section. As in the "Drawings Which Make Themselves," she continued to work with folds, but now the inspiration was more historical than existential—the drapery patterns of Renaissance and Byzantine paintings. The material she chose to work in was natural linen, which, in emulation of her historical models, she stiffened with gesso and varnish and marked for folding with chalk plumb lines, creating eight variations on the combined dimensions of a square and the rectangle formed from its golden section. "Like all her major works," wrote Naomi Spector, "these were paintings which made themselves—that is, they were self-generating from the preliminary choices of materials and premises,"

A much less favorable reading of the process came from Max Kozloff on the occasion of the "Eight Contemporary Artists" show at the Museum of Modern Art, where Rockburne first exhibited the "Golden Section Paintings." Reacting against the minimalist/conceptualist order that prevailed over that eclectic presentation—ranging from the monochrome painted panels of Brice Marden to the handwritten indexes of Hanne Darboven—Kozloff argued that "symbolically, the brittle patterns employed by this squad of artists speak not of a clarifying order but of an imprisoned mentality, capable only of operating in dumb response to its external logic." For Rockburne, at least, the "external logic" was hardly the driving force behind her work: "I never totally rely on theory," she told Roberta Olson, "because the act of forming a statement visually has always been paramount for me."

In that respect, the "Golden Section Paintings" marked a kind of turning point: she had wanted to introduce color into those works, but felt that it would be too complicated, both technically and intellectually. And after that, "there was only one place to go." But in the works that followed, culminating in the "Robe Series" of 1976, she extended the golden section into the domain of color. As the title implies, the "Robe Series" was inspired by the rendering of garment folds in late medieval paintings, and specifically Duccio's *Maestà* altarpiece (1308–11). The altarpiece, for Rockburne, was already a shaped canvas; her objective with the series was to match

shape and color in such a way that the painted surfaces would be inseparable from their supports. But as is clear from the series' four paintings—*Discourse, Noli Me Tangere, The Descent,* and *Sepulchro*—she was also attempting to endow the color/shapes with the expressive content of Duccio's archetypal Christian themes. The diagonal cascade of *The Descent*, for example, corresponds to the disposition of the *Descent from the Cross*, while the horizontal organization of *Sepulchro* follows that of the *Pietà*, and in each of the paintings there is a direct quotation from some visual element in Duccio's altarpiece panels.

As Rockburne had anticipated, the use of color entailed painstaking experimentation with color swatches and preliminary drawings, but the results were met with great enthusiasm—"a whole lot more than the sum of her past works," in the words of Ellen Lubell. In particular, the "Robe Series" permitted critics to recognize the personal, expressive dimension of Rockburne's work and even to view her earlier pieces in a different light. Echoing Max Kozloff's outlook on the battle of the intellect and the senses, Leo Rubenfien wrote, "Needless to say, Rockburne has heretofore opted generously for the cerebral side." But in light of the latest paintings, he went on, "the redundant presence of the golden section may not have been an actual limitation of Rockburne's as much as a metaphor for limitation." And, he concluded, "what makes [the paintings of the "Robe Series"] interesting is their nagging interest in the other, sensual side, and their dogged progress toward it."

For Rockburne herself, the "progress" was far less conflictual than cumulative. "Usually each piece is related to a vision," she explained in 1978. "The vision itches my consciousness. The itch is partially caused by the accumulation of experiences from other works, coupled with an emotional need to expand." That dynamic was illustrated even more clearly in the four interrelated series of drawings that she produced after the "Robe Series" and exhibited together at the John Weber Gallery in 1978. The first of those, the "Roman Series," done on brown kraft paper, took up the curve motif of her earlier series "In Consideration of the Curve" (which had just been destroyed when a steam pipe burst in her loft). Her subsequent "Vellum Curve Series" applied curvilinear motifs—now in colored pencil—to golden section forms made out of translucent vellum paper, while the "Combination Series" combined units of the "Vellum Curve Series" in order to examine once again the properties of layering. With the "Arena Series"—alluding to Giotto's frescoes in the Arena Chapel in Padua—all of Rockburne's con-

cerns, from set theory and the golden section to the relationship of form, color, and art-historical tradition, were brought together in eight more drawings on folded vellum. All four series were completely mapped out before Rockburne began work, but once again, as she made clear in her project notes for the "Arena Series," that kind of calculation was a means, not an end in itself: "I always seem to have a vision in my eyes and in my head. Realizing the vision is the joy of working and living. So even though the work, even after certain choices, seems to be following a plan (or theory)—the real look of the work is in my head. Obtaining this vision is why the work is so slow in becoming."

With the "Egyptian Paintings" of 1980, Rockburne temporarily put color aside for a group of monochromatic, modular constructions that were, in her words, "out of step" with the contemporary art scene. Once again working with gessoed linen folded into modular triangles, she now fashioned them into elegant relieflike configurations (one in black, all the rest in white) that emphasized contour and plastic surface rather than solid form and transparency. Like the "Robe Series," with its evocation of Christian art and tradition, those works, bearing titles like *Scarab, Stele, Seti*, and the black *Basalt*, tapped the rich associations of ancient Egypt, and more than one critic admired their transcendent quality. The spiritual dimension was made even more explicit in Rockburne's next major series of paintings, "The Way of the Angels" (1982), inspired by Fra Angelico's Linaiuoli Tabernacle in Florence. Made out of folded vellum painted on both sides with watercolor, works like *Guardian Angel* and *Seraphim: Love* conjure up celestial beings with wing shapes and fire colors emerging out of the layers of translucent paint. In a group of oil paintings that she called "Inner Voice" (1982–83), Rockburne continued to work with her geometric repertoire of triangles and squares but, as in the watercolors, broke open the surfaces with streaks of color.

That "rough painterliness," as Brian O'Doherty calls it, has prevailed in her more recent works, which are often multipaneled individual paintings that she has brought to completion over long periods of time. In a journal entry from 1984, she described the process of rethinking, and actual repainting, that went into *Extasie* (1983–84), a sensual composition that bears the title of a Ben Jonson love poem: "I decided to paint this painting twice from the outset, as I often have with other works. I thoroughly want the experience of this paint, this structure, this feeling, to be known to me before I make the painting. Then when I begin again, so much is known to me that I can 'stand outside

of myself' and enter a state of ecstasy." Of another work, *Exsultate* (1985–86), she explained that it developed as she was listening to Mozart's *Exsultate Jubilate* but was completed only after she visited Borromini's baroque church of Sant'Ivo in Rome and saw "the torsion, the theme of the angle, and the light that corrodes and bends."

In the view of critics (who have been quite receptive to this latest phase of Rockburne's work), her achievement lies in a kind of heroic synthesis of reason and emotion—"the unlikely but promising marriage of intellectual acuity with feeling" according to Jane Bell, for whom Rockburne is "an artist whose sensitivity emerges virtually in spite of itself." For Rockburne, on the other hand, continuity rather than opposition seems to be at the core of her approach to art: "What I do is make a physical shape that has its emotional shape within me," she explained to John Gruen. "I'm trying to make those two things correspond in the hope that it's the same emotional shape that other people have and that they will recognize."

Rockburne lives and works in a large, comfortable, and perfectly organized SoHo loft. She claims to have "an eighteenth-century mind and the kind of humanism that goes with it. At the same time, she insists that "I've never wanted to understand my work in a so-called logical way. I don't want to pigeonhole an experience. I don't like my work to be defined. Like love, it should remain undefined."

EXHIBITIONS INCLUDE: Bykert Gal. NYC 1970, '72, '73; Gal. Ileana Sonnabend, Paris 1971; New Gal., Cleveland 1972; Gal. Toselli, Milan 1972, '73, '74; Univ. Rochester Art Gal., N.Y. 1972; Gal. d'Arte, Bari (Italy) 1972; Lisson Gal., London 1973; Hartford Col. Art Gal., Conn. 1973; Daniel Weingerg Gal., San Francisco 1973; Gal. Schema, Florence 1973, '75; Gal. Charles Kriwen, Brussels; John Weber Gal. 1976, '78; Texas Gal., Houston 1980, '81; Xavier Fourcade Gal., NYC from 1981; Chicago Arts Club 1987; Anders Tornberg Gal., Lund (Sweden) 1987; Andre Emmerich Gal., NYC 1987. GROUP EXHIBITIONS INCLUDE: Whitney Annual 1970; "Works for New Spaces," Walker Art Cntr., Minneapolis, and Bykert Gal., NYC 1971; "white on White," Mus. of Contemporary Art, Chicago 1972; Documenta 5, Kassel, West Germany 1972; "420 West Broadway," Festival of Two Worlds, Spoleto 1972; "Options and Alternatives: Some Directions in Recent Art," Yale Univ. Art Gal., New Haven 1973; "Works in Spaces," San Francisco Mus. of Art 1973; "Young American Artists," Genthofte Kunstvennor and Gentofte Kommune (Denmark) 1973; "2-D into 3-D," NY Cultural Cntr., NYC 1973; "Arte come Arte," Comunitario di Brera, Milan 1973; "American Drawing," Whitney Mus. of American Art, NYC 1973; "Some Recent American Art," MOMA, NYC 1974; "Line as Language: Six Artists Draw," Princeton Univ. Art Mus.

1974; "Political Art," Max Protech Gal., Washington, D.C. 1974; "Choice Dealers/Dealer's Choice," NY Cultural Cntr., NYC 1974; "Basically White," Inst. Contemporary Arts, London 1974; "Eight Contemporary Artists," MOMA, NYC 1974; "Mel Bochner, Barry Le Va, Dorothea Rockburne, Richard Tuttle," Contemporary Arts Cntr., Cincinatti 1975; Corcoran Biennial, Washington, D.C. 1975; "Modern Painting 1900 to the Present," Mus. of Fine Arts, Houston 1975; "Drawing Now," MOMA, NYC 1976; Whitney Biennial 1977; Documenta 6, Kassel, West Germany 1977; "Inaugural Exhib.," New Mus. of Contemporary Art, NYC 1977; "View of a Decade," Mus. of Contemporary Art, Chicago 1977; "HKK Foundation for Contemporary Art," Milwaukee Art Cntr. 1978; Whitney Biennial 1979; "Explorations in the 70's," Pittsburgh Plan for Art 1980; "With Paper, About Paper," Albright-Knox Art Gal., Buffalo 1980; Venice Biennale 1980; "Locus," MOMA, NYC 1981; "Abstract Drawings 1911–1981," Whitney Mus. of American Art 1982; "A Century of Modern Drawings," Mus. of Fine Arts, Boston 1983; "Gemini GEL: Art and Collaboration," National Gal. of Art, Washington, D.C. 1985; "An American Renaissance: Painting and Sculpture since 1940," Mus. of Art, Fort Lauderdale 1986.

COLLECTIONS INCLUDE: Whitney Mus. of American Art, MOMA, Metropolitan Mus. of Art, NYC; Corcoran Gal. Art, Washington, D.C.; Philadelphia Mus. of Art; High Mus. of Art, Atlanta; Minneapolis Art Inst.; Mus. of Fine Arts, Houston; HKK Foundation, for Contemporary Art. Inc., Milwaukee; Ludwig Mus., Aachen.

ABOUT: Boice, B., "Dorothy Rockburne" (cat.), Hartford Art School, 1973; Collins, J.L. Women Artists in America, vol. 2, 1977; "Dorothy Rockburne, A Personal Selection: Paintings 1968–1986" (cat.), Xavier Fourcade Gal., 1986; "Drawing: Structure and Curve (cat.), John Weber Gal., 1978; Emanuel, M., et al, Contemporary Artists, 1983; "Explorations in the 70's" (cat.), Pittsburgh Plan for Art, 1980; Krauss, R., "Line as Language: Six Artists Draw" (cat.), Princeton Univ. Art Mus., 1974; Licht, J., "Eight Contemporary Artists" (cat.), MOMA, 1974; "Mel Bochner, Barry Le Va, Dorothea Rockburne, Richard Tuttle" (cat.), Contemporary Arts Cntr., Cincinnati, 1975; Who's Who in American Art, 1986; "With Paper, About Paper" (cat.), Albright-Knox Art Gal., 1980; "Working with the Golden Section" (cat.), John Weber Gal., 1976. Periodicals—Artforum September 1970, February 1971, March 1972, April 1973, November 1973, December 1974, January 1977, January 1979, March 1979, April 1981, October 1984, Summer 1986; Art in America November 1978, January 1982, February 1983, February 1986; ARTnews Summer 1974, December 1981, January 1983, May 1985, March 1988; Arts Magazine May 1986.

ROTHENBERG, SUSAN (January 20, 1945–), American painter and printmaker who is widely considered one of the most talented and original painters of her generation. Susan

SUSAN ROTHENBERG

Rothenberg first gained the attention of critics and collectors alike in the mid-1970s with her disconcerting, strangely compelling paintings of horses. In those densely worked, nearly monochromatic canvases, one or two vertical or diagonal lines divide the strongly delineated contours of a horse, creating an extraordinary tension between the evocative image and the blankly geometric bars or axes. In the horse paintings Rothenberg blurred the usual boundary between abstraction and figuration, synthesizing the two styles to create works of formal purity and poetic charge. Her early work was classified as new image painting, a critical designation applied to the work of a loosely defined group of artists who reacted to minimalism by depicting representational images without abandoning the formalist strategies of reductive abstraction. In Rothenberg's case the resulting works were both structurally austere and iconic, hermetic and infinitely suggestive.

Toward the end of the 1970s, the figures in her paintings and prints became increasingly disintegrated and allusively human in form. The new direction of her work has culminated in paintings which, while not realist, admit rather than fight illusionism. In contrast to the impersonal horse image, her recent paintings have featured, in brushily abstract style, subjects derived from her own experience. The artist has also introduced splashes of moody color, switched from acrylic to thicker, more expressive oil paint, and allowed formerly flat surfaces to acquire murky depth. A key figure in the transition from minimalism to neo-expressionism, Rothenberg has

gone on to establish a new and provocative idiom for her painting.

The artist was born in 1945 in Buffalo, New York, where she was raised by parents who strongly supported her early interest in painting and drawing. "I think you often become what you are praised for when you are small," she told Lisbet Nelson in 1984, "and I think that was about the only thing I was praised for. I was not a real well behaved child." Her early experiments in art were also encouraged by a family friend and neighbor, "Dr. Joe" Rosenberg. An enthusiastic amateur painter, he allowed her to work in his studio. She took art classes in high school, then studied sculpture at Cornell until, after two years, the department head deemed her untalented. A five-month interval in Greece followed, after which Rothenberg returned to Cornell and concentrated on painting. After graduating in 1967, she entered a somewhat aimless period. She began a master's degree at the Corcoran School of Art in Washington, D.C., but soon left the program. On her own she did some painting, but remembers spending "a lot of time" in a jazz bar. By the fall of 1969, she found herself back in Buffalo. From there she boarded a train to Nova Scotia, planning, she told Grace Glueck, in 1984, "to get lost in the woods and teach English in some backwater town." But at Montreal she impulsively boarded a train to New York City, where her artistic career was to begin.

In New York Rothenberg settled in a Lower West Side studio and became part of a community of interdisciplinary artists that included painters, musicians, composers, and dancers. Among them was the sculptor George Trakas, whom she met when both were performing in a piece by the choreographer Joan Jonas. Rothenberg and Trakas married in 1971, and she credits his intense dedication to his work as an important influence. Her own art during that period reflected a "working through" of the myriad influences around her, and ranged from punching holes in plastic to geometric pattern painting. Minimalism was still the dominant mode, but Rothenberg found it uncongenial and, finally, tedious. By 1973, four years after her arrival in the city, she grew bored with the geometric pattern painting she had been doing. The only good thing about her pattern paintings, she decided, was the simple pencil line she drew down the middle. She had had her daughter, Maggie, by then, and as she explained to Hayden Herrera, in 1984, "some time after she was born the image of the horse came out." In front of a canvas one day, she recalled, "I drew a line down the middle, and before I knew it, there was half a horse on either side."

Over the next six years Rothenberg would complete a series of about forty horse paintings. Her first exhibited work was singled out by many reviewers of the 1974 New Talent show in New York. In "Triphammer Bridge" (1974), the attenuated silhouette of a stationary black horse, poised on a rich brown background, is bisected by a vertical line. Critics were startled and beguiled by Rothenberg's stark, formalist treatment of a such a conventional and culturally resonant image. The horse was not, as some viewers speculated, a private totem for the artist. Rather, Rothenberg told Hayden Herrera, she depicted that particular image simply because it was "something real, something recognizable, and something that divided perfectly in half by virtue of it['s] being not quite symmetrical. It has an innate power that carried my formalist thinking." Her choice of image may have been quixotic, but its impact was forceful, even visceral. While the horse is redolent with literary and mythic associations, on Rothenberg's canvas it functions primarily as a vehicle for her exploration of formal problems, a duality that charges the painting with an arresting tension. Abstractly pure, beautifully executed, anti-illusionist, the early horse paintings largely incorporate the minimal ethic, what Rothenberg refers to as "the dictum of the day."

But perhaps more significant, her art, along with that of other new image painters like Neil Jenney, Jennifer Bartlett, and Lois Lane, signaled a fresh direction in painting. Rothenberg's horse motif reflects the postminimalist return to representation—in her case of an emblematic rather than realist kind. The artist told Grace Glueck that the horse was "a way of not doing people, yet it was a symbol of people, a self-portrait, really." While not admitting the strident self-expression of the neo-expressionists, neither is her work depersonalized in the manner of non-objective art. In addition, even her most austere works demonstrate painterly values. Surfaces are heavily worked; indeed, in some canvases the scumbled monochromatic field attains an almost frescolike effect. In that respect, as in her iconic treatment of a prosaic image, the debt to Johns is apparent. Rothenberg herself has attested to that, noting in 1982 that her work "comes right out of Jasper Johns's targets." The disrupted surface, like the eloquent horse image, gives Rothenberg's paintings an expressive energy. But her gestural brushwork is as controlled as her deployment of a symbolic image is restrained. Robert Stoor has noted that her surface markings "are gritty and abrupt . . . but their main function outside of drawing seems to be not so much to stimulate feeling as to activate the canvas—especially where there are not figurative ele-

ments or tone or color changes." Rothenberg's paintings operate quietly in their own context, and in a strong sense painting itself is their subject.

Over the years the horse paintings evolved from primitive, deliberately crude renderings to elegant, fragmented depictions that possessed an almost oneiric quality. The first horses, outlined or silhouetted and invariably facing left, reminded many viewers of cave paintings. Figure and ground were often the same color—black, white, and a fleshy sienna were the main hues—reinforcing the impression of flatness. Some early horses were wooden-looking and inert, but increasingly they appeared in motion, galloping headlong across the canvas. In later works they were dislocated from their familiar profile stance, turning to confront the viewer directly. Several late horses assumed a quasi-human form. In *Tuning Fork* (1980), for instance, the horse looms frontally, the animal and its elongated shadow becoming like an inverted tuning fork and resembling, the artist has acknowledged, a human figure.

The formal strategy of the painting altered too, the simple bands first replaced by diagonals crisscrossing the canvas and then by chalky-white bone shapes. "One of the big elements that the geometry gave the painting was tension," Rothenberg explained to Lisbet Nelson. "And at one point I found that a bone could create that same feeling, so the bones took over the tension factor; there were the soft contours of the horse, the sharp lines of the stretcher, and the bones, which also were more integrated with the subject matter. Then I found I could extrapolate—the bones didn't have to make any more sense in terms of skeletal armature than the horse had to conform to a real horse. And then all sorts of things just started to happen. I began to wing it with the bones. And the work certainly got more psychologically intense, since bones have so many connotations." Also contributing to the increasing structural complexity of the work was Rothenberg's dismemberment of the horse figure. The dissected parts were made to overlap each other, forming strange configurations. The figures that emerged were sometimes allusively human, and for Rothenberg, who was not interested in depicting the whole human form, that development signaled the culmination of the horse series.

Even more haunting paintings followed. In the late 1970s, as the horse series was winding up, Rothenberg began painting dismembered heads and hands. "I suppose I connected to it because that's what I work with, a head and a hand, and I thought, why not paint it." She start-ed with nine-inch studies, "mesmerizing at that size," she found, and moved on to five ten-foot-square paintings based on the studies, a project that took about a year. Created during a period of personal crisis—she and her husband were divorcing—the paintings have been described by the artist as "very confrontational." The surfaces are heavily worked, first underpainted in dark, dense flashes mixed with acrylic and then thickly overpainted in white. Etched into the grayish white surface are the black, blue, and red contours of hands—open, cupped, fisted—and of bluntly shaped heads. In a review of her 1981 show of those five paintings at the Willard Gallery, Hal Foster noted that "the effect precedes recognition of the image. It is . . . the tension between the tactile and the visual, the immediate and the removed. The tension is stressed here, doubled in fact, because it is not only represented but experienced."

Rothenberg's next challenge, after painting in acrylic for twelve years, was to learn to use oils. With that change in medium there also came a major shift in the content of her paintings. In the summer of 1981 the artist stayed in a house on a creek in Long Island, and she began painting the boats parked out front while teaching herself to use oil paint. Sailboats proved a congenial image, an apposite symbol for the freedom she was then experiencing in her life. Movement, space, light, depth—all suggested by the sailboats—became elements she sought to incorporate in her work. "The boats led me down a different avenue of painting," Rothenberg has explained. "I guess I had had a lot of rules, and they started to break up with the sailboat image." Instead of an image and ground, her new paintings comprised "a figure and a sense of location." She liked the incremental way she could create a surface with oils, and the way she could scrape off paint when the canvas had become too congested. Whereas in her earlier work the ground was activated by applying paint lavishly, now she could create an animated surface with variegated brushwork, stroking the paint on to make a choppy field (which she terms "weather"). Her canvases remain beautifully painted, but the formal distancing techniques she formerly employed have given way to a frank expressionism. Skimming sailboats, her daughter's cartwheel, a neighbor with her grandchild, even a scene from her own family history all became subjects. But the paintings are representational in an interpretative rather than realist way; she is, she has indicated, interested in capturing "the feelings you get from the objects that you see." With hazy, enigmatic images and curdled, atmospheric fields, Rothenberg strives to convey the essences of her subjects.

Those subjects are, increasingly, human in form, but they are blurred, generalized figures, often indeterminate or ghostly in appearance. In a review of Rothenberg's 1985 exhibition at the Willard Gallery, Nancy Grimes noted how in the figure paintings "the simplified, delineated forms of the past swell into modeled volumes," which "dissolve into thickets of atmosphere." Frequently those figures are placed in ambiguous scenarios. In *Red Blush* (1985), for instance, "two people engage in an obscure activity that involves one holding the other's foot." Rothenberg emphasizes that even in her depictions of people she does not "mean to tell a story. What I mean to do," she told Grace Glueck, "is to catch a moment, the moment to exemplify an emotion. That intention is the same as it has always been." This is apparent in paintings like *Biker* (1985), in which the cyclist who zooms through a puddle of water is not a compelling narrative component; rather, impressions of movement and energy dominate the canvas and command the viewer's attention. In her 1987 show at the Sperone Westwater Gallery Rothenberg invested the moments she was "catching" with great intensity by representing nearly all her figures in almost febrile motion. Whirling, weaving, bobbing, juggling, spinning, dancing figures abound—whatever her recent works may lack in psychic charge, they indubitably possess immense dynamism.

The shift in content and medium has not been received uncritically; some reviewers contend that the persistent brushwork—sometimes a veritable haze of strokes—threatens to overwhelm the abstract central images and to compromise the pictorial succinctness for which Rothenberg is known. Others consider that the recent paintings capturing movement and moment are intriguing and successful despite the occasional lack of cohesion. Reviewing Rothenberg's 1987 Sperone Westwater show, Kay Larson remarked that "the dance of the figures through the whirlwind surface is a fantasy of action that corresponds to the actual movements of the painter's brush, and to the fluid state envisioned in the painter's eye. . . . Eye and mind are entangled in a great and magnificently subtle exchange that has always been the particular province of the painter's."

Rothenberg lives and works in a loft on the western edge of Tribeca, a popular artist's enclave in downtown Manhattan, with her teenage daughter. (She and George Trakas, divorced in 1979, remain friends.) Lisbet Nelson described the artist as "cheerful with a mischievous edge, friendly, straightforward, articulate, garrulous, even, once she gets going. Indeed, she can seem pixieish, tiny as she is and playful as she looks

when she is grinning. But . . . a streak of self-deprecating, rather deliberate naivete . . . clearly masks a disciplined private seriousness." One quickly senses, Nelson wrote, that she "is someone who has learned things the hard way, through a painstaking and occasionally painful process of trial and error." That impression is corroborated by the artist's description of her working method as "corrective": "I make a mark and retreat, and wait, and wait some more. And then I make another. It's all very mysterious. And gradual. You sort of sneak up on the picture and get one piece at a time."

EXHIBITIONS INCLUDE: "Three Large Paintings," 112 Greene Street, NYC 1975; Willard Gal., NYC 1976, '77, '79, '81, '83; Speorne-Westwater, NYC since 1986; Akron Art Mus. 1981; "New Image Painting," Whitney Mus. of American Art, NYC 1979; "American Painting: The 80s," Grey Art Gal. New York Univ. 1980; Biennale, Paris 1980; "Focus on Figure," Whitney Mus. of American Art, NYC 1982; Stedelijk Mus., Amsterdam; "Zeitgeist," West Berlin 1982; Barbara Krakow Gal., Boston 1984; California State Univ., Long Beach 1985; Des Moines Art Cntr. 1985; "Avant-Garde in the Eighties," Los Angeles County Mus. of Art 1987.

COLLECTIONS INCLUDE: MOMA, NYC; Whitney Mus. of American Art, NYC; Albright-Knox Gal., Buffalo, N. Y.; Akron Art Mus., Ohio; Walker Art Cntr., Minneapolis; Art Mus. of South Texas, Corpus Christi; Mus. of Fine Arts, Houston; Stedelijk Mus.; Dallas Mus. of Fine Art; Carnegie Inst. Mus. of Art.

ABOUT: Emanuel, M., et al. Contemporary Artists, 1983. Current Biography, 1985. *Periodicals*—Artforum Summer 1979, Summer 1981, Summer 1983; Art in America September–October 1976, December 1982; ARTnews September 1974, February 1978, September 1980, February 1984, October 1985, October 1986, May 1987; Arts Magazine June 1977, June 1983, June 1986, April 1987; Connoisseur April 1984; New York November 9, 1987; New York Times April 13, 1979, September 23, 1979, September 20, 1981, July 22, 1984; Saturday Review February 1981; Washington Post September 2, 1985.

***ROUSSE, GEORGES** (July 28, 1947–), French painter and photographer, caught the attention of the Paris art world in the early 1980s with the large painted figures that he photographed in decrepit architectural settings. At the time, he was identified with the emerging figuration libre (free figuration) group, but in the intervening years, the evolution of his personal idiom and his philosophy of art have set him apart from the youthful members of figuration libre as a leading figure in the postmodern synthesis of conceptual and formal concerns.

°roōs

Rousse was born in Nice but spent time in Metz, West Germany, where his father was posted as an officer in the French foreign legion. The youngest of three children, he grew up dreaming of adventure and enlisted in the paratroopers at the age of eighteen. After his release three years later, he turned to the example of his older brother, a doctor, and entered medical school but dropped out after one year. He then apprenticed himself to a photographer in Nice. "My parents, wild with anger, slammed the door in my face!" Joining the French Communist party, he worked as a photographer for their local newspaper and eventually set up a studio. His own work consisted of black-and-white photos influenced by the documentary style of the British land artists: "That's to say that I was intervening in a very minimal way, with flash shots of branches that interested me for their graphic qualities."

When his wife, Anne-Marie, got a job in Paris in 1976, the couple moved there with their four-year-old daughter, Emmanuelle (their second daughter, Julie, was born the following year). For the next five years, Rousse worked the night shift in a photo lab, but made use of the daytime to explore the city. He had started draping the trees he photographed with silver paper, but this effectively negated the natural aspect of his images, and he was dissatisfied with his work. Feeling the need to address more immediate subjects, he then turned to photographing abandoned buildings—housing projects, factories, warehouses. For him these were "the terrain of games and adventures. Places for dreaming, but also unsettling spots where you don't ever really know what you're going to discover, or if they're visited, lived in, with [their] bizarre atmospheres and a strong emotional impact."

In these modern "ruins," Rousse found both a commentary on contemporary urban society (with explicit political overtones) and a link with European painting tradition. In fact, he had been increasingly drawn toward painting since shortly after his arrival in Paris, when the opening of the Pompidou Centre gave him access to a vast collection of modern art: "That was the first time I was able to look at painting up close. I liked it," he recalled, adding that he was also inspired by the gallery talks, which were "rather interesting for somebody like me who didn't know anything." It was during one of those talks that he discovered the Russian suprematist painter Kasimir Malevich's *White Square*, which became a kind of "trigger" for all of his artistic instincts.

Despite that rather profound experience, Rousse was reluctant to begin painting because he had no formal training, but he did switch to color photographing—which he considered the equivalent of painting—and he started photographing the work of other artists, including the first group exhibition, held in June 1981, of what was soon to be called figuration libre. Those youthful artists—they were at least ten years younger than Rousse—encouraged him to try painting himself, and, perhaps more important, their comic-book-style "bad art," with its absence of technical polish, gave him the confidence he needed. The result was that he began peopling the condemned buildings he photographed with large human figures, whether painted on paper and glued up or applied directly to the wall.

"In my first photographs," he told Jean de Loisy in 1985, "I felt something missing, which I understood to be my imagination. In painting, it's transmitted." From the very beginning, his mixed-media photographs remained untitled because, as he later explained, "My actors are only a dream; my work resembles a fiction." The condemned sites were particularly rich in associations for him: working on site was "not only the recreation of an abandoned artist's workshop, which preserves on its walls the traces of paintings quickly made, but also the desire to make for myself a kind of imaginary museum based on these empty, abandoned workshops." Photography, he explained, was simply the mechanical means of achieving that; his real concern was with the decaying space and the painting within it: "If it's true that at the outset I wanted to play doubly on the identification of color [photography] and painting, my work is in fact more painting than photography, because it comes from a hunger for painting, a contact with the site. The painting, even if it's minimal and there are few things to see, is the driving force."

Like the images of his figuration libre friends Robert Combas, Hervé Di Rosa, Rémy Blanchard, and others, Rousse's crudely drawn figures evoked any number of traditions from naive painting and the art of the insane to the modernism of Matisse and Picasso. But in contrast to figuration libre, there was no apparent narrative: in Rousse's words, the figures were intended to create an "emotional shock" because of the "strangeness" of their relationship to the surrounding space. Above all, they were not simply paintings: they existed only in conjunction with photography and architecture, as mechanical reproductions preserving a physical setting that had otherwise been destroyed. As one of his early admirers, the critic Michel Nuridsany, pointed out, "What started in the beginning with inscription, with a trace, with graffiti, all of which introduced disorder into the condemned

space, captured by the camera just before it disappeared, has gradually become reflection on space and plane, with the figure serving to activate the desire phenomenon of yearning and resistance."

Nonetheless, Rousse was generally treated as part of the rising tide of figuration libre: his work was first shown with that of Combas, Di Rosa, and others in "L'Air du Temps: Figuration Libre en France" at Nice in early 1982, and he was featured in *Art Press*'s dossier on "Thirty Young Artists" that April. His visibility was particularly enhanced by his inclusion in the 1982 Paris Biennale, and he began to receive invitations to work in sites throughout France and elsewhere in Europe. Despite his instant success, he held very much to the private, personal dimensions of his activity, continuing to work alone and pursue a kind of communion with each environment. In March 1983, for example, he was invited to Bordeaux, where the warehouses of the colonial navy were about to be replaced with a new museum of contemporary art. "I had envisioned paintings that were very colorful and large," he told Patrice Bloch and Laurent Pesanti, "but when I got to the site, I realized that was impossible. The light, the repetition of the arches, the monochrome aspect of the place, the wood and the stone, all of that demanded something else." Among the images he came up with were a row of doors on which he had painted female figures, the upper portion of a room with four male figures floating between wall and ceiling, and perhaps most interesting of all, an archway painted with a male torso twisted unmistakably in the style of Romanesque sculpture.

As various critics pointed out, Rousse's manipulation of perspective, both in the rendering of the figures and in the positioning of the camera, recalled the pictorial illusions of the seventeenth century, notably the anamorphoses ("transformed" images) best known through Hans Holbein's double portrait, in London's National Gallery, *The Ambassadors*. But at the same time, the use of the camera to record his otherwise impermanent work placed him in the contemporary context of photo-documentation as it had been practiced by Robert Smithson, Robert Longo, Walter De Maria and others in the late 1960s and 1970s. That play on tradition and modernity was also picked up by the critics; as Bloch and Pesanti wrote of the Bordeaux project, "Working on the space in order to make new images of another time, singing the praises of places, of their temporality through their life and death, it's in this entirely photographic perspective that Georges Rousse succeeds in making something new."

In 1983 Rousse was sent to the United States on a French government grant to work at P.S. 1, the artists' space in Long Island City, New York, and the experience freed him up, allowing him to some degree to break out of his self-imposed formats. For one thing, he did not limit himself to condemned sites and actually executed some of his paintings at P.S. 1; for another, he experimented with new graphic forms, patterning surfaces into numbered areas like one does in children's coloring books. That play on abstract and figurative design was taken still further in a group of what he called "self-destructive" works he did for Art Prospect 1983, among others, where he began with a similarly numbered drawing and then covered it over with a monochrome painting. And while he continued to work with some figurative images—gargoyles for the Musée des Augustins Toulouse, (1983), wrestlers for the municipal museum of La Roche-sur-Yon (1983)—geometric abstractions gradually came to predominate. In a series of transitional works, done in Nice, Sydney, Berlin, and elsewhere during 1984, volumetric shapes were painted or chalked around the usual repertoire of human figures, some of whom seemed to be trying to escape their confinement. Then the figures were eliminated entirely, and chalky shapes rose up in an ambiguous third dimension from the surface of objects in the room—a transparent cylinder over a toilet, a rectangular block over a table top, a thin plank over a sawhorse. "People," explained Rousse, "would have been too much in these new monumental forms."

By that time, the notion of a figuration libre group had more or less played itself out, and in any case, Rousse had securely established a separate identity; "I like their work," he told Georgina Oliver, "but I'm older than they are. They're really very young; at thirty-five my concerns are different. For instance, they're into rock in a big way. I don't mind it, but personal content and space are more important to me." To some extent, he did continue to be "marketed" with the others—in group shows promoting the "new French art" that was finally able to compete with that of American artists, and in media ventures like the advertising campaign for Charles Jourdain shoes (for which he outfitted some of his floating figures in the requisite footwear). But while the younger artists moved into the mass production of their work, with T-shirts, decals, toys, jewelry, and comic books, Rousse reinforced the singularity of what he was doing. In order to create more intricate combinations of real space and geometrical illusion, he turned to the use of mirrors, often in combination with existing window reflections. At the same time, he emphasized the artistry of

the photograph, not only by working on an increasingly large scale—2 x 2.5 m. at the Monastery of the Sisters of the Good Shepherd in Montreal (1985)—but by limiting the editions to three copies, or in some cases, a single one.

The focal point of his elaborate manipulations of light, space, and technology, Rousse explained to Jean de Loisy in 1985, was "the reproduction of the work of art." With the elimination of the figure and the substitution of a vocabulary of line and plane, along with the use of the insubstantial chalk medium, Rousse's interest in light, in surface and depth, in pictorial and photographic illusion, all of which certainly informed his work from the beginning, now directly constituted the content of the photographic image. If the earlier figures had routinely defied the norms of their architectural settings by being wrapped around wall surfaces, cutting across windows, or floating onto the ceiling, the new geometric forms and their patently illusionistic volumes compounded the perceptual challenge to the viewer. The illusory forms themselves became more elemental—basic geometric shapes recalling the minimalist sculpture of the late 1960s—but the play on illusion and reality was ever more complex. "I really like to work with nothing at all," Rousse told Jean-Louis Marcos in 1986; "a window is almost nothing at all, but lots of things happen there. . . . That's what interests me."

Even though he continues to work in sites awaiting destruction, there is far less evidence of decay. In the six photographs he made at the Van Gogh Hospital in Arles in 1986, for example, the barren rooms with their cracked and peeling walls are transformed by the richness of the southern light, by the dramatically deep perspectives, and above all, by the sensuousness of the geometric forms Rousse has conjured up with his camera, as if, in the words of Dorine Mignot, "he sees their existence as solace for earthly woes." In still other works, notably the series from the southern French town of Castres (1986), reflections from outside the windows— the same natural views that interested Rousse in his earliest photographs—appear on the forms inside, adding yet another dimension of space and place to the image. For some critics, the effect approached religiosity, and in any case the work was recognized as increasingly enigmatic. As Colin Gardner pointed out, Rousse has succeeded in reversing the phenomenon signaled by Walter Benjamin in "The Work of Art in an Age of Mechanical Reproduction": the camera becomes the means of creating rather than destroying the "aura" of a work of art, for, wrote Gardner, "it is the very act of photography that imbues Rousse's paintings and their environments with significance."

In September 1985 Rousse was awarded the Prix de Rome, which enabled him to spend two years living and working at the Villa Medicis in Rome. By the time that he returned to Paris, his work had evolved into virtually pure abstractions of light and color, but the physical site, and his experience of it, were now evoked in texts written over the photographs. The image, he explained in an exhibition statement in May 1987, "would only show a skilled intervention at a site. This site, in order to become a space, must be inhabited by thought. Painting has long been speech in evolution. Since the habitation of the site remains a mute meditation, now nonvisible, the written [text] becomes an existential need in my practice of art. If the photo is the memory of the real, it is for me the continuation of the painter's gesture, the persistence of color and light."

EXHIBITIONS INCLUDE: Bibliothèque National, Paris 1982; Gal. Farideh Cadot, from 1983; Nicola Jacobs Gal., London 1983; CAPC, Mus. d'Art Contemporain, Bordeaux 1983; Halle Sud, Geneva 1984; Annina Nosei Gal., NYC 1984; Mus. municipal de la Roche-sur-Yon 1984; Gal. Michael Haas, Berlin 1984; Mendelsohn Gal., Pittsburgh 1984; Mus. des Beaux-Arts, Orleans 1985; Quay Gal., San Francisco 1985; Gal. Grits Insam, Vienna 1985; Gal. Graff, Montreal 1985; Association du Méjan, Arles 1986; Art Francais/Positions, Berlin 1986; Ateliers Internationaux des Pays de la Loire 1986; Pontevedra Biennale 1986; AREA, Cntr. d'Art Contemporain de la Ville de Castres 1987; Studio Claudio Guenzani, Milán 1987; Third Eye Cntr., Glasgow 1987; Arnolfini Gal., Briston 1987; "Artistas Franceses," Mus. Español de Arte Contemporaneo, Madrid 1987. GROUP EXHIBITIONS INCLUDE: "Des photographies dans les paysages," Gal. de France, Paris 1981; "L'Air du Temps: Figuration Libre en France," Gal. d'Art Contemporain des Mus. de France 1982; Salon de Montrouge 1982, '83; "Un Regard Autre II," Gal. Farideh Cadot, Paris 1982; Paris Biennale 1982; "L'Art en sous-sol, ou Felix Potin vu par le Groupe de la Figuration Libre," Réseau Art, Art Prospect, Paris 1982; "Figures Imposées," Espace Lyonnais d'Art Contemporain, Lyon 1983; "Au Pied du Mur," Kunstlerhaus, Stuttgart 1983; "Marseille, Art Prestne," Gal. Athanor, Marseille 1983; "France-Tours Art Actuel," Tours Biennale 1983; Gabrielle Bryers Gal., NYC 1983; Gal. Verrière, Lyon 1983; "Le Musée Décalé: Trace, Empreinte?" Mus. des Augustins, Toulouse 1983; "Three French Artists," Zabriskie Gal., NYC 1983; "Peindre et Photographier," Espace Niçois d'Art Contemporain 1983; "Réseau Art 83," Art Prospect 1983; Taidemus., Tampere (Finland) 1983; "New French Painting," London, Oxford, Southampton, Edinburgh 1983–84; "Neue Bilder aus Frankreich," Insbrück, Vienna 1983–84; "France, Une Nouvelle Generation," Hotel de Ville, Paris 1984; "French Sprit Today," Fischer Art Gal., Univ. Southern Calif., Mus. of Contemporary Art, La Jolla 1984; Sydney Biennale 1984; "Premiers Ateliers Internationaux d'Art Vivant," Abbaye Royale de Fontevraud 1984; "The Human Con-

dition Biennial III," San Francisco Mus. of Modern Art 1984; "Individualités," Gal. Nazionale d'Arte Moderna, Rome and Chartreuse de Capri 1984; "Perspectives," Kunstmus., Basel 1984; "Content: A Contemporary Focus 1974–84," Hirshhorn Mus. and Sculpture Garden, Washington, D.C. 1984; "Twelve French Artists in Space," Seibu Mus., Tokyo, and O'Hara Mus., Karachi 1985; "Le Style et le Chao," Mus. de Luxembourg, Paris 1985; "Photographies Contemporaines en France," Cntr. Georges Pompidou Paris 1985; "Rendez-Vous," Kunstlerwerkstatt Lothringerstrasse, Munich 1985; "Les Territoires de la Biennale," Maison des Arts, Belfort 1985; "Telephone Graffiti," Gal. Pierre Lescot, Paris 1985; "Ce n'est pas une photographie," Mont-de-Marsan 1985; Tadeimuseo, Porin (Finland) 1985; "Hommage à Raymond Hains," Fondation Cartier 1986; "Art Français: Position," Berlin 1986; "Pictura Loquens," Villa Arson, Nice 1986; "Creations pour un FRAC," Fondation National des Arts Graphiques et Plastiques, Paris 1986; "Atout Verre," Cirva, Marseille 1986; "Arte in Francia 1960–1985," Pal. Reale, Milan 1986; "Photography as Performance," Photographers' Gal., London 1986; "French Art Today," Guggenheim Mus. 1986; "Rousse, Faucon, Kern," Mus. de Bar-le-Duc 1986; "Correspondances Europe," Stedelijk Mus., Amsterdam 1986; "En la Frontera," Saragossa 1987; "Blow-Up," Württembergischer Kunstverein, Stuttgart 1987.

COLLECTIONS INCLUDE: Mus. Réattu, Arles; Mus. d'Art Contemporain, Bordeaux; Albright-Knox Art Gal., Buffalo, N.Y.; Cartier Fondation; de Mesnil Foundation, Houston; Chase Manhattan Bank; Solomon R. Guggenheim Mus., NYC; Gal. d'Art Contemporain des Mus. de Nice; Fonds National d'Art Moderne, Paris; Cntr. Georges Pompidou, Paris; Fonds Regional d'Art Contemporain, Pays de Loire and Rhone-Alpes; Mus. Municipal de La Roche-sur-Yon; Mus. de Toulon.

ABOUT: "L'Air du Temps" (cat.), Gal. d'Art Contemporain des Musées de Nice, 1982; "Correspondence Europe" (cat.), Stedelijk Mus., Amsterdam, 1986; Dennison, L. "Angels of Vision: French Art Today" (cat.), Solomon R. Guggenheim Mus., 1986; "Figures Imposées" (cat.), ELAC, Lyon, 1983; "French Spirit Today" (cat.), Fischer Art Gal., Univ. of Southern California, 1984; "Georges Rousse" (cat.), Mus. des Beaux-Arts d'Orléans, 1985; "Georges Rousse, suivi d'un extrait des Chants de Maldoror de lautrémont," Actes Dus, 1986; "Georges Rousse" (cat.), AREA Cntr. d'Art Contemporain, Castres, 1987; "Individualités" (cat.), Gal. Nazionale d'Arte Moderna, Rome, 1984; Lemaire, G.-G. "Pictura Loquens" (cat.), Cntr. National d'Art Contemporaine, Nice, 1986; Millet, C. "France: Une Nouvelle Generation" (cat.), Hotel de Ville, Paris, 1984; "New French Painting" (cat.), Mus. of Modern Art, Oxford, 1983; "Photography as Performance" (cat.), Photographers' Gal., London, 1986; "Premiers Ateliers internationaux d'art vivant" (cat.), Abbaye Royale de Fontevraud, 1984. *Periodicals*—Artforum February 1986; Art in America May 1984, January 1987; Artistes June–July 1982; Art Press January 1983; Arts Magazine November 1984, November 1986; Beaux-Arts May 1983, January 1984; Eighty Magazine

(Paris) October–December 1984; Flash Art (Paris) Spring 1984; Flash Art International (Milan) May 1983, November 1983, November 1984, January 1985; Galeries April 1986; Images April 1983; Kanal October 1984; La Presse (Montreal) October 19, 1985; New York Times August 5, 1983, October 10, 1986; Parachute March–May 1986.

FILM: Loisillon, C. Georges Rousse, 1985.

***RUSCHA, EDWARD (JOSEPH)** (December 16, 1937–), American painter, draftsman, book creator, and filmmaker of German-Bohemian and Irish descent who was born in Omaha, Nebraska. When he was five, his family moved to Oklahoma City, Oklahoma, where he grew up. Soon after graduating from high school, he and a friend drove to Los Angeles—"I liked palm trees and hot rods," he recalled in 1971—where he enrolled at the Chouinard Art Institute to study industrial and graphic design. Upon graduating in 1960, he went to work for a large advertising agency, doing layouts and graphics. He found the work "sheer hell," and abandoned it after a year to work full time as a painter. Success came to him early and relatively easily: since 1963, the year of his first solo show at the Ferus Gallery in Los Angeles, he has been one of the country's best-known West Coast artists. His 1982 retrospective exhibition, which he characteristically entitled "I Don't Want No Retro Spective," traveled from coast to coast and was a great popular success.

In Ruscha's most characteristic work, the subject matter is typography. In his earliest paintings and drawings, a single word is often the sole image, usually spelled out across the upper middle of the canvas or paper. These early pieces were often rendered illusionistically, as if composed of three-dimensional strips of folded paper or glistening splashes of liquid. Later, in the 1970s and 1980s, he turned to illustrating catchphrases, mostly in flat, two-dimensional block capitals. One of his earliest exhibited paintings was *Large Trademark with Eight Spotlights* (1962), a rendering of the Twentieth Century–Fox logo in traditional midnight blue and orange. "It didn't mean," he explained in 1982, "I was really into sign culture—community graphics—as such, although I do respond to it. I think my work always came more from the printed page than from big things out there because, for one thing, none of my paintings is big. I'm thinking of James Rosenquist and how his work came directly from his experience of painting billboards for the public. If I'd had that kind of experience, I'd probably be painting bigger paintings of bigger things."

°rū´sha

EDWARD RUSCHA

In addition to his fascination with typography, Ruscha has also been intrigued with words as a subject because "they exist in a world of no-size. Take a word like 'smash'—we don't know it by size. We see it on billboards, in four-point type, and all stages in between. On the other had, I found out that it is important for *objects* to be their actual size in my paintings. If I do a painting of a pencil or magazine or fly or pills, I feel some sort of responsibility to paint them natural size—I get out the ruler. Some of these ideas came together and blended in the late 1960s when I painted words like 'adios' and 'hey' and had cherries and kidney beans in the letters. The beans and cherries were painted actual size, but the words were still in this anonymous world of no-size."

A sensational early painting that had nothing to do with words was *The Los Angeles County Museum on Fire* (1965–68), a careful architectural rendering, in oblique aerial perspective, of one of the West Coast's major cultural institutions as if it were about to be engulfed in flames. Ruscha maintained in 1982 that although he had no "particular gripe" against the museum, he did "have a basic suspicion of art institutions, period. You can engrave that in marble." Lawrence Dietz wrote that some people may take offense at the painting and consider it "an appalling, even tasteless criticism of the art contained in the building, but anyone who has been left dumbstruck by the architecture of the place—it looks like a Miami Beach hotel designed by Mussolini's personal architect—may well take the painting as the best suggestion yet for large-scale urban renewal."

By the end of the 1960s, Ruscha had decided that he "didn't like oil painting anymore." "I can't bring myself to put paint on canvas," he remarked in 1972. "I find no message there anymore." In another interview he said, "I'd prefer my painting to come to an end. I'd be satisfied to paint myself into a corner, and then just give it up. It's not a vocation—I just use painting. Painting for me is a tool. All the things I achieve through it become obsolete. I'm terrified to think I'll be painting at sixty."

He had gotten interested "in the art of staining things instead, and then it began to seem natural to stain things with things that really stain, like carrot juice. It seemed simple—the direct way between A and B—as opposed to trying to *illustrate* a stain using traditional illustrator's tools like oil paint." One much-discussed highlight of his career at that point was a portfolio of six "organic" screenprints, entitled *News, Mews, Pews, Brews, Stews & Dues* (1970), which he made under contract in London for Editions Electo. He arrived in the British capital for his assignment with no definite ideas but with "strong feelings for color that I knew I could get from natural organic substances." When he found that it was indeed possible to print such substances using the silkscreen process, he was determined "to maintain a definite quality control. The edges had to keep their sharpness, and some substances would not allow it." Those that turned out to be unusable included cream, which left a slimy deposit, and tomato paste and mustard, which dried to gray dust. "I could not print carnations," he said, "because when we broke them up, they just turned to water. It was a nice color, but it squeezed right out on the silkscreen press. Iodine is beautiful but it creeps out all over the paper. The substance has to have either an oily base or a pasty kind of base the keeps hold of itself and is not too runny." The six prints were the result of that eccentric research: each showed a single word in Old English typeface. The artist declared himself especially pleased with *Brews:* "The pleasure of it is both in the wit and the absurdity of the combination. I mean, the idea of combining axle grease and caviar!" He then listed the other five: "*News* is blackcurrant preserves blended with salmon roe and the letters are blank; *Mews* is a combination of egg, which forms the letters, and solid pasta sauce; *Pews* is a mixture—60 percent chocolate syrup and 40 percent coffee mixture—the letters are squid in ink; *Stews* has no background—the letters here are baked beans blended with daffodils, chutney, tulip leaves and stalks, caviar, and cherry pie filling; *Dues* is combined pickle letters printed over solid pickle background." The series was not a great commercial success: the

prints were found to fade over a fairly short peri-
od of time, and critics complained that the colors
were surprisingly ordinary for such bizarre in-
gredients. A more successful screenprint was
Pepto-Caviar Hollywood (1970), based on the
famous sign in the Hollywood Hills which the
artist has rendered many times in various media
and which he can see from the front door of the
studio he has occupied since 1965 on Holly-
wood's Western Avenue. His organic version of
that landmark features the sky screened in phos-
phorescent pink Pepto-Bismol and the sign in
bilious yellowish brown caviar, thus juxtaposing
a popular stomach remedy with a popular Hol-
lywood luxury food. Although the artist saw the
humor in the combination, he claimed simply to
have found "two substances that wouldn't mix
very well and were really comfortable togeth-
er. . . . Caviar is grainy, and you never know
where the little eggs are going to pop through.
But that's what I like—each print is different."
Selected as the United States entrant at the thir-
ty-fifth Venice Biennale in 1970, Ruscha pro-
duced 360 prints in chocolate.

If words and phrases have always been the
center of attention in Ruscha's paintings, draw-
ings, and prints, in another of his activities—
creating books—he is virtually nonverbal. In
1962 he began to publish many books, often two
a year, most of them collections of his snapshot-
like photographs and all of them informed with
his particular brand of laconic, apparently ironic
West Coast humor. "If there is any facet of my
work that I feel was kissed by angels," he said in
1972, "I'd say it was my books. My other work
is definitely tied to a tradition, but I've never fol-
lowed tradition in my books. The books are just
neuter gender, and that's what I like about them.
That's why I feel so free when I do them.
They're the easiest things to do, and sometimes
the best. I like the idea of spending $2,000 on
something that's totally frivolous and spontane-
ous. When I start on one of these books, I get to
be impresario of the thing, I get to be major
domo, I get to be creator and total proprietor of
the whole works, and I like that. It's nice. And
I'm not biting my nails over whether the book
is going to hit the charts or not."

His first book, *Twenty-Six Gasoline Stations*
(1962), like most of the others, contains just what
the title specifies: twenty-six stations chosen
from among the hundreds stretching along
Route 66 from California to Oklahoma, each
identified by a one-line caption giving name and
location. "I had a vision that I was being a great
reporter," Ruscha recalled several years later. "I
drove back to Oklahoma all the time, five or six
times a year. And I felt there was so much waste-
land between L.A. and Oklahoma City that

somebody had to bring in the news to the city.
It was just a simple, straightforward way of get-
ting the news and bringing it back. I think it's
one of the best ways of just laying down the facts
of what is out there. I didn't want to be allegori-
cal or mystical or anything like that. It's nothing
more than a training manual for people who
want to know about things like that." He claims
to have had the book's title in mind even before
he took the photos. The title is all that appears
on most of his books' covers, printed in evenly
spaced capitals on a white or light-colored back-
ground. "Type always gives it a manual look,"
he says. "It has that factual kind of army-navy
data look to it that I like." For the first book, he
photographed about fifty stations and culled the
results to correspond to the title. In later books,
he photographed no more subjects than the title
required, having come to realize that editing in-
volved aesthetic choices he did not want to
make. He firmly disclaims any interest in the
aesthetic quality of his photos.

A book similar to his first, *Some Los Angeles
Apartments* (1965), features thirty-four photos
of ordinary-looking American apartment build-
ings, each accompanied by an identifying ad-
dress. Most have "vacancy" signs in front, and
names that are perhaps characteristic of the
West Coast: "The Elite V," "Lee Tiki," and
"Fountain Blu." *Every Building on the Sunset
Strip* (1966) is printed on a single, twenty-seven-
foot-long accordion-folded sheet with the pan-
oramas facing each other on one side of the
sheet, the reverse being blank. "All I was after,"
Ruscha explained, "was that store-front plane.
It's like a Western town in a way. A store-front
plane of a Western town is just paper, and every-
thing behind it is just nothing." The book's cen-
tral witticism, rendering the Strip in strip form,
was not lost on critics. *Thirty-four Parking Lots*
(1967) contains, for some reason, only thirty-one
aerial photos of empty parking lots, apparently
shot early on a Sunday morning. For Ruscha, the
lots' chief interest lay not in "parking patterns
and their abstract design quality," about which
architects continually write him, but in "the oil
droppings on the ground." *Nine Swimming
Pools* (1970) contains color plates distributed
seemingly at random among the book's sixty-
four blank pages. *Real Estate Opportunities*
(1970) is twenty-five photos of vacant and par-
ticularly nondescript Los Angeles building sites.
"Sometimes the ugliest things have the most
potential," said Ruscha of that "self-assignment."
"I went off in the car and I went down to these
little towns, to Santa Ana, Downey, places like
that. I was exalted at the same time that I was
repulsed by the whole thing." His other books in-
clude *Various Small Fires* (1964), *Business Cards*

(with Billy Al Bengton, 1967), *Crackers* (with Mason Williams, 1968), *Babycakes* (1969), *Records* (1971), *Colored People* (1971), *Dutch Details* (1972), and *Hard Light* (with Lawrence Weiner, 1972). Despite the obvious pleasure Ruscha derived from making books, he has produced none since the mid-1970s. "I wanted books that weren't books," he said in 1973. "I like people to say, 'What's it *for*? I don't understand it.' But at the same time I wanted it to be hot, almost too hot to handle. Classic intellectuals were repulsed by them, but children loved them."

Ruscha's rather insistent whimsicality is readily apparent in his two films, *Premium* (1974) and *Miracle* (1975), which are both ostensibly straightforward shaggy-dog stories. The former, based on the Ruscha-Williams book *Crackers,* stars artist Larry Bell, comedian Tommy Smothers, and designer Rudi Gernreich. Bell lures a girl into a sleazy hotel room where he induces her to lie down on a literal bed of lettuce. After dousing her with salad dressing, he abandons her on the pretext of having forgotten crackers, then signs into a more expensive hotel room to eat saltines in bed alone. *Miracle*'s theme is also sexual displacement: a grimy auto mechanic finds a kind of salvation by ignoring his friends, his girlfriend, and the outside world in general in order to concentrate on his soul's real need, repairing the carburetor of a red 1965 Ford Mustang. The mechanic is ultimately transformed into an immaculate, white-coated scientist, peering through a microscope and finally solving his problem.

Since the mid-1970s, much of Ruscha's work has consisted of a large number of pastel drawings of phrases, usually American idioms such as "Just Us Chickens," "Squeaky Lil' Tummies," and "G-Gosh It's a Sm-Small W-World." These are spelled out in plain block letters on utterly anonymous backgrounds. Although he was fond of discounting any connection between his early one-word works and conceptual art, calling his aim "more visual than conceptual," this cannot be true of these newer colloquialisms. Yet his aim, apparently, has not changed: "I'm not thinking of the literary aspects. I'm not a poet. I'm more of a wordsmith—like a tunesmith—than I am a writer. I go for quick, simple combinations of things. I'm not into storytelling, I'm more into just—still—exercising my own fantasies."

Placing Ruscha in the American artistic spectrum is a perplexing subject that has often exercised art critics. According to Peter Plagens, his art is "easygoing, nonmilitant pop, as at home in southern California as was impressionism on the banks of the Seine." "An aberrant formalist with surrealist overtones," claimed Vivien Rayner, "but surely . . . no more aberrant and surrealistic than the culture he depicts and implies." Kay Larson called his work "extremely sophisticated banality . . . never out of style . . . an infinite universe of repeatable art." Mark Stevens agreed: Ruscha's "cultural stance, while serious, does not possess much power or depth. To draw beauty from the banal is a respectable but tired modern strategy. To be witty and hip is delightful, but not often the stuff of great art." Henry Geldzahler's judgment is typically eclectic: "It is difficult to pigeonhole his style at all. Conceptual, pop, surrealistic, dada, neo-dada, earth art—all these are, arguably, elements of his style. Ruscha can be pinned down partially by any of these labels, and yet he escapes all of them." The artist himself would prefer no label at all: "My art is extremely personal. It would be nice if other people understood everything I do, but I know that communication is limited. I consider myself lucky if people get just a feeling from my work, a sense of how things are. At the same time I try to avoid labels. The best labels are pressure-sensitive. They should be peeled off easily, because labels pin a man down. I've been grouped with pop artists, conceptual artists, surrealists. If any of these labels stuck, my career would probably be over, because fashions come and go. I've survived as an artist . . . because there's one basic truth about the work I do. I'm an American artist. I went to Europe in 1961, trying to learn about the history of art, but all I did was yawn a lot. Later I realized that the dominant influences on my work are American. Like the early Americans, I'm basically a rebel."

EXHIBITIONS INCLUDE: Ferus Gal., Los Angeles 1963, '64, '65; Alexander Iolas Gal., NYC 1967, '70; Irving Blum Gal., Los Angeles 1968, '69; Gal. Rudolf Zwirner, Cologne 1968; Nigel Greenwood, London 1970, '73; Univ. of California at Santa Cruz 1972; Corcoran Gal., Miami 1972; Minneapolis Inst. of the Arts 1972; DM Gal., NYC 1973, '74, '75, '78, '80, '82, '84; Gal. Françoise Lambert, Milan 1973, '74; John Berggruen Gal., San Francisco 1973; Ace Gal., Los Angeles 1973, '75, '76, '77, '78, '80; Texas Gal., Houston 1974, '79; Gal. Ricke, Cologne 1975, '78; Glaser Gal., La Jolla, Calif. 1975; Arts Council of Great Britain (toured the United Kingdom) 1975; Los Angeles Inst. of Contemporary Art 1976; Wadsworth Atheneum, Hartford 1976; Stedelijk Mus., Amsterdam 1976; Dootson-Calderhead Gal., Seattle 1976; Albright-Knox Art Gal., Buffalo 1976; Inst. of Contemporary Art, London 1976; Fort Worth Art Mus. 1977; Nova Gal., Vancouver 1977; MTL Gal., Brussels 1978; Gal. Rudiger Schöttle, Munich 1978; Auckland City Art Gal., New Zealand 1978; Richard Hines Gal., Seattle 1979; InK, Zurich 1979; Portland Cntr. for the Visual Arts 1980; Foster Goldstrom Gal., San Francisco 1980; Arco Cntr.

for Visual Art, Los Angeles 1981; "The Works of Edward Ruscha: I Don't Want No Retro Spective," organized by the San Francisco Mus. of Modern Art, traveled to Whitney Mus. of American Art, NYC, Vancouver Art Gal., British Columbia, San Antonio Mus. of Art, and Los Angeles County Mus. of Art 1982–83; Bernard Jacobson Gal., London 1982. GROUP EXHIBITIONS INCLUDE: San Francisco Mus. of Modern Art 1976; Whitney Mus. of American Art, NYC 1977, '79; Los Angeles Inst. of Contemporary Art 1977; Moderna Gal., Ljubljana 1977; Fine Arts Gal. of San Diego 1977; Mus. Bochum, West Germany 1978; Art Inst. of Chicago 1979; MOMA, NYC 1980; Hayward Gal., London 1980.

COLLECTIONS INCLUDE: MOMA, NYC; Whitney Mus. of American Art, NYC; Hirshhorn Mus. and Sculpture Garden, Washington, D.C.; Contemporary Art Foundation, Oklahoma City; Inst. of Arts, Minneapolis; Los Angeles County Mus. of Art; Norton Simon Mus. of Art, Pasadena, Calif.; Oakland Art Mus., Calif.; Stedelijk Mus., Amsterdam.

ABOUT: Current Biography, 1989; Emanuel, M., et al. Contemporary Artists, 1983; Lippard, L. R. Changing: Essays in Art Criticism, 1971; Who's Who in American Art, 1989–90. *Periodicals*—Artforum February 1965, March 1971, Summer 1978, December 1980, October 1982; Art in America November–December 1973, October 1982, Summer 1984; Art International May 1971, November 1971; ARTnews April 1972, March 1973, March 1975, October 1976, March 1978, March 1979, September 1979, March 1981, April 1982, November 1982; Art-Rite Winter–Spring 1975–76; Arts and Architecture Autumn 1982; Arts Magazine April 1973, March 1975, January 1978, December 1980, May 1981, May 1984; Avalanche Winter–Spring 1973; Design Quarterly vol. 78–79 1970; Esquire January 1977; Flash Art February–March 1975, May 1975; Los Angeles Times March 28, 1976; National Observer July 28, 1969; Newsweek August 23, 1982; New York Times August 27, 1972, September 10, 1972, January 29, 1976, October 3, 1980, July 8, 1982, July 16, 1982, March 9, 1984; Portfolio March–April 1982; Rolling Stone December 6, 1973; Village Voice April 11, 1974, October 8, 1980, August 3, 1982.

RYMAN, ROBERT (1930–), American painter, born into a middle class family in Nashville, Tennessee. He studied saxophone at the Tennessee Polytechnic Institute in Cooksville (1948–49) and at the George Peabody College for Teachers in Nashville (1949–50). After two years of service in the United States Army (1950–52), during which he played in the band and met other musicians, he moved to New York City, where he still lives and works.

His mother, a gifted amateur pianist, fostered Ryman's childhood interest in music, which developed in the course of his teens into an ardent desire to play jazz. In Nashville, the world capi-

ROBERT RYMAN

tal of country music, he had to rely on the radio to hear the music he loved. "It was extremely difficult to find any jazz," he told Nancy Grimes in a 1986 interview. "You'd have to stay up late at night and fool around with the dial trying to pick up a New York station." As soon as he left the army, he recalled, "I came straight to New York. I couldn't wait. I realized then that if I was going to pursue music, I had to come to New York."

But he was, until his big move, entirely ignorant of art. "I never saw a painting until I came to New York, except for landscapes in some oddball situation you might find in Nashville." Once in New York, working at meaningless odd jobs and studying jazz, he gravitated more and more to the city's art museums, becoming ever more fascinated by painting. Eventually he bought some oil paints, brushes, and canvas boards: "I thought I would try and see what would work. That was the first step. I just played around. I had nothing really in mind to paint. I was just finding out how the paint worked, colors, thick and thin, the brushes, surfaces." His first painting was mainly green. As his desire to paint became stronger, his interest in playing music professionally waned and eventually ceased altogether.

While Ryman was teaching himself to paint, he took jobs more central to his new obsession. Working as a guard at the Museum of Modern Art, he met the artists Sol LeWitt and Dan Flavin, and found time to imbibe the spirit of the great painters whose canvases were hanging all around him. He was particularly stirred by the

work of Henri Matisse and Mark Rothko. "Matisse," he told Grimes, "seemed to know just exactly what he was doing. He was very sure. He could do seemingly very few things and make them enormous." Rothko's effect on the young and impressionable autodidact was even more profound. "When I saw this Rothko—the Modern had one painting of his—I had been looking at Matisse, Picasso, and so on. But when I saw this Rothko I thought, 'Wow, what is this? I don't know what's going on, but I like it.' I knew there was something there. What was radical with Rothko, of course, was that there was no reference to any representational influence. There was the color, the form, the structure, the surface, and the light—the nakedness of it, just there. There weren't any paintings like that." Following another job in the Art Division of the New York Public Library, he determined that the time had come to end his self-imposed apprenticeship. In 1960 he took a studio on the Bowery, and from that time began to exhibit his early works to the public.

Virtually from the beginning of his life as a painter, Ryman concentrated on exploring the permutations of a square format and white paint—aspects of his work that remained constant over the next three decades as signatures. He has always seen the square as the ideal space, the standard form that relieves him of all worries about proportion. White paint seems to him the material possessing the greatest range of properties—tone, transparency/opacity, consistency/thickness/viscosity, luminosity/reflectivity, and so forth. On his various chosen surfaces (he has used cotton, linen, cardboard, copper, steel, wood, Plexiglas, and many others) it becomes the most varied and at the same time the most neutral of all colors. Yet when asked by Phyllis Tuchman in 1971 whether he makes "white paintings," Ryman answered firmly, "No," seeming to suggest that to him whiteness, like squareness, was a decision that effectively liberated him from confusion or indecision: "The white just happened because it's a paint and it doesn't interfere. I could use green, red, yellow, but why? It's a challenge for me to use paint and make something happen with it, without having to be involved in reds, greens, and everything, which confuse[s] things. But I work with color all the time. I don't think of myself as making white paintings, I make paintings; I'm a painter. White paint is my medium." Fifteen years later he continued to maintain essentially the same thing: "It was never my intention to make white paintings. And it still isn't. I don't even consider that I paint white paintings. The white is just a means of exploring other elements of the painting, that can make it clear. White enables other things to become visible."

Freed by his devotion to those constants, Ryman has been able to concentrate on the myriad other aspects of his paintings: the size of the square; the nature of the material to receive the paint; whether that material should be stretched or unstretched, prepared or natural; the size of the stretcher bars, if any; the size of the brushes, if any; the type of white paint to use, its tone, transparency, etc.; which hanging device to use, if any; the ultimate relation of the painting to the wall, to the viewer, to other paintings in the series, to other unassociated works. "I consider everything to be part of it," he said in 1986. "Even the edge, the sides, the color, the surface, the structure, the way it's made, the visible fastening to the wall. It's all part of the composition." Yet all those are only a few of the steps carefully pondered by the artist, both by themselves and in combination with every one of the others. "Ryman is concerned," according to Christel Sauer, "with the process of painting as the sum of the single decisions which together make a painting. Their complexity is made visible by the constants 'square' and 'white paint.'" The artist himself, finally, utterly rejects the notion that the complexity of his work amounts to a programmed demonstration within its two constant limitations of the wide variety of possibilities inherent in the craft of painting. Such has never been his intention: he has always striven for spontaneity. "I work," he told Achille Bonito Oliva in 1973, "really more according to emotion. I mean, I make things by following my intuition because I have the feeling that it's right—more than that I try to justify it in advance. To express it more clearly: I want to say that it's really necessary for me that what I make surprises me. When my work surprises me then I know that there is something good about it."

The successive series Ryman exhibited from the 1960s now appear as landmarks in a still-expanding career. The "Winsor" series of 1966, for example, consists of six six-foot squares of stretched linen covered with two-inch-wide horizontal rows of white oil paint. The brush's trajectory, the systematic thickening and thinning of the paint, create a satisfying tactility. The series' title refers, typically and literally for Ryman, to the Winsor & Newton brand of paint used. The "Standard" series of 1967 showed thirteen four-foot squares of cold-rolled steel covered with three-inch-wide strokes of white enamel. "The thinness of materials," the artist has recalled, "interested me, because my painting has a lot to do with the wall plane. The thinness of materials allows clarity of working with the wall plane and the environment. The painting is not simply the painted plane with the composition, but it's the wall plane, even the corners

and floor." The "V" series of 1969, which established Ryman as one of the most important minimalist artists, and one of the few painters of that dominant avant-garde movement of the 1970s, was five corrugated-cardboard panels covered with enamelac. That flat, opaque material was also dominant in the "General" series of 1970. His preferred material became wood in the "Midway" and "Zenith" series of 1974–75; the extremely objective application of the paint in those series led to the twenty-two-foot-long *Varese Wall* and the "Vector"and "Avon" series shown in the Basel Kunsthalle in 1975, which, along with the retrospective exhibition mounted in 1972 by the Guggenheim Museum in New York, were Ryman's greatest public successes of the decade.

During the 1970s and into the 1980s, Ryman, as an extension of his interest in his paintings' relation to the wall plane, began to experiment with the many ways his paintings could be fastened to the wall. His discovery that "paintings could be visibly attached and bring the wall literally into the painting" led to the oil-on-steel *Archive* (1980), with its obtrusive brackets emphasizing the literal truth that the painting is, after all, an object with size and heft, a weight affixed to a support. The artist's understanding of how a painting is attached to a wall changed his approach to painting, as he told Grimes: "All of the paintings since 1976 have been visibly fastened, and I used that compositionally. It gave me an added dimension that I could use in developing painting." The exploitation of brackets and other hanging fixtures as elements in the artistic composition continued in *Range* (1983), whose long aluminum brackets, together with strips of bare or enamelac-covered fiberglass at the edges, frame a smoothly expansive white field.

Ryman continues to refine his vision of painting—utterly nonrepresentational, profoundly minimalist in inspiration—as part of an artistic avant-garde with only a small audience. The questioning of old assumptions so popular among the young artists of the mid-1980s filled him with dismay but left him essentially untouched. There was still much that he felt he had to accomplish in his own work. "I think," he told Grimes, "painting is moving too slowly, but, of course, it's the nature of painting to evolve slowly. You become impatient for more. I feel that the possibilities of painting are so great that we've just scratched the surface, and I think that it's a matter of learning to see in different ways and developing our capacity to see things we're not seeing now." "The special character of each painting," wrote Naomi Spector in 1977 of Ryman's work, "comes out in the doing of it. If the destination were completely known at the beginning, the journey would not be worth the making. The excitement for the artist as well as his viewers comes in living out the discoveries of new visual experiences. Just as the making of a painting involves not only the material and the action but the mental and emotional running of a chosen course, so does the seeing of each of these paintings involve traveling the same path so that we may sense and think about things we were unaware of before. Rman continually gives us reason for confidence in the tradition of painting based not only on intellect, but on intuition. In the exercise of his spare intention to avoid expression and to do nothing with painting but reveal its own nature, he is still making new works whose meaning and look are completely individual."

EXHIBITIONS INCLUDE: Paul Bianchini Gal., NYC 1967; Gal. Konrad Fischer, Düsseldorf 1968, '69, '73; Heiner Friedrich, Munich 1968, '69; Fischbach Gal., NYC 1969, '70, '71; Gal. Yvon Lambert, Paris 1969; Gal. Françoise Lambert, Milan 1969; Ace Gal., Los Angeles 1969; Dwan Gal., NYC 1971; Current Editions, Seattle 1971–72; Gal. Heiner Friedrich, Cologne 1971, '72; John Weber Gal., NYC 1972, '73, '74, '75; Solomon R. Guggenheim Mus., NYC 1972; Gal. Annemarie Verna, Zurich 1972, '77; Gal. del Cortile, Rome 1972; Lisson Gal., London 1972; Gal. San Fedele, Milan 1973; Art & Project, Amsterdam 1973; Stedelijk Mus., Amsterdam 1974; Westfälischer Kunstverein, Münster 1974; Palais des Beaux-Arts, Brussels 1974; Kunsthalle, Basel 1975; P.S. 1, Long Island City, N. Y. 1977; Gal. Gian Enzo Sperone, Rome 1977; Whitechapel Art Gal., London 1977; Gal. Charles Kriwin, Brussels 1977; InK, Halle für internationale neue Kunst, Zurich 1978, '79, '80; Gal. Maeght Lelong, NYC 1986; Hallen für Neue Kunst, Schaffhausen, Switzerland 1986; Saatchi Collection, London 1986; Mus. of Contemporary Art, Los Angeles 1987. GROUP EXHIBITIONS INCLUDE: "Eleven Artists," Kaymar Gal., NYC 1964; "Systemic Painting," Solomon R. Guggenheim Mus., NYC 1966; "Rejective Art," American Federation of Arts, NYC 1967; "Normal Art," Lannis Mus. of Normal Art, NYC 1967; "When Attitudes Become Form/Works-Concepts-Processes- Situations-Information," Kunsthalle, Bern, moved to Mus. Haus Lange, Krefeld, and Inst. of Contemp. Arts, London 1969; "Anti-Illusion: Procedures/Materials," Whitney Mus. of American Art, NYC 1969; "Using Walls (Indoors)," Jewish Mus., NYC 1970; "Conceptual Art, Arte Povera, Land Art," Gal. Civica d'Arte Moderna, Turin 1970; "Sixth Guggenheim International Exhibition," Solomon R. Guggenheim Mus., NYC 1971; Documenta 5, Kassel 1972; "Bilder-Objekte-Filme-Konzepte," Städtisches Gal. im Lenbachhaus, Munich 1973; "Contemporanea," Parcheggio di Villa Borghese, Rome 1974; "Fundamental Painting," Stedelijk Mus., Amsterdam 1975; "American Artists: A New Decade," Detroit Inst. of the Arts 1976; "Biennial Exhibition," Whitney Mus. of American Art, NYC 1976; Documenta 6, Kassel 1977; "New Work on Paper 3," MOMA, NYC 1985.

COLLECTIONS INCLUDE: Gal. d'Arte Moderna, Milan; Mus. des Beaux-Arts, Brussels; Mus. of Contemporary Art, Paris (Pompidou Cntr.); Los Angeles County Mus. of Art; Mus. of Contemporary Art, Los Angeles; MOMA, Whitney Mus. of American Art, and Solomon R. Guggenheim Mus. of Art, NYC; Carnegie Inst., Pittsburgh; Inst. of Contemporary Art, Chicago.

ABOUT: Battcock, G. The New Art, 1966; Bonito Oliva, A. Europe/America, 1976; Diamondstein, B. Inside New York's Art World, 1979; Emanuel, M., et al. Contemporary Artists, 1983; Gurin Bowman, R., ed. American Abstract Artists, 1936–1966, 1966; Lippard, L. Changing: Essays in Art Criticism, 1971; Who's Who in American Art, 1989–90. *Periodicals*—Artforum May 1971, September 1973; Art in America January–February 1967, May–June 1972; ARTnews Summer 1986; Studio International February 1974, March 1974.

DAVID SALLE

***SALLE, DAVID** (September 28, 1952–), is one of the most influential of the artists who, in the early 1980s, reacted against pop and minimalism, the dominant art styles of the 1960s and 1970s. Labelled neo-expressionists, artists like Malcolm Morley, Anselm Kiefer, and Julian Schnabel have reintroduced myth, fantasy, eroticism, and psychological narrative into contemporary art, sounding impassioned notes in a medley of images and motifs that is sometimes romantic, sometimes angst-ridden, other times merely bombastic.

Early in his career the "neo-expressionist" tag was misapplied to Salle, whose common ground with younger painters working in expressionist modes is largely generational. For in a work by David Salle there is no primitivism, none of Schnabel's operatic grandiloquence, and none of Kiefer's rhetorical, deeply felt evocations of Teutonic and biblical myth. Salle's work is infused not with nature but with culture, especially the visual culture of the past one hundred years, and it registers the current mood of ambivalence toward modernism that is at the heart of so-called postmodern sensibility. As one of Salle's most enthusiastic champions, the poet-critic Peter Schjeldahl, pointed out in *Art in America*, the "art-historical question of whether Salle is a gravedigger of modernist traditions or a resurrector of them" has vexed the artist's critics, for "he has been praised or condemned as both." As a writer explained in *ARTnews*, Salle and other contemporary artists like Robert Longo, Cindy Sherman, and Sigmar Polke "explore the consequences of appropriating images with extra-aesthetic associations derived from mass culture, the media, history, and religion for artworks whose final appearance is still largely determined by the formal traditions and compositional techniques of painting." More specifically, almost all of Salle's imagery is denatured, images of images which have been borrowed from art history, comic books, popular photography, advertising, academic how-to-draw manuals, and pornographic magazines. But to know the sources of Salle's always vaguely familiar images is "to know nothing useful," as Schjeldahl has said.

Like Longo and Sherman, Salle is a member of the first generation of American artists to grow from crib to college before the desolating, unwavering glare of the tube. All three of those artists are known for their enticing, handsomely mounted pictorial extravaganzas, but the point of Salle's picture shows is that there is no point. His image-laden canvases are a tease. They induce expectations of meaning and order, and seem to promise disclosure of narrative if only the viewer will puzzle it out. But his paintings ultimately defy narrative interpretation, and their calculated, coquettish frustration of desire accounts for the "unblunted edge of perversity and willfulness [that makes Salle's art] anything but embraceable," to quote Schjeldahl.

For example, one of Salle's most spectacular paintings is a huge diptych entitled *What Is the Reason for Your Visit to Germany?* (1984; approximately eight by sixteen feet). The background drawing is of a monumental nude woman; bent over on all fours, her hands resting on the floor, she peers at the viewer from between outspread legs. Indeed, thrust right between her columnar legs, the viewer is coerced into the role of physical aggressor. But the gaze

°säl ā´

this Valkyrie returns is bland, impassive; more expressive are her heavy breasts, which resemble bombs, and her erect nipples, which are aimed at the spectator like bullets. She has been rendered in grisaille (from a photograph Salle himself took) and then suffused in a thin red acrylic wash so subdued and dark that the picture literally drank the light of six floodlights which were trained on it at the Leo Castelli Gallery in the spring of 1984. Drawn over her left leg is a cartoon sketch in black outline of Lee Harvey Oswald taking Jack Ruby's bullet. The image is repeated over her right leg, but here Oswald's head is obliterated by a phallic-shaped tornado of de Kooning- or Riopelle-esque brushwork. Stenciled over the center of the canvas in large letters is the word "FROMAGE." (As in, "Say 'cheese'," perhaps, or "cheesecake.") The smaller panel is a minimal-looking sheet of lead attached to plywood and pounded down over a saxophone, which shows in relief.

Describing the Baudelairean poetry of that painting—and Salle's dandified sensibility might well have appealed to Baudelaire—Schjeldahl spoke in the voice of "a tour guide in Hell: Over here you will observe the Saxophone Memorial to Cancelled Joy, and there goes a dust devil of Somebody's Violent Emotion. The Assassin Assassinated Replication Gizmo, as you see, is functioning smoothly. Her? Don't mind Her, or do think of Her as, perhaps, the weather here. (Rather oppressively hot, I'm afraid.) You might even say she puts you in the picture, or not. It's as you choose. (Say 'cheese,' please.)"

Except for Schnabel, Salle is the most controversial of the painters who emerged after 1980 and quickly became "art stars"—young, financially secure avant-gardists who are avidly courted by wealthy collectors and fussed over by media mavens and trendy followers of fashion. Feminists have alleged that his work is misogynistic. Hilton Kramer, the art critic and spokesman for neoconservatism, has judged him "the worst" of the new American painters, one "whose facile conjunctions of abstraction and representation . . . are little more than a formula designed to satisfy every taste." He has also been called a plagiarist of Francis Picabia, an inferior imitator of Sigmar Polke, and a slavish striver after Jasper Johnsian effects. (Salle has acknowledged Johns as his mentor, but an even stronger debt is owed to the early pop paintings of James Rosenquist. It is hard to look at one of Rosenquist's collage-like arrangements of fragmented imagery from Madison Avenue and not think of Salle as a derivative artist.) The flatness and occasional awkwardness of his draftsmanship has been remarked by Robert Hughes of *Time* and Kay Larson of *New York* magazine.

Even admirers of Salle's work have been disturbed by his hard- and soft-core representations of women, many of which are copied from pornographic magazine photographs. Several of these women are on all fours like an animal in heat; some nudes' buttocks are practically rubbed against the viewer's face; other women wearing black bra and underpants cavort or crawl submissively on the floor. Nude women *are* often innocently posed—they have been drawn, or rather, traced, from academic manuals—but in Salle's *mise-en-scènes* featuring provocatory nudes there is an undeniable smarminess. It is a leering, elbow-in-the-ribs smuttiness of the kind associated with 1950s men's locker-room attitudes toward women. As painting in the "hip," smugly knowing 1980s, it displays Salle's mastery of attitude—the attitude of the Duchampian smirk.

Feminist critics have noted that Salle's nude women seem either vacant or remote and self-engrossed. But as Catherine Millet pointed out in *Flash Art*, "all the explicitly pornographic representations are characterized, in a surprising manner, by an incredible sense of indifference. They are in no way idealized (the "beauty" of the bodies is always banal). . . . The slightly sordid feeling that is generally attached to [pornography] is mitigated in such a way as to release neither immediate voyeuristic excitement, nor, on the other hand, any repression." In fact it is the Warholian flatness of Salle's drawing, which both Hughes and Larson derided, that makes the violation and exploitation of the nudes less than total. Discussing the artist's dispassionate, even affectless, treatment of all of his motifs, Schjeldahl wrote that "the most indecent of Salle's female images is dignified when compared to the kindest of his self-portraying male ones: a rogues' gallery of often cartooned demons, plug-uglies, and morons. Nor are objects, materials, and art styles spared. All present sliding scales of effect and affect, from near sublimity to yakking derision."

Another reason Salle is controversial is that to speak of him as a painter at all is to strain the language. He is more like an elusive ventriloquist whose dummy-pictures utter nothing but non sequiturs. Moreover, his representations of second- and third-hand images look impersonal because, often, they have been traced from photos projected onto the canvas rather than drawn from life. Most of Salle's background scenes are rendered in grisaille, which gives them a floating, phantomlike presence, and then suffused with a uniform wash of monochromatic color. The color is either sour and acidic or voluptuous and candy sweet. Superimposed on this mélange of colors and unconnected images are rough line

drawings, usually of more nude women. Although they appear to have been quickly sketched, these line drawings are often traced from photographs as well.

That Salle traces does not detract from his compositional genius (his way of shuffling images on the canvas is *the* striking feature of his work) or the elegance of his finished compositions. One of Salle's greatest gifts is that he "has the touch and eye of a born painter-decorator," as Sanford Schwartz claimed in his profile of the artist in the *New Yorker,* and his canvases have the icy glamour of a pop painting by Rosenquist or Alex Katz.

But if Salle's sensibility is that of a dazzling graphic designer, it has been shaped by Duchamp, Johns, pop, and conceptual art. Like most painters his age, Salle attended art school in the early 1970s, when the influence of conceptualism was at its peak, and Salle was for a time a conceptual artist. Again like most post-pop painters, Salle has been influenced by Duchampian iconoclasm—what are his borrowed images but visual readymades or electronically generated found objects?—and by Johnsian detachment. Salle has rightly been called one of the most "cerebral" of contemporary artists.

Perhaps the crucial influence on Salle has been television. His image-laden work reflects, and comments on, a media-saturated world and a moment in its history when Marshall McLuhan's "medium is the message" age and Andy Warhol's electronic future where "everyone will be famous for fifteen minutes" have come to pass. In a corruscating essay on the current art scene in *Time* entitled "Careerism and Hype Amidst the Image Haze," Robert Hughes wrote of Salle, "His imagery mimics the nullifying influence of TV, its promotion of derisive inertia as *the* hip way of seeing. . . . Nobody could call Salle unfaithful to his sources (which are as often high art as mass media), and his paintings do tell a certain truth about the image-glutted conditions of seeing in the mid-1980s. That is to say, they bear signs of social meaning beneath their inert stylishness, and they exude a creepy sense of the disconnectedness of things."

Salle was born in Norman, Oklahoma, to Alvin and Tillie Dean Brown Salle, who were both first-generation children of immigrants of Russian-Jewish origin. Both Salle's grandfathers emigrated from the same region in Russia and settled in the midwestern United States after stopovers in Montreal. Along the way, both worked in the junk business, his mother's father more profitably than his paternal grandfather, who discarded his Russian surname and dreamed up and adopted the family name "Salle."

His maternal grandfather settled in Tulsa, the commercial heart of the Oklahoma oil industry, and he was on the verge of becoming very well-to-do when he died. Shortly thereafter the family business in spare industrial parts was wiped out during the Great Depression. Salle's grandmother found work as a housemother for the Jewish fraternity at the University of Oklahoma in Norman, where her daughter grew up.

Tillie Dean Brown found an admirer when an uncle introduced her to Alvin Salle, a young noncommissioned officer from Ohio serving on an army base near Tulsa. They courted through letters and married after the war. In 1949 they had a son, Mark (who is now a lawyer in Kansas City), and David followed three years later. In 1954 Alvin Salle moved the family to Wichita, Kansas, where he worked in a downtown clothing store.

From a very early age David Salle experienced Wichita as "an oversized cowtown, and one of the ugliest cities you could imagine," as he told Gerald Marzorati, who wrote about the artist and his career at length in *ARTnews.* Strongly encouraged by his mother, the seven-year-old boy sought creative outlets for the relief of boredom, first trying the piano and then, successfully, drawing, which he did compulsively, using a college textbook, *The Natural Way to Draw.* His mother showed her son's efforts to Betty and William Dickerson, who ran the Wichita Art Association. As Marzorati wrote, "Betty Dickerson admitted Salle, age eight, to life-drawing class—adult level."

Although they had absorbed the modernist currents in early twentieth-century American art at the Chicago Art Institute in the 1920s and at the art colony that flourished in Taos, New Mexico in the 1930s, the Dickersons taught a strict academic curriculum. By the time he was in high school Salle was attending art classes two or three times a week and "all day Saturday and hanging out at the Dickersons' house all day Sunday." Utterly bored with formal day-schooling, Salle was stimulated by the sophisticated talk of his elders, which he heard at Betty Dickerson's Sunday open-house affairs. "The local artists would come by and talk about painting. There might be fifteen people discussing books, listening to music, reporting on something they'd seen in their travels. I loved it. I was always the youngest one there."

In 1970 Salle left Wichita for southern California, enrolling at the California Institute of the Arts. Located in Valencia, near Los Angeles, CalArts is a small school with no required classes

and no grading system. There Salle abandoned painting, which he had begun to do in the lyrical manner of Richard Diebenkorn, for conceptual art. Influenced by the conceptualist John Baldessari, who was then teaching at CalArts, Salle came to terms with the questions: "What *is* 'art'?" "How does the 'art object' function?" "How does art confer and receive meaning?"

After experimenting with performance and video art as an undergraduate, Salle began to address those questions in plastic works that were unabashedly pictorial. In May 1975, the month he received his master of fine arts degree, Salle showed a series of large photo-text diptychs at the Claire Copley Gallery, Los Angeles. The photographs were taken from popular magazines and the texts were "ad-copy smooth," to quote Marzorati. But in no way did text and picture relate. Those handsome pieces only *looked* as if they meant something. (The discontinuity of word and visual image is an effect Salle now achieves with amusingly gratuitous titles like *How Close the Ass of a Horse Was to Actual Glue and Dog Food* or *Wild Locusts Ride.*) The painter Eric Fischl, who also attended CalArts and is now a close friend of Salle's in New York, told Marzorati that "David . . . restated for his generation the whole thing about the meaningfulness of meaninglessness. . . . He puts the images out there as if he were talking only in nouns. The nouns call up things, but they don't connect."

In September 1975 Salle moved to New York City. He worked at odd jobs—teaching drawing at a New Jersey community college and later working in the art department of a publisher of pornographic magazines—and moved from sublet to sublet in unfashionable sections of downtown Manhattan. His photo-text diptychs generated little interest in SoHo, where minimalism, conceptualism, performance, and process art had developed ten years before. But in the fall of 1976 Salle showed new work at Artists Space, a noncommercial gallery in SoHo for emerging artists. Executed on backdrop paper, these large-scale pieces (some as big as nine by thirteen feet) juxtaposed unrelated images and art styles. One work, for example, was skeined with Pollock-like tangles of paint; glued around its border were sixteen *New Yorker*-style cartoon drawings of businessmen; at its center was a black-and-white photo of the interior of an empty loft. "Already in those Artists Space pieces I was interested in rhyming things that don't necessarily rhyme," Salle explained in the interview with Marzorati.

Salle's show failed to attract much attention, and none of the delicate paper pieces survived

his vagabond lifestyle. About 1977 he began again to paint and draw directly on canvas, academic-looking or fashion magazine-looking depictions of furniture, cars, and nude women. The women were often traced from photos Salle took home from the office of his pornographic magazine employer. Later he began taking the women from photographers' manuals from the 1950s and early 1960s. Also in 1977, he began to soak canvases in thin fields of monochromatic color, which, as Marzorati wrote, "gave the [paintings] mood. . . . The color also acted as glue; the images were starting to seem to matter to one another."

Within two years Salle had hit upon the pictorial device that would give his work a distinctive look. One day in the late summer of 1979 he superimposed over a "finished" canvas a line sketch of his wife, Diane, smoking a cigarette. Feeling that his work had "needed something— something with my hand"—Salle realized that his paintings now looked and felt complete, with their fields of bleak color over a dense skein of images.

Salle's technique of layering a line drawing over other images was a personal breakthrough, not an art-historical innovation. Sigmar Polke, a progenitor of "capitalist realism," the German version of pop art, had been layering figurative images since the early 1970s, and one of dada's precursors, Francis Picabia, had overlapped images in his series of "Transparency" paintings in the 1920s. (Interest in Picabia has been revived by the work of Polke, Salle, and their many imitators.)

In 1980 Salle joined the Mary Boone Gallery, which had opened in SoHo the previous year with two highly publicized showings of Julian Schnabel's neo-expressionist paintings. In 1981 the influential art dealer Leo Castelli, who almost twenty-five years before had "discovered" Jasper Johns and Robert Rauschenberg and had not taken any new artists into his prestigious gallery in a decade, entered into partnership with Mary Boone as co-representative of both Salle and Schnabel. Salle's first solo show at both the Boone and Castelli galleries opened in March 1982 and became one of the "blockbuster" art "events" of the first half of the decade. Large, attractive crowds swelled both of the loft-sized SoHo emporiums to see twenty of the artist's large-scale paintings, all of which had been sold prior to their exhibition. Champagne was served on silver trays and the presence of magazine photographers added to the occasion's glitz. In his *Village Voice* review of the show, Peter Schjeldahl described in reverential tones the delayed-reaction effect on him of Salle's work: "It

was an abstracted sensation of dislocation, yearning, and loss which started resonating with my sense of what both art and life are like here in the twentieth century. Salle's harsh artifice [now] seemed heroic, an earnest of authenticity—without ceasing to also seem perverse, against the grain."

Salle's next large solo show came in the spring of 1984 at the Leo Castelli Gallery. Among the eleven imposing paintings he exhibited were such major works as *B.A.M.F.V.* (101 by 145 inches, 1983); *Brother Animal,* an eight-by-fourteen-foot diptych of 1983 with legless Eames chairs attached to the painting on the right panel; *Tennyson* (78 by 117 inches, 1983); *Portrait of Michael Hurson* (86 by 130 inches, 1984); and *What Is the Reason for Your Visit to Germany?*

Reviewing the show in the *New Yorker*, Sanford Schwartz wrote that Salle is "[close] to being a new kind of classical master," one whose work "seems to capture the early 1980s" in the way Renaissance tapestries "often presented . . . an overview of contemporary life in its most up-to-the-minute appearance." "*B.A.M.F.V.*," he wrote, "has the all-over composition—and presence—of Renaissance tapestries."

It is a diptych that brings together many elements. On the right panel a series of drawings of a matador swirling his cape is combined with a melancholy picture of a nude woman smoking. The larger panel on the left features a colorful drawing of a cartoon duck, a menacing, goonish creature who is nursing a beer and what may be a violent grudge. But against what or whom? Donald Duck? Or is this funny yet disquieting fiend the dark side of Donald Duck? There is also a smaller drawing of an absurdly normal middle-aged couple in ridiculous dress—he is bespectacled and wears a lei around his neck, she is got up in a monkey costume. (Schjeldahl called them "the World's Most Embarrassing Parents.") There are other images and attached objects, as well as a vibrant interplay of colors—luscious pinks, a creamy apricot, a cool blue-gray, and voluptuous yellow-orange sexually explicit line drawings on satin of nude women. *B.A.M.F.V.*'s only flaw may be that its tour de force effect is too studiously achieved. But at the 1985 Whitney Biennial it looked the more powerful hanging on the wall opposite two of Jasper Johns's strongest paintings of the past fifteen years.

Salle's show at the Mary Boone Gallery in the spring of 1985 was praised by critics who had thought his reputation as a "painter's painter" unearned, that it had been manufactured by a handful of Salle-infatuated critics and prominent art dealers and collectors. In *New York* Larson wrote: "Salle's art has always been ignited by doubt, especially doubt about the ability of painting to sustain meaning outside itself, to illuminate anything but its own nature. . . . In the beginning, I felt that his anxiety infected even his relationship to his own work. The early paintings [seemed] pasted together hastily under that catchword 'appropriation' in order to keep from himself his fears about having nothing to say. But Salle has listened to his doubts and recognized in them a comment on consumer culture and the alienation it creates between people and things. . . . The work now holds together; . . . it has a force and power that finally seems to be Salle's own."

A wall-sized diptych entitled *Miner* (1985) quickly became one of Salle's most popular paintings. The right panel is a portrait of a miner, a melancholy, Walker Evans-like icon of Depression-era coalfield strife. Diamond rings drawn over each arm are reminders, Larson wrote, "of the outcome of his labor," just as the drips and splatters of paint below those baubles represent the blood and sweat that belie their opulence. (The tensions underlying surface glamour is a standard Salle theme.) Anchored to the canvas above each of the miner's slumped shoulders are cheap cafe tabletops; their violently smashed-out surfaces suggest the inevitable fate of disposable objects in a consumer culture. Painted on the upholstery fabric which comprises the left panel—it is redolent of kitschy, 1950s interior design styles—are overlaid line sketches of a young woman and more cafe tables. The female "object of desire" is as far from the miner's grasp as the rings. As Larson pointed out, "a political comment threatens to emerge, yet the picture will not allow tight connections among its parts. Dissociation is the message, but not the only one. The visual puns may recall Johns, but the mystery is of a different order—less cerebral, more like a Ross Macdonald story, with its overtones of the decay of hope, the imminence of pain."

EXHIBITIONS INCLUDE: Artists' Space, NYC 1976; The Kitchen, NYC 1977, '79; Aninna Nosei Gal., NYC 1980; Gal. Bishofberger, Zurich 1980, '82, '84; Mary Boone Gal., NYC since 1981; Larry Gagosian Gal., Los Angeles since 1981; Leo Castelli/Mary Boone Gals., NYC since 1982; Documenta 7, Kassel, West Germany 1982; "New Art," Tate Gal., London 1983; Biennale, Paris 1985; "Retrospective," Whitney Mus. of American Art, NYC 1987; Mus. of Contemporary Art, Chicago 1987; "Avant-Garde in the Eighties," Los Angeles County Mus. of Art 1987; "Contemporary American Art," Sara Hilden Art. Mus., Tampere, Finland 1988.

ABOUT: David Salle (cat.), 1983; David Salle Paintings (cat.), 1983; Schjeldahl, P. Contemporary American

Art (cat.), 1988. *Periodicals*—Art in America September 1984; Art Monthly March 1983; ARTnews Summer 1984, May 1985; Arts Magazine November 1985; Flash Art Summer 1985; New York May 20, 1985; New Yorker April 30, 1984; New York Times Magazine January 11, 1987; Time June 17, 1985; Village Voice March 23, 1982, February 3, 1987.

SALOMÉ (1954–), German painter recognized as the most flamboyant, but also the most talented, of Berlin's "young fauves," who infused new life into German art in the early 1980s. Although widely exhibited under the neo-expressionist banner, his paintings have a great deal more to do with postwar German society than with prewar German art, and along with his other ventures in performance, punk music, and film, they offer an ongoing challenge to the norms of contemporary culture.

Salomé began life as Wolfgang Cielarz, and the impression he gives of his childhood is as bleak as the Karlsruhe suburb where he was born: his father, he says, was a drunkard, his brother a neo-Nazi, and by the time he reached adolescence he was being told, "People like you used to get sent to the camps." At the age of nineteen, after earning a diploma in industrial drafting, he left for West Berlin, where he joined a group of transvestites and became active in the gay rights movement. As he later explained to Elke Sonntag, since his friends had all adopted colorful "liberated names" like Klara Bella Kuh, Baby Jane, Anne Boleyn, and Rosa Luxemburg, "I needed a name. I didn't want to call myself 'Wolfgang Ludwig Goethe,' and after serious research, he finally decided on Salomé: "the one who lives and kills in the name of love and revolution."

At the time, he was working as a technical draftsman, but after he met a painting student, Rainer Fetting, and the two started living together, he became increasingly interested in art. In 1974 he applied to the Berlin Hochschule (presenting himself for his interview in orange wig, fur coat, and high heels) and was accepted as a student of Karl Horst Hödicke, one of the leading painters in the city's first postwar generation. "Then the time of masquerade began," he recalled; "I only painted what in any kind of way had to do with myself: foam rubber, underwear, shoes, screens, and myself." Indeed, his student works included numerous self-portraits of the tall, thin, and virtually bald Salomé (he started losing his hair at the age of fourteen) in increasingly flamboyant poses ranging from the nude "Fuck" series (1977) to the "Strip" triptych (1977) or the "TV-Warrior" series (1978), where he appears in garter belt, stockings, and high heels; there were also S & M couples with leather and whips (*Der Henker und sein Opfer/*The Executioner and His Victim, 1978) and one four-part series with the lyrical title "Frühling, Sommer, Herbst, und Winter" (Spring, Summer, Fall, and Winter, 1978) that was based on images taken from a gay porn magazine. "At night when the janitor shut down the studios," he later recalled, "he turned the canvases [to the wall]—that's how much he was upset." (Six years later, when some of those paintings were shown at the vast "von hier aus" exhibit in Düsseldorf, a couple of outraged viewers defaced them with spray paint.)

Like Fetting, Salomé came under the influence of the neo-expressionist idiom that prevailed at the Hochschule, but where Fetting used strong colors and lively brushwork to create very sensual images—male nudes and couples with obvious homosexual connotations—Salomé's figures were not sensual but provocative. They were, he explained to Matthew Collings, "against middle-class thinking and living. These values bring a lot of regulations, like antigay, antiwomen. They are against anything which has to do with the body, with the body from the neck down." It was because of that oppositional stance, he contends, that the galleries were not interested in showing his work (or Fetting's, for that matter) and the critics did not want to write about it. As a result, he and another friend from the Hochschule, Helmut Middendorf, decided in 1977 to start their own cooperative gallery, and they were soon joined by Fetting and a fourth painter, Bernd Zimmer. According to Salomé, the seed money for the Galerie am Moritzplatz (named for the street where it was located in the rundown immigrant quarter of Kreuzberg) came from the tips he was earning as a barmaid at a Faschings-kneipe (carnival bistro), and over the four years of its existence, he was the one who took charge of the finances and other practical matters. There were not a lot of sales, he told Sonntag, but there were always parties, and the gallery became "a kind of Mecca" for a youthful art scene.

In fact, the activities at am Moritzplatz were part of a larger counterculture in West Berlin, one that was heavily inflected by new wave and punk. Salomé and his friends were all habitués of SO-36, a nearby discotheque, and he, Fetting, and Luciano Castelli, a Swiss performer-painter who came to Berlin in 1978, formed their own rock group, Geile Tiere (Animals in Heat), which gave concerts there and elsewhere. Salomé and Fetting likewise made a number of super-8 and 16mm films in the late 1970s, and Salomé, who also participated in two films by Robert van Ackeren, was primarily active as a performance artist during that period.

For him, the turning point came in the summer of 1979 with his "fairy-tale discovery" as a painter: The Swiss collector-dealer Thomas Amman appeared at his studio, bought ten paintings, and left the money on the table. Collective recognition soon followed; by the next winter, the am Moritzplatz painters found themselves transformed into a movement with a group exhibition called "Heftige Malerei" (Violent Painting) at the Haus am Waldsee in Berlin. Salomé, Fetting, Middendorf, and Zimmer had coined that name as the one-time title of their first group exhibition at am Moritzplatz in 1978; two years later it was taken over by the curators, critics, and the all-important dealers to signal a new phase in German painting, which was perceived as both an extension of the prewar German expressionist tradition and a breakthrough—paralleling the transavangardia in Italy and the nouvelle figuration in France—after twenty-five years of American domination. In short order, they were included in the watershed exhibition of new European painting called "Après le Classicisme" (After Classicism) at Saint-Etienne in 1980, the Goethe Institute's traveling exhibit of "Ten Young Painters from Berlin" in 1981–1982, and other major exhibits in Germany and abroad, and they soon had gallery representation, not only in Germany but elsewhere in Europe and in New York (Salomé had his first solo exhibit at Anina Nosei in 1980, and the following year he received a German government scholarship to work at P.S. 1, the Institute for Art and Urban Resources, in Long Island City).

Of the four "violent painters" of am Moritzplatz (who were also grouped with a variety of other German painters as the "young fauves"), Salomé was probably the most misrepresented by the group phenomenon, even though it brought him tremendous attention—his pointed social criticisms were deflected into self-expression; his subjects amalgamated into style, and the style in turn subsumed to the parentage of German expressionism. As Salomé himself countered in 1981, "I understand expressionism in a totally different way from the great pundits of art. For me it's not a question of style but a way of life. It's related to the feeling of being free, to work freely, to deal with themes that are nagging us." By that time his repertoire of themes had expanded considerably—while continuing to "shock the bourgeoisie" with highly charged sexual images, he also turned to the music scene (*Dschungel,* 1979), to portraits of friends (*Nina,* 1980), and also "portraits" of Bertold Brecht and the painter Ernst Ludwig Kirchner, which he superimposed on pages of handwritten text. His style, meanwhile, became somewhat lyrical as he moved into a lighter palette and more rhythmic brushwork.

Since 1979 he had been deeply involved, both personally and professionally, with Luciano Castelli; in addition to their music group, they did performances together and, often working from photographs of themselves, painted collaborative (and often erotic) canvases side by side in the same studio (sometimes joined by Fetting). An appearance as "big birds" on a trapeze at a Claudia Skuda fashion show, for example, gave rise to a joint *Big Birds* painting, and their 1981 presentation at the Performance Festival in Lyon, "La Chienne et son Chien" (The Bitch and Her Dog), with Salomé dressed as a geisha leading Castelli, painted as a spotted dog, on a leash, became *Japan-Dog-Bitch* (1981), another two-part canvas joined down the middle with a row of pseudo-Japanese characters. In these paintings too, notwithstanding the shock value, there was also deeply felt social commentary, as Salomé made quite explicit with regard to their 1981 painting *KaDaWe,* a four-part canvas showing twelve naked men (in very delicate pink tones) hung from a rack like sides of beef. As he explained to Cynthia Jaffee McCabe, it was inspired by the sight of the newly remodeled meat market in Berlin's largest department store, KaDaWe: "The symbolism is clear. These creatures that we kill and eat symbolized to us what men are capable of doing to each other. Also that we are all equal, we are all meat, all made of flesh and blood."

Am Moritzplatz was formally disbanded in 1981, and in the period that followed, Salomé's work became even less "violent," although, as he pointed out to Behm, his approach remained exactly the same: "I've only painted what concerns me." In that way, images of Sumo wrestlers were inspired by a visit to Japan, and, he told Behm, he painted a series of abstract, impressionistic swimmers for the simple reason that "the summer of 1982 was very beautiful. We swam a lot." In 1983 he turned to female erotica with groups of pink-skinned, yellow-haired women cavorting in fields or against Matisselike flat-color backgrounds.

For an exhibit of their joint paintings at Bordeaux early in 1983, Salomé, Castelli, and Fetting traveled to France, inaugurating the exhibition with a Geile Tiere concert and then giving two more performances in Paris. On that occasion, the critic Michel Nuridsany singled out Salomé (who also had a solo exhibit in Paris) as "the most talented of the three, the most original, and the most powerful." But, he added, the twenty-nine-year-old artist was already showing clear signs of being "winded." For Salomé himself, it was rather a question of his work getting "quieter." "It can't be wild forever," he told Matthew Collings. "You develop the work in a more

sophisticated way." Indeed, after ten years in Berlin, he decided he needed a change and settled in New York; then, with what Ursula Frohne called "a refreshing Americanized glance," he undertook the "Götterdämmerung," a series of drawings, watercolors, and monumental paintings evoking Wagner's Ring Cycle with explosive configurations of color and line. The theme, he indicated to Klaus Ottman, represented "an interesting point in German history and a certain aspect of the German personality, two elements that have a lot to do with the German soul. Doing the Wagner pieces is a way of learning about myself; it's like looking into a mirror."

A similar exercise, albeit in a very different mode, was clearly involved in his next major project, *Frauen in Deutschland (Women in Germany*, 1985), which featured a dozen interpretative portraits of his close women friends—ranging from his dealer, Ingrid Raab, to tavernkeeper Toni Reichenabach—each one in a somewhat different style and ultimately evoking Salomé as much as the subject. In his interview with Ottman around the time of *Women in Germany*, Salomé reiterated that he's "not painting for others. Naturally I'm happy and satisfied when people like what I do, but mainly I'm painting for myself." Nonetheless, he insisted, "I don't see my paintings as narcissistic. I see them mainly as public education. I'm not out of social context." As various critics have pointed out, the interest of Salomé's work lies precisely at the juncture of his unabashed self-involvement and the social statement that represents. "Salomé's art is the *mise-en-scène* of his person," wrote Heinz Peter Schwerfel in 1982. "He doesn't symbolize, he embodies: at one and the same time he is an oppressed minority, a creative subculture, an artist, an individual."

EXHIBITIONS INCLUDE: Gal. am Moritzplatz, Berlin 1977–81; Gal. Anderes Ufer, Berlin 1978; Gal. Interni-Raab, Berlin 1979, '82; Gal. Hermeyer, Munich 1980, '82; Theater Freie Volksbühne, Berlin 1980; Gal. Lietzow, Berlin 1981; Annina Nosei Gal., NYC 1981; Cntr. d'Art Contemporain, Geneva 1981 (with Castelli); Gal. Bruno Bischofberger, Zurich 1982, '83; Gal. Zwirner, Cologne 1982; Gal. Farideh Cadot, Paris 1983; CAPC, Bordeaux 1983 (with Castelli and Fetting); Gal. il Capricorno, Venice 1983; Gal. Akira Ikeda, Nagoya 1983; Gal. Raab, Berlin, from 1984; Gal. Thomas, Munich 1984; Davies/Long Gal., Los Angeles 1985; Studio d'Arte Cannaviello, Milan 1985. GROUP EXHIBITIONS INCLUDE: "Kunstpreis junger Westen," Recklinghausen 1975; Deutscher Künstlerbund, Berlin 1975; Neue Gal., Aachen 1975; "Die zwanziger Jahre heute," Berlin 1977; Deutscher Künstlerbund, Stuttgart 1979; "Heftige Malerei," Haus am Waldsee, Berlin 1980; "Après le Classicisme," Mus. d'Art et d'Industrie, Saint-Etienne 1981; "10 Young Painters from Berlin," Goethe Inst. (trav. exhib.) 1981–'82; "Rundschau

Deutschland 1," Fabrik, Munich 1981; "Westkunst," Cologne 1981; "Situation Berlin," Mus. d'Art Contemporian, Nice, 1981; "Im Westen nichts Neues," Kunstmus., Lucerne, Neue Gal., Aachen, Cntr. d'Art Contemporain, Geneva 1981–82; "Figures, Forms, and Expression," Albright-Knox Art Gal., Buffalo 1981; "New Figuration in Europe," Indianapolis Mus. of Art and Milwaukee Art Mus. 1981; Sydney Biennale 1982; Documenta 7, Kassel, West Germany 1982; "Zeitgeist," Martin-Gropius-bau, Berlin 1982; Venice Biennale, 1982; "Critical Perspectives," P.S. 1, Inst. for Art and Urban Resources, Long Island City 1982; "New Figuration: Contemporary Art from Germany," Frederick S. Wight Art Gal., UCLA Mus. of Modern Art, Tel Aviv 1983; "Modern Nude Painting," National Mus. of Art, Osaka 1983; "Artistic Collaboration in the 20th Century," Hirshhorn Mus. and Sculpture Garden, Washington, D.C. 1984; "An International Survey of Recent Painting and Sculpture," MOMA, NYC 1984; "von hier aus," Messehallen, Düsseldorf 1984; "La Metropole Retrouvée," Palais des Beaux-Arts, Brussels 1984; "Tiefe Blicke," Hessisches Landesmus., Darmstadt 1984; "Museum? Museum! Museum," Mus. für 40 Tage, Hamburg 1985; "1945–1985 Kunst in der Bundesrepublik Deutschland," Nationalgal., Berlin 1985; "Der Selbstporträt im Zeitalter der Photographie," Akademie der Künste, Berlin, Mus. Cantonal des Beaux-Arts, Lausanne, Würtembergischer Kunstverein, Stuttgart 1985; "The European Iceberg," Art Gal. of Toronto 1985; Sao Paulo International 1985.

ABOUT: Billeter, E. Luciano Castelli, A Painter Who Dreams Himself, 1986; Celant, G. "The European Iceberg" (cat.), Art Gal. of Toronto, 1985; Faust, W. M. and G. de Vries, Hunger nach Bildern, 1982; Joachimides, C., et al. "La Metropole Retrouvée" (cat.), Palais des Beaux-Arts, Brussels, 1984; Klotz, E. Die neuen Wilden in Berlin, 1984; McCabe, C. "Artistic Collaboration in the 20th Century" (cat.), Hirshhorn Mus. and Sculpture Garden, Washington, D.C. 1984; "1945–1985 Kunst in der Bundesrepublik Deutschland" (cat.), Nationalgal., Berlin, 1985; "Salomé: Frauen in Deutschland" (cat.), Gal. Raab, Berlin, 1986; "Salomé bei Thomas" (cat.), Gal. Thomas, Munich, 1984; "Salomé, Castelli, Fetting" (cat.), CAPC, Bordeaux, 1983; "Tiefe Blicke" (cat.), Cologne, 1985. *Periodicals*—Artforum September 1981; Art in America September 1982; Art Press May 1982; Artscribe September–October 1984; Connaissance des Arts November 1984; Flash Art January–February 1981, April–May 1984, December 1985–January 1986; Kunstwerk April 1984; Le Figaro (Paris) February 11, 1983.

SAMARAS, LUCAS (September 14, 1936–), Greek-American sculptor, painter, photographer, assemblage and environmental artist who has accomplished one of the rarest feats in modern art: using self-obsession, hostility, childishness, and compulsiveness to drive the creation of a truly original body of work. Like

LUCAS SAMARAS

an ingenious child desperate for attention, Samaras never fails to try to shock his audience; but that impulse is tempered and made palatable by the artist's brilliant use of unconventional materials, his sense of humor, and his willingness to expose even the less admirable parts of himself to public scrutiny and judgment.

Samaras's childhood in the small town of Kastoria, Greece, was strongly influenced by the horrors of World War II and, in its aftermath, the Greek Civil War. Bombings and executions were commonplace occurrences in his environment; Samaras, who lived with his mother and two aunts (his father had emigrated to the United States when the boy was three years old), played often with unfired bullets he found on the street, throwing them into the fire to make them explode. He and his cousin wandered through Kastoria's seventy-two churches, peeking into the black boxes of human bones that were stacked, according to custom, against the church walls. "I grew up with the Chapel of St. George across the street, with the waxy icons, boxes with bones, smell of incense and old people, darkness and heavy oppressive eternity," the artist has recalled.

In 1948 Samaras and his family moved to the United States, where they rejoined his father and settled in a small apartment in West New York, New Jersey. Already adept at drawing and making small objects (despite his father's strong disapproval of art as a career), Samaras won an art scholarship to Rutgers University in 1955. Allan Kaprow, who was teaching at Rutgers and had approved the scholarship, described his submis-

sion, a portfolio of semiabstract crucifixion drawings and watercolors, as "somewhere between futurism and Feiningeresque cubism." Another of Samaras's teachers at Rutgers, George Segal, characterized the young artist as "arrogant, silent, egotistical, self-contained, very intelligent, intensely interested in being an artist." The other students held him in some awe, at the same time recognizing that Samaras was already an accomplished actor who worked hard to create an enigmatic public persona. Samaras worked feverishly, using whatever he had at hand—including his own T-shirt and bedsheets—as material for post–abstract expressionist paintings with a Rauschenbergian flavor. His honors project, an elegant manuscript of photographs and poems that included pages of obscenities, offended the dean and led indirectly to Kaprow's being fired from the Rutgers faculty. After his graduation in 1959, Samaras did two and a half years of graduate work with Meyer Schapiro at Columbia University.

Samaras's fairly traditional early work—pastels and oils of figures and still lifes, which he displayed at his first one-person show at the Reuben Gallery in Manhattan—quickly gave way to more adventurous explorations. His penchant for role playing led him to participate in the "happenings" of Kaprow and Claes Oldenburg. Oldenburg noted that Samaras was perfect for certain kinds of performances. "Whatever he did he did very slowly, obsessively, calculatedly. . . . I could set him onto obsessional activity. Like buttering bread. In one of my happenings he butters hundreds of slices of bread." (Many of his later works displayed that same predilection for obsessive craftsmanship—drawings made of hundreds of fine parallel lines, paintings layered with spaghetti strands of liquid aluminum or yarn, or boxes with innumerable small objects glued on them.) Samaras never created his own happenings, though he did craft some striking environments in the mid-1960s. He also studied acting for a time with Stella Adler and later dabbled in film and video.

In mid-1960, after months of experimentation with crude cloth-and-plaster figures (Segal had introduced him to plaster at Rutgers), Samaras created his first boxes. He stuffed plaster-impregnated rags into wooden boxes, shaping them into faces and figures, coating them with feathers or wrapping them with string. One revealing box contained a plaster face on one side and a mirror covered with tacks on the other. Soon Samaras began adding incrustations of outward-facing nails, razor blades, bullets, tacks, screws, nuts, and pins to his paintings and pastels, giving free rein to the artist's fear of and anger at his audience. Broken cups, plates, and

spoons began to appear in the boxes and collage works soon after. Those objects (they no longer could reasonably be called paintings or sculptures in the traditional sense), most displayed at the Reuben Gallery, fell into the category of what was later called "pre-pop." Other Reuben artists, like Kaprow, Oldenburg, Segal, Jim Dine, Red Grooms, and Rosalyn Drexler, used commonplace real materials in their work—hence the link with pop—but Samaras knew how to turn everyday objects into threats. There was an erotic dimension to many of the boxes as well: several 1965 boxes are covered or filled with hair, contain phallic shapes or symbols (fish), or incorporate actual body parts (bones).

In his show at the Green Gallery in December 1961, he exhibited the first of what would become a series of "Dinners": goblets filled with pins; a soup bowl filled with red-painted cotton and topped with broken glass; bent forks, spoons, and knives attacking a broken plate; and a plate with cotton scrambled eggs from which two doll's eyes stared out. His boxes and books from 1962 onward were often covered with a furry coating of pins; one book sprouts a knife and razor blade from its pages as well. "I made it my business not to be sidetracked from my interest in intimate but quite lethal things," he wrote in a 1972 catalog.

The obverse of Samaras's aggression is his self-obsession. In his work, this is expressed in his use of autobiographical materials, in his fascination with mirrors, and in his increasing reliance on self-portraiture. Probably the most thoroughly autobiographical installation ever made was Samaras's *The Room* (1964), a painstaking recreation at the Green Gallery of the manifold contents of his old room in his parents' apartment. (His family had moved back to Greece, and Samaras was now living in an apartment in Manhattan.) As Samaras said in a 1966 interview, "I guess I wanted to do the most personal thing that any artist could do, which is, do a room that would have all the things that an artist lives with, you know, clothes, underwear, artworks in progress. . . . It was as complete a picture of me without my physical presence as there could possibly be." Samaras has even used parts of his own body in his objects—one box contained a plaster finger with Samaras's own fingernail glued to it.

Mirrors figure prominently in many of the boxes and wall works, as well as three complete environments, notably *Mirror Room* (1966), shown at Samaras's breakthrough Pace Gallery show in 1966, and *Mirror £3* (1967), exhibited at the 1968 Documenta in Kassel, West Germany. *Mirror Room* was a cube, large enough to be entered by a narrow door, that was paneled inside and out with mirrors. Inside were a simple, nonfunctional table and chair, also mirror-covered. Visitors were treated to a uniquely disorienting experience as their fragmented reflections multiplied endlessly. "Narcissism was there in this lonely crystalline space," noted the artist in a 1972 catalog, "but not to the degree that it was expected. The geometry, the abstractness, the shafts and splinters of light had the edge over the echoing bodies." Disquieting as the *Mirror Room* was, Samaras's mirror structure at Documenta was still worse, for those brave enough to enter it. Also a cube mirrored in and out, this environment included sharp, macelike spikes scattered over its surface. The unwary who entered its floor-level hatch invariably knocked their heads on a spike situated just above the opening as they stood up inside. "It was pretty lethal," Samaras said. "Like sending a torture machine to the land of torture. . . . But I don't think they saw my vengeance."

From the mid-1960s, the idea of transformation has been a central one in Samaras's work. The public and critics alike found his transformations of everyday objects—everything from flowers to plates to chairs—into recognizable but bizarre variations of their original forms to be the most accessible of his works. Especially popular was his series of transformed chairs (first shown as a group at the Pace in 1970), which included a chair made of flowers, a "wheelchair" with a spike sticking up from the seat, a chair carefully burned black all over, and raked-back chairs piggybacking one upon another toward the ceiling. None of the chairs were fit to sit upon, but viewers appreciated the artist's whimsical inventiveness. Another series of chairs, most constructed of wire hangers or encrusted with glass beads, were shown at Pace in 1987.

The chief subject of Samaras's transforming magic is not physical objects but himself, and the perfect medium for his explorations into self-image has been photography. Through the 1970s the artist was absorbed in producing a series of "Autopolaroids" and "Phototransformations." The "Tutopolaroids," Polaroid photos of himself alone taken in his apartment late at night, explore and expose both his body and his secret feelings about it. Multiple images abound: Samaras makes love to himself, reproduces himself, then turns himself into a fetus, a woman, or one of his paintings. Nude, he strikes exaggerated "artistic" poses, adorns himself with plastic fig leaves, or draws over his image. The work is not merely confessional, kinky, or self-mocking; as Kim Levin noted, it is primarily theatrical. "The self-revelation [of the "Autopolaroids"] is obvious; he seems to expose

himself totally. But that makes them no less enigmatic: balancing nakedness and secretiveness, they are private, exposed, vulnerable, yet all is facade, artifice, invention." Samaras himself said of these works that they provided him with the opportunity to be "my own critic, my own exciter, my own director, my own audience." This was true also of the "Phototransformations" and a later series of "Phantasmata," Polaroids that Samaras altered by folding, cutting, assembling, and painting onto them while the emulsion was still wet. Heightening the theatrical aspect of the works, he used colored gels, dramatic lighting, and draped fabrics to create a stage for his own performance. A series of "Sittings" (early 1980s), using the new large-format Polaroid process, included for the first time images of other people (his dealer, critics, and friends from the art world, posed nude among the props he had used in earlier photos), but Samaras, as master of erotic ceremonies, is present at the margin of the pictures and always steals the show.

Recently Samaras has returned to painting with a savage series of acrylic portraits: *The Failed Artists, The Art Dealers, The Art Collectors, The Spectators,* and *The Artist's Friends* (all circa 1985). These black death's-heads, the most aggressive work he has done to date, are not of specific individuals, but of types; they are, as the artist has admitted, a harsh judgment on his associates in the art world—and an experiment to see how far he can push his personal relationships. In an interview with Samaras, Arnold Glimcher, his dealer at Pace, compared the paintings to the "Sittings": "In the sittings you used all of us in an erotic way . . . we were all giving you something by taking our clothes off. And I think, in a way, you've done the same thing with these images, but you are testing us further. I believe that you were saying, you took your clothes off for me, now take your skin off." It may be that Samaras, having bared his own psyche repeatedly and in every possible way, is now branching out and requiring it of his audience as well.

Samaras is often described as an acrobat walking the edge of a narcissistic abyss that we all are aware of and attracted to, but will not approach. Robert Pincus-Witten, finding in Samaras's work "a genial and demonic delusory pattern," pronounced him "crazy, but great crazy." While many artists have fed off of Samaras's innovations in sculpture, object decoration, and especially "body art," the artist himself is a loner, a part of no movement or group and reluctant even to admit his debts to past artists. The artist Richard Bellamy considers Samaras to be "totally autotelic, self-engendered. That kind of

narcissism that, being so extreme and so self-conscious, becomes something else. He's turned all of what might be termed neuroticisms in his behavior to such conscious perfection that it's quite something other than bizarreness. He has made a consistent fabric of his personality; it's quite seamless."

EXHIBITIONS INCLUDE: Rutgers Univ. Gal., New Brunswick 1955, '58; Reuben Gal., NYC 1959; Green Gal., NYC 1961, '64; Sun Gal., Provincetown, Mass 1962; Pace Gal., NYC 1966 '68, '70, '71, '72, '74, '75, '76, '78, '80, '84, '85, '87; Sachs Print Gal., NYC 1969; MOMA, NYC 1969, '75; Kunstverein, Hanover, West Germany 1970; Phyllis Kind Gal., Chicago 1971; Mus. of Contemporary Art, Chicago 1971; Whitney Mus. of American Art, NYC 1972; Makler Gal., Philadelphia 1975; Calif. State Univ., Long Beach 1975; Art Gal., Univ. of North Dakota, Grand Forks 1976; Art Gal., Wright State Univ., Dayton, Ohio 1976; Inst. of Contemporary Art, Boston 1976; Seattle Art Mus. 1976; A.C.A. Gal., Alberta Col. of Art, Calgary, Canada 1976; Margo Leavin Gal., NYC 1976; Gal. Zabriskie, Paris 1977; Walker Art Cntr., Minneapolis 1977; Mayor Gal., London 1978; Akron Art Inst., Ohio 1978; Richard Gray Gal., Chicago 1979; Corcoran Gal., Washington, D.C. 1979; Indianapolis Mus. of Art 1980; Denver Art Mus. 1981; Gal. Watari, Tokyo 1981; Lowe Art Mus., Univ. of Miami 1982; Mus. of Photographic Arts, San Diego 1984; International Cntr. of Photography, NYC 1984; Bernier Gal., Athens, Greece 1986. GROUP EXHIBITIONS INCLUDE: "Art of Assemblage," MOMA, NYC 1961; "Lettering by Hand," MOMA, NYC 1962; "28th Corcoran Biennial," Washington, D.C. 1963; "Sculpture Annual," Whitney Mus. of American Art, NYC 1964; "American Sculpture of the Sixties," Los Angeles County Mus. of Art 1967; Documenta 4, Kassel, West Germany 1968; "Dada, Surrealism and Their Heritage," MOMA, NYC 1968; "The Twentieth Century: 35 American Artists," Whitney Mus. of American Art, NYC 1974; "71st American Exhibition," Art Inst. of Chicago 1974; "Bodyworks," Mus. of Contemporary Art, Chicago 1975; "200 Years of American Sculpture," Whitney Mus. of American Art, NYC 1976; Documenta 6, Kassel, West Germany 1977; "Mirrors and Windows: American Photography since 1960," MOMA, NYC 1978 and U.S. tour 1978–80; "One of a Kind: Polaroid Color," Corcoran Gal., Washington, D.C. 1979 and U.S. tour 1979; "La Photo Polaroid," Mus. d'Art Moderne, Paris 1980; "Drawings: The Pluralist Decade: Biennale," Venice 1980.

COLLECTIONS INCLUDE: Metropolitan Mus. of Art, Whitney Mus. of American Art, MOMA, and Solomon R. Guggenheim Mus., NYC; Albright-Knox Gal., Buffalo, N.Y.; Wadsworth Atheneum, Hartford, Conn; Aldrich Mus., Ridgefield, Conn; Art Inst. of Chicago; Los Angeles County Mus. of Art; City Art Mus., St. Louis; Walker Art Cntr., Minneapolis; Fort Worth Art Mus., Tex.

ABOUT: Alloway, Lawrence. Samaras: Selected Works 1960–66 (cat.) 1966; Cummings, Paul. Artists in Their

Own Words, 1979; Current Biography, 1972; Eman-
uel, M., et al. Contemporary Artists, 1983; Levin, Kim.
Lucas Samaras, 1975; Samaras, Lucas. Lucas Samaras,
1972; Siegfried, Joan. Lucas Samaras Boxes (cat.),
1971; Whitney Museum of American Art, Samaras Al-
bum: AutoInterview, AutoBiography, AutoPolaroid
(cat.) 1971; Whitney Museum of American Art, 200
Years of American Sculpture, 1976; Who's Who in
American Art, 1989–90. *Periodicals*-Aperture Fall
1984; Artforum October 1966, December 1968, March
1977, February 1980, May 1983, June 1984, Summer
1985; Art in America November–December 1970,
March 1981, October 1982, October 1985, May 1987;
ARTnews April 1976, Summer 1979, November 1980,
December 1980, November 1984, May 1987; Arts
Magazine May 1978, November 1979, May 1983,
April 1984; Artweek November 3, 1984; Camera 1974;
Craft Horizons December 1972; Flash Art November
1984, October–November 1985; New York Times Au-
gust 24, 1969, October 31, 1976; Smithsonian February
1973; Studio International March 1973; Time Septem-
ber 20, 1968, November 9, 1970, November 27, 1972.

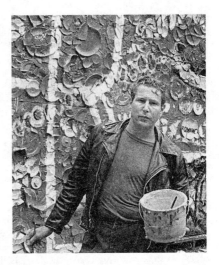

JULIAN SCHNABEL

***SCHNABEL, JULIAN** (October 26,
1951–), American painter and sculptor, is the
most controversial artist of his generation. Born
in Brooklyn, he grew up in an affluent Jewish
neighborhood until he was about fourteen, when
his father, a businessman, moved the family to
Brownsville, Texas. Feeling out of place, Schna-
bel turned inward. "If I didn't get along with
people," he once recalled, "I just spent time by
myself painting. And I didn't get along with peo-
ple a lot."

Following his graduation from high school,
Schnabel enrolled at the University of Houston
in 1969. Art teachers advised him to "think
visually"—that is, in abstract terms—but the
headstrong young student already was painting
representationally, and several of his early works
were semi-narrative. After receiving his B.F.A.
degree, he moved to New York and won admit-
tance to an independent study program offered
by the Whitney Museum of American Art. He
experimented with a variety of styles but refused
to settle with one of the orderly modes of ab-
straction then fashionable in the postminimalist
'70s.

After finishing his studies at the Whitney,
Schnabel stayed on in Manhattan. He drove a
cab and worked at other odd jobs but eventually
returned to Texas, where the pace was more re-
laxed and the cost of living lower. There, he de-
voted more time to painting, producing rough-
hewn works with built-up surfaces in which he
dug out craterlike pits and made jagged inci-
sions. These works were shown in 1976 at hius
first solo exhibition, which was held at Houston's
Contemporary Arts Museum.

Not long after that show, Schnabel went back
to New York. He found work as a cook, and
when he had saved enough money he traveled
to Europe. He stayed in Paris for several months,
finding time to paint before moving on to Milan,
where a collector financed a series of ten paint-
ings. Returning to New York, he again worked
as a cook at Mickey Ruskin's Village restaurant,
the Locale, which was a downtown artist's hang-
out. He also found a studio in a building owned
by another young artist, Ross Bleckner.

The amiable, garrulous Schnabel, who was
once called by a friend the "major of SoHo" be-
cause of his penchant for speaking to almost ev-
eryone he met on the street, invited all the
Locale regulars to his studio to look at his work.
One viewer was a young unknown art dealer
named Mary Boone, who was about to open a
tiny gallery on the ground floor of the building
that also housed the exhibition space owned by
Leo Castelli. In an interview with Anthony Ha-
den-Guest of *New York*, Boone admitted that
her initial impression was ambivalent. "It was
lush," she recalled. "Holes were dug out of [the
paintings]. I was a bit nonplussed. . . . It wasn't
what people were doing then."

However, the visceral impact of Schnabel's
work stayed with Boone, who offered him a
show at her fledgling gallery. Only four paint-
ings were shown at the February 1979 exhibi-
tion, but each was sold, even though the show
drew sparse critical attention. But at his second
show at Boone's gallery in November, Schnabel
unveiled his plate paintings—huge, thickly im-
pastoed canvases with shards of broken crockery

°shnä´ bel

affixed to them. The idea for these paintings, which incorporated figures and other familiar shapes and images, had come to Schnabel during a trip to Barcelona in the summer of 1978. There he was spellbound by the expressive power of Antonio Gaudí's architecture, especially the mosaic benches in Güell Park, from which he conceived the idea of "plate paintings," the works, he said, he knew he had been "born to make."

Once again the show sold out, with the paintings now commanding prices of up to $6,000. The brooding, emotional tone of the canvases snared the attention of critics who had considered the contemporary New York art world somnolent. In an *Art in America* (November 1979) review, René Ricard wrote, "Maybe these paintings shouldn't be kept in the home at all, but, rather, chained in the basement like a pet gorilla." A *Village Voice* reviewer described a Schnabel plate painting as a "wild, wonderful tantrum," and another critic pointed out that, while there was a brutality in the artist's approach, the work became "heroic not through applied force but through the interplay of the painted imagery—mostly writing torsos—with the dishes."

In 1981 Schbabel became an art-world "superstar" when a joint exhibition of his work was mounted in SoHo by Boone and Leo Castelli, the art dealer who had "discovered" Jasper Johns and Robert Rauschenberg in the 1950s. Castelli saw in Schnabel's work something new, a quality that he had not encountered in painting since the heyday of pop and minimalism in the '60s. In addition to several plate paintings, Schnabel also showed gigantic works crammed with expressive imagery and iconic shapes and encrusted with a variety of objects and materials, including antlers, gold leaf, and charred blocks of wood. One painting, *Death,* was done on pink velvet, while another incorporated images of the beat novelist William Burroughs and the crucifixion of Christ. In a much noticed review in the *New York Times* (April 17, 1981), Hilton Kramer wrote, "For eyes starved by the austere nourishment of Minimal Art . . . Schnabel's work provides the equivalent of a junk-food binge. It is understandable, therefore, if it causes a certain amount of indigestion in the process. . . . Crockery and claptrap [aside] . . . [he] is a painter of remarkable powers."

Having received the Castelli imprimatur, Schnabel's work now sold for prices that were then unheard of for a 29-year-old painter, with some canvases going for as much as $40,000. In addition, Schnabel began to exhibit extensively in Europe, and in 1982 he participated in the large group show held at the Martin-Gropious-

Bau in West Berlin. Called "Zeitgeist," the show was a largely successful effort by several influential American and European art dealers to announce the arrival of a new group of international painters who had repudiated the cool, orderly, geometrical strategies that had developed out of color-field painting and minimalism. In an essay titled "Thoughts on the Origins of 'Zeitgeist,'" the critic Robert Rosenblum wrote: "The ivory towers where artists of an earlier decade painstakingly calculated hairbreadth geometries, semiotic theories, and various visual and intellectual purities have been invaded by an international army of new artists who want to shake everything up with their self-consciously bad manners. Everywhere, a sense of liberating eruption can be felt, as if a turbulent world of myths, of memory, of molten, ragged shapes and hues had been released from beneath the repressive restraints of the intellect which reigned over the most potent art of the last decade."

By 1982 Schnabel was considered one of the avatars of the "new" style labeled neoexpressionism. Because the other leading neoexpressionists—such as Polke, Baselitz, and Penck in Germany, and Clemente, Chia and Cucchi in Italy—were Europeans with significant exposure in New York, the entire group of artists was considered to be a part of the new "Transavangardia." Indeed, fashionable young artists were being coddled by dealers and collectors and courted by trendy nightclub owners like Steve Rubell, who called Schnabel and his friends the "new royalty."

However, this "scene" attracted a persuasively eloquent detractor in Robert Hughes, the author of *The Shock of the New* and the art critic for *Time* magazine. In Hughes's view, the hoopla surrounding the new art was dealer- and collector-created hype, a product of the thoroughgoing transformation of art into commodity during the 1980s, especially in downtown Manhattan, where Wall Street and real estate money was being poured into SoHo galleries, boutiques, restaurants, and nightclubs. Hughes singled out Schnabel as an especially "mediocre and overblown painter" and an appallingly poor draftsman. Schnabel, he said, was the product of the "worst hype since the South Sea Bubble." In *Time* (November 1, 1982) he wrote, "Schnabel's work is tailor-made to look important. It is big, and stuffed with clunky references to other Great Art. . . . Its imagery is callow and solemn, a Macy's parade of expressionist bric-a-brac."

As Schnabel's fame grew, so, too, did the fortunes of the Mary Boone Gallery and its propri-

etor, who became a celebrity in her own right. Schnabel came to resent the idea that his success was the result of Boone's clever promotional strategies or, for that matter, of his association with Castelli. Because he was further irked by the way Boone's name was always mentioned when his work was discussed, Schnabel stunned the New York art community in the spring of 1984 when he left Boone, Castelli, and SoHo for the Pace gallery on 57th Street. There, he mounted one of the strongest shows of his career in November 1984. The most memorable painting was *Nicknames of maitre d's*, an enormous (108 by 252 inches), image-crowded work of oil and modeling paste on velvet. Another strong "velvet painting" was *Resurrection: Albert Finney Meets Malcolm Lowry*, while in *Humpty Dumpty*, an oil painting on linoleum, Schnabel continued to experiment with oils on unusual surfaces.

Schnabel's mid-career retrospective in 1987 at the Whitney Museum of American Art was a critical success, and one year later he published an autobiography entitled *CVJ and Other Nicknames of Maitre d's*. While the artist's work has been attacked in some quarters as shrill and bloated, Schnabel himself is an immensely engaging, personable, and outgoing man. His wife Jacqueline owns a clothing boutique in SoHo. They have two daughters and maintain two homes, a large loft-studio in Manhattan and a house with an open barn-studio in Bridgehampton, Long Island.

Schnabel feels that his work has little to do with the concerns of postmodernism. It is not self-consciously ironic and is not involved in strategies of appropriation. His work, he says, is about states of mind and about the distillation of direct, unmediated feeling. In a statement that could apply to his own work, he said of van Gogh, "What is important . . . is the way his paintings are able to convey a mental state. That's what is interesting. That's what a painter does." "Painting," he told Gerald Marzorati of *ARTnews* (April 1985), "makes me feel that I don't have to kill myself. But the paintings themselves, it's not important that I make them. It's just important that *somebody* makes them. . . . These paintings don't describe my ego. . . . I believe that . . . my work is about love. Love and Sadness."

EXHIBITIONS INCLUDE: Mary Boone Gal., NYC 1979, '81; Margo Leavin Gal., Los Angeles 1981; "A New Spirit in Painting," Royal Academy, London 1981; Whitney Biennial, Whitney Mus. of American Art, NYC 1981; Tate Gal., London 1982; "Zeitgeist," Martin-Gropius-Bau, West Berlin 1982; Mary Boone–Leo Castelli Gals., NYC 1982, '83; Gal. Bischofsberger, Zurich 1983, '84, '85; Gal. Daniel Templon, Paris 1983; Waddington Gals., London 1983, '85; Pace Gal., NYC since 1984; Gal. Sperone, Rome 1985; "Legendes," Mus. d'Art Contemporain, Bordeaux 1984; Whitechapel Art Gal., London 1986; Carnegie International, Carnegie Inst., Pittsburgh 1986; Retrospective, Whitney Mus. of American Art, NYC 1987.

ABOUT: Dickhoff, W. "Julian Schnabel" (cat.), 1986; Gablik, S. Has Modernism Failed? 1984; Schnabel, J. CVJ and Other Nicknames of Maitre d's, 1988. McEvilley, T. "Julian Schnabel: Paintings 1975-1986" (cat.), 1986. *Periodicals*—Art in America December 1982; ARTnews Summer 1982, April 1985; Harpers July 1983; Newsweek May 11, 1981; New York April 19, 1982; New York Times April 17, 1981, October 8, 1982; SoHo News April 22, 1981; Time November 1, 1982; Village Voice December 3, 1979, February 23, 1982.

SCHNEEMANN, CAROLEE (October 12, 1939–), American painter, performance artist, filmmaker, writer, and the originator of "body art" who is perhaps the most controversial figure among the founders of performance/"happenings" movement in America in the early 1960s. Her work, which is complex, varied, and consistently daring, is far less well known than that of other innovators in the genre, such as Allan Kaprow or Claes Oldenburg, although it has been of crucial importance to the development of second-generation performance artists, especially women such as Kathy Acker, Hannah Wilke, and Diane Blell. Schneemann's neglect is rooted in two difficulties—one social, the other intellectual—that most viewers experience when encountering her work. First, her films and performances are overtly feminist and intensely physical, usually involving her own nudity and sometimes sexual activity; they invoke and challenge common sexual taboos and complacencies. As Lawrence Alloway has noted, that "has tended to seal off her career in a Dionysian cul-de-sac" (Schneemann would prefer to call that Aphroditean), allowing her works to be dismissed as exhibitionism. Second, they are uncompromisingly complex, Raushcenbergian in structure, requiring repeated viewings to comprehend and appreciate, and considerable stamina and sympathy on the part of her audience.

Schneemann's roots are not in theater or dance, although her work has been subsumed under those categories by some critics, but in painting and collage. Those were her first media and remain the foundation of her artistic vocabulary. She has written that she believes she was "born to make images" and that she began to draw before she could talk. As a child she listened to stories about the Great Goddess—the

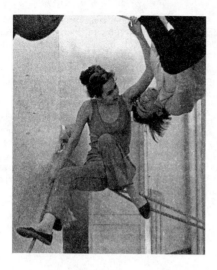

CAROLEE SCHNEEMANN

earth mother, the prehistoric deity whose worship was controlled primarily by women—told by her Scottish nurse. There was never any question that she would study art. In the late 1950s and early 1960s Schneemann attended several art schools, including Bard College, where she received her bachelor's degree, the University of Illinois, Urbana, where she earned an M.F.A. degree, and the Columbia University School of Painting and Sculpture, the New School for Social Research, and the Universidad de Puebla, Mexico.

Although her early paintings seem to come out of abstract expressionism, Schneemann was in fact more profoundly influenced by the European branch of modernism, especially the work of the collagist Kurt Schwitters and, obliquely, Cézanne. She also credits Wilhelm Reich, Antonin Artaud, and Simone de Beauvoir as philosophic influences: a sexual-theatrical-feminist/biographical matrix within which her own progress can be charted. The paintings themselves are complex, often confusing, mixing vigorous passages of brushwork in individual textured areas with mixed-media elements (often on a different level of the constructed canvas) that have biographical significance for the artist, such as snapshots of friends or herself and her lover. (Her body, "part of the Nature" she wanted to paint, figures prominently in even her earliest works. "The life of the body is more variously expressive than a sex-negative society can admit," she wrote in 1968. "In some sense I made a gift of my body to other women: giving our bodies back to ourselves.") *Native Beauties*

(1962–64), perhaps the most accomplished of the painting-collages, incorporates several distinct images on two planes of different depths. On the lower plane is a seashore, a painted background overlaid with pebbles, shells, a photo of the ocean, and a scattering of small bones glued to the surface. On the upper plane, a dead canary, hanging above a teacup painted to match the bird, is flanked by two boxes, one with a delicately painted-over photo of a Senegalese woman, one with a photo of Schneemann sitting on the beach feeding her cat, Kitch. Auras of glowing paint and the work's boxy wooden structure both isolate and emphasize the biographical, representative elements, which evoke the same kind of memory-fantasy that can be found in Joseph Cornell's boxes. (Those collage-paintings received a long-delayed retrospective at the Max Hutchinson Gallery in New York City in 1982.)

In 1962 Schneemann arrived in New York, immediately connecting with Rauschenberg, Oldenburg, Robert Morris, Philip Corner, and other artists and dancers who were creating volatile new art/theater/dance forms. Her first public exposure was at Corner's Living Theater in 1962; she contributed *Glass Environment for Sounds and Motion,* "an enlarged collage," as she described it, that aimed to overcome and destroy "solid forms, frames, fixed conventions or comprehensible planes, the proscenium stage and the separation of audience and performer." She joined the group of artists working at the Judson Dance Theater, the adventurous forum for avant-garde performance where Lucinda Childs, Trisha Brown, Yvonne Rainer and other choreographers were transforming the vocabulary of dance, and eagerly participated in several happenings organized by Rauschenberg and Morris. These included Morris's *Site* (1964), in which she impersonated Manet's *Olympia* with stunning effect. In 1963 she founded the Kinetic Theater to encourage a new hybrid of theater and dance.

Well before environments became an accepted art form, Schneemann began turning her studios into architectural collages, integrating her living space with her work by arranging paintings in progress and other personal materials into a structured whole. From the utilization of her immediate, familiar space as art, it was only a short step to the use of her body, and not just an image of it, as a medium of expression—the body as environment. That was the initial impetus for her first performances, which brought her considerable notoriety. *Eye Body* (1963), for example, married collage, dance, and ritual; Schneemann treated her body as "a source of collage transformations—its juxtaposition/extension to constructions, kinetic light boxes,

and the constructed environment I had been making in my studio generally; ambiguities both spatial and tactile; change of flesh forms by paint, grease, water, oil, powder, crayon, transparent plastic." At one point in this work the nude, body-painted Schneemann draped herself with live snakes to prove her power over the serpent—current phallic symbol and ancient vulvic symbol of the cosmic energy of the womb. Beyond her body's function as a medium for aesthetic discovery, with this work Schneemann announced a further agenda: to use her body as a stage for feminist theater.

Meat Joy (1964), her best-known and most elaborately staged Kinetic Theater (her version of happenings) performance, evolved, Schneemann has written, from dreams and other image fragments dating back to 1960. She imagined a "visual drama" of "flesh jubilation" employing found performers and Parisian débris. In 1964 she pulled together enough money to go to Paris, where she had been invited by Jean-Jacques Lebel to take part in a theatrical "Festival of Free Expression." There she found potential performers in bars, restaurants, and on the street and drilled them in a variety of sensitizing exercises to develop "rich and freely expressive responsiveness to one another." Their task: to act out on stage a highly structured sexual ballet that would culminate in a confused mass of human bodies (the performers) mixed with fresh fish, chicken parts, sausage—an indulgence of flesh that was "simultaneously comic, disturbing, exhilarating." Her ultimate purpose in creating Meat Joy, she has written, was to take a stand against "fragmentation, depersonalization, and, in general, inertness, nonsensuousness—both in the theater and out." Schneemann intended the piece to be performed without clothes, but the authorities in Paris, and later in New York, would not allow that; the spectacle of men and women (including Schneemann as the central female character) in bathing suits rolling around with one another, drenched with grease and meat, was disturbing enough. It was, however, a success of a kind for Schneemann, who immediately rose to the forefront of experimental theater in the United States, if only for a short time, and managed by her notoriety to eke out a living on the fringe of the New York moneyed avant-garde.

The years 1965 to 1967 were highly productive for Schneemann (several major performances and the beginning of her experiments with film), and also marked the period of her greatest interest in audience participation. Watertight/Water Needle (1966), for example, incorporated an aerial structure of rope rigging on which performers climbed, dangled, and danced. The audience, placed directly below, could feel every risk the performers took, and the risk to themselves from falling bodies. Lighting, slideshows, and other projected elements had for several years been part of her performance works, but by 1967 her films could stand on their own. Viet Flakes (1965) (part of the antiwar intermedia piece Snows), a montage of news photos of the war merging, in the artist's words, with "the terrified expressions of people burning, dragged, drowning," was a searing indictment of murder taking the guise of politics. But her reputation as a filmmaker is based essentially on her "Autobiographical Trilogy"—Fuses (1967), Plumb Line (1971), and Kitch's Last Meal (1978).

Those films, dense, difficult, erotic, at times inpenetrably personal, combine all of Schneemann's varied approaches and subjects. "Ironically," wrote Scott MacDonald in 1980, "the most obvious pleasures of Schneemann's films—their unusual intimacy and emotional authenticity, their sensuous rhythms and gorgeous textures—frequently blind viewers to the considerable formal intricacy and ingenuity of her work." Fuses, a graphic exploration of Schneemann's sexual relationship with James Tenney, records not only the diversity of their lovemaking but also the ongoing experiments Schneemann performed on the film itself: she shot at various angles, exposures, and speeds, superimposed images, drew and painted on the film stock, and even baked parts of the film in her oven. The relationship between Schneemann and Tenney, noted MacDonald, reveals an equally balanced interaction between love and art. Plumb Line, which grew out of a period of illness and emotional problems for the artist, is more overtly political (though hardly less revolutionary); she builds image on image to retell in symbols the story of a failed affair with a dominating, insensitive man. The film, it is clear, furnished a way for Schneemann to clarify and overcome her own obsession and loss. Finally, Kitch's Last Meal is Schneemann's biography of her cat, Kitch, who stands in the film as both a symbol for the artist herself and for the mundane aspects of life rarely put into art. "Together," wrote MacDonald, those films, which were not originally conceived of as a trilogy, "demonstrate a consistent and coherent aesthetic challenge to those experiential realities which seem to limit—and thereby diminish—our potential for living authentic and realized lives." Nonetheless, those films have been completely passed over in current literature on the avant-garde biographical film.

The early 1970s saw Schneemann's concerns narrowing. She no longer sought to integrate her

audiences into her performances; instead viewers were excluded as the artist increasingly sought within herself, both literally and spiritually, for inspiration. *Up to and Including Her Limits* (1974–75) was a solo performance in which Schneemann, naked, swung on a rope harness, drawing on the gallery walls until she reached a trance state—"my only thought is to be an extension of the rope itself"—and then total exhaustion. Supplementing her performance were screenings of *Kitch's Last Meal* (then in progress), and an exploration of literary vulvic space: Schneemann, again naked, unrolled bit by bit a long scroll from her vagina and read from it a mixture of stories, aesthetic statements, and jokes. A complex of sculptural, photographic, and filmic images accompanied one recent performance, *Fresh Blood: A Dream Morphology* (1981), a storytelling event beginning with the recounting of a dream of an umbrella and leading to the presentation of a real umbrella as a symbol of femaleness. In Schneemann's ever more involved installations, wrote Sherry Buckberrough in 1981, viewers "activated mind and body to move through the space from image to reflection, from past to present, from thought to sensation. In doing so, one discovered that unique area between real life and dream life in which the merger of Schneemann's personal history, aesthetic sensibility, mythic understanding, and erotic fantasy became clear."

Schneemann has expressed scorn for artists who lead completely normal lives while claiming great creative breakthroughs; so much of her own life, including its most intimate moments, has been made public through her work and writings that it can hardly be called mundane. In 1972 she married the British conceptual artist Anthony McCall; in 1976 she began living with the filmmaker Bruce McPherson. Since the mid-1970s her work has definitely been out of fashion; overt feminism and body art were increasingly absent from the art scene in the 1980s. "The risks [and] innovations I undertook left me isolated," she has said; "attention is now directed to those coming after me into once taboo, forbidden, or restricted areas." And Schneemann's own way of working—she depends on a concretion of images and feelings to reach critical mass before venturing new works, most of which have at least the potential for emotional damage to her—has not helped her to maintain a constant presence in the art world. "If I have to go out and sell ideas," she told Ted Castle in 1983, "it can drive off that subtle, elusive power that's going to give me a whole work all at once."

EXHIBITIONS AND PERFORMANCES INCLUDE: Philadelphia Art Alliance 1958; Lawrence Col. Gal., Appleton, Wisc.

1959; "Labyrinths," Sidney, Ill. 1960; Glass Environment for Sounds and Music, Living Theater, NYC 1962; Chromelodeon, Newspaper Event, and Lateral Splay, Judson Dance Theater 1963; Meat Joy, Festival of Free Expression, Paris, London, and NYC 1964; Music Box Music, New School for Social Research, NYC 1964; Noise Bodies, Festival of the Avant-Garde, NYC 1965; Watertight/Water Needle, St. Mark's Church, NYC 1966; Snows, Martinique Theater, NYC 1967; Night Crawlers, Expo '67, Montreal 1967; Ordeals, Judson Church, NYC 1967; Snug Harbor, Avant-Garde Festival, Staten Island, NYC 1967; Object in Process, Something Else Gal., NYC 1968; Illinois Central Transposed, Intermedia '68, NYC 1968 and Media Palace, Boston 1969; "Expansions," Round House, London 1969; Thames Crawling, Underground Film Festival, London 1970; Happenings and Fluxus, Kolnischer Kunstverein, Cologne 1971; Film/Action Theater, Paradiso Theater, Amsterdam 1971; Icestrip, Ices Festival, London/Edinburgh 1972; Subtle Gardening/Cooking with Apes, Fylkingen Sound and Music Symposium, Stockholm 1973; Film Retrospective, California Univ. System, 1974; Up to and Including Her Limits, Univ. Art Mus., Berkeley, London Filmmaker's Cooperative, Art Meeting Place, London, Artists' Space, NYC, Anthology Film Archives, NYC, and The Kitchen 1974–76; "Interior Scroll," East Hampton, N.Y. and other various locations from 1975; Fresh Blood: A Dream Morphology and other works, Real Art Ways, Hartford, Conn. 1981; Max Hutchinson Gal., NYC 1982; "Blam! Pop! Minimalism and Performance 1958–1964," Whitney Mus. of American Art, NYC 1984.

COLLECTIONS INCLUDE: Mus. of Contemporary Art, Chicago; Max Hutchinson Gal., NYC; Gimpel Gal., NYC; Archives Jean Brown, Tyringham, Mass.; Erotica Archives Mus., Yugoslavia.

FILMS: Viet Flakes, 1965; Autobiographical Trilogy: Fuses, 1967, Plumb Line, 1971, Kitch's Last Meal, 1978.

BOOKS: Parts of a Body House Book, 1972 (unpublished); Cézanne, She Was a Great Painter, 1975; ABC—We Print Anything—In the Cards, 1977; More Than Meat Joy, 1979; Fresh Blood, c. 1980 (unpublished).

ABOUT: Benedikt, M. Theatre Experiment, 1967; Lippard, L. From the Center, Overlay 1983. Who's Who in American Art, 1989–90. *Periodicals*—Afterimage March 1980, Summer 1982; Artforum May 1976, November 1980, October 1983, Summer 1983, March 1984; Art in America March 1980, November 1982, October 1984; ARTnews December 1982; Arts Magazine October 1981, May 1983; Film Quarterly Fall 1980.

SCHOLDER, FRITZ (October 6, 1937–), American painter, born in Breckenridge, Minnesota. A thoughtful but intense man, Fritz

FRITZ SCHOLDER

Scholder has fought to preserve his artistic free-
dom. Although he is part German, English, and
French, as well as part Native American, critics
have sometimes accentuated his Indian heritage.
Known early in his career for his Indian subject
matter, Scholder refused to be stereotyped and
struggled to free himself from this idiom.
Scholder's current work is both universal and
metaphysical and derives much power from a
strong sense of color. He has had many imitators,
but among the many directions of contemporary
art, his own vision is the only one he follows.

Scholder started drawing as a child. "I was
very shy," he has said, "and I would sit in my
room and paint and draw. My parents and my
sisters were very supportive. My mother wanted
me to be a pharmacist, but realized that I was set
on doing what I wanted to do. To be an artist in
those days meant that I would become a teacher
of art, because that is what artists did. So I went
and got all my degrees thinking that I would
probably teach."

Scholder's father's position in the Bureau of
Indian Affairs necessitated many moves during
his childhood. It was in South Dakota that
Scholder was exposed to Oscar Howe, a Sioux In-
dian painter who had absorbed the cubist form
of the modernists. Scholder has stated, "It was in-
teresting for me to see somebody who was seri-
ous about being an artist. He let us paint in the
class room and that is what he (Howe) did!" His
family's next move took Scholder to Wisconsin,
where he graduated from high school and at-
tended Wisconsin State as a freshman. He de-
scribed the school as Bauhaus-influenced.

Another transfer of his father's brought young
Scholder to California, where he enrolled at Sac-
ramento City College, where he Scholder was a
student of Wayne Thiebaud. He reminisced:
"Thiebaud taught me a great deal. He was a
good teacher. We looked up to him. A lot of us
young starving artists were students of his. He
was a role model. A year later Thiebaud became
famous. I saw Warhol's soup cans and that
shocked me; I saw Thiebaud's pies and cakes, it
was the beginning of pop art. I continued with
pure painting. It was Thiebaud who in 1958
gave me my first one-man show."

In 1958 Scholder married Peggy Stephenson.
A year later his son, Fritz William Scholder VI,
was born. In 1965, the marriage ended in di-
vorce and the following year he married Ro-
mona Attenberger in Santa Fe.

In 1960 Scholder won first prize in the Tenth
Southwestern Painter's Festival. After receiving
a B.A. degree from Sacramento College in 1960,
Scholder attended the University of Arizona,
where he received an M.F.A. degree in 1964.
That year Scholder joined the faculty of the In-
stitute of American Indian Arts in Santa Fe. He
taught "Advanced Painting and Art History" un-
til 1969, when he resigned. Reminiscing about
that period in his life, he stated, "I love to teach,
but fortunately early on I realized that I have to
find time to paint; and as always there is not
enough time."

In 1965, influenced by the New Mexico land-
scape, Scholder started his "New Mexico" series,
a group of nonobjective paintings with horizon-
tal stripes. In 1966 Scholder began a short series
on "Butterflies" and the following year Scholder
launched his "Indian" series, which brought him
much critical acclaim and attention. He contin-
ued his "Indian" series into 1980.

On his arrival in Santa Fe Scholder said, "I
vowed that I would not paint the Indian. Non-
Indian artists had painted the subject as a noble
savage and the Indian painter had been caught
in a tourist-pleasing cliché. I retracted my vow
of 1964 for several reasons, one of these being a
teacher's frustration upon seeing students with
a good idea fall short of the solution. One winter
evening early in 1967 I decided to paint an Indi-
an. It soon became evident that it was time for
a new idiom in Indian painting."

Depicting Indians as individuals rather than
stereotypes made Scholder into a "wunderkind"
of American painting. Joshua C. Taylor from the
Smithsonian wrote, "In the past few years
Scholder has emerged as a major American
painter, not because he represents a particular
tendency in art or because he has founded a new
school of his own, but because of the vitality and

the personal intensity of his continuously surprising paintings and prints. Scholder's eye ranges freely beyond the modish peripheries of art." J. J. Brody, in his book *Indian Painters and White Patrons*, argued that Scholder revolutionized the form and especially the content of Indian art.

In 1972 the State Department sent Scholder's work and the artist to the capitals of Europe. The tour started in Bucharest, Rumania, continued on to Transylvania, where Scholder became interested in the Vampire legend, then went on to Germany. Inspired by the trip, Scholder painted his "Vampire" series in his Berlin hotel room.

In 1974 Scholder traveled to Basel, Switzerland where he had a one-man exhibition at the Basel V International Art Fair. A trip to Egypt followed, resulting in a series of paintings and lithographs depicting the Sphinx and mystic Egyptian rulers and personages. Fascinated by Egypt, Scholder returned in 1982 with a team of Egyptologists to see tombs not usually open to the public.

Scholder considers painting autobiographical and likes to paint in series. Often his series encompass mystical and magical personages, dreamers, androgynous lovers, and ancient Egyptian figures complete with sarcophagus. They are ambiguous apparitions, some Indian in origin, others generalized, wrapped in flowing garments.

In 1980 Scholder started "The American Portraits," followed by the "Dream" series depicting faceless lovers embracing. That was followed by a "Shaman" series, the Indian healer and priest through whom both good and evil can be convoked. "Monster Love" was a continuation of his "Dream" series. In explaining "Monster Love," Scholder has said, "I always felt that I cut short my "Dream" series; one day I got back to the studio and found that my 'Lovers' were becoming very aggressive; I thought 'Monster Love' was an interesting title." More recently, he has turned to sculpture using the same themes.

Scholder has always been sensitive to rituals and symbolism. As an artist, he has been aware of the need to reevaluate to avoid the status quo. He has explained, "I have never lived my life in an orthodox way. Most artists realize that there are so many possibilities and the need for introspection."

Scholder feels that everything in life is part of the process of painting. He loves to travel and describes himself as a bookaholic. "I am constantly reading. I go to concerts and see films and travel to New York just to see an exhibition. As far as going into the studio, I go an average of two or three times a week and I never know

when. I like to be very open. When I get too nervous I know it is time to get in there and start working. I like to produce. It's still very special to me to walk into the studio. I don't know whether it would be special if I did it every day. The act of painting, like most human activity, is at best paradoxical. Why should one indulge in an endeavor which supposedly reached its zenith in the Renaissance? Why does a painter paint? The answer is obvious. One paints because one must. I have always drawn and I will never stop. For me, there was never any question about what I would do and that I would be successful." He added, "You may call me an expressionist painter, because that is simply one who is interested in color and in expressing the subject."

Scholder works rapidly and with much energy. His Scottsdale studio stands separate from his walled adobe house. He works at a furious pace. He has made as many as sixteen monotypes in one night, a record even for him. He likes to work to rock music, which creates an artificial atmosphere of energy. His brush strokes are energetic, he uses drips, and his colors have become increasingly mystical and luminous. "You have to remember," he remarked, "that I started my professional career doing large expressionist paintings."

Talking about the relationship of the artist and the regional museums, Scholder became pensive: "It is not an easy one. I think there is a love-hate relationship because the museum has changed its personality. They have a power that they never had before, that is, working with living artists, which is very different from working with dead artists. They will often use artists as a pawn for plays of prestige. Most of the time when museums mount shows, I find that they really are not interested in the artist, but in putting on a blockbuster which will bring the so-called society people and wealthy people into their realm to give money for their projects."

Scholder feels that his time is so precious that he has confined his teaching activities to "artist in residence" status at institutions like Dartmouth, California universities, and the Oklahoma Summer Art Institute. His advice to young artists is to enter competitions so as to be seen and to travel. In 1983 he addressed the graduating class of the College of Fine Arts at Arizona State University: "Initially you must learn the rules so that you will know which ones to break. You will need to transcend the mundane. Yet the paradox in becoming a free individual is the need to be pragmatic in the beginning. One must determine how one is going to function in this society. It takes work and many hours to become good at anything. Hard work, knowledge,

imagination, timing and one's own uniqueness are the ingredients for public success. Private success consists of integrity to one's self and one's work and to developing a finesse for living."

Scholder is deeply involved in the creative process, which he views as both an intellectual and emotional process: "It is walking a tightrope between both; if it is just intellectual, it is going to be dead; if it is just emotional, then it's off the wall and you have no discipline. If you want to talk about the creative process, you truly want to use both approaches, but in an unconscious way. When you walk into the studio, you push everything to the back of your mind, because you can't be obvious; it has to be intuitive. You kind of open up. I get so involved in the process that when I stand back and look on what I have done, I am constantly surprised."

Part of the year Scholder lives in Scottsdale, Arizona, in an adobe house on a dirt road not far from town. The house is filled with books, art, and ritual objects that express Scholder's taste and collector's instincts. He brought back from Egypt a sarcophagus, a mummified cat's head, and ancient potions. A rhinoceros head looks down from the living room walls and a realistic female nude sculpture reclines in front of his desk. One of his prized possessions is a sketch of a buffalo head done by Picasso. Like a true collector, he bemoans running out of space. Scholder also owns a ranch in Galisteo, New Mexico, which he shares with his wife Romona. In 1982, he bought a loft in New York City which he sold in 1986.

Many honors have been accorded to Fritz Scholder. In 1983 he won the Governor's Award in the Visual Arts in New Mexico and was named "Honored Artist." He was made Societaire Salon D'Automne in Paris in 1984. Three institutions—Ripon College, Wisconsin; Concordia College, Minnesota; and the University of Arizona—have awarded him an honorary doctorate of fine arts. He was the subject of three movies on art made by the Public Broadcasting System. Scholder is proudest of having received in 1985 the Golden Plate Award for achievement.

Scholder dreams of taking a year off from teaching so that he can paint, but not show. There are many things he would like to explore, including the Carnival in Venice, the Cannes Film Festival, and holography. Recently he designed a line of jewelry, which is being handled by most of the major museums. "Art does not always have to be serious. I love jewelry, I love all kinds of things. A little-known fact is that I studied with Charles Loloma as a young person and did some nice jewelry. It just took too much time out from painting!"

Perhaps Patrick T. Houlihan, the director of the Southwest Museum, Los Angeles, summed it up best: "Scholder continues seeking new worlds around and within himself to explore his art. At its best, it is an art that results in an affecting presence about any subject that concerns him and which he believes should concern us."

EXHIBITIONS INCLUDE: Sacramento City Col., 1958; Artists' Cooperative Gal., Sacramento 1958, '59; E. B. Crocker Art Gal., Sacramento 1959, '72; Univ. of Arizona Mus. of Art, 1964, '85; Esther Bear Gal., Santa Barbara, Calif. 1971; Heard Mus., Phoenix 1971; The Jamison Gal., Santa Fe 1971, '72, '73, '74; Tally Richards Gal. of Contemporary Art, Taos 1971, '73, '75, '78, '80, '82; Maxwell Gal., San Francisco 1974; International Art Fair, Basel, Switzerland 1974; National Collection of Fine Arts, Smithsonian Instn. (two-man show), 1972; Cordier & Ekstrom, Inc., NYC 1972, '74, '76, '78; Hayden Gal., Massachusetts Inst. of Technology, Cambridge 1973; Hopkins Cntr., Dartmouth Col., Hanover, N.H. 1973; Marilyn Butler Fine Art, Scottsdale, Ariz. 1981, '84, '85, '86, '87; Rizzoli Gal., Chicago 1983; Tuscon Mus. of Art 1981; Fresno Art Mus. Cntr., Calif. 1976, 1981; Nimbus Gal., Dallas, Tex. 1985; ACA Gal., NYC 1982, '84; Tweed Mus. of Art, Univ. of Minnesota, Duluth 1980; Gerald Peters Gal., Dallas, Tex. 1987.

COLLECTIONS INCLUDE: Albright-Knox Art Gal., Buffalo, N.Y.; Art Gal. of Ontario, Toronto; Art Mus., Univ. of New Mexico, Albuquerque; Bibliotheque National, Paris; Brooklyn Museum, N.Y.; Cntr. Culturel Americain, Paris; Chicago Art Inst.; Cincinnati Art Mus.; Cleveland Mus. of Art; Corcoran Gal. of Art, Washington, D.C.; Dallas Mus. of Fine Arts; Denver Art Mus., Colo.; El Paso Mus. of Fine Arts, Tex.; Fogg Art Mus., Cambridge; Fort Worth Art Mus., Tex.; Heard Mus., Phoenix; High Mus. of Art, Atlanta; Hirshhorn Mus. and Sculpture Garden, Washington, D.C.; Hopkins Cntr., Dartmouth Col., Hanover, N. H.; Los Angeles County Mus.; Milwaukee Art Cntr., Wisconsin; Mus. of Art, Carnegie Inst., Pittsburgh; Mus. of Contemporary Art, Chicago; Mus.of Fine Arts, Boston; Mus. of Fine Arts, Houston, Tex.; MOMA, NYC; Mus. of New Mexico, Santa Fe; National Mus. of American Art, Smithsonian Inst., Washington, D.C.; Philadelphia Mus. of Art; Philbrook Art Mus., Tulsa, Okla.; Phoenix Art Mus.; Portland, Art Mus., Ore.; San Diego Fine Arts Gal., Calif.; San Francisco Mus. of Modern Art; Seattle Art Mus., Washington; Tucson Mus. of Art, Ariz.; Tweed Mus. of Art, Duluth, Minn.; Univ. of Arizona Mus. of Art, Tucson; Univ. Art Collections, Arizona State Univ., Tempe; Univ. Art Museum, Univ. of California, Berkeley; Walker Art Cntr., Minneapolis, Minn.; William Rockhill Nelson Gal., Kansas City, Mo.

ABOUT: Adams, Clinton. Fritz Scholder: Lithographs, Boston, New York Graphic Society, 1975; Breeskin, H. and R. Turk. Scholder/Indians, 1972; Brody, J. J. Indian Painters and White Patrons, 1970;' Current Biography, 1985; Monthan, Guy and Doris Monthan. Art and the Indian Individualists, 1975; Scholder, Fritz. Indian Kitsch: The Use and Misuse of Indian Images, 1979;

Taylor, Joshua C. et al. Fritz Scholder, 1982; Who's Who in American Art, 1989–90. *Periodicals*— American Indian Arts Magazine, Spring 1979; Artweek, November 15, 1975; New Yorker, June 17, 1969; Scottsdale Daily Progress June 20, 1980; Southwest Art, Fall 1978; Southwest Profile, February 1987.

FILMS: Fritz Scholder, PBS, 1976; Fritz Scholder: An American Portrait, PBS, 1983; The West of the Imagination, PBS, 1986.

***SCHÖNEBECK, EUGEN** (1936–), German painter, gave up painting at the age of thirty, but his five-year career in the first half of the 1960s marks a major episode in the history of postwar German art, one that anticipated the neo-expressionist currents of the 1970s and 1980s. In the opinion of the author and critic Robert Hughes, he is one of the few artists since World War II to have expanded the vocabulary of expressionist painting.

Schönebeck, like his near-contemporaries Georg Baselitz and Markus Lüpertz, was one of the "crossover" artists who made his way to West Berlin from the Eastern bloc. Born in Dresden, he originally went to East Berlin to study wall painting in 1954, but a year later he decided to cross over and enrolled in West Berlin's Hochschule für Bildende Künste. At that time, only a decade after the end of Nazi rule, West Berlin, like most of Germany, offered a rather barren cultural landscape that was enlivened mainly by importations from France. Schönebeck, who had been trained in socialist realism in the East, became a student of the colorists Hans Jaehnisch and Hans Kuhn and was duly caught up in the prevailing trends of tachism and art informel.

By the time he finished his studies in 1961, his work was still basically in the abstract mode of art informel, but he was looking to go beyond that new establishment, and to some extent, looking to shock its complacent patrons. That November, he and his friend Baselitz, who was still a student at the Hochschule, organized an exhibition of their work, which they called "Pandämonium." The Pandemonium Manifesto that they issued to mark the event was full of violent imagery largely inspired by Isidore Ducasse, the Count of Lautréamont (whose sadistic tales had already exerted their fascination on the surrealists) and evoking the likes of "orchestrations of the flatulent, warty, mushy, jelly-fish beings, bodily members, braided erectile tissue, mouldy dought, gristly growths in a desert landscape." Their basic idea was that a new order would be born of the chaos of pandemonium and that the artist was to be the vehicle of its expression—a "juvenile cry," as the critic Johannes Grachnang

later described it, that reflected "the pain of living in this time and in these conditions."

According to Baselitz, the immediate impact of their gesture was quite limited—no one came to the exhibition, and their pronouncements, considered "too loud, too authoritarian" (and too fascistic by some), attracted little support. Nonetheless, they staged a "Pandämonium II" exhibit the following spring, accompanied by another manifesto (now alluding to Artaud as well as Lautréamont), and a certain momentum began to catch on. In his own work, Schönebeck actually began to give visual form to the kind of tortured imagery verbalized in the Pandemonium manifestos: in paintings like *Der Gehängte* (The Hanged), *Der Gefolterte* (The Tortured), *Der Köder* (The Bait), abstract configurations gave way to battered human figures depicted in somber tones against animated backgrounds. By 1963 the figures had become increasingly defined and the colors much brighter. In some cases—*Figur mit Vogel* (Figure with Bird), for example—the effect was poetic; more often, as in *Dresdener Tiere* (Dresden Beasts) or *Kreuzigung* (Crucifixion), the figures were grotesquely deformed. The same development is even more apparent in the drawings Schönebeck made during the early 1960s, where visually charged but essentially formless configurations, mainly in brush and ink, evolve into human figures mutilated by the violence of brush and penstrokes and culminate in a series of caricatural beings with scaly bodies, oversized heads (sometimes those of elephants), and variously distorted sexual organs.

With the increasing recognition of their work, Schönebeck and Baselitz grew apart, and by 1964 their friendship had come to an end. From that point on, Schönebeck moved in a very different direction, abandoning the theme of tortured individuals for a more socially conscious interrogation of the human condition. In the process, he turned again to the socialist realist tradition he had studied before going to West Berlin and attempted to reintegrate it with Western currents of modern art. In fact, his ideal of socialist realism was quite removed from the academic naturalism taught in East Germany, and the models he chose to follow included Léger, the Soviet painter Alexandre Deineka, and the Mexican muralists. The first expressions of his new synthesis were a series of monumental figures—*der wahre Mensch* (The True Man), *Männerkopf* (Man's Head), and several simply called *Bildnis* (Portrait), all 1964 —that filled the whole canvas with their physical presence and potential energy, but which were visually silenced by bars crudely painted over their mouths. In a second series of eight paintings dat-

ing from 1965–66, Schönebeck shifted from representations of the oppressed to portraits of exemplary figures with whom he hoped his viewers would identify—political leaders like Lenin, Trotsky, and Mao; the writers Mayakovsky and Pasternak; the mural painter Siquieros. Monumental in size and conception, those paintings were the result of a laborious process of refining detailed studies into an elemental whole. *Der Rotarmist* (The Red Army Soldier, 1965), for example, showing a military figure with a gun in his upraised hand, easily recalls revolutionary posters from the Soviet Union or China, but at the same time there is a subtle play of color and planes that adds a pictorial dimension to the poster-art play of form and contour. Likewise, *Mayakowski* (1965) is more than just a stylized hero portrait: shown against a vibrant pink ground, the towering figure looms out of one side of the canvas but uneasily eyes the void left on the other.

Ultimately, Schönebeck decided that the task he had set for himself was futile and that art was incapable of changing social realities. As a result, he decided to stop painting. Already somewhat withdrawn and prone to depression, he shut himself off from the art scene and rebuffed most efforts to study his existing work (which consisted of some twenty-five to twenty-seven paintings and about five hundred drawings). In the 1970s he was totally eclipsed by Baselitz, to the extent that his name was often omitted from accounts of the Pandemonium exhibitions and manifestos. But in the 1980s he began to attract attention again as critics realized how talented he had been (much more so than Baselitz, according to some) and the extent to which his work had anticipated later developments. "In front of these paintings and drawings," wrote Christos Joachimedes on the occasion of a 1981 exhibition that included some of Schönebeck's work, "it's hard to convince yourself that they date from the mid-1960s, a time when no artist in Germany—with the exception of Gerhard Richter in Düsseldorf, and in a totally different context—could get anything at all from the exploration of a realist visual language. It's hard to imagine that these canvases saw the day before the student revolts of the 1960s and before Europe was swept by the wave of photo-realism." At the time of that exhibit, according to Joachimedes, Schönebeck, still living in Berlin, expressed interest in resuming that work along the lines of *Der Rotarmist,* and he indicated also that a good number of the canvases he painted in the 1960s were incomplete and in need of reworking. Although no new work was forthcoming, he participated in two major retrospectives of postwar German art in 1985, and the follow-

ing year he showed fifty previously unexhibited drawings from the early 1960s, again prompting critics to hail him as "an artist ahead of his time."

EXHIBITIONS INCLUDE: Pandämonium I and II, Berlin 1961–62 (with Georg Baselitz) Hilton-Colonnade Gal., Berlin 1962; Gal. Benjamin Katz, Berlin 1965; Internationaler Informations-and-Kunstmarkt, Düsseldorf 1973; Gal. Abis, Berlin 1973; Gal. Silvia Menzel, Berlin 1986. GROUP EXHIBITIONS INCLUDE: Grosse Berliner Kunstausstellung, Berlin 1965; "Das Porträt," Haus der Kunst, Munich 1966; Gal. Motte, Milan and Paris 1967; "Junge Berliner Maler," Goethe Inst., Athens 1967; Gal. Hansen, Copenhagen 1967; Ströher Collection, Düsseldorf and Bern 1968; "Zeichnungen 2," Städtische Mus. Leverkusen, Moirsbroich 1972; "14 x 14," Staatliche Kunsthalle, Baden-Baden 1973; Gal. Abis, Berlin 1973, '74; Böttcherstrasse, Bremen 1974; Berlin Biennale, 1974; Produzentengal. Hacker, Berlin 1974; Goethe Inst., Rio de Janeiro 1975; "Eight from Berlin," Edinburgh, Berlin, Cologne 1975; Documenta 6, Kassel 1977; Akademie der Künste, Berlin 1978; "Der gekrümmte Horizont," Berlin 1978; "Geist der Avantgarde—Zeichen des Glaubens," Berlin 1980; "Peinture en Allemagne," Palais des Beaux-Arts, Brussels 1981; "German Drawings of the '60s," Yale Univ. Art Gal., New Haven and Art Gal. of Toronto, 1982; "German Art in the Twentieth Century," Royal Academy, London 1985; "1945–1985: Kunst in der Bundesrepublik Deutschland," Nationalgal. Berlin 1985.

COLLECTIONS INCLUDE: Bayerische Staatsgemäldesammlungen, Munich; Hessisches Landesmus., Darmstadt (Sammlung Ströher).

ABOUT: "Baselitz Schilderijen/Paintings 1960–1983" (cat.), Whitechapel Gallery, London, 1983; Dietrich-Boorsch, D. "German Drawings of the '60s" (cat.), Yale University Art Gallery, 1982; "Eugen Schönebeck" (cat.), Gallery Abis, Berlin, 1973; "Eugen Schönebeck: Zeichnungen" (cat.), Gallery Silvia Menzel, 1986; "14 x 14" (cat.), Staatliche Kunsthalle, Baden-Baden, 1973; Joachimides, C., et al. "German Art in the Twentieth Century" (cat.), Royal Academy, London, 1985; "Peinture en Allemagne" (cat.), Palais des Beaux-Arts, Brussels, 1981; "1945–1985, Kunst in der Bundesrepublik Deutschland" (cat.), Nationalgalerie, Berlin, 1985. *Periodicals*—Artforum March 1987; Flash Art February–March 1982; Print Collectors' Newletter May–June 1982.

SCOTT, TIM (April 18, 1937–), British abstract sculptor, was born in Richmond, Surrey. He attended private school in Switzerland before spending 1954 at the Turnbridge Wells School of Art in Kent. From 1954 to 1959 he was a student in London simultaneously at the Architectural Association and, under Anthony Caro, the St. Martin's School of Art. In 1959–61 he studied in Paris at the Atelier Le Corbusier-Wogenscky, where he prepared a thesis on the

Villa Savoie. After a year practicing as an architect in the London firm of Fry, Drew and Partners, he returned to St. Martin's as lecturer, where he is currently head of the school's department of sculpture.

Anthony Caro's charismatic influence permeated that department during the 1950s, even though his best-known works—the painted, geometric, horizontally oriented steel constructions—date from 1959, the year of his discovery in the United States of the work of David Smith. In its cool abstraction, use of color, and horizontal development, much of Scott's work from the 1960s owes an obvious debt to Caro, but he transformed and particularized the master's influence into something entirely his own. Kenworth Moffett called Scott "the only sculptor to come directly out of the Caro school to achieve original work equal in quality to Caro's own. . . . He is the first to make mixed materials and plastic yield modern sculptural masterworks."

Scott's earliest works are clean, bright, colorful, and very large. At his first individual exhibition, in 1966, the only four pieces shown seemed to crowd the very considerable space of London's Waddington Galleries. *January the First* (1964), for example, which is eight by five feet in floor space and all in bright blue, is a densely packed juxtaposition of triangular pieces of flat acrylic sheets with stacked, uniform, fiberglass spheres. *Quantic of Sakkara* (1965) is a fourteen-by-eight-foot formation of interesting planes and linear shapes in tubular steel, plywood, and sheet aluminum. A common critical reaction to that exhibition was that the artist seemed to have radically altered one of sculpture's primary values—texture, tactility, the way in which a work's surface reveals its mass, density, and character—by means of color. Another feature, one which has become almost a constant in all of Scott's work, was also evident at that early show: the art has an overt multidimensionality, which demands viewing from several vantage points. "Nobody," wrote John Russell, "can take a big piece of his and say, 'That's the front,' or 'From here you can really see what he's getting at.' Each piece has a hundred identities, and the color works as a factor of multiplication."

Color, to Scott, was an essential part of the idea of abstraction in sculpture. "The use of color surfaces in sculpture," he wrote in 1968, "is an expression of the continuing awareness of surface as texture, a tradition reaching directly to us through Rodin and Brancusi. The fact of the actual textural variety of surface application of color, both in the application of pigments and finishes, and in the use of self-colored material, furthers this. Surface as color is an extension from the confines of the 'natural' state of a material, traditionally dominant, of means by which the density and mass of a volume may be altered. Surface is the vocabulary, the means by which sculpture is 'read,' and what takes place is a broadening, a reinvention of that vocabulary. The gamut of color used in relation to shape is descriptive of ranges of mood and intensity, and in this respect bears much resemblance to the use of the term in musical definition." Color also possessed, for Scott, the quality of altering the viewer's perception of volumetric space: "A dominant assumption of sculpture in the past has been that of volume as constant throughout its mass. That is to say of material as a complete expression of constant section. With the exteriorization of mass by surface expression through color, definition by section becomes immediately of an ambiguous nature, thus extending volumetric space *into* as well as *around* the work." Finally, unlike in the sculpture of Caro, the color in Scott's works is usually inherent in the materials rather than applied.

Scott's great series "Bird in Arras" (1967–69), is the artistic realization of those theories. The seven pieces have in common their materials: flat, rectangular, variously colored acrylic sheets screwed to variously colored tubular steel. The properties of both materials—the steel's strength, linearity, flexibility, and opacity; the plastic's rigidity, flatness, and combined reflectiveness and semitransparency—are made to contrast with and reinforce each other. All the pieces are large, ranging from ten to twenty-seven feet in length. In addition to color, the series is concerned with line, weightlessness, and elevation as properties in themselves; the volumetric concerns of Scott's earlier work are not strongly in evidence. In *Bird in Arras No. IV*, generally considered to be among the series' finest pieces, volume is eliminated altogether. Between two irregular tubular arches several acrylic sheets are rigidly suspended, but seem to be swinging in midair, setting up a complex interplay of line and color among the sheets and between them and the light-colored tubing. *Bird in Arras No. VII* completely reverses the sculptural idea of strong tubes supporting airy plastic: here several of the transparent acrylic sheets touch the ground at the corners, creating the illusion that color itself has substance, and is supporting the mass of tubing and plastic. This challenging and original series, unfortunately, has been united for public exhibition only once, in 1973 at Boston's Museum of Fine Arts.

Scott surprised many by avoiding color in much of his work of the 1970s. The "Counterpoint" series (1970–73), for example, combined flat and tubular unpainted steel and

aluminum with thick slabs of clear Plexiglas. Most of the twenty pieces in the series confirm the multidimensional aspect of Scott's work: the Plexiglas's translucent edges form constantly varying patterns of angles, lines, and refractions as the viewer proceeds around each work. More than one critic remarked that the sculptor seemed to have hit upon a way to force changes in the spectator's position, and that the clear window-shaped pieces of Plexiglas acted metaphorically as finders or framers of views.

The artist's work of the mid-1970s offered an even greater surprise. Abandoning completely plastic and its generous effects on light and texture, Scott turned to making large rusting steel structures and to the technique of welding— neither of which had ever been part of his artistic repertory. The fundamentally tripodal shapes of the "Nataraja" series seemed to some critics frankly earthbound, compared with the soaring defiance of gravity evident in the "Bird in Arras" series. The newer works were assembled, according to Fenella Crichton, so that "the individual parts perform a perilous balancing act. Crudely chopped-off lengths of square and cylindrical piping are welded together at curious angles, so that the steady upward progression of the parts is constantly undermined by a gravitational pull in the opposite direction." Crichton concluded, however, by praising these sculptures' "energetic ambiguity": "Scott is using steel as if it had the lightness of plastics." During a summer in residence at Bennington College, Vermont, in 1976, Scott produced a tremendous outpouring of sculpture, nearly all of it in his newly chosen material—cold-pressed steel scrap—in such geometric units as cylinders, spheres, cubes, wedges, and beams. The works seemed to share little of the brutalism usually associated with this material; in his hands it seemed to lose its gravity and weight and to convey plasticity and even softness.

Scott was appointed Arts Council sculptor in residence for 1978–79 at the Polytechnic of North London, where his task was to produce a large-scale piece of work for the college to put on permanent exhibition. As studies for this commission he produced "Alingana," a series made entirely of densely massed pieces of oiled steel and forged steel, which looked, again, quite unlike anything he had ever done. He seemed deliberately to select components with the least potential grace—heavy tubular sections and great chunky disks—then proceeded to weld them into a series of massively precarious agglomerations of metal, full of rhythm and movement. One critic saw Scott by means of this series completely liberating himself from Caro's shadow and establishing his linkage to the long modernist tradition of cubist and postcubist sculpture.

Scott married Malkanthi Wirecoon in 1958. They have five children and live in west central London.

EXHIBITIONS INCLUDE: Waddington Gals., London 1966, '69, '73, '75, '77; Whitechapel Art Gal., London 1967; Mus. of Modern Art, Oxford 1969; Lawrence Rubin Gal., NYC 1969, '71; Tate Gal., London 1971; Mus. of Fine Arts, Boston 1973; André Emmerich Gal., NYC 1974; Tibor de Nagy Gal., NYC 1977; Knoedler Gal., London 1979, '80. GROUP EXHIBITIONS INCLUDE: "Young Contemporaries," RBA Gal., London 1958–59; "26 Young Sculptors," ICA, London 1961; "New Generation," Whitechapel Art Gal., London 1965; "Primary Structures," Jewish Mus., NYC 1966; "20th-Century British Sculpture," Whitechapel Art Gal., London 1981.

ABOUT: *Periodicals*—Art and Artists August 1971; Artforum June 1971; Art in America May 1973, May 1975; Art International February 1970, October 1973, September 1975, January 1979, April 1979; ARTnews May 1966, Summer 1969, Summer 1971, May 1973, February 1975, March 1977; Arts Magazine May 1969, Summer 1969, Summer 1971, Summer 1973, November 1974, February 1975; Studio International March 1966, January 1969, January 1970, June 1973, February 1974.

SERRA, RICHARD (ANTHONY) (November 2, 1939–), American sculptor, was born in the Excelsior district of San Francisco, the second of three sons of Tony Serra, a factory worker and an emigrant from Mallorca, and Gladys Serra, who was of Russian-Jewish extraction. When he was four his family moved to the Avenues, a district in the western part of the city bordering the beach and Golden Gate Park. There the Serras became close friends with the Di Suvero family, whose son Mark, Serra has recalled, was always making sculptures as a child, while Serra himself was always painting and drawing. Serra was encouraged in his art by both parents, who often took him to museums and discussed his drawings with him nearly every evening. His mother, in particular, was, according to Serra in a 1984 interview in *ARTnews*, "more than a Sunday painter. It was something she enjoyed, something she *did*." She made sure that her gifted son became acquainted with the rudiments of art history, "so that I could identify paintings as well as most kids could identify cars."

After being educated in the San Francisco public school system, Serra attended the University of California at Berkeley, transferring after a year to the Santa Barbara campus. He was an English major, but took many art courses, find-

RICHARD SERRA

ing the academic subject "totally interesting and totally private." He received his bachelor's degree in 1961.

Intending to do graduate work in English, he also applied on a whim to Yale University's School of Art and Architecture, sending with his application a portfolio of a dozen paintings and drawings. He was accepted; the art department felt, as they said in their letter of acceptance to him, that they thought they could teach him something. In New Haven he worked with Josef Albers, then just beginning his retirement from the chairmanship of the school's department of design, on his epochal book *The Interaction of Color* (1963). In his last year he taught as a docent and also studied under Robert Rauschenberg, Frank Stella, and Philip Guston. "When such diverse artists came to criticize your work," Stella remarked in the *ARTnews* interview, "all with a dogmatic opinion of what was right and what was wrong, within the same week two people might tell you things that were totally contradictory. This made you realize that they were as vulnerable as you were, that we were all on the same level. It destroyed the myth of the genius artist and threw you back on your own work, which was a very healthy thing. It made the transition from being a student to being a working artist much easier. We were already away from the school, in a private building, and most of us were heading to New York anyway."

Serra took his master's degree in fine arts from Yale in 1964, winning a traveling fellowship for a year's study in Paris. He shared a studio there with the artist Nancy Graves, to whom he was married at the time. He also met his lifelong friend Philip Glass, then in Paris on a Fulbright grant to study with Nadia Boulanger. "In the evenings," Serra told Alfred Pacquement in 1983, "we'd go to La Coupole and often Giacometti would be there. One day he showed us his studio. We went to see Beckett's plays, Buster Keaton's films, and John Cage's Silence. . . . But for me, then a painter, the essential experience of that stay in Paris was to discover Brancusi: that produced my transition to sculpture. Before coming to Paris I'd had no idea of his existence, no more than that of Giacometti, no more than sculpture in general. What interested me in Brancusi's work was how he was able to imagine a volume with a line as its edge—in sum, the importance of drawing in sculpture."

The year 1965–66 was spent in Florence on a Fulbright fellowship. Serra traveled a good deal—to Spain and North Africa, even walking from Athens to Istanbul. In May 1966 he had his first one-man show, "Animal Habitats," at Rome's Galleria La Salita. He returned to the United States in the autumn of 1966, eager to begin to make a mark on the art world, which included Carl Andre, Liza Bear, Eva Hesse, Nancy Holt, Jasper Johns, Joan Jonas, Donald Judd, Philip Leider, Bruce Nauman, Steve Reich, Robert Smithson, and Michael Snow. He became a client of Leo Castelli, indisputably the leading avant-garde dealer of the time.

The art shown in Serra's earliest American exhibitions demonstrated many of the qualities for which his work has become known: hard, "unartistic" materials; resolute expressionlessness; the repetition of simple forms; and an unwillingness to concede anything to viewers' comfortable preconceptions. *Belts* (1967) consisted of cut strips of vulcanized rubber, hung in jumbled masses in a straight line from eleven hooks along a painted brick wall: they looked vaguely like horse harnesses, except that the first mass had blue neon tubing arranged haphazardly among the rubber strips. Serra produced a few other works in rubber during 1967 before turning to lead as a primary medium. *Splashing* (1968) and *Casting* (1969) are multiple strips of cast lead which was thrown or poured while in a molten state into the corners of rooms. In *Tearing Lead from 1:00 to 1:47* (1969), a lead sheet has been torn by hand into a square, with the tearings loosely arranged alongside. *Thirty-five Feet of Lead Rolled Up* (1968) is a twenty-four-inch cylinder of rolled lead sheeting, displayed lying on its side on the floor. Such early efforts by the artist are usually discussed in terms of the minimalist aesthetic prevalent at the time; they are, in the well-known terms of the negative definition of minimalism,

"nonmetaphorical, nondepictive, and non-illusionistic." Thorough investigation of materials was also a part of the aesthetic; after a short time with lead, Serra switched to rolled lead antimony and steel. By 1970 he was working almost exclusively in steel, from then on the essential material of his entire career.

Serra's association with steel dates from his teenage years. He worked in a U.S. Steel factory in California at the age of seventeen, and later, while in college, in order to help defray his educational expenses, he worked summers for, variously, Kaiser Steel and Bethlehem Steel. He says he chose the steel mill jobs for the "quick money" they provided—"the most you could get paid for slave labor." He did not immediately begin to work in steel at the outset of his career because he felt he "knew too much about" the medium, but at the same time he sensed that the artists who used it extensively didn't really grasp its full potential. He has been "working in and out of" steel mills as an artist ever since the early 1970s, and has come to appreciate the predicament of the workers whose lives revolve around them: with his wife, Clara Weyergraf, he made a twenty-nine minute film, *Steelmill/Stahlwerk* (1979), which effectively conveys the entrapment of the workers amid their gigantic and intimidating rolling machines and blast furnaces.

A sense of "imminent imbalance," in the artist's phrase, was first evident in his works of the late 1960s and early 1970s. In 1969, working in Bethlehem Steel's Skullcracker Yard in Pomona, California under commission from the Los Angeles County Museum, Serra created *Skullcracker Series: Stacked Steel Slabs*, fifteen hot-rolled steel slabs, each of them eight by ten feet and weighing thousands of pounds, stacked in a pile almost to the point of tipping. In *One Ton Prop (House of Cards)* of the same year, four plates of lead antimony, each four feet square, are balanced seemingly loosely against each other to make a cube. Even in a photograph, the piece looks dangerous to approach or to touch. Serra apparently relishes the ability of his art to convey such powerful feelings of danger; they have not diminished as the works have grown ever more enormous. *Sight Point* (1970) consists of three plates of Cor-Ten steel, each ten by forty feet, balanced against one another to form a huge vertical construct. The viewer is invited (or dared) to walk into the interior of the sculpture, where far overhead a triangular patch of sky can be seen. Similar in feeling is *Terminal* (1977), four trapezoidal Cor-Ten steel plates, each forty-one feet high, which were set up on a traffic island near the central railroad station in the West German city of Bochum.

The public furor that greeted the installation of *Terminal* gave Serra his first taste of the kind of controversy that his artistic career has strongly attracted ever since. Many residents of Bochum hated the work and wrote impassioned letters to the newspapers complaining about its ugliness and about the waste of public money, and threatening, most significantly, that the Social Democratic Party, which controlled the city council responsible for buying and installing the sculpture, would never be reelected. The opposition Christian Democratic Union, during the ensuing election campaign, put up posters featuring *Terminal* with the legend "This will never happen again—CDU for Bochum." The CDU, said Serra in a 1980 interview with Douglas Crimp in *Arts* magazine, "handed out leaflets which said that if the sculpture had been made of stainless steel it might be acceptable, but this rusty monster in front of the depot was an insult to all the workers from the nearby steelmills."

Other controversies followed in quick succession. In 1978 Serra angrily resigned from an extremely important public commission, awarded by the Pennsylvania Avenue Development Corporation in Washington, D.C., to collaborate with the architect Robert Venturi on the development of a plaza between the White House and the Treasury Building. The artist originally envisioned one of his vertically oriented sculptures for the site, but Venturi wanted instead two pylons which would frame the Treasury Building, a notion Serra dismissed as "reactionary and rhetorical." He told Crimp in 1980 that Venturi's architectural vocabulary was similar to that of Albert Speer, Hitler's chief architect: "Two monumental structures framing the Treasury Building relate to a long tradition of urban design, from Babylonia to Nazi Germany. . . . I wasn't interested in framing the Treasury Building. I wanted the plaza to be inclined and to build a piece that would be perpendicular to that incline and thus off axis from the surrounding buildings. . . . I was told by the head of the PADC that if it came to a decision between an architect and an artist, they would always defer to the architect. . . . The PADC threatened me with the statement, 'If you don't comply with Venturi's scheme, you'll never get another commission.'"

In the late 1970s Serra became involved in a lengthy controversy at the Centre Beaubourg in Paris over a scheme to add one of his sculptures to a space resulting from the alteration of the original design for the famous building by the architects Renzo Piano and Richard Rogers. Serra proposed a curved, rolled-steel piece, 120 feet long and nine feet high. After at least half a dozen trips to France, Serra finally saw his plans for

the piece approved by the cumbersome French bureaucracy. "I then went to southern France," he told Crimp, "to order the steel and have the plates rolled. In the meantime, . . . Piano saw a model for the sculpture and told Pontus Hulten, the director of the museum, that he wouldn't have this work in his building. Pontus Hulten asked me to propose another work, explaining that in this instance we were all just civil servants. I refused. . . . [T]he nature of my sculpture would have completely altered the space [provided]. Richard Rogers, the English architect, said that people wouldn't be able to walk into the doorway, to which I replied, 'You mean they'll have to walk around the sculpture?'"

Controversy reached a crescendo in Serra's career during the 1980s in New York City, supposedly one of the most amenable places in the world for public sculpture. *TWU* (1980), a thirty-six-foot-high construct of three Cor-Ten steel plates, was set on a traffic island in SoHo, the lower Manhattan artists' enclave. That year *St. John's Rotary Arc*, 200 feet long and twelve feet high, was installed near the exit from the Holland Tunnel in lower Manhattan. Both, reportedly, were much disliked by the public; with regard to the former, an amateur art critic wrote to the *Village Voice* in November 1981, describing it as "enormous I-beams welded together at an angle and vertically planted in the concrete. Its scale was so enormous that the neighboring buildings on both sides of the street were dwarfed and the whole area suddenly possessed the warmth of a seconds yard at a steel mill. . . . [A]nother artist tied several pairs of old shoes and sneakers together and hurled them to the top of the gargantuan monument where they dangled on either side, cheerfully negating the overbearing monumentality of the piece."

No controversial event in Serra's career, however, can begin to compare for sheer intensity to the hysterical reception accorded *Tilted Arc* (1981), a Cor-Ten steel work twelve feet high, 120 feet long, weighing seventy-three tons, and tilting one foot off the vertical axis, that was installed under the terms of a commission awarded Serra in 1979 by the General Services Administration. The sculpture bisects the architecturally grim plaza in front of the equally drab Jacob Javits Federal Building in downtown Manhattan. According to the artist, the effect of the work was entirely salutary; it "transformed the context . . . of the plaza from one of decoration to one of sculpture." Those who saw it every day did not agree: soon 1,300 federal workers signed a petition demanding that it be removed from their lunchtime oasis. Even Peter Schjeldahl, the *Village Voice* critic most receptive to experi-

mental art, called *Tilted Arc* a failure and a public outrage, "so mistaken, so wrong, *so bad*." Serra's rejoinder, in which he declared that the work described "a truly lyrical line," satisfied no one, and the controversy festered for the next four years. Finally, in March 1985, the GSA convened a public hearing with the intention of resolving once and for all the issue of the sculpture.

Fifty-six people testified against the siting of the work, insisting on its relocation, and 118 people defended it, among them former senator Javits, Senator Howard Metzenbaum, William Rubin, sculpture curator of the Museum of Modern Art, the artist Frank Stella, and Serra's old friend Philip Glass. Serra testified at length about the piece: "As you cross the plaza on the concave side," he said, "the sweep of the arc creates an amphitheaterlike condition. This newly created concave volume has a silent amplitude which magnifies your awareness of yourself and the sculptural field of space. The concavity of the topological curve allows one to understand the sweep of the entire plaza. However, upon walking around the convexity at the ends, the curve appears to be infinite. Understanding the simple distinction between a plane leaning toward you that is curved and concave, and a plane leaning away from you that is curved and convex, is crucial. This establishes new meanings among things."

Evidently not appreciating such distinctions, the acting head of the GSA, Dwight Ink, decided two months later that *Tilted Arc* would have to be moved to another site. The artist's response was utterly furious: the sculpture was site-specific—"to relocate the work is to destroy it," he said. "It was built specifically for that place." He sued the GSA for $30 million in punitive damages. "I was told," he said in an interview with *People* magazine, "that this was a binding contract with the government, and I believed them. . . . I have the weight of the government—not only their deception but their heel—on my head. . . . It is strange that in 1985 the government would have a policy of art extermination." Finally, he announced that he and his wife would go into exile if the sculpture were moved: "I can't stay in a country that commissions my work and then wantonly and willfully destroys it." Four years later the work, as well as Serra and his wife, were still in place in Manhattan.

Yet the artist has persistently refused to come to terms with the hostility so plainly aroused by his work. He has always expressed bemused surprise when asked about the aggressiveness of his huge, rusty steel walls that literally stop people in their tracks and occasion great outrage. "I

don't think it is the function of art to be pleasing," he has said. He also quibbles about his critics' use of words: "When people see my large-scale works in public places, they call them monumental, without ever thinking about what the term means. Within the history of public sculpture, they are small to medium in size. Does *TWU* overwhelm or dominate that space? When we look at these pieces, are we asked to give any credence to the notion of a monument? They do not relate to the history of monuments. They do not memorialize anything. They relate to sculpture and nothing more. They do not cry out to be called monuments. A steel curve is not a monument." His critics rejoin that such statements simply reflect Serra's arrogance.

In August 1985 the St. Louis Board of Aldermen decided to remove *Twain* (1982), an irregular polygon made up of eight forty- to fifty-foot-long plates of Cor-Ten steel, which had been sited on a vacant lot downtown, a few blocks from Eero Saarinen's Jefferson Memorial Arch, one of the best-known pieces of public sculpture in America. *Clara-Clara* (1983), originally destined for Paris's Centre Beaubourg to coincide with a retrospective exhibition of Serra's work, was found to be too large for the site, so was temporarily installed in the Tuileries, just inside the Place de la Concorde entrance, aligned along the famous axis with the Obélisque and the arcs de Triomphe and de la Carrousel in the distance. Serra was not heard this time to utter any complaints about his art's framing public monuments, and the French press was predictably delighted at this "homage" paid by a foreign modern artist to the City of Light.

Serra's works have featured in some spectacular accidents involving their installation or dismantling. In 1971 a worker helping to install a two-piece sculpture at the Walker Art Center in Minneapolis was killed when one of the steel plates fell on him. In a subsequent lawsuit, the jury absolved Serra and the museum of any blame in the accident. In October 1988 two workers were injured, one of them seriously, while moving a sixteen-ton piece, *Reading Cones,* from the Leo Castelli Gallery in New York. The accident also caused severe structural damage to the historic building housing the gallery.

In addition to *Steelmill/Stahlwerk,* Serra has made the following short films: *Hand Catching Lead* (1968); *Hands Scraping* (1968); *Frame* (1969); *Tina Turning* (1968); *Vail* (1971 with Joan Jonas); *Paul Revere* (1971); *Mix Match Their Courage* (1974); and *Railroad Turnbridge* (1976). In 1970 he helped the late Robert Smithson in the construction of the famous *Spiral Jetty* in Utah's Great Salt Lake.

Serra has won a Guggenheim grant (1970), the Skowhegan Sculpture award (1976), the Kaiser-ring award for sculpture from Goslar, West Germany (1981), a fellowship from the Bazalel Academy in Jerusalem (1983), the Carnegie prize (shared with Anselm Kiefer, 1985), and was made a chevalier des arts et des lettres by the French government. Such honors not withstanding, the blue-eyed, curly-haired artist identifies primarily with the working class which he expresses by favoring workman's clothes that are well suited to his sturdy frame.

EXHIBITIONS INCLUDE: Gal. La Salita, Rome 1966; Gal. Ricke, Cologne 1968, '70, '73; Gal. Lambert, Milan 1969; Castelli Warehouse, NYC 1969; Joseph Helman Gal., St. Louis 1970; Univ. of California, San Diego 1970; Pasadena Art Mus., Calif. 1970; Ace Gal., Los Angeles 1970, '72, '73, '74, '75, '76, '78; Videogal. Gerry Schum, Düsseldorf 1972; Gal. Toselli, Milan 1973; Castelli Graphics, NYC 1973, '81; School of Visual Arts, NYC 1974; Leo Castelli Gal., NYC 1974, '81, '82. '84, '86, '87, '88; Portland Cntr. for the Visual Arts, Oregon 1975; Gal. Daniel Templon, Paris 1977, '84; Gal. Bochum, West Germany 1977, '83, '86; Stedelijk Mus., Amsterdam 1977; Künsthalle, Tübingen, West Germany 1978; Staatlich Kunsthalle, Baden-Baden, West Germany 1978; Blum Helman Gal., NYC 1978, '81, '83; Matrix Gal., Univ. of California, Berkeley 1979; KOH Gal. Tokyo 1979, '81; Richard Hines Gal., Seattle 1979; Gal. Schmela, Düsseldorf 1979; Mus. Boymans-van Beuningen, Rotterdam 1980; Hudson River Mus., Yonkers, NYC 1980; Monchehausmus., Goslar, West Germany 1981; Gemini GEL, Los Angeles 1982, '85; St. Louis Art Mus. 1982; Carol Taylor Art, Dallas 1982; Larry Gagosian Gal., Los Angeles 1983, '84; Akira Ikeda Gal., Tokyo 1983, '85, '87; Mus. National d'Art Moderne, Paris 1983; Gal. Reinhard Onnasch, Berlin 1983; Gal. Nordenhake, Malmö, Sweden 1984; Mus. Haus Lange, Krefeld, West Germany 1985; Le coin du miroir, Dijon, France 1985; Gal. Maeght Lelong, NYC 1985, '86; Gal. Stein, Milan 1985; MOMA, NYC 1986; Middendorf Gal., Washington, D.C. 1986; New City, Venice, California 1986; Mus. de Brou, Bourg-en-Bresse, France 1986; Jean Bernier Gal., Athens 1986; Louisiana Mus., Humlebaek, Denmark 1986; Hoffman-Borman Gal., Santa Monica, Calif. 1986; Pace Gal., NYC 1987; Westfälisches Landesmus., Münster, West Germany 1987; Städtische Gal. im Lenbachhaus, Munich 1987; Künsthalle, Basel 1988. GROUP EXHIBITIONS INCLUDE: "From Arp to Artschwager I, II, III," Richard Bellamy, Noah Goldowsky Gal., NYC 1966, '67, '68; "Annual Exhibition: Sculpture," Whitney Mus. of American Art, NYC 1968, '70; "New Media: New Methods," MOMA, NYC 1969; "No. 7," Paula Cooper Gal., NYC 1969; "Between Man and Matter," Tenth International Art Exhibition of Japan 1970; "Program III," Gal. Ricke, Cologne 1970; "3-00 New Multiple Art," Whitechapel Art Gal., London 1970; "Prospect 71," Städtischen Künsthalle, Düsseldorf 1971; "Judd/Serra," Leo Castelli Gal., NYC 1971; Whitney Biennale 1973, '75; "Art in Space: Some Turning Points," Detroit Inst. of the Arts 1973; "Interventions in Landscapes," Hayden Gal., MIT, Cambridge, Mass.

1974; "Art Now," John F. Kennedy Cntr. for the Per-
forming Arts, Washington, D.C. 1974; "Color as
Language," Mus. del Arte Moderno, Bogotá, traveling
to São Paulo, Rio de Janeiro, Caracas, Mexico City
1975; "Sculpture: American Directions 1945–1975,"
National Collection of Fine Arts, Smithsonian Instn.,
Washington, D.C. 1975; Berlin Festival, Academy of
Arts, Berlin 1976; "20th-Century American Art,"
Whitney Mus. of American Art, NYC 1977; A View of
a Decade," Mus. of Contemporary Art, Chicago 1977;
"Structures for Behaviour," Art Gal. of Ontario 1978;
"Drawings for Outdoor Sculpture, 1946–1977," Lagu-
na Gloria Art Mus., Austin, Tex. 1978; "Ten-Year An-
niversary Exhibition," Gal. Daniel Templon, Paris
1978; "Contemporary Sculpture: Selections from the
Collection of the Museum of Modern Art," MOMA,
NYC 1979; "Donald Judd, Bruce Nauman, Richard
Serra: Sculpture," Richard Hines Gal., Seattle 1980;
"Twenty American Artists," San Francisco Mus. of
Modern Art 1980; Venice Biennale 1980; "Cast,
Carved, and Constructed," Margo Leavin Gal., Los
Angeles 1981; "Group Exhibit," Akira Ikeda Gal., To-
kyo 1982; "New York School: Four Generations," Solo-
mon R. Guggenheim Mus., NYC 1982; "Sculpture:
The Tradition in Steel," Nassau County Mus. of Fine
Art, Roslyn Harbor, N.Y. 1983; "Content: A Contem-
porary Focus, 1974–1984," Hirshhorn Mus. and Sculp-
ture Garden, Washington, D.C. 1984; "Philip Johnson
Collection," MOMA, NYC 1985; "Qu'est-ce que la
sculpture moderne?" Mus. Nationale d'Art Moderne,
Cntr. Georges Pompidou (Beaubourg), Paris 1986;
"Kiefer and Serra," Saatchi Foundation, London 1986;
"Philip Glass/Richard Serra: A Collaborative Acoustic
Installation," Ohio State Univ. Art Gal., Columbus
1987; "1988: The World of Art Today," Milwaukee Art
Mus., Wis. 1988.

ABOUT: Celant, G. Arte povera, 1969; Current Biogra-
phy, 1985; Emanuel, M., et al. Contemporary Artists,
1983; Hunter, S. American Art of the 20th Century,
1971; Krauss, R. Passages in Modern Sculpture, 1977;
Muller, G. The New Avant-Garde: Issues for Art of the
Seventies, 1972; Pincus-Witten, R. Postminimalism,
1977; Serra, R., and C. Weyergraf. Richard Serra: In-
terviews, Etc. 1970–1980, 1980. Who's Who in Ameri-
can Art, 1989–90. Periodicals—Artforum April 1968,
February 1969, September 1969, February 1970, April
1970, September 1970, May 1972, September 1972,
November 1973, December 1974, December 1979,
September 1980; Art in America January–February
1969, May–June 1971, May 1972, March 1973, Janu-
ary–February 1975, May–June 1976, Summer 1981,
September 1985; Art International May 1969, April
1972, March–April 1977; ARTnews February 1970,
February 1975, May 1976, March 1984; Arts Magazine
April 1973, November 1980; New Yorker May 20,
1985; New York Times April 16, 1982, May 19, 1985,
October 27, 1988; People April 1, 1985; Studio Interna-
tional October 1973; XXe siècle December 1973; Vil-
lage Voice October 14, 1981, November 4, 1981;
Vogue September 1972.

SHAPIRO, JOEL (1941–), American sculp-
tor and draftsman, was born in New York City,
the son of Joseph and Anna Shapiro, respectively
an internist and a microbiologist. Although his
parents were scientists, both were interested in
art; his mother studied and practiced sculpture
and his father collected primitive art. Shapiro
was brought up in Queens, first in Sunnyside,
then in Beechurst, where he took art classes at
Bayside High School, but he had no idea then
that he would become an artist. "That was too
much fun," he said of his early art studies in an
interview in 1986. "That was something I actual-
ly did well. I was always trying to pursue some-
thing I wasn't doing well." He graduated from
New York University in 1964, still intending to
fulfill his parents' expectation that he would be
a physician, but actually uncertain about his fu-
ture.

The following two years, which Shapiro spent
in India with the Peace Corps, were to him an
"exciting and independent" experience. He was
stationed in the south of the country, and took
every opportunity to visit India's major artistic
sites: Ajanta, Ellora, Mahabalipuram, Tanjore.
"Generous outpourings of work," he called them
later, "representing the whole range of human
experience." He met people on the subcontinent
"who took art seriously," who encouraged his
growing sense of "freedom and accom-
plishment." Chief among these was the art edu-
cator Amy Snider (later his first wife), who ur-
ged him to develop and act upon his growing
interest in and commitment to art. Upon his re-
turn to New York he rented a studio on Broad-
way and Bleecker Street, at the same time
registering for course work at NYU's School of
Education—he thought he would have to teach
to earn a living. He need not have worried; his
artistic career took off with surprising speed.

Shapiro began to show his work in 1969, the
same year he completed a master's degree in
fine arts at NYU. One of his drawings, a cluster
of dyed, painted nylon filaments which was sta-
pled to the wall, appeared in a group show at the
Whitney Museum of American Art. In the same
year he was taken on as a client by Paula Cooper,
whose gallery was the first to open in SoHo
—"the only place to show," he said later. "People
reacted favorably to my work." His first one-
man show occurred at the Cooper Gallery in
March 1970; it was an installation of narrow
shelves, on each of which lay a 5/8-inch slab of
a particular material—steel, brass, aluminum,
copper, glass, rubber, wood, felt, cement, and so
forth. Paying attention only to materials rather
than making personal gestures or imitating reali-
ty was an approach exactly attuned to the rigid
minimalist aesthetic in vogue during the late

JOEL SHAPIRO

1960s and early 1970s. Another work of the same period, *75 lbs.* (1970), which consisted of a long seventy-five-pound bar of magnesium lying on the floor side by side with a much shorter seventy-five-pound bar of lead, conveyed precisely the same aesthetic distance from any kind of expressionism. Such reductive and simplistic essays in minimalism seemed too restrictive even to their perpetrator: "Minimalism," he told Ruth Bass in 1986, "was very attractive and very seductive. That was the current way of working. It made a lot of sense and was a very easy way to understand work. So that was the way I began to work. But for me it wasn't enough, so I began to admit more into the work, admit whatever I could."

What Shapiro began to admit into his art were out-of-scale objects familiar in daily life: tiny models of a bird, a bridge, a horse, a coffin, a chair, a table, and, most memorably, a house. He liked to show those miniatures in vast, unromantic spaces that dwarfed them, where their size encouraged a radical adjustment of perception on the part of the viewer. A show in 1973 at the Clocktower, a series of enormous abandoned rooms at the top of an old office building in lower Manhattan, consisted of a small iron bridge in the center of one huge room, a miniature balsawood ladder against the wall of another, and two hand-sized bronze birds on a shelf in a third. His first "house" (1973–74) was made, in the artist's own description, "by banging six pieces of wood together." Cast in iron, it measured 5 1/2 x 6 5/8 x 5 inches. He proceeded to make many other houses, all of them tiny, some with suggestions

of windows or doors, some placed directly on the floor, some on a shelf or other field, some placed on end, some cut into sections. Mark Ormond in 1986 described one of Shapiro's houses from 1975 (almost all were untitled): "[It] appears at first glance to be nothing more than a cast-iron brick. But upon moving around the work, the viewer discovers that two of its sides contain small, rectangular voids. These can be read as part of the formalist play of shape against mass or mass against void. Eventually, however, the viewer thinks 'house,' . . . for the voids read too much like windows, although it is not possible to interpret them as such without some hesitation. Even the meaning of this 'house' contains an ironic ambiguity, for this fortresslike mass can be interpreted simultaneously as protective and sheltering or as ominous and threatening. The scale of the sculpture is also filled with contradictions. Designed to sit alone in an open area, the object commands a vast amount of space, thus extending the presence of the work well beyond its actual size. The sculpture is oddly toylike because of its diminutive scale, and especially because of its tiny 'windows'; nonetheless, the work asserts a monumental presence because of the way it aggressively dominates the surrounding space."

For the artist himself, it was the *idea* of the house—not at all its material—that was meaningful. His turning away from the materialistic aspect of minimalism was complete. "I took the metaphor of the house," he wrote in the catalog for the major retrospective of his work in 1982 at the Whitney Museum, "and isolated it. I took a house and plopped it in the middle of a field—not a grassy, green field, I mean an area. This house is not engaged so much with the space that it actually occupies, but functions in a much more psychologically determined space instead. It is removed. It is very sentimental. It gives a real sense of isolation. This small, longing house is removed from you, but you can feel it. . . . The house form was dominating my work at that time and I began looking for any possible way out. I started looking at factories and I did a very low-lying structure and then I did the house with a cut in it, a quarter removed. I was interested in disrupting the image. I was trying to cut into it, rip it up, but that house kept creeping back into my work."

The critic Roberta Smith contributed an extremely appreciative essay to the 1982 retrospective's catalog, in which she called Shapiro's career "one of the outstanding achievements in American art since 1970." Such a grand encomium did not sit well with other critics, among them Kay Larson, who saw the whole process of reaction to minimalism as a purely art-historical

diversion, a wan joke with a wispy punch line: "Minimalist space in a Platonic ideal," she wrote in a sharp review of the retrospective in *New York*; "a last gasp of the Newtonian rational mind trying to come to terms with the warped and impure space of modern relativity theory. Trouble comes when minimalist purity is threatened—in this case by too many little Shapiros, which crowd one another on the floor and turn the room itself into a wastebasket for curious things. Shapiro's [casts] are small in order to jostle one's expectations of the scale of space around them; they are dense in order to pull space in close to them. So far, Shapiro has done nothing out of the ordinary. But the houses become 'homes' very quickly, and those homes have 'yards'—flat stretches of bronze, or sometimes bits of an abstract driveway or picket fence. In other words, Shapiro has begun to tell a joke about the cute connotations and emotional baggage attendant on tininess (why else would humans squander such sentiment on dolls if not because they are cute, cuddly, and small?). . . . Far more than most sculptors, Shapiro is tied to a historical conception of his purpose. These works are just the punch line to a shaggy-dog begun by Richard Serra, Robert Morris, Eva Hesse, and—Smith argues—Giacometti, David Smith, and Brancusi. Dependence on an idea makes Shapiro attractive to critics who know those artists' stories almost better than their own, but it limits him, ultimately, to a narrow art-historical realm of reaction and abreaction. . . . We may see more and better from him. The question remains: Why have we already seem so much of him?"

Shapiro's work began in the 1980s to approach or even exceed life-size dimensions, a definite break from the scale of his work of the 1970s. The strong suggestion of the human body apparent in the new work, however, seemed thematically a natural extension of the house motif. The new figures—again, most of them were untitled—were sculptures of squared-off wood or wood cast into bronze, in which a boxy "torso" functions as a fulcrum from which project "legs," "arms," "heads," "necks," "hands," or "feet." Nearly all those compositions are off-axis—none of the elements are exactly on either the horizontal or the vertical. The various parts of the compositions are put together in apparently odd ways, at peculiar angles, that, in Mark Ormond's words, "work against the implied geometry of the individual planks or beams. The disparity of the length of the appendages also increases the staccato rhythm of the piece. The same staccato pace is set up in the relationship of the viewer to the work. Just as the sculpture has no horizontal or vertical axiality, it also has

no primary axis for the viewer to approach it, in the sense that it has no front or back. Instead the work, which is intended to be seen in the round, consists of a number of different compositions and viewpoints that abruptly arrest the viewer as they demand to be read and analyzed."

Shapiro described one of the most strongly figurative of those pieces (untitled, 1980–81) in this way for the Whitney catalog: "I think it is important that a convincing piece of sculpture could be put together so simply and be figurative without having to get involved with literally describing human movement, but rather it describes one's idea of movement or one's internal feeling of movement. . . . Although the piece is very much about joining. I was interested in the unification of it through casting and the insistence on its form through casting. I was adamant about its being cast as one piece. Once it was cast in bronze and it became so permanent, I wanted to break it up again. . . . I'm more interested in how one thinks about something than in what something looks like. I am interested in what a house or a figure might mean, or what it means to me. I am interested in my capacity to refer to it in terms of sculpture, but not to illustrate it or describe it."

In his work of the mid-1980s, the artist seemed to have moved away somewhat from the figurative. In a work of 1986, a hollow wooden box, painted dark blue, is supported by three slender unfinished wooden sticks. The box, raised on its stiltlike tripod more than five feet off the floor and tilted away from the horizontal, seems to invite the viewer to look into its unpainted, hollow interior. A much larger work, one of Shapiro's first exercises on a monumental scale, is a fourteen-foot-high bronze exhibited in late 1986 in the forecourt of Mies van der Rohe's famous Seagram building, perhaps New York's most revered modernist icon. Critics seemed delighted with the untitled work, taking it as an earnest indication that the former minimalist miniaturist could now hold his own with the "big guys" of late twentieth-century monumentalism. "Although all installations in the [Seagram] plaza are temporary," remarked Ruth Bass, "Shapiro's brown patined bronze looked as if it had been made to sit in front of this particular building. The form and color of the bronze sections were in perfect harmony with the building's elegant bronze facade. At the same time, there was a sense of movement and volition that served as a counterpoint to the formal beauty of [the Mies] design." Bass especially admired the way in which, in the artist's most recent work, "blunt, unmodulated forms are put together to appear abstract when viewed from some vantage points and figurative when viewed from

others. . . . As one walks around the [Seagram] sculpture, the relationship of one form to another changes, making the viewer aware that there is not one specific message here or even a specific figure in a specific pose." Shapiro's own comment on the piece also emphasized its changeability from the viewer's perspective; "It figures and disfigures as you walk around it. One side is more emblematic, one side is abstract. The problem is to register a thought in space, to somehow externalize a thought or feeling into space, into the world." For the sculptor, then, it is now the thought that counts most of all. The important thing is not to refer explicitly to anything—human form of specific idea—but to capture emotion: "I have not wanted the work[s] to be explicitly referential in the way that a realist painter might paint a particular arm. I'm not interested in that particularness, in the mimetic aspects. I've always wanted that reduced form, but loaded up, and that, of course, is my real intention—to load form up a much as I can."

Shapiro has regularly, since the beginning of his career, made and exhibited drawings of rectangular or trapezoidal figure-related forms. His preferred mediums are charcoal and chalk, the forms are almost invariably boxlike and imposing, as well as black or dark brown in color (color has never been an important element of his work), and he likes to leave fingerprints or smudges all over his work on paper. Although they do not really function as preliminary drawings for his sculpture, they do not either exist independently of the three-dimensional work, and it is probably safe to say they would have attracted little notice if it were not for that work's frequent exhibition.

EXHIBITIONS INCLUDE: Paula Cooper Gal., NYC 1970, '72, '74, '75, '76, '77, '79, '80, '82, '83, '84, '86; Clocktower, NYC 1973; Gal. Salvatore Ala, Milan 1974; Walter Kelly Gal., Chicago 1975; Mus. of Contemporary Art, Chicago 1976; Max Protetch Gal., Washington, D.C. 1977; Albright-Knox Art Gal., Buffalo 1977; Gal. Aronowitsch, Stockholm 1977, '80, '83; Gal. Nancy Gillespie-Elisabeth de Laage, Paris 1977, '79; Greenberg Gal., St. Louise 1978; Gal. M. Bochum, West Germany 1978; Akron Art Inst. 1979; Gal. Mukai, Tokyo 1979, '80, '81; Whitechapel Art Gal., London 1980; Asher/ Faure Gal., Los Angeles 1980, '83, '86; Mus. Haus Lange, Krefeld, West Germany 1980; Moderna Mus., Stockholm 1980; Brooke Alexander, Inc., NYC 1980; Delehunty Gal., Dallas 1980; Bell Gal., Brown Univ. 1980; Georigia State Univ. Art Gal. 1980; Contemporary Arts Cntr., Cincinnati 1980; Ackland Art Mus., Univ. of North Carolina at Chapel Hill 1981; John Stoller Gal., Minneapolis 1981; Daniel Wenberg Gal., San Francisco 1981; Israel Mus., Jerusalem 1981; Young Hoffman Gal., Chicago 1981; Portland Cntr. for the Visual Arts, Oregon 1982; Yarlow/Salzman Gal., Toronto 1982; Whitney Mus. of American Art, NYC

1982; Dallas Mus. of Fine Arts 1982; Arts Gal. of Ontario, Toronto 1982; La Jolla Mus. of Contemporary Art, Calif. 1982; Knoedler Kasmin, London 1985; Stedelijk Mus., Amsterdam 1985; Kinstmus., Dusseldorf 1985; Staatliche Kunsthalle, Baden-Baden 1985; Seattle Art Mus. 1986; Gal. Daniel Templon, Paris 1986; Ringling Mus. of Art, Sarasota, Fla. 1986; Donald Young Gal., Chicago 1987; John Berggruel Gal., San Francisco 1987; Hirshhorn Mus. and Sculpture Garden., Washington, D.C. 1987. GROUP EXHIBITIONS INCLUDE:
Mus. of American Art, NYC 1969, '70, '73, '77, '78, '79, '80, '81, '82; Paula Cooper Gal., NYC 1969, '70, '72, '73, '74, '75, '76, '77, '78, '81; MOMA, NYC 1970, '79; Albright-Knox Art Gal., Buffalo, N.Y. 1971, '81; Art Inst. of Chicago 1974, '75, '82; Clocktower, NYC 1975; Venice Biennale 1976; Akad, der Kunste, Berlin 1976; Art Gal. of New South Wales, Sydney 1976; Inst. of Contemporary Art, Philadelphia 1975, '77, '78; Documenta 6, Kassel, West Germany 1977; Mus. of Contemporary Art, Chicago 1977; Walker Art Cntr., Minneapolis 1977; New Mus., NYC 1977; Blum/Helman Gal., NYC 1978; Venice Biennale 1978; Stedelijk Mus., Amsterdam 1978; La Jolla Mus. of Contemporary Art, Calif. 1979; Stadtische Gal. im Lenbachhaus, Munich 1979; Kulturhistorisches Mus., Bielefeld, West Germany 1980; Inst. of Contemporary Art, Boston 1980; Hayward Gal., London 1980; Venice Biennale 1980; Los Angeles Inst. of Contemporary Art 1980; National Mus. d'Art Moderne, Paris 1981; Louisiana Mus., Humlebaek, Denmark 1981; Kunsthalle, Basel 1981; Documenta 7, Kassel, West Germany 1982; San Francisco Mus. of Modern Art 1982.

ABOUT: Cathcart, L. Joel Shapiro 1977; Krauss, R. Joel Shapiro 1976; Krauss, R. Critical Perspectives in America Art, 1976; Lyons, L. Scale and Environment: 10 Sculptors, 1977; Smith, R. Joel Shapiro, 1980; Smith, R., et al. Joel Shapiro 1982; Tucker, M., et al. Early Works by Five Contemporary Artists 1977. *Periodicals*—Architectural Digest June 1984; Artforum November 1980, February 1976, December 1973, November 1984, November 1986; Art in America April 1976, November 1984, November 1986; ARTnews November 1984, March 1987; Arts Magazine November 1980, January 1981, November 1984, November 1986, March 1987; Avalanche Summer 1975.

SHERMAN, CINDY (January 19, 1954–), American photographic artist, was born in Glen Ridge, New Jersey, the youngest of five children. Neither of her parents followed contemporary art. Her mother was a teacher, her father an engineer whose hobby was collecting cameras and taking family photos. In 1957 her father moved the family to Huntington Beach, on the North Shore of Long Island, a quiet, middle-class suburb about an hour from New York City. She spent a lot of time drawing as a child but also a lot of time playing dress-up and applying elaborate make up jobs. "I would secretly put on makeup at home and turn into a different

CINDY SHERMAN

person," Sherman told Gerald Marzorati in a 1983 *ARTnews* interview. "I was obsessed with being presentable."

In 1972 Sherman enrolled in SUNY Buffalo, a popular school for aspiring artists. At her mother's suggestion, Sherman, who then considered herself a painter, declared her major as art education, which seemed more practical than a pure art curriculum. In her sophomore year, however, she met Robert Longo, a fellow art student from Long Island at a party. It was a meeting, and ensuing relationship, that was to galvanize Sherman's artistic pursuits. Longo was glib, garrulous, and ambitious, whereas Sherman was tentative; he was worldly and New York-oriented while Sherman had passed a relatively sheltered childhood and was afraid of the city. Sherman lived on campus, Longo in his own studio at Hallwalls, a small gallery which, largely through Longo's dedication, became a major showcase for new art in upstate New York. "Here was this guy," Sherman recalled, "and he had all these people around him at [a] party and he was talking about conceptual art or something. I was just so amazed." Longo remembers Sherman during her last couple years of college spending a lot of time reading art journals. "It was like there existed this way to catch up real fast, and Cindy did it."

Sherman also spent a good deal of time making herself up—spending hours before the mirror until she would become virtually unrecognizable in outlandish outfits and, often, a wig. Sometimes she would venture out that way; usually, though, she did it just for herself, to see how "transformed" she could look.

By 1975, her junior year, Sherman was growing disenchanted with painting. She took her first photography course, but the purely technical emphasis so bored her that she failed it. Her second photography course, however, was more conceptual and completely won her over. One of her first assignments for this class was to do a series of photographs dealing with the passage of time. Sherman took Longo's advice and began her series with a photograph of herself wearing no make-up and ended with one of her face completely, unrecognizably made up. "The work got all this feedback," she said. "It dawned on me that I'd hit on something." Encouraged in the creation of a unique artistic persona, Sherman moved into Hallwalls, where she had her own studio and eventually became the gallery's secretary. She also worked with people on some performance pieces.

In 1975 Sherman completed what she called her series of "Cutouts" in which she made up a simple, usually melodramatic plot, cast herself in the roles, and photographed the "characters." Then she would cut out the photographs, paste them onto stiff paper, and hang the paper panels sequentially (according to the plot) on a wall. Linda Cathcart, then the curator of the prestigious Albright-Knox Art Gallery in Buffalo, saw Sherman's cutouts and decided to include them in an Albright-Knox exhibition of work by New York State artists.

In 1977, Sherman, who had won an NEA Fellowship, moved to downtown Manhattan with Longo, living in a sublet loft on Fulton Street, near the fish market. Sherman and Longo parted amicably a few years later. They remained close friends, and maintained a studio in their old building. Sherman's first months in New York were, by her own admission, very tough. She felt overwhelmed by the city and left her studio only for occasional trips to the cinematic revival house on Bleecker Street. She hadn't yet "invented a personality for the street," she told Marzorati, and though she was sick of doing cutouts she was unable to move on to something new. However, one evening the painter David Salle, who was living nearby, invited Longo and Sherman to his studio. Salle, who had been working for a publisher of pornographic magazines, had some back issues laying around. Sherman was captivated by the pictures' narrative ambiguity: "They seemed like they were from '50s movies, but you could tell that they weren't from *real* movies. What was interesting to me was that you couldn't tell whether each photograph was just its own isolated shot, or whether it was in a series that included other shots that I wasn't seeing."

In late 1977 Sherman did the first in her series

of black-and-white "Untitled Film Stills," of which she would eventually execute about 75. For these, Sherman made herself up as women in movies from the 1940s and 1950s, particularly from the *film noir* genre. Mostly she photographed herself in her studio or had friends photograph her "on location" on quiet lower Manhattan streets, which, with their old warehouses, had a distinctly noirish look. In her first "still," Sherman—looking like a classic gangster's "moll"—leans against a doorway in a dark, ominous hallway. In other photographs, Sherman "cast" herself as an underworld seductress getting a raw deal, as a '50s housewife, as a sweet-faced ingenue overwhelmed by the big city, as a hitchhiker in a plaid pleated skirt.

The images in this series of small black-and-white photographs are intriguing chiefly because of the tension with which Sherman infuses them. They look exactly like old film stills, yet it is obvious that they are not from movies. For example, in one photo a recent telephone book is propped against a door. The "movies" from which these "stills" originate exist only in Sherman's imagination, or in the fantasies of spectators. The photographs constitute a powerful evocation of a period and a genre—a genre period perhaps? the black and white '50s? There also was the matter of Sherman's persona. Sherman played her characters straight, without irony, without condescension. Yet she did not "become" the character in the manner of method acting; she called attention to the actress playing the character. As Sherman explained, "There's also me making fun—making fun of these role models of women from my childhood. And part of it maybe is to show that these women who are playing these characters—maybe these actresses know what they're doing, know they are playing stereotypes—but what can they do?"

Toward the end of the "Untitled Film Stills" period, Sherman again felt restless. The vagaries of location work and having to rely on the participation of others in making her photographs struck her as intolerable problems. She wanted to work alone and indoors. She moved into her own studio apart from Longo and began using a Nikon F3 equipped with auto-winder on a tripod. She arranged spotlights on floor stands and before she began shooting, would lean a full-length mirror against the tripod and start to move, watching herself.

In 1980 Sherman took 14 photographs of herself in front of rear-screen projections (usually of outdoor settings). Technically and artistically, this series is considered transitional. The screens did not foster the illusory settings Sherman was after, and they presented lighting problems besides. Her next series, which were shown in late 1981 at Sotto's Metro Pictures, was a runaway success and thrust her into the art-world limelight. The series grew out of an *Artforum* assignment to do a multi-page spread (the magazine declined to publish the photos). Now more interested in formal considerations, Sherman began work on Playboy-like centerfolds based loosely on those she had seen at Salle's studio in 1977. The twelve photographs in this series—blown up to two feet by twelve feet and often referred to by critics as "horizontals"—constituted an artistic leap forward. The color was luminous, the close cropping dramatic and intense, and the lighting, inspired by *2001* and *Close Encounters of the Third Kind*, displayed expert visual control and there were even special effects, such as the sprayed-on sweat in *Untitled #86*. Sherman's face is riveting and yet opaque in the horizontals—a face "lost in thought," hauntingly present by virtue of a fundamental absence. It was as though Sherman had created the impossible—pictures of faces that were really photographs of thoughts. She explained: "I think I showed this part of these people you see in centerfolds—the part that the photographer doesn't want to take pictures of."

Sherman's next major series began as an assignment for Dianne B., an exclusive SoHo boutique. The owner contracted Sherman to do four full-page ads for *Interview*, using clothes from the designers the store carried. Sherman described the way she approached this series: "I just began by playing here in the loft in front of the mirror with the Dorothee Bis Clothes. I wasn't modeling. I didn't care about that. I wanted to block out what the clothes were meant to be. And I wanted to get beyond what they looked like on . . . on me . . . I wanted to make them . . . abstract. I even put on this skull cap before I put on the wigs I use. I wanted to get rid of the idea that these clothes could make me look beautiful. I wanted to go blank."

Peter Schjeldahl has dubbed the photographs in this series "costume dramas." They are among Sherman's most theatrical images. They are also largely devoid of narrative, and many are aggressive and menacing, even nightmarish. In one, Sherman, dressed in an outfit borrowing its "chic" from the tattered garb of bag ladies, stands with arms outstretched; a crazed, almost psychotic and impossibly wide smile shows blackened teeth, and with her narrowed eyes, she looks part pirate, part witch. In another, Sherman wears a classic black suit—fitted jacket, narrow skirt—a platinum wig mussed so that her entire face, save one glaring eye, is hidden, with red make-up around that eye and on her

hands. She stands stock still, fist clenched—"Frances Farmerish" Sherman called this character. In that image, fury is ratcheted to the point of dementia, and elegance goes haywire. Writing of this series in *Art in America*, Jamey Gabrell pointed out, "Having shed the constraints of predetermined narratives, her characters have acquired an almost Gothic quality. They are emotional fantasies turned flesh and blood, personal fictions embodying those marginal, eccentric states of being that have no comfortable place in society of mass media."

In 1985 Sherman's imagery changed dramatically. She produced a series of large color pictures of mythic creatures, some portrayed in a desert setting, others in what appeared to be the Black Forest. The series grew out of an assignment for *Vanity Fair* magazine. The pictures she exhibited in 1987, the year her traveling retrospective reached the Whitney Museum, also dealt with hideous visions of death and hysteria. In 1990, however, she displayed a return to portraiture and an abandonment of images of the unspeakable in her show at Metro Pictures. Her previous work, she told *People* (November 30, 1987), may have been "aimed at the art world. I got lots of very positive publicity, and it gave me the creeps. I wanted to make something that would dare people to hype it."

Peter Schjeldahl has discussed the reasons for the wide appeal of Sherman's work: "What is instantly recognizable . . . is the universal state of daydream, or reverie, the moments of harmless, necessary psychosis that are a recurring mechanism in anyone's mental economy . . . These are moments when consciousness dissolves back on itself, when wish and reality, personal and collective memory are one and the physical world ceases to exist. It is a loss of self, protected from panic by being unconscious, an interlude of vagueness automatically forgotten. Sherman makes it concrete."

EXHIBITIONS INCLUDE: Hallwalls, Buffalo 1977, '79; Visual Studies Workshop, Rochester 1977; Contemporary Arts Mus., Houston 1980; The Kitchen, NYC 1980; Metro Pictures, NYC since 1980; Saman Gal., Genoa 1981; Young/Hoffman Gal., Chicago 1981; Gal. Chantal Crousel, Paris 1982; Larry Gagosian Gal., Los Angeles 1982; Stedelijk Mus., Amsterdam 1982; The St. Louis Art Mus. 1983; Gal. Shellmann & Kluser, Munich 1983; Fine Arts Cntr. Gal., SUNY Stony Brook 1983; Mus. d'Art de d'Industrie de Saint Etienne, France 1983; Seibu Gal. of Contemporary Art, Tokyo 1984; Laforet Mus., Tokyo 1984; Gal. Monika Spruth, Cologne 1984; Akron Art Mus. 1984, (trav. exhib. to Inst. of Contemporary Art, Philidelphia; Mus. of Art, Carnegie Inst., Pittsburgh; Des Moines Art Cntr.; Baltimore Mus. of Art; Whitney Mus. of American Art, NYC.) 1984–'87; GROUP EXHIBITIONS INCLUDE: Albright-

Knox Art Gal., Buffalo 1975, '76, '77; Hallwalls, Buffalo 1975, '76, '77, '79; Castelli Graphics, NYC 1980; Cntr. Pompidou, Paris 1981; Haden Gal., MIT, Cambridge 1981; Venice Biennale; Documenta 7, Kassel, West Germany 1982; Walker Art Cntr., Minneapolis 1982; Inst. of Contemporary Art, London 1982; MOMA, NYC 1982; Hirshorn Mus. and Sculpture Garden, Washington, D.C. 1983; Whitney Mus. Biennial, NYC 1983, '85; Kunstmus., Lucerne 1983; Forum Stadpark, Graz, Austria, 1983; Tate Gal., London 1983; Mus. de Arte Moderna, Rio de Janeiro 1984; Mus. Rufino Tamayo, Mexico City 1984; Rheinhallen, KolnMesse, Cologne 1984.

COLLECTIONS INCLUDE: MOMA, NYC; Tate Gal., London; Cntr. Georges Pompidou, Beaubourg, Paris; Stedelijk Mus., Amsterdam; Australian National Gal., Canberra; Baltimore Mus. of Art; San Francisco Mus. of Art; Walker Art Cntr., Minneapolis; Mus. of Fine Arts, Houston; Albright-Knox Art Gal., Buffalo; Hayden Gal., MIT, Cambridge; George Eastman House, Rochester; Mus. Folkwang, West Germany; Rijksmus. Kroller-Muller, Otterlo, Holland.

ABOUT: Cathcart, L. "Cindy Sherman" (cat.), 1980; Smith, R., "Body Language" (cat.), 1982; Cindy Sherman, 1984; Current Biography, 1990. *Periodicals*—ARTnews September 1983; Art in America March '84; Frankfurter Allgemaine Magazine September '84; Parachute September–October 1982; Screen November–December 1983;

SIMONDS, CHARLES (November 14, 1945–), American sculptor and ceramicist, is best known for the diminutive clay structures he erected on nooks and crannies of the urban landscape. The meticulously crafted buildings clung to crumbling wall niches, jutted from window sills and gutters, emerged from sidewalk crevices. Fashioned from tiny clay bricks, they were the abandoned dwelling places of the Little People, an imaginary itinerant civilization. In the words of the artist, they were "guaranteed to be destroyed. The point was the energy of it, the doing-ness." Simonds went on to create more permanent, large-scale sculpture that continues to explore the relationship of people to their shelters, and of that architecture to the landscape that supports it.

Born on Manhattan's Upper West Side, Simonds is the younger son of Vienna-trained psychoanalysts. His mother was especially interested in how children develop awareness of their bodies, and Simonds has partly attributed his own preoccupation with the relation of body and dwelling to that early influence. He encountered the primary medium of his art at a young age as well, becoming "involved with clay" as a fourth-grade student. He and his older brother went on to study clay modeling with two Italian

CHARLES SIMONDS

architectural sculptors in New York. "There was never much question as to what I was going to do in life, because working with clay was what I *could* do," the artist told Phil Patton in 1983. "There are things I watch my hand do that are almost thoughtless. I can remember the moment of learning them. It's knowledge you have in the hand." Family trips to the Southwest, where Simonds saw Indian pueblo architecture, and frequent visits to the American Museum of Natural History, which contributed to his fascination with plant and animal forms, would prove to be further influences on the character of his work.

Simonds majored in art at the University of California at Berkeley, where he produced welded sculpture and also worked in plastic. After graduating in 1967, he obtained an M.F.A. degree from Rutgers University, then taught art at Newark State College from 1969 to 1971. Meanwhile he was establishing and filming the private rituals that express the close interrelation of earth, body, and architecture which forms the "central equation" of his work. For his 1970 film *Birth*, he buried himself in the earth and then slowly emerged from it, enacting his personal origin myth. In *Landscape/Body/Dwelling*, first performed in 1970 and filmed in 1971 and 1973, he lay naked in a claypit and constructed small clay buildings on his stomach and thigh. His mud-covered form was presented as an outgrowth of the ground beneath it as well as a landscape for the tiny structures he perches on top of himself. *Landscape/Body/Dwelling* articulates, in Simonds words, "a process of transformation of land into body, body into land." He

considers his five films, all made in the early 1970s, the "key to understanding [his] value system." Their subject prefigures the central theme of his best work, an underlying aesthetic simply defined by the artist as "the relation between your body and your dwelling, through time."

With his "Dwellings," Simonds extended a personal fantasy to a public context. In 1970 the small clay structures of the Little People began appearing in the streets of SoHo. Simonds first mass-produced minuscule clay bricks with a rolling cutter, then selected a site for his construction. Often working before an impromptu audience, he would set the bricks in place with pincers, using thinned Elmer's glue as a mortar.

The "Dwellings" were intended to provoke viewers to contemplate the physical and social structures of their own lives, and Simonds came to find New York's battered Lower East Side a particularly meaningful locale for his work. From 1972 into the late 1970s he worked there predominantly, and the artist and his work becoming well known to area residents. To some critics the miniature buildings have recalled Robert Smithson's drawings for fantasy architecture, and Simonds has acknowledged him, as well as Claes Oldenburg, then also a street artist, as influences. Various cultural sources for the buildings are "recognized" by viewers, although they have been more accurately described as "something like universal prototypes of primitive dwellings." In Spain, Simonds has said, "the people think the structures are Spanish houses, or North African ones. On the Lower East Side, which is heavily Puerto Rican, people think they are Puerto Rican." For most American viewers, the clusters of adobe-like houses and the features that surround them—kivas and other ceremonial places, steep steps and ladders scaling terraced hillsides, stretches of barren sand—are strongly reminiscent of Southwest Indian architecture, particularly the cliff-dwellings at Mesa Verde, Colorado. But unlike those enduring examples of primitive residences, the abandoned dwellings of the Little People were fragile and ephemeral, destroyed by the depredations of children or inclement weather within weeks or days or even hours of their creation.

The Little People, whose fictional ethnography has been elaborately worked out by the artist, consist of four groups distinguished by the shapes of their buildings. The distinctive characteristics of the various tribes were summarized in a review of Simonds's 1981 display in the Projects Room at the Museum of Modern Art: "The builders of circular dwellings yearly integrate group energy in a winter solstice collective

dance, orgasm, and reaffirmation; the spiral people aspire upward with mathematical precision and growing depression; the linear people are constant migrants (their more audacious branches wandering through SoHo and the Lower East Side); and the walled cities' people are functionally oriented specialists. A complex culture, reduced to microfiche." Simonds noted that the fantasy of the Little People is a "powerful force" in his life and adds that it has given him "tremendous energy." Wishing to evoke a similarly potent imaginative response from viewers, he encouraged them to conjure up personal visions of the Little People. While most of his street pieces were quickly destroyed, Simonds found he was able "to build up a population in people's minds. The Little People exist to a much greater extend in the imagination than they ever could in real life. . . . People have a vivid image of a particular dwelling at a site where I've made one, even though the thing is no longer there."

The transience of the street art—in all, several hundred pieces constructed in cities around the world, including Berlin, Paris, Venice, Dublin, Shanghai, and Guilin, China—was, as Charles Beardsley noted in a 1979 review, "an inevitable consequence of Simonds's desire not to produce objects but to transmit ideas" about people's relation to their environment through time. The quasi-archaeological look of the structures, for instance, evokes an altered conception of time by reminding viewers that the contemporary city constitutes only a stage in the vast continuum of human evolution, that someday it too will appear merely as a relic from another age. Simonds also intended for his works to transform, at least temporarily, ravaged sites. The deteriorating urban structures that support the dwellings become the surface of this miniature world, so that the city itself functions as a landscape.

Simonds used his private myth to transform the grim reality of the city in more enduring ways as well. From residents of the Lower East Side, the area where he primarily worked, he wished to elicit an awareness of the correlation between the pattern of creation and destruction that characterizes the habitations of the Little People and the instability of their own neighborhood. Simonds's goal was to channel the local political energy that he believed this identification would engender into projects that would benefit the community. In 1974, a vacant lot on East Second Street was converted into a park/playlot called La Placita, an undertaking Simonds planned and executed in conjunction with community groups and with the direct encouragement of Robert Smithson. La Placita is, in Simonds's words, "a respite from the city . . . a

continuous reminder of the earth's contours beneath the asphalt." Among other plans for land reclamation in an urban setting was an ingenious proposal to drape the abandoned steel skeletons of two towers at Breezy Point in Brooklyn with vines and other trailing plants; the project failed to receive bureaucratic approval, though, and instead the structures were dynamited at a cost of two million dollars.

Other innovative works with which Simonds expressed his ideas about the interrelation of people and their environment were Growth House (1976) and Floating Cities (1978). Growth House, one of several projects the artist undertook at Artpark in upstate New York, was a circular structure made from "growth bricks." These burlap sacks of soil and seed sprouted greenery, produced a harvest of vegetables, and finally disintegrated at the end of autumn. The critic Lucy Lippard explained that the work was a "metaphoric architecture," functioning first as shelter and, after evolving through various phases, finally merging back into the earth. Floating Cities is Simonds's vision of the way people might live in the future. The work comprises a group of model barges, all carrying structures of contemporary life—houses, factories, farms, churches, etc. The barges can be moved about the "ocean" beneath them with a croupier's stick, representing the geographical freedom of the components of this future society. Migratory like the Little People, this whole civilization can constantly group and regroup, entering into new configurations on the basis of economic need and desire. Simonds describes Floating Cities as both a game and "a critique of the structure we have now."

All of Simonds's work, diverse as it is, is unified by his continuing interest in the ways in which people respond to and adapt their environment; but it is the clay pieces that viewers generally find most evocative and compelling. Clay, with its capacity for sensuous molding as well as museologically precise construction, has been a fitting medium for Simonds's deft hands, fecund imagination, and implicit social message. He has collected clay from pits near Sayreville, New Jersey, where he performed his ritual mythologies, and from various locations on his extensive travels. "Each clay is different," he has explained, "it responds differently when you touch it." The color of the clay he uses on any given piece is "important but not programmatic." To him the gray "suggests stone, block, or rocks," while he finds red clay "extraordinary for its fleshiness. It's rubbery; it almost springs back when you touch it. For me, its association with the body is inescapable." Phil Patton has noted how often in Simonds's work

"the earth takes on feminine forms, with towers and other constructions assuming phallic and masculine shapes." The art resists rigid schematicization, however, and the traditional gender association of the natural and corporeal with the feminine, and of craft and (in this case primitive) technology with the masculine, is not always applicable. Simonds's meaning is more general: by forming the landscapes of his pieces to resemble human features—lips, breasts, buttocks, phalluses, pudenda—he directly relates body to earth and also intimates psychological and sexual signification of shelter.

That theme is perhaps best realized in *Circles and Towers Growing* (1978), executed during a year spent in Berlin on a D.A.A.D. (German Academic Exchange Service) grant. The work consists of twelve tabletop constructions, each measuring thirty inches square, that encapsulate the geologic and cultural development of one landscape. *Circles and Towers Growing* was the centerpiece of a major exhibition of Simonds's work that originated at the Museum of Contemporary Art in Chicago, and in that show's catalog the artist explained that the purpose of the work was to "show the evolution of a landscape and an architecture in [his] imaginary universe . . . the same place at successive moments of time." The first section in the series is a barren, parched plain. From cracks in its surface erupt breast- and liplike forms in the subsequent piece, and by the third, colonization by the Little People has begun. Crude at first, their ritual dwellings increase in complexity and sophistication (the final structure is an astronomical observatory) before decay overtakes them. In the last desolate-looking piece, clay rubble is strewn across the dusty earth. Created for exhibition in Europe, *Circles and Towers Growing* was shown at the Museum Ludwig in Cologne, the National Gallery in Berlin, and the Galerie Baudoin Lebon in Paris. As part of the 1983 Museum of Contemporary Art show, it traveled to museums in Los Angeles, Fort Worth, Houston, and New York.

At an earlier point in his career Simonds eschewed the established art-world milieu of museums and galleries, feeling that his art better fulfilled its purpose in urban streets. But his view now, as he told Phil Patton in 1983, "is not to exclude any way of working. I accomplished what I wanted to do on the Lower East Side, so there was no purpose in continuing. It's not as if you can fundamentally change things there. You can only scratch the surface, and that will always be true." Today Simonds's clay pieces are in a number of permanent collections around the country. One dwelling, in the stairwell of the Whitney Museum, has a tower that "signals" to another structure on a ledge across the street.

Some critics feel that museums and galleries offer too pristine a setting for the work, making his pieces look precious or contrived. Undeniably, many of his structures derive their greatest meaning and effect from provocative juxtaposition with a full-scale city environment. Simonds has managed to preclude that criticism of his work in certain museums by incorporating his dwellings into the structure of the building. At the Museum of Contemporary Art in Chicago, for instance, he built a forty-foot-long complex of buildings in a stretch of brick wall dating from when the museum building was a bakery.

Simonds's work has always been especially appreciated in Europe, and he has had solo exhibitions in Genoa, Paris, Münster, Bonn, and Cologne. In 1973 he was termed "one of the revelations" of the Paris Biennale, in which his work appeared again in 1975. At the thirty-seventh Venice Biennale he used part of his space to indicate to viewers where in the poorer sections of the city they could locate his small structures. "One goes to find them," noted one reviewer, "and discovers tiny constructions . . . , mysterious and poignant works abandoned in the rain and destined to fall apart." His work was also exhibited at the 1977 Documenta, Kassel, West Germany. Permanent installations in museums abroad include a colony of dwellings in a wall of the Kunsthaus in Zurich and a work at the Art Gallery of South Australia. His miniature villages, which he continues to build for collectors, command prices of up to $30,000.

Simonds lives and works in a large Manhattan loft with a striking view of the Empire State Building. He is married and has a young daughter.

EXHIBITIONS INCLUDE: Paris Biennale 1973, '75; "La Placita," Artpark, NYC 1978; "Growth House," Artpark, NYC 1978; Documenta 6, Kassel, West Germany 1977; "Circles and Towers Growing," Mus. Ludwig, Cologne, National Gal., Berlin, Gal. Baudoin Lebon, Paris ca. 1979–80; "Charles Simonds," Mus. of Contemporary Art, Chicago 1983; Leo Castelli Gal., NYC 1986.

COLLECTIONS INCLUDE: MOMA, Metropolitan Mus. of Art, and Whitney Mus. of American Art, NYC; Mus. of Contemporary Art, Art. Inst., Chicago; MOCA, Los Angeles.

ABOUT: Emanuel, M., et al. Contemporary Artists, 1983. *Periodicals*—Artforum February 1974, March 1975, March 1979, January 1980, Summer 1980; Art in America May 1975, July 1977, January 1979, February 1983; Art International February 1979; ARTnews January 1980, February 1983, February 1985; Arts Magazine February 1982; Ceramics Monthly April 1985; Chicago Tribune November 8, 1981; New York Times December 13, 1981.

SLATER, GARY (October 27, 1947–), American artist, is a sculptor who likes to experiment and interpret new materials. Slater has worked during the last fifteen years to have his geometric shapes complement the spacious western landscape for which he feels a special affinity. His nonobjective forms often soar into the sky. Slater has created cubes, rectangles, cutout cubes, split circles and various forms in stainless steel, which at times he has combined with copper inserts. He also uses tubular steel, Cor-Ten, painted steel and cast bronze. He is particularly excited by the use of color, which has begun to assume an important role in his work. Slater takes his materials from an industrial world that is constantly improving its technology. He is an accomplished craftsman and artist who enjoys the physical aspects of working with a variety of materials.

Slater was born in Montevideo, Minnesota, the youngest of three children. The family lived in Northfield, a small agricultural town. His father was a sales manager for a grain company. His mother was a housewife who enjoyed Sunday painting. Slater's upbringing was uneventful. "Northfield was a friendly and safe town. I was active in track and field events and wanted to be a cowboy. I went hunting and fishing a lot! I also had a penchant for shiny things. I played with matches as child, resulting in some spankings and parental distress." He added: "I am surprised I made it into adulthood!"

Slater attended Northfield High School: "It was a modern place. I had no art training of any kind. I concentrated on French and anticipated becoming a French teacher. When I look back, I had no idea on what to do in life." After graduating, Slater entered St. Olaf College, a coeducational school, in 1965, still pursuing his interest in French. However, he started taking courses in sculpture and wood carving with Arnold Flaaten, a popular teacher and sculptor at the school whom Slater remembers as "understated, but encouraging." In 1967 Slater transferred to the University of Minnesota for a B.F.A. program. His teacher, Kathrine Nash, encouraged him to concentrate on sculpture. "I loved the physical aspect of the work" added Slater. "I also took painting and drawing and hated it. Kathrine Nash was very positive and encouraging; her classes were very structured. As you progressed, you couldn't help but learn the technical things you needed to know."

Slater felt that he had found his direction in life and that sculpture would become his profession. His mother approved of his artistic endeavors. His father never prodded him in any other direction, but said to him: "Do what you do well, and be happy with what you are doing." That

GARY SLATER

philosophy is not too far from Slater's: "My aim in life is simply to be respected as somebody who is doing good work." Asked whether he was involved with any of the campus turmoil of that period, Slater answered that he was indifferent to political activities at the university, feeling that they were not worthwhile. He faced a draft, but was deferred.

Slater graduated with a B.F.A. degree in 1970 and fulfilled his desire to go west by continuing his schooling at Arizona State University. He studied with Ben Goo, a well-respected teacher and sculptor. Slater felt that he had to go his own way to develop as an artist. He did not ask many questions in class, staying aloof and independent. He completed his work for an M.F.A. degree in 1973. Even in his student days, Slater accepted commissions, and in 1973 he received his first major commission from the Western Savings Bank in Scottsdale, Arizona. At that point, he made a "faint effort" to land a teaching job in the arts, but did not really care whether he obtained one or not. However, he did receive an artist-in residence grant from the Mesa Public Schools.

Slater is a spare, laconic man who speaks in short sentences. He particularly likes to work in stainless steel, though he considers it an arduous and time-consuming process. Slater explained: "I had been trying to polish stainless for a long time, but was never satisfied. Dennis Jones, a sculptor at the University of Arizona, showed me how to polish in less than half an hour. Stainless steel is a very hard metal, whereas copper, steel, bronze, and aluminum are relatively soft when

compared to stainless. A lot of different tools are involved depending on the size of the piece. Normally, I use a seven-inch sander and there are three to five sanding steps, followed by three or four buffing steps with different compounds and wheels. All this is necessary to achieve a smooth and shiny surface. Welding is easy work compared to it, though it requires concentration. The finishing process takes about eighty percent of the time. The work is hard and I use assistants."

Sometimes Slater has pieces precut by a commercial place, especially things he cannot handle in terms of available machinery. "I have sheets of metal cut down to a certain size, and pieces of steel rolled to a specific size. Other than the shearing and rolling, I do everything myself."

Slater works with architects and developers. He has collaborated with Alfred Beadle, a contemporary architect in the Bauhaus tradition. "He got me started working in a geometric way with sculpture," he added appreciatively. "My largest sculpture to date is twenty-one feet and weighs 3,000 pounds. It is made of painted tubular steel."

He is also interested in sculptural fountains and the flow of water. One of his favorite pieces, *Sun, Wind and Rain* is made from burnished steel. Burnishing enhances the texture of steel with swirling grooves and lines. Jan Sheridan described that particular piece: "The abstract sculpture consists of four irregular rectangles, one horizontal and three obliquely vertical. Three of the forms emit cool, pencil-thin streams of water from their lower edges. The cascading fountain flows into a circular pool at the base of the sculpture." Slater has said about his work: "My forms are geometric and I believe they both complement and contrast [with] the open, spacious western countryside."

Conceptually, Slater makes skimpy sketches. He calls them "scribbles on paper," but they help him by indicating the direction of a line or a shape. "Nobody but me could make any sense of them. From there, I go to a small model, still very rough. I do it real fast; if it is a commission model, I finish it carefully. Between the time I start a small maquette and by the time I finish, the work has changed greatly."

When asked his opinion on the art of the 1980s Slater stepped aside modestly: "I don't have a good overview, it is going in so many different directions. One direction I see is the use of color. The neon movement is gaining ground and that is a color statement primarily. I myself am using texture and color more and more."

Slater has been married to his wife Paula since 1968. They have three children. Slater goes to work at his studio every day; he arrives about 8 A.M and goes home by around 6 P.M. He tries to avoid working on Sundays or holidays. In discussing his family, Slater said: "Having children has influenced my life enormously. After our first child, I had to take a job in a welding shop. I vowed that would never happen again. With each new child, there are added responsibilities. Your work needs to be better, it has to be crafted, and has to be competitive in terms of other artists' work." In 1976 Slater received a purchase award from the Tucson Museum of Art, and a year later won another purchase award from the city of Palo Alto, California for an outdoor sculpture piece.

Slater's studio, which he shares with another sculptor, is situated in an old industrial park about a ten-minute drive from his home. It is a large shed with a small adjoining office. The studio contains primarily machine-shop equipment like sanders, buffers, hoists, a band saw, and welding equipment. The place is cluttered with work in progress, components, and leftover metal pieces. The studio opens onto a yard with a large cement slab, where some very large pieces stand. Slater commented: "You have to make sure, if you want to discard a piece, to destroy it completely, or you may encounter it again."

Like many artists, Slater likes to work in series. One of his series, the "Boomerang" series, comprised large pieces, angular, jutting upward toward the sky. In his "Sonora" series (1982) he combined stainless steel with inserts of crushed copper pieces. Slater became fascinated with stainless-steel cubes: "I find the cube shape strong, incisive, and exciting. It gives me a feeling of solid mass and it can be used in an infinite variety of ways. Sometimes I get tired of it and turn to something else. But I always come back to cubes, because there is much to be done before I have fully explored and expressed the possibilities."

The art critic Dr. Harry Wood commented on Slater's cubes: "Not being much of a cube lover myself, I was surprised that I found Gary Slater's stainless steel stacks dynamic and powerful. Two things which he does turn the sterile steel crates into vivid experiences. First, he welds them together in precarious piles that impinge on the body's balance system. Viewing one is like teetering across a canyon on a high cat walk." Secondly, he offsets the hard-sharp nonhumanity of cubes by sanding them in swirling patterns with various coarse or fine grits. Wood concluded: "Is Gary Slater part of the megamachine or part of the revolt? Try his work on your eye and discover for yourself."

In Slater's recent "Desert Flower" series, which he feels represents a high point in his career, he combines all the metals he has worked with over the years. In starting "Desert Flowers," Slater felt the need to try something new. He wanted to break with his previous exploration of form. The new shapes enjoy an inventive purity and freedom. Slater plays with materials and explores more fully texture, form, shape, and color. He uses red, blue, and yellow and colorful patinas. "If a piece is well done, large or small, the spirit of the piece is still the same."

Slater likes to discuss the technical aspects of sculpture: "I consider sculpture the strongest form of expression. Each metal has its own advantages. Each metal has its own character. Copper is hard to put together and control; it buckles and discolors. Both stainless steel and Cor-Ten are predictable, although stainless steel is more expensive and harder to work with. It takes about three times longer to create a stainless steel piece, but I like the idea of permanence. Steel is certainly one of the most indestructible materials." He added assertively, "I take a great deal of care that any finishes I put on will last."

Slater does not follow art criticism. He considers most critics too cerebral and convoluted. Sometimes, it seems, he feels that the world should come to him. He likes the early work of the Californian sculptor Fletcher Benton, respects George Segal, and is impressed with the work of Jerry Peart, an expatriate Arizonian now living in Chicago and doing "large, colorful" sculptures.

Gary Slater is not a man in a hurry. He carries with him the countenance of a solid midwesterner. Repeatedly he uses words like well crafted, well thought out, technically sound, and challenging. He feels that in the ever-changing artistic climate he is involved with the technology while relishing the inventiveness of abstraction. He feels liberated by the use of color and shows an intense appreciation of texture. Slater has summed up his own artistic philosophy: "In a controversial world, I want my art to be enjoyed and I want it to last."

EXHIBITIONS INCLUDE: Bowers Mus. (two man show), Santa Ana 1974; Southwest Fine Arts Biennial, Mus. of New Mexico, Santa Fe 1976; National Drawing and Small Sculpture Show, Kutztown State Col., Penn. 1977; Outdoor Sculpture Show, Palo Alto 1977; Ariz. State Univ. (two man show), Tempe 1979; Arizona Biennial, Tucson Mus. of Art, 1980; Mus. of Northern Arizona, Flagstaff 1980; Fine Arts Cntr., Tempe, Ariz. 1984; Elaine Horwitch Gal., Santa Fe, N. M. 1984; Kimball Art Cntr., Park City, Utah 1985, '87; "Jewels of the Desert," Elaine Horwitch Gal., Palm Springs, Calif. 1986; Juried Invitational Tucson Sculpture Exhibition, 1987; Elaine Horwitch Gal., Sedona, Ariz. 1988;

COLLECTIONS INCLUDE: Century Square Offices, Pasadena; WTTW Television, Chicago; International Harvester Corporation; River Forest State Bank, Ill.; Ambassador Row Shopping Cntr., Lafayette, La.; Metro Cntr. Offices, Albuquerque; Sentry Cntr. Insurance, Scottsdale; Western Electric, Phoenix; Western Savings, Phoenix; Memorial Hospital, Phoenix; Westridge Mall, Phoenix; St. Joseph's Hospital, Phoenix; Westcourt Hotel, Phoenix; American Telephone & Telegraph, Phoenix; Desert Samaritan Hospital, Mesa; Patterson Arriba Development, Chandler; Univ. Towers, Tempe; Arizona Commerce Bank, Phoenix; Nabisco Corporation, E. Hanover; Maurin-Odgen Development, Lafayette; Bowers Mus., Santa Ana; City of Monterey Park; City of Palo Alto; Univ. of Minnesota, Minneapolis; New Mexico Mus. of Fine Art, Santa Fe; Del Mar Col., Corpus Christi; City of Phoenix; Arizona State Univ., Tempe; Phoenix Community Col.; C T & E, Dallas; Tucson Mus. of Art.

ABOUT: Who's Who in American Art, 1989–90. Periodicals—Arizona Republic August 24, 1980, July 7, 1985; Art Talk June–July 1986; Scottsdale Daily Progress August 18, 1978; Scottsdale Progress November 14, 1976; Southwest Art December 1980.

SOTO, JESÚS RAFAEL (June 5, 1923–), Venezuelan-born French artist, was born in Ciudad Bolívar, a small city on the Ontario River in the eastern interior of Venezuela. He studied at the Escuela de Artes Plásticas y Aplicadas in Caracas (1942–47), then was named director of the Escuela de Bellas Artes in Maracaibo, the country's second city and a major petroleum center. In 1950, dissatisfied with administration and feeling unfulfilled as an artist, he resigned his post and left for Paris, where he has lived and worked ever since.

"When I went to Caracas in 1942," he told the Journal de Genève in 1970, "I came into contact with so-called modern art, especially with the French school. It was then that I came to know the work of Cézanne and Van Gogh. What particularly impressed me at the time was a still life of Braque's from the period of synthetic cubism. I was entranced by it, and immediately set to work on pure art—I am not afraid to employ that term. For me, art is a science, through which a greater knowledge of the universe is achieved. From that time onward I sought the artists who, in the course of history, had adopted this same position: Cézanne, the cubists, etc."

Soto's earliest paintings, done when he was still in Venezuela, were landscapes and still lifes very much in the manner of Cézanne. But all figurative content disappeared from his art once he arrived in Europe. "Suddenly," he continued, "the need arose in me to find contemporary art. . . . In Paris I discovered Mondrian,

Malevich, and the whole spirit of the Bauhaus, artists who had not yet been given their true dimension. Some were unknown and others were very little appreciated. Nevertheless, I set myself the task of studying their works, and succeeded in assimilating them within a relatively short period of time. From that point onward my work began to develop in an evolving way. My work is the result of those discoveries and that attitude. About 1950, abstract art was in the process of working out a new and still limited mode of expression. It was necessary, however, to use that art in order to reach new horizons. Rather than deny space and its dimensions, I determined to use it. This situation led me to confront the problems of time and its utilization, and to formulate the fourth dimension as a plastic element."

Soto's earliest works in Europe were paintings using the principle of the series. "I began with the idea of repetition of a single element as the only way, for the moment, to abolish form as well as the flat surface of the canvas." Those series paintings look like typical examples of optical art: repeating patterns, rather large in size, predominantly black and a single light color. He gradually refined them in 1951–54, especially in a group of works called "Superimpositions," in which a regular grid of small, identical dots is applied to a piece of square or rectangular clear plastic, which is then set at an angle over a second grid, similarly dotted. The dots' density varies at different points in the work.

The artist's major breakthrough, however, occurred in 1954, with a work similar to the Superimpositions, in which the transparent grid, covered with white dots, was fixed not directly to the black-dotted backing panel, but instead eight centimeters in front of it. That was Soto's first kinetic composition, so termed because the changing, vibrational effect is obtained by the spectator's own movement: "I succeeded in creating true sensations of optical movement and thus, in progressive steps, constantly succeeded in conferring movement on the image, resorting to no other means but man. I made a great effort to find an expression in which the human being would serve as a motor, at the same time as I felt that the spectator was becoming an integral part of the work. It was then that I developed that type of symbiosis, that communion, of man–work of art."

In 1955 he participated in the epochal group exhibition "Le Mouvement" at the Denise René Gallery in Paris, joining Agam, Bury, Calder, Duchamp, Jacobsen, Tinguely, and Vasarely. In *Spiral with Red* (1955), his principal work for that exhibition, two spirals, one of transparent Plexiglas, are superimposed, separated by fif-

teen centimeters. The viewer's movement causes the spirals to join and separate, the masses to link and draw apart. To Jean Clay, a critic who has appreciated Soto's art from the beginning, the piece resolved "two fundamental problems . . . at one and the same time: 1. the problem of movement— . . . time is added to the three plastic dimensions and the work cannot be interpreted without the concept of duration; 2. the problem of destruction of form, of dilution of matter, since as the spectator moves the volumes recorded by the artist alter incessantly."

Soto's art from that time on developed that insight: all the works are made to move with no motor but the spectator. In a series called "Writings," begun in 1963, thin, curved wires are suspended above a panel covered with thin, regular, vertical lines. Another series, "Vibrations," from about the same time, accomplished the same illusion with similar materials. One of those pieces, *Vibration* (1965), was exhibited in "The Emergent Decade" at the Guggenheim Museum in New York City in 1966.

The artist's interest in spectator participation grew apace. In the late 1960s and during the 1970s, he produced an extensive series called "Penetrables," forests of thin tubes or strands of nylon suspended from ceiling to floor, forming an environment through which spectators were encouraged to walk. In 1969, at the Musée d'Art Moderne de la Ville de Paris, he exhibited a vast Penetrable covering five hundred square meters. "It's a question of demonstrating," he remarked at the time, "that we live in space. My strands are there to represent the flow of invisible matter in which we move throughout our existence." He then discussed a theme that has featured in many of his interviews: the vast difference between the art of the past and that of today. "When we go around a room covered with paintings, . . . we remain always facing the work. We remain observers. With my Penetrables, which invade the totality of spaces, we are no longer in front of the work, we are within it. Furthermore, we know today that man is not on one side and the world on the other, as they believed in the Renaissance. We swim in the space-time-matter trinity as a fish swims in water."

Soto's cool, grave, elegant constructions, needing spectator participation for their proper functioning, became extremely popular. During the 1969–70 season, he had more simultaneous exhibitions throughout Western Europe than any other artist of his generation: six shows in Italy alone, plus a vast traveling retrospective in the major modern museums of Bern, Düsseldorf, Hanover, Amsterdam, and Brussels. Acclaim

was not the only critical reaction, however: his work was never particularly well received in the United States. One critic confessed to his lack of admiration for the *Guggenheim Penetrable* (1974), the centerpiece of the artist's only American retrospective, at the museum in 1974: "And yet emerging from this experience, one has the feeling, so what? The question that arises with Soto's involvement of the viewer is how participatory is it really? Although the works force one into an awareness of one's perception, it is an awareness that does not question but merely receives the information as given. One is simply presented with certain perceptual phenomena, which does not lead one anywhere beyond the fact that they exist."

In the late 1970s, Soto turned more and more to environmental art on a grand scale, much of it executed for corporate sponsors. Of those pieces, perhaps the most talked about was the very large off-the-floor group of translucent tubes installed in 1977 in the huge central indoor space of the Royal Bank Plaza in Toronto. As workers and clients passed through the bank, the tubes seemed to change position and relationship. By that time, however, the artist had apparently abandoned the more direct spectator participation of the Penetrables. The colors of his materials became even more muted than usual—they have always been quiet and suggestive, rather than dominant and assertive. "I think when less color is used," he explained to Nick Johnson in an interview about the Royal Bank installation, "especially in a large work, the environment, the relationships of space, light, and time, give it many more shades than one could ever actually paint there. This gives the sun, or the movement of the sun, a greater chance of bringing out all the possibilities. Or the moon. . . . The more I do large-scale work the more subdued the color is going to be, to obtain the maximum possible variation."

Soto's artistic vision and his attempts to describe it have remained remarkably consistent over the years. People must realize, he believes, that art has undergone and is undergoing the same evolution as every other human conception and value; they must also accept that figurative art of all kinds is meaningless and dead. Socialist realism, for example, was "a total catastrophe." He is always the uncompromising modernist. "I have been lucky," he said to Johnson, "because I am satisfied with the road I have taken, apart from whether my work is worth anything or not. I am satisfied because I have been able to work with very few detours. A few times I've been interested in expressionist ideas because I don't want to miss anything. I want to know everything. But in general I'm a pure structure type.

I've been fortunate from the beginning to travel this single path knowing that as long as I stay within what I call a sense of pure structure in art I am doing the best I can. It is difficult, above all in this culture, which thinks of art as the unburdening of the spirit instead of as a necessary function in society. This is an enormous mistake. There is no more spiritual unburdening in being an artist than in being a scientist or a philosopher. To be a great artist you need just as much talent as you need to be a great scientist or a great philosopher. But since the Renaissance we have been led to believe that art is something that comes when we are worn out, after we have given everything we've got, then comes a kind of relaxing and something called free spirit and profundity. This concept is absolutely wrong. Art is as important as anything else we do and in order to be important it needs the same strength of knowledge and of spirit."

Soto has won several prizes in his native Venezuela, as well as the Wolf prize at the São Paulo Bienal in 1963 and the David Bright prize at the Venice Biennale in 1964. In 1973 he was honored by his native city when the Jesús Soto Museum of Modern Art opened in Ciudad Bolívar.

EXHIBITIONS INCLUDE: Atelier Libre de Arte, Caracas 1949; Gal. Denise René, Paris 1956, '67, '70; Mus. of Modern Art, Caracas 1957, '61, '79; Gal. Rudolf Zwirner, Essen 1961; Gal. Brusberg, Hanover 1961; Gal. Ad Libitum, Antwerp 1962; Gal. Edouard Loeb, Paris 1962, '65; Mus. Haus Lange, Krefeld, West Germany 1963; Gal. Muller, Stuttgart 1964; Kootz Gal., NYC 1965; Signals Gal., London 1965; Gla. Schmela, Düsseldorf 1966; Gal. del Naviglio, Milan 1966, '69; Gal. del Deposito, Genoa 1966; Pfatzgal., Kaiserlautern, West Germany 1966; Gal. Françoise Mayer, Brussels 1968; Kunsthalle, Bern 1968; Stedelijk Mus., Amsterdam 1968; Marlborough Gal., Rome 1968; Palais des Beaux-Arts, Brussels 1969; Gal. Lorenzelli, Bergamo 1969; Notizie, Turin 1969; Gal. Flori, Florence 1969; Gal. Giraldi, Livorno 1969; Gal Estudio Actual, Caracas 1969; Mus. d'Art Moderne de la Ville, Paris 1969; Svensk-Franska Kunstgal., Stockholm 1969; Gal. Godart Leffort, Montreal 1970; Gal. Suvremene, Zagreb 1970; Gal. della Nova Loggia, Bologna 1970; Gal. Semiha Huber, Zurich 1970; Kunstverein, Mannheim 1970; Marlborough Gal., NYC 1970; Gal. Buchholtz, Munich 1970; Ulm Mus., West Germany 1970; Mus. of Contemporary Art, Chicago 1971; Gal. Rotta, Milan 1971; Martha Jackson Gal., NYC 1971; Gal. Denise Gené-Hans Meyer, Düsseldorf 1971; Mus. de Bellas Artes, Caracas 1971; Gal. Pauli, Lausanne 1971; Gal. Beyerler, Basel 1972; Gal. Levi, Milan 1972; Mus. de Arte Moderno, Bogotá 1972; Gal. Tempora, Bogotá 1973, '81; Corsini, Rome 1973; Gal. Godel, Rome 1973; Solomon R. Guggenheim Mus., NYC 1974; Denise René Gal., NYC 1974, '75; Cntr. Georges Pompidou, Paris 1979. GROUP EXHIBITIONS INCLUDE: "Le Mouvement," Gal. Denise René, Paris 1955; Bienal, São Paulo 1957, '63; Biennale, Venice 1958, '62, '64;

"International Exhibition," Carnegie Inst., Pittsburgh 1967.

ABOUT: Boulton, A. Soto, 1973; Clay, J. Soto, 1969; Emanuel, M., et al. Contemporary Artists, 1983. *Periodicals*—Artforum February 1975; Art in America February 1965, December 1965, January 1966, January 1971, February 1975; ARTnews February 1963, April 1965, March 1966, December 1969, November 1971; Artscanada Autumn 1972, March 1978, October–November 1978; Arts Magazine May 1965, May 1966, November 1971, May 1975; Connaissance des Arts June 1969, December 1974; Connoisseur April 1972, May 1975; Studio International September 1965, January 1966, February 1967, September 1969; XXe Siècle December 1978.

STÄMPFLI, PETER (July 3, 1937–), Swiss expatriate painter whose pursuit of image as structure led him on a fairly unique itinerary, quite independent of short-term trends and fashions. In the early 1960s Stämpfli was one of the first European artists to seek figurative alternatives to the waning traditions of postwar abstraction; by the end of the decade he was working his way through representation to a new, abstract geometry that he has continued to develop—notwithstanding the Conceptual art of the 1970s and the new figuration of the 1980s—for nearly twenty years.

The son of an industrialist, Stämpfli was born in Deisswill, in the German-speaking canton of Bern. "I always dreamed of being a painter," he told Alfred Pacquement in a 1978 interview, adding that he still had small, abstractlike paintings that he did from the time he was five years old. As a matter of course, he prepared to enter the Ecole des Beaux-Arts in nearby Bienne following high school, but once accepted, he discovered that the program was oriented to applied rather than fine arts, and after two years he left to study with Max von Mühlenen, a disciple of André Lhote, in Bern. There his experience was more positive, largely because von Mühlenen did not attempt to impose his own style but instead presented his student with different options. Stämpfli remained with him for another two years, also working as his assistant on various commissions for church windows and mural paintings. He then spent two years in the Swiss military, but instead of resuming work in Bern, he abruptly packed two suitcases and went to Paris.

Behind that move, he indicated, was an exhibition of contemporary American art that he saw in Basel and which gave him his first exposure to the paintings of Jackson Pollock, Franz Kline, and Sam Francis. For the twenty-two-year-old Stämpfli, who was then painting abstract landscapes, "it was a shock. Enormous canvases, something unknown, a totally new space. . . . I understood that I couldn't go back to my teacher anymore, couldn't limit myself to the world that I knew." Arriving in Paris early in 1960, he made his way to Montmartre and stumbled upon a big, damp studio, once occupied by Picasso, in the famous Bateau-Lavoir. That space allowed him to work on a large scale, and he began painting in the spirit of the Americans he had just discovered, especially Pollock. After a difficult period of isolation, he began meeting people—including his future wife, Ana Maria Torello, whom he married in 1961—and frequenting the galleries. For a time he experimented with color through geometric designs but he then began to reconsider the problem of figuration. "The problem I was starting to pose for myself," he told Pacquement, "was how to reintroduce figuration into painting in a different way. Obviously I wasn't interested in making portraits or still lifes, but to arrive at a new expression, a new vision."

Chronologically, his shift in focus coincided with the emergence of the nouveaux réalistes in France and the American pop artists. Similarly inspired by the manifestations of mass culture he saw around him—in particular, subway posters and magazine ads—he began enlarging images taken from magazines and painting them on colored grounds. Around the end of 1962, he eliminated the surrounding colors in order to isolate the figure on a stark white ground, and over the next couple of years, he developed a repertoire based on conventional objects and actions that became strikingly unconventional when taken out of their usual contexts: a silhouetted self-portrait walking into the nonexistent depth of the otherwise empty canvas (*Autoportrait au raglan,* 1963), a single rose painted from a magazine ad (*Rubis,* 1963), the dashboard of a car (*Ma voiture,* 1963), a hand applying eye makeup (*Fard,* 1965) or holding a wine glass or a cigarette (*Cocktail,* 1963; *La Cigarette,* 1964), or a woman doing the laundry (*Machine à laver,* 1963).

Those outsized emblems of consumer society, flatly rendered, with none of the hi-tech dazzle of pop art, attracted considerable attention when Stämpfli began exhibiting them in 1963. The critic Gérald Gassiot-Talabot, for example, wrote after the Paris Biennale, "A certain poetry of the unexpected, I would say almost a kind of mystery, springs from this painting obsessed with the object." As he took pains to point out, that sensibility had little in common with the "brute statement" of pop art, yet in other quarters those and subsequent works were often

thrown in with the general American phenomenon and, in particular, paired up with the paintings of James Rosenquist. Stämpfli himself freely acknowledged his interest in the pop movement, as well as a certain conceptual influence from Roy Lichtenstein and Tom Wesselman, but he insisted that his intentions were quite different, especially in relation to Rosenquist, whose paintings "explained too much about the relationship of one image to another." In his own work, he later pointed out, the object was interpreted formally, not narratively: "No lipstick smudge appears on the wine glass. The eye of the woman applying eye shadow is expressionless. My aim was to present both fragments and objects in an emotionless manner, without a demand for narrative interpretations. They were to possess the coldness of illustrations found in dictionaries." And, he noted, in further contrast to the Madison Avenue mode of pop art, "I doubt that advertisers would find my way of presenting the products suitable for enticing consumers to buy them."

Stämpfli's determined pursuit of the iconic image resulted in an evermore restricted visual focus; the fragment gave way to single images—pastries (*Baba*, 1964), a mouth (*Bouche*, 1964), the front wheel of a car (*Grand Sport*, 1966); then, with the pair of lips that he called *Rouge Baiser* (*Red Kiss*, 1966), he decided that the white ground was also unnecessary and simply cut it away, "so that this mouth is suspended in the air, so that it lives by itself without being attached to anything."

It was also around this time that the car wheel began to figure prominently in his repertoire. The car had always attracted him as an emblem of movement and speed, and after *Ma voiture* he had painted various interior and exterior views, always fragmentary, always immobile, and always presenting the same pristine appearance as the unsmudged wine glass or the expressionless eye. But in the course of the late 1960s, the wheel emerged as an autonomous element, offering him the possibility of the kind of representational abstraction that he had always been seeking. That evolution, the "essential step," as he calls it, was *SS 396 no. 2* (1969), a frontal image of a wheel basically schematized into three concentric circles, which he then proceeded to cut out like a geometric canvas. "No photo, no magazine had represented a wheel in that way," he pointed out to Pacquement, indicating that it was "like the creation of a kind of abstract painting where the forms, only because they are familiar to us, make us think of a wheel."

The same year, Stämpfli made a short film, *Firebird,* which was a rapid montage of car fragments, much like his earlier paintings, but after *SS 396 no. 2* (the wheels, like the car parts before them, usually bore the names of the models), Stämpfli did not paint any more wheels. "That would have been repetitive, and I didn't see any sense in it," he insisted. Instead, with the seemingly inevitable "logic" that has governed his development, he turned his attention to the next sub-unit of the car, which was the tire. Working alternately with shaped and rectangular canvases, he used what might seem to be one of the least intriguing aspects of automobile anatomy—the dark, dense, rubber tire—in order to explore variations of structure, scale, and form. In keeping with the appearance of the real-life models, his palette, which had been disposed to the rich reds of lipstick and the shiny blues of car bodies, now fell within the range of blacks, browns, and beiges; external light sources and the highlights they had produced were likewise abandoned, but in their place, the tire treads themselves—as subtly varied as any hard-edge painter's canvases—provided a lively surface pattern.

For the Swiss pavilion at the 1970 Venice Biennale Stämpfli assembled a group of these tire paintings as an environment, with the shaped canvases resting against the wall at floor level like sculptural presences and the more fragmentary rectangular paintings hung above them. François Pluchart, who considered the installation to be the "best participation in the Biennale," noted that Stämpfli "played the game of austerity to the hilt," with the result that the paintings "not only don't compete with each other, but on the contrary, are mutually enhancing." In his view, "It is in this concision, which is both an analysis and a synthesis, that Stämpfli's success lies." In his catalog essay for the Biennale exhibit, Félix Baumann suggested that alongside the "kinship" between Stämpfli and the American pop artists, his work bore comparison with the French literary phenomenon of the *nouveau roman,* or "new novel," associated with Alain Robbe-Grillet and Nathalie Sarraute: "With these writers, as with Stämpfli, a detail or an insignificant fact assumes capital importance because a chance observation that becomes the object of a long development is condensed, intensified, and amplified. By contrast, the action of the story is reduced to its most simple expression, with the framework that encloses the mass of isolated observations reduced to a strict minimum."

The appropriateness of that comparison was to become increasingly evident in the works that followed. Later in 1970, for example, Stämpfli was to exhibit a single monumental tire, *M 301,* measuring nearly seven feet wide and twenty

feet long, and which he laid out on the the gallery floor. The following year, for the Paris Biennale, that horizontal tread gave way to another giant canvas, *Royal,* which was mounted vertically against the wall with a silk-screened "tire track" extending more than a hundred feet into the exhibition space. "My interest," he later recalled, "was shifting toward the structures within the painting. Already the form didn't count so much anymore." Indeed, by the mid-1970s he had once again narrowed his focus—"like a long traveling shot," in the words of Daniel Abadie—to the tire track itself. A by-product of that evolution was a second film, *Ligne Continue* (Continuous Line, 1974), which was inspired by the road markings Stämpfli saw every day as he drove to his studio, and which consisted of lines and tire tracks painted directly on the film stock. The separation of track and tire in his paintings occurred around the same time with *M301 no. 3* (1974), a long strip of canvas painted with the track alone and exhibited on a mounting diagonal that, like the film, recreated the sensation of the highway perspective.

By the time of his 1976 exhibition at the Galerie Jean Larcade in Paris, the tracks had become allover patterns, linear configurations clearly derived—for anyone aware of Stämpfli's earlier work—from the tire motifs, yet autonomous visual entities. Toward the end of the decade, working in pencil or pastels, he experimented with more complicated spatial illusions that were reminiscent of stylized architectural drawings but derived nonetheless from the same textured tire surface that had been his point of departure for the last decade. At the same time, through the use of pastels, he began to reinvest that abstract geometry with the offbeat color of his early works, although now in lively, mosaic-like combinations rather than the monochromes of the 1960s. "In playing with the basic structures of [the] simplest kind of image," wrote Raoule-Jean Moulin in 1981, "the painter leads us to conceive [of the fact] that the image doesn't hold, or no longer holds, what was known, or what was thought to be known. . . . In this way, he projects us into the mental space where he operates, where the persistence of the tire poses the question of painting."

During the 1980s, as the patterning of Stämpfli's canvases became larger and more stylized, and the colors bolder and more often primary, the artist unexpectedly found himself back in fashion alongside the youthful neo-geo painters of New York City. For Stämpfli, a soft-spoken but convivial man who tends to emphasize the element of "logic" in his development, the question of being "in" or "out" seems largely beside the point—since he made the switch from

wheels to tires in 1969, he acknowledged, he has never attempted so much as a drawing of another motif. To be sure, the tire itself has long since lost its original connotations for him, and the tire names have duly been replaced by unrelated titles like *Gipsy* (1980), *Ferlom* (1982), or *Petra* (1987). Yet, as Gilbert Lascault suggested on the occasion of Stämpfli's 1987 retrospective in Lyon, the fact that those paintings still "belong to the universe of the tire" endows them with a special complexity, a geometry that is "richer and more subtle than those chosen by painters who go directly to abstraction."

EXHIBITIONS INCLUDE: City-Gal., Zurich 1966; Gal. Jean Larcade, Paris 1966–78; Gal. Tobiès & Silex, Cologne 1967; Saõ Paulo Bienal 1967; Cntr. de Artes Visuales del Inst. Torcuato D'Tella, Buenos Aires 1968; Gal. Bischofberger, Zurich 1969; Gal. Rive Droite, Paris 1969–71; Venice Biennale 1970; Gal. Richard Foncke, Ghent 1971; Gal. Christian Stein, Turin 1971; Pal. des Beaux-Arts, Brussels 1972; Mus. Gal., Paris 1974; Mus. de L'Abbaye Sainte-Croix, Les Sables-d'Olonne 1976; Gal. Maeght, Zurich from 1979; Mus. d'Art et d'Industrie, Saint Etienne 1979; Mus. National d'Art Moderne, Paris 1980; Gal. Maeght, Paris 1980; Kunsthaus, Aargau 1982; Gal. Sapone, Nice 1982; Gal. Lelong, Paris 1987. GROUP EXHIBITIONS INCLUDE: "42 Junge Schweizer," Kunstmus., Saint Gall and Mus. Schloss Morsbroich, Leverkusen 1960; Paris Biennale 1963, '65, '71; Third International Young Artists Exhibition, Tokyo, Calcutta, and New Delhi 1964; "Unter Vierzig," Gal. d'Art Moderne, Basel 1967; "Wege und Experimente," Kunsthaus, Zurich, Wolfgang Gurlitt Mus., Linz, Gal. am Landesmus. Joanneum, Graz 1968; "22 Jonge Zwitsers," Stedelijk Mus., Amsterdam and Kunsthalle, Bern 1969; "Distances," ARC, Mus. d'Art Moderne de la Ville de Paris 1969; "The Swiss Avant-Garde," NY Cultural Cntr., 1971; "60-72: Douze Ans d'Art Contemporain en France," Grand Palais, Paris 1972; "Contemporary Swiss Art," Tel Aviv Mus. 1973; "Hyperréalistes Américains, Réalistes Européens," Kunstverein, Hanover, Cntr. National d'Art Contemporain, Paris, Mus. Boymans, Rotterdam, Rotonda divia Besana, Milan 1974; "Panorama del'Art Français 1960–1975" (trav. exhib., Athens, Thessalonika, Istanbul, Teheran, Baghdad, Tel Aviv, Cairo, Tunis, Algiers, Casablanca, Rabat) 1975; "Aspects of Realism" (trav. exhib., Stratford, Vancouver, Winnipeg, Montreal) 1976; "Paris–New York," Cntr. Georges Pompoidou, Paris 1977; "Mythologies Quotidiennes," ARC, Mus. d'Art Moderne de la Ville de Paris 1977; "Biennale de Paris, une Anthologie, 1959–1967," Fondation National des Arts Plastiques et Graphiques, Paris 1977; "Tendances del'Art en France 1968–1978," ARC, Mus. d'Art Moderne de la Ville de Paris 1979; "Schweizer Kunst," Kunsthaus, Zurich and Mus. Cantonal, Lausanne 1980; "Tendances de la Peinture Figurative Contemporaine," Forum des Cholettes, Sarcelles and Mus. de Belfort 1981; "1960," Mus. d'Art et d'Industrie, Saint Etienne 1983; "Entwicklung zur Gegenwart," Kunsthaus, Aargau 1984; Antwerp Biennale 1985; "39, ruhrfestspiele—Dinge des Menschen," Städt. Kunsthalle, Recklinghausen 1985;

"Das Automobil in der Kunst," Hause der Kunst, Munich 1986; "ler Festival International du Dessin Contemporain, Grand Palais, Paris 1987.

COLLECTIONS INCLUDE: Gotthard Bank, Lugano; Mus. National d'Art Moderne, Paris; Mus. d'Art et d'Industrie, Saint Etienne; Rainbow Foundation, Hara Mus., Tokyo; Kunsthaus, Zurich; Collection de la Peau de Lion, Zurich; Collection Bruno Bischofberger, Zurich.

ABOUT: Emanuel, M., et. al. Contemporary Artists, 1983; Jouffroy, A. La Peinture de Stämpfli, 1970; "Peter Stämpfli" (cat.), Kunsthaus, Aargau, 1982; "Peter Stämpfli: Oeuvres récentes" (cat.), Cntr. Georges Pompidou, Paris, 1980; "Stämpfli" (cat.), Galerie Maeght, Paris, 1980; "Stämpfli" (cat.), Salon d'Automne, Lyon, 1987. *Periodicals*—Art/Cahier 5 (1978); L'Humanité (Paris) January 12, 1981; Leondardo Spring 1979; Opus International May 1977; *Video*—Un entretien avec Daniel Abadie, Lyon, 1987.

GEORGE SUGARMAN

SUGARMAN, GEORGE (May 11, 1912–), American abstract sculptor, was born in New York City. His father worked for a time as an oriental rug salesman, and the artist remembers loving as a very young child the rugs' beautiful and vivid designs. Sugarman attended public schools in New York, then City College, from which he took a B.A. degree in 1938. He served all of World War II (1941–45) in the navy, but had made no clear choice of career by the end of the 1940s. He left for France to study art on the GI Bill in 1951, enrolling in the sculpture classes taught in Paris by Ossip Zadkine, whose cubist style—owing much to Zadkine's own teacher, Jacques Lipchitz—Sugarman briefly took on as his own. He lived and traveled in Europe for several more years, returning to New York in 1955.

Sugarman is generally considered among the most innovative, and least well known, of long-practicing, contemporary American sculptors. As Elizabeth Frank put it, he "has had so many ideas, and invented so many problems and solutions outside the stream of fashion, that his whole career needs to be seen in context." He has always been a maverick, not a follower, and has always found something to react against in the prevailing artistic rage of the moment. Moreover, there is in his work a consistent vision that interrelates the whole of his artistic production. Some of the sculptural problems he has faced he formulated into a statement: "What would happen if: I put sculpture on the floor; I put it on the ceiling; I got rid of the pedestal or integrated it; I covered whole walls with sculpture; I separated the parts of a sculpture and made them diverse; I used color; I extended the relationships into space in all directions; I combined elements of painting and sculpture." The statement was made for a show of relief collages and models for public sculpture at the Robert Miller Gallery in New York in 1980; every one of the problems, however, he had long since faced and solved.

Characteristics of cubist sculpture, in particular the tightly interlocking masses, are plainly visible in Sugarman's earliest work from the 1950s, which was on a modest scale, done mainly in terra-cotta. What struck him most forcefully about New York after four years in Europe was the "conglomerate but somehow cohesive structure of the city." That unplanned energy, synergistic in nature, which attained its force from its cumulative effect, was an idea he wanted to put into plastic form: unity out of disparity.

He soon switched his principal medium from clay to laminated wood—the pine pallets abandoned by deliverymen were free for the taking all over lower Manhattan, and Sugarman had very little money. His sculptures grew larger, with more open, abstract forms. In the late 1950s he became a founding member of two important artistic circles, the New Sculptor Group, which sought a truly nonreferential abstract sculpture, and the Brata Gallery, a twenty-member artists' cooperative. Among his fellow members in the latter group was Al Held, who has remained a close friend for many years. Working in laminated wood—Sugarman clamped and glued the pallets together, forming thicker pieces which he then shaped with chisel or power tools—allowed the artist greater freedom to articulate sculptural space, extending his forms much further than had been hitherto possible. He began making

wall reliefs, forerunners of those he and others produced in the 1970s and 1980s, in which the elements could be added endlessly, in a non-repeating series (*The Wave* and *The Wall*, both 1959). The idea of the continuum was extended into an extraordinary piece (not a wall relief) called *Six Forms in Pine* (1959), remarkable for its horizontal extension, growth, and change over its twelve-foot length and also for its suspension between two pedestals of unequal size. The disjunctive clarity and conjunctive unity of the six concomitant forms were new in sculpture, and the piece won the virtually unknown sculptor second prize (after Alberto Giacometti and before David Smith) at the 1961 International Exhibition of Contemporary Painting and Sculpture at the Carnegie Institute, Pittsburgh. The prize alleviated Sugarman's struggle slightly, but there was no general rush to buy his work or to offer him exhibitions. Beginning in 1960, however, he began teaching sculpture in the graduate division of New York's Hunter College, a position he has retained ever since.

Sugarman was one of the first sculptors to use polychromy, in a work called *Yellow Top* (finished on December 31, 1959). (The piece was also remarkable in that it stood directly on the floor without a pedestal; it was completed several years before the first "de-pedestalized" work by Anthony Caro, generally considered the father of the innovation.) The bright, opaque colors of *Yellow Top* clarify and separate each of the work's solid areas. The color scheme was chosen by no means haphazardly: twelve successive coats of paint were needed before Sugarman was satisfied. "It's not a matter of indifference to me," he said in 1963, "whether a certain form is green or black or red. Certain forms and their particular relationships to the next form must be one certain color, whereas in the decorative sense, anything that's pleasing will do." It is generally thought that the primary influence on Sugarman with regard to polychromy was the American painter Stuart Davis, whose 1957 retrospective exhibition featured a catalog with several of Davis's obiter dicta on the subject: "Color must be thought of as a texture which automatically allows one to visualize it in terms of space. . . . Every time you use a color you create a space relationship. It is impossible to put two colors together, even at random, without setting up a number of other events. Both colors have a relative size."

The conjoining of the ideas of color, texture, size, and space had an obvious appeal for Sugarman, sharpening his perceptions about the nature of the forms he was creating. "It was just after I finished *Yellow Top*," he recalled in 1967, "that I realized I wasn't really changing the forms, that there were families of forms, that I would have to make my sculpture out of forms, each one from a different family." The repeated leaflike organic forms of *Yellow Top* were merely the beginning; after only a few years of experimentation, he came to see color as absolutely integral to his work. "In my sculpture," he said in 1963, "the color is as important as form and space. . . . It is used to articulate the subject as much as form articulates the sculpture in space. . . . Just as the form clarifies the space, the color works with the form to help all these other factors along." He achieved a kind of summation of that phase of his work with *Inscape* (1964), a meandering floor piece covering more than a hundred square feet but never more than two feet in height. It consists of about ten extremely disparate forms, dissociated but conjoined, each painted a different, bright color. "Sprawling like a fantastic landscape," wrote Irving H. Sandler, a critic with a particular fondness for and insight into Sugarman's work, "*Inscape* pointed the way to an environmental sculpture large enough to be walked into or to be integrated with architecture. . . . The viewer towered over the work, which hugged the floor; he looked down at it." Sugarman continued to elaborate and refine the importance of polychromy in his work over the next several years; such pieces as *Change* (1965) and *Two in One* (1966) are still regarded as among the best sculpture produced by anyone during the 1960s. His forms grew steadily larger, his "inquiries into form and space" took place on an ever-grander scale. "I like," he wrote in a kind of credo in 1967, "the kind of art that makes a major statement, that keeps aims large. Affirmation, even to the point of ecstasy.

"Abstraction, clarity, specificity, objectivity—without imposed structures. Emotionally neutral, i.e., not heroic or antiheroic, not sentimental or antisentimental. To make the attempt (inevitably intuitive) to deal with the complexity of the physical and emotional world of today, not to deny it; to face it, not to avoid it.

"To attempt less is to achieve less, even if that attempt is successful. Art should not be like a one 100-yard dash, a quart of milk or a size-40 jacket. The artist is not a tidy shopkeeper. Art is not measurable. Sculpture and painting should not be reduced to a minor art, with the minimal interest of pottery or an *objet d'art*." In general, Sugarman seemed to have taken the possibilities of indoor scale to their limit.

During the 1970s the artist became involved in exploring the differences between gallery sculpture and sculpture appropriate for public places. In some of his exhibitions of the first half

of the decade, individual works existed on both levels: as completed sculptures of moderate size, and as models for potential enlargement into major public statements. *Roxanne* (1974), for example, a sculptural group consisting of four separate elements, each painted a different color, disposed horizontally with subordinate vertical axes, measured about five feet at its largest horizontal dimension, but was also projected to be made at twenty-four feet. Interest in public sculpture forced him to abandon his favorite material, wood, for steel and its durability. In his earliest metal pieces, such as *Square Spiral* (1968), the metal is bent into square sectional forms, then painted, so as to suggest laminated wood, but as he worked more with the material he allowed its own properties to emerge. He became ever more keenly aware of the distinction between public and private art. "There are two different art contexts," he said in 1980, "one having to do with public life, the function of buildings, the movement of people, and their comfort as well as their aesthetic enjoyment. The other context is the gallery and museum situation, where audiences may not understand but their minds work within that context—that audience that cares more for beautiful and aesthetically realized objects."

The artist had already successfully accomplished several public commissions in various parts of the United States when he became embroiled in a major national controversy over a large installation, *People Structure* (1976), intended for the new Federal Courthouse in Baltimore. The work consisted of two blue-and-yellow steel bowers or gazebos for sitting and resting under, plus a number of smaller forms for play and contemplation—all set in the middle of a rather stark, flat, cobblestone plaza. After extended hearings, during which the artist termed the ribbonlike structure of bright overlapping cutout forms "something the public can stroll in and sit upon; something they'll feel comfortable with," it became apparent that the opposition to the installation was being led by none other than the chief federal judge for the district centered on Baltimore—undoubtedly the building's most important occupant. "The sculpture would present a serious security problem," wrote the judge to the chief of the General Services Administration, under whose public-art program numerous artists had achieved commissions throughout the country. "The art work could be utilized as a platform for speaking or hurling objects by dissident groups demonstrating in front of the building. . . . Its contours would provide an attractive hazard for youngsters naturally drawn to it, and most important, the structure could well be used to secret bombs or other explosive objects."

Sugarman was quite upset by the controversy, but publicly adopted a rather bemused tone: "I've never heard of death by sculpture," he replied to the judge's attack. "And I may be an optimist, but I don't look on the public as a terrifying body of people. To me the law represents the people, the wishes of the people. I tried to express what I feel the idea of the law should be, an expression of community, in a work accessible to all, whether they see it as art or simply as something they can enjoy." He did, however, "open up" the more enclosed areas of the sculpture in an attempt to satisfy the chief judge. When he refused to withdraw his objections, the artist organized petitions with Artists Equity and presented the GSA with numerous letters from museum officials across the country. The GSA finally ruled in favor of the art, and to date *People Sculpture* has harbored no bombers and few dissidents of note.

In the 1980s Sugarman continued to fulfill public commissions, and after a hiatus he returned to the galleries with relief collages and drawings and paintings on paper. The connection between them and his sculpture is interesting. He has never done renderings for his sculpture works, but instead has used drawing to select ideas worth elaborating sculpturally. The draftsmanship seems complex, crowded, even messy, yet entirely exuberant and energetic. "The movement from drawing to sculpture is reductive," wrote Jon R. Friedman. "The numerous contingencies that are the very stuff that makes the drawings breathe are purged away, leaving an assortment of tidy artifacts ready to be assembled." Friedman feels that the paintings, mostly done in bright acrylic colors on paper, "are clearly the work of a sculptor, and it is the steady sculptural instinct infusing them that accounts for their success as paintings. Even while he piles up pattern upon pattern, dividing and subdividing his surface, Sugarman sustains a spatial clarity that defeats the possibility of congestion and confusion. This isn't a programmatic stratagem, but an instinctive grasp of the spatial implications of drawn and painted marks. Here, on paper, you can feel Sugarman shaping and building with color. Not calculating and engineering, but playing, abandoning himself to a pleasurable and complicated improvisation."

The artist Brad Davis was Sugarman's assistant from 1967 to 1969 and contributed a number of "Recollections" to the catalog of the extensive retrospective exhibition on the artist—the only one ever mounted in America—in Omaha, Philadelphia, and Columbus, Ohio, in 1981–82. Davis recalled how well the artist paid and treated his five assistants, who rewarded

him with "real devotion and quality work. He often said he was a lousy craftsman and appreciated the work we did." Davis's most interesting remarks confirm what some critics have said regarding Sugarman's attachment to form and aversion to style: "Style was something George tried hard to avoid in his own work and criticized strongly in others. He felt style was okay if it occurred naturally as a result of the artist's hand or personality, but it was never a pursuit in itself. George has always talked of 'pushing' his work so it never becomes a style for him. Some criticize his work for its endless change and pursuit of new forms and means. For me it is one of his strengths and signs of integrity of purpose." Finally, Davis sees Sugarman as an artist acutely aware of the artistic ideas flowing about him, yet never taken in by any of them: "George has always responded to the major ideas of the time. His early work has the gesture, rawness, and emotion of abstract expressionist sculpture. He responded to the clarity of form and the gestalt of groupings important to Minimalism, and his use of complex color and repetition relates strongly to the newer pattern and decoration. In each case George was a forerunner in the use of those ideas. He developed a very personal and distinctive use of them. As a consequence he was never really identified with the movements as such, and often overlooked when they were discussed. Still, George remains one of the great individualists."

EXHIBITIONS INCLUDE: Widdifield Gal., NYC 1958; Stephen Radich Gal., NYC 1961, '64, '65, '66; Philadelphia Art Alliance 1965; Gal. Schmela, Düsseldorf 1967; Gal. Ziegler, Zurich 1967, '70, '81; Fischbach Gal., NYC 1967; "Plastiken, Collagen, Zeichnungen," Kunsthalle, Basel, traveled to Leverkusen, Barlin, and to Amsterdam 1969–70; Zabriskie Gal., NYC 1974; Robert Miller Gal., NYC 1977, '78, '80, '89; "Shape of Space," Joslyn Art Mus., Omaha, traveled to Inst. of Contemporary Art, Philadelphia, and Columbus Mus. of Art, Ohio 1981–82. GROUP EXHIBITIONS INCLUDE: Bienal, São Paulo 1963; "Recent American Sculpture," Jewish Mus., NYC 1964; "Sculpture of the 60s," Los Angeles County Mus. of Art, 1967; "Art Vivant 1965–68," Fondation Maeght, Saint-Paul-de-Vence, France 1968; "Monumental Art," Contemporary Arts Cntr., Cincinnati, Ohio 1970; "American Drawings," Whitney Mus. of American Art, NYC 1973; "Sculpture: American Directions," National Collection of Fine Arts, Washington, D.C. 1975. "Contemporary Sculpture from the Collection," MOMA, NYC 1979.

ABOUT: Battcock, G., ed. Minimal Art, 1968; Day, Holliday T., et al. The Shape of Space: The Sculpture of George Sugarman, 1981; Emanuel, M., et al. Contemporary Artists, 1983; Janis, H. and R. Blesh. Collage: Personalities, Concepts, Techniques, 1962; Rickey, G. Constructivism, 1967; Who's Who in American Art,

1989–90. Periodicals—American Institute of Architects Journal October 1976; Architectural Digest June 1984; Artforum Summer 1969, December 1976, Summer 1982; Art in America January 1967, May 1969, July 1969, November 1974, April 1980, April 1983, September 1983; Art International Summer 1969, February 1970; ARTnews February 1959, September 1959, November 1959, February 1960, December 1961, May 1964, April 1965, May 1966, May 1967, May 1968, May 1969, December 1974, December 1976; Arts Magazine February 1960, December 1961, May 1964, June 1966, May 1967, April 1968, May 1968, May 1969, November 1970, December 1974, April 1980, Summer 1980, June 1981, January 1982, October 1982, December 1982; Craft Horizons March 1967, February 1975; Flash Art January–February 1980; Studio International March 1962, July 1964, January 1965, August 1965, July 1966, June 1968, June 1969.

SULTAN, DONALD (May 5, 1951–), American painter and graphic artist, is steadily gaining an international reputation as one of the most innovative of those artists of his generation who have sought a return to recognizable imagery. Much excitement centers around the disparity between Sultan's extremely elegant, precise images and the "kitchen-floor" materials in which they are executed: vinyl tiles, tar, plaster (or Spackle), latex paint, and Masonite board. Sultan's work not only presupposes a special imaginative feel for the possibilities of such unlikely media but demands considerable manual labor. "Physical engagement" though, the artist maintained, "helps you to feel you've made the *thing itself*, not illustrated it." As the critic Barbara Rose noted, he exhibits "a typically American willingness to experiment with surfaces as well as media and techniques." Attempts to categorize his work in terms of style are resisted by Sultan, who sneers at the idea of being called a neo-or post-anything,— a neofigurative painter, for example. "People are just kidding themselves with these labels. And making a lot of money. I am going my own way. I always have been," he has asserted; and further, although most "neo" movements deny it, true newness in art is still possible, according to Sultan. "There's no point in walking into the future backwards."

At one stage in his career Sultan realized that the smell of tar and solvent in his studio recalled pleasurably the smell of his father's prosperous automobile tire factory in Asheville, North Carolina where the painter was born, the second of four children. His father had wanted to be an artist, and the basement of their home was lined with photographs of Jackson Pollock's paintings. Sultan was sent north to study at the Wilbraham (Massachusetts) Academy, then returned to at-

DONALD SULTAN

tend the University of North Carolina at Chapel Hill as a dramatic arts major. An early interest in set designing—he had acted in and done scenery for children's plays in Asheville and worked in summer stock on Cape Cod—eventually shifted, and he graduated with a B.F.A. degree in painting in 1973. The following two years were spent at the Art Institute of Chicago's graduate school of art, where in relative freedom from formal instruction he worked his way through a variety of contemporary styles: beginning with performance, minimalism, and process art. It was straight painting that, in the end, most interested him and he began to do abstract designs à la Pollock, applying thick layers of acrylic paint to canvas laid on the floor. Later he tried pouring the paint on to the canvas and embedding small objects (including tiny wooden figures he carved himself) in the fast-drying puddles of acrylic. Later still he began to do trompe l'oeil versions of those "debris paintings," as he called them, and which led him to his concern with images per se. Meanwhile, he also learned to draw by copying the drawings of the old masters and adding his own touches, relating them to today's world.

While still in graduate school he and some friends organized the N.A.M.E. Gallery, an artist's cooperative that brought in participants from all over the country and still functions in Chicago. Sultan's first solo show was held there in 1976. After receiving his M.F.A. degree in 1975 Sultan moved to New York City in order to compile a book of essays by artists on their own art, to be issued by N.A.M.E. It was in New

York that he hit by chance upon the technique now central to his work. He had been supporting himself doing construction jobs, painting in his spare time, while employed as a handyman at a midtown art gallery he noticed workmen laying linoleum tiles on the lobby floor of the building, heating the tiles with a blowtorch to make them easier to cut. Intrigued, Sultan began experimenting with vinyl tiles, which delighted him with their colors flecked with white which gave an effect of spatial depth and suggested clouds or waves. The first of his "puzzle pictures" was made by gluing a square of tile to Masonite with tarlike butyl rubber, then cutting two pieces out of the tile, leaving indentations that suggested animal forms; the cutout portions were then brought together and glued to the tile surface below to evoke another shape, perhaps a table.

The artist's first solo exhibition in New York, at Artists Space in 1977, included several of those shape-transforming compositions. As he developed his approach he began to "draw" with butyl rubber on paper—a caulking gun serving as a pencil would—and to "paint" with it, spreading it on the vinyl tiles (coated with gesso so the tar would adhere) and then cutting the tar away to form images. One of the key images in this series of paintings was a silhouette of a factory building, with a smokestack at either end of a flat roof; by washing down the exposed sections of tile with solvent, he produced an effect of smoky sky.

As the *New Yorker* critic Calvin Tomkins noted, a sort of metaphor is at work in Sultan's making a picture of a factory with factory materials. Asked where he derived that and other motifs repeated throughout his work, the artist replied, "I had always painted what was around me, and I was in New York. A lot of it came from New York." By the same process of visual transformation as in the earlier puzzle pictures, the factory silhouette can be read as an upside-down table in some paintings, even as late as one *Foundry* (July 3, 1987) done in latex paint and tar on canvas. In others, the chimney shapes have been turned into enormous glowing cigarettes or even into the shapes of tulips. In any case, although his art is a blending of process and imagery, the ideas for his imagery come first; his chosen materials and methods do not dictate the form. "Ideas are the only thing that's really important," he has said.

Some of Sultan's larger paintings of the late 1970s do not use tar, and instead suggest landscapes or seascapes simply by the use of different shades of tile—blue and gray for example, with white marbling. A jagged hole hammered into the tile and then filled with spackling compound

becomes an iceberg. At the same time that the eye is drawn into the picture space, the picture itself seems to project into the viewer's space, because of its mounting—vinyl tile glued to Masonite, glued in turn to a plywood backing, which itself is attached by steel rods to a stretcher bar. In contrast, Sultan's later paintings are curiously devoid of depth, partly as a result of his homogeneous color schemes, a palette intentionally limited to his favorite colors, black and yellow, in order to "standardize" his work.

In the mid-1980s images of lemons, both (unexceptionally) in yellow and (somehow unlikely) in black, are practically Sultan's trademark. A whole group of paintings and drawings evolved from the inspiration of a still life of a lemon by Manet, which Sultan saw in the 1983 Manet retrospective at the Metropolitan Museum of Art. Epitomizing the Sultan style, the shapes (singly, or in various groupings—as in *Four Lemons*, (November 21, 1984), in tar, oil and tile) are silhouetted against featureless backgrounds, with no illusion of space yet perceivable as volumes. They therefore make a direct, confrontational impact on the viewer. Impersonal and somehow abstract in their spatial isolation, the fruits are at the same time immediately recognizable and even sensual. In the "Black Lemon" series, (charcoal drawings on paper, 1985–86), the nipple-like shapes of the stem and blossom ends of the fruits are erotically explicit. Like the "Black Tulip" series of 1983–84, they are major components of his substantial body of works on paper. Among the artist's of very large prints is a series of four aquatints (roughly five feet by four feet) titled "Black Lemons," done between 1984–85 and published in an edition of ten copies. Exploring the possibilities of that technique, he has emphasized the contrast between the rich black surfaces and the soft, feathery contours of the fruits.

In more recent paintings Sultan has introduced other tonalities, colors that he applies directly from the tube rather than mixing himself. In the large (97 x 97 inch) *Flowers and Vase* (January 24, 1985), for example, yellow, violet and light green oil paint has been applied to the shapes cut out of panels of tar-coated tile—joined so that the composite image gives the effect almost of a Rorschach inkblot figure. The stilted, patterned look creates another tension in Sultan's art, an odd contrast between realism and illusion in addition to that between media and image. As he has noted, by simplifying and isolating forms, he challenges the viewer to see them as abstract shapes only suggestive of images projected by images projected by the viewer's own imagination.

Occasionally his technique has produced more tender, delicate images. *Gladiolus* (January 3, 1987), in chalk and tar on tile, for example, has feathery white flowers and long stems that seem to be seen through a glass vase, set off against a stark black background. In *Lilac and Roses in a Vase* (July 12, 1987), or *Four Pears* (October 26, 1987), nuances of color and shape are conveyed despite the seemingly improbable use of a combination of tar, Spackle, oil paint and gouache on vinyl tile.

Since about 1981 Sultan has been doing large landscapes, at first composed of a repeated stylized motif seen in silhouette—as in *Steers* (March 2, 1983), done in oilstick, tar, and plaster, which gives an illusion of several animals browsing in a field. Recently, his landscapes have taken on more narrative content and dramatic effect, with timely themes such as environmental pollution or industrial decay. Many of his "event pictures" (his term) have been inspired by newspaper photographs. Although the artist believes that paintings are actually more dramatic without figures (which, he feels, somehow eliminate the viewer), he has on occasion included the human figure within natural contexts. The 1983 *Cantaloupe Pickers* shows three migrant workers and alludes to that form of labor. *Early Morning* (May 20, 1986), shows a fireman trying to put out a raging yellow blaze in an industrial building; readable as such, it is also an abstract design. As Sultan commented, "I want my paintings to be almost indecipherable, as if the viewer were inside the painting, in the fire, in a state of confusion." When he paints flames (as also in a series of pictures of forest fires) he uses yellow latex paint, which does not dissolve when turpentine is applied to the surface but instead takes on a lurid, glowing tone. And as the painter proceeds with his work he makes a sound of crackling flames in his throat, "to keep it moving in my head," he explains. Such vocal accompaniment may be part of his belief in "clear painting," painting in which the artist's intention is definite and in harmony with the means used to fulfill it. Other "event pictures" include *Pumps* (January 19, 1984). Done in latex and oil paints over a foundation of Cor-Ten steel encrusted with dead leaves, it is a deliberate metaphor for the conflict between the natural environment and encroaching industry. Inspired by a news story about a sulfuric acid spill in New Jersey—and incorporating visual stimuli from waterfront paintings by Manet and Whistler—*Poison Nocturne* (1985) conveys the sinister aspect of a polluted industrial site.

Sultan was awarded a Creative Artist's public service grant for 1978–79 and a National Endowment for the Arts award for 1980–81. Since

1975 his work has received increasingly serious critical attention. While his success can also be measured by the fact that between 1977 and 1980 prices for his paintings rose from $300 to $6,000, and that by 1985 one of his works fetched $60,000, the artist has never had the kind of promotion that has raised some of his contemporaries to superstardom. Neither his art nor his attitude toward it lends itself to that kind of hype. He is content to live quietly with his wife, the former Susan Reynolds, whom he married in 1979, and their daughter, Frances (born in 1981), in a loft in the Tribeca section of lower Manhattan. Nor does he have much social contact with neighboring artists; in fact, his best friend is the playwright David Mamet. Near his home Sultan has a studio, where, as has become common practice with busy artists in recent years, he works with the help of assistants. Three of them, at present, are employed to cut away the vinyl—using blowtorch and chisel—along the artist's white chalk outlines, and to fill the cutout shapes with plaster, which Sultan then paints over in oils or gouache. The neatly organized studio also includes a small office, the domain of his bookkeeper. Not a "downtown" painter, he shows in established, prestigious midtown spaces and since 1982 has been represented by the Blum Helman Gallery on 57th Street.

A medium tall "and more than medium good-looking" man, Donald Sultan has wavy dark hair that does not wholly conceal his very high forehead. His dark, serious eyes are framed by modish round glasses. His smile is boyish, his manner friendly yet extremely self-confident. "With me it's always picture-to-picture. But I think I'll probably keep on going the way I have," he asserts. And the artist unreservedly admits he has always thought he was a great painter. "It wasn't a conscious decision. I think what happens is you decide to make paintings *you* want to see."

EXHIBITIONS INCLUDE: N.A.M.E. Gal., Chicago 1976; Artists Space, NYC 1977; Willard Gal., NYC 1979, '80; Blum Helman Gal., NYC 1982, '84, '85, '86, '87; Akira Ikeda Gal., Tokyo and Nagoya, Japan 1983, '87; Barbara Krakow Gal., Boston 1985 (trav. exhib. of prints); Gal. de l'Estampe Contemporaine, Bibliothèque National, Paris 1986; Mus. of Contemporary Art, Chicago 1987 (retrospective). GROUP EXHIBITIONS INCLUDE: The Ackland Art Mus., Chapel Hill, N.C. 1972, '73; N.A.M.E. Gal. 1975; "Graduate Painters," Art Inst. of Chicago 1975; "1979 Biennial Exhibition," Whitney Mus. of American Art, NYC; "New Directions: A Corporate Collection," Sidney Janis Gal., NYC 1981 (trav. exhib.); "Black and White," MOMA, NYC 1981; "Prints from Blocks—Gauguin to Now," MOMA 1983; "The American Artist as Printmaker," Brooklyn Mus., N.Y. 1983; "An International Survey of Recent Painting and Sculpture," MOMA, NYC 1984; "Images and Impressions: Painters Who Print," Walker Art Cntr. Minneapolis 1984; "Monumental Drawings: Work by 22 Contemporary Americans," Brooklyn Mus., N.Y. 1986; "The New Romantic Landscape," Whitney Mus. of American Art, NYC 1987.

COLLECTIONS INCLUDE: MOMA, Solomon R. Guggenheim Mus. and Metropolitan Mus. of Art, NYC; Albright-Knox Art Gal., Buffalo; Mus. of Fine Arts, Boston; Fogg Art Mus., Harvard Univ., Cambridge, Mass.; Hirshhorn Mus. and Sculpture Garden, Washington, D.C.; High Mus. of Art, Atlanta; Art Inst. of Chicago; Walker Art Cntr.; Australian National Gal. Canberra.

ABOUT: Warren, Lynne, and Ian Dunlop. Donald Sultan, 1987; Who's Who in American Art, 1989–90. *Periodicals*—ARTnews March 1985, March 1987, April 1987, November 1988; Arts Magazine June 1979, March 1984, April 1984; Flash Art May/June 1986; New York Times April 30, 1982, April 12, 1985, December 13, 1985, April 24, 1987; Print Collectors Newsletter September–October 1985.

SWARTZ, BETH AMES (February 5, 1936–), American painter and visionary artist, was born in New York City. Always a strong colorist, she abandoned watercolors and started a spiritual search into the fields of psychology, Zen, creativity, and the roots and motivation of myth. Swartz derives much of her power from her inward searching of emotional sources of strength, which she transposes and transmits in her art. Working primarily in multi-layered levels of colors and materials, her work is concerned with color, light, and the manipulation of texture. Always abstract, never figurative, her paintings of the 1980s search for a spiritual center. Swartz engages the eye and the mind, leading the spectator to a journey into the self. She is firmly convinced that the role of the artist is to see, interpret, and change the tenets of culture.

Swartz was reared in an academically ambitious family of Jewish immigrants. Her father rose to the position of assistant superintendent in the New York City school system. He was also trained as a lawyer and wrote to supplement his income. Basically, he considered himself an educator and a scientist.

The youngest of three children Swartz grew up with her brother and sister, in a household where academic standards were high. Her older brother achieved fame as a biochemist. The "Ames test," concerned with screening materials for teratogenicity, has become a standard testing procedure. As a child, Swartz loved to dance and took singing lessons. Her mother noticed her artistic inclinations early and sent her to the Art

BETH AMES SWARTZ

Students' League when she was thirteen years old. There she had an opportunity to draw from live models. Swartz entered the very competitive Bronx High School of Science and Arts where she took two hours of art classes every day. Though she considers herself a happy adult, Swartz, as a child, sometimes felt like "a square peg in a round hole."

"My parents were very authoritarian and the only way I had to express my feelings was through art. It became a pipeline to my unconscious very early in life. I had a strict old-fashioned upbringing. My mother noticed that I was a fearful child and that art was a good outlet for me—a way to express my feelings. Being the youngest, I was picked on a lot. So art became like a comforter for me. When I felt people were not to be trusted, I would spend hours painting. I felt that I was never quite good enough for my parents."

When Swartz entered college, she decided that she wanted to teach. She enrolled in the College of Home Economics at Cornell University. She majored in child development and in design. At Cornell, she came under the influence of Frances Wilson Schwartz in the child development department; "I took many art courses, but did not know at the time that I would become an artist. I thought I would be an art teacher. I was very interested in creativity and really began to understand getting in touch with the creative unconscious. There was a book that Frances Wilson Schwartz lent me: *The Biology of the Spirit* by Edward Sinnott. Reading the book, I began to feel the interconnectiveness of

all life in relation to nature." She added, "I feel my work has always been [rooted in] nature.

In 1956 Swartz graduated from Cornell University and traveled in Europe visiting museums. In 1959 she received an M.A. degree in art education from New York University. Though she was prepared to teach at the college and high school level, Swartz actually taught elementary school, primarily art and drawing. She elaborated: "I love to teach. I love to help people open up their creativity." In 1959 Swartz married a young lawyer: "I got married in New York. He courted me with *Arizona Highways* under his arm. We moved to Arizona." In 1967 her daughter, Julianne, was born, followed by a son, Jonathan, in 1970. She felt that in relationship to her children "everything in life has an opportunity to be a high movement." She loves to quote Joseph Campbell: "Follow your bliss," and adds, "I have a lot of bliss in my relationship with my children." She was divorced in 1984.

There is no doubt that the move to Arizona was crucial to Swartz's career and outlook. She found the western landscape harsh compared to the softness and greenness of the East, but eventually felt connected to it. Describing her own work, she said, "From 1960 to 1976, I was primarily a watercolorist; my work was lyrical and abstract and shied away from realism. I always had interesting titles that related to my life and my topography. I took some titles from the poet e. e. cummings. When I worked, I actually moved around the paper in a rhythmic dance to splatter paint and build up dots into layers, a harbinger of my later work with layered materials. My early works were lyrical and expressionistic, they reminded you of Frankenthaler and Jenkins. However, I always wanted to get more power into my work, more depth, and in 1970 I started to work with collage and watercolor. In 1971, I took my first trip down the Colorado River. It changed my life and my art. It really connected me with the Arizona landscape."

Though Swartz had stopped teaching full-time in 1964, she continued her involvement as a part-time consultant with Vista and the Headstart program throughout the 1970's. Even now, she still teaches privately: "I teach collage, watercolor and some writing. I create an atmosphere of unconditional love and support. It opens up the fifth chakra. It is the part of the body where our ability to express who we are and what we want, as symbolized by the vocal chord, is centered. I am an educator! It's in my blood!"

Swartz was groping toward growth in her own life as a woman and an artist. In 1974 she met George Land and was excited by the idea that

the basic elements sustain life. "I did a series of the elements: Earth Series, Air Series, Water Series, and than I came to Fire. I realized, I could not make a picture of fire; I really wanted to work with fire as an art form. I had been booked into the Scottsdale Center for the Arts for a one-person show; I told its director, John Armstrong, that I was turnig into a 'fire woman.' It took me two years to develop my 'fire' work. The early 'fire' works were a continuation of the idea of the flow of color and water on paper; I was working with the flow of fire and smoke on paper; this work was almost devoid of color which was interesting because I was really a colorist. The early 'fire' works were timid. In 1976 I developed a process ritual. I would role out the paper; I called that birth. Then I would mutilate the paper; that was death or disorder. In the beginning, I used ice, too. I burned the paper with a torch, which is a sort of death, and then I took the fire, a transforming energy force that was ordering and disordering, and I would use the earth as a sort of healing. The work was physically exhausting for me," Swartz added pensively: "We go through many small deaths in our life."

Her experimentation with fire led to a break with her artistic past. She outgrew lyrical abstraction and immersed herself into her "fire" works, replacing her graceful brushwork and washes with a more elemental and physical depth. In an article in *Arizona Arts and Lifestyle*, the art critic Barbara Pearlman stated: "As Swartz demonstrates, the chief requisite for change is the act of disordering combined with its counterparts: order and reordering. Taken together, they signify refusal to yield to entropy, to destructive impulses, above all to decay. . . . "The elements of risk, disorder, and healing in Swartz's beautiful painting-collages echo experiences all of us have faced, perhaps more often than we realize: the sometimes frightening need to plunge ourselves into various degrees of disorder so that we can continue psychological and physical growth. For without growth, we die. After disorder comes the building of new equilibriums, relationships, jobs. This is what Beth Ames Swartz's art is about. Change as a creative process. Change as a psychological and aesthetic imperative."

In 1976 Swartz created her "I Love Mommy" series, a number of acrylic watercolors in which she' expressed her inner feelings about her mother's failing health. In 1977 Swartz's use of fire became bolder in her work and she created a "Smoke Imagery" series. (Her work now includes mutilation, burning, and pigment). In the same year, Swartz conceived the "Torah Scroll" series of layered mixed media on paper. In the catalog "Inquiry into Fire" (1978), Melinda

Wortz summarized: "Although Beth Ames Swartz has been working in isolation for twenty years, she now finds herself a participant in the international community of artists engaged in similar pursuits." Wortz has described the beauty of the work as "unabashedly lyrical."

In 1979 Swartz launched her "Sedona" series which was influenced by the Sedona Red Rock country. Mary Carroll Nelson, in her book *Connecting—The Art of Beth Ames Swartz* described the development of the "Sedona" series in detail: "The deep red color of northeastern Arizona triggered the next change in Swartz's art. She began a series based on the Sedona Red Rock area that included earth of the region in her layering. The idea began simply as an innovation in technique, but it grew into an altered philosophical relationship to her work. Her tangible connection with the earth broadened as she worked on the Sedona series. Swartz added a distinct new step to her process/ritual in creating this series. After painting a scroll, she ripped the entire work into large fragments and painted every torn edge—its back surface—to eliminate rawness. She then created a mosaic of fragments against a black background which showed through as cracks of strongly defined negative space. In their final form, these mosaics gleamed with color and texture. They are beautiful objects that appear to have been torn from a canyon wall, just at sundown."

In 1980 Swarz traveled to Israel seeking out ten historical sites. She correlated each site with a female biblical figure and reaffimred her own heritage. The following year "Israel Revisited" opened at the Elaine Horwitch Gallery in Scottsdale; that exhibition was followed by a national tour encompassing the East and West coasts, including a solo show at the Jewish Museum in New York. The tour established Swartz as a major artist. In *Arts Magazine* (September 1981), Harry Rand discussed Swartz's work: "In the late 1970's, she veered from the prevalent lyric abstraction she practiced. Her alternative was violent rejection and her means vigorous; fire became her natural tool and ally. The size of her work increased, her range of color broadened. A greater variety of color schemes appeared and more variation of hue enlivened each composition. Her works became layered as ply after ply was added to enrich the surfaces and build up forms. Texture started to play an independent and prominent role, no longer just the resultant track of the application of pigment. . . . The beauty she achieves is striven for as a goal in her work parallel to the ethical pursuit of artistic assumptions and procedures. And the beauty is manifest. . . . Swartz has staying power and the experience to grow in depth beyond what we see

in her present work; she has the facility to capitalize on her strengths."

The success of those complex and unique works led Swartz to seek out sites from other civilizations. Apart from the "Sedona" series, there is a "Black Sand Beach" series concerned with the volcanic nature of Hawaii, the "Monument Valley" series, and her "Ten Sites" series which is part of "Israel Revisited."

Swartz, a svelte and vivacious woman, likes to get involved with large projects. A major installation, "A Moving Point of Balance" is touring the United States into the 1990s. It is a participatory, multimedia event consisting of seven seven-foot-square paintings. The number seven symbolizes seven sacred sites in the American Southwest and Europe and the seven energy centers, or chakras, of the body. In Swartz's words, "it is a form of performance which allows the viewer to become a part of the art experience. It is a contemporary statement, with echos of early shamanic environments; a ritual journey into the self."

Brilliant colors abound. The paintings are set in semidarkness and are enhanced by synthesized music. The vibrant colors of the paintings are spotlighted by colored lights and the viewer stands in front of each painting bathed in a circle of light, each of which corresponds to a specific chakra, beginning with the base of the spine and concluding with the crown of the head. It is an environment designed to create harmony and reflection.

Swartz calls the installation "an experience in inner transformation and self-healing." She explained: "I had many intense visionary experiences, including physical, psychological and spiritual changes. To translate my new awareness into tangible form, it was necessary for a new artistic language to emerge—a different form of expression from my previous work." It took Swartz three and a half years to finish "A Moving Point of Balance"—the culmination of her ideas dealing with shamanism and participatory and transformative art. She intends to keep the seven paintings as a unit to be housed together to preserve their integrity.

In 1987–88 Swartz painted the "Celestial Visitation" series motivated by the illness and subsequent death of her mother. The magnificent paintings in that series build up layers of paint, quartz crystals, rose quartz, shards, mica, broken mirror fragments, amethyst, gold and silver leaf, and are truly opulent creations. Though motivated by personal grief, the "Celestial Visitations" are not filled with gloom or angst. They are an affirmation of spirituality. Titles like 'The Angels of Joyousness,' 'The Angels of Shared Purpose,' and 'The Angels of Abundance' bespeak deliverance rather than death. Swartz sees humanity as spiritual as well as a earthyly: "We can be both a wave and a particle at the same time."

Swartz has paid tribute to Jackson Pollock: "Without his breakthrough it would not have been easy for me to move into the intuitive and subconscious movement with my body. When I throw paint on the paper it is certainly reminiscent of Pollock. I carry it one step further, who knows, if he had lived he would have done the same."

Swartz lives in Scottsdale, Arizona in the midst of a desert landscape. At night she can see the starry sky, though some city lights are also blinking in the distance. While the house is not isolated, the sounds of coyotes howling in the desert can occasionally be heard. Her home displays her own and other artists' work. Her house is separated from her studio by a swimming pool. The studio is spacious and splattered with paint; it contains an ample storage area and a separate office. Engaged in art and community projects, Swartz at times is over involved in myriad activities, but she never lets other pursuits interfere with her art. She produces about twenty paintings a year, as well as numerous works on paper. She has also made some monotypes, but does not do prints anymore. To her, it is an unsatisfactory medium.

As an artist, Beth Ames Swartz is a seeker. She is also an ecologist, feminist, and community activist. She is interested in creating beauty out of chaos and out of destruction. A transformative artist, she believes that transformation evokes the idea of moving from one form to another. Swartz is interested in the transmission of energy. An artist of real daring, she has said, "I never allow myself to rest safely too long; I always jump off the bridge and try to fly on the way down. It is not very much fun for me to stay too long aesthetically in an area that I have already solved."

Swartz feels a keen sense of purpose. She is concerned with the ecology of the earth, and the transformation of culture, rather than the elitism and the competitive syndrome of the art world. Swartz is an artist in her prime. Her work is spiritual, sensuous, and opulent. It is unclear what new path her art will take, but it is safe to predict that she will follow her own voices. She is driven by a vision. To Swartz art is a vehicle for moving beyond the present.

EXHIBITIONS INCLUDE: Gal. Janna, Mexico City 1971; Arizona State Univ., Tempe 1972; Pavillion Gal., Scottsdale, Ariz. 1975; Bob Tomlinson Gal., Albuquerque, N.M. 1976; "Ten Take Ten," ten-year retrospective,

Colorado Springs Fine Art Cntr. 1977; "Inquiry Into Fire," Scottsdale Cntr. for the Arts, Ariz. 1978; Springfield Art Mus., Mo. 1979; Frank Marino Gal. 1979, '81; "Israel Revisited" Jewish Mus., NYC (trav. exhib., Univ. of California, Irvine; Skirball Mus., Los Angeles; Univ. of Arizona Mus.of Art, Tucson; Judah Magnes Mus., Berkeley; Beaumont Mus. of Art; Albuquerque Mus. of Art; American Cultural Cntrs. in Tel Aviv and Jerusalem) 1981–1983; J. Rosenthal Fine Arts, Chicago 1982; Sun Valley Cntr. for the Arts and Humanities, Idaho 1982; Gal. York, Pa. 1984, '86; ACA Gals., NYC 1985; "A Moving Point of Balance" (trav. exhib.) 1985–1991; Elaine Horwitch Gal., Scottsdale, Ariz. 1979, '80, '82, '84, '86, '88; Plaka Art Gal., Athens, Greece 1989; Naplion Art Gal., Greece 1989; Gal. Yolanda Rios, Sitges. (Barcelona), Spain 1989; New Gal., Houston 1989; Elaine Horwitch Gal., Palm Springs, Calif. 1989.

COLLECTIONS INCLUDE: National Mus. of American Art, Smithsonian Instn., Washington, D.C.; San Francisco Mus. of Modern Art, Calif.; Jewish Mus., NYC; Denver Art Mus.; Herbert F. Johnson Mus. of Art, Cornell Univ., Ithaca, N.Y.; Phoenix Art Mus.; Art Mus. Univ. of Arizona, Tempe; Scottsdale Cntr. for the Arts, Ariz.; Mus. of Fine Art, Santa Fe, N.M.; Albuquerque Mus. of Art, N.M.; Tucson Mus. of Art, Ariz.; Everson Mus. of Art, Syracuse, N.Y.; Brooklyn Mus. N.Y.; Univ. of Arizona Mus. of Art, Tucson; Beaumont Art Mus., Tex.

ABOUT: "Arizona Women '75" (cat.), Tucson Art Museum, 1975; "Beth Ames Swartz 1982–1984," (cat), 1988; "Inquiry into Fire" (cat.), Scottsdale Center for the Arts, 1979; "Israel Revisited: Beth Ames Swartz" (cat.), 1981; Lippard, Lucy. Overlay: Contemporary Art and the Art of Pre-History, 1983; Nelson, Mary Caroll. Connection: The Art of Beth Ames Swartz, 1984. Periodicals—Arizona Arts and Lifestyle Winter 1980; Arizona Arts and Travel April 1984; Art in America April 1981; Artlines October 1983; ARTnews April 1978, December 1980, February 1982; Arts Magazine May 1979, September 1981; Artspace Winter 1978, Winter 1980, Summer 1982; Artweek May 1975; Fiberarts July–August 1982; Los Angeles Times May 15, 1982, April 29, 1986; Phoenix Metro Magazine May 1987; Scottsdale Progress Weekend Magazine May 6, 1988; Staten Island Advance March 1, 1988; Woman's Art Journal Fall–Winter 1981–82.

FILM: The New Art of the American West.

*TAAFFE, PHILIP (1955–), American painter who is generally categorized with the artists of the new abstraction and whose name became known in 1984 for his reworking of op paintings by Bridget Riley. Over the years, those "appropriations" have developed into more personal, more intricately designed and lyrical paintings. Taaffe, at times, begins his work with elements from others' art (i.e. Ellsworth Kelley, Paul Feeley, or certain painters of the New York School), yet by reconstructing the original motif

PHILIP TAAFFE

in his own elaborate manipulations of color and collage, he reintroduces that historical information and explores it through the eyes of the present world, thereby simultaneously incorporating the present into the painting. The viewer confronts his or her world as now part of the painting which has become a manifestation of past and present.

David McCracken, writing in the Chicago Tribune (April 15, 1988), has explained that Taaffe began his "elaboration and colonization of past art" in 1983, after he completed a number of geometric paintings. McCracken quoted Taaffe as saying of that transitional period, "These [geometric] paintings had an op quality to them, so when I decided to move on and change the scale of the work I figured it would probably be important to examine the sources of this opticality, how it was rooted historically, how that painting could be significant now." Taaffe, in his process of using hand-carved linoleum plates to collage, actually takes apart and rebuilds the op paintings, based on his examination of op's origins and significance then and now.

In 1984 Taaffe had his first one-man show in New York at the Pat Hearn Gallery (still his New York representative). His paintings in the show included versions of Bridget Riley's waving surfaces of black and white stripes. Walter Robinson points out in his review of the show for Art in America (January 1985) that Taaffe's paintings are, in appearance, replications of Bridget Rileys', yet it is in his fabrication of the paintings that make them completely his own. Bridget Ri-

°tä´ fē

ley once told Taaffe that she never touched her paintings. Her assistants would paint what she explicated in a drawing. She would give a final review when the work was completed. Her work has an impersonal quality. Taaffe, on the contrary, is totally submersed in his elaborate process of making his paintings, which, when completed, expose a thick, layered, hand-crafted surface.

For example, a 1986 Taaffe painting, *Defiance*, a red and blue "Riley" of undulating waves, was featured in *Esquire*'s series, "How a Painting Happens" (December 1986). Narrating his laborious process—Taaffe explained how he used lino-prints to make colored stripes (for *Defiance* he uses blue stripes) on paper which were then collaged on to the canvas. (Taaffe can use the same plate repeatedly.) When ready for the next application of color, Taaffe revealed his motives for choosing particular hues. For *Defiance*, he wanted darkness and fire so he then applied a mixture of acrylics which was absorbed by the white areas of raw paper. The blue area resisted the new rusty color thereby creating the "fiery" image that ran behind the blue waves. Taaffe said that for that painting, he wanted "the viewer to feel the idea, to feel the fire and the moisture at the same time, to be cool and hot . . . one thing subverting the other." *Defiance*, Taaffe explained, is titled after "a passage in the Book of Daniel in which the Jewish administrators defy King Nebuchadnezzar and are thrown into the fiery furnace." (Taaffe often titles paintings with ancient and religious references. The designs and motifs in the paintings also evoke images of medieval days.) Robinson, in his *Art in America* review, wrote, "Taaffe has sought to extend the emotional pitch of the simple op graphics with added color."

In choosing op to rework, Taaffe has indeed taken on an emotionally void (though perceptually intriguing) form of work, and by making color and handmade fabrication necessary parts of his art, he has invented a sort of expressionistic op. By titling the painting with such historical references (*Defiance* or his 1985, *Crucifixion*), he is bringing into the present many layers of history. One could say all time is brought together in one visual experience. The critic Carlo McCormick, writing in *Artforum* (November 1985), discussed that manipulation by the artist: "Taaffe and [Peter] Schuyff are intentionally discarding the academic rigidity of their predecessors' work so as to invest that otherwise dry form of nonexpression with an overheightened emotionalism. As op tried to replace it with transcendence, now the ego is supreme and the artists' hand is seen everywhere."

Taaffe realized that, in a way, he was violating the original paintings from which he borrowed. In the *New Yorker* (November 24, 1986), he was quoted as saying, "I do admire [Riley's] work a lot, but unfortunately there's always some violence involved in taking another artist's work and making it your own. What I think I'm doing is romanticizing the space of op art. There isn't much room to move around in op art, but in my paintings, I think there is." Taaffe tries not to get too romantic with the work—it would then become self-indulgent, he feels. Nor does he want to sentimentalize the past; he wants instead to investigate it.

In 1986 Taaffe had a one-man show with the Pat Hearn Gallery (the same year he had solo exhibits in Hamburg and Koln, as well as paintings in various group shows both in the United States and abroad). Five of the paintings in that show were near replicas of various Barnett Newman paintings from 1949 on. One such painting, titled *Homo Fortissimus Excelsus*, is almost exactly the size and color of Newman's 1950–51 painting, *Vir Heroicus Sublimus*. Newman's is oil on canvas, an alarming red color field divided by five vertical bands (zips, as Newman called them) which are visible yet simultaneously lost in the immense red field. Newman subverts the rationalism of geometry by allowing the zips to be engulfed by the total experience. In Taaffe's "near replication," he substitutes ornamental rope imagery for zips. When one looks at the Taaffe up close, the layering effect is very apparent. By collaging the painting, Taaffe has rebuilt the Newman, but he has done so in his own decorative style. By intertwining elements of abstract form with psychological and emotional ingredients, Taaffe has reinforced the goals of Newman and many other artists of the New York School—Clyfford Still, Mark Rothko, Ad Reinhardt, and later Ellsworth Kelly. They wanted to subvert expectations with the total experience of this interweaving which Taaffe has made manifest by the very physicality of his art meshed with color and decoration.

Taaffe has theorized at length on his impressions of Newman and his art, but the explanations Taaffe has given for recreating his paintings can at times sound obscure. The critic Jeanne Silverthorne, in *Artforum* (April 1986) wrote, "It is possible that Taaffe is ruminating on how our burden of information (history) prevents us from being taken in by what we see, seeing is no longer believing." Jeanne Siegel in *Flash Art* (April 1986) interpreted the logic behind the work, writing, "Taaffe's intention is to realize these paintings in a manner as close to what Newman has accomplished. He sees the original as subject, as though it were an easel

painting or a depiction of a still life. . . . Taaffe has purged the original of its significant meaning—flatness, oneness, abstraction, as a symbol of creation." Taaffe has indicated that he wants his Newman images to become primeval color-field paintings, to make the color-field become as it was in the earliest age.

Taaffe experimented with that primeval hypothesis in a 1987 painting, *Vertebrae*—a horizontal, silkscreen collage of two symmetrical columns of turkey-leg-shaped prints in varying color combinations. "The painting is of dinosaur vertebrae," Taaffe has explained, "a big dinosaur bone, but also has the emphasis of a color-field painting, a Kenneth Noland or a Barnett Newman. It is obliquely referential; I want to make it a deeper artifact than either thing itself. . . . It's dinosaur vertebrae as a color-field painting."

Green Blue, a 1987 silkscreen collage, is exemplary of Taaffe's absorbtion of Ellsworth Kelly's work. It is a combination of Kelly's form imagery with the added detailing of a Taaffe. Prints of flowers decorate the background of the painting, like wallpaper or decals in a pop sense, while orange waves corkscrew down a Kelly-like arrow shape which is layered on top of the flowers. Taaffe is concerned with the imagery of Kelly but fuses his sensibility with those images to produce a layering effect. He has said, " [Kelly's] work has sometimes served as the pretext for mine—the starting point—but the image is internalized in a complete way." The painting *Green Blue* can be said to show influences of Matisse in the flower motif, of Kelly in the arrow shape, of Newman in color, and of Riley in waves. Perhaps that is Taaffe's intent: to realize visually his idea of how we absorb history. There is no starting anything from zero; all of history will subconsciously seep into one's every gesture. Taaffe demonstrates this by representing bits of history in weaves and layers to make a painting. It is as if a geologist cut a chunk of earth out from under the ground on which he stood and examined the layers of sediment to understand his present ground, and then replaced the dirt, layer by layer. The dirt now contains his reflections on it, and he now contains the knowledge of past geologic ages.

Jeff Perone praised Taaffe in *Arts Magazine*, (Summer 1987): "When he fills up a field with waves and funny amoebalike forms . . . he's like a great, young jazz musician taking the historical basics and improvising, embellishing with discordant detail, juggling and mixing old tunes and coming up with a style of his own." Most reviews of Taaffe's contribution to the 1987 Whitney Biennial were similarity positive.

Michael Brenson wrote in the *New York Times*, "With unnatural color and with an unpredictable sense of pictorial relationships and timing, he pieces those ideas together in ways that can be jarring and revealing . . . his work holds up." His detractors found his work cynical and retrograde. Taaffe has cited his meticulous obsessive labor in refuting the charge of cynicism but has acknowledged that he has set himself up for the criticism that his paintings are retrograde. "Yet," he contended, "going back to the past is a way of providing an immediate pool of knowledge and information. Renegotiated or reinvented, it allows more knowledge to enter the work. If the historical image is made immediately manifest, the work becomes reflective rather than retrogressive; it reflects those sacred and inspired moments and incorporates them into our moment. It enables a criticality to develop and gives us some sense of direction."

Born in 1955 in Elizabeth, New Jersey, Taaffe decided at an early age to be a painter, and his enthusiasm for painting hardly wavered since then. While many writers, critics, and artists of his generation have taken to heart the words of the French philosopher Jean Baudrillard and adopted theoretical doubts about painting, Taaffe is still committed to that means of expression. In 1986 he was quoted as saying, "I think we've gotten to the point now where it's been proven that painting cannot be killed. . . . It won't die, and we have to accept that fact." Eleanor Heartney wrote in *ARTnews* (September 1987), "Long after Baudrillard has ceased to be required art-world reading, we will still be interested in looking at work, like Taaffe's, that is visually as well as conceptually compelling."

In May 1989 Taaffe had two solo exhibits in New York, at the Pat Hearn and the Mary Boone Galleries, which received mostly favorable reviews. The new paintings seemed even more elaborate in detail and historical reference than ever before. Paintings like *Ahmed Mohammed, Aurora Borealis,* and *Quadro Vesuviano* showed further progessions toward investigations in ancient and medieval details, especially with images of wrought iron twistings and baroque figures. "In *Ahmed Mohammed,* where a Gottlieb-scape of horizon and floating spheres is seen through enormous fragments of Islamic script," according Roberta Smith, " [Taaffe] tries out an openness and a scale his work has never had before. . . . In their taut distillations of modern and medieval, purity and violence, art and craft, these paintings telegraph Mr. Taaffe's historical sources and his high ambitions convincingly and instantaneously—signaling a fierce ability to make paintings that force us to look first and ask questions later."

ley once told Taaffe that she never touched her paintings. Her assistants would paint what she explicated in a drawing. She would give a final review when the work was completed. Her work has an impersonal quality. Taaffe, on the contrary, is totally submersed in his elaborate process of making his paintings, which, when completed, expose a thick, layered, hand-crafted surface.

For example, a 1986 Taaffe painting, *Defiance*, a red and blue "Riley" of undulating waves, was featured in *Esquire*'s series, "How a Painting Happens" (December 1986). Narrating his laborious process—Taaffe explained how he used lino-prints to make colored stripes (for *Defiance* he uses blue stripes) on paper which were then collaged on to the canvas. (Taaffe can use the same plate repeatedly.) When ready for the next application of color, Taaffe revealed his motives for choosing particular hues. For *Defiance*, he wanted darkness and fire so he then applied a mixture of acrylics which was absorbed by the white areas of raw paper. The blue area resisted the new rusty color thereby creating the "fiery" image that ran behind the blue waves. Taaffe said that for that painting, he wanted "the viewer to feel the idea, to feel the fire and the moisture at the same time, to be cool and hot . . . one thing subverting the other." *Defiance*, Taaffe explained, is titled after "a passage in the Book of Daniel in which the Jewish administrators defy King Nebuchadnezzar and are thrown into the fiery furnace." (Taaffe often titles paintings with ancient and religious references. The designs and motifs in the paintings also evoke images of medieval days.) Robinson, in his *Art in America* review, wrote, "Taaffe has sought to extend the emotional pitch of the simple op graphics with added color."

In choosing op to rework, Taaffe has indeed taken on an emotionally void (though perceptually intriguing) form of work, and by making color and handmade fabrication necessary parts of his art, he has invented a sort of expressionistic op. By titling the painting with such historical references (*Defiance* or his 1985, *Crucifixion*), he is bringing into the present many layers of history. One could say all time is brought together in one visual experience. The critic Carlo McCormick, writing in *Artforum* (November 1985), discussed that manipulation by the artist: "Taaffe and [Peter] Schuyff are intentionally discarding the academic rigidity of their predecessors' work so as to invest that otherwise dry form of nonexpression with an overheightened emotionalism. As op tried to replace it with transcendence, now the ego is supreme and the artists' hand is seen everywhere."

Taaffe realized that, in a way, he was violating the original paintings from which he borrowed. In the *New Yorker* (November 24, 1986), he was quoted as saying, "I do admire [Riley's] work a lot, but unfortunately there's always some violence involved in taking another artist's work and making it your own. What I think I'm doing is romanticizing the space of op art. There isn't much room to move around in op art, but in my paintings, I think there is." Taaffe tries not to get too romantic with the work—it would then become self-indulgent, he feels. Nor does he want to sentimentalize the past; he wants instead to investigate it.

In 1986 Taaffe had a one-man show with the Pat Hearn Gallery (the same year he had solo exhibits in Hamburg and Koln, as well as paintings in various group shows both in the United States and abroad). Five of the paintings in that show were near replicas of various Barnett Newman paintings from 1949 on. One such painting, titled *Homo Fortissimus Excelsus*, is almost exactly the size and color of Newman's 1950–51 painting, *Vir Heroicus Sublimus*. Newman's is oil on canvas, an alarming red color field divided by five vertical bands (zips, as Newman called them) which are visible yet simultaneously lost in the immense red field. Newman subverts the rationalism of geometry by allowing the zips to be engulfed by the total experience. In Taaffe's "near replication," he substitutes ornamental rope imagery for zips. When one looks at the Taaffe up close, the layering effect is very apparent. By collaging the painting, Taaffe has rebuilt the Newman, but he has done so in his own decorative style. By intertwining elements of abstract form with psychological and emotional ingredients, Taaffe has reinforced the goals of Newman and many other artists of the New York School—Clyfford Still, Mark Rothko, Ad Reinhardt, and later Ellsworth Kelly. They wanted to subvert expectations with the total experience of this interweaving which Taaffe has made manifest by the very physicality of his art meshed with color and decoration.

Taaffe has theorized at length on his impressions of Newman and his art, but the explanations Taaffe has given for recreating his paintings can at times sound obscure. The critic Jeanne Silverthorne, in *Artforum* (April 1986) wrote, "It is possible that Taaffe is ruminating on how our burden of information (history) prevents us from being taken in by what we see, seeing is no longer believing." Jeanne Siegel in *Flash Art* (April 1986) interpreted the logic behind the work, writing, "Taaffe's intention is to realize these paintings in a manner as close to what Newman has accomplished. He sees the original as subject, as though it were an easel

painting or a depiction of a still life. . . . Taaffe has purged the original of its significant meaning—flatness, oneness, abstraction, as a symbol of creation." Taaffe has indicated that he wants his Newman images to become primeval color-field paintings, to make the color-field become as it was in the earliest age.

Taaffe experimented with that primeval hypothesis in a 1987 painting, *Vertebrae*—a horizontal, silkscreen collage of two symmetrical columns of turkey-leg-shaped prints in varying color combinations. "The painting is of dinosaur vertebrae," Taaffe has explained, "a big dinosaur bone, but also has the emphasis of a color-field painting, a Kenneth Noland or a Barnett Newman. It is obliquely referential; I want to make it a deeper artifact than either thing itself. . . . It's dinosaur vertebrae as a color-field painting."

Green Blue, a 1987 silkscreen collage, is exemplary of Taaffe's absorbtion of Ellsworth Kelly's work. It is a combination of Kelly's form imagery with the added detailing of a Taaffe. Prints of flowers decorate the background of the painting, like wallpaper or decals in a pop sense, while orange waves corkscrew down a Kelly-like arrow shape which is layered on top of the flowers. Taaffe is concerned with the imagery of Kelly but fuses his sensibility with those images to produce a layering effect. He has said, " [Kelly's] work has sometimes served as the pretext for mine—the starting point—but the image is internalized in a complete way." The painting *Green Blue* can be said to show influences of Matisse in the flower motif, of Kelly in the arrow shape, of Newman in color, and of Riley in waves. Perhaps that is Taaffe's intent: to realize visually his idea of how we absorb history. There is no starting anything from zero; all of history will subconsciously seep into one's every gesture. Taaffe demonstrates this by representing bits of history in weaves and layers to make a painting. It is as if a geologist cut a chunk of earth out from under the ground on which he stood and examined the layers of sediment to understand his present ground, and then replaced the dirt, layer by layer. The dirt now contains his reflections on it, and he now contains the knowledge of past geologic ages.

Jeff Perone praised Taaffe in *Arts Magazine*, (Summer 1987): "When he fills up a field with waves and funny amoebalike forms . . . he's like a great, young jazz musician taking the historical basics and improvising, embellishing with discordant detail, juggling and mixing old tunes and coming up with a style of his own." Most reviews of Taaffe's contribution to the 1987 Whitney Biennial were similarity positive.

Michael Brenson wrote in the *New York Times*, "With unnatural color and with an unpredictable sense of pictorial relationships and timing, he pieces those ideas together in ways that can be jarring and revealing . . . his work holds up." His detractors found his work cynical and retrograde. Taaffe has cited his meticulous obsessive labor in refuting the charge of cynicism but has acknowledged that he has set himself up for the criticism that his paintings are retrograde. "Yet," he contended, "going back to the past is a way of providing an immediate pool of knowledge and information. Renegotiated or reinvented, it allows more knowledge to enter the work. If the historical image is made immediately manifest, the work becomes reflective rather than retrogressive; it reflects those sacred and inspired moments and incorporates them into our moment. It enables a criticality to develop and gives us some sense of direction."

Born in 1955 in Elizabeth, New Jersey, Taaffe decided at an early age to be a painter, and his enthusiasm for painting hardly wavered since then. While many writers, critics, and artists of his generation have taken to heart the words of the French philosopher Jean Baudrillard and adopted theoretical doubts about painting, Taaffe is still committed to that means of expression. In 1986 he was quoted as saying, "I think we've gotten to the point now where it's been proven that painting cannot be killed. . . . It won't die, and we have to accept that fact." Eleanor Heartney wrote in *ARTnews* (September 1987), "Long after Baudrillard has ceased to be required artworld reading, we will still be interested in looking at work, like Taaffe's, that is visually as well as conceptually compelling."

In May 1989 Taaffe had two solo exhibits in New York, at the Pat Hearn and the Mary Boone Galleries, which received mostly favorable reviews. The new paintings seemed even more elaborate in detail and historical reference than ever before. Paintings like *Ahmed Mohammed, Aurora Borealis*, and *Quadro Vesuviano* showed further progressions toward investigations in ancient and medieval details, especially with images of wrought iron twistings and baroque figures. "In *Ahmed Mohammed*, where a Gottlieb-scape of horizon and floating spheres is seen through enormous fragments of Islamic script," according Roberta Smith, " [Taaffe] tries out an openness and a scale his work has never had before. . . . In their taut distillations of modern and medieval, purity and violence, art and craft, these paintings telegraph Mr. Taaffe's historical sources and his high ambitions convincingly and instantaneously—signaling a fierce ability to make paintings that force us to look first and ask questions later."

1967 to 1970. The spare, laconic quality of these slate-gray painted canvases scribbled over with white crayon marks, and the often repetitive arrangement of this schemata, found great favor with the minimalists, though Pincus-Witten remarked on the ennui and lassitude to be felt in these works. As a group they resemble slated or blackboards on which words, numbers, geometrical configurations, or rhythmic rows of loops and circles (as in old-fashioned penmanship exercises) have been semi-obliterated by smudges of white paint, as if by a blackboard eraser. Notable among the series is the 1970 *Treatise on the Veil (Second Version)*, a huge canvas 10 feet high by 32 feet wide, interpreted as a visual metaphor for the Orpheus legend. Crayon lines drawn on the gray housepaint-covered surface suggest a musical staff, the speed and duration of the markings comparable to the flow of music. And indeed Twombly has called such works of the late 1960s his "time-line" drawings; as Pincus-Witten observes, Twombly's line marks distance and time between spaces.

After 1971 the artist began to introduce collage more frequently into his work, developing a technique he had been using since 1959. A 1968 collage (untitled) combines a reproduction of Leonardo's drapery studies, taped onto a canvas, with Twombly's own penciled schemata. The 1972 *Captive Island Collage* utilizes a postcard picture of Florida (the title is the name of the site of Rauschenberg's Florida home) veiled over with crayon marks. *Narcissus* (1976) consists of pictures of the flower collaged on sheets of drawing paper and almost obliterated by the artist's drawn and penciled scrawls. He has never, however, totally abandoned his main theme. Thus, between 1977 and 1978 he completed one of his most ambitious compositions, *Fifty Days at Iliam* [sic]. Done in oil paint, crayon, and pencil on canvas, and measuring 85 feet wide by 10 feet high overall, it is an assemblage of 10 parts, on which the artist worked more or less simultaneously. The painting is now permanently installed in the Philadelphia Museum of Art. What is attempted here is a visual interpretation of Homer's *Iliad*, using as a controlling image "The Shield of Achilles," which is subjected to a series of often violent metamorphoses. In various sections of the composition, such as "Shades of Achilles, Patroclus and Hector" or "House of Priam," the scribbled names of the Trojan War protagonists and their protective deities can be detected.

To distinguish between "painting" and "drawing" in Twombly's art is virtually impossible; he draws on canvas (paint is really only the ground), paints on drawing paper. The fusing of media is exemplified in the 1972 *Bolsena*, done in oilstick and pencil on paper, but classified as a painting. As in many of his other later paintings, the markings that allude to the architecture and landscape of this site (one of his favorite places) can be compared to "a list of thoughts or impulses" arising from the artist's visual perceptions as influenced by his reading; in this case, a line from Mallarmé is inscribed. A certain lyricism modifies the obsessive jotting of factual data. According to the Museum of Modern Art curator Bernice Rose, the source of Twombly's art has always been the gestural act of drawing, and the tension between drawing and painting is ever present in his work. The artist himself admits to "mainly having a feeling for paper rather than for paint"; and between 1975 and 1980, drawings, per se, dominated in his output. Apart from automatic drawing, he continuously experiments with technique, holding his pencil at different angles, for example, to get different linear and tonal effects.

Despite this interest in line and tone, Twombly has done relatively few prints. Only 77, mostly en suite, were published between 1953 and 1984, but these works do employ a wide range of graphic media. They include etchings, printed in the 1960s at Tatyana Grosman's Universal Limited Art Editions studios; screen prints—16 of these, under the title *8 Odi de Horazio*, published in 1968 in Milan; lithographs, drawn by the artist directly on the stone and printed in 1971 at Rauschenberg's Untitled Press on Captiva Island; and a combination of lithograph and collotype, in *Natural History, Part I. Mushrooms* and *Part II. Some Trees of Italy*, printed in Zurich in 1974 and 1975–76, respectively. Here, adopting the collage technique, the artist began each print with a textbook illustration, added fragments of photographs or magazine illustrations and then, after the printing, applied hand-drawn touches in crayon. Portfolios such as *Six Latin Writers and Poets* (Zurich, 1976) and *Five Greek Poets and a Philosopher* (Zurich, 1978) evoke the associations their names arouse. In these mixed-media prints (eight in each suite) the schemata consists only of the scribbled, sometimes incomplete, name of the eponymous subject.

Twombly's way of painting, per se, has often involved a direct physical handling of the medium: digging into paint with pencil or crayon, or with a palette knife or the end of a brush, even drawing on a paint-covered surface with his fingernails. Construction of three-dimensional objects has, therefore, been a natural counterpart to two-dimensional representation throughout his career. Between 1952 and 1954 Twombly made totemic figures from found pieces of wood, plastic, string, wire, shells, nails and

screws. As he admits, these forms were "kind of homemade-looking." In later years he has produced such acclaimed works as *Cycnus* (1978). A rhythmic, undulating form made of linen, palm leaf and wood, painted over, it suggests at the same time a palm leaf, or the swan of its Greco-Roman title. Still later works include painted bronzes, such as a 1983 piece suggestive of a plant form.

Recent photographs of Cy Twombly, some with his son, Alessandro, show a man with ruggedly handsome features, a lean face and high forehead—another version of the tall, grave, dark-haired young man seen in photographs taken by Rauschenberg in the 1950s. It is known only that the artist is married to Tatia Franchetti, a member of a distinguished and wealthy Italian family; that their son is now in his late twenties; and that they have a palatial home in Rome, a fitting background to Twombly's superb collection of ancient art and works by some of his contemporaries.

EXHIBITIONS INCLUDE: Kootz Gal., NYC 1951; Seven Stairs Gal., Chicago 1951; Stable Gal., NYC 1953, '55, '57; Gal. Contemporanea, Florence 1953; Gal. La Tartaruga, Rome 1958, '60, '61, '63, '65, '67, '68; Gal. del Naviglio, Milan 1958, '60, '61; Leo Castelli Gal., NYC 1960–76; Palais des Beaux-Arts, Brussels 1965; Stedelijk Mus., Amsterdam 1966; Milwaukee Art Cntr. 1968; Modern Art Agency, Naples 1970, '72, '74, '75; Gal. Sperone, Turin 1971, '73 and Gal. Gian Enzo Sperone, Rome 1976; Kunstmus., Basel 1973; Kunsthalle, Bern 1973; Inst. of Contemporary Art, Univ. of Pennsylvania, Philadelphia, and San Francisco Mus. of Modern Art 1975 (retrospective); Mus. d'Art Moderne, Paris 1976; Whitney Mus. of American Art, NYC 1979 (retrospective); Gal. Karsten Greve, Cologne 1981–82; Blum Helman Gal., NYC 1982; Stephen Mazoh Gal., NYC 1983; Staatliche Kunsthalle, Baden-Baden 1984; Dia Art Foundation, NYC 1985; Hirschl & Adler Modern, NYC 1986; Zurich Kunsthaus 1987 (retrospective); Whitechapel Art Gal., London 1987–88 (traveling show); Sperone Westwater Gal., NYC 1989. GROUP EXHIBITIONS INCLUDE: Spoleto Festival (Italy) 1958; "Art and Writing," Stedelijk Mus. 1963; Venice Biennale 1964; Whitney Biennial 1973; "Drawing Now," MOMA, NYC 1976.

COLLECTIONS INCLUDE: MOMA and Whitney Mus. of American Art, NYC; Rhode Island School of Design, Providence; Philadelphia Mus. of Art; Milwaukee Art Cntr.; Gal. Nazionale d'Arte Moderna, Rome; Wallraf-Richartz Mus., Cologne; Hessisches LandesMus., Darmstadt.

ABOUT: Barthes, R. "The Wisdom of Art," in Whitney Mus. retrospective exhibition catalogue, 1979; Bastian, H. Cy Twombly: Paintings 1952–1976, 1978; Bastian, H. Cy Twombly: Das graphische Werk, 1953–1984; A Catalog Raisonné of the Printed Graphic Work, 1985; Bastian, H. and S. Delehanty. Cy Twombly: Paintings,

Drawings, Constructions, 1951–1974, 1975 (Inst. of Contemporary Art exhibition catalog); Current Biography April 1988; Gal. Karsten Greve, Cologne, Cy Twombly: Bilder und Zeichnungen, 1975; Rose, B. Drawing Now, 1976 (MOMA exhibition catalog); Smith, R. Cy Twombly, 1986 (Hirschl & Adler Modern exhibition catalog); Stephen Mazoh Gal., NYC, Cy Twombly Paintings, 1983; Tomkins, C. Off the Wall, 1980. *Periodicals*—American Artist October 1979; Artforum April 1974, May 1979, October 1986; Art in America September 1979; ARTnews January 1955, February 1979, February 1986; New York Times August 17, 1969, April 13, 1979, April 22, 1983, April 25, 1986, January 22, 1988, March 19, 1989; Time June 17, 1985.

VAN ELK, GER(ARD PIETER) (March 9, 1941–), Dutch conceptual artist who works with painting, photography, and sculpture in order to interrogate the media themselves and the messages that they bear. Around that conceptual core, steeped in the first-person irony of the dada and surrealist traditions, his formal preoccupations have encompassed sculptural idioms close to *arte povera*, the mass-culture images of photography, and a dialogue with painting styles ranging from the Dutch masters to American abstract expressionism.

Born in Amsterdam, Van Elk entered the School of Applied Arts there at the age of eighteen. From the outset, he removed himself from the artistic mainstream: at a time when most artists were fashioning images in one way or another, he was experimenting with the formal properties of materials, notably the plastic he obtained from a relative's factory, "to show how a material as manipulable and devoid of character as plastic could still speak a language," he later explained. In 1961 he and his friend Wim T. Schippers founded their own movement, adynamism, which was intended as a negation of the "dynamic vitality" of tachist painting. Their "Adynamic Manifesto" was published in *Vrij Nederland* that December, and the following year they had their first exhibition at the Museum Fodor. For the occasion, Van Elk presented what was to be the first of many tongue-in-cheek commentaries on contemporary art: brightly colored assemblages of discarded plastic, kitschy pastel drawings, and another group of drawings that were entirely blank except for their geometric borders.

By the time of that exhibit, Van Elk had left the School of Applied Arts and decided to go to the United States, since his father was then living in Hollywood and he was curious to see California. "I went like an emigrant with thirty dollars in my pocket," he told Gijs van Tuyl in 1981, re-

calling that he worked for six months as a baker in Connecticut before leaving for the West Coast. There he spent two years studying art and art history at the Immaculate Heart College in Los Angeles; among his instructors were Henry Miller and John Cage. (Cage, he indicated, was quite stimulating, but he found Miller "vague and unfocused.") In the mid-1960s, after his return to Holland, he resumed the study of art history at the Rijksuniversiteit in Groningen while continuing what he described as "formal and theoretical exercises" on the transformation of materials: amorphous polyurethane pieces, cord sculptures hung on the wall, color projections, and painted photographs and films.

The events of May 1968 passed him by—"I was totally involved in making art," he has insisted—and in the face of concerted attacks on all the institutions of modern art, he held fast to his identity as an artist: "One must never say 'I'm not an artist,'" he declared in 1968, defending "the typical European art direction we are now working on. A little sensitive, highly individual art." Nonetheless, his work at the time—mainly concerned with borders and spatial dividers—was very much in tune with the collective groundswell in Europe and the United States, and he participated in several pathbreaking exhibits at the end of the decade. In the so-called microemotive exhibition organized at Amalfi in 1968, for example, he presented a *Plinth Piece* consisting of a strip of velveteen bordering a rock formation, and for a 1969 Amsterdam exhibit of *arte povera* and conceptual art that he helped to organize ("Op Losse Schroeven/ Square Tags in Round Holes") he suspended a miniwall of brick over a table in the museum cafeteria and divided a large staircase down the middle with a canvas curtain.

As Rudi R. Fuchs later pointed out, such pieces were effective illustrations of ideas rather than expressions of form (if anything, they were antiform, in the spirit of *arte povera*), and thus offered Van Elk little margin for variation. As a result, his work tended to evolve through a succession of different forms and materials, and this was to remain characteristic throughout his career. In 1968 he bought a camera—not to make art, he stressed to van Tuyl, but "to learn how to use it"—and he soon turned to photography as a way of making his ideas clearer and more accessible. For the landmark "When Attitude Becomes Form" exhibit at the Berne Kunsthalle in 1969, he photographed a square meter of asphalt across the street from the museum, made a life-size color print, and set it back in place in the street under a sheet of plastic. "In one hour," he recalled, "the footprints made it impossible to distinguish the altered spot. The imagination—

i.e., the photograph—had taken the place of reality, but it was fascinating to see that in so little time, reality was restored. It was a self-regenerating transformation."

Over the next few years, Van Elk continued to explore similar paradoxes of representation through the mechanical reproduction of photography, as well as video and film. His frame of reference was frequently art-historical, as in *Paul Klee—Um den Fisch (Around the Fish), 1926* (1970), where he transformed a particularly emblematic Paul Klee painting of a fish and various occult symbols into a fish dinner, which was then eaten; this real-life event was duly transformed into art through a series of eight color slides recording the stages of the meal right down to the fish bones (obviously the most Klee-like image of all), which he projected onto an upright table covered with the requisite white tablecloth. In other works, he went directly to art theory, as with the four-minute film he made for a Dutch TV program, *Einige Aspecten van schilderen en beeldhouwen (Some Aspects of Painting and Sculpture)* (1970–71), in which he used his own body to illustrate the notions of color and texture. In still other works, he looked at representation in the mass media through manipulated photographs, as in the four-part *Symmetry of Diplomacy* (1971–72) (inspired by press photos in the *Peking Review*), where mirror-image tableaux of supposed diplomats (again Van Elk) offered a satirical commentary on the formalism of the diplomatic process.

Critics like Wim Beerens and Rudi R. Fuchs have frequently drawn attention to duality and contrast as an essential feature of Van Elk's work, beginning with the plinth pieces and dividing walls and continuing in different ways throughout his career—symmetry of form, duality of materials, contrast of reality and representation—all of which serve the essential aim Van Elk defined in a 1972 interview: "to present a work of art from which you can distill all sorts of facets and double meanings just by looking at it." With the switch to the camera, Van Elk frequently served as his own model, but, he contended, that was a matter of efficiency rather than vanity: he knew exactly what he wanted and "it's easy to get someone else to press the button." Nonetheless, the individualism that he had verbally espoused several years earlier became a prominent feature of his art, evoking comparison with the California artist Bruce Nauman, whom Van Elk readily acknowledged as an important influence. Indeed, by 1973, when he had begun to combine his photographs with painting, he was well aware of the distance separating his very anecdotal work from the primary statements of the *arte povera* group with

whom he had been associated in the late 1960s; his sensibility, while thoroughly steeped in European tradition, had also begun to reflect American art and society.

That hybrid spirit was apparent in what turned out to be a transitional group of objects dating from 1973. *It's Me Twice as Flat as I Can Be,* for example, was a large wall hanging fashioned out of rope and bamboo; in that respect it was not unrelated to *arte povera,* but it also took a Nauman-like turn with the incorporation of two head shots of the artist, one in profile and one full face. Similarly, for *LA Freeway Flyer* (the name of a bus) Van Elk took six walking canes and extended them end to end to form a kind of diagonal thunderbolt across the wall to convey the speed of the transport, but he gave yet another anecdotal twist to the image by wrapping the canes with color contact prints of cars lining the freeway. In those works there was no pretense to the universality of *arte povera* or conceptual art, but rather, abstractions were pointedly expressed through their most tangible, if not banal, dimensions.

The real turning point for Van Elk came when he began combining his photographs with painting. For him, the development was a very personal, individual one. As he explained to van Tuyl, "I'd had enough of shock effects, and I was moving more toward content. I was probably giving more place to feeling and analyzing less. . . . You arrive at the conclusion that art is the product of the individual. You make what is beautiful to you and it gives you more pleasure." From that moment on, he noted, "the elements became more realistic." A key work in that evolution was *C'est moi qui fait la musique (It's Me Who Makes the Music)* (1973), which confronts the issue of painterly representation head-on, so to speak, with a photographic image of Van Elk playing a grand piano squeezed into a triangular (framed) canvas. With an obvious jibe at the monumental shaped canvases then in vogue, Van Elk here "makes the music" by recombining and retouching photographic images so that the piano collapses like one of Salvador Dali's watches to fill the right-hand corner of the triangle, and the tails of his evening dress coat take a downward swoop into the left-hand corner. In the four-part series "The Adieu" (1974), he pursued that play on art and artifice with painted photographic images of easel paintings (and their easels) rendered in extreme perspectives on irregularly shaped canvases; the "adieu"—to easel painting—then consisted in hanging each picture so that the image rather than the frame was aligned to the viewer and the room.

Throughout the remainder of the decade Van

Elk reworked those perceptual and conceptual issues—along with the related one of mass-media representation—in a variety of photo-paintings, ranging from the painterly canvases of the "Symmetrical Landscapes" (1975) to the photographic tableaux of the "Missing Persons" series (1976). During that period he maintained frequent contact with the United States—in 1975 he became the first Dutch artist to have a solo exhibit at the Museum of Modern Art in New York—and developed an international reputation that surpassed his recognition at home (in part, at least, as Wim Beeren indicated, because his commitment to art as an "authentic inviolable category" was at odds with the predominantly social thrust of art in the Netherlands at that time). In 1980 his retrospective at Venice was hailed as one of the best in the Biennale, and that exhibition was then revised and expanded for a European tour that included Basel, Paris, and Rotterdam.

By that time Van Elk himself had moved in yet another direction, once again incorporating the notion of sculpture—if not the fact—into his problematic of artistic form. For example, the *Roquebrune Sculpture* (1979), a flat canvas triangle bisected into painted and photographed sections representing the texture of a mountain, took on the illusion of depth because of the manipulation of the surface patterns. Similarly, the *Mont Blanc Mountain Sculpture* (1980) "built up" perfectly flat layers of canvas on the floor through the illusion of depth in the photographic image of Mont Blanc. In other works, like *Olympic Sportive* (1979) and *Sportive Sculpture* (1980), a square piece of canvas was gathered and pushed into a three-dimensional wall "sculpture" bearing four symmetrical images of the artist converging at the conelike center. Still other works, including *Push Nose Balance Sculpture* (1970) and *Triangle Balance Pull* (1980), were canvas cutouts of photographic images (again Van Elk) in improbable positions of tension that generated an illusionistic space around them, while *Rainbow Babies* (1980), canvas cutouts of twin putti bearing rippled banners, were hung at the top of the wall in an obvious evocation of baroque ceiling paintings.

When these pieces were exhibited in New York in 1981, Kate Linker noted approvingly that these hybrid painting-photo-sculptures added yet another layer of contradiction to Van Elk's ongoing artistic interrogation, focusing not only on the "impossibility of seizing reality in a world that is endlessly mediated by codes, but also the evasiveness of the very codes that claim to interpret experience." And Van Elk's work itself was at the mercy of such codes, Linker argued, suggesting that in the formalistic climate

of the 1970s, it had tended to look somewhat "unserious and unshaped," whereas it was now seen differently because of the resurgence of representation. For other critics, meanwhile, it seemed clear that Van Elk's outlook had changed as well, and that there was a "more sober and disquieting tone" to the latest phase, if not what Paul Groot, referring to the canvas cutouts, called "something horrible about them."

In any case, Van Elk took a brief break from his self-representational pursuits and reimmersed himself in art history, beginning with a group of flower paintings that played off the "photographic" realism of seventeenth-century Dutch still lifes against the painterly surface of abstract expressionism. Another series of eight shaped canvases followed, now with obtrusively sculptural frames and a much more evocative, less illustrative reflection on the nature of the painting medium, which is achieved through the juxtaposition of abstract patterns, photographic images, and even an occasional object, like the toy cars imbedded in the thick surface of the diamond-shaped *Long Island Expressway* (1984).

All of those works bore the mark of the Dutch masters in their insistent gray-black palettes accented with blue and orange at the same time that they evoked the surface and space of the American abstractionists. Yet as more than one critic noted, those insistent allusions to the art of the past did not belong to the current vogue for revival styles but rather, in the words of Régis Durand, constituted "a superb homage and 'return' to painting," not in the sense of a concession to the latest fashion (which is already passé) but that of a fairly humorous dialogue with the great traditions of the United States and Holland, and for Durand, if a work like *Long Island Expressway* was less "philosophical" than the *LA Freeway Flyer* of a decade before, it was much more enjoyable to look at. That visual bravado continued with several groups of large photopaintings done in 1986–87, where the formal idioms of past and present were seamlessly juxtaposed and maintained in visual and conceptual equilibrium through Van Elk's own, first-person presence. Whether as a stand-in for French president François Mitterrand in *FM Portrait of a Decision* (1986), a pair of almost seventeenth-century Dutch burghers in *The Western Stylemasters* (1987), or the Virgin Mary and Jesus Christ in *Honda Gothic* (1986), he reaffirmed, with equal measures of irony and craft, "It's me who makes the music."

In 1981 Van Elk explained to Jules B. Farber, "The main thread through all my work is reality. I isolate certain elements from reality and give them a new order in combinations you otherwise do not see in real life. But that doesn't mean I change reality. I represent it different. My works are intended to make people think it could also be this way." But as his longtime friend Wim Beeren pointed out, "His works are never so abstract as to be completely outside collectively experienced reality. Nor are they ever so realistic as to fail to take account of abstraction in art as a recognizable factor in itself. Ger Van Elk is the dupe of neither reality nor art."

EXHIBITIONS INCLUDE: Mus. Fodor, Amsterdam 1962 (with Wim T. Schippers); Dilexi Gal., Los Angeles 1962; Inst. voor Kunstgeschiednis, Groningen 1965; Gal. Swart, Amsterdam 1966; '68; Gal. de Mangelgang, Amsterdam 1967; Gal. Espace, Amsterdam 1967; Gal. La Nuova Loggia, Bologna 1968 (with Marinus Boezem); Koninklijke Academie voor Beeldenden Kunste, Hertogenbosch 1969; Gal. Walenkamp, Leiden 1969; Kunstkring, Rotterdam 1969; Art & Project, Amsterdam, from 1970; Mount San Antonio Col., Walnut, Calif. 1971; De Utrechtse Kring, Neudeflat, Utrecht 1971; Pomona Art Gal., Claremont, Calif. 1971; Montgomery Art Cntr., Pomona, Calif. 1972; Nova Scotia Col. of Art and Design, Halifax 1972; Kabinett für Actuelle Kunst, Bremerhaven 1972, '75; Utrechtse Kring, Utrecht 1972; Stedelijk van Abbemus., Eindhoven 1973; Gal. Ernst, Hanover 1973; Wide White Space, Antwerp and Brussels 1973; Gal. Waalkens, Finsterwolde (Netherlands) 1973; Gafiek 50 VZW, Wakken (Belgium) 1973; Claire Copley Gal., Los Angeles 1973; Nigel Greenwood Gal., London, from 1974; Stedelijk Mus., Amsterdam 1974; Pal. des Beaux-Arts, Brussels 1974, '75; MOMA, NYC 1975; Stedelijk Mus. de Lakenhal, Leiden 1974; Badischer Kunstverein, Karlsruhe 1977; Rheinisches Landesmus., Bonn 1977; Kunstverein, Braunschweig 1977; Marion Goodman Gal., NYC, from 1978; Hansen-Fuller Gal., San Francisco 1978; Gal. Lucio Amelio, Naples 1980; Venice Biennale 1980; Kunsthalle, Basel 1980; Mus. d'Art Moderne de la Ville de Paris, 1980; Fruit Market Gal., Edinburgh 1981; Serpentine Gal., London 1981; Arnolfini Gal., Briston 1981; Gal. Durand Dessert, Paris, from 1982; Gal. Massimo Minimi, Rome 1986. GROUP EXHIBITIONS INCLUDE: "Signalement 67," Stedelijk Mus., Amsterdam 1967; "Rassegna d'Arti Figurative," Arsenali, Amalfi 1968; "Junge Kunst aus Holland," Kunsthalle, Berne 1969; "Op Losse Schroeven/Square Tags in Round Holes," Stedelijk Mus., Amsterdam and Folkwang Mus., Essen 1969; "When Attitude Becomes Form," Kunsthalle, Berne and Inst. of Contemporary Arts, London 1969; "Pläne und Projekte als Kunst," Kunsthalle, Berne 1969; Tokyo Biennale, 1970; Prospect 71, Kunsthalle, Düsseldorf 1971; Documenta 5, Kassel 1972; "Reflection and Reality," Pal. des Beaux-Arts, Brussels and Fruit Market Gal., Edinburgh 1976; "Seven Dutch Artists," Mücsarnok Mus., Budapest 1977; Documenta 6, Kassel 1977; "Europe in the Seventies," Chicago Art Inst. 1977 (trav. exhib.); Venice Biennale 1978; "Made by Sculptors," Stedelijk Mus., Amsterdam 1978; "With a Certain Smile?" InK, Halle für internationale neue Kunst, Zurich 1979; Sydney Biennale 1979; "Artist and Camera," Mappin Art Gal., Sheffield 1980 (trav. ex-

hib.); "Oeuvres photographiques du FRAC Champagne- Ardenne," Cntr. Culturelde Troyes, 1986; "L'Epoque, la mode, la morale, la passion," Cntr. Georges Pompidou, 1987.

FILMS AND VIDEOS: The Absorption of a Shadow, 1969; The Fluttering Pennon, 1969; How Van Elk Inflates His Left Foot with His Right One, 1969; The Shaving of the Cactus, 1970; Einige aspecten van schilderen en beeldhouwen (Some Aspects of Painting and Sculpture), 1970–71; La Pièce, 1971; The Flattening of the Lake's Surface, 1972; Short Play with Morandi, Klee and Kandinsky, 1972.

COLLECTIONS INCLUDE: Stedelijk Mus., Amsterdam; Pal. des Beaux-Arts, Brussels; Stedelijk van Abbemus., Eindhoven; Mus. van Hedendaagse Kunst, Ghent; Frans Halsmus., Haarlem; Gemeentemus., The Hague; MOMA, NYC; Rijksmus. Kröller-Müller, Otterlo; Cntr. Georges Pompidou, Paris; Mus. Boymans-van Beuningen, Rotterdam.

ABOUT: Emanuel, M., et al. Contemporary Artists, 1983; "Ger Van Elk" (cat.) Stedelijk Mus., Amsterdam, 1974; "Ger Van Elk" (cat.), Venice Biennale, 1980; "Ger Van Elk" (cat.), Mus. Boymans-van Beuningen, Rotterdam, 1980; "Ger Van Elk" (cat.), Fruit Market Gal., Edinburgh, 1981. Periodicals—Art and Artist September 1968; Artforum March 1974, January 1978, January 1982; Art in America February 1982; Artistes March–April 1981; Art Press February 1981, December 1984; Arts Magazine September 1968; Flash Art Summer 1982; International Herald Tribune April 18–19, 1981; Libération November 12, 1984; Studio International June 1971, January 1976.

VOULKOS, PETER (January 29, 1924–), American sculptor and ceramist, is best known for almost single-handedly fashioning clay into a serious medium for modern abstract sculpture; in fact, he is one of the last of the hardcore abstract expressionists and one of the few important sculptors to emerge from that movement. The leading exponent of the West Coast ceramics movement, Voulkos preaches the gospel of clay with prodigious feats of wheel throwing, slab building, and abstract expressionist glazing in hundreds of public demonstrations across the country. Less well known, at least on the East Coast, are Voulkos's mammoth bronze works for public spaces (which continue David Smith's style of macho formalism) and his thousands of elegant, functional plates and pots. His work, wrote the critic Thomas Albright, "manages to combine aggressive self-assertion with disarming sophistication, the brute power of industrial fabrication with the classical elegance of ancient Chinese artifacts." Rose Slivka called Voulkos "the first of the new breed of artists who cross all lines from craft to art and vice versa."

Born in Bozeman, Montana, Voulkos left his hometown for Portland, Oregon, after he graduated from high school in 1941. In Portland he worked for two years as a foundry apprentice making parts for the Navy, then served for three years as a nose gunner with the Army Air Corps in the Pacific. Returning to Bozeman, he studied commercial art at Montana State University, where he considered himself a painter and found early inspiration in the works of Picasso. (Voulkos continues to paint, but his paintings have been completely overshadowed by his three-dimensional work. Picasso's influence, however, shows up clearly in the surface treatment of his pots and ceramic sculpture.)

Voulkos did not take a class in ceramics until his senior year, but that first experience with clay, he claimed, was the one in which he found himself as an artist. "I began to understand what art was all about through clay; I hadn't even known what I was doing as a painter. Clay is an intimate thing—just beautiful! It's a blob of nothing, then the minute you touch it, it moves." Though his earliest clay pieces were strictly functional, not sculptural—the traditional potter's bowls, plates, mugs, covered jars, narrow-necked bottles, and other vessels—Voulkos was already a technical innovator, developing new techniques of slip and wax-resist surface decoration with inlaid and raised lines. Before his graduation in 1949 Voulkos had already won several important prizes for his ceramics, including the Potters Association Prize at the Ceramics National Exhibition in Syracuse, New York.

In 1950–52 Voulkos studied for an M.F.A. degree in ceramics at the California College of Arts and Crafts in Oakland, California. There his pots, which were growing in size (the artist apparently overestimated by a factor of four or more the scale of Greek and Asian ceramics he saw reproduced in books, and was moved to match or exceed them), and his method of working were already understood to be different from anything that had been done before. Manual Neri, a California ceramist who later joined Voulkos's circle, described Voulkos's strenuous approach to clay: "His attitude toward the medium was the main thing; he forced himself onto the material, completely imposing himself on it, instead of taking that kind of sacred approach toward ceramics that most people did." Though Voulkos liked to manhandle his clay, he developed increasing sensitivity to and respect for the kind of "beautiful accidents"—inadvertent tears, bulges, slumps, and glazing oddities—that always happen in the course of making ceramics, and that are central to the aesthetic of Asian, especially Japanese, pottery. During a brief return to Montana in 1952 Voulkos met Shoji Hamada,

the revered Japanese folk potter, and the English ceramist Bernard Leach.

Voulkos was still ignorant of current trends in painting (American sculpture in the early 1950s being restricted to a few solitary toilers like David Smith), but a stint as a ceramics instructor at Black Mountain College during the summer of 1953 changed that. There Voulkos met the leaders of the American avant-garde, who lured him to New York later that summer, where he encountered abstract expressionism for the first time. Action painting was a profound eye-opener for Voulkos; he immediately began to see in clay, with its unmatched plasticity and responsiveness, a new medium for three-dimensional abstract expressionism, appropriating as well the vigorous gestures and showmanship he observed in de Kooning, Franz Kline, and others. It was that insight that enabled him to "elevate" clay from the ghetto of craft, where it received no serious attention from the art establishment, to a "legitimate" medium for artistic investigation.

The following six years were arguably the most important in his career—and, as some critics have argued, for the development of southern California painting and sculpture. Voulkos became one of the most important catalysts in the energizing of West Coast art with New York School ideas. Invited by Los Angeles's Otis Art Institute in 1954 to set up a new ceramics department, he presided over a revolution in clay handling, as described by the art historian Sylvia Brown: "At Otis, Voulkos and his students were throwing hundreds of pots a day in frenzied competition, each using as much as one hundred pounds of clay. Rejecting classical forms and traditions of craftsmanship, they emphasized speed, accident, and the clay's own qualities—its weight and density, its propensity to bend and sag and wobble. They exploited the ragged edges formed by a tear, the thin line of an incision, the dark hollow of an interior space, a rough natural surface or a smooth glassy glazed one, along with tracks, fingerprints, score marks and fractures." That "more light-hearted, deft, and clean [abstract expressionist] aesthetic," as it was called by the California art chronicler Peter Plagens, thrived under Voulkos's direction, and has now become part and parcel of art ceramics instruction throughout the country. Among the artists who studied under Voulkos at Otis were John Mason, Kenneth Price, Billy Al Bengston, Michael Frimkess, and Malcolm McLain.

By the late 1950s the artist's own work grew progressively larger and more free form. He moved away from using predominantly symmetrical, wheel-thrown (i.e., traditional) forms toward a hybrid of cut, draped, and layered clay slabs over an armature of wheel-thrown cylinders, asymmetrical forms that, as Voulkos has noted, owed much to the blocky, thrusting sculptures of Fritz Wortruba, which he first saw in 1955. Eventually his pieces grew so large—some weighed up to a ton—that Voulkos had to construct and fire them in parts and assemble them with epoxy afterward. At the same time his handling of surface decoration became more expressionist in approach, with slashing incisions and Picassolike swirls of glaze and enamel competing for attention with the three-dimensional forms. Typical of the artist's huge, chunky, and poly-chromed clay works of the late 1950s are *Rondena* (1958), *Sitting Bull* (1959), and *Little Big Horn* (1959). Sylvia Brown described those "bulbous modules" as "rough and ugly, with a harsh blackened surface, like bark or volcanic rock, which contributes to the commanding totemic presence of the whole."

By the late 1950s Voulkos was making sculpture, not pots, and at least in part because of that lost his position at Otis in 1959. He then moved to the University of California at Berkeley, where he was joined by other young artists, including Ron Nagle, Stephen de Staebler, and James Melchert. As Hal Fischer has pointed out, much of Voulkos's reputation rests on the many ceramics demonstrations he has given at colleges and art centers across the country. They fully qualify as a variety of performance art or athletic event: the artist handling immense masses of clay (Voulkos has earned the nickname "Gorilla Man" for his ability to wedge and throw a larger hunk of clay than anyone else), pushing the material and his own endurance to their physical limits while the audience shares with him the suspense of whether the kiln will produce success or spectacular failure. "It's like jazz," the artist explains. "You have to start improvising, and you can't screw it up. And you don't know the clay, the people, or the equipment."

Through the mid-1960s Voulkos's demonstrations yielded most of his output in clay as he turned his attention to a new medium: bronze sculpture. At the suggestion of Don Haskin, also a Berkeley faculty member, Haskin, Voulkos, and the sculptor Harold Paris set up the Garbanzo Works Foundry to create monumental works in bronze. As with ceramic sculpture, Voulkos took a constructivist or assemblage approach to bronze, casting stock parts in a few characteristic shapes—slabs, various sizes and bends of tubing, domes, and blocks—and storing them for later use. In fact, Voulkos often did not weld his sculptures together until all the parts had arrived at the exhibition site, a practice he began with his first show of bronzes in Los Angeles in 1961.

Voulkos's early bronzes were primarily horizontal in orientation, a reaction to the verticality of his ceramic pieces (for example, *Honk* of 1963 is a composition of cantilevered slabs topped with twisted and flattened cylinders), but by 1965 they had become much more aggressively three-dimensional, as well as monumental in scale. As the sculptures grew, so did Voulkos's ability to attract major commissions. *Dunlop* (1965) was erected on the Albany Mall in New York, and *Big A* (1964–65) in Fresno. His best-known commission is the thirty foot-high piece erected outside the San Francisco Hall of Justice in 1971. *Hall of Justice*'s four-tiered tower of cells, curling around and through the tier, and strong horizontal outburst of hairpin-curved tubing are typical of the artist's compositions, which depend on (and sometimes suffer from) the tension between architectural space (defined by Voulkos's frequent use of supported platforms) and free form, curvilinear shapes (the snaky tubes). Hal Fischer noted that "although obviously three-dimensional, Voulkos's sculptures do not invite a 360-degree view. In fact, they exist almost as theater pieces, defining a 280-degree perspective with an obvious sense of front and back. This is in contradiction to Voulkos's ceramic sculptors, which are implicit in their roundness."

Since the early 1970s Voulkos has returned to more traditional forms in his clay work, but those forms, and their decoration, display a new sensitivity and subtlety. Several recent exhibitions have included tall stacked pots and large wheel-thrown plates that the artist uses as canvases for quickly drawn incisions and almost loving handprints. Ann-Sargent Wooster described Voulkos's clay drawing style as combining "ornamental calligraphy such as the Chinese and Persian (though without any reference to a known alphabet) with a more primitive form of drawing. One feels the hand making the work and marking it." Voulkos seemed satisfied to work masterly variations on familiar forms as he indicated in 1978: "I have it down in my ceramics now to a few shapes I like, and you can go and go on that. . . . The risks, the differences are still there, but they are really subtle." In the mid-1980s he showed a range of forms created in low-temperature wood-fired kilns: low, heavy cylindrical stacks, with a limited glaze palette of browns, dark blue, and white, and three-foot-wide plates incised and built up to create the impression of a spare topography.

Voulkos is "a man of dark, rough-hewn good looks, the type who projects a Zorba like animal energy and raw physical strength," according to Thomas Albright. He is powerfully built, with a barrel chest, broad shoulders, and wide hands with long, tapering fingers. "One is struck," wrote Rose Slivka, "by what appear to be easy, slow movements in which there is no waste or hesitation. The entire presence of Peter Voulkos suggests sure and total communication among all elements—heart, brain, hands, bodily strength—geared for action."

The artist lives in an immense San Francisco studio equipped with a large foundry and kiln as well as poker and pool tables. He is in the process of renovating several other industrial spaces around the Bay Area and has opened his own gallery with Jim Leedy in Kansas City, Missouri. Voulkos has been married twice and has one child from each marriage. He is usually surrounded by a group of like-minded artists and students, who join him for marathon pool and card games as well as cooperative art making. A craftsman at heart, Voulkos treasures the hands-on experience of making sculpture or pots: "Making sculpture to me is going with it all the way. Just looking at the final thing is nothing— its absolutely nothing. You know, you're just looking at an object. I'm involved in all that stuff in between—that's important. If you don't see that in-between stuff day in and day out, well, hell, you're just making a product."

EXHIBITIONS INCLUDE: Felix Landau Gal., Los Angeles 1956, '58; Univ. of Southern California, Los Angeles 1957; Art Inst. of Chicago 1957; Pasadena Art Mus., Calif. 1958; MOMA, NYC 1961; Bonnier Gal., NYC 1961; Gal. Unlimited, San Francisco 1964; Primus-Stuart Gal., Los Angeles 1964; Los Angeles County Mus. of Art 1965; David Stuart Gal., Los Angeles 1965, '69; Quay Gal., San Francisco 1968, '74; Kansas City Art Inst., Mo. 1975; Helen Drutt Gal. 1975; Braustein/Quay Gal., NYC 1975–76, '78; Yaw Gal., Bloomfield Hills, Mich. 1976; Detroit Inst. of Art 1976; Exhibit A Gal., Evanston, Ill. 1976, '79, '81; Contemporary Craft Assn., Portland, Oreg. 1977; San Francisco Mus. of Modern Art 1978; Contemporary Arts Mus., Houston 1978; Mus. of Contemporary Crafts, NYC 1978; Milwaukee Art Cntr., Wis. 1979; Jacksonville Art Mus., Fla. 1981; Thomas Segal Gal., Chicago 1981; Charles Cowles Gal., NYC 1981; Leedy-Voulkos Gal., Kansas City, Mo. 1986. GROUP EXHIBITIONS INCLUDE: "World's Fair," Brussels 1958; "International Ceramic Exhibition," Ostend, Belgium 1959; "Biennial I," Paris 1959; "World's Fair," Seattle 1962; "International Sculpture Exhibition," Battersea Park, London 1963; "200 Years of American Sculpture," Whitney Mus. of American Art, NYC, 1976; "California Clay," Braustein/Quay Gal. 1976; "International Exhibition," Art Cntr., Tokyo 1983; "Marer Collection of Contemporary Ceramics," Pomona Col., Claremont, Calif. 1984; "From Vienna to the Studio Craft Movement," Detroit Inst. of Arts 1986.

COLLECTIONS INCLUDE: Archie Bray Foundation; MOMA, Whitney Mus. of American Art, and Mus. of Contemporary Crafts, NYC; Japanese Craft Mus.; Los Angeles

County Mus. of Art; San Francisco Mus. of Modern Art; Oakland Mus. Calif.; Baltimore Mus. of Art; Norton Simon Mus., Pasadena, Calif: Everson Mus., Syracuse, N.Y.; Folk Art Mus., Tokyo; Portland Art Mus., Oreg.; Den Permanente, Copenhagen; Smithsonian Instn., Washington D.C.

ABOUT: Coplans, John. "Abstract Expressionist Ceramics" (cat.) 1966; Emanuel, M., et al. Contemporary Artists, 1985; Nordness, Lee. Objects: USA, 1970; Slivka, Rose. Peter Voulkos: A Dialogue with Clay 1978; Whitney Museum of American Art, "200 Years of American Sculpture" (cat.) 1976. *Periodicals*—Apollo December 1986; Artforum June 1965, November 1978, November 1983; Art in America July 1976, March 1979; Art International Summer 1973; ARTnews Summer 1965, October 1978. Ceramics Monthly February 1976, Summer 1981, September 1982; Ceramic Review May 1979; Craft Horizons September–October 1956, June 1966, October 1974, February 1978, February 1979; New Art Examiner May 1986; Studio Potter December 1984.

FILM: Voulkos & Co., 1976.

JIM WAID

WAID, JIM (November 2, 1942–), American painter, who does not fit neatly into any categories. His paintings consciously include biomorphic and organic forms with strong linear elements. As an artist, Waid tries to understand the idea of growth and genesis as related to the universe. He creates visual excitement with bold colors. The work is both specific and non-objective. Waid incorporates the forces of natural phenomena into his paintings. The surfaces are luxurious and thick with paint. By etching, scraping and digging into the paint, Waid endeavors to render a surface in which the figures and ground are united. He synthesizes forms much like a musician synthesizes sound.

Jim Waid's work shows an ultimate understanding and respect for the fecundity of nature. It is based on contemplation and a personal inner vision. His forms dwell on the edge of recognition, but require a refined sensibility from the viewer.

Waid was born in Elgin, Oklahoma and lived in a number of tiny towns as a child. He was the youngest of three boys. His father was in the education department of the University of Oklahoma, but was also the principal of a school which handled first through twelfth grade. It was a training school for teachers. Waid attended this school. "Both my parents were teachers most of their life. My father was a pedagogue. My mother taught elementary school. I was exposed to a lot of education."

In 1954, Waid's parents left Norman, Oklahoma and moved to Carlsbad, New Mexico where

his father was principal of a high school. Another move to the Eastern New Mexico University followed.

"As a boy, I visited the Carlsbad caverns. At the time, I did not feel that the caves influenced my art. Still, I realize that particular organic forms are of interest to me. Maybe, I was influenced without knowing it. All the way through grade school and high school, I was making a lot of drawings. I was a pretty good student; I had a fairly normal upbringing. I played football and did a lot of sports, sang in the choir, but always I drew. I decorated all my book reports. I was also interested in mathematics. In 1960, I graduated from Portales high school in New Mexico. My college freshman year was spent at Eastern New Mexico University where my father taught. I toyed with the idea of majoring in history, but turned towards art. I decided to become an artist without having an understanding of what that really meant. My parents, who were both academic people were fairly supportive. They encouraged me and my brothers in all our endeavors. They also did not understand what becoming an artist entailed. They were a little apprehensive about it. They had no understanding of abstract art. Still, they encouraged me. They paid for my schooling."

Waid spent the following year at the University of New Mexico. He read Jack Kerouac's book "On the Road." These were the wild sixties, rebellion was in the air. He decided to drop out of college and went hitchhiking across the country. 1962 found him in New York City where he met the painter Stuart Davis. A thirty minute meet-

ing lasted a couple of hours. "It was impressive for me to be in his studio—but I was not his assistant. I ran a few errands for him. He talked a lot about Arshile Gorky; he told wonderful anecdotes. I had no work of my own to show him; knowing him did not change my life."

After two months in New York, Waid returned to resume school at the University of New Mexico in Albuquerque. "I was twenty years old. Students were getting excited about the Vietnam war. There were student protests. I observed. I may have participated in one protest. I was already married to Beverly Lapsley. We had a child. I took a class with master printer Garo Antreasian on lithography, but I was not a good lithographer. He told me to become a painter. Later, the print workshop of the university became the Iamerind workshop. Art was exciting! Anything seemed possible! Everyone was doing all kinds of things. My interests early on was all abstraction. I saw slides of De Kooning, Kline and Jackson Pollock's work. I had instant sympathy with it. Teaching at that time was based on abstract expressionist ideas. I did not have a problem understanding that it was art."

In 1965, Waid graduated with a B.F.A. from the University of New Mexico and moved to New York City. He became an insurance investigator. It was the kind of job that allowed him to pursue art. His hours were flexible, "I was able to got to galleries and museums where I got as much art education as I ever got."

In 1968, Waid and his wife decided to move back to the Southwest. A number of non-professional, varied jobs followed. In 1969, Waid was offered a graduate assistantship at the University of Arizona; it was the only way he could afford to go to school. As a graduate student, he started teaching at Pima Community College and after graduating with an M.F.A. degree in 1971, he became a full time faculty member at Pima. He taught painting, drawing, design and color theory until 1980. In 1974, he had his first gallery show.

Like most artists, Waid's work has undergone several changes. When he started painting, he was influenced by Morris Louis and Helen Frankenthaler; he was interested in processing and staining canvas. "Nineteen seventy-six was a watershed year for me. I was getting dissatisfied and started introducing an element of linear drawing instead of solely painting flowing fields of color, and abstractions. I added more interior structure to the painting. I started to go out into the Sonora desert around Tucson looking, just looking. This started influencing my thinking in terms of shapes and growth. I tried to make my work a sort of equivalency of the growth process.

I painted this way from 1976 to 1978. My paintings were becoming more direct, more process oriented. By the time I got to the early 1980s, my paintings had become denser, the wood of the trees looked more graphic and I was including many more organic forms. I was looking at seed pods, roots, rocks, a whole mix of things. I was examining microphotography and the way molecular structures are designed by scientists. I was trying to understand the idea of natural growth to give my paintings a visual existence."

In a review in Arts Magazine (October 1981), Roger Harlan discussed Waid's work: "Jim Waid, after working more than a decade in Arizona, has produced canvases that function on their own as abstract paintings, but are suggestive of the desert's organic forms. His recent works presents strong evidence that Waid is one of the most important contemporary artists in the Southwest."

William Peterson made the following observations in an article in ARTnews (March 1986): "Waid's painterly virtuosity is rooted in the abstract expressionist improvisations, but having matured in the Southwest, his work has matured as a hearty hybrid. It combines his insatiable curiosity about paint as a material and expressive substance with his uncanny ability to evoke the moods and atmosphere of the desert environment." In describing "Canyon del Oro," Peterson continued: "Like a desert Danee showered with golden heat and light, the mural size 'Canyon del Oro' seems like a gorgeous abstract landscape. A molten textured wall of red and orange advances with a variety of fragments in brilliant iridescent colors sent crackling ahead of it."

Waid works primarily with acrylic paint. "At first I did it because it seemed modern. When it comes to staining, you have to use acrylics. In twenty years, I learned how to do things with it that you cannot do with oils. When I start a painting, I have a somewhat generalized idea of what I want to do. I may have ideas about certain kinds of color combinations. I may have certain directional ideas; Usually, my paintings end up very different from what I expected. I do not have a real blueprint. So in that sense it is like a surrealist idea. I also do a lot of drawings, especially with oil pastels. I work on paper. I used to do a lot of studies. Now, I need to start afresh. It is very hard for me to repeat something! There is a spontaneous aspect to the way I derive the image. If I try and repeat the same thing, it seems kind of dead."

Peter Bermingham, director of the University of Arizona Museum of Art, commented in a catalog: "Jim Waid, however, is hardly an unconscious painter. His vision and the decisions that

structure it on canvas are stimulated by a vast array of information which he seems to be constantly studying. . . . he will not allow himself to do more than suggest something of what he has absorbed."

Waid does not think of himself as a color field painter. He has outgrown that stage of his development. He does not consider himself a landscpe painter, to him, it is a limiting definition. "I am interested in the growth principle. It is manifest all the way from plants to planetary structure." His paintings of the late 1980s have recognizable forms. He is less interested in photography than in color printing processes and magazine colors. "On occasion I will go out and photogaph directly, but only as an aid to memory. When I stand in front of a canvas, I like to explore complex ideas. I don't even think much about these ideas. I am really trying to explore color relationships. I am interested in using organic forms. I used to teach color theory. At one point, I was interesded in Albers' teaching of color. I think, I learned from it. Now, it has become intuitive. I am interested in the reality, the sensation, but not in a lot of theoretical ideas or preconceptions." Waid continued: "There are not too many people here to bounce ideas off, like in New York. I have been influenced by the desert. I am talking about walking and sitting down and absorbing as much as I can. I started noticing how other things grow. I started thinking how totally surrealistic, how wild! Why can't I be more adventuresome in the way I paint. It gave me confidence to experiment more. I started to see plants growing, radiating out, nature uses the same forms."

Jim Ballinger, art historian, described Waid's work: "A superb painting by this artist will not let you go. Whether derived from his studies of the desert or another aspect of nature, the viewer will lock onto that underlying structure and than enjoy the pure celebration of paint and its application which Waid can conjure. He defines space by pushing color forward and backward much in the tradition of two great American painters, John Marin and Hans Hofmann."

Technically, Waid is involved with all aspects of painting. "I usually start off with a colored ground. I add a number of very intuitive shapes on it. Sometimes I glue cloth on; these are elements from other paintings that I have cut out or paint fragments. Often, I put red paint over these. I scrape through the red paint revealing what is underneath giving a lot of linear and graphic qualities that suggest something else. They are made integral with the imagery. I end up with a light and dark structure. If I have a lot of black, I scrape away; maybe the black starts

changing into other colors. I begin to see shapes that I want to emphasize, others that I want to de-emphasize. Basically, I keep working on a painting until I get something I like. I work on several paintings at a time."

In his studio, Waid enjoys working, "morning, afternoon, and night." He produced about twenty-five to thirty paintings a year, as well as many oil pastels with heavily worked surfaces. While he makes sketches, he does not scale up. His studio and house are located on the same property. The studio is in a separate building. Originally 16 x 24 feet, Waid has increased its size by adding another larger room. He works on three walls as well as on the floor. The windows are located on the north side. The studio contains a storage for paintings, materials and files. Waid characterizes it "as a nice open space." He paints using both natural and artificial light. He prefers working indoors. Occasionally, a very large painting will require outdoor work.

Waid usually starts his paintings on the floor "in a very gestural, intuitive way which suggests something to me. One of the hardest things has been learning to accept my own ideas and feelings, to trust my own sensibility, a process that I doubt I will ever complete. After spending time in the desert, I begin to sense the intelligence of the plants, rocks, insects and the simple fact of my intelligence being just another part of the landscape."

Married since 1962, his wife Beverly is a homemaker and mother of three children, two sons and a daughter. Waid characterizes her as "being immensely helpful to me."

Since 1981, Waid has spent all his time painting. In 1985, he received a visual fellowship grant from the National Endowment for the Arts. He is a shrewd observer of the contemporary art scene. "I see artists doing realist work of all kinds, and abstract work; the conceptional artists are doing their thing. I see very strong painting in the future. Of the current icons, I like Anselm Kiefer; I respect Ellsworth Kelly and like Frank Stella's recent paintings." He admires George McNeil, an older New York painter who, he feels, has been neglected by the public and curators. Waid added that he did not experience rejection in the early years of his career; what he encountered was indifference. "There was not much response to my work," he has stated simply. Waid feels that over the years "there has been a certain amount of stroking." In 1986 the Metropolitan Museum bought one of his large paintings, *Gazelle*, as well as two works on paper.

Devoted to his art, Waid does not have a master plan for his career. He wants to stay in Arizo-

na but would like to spend some time in New York every year to expose himself to that city's vitality and rush of ideas. An independent man, Waid is not a blind follower of trends. He sometimes disagrees with and questions curatorial decisions. "You go to the Whitney Museum, the curatorial staff is very young; they ignore mature artists who are not on the 'cutting edge of current art issues.' They are interested in what is hot right now and do not have a broad view of things. I believe however great Picasso was at eighteen, or Frank Stella at twenty-five, that painting is an older person's art form. It does not all have to be despair and irony. I am not interested in dissonance."

An intensely absorbed artist, Waid's concerns are with the painterly interpretation and abstraction of natural forms. The boldness of his color and the integrity of his work set him apart from modish and temporary concerns. His view and interpretation of shapes have a potential for transformation and invention. Waid avoids distortion, always maintaining an emphasis on biomorphic and architectural concerns. His forms are rich and his groupings, though random, belong together; his surfaces are dense and energetic. Powerful elements move together in harmony. His total image invites spiritual contemplation.

Waid succeeds in liberating the viewer from preconceptions and stresses perception with a sensuous rendition of surfaces, shapes, color and line. He astonishes with his inventiveness, spontaneity and the rhythm inherent in his compositions. He is a stranger to angst, despair, and doubt. He loves the improvisational nature of painting. Perhaps Helen Frankenthaler's words apply to his work: "Whatever it is that makes a painting great, that gives it its spirit is not verbal" applies to his work."

EXHIBITIONS INCLUDE: Harlan Gal., Tucson, Ariz. 1974; Univ. of Montana, Missoula 1974; Yuma Art Cntr., Ariz. 1976; Touring Exhibition of Arizona (sponsored by the Arizona Commission on the Arts and Humanities) 1977; Riva Yares Gal., Scottsdale, Ariz. 1980, '86, '89; Tucson Mus. of Art, Ariz. 1981; Adam L. Gimbel Gal., NYC 1982, '83; Jonson Gal., Univ. of New Mexico, Albuquerque 1985; Univ. of Arizona, Mus. of Art, Tucson 1985; Linda Durham Gal., Santa Fe, N.M. 1987; Southwest Texas State Univ. San Marcos 1987; Shoshana Wayne Gal., Santa Monica, Calif. 1988.

COLLECTIONS INCLUDE: Metropolitan Mus. of Art, NYC.; Phoenix Art Mus., Ariz.; Tucson Mus. of Art, Ariz.; Albuquerque Mus. of Art; Mus. of Fine Arts, Mus. of New Mexico, Santa Fe; Jonson Gal., Univ. of New Mexico, Albuquerque; Yuma Art Cntr., Ariz; Salt River Project, Phoenix; Mus. of Art, Univ. of Arizona, Tucson; Mus. of Art, Arizona State Univ, Tempe;

Dworsky & Associates, Los Angeles, Calif; Cooper & Lybrand, Seattle, Wash.; Chemical Bank, NYC; IBM, Montvale, N.J.; Prudential Insurance Co., Chicago, Ill.; Superior Court Art Trust, Washington, D.C.; Coca Cola Bottling Co., Atlanta, Ga.; McDonald's Corporation, Chicago, Ill.; Charles B. Goodard Cntr. for the Visual Arts, Ardmore, Okla.

ABOUT: "Jim Waid" (cat.), 1989; *Periodicals*— Albuquerque Tribune August 16, 1986; Arizona Daily Star October 18, 1981; Art in America April 1981, January 1987; ARTnews December 1980, March 1986; Arts Magazine October 1981; Artspace Spring 1977, Fall 1983, Winter 1985, Fall 1986; Art Week November 16, 1974; New Art Examiner January 1987; New Mexican October 10, 1986; Santa Fe Reporter October 8, 1986; SoHo Weekly News July 26, 1979, June 7, 1979.

WALKER, JOHN (November 12, 1939–), English expatriate painter has stood in the forefront of the British school since the mid-1960s with an individual style that has always kept somewhat in touch with current fashion yet remained outside of it. Faithful to the romantic spirit of the abstract expressionists, he has consistently maintained a high level of visual energy in his canvases while using the painted image as a means of reflection on the nature of painting itself.

Walker was born in the industrial city of Birmingham. He told Tony Godfrey and Adrian Searles in a 1978 interview, "Since I was a young child, the only thing I could ever do, or wanted to do, was paint." Bypassing grammar school for a junior art school, he acquired ample experience in commercial techniques but had little exposure to the fine arts, to the extent that his knowledge of the old masters came from Bible illustrations. It was only when he entered the Birmingham College of Art at the age of sixteen that he was introduced to "good painting." The example of Goya loomed especially large, and he spent a year copying the works of the Spanish painter, who fueled his own youthful preoccupation with memories of war.

At the time, he was a confirmed figurative painter, doing autobiographical renderings and images of World War I, originally based on his father's recollections and later reinterpreted through Goya. The first of a series of revelations about the possibilities of abstraction came with an exhibition of postwar American painting—in particular Jackson Pollock's *Number 12* (1952) —that he saw at the Tate Gallery in 1959: "I didn't go back [from the Tate] as a sudden convert to abstract painting, but for the first time I knew that there could be abstract painting that had the power of Goya." The following year, af-

ter completing his studies in Birmingham, he went off to Paris and enrolled in the Académie de la Grande Chaumière. His paintings through the mid-1960s remained figurative, often reworking Goya motifs in a gestural style influenced by abstract expressionism (especially de Kooning) and Francis Bacon. While in Paris he did etchings of street beggars that bore the imprint of Rembrandt and experimented with war photos taken from magazines, on which he inscribed written phrases.

The various problems that he was exploring in his early works (and which were to remain central throughout his career)—ambiguities of image, abstraction, and spatial relations coupled with a rather insistent if indirect social message—came together in his 1964–66 "Studies for Anguish," a group of some twenty-five paintings and two series of collages that he later described as an attempt to "achieve a petrified scream." Working from cardboard models, Walker effectively "represented" abstract forms with illusions of light, shade, and volume; as Richard Morphet observed at the time, those forms "seemed to have come from nowhere and yet to be very specific." In *Anguish* (1965), for example, a kind of vertical wedge indented on the right side (actually derived from Goya's portrait of the Duchess of Alba), coupled with an even more ambiguous birdlike form, both of them spray painted, stand out against a rectangular grid that suggests a cyclone fence or some other barrier. That painting won third prize at the prestigious John Moores exhibition in 1965 (the jury was chaired by the New York critic Clement Greenberg) and attracted considerable attention in English art circles with its mixture of idioms and techniques that ignored the prevailing hard-edge norm.

Around the time of the John Moores exhibit, Walker encountered another major influence: the hard-edge paintings of Kenneth Nolan. The diamond-shaped canvases that he saw in a London gallery, he recalled, actually gave him a stomachache: "It was a big thing that there were paintings that bold and that abstract. . . . That made me sick, and I went back to my studio and somehow had to resolve shapes that were meaningful for a particular kind of angst." Over the next few years, Walker continued to explore similar ambiguities of representation and abstraction, surface and space, with larger canvases, more insistent geometry, and more eclectic handling of paint. In a transitional work like *Blackwell* (1966), enigmatic green cabbage shapes float on the purple-stained ground of a rhomboid-shaped canvas. By the end of the year, Walker had switched to trapezoids, for both the canvas support and the forms painted

on it; reintroducing the grid, he overlaid it with a combination of spray painting, staining, and thick encrustations of paint pushed through wire mesh. With his appointment as a fellow at Leeds University late in 1967, he acquired a much larger studio, which allowed him to work on an even more monumental scale, and his long, low canvases, already fourteen or seventeen feet across, now reached as much as twenty-two feet in width. He had turned to the trapezoid shape, he explained, precisely in order to maximize the distance between the two ends of the painting. "I don't really wish to allow people to see the whole of the picture at once," he said. Formally, the influence of Anthony Caro's floor-hugging sculpture was unmistakable, but conceptually those huge canvases required even more viewer participation, with the details of paint application demanding to be "read" like a text.

In 1969 Walker received a Harkness fellowship, which allowed him to visit New York for two years; he had wanted to go to that city in order to test his reactions to contemporary developments on the spot, and ultimately he wound up spending much of the next decade in the United States. The immediate impact of the move—through exposure to artists he had never seen in England, including Ray Parker, Jack Youngerman, and especially Al Held—was to strengthen the structural aspect of his work. While he was still in London he had returned to the rectangular canvas, and after experimenting with a variety of painted shapes—trapezoids, crosses, rectangles—he settled on a kind of truncated lozenge as the main surface figure; it was that format, juxtaposed with an allover field of color, that he maintained during his early years in New York. As various observers pointed out, with those paintings he managed to draw on the premises of abstract expressionism, from the conceptual emphasis on process and direct emotional engagement to the formal concerns with frontality and the creation of an allover field, and at the same time, he was able to impose his own sense of structure through the grids, the lozenges, and the controlled paint surface.

That "renewal of modernist painting," as Patrick McCaughey called it, drew praise from critics on both sides of the Atlantic—Clement Greenberg singled out *Touch* (1970) as one of the best works at Dublin's ROSC 1971—and Walker received official sanction with a solo exhibition at the British pavilion of the 1972 Venice Biennale. But almost immediately after Venice, he embarked on a very different venture: Working in chalk (which he had already used in two 1966 paintings), he executed a group of monumental drawings on the walls of the Ikon Gallery in his native Birmingham, and sub-

sequently in Hamburg, London, and New York as well. According to Walker, those "Blackboard Pieces," measuring some ten by twenty feet, were inspired by his habit of using a blackboard to make studio models for his paintings; their provisional character was guaranteed by the nature of the medium, since the chalk began to flake off the wall even in the course of the exhibits. Once again, the results, however impermanent, impressed critics as a fruitful variation on his preoccupation with shape and surface. "It was a unique occasion," wrote Tim Hilton after the Ikon show, "not merely because of the short life span of the works, but because of their evident high quality and quite noble assumption of a status normally accorded only to painting."

For Walker himself, the change in medium clearly freed him from the inevitability of his painting style as it had evolved from the time of the "Anguish" series. By his own account, he turned to the works in chalk at a time when he was unable to paint, but he then realized that they could not be translated back into the "nobler" paint medium and that he had to develop an equivalent, with the result that when he resumed painting, he "poured on chalk and dry pigment; [and] built up something that looked built, constructed, layered." The "Juggernaut" series that followed the "Blackboard Pieces" was in fact an exercise in collage on a monumental scale: giant canvases filled with canvas shapes but pasted and covered with the chalk and dry pigment that he described. Once again, an artistic catalyst was at work, this time an exhibition of works from the Hermitage Museum in Leningrad, which introduced Walker to certain paintings of Matisse from the postfauve period when the French colorist was coming to terms with the planar vision of his cubist contemporaries. "What really struck me about these paintings," he recalled to Godfrey and Searle, "what really hit me, was the architecture of them, the idea of something built. . . . I guess it seemed to me that this was what my art lacked at the time. The collage was a deliberate attempt to literally build something."

In *Juggernaut I* (1973–74) Walker actually incorporated formal elements of Matisse's *Nasturtiums and the Dance* (1912) and *Madame Matisse* (1913), but those allusions remained very much a private gesture, subsumed to an expressionist drama of shapes, hues, and textures that evoke comparison with the New York School. At any rate, it was the "inventiveness" of that brash, imposing series—"a powerful painted presence," in Walker's own words—that drew the praise of the critics: as the London *Times* wrote when the "Juggernauts" were exhibited at the Nigel Greenwood Gallery, Walker

was "one of Britain's most energetic and inventive painters."

After the "Juggernaut" series, he continued experimenting with his own version of action painting in another group of painted collages called the "New York" series, which, for the New York critics, was seen as a mixture of European and American styles, while for the Europeans, it was overwhelmingly American. At the time, Walker indicated that England was obviously the most important influence on his work, that he was following the example of Matisse in his most cubist phase, and that no small influence came from his students (he had been teaching at Cooper Union and Yale and was a visiting artist at Columbia University), but that ultimately, "my culture is my studio," where, he noted, he surrounded himself with reproductions of El Greco, Van Gogh, Chardin, Seurat, Picasso, and Jackson Pollock.

With the "Numinous" series that he began in 1976, Walker's citation of past masters became much more explicit; in the process, quite unobtrusively—and as if by coincidence—figuration made its way back into his work. Where he had previously adapted a structural relationship from Matisse, he now adapted a structural image from Manet (who was in turn looking back to Walker's mentor, Goya): the metaphorically rich motif of the shuttered window that appears in Manet's *The Balcony* (1868). But in laying claim to that modernist lineage, Walker went beyond mere citation by "peopling" the borrowed balcony with his own repertoire of abstract collage forms. As he explained in a 1978 interview with David Sweet, "Matisse and Picasso took figurative painting almost to abstraction and then they stopped. I'd like to come the other way and stop, just this side of abstraction." Downplaying any great departure in his combination of abstract and figurative motifs, he insisted, "I don't see it as a traumatic change to have things in a painting, a balcony if you want to call it that. Really these paintings are about 'What can I put in a painting and what does it look like?' That's all. I'm not making a big art statement. I'm making a personal statement in my studio about what happens if I put a 'thing' in a painting. . . . It's not designed to link figurative and abstract painting. . . . I don't see them as that different."

Notwithstanding that disclaimer, over the next few years it was precisely the tension between figure and form, inherent in his dialogue with the past masters, that allowed his work to evolve beyond the "balancing act" (as David Tannous put it) of surface and structure. Nor had that approach simply taken hold with the

"Numinous" series of 1976–78: in retrospect, it was already at work in the "Anguish" paintings, where the curious hourglass shape perceived as a folded paper was derived from Goya's *Duchess of Alba*. After the "Numinous" series, Walker probed even more deeply into the legacy of modernism, and the modernist tradition of art about art, with the "Labyrinth" series, based on Velazquez's *Las Meninas*; with the "Alba" series, featuring the Goya-derived silhouette in a variety of planar, stagelike settings, and with several individual paintings that reworked elements from Manet, Velazquez, Goya, and Matisse. That eye on the past soon had a pronounced effect on Walker's technique as well—collage, chalk, and acrylics gave way to oil paint, wax, and alkyd resin, used to create an effect that was at once more fluid and, through the use of sfumato, impasto, and scumbling, more "old masterly." Indeed, as Jack D. Flam pointed out in an insightful reading of what he calls Walker's "objective abstract painting," those works are not variations on the masters, in the mode of Picasso's variations on *Las Meninas*, for example, but rather, allusions that embody "fixed realities with identical points of reference." As such, they do not preserve the integrity of the earlier paintings but incorporate formal and compositional elements as emblems of an otherwise intangible history of art. Citing Walker's *Picnic* (1978–79), which "alludes" to Manet's *Déjeuner sur l'herbe* (itself a quotation of a Marcentonio engraving after Raphael, and of Giorgione's *Fête champêtre*), Flam wrote that "here is an essentially abstract painting that dares to have objects and deep space and that straightforwardly acknowledges the artist's deep painting culture and historical ambitions."

"Like all ambitious and significant art," Flam remarked approvingly, Walker's recent work had "the virtue of imagining the world as strongly as the world exists," noting in conclusion, "As to what he will do next, it is difficult to predict. And one has the impression that this is exactly as he wants it to be." In fact, among the things that Walker did "next" was to accept a visiting professorship at Monnash University in Melbourne, Australia in 1979, followed by another at the Prahran Technical College, also in Melbourne. With that move (he has divided his time between Australia and the United States ever since), his work again assumed new formal and thematic dimensions. As can be seen from the "Oceania" series (1979–84), the new physical setting exerted a considerable influence on Walker's sense of space and color, but the human context—the exposure to aboriginal culture—was even more profound in its impact. If the earlier works embodied a personal dialogue with his own post-Renaissance tradition, Walker now addressed himself to the collective confrontation between East and West. In a work like the monumental *Oceania IV* triptych (1982), for example, multiple representations of the brightly colored (or "dressed") Alba are coupled with a skull, a totemic head on a stake, and a written text from the Book of Matthew: "In truth, in very truth, I tell you I am the door." In other paintings bearing the same visionary pronouncement, such as *In Truth II* (1981–82), the Alba is pierced with arrows like a latter-day Saint Sebastian. "However well intended," Walker commented, "it was missionary zeal that has destroyed Oceania. We may be tempted to equate Christianity with goodness, but here in Oceania, one sees the effects of a misdirected application of missionary zeal."

When those and other Oceania paintings were exhibited in New York in 1983, Walker's revelatory posture struck some critics as overblown; Donald Kuspit, for example, concluded that the paintings suffered from "stale emblems" and an "overorganized ego." But others were much more impressed with the new phase of Walker's work: Paul Brach, who in a review acknowledged that he had found the earlier paintings "tough-minded, well made, muscular, but somehow not fully engaged with the subject matter," now felt himself confronted with work that was "earnest, ambitious, and far more resolved." And in England, his position as an outstanding contemporary artist was confirmed once again in 1985 with simultaneous painting and print retrospectives at the Hayward and Tate galleries. By that time, as the London critic John McEwen pointed out, Walker was "more a visitor than a returning son," albeit among the most honored by the English art establishment. According to McEwen, Walker "has a careerist attack, an urgency of ambition and scale of turnover that has proved too large to be contained by the amateur conventions of English art attitudes," all of which makes his self-imposed exile inevitable. But the background to his success story is one of almost romantic isolation, stemming not from geography but from artistic sensibility. Indeed, it is the tenacity of Walker's vision that sets his work apart—his unwavering commitment to an artistic mission that simultaneously ties him to the past and plunges him into the present. "I do believe great painting is timeless and therefore of this time," he told Godfrey and Searle in 1978. But, he continued, "when I'm painting . . . I prefer myself and not the weight of art in my studio—I have to do my own screaming. I'm trying to think, to search for some forms that will give me ties that will place me in the continuity of the past, the present, and the future."

EXHIBITIONS INCLUDE: Axion Gal., London 1967, '68; Park Square Gal., Leeds 1968, '73; Hayward Gal., London 1968; City Art Gal., Leeds 1969; Nigel Greenwood Inc., London, from 1970; Reese Palley Gal., NYC 1971, '72; Venice Biennale, 1972; Studio La Città, Verona 1972; Ikon Gal., Birmingham 1972; Gal. Rolf Ricke, Cologne 1972; Kunstverein, Hamburg 1973; Städtisches Mus., Bochum 1973; Cunningham Ward Gal., NYC 1973–78; MOMA, NYC 1974, '78; Gal. Swart, Amsterdam 1974; Gal. Marguerite Lamy, Paris 1976; Reed Col., Portland, Ore. 1976; Powell Street Gal., Melbourne 1977, '79; Phillips Col., Washington, D.C. 1978, '82 (trav. exhibs.); Art Gal. of New South Wales, Sydney 1978; Univ. of Massachusetts, Amherst 1979 (trav. exhib.); Betty Cunningham Gal., NYC 1980; National Art Gal., Wellington, New Zealand 1981 (trav. exhib.); Theo Waddington Gal., London 1981; Knoedler Gal., NYC, from 1983; Hayward Gal., London 1985; Tate Gal., London 1985; Knoedler Gal., Zurich 1986. GROUP EXHIBITIONS INCLUDE: John Moores Exhibition, Walker Art Gal., Liverpool 1965; "European Painters Today," Mus. des Arts Décoratifs, Paris, Jewish Mus., NYC, Kunsthalle, Düsseldorf 1968; "New British Painting and Sculpture," Frederick S. Wight Gal., Univ. of California, Los Angeles, 1968; Paris Biennale, 1969; "Contemporary Artists in Britain," National Mus. of Modern Art, Tokyo 1970; "British Painting and Sculpture," National Gal., Washington, D.C. 1970; ROSC 1971, Dublin 1971; "Towards Painting," Tate Gal., London 1973; "Color as Language," MOMA, NYC 1975 (trav. exhib.); "Arte Inglese Oggi," Pal. Reale, Milan 1976; "25 Years of British Painting," Royal Academy, London 1977; "Critic's Choice," Inst. of Contemporary Art, London 1978; "Baroques '81," Mus. d'Art Moderne de la Ville de Paris 1981; "Aspects of British Art Today," Metropolitan Art Mus., Tokyo 1982.

COLLECTIONS INCLUDE: Ulster Mus., Belfast; Mus. am Ostwall, Dortmund; Scottish National Gal. of Modern Art, Edinburgh; City Art Gal., Leeds; Arts Council of Great Britain, London; Tate Gal., London; Victoria and Albert Mus., London; MOMA, and Solomon R. Guggenheim Mus., NYC; National Gal. Art, Washington, D.C.

ABOUT: Emanuel, M., et al. Contemporary Artists, 1983; "John Walker" (cat.), British Pavilion, Venice Biennale, 1972; "John Walker" (cat.), Phillips Collection, Washington, D.C. 1978, 1982; "John Walker, Drawings" (cat.), Nigel Greenwood, Inc., London, 1978; "John Walker, Drawings" (cat.), National Gallery of Art, Wellington, 1981; "John Walker, Prints 1976–1984" (cat.), Tate Gallery, London, 1985. *Periodicals*—Artforum February 1977, April 1978, October 1980, November 1984; Art in America January–February 1979, Summer 1983, June 1985; Art International September 1971; Artlog 1 1978; Artscribe June 1978, October 1981, March–April 1985; Arts Magazine December 1980; Flash Art October–November 1981, Summer 1983; Studio International September 1968, April 1971, June 1972, March 1985.

WEGMAN, WILLIAM (February 12, 1942–), American video and performance artist and photographer, employs a deceptively mild, childlike sense of humor to make palatable disturbing insights into conventional ways of perceiving the world and making art. A typical Wegman photograph, video work, or drawing amusingly makes the familiar into the alien or changes one thing into a totally unrelated other—a process called "transference of identity" by the curator Lisa Lyons. Wegman's aim is to reveal the flimsy grounds on which we base the most common place judgments and the easy interchangeability of even such seemingly hermetic categories as "mouth" and "stomach," "original work" and "documentation," and "man" and "dog." The unpolished, unassuming quality of his works—they usually star just Wegman and/or his dog, plus the simplest and most transparent of props—makes them singularly unthreatening, even charming. That quality, plus the popularity of his pet Weimaraner and "collaborator," the late Man Ray, has helped make Wegman one of the best known video artists. His videos have appeared on such popular television programs as *Saturday Night Live,* the David Letterman Show, and *Alive from Off Center.*

Wegman was born in Holyoke, Massachusetts. Like most artists of his generation, he was educated in college art programs, earning a B.F.A. degree from the Massachusetts College of Art in 1965 and an M.F.A. degree from the University of Illinois, Urbana, in 1967. He taught art in the Wisconsin university system for three years, before moving to California in 1970 to lecture at California State University, Longbeach. Minimalism, then at the height of its influence, was the first major influence on Wegman; in the late 1960s he made minimalist sculptures and tried his hand at process works and series art, using, among other materials, stacked squares of linoleum.

However, as Wegman wrote in 1974, he quickly gave up the pure minimalist faith. "I started to get into a less homogeneous sort of material; material that had information associated with it and had a content. Like nails rather than steel, or doors rather than wood." Wegman began using his sharp ability to imitate—his early minimal pieces were virtually indistinguishable from those of any number of other minimalists—in the service of parody. Send-ups of minimalism provided fertile ground for Wegman's early experiments with transposed patterns, objects, and situations, word play, and visual puns. For example, his 1971 photo of a piece of Masonite leaning against a white wall (à la Richard Serra) appears to be a standard photo-

WILLIAM WEGMAN

documentation of a site-specific work—but there are two shoes peeking out from beneath the Masonite, and the photo is labeled "To Hide His Deformity He Wore Special Clothing."

Around 1970 Wegman dropped sculpture and process works to concentrate on photography, drawing, and, as the technology became available, video. Also in 1970, at the urging of his wife, Gayle, he acquired a six-week-old puppy whom he named Man Ray (Weimaraner—Weimar—Bauhaus—Man Ray). Immediately Man Ray, a willing and personable performer, came to occupy the center of Wegman's art, and did so until the dog's death in 1982. So strong an impression did the dog create that in the years of his greatest notoriety he was often recognized on the street while Wegman himself was not. One German art journal went so far as to claim that the dog was the dominant creator in their artistic dyad.

Wegman, of course, worked hard to create just that impression—to turn Man Ray into a collaborator in the art world's only man-and-dog act. Sometimes the dog would subvert Wegman's designs, creating "mistakes" that the artist could adapt to his own purposes. But more often, Man Ray acted as a safe repository for audience sympathy, even identification: the affectionate indignities to which Wegman subjected him—dressing the dog in silly costumes, dumping a load of flour on him, and so on—would not have been quite so acceptable if inflicted on another human being. At the same time, the imperturbable dog served as a shield behind which Wegman could take refuge from the public. As

Wegman himself noted, "[Man Ray] takes a lot of pressure off me. It's like having a third person in a conversation; one of you doesn't have to talk all of the time."

Certainly Wegman's use of Man Ray in his work represented a giant step forward in the artist's rediscovery of "content" (as was the use of his own image, which began at about the same time), but Wegman still found considerable value in treating the dog like a contentless object. The humor in many of his set-ups derives from the tension between Man Ray's obvious intelligence and expressivity and the absurd uses to which they are put. In one series of photographs called "Before/On/After: Permutations" (1972) a parody of both process art and certain kinds of perception or behavioral experiments, Man Ray is seen to get on and off a pedestal according to the display of geometric symbols on a card in front of him. Has the dog been trained to understand the symbols? Is there a metaphorical relationship between the symbols and the dog's position? In reality there is no relationship between symbols and dog except the one that we inject, knowing that the piece is supposed to be art of a kind that looks familiar. Wegman's point is that we prefer to create meaning out of expectations and habit, not necessarily out of understanding. "Ray-O-Vac" (1972), a related series, had the dog climbing up and then down from a graduated array of old vacuum tube and battery testers. The simple pun in the title, which appears to be all the artist intended, is supplemented by Man Ray's apparent understanding of the situation's inanity—but like a good dog, he goes along anyway. That quality of Man Ray's—the appearance of understanding his situation in an almost human way—was put to good use in Wegman's altered photograph *Contemplating Art, Life, and Photography* (1975–79). Man Ray, the dreamer, sits on the water in the middle of a lake at sunset, pondering the great issues; if we can accept that the dog (through photographic trickery) is sitting on the water, asks Wegman, why can't we accept him as a philosopher?

Indicative of Wegman's verbal orientation are a number of written narratives that he has produced over the years. Some of them work both as short stories and as dramatic readings on tape (for example, *Rage and Depression,* 1974). Others are purely literary and have some of the qualities of allegory, as in the following tale, a rather complete and amazingly compact description of artistic competitiveness and art criticism:

Our family didn't have anything to do one Sunday so we all made cutouts. I thought Dad's was the best but Mom

thought mine was. Dad voted for Mom's and so did my sister, so Mom won. Mom admitted afterwards that she thought hers was the best but didn't think it was right to vote for herself. Dad thought mine would have won if I had kept it simpler. Everyone criticized my sister on technical grounds.

The 1970s were the most fruitful period in Wegman's video career. Supported by grants from the Guggenheim Foundation (1975) and the National Endowment for the Arts (1975–77), he and Man Ray worked in complete isolation in his loft using a reel-to-reel VTR and inexpensive black-and-white camera. In form, the tapes (collected as *Seven Reels 1970–1977*) are unedited, with ambient sound and no technical flash. They are little more than short skits or quick clips of odd situations whose meaning is often not understood until well after they are over. Some clips feature Wegman alone, as in the widely seen "stomach tape" featuring the artist contorting his abdomen to create surprisingly convincing human faces. But the tapes with Man Ray have been the most popular, starting with the dog's well-known debut as a puppy chewing on a microphone (1970), through clips of his catching a cookie and lapping up a trail of milk right up to the camera lens, to the dog enduring Wegman's patronizing instructions on how to spell. It is not necessary to be a dog lover to like and understand those pieces. Anyone can sympathize with the dog's plight as he squirms to get free from Wegman, who struggles to hold him while pretending to be a late-night-TV used-car salesman. "Just as this dog trusts me," Wegman intones, "I would like you all out there to trust me and come down to our new and used car lot." (How many times have we all been used without our consent to validate the assertions of others?) Man Ray gives the lie to Wegman's persona and creates the meaning of the piece.

Man Ray Man Ray (1979) was the dog's greatest role, and remains Wegman's most elaborate and sustained video project. Man Ray plays both himself and the "real" Man Ray in a mock documentary that intertwines the events of both their lives. Effectively held up for ridicule is the shallow solemnity with which great artists are treated, especially in television mini-biographies with their meaningless cuts from shots of the subject's home to interviews with former associates (all faithfully parodied). *Man Ray Man Ray* was most recently broadcast as part of PBS's *Alive from Off Center* in 1985.

Wegman's series of large-format color Polaroids (1978–82), taken at the Polaroid Corporation's photographic laboratories in Cambridge, Massachusetts, have been widely reproduced and admired. Those intensely vivid photos, his last collaborations with Man Ray, put the dog through some of his most unexpected permutations. Man Ray becomes a bat (*Ray Bat*, 1980), an airedale (*Airedale*, 1981), a stegosaurus (*Flora and Fauna*, 1981), a Brooke Shields look-alike (*Brooke*, 1980), and Louis XIV (*Suit/Suite*, 1979). The images are simple, using ordinary, even cheesy props in an unadorned studio setting. (The one exception is *The Kennebago*, 1981, in which Man Ray is an Indian chief in a canoe on a lake.) As Laurance Weider has noted, "These photographs evidence the same wit and concerns as [Wegman's] drawings and altered photographs, but as 'through-the-back-door' photography, they are more immediately related to Wegman's videotapes. In single photographs, Wegman and Man Ray manage to condense the extended conceits of the video performances into one elegantly composed and articulate image," (*Man's Best Friend*, 1982). In 1983 the photos formed the centerpiece of a traveling retrospective, "Wegman's World," sponsored by the Walker Art Center.

Wegman lives in a sparsely furnished loft in Manhattan's financial district. Brown-haired and slightly built, he can be almost painfully shy and diffident in person. (Even when he appears in his own videos, he always adopts a disguising persona.) Craig Owens has pointed out that Wegman has consistently denied that he is a master of contemporary art, although there have been some critical efforts to elevate him to that position. "As soon as I got funny," Wegman he said, "I killed any majestic intentions in my work." Owens links the success of his work, especially the videotapes, to Wegman's understanding of the essential dynamics of the joke, and to "the ways in which Wegman has effectively jettisoned the whole ideology of achievement."

EXHIBITIONS INCLUDE: Gal. Sonnabend, Paris 1971, '73, '75; Pomona Col. Art Gal., Calif. 1971; Sonnabend Gal., NYC 1972, '77; Gal. Ernst, Hanover, West Germany 1972; Konrad Fischer, Düsseldorf 1972, '73, '75, '79; Los Angeles County Mus. of Art 1973; Texas Gal., Houston 1973, '74; Modern Art Agency, Naples 1974; Gal. D, Brussels 1974; Gal. Aleesandra Castelli, Milan 1975; The Kitchen, NYC 1976; Bruna Soletti, Milan 1977, '82; Rosamund Felsen Gal., Los Angeles 1978; Univ. Art Mus., Berkeley, Calif. 1978; Holly Solomon Gal., NYC 1979, '80; Otis Inst., Parsons School of Design, Los Angeles 1979 (traveled to Univ. of Colo. Art Gal., Boulder and Aspen Cntr. for Visual Arts, Col.); Marianne Deson Gal., NYC 1980; Gal. Vivianne Esders, Paris 1981; Magnuson Lee Gal., Boston 1981; Yarlow/Salzman Gal. Toronto 1981; Castelli/Goodman/Solomon, East Hampton, N.Y. 1981; Dart Gal., Chicago 1982; Fraenkel Gal., San Francisco 1982; Walker Art Cntr., Minneapolis 1982 (traveled to Fort Worth Art Mus., Contemporary Arts Cntr., Cincinnati, Corcoran Gal. of Art, Washington, D.C., Newport Harbor Art Mus., Calif., and De Cordova Mus., Lin-

coln, Mass. 1982–83). GROUP EXHIBITIONS INCLUDE: "11 Los Angeles Artists," Hayward Gal., London 1971; Documenta 5, Kassel, West Germany 1972; "Spoleto Festival," Spoleto 1972; "Whitney Annual," Whitney Mus. of American Art, NYC 1973; "Matrix 9," Wadsworth Atheneum, Hartford, Conn. 1975; Städtisches Mus. Leverkusen, West Germany 1975; "Video Art: An Overview, San Francisco Mus. of Modern Art, 1976; "Contemporary American Photo Works," Mus. of Fine Arts, Houston and Mus. of Contemporary Art, Chicago 1978; "The Altered Photograph," P.S. 1, NYC 1979; "Around Picasso," MOMA, NYC 1980; Kröller-Müller National Mus., Otterlo, Netherlands 1980; "Pier and Ocean," Hayward Gal., London 1980; "Instant Photography," Stedelijk Mus., Amsterdam 1981; "Not Just for Laughs: The Art of Subversion," New Mus., NYC 1981; "Biennial," Whitney Mus. of American Art, NYC 1981; "Biennale," Sydney 1981; "The Decade," Stedelijk Mus., Amsterdam 1982; "Momentbild: Künstlerphotographie," Kestner-Gesellschaft, Hanover, West Germany 1982.

COLLECTIONS INCLUDE: MOMA, Whitney Mus. of American Art, The Kitchen, and Holly Solomon Gal., NYC; Univ. of Massachusetts, Amherst; Kestner-Gesellschaft, Hanover; Donnell Film Library, New York Public Library; WNET, NYC; Dart Gal., Chicago; Art Gal. of Ontario, Toronto; Castelli-Sonnabend Tapes and Films, Inc., NYC; Ed Ruscha Collection, Los Angeles.

VIDEOTAPES: Seven Reels, 1970–77; Gray Hairs, 1975; Man Ray, Man Ray, 1979.

BY THE ARTIST: Man's Best Friend, 1982.

ABOUT: *Periodicals*—Arnolfini Review, May–June 1979; Art and Artists February 1973; Artforum November 1969, March 1975, February 1980; Art in America May 1973, January 1975, September 1970, March 1983; Art Monthly, no. 27 1979; ARTnews May 1977; Arts Magazine June 1977, May 1982; Artweek October 2, 1982; Domus July 1979; Village Voice April 9, 1978.

WESTERMANN, H(ORACE) C(LIFFORD)

(December 11, 1922–November 3, 1981), American sculptor who was a seminal figure in the postwar development of Chicago figurative art. Westermann specialized in making carefully crafted tableaux enclosed in wooden boxes, little theaters of the imagination like those of Joseph Cornell. But where Cornell's miniature worlds are nostalgic, pleasurable, and elegant, Westermann's are nightmarishly violent. His assemblages are designed to evoke a sense of paranoia, to remind the viewer of the nearness, the suddenness, the randomness of death. Haunted houses, ships drifting among sharks, half-human figures threatened by knives—these are the typical contents of his display cases, meticulously

H. C. WESTERMANN

presented as if in a museum of psychosis, but with a splash of absurdist humor that rescues them from absolute hopelessness. They are, Martin Friedman wrote, "predicaments rather than descriptions."

The fear and tension evident in Westermann's work derives originally from his experience of combat during World War II, especially of kamikaze attacks. Born in Los Angeles, he joined the marines in 1942 at the age of twenty, after working as a laborer in sawmill and mining operations in the Pacific Northwest. He served for four years in the Pacific, mostly as an antiaircraft gunner on the USS *Enterprise*. While still in the marines he began sketching aboard ship. In 1947 he entered the Art Institute of Chicago on the G.I. Bill to study commercial art. He supported himself by working as a janitor at the Institute. On his return from a year as an infantryman in Korea he switched to painting and sculpture. His work in the 1957 "No Jury Show" at Chicago's Navy Pier caught the attention of the gallery owner Allan Frumkin and the collector Joseph Shapiro; later that year Frumkin gave Westermann his first gallery exhibition. The Frumkin Gallery was a favorite showplace of Chicago's so-called monster roster, a loose-knit group of virulently anti–New York figurative artists and expressionists that included Leon Golub, Nancy Spero, and Cosmo Campoli. The prevailing subjects of the group—birth, monstrosity, dehumanization, and death—fitted well with Westermann's own preoccupations. Although he never explicitly linked himself with the monster roster, he continued to be identified

with it even after he moved to Connecticut in 1961.

By the mid-1950s Westermann had begun to produce his idiosyncratic boxed tableaux. His first sale of one of those artifacts was to the Bauhaus architect Mies van der Rohe in 1955. Several freestanding sculptures also date from the 1950s, among them *The Great Mother Womb* (1957), a rotating wooden "womb" whose interior is accessible through a caesarian door, and *Angry Young Machine* (1959), an amalgam of skyscraper, waterworks, and sculpture that is sticking out its tongue.

Over the years Westermann attracted a small cult following, but it was not until the late 1970s that he began to receive substantial critical attention. A retrospective exhibit of his work was shown at the Whitney Museum of American Art in the summer of 1978 and subsequently toured museums across the country. "Now that irony, memory, autobiography, humor, and outright obsessiveness have asserted their claims in art once more," wrote *Time* magazine's Robert Hughes of the show, "Westermann's importance cannot be shrugged off." A solo show of his work opened at the Fourcade Gallery in Manhattan in November 1981, shortly after Westermann's death of a heart attack at the age of fifty-eight.

Westermann's art underwent very little change, thematic or otherwise, in the quarter century covering his work as a professional artist. Rather, he practiced the subtle refinement of effect, the selection of detail that would most unsettle the viewer. Donald B. Kuspit, reviewing his Whitney show, wrote: "Westermann teaches us that it is still possible to make good art out of direct experience, not just out of the experience of other art. This used to be the true American way, whether for abstract or 'literary' art. . . . At his best, Westermann resembles a soldier unable to come to terms with civilian life and with the adventure of risking death. Works referring explicitly to death are in fact among his most moving, most funny work." Ultimately, in the view of Kuspit and other critics, Westermann exhausted the autobiographical sources from which he had drawn but found it difficult to move beyond his habitual themes.

The most striking examples of Westermann's attempts to rework experience are his series of "death ships," begun in the early 1950s. These include *American Deathship on the Equator* (1972), *Walnut Deathship in a Chestnut Box* (1974), and *Deathship of No Part* (1968). Sealed in museum-quality glass cases or wooden coffins, the ships are on their way to, or have recently come from, an encounter with disaster. Some are the targets of Japanese suicide attacks, such as

the one that Westermann survived on the *Enterprise. American Deathship on the Equator*, of beaten copper and amaranth wood, is a gutted hull encircled by the fins of hungry sharks. With his series of finely carved miniature houses, also dating from the 1950s, Westermann puts the viewer in the role of voyeur at someone else's nightmare. In *Battle to the Death in the Icehouse*, one glimpses through the windows of a tiny redwood house a man fighting off animals with an axe. The windows of the *Suicide Tower*, which is surrounded by an open stairway leading to a jumping-off platform, reveal bridges and highways.

What sets Westermann's sculptures apart from those of most assemblage artists is the quality of his craftsmanship. It is the juxtaposition of fine cabinetry with horrific subject matter, more than the subject matter itself, that gives his work its sense of mystery and displacement. The joinery, lamination, and finishing in his boxes and cases would make a professional cabinetmaker proud. Indeed, Westermann helped support himself in art school as a carpenter and plasterer, but his standards were too high for the contractors who employed him. His woodwork, joined and finished by hand, often incorporates rare hardwoods (Gabonese or Makassar ebony, vermilion, teak, padauk, mazuma) along with pine, maple, and fir. He was also a skilled metal and glass worker; many of his objects incorporate carefully fitted sheet metal, industrial metal lathing, copper and galvanized pipe, and even tin ductwork. Hilton Kramer noted that "there was something about the way he handled wood, metal, and other materials that allowed him to temper the ferocity of his imagination with the sweet reasonableness of his dedicated craftsmanship." But John Ashbery wrote of his boxes: "One frequently has the sense of peeking into a Faberge egg and coming eyeball to eyeball with a scorpion."

In other sculptures Westermann displayed a particularly American variety of dadaist wit. They appear naive and knowingly wry at the same time. References to Indians, cacti, circuses, American church architecture, nineteenth-century folk sculpture, farm implements, and newspaper cartoon characters abound. Westermann liked to confound his viewers' expectations with visual and verbal paradoxes. *Westermann's Table* (1966) presents a pile of thick leatherbound books—the Bible among them—pierced through the middle and fastened to a table by a steel bolt. *Walnut Box* (1966) is both a box made of walnut wood and a box containing walnuts; *Imitation Knotty Pine* (1966) is a precisely dovetailed box of clear pine with knots inlaid. "Imagine a jack-o'-lantern with its

familiar, genial features . . . notched—not into the usual pungent orange vegetable—but into a smooth and weighty oval Connecticut granite fieldstone!" wrote Emily Wassermann in 1971. "It's like biting into chocolate and finding you've been tricked with a rubber toy substitute instead: Westermann is always tripping you at the threshold of your ordinary expectations."

His black humor is also on display in his watercolor drawings, in which a cartoon figure with a "W" on his chest reels through violent and erotic adventures in exotic locales in the manner of Indiana Jones. If, as Kramer wrote, "his crazy coffins and mysterious death ships are purged of their terror and absurdity by the beauty of their execution," there was no such escape in his drawings, in which "he allowed the more violent aspects of his vision an unfettered freedom of expression." Ralph Pomeroy, in *Contemporary Artists,* called them "a marriage between [R.] Crumb and Hieronymus Bosch." Sculptures such as *A Close Call* (1965), a wooden doll-man in a box who is nearly impaled by a wooden dagger thrust into the glass top, draw upon the same cartoon/cinematic sources.

Ann Lee Morgan, noting Westermann's dada-like use of descriptive lettering, wrote that his "neonaive sculptures are lovingly polished but plastically simple. They suffer in general from a lack of formal invention to give life to the concepts that brought them into existence. Because of this, his works share with [Chicago artists Ed] Paschke's and [Jim] Nutt's a distinctly literary (i.e., verbal) dimension that coexists uneasily with their aggressive anti-intellectualism." Martin Friedman, however, suggested that "so complex is the iconography of a Westermann sculpture that formal issues seem secondary. But aside from the obvious care exercised in constructing his pieces, there is a definite preoccupation with the overall shapes, with interrelationships of carved elements and with the animating properties of wood, color, and texture. . . . Westermann's is a bizarre and disturbing art which seems to be of no particular period; if it is strongly moralistic, it is also totally atopical. His monumentally crafted sculptures are repositories of frustrations and apprehensions."

Long after he left the marines, Westermann retained his identity as a sailor. Robert Hughes wrote that "if artists were comic-strip [characters] Horace Clifford Westermann would be Popeye. The gimlet stare, the laconic speech, the cigar stub jutting like a bowsprit from the face, the seafaring background and fo'c'sle oaths, the muscular arm—all are there." His trademark signature was an anchor. Even in his later years

the wiry artist looked as if he could still perform as the top man in a balancing act—which indeed he had done in 1946, on a USO tour.

Critics disagree on where to place Westermann's work among the movements of contemporary art. In fact, his oeuvre fits in none of the usual pigeonholes, and that is a large part of its appeal. Westermann shirked art-world rituals and never publicly associated himself with any group or style. He has influenced the "hairy who" artists of Chicago, notably Jim Nutt, and Robert Arneson and other "funk" artists of San Francisco, who appreciated his disinterest in conventional art and his uninhibited embrace of the irrational. To Kuspit, his "conscious demonstration that art is regression in the service of the ego" makes him an expressionist. To Franz Schultze, "Westermann is a fantast who deals in magical images, surreal ideas and irrational connections. . . . But there is an admirably lucid and refining rationality in its context, if not in its implication." In general he is regarded as an American original, a dadaist without the ideology and with a heavy burden of anxiety. Ashbery sees him as "a sort of homegrown Duchamp, with W. C. Fields, William Burroughs, and Buz Sawyer lurking somewhere in his family tree."

EXHIBITIONS INCLUDE: National Col. of Education, Wilmette, Ill. 1954; Rockford Col., Ill. 1956; Allan Frumkin Gal., Chicago 1957, '62, '67, '71, '73, '76 and NYC 1963, '65, '67, '68, '70, '71, '73, '74; Dilexi Gal., Los Angeles 1962, '63; Kansas City Art Inst. 1966; Los Angeles County Mus. of Art, (trav. exhib.) 1968; Gal. Rudolf Zwiner, Cologne 1972; Gal. Nevendorf, Hamburg 1973; Corcoran Gal., Los Angeles 1974; Berggruen Gal., San Francisco 1977; Fine Arts Cntr., Univ. of Rhode Island 1977; Whitney Mus. of American Art (trav. retrospective), NYC 1978; Serpentine Gal., London 1980; Fourcade Gal., NYC 1981. GROUP EXHIBITIONS INCLUDE: "59th Chicago and Vicinity Show," Chicago 1956; "No Jury Show," Navy Pier, Chicago 1957; "New Images of Man," MOMA, NYC 1959; "Surrealist Art," MOMA, NYC 1960; "New Realism," Gemeentemus., The Hague 1964; "American Sculpture of the 60s," Los Angeles County Mus. of Art 1967; Documenta 4, 1968, Documenta 5, 1972, Kassel, West Germany; São Paulo Bienal 1973; "71st American Exhibition," Art Inst. of Chicago 1974; "Masterworks in Wood," Portland Art Mus., Ore. 1975; "200 Years of American Sculpture," Whitney Mus. of American Art, NYC 1976; "One Major New Work Each," Fourcade Gal., NYC 1980; "Group Sculpture Show," Fourcade Gal., NYC 1981.

COLLECTIONS INCLUDE: Whitney Mus. of American Art, and MOMA, NYC; Wadsworth Atheneum, Hartford, Conn.; Art Inst. of Chicago; Walker Art Cntr., Minneapolis, Minn.; Los Angeles County Art Mus.; Seattle Art Mus.; Mus. of Contemporary Art, Chicago; Des Moines Art Cntr., Iowa; Norton Simon Art Mus., Pasadena; Xavier Fourcade Gal., NYC.

ABOUT: Adrian, Dennis. H. C. Westermann, 1980; Andersen, Wayne. *American Sculpture in Process: 1930–1970*, 1975; Annual Obituary 1981; Armstrong, Tom, et al. 200 Years of American Sculpture, 1976; Emanuel, M., et al. Contemporary Artists, 1983; Haskell, Barbara. H. C. Westermann (cat.), 1978; Kozloff, Max. H. C. Westermann (cat.), 1968; Schultze, Franz. *Fantastic Images: Chicago Art Since 1972. Periodicals*—Artforum December 1971, September 1978; Art in America September–October 1973, January–February 1979; Art International March–April 1981, November–December 1982; ARTnews March 1967; Flash Art December–January 1981–82; New York June 19, 1978, November 16, 1981; New York Times November 5, 1981; Time June 19, 1978.

WOODROW, BILL (1948–), British sculptor, was born in Henley-on-Thames, Oxfordshire. He attended the Winchester School of Art in Winchester (1967–68), then, in London, the St. Martin's School of Art (1968–71) and the Chelsea School of Art (1971–72). He has never taught formally in art schools, and has for a long time lived and worked in Brixton, the strife-torn London district south of the Thames.

Sculpture at St. Martin's during Woodrow's time there was firmly under the influence of Anthony Caro, whose large, formalist, abstract steel constructions dominated much of British sculpture during the 1960s and early 1970s and spawned a host of imitators. Woodrow has recalled that the single greatest taboo at St. Martin's, where Caro taught for many years, was narrative art: the Caro-ites strongly discouraged all consideration of content in art beyond the self-contained and self-referring rigors of formalist composition. Woodrow, however, was determined from the start to follow his own inspiration: even as a student his pieces seemed to tell surreal, enigmatic stories. In one, he launched a small raft onto the Serpentine in London; aboard were a high-heeled shoe and a plastic daffodil! Another installation consisted of a series of papier-mâché pigeons placed amid rocks of the same material. The narrative content of such works was certainly apparent, if not entirely clear.

Woodrow's earliest exhibited work was basically pictorial, concerned with nature and landscape. In his first solo exhibition, in 1972, at London's Whitechapel Gallery, large, blown-up photographs of rural scenes were bisected by natural objects: a branch clearly seen in a photo was positioned directly in front of the photo, setting up a not-so-subtle dialogue between image and reality. The exhibition attracted little attention.

The rest of the 1970s was a time of self-

BILL WOODROW

examination for the artist; he did not exhibit again until 1979, when he embedded in plaster a portable record player, the first of a series of objects—vacuum cleaners, hair dryers, carpet sweepers—to be encased in plaster or concrete. The encasing material was then chipped away until the objects partially reemerged: fossils of the industrial age, they had lost whatever utility they had once possessed. Also in 1979 he created the series "Breakdowns," in which various objects—a television set, a bicycle, a toaster—were taken apart and arranged in pieces side by side, while beside the arrays stood facsimile reproductions of the objects, in black-painted wood. The series was generally seen as a comment on the stereotypical effects of mass production.

In 1980 Woodrow began the quasi-recycling of household appliances, principally broken, discarded, single- and twin-tub washing machines. First carefully cutting into the white enameled casing of the appliances, he then fashioned various objects from the sheet steel: a guitar, a chainsaw, a 9mm machine gun. The fashioned objects were then joined to the appliance by a strip of metal, referred to by all critics as an "umbilical cord." The pieces bespoke an obvious sense of humor, irony, resourcefulness, and perhaps also an instinct for parody—the guitar looked very much like the ones Picasso made in 1912–14 of scrap tin and cardboard. The works in general also reaffirmed Picasso's constant demonstration that art may be made from anything and that the artistic category termed sculpture may be defined very widely indeed.

The found objects of the inner city, the detri-

tus of modern civilization, have remained Woodrow's basic artistic material. He soon extended the quick take of the refashioned appliances into a series of "incidents," which pointed to a strengthening of the narrative line in his art. *Electric Fire, Car Seat and Incident* (1981) reminded one critic of a stage or film set. The back of a space heater ("electric fire" in British English) was cut out to form a handgun (a "heater"), which rested on a car seat's red plastic upholstery. The back of the seat was cut out to make a pool of blood on the floor. Whatever story the piece told seemed underlined by the umbilical connections between its elements. Allusions to violence have since reappeared often in Woodrow's work.

The relations of postindustrial modern man to the "primitive" is another of his themes. In *Car Door, Ironing Board, Twin-Tub with North American Indian Headdress* (1981), the last item in the title is made from the first three, and is connected to them in Woodrow's usual way. The very cunningly fashioned headdress is displayed in the foreground on a stand like those used in museums of tribal art. To Michael Newman, the piece seemed to comment "at once on how industrial societies tend to absorb images of 'the primitive' into popular culture (via movies, TV, comic books), how they tend to impose the values of consumer society on 'primitive' peoples themselves, and even how they tend to award the artist the role of honorary 'primitive,' someone quaintly alienated from mass values." Woodrow plainly rejects such a role, however; the images and objects of his own culture are an integral part of his approach to art, and seem to want to teach us a great deal. His appropriation of the objects of mass production (and his attitude toward them) is strikingly similar to the method of his countryman Tony Cragg (who has also used the image of the North American Indian). Both artists, in Michael Newman's words, "invite us to experience the postindustrial world as a plenitude rather than a rubbish heap."

Woodrow left London for New York City in the summer of 1983 to prepare for his first American show at the Barbara Gladstone Gallery. His entire tool kit consisted of two hammers, three pairs of pliers, and two metal cutters (to turn right- and left-hand corners). As usual, he would create the pieces for his show without assistants, without a large studio, finding on site whatever materials were needed. After nine intense weeks of creative activity, his show opened to critical acclaim. It contained several very striking works, including *Tattoo* (1983), in which a panther, constructed of black nylon (and looking, in silhouette, very much like a predator out of Douanier Rousseau), attacks the gleaming

haunch of a New York yellow Checker taxicab; the debris left behind the animal is also made of black nylon. Another New York work, *Cello/Chicken/Two Car Hoods* (1983), demonstrated, in Lynne Cooke's words, that "the new generation never fully usurps the authority of the old, never attains quite the same level of reality." The cello and chicken, attached to the car hoods from which they were fashioned, are obviously not real; they even seem less real than the battered industrial prefabrications beside them, with their functional cutouts. Woodrow's art is forever asking teasing questions about the relationships between its elements. The answers, once tentatively offered up, are never wholly clear or satisfactory. It seems fruitless, in any case, to search for any work's specific meaning. The art's secrets reveal themselves slowly, and for all its humor, it is never meant to be merely amusing. "I think quite often wit is involved," Woodrow has said, "but I would never set out to make a humorous work. That would be a disaster. Wit is involved with a sort of cynicism, and the combination of these two things can be very powerful."

During the 1980s Woodrow traveled extensively to produce his indigenous shows—to West Germany, France, the Netherlands, Italy, Switzerland, Canada, and Australia. "Ever since I was a kid," he has said, "I've had this urge to travel, to go to the world's cities and spend time absorbing their unique character. When I was a kid, I had no idea how I'd do this. It never occurred to me that it would happen this way. I didn't get into art to travel; now I travel to do my art." One of the most remarkable of his shows, entitled "Natural Produce: An Armed Response," took place in 1985 at the La Jolla Museum of Contemporary Art in the well-manicured, extremely conservative suburb of San Diego, California. The show's seven sculptural pieces were created under unusual circumstances, for La Jolla's urban refuse is, for the most part, invisible. "The garbage," the artist told a local interviewer, "is wrapped up mostly or closed up in skips—dumpsters you call them here—so you can't see what it is. Then, too, people get awfully nervous if they see you rummaging through their trash. So I went to junk stores and yards." The need to buy the raw materials for his art did not, however, diminish its ultimate power in any way. In a 1985 interview, Woodrow talked at length about the meaning of the show's title: "'Natural Produce' refers to the importance put on health here, partly to the notion of 'health food' and the like, but also to the way the cyclists are fitted out with all the right gear, the fashionable garb and the machinery of the sport they pursue, for health. I notice the runners

are the same. It's quite remarkable. But also, I'm putting forward the notion that my materials are 'natural produce.' They do, indeed, come to me as a result of a 'natural' process of production and obsolescence. The idea of 'Armed Response' came up when someone pointed out all the signs on houses and businesses announcing the property was protected by some private security company whose patrols carried guns. That's something I hadn't seen before at all. It's a very blatant statement about fear in this vacationlike environment and it says, 'If you come unwanted into my garden to take my natural produce, which is my property, you'll get shot.' Now, I don't feel shocked by these things. I find them fascinating. I see them as products of a culture—another 'natural product'—and that's what's so stimulating about traveling: seeing these different things and observing the environment where one happens to be and allowing it into my art."

One of the La Jolla show's most successful pieces was *Still Waters* (1985), in which the head of an elk, fashioned from car hoods, seems to push through the surface of the water, which is suggested by three very dirty old box springs. Its antlers have snagged a key, a gold bar, and a microphone (images of power and control, which the artist has used before). Behind the elk, emerging from another mattress, but connected to the animal by the metal strands characteristic of Woodrow's style, are larger debris—a chair, a stepladder, the smashed bow of a small boat. The elk, seemingly unhindered by all this human flotsam, continues on its way. Woodrow commented on the meaning of that work: "A consistent concern in my work relates to the idea of opposition between nature and people. Nature is a self-governing system that looks after itself, whereas it appears the system that people have at the moment is creeping outside of self-regulation. The two are so far apart that when we say 'nature,' it means everything except people and what they do. It's not a good situation.

"To get to this idea, one of the things I exploit more or less consciously in my work is the image of animals. It's something I call the 'Bambi syndrome.' When you have an animal or an image of an animal, people identify with it in a sentimental sort of way. I definitely exploit this to draw people to the work and then to engage them in other aspects of the piece. It's sort of a punch that engages other issues."

Perhaps the most southern Californian in flavor of the pieces in that show was *Trivial Pursuits* (1985). Here a slightly damaged door to a silver Porsche 928 seems to sprout delicate green foliage (Woodrow had been painting his creations for some time), whose flowers have attracted a blue hummingbird. The flowers, however, are in the shape of a padlock, a jewel box, and a handgun. The bird, with its long beak, seems to be picking the padlock. The artist's comments on that piece reveal his thought processes: "Keys, locks, and boxes are mysterious, and I find their forms visually beautiful, especially the older kinds. They can close something in, or they can let something out. They can seem both menacing and welcome because of this. In the work with the elk head, I wanted to have a key caught up in the antlers to suggest the elk was taking away these possibilities. And the microphone that's also in the antlers refers to the equipment you see often in images of musicians and politicians. It's a means by which one person—one small person—acquires great power through the technology of amplification.

"As for the gun, back home, I couldn't legally get a handgun at all. The whole situation here with guns represents an attitude that's amazing to Europeans. Combined with the Porsche door, which obviously suggests wealth, and the locked box, which might hold jewels, you don't know whether the gun is for defense or for offense.

"Nevertheless, the thing that was strongest for me in *Trivial Pursuits* was the hummingbird. I'd done a hummingbird before, in Australia. But when I actually saw the birds living in the wild here, I wanted to do the image again. This became combined in my mind with the notion of a bird picking a heavy padlock that's very female in shape. So there's also this sort of male-female thing and a connotation of forbidden fruit."

EXHIBITIONS INCLUDE: Whitechapel Art Gal., London 1972; Kunstlerhaus, Hamburg 1979; The Gal. Acre Lane, London 1980; New 57 Gal., Edinburgh 1981; Gal. Wittenbrink, Regensburg, West Germany 1981; Lisson Gal., London 1981, '83; Gal. Eric Fabre, Paris 1982; Ray Hughes Gal., Brisbane, Australia 1982; Gal. Venster, Rotterdam 1982; Gal. Michele Lachowsky, Antwerp 1982; Gal. Toselli, Milan 1983; Mus. van Hedendaagste Kunst, Ghent 1983; Mus. of Modern Art, Oxford 1983; Barbara Gladstone Gal., NYC 1983, '84, '85; Locus Solus, Genoa 1983; Mercer Union, Toronto 1984; Mus. de Toulon, France 1984; Kunsthalle Basel, Switzerland 1985; Donald Young Gal., Chicago 1985; La Jolla Mus. of Contemporary Art, Calif., (traveled to Univ. Art Mus., Univ. of California at Berkeley) 1985. GROUP EXHIBITIONS INCLUDE: "Objects and Sculpture," Inst. of Contemporary Art, London, (traveled to Arnolfini Gal., Bristol) 1981; "British Sculpture in the 20th Century," Whitechapel Art Gal., London 1981; Sydney Biennale 1982; "Leçon des Choses," Kunsthalle, Bern (traveled to Mus. d'Art et d'Histoire, Chambéry, France and Maison de la Culture, Chalon-sur-Saône, France) 1982; Venice Biennale 1982; Paris Biennale 1982; "Australian Perspecta," Art Gal. of New South Wales, Sydney 1983; "The Sculp-

ture Show," Hayward Gal., London 1983; "New Art," Tate Gal., London 1983; São Paulo Bienal 1983; "An International Survey of Recent Paintings and Sculpture," MOMA, NYC 1984; "Skulptur im 20. Jahrhundert," Merian Park, Basel 1984; "Terrae Motus I," Fondazione Amelio, Naples 1984; "Space Invaders," Mackenzie Art Gal., Regina, Canada 1985; "The British Show," British Council, London (traveled to Art Gal. of Western Australia, Perth, Art Gal. of New South Wales, Sydney, and Queensland Art Gal., Brisbane) 1985; "Nouvelle Biennale," Paris 1985; "Currents," Inst. of Contemporary Art, Boston 1985; "Carnegie International," Carnegie Inst. Mus. of Art, Pittsburgh 1985.

ABOUT: *Periodicals*—Artforum December 1981, January 1984; Art in America November 1983; ARTnews October 1981, May 1982, September 1983; Arts Magazine November 1983; Connoisseur April 1984; Flash Art February–March 1982, January 1984; Guardian January 14, 1982; Observer April 24, 1983; San Diego Magazine October 1985; Studio International July 1983.

YARBER, ROBERT (1948–), American painter whose brashly expressive paintings—large, often elongated canvases featuring hot video hues and darkly gripping scenarios—have the look and feel of a movie screen, presenting images more lurid than life. In settings like glitzy casinos, luxury resorts, and high-rise balconies that jut into nocturnal urban skies, conflicts of existence are played out. Yarber depicts people assailed by or victims of primal emotion—rage, passion, fear, loss. In some of the most striking paintings, the figures, corresponding to the unfettered expression of feeling, are themselves not bound to anything but sail past terraces or float by windows. Collectively and sometimes individually, Yarber's paintings convey a kind of emotional dialectic in their portrayal of both the traumas and the comforts of communion, the constant proximity of pleasure and danger inherent in involvement with others. More narrowly, they are about confronting the nightmare world fashioned by one's unconscious, a place Yarber depicts as disconcerting yet utterly familiar.

Yarber has said that he seeks to "map out the trajectory of . . . conflicting desires, the attraction and revulsion felt in states of emotional upheaval." The tension resulting from the juxtaposition of emotional dualities informs paintings like *Double Suicide* (1982), in which one couple sleeps peacefully entwined in a dim bedroom while another embracing pair plunges past their high-rise window. Romance is presented as a form of annihilation for the outside couple, quite literally falling in love. They may be comple-

mentary to the inside lovers, illustrating the inverse of joining up—falling out. But the painting's title suggests they are an emanation of the interior pair, signifying their ultimate emotional fate.

Impressions of alienation and unreality are heightened in many of Yarber's paintings by the presence of figures, like the sleeping couple in *Double Suicide*, who are oblivious to other figures' startling or conventional behavior: acts of sudden violence, public lovemaking, midair suspension. The figures brawling or embracing or floating by usually do so unnoticed, as though they are merely phantasms acting out the unconscious desires of their passive witnesses. In *Casino* (1985), for instance, a variety of discrete private dramas unfold in the center foreground of the canvas. A purplish light bathes the cavernous gambling palace and the scores of background figures who mill about or hunch over tables. In the left foreground, next to a roulette table, a man and woman clutch at one another on the floor. Two men at the right end of the table grapple, one held in a death grip. Next to the strangling man a couple pummel and toss drinks at one another. And at the left end of the table, three men focus on the roulette wheel before them, indifferent to the paroxysms of ecstasy and brutality all around them. Like other Yarber works, *Casino* shows the disjunction between ordinary, sanctioned behavior and that motivated by uncensored passions.

For all the familiarity of images like glittering city lights and glossy swimming pools, Yarber's paintings are decidedly otherworldly. In part this is due to the bold, skillful use of color. Electric hues, some almost fluorescent, are accentuated by dark, shadowy backgrounds. Too, the deep perspective employed in paintings like *Casino, Man on Floor,* and *Public Discord*—in which the interior space is immense, stark, umbrageous—gives the impression of events occurring in a vast, self-contained vacuum. Hermetic as a dreamworld, these settings share features of, but ultimately seem distanced from, a regular social context. Most instrumental in conveying dislocation from the "real" world are the figures poised in midair, flailing, floating, or jumping through space.

Yarber describes hypersuspension as "an ongoing obsession" of his. He relates it partly to Early Christian through baroque sacred painting, in which the image of the sacred or miraculous derives its potency from its placement within a familiar, recognizable context. (Figures of saints, for example, will be shown suspended in space in an otherwise quotidian scene.) "The sacred must . . . be seen as something that can

take place on the ordinary plane of reality," Yarber has explained. "While all else rests in its natural place, the suspended figure suggests the force of another order." The hovering people in Yarber's paintings can readily be seen as a contemporary expression of that idea, but the "other order" evoked in his canvases seems to reflect modern theories of the unconscious rather than to pay mystical religious tribute.

Yarber, who lives in Austin, Texas, was born in Dallas in 1948. Of the resort hotels often depicted in his paintings, he has said, "I grew up going to those places. We did a lot of hotels, traveled a lot. When I was growing up in Dallas, my periodic visits to California were so lush." Yarber received a bachelor's degree in fine arts from Cooper Union College in New York in 1971 and a master of fine arts degree from Louisiana State University in 1974. In 1982 and 1983 he taught painting and lectured at the University of California at Berkeley and at the University of Texas at Austin. The artist received a National Endowment for the Arts Fellowship Grant in 1983. His work has appeared in dozens of group shows since 1967, including the 1985 Whitney Biennial. Among his solo outings were two exhibitions at the Sonnabend Gallery in New York, which represents him.

In the summer of 1985, two of Yarber's paintings were included in the art sponsor/critic Archille Bonito Oliva's "Nuove Trame Dell'Arte" show. The exhibition was installed in the half-ruined caste where Oliva had introduced the "three C's"—Chia, Clemente, and Cucchi—in 1979. The 1985 show featured the work of sixty-three artists, predominantly neo-expressionists, born between 1947 and 1959. Robert Yarber was one of sixteen Americans. John R. Clarke, writing about the exhibition for *Arts* magazine, considered that Yarber's canvases "turned the show around." *Resort* and *Man on Floor,* hung in the castle's largest room, "literally jumped out from the wall, bursting with figural energy," Clarke wrote. *Man on Floor* contains many elements almost standard to a Yarber composition: the action occurring in a sleek interior at night, the falling figure motif, an apparent victim of violent action, and bystanders who are oblivious or indifferent to the victim's plight. A bar, bordered by a desolate row of empty stools, snakes down the right side of the canvas. On the extreme right is one arm and part of the head of the bar's single patron, whom the barman tends. To the left is a series of floor-to-ceiling windows, beyond which a shimmering pool can be glimpsed. Over the water, finger-shaped protrusions emerge from a dark cloud, seemingly pointing toward the interior scene. Inside, in the center foreground of the painting, a man lies face down on the carpet, apparently dead. His limbs are splayed, as though he has fallen from a great height. On a screen over the heads of the unconcerned customer and bartender, a figure clutching a spear falls through the air, perhaps an ironic identification of the *Man on Floor* as a fallen warrior. The painting is formally arresting as well. "Figures and architecture appear to be solid because of chiaroscuro," Clarke commented, "but it is a tenuous illusion. Yarber delineates them in cool and warm complementary colors so that the viewer rapidly distinguishes their lighted from their shaded sides. This color convention . . . causes the figures' volumes to empty out so that they once again become transparent drawings. The blacks of the background (blue-black, red-black, green-black) show through the figures and the background, consigning them to an unreal world."

In terms of subject matter the paintings are, Yarber has said, "exercises in memory, of my childhood fantasies of California." He prefers personal recall to photographs as a source of images, but he does use postcards and travel brochures "to call up these private recollections." Generally the artist does not commit his ideas to paper or canvas right away. When he is ready, he often works up a finished pastel from loose sketches. Done on black paper, the pastels possess "an immediacy and directness" he finds appealing. Yarber has said that when he first became aware of art, in the 1960s, "there was a movement from the gestural to the slick going on. I've always been mixed up about whether to hide or show the gesture. In pastel you can do both, by smearing areas in smooth veils of color and then scribbling over them." Although some of the paintings are worked up directly on the canvas, many are the result of a more involved process. "The transfer of the idea from pastel to painting can be loose or more explicit," Yarber has explained. He often photographs the pastels and paintings "at all stages of development. There is a layering going on." This emphasis on process can be seen in the finished pieces, in which acrylic underpainting is overlaid with oil pigment and glazes.

The sophisticated rendering of Yarber's darkly gleaming universe is integral to the effect of these neon epics, whose meanings finally remain ambiguous. But for all the dissension and alienation in the paintings, the outwardly grimmest convey something magical as well: the heady release, however transient, and power, however illusory, of moving unbounded through space. The depictions of jumpers are not, Yarber explains, narratives about suicide. Instead he means to portray "both heroic and tragic figures. They're trying to wrest themselves from their

milieu to an alternative reality. . . . One imagines that their attempt will prove futile, if gravity has its way. However, this is a painting, so they are now held forever in mid air. The hope is held out for miraculous salvation; there are intimations of immortality. They fly."

EXHIBITIONS INCLUD
E: Bowery Gal., NYC 1970; Univ. of New Orleans 1974; Simon Lovinsky Gal., Los Angeles 1981; Dominican Col., San Rafael, Calif. 1981; Simon Lovinsky Gal., San Francisco 1981; Steven Lieber Gal., Dallas 1983; Mattingly Baker Gal., Dallas 1984; Southwestern Univ., Georgetown, Texas 1984; Asher/ Faure Gal., Los Angeles 1984, '87; Vollum Col. Cntr. Gal., Reed Col., Portland 1985; Sonnabend Gal. NYC 1985, '87; Greene Gal., Coconut Grove, Fla. 1987; Thomas Cohn Arte Contemporanea, Rio de Janeiro 1987. GROUP EXHIBITIONS INCLUDE: Dallas Mus. of Fine Arts 1967; Bowery Gal., NYC 1969, '71; Oakland Mus.of Art, Calif. 1979; Blackfish Gal., Portland 1980; Los Angeles Inst. of Contemporary Art 1981; San Francisco Art Inst. Gal. 1982; Anthology Film Archives, NYC 1982; Fisher Gal., Univ. of Southern California, Los Angeles 1983; Oakland Mus., Calif. 1983; San Francisco Art Inst. 1983; San Antonio Art Inst. 1983; Waco Art Cntr., Texas 1983; New Mus. of Contemporary Art, NYC 1984; 41st Venice Biennale 1984; San Francisco Mus. of Contemporary Art 1984; Tracey Garet Gal., NYC 1984; P.S. 1, Long Island City, NYC 1984; Artist's Space, NYC 1984; Alternative Mus., NYC 1984; Larry Gargosian Gal., Los Angeles 1984; Whitney Mus. of American Art, NYC 1985; Delaware Art Mus. 1986; Mus. of Fine Arts, Boston 1986; Indianapolis Mus. of Art 1986; Cntr. National d'Art Contemporain, Paris 1986; Holly Solomon Gal., NYC 1987; Stamford Mus. 1987; M-13 Gal., NYC 1987.

ABOUT: *Periodicals*—Artforum October 1983, January 1986; Art in America March 1986; ARTnews January 1986; Arts Magazine September 1986; Art Week August 14, 1982, September 17, 1983, April 23, 1983, August 11, 1984; New York Times March 22, 1985.

Photo Credits

Julian Alberts: photo by Charles Ashby; *Arman*: © Hans Namuth 1975; *Robert Arneson*: © Harvey Stein 1986; *Richard Artschwager*: © Hans Namuth 1988; *Alice Aycock*: photo by Sylvia Plachy.

John Baldessari: photo by Robin Holland; *Miguel Barcelo* © Hans Namuth 1990; *Jennifer Bartlett*: © Harvey Stein 1986; *Jean Michel Basquiat*: © Sylvia Plachy; *Lynda Benglis*: © Harvey Stein 1986; *Ross Bleckner*: © Hans Namuth 1987; *Jonathan Borofsky*: photo by Robin Holland.

Louisa Chase: © Harvey Stein 1986; *Sandro Chia*: © Timothy Greenfield-Sanders; *Francesco Clemente*: © Timothy Greenfield-Sanders; *Sue Coe*: photo by Robin Holland; *Robert Combas*: © Hans Namuth 1990; *Philip C. Curtis*: photo by Jose Bermudez.

Eric Fischl: © Timothy Greenfield-Sanders 1988; *Mary Frank*: © Hans Namuth 1978; *Jane Freilicher*: © Timothy Greenfield-Sanders.

Gilbert & George: © Timothy Greenfield-Sanders; *Leon Golub*: photo by Fred W. McDarrah; *Nancy Graves*: photo by Robin Holland.

Keith Haring: photo by Robin Holland; *Michael Heizer*: © Harvey Stein 1986; *Eva Hesse*: photo by Fred W. McDarrah; *Margo Hoff*: photo by Fred W. McDarrah; *Jenny Holzer*: photo by Robin Holland; *Bryan Hunt*: © Timothy Greenfield-Sanders.

Anselm Kiefer: © Benjamin Katz/Time Magazine; *Jeff Koons*: © Timothy Greenfield-Sanders; *Joseph Kosuth*: © Timothy Greenfield-Sanders; *Barbara Kruger*: © Timothy Greenfield-Sanders.

Sherrie Levine: © Timothy Greenfield-Sanders; *Robert Longo*: © Harvey Stein 1986.

Brice Marden: © Timothy Greenfield-Sanders; *Richard Miller*: Howard Ross; *Elizabeth Murray*: © Hans Namuth 1987.

A. R. Penck: photo by Robin Holland.

Faith Ringgold: photo by Fred W. McDarrah; *Susan Rothenberg*: © Harvey Stein 1983; *Edward Ruscha*: © Harvey Stein 1984; *Robert Ryman*: © Timothy Greenfield-Sanders.

David Salle: photo by Robin Holland; *Lucas Samaras*: © Hans Namuth 1980; *Julian Schnabel*: © Hans Namuth 1985; *Carolee Schneemann*: photo by Fred W. McDarrah; *Richard Serra*: © Hans Namuth 1990; *Joel Shapiro*: photo by Mark Stern; *Cindy Sherman*: photo by Robin Holland; *Charles Simonds*: © Robin Holland 1982; *George Sugarman*: © Hans Namuth 1986; *Donald Sultan*: photo by Robin Holland.

Philip Taaffe: © Hans Namuth 1987.

Jim Waid: photo by Cynthia Gans-Lewis; *William Wegman*: photo by Robin Holland; *H. C. Westermann*: photo by Fred W. McDarrah; *Bill Woodrow*: © Robin Holland 1987.